The Compact Photo-Lab-Index

**The Cumulative Formulary
of Standard Recommended
Photographic Procedures**

Ernest M. Pittaro, *Editor*

Morgan & Morgan, Inc., *Publishers*
145 Palisade Street
Dobbs Ferry, N.Y. 10522

The Fountain Press, London

1

The Compact Photo-Lab-Index

BASIC SET PUBLISHED: June, 1939
THIRTY-SIXTH EDITION: 1978
2nd COMPACT EDITION, 1979

THE COMPACT PHOTO-LAB-INDEX

© Copyright 1979

BY MORGAN & MORGAN, INC.

International Standard Book Number 0-87100-133-0 (hardbound)

International Standard Book Number 0-87100-116-0 (softbound)

Library of Congress Catalog Card Number: 77-79076

———————

MORGAN & MORGAN, INC.
145 Palisade Street
Dobbs Ferry, New York 10522
Tel.: (914) 693-9303

ACKNOWLEDGMENTS AND DIRECTORY

THE EDITOR and THE PUBLISHERS extend their appreciation
and thanks on behalf of photographers and users of photographic
materials, to the manufacturers of photographic materials that
appear in this book.

Printed in U.SA.

The Compact Photo-Lab-Index

AGFA-GEVAERT—Pages 16 thru 35

EASTMAN KODAK—Pages 36 thru 374

(Continued on following page)

EASTMAN KODAK—Continued

(Continued on following page)

The Compact Photo-Lab-Index

EASTMAN KODAK—Continued

Processing, Low Temperature Kodak Amidol-Catechol Developer SD-22 **358**
Processing, Low Temperature Notes **358**

REDUCERS

R-2 Permanganate **342**
R-4a Farmer's **342**
R-7 Ferric-Alum Proportional **344**
R-8a Modified Belitzki **345**
R-15 Persulfate **345**
R-4b Two-Solution Farmer's **343**
Reducer, Acid Permanganate Persulfate R-5 **344**
Reducer, Farmer's R-4a **342**
Reducer, Permanganate R-2 **342**

REPLENISHERS

Microdol-X Replenishment **306**
Replenisher D-19R **311**
Replenisher DK-20R **313**
Replenisher DK-25R **314**
Replenisher DK-50R **316**
Replenisher DK-60aTR **317**
Replenisher D-61R **319**
Replenisher D-76R **320**

Replenisher D-94R **322**
Replenisher for Fixing Bath F-10R **331**

DEVELOPERS, PAPER

GAF 103 Paper Developer **450**
Reciprocity Data, Color Films **172**
Separation Negatives, Making **262**

SPECIAL FORMULAS

Anti Calcium **351**
S-6 Stain Remover **349**
S-10 Stain Remover **349**
TC1 Tray Cleaner **350**
TC3 Tray Cleaner **350**

TONERS

T-1a Hypo-Alum Sepia Toner **352**
T-7a Sulfide Sepia Toner **353**
T-8 Polysulfide Toner (Sepia) **353**
T-11 Iron Toner **354**
T-12 Iron Toning Bath **354**
T-18 Toning Bath **355**
T-20 Single Solution Dye Toner **355**
T-21 Gold Toner (Nelson) **356**

FUJI—Pages 375 thru 418

STILL FILMS

F-II Color Negative Film 135, 126, 110, 120 **375**
F-II 400 Color Negative Film 135, 120, 110 **379**
Fujichrome R-100 (135) Daylight Type **385**
Fujicolor Paper Resin Coated Type 8907 **391**
Fuji Authorized Processing Laboratories in USA **395**
Single 8 Fujichrome R-25 **396**
Single 8 Fujichrome RT-200 **399**

PROFESSIONAL MOTION PICTURE FILMS 402 thru 418

Fujicolor Reversal TV Film RT-100 16mm Type 8426 **402**
Fujicolor Reversal TV Film RT-400 16mm Type 8425 **406**
Fujicolor Negative Film 35mm Type 8517, 16mm Type 8527 **410**
Fujicolor Positive Film 35mm Type 8812, 16mm Type 8822, 16/8 Type S Type 8822 **413**
Fujicolor Positive HP Film, 35mm Type 8813, 35/16 Type 8823, 16mm Type 8823, 35/8 Type S Type 8823, 16/8mm Type S Type 8823, 16/8mm Type R Type 8823 **416**

GAF—Pages 419 thru 461

DEVELOPERS, HOW THEY WORK 435

Gafmate Developer **419**

DEVELOPERS, FILM, by number

GAF 12 Fine-Grain Tank **441**
GAF 17 Fine-Grain Borax Tank **441**
GAF 17a Replenisher **441**
GAF 17M Fine-Grain Metaborate **442**
GAF 17M-a Replenisher **442**
GAF 20 M-H Positive **442**
GAF 22 M-H Title **443**
GAF 30 X-Ray **443**
GAF 40 M-H Tray **443**
GAF 42 M-H Tank **444**
GAF 45 Pyro **444**
GAF 47 Metol-Hydroquinone **445**
GAF 47a Replenisher **445**
GAF 48M Metaborate Tank **445**
GAF 48M-a Replenisher **446**
GAF 61 M-H Tray **446**
GAF 64 Rapid M-H (Tropical) **446**
GAF 70 Hydroquinone Caustic **446**
GAF 72 Glycin **447**
GAF 79 Paraformaldehyde (one solution) **447**
GAF 79b Paraformaldehyde (two solution) **448**
GAF 81 Long-Life Reprolith **448**
GAF 90 High Contrast M-H Tray **448**
GAF 110 Direct Brown-Black Developer **450**

GAF 113 Amidol Paper Developer **451**
GAF 115 Glycin Hydroquinone Developer **451**
GAF 120 Soft-Working Paper Developer **451**
GAF 125 Metol-Hydroquinone Developer **452**
GAF 130 Universal Paper Developer **452**
GAF 135 Warm-Tone Paper Developer **453**
Miradol **425**
Vividol **426**

FIXING BATHS

Fixing Baths, How They Work **438**
Acid Fixer with Hardener (package) **429**
GAF 201 Acid Hardening Fixing Bath **453**
GAF 202 Chrome Alum Fixing Bath **454**
GAF 203 Nonhardening Metabisulfite Fixing Bath **454**
Shurfix **424**
Shurfix Type II Fixer & Hardener **428**
Vivistop Short Stop **427**
Hardening Bath, Chrome Alum GAF 216 **455**
Hazards and Safety Precautions **430**

INTENSIFIERS

GAF 330 Mercury Intensifier **460**
GAF 331 Monckhoven's Intensifier **458**
GAF 332 Chromium Intensifier **459**
Pinkakryptol Green Desensitizer GAF 351 **461**
Rapid Processing Procedure for Films **449**

(Continued on following page)

5

The Compact Photo-Lab-Index

GAF—Continued

ILFORD—Pages 462 thru 565

(Continued on following page)

6

The Compact Photo-Lab-Index

ILFORD—Continued

POLAROID

(Continued on following page)

MISCELLANEOUS MANUFACTURERS

The Compact Photo-Lab-Index

DIRECTORY OF MANUFACTURERS

ACME-LITE MFG. CO.
4650 W. Fulton St.
Chicago, Ill. 60644
(312) 379-6860

ACUFINE, INC.
439-447 E. Illinois St.
Chicago, Ill. 60611
(312) 321-0240

ADVANCE PRODUCTS CO.
Central at Wabash
Wichita, Kans. 67201
(316) 263-4231

AETNA OPTIX, INC.
44 Alabama Ave.
Island Park, L.I., N.Y. 11558
(212) 889-8570

AGFA-GEVAERT, INC.
275 North St.
Teterboro, N.J. 07608
(201) 288-4100

AMERICAN NATIONAL STANDARDS INSTITUTE
1430 Broadway
New York, N.Y. 10018
(212) 868-1220

AMGLO INDUSTRIES, INC.
5301 Wesley Terrace
Rosemont, Ill. 60018
(312) 671-4321

BEMISS-JASON CORP.
3250 Ash St.
Palo Alto, Calif. 94300
(415) 493-0740

BERKEY MARKETING COMPANIES, INC.
25-20 Brooklyn Queens Expressway
Woodside, New York 11377
(212) 932-4040

BESELER PHOTO MARKETING COMPANY, INC.
8 Fernwood Road
Florham Park, New Jersey 07392
(201) 822-1000

BEST PHOTO INDUSTRIES, INC.
Bowman Field
Louisville, Ky. 40205

B D CO., THE
P.O. Box 3057
2011 West 12 St.
Erie, Pa. 16512
(814) 453-6967

BERG COLOR-TONE, INC.
P.O. Box 16
East Amherst
New York 14051

BOURGES COLOR CORPORATION
84 Fifth Ave.
New York, N.Y. 10011
(212) 924-8070

BRAUN NORTH AMERICA
PHOTO PRODUCTS DIVISION
55 Cambridge Parkway
Cambridge, Mass. 02142
(617) 492-2100

CHEMCO PHOTO PRODUCTS COMPANY
A DIVISION OF POWERS CHEMCO, INC.
Glen Cove
New York 11542
(516) 676-4000

CHRISTIE CHEMICAL CO. LTD.
7995 14th Avenue
Montreal, Quebec H1Z 3M2
725-9381

CLAYTON CHEMICAL CO., DIV. OF APECO
2100 Dempster
Evanston, Ill. 60204
(312) 328-0001

CODA, INC.
196 Greenwood Avenue
Midland Park, N.J. 07432
(201) 444-7755

COMPCO CORP.
1800 N. Spaulding Ave.
Chicago, Ill. 60647
(312) 384-1000

duPONT de NEMOURS & CO., E. I.
General Services Dept.
Product Inquiry Ref. Sec.
1007 Market St.
Wilmington, Del. 19898
(302) 774-2421

DURA ELECTRIC LAMP CO., INC.
64 E. Bigelow St.
Newark, N.J. 07114
(201) 243-0014-0015

DURACELL PRODUCTS COMPANY
Div. of P. R. Mallory & Co., Inc.
S. Broadway
Tarrytown, N.Y. 10591
(914) 591-7000

(Continued on following page)

The Compact Photo-Lab-Index

DURO-TEST CORPORATION
North Bergen
New Jersey 07047
(201) 867-7000

EASTMAN KODAK CO.
343 State St.
Rochester, N.Y. 14650
(716) 325-2000

EDWAL SCIENTIFIC PRODUCTS CORP.
12120 S. Peoria St.
Chicago, Ill. 60643
(312) 264-8484

EDNALITE CORP.
200 N. Water St.
Peekskill, N.Y. 10566
(914) 737-4100

ETHOL CHEMICALS INC.
1808 North Damen Ave.
Chiacgo, Ill. 60647
(312) 278-1586

FR, DIV. of PHOTOMAGNETICS, INC.
Photo Products Div.
420 Commercial Sq.
Cincinnati, Ohio 45202
(513) 421-4600

FR, DIV. of PHOTOMAGNETICS, INC.
Chemical Div.
16 Gordon Pl.
Yonkers, N.Y. 10703
(914) 375-0600

FUJI PHOTO FILM, U.S.A.
350 Fifth Ave.
New York, N.Y. 10001
(212) 736-3335

GAF CORPORATION
Binghamton
New York 13902
(607) 729-6555

GALLERY 614
614 West Berry St.
Fort Wayne, Indiana 46802
(219) 422-6203

GENERAL ELECTRIC CO., LAMP DIV.
Nela Park
Cleveland, Ohio 44112
(216) 266-2258

GENERAL PHOTO PRODUCTS CO.
182 Cole Avenue
Williamstown, Mass. 01267
(413) 458-5761

GTE SYLVANIA
100 Endicott St.
Danvers, Mass. 01923
(617) 777-1900

HANIMEX (U.S.A.), INC.
7020 N. Lawndale Ave.
Chicago, Ill. 60645
(312) 676-0700

HARCO INDUSTRIES
10802 N. 21st Ave.
Phoenix, Ariz. 85029
(602) 944-1565

HARRISON & HARRISON
6363 Santa Monica Blvd.
Hollywood, Calif. 90038
(213) 464-8263

HEICO, INC.
Delaware Water Gap
Pennsylvania 18327
(717) 476-0353

THE HOLLINGER CORPORATION
3810 S. Four Mile Run Drive
Arlington, Virginia 22206
(703) 671-6600

HONEYWELL PHOTO PRODUCTS, INC.
5501 S. Broadway
P.O. Box 1010
Littleton, Colo. 80120
(303) 794-8200

THE H&W CO.
Box 332
St. Johnsbury, Vt. 05819
(802) 748-8743

PHILIP A. HUNT CHEMICAL CORPORATION
Roosevelt Pl.
Palisades Park, N.J. 07650
(201) 944-4000

HUSTLER PHOTO PRODUCTS, INC.
P.O. Box 14
St. Joseph, Mo., 64502
(816) 233-1237

(*Continued on following page*)

DIRECTORY OF MANUFACTURERS (continued)

ILFORD, INC.
West 70 Century Road
P.O. Box 288
Paramus, New Jersey 07652
(201) 265-6000

ITEK GRAPHIC PRODUCTS DIVISION
1001 Jefferson Road
Rochester, N.Y. 14603
(716) 244-5600

ITT
Photo Lamp Products
133 Terminal Ave.
Clark, N.J. 07066
(201) 381-2828
(212) 964-7970

JAMIESON PRODUCTS CO.
9341 Peninsula Drive
Dallas, Texas 75218
(214) 321-0279

KMS INDUSTRIES INC.
P.O. 1778
Ann Arbor, Michigan 48106

LUMINOS PHOTO CORP.
25 Wolffe St.
Yonkers, N.Y. 10705
(914) 965-5254
Telex 13-1575

MALLORY BATTERY CO. INC.
South Broadway
Tarrytown, N.Y. 10591
(914) 591-7000

3M COMPANY, PHOTOGRAPHIC PRODUCT DIV.
3M Center 220-3E
St. Paul, Minn. 55101
(612) 733-1110

JOHN G. MARSHALL MANUFACTURING CO., INC.
167 North 9th St.
Brooklyn, N.Y. 11211
(212) 387-6600

MAY & BAKER LTD.
Dagenham Essex RM10 7XS
England
Tel. 01-592-3060

METALPHOTO CORP.
18531 S. Miles Road
Cleveland, Ohio 44128
(216) 475-0555

MINMAX
P.O. Box M
Harbor City
California 90710
(213) 530-8610

MORGAN & MORGAN, INC.
145 Palisade St.
Dobbs Ferry, N.Y. 10522
(914) 693-9303

NATIONAL AUDIO VISUAL ASSOCIATION
3150 Spring St.
Fairfax, Va. 22030
(703) 273-7200

NEGA-FILE, INC.
P.O. Box 78
Furlong, Pa. 18925
(215) 348-2356

NORTH AMERICAN PHILIPS LIGHTING CORP.
Bank St.
Hightstown, N.J. 08520
(609) 448-4000

PATERSON PRODUCTS LTD.
2-6 Boswell Court
London WC1N 3PS
Tel. 01-405-2826
Telegrams: Patview London WC1—Telex 897822

POLAROID CORPORATION
Cambridge, Mass. 02139
(617) 864-6000

POLAROID HOT LINE
Call Collect:
(617) 547-5176
Mon.-Fri., 9 a.m.-4:30 p.m.
Eastern Time

RETOUCH METHODS CO., INC.
P.O. Box 345
Chatham, N.J. 07928
(201) 377-1184

ROCKLAND COLLOID CORP.
599 River Road
Piermont, N.Y. 10968
(914) 359-5559

ROSCO LABORATORIES, INC.
36 Bush Ave.
Port Chester, N.Y. 10573
(914) 937-1300

(Continued on following page)

DIRECTORY OF MANUFACTURERS (continued)

SEAL, INC.
550 Spring St.
Naugatuck, Conn. 06770
(203) 729-5201

SOCIETY OF MOTION PICTURE & TELEVISION
ENGINEERS
862 Scarsdale Ave.
Scarsdale, N.Y. 10583
(914) 472-6606

SPIRATONE, INC.
135-06 Northern Boulevard
Flushing, N.Y. 11354
(212) 886-2000

SUPREME PHOTO PRODUCTS
543 W. 43rd St.
New York, N.Y. 10036
(212) 695-4200

SYLVANIA (See
GTE SYLVANIA)

TIFFEN MANUFACTURING CORP.
71 Jane Street
Roslyn Heights, N.Y. 11577
(516) 621-2700

TKO CHEMICAL CO.
303 South 5th St.
St. Joseph, Mo. 64501
(816) 232-7194

TRI-COLOR PRODUCTS
P.O. Box 371
Woodland Hills
California 91364
(213) 346-1160

UNICOLOR DIV. PHOTO SYSTEMS, INC.
P.O. Box 306
Dexter, Mich. 48130
(313) 426-4646

WESTON INSTRUMENTS
Div. of Daystrom Inc.
614 Frelinghuysen Ave.
Newark, N.J. 07114
(201) 243-4700

WESTINGHOUSE LAMP DIV.
Westinghouse Plaza
Bloomfield, New Jersey 07003
(201) 465-0222

XEROX CORPORATION
Xerox Square
Rochester, N.Y. 14644
(716) 546-4500

The Compact Photo-Lab-Index

INTRODUCTION

This Compact Photo-Lab-Index offers to the professional and amateur photographic worker a vast collection of essential photographic data in easily used form.

The information in the Compact Photo-Lab-Index has been extracted from the larger Lifetime Edition, giving the reader important data in an easily used form.

The subject matter is indexed according to manufacturer, and black edge tabs on the pages will aid the reader in locating the products of a specific company.

There are many useful formulas in the Compact Photo-Lab-Index so that the experimenter may compound his own photographic solutions if he wishes to do so.

For further information beyond the scope of this Compact Edition, the reader is referred to the larger loose-leaf edition and Supplement Service of the Lifetime Edition of the Photo-Lab-Index which is available from your local photographic dealer or from Morgan & Morgan Inc., Publishers.

Photography is becoming such a vast field of activity that it would be difficult to name all its current applications. This accounts for the multiplicity of formulas required to cover specifically certain phases of photography. Actually most photographic formulas are made up of less than a dozen chemical ingredients. They differ from each other chiefly in the proportions of those ingredients. Slight changes in these proportions have great effect upon the relative performance of the solutions.

As photography increases in popularity, attracting constantly growing numbers of practitioners, the need for standardized information becomes increasingly apparent. Constant additions of new materials, such as films, papers, with their respective properties, make it difficult to keep track of all recommended procedures. Adding to this confusion are literally hundreds of "private" brands of photographic solutions and procedures containing little known or altogether unknown characteristics, but distinguished by the extravagant and often imaginary claims made for them by their producers and distributors. This situation makes it imperative to determine what is to be considered a truly **Recommended Procedure.** After extensive investigation and consultations with outstanding impartial experts and constant users of photographic products, it was decided to **consider that photographic procedure, as "recommended," which is published by the manufacturer of the photographic material is most suitable and best for securing consistently satisfactory results.**

ARRANGEMENT OF FORMULAS

To facilitate their intelligent use and application, all formulas throughout the **Photo-Lab-Index** are offered not only in a uniform typographical arrangement, but also in a uniform standard of volume, whenever possible. The standard adopted is the U.S. Customary (avoirdupois) unit of volume, 32 ounces (1 quart), and the metric unit of volume of 1.0 liter (1000.0 ml). These units have been found most practical and useful for many reasons: formulas uniformly expressed in these units are readily understood, easily compared with one another, readily converted into larger or smaller volumes by simple multiplication or division. Especially when a formula is expressed in the metric system, it immediately creates a mental picture of the relative concentrations of the various ingredients, as it gives visually a percentual relationship of each ingredient to the total volume. The two systems of measurement, the U.S. Customary (avoirdupois) and the metric, offer solutions of practically identical concentrations in two methods of measurement. It should be remembered that, while formulas expressed in either 32 ounces or 1.0 liter volumes are practically equivalent as far as their strength and composition are concerned, they represent distinctly different totals of volume. One liter equals 33.81 fluid ounces while 32 ounces (one quart) equals 0.9463 liter.

Only in a few instances were formulas left expressed in larger units of volume than 32 ounces or 1.0 liter, as originally published by the manufacturer, to avoid introduction of an error which, due to the nature of the formula, may have become cumulative.

The Compact Photo-Lab-Index

Names of chemicals used throughout the **Photo-Lab-Index** have been standardized. With the exception of trade names given to certain ingredients and recommended by their respective makers, all names of chemicals are those accepted in standard textbooks of chemistry. Certain photographic ingredients, such as p-Methylaminophenol Sulfate, are offered under a variety of trade names. Ansco carries it under the name of Metol; Eastman Kodak Co., under the name of Elon; DuPont Co., under the name of Rhodol; The Mallinckrodt Co. names their product Pictol; Merck & Co. supply it under the name Photol. While it may be assumed that many of these are interchangeable it seems wiser to use ingredients as specified in the formula.

Similarly, terms such as caustic soda, caustic potash, are replaced by their correct chemical names: sodium hydroxide and potassium hydroxide, respectively.

Spelling of such names as sulfite, sulfate, sulfuric, etc., has been simplified by the use of the letter "f" in place of the letters "ph" wherever it appeared expedient. Wherever such substitutions might have resulted in misunderstandings, the original spelling was left intact.

CHARACTERISTIC AND CONTRAST INDEX CURVES

Very few photographers use the unreliable "inspection" method of development. Time and temperature methods of development are superior for accuracy and reproducibility. This method can be used only when controlled conditions are established to allow a given film to reach a certain degree of development on a predictable basis. Some of the variables are: the film itself, exposure, developer, temperature, agitation, time of development, and fixation. To bring these variables under control, standard sensitometric procedures should be used. Whenever manufacturers supply characteristic curves or contrast index curves, they are published in **Photo-Lab-Index.** These can be used as a basis for deriving control methods for your processing.

CONTRAST INDEX

Recommendations for development of films have, in the past, been based on development to a specific gamma. Gamma takes into account only the slope of the straight line portion of the curve; it ignores the toe and shoulder sections as being outside the range of "correct exposure." This approach was both theoretically satisfactory and practically useful as long as one considered the older types of film, used in larger cameras, where fairly dense negatives were preferred for contact printing, and for enlarging in large diffusion type enlargers, on simple bromide papers.

Currently, the trend is to smaller negatives, printed on condenser enlargers, on mixed chloro-bromide papers. In general, for such work, a thinner negative is preferred, and this thinner negative is attained, not by development to a lower gamma, but by using the minimum practical exposure, which implies the use of a good deal of the toe portion of the characteristic curve. Modern negative materials are designed to be exposed in this manner; unlike the older films which had a short sharp toe and a long straight line portion, the newer films have long sweeping toes and the straight line section may be substantially curved. When making exposures on such films, gamma is not a reliable indicator of the density scale of the negative.

The diagram below shows the characteristic curves of two materials, A and B, having different curve shapes, developed to equal gamma. It is not possible to print both these negatives on the same grade of paper, since the one on Film A has a density range of 1.00 and the one on Film B has a range of only .78.

It is obvious that a new measure of development contrast must be adopted if various materials are to be developed in such a way that the resulting negatives can all be printed on the same grade of paper. In effect, this is done by drawing a straight line on the characteristic curve, connecting the lowest and highest density normally used in practice. The slope of this line in analagous to gamma, and is called Contrast Index. Usually the low point of the line is found by using an arbitrary low density point of 0.1 above base-plus-fog, then finding the upper point by striking an arc of 2.0 density units to intersect the characteristic

14

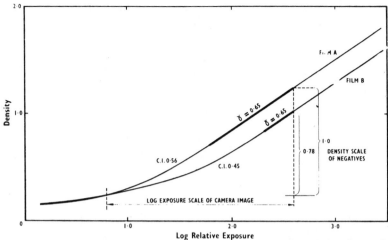

curve. A straight line is drawn connecting the two points, and the slope of this line is the Contrast Index.

In the drawing below, the same two films shown in the previous graph have been developed to equal Contrast Index of 0.56; however, to attain this, Film A has been developed to a gamma of 0.65 and Film B has been developed to a gamma of 0.86. Both negatives have a density scale of 1.0 and both will print on the same grade of paper.

For normal paper (Grade 2), a Contrast Index of 0.56 is suitable for printing on a diffusion type enlarger, and a Contrast Index of 0.45 will be satisfactory with condenser-type enlargers.

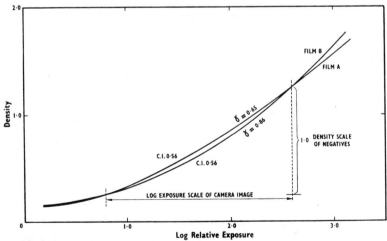

For those who are interested in the theoretical and practical implications of Contrast Index beyond this necessarily brief explanation, we recommend the following:

15

AGFA BLACK-AND-WHITE STILL FILMS

ISOPAN ISS—ASA 100

A moderate speed, fine grain, panchromatic film offering wide latitude in exposure and development. Available in the U.S. in 120 rolls in bulk quantity only.

DIA COPEX R

A reversal, panchromatic film for photography in daylight and artificial light. It produces brilliant transparencies in black-and-white which are particularly suited for projection to very large dimensions. Dia Copex R is capable of recording subjects of high contrast. It therefore offers a solution where the tone range of any paper available (of a maximum tone range of 50 to 1) proves to be insufficient. In contrast to other miniature films the anti-halation layer is between the base and the emulsion, and thus stops the light from reaching the base and producing halation. The anti-halation layer completely disappears in the reversal bath.

The processing of Dia Copex R can be carried out only by one of the authorized Agfa-Gevaert laboratories shown on the list of addresses enclosed with each film. Available in 35mm only.

AGFA COLOR STILL FILMS

AGFACHROME CT 18
ASA—Daylight 50, Tungsten 12

A very fine-grain, medium-speed, color transparency film balanced for 5500 K exposure (daylight, electronic flash or blue flash bulbs) without a filter and for tungsten (3200 K) with a Kodak Filter No. 80A. Available in 35mm, 120 rolls, 126 cartridges.

AGFACOLOR CNS
ASA—Daylight 80, Tungsten 20

A double-masked, very fine-grain color negative film balanced for daylight exposure without a filter and for tungsten (3200 K) exposure with a Kodak Filter No. 80A. Available in 35mm, 120 rolls, 126 cartridges. Sold with processing included.

AGFACHROME CT-18 ASA 50
Reversal Color Film

GENERAL PROPERTIES

Agfachrome CT-18 is a reversal type color film producing color transparencies for projection and other uses. It is designed for daylight exposure without filters, and is sold with processing and mounting included. Available in 35mm, 120 rolls, 126 cartridges.

FILM SPEED

Daylight—ASA 50 No filter required.
Tungsten (3200 K)—ASA 12 With
 Filter No. 80A

DAYLIGHT EXPOSURE TABLE

**Lens Opening and Exposure Value With Shutter
1/100 to 1/125 seconds**

Subjects	Bright Sun	Hazy Sun	Heavy Overcast
Beach, snow scene	f/16 (15)	f/11 (14)	f/8 (13)
Open landscape	f/11 (14)	f/8 (13)	f/5.6 (12)
Landscape with foreground	f/8-11 (13½)	f/5.6-8 (12½)	f/4-5.6 (11½)
Persons outdoors	f/8-11 (13½)	f/5.6-8 (12½)	f/4-5.6 (11½)
Portraits in shadow	f/5.6 (12)	f/4 (11)	f/2.8 (10)

FILL-IN FLASH OUTDOORS

Blue flash lamps or electronic flash can be used to fill in harsh shadows when exposing outdoors in bright sunlight. Use the table below to set lens openings and shutter speeds for various flash lamps.

(Continued on following page)

The Compact Photo-Lab-Index

Blue Bulb Type	Bowl-Shaped Reflector Size	Distance in Feet	Lens Opening	Shutter Speed
5B, 25B	3-inch	5-8	22	1/25
M5B, M25B	3-inch	8-12	22	1/25
5B, 25B	4-inch	12-18	16	1/50
11B, 40B, 22B	6-7-inch	12-18	22	1/25
2B	6-7-inch	16-22	16	1/50

UNIT OUTPUT

EFFECTIVE CANDLE-POWER SECONDS	350	500	700	1000	1400	2000	2800	4000	5600
GUIDE NUMBER	36	45	50	60	72	85	100	125	145

Synchronization	X or F			M			Focal-plane	
Between Lens Shutter Speed	AG-1B M2B	M25B	M5B, 5B or 25B	11B or 40B	2B or 22B	Shutter Speed	6B or 26B	
1/25-1/30	85	110	110	140	160	1/50	85	
1/50-1/60	—	100	100	120	140	1/100	52	
1/100-1/125	—	—	90	110	120	1/250	32	
1/200-1/250	—	—	70	90	110	—	—	

ELECTRONIC FLASH GUIDE NUMBERS

Trial exposures with various electronic flash units may be estimated from the table below, but some correction will probably have to be made due to variation in unit efficiency and reflector design. An 81A filter may be used to compensate for the excessive blue output of some electronic flash units.

FLASH EXPOSURE GUIDE NUMBERS

Guide numbers for blue flash lamps are given in the table below; they also apply to the same lamps without blue coating, if an 80C filter is used over the camera lens.

RECIPROCITY FACTOR

Neutral color balance is based on an exposure of 1/125 second. Longer exposures may tend to produce a slight shift to warmer tones; shorter exposures tend to cooler tones.

FILTERS

The following filters may be used with Agfachrome:

Skylight Filter—Useful for obtaining extra contrast in photos at high altitudes and at the beach, where ultraviolet rays may result in excessive blueness.

No. 80C Filter—Use this filter when lighting with clear flash bulbs only. Blue flash bulbs require no filter.

No. 80B Filter—Use when lighting with photoflood lamps of 3400 K rating.

No. 81A Filter—New electronic flash units whose lighting elements are not yet broken-in may cause excessive blueness. This filter corrects the blueness.

PROCESSING

Agfachrome CT-18 is sold with processing and mounting included in the purchase price for processing in Agfa's own processing stations.

SPECIAL ASA 100 PROCESSING

Wherever light sources are limited, or to create special effects, Agfachrome CT 18 can be exposed at ASA 100 with special processing at the Agfa-Gevaert Processing Laboratory, Flushing, New York. Keep in mind, though, that the optimum quality of Agfachrome CT is obtained when used at ASA 50 with normal processing. If the speed boosting service is selected, the entire roll of film must be exposed at ASA 100. There is an additional charge for this service, and the aluminum container for the film must be clearly labeled, "ASA 100 PROCESSING." For additional information contact: Agfa-Gevaert Processing Laboratory, Inc., P.O. Box 711, Flushing, New York 11352.

(Continued on following page)

AGFA-GEVAERT

17

SPECTRAL CHARACTERISTICS

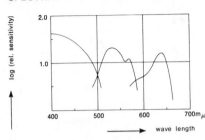

SENSITOMETRIC CURVES

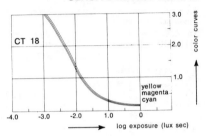

AGFACOLOR CNS

Color Print Film for Daylight Exposures

ASA D 80

GENERAL PROPERTIES

A double-masked, very fine-grain color negative film designed for exposure by daylight, electronic flash and blue flashbulbs (approx. 5,500 K) and xenon lighting. CNS film has a gamma of 0.58 when developed in accordance with instructions. Highly effective protection against halation by a layer of colloidal silver beneath the emulsion layers. Available in 35mm, 120 rolls and 126 cartridges.

ELECTRONIC FLASH GUIDE

The guide numbers given below are approximations, since variations may occur with different types of electronic flash equipment.

Light Output of Unit (Candlepower-seconds)	350	500	700	1000	1400	2000	2800	4000	5600	8000
Guide Number for Trial	32	40	45	55	65	80	95	110	130	160

EXPOSURE GUIDE: FOR BLUE FLASHBULBS

Guide No.	Reflector Types	Flash-bulbs		CNS Film					
50		AG-1B		CNS Film	1/30 sec				
			feet	4-5	6	8-10	12	15-20	25
			lens opening	11	8	5.6	4	2.8	2
65		AG-1B M2B		CNS Film	1/30 sec				
			feet	4-5	6	8-10	12	15-20	25
			lens opening	16	11	8	5.6	4	2.8
100		AG-1B M2B		CNS Film	1/30 sec				
			feet	5	6	8-10	12-15	20	25
			lens opening	22	16	11	8	5.6	4
95		M3B M5B 5B		CNS Film	1/30 sec				
			feet	4-5	6	8-10	12	15-20	25
			lens opening	22	16	11	8	5.6	4
140		M3B M5B 5B		CNS Film	1/30 sec				
			feet	6	8	10-12	15	20-25	
			lens opening	22	16	11	8	5.6	

*Polished bowl reflector.

(Continued on following page)

The Compact Photo-Lab-Index

USE OF FILTERS

There is no need to use correction filters on the camera. Neutral prints are obtained by the use of suitable printing filters.

For exposures at high altitudes or at the seaside we recommend a colorless UV filter which requires no increase in exposure time. In addition, a polarizing filter can be used to reduce reflections.

PROCESSING

Darkroom Lighting

Total darkness or Agfa Darkroom Safe-light Screen G 4 (formerly 170), 15 watt lamp 30 in. away.

Effect in print:

Yellow:	more saturated	compared with
Blue:	lighter	prints from
Green:	less blue	unmasked negatives
Magenta:	less yellow	

The red mask eliminates red secondary density of the cyan dye.

Effect in print:

Red:	more saturated	compared with
Magenta:	rather more	prints from
Green:	saturated	unmasked negatives
	less degraded	

SENSITIZATION

Prints

The best prints and enlargements are obtained from CNS negatives by using Agfacolor Paper MCN 111.

Black-and-white prints from CNS film do not yield satisfactory results.

Masking

The masks form automatically in the bleaching bath according to negative gradation and density resulting during color development.

Yellow secondary density of the magenta dye is eliminated by the yellow mask.

CNS
equal-energy spectrum

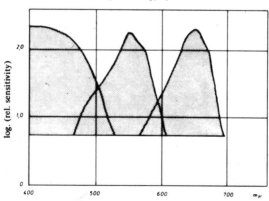

(Continued on following page)

19

AGFA BLACK-AND-WHITE PAPERS

AGFA BROVIRA

Agfa Brovira is a standard enlarging speed paper used for all kinds of photography. It is available in both single and double weight, six degrees of contrast, and a variety of surfaces. Image tone of Brovira is neutral black on white stock. The white paper base contains an optical brightening agent which produces a brilliant white in the highlights.

AGFA PORTRIGA RAPID

A chlorobromide enlarging paper of moderate speed yielding warm black to brown-black image tones, in double weight glossy and fine-grain semi-matt surfaces for salon prints, portraits, etc.

AGFA CONTACTONE

Contactone is a fast contact paper, also suitable for projection printing in machines having a sufficiently strong light source. It features simple processing, and extreme resistance to fogging or staining.

DEVELOPMENT OF AGFA PAPERS

Agfa papers respond well to almost any conventional paper developer, producing tones from black to brown-black. Several developers producing very warm black to chocolate brown and even olive brown colors are given in this section.

SURFACES AND CONTRASTS OF AGFA BLACK-AND-WHITE PAPERS

	Glossy	White Fine-Grained Luster	White Fine-Grain Semi-Matt
Brovira	1 SW, WH 1,2,3,4,5,6	119 DW, WH 2,3,4,5	
	111 DW, WH 1,2,3,4,5,6		
Portriga Rapid	111 DW, WH 2,3,4		118 DW, WH 2,3,4
Contactone	1 SW, WH 0,1,2,3		
	111 DW, WH 1,2		

CONTRAST GRADES OF AGFA PAPERS:

1: Extra soft
2: Soft
3: Medium soft
4: Normal
5: Hard
6: Extra hard

STOCK COLOR OF AGFA PAPERS

WH: White with brightener for maximum highlight brightness

SW: Single weight
DW: Double weight

(Continued on following page)

AGFACOLOR MCN III PAPER

GENERAL DESCRIPTION

Agfacolor Paper Type MCN III is a high-speed color paper for printing color negative materials. MCN III is suitable for amateur photo finishing and professional applications. It is available in standard sheet and roll sizes.

EMULSION STRUCTURE

Upper layer:
 sensitive to blue light, develops yellow dye
Middle layer:
 sensitive to green light, develops magenta dye
Bottom layer:
 sensitive to red light, develops cyan dye

MAXIMUM SENSITIVITIES

Blue sensitive layer:
 approx. 455 millimicron
Green sensitive layer:
 approx. 550 millimicron
Red sensitive layer:
 approx. 700 millimicron

SAFELIGHT FILTER

Agfa-Gevaert 0 8 (transmission maximum at 580 millimicron)

NOTE: Safelight filters of other manufacture can be used, provided they have similar spectral transmission characteristics. We recommend testing your safelights.

STORAGE

Refrigeration recommended. (Temperatures below 50°F)

Note:

Treatment in stop-fix, bleach fix, second wash and stabilizer may be extended, if this is more practical due to the design of the processing equipment.

Caution: Do not use brass tanks or other brass parts with bleach fix.

KEEPING PROPERTIES OF AGFA COLOR PAPER CHEMICALS

Mixed in stoppered bottles
 Developer—1 month
 Secondary Solutions—3 Months
 Keeping properties of solution in a well-replenished processing line are excellent.

CAPACITY OF SOLUTIONS WITHOUT REPLENISHMENT

 Developer—40 8x10's per gallon
 Secondary Solutions—120-8x10's
 per gallon

PROCESSING TIMES AND SEQUENCES
(Continuous processors, Basket lines and Tray Processing)

	77°F Time	85°F Time	
Developer Pa 1/60	3 min.	2 min.	D
After Rinse	¾ min.	½ min.	A R K
Stop-fix PPa II/KM	1¾ min.	1 min.	
Bleach-fix PPa III/KM	3½ min.	2 min.	L I
Wash	5¼ min.	5 min.	G H
Stabilizer Pa VI S	1¾ min.	1 min.	T

(Continued on following page)

AGFACOLOR MCN 111 PAPER (continued)

REPLENISHING RATES

Solution		Per Sheet 8″ x 10″	Per Foot* 3½″ Wide
Developer Replenisher	RPa 60	22ml	11ml
Stop-fix Replenisher	RPPa II/KM	28ml	14ml
Bleach-fix	PPa III/KM**	28ml	14ml
Stabilizer Replenisher	RPa VI S	22ml	11ml

*To obtain 5″ rates, multiply the 3½″ rates by 1.43. Likewise, to obtain rates for 8″ paper use 2.29.

**Bleach-fix is replenished with starter solution.

PREPARATION OF SOLUTIONS

The preparation of the different starter and replenisher solutions is very simple. Each component of a mix is identified by a letter. When preparing the solution, the various parts are simply dissolved in alphabetical order. The label on each chemical kit gives complete instructions for mixing.

When making a stabilizer, or a stabilizer-replenisher, formaldehyde (which is not part of the kit) should be added to the mix. The recommended quantity to be added is given on the label of the stabilizer kit.

With the use of a pressure ferrotyper, the formaldehyde to be added to stabilizer and stabilizer-replenisher should be reduced to 1 oz. per gallon. A higher concentration may result in poor gloss.

PRINT DEFECTS AND THEIR CAUSES

Print Defects	Causes
Gradual loss of density	Sign of under-replenishment of developer
Gradual gain of density	Sign of over-replenishment of developer
Less density, Possibly blue shadows, Lower contrast.	Low developing temperature; Under-replenishment; Developing time too long.
High density Possibly yellow shadows, Higher contrast.	High developing temperature; Over-replenishment; Developing time too long.
Low density, Low contrast, Green shadows.	Developer heavily under-replenished. pH too low.
Stain, gray or gray-yellow, Increase in overall density and contrast	Developer heavily over-replenished.

(Continued on following page)

PRINT DEFECTS AND THEIR CAUSES (continued)

Whites have heavy yellow cast	Contamination of developer with stop-fix or bleach-fix.
Very light and green prints	Contamination of developer with formaldehyde.
Color balance shifting during the day from red toward cyan	Heavy oxidation of developer during night or weekend. (Turn off pumps overnight, possibly add replenisher before starting in the morning.)
Density and contrast normal, but color balance too blue, especially in shadows.	Insufficient after-development in first wash. (Increase wash time, decrease wash rate, do not use squeegee between developer tank and wash tank.)
Heavy staining, possibly all colors, partially or over entire area.	Traces of stop-fix in wash after developer.
Stain gray or gray-yellow	Stop-fix and bleach-fix under-replenished.
Red shadows	pH of bleach-fix too low; temperature too low; under-replenished, time too short.
Red shadows, Whites gray-yellow, Colors possibly have somewhat higher gray content.	Heavily under-replenished bleach-fix.
Whites, cyan or gray	Insufficient wash; insufficient formaldehyde in stabilizer; prints possibly washed again after treatment in stabilizer.

NOTE: Whenever the developer is found to be contaminated, the replenisher should also be checked, since the contamination could have originated from the replenisher.

When a processing error is traced to the bleach-fix and this bath is being changed, it is advisable to also change the stop-fix.

AGFACOLOR PAPER CONTROL STRIPS

MCNIII test strips to be used in the control of the paper processing are available in packages of 25. The size of the pre-exposed materials is 3½" x 10¾".

A factory-processed master is enclosed with each package, as well as instruction for the evaluation.

(Continued on following page)

AGFA-GEVAERT

PROCESSING TIME FOR RAPID DRUM TYPE PROCESSORS (77F)

Pre-rinse (water in tray)	½ min.	½ min.	D
Developer		2½ min.	A R
			K
Wash		½ min.	
Stop-fix		1 min.	L I
Bleach-fix		2 min.	G H
Wash		2 min.	T
Stabilizer		1 min.	

AGFACOLOR MCN 310 AND MCS 317 PAPERS

MCN 310

Agfacolor Paper MCN 310 is a resin coated, self-glossing, high speed color paper designed for printing color negatives for photofinishing use. Available in rolls only.

MCS 317

Agfacolor Paper MCS 317 is a resin coated, silk surface, high speed color paper designed for portrait printing. Available in rolls only.

SAFELIGHT
Agfa-Gevaert 08.

STORAGE
Below 50 F.

PROCESSING
Agfacolor process 85.

AGFACOLOR PROCESS 85

Solution		Time	Temp.
DEVELOPER	82/85 CD	1 min. 50 sec.	95 F.
*BLEACHFIX	85/86 BX-R	2 min. 45 sec.	95 F.
WASH		2 min. 45 sec.	95 F.
FINAL BATH	85 FI	55 sec.	95 F.
SPRAY WASH		5 sec.	95 F.

*FOR STARTER SOLUTIONS ADD 85BX-S.

REPLENISHERS

DEVELOPER	85 CDR
BLEACHFIX	85/86 BXR
FINAL BATH	85 FI

REPLENISHER RATES PER SQ. METER

DEVELOPER	85 CDR	200 ml
BLEACHFIX	85/86 BX-R	300 ml
FINAL BATH	85 FI	300 ml

(Continued on following page)

AGFACOLOR PROCESS 82

DEVELOPER	82/85 CD	3 min.	85 F.
*STOPFIX	82SX-R	1 min.	85 F.
WASH		1 min.	85 F.
BLEACHFIX	82BX	3 min.	85 F.
WASH		5 min.	85 F.
**FINAL BATH	82FI	1 min.	85 F.
RINSE		5 min.	

*FOR STARTER SOLUTION ADD 82SX-S.

REPLENISHERS

DEVELOPER	82 CDR
STOPFIX	82 SX-R
BLEACHFIX	82 BX
**FINAL BATH	82 FI

**PLUS ADDITION OF 37% FORMALIN. SEE LABEL FOR AMOUNT TO BE ADDED.

REPLENISHMENT RATES PER SQ. METER

DEVELOPER	82 CDR	260 ml
STOPFIX	82 SX-R	520 ml
BLEACHFIX	82 BX	520 ml
FINAL BATH	82 FI	390 ml

AGFA-GEVAERT PHOTOGRAPHIC FORMULAS

NEGATIVE DEVELOPER—Agfa 8
Glycin, Normal Contrast

Warm Water (125 F or 52 C)	24 ounces	750.0 ml
Sodium Sulfite, desiccated	183 grains	12.5 grams
Glycin	30 grains	2.0 grams
Potassium Carbonate	365 grains	25.0 grams
Add cold water to make	32 ounces	1.0 liter

Develop medium speed films from 10 to 12 minutes at 68 F (20 C)

FINE GRAIN DEVELOPER—Agfa 14
Metol-Sulfite, Soft Working

Warm Water (125 F or 52 C)	24 ounces	750.0 ml
Elon	65 grains	4.5 grams
Sodium Sulfite, desiccated	2 oz.365 grains	85.0 grams
Sodium Carbonate, monohydrated	18 grains	1.2 grams
Potassium Bromide	7½ grains	0.5 grams
Add cold water to make	32 ounces	1.0 liter

Develop from 10 to 20 minutes depending on type of film and contrast desired.

(Continued on following page)

25

TROPICAL FINE GRAIN DEVELOPER—Agfa 16

Warm Water (125 F or 52 C)	24 ounces	750.0 ml
Elon	88 grains	6.0 grams
Sodium Sulfite, desiccated3 oz.	145 grains	100.0 grams
Sodium Carbonate	175 grains	12.0 grams
Potassium Bromide	45 grains	3.0 grams
Then add slowly to avoid caking:		
Sodium Sulfate, anhydrous1 oz.	145 grains	40.0 grams
Add cold water to make	32 ounces	1.0 liter

Developing times:

65 F (18 C) ..	9 to 11 minutes
75 F (24 C) ..	6 minutes
85 F (29 C) ..	3 minutes

HIGH CONTRAST DEVELOPER—Agfa 40
For Films and Plates

Warm Water (125 F or 52 C)	24 ounces	750.0 ml
Elon	22 grains	1.5 grams
Sodium Sulfite, desiccated½ oz.	44 grains	18.0 grams
Hydroquinone	37 grains	2.5 grams
Potassium Carbonate½ oz.	44 grains	18.0 grams
Add cold water to make	32 ounces	1.0 liter

Development time 4 to 5 minutes.

PAPER DEVELOPER—Agfa 100
For Normal Contrast

Warm Water (125 F or 52 C)	24 ounces	750.0 ml
Elon	15 grains	1.0 gram
Sodium Sulfite, desiccated	180 grains	13.0 grams
Hydroquinone	45 grains	3.0 grams
Sodium Carbonate monohydrated	1 ounce	30.0 grams
Potassium Bromide	15 grains	1.0 gram
Add cold water to make	32 ounces	1.0 liter

Use full strength; develop 1-2 minutes.

SOFT PAPER DEVELOPER—Agfa 105
For Low Contrast

Warm Water (125 F or 52 C)	24 ounces	750.0 ml
Elon	45 grains	3.0 grams
Sodium Sulfite, desiccated	½ ounce	15.0 grams
Potassium Carbonate	½ ounce	15.0 grams
Potassium Bromide	6 grains	0.4 grams
Add cold water to make	32 ounces	1.0 liter

Use full strength; develop 1½ minutes.

HARD PAPER DEVELOPER—Agfa 108
For High Contrast

Warm Water 125 F or 52 C)	24 ounces	750.0 ml
Elon	75 grains	5.0 grams
Sodium Sulfite, desiccated1 oz.	145 grains	40.0 grams
Hydroquinone	88 grains	6.0 grams
Potassium Carbonate1 oz.	145 grains	40.0 grams
Potassium Bromide	30 grains	2.0 grams
Add cold water to make	32 ounces	1.0 liter

Use full strength; develop 1-2 minutes.

(Continued on following page)

BROWN TONE PAPER DEVELOPER—Agfa 120

STOCK SOLUTION

Warm Water (125 F or 52 C)	24 ounces	750.0 ml
Sodium Sulfite, desiccated	2 ounces	60.0 grams
Hydroquinone	350 grains	24.0 grams
Potassium Carbonate2 oz.	290 grains	80.0 grams
Add cold water to make	32 ounces	1.0 liter

This developer will produce a variety of brown to warm black tones on various papers depending on dilution and exposure time. The following table lists the dilution and exposure for various tones on Agfa papers.

Development Conditions for Agfa Developer 120

Paper type	Image tone	Exposure time	Dilution	Development time at 68 F (20 C)
Brovira	warm black	normal*	1:5	4-5 minutes
Portriga	brown-black	1½ x longer	1:4	3 minutes
Rapid		than normal*		

*By normal exposure is to be understood the exposure required to produce the best possible print when developed for 1-1½ minutes in Agfa 100.

BROWN TONE DEVELOPER—Agfa 123
For Portrait Papers

STOCK SOLUTION

Warm Water (125 F or 52 C)	24 oz.	750.0 ml
Sodium Sulfite, desiccated	2 oz.	60.0 grams
Hydroquinone	350 grains	24.0 grams
Potassium Carbonate2 oz.	290 grains	80.0 grams
Potassium Bromide	365 grains	25.0 grams
Add cold water to make	32 ounces	1.0 liter

This developer produces tones ranging from brown black to olive brown on Portriga Rapid paper depending on dilution and exposure. The table below gives the typical development conditions for the various tones.

Development Conditions for Agfa Developer 123

Paper type	Image tone	Exposure time	Dilution	Development time at 68 F (20 C)
Portriga	a) brown-	2½ x longer	1:1	2 minutes
Rapid	black	than normal*		
	b) neutral	2 x longer	1:4	5-6 minutes
	to sepia	than normal*		
	brown			

The term "normal exposure" means the exposure required to produce the best possible print when developed for 1-1½ minutes in Agfa 100.

(Continued on following page)

The Compact Photo-Lab-Index

STOP BATH—Agfa 200

For Papers

Glacial Acetic Acid (99%)	5 fl. drams	20.0 ml
Cold water to make	32 ounces	1.0 liter

STOP BATH—Agfa 201

For Films

Potassium Metabisulfite	1 oz. 145 grains	40.0 grams
Cold water to make	32 ounces	1.0 liter

ACID FIXING BATH—Agfa 300

Non-Hardening, for Papers

Warm Water (125 F or 52 C)	24 ounces	750.0 ml
Sodium Thiosulfate (Hypo)	6¾ ounces	200.0 grams
Potassium Metabisulfite	½ oz. 70 grains	20.0 grams
Add cold water to make	32 ounces	1.0 liter

ACID HARDENING FIXiNG BATH—Agfa 302

For Films and Papers

Warm Water (125 F or 52 C)	24 ounces	750.0 ml
Sodium Thiosulfate (Hypo)	6¾ ounces	200.0 grams
Potassium Metabisulfite	½ oz. 70 grains	20.0 grams
Potassium Alum	½ ounce	15.0 grams
Sodium Sulfite, desiccated	¼ ounce	7.5 grams
Glacial Acetic Acid 99%	3 fl. drams	12.0 ml
Add cold water to make	32 ounces	1.0 liter

RAPID FIXING BATH—Agfa 304

For Films and Plates

Warm Water (125 F or 52 C)	24 ounces	750.0 ml
Sodium Thiosulfate (Hypo)	6¾ ounces	200.0 grams
Ammonium Chloride	1 oz. 290 grains	50.0 grams
Potassium Metabisulfite	½ oz. 70 grains	20.0 grams
Add cold water to make	32 ounces	1.0 liter

HARDENING BATH—Agfa 400

Potassium Alum	3 oz. 145 grains	100.0 grams
Cold water to make	32 ounces	1.0 liter

HARDENING BATH—Agfa 401

Formalin (40% Formaldehyde)	3¾ fl. ounces	120.0 ml
Add cold water to make	32 ounces	1.0 liter

(Continued on following page)

HARDENER—Agfa 402

For Extreme Hardening

Water 16 ounces 500.0 ml
Alcohol 16 ounces 500.0 ml
Formalin (40% Formaldehyde) 3¾ fl. ounces ... 120.0 ml

Immerse film or plate for from 5 to 10 minutes for maximum hardening.

PROCESSING OF AGFACOLOR NEGATIVE FILMS

Baths	Code	Spec. grav. (fresh solution)	Processing times in min.	Process. temperat. (C)	Work. cap. per litre (without replen.)
Ac Film Developer S	NPS I	1.065-1.070	8①	20 ± 0.2	6 films
Ac Intermediate Bath for negative Film (addition of 30 ml. NPS I/liter	NZW	1.025-1.030	4②	20 ± 0.5	6 films
First Wash (thorough)	—	—	14③	17 ± 3	—
Ac Bleaching Bath for negative film	N II	1.050-1.055	6④	20 ± 0.5	6 films
second wash (thorough)	—	—	6	17 ± 3	—
Ac Fixing Bath for negative film	N III	1.090-1.095	6⑤	20 ± 1	6 films
Final Wash (thorough)	—	—	10	17 ± 3	—
Agfa Agepon Final Bath 0.5%	—	—	1	20 ± 1	10 films

NOTES:

① Development time depends on agitation of the films in the processing system (tank or machine) and may be varied between 7 and 9 minutes according to the result of sensitometric tests. Sensitometric test strips can be supplied in packets containing 25.

In larger tank systems it is necessary to provide nitrogen gas agitation of the developer (in addition to any forced circulation). Pressure setting at reduction valve on the gas cylinder approx. 7 lb. sq. in., magnetic valve timer adjusted to nitrogen bursts lasting 2-3 sec. with intervals of 15-20 sec. The holes in the tubes from which the gas emerges must be arranged obliquely towards the base of the tank and placed so as to ensure even distribution of nitrogen bubbles over the entire area covered by the tank. Developer replenisher (RNPS) should be used for re-

plenishment of **Film Developer S** in machine and deep tank processing. Every time a fresh solution of the bath is prepared, specific gravities should be checked in order to make quite certain that concentrations are correct (avoidance of compounding errors).

② Agfacolor Negative Intermediate Bath must be given an addition of 30ml Agfacolor Film Developer S per liter when preparing the solution.

Agfacolor Intermediate Bath controls subsequent development of the films after the development process proper in Film Developer S; nitrogen gas agitation should therefore be provided in the Negative Intermediate Bath tank as for the developer.

If necessary the time in the Intermediate Bath may be varied between 3 and 5 minutes to suit the number of

(Continued on following page)

cycles and cycle time of frame developing machines. The temperature of the bath must be 20 C ± 0.5 and thorough agitation of the films in the Intermediate Bath is very important to ensure uniform results. Normal working solution not containing developer is used to replenish the Intermediate Bath.

③ The first wash must completely remove developing agents from the films, otherwise an excessive, magenta fog (bleaching fog) occurs in the bleaching bath. To ensure satisfactory removal of traces of developer, the washing operation should, where possible, be split up among 3 tanks with a separate flow of water, washing for 5 minutes in each tank. In this case washing intensity should be adjusted so that the flow of water is at least 5-6 liters per minute. In certain cases (dependent on composition of the water used) washing temperatures above 20 C may result in formation of a high basic fog density. In such cases it is advisable to prolong treatment of the Agfacolor Negative Intermediate Bath to 5 minutes.

The first wash can be prolonged to 20 minutes if conditions in the machine require this.

④ The stated bleaching condition should be adhered to exactly as, with the masked Agfacolor Negative Film CNS, the mask is formed to the prescribed density in the bleaching bath. It is therefore necessary, when processing in systems without automatic temperature-control, for the bleaching bath tank to have a thermostatic control made of stainless steel or other metal with a plastic coating to prevent damage by corrosion. The Replenisher RN II is used for replenishment of the Bleaching Bath.

If required the treatment time in the Bleaching Bath can be extended to a maximum of 8 minutes or reduced to 4½ minutes to suit the number of cycles and cycle time of frame developing machines. Processing times below 4½ minutes are not acceptable.

⑤ A special Replenisher RN III for the Fixing Bath is now supplied to keep the activity of this bath at a consistent level.

The Fixing Bath processing time can, also if required, be extended up to 8 minutes or reduced to 4½ minutes, but shorter times are not acceptable as the film may then not be completely fixed.

REPLENISHMENT OF PROCESSING BATHS FOR AGFACOLOR NEGATIVE FILMS

When processing Agfacolor negative films in developing machines and big tank systems, exhaustion of the various baths can be prolonged considerably beyond the normal working capacity by regular replenishment; the baths can then be used for a long period without preparing a fresh solution. The following particulars apply to either one 120 roll film or a minature film with 36 exposures but should only be regarded as a guide since it is not possible to state exact quantities in view of differing processing conditions at various firms. Replenishment must therefore be undertaken according to results of sensitometric tests.

The amount of replenisher can be reduced by about 30% per film for miniature films with 20 exposures and Pak 126 cartridge films. If required replenishment can also be adjusted to an average amount between miniature films with 36 and 20 exposures and Pak 126 cartridge films.

(Continued on following page)

The Compact Photo-Lab-Index

Bath	Amount of Replenisher per 120 roll film 36 exp. min. film	Permissible pH value range	Permissible spec. grav. range	Spec. grav. of repl. solns. (20 C)
Ac Film Developer S	80 ml RNPS	11.0-11.3	Non-indicative	1.070-1.075
Ac Intermediate Bath	100-150 ml NZW working solution without addition of developer	10.2-10.5*	Non-indicative	1.025
Ac Bleaching Bath	50 ml RN II	5.8-6.2	Non-indicative	1.060-1.065
Ac Fixing Bath	50 ml RN III	7.0-7.6	1.080-1.120	1.110-1.115

*It is necessary to add to the Agfacolor Negative Intermediate Bath 30 ml. Film Developer S per liter working solution. The stated pH values apply to a bath properly prepared with developer. The pH value of the Intermediate Bath gradually increases due to carry-over of developer solution. On reaching the upper tolerance limit, a fresh solution of the bath should be prepared. If the pH value rises very rapidly, the amount of replenisher should also be increased. Normal working solution is used as a replenisher but without an addition of developer.

Every time a fresh solution of replenisher is prepared the specific gravities should be checked in order to make quite certain that the concentration is correct (avoidance of compounding errors).

CONTROL OF AGFA COLOR NEGATIVE FILM PROCESSING BATHS BY pH VALUE AND SPECIFIC GRAVITY

Apart from using sensitometric tests to control the activity of the various Agfacolor processing baths, they can also be tested by a simple measurement of the pH value and specific gravity. The following table contains useful information for assessing the results of such readings obtained from Agfacolor Negative Processing Baths.

(Continued on following page)

The Compact Photo-Lab-Index

Bath	pH value	Specific gravity	Findings	Measures necessary
	11.0-11.3	Non-indicative	In order	No changes
	10.9	Non-indicative	Usable	Possibly increase amount of replenisher slightly according to result of sensitometric test
Agfacolor Film Developer S (NPS I)	10.8	Non-indicative	Only limited usability	Dependent on result of sensitometric test; fresh solution may be necessary
	10.7	Non-indicative	Useless	Prepare fresh solution
	10.2-10.5	Non-indicative	In order	No changes
Agfacolor Negative Intermediate Bath (NZW)	Above 10.5	Non-indicative	Useless	Prepare fresh solution
	5.8-6.2		In order	No changes
	5.7		Usable	Dependent on result of sensitometric test; fresh solution may be needed or adjustment of pH value. Add about 1 g trisodium phosphate to raise pH value by 0.1 pH per liter
Agfacolor Bleaching Bath (N II)		Not suitable as a control		
	6.3		Usable	Dependent on result of sensitometric test; fresh solution may be needed or adjustment of pH value. Add about 2 g monopotassium phosphate to lower pH value by 0.1 pH per liter
Agfacolor Bleaching Bath (N II)		Not suitable as a control		
	Below 5.7		Useless	Prepare fresh solution
	Above 6.3		Useless	Prepare fresh solution
	7.0-7.6	1.090	In order	No changes
	7.0-7.6	1.080	Usable	Increase existing amount of replenisher by about 10%
Agfacolor Fixing Bath (N III)	7.0-7.6	1.060	Useless	Prepare fresh solution
	Below 7.0	Unimportant	Useless	Prepare fresh solution
	7.6-8.0	1.090-1.080	Usable	No change provided spec. grav. usable
	Above 8.0	Unimportant	Useless	Prepare fresh solution

RODINAL

Rodinal is based upon para-amino-phenol. Rodinal was developed in Germany by Dr. M. Andresen, and has remained unchanged throughout the years. Rodinal was originally used as a rapid developer for high speed processing of plates and sheet film, and was rediscovered with the introduction of modern thin-emulsion, ultra fine-grain films. Upon dilution, Rodinal was found to deliver the extreme sharpness high acutance and fine grain.

To use, first dilute the concentrated liquid in distilled water already adjusted to the working temperature. A finely graduated measure (about 10 ml. divisions) or a graduated pipette is necessary for exact measurement.

Rodinal keeps indefinitely in the original, unopened packaging. After opening the bottle, the concentrate will keep for at least 6 months if properly sealed.

Table 1 gives information for processing film exposed at the manufacturer's suggested ASA rating of subjects of normal contrast. For low subject contrast, try increasing processing time by about 40%. For high contrast subjects, decrease by the same amount. Dilution is 1:25 unless otherwise noted.

Rodinal is a highly concentrated solution which is diluted by the user to get a working solution. Generally, one part Rodinal is added to 50-100 parts of water. This working solution is discarded after use. It is interesting to note that the Rodinal system of one-time use antedates by about sixty years the now fashionable "single use" developing method.

CONTRAST CONTROL

The degree of dilution of Rodinal solution can be varied by the photographer to fit the contrast characteristics of his film and of the scene. To increase contrast, the degree of concentration is increased, and to decrease contrast, the degree of dilution is increased. For example, if a photographer photographs a subject with low contrast he can increase his negative contrast by using a more concentrated solution.

DEVELOPMENT TIMES

In addition to giving the photographer control over contrast, the variable dilution of Rodinal allows him to control his developing times should he require shorter processing times.

TEMPERATURE CONTROL

Temperature control, so important in 35mm photography, is simple with Rodinal since the temperature of the water can easily be adjusted and maintained because of the very small quality of Rodinal to be added. Development times are given for 68°F. For 65°F., increase developing times 20%. For 72°F., decrease developing times 20%.

TABLE 1

Kodak Film	ASA	Development Time in Minutes at 68° F (20° C)
Panatomic-X	32	6
Panatomic-X	64 (Dilution 1:50)	9
Tri-X Pan	400	7
Tri--X Pan Prof (120)	320	7
Ektapan Sheet	100	6.5
Verichrome Pan	125	10
Royal X	1250	8
2475 Recording	1000	11

Ilford Film	ASA	Development Time in Minutes at 68° F (20° C)
Pan F	50	4
FP-4	125	5
HP-4	400	6

(continued on following page)

The Compact Photo-Lab-Index

Table 2 gives general guidelines for exposing Kodak's Plus-X and Tri-X as well as Ilford FP-4 and HP-4 films for a variety of lighting situations and for processing the results.
Remember: These are guidelines only. Test them in your system. You may want to adjust processing times to suit your requirements.

SHARP, HIGH RESOLUTION

Negatives developed in Rodinal are free from stain, and have a tight, even, very sharp grain structure which helps maintain the extremely fine grain inherent in today's thin emulsion films. It can be used with medium speed films, tends to yield somewhat coarse grain with high speed films.

Since it is used in highly diluted form, Rodinal has a compensating action. This means that highlights develop quickly while shadows develop less quickly. The developer in the highlight area is exhausted while the developer in the shadow area is still working, bringing out shadow detail. The effect on negatives is to give more even contrast and avoid blocked highlights.

PROCESSING RECOMMENDATIONS

Since Rodinal is not a fine-grain developer as such, it is recommended primarily for the slower, fine-grain, thin-emulsion materials.

RECOMMENDATIONS

The tables below give approximate recommendations for using Rodinal with AGFA films. Rodinal may also be used with other films by taking the AGFA film recommendations as a point of departure and experimenting a little. Under normal circumstances, there should not be too much difference in processing methods using Rodinal with other films of the same class. Since Rodinal is extremely flexible, the individual photographer can determine the degree of dilution and the developing times which best fit his working method and his materials.

TABLE 2

DEVELOPING TIMES FOR RODINAL WITH KODAK'S TRI-X & PLUS-X FILMS & ILFORD FP-4 AND HP-4 FILMS

PLUS-X AND FP-4

Light Intensity	Contrast	Effective Film Speed	Dilution	Time at 68° F
Bright	Highest	80	1:100	10.5 min.
Bright	High	125	1:100	11.5 min.
Bright	Moderate	160	1:75	11.5 min.
Bright	Low	400	1:50	12 min.
Dim	High	400	1:75	12.5 min.
Dim	Moderate	400	1:50	13 min.
Dim	Low	600	1:50	14 min.
Very Dim	High	800	1:75	15 min.
Very Dim	Low	800 (at 75° F)	1:50	16.5 min.
Normal	Moderate	200	1:85	12 min.

(Continued on following page)

34

TABLE 2 (continued)

TRI-X AND HP-4

Light Intensity	Contrast	Effective Film Speed	Dilution	Time at 68″ F
Bright	High	250	1:85	14 min.
Bright	Moderate	400	1:75	14.5 min.
Bright	Low	400	1:50	14.5 min.
Dim	High	600	1:75	15.5 min.
Dim	Moderate	800	1:50	16.5 min.
Very Dim	High	1200	1:65	17.5 min.
Very Dim	Low	1600	1:50	18.5 min.
Very Dim	High	3200	1:65	20 min.
Very Dim	Low	6400 (at 75° F)	1:50	22.5 min.
Available Light	Moderate	800	1:100	17.5 min.

TABLE 3

Degree of Dilution	Working Solution	Amount Rodinal
1:25	17 oz.	12.5 ml
1:50	17 oz.	10 ml
1:75	17 oz.	7.5 ml
1:100	17 oz.	5 ml

One ounce = approximately 30 ml.

EASTMAN KODAK

KODAK COLOR FILMS

KODAK COLOR FILM (Code) ROLL FILMS	BALANCED FOR	DAYLIGHT Speed	DAYLIGHT Filter	FLASH Bulb	FLASH Filter	PHOTOLAMPS (3400 K) Speed	PHOTOLAMPS (3400 K) Filter	TUNGSTEN (3200 K) Speed	TUNGSTEN (3200 K) Filter	ELECTRONIC FLASH Filter	PROCESSING Kodak Chemicals[8]
KODACHROME 25 (Daylight) (KM) For color slides[1]	Daylight, Electronic Flash, Blue Flash	25	None	Blue	None	8	80B	6	80A	None	By Kodak labs and by photofinishers. Sent to Kodak by dealers or direct by users with KODAK Mailers.
KODACHROME 40, 5070 (Type A) (KPA) For color slides[1] 135-36 only	Photolamps (3400 K)	25	85	Blue	85	40	None	32	82A	85	Not for user processing
KODACHROME 64 (Daylight) (KR) For color slides[1]	Daylight, Electronic Flash, Blue Flash	64	None	Blue	None	20	80B	16	80A	None	Not for user processing
KODACOLOR II (C) For color prints[2]	Daylight, Electronic Flash, Blue Flash	100	None	Blue	None	32	80B[6]	25	80A[6]	None	Flexicolor Process C-41 — By Kodak, other labs, or users. Sent to Kodak by dealers, or direct by users with KODAK Mailers.
KODACOLOR 400 (CG) For color prints[2]	Daylight, Electronic Flash, Blue Flash	400	None	Blue	None	125	80B[6]	100	80A[6]	None	
EKTACHROME 64 (Daylight) (ER) For color slides[1]	Daylight, Electronic Flash, Blue Flash	64	None	Blue	None	20	80B	16	80A	None[7]	Process E-6
EKTACHROME 200 (Daylight) (ED) For color slides[1]	Daylight, Electronic Flash, Blue Flash	200	None	Blue	None	64	80B	50	80A	None[7]	
EKTACHROME 160 (Tungsten) (ET) For color slides[1]	Tungsten	100	85B	–	–	125	81A	160	None	–	
EKTACHROME 64 Professional (Daylight) (EPR)[1] 120, 135-36[3], long rolls (5017)	Daylight, Electronic Flash, Blue Flash	64[4]	None	Blue	None	20	80B	16	80A	None[7]	By Kodak, other labs, or users. Sent to Kodak by dealers, or direct by users with KODAK Mailers.
EKTACHROME 50 Professional (Tungsten) (EPY)[1] 120, 135-36[3], long rolls (5018)	3200 K Tungsten	40 at 1/50 sec	85B	–	–	40 at ½ sec	81A	50[4] at ½ sec	None	–	
EKTACHROME 200 Professional (Daylight) (EPD)[1] 120, 135-36[3], long rolls (5036)	Daylight, Electronic Flash, Blue Flash	200[4]	None	Blue	None	64	80B	50	80A	None[7]	
EKTACHROME 160 Professional (Tungsten) (EPT)[1] 120, 135-36[3], long rolls (5037)	Tungsten	100	85B	–	–	125	81A	160[4]	None	–	
VERICOLOR II Professional, Type S (VPS)[1] 120, 135-20, 135-36, 220 Expose 1/10 sec or less	Electronic Flash, Daylight, or Blue Flash	100	None	Blue[5]	None	32	81A	25	80A	None	Flexicolor Process C-41 — By Kodak, other labs, or professional finishers. Sent to Kodak by dealers, or direct by users with KODAK Mailers.
VERICOLOR II Professional, Type L (VPL)[1] 120 only Expose 1/50 to 60 sec	3200 K Tungsten	50 at 1/50 sec	85B	Not recom.		50 at 1 sec	81A	64 at 1 sec[4]	None	Not recom.	Type L film is not printed by Kodak.

KODAK COLOR FILMS (continued)

SHEET FILMS	BALANCED FOR	DAYLIGHT		FLASH		PHOTOLAMPS (3400 K)		TUNGSTEN (3200 K)		ELECTRONIC FLASH	PROCESSING
		Speed	Filter	Bulb	Filter	Speed	Filter	Speed	Filter	Filter	
EKTACHROME 64 Professional¹ 6117 (Daylight)	Daylight, Electronic Flash, Blue Flash	64⁴	None	Blue	None	20	80B	16	80A	None⁷	By user labs or professional finishers not by Kodak. Process E-6.
EKTACHROME Professional¹ 6118 (Tungsten)	3200 K Tungsten	40 at 1/50 sec	85B	—	—	40 at ½ sec	81A	50⁴ at ½ sec	None	—	
VERICOLOR II Professional, 4107, Type S² Expose 1/10 sec or less	Electronic Flash, Daylight, or Blue Flash	100	None	Blue⁵	None	32	80B	25	80A	None	Flexicolor Process C-41. By user labs or professional finishers not by Kodak.
VERICOLOR II Professional, 4108, Type L² Expose 1/50 to 60 sec	3200 K Tungsten	50 at 1/50 sec	85B	Not recom.		50 at 1 sec	81A	64 at 1 sec⁴	None	Not recom.	

LONG ROLLS (Wider than 16mm)	BALANCED FOR	DAYLIGHT		FLASH	PHOTOLAMPS (3400 K)		TUNGSTEN (3200 K)		ELECTRONIC FLASH	PROCESSING
		Speed	Filter	Filter	Speed	Filter	Speed	Filter	Filter	
EKTACHROME MS 5256 (EMS)	Daylight	64	None	None	20	80B	16	80A	80A	By Kodak (35 mm only), other labs, or users. Sent to Kodak by dealers. Process ME-4.
EKTACHROME EF 5241 Daylight (EF)	Daylight	160	None	None	50	80B	40	80A	80A	
EKTACHROME EF 5242 Tungsten (EFB)	3200 K Tungsten	80	85B	85B	100	81A	125	None	None	
VERICOLOR II PROFESSIONAL, Type S (VPS), 5107³ (On ESTAR Base), 5025 (On Acetate Base) Expose 1/10 sec or less	Electronic Flash, Daylight, or Blue Flash	100	None	None	32	80B	25	80B	80A	Flexicolor Process C-41. By Kodak, other labs, or users. Sent to Kodak by dealers.

NOTES:
1 Must be processed into slides or transparencies before prints can be made.
2 Must be developed to negatives before prints or slides can be made.
3 Also available in long rolls, 35mm perforated.
4 See film instructions.
5 Or clear bulbs with No. 80C Filter; use No. 80D Filter with zirconium-filled clear bulbs such as AG-1 and M-3.
6 Filter recommendations are for critical use in making negatives to be printed by photofinishers.
7 If results are consistently bluish, use a CC05Y or CC10Y Filter with EKTACHROME Films for Process E-6; use a No. 81B Filter with KODACOLOR II Film. Increase exposure ⅓ stop when a CC10Y or No. 81B Filter is used.
8 Chemicals other than the KODAK Chemicals listed may be available.

EASTMAN KODAK

37

KODAK BLACK-AND-WHITE FILMS (Still)

KODAK FILM(Code) ROLL FILMS	PROPERTIES & PURPOSE	SPEEDS	
		Daylight	Tungsten
VERICHROME PAN (VP) rolls and for Cirkut cameras	All-round use.	125	125
PLUS-X PAN (PX)–135[1]	General-purpose film.	125	125
TRI-X PAN (TX)[1]	Very fast. For limited light, action.	400	400
PANATOMIC-X (FX)–135[1] PANATOMIC-X PROFESSIONAL (FXP)–120	Extremely fine grain, very high resolving power.	32	32
PLUS-X PAN PROFESSIONAL (PXP)– 120 and 220 in 5-roll pro-pack; film packs	General-purpose film, retouching surface on emulsion side.	125	125
TRI-X PAN PROFESSIONAL (TXP)– 120 and 220 in 5-roll pro-pack.	Superior highlight brilliance, good contrast control, retouching surface on both sides.	320	320
ROYAL-X PAN (RX)–120 only	Ultra-fast. For existing light.	1250[3]	1250[3]
RECORDING 2475 (ESTAR-AH Base) (RE)–135-36[1]	Ultra-fast panchromatic. For adverse light conditions.	—	1000-4000[3]
HIGH CONTRAST COPY 5069 (HC)–135-36[1]	Panchromatic. For line copying.	—	64
HIGH SPEED INFRARED (HIE)–135-20 only	Haze penetration, special effects and purposes.	—[3]	—[3]

[3] See film instructions.
[1] Also available in long rolls, 35mm perforated.

(*Continued on following page*)

38

EASTMAN KODAK

KODAK BLACK-AND-WHITE FILMS (Still)

SHEET FILMS	PROPERTIES & PURPOSE	Daylight	Tungsten
EKTAPAN 4162 (ESTAR Thick Base)[2]	For portraits by electronic flash and general use.	100	100
PLUS-X PAN PROFESSIONAL 4147 (ESTAR Thick Base)[2]	Excellent definition. For portrait and commercial work.	125	125
SUPER-XX PAN 4142 (ESTAR Thick Base)	Long tonal gradation. Color-separation negatives.	200	200
TRI-X PAN PROFESSIONAL 4164 (ESTAR Thick Base)[2]	Superior highlight brilliance, good contrast control.	320	320
TRI-X ORTHO 4163 (ESTAR Thick Base)	Superior body highlight brilliance. For portraits and commercial subjects.	320	200
ROYAL PAN 4141 (ESTAR Thick Base)[2]	High speed. General purpose.	400	400
ROYAL-X PAN 4166 (ESTAR Thick Base)	Ultra-fast. For available-light exposure.	1250[3]	1250[3]
COMMERCIAL 6127 and 4127 (ESTAR Thick Base)	Blue-sensitive. For continuous-tone copying, transparencies.	50 (20[4])	8
CONTRAST PROCESS ORTHO 4154 (ESTAR Thick Base)	Extremely high contrast. For line copies.	100[4]	40
CONTRAST PROCESS PAN 4155 (ESTAR Thick Base)	Extremely high contrast. For copies of colored line originals	100[4]	80
PROFESSIONAL COPY 4125 (ESTAR Thick Base)	Retains highlight gradation in copies.	25[4]	12
HIGH-SPEED INFRARED 4143 (ESTAR Thick Base)	Haze penetration, special effects. Document copying.	—[3]	—[4]
LONG ROLLS (Wider than 16mm)	PROPERTIES & PURPOSE	Daylight	Tungsten
PLUS-X PAN PROFESSIONAL 2147 (ESTAR Base)	Good definition and excellent latitude.	125	125
PLUS-X PORTRAIT 5068	For portrait and school work. Retouching surface.	125	125
Direct Positive Panchromatic 5246	For reversal processing to slides.	80	64

NOTES:
1 Also available in long rolls, 35mm perforated.
2 Also available in long rolls, 3½ inch wide.
3 See film instructions.
4 Speed to white-flame arc.

(Continued on following page)

39

KODAK MOTION PICTURE FILMS (Color)

KODAK FILM (Code) COLOR FILMS	BALANCED FOR	FILM SPEED AND KODAK WRATTEN FILTER NUMBER						PROCESSING Kodak Chemicals§
		Daylight		Photolamps (3400 K)		Tungsten (3200 K)		
		Speed	Filter	Speed	Filter	Speed	Filter	
KODACHROME 25 (Daylight) 8 mm and 16mm	Daylight (KM)	25	None	Not recommended		Not recommended		By Kodak labs and photofinishers. Sent to Kodak direct by users with Kodak Mailers. *(Not for user Processing)*
KODACHROME 40 (Type A) 8 mm, super 8 silent & sound, & 16 mm	Movie Light (3400 K) (KMA)	25	85	40	None	32†	82A	
EKTACHROME 160 (Type A) For use in limited light. Super 8 & super 8 sound only	Tungsten (ELA)	100	85°	160	None	160	None‡	*(Ektachrome Movie)*
Type G EKTACHROME 160 For use in limited light. Super 8 only	Use in any type of light (EG)	160	None	160	None	160	None	
EKTACHROME MS 7256 (EMS) 16 mm	Daylight (EMS)	64	None	20	80B	16	80A	By Kodak and other labs. Sent to Kodak by dealers. *(Processes ME-4)*
EKTACHROME EF Super 8 (Daylight) 16mm	7241, Daylight (EF)	160	None	50	80B	40	80A	
EKTACHROME EF ... Tungsten (EFB) 16mm	7242, 3200 K Tungsten	80	85B	100	81A	125	None	

° Also for fluorescent lights, mercury-vapor lamps, carbon-arc spotlights, and television screens.
† Does not apply for KMA super 8—use of 3200 K tungsten is not recommended with super 8.
‡ Also for existing tungsten.
§ Chemicals other than the KODAK Chemicals listed may be available.

(Continued on following page)

EASTMAN KODAK

40

KODAK MOTION PICTURE FILMS (Black-and-White)

KODAK FILM (Code) BLACK-AND-WHITE FILMS	PROPERTIES & PURPOSE	SPEEDS Daylight	SPEEDS Tungsten
PLUS-X REVERSAL 7276 (PXR)–super 8 & 16 mm	General use. Processes to projection original.	50	40
TRI-X REVERSAL 7278 (TXR)–super 8 & 16 mm	High speed. Processes to projection original.	200	160
4-X REVERSAL 7277 (4XR)–16mm	Very fast. For limited light. Processes to projection original.	400	320
EASTMAN PLUS-X NEGATIVE 7231 (PXN)–16 mm	General purpose. Processes to negative.	80	64
EASTMAN DOUBLE-X NEGATIVE 7222 (DXN) 16 mm	High speed. Processes to negative.	250	200

EASTMAN KODAK

(Continued on following page)

41

The Compact Photo-Lab-Index

INCIDENT-LIGHT ILLUMINATION (in footcandles)
(Shutter speed 24 frames/sec.—approx. 1/50 sec.)
NOTE: Data applies to color or black-and-white motion-picture films.

Exp. Index (Daylight or Tungsten)	f1.4	f2	f2.8	f4	f5.6	f8	f11
				Lens Opening			
12	200	400	800	1600	3200	6400	13000
16	140	280	550	1100	2250	4500	9000
20	125	250	500	1000	2000	4000	8000
25	100	200	400	800	1600	3200	6400
32	70	140	280	550	1100	2250	4500
40	63	125	250	500	1000	2000	4000
50	50	100	200	400	800	1600	3200
64	40	80	160	320	640	1280	2500
80	30	60	120	250	500	1000	2000
100	26	50	100	200	400	800	1600
125	18	35	70	140	280	560	1100
160	14	28	55	110	225	450	900
200	13	25	50	100	200	400	800
250	10	20	40	80	160	320	640
320	7	14	28	55	110	225	450
400	6	13	25	50	100	200	400

Film	Type Number	Edge Ident. Code	Exposure Index Daylight	Exposure Index Tungsten (3200 K)
EASTMAN Color Negative	5254	A°	32‡	50
EASTMAN EKTACHROME Commercial	7252	C°	16‡	25
KODAK EKTACHROME MS	5256 / 7256		64	16§
KODAK EKTACHROME EF (Daylight)	5241 / 7241	EF°	160	40§
KODAK EKTACHROME EF (Tungsten)	5242 / 7242	EFB°	80‡	125
EASTMAN PLUS-X Negative	4231 / 7231	H†	80	64
EASTMAN DOUBLE-X Negative	5222 / 7222	C†	250	200
EASTMAN 4-X	5224 / 7224	G†	500	400
KODAK PLUS-X Reversal	7276		50	40
KODAK TRI-X Reversal	7278		200	160

°Latent image †Visible-ink print ‡Including No. 85 filter §Including No. 80A filter

FILTER FACTORS
for EASTMAN KODAK Black-and-White Films

Filter	EASTMAN Neg. Films PLUS-X	EASTMAN Neg. Films DOUBLE-X	EASTMAN Neg. Films 4-X	KODAK Rev. Films PLUS-X	KODAK Rev. Films TRI-X	KODAK Rev. Films 4-X
No. 3	1.5	1.5	1.5	1.5	1.5	1.5
No. 8 (K2)	2.0	1.5	2.0	2.0	2.0	2.0
No. 12 (Minus Blue)	2.0	2.0	2.5	2.0	2.0	2.0
No. 15 (G)	2.5	3.0	3.0	2.5	2.5	2.5
No. 21	3.0	3.0	3.5	3.0	3.0	3.0
No. 23A	5	5	5	5	5	5
No. 8N5	5	5	5	6	6	6
No. 25	8	8	8	10	10	10
No. 29	16	20	25	40	40	40
No. 56	4	4	4	4	4	4

NEUTRAL-DENSITY FILTERS

Density	0.3	0.6	0.9	1.0
Factor	2	4	8	10
Exposure Increase (Stops)	1	2	3	3⅓

The Compact Photo-Lab-Index

	Speed	Additive Speed Value	Weston	B.S.I. Log. Scheiner	D.I.N.
KODAK					
35mm Films		in °		in °	
Direct Positive Pan	D 80	4.5	64	30	20
High Contrast Copy	T 64	4	50	29	19
Panatomic-X	ASA 32	3	24	26	16
Plus-X & Plus-X Portrait	ASA125	5	100	32	22
Tri-X Pan	ASA400	7	320	37	27
Recording Film 2475	ASA1000	8	650	40	30
Roll Films & Packs					
Plus-X Professional	ASA125	5	100	32	22
Royal-X Pan	ASA1250	8.5	1000	42	32
Tri-X Pan Professional	ASA320	6.5	250	36	26
Verichrome Pan	ASA125	5	100	32	22
Sheet Films					
Commercial	D 50	4	40	28	18
	T 16	2	12	23	13
Ektapan	ASA100	5	80	31	21
Contrast Process Ortho	D 100	5	80	31	21
	T 50	4	40	28	18
Contrast Process Pan	D 100	5	80	31	21
	T 80	4.5	64	30	20
Gravure Copy Film	D 25	3	20	25	15
	T 12	2	10	22	12
Plus-X	ASA125	5	100	32	22
Royal Pan 4141	ASA400	7	320	37	27
Royal-X Pan	ASA1250	8.5	1000	42	32
Super Panchro Press Type B	ASA250	6	200	35	25
Super-XX Pan 4142	ASA200	6	160	34	24
Tri-X Ortho	D 320	6.5	250	36	26
	T 200	6	160	34	24
Tri-X Pan (Estar Base) Prof. 2164 ..	ASA320	6.5	250	36	26
Plates					
Process	T 12	2	10	22	12
Super Panchro Press	ASA160	5.5	125	33	23
Tri-X Panchromatic Plates	ASA250	6	200	35	25
Kodak 33 Positive	D 40	3.5	32	27	17
	T 16	2	12	23	13
Motion Picture Films					
Eastman Double-X Neg. 5222/7222.	ASA250	6	200	35	25
Eastman Plus-X Negative 5231/7231.	ASA 80	4.5	64	30	20
Kodak Plus-X Reversal 7276	ASA 50	4	40	28	18
2475 Recording	ASA1000	8	800	41	31
*2485 Recording	ASA5000	10.5	4000	48	38
Kodak Tri-X Negative 7202	ASA400	7	320	37	27
Kodak Tri-X Reversal 7278	ASA200	6	160	34	24
Eastman 4-X Negative 5224/7224 ..	ASA500	7.5	400	38	28
Kodak 4-X Reversal 7277	ASA400	7	320	37	27
Eastman Direct MP Film 5360	—	—	—	—	—

B.S.I. Log values may be used with meters calibrated in Scheiner degrees.

EASTMAN KODAK

SPEEDS OF COLOR FILMS

EASTMAN KODAK (side margin)

	Speed		Additive Speed Value	Weston	B.S.I. Log. Scheiner	D.I.N.
KODAK						
35mm Still Films			in °		in °	
Ektachrome-X Film	D	64	4	50	29	19
	T	20*	2.5*	16*	24*	14*
High Speed Ektachrome Daylight ..	D	160	5.5	125	33	23
High Speed Ektachrome, B	D	80¶	4.5¶	64¶	30¶	20¶
	T	125‡	5‡	100‡	32‡	22‡
Kodachrome 25, Daylight	D	25	3	20	25	15
	T	12*	2*	10*	22*	12*
Kodachrome 40, Type A	D	25§	3§	20§	25§	15§
	T	40	3.5	32	27	17
Kodachrome 64, Daylight	D	64	4	50	29	19
	T	25*	3*	20*	25*	15*
Roll Films						
Ektachrome Prof. Daylight type	D	50	4	40	28	18
Kodacolor-X			See 35mm Still Films Above			
Ektachrome-X			See 35mm Still Films Above			
Sheet Films						
Ektacolor Professional	D	64§	4§	50§	29§	19§
6102 Type L	T	100‡	5‡	80‡	31‡	21‡
Ektacolor Professional	D	100	5	80	31	21
6101 Type S	T	32*	3.5*	24*	26*	16*
Ektachrome 6115 Daylight	D	50	4	40	28	18
Ektachrome Type 6116	D	25¶	3¶	20¶	25¶	15¶
Ektachrome Type B	T	32‡	3.5‡	24‡	26‡	16‡
Motion Picture Films						
Eastman Color Neg. Film 5254	D	64§	4§	50§	29§	19§
and 5247	T	100	5	80	31	21
Eastman Ektachrome Com 7252	D	16§	2§	12§	23§	13§
Tungsten	T	25	3	20	25	15
Kodak Ektachrome EF 5241/7241	D	160	5.5	125	33	23
Daylight	T	50*	4*	40*	28*	18*
Kodak Ektachrome EF 5242/7242	D	80§	4.5§	64§	30§	20§
Tungsten	T	125‡	5‡	100‡	32‡	22‡
Kodak Ektachrome MS Film	D	64	4	50	29	19
5256/7256 Daylight	T	20*	2.5*	16*	24*	14*
Kodachrome 25 Daylight			See 35mm Still Films Above			
Kodachrome 40 Type A			See 35mm Still Films Above			
Super 8 Films						
Ektachrome 40 Type A Super 8						
for Movie Light		40	3.5	32	27	17
Ektachrome 160 Type G (All light) .		160	5.5	125	33	23

B.S.I. Log values may be used with meters calibrated in Scheiner degrees.

*With Wratten Filter No. 80B †With Ilford Filter No. 351
§With Wratten Filter No. 85 ¶With Wratten Filter No. 85B
‡Used with 3200 K Lamps

The Compact Photo-Lab-Index

KODAK BLACK-AND-WHITE SHEET FILMS

	SPEEDS	
	ASA Daylight	Tungsten
ROYAL-X Pan 4166 (ESTAR Thick Base)	1250	
ROYAL Pan 4141 (ESTAR Thick Base)	400	Use
TRI-X Pan Professional 4164 (ESTAR Thick Base)	320	the
Super Panchro-Press 4146, Type B	250	same speed
SUPER-XX Pan 4142 (ESTAR Thick Base)	200	numbers as
PLUS-X Professional 4147 (ESTAR Thick Base)	125	are given
EKTAPAN 4162 (ESTAR Thick Base)	100	for daylight
LS Pan 4160 (ESTAR Thick Base)	50	
Contrast Process Pan 4155 (ESTAR Thick Base)	100*	80
TRI-X Ortho 4163 (ESTAR Thick Base)	320	200
Contrast Process Ortho 4154 (ESTAR Thick Base)	100*	50
Professional Copy 4125† (ESTAR Thick Base)	25*	12
Professional Line Copy 6573	—	16
Commercial 6127	20*	8
Commercial 4127 (ESTAR Thick Base)	20*	8
Fine Grain Positive 7302	—	10

Note: The above speed numbers are for use with meters marked for ASA speeds. They normally lead to the minimum exposure needed to yield high-quality negatives.

*Speed to White-Flame Arc.
†Formerly KODAK Gravure Copy Film.

KODAK Color Sheet Films	Daylight		3200 K		Photoflood	
	Speed	Filter	Speed	Filter	Speed	Filter
Process E-3						
EKTACHROME 6115, Daylight Type	50	none	Not Recommended			
EKTACHROME 6116, Type B	25	85B	32	none	25	81A
Process C-22						
EKTACOLOR Prof. 6101, Type S ...	100	none	25	80A	32	80B
EKTACOLOR Prof. 6102, Type L ...	64	85	64	none	64	81A

The speeds given in the above table apply for the exposure times given in the instruction sheets that accompany the film.

EASTMAN KODAK

45

KODAK PANATOMIC-X FILM
ASA 32

GENERAL PROPERTIES

An extremely fine grain, panchromatic film with good sharpness and antihalation characteristics. It has slow speed and medium contrast. Intended for use whenever a considerable degree of enlargement is required. Available in 120 and 135, and 35mm and long rolls.

FILM SPEED
ASA 32

This number is based on a USA Standard and is for use with meters and cameras marked for ASA speeds, in either daylight or artificial light. It will normally lead to approximately the minimum exposure required to produce negatives of highest quality.

If, with normal development, your negatives are consistently too thin, increase exposure by using a lower number; if too dense, reduce exposure by using a higher number.

DAYLIGHT EXPOSURE TABLE

Shutter Speed 1/125 Second			Shutter Speed 1/60 Second	
Bright or Hazy Sun Distinct Shadows		**Cloudy Bright No Shadows**	**Heavy Overcast**	**Open Shade†**
On Light Sand or Snow	**Average Subjects**			
f/11	f/8*	f/4	f/4	f/4

*f/4 at 1/125 second for backlighted close-up subjects.
†Subject shaded from the sun but lighted by a large area of sky.

FILTER FACTORS

Increase the normal exposure by the filter factor in the table.

Filter	No. 6 (K1)	No. 8 (K2)	No. 15 (G)	No. 11 (X1)	No. 25 (A)	No. 58 (B)	No. 47 (C5)	Polarizing Screen
Daylight	1.5	2*	2.5	4	8	6	8	2.5
Tungsten	1.5	1.5	1.5	4*	5	6	16	2.5

*For correct gray-tone rendering of colored objects.

ELECTRONIC FLASH GUIDE NUMBERS

Use this table as a starting point in determining the correct guide number for electronic flash units rated in beam-candlepower-seconds (BCPS). Divide the proper guide number by the flash-to-subject distance in feet to determine the f-number for average subjects.

Output of Unit —BCPS	350	500	700	1000	1400	2000	2800	4000	5600	8000
Guide Number	24	28	32	40	50	55	65	80	95	110

(Continued on following page)

EASTMAN KODAK

The Compact Photo-Lab-Index

FLASHBULB GUIDE NUMBERS

Divide the proper guide number by the flash-to-subject distance in feet to determine the f-number for average subjects. These guide numbers are for blue flashbulbs. If you use clear flashbulbs, reduce the lens opening by ⅔ stop.

Synchronization	Shutter Speed	Flashcube	Shallow Cylindrical Reflector	Intermediate-Shaped Reflector	Polished Bowl-Shaped Reflector	Intermediate-Shaped Reflector		Polished Bowl-Shaped Reflector			
		Flashcube	AG-1B	M2B	AG-1B	M2B	AG-1B	M3B 5B 25B	6B* 26B*	M3B 5B 25B	6B* 26B*
X	1/30	50	36	50	50	70	80	75	NR	100	NR
M	1/30	34	26	NR	36	NR	50	65	70	90	100
	1/60	40	26	NR	36	NR	50	65	50	90	75
	1/125	28	22	NR	30	NR	45	55	34	75	50
	1/250	22	18	NR	26	NR	36	42	24	60	34
	1/500	18	14	NR	20	NR	28	32	17	45	24

*Bulbs for focal-plane shutters; use with FP synchronization.
NR = Not Recommended.

SAFELIGHT

Handle film in total darkness. However, when development is half completed, you can use a safelight at 4 feet for a few seconds. Equip the safelight with a Kodak Safelight Filter, No. 3 (dark green) or equivalent and a 15-watt bulb.

PROCESSING

Development: Developing times are for small roll-film tanks with agitation at 30-second intervals throughout development.

Rinse: Kodak Indicator Stop Bath or Kodak Stop Bath SB-5, at 65 to 75 F for 30 seconds with agitation. A running-water rinse can be used if an acid rinse bath is not available.

Fix: Kodak Fixer or Kodak Fixing Bath F-5 for 2 to 4 minutes; or Kodak Rapid Fixer or Kodafix Solution for 1 to 2 minutes at 65 to 75 F with agitation.

Wash: 20 to 30 minutes in running water at 65 to 75 F. To minimize drying marks, treat in Kodak Photo-Flo Solution after washing, or wipe surfaces carefully with a Kodak Photo Chamois or a soft viscose sponge.

Kodak Hypo Clearing Agent can be used after fixing to reduce washing time and conserve water. First, remove ex-

KODAK Packaged Developers	Developing Times in Minutes†				
	65 F	68 F	70 F	72 F	75 F
D76	6	5	4½	4¼	3¾
D-76 (1:1)	8	7	6½	6	5
MICRODOL-X	8	7	6½	6	5
MICRODOL-X (1:3)*	—	—	11	10	8½
POLYDOL	6½	5½	5	4½	3½
HC-110 (Dilution B)	4¾	4¼	4	3¾	3¼

*For greater sharpness.
†Unsatisfactory uniformity may result with development times shorter than 5 minutes.

(Continued on following page)

EASTMAN KODAK

The Compact Photo-Lab-Index

cess hypo by rinsing the film in water for 30 seconds. Then bathe the film in the Kodak Hypo Clearing Agent solution for 1 or 2 minutes, with moderate agitation, and wash it for 5 minutes, using a water flow sufficient to give at least one complete change of water in 5 minutes.

SPECIAL PROCESSING FOR SLIDES

When you use Panatomic-X Film, 135 size, as a positive slide film, expose it at a speed of 80 for daylight and 64 for tungsten. Process your film in the Kodak Direct Positive Film Developing Outfit. With the temperature of all the solutions at 68 F, follow the processing steps below. Agitate continuously during the first 30 seconds in each solution, and for 5 seconds every minute thereafter.

1. First Developer8 minutes
2. Water Rinse2 to 5 minutes*
3. Bleach1 minute
4. Clearing Bath2 minutes
5. Redeveloper8 minutes
6. Water Rinse1 minute
7. Fixing Bath5 minutes
8. Wash20 minutes

*A 2-minute rinse is sufficient with a running-water wash and good agitation.

KODAK PLUS-X PAN FILM

ASA 125

GENERAL PROPERTIES

A medium speed panchromatic film with medium contrast and extremely fine grain. This film offers excellent sharpness in enlargements. Available in 135 magazines, and 35mm and 70mm long rolls.

CONTRAST-INDEX CURVES
KODAK PANATOMIC-X FILM

KODAK Developers
1. HC-110 Dilution B
2. D-76
3. D-76 (1:1) and MICRODOL-X
4. MICRODOL-X (1:3) at 75°F (24°C)
5. POLYDOL

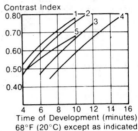

Time of Development (minutes)
68°F (20°C) except as indicated.
Large Tank, agitation at
1-minute intervals.

SAFELIGHT

Total darkness is required until the bleaching step is completed. For the rest of the process you can use a safelight equipped with a Kodak Safelight Filter 0A (greenish yellow) or equivalent and 15-watt bulb. Keep the safelight at least 4 feet from the film. Do not turn on the normal room lights until the film has been fixed, or the highlights may appear gray.

FILM SPEED
ASA 125

This number is for use with meters marked for ASA Speeds or Exposure Indexes in either daylight or artificial light. It will normally lead to approximately the minimum exposure required to produce negatives of highest quality.

If, with normal development, negatives are consistently too thin, increase exposure by using a lower number; if too dense, decrease exposure by using a higher number.

DAYLIGHT EXPOSURE TABLE
Shutter speed at 1/100 or 1/125.

Bright or Hazy Sun on Light Sand or Snow	Bright or Hazy Sun (Distinct Shadows)	Cloudy Bright (No Shadows)	Heavy Overcast	Open Shade†
f/22	f/16*	f/8	f/5.6	f/5.6

*f/8 for backlighted closeup subjects.
†Subject shaded from sun by lighted by a large area of sky.

(Continued on following page)

The Compact Photo-Lab-Index

FILTER FACTORS

Multiply normal exposure by filter factor given below.

KODAK WRATTEN Filters	No. 6	No. 8	No. 11	No. 15	No. 25
Daylight	1.5	2*	4	2.5	6
Tungsten	1.2	1.5	4*	1.5	4

*For correct gray-tone rendering of colored objects.

ELECTRONIC FLASH GUIDE NUMBERS

To determine the F-number for average subjects, divide the proper guide number by the distance (in feet) from flash to subject.

Output of Unit (BCPS or ECPS)	350	500	700	1000	1400	2000	2800	4000	5600	8000
Guide Number for Trial	45	55	65	80	95	110	130	160	190	220

SAFELIGHT

Handle and process the film in total darkness. After development is half completed, a Kodak Safelight Filter No. 3 (dark green) or equivalent in a suitable safelight lamp with a 15-watt bulb can be used for a few seconds only. Keep the safelight at least 4 feet from the film.

PROCESSING—135 Magazines

Development: Develop at the approximate times and temperatures given below.

KODAK Packaged Developers	SMALL TANK—Agitation at 30-Second Intervals					LARGE TANKS—Agitation at 1-Minute Intervals				
	65 F	68 F	70 F	72 F	75 F	65 F	68 F	70 F	72 F	75 F
HC-110 (Dil. B)	6	5	4½ *	4*	3½ *	6½	5½	5	4¾ *	4*
POLYDOL	6½	5½	4¾ *	4¼ *	3¼ *	7½	6	5½	4¾ *	3¾ *
MICRODOL-X	8	7	6½	6	5½	10	9	8	7½	7
MICRODOL-X (1:3)	—	—	11	10	9½	—	—	14	13	11
D-76	6½	5½	5	4½ *	3¾ *	7½	6½	6	5½	4½ *
D-76 (1:1)	8	7	6½	6	5	10	9	8	7½	7

*Developing Time in Minutes**

*Unsatisfactory uniformity may result with development times shorter than 5 minutes.

Rinse: Kodak Indicator Stop Bath or Kodak Stop Bath SB-5, at 65 to 75 F, for 30 seconds with agitation. A running-water rinse can be used if an acid stop bath is not available.

Fix: Kodak Fixer or Kodak Fixing Bath F-5 for 5 to 10 minutes or Kodak Rapid Fixer or Kodafix Solution for 2 to 4 minutes, at 65 to 75 F with agitation.

(Continued on following page)

EASTMAN KODAK

The Compact Photo-Lab-Index

Wash: For 20 to 30 minutes in running water at 65 to 75 F. To minimize drying marks, treat the film in Kodak Photo-Flo Solution after washing, or wipe the surfaces carefully with a Kodak Photo Chamois or a soft viscose sponge.

PROCESSING—Long Rolls
(Up to 100-Foot Lengths)
Development: Recommended developing times and temperatures for long rolls on spiral reels.

Secure the end of the film with a rubber band or waterproof tape to prevent the film from unwinding during processing. Then use the following agitation procedure.

1. Lower the reel into the developer, giving it a vigorous turning motion sufficient to cause the reel to rotate one-half to one revolution in the developer. Raise and lower the reel approximately one-half inch (keeping the reel in the solution) for the first 15 seconds of the development, tapping it against the bottom of the tank to release air bubbles from the film.

2. Agitate once each minute by lifting the reel out of the solution, tilting it 30 degrees to drain 5 to 10 seconds, and immersing it again with a vigorous turning motion sufficient to cause the reel to rotate one-half to one revolution in the developer. Alternate the direction of rotation each minute.

3. Agitate in the same manner in the stop bath and once per minute in the fixing bath.

Note. Too little agitation during development will cause mottle and uneven development. Too much pumping of the reel in and out of the developer can produce streaks across the film at the reel spokes. Too much turning of the reel in the solution can cause longitudinal streaks on the film. The agitation procedure just described provides a compromise which minimizes these undesirable effects.

KODAK Packaged Developers	Developing Time (in Minutes)	
	68 F 20 C	75 F 24 C
HC-110 (Dilution B)	6	4¼
POLYDOL	6½	4

50

KODAK PLUS-X Pan Film In 135 Magazines

Use this film for general black-and-white picture-taking. It offers the optimum combination of medium speed, very fine grain, and very high sharpness even at a high degree of enlargement.

HANDLING

Load and unload your camera in subdued light. After you make the last exposure and before opening the camera, rewind the film into the magazine.

DAYLIGHT PICTURES

Set your exposure meter or automatic camera at **ASA 125.** If your negatives are consistently too light, increase exposure by using a lower film-speed number; if too dark, reduce exposure by using a higher number.

If you don't have an exposure meter or automatic camera, use the exposures given in the following table.

DAYLIGHT EXPOSURE TABLE FOR *PLUS-X* PAN FILM				
For average subjects, use f-number below appropriate lighting condition.				
Shutter Speed 1/250 Second	Shutter Speed 1/125 Second			
Bright or Hazy Sun on Light Sand or Snow	Bright or Hazy Sun (Distinct Shadows)	Cloudy Bright (No Shadows)	Heavy Overcast	Open Shade†
f/16	f/11*	f/8	f/5.6	f/5.6

*f/8 at 1/125 second for backlighted close-up subjects.
†Subject shaded from the sun but lighted by a large area of sky.

FLASH PICTURES

Blue Flashbulbs: Determine the f-number for average subjects by dividing the guide number for your reflector and flashbulb by the distance in feet from the flash to your subject. Use these numbers as **guides**—if your negatives are consistently too light, increase exposure by using a lower guide number; if too dark, reduce exposure by using a higher guide number.

Caution: Bulbs may shatter when flashed; use a flashguard over your reflector. **Do not use flash in an explosive atmosphere.** See flashbulb manufacturer's instructions.

For successful flash operation, clean battery ends and equipment contacts often with a cloth dampened with clean water only. If the contacts are difficult to reach with a cloth, use a water-dampened cotton swab to clean them. Use live batteries; test them regularly and replace weak ones.

ELECTRONIC FLASH

This table is for use with electronic flash units rated in beam candle-power seconds (BCPS). To determine the f-number, divide the guide number for your flash unit by the distance in feet from the flash to your subject. If exposure is unsatisfactory, change the guide number as described under "Blue Flashbulbs."

(Continued on following page)

The Compact Photo-Lab-Index

Output of Unit BCPS	350	500	700	1000	1400	2000	2800	4000	5600	8000
Guide Number	45	55	65	80	95	110	130	160	190	220

			GUIDE NUMBERS FOR BLUE FLASHBULBS				
Type of Reflector	Flashbulb	Shutter Speed					
		X Sync	M Synchronization				
		1/30	1/30	1/60	1/125	1/250	
(cube)	Flashcube	100	70	65	55	44	
	Hi-Power Cube	140	90	90	80	65	
(reflector)	AG-1B	75	50	50	42	36	
(reflector)	AG-1B	100	70	70	60	50	
	M2B	100	NR	NR	NR	NR	
(reflector) *	AG-1B	150	100	100	85	70	
	M2B	130	NR	NR	NR	NR	
(reflector)	M3B, 5B, 25B	140	130	120	100	85	
	6B†, 26B†	NR	140	100	70	50	
(reflector) *	M3B, 5B, 25B	200	180	180	150	120	
	6B†, 26B†	NR	200	140	100	70	

*Polished bowl. †Bulbs for focal-plane shutter. NR—Not Recommended.

Caution: Bulbs may shatter when flashed; use a flashguard over your reflector. Do not use flash in an explosive atmosphere. See flashbulb manufacturer's instructions.

FILTERS

When you use a filter, increase the normal exposure by the factor indicated in the table. However, if your camera has a built-in exposure meter that makes the reading through a filter used over the lens, see your camera manual for instructions on exposure with filters.

Kodak Wratten Filter	No. 6 (K1)	No. 8 (K2)	No. 11 (X1)	No. 15 (G)	No. 25 (A)	Polarizing Screen
Tungsten	1.2	1.5	4*	1.5	4	2.5
Daylight	1.5	2*	4	2.5	6	2.5

*For correct gray-tone rendering of colored objects.

PROCESSING

Take the exposed film to your photo dealer for developing and printing. If you want to process the film yourself, follow these instructions:

Handle in Total Darkness. However, when development is half completed, you can use a safelight at 4 feet for a few seconds. Equip the safelight with a Kodak Safelight Filter, No. 3 (dark green) or equivalent and a 15-watt bulb.

To open the 135 magazine, hold the magazine with the long end of the spool down and use a lid lifter or a hook-type bottle opener to remove the upper end cap from the magazine.

(Continued on following page)

Develop for the following times.

Rinse in Kodak Indicator Stop Bath or Kodak Stop Bath SB-5, at 65 to 75 F (18 to 24 C), for 30 seconds with agitation. You can use a running-water rinse if an acid stop bath is not available.

Fix in Kodak Fixer or Kodak Fixing Bath F-5 for 5 to 10 minutes, or Kodak Rapid Fixer or Kodafix Solution for 2 to 4 minutes, at 65 to 75 F (18 to 20 C) with agitation.

Wash the film for 20 to 30 minutes in running water at 65 to 75F (18 to 24 C). To minimize drying marks, treat the film in Kodak Photo-Flo Solution after washing, or wipe the surfaces carefully with a Kodak Photo Chamois or a soft viscose sponge.

You can use Kodak Hypo Clearing Agent after fixing to reduce washing time and conserve water. First, remove excess hypo by rinsing the film in water for 30 seconds. Then, bathe the film in the Kodak Hypo Clearing Agent solution for 1 or 2 minutes with moderate agitation, and wash it for 5 minutes, using a water flow sufficient to give at least one complete change of water in 5 minutes.

Note: For best results, keep the temperatures of the rinse, fix, and wash close to the developer temperature.

Dry in a dust-free place.

PROCESSING DATA

New Developing Times (in Minutes)

Kodak Packaged Developers	SMALL TANK—(Agitation at 30-Second Intervals)					LARGE TANK—Agitation at 1-Minute Intervals				
	65 F 18 C	68 F 20 C	70 F 21 C	72 F 22 C	75 F 24 C	65 F 18 C	68 F 20 C	70 F 21 C	72 F 22 C	75 F 24 C
HC-110 (Dilution B)	6	5	4½°	4°	3½°	6½	5½	5	4¾°	4°
Polydol	6½	5½	4¾°	4¼°	3¼°	7½	6	5½	4¾°	3¾°
D-76	6½	5½	5	4½°	3¾°	7½	6½	6	5½	4½°
D-76 (1:1)	8	7	6½	6	5	10	9	8	7½	7
Microdol-X	8	7	6½	6	5½	10	9	8	7½	7
Microdol-X (1:3)	—	—	11	10	9½	—	—	14	13	11

NOTE: The development times have been changed as a result of a recent comprehensive study of all the factors affecting development.

°Unsatisfactory uniformity may result with development times shorter than 5 minutes.

EASTMAN KODAK

KODAK PLUS-X
Pan Professional Film

PXP220 and PXP120

Medium-speed panchromatic film with extremely fine grain and high resolving power. Medium contrast, wide exposure latitude. Very high sharpness even at high degrees of enlargement.

PXP220

Important: PXP220 film is for use in professional roll-holders and cameras designed to accommodate the longer length of film. Some cameras that take 120 film can be modified to accept the PXP220 film. The 220-size roll of film is about twice the length of the 120-size roll, and has no backing paper on the film itself. The film has a paper leader and trailer. Be sure that the processing equipment used can accommodate the extra length of 220-size film.

Caution: Since this film does not have the usual backing paper wound the length of the film, special care in loading and unloading the camera is necessary to avoid light fog on this sensitive emulsion. Load and unload the camera in subdued light.

PXP120

PXP120 film is a normal length roll film, and it can be used in cameras accepting 120-size film.

To use this film, load and unload your camera in subdued light, never in direct sunlight or exceptionally strong artificial light.

Darkroom Handling: Total darkness required. After development is half completed, a Kodak Safelight Filter No. 3 (dark green) or equivalent in a suitable safelight lamp with a 15-watt bulb can be used **for a few seconds only.** Keep the safelight at least 4 feet from the film.

EXPOSURE

Speed: ASA 125

This number is for use with meters and cameras marked for ASA Speeds or Exposure Indexes, in either daylight or artificial light. It will normally lead to approximately the minimum exposure required to produce negatives of highest quality.

If, with normal development, your negatives are consistently too thin, increase exposure by using a lower number; if too dense, reduce exposure by using a higher number.

OUTDOOR EXPOSURE GUIDE FOR AVERAGE SUBJECTS

For shutter speed of 1/100 or 1/125 second.

Set Shutter at 1/100 or 1/125 Second

Bright or Hazy Sun on Light Sand or Snow	Bright or Hazy Sun (Distinct Shadows)	Weak, Hazy Sun (Soft Shadows)	Cloudy Bright (No Shadows)	Open Shade† or Heavy Overcast
f/22	f/16*	f/11	f/8	f/5.6

*f/8 for backlighted close-up subjects.
†Subject shaded from the sun but lighted by a large area of sky.

FILTER FACTORS

Multiply normal exposure by filter factor given below.

Kodak Wratten Filter	No. 6	No. 8	No. 11	No. 15	No. 25	No. 47	No. 58	Polarizing Screen
Daylight	1.5	2*	4	2.5	6	6	8	2.5
Tungsten	1.2	1.5	4*	1.5	4	12	8	2.5

FLASH EXPOSURES

To determine the f-number for average subjects, divide the appropriate guide number by the distance (in feet) from flash to subject.

(Continued on following page)

EASTMAN KODAK

The Compact Photo-Lab-Index

ELECTRONIC FLASH GUIDE NUMBERS

Output of Unit (BCPS or ECPS)	350	500	700	1000	1400	2000	2800	4000	5600	8000
Guide Number for Trial	45	55	65	80	95	110	130	160	190	220

GUIDE NUMBERS FOR BLUE FLASHBULBS

Between-Lens Shutter Speed	Synchro-nization	Flash-cube	AG 1B†	M2B‡	M3B† 5B§ 25B§	Focal-Plane Shutter Speed	6B 26B§
Open 1/25-1/30	X or F	100	150	130	200	1/25-1/30 1/50-1/60	200 140
1/25-1/30	M	70	100	NR**	180	1/100-1/125	100
1/50-1/60	M	65	100	NR	180	1/200-1/250	70
1/100-1/125	M	55	85	NR	150	1/400-1/500	50
1/200-1/250	M	44	70	NR	120	1/1000	34
1/400-1/500	M	36	55	NR	90		

°For hi-power cubes, multiply flashcube guide numbers by 1.4.
Bowl-shaped polished reflector sizes: †2-inch; ‡3-inch; §4- to 5-inch. All guide numbers are for bowl-shaped, polished reflectors; they do not apply to other shapes of reflectors. For shallow cylindrical reflectors, divide these guide numbers by 2. For intermediate-shaped reflectors (such as the shallow fan-shaped reflector), divide these guide numbers by 1.4.
°°NR—Not Recommended.

Clear Bulbs: If you use clear flashbulbs instead of blue, decrease lens opening ⅔ stop.

Caution: Since bulbs may shatter when flashed, use a flashguard over the reflector. **Do not flash bulbs in an explosive atmosphere.**

PROCESSING DATA

Develop for the approximate times given.

Kodak Packaged Developers	SMALL TANK—(Agitation at 30-Second Intervals)					LARGE TANK—(Agitation at 1-Minute Intervals)				
	65 F 18 C	68 F 20 C	70 F 21 C	72 F 22 C	75 F 24 C	65 F 18 C	68 F 20 C	70 F 21 C	72 F 22 C	75 F 24 C
HC-110 (Dilution B)	6	5	4½°	4°	3½°	6½	5½	5	4¾°	4°
Polydol	6½	5½	4¾°	4¼°	3¾°	7½	6	5½	4¾°	3¾°
D-76	6½	5½	5	4½°	3¾°	7½	6½	6	5½	4½°
D-76 (1:1)	8	7	6½	6	5	10	9	8	7½	7
Microdol-X	8	7	6½	6	5½	10	9	8	7½	7
Microdol-X (1:3)	—	—	11	10	9½	—	—	14	13	11

°Unsatisfactory uniformity may result with development times shorter than 5 minutes.
NOTE: Do not use developers containing silver halide solvents.

Rinse at 65 to 75 F (18 to 24 C) with agitation.
 Kodak Indicator Stop Bath—
 30 seconds or
 Kodak Stop Bath SB-5—30 seconds
Fix at 65 to 75 F (18 to 24 C) with agitation.
 Kodak Fixer—5 to 10 minutes or
 Kodak Fixing Bath F-5—
 5 to 10 minutes or
 Kodak Rapid Fixer—
 2 to 4 minutes or
 Kodafix Solution—2 to 4 minutes

Wash for 20 to 30 minutes in running water at 65 to 75 F (18 to 24 C). To minimize drying marks, treat in Kodak Photo-Flo Solution after washing. To save time and conserve water, use Kodak Hypo Clearing Agent.

Dry in a dust-free place.

Storage: Keep unexposed film at 75 F (24 C) or lower. Process film as soon as possible after exposure.

(Reproduced with permission from a Copyrighted KODAK Publication)

The Compact Photo-Lab-Index

KODAK PLUS-X PAN PROFESSIONAL FILM 2147 (ESTAR Base)

GENERAL PROPERTIES

These are medium-speed, panchromatic films with fine grain and high acutance. They have sensitometric characteristics similar to other Kodak Plus-X Films, but the emulsion is coated on ESTAR Base for greater resistance to mechanical damage and better dimensional stability. They are recommended for general negative making, particularly when a high degree of enlargement is needed. Plus-X Pan Professional Film 2147 is available in 35mm and 70mm long rolls. Plus-X Pan Professional Film 4147 is available in sheets and 3½-inch long rolls.

FILM SPEED
ASA 125

This number is for use with meters marked for ASA speeds, in either daylight or artificial light. It will normally lead to approximately the minimum exposure required to produce negatives of highest quality.

If, with normal development, negatives are consistently too thin, increase exposure by using a lower number; if too dense, reduce exposure by using a higher number.

DAYLIGHT EXPOSURE TABLE

Shutter Speed (1/250 Second)		Shutter Speed 1/125 Second		
Bright or Hazy Sun on Light Sand or Snow	Bright or Hazy Sun (Distinct Shadows)	Cloudy Bright (No Shadows)	Heavy Overcast	Open Shade†
f/16	f/11*	f/8	f/5.6	f/5.6

*f/5.6 at 1/250 second for backlighted close-up subjects.
†Subject shaded from the sun but lighted by a large area of sky.

FILTER FACTORS

Multiply the normal exposure by the filter factor given below.

KODAK WRATTEN Filter	No. 6 (K1)	No. 8 (K2)	No. 11 (X1)	No. 15 (G)	No. 25 (A)	No. 58 (B)	No. 47 (C5)	No. 29 (F6)	Polarizing Screen
Daylight	1.5	2*	—	2.5	8	6	6	25	2.5
Photoflood or high-efficiency tungsten	1.5	1.5	4*	1.5	5	6	12	12	2.5

*For correct gray-tone rendering of colored objects.

(Continued on following page)

EASTMAN KODAK

The Compact Photo-Lab-Index

FLASH EXPOSURE GUIDE NUMBERS

Clear Flashbulbs. To get f-number, divide guide number by flash-to-subject distance in feet, taken to a point midway between nearest and farthest details of interest. In small white rooms, use one stop smaller.

Between-Lens Shutter Speed	Synchronization	AG-1*	M3† 5‡, 25‡	11§ 40§	2§ 22§	Focal-Plane Shutter Speed
Open 1/25-1/30	X or F	180	280	280	340	1/25
1/25-1/30	M	120	240	240	320	1/50
1/50-1/60	M	120	240	220	300	1/100
1/100-1/125	M	100	200	200	260	1/250
1/200-1/250	M	80	160	150	200	1/500
1/400-1/500	M	65	120	120	150	1/1000

Bowl-Shaped Polished Reflectors: *2-inch; †3-inch; ‡4- to 5-inch; §6- to 7-inch. All guide numbers are for bowl-shaped, polished reflectors; they do not apply to other shapes of reflectors. For shallow cylindrical reflectors, divide these guide numbers by 2. For intermediate-shaped reflectors (such as the shallow fan-shaped reflector), divide these guide numbers by 1.4.

ELECTRONIC FLASH GUIDE NUMBERS

This table is intended as a starting point in determining the correct guide number. The table is for use with equipment rated in beam candlepower-seconds (BCPS) or effective candle-power-seconds (ECPS). Divide the appropriate guide number by the flash-to-subject distance in feet to determine the f-number for average subjects.

SAFELIGHT

Handle in total darkness. After development is half completed, a Kodak Safelight Filter No. 3 (dark green) or equivalent in a suitable safelight lamp with a 15-watt bulb can be used at 4 feet from the film for a few seconds only.

Output of Unit (BCPS or ECPS)	350	500	700	1000	1400	2000	2800	4000	5600	8000
Guide Number for Trial	45	55	65	80	95	110	130	160	190	220

RECIPROCITY EFFECT ADJUSTMENTS

Exposure Time (seconds)	Exposure Adjustments	Development Adjustments
1/1000	none	+10%
1/100	none	none
1/10	none	none
1	1 stop more	10% less
10	2 stops more	20% less
100	3 stops more	30% less

(Continued on following page)

PROCESSING FOR SHEET FILM 4147

Development: Develop at approximate times and temperatures given below.

KODAK Developer*	Developing Times (in Minutes)									
	Continuous Agitation (Tray)					Intermittent Agitation† (Tank)				
	65 F	68 F	70 F	72 F	75 F	65 F	68 F	70 F	72 F	75 F
POLYDOL	7	6	5½	5	4½	9	8	7½	7	6
HC-110 (Dilution B)	6	5	4¾	4½	4	8	7	6½	6	5
DK-50 (1:1)	5	4½	4¼	4	3½	6½	6	5¾	5½	5
D-76	7	6	5½	5	4½	9	8	7½	7	6
MICRODOL-X	9	8	7½	7	6	11	10	9½	9	8

*Available in convenient ready-to-mix form in several sizes.

†Agitation at 1-minute intervals during development.

Unsatisfactory uniformity may result with development times of less than 5 minutes.

Rinse: Kodak Indicator Stop Bath 30 seconds or Kodak Stop Bath SB-5 —30 seconds.

Fix: Kodak Fixer—5 to 10 minutes or Kodak Fixing Bath F-5—5 to 10 minutes or Kodak Rapid Fixer—2 to 4 minutes.

Wash: For 20 to 30 minutes in running water at 65 to 75 F. To minimize drying marks, treat in Kodak Photo-Flo Solution after washing. To save time and conserve water, use Kodak Hypo Clearing Agent.

PROCESSING FOR LONG ROLLS ON SPIRAL REELS

Process Control: To maintain uniform negative quality in both spiral reel and mechanized processing, the developer activity should be monitored with Kodak Control Strips, 10-step (for professional B&W film).

Development: Develop for approximate times and temperatures given below.

CONTRAST INDEX CURVES

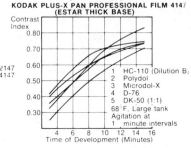

KODAK PLUS-X PAN PROFESSIONAL FILM 2147 (ESTAR BASE)
KODAK PLUS-X PAN PROFESSIONAL FILM 4147 (ESTAR THICK BASE)

1 HC-110 (Dilution B)
2 Polydol
3 Microdol-X
4 D-76
5 DK-50 (1:1)
68 F, Large tank Agitation at 1 minute intervals

KODAK Packaged Developers	Developing Times (in Minutes)	
	68 F	75 F
DK-50 (1:1)	6½	4½
POLYDOL	9	5½
HC-110 (Dilution B)	8	6

(Continued on following page)

EASTMAN KODAK

CHARACTERISTIC CURVES

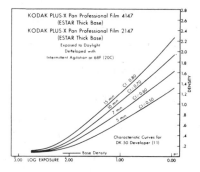

Secure the end of the film with a rubber band or waterproof tape to prevent the film from unwinding during processing. Then use the following agitation procedure.

1. Lower the reel into the developer, giving it a vigorous turning motion sufficient to cause the reel to rotate one-half to one revolution in the developer. Raise and lower the reel approximately ½ inch (keeping the reel in the solution) for the first 15 seconds of the development, tapping it against the bottom of the tank to release air bubbles from the film.

2. Agitate once each minute by lifting the reel out of the solution, tilting it 30 degrees to drain 5 to 10 seconds, and immersing it again with a vigorous turning motion sufficient to cause the reel to rotate one-half to one revolu-

tion in the developer. Alternate the direction of rotation each minute.

3. Agitate in the same manner in the stop bath and once per minute in the fixing bath.

Note: Too little agitation during development will cause mottle and uneven development. Too much pumping of the reel in and out of the developer can produce streaks across the film at the reel spokes. Too much turning of the reel in the solution can cause longitudinal streaks on the film. The agitation procedure just described provides a compromise which minimizes these undesirable effects.

Rinse: Kodak Indicator Stop Bath or Kodak Stop Bath SB-5, at 65 to 75 F, for 30 seconds with agitation. A running-water rinse can be used if an acid rinse bath is not available.

Fix: Kodak Fixer or Kodak Fixing Bath F-5 or F-6 for 5 to 10 minutes, or Kodak Rapid Fixer for 2 to 4 minutes at 65 to 75 F with agitation.

Wash: For 20 to 30 minutes in running water at 65 to 75 F. To minimize drying marks, treat in Kodak Photo-Flo Solution after washing, or wipe surfaces carefully with a Kodak Photo Chamois or a soft viscose sponge.

Kodak Hypo Clearing Agent can be used after fixing to reduce washing time and conserve water. First, remove excess hypo by rinsing the film in water for 30 seconds. Then bathe the film in the Kodak Hypo Clearing Agent solution for 1 or 2 minutes, with moderate agitation, and wash it for 5 minutes, using a water flow sufficient to give at least one complete change of water in 5 minutes.

KODAK PLUS-X Pan Professional Film 4147 (ESTAR Thick Base)

Medium-speed, panchromatic film. Dimensionally stable, .007-inch (0.18-mm) Estar Thick Base. Fine grain, high resolving power. Excellent sharpness in enlargements. Retouching surface on both sides.

EXPOSURE

Speed: ASA—125 22—DIN

Safelight: Handle and process the film in total darkness. After development is half completed, you can use a Kodak Safelight Filter No. 3 (dark green) or equivalent in a suitable safelight lamp with a 15-watt bulb at not less than 4 feet (1.2m) from the film **for a few seconds only.**

(Continued on following page)

The Compact Photo-Lab-Index

Outdoor Exposure Guide for Average Subjects

Set Shutter at 1/125 Second

Bright or Hazy Sun on Light Sand or Snow	Bright or Hazy Sun (Distinct Shadows)	Weak, Hazy Sun (Soft Shadows)	Cloudy Bright (No Shadows)	Open Shade† or Heavy Overcast
f/22	f/16*	f/11	f/8	f/5.6

*f/8 for backlighted close-up subjects.
†Subject shaded from the sun but lighted by a large area of sky.

Filter Factors: Multiply normal exposure by filter factor given below:

Kodak Wratten Filter	No. 6	No. 8	No. 11	No. 15	No. 25	No. 58	No. 47	No. 29	Polarizing Screen
Daylight	1.5	2*	4	2.5	8	6	6	25	2.5
Tungsten	1.5	1.5	4*	1.5	5	6	12	12	2.5

*For correct gray-tone rendering of colored objects.

Flash Pictures. To get the lens opening for electronic flash or flashbulbs, divide the guide number by the distance from flash to subject.

Electronic Flash Guide Numbers

Output of Unit (BCPS or ECPS)	500	700	1000	1400	2000	2800	4000	5600
Guide No. for Distances in Feet	55	65	80	95	110	130	160	190
Guide No. for Distances in Meters	17	20	24	29	33	40	50	60

Guide Numbers for Blue Flashbulbs (for Distances in Feet Only)

Between-Lens Shutter Speed	Synchro-nization	M2B°	M3B° 5B† 25B†	11†§ 40†§	22B† 2B†	Focal-Plane Shutter Speed	6B† 26B†
Open 1/25-1/30	X or F	130	200	280	260	1/25-1/30	200
1/25-1/30	M	NR	180	240	240	1/50-1/60	140
1/50-1/60	M	NR	180	220	220	1/100-1/125	100
1/100-1/125	M	NR	150	200	200	1/200-1/250	70
1/200-1/250	M	NR	120	150	140	1/400-1/500	50
1/400-1/500	M	NR	90	120	110	1/1000	34

Bowl-Shaped Polished Reflector: *3-inch; †4- to 5-inch; ‡6- to 7-inch. All guide numbers are for bowl-shaped polished reflectors; they do not apply to other shapes of reflectors. For shallow cylindrical reflectors, divide these guide numbers by 2. For intermediate-shaped reflectors (such as the shallow fan-shaped reflector), divide these guide numbers by 1.4.
§Clear bulbs listed because blue bulbs are not available.
NR = Not recommended.

Clear Bulbs: If you use clear flash-blubs instead of blue bulbs, decrease lens opening ⅔ stop.

Caution: Since bulbs may shatter when flashed, use a flashguard over the reflector. Do not flash bulbs in an explosive atmosphere.

(Continued on following page)

The Compact Photo-Lab-Index

PROCESSING PROCEDURE
With agitation, develop, rinse, and fix
at 65 to 75 F (18 to 24 C).

1. Develop:

Kodak Packaged Developers	Developing Time (in Minutes)									
	TRAY (Continuous Agitation) or TANK (Gaseous-Burst Agitation†)					TANK (Agitation at 1-Minute Intervals)				
	65 F 18 C	68 F 20 C	70 F 21 C	72 F 22 C	75 F 24 C	65 F 18 C	68 F 20 C	70 F 21 C	72 F 22 C	75 F 24 C
HC-110 (Dilution B)	6	5	4¾°	4½°	4°	8	7	6½	6	5½
Polydol	7	6	5½	5	4½°	9	8	7½	7	6
Microdol-X	9	8	7½	7	6	11	10	9½	9	8
D-76	7	6	5½	5	4½°	9	8	7½	7	6
DK-50 (1:1)	5	4½°	4¼°	4°	3½°	6½	6	5¾	5½	5

†1 second every 10 seconds; pressure to raise solution level ⅝ inch (16 mm).
°Unsatisfactory uniformity may result with development times shorter than 5 minutes.
NOTE: Do not use Kodak Developer DK-20 or other developers containing silver halide solvents, such as thiocyanates or thiosulfates.

2. Rinse: Kodak Indicator Stop Bath —30 seconds or Kodak Stop Bath SB-5—30 seconds.

3. Fix: Kodak Fixer—5 to 10 minutes **or** Kodak Fixing Bath F-5—5 to 10 minutes **or** Kodak Rapid Fixer—2 to 4 minutes.

4. Wash: For 20 to 30 minutes in running water at 65 to 75 F (18 to 24 C).

To minimize drying marks, treat in Kodak Photo-Flo Solution after washing. To save time and conserve water, use Kodak Hypo Clearing Agent.

5. Dry in a dust-free place.

Mechanized Processing: For information write to Kodak in your country. In U.S.A., write to Eastman Kodak Company, Rochester, N.Y. 14650.

KODAK PLUS-X PAN PROFESSIONAL FILM 4147 (ESTAR THICK BASE)

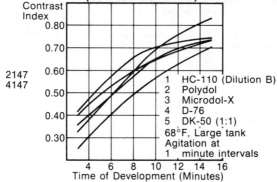

1 HC-110 (Dilution B)
2 Polydol
3 Microdol-X
4 D-76
5 DK-50 (1:1)
68°F, Large tank
Agitation at
1 minute intervals

EASTMAN KODAK

KODAK PLUS-X
Pan Professional Film Pack

IMPORTANT—
SEE NEW DEVELOPMENT TIMES

Medium-speed panchromatic film with extreme fine grain and high resolving power. Medium contrast, wide exposure latitude. Very high sharpness even at high degrees of enlargement.

Handle the pack only by the edges. Pressure on the **Safety Cover** must be avoided to prevent light from entering the pack and fogging the edges of the film.

When the pack is securely in position for use, carefully pull the tab marked "Safety Cover" straight out as far as it will come. After you have made the first exposure, pull the tab marked "1" **straight out as far as it will come, holding back the remaining tabs to avoid pulling more than one at a time.** This leaves film No. "2" ready for use.

In the same manner, expose each successive film and pull its tab. The tabs can be left attached or torn off.

When all the tabs have been pulled, the pack can be removed from the adapter in subdued daylight.

CAUTION

Pull the tabs in numerical order.

Pull only one tab after each exposure.

Do not remove the pack from the adapter in the light until all films have been exposed, and the tabs pulled.

COLD WEATHER OPERATION

Due to inherent film brittleness under conditions of low relative humidity or temperature, film-pack performance can be improved by exposing films as soon as possible after removing from foil wrap and by pulling tabs evenly and slowly after each exposure.

EXPOSURE
SPEED: ASA 125

This number is for use with meters and cameras marked for ASA Speeds or Exposure Indexes, in either daylight or artificial light. It will normally lead to approximately the minimum exposure required to produce negatives of highest quality.

If, with normal development, your negatives are consistently too thin, increase exposure by using a lower number; if too dense, reduce exposure by using a higher number.

OUTDOOR EXPOSURE GUIDE FOR AVERAGE SUBJECTS:
Set Shutter at 1/100 or 1/125 Second

Bright or Hazy Sun on Light Sand or Snow	Shadows) Bright or Hazy Sun (Distinct)	Weak, Hazy Sun (Soft Shadows)	Cloudy Bright (No Shadows)	Open Shade† or Heavy Overcast
f/22	f/16*	f/11	f/8	f/5.6

*f/8 for backlighted close-up subjects.

†Subject shaded from the sun but lighted by a large area of sky.

FILTER FACTORS

Multiply normal exposure by filter factor given below:

Kodak Wratten Filter	No. 6	No. 8	No. 11	No. 15	No. 25	No. 47	No. 58	Polarizing Screen
Daylight	1.5	2*	4	2.5	6	6	8	2.5
Tungsten	1.2	1.5	4*	1.5	4	12	8	2.5

*For correct gray-tone rendering of colored objects.

(Continued on following page)

EASTMAN KODAK

FLASH

To determine the f-number for average subjects, divide the appropriate guide number by the distance (in feet) from flash to subject.

GUIDE NUMBERS FOR BLUE FLASHBULBS:

Between-Lens Shutter Speed	Synchro-nization	AG1B	M-3B 5B†, 25B†	2B† 22B†	Focal-Plane Shutter Speed	6† 26B†
Open 1/25-1/30	X or F	150	200	260	1/25-1/30	200
					1/50-1/60	140
1/25-1/30	M	100	180	240	1/100-1/125	100
1/50-1/60	M	100	180	220	1/200-1/250	70
1/100-1/125	M	85	150	200	1/400-1/500	50
1/200-1/250	M	70	120	140	1/1000	34
1/400-1/500	M	55	90	110		

Bowl-Shaped Polished Reflectors: *2-inch; †3-inch; ‡4- to 5-inch; §6- to 7-inch. All guide numbers are for bowl-shaped polished reflectors; they do not apply to other shapes of reflectors. For shallow cylindrical reflectors, divide these guide numbers by 2. For intermediate-shaped reflectors (such as the shallow fan-shaped reflector), divide these guide numbers by 1.4.

Clear Bulbs: If you use clear flashbulbs instead of the blue bulbs, decrease lens opening ⅔ stop.

Caution: Since bulbs may shatter, use a flashguard over the reflector. **Do not flash bulbs in an explosive atmosphere.**

ELECTRONIC FLASH GUIDE NUMBERS

Output of Unit (BCPS or ECPS)	350	500	700	1000	1400	2000	2800	4000	5600	8000
Guide Number for Trial	45	55	65	80	95	110	130	160	190	220

SAFELIGHT

These films are extremely sensitive to light of all colors and should be handled and developed only in **total darkness.** However, a Kodak Safelight Filter No. 3 (dark green) or equivalent in a suitable safelight lamp with a 15-watt bulb can be used for a few seconds after development is 50% completed, provided it is kept at least 4 feet from the film.

REMOVAL OF FILMS FROM PACK
TO REMOVE ALL FILMS

Place the film pack face down on a table covered by a clean sheet of paper. Remove the metal light lock by pulling it off the end of the case. Raise the back of the case; then take out the paper Safety Cover and exposed films. Discard the Safety Cover and separate the film from the backing paper.

REMOVAL OF THE FILM FROM THE BACKING PAPER

Pinch the backing paper and the end of the tab together at one corner where the film is attached; then strip off the film.

TO REMOVE ONE OR MORE EXPOSED FILMS

From a partially exposed pack, remove the light lock and open the case as described above. Hold the torn tab of the Safety Cover; then withdraw the exposed films by grasping the torn tabs. **Do not remove the Safety Cover, or abrasion of the next film may occur.**

Lower the back of the case and Safety Cover to the original position. Replace the light lock by holding the case tightly closed and tilting the light lock slightly. The sides of the light lock must be on the outside of the case and pushed all the way on.

Before turning on the light, replace the film pack in the adapter and put the exposed films in a lighttight container. Before developing the films, separate them from the backing paper as described above.

DEVELOP at approximate times and temperatures given below.

(Continued on following page)

EASTMAN KODAK

The Compact Photo-Lab-Index

PROCESSING TIMES

Developing Times (in Minutes)

Kodak Packaged Developers	TRAY (Continuous Agitation)					LARGE TANK° Agitation at 1-Minute (Intervals)				
	65 F 18 C	68 F 20 C	70 F 21 C	72 F 22 C	75 F 24 C	65 F 18 C	68 F 20 C	70 F 21 C	72 F 22 C	75 F 24 C
HC-110 (Dilution B)	5	4½°	4°	3¾°	3¼°	6½	5½	5	4¾°	4°
Polydol	5½	4¾°	4¼°	3¾°	3°	7½	6	5½	4¾°	3¾°
D-76	5½	4¾°	4½°	4°	3½°	7½	6½	6	5½	4½°
D-76 (1:1)	7	6	5½	5	4½°	10	9	8	7½	7
Microdol-X	7	6	5½	5	4¾°	10	9	8	7½	7
Microdol-X (1:3)	—	—	10	9	8½	—	—	14	13	11

°Unsatisfactory uniformity may result with development times shorter than 5 minutes.
NR—Not Recommended.
NOTE: Do not use developers containing silver halide solvents.

RINSE at 65 to 75 F (18 to 24 C) with agitation.
 Kodak Indicator Stop Bath—
 30 seconds or
 Kodak Stop Bath SB-5—30 seconds

FIX at 65 to 75 F (18 to 24 C) with agitation.
 Kodak Fixer—5 to 10 minutes or
 Kodak Fixing Bath F-5—
 5 to 10 minutes or
 Kodak Rapid Fixer—
 2 to 4 minutes or
 Kodafix Solution—2 to 4 minutes

WASH for 20 to 30 minutes in running water at 65 to 75 F (18 to 24 C). To minimize drying marks, treat in Kodak Photo-Flo Solution after washing, or wipe surfaces carefully with a Kodak Photo Chamois or a soft viscose sponge. To save time and conserve water, use Kodak Hypo Clearing Agent.

DRY in a dust-free place.

STORAGE: Keep unexposed film at 75 F (24 C) or lower. Process film as soon as possible after exposure.

KODAK PLUS-X
Portrait Film 5068

35mm AND WIDER IN LONG ROLLS

Medium-speed panchromatic film with extreme fine grain and high resolving power. Medium contrast, wide exposure latitude. Excellent sharpness in enlargements. Particularly suitable for school photography and other applications where portrait negatives are made in long rolls. Emulsion side of film is suitable for retouching.

Safelight: Handle and process film in total darkness. After development is half completed, a Kodak Safelight Filter No. 3 (dark green) or equivalent in a suitable safelight lamp with a 15-watt bulb can be used **for a few seconds only.** Keep the safelight at lec 4 feet from the film.

EXPOSURE

Speed: ASA—125

This number is for use with meters and cameras marked for ASA Speeds or Exposure Indexes, in either daylight or artificial light. It will normally lead to approximately the minimum exposure required to produce negatives of highest quality.

If, with normal development, negatives are consistently too thin, increase exposure by using a lower number; if too dense, reduce exposure by using a higher number.

OUTDOOR EXPOSURE GUIDE FOR AVERAGE SUBJECTS
Set Shutter at 1/100 or 1/125 Second

Bright or Hazy Sun on Light Sand or Snow	Bright or Hazy Sun (Distinct Shadows)	Weak, Hazy Sun (Soft Shadows)	Cloudy Bright (No Shadows)	Open Shade† or Heavy Overcast
f/22	f/16*	f/11	f/8	f/5.6

*f/8 for backlighted close-up subjects.
†Subject shaded from sun but lighted by a large area of sky.

FILTER FACTORS

Multiply normal exposure by filter factor given below:

Kodak Wratten Filter	No. 6	No. 8	No. 11	No. 15	No. 25	Polarizing Screen
Daylight	1.5	2*	4	2.5	6	2.5
Tungsten	1.2	1.5	4*	1.5	4	2.5

*For correct gray-tone rendering of colored objects.

ELECTRONIC FLASH GUIDE NUMBERS

To determine the f-number for average subjects, divide the proper guide number by the distance (in feet) from flash to subject.

Output of Unit (BCPS or ECPS)	350	500	700	1000	1400	2000	2800	4000	5600	8000
Guide Number for Trial	45	55	65	80	95	110	130	160	190	220

PROCESSING DATA

Recommended Development for Long Rolls (up to 100-Foot Lengths) on Spiral Reels:

Kodak Packaged Developers	Developing Time (in Minutes)	
	68 F 20 C	75 F 24 C
HC-110 (Dilution B)	6	4¼
Polydol	6½	4

(Continued on following page)

EASTMAN KODAK

Recommended Development for Short (up to 5½-Foot Lengths):

Kodak Packaged Developers	SMALL TANK—(Agitation)					LARGE TANK—(Agitation at 1-Minute Intervals)				
	65 F 18 C	68 F 20 C	70 F 21 C	72 F 22 C	75 F 24 C	65 F 18 C	68 F 20 C	70 F 21 C	72 F 22 C	75 F 24 C
HC-110 (Dilution B)	6	5	4½°	4°	3½°	6½	5½	5	4¾°	4°
Polydol	6½	5½	4¾°	4¼°	3¾°	7½	6	5½	4¾°	3¾°
D-76	6½	5½	5	4½°	3¾°	7½	6½	6	5½	4½°
D-76 (1:1)	8	7	6½	6	5	10	9	8	7½	7
Microdol-X	8	7	6½	6	5½	10	9	8	7½	7
Microdol-X (1:3)	—	—	11	10	9½	—	—	14	13	11

°Unsatisfactory uniformity may result with development times shorter than 5 minutes.
NOTE: Do not use developers containing silver halide solvents.

In loading the reel, secure the end of the film with a rubber band or waterproof tape to prevent the film from unwinding during processing. Then use the following agitation procedure.

1. Lower the reel into the developer, giving it a vigorous turning motion sufficient to cause the reel to rotate one-half to one revolution in the developer. Raise and lower the reel approximately one-half inch (keeping the reel in the solution) for the first 15 seconds of the development, tapping it against the bottom of the tank to re-release air bubbles from the film.

2. Agitate once each minute by lifting the reel out of the solution, tilting it 30 degrees to drain 5 to 10 seconds, and immersing it again with a vigorous turning motion sufficient to cause the reel to rotate one-half to one revolution in the developer. Alternate the direction of rotation each minute.

3. Agitate in the same manner in the stop bath and once per minute in the fixing bath.

Note: Too little agitation during development will cause mottle and uneven development. Too much pumping of the reel in and out of the developer can produce streaks across the film at the reel spokes. Too much turning of the reel in the solution can cause longitudinal streaks on the film. The agitation procedure just described provides a compromise which mimizes these undesirable effects.

Rinse at 65 to 75 F (18 to 24 C) with agitation.
 Kodak Indicator Stop Bath—
 30 seconds or
 Kodak Stop Bath SB-5—30 seconds
Fix at 65 to 75 F (18 to 24 C) with agitation.
 Kodak Fixer—5 to 10 minutes or
 Kodak Fixing Bath F-5—
 5 to 10 minutes or
 Kodak Rapid Fixer—
 2 to 4 minutes or
 Kodafix Solution—2 to 4 minutes
Wash for 20 to 30 minutes in running water at 65 to 75 F (18 to 24 C). To minimize drying marks, treat in Kodak Photo-Flo Solution after washing, or wipe surfaces carefully with a Kodak Photo Chamois or a soft viscose sponge. To save time and conserve water, use Kodak Hypo Clearing Agent.
Dry in a dust-free place.
 The film can be air-dried on a spiral reel. More rapid drying can be obtained with a rotating-reel unit with forced warm air. For detailed information on this drying unit, write Eastman Kodak Company, Department 412-L, for a copy of **Processing Long Rolls of Film in Spiral Reels** (Kodak Pamphlet No. J-7). Rinse the reel well in water and dry it thoroughly before using it again.
Mechanized Processing: For information, write to Eastman Kodak Company, Rochester, New York 14650.
Storage: Keep unexposed film at 75 F (24 C) or lower. Process film as soon as possible after exposure.

EASTMAN KODAK

KODAK SUPER-XX
PAN FILM 4142
(ESTAR Thick Base)
ASA 200

GENERAL PROPERTIES

A moderately high-speed, fine-grain, panchromatic film for general purposes in portrait, commercial, and industrial photography. It is recommended for making color-separation negatives and for black-and-white negatives from color transparencies. Available in sheet film.

FILM SPEED
ASA 200

Exposure for Separation Negatives from Color Transparencies: Adjust enlarger equipped with a tungsten lamp to give 3 footcandles (32 meter-candles) of illumination at exposure plane, measured without filters, and with the lens at f/4.5. Trial exposures for average transparencies are:

Color of Exposing Light	KODAK WRATTEN Filter No.	Enlarger Lens Opening	Exposure Time
Red	29	f/8	25 sec
Green	61	f/8	15 sec
Blue	47B	f/8	30 sec

Use ½ stop more exposure for low-key subjects, ½ stop less for high-key. A density of 3.0 in the transparency should reproduce with a density of about 0.35 to 0.40.

Exposure for Direct Separation Negatives: Typical exposure conditions for a conventional camera with 450 footcandles (4800 meter-candles) of tungsten illumination (3200K) on the subject are:

Color of Filter	KODAK WRATTEN Filter No.	Camera Lens Opening	Exposure Time
Red	29	f/16	15 sec
Green	61	f/16	12 sec
Blue	47B	f/16	20 sec

FILTER FACTORS

KODAK WRATTEN Filter	No. 6 (K1)	No. 8 (K2)	No. 15 (G)	No. 11 (X1)	No. 25 (A)	No. 29 (F)	No. 58 (B)	No. 47 (C5)	Polarizing Screen
Daylight	1.5	2*	3	4	8	16	8	5	2.5
Photoflood or high-efficiency tungsten	1.5	1.5	2	3*	4	8	8	10	2.5

*For correct gray-tone rendering of colored objects.

(Continued on following page)

EASTMAN KODAK

67

The Compact Photo-Lab-Index

FLASHBULB GUIDE NUMBERS

Clear Flashbulbs: To get f-number, divide guide number by flash-to-subject distance in feet, taken to a point midway between nearest and farthest details. In small white rooms, use one stop smaller.

Between-Lens Shutter Speed	Syn-chro-nization	AG-1*	M3† 5‡, 25‡	11§ 40§	2§ 22§	Focal-Plane Shutter Speed
Open 1/25-1/30	X or F	220	340	340	450	1/25
1/25-1/30	M	150	300	300	400	1/50
1/50-1/60	M	150	300	280	380	1/100
1/100-1/125	M	130	240	260	320	1/250
1/200-1/250	M	100	200	200	240	1/500
1/400-1/500	M	80	150	150	180	1/1000

Bowl-Shaped Polished Reflectors: *2-inch; †3-inch; ‡4- to 5-inch; §6- to 7-inch. All guide numbers are for bowl-shaped, polished reflectors; they do not apply to other shapes of reflectors. For shallow cylindrical reflectors, divide these guide numbers by 2. For intermediate-shaped reflectors (such as the shallow fan-shaped reflector), divide these guide numbers by 1.4.

ELECTRONIC FLASH GUIDE NUMBERS

This table is intended as a starting point in determining the correct guide number. The table is for use with equipment rated in beam candlepower-seconds (BCPS) or effective candle-power-seconds (ECPS). Divide the appropriate guide number by the flash-to-subject distance in feet to determine the f-number for average subjects.

SAFELIGHT

Handle in total darkness. After development is half completed, a Kodak Safelight Filter No. 3 (dark green) or equivalent in a suitable safelight lamp with a 15-watt bulb can be used at 4 feet from the film for a few seconds only.

Output of Unit (BCPS or ECPS)	350	500	700	1000	1400	2000	2800	4000	5600	8000
Guide Number for Trial	60	70	85	100	120	140	170	200	240	280

RECIPROCITY EFFECT ADJUSTMENTS

Exposure Time (seconds)	Exposure Adjustments	Development Adjustments
1/1000	none	10% more
1/100	none	none
1/10	none	none
1	1 stop more	10% less
10	2 stops more	20% less
100	3 stops more	30% less

(Continued on following page)

EASTMAN KODAK

The Compact Photo-Lab-Index

PROCESSING

Development for General Black-and-White Photography: Develop at approximate times and temperatures given below.

Developing Times (in Minutes)

KODAK Developer*	Continuous Agitation (Tray)					Intermittent Agitation† (Tank)				
	65 F	68 F	70 F	72 F	75 F	65 F	68 F	70 F	72 F	75 F
POLYDOL	11	9	8	7	6	13	11	10	9	8
HC-110 (Dil. A)	4½	4	3¾	3½	3	6	5	4½‡	4¼‡	3½‡
HC-110 (Dil. B)	8½	7	6½	6	5	11	9	8	7	6
DK-60a	4½	4	3¾	3½	3	6	5	4½‡	4¼‡	3½‡
DK-50	5½	5	4¾	4½	4	8	7	6½	6	5
DK-50 (1:1)	9	8	7½	7	6	11	10	9½	9	8

*Available in convenient ready-to-mix form in several sizes.

†Agitation at 1-minute intervals during development.

‡Unsatisfactory uniformity may result with development times of less than 5 minutes.

Development for Color-Separation Negatives: Adjust times to obtain desired density range, about 1.4 with normal subjects. Develop at 68 F with agitation.

Development Times Minutes

Dye Transfer Process	KODAK Developer	Red	Green	Blue	Approx Gamma
For color-separation negative made directly from the subject or from masked color transparencies*	HC-110 (Dil. A)	4½	4½	7	0.90
For color-separation negatives made from unmasked transparencies	HC-110 (Dil. B)	4½	4½	7	0.70

*Using tungsten illumination as light source.

CHARACTERISTIC CURVES

Rinse: Kodak Indicator Stop Bath or Kodak Stop Bath SB-5 for 30 seconds.

Fix: Kodak Fixer or Kodak Fixing Bath F-5 for 5 to 10 minutes, or Kodak Rapid Fixer for 2 to 4 minutes.

Wash: For 20 to 30 minutes in running water at 65 to 75 F. To minimize drying marks, treat in Kodak Photo-Flo Solution after washing. To save time and conserve water, use Kodak Hypo Clearing Agent.

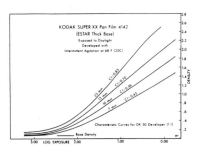

(Continued on following page)

4142 (ESTAR THICK BASE)
KODAK SUPER-XX PAN FILM

CONTRAST INDEX CURVES

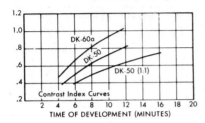

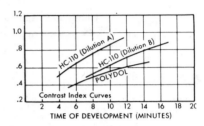

KODAK TRI-X PAN FILM
ASA 400

FILM SPEED
ASA 400

GENERAL PROPERTIES

A high-speed panchromatic film with fine grain and excellent sharpness. Its high speed makes it especially useful for photographing dimly lighted subjects and fast action, for extending the distance range for flash pictures, and for photographing subjects requiring good depth of field and high shutter speeds. Available in 126 cartridges, 135 magazines, 120, 620 and 127 rolls.

DAYLIGHT EXPOSURE TABLE

Shutter Speed 1/500 Second

Shutter Speed 1/250 Second

Bright or Hazy Sun Distinct Shadows	Bright or Hazy Sun Distinct Shadows			
On Light Sand or Snow	Average Subjects	Cloudy Bright No Shadows	Heavy Overcast	Open Shade†
f/22	f/22*	f/11	f/8	f/8

*f/11 at 1/250 second for backlighted close-up subjects.
†Subject shaded from the sun but lighted by a large area of sky.

FILTER FACTORS

Increase exposure by the filter factor in the table below.

Filter	No. 6 (K1)	No. 8 (K2)	No. 15 (G)	No. 11 (X1)	No. 25 (A)	No. 58 (B)	No. 47 (C5)	Polarizing Screen
Daylight	1.5	2*	2.5	4	8	6	6	2.5
Tungsten	1.5	1.5	1.5	3*	5	6	12	2.5

*For correct gray-tone rendering of colored objects.

(Continued on following page)

FLASHBULB GUIDE NUMBERS

Divide the proper guide number by the flash-to-subject distance in feet to determine the f-number for average subjects. These guide numbers are for blue flashbulbs. If you use clear flashbulbs, reduce the lens opening by ½ stop.

Synchronization	Shutter Speed	Shallow Cylindrical Reflector Flashcube	Intermediate-Shaped Reflector		Polished Bowl-Shaped Reflector		Intermediate-Shaped Reflector		Polished Bowl-Shaped Reflector		
		Flashcube	AG-1B	M2B	AG-1B	M2B	AG-1B	M3B 5B 25B	6B* 26B*	M3B 5B 25B	6B* 26B*
X	1/30	180	130	190	180	240	260	260	NR	400	NR
M	1/30	120	90	NR	130	NR	180	240	260	400	360
	1/60	120	90	NR	130	NR	180	220	180	350	260
	1/125	100	75	NR	110	NR	150	180	120	290	170
	1/250	75	65	NR	90	NR	130	150	85	240	120
	1/500	65	50	NR	70	NR	100	110	60	170	85

*Bulbs for focal-plane shutters; use with FP synchronization.
NR = Not Recommended.

ELECTRONIC FLASH GUIDE NUMBERS

This table is intended as a starting point in determining the correct guide number for electronic flash units rated in beam-candlepower-seconds (BCPS). Divide the proper guide number by the flash-to-subject distance in feet to determine the f-number for average subjects.

Output of Unit—BCPS	350	500	700	1000	1400	2000	2800	4000	5600	8000
Guide Number	85	100	120	140	170	200	240	280	340	400

PROCESSING

Development: Develop at the approximate times and temperatures given below.

Developing Times (in Minutes)*

KODAK Packaged Developers	SMALL TANK—(Agitation at 30-Second Intervals)					LARGE TANK—(Agitation at 1-Minute Intervals)				
	65 F	68 F	70 F	72 F	75 F	65 F	68 F	70 F	72 F	75 F
HC-110 (Dil. A)	4¼*	3¾*	3¼*	3*	2½*	4¾*	4¼*	4*	3¾*	3¼*
HC-110 (Dil. B)	8½	7½	6½	6	5	9½	8½	8	7½	6½
POLYDOL	8	7	6½	6	5	9	8	7½	7	6
DK-50 (1:1)	7	6	5½	5	4½*	7½	6½	6	5½	5
MICRODOL-X	11	10	9½	9	8	13	12	11	10	9
MICRODOL-X (1:3)	—	—	15	14	13	—	—	17	16	15
D-76	9	8	7½	6½	5½	10	9	8	7	6
D-76 (1:1)	11	10	9½	9	8	13	12	11	10	9

*Unsatisfactory uniformity may result with development times of less than 5 minutes.

(Continued on following page)

EASTMAN KODAK

The Compact Photo-Lab-Index

SAFELIGHT
Handle in total darkness. However, when development is half completed, you can use a safelight at 4 feet for a few seconds. Equip the safelight with a Kodak Safelight Filter No. 3 (dark green) or equivalent and a 15-watt bulb.

Rinse: Kodak Indicator Stop Bath or Kodak Stop Bath SB-5, at 65 to 75 F, for 30 seconds with agitation. You can use a running-water rinse if an acid stop bath is not available.

Fix: Kodak Fixer or Kodak Fixing Bath F-5 for 5 to 10 minutes, or Kodak Rapid Fixer or Kodafix Solution for 2 to 4 minutes, at 65 to 75 F with agitation.

Wash: For 20 to 30 minutes in running water at 65 to 75 F. To minimize drying marks, treat in Kodak Photo-Flo Solution after washing, or wipe surfaces carefully with a Kodak Photo Chamois or a soft viscose sponge.

You can use Kodak Hypo Clearing Agent after fixing to reduce washing time and conserve water. First, remove excess hypo by rinsing the film in water for 30 seconds. Then, bathe the film in the Kodak Hypo Clearing Agent solution for 1 or 2 minutes with moderate agitation, and wash it for 5 minutes, using a water flow sufficient to give at least one complete change of water in 5 minutes.

CONTRAST-INDEX CURVES

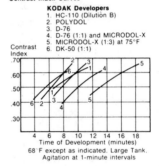

KODAK TRI-X Pan Film/5063
Contrast Index Curves

KODAK Developers
1. HC-110 (Dilution B)
2. POLYDOL
3. D-76
4. D-76 (1:1) and MICRODOL-X
5. MICRODOL-X (1:3) at 75°F
6. DK-50 (1:1)

Contrast Index

Time of Development (minutes)
68°F except as indicated. Large Tank.
Agitation at 1-minute intervals

KODAK TRI-X PAN PROFESSIONAL FILM
ASA 320

GENERAL PROPERTIES
A high-speed, panchromatic film which yields negatives with good gradation and brilliant highlights. It can be used with all types of lighting, both outdoors and indoors. The emulsion gives good exposure latitude and control of contrast in development. Kodak Tri-X Films in rolls and film packs have retouching surfaces on both sides of the film. Available in 120 and 220-size roll films and film packs.

FILM SPEED
ASA 320
This number is for use with meters and cameras marked for ASA Speeds, in either daylight or artificial light. It will normally lead to approximately the minimum exposure required to produce negatives of highest quality.

If, with normal development, your negatives are consistently too thin, increase exposure by using a lower number; if too dense, reduce exposure by using a higher number.

DAYLIGHT EXPOSURE TABLE
This exposure table is for average subjects and a shutter speed of 1/250 second.

Bright or Hazy Sun on Light Sand or Snow	Bright or Hazy Sun (Distinct Shadows)	Cloudy Bright (No Shadows)	Heavy Overcast	Open Shade†
f/22	f/16*	f/8	f/5.6	f/5.6

*f/8 for backlighted closeup subjects.
†Subject shaded from the sun but lighted by a large area of sky.

(Continued on following page)

EASTMAN KODAK

The Compact Photo-Lab-Index

FILTER FACTORS

Multiply the normal exposure by the filter factor given below.

KODAK WRATTEN Filter	No 6 (K1)	No. 8 (K2)	No. 15 (G)	No. 11 (X1)	No. 29 (F)	No. 25 (A)	No. 58 (B)	No. 47 (C5)	Polar-izing Screen
Daylight	1.5	2*	2.5	4	16	8	8	6	2.5
Photoflood or high-efficiency tungsten	1.5	1.5	2	4*	10	5	8	10	2.5

*For correct gray-tone rendering of colored objects.

FLASHBULB GUIDE NUMBERS

Divide the guide number by the flash-to-subject distance in feet to find the f-number for average subjects. These guide numbers are for blue flashbulbs. If you use clear flashbulbs, reduce the lens opening ⅔ stop.

Between-Lens Shutter Speed	Syn-chro-nization	Flash-cube	AG-1B†	M2B‡	M3B‡ 5B§ 25B§	Focal-Plane Shutter Speed	6B§ 26B§
Open	X or F	160	240	220	320		
1/25-1/30						1/25-1/30	320
1/25-1/30	M	110	160	NR**	300	1/50-1/60	240
1/50-1/60	M	110	160	NR	280	1/100-/125	150
1/100-1/125	M	90	140	NR	240	1/200-1/250	110
1/200-1/250	M	70	110	NR	180	1/400-1/500	75
1/400-1/500	M	60	90	NR	140		

Bowl-shaped polished reflector sizes: †2- inch; ‡3-inch; §4- to 5-inch. All guide numbers are for bowl-shaped, polished reflectors; they do not apply to other shapes of reflectors. For shallow cylindrical reflectors, divide these guide numbers by 2. For intermediate-shaped reflectors such as the shallow fan-shaped reflector), divide these guide numbers by 1.4.

**NR = Not Recommended.

ELECTRONIC FLASH GUIDE NUMBERS

This table is intended as a starting point in determining the correct guide number. The table is for use with equipment rated in beam candlepower-seconds (BCPS) or effective candle-power-seconds (ECPS). Divide the appropriate guide number by the flash-to-subject distance in feet to determine the f-number for average subjects.

Output of Unit (BCPS or ECPS)	350	500	700	1000	1400	2000	2800	4000	5600	8000
Guide Number for Trial	75	90	110	130	150	180	210	250	300	360

(Continued on following page)

EASTMAN KODAK

The Compact Photo-Lab-Index

RECIPROCITY EFFECT ADJUSTMENTS

Exposure Time (seconds)	Exposure Adjustments	Development Adjustments
1/1000	none	10% more
1/100	none	none
1/10	none	none
1	1 stop more	10% less
10	2 stops more	20% less
100	3 stops more	30% less

SAFELIGHT

Handle in total darkness. After development is half completed, a Kodak Safelight Filter No. 3 (dark green) or equivalent in a suitable safelight lamp with a 15-watt bulb can be used at 4 feet from the film for a few seconds only.

PROCESSING

Development: Develop at approximate times and temperatures given below.

Recommended Development for Roll Films:

KODAK Packaged Developers	SMALL TANK—(Agitation at 30-Second Intervals)					LARGE TANK—(Agitation at 1-Minute Intervals)				
	65 F	68 F	70 F	72 F	75 F	65 F	68 F	70 F	72 F	75 F
HC-110 (Dil. A)	NR	NR	NR	NR	NR	NR	NR	NR	NR	NR
HC-110 (Dil. B)	10	9	8	7	6	11	10	9	8	7
POLYDOL	10	9	8	7½	6½	11	10	9	8	7
D-76	9	8	7½	7	6	10	9	8½	8	7
MICRODOL-X	11	10	9	8½	7½	12	11	10	9	8
DK-50 (1:1)	9	8	7½	7	6	10	9	8½	8	7

Developing Times (in Minutes)

Recommended Development for Film Packs:

KODAK Packaged Developers	Temp (F)	Developing Times (minutes)	Large Tank (1-min. agitation)
HC-110 (Dilution B)	68	8	10
	75	5	7
POLYDOL	68	8	10
	75	6	7
D-76	68	7	9
	75	5	7
MICRODOL-X	68	9	11
	75	7	8
DK-50 (1:1)	68	7	9
	75	5	7

(Continued on following page)

The Compact Photo-Lab-Index

Rinse: Kodak Indicator Stop Bath or Kodak Stop Bath SB-5 at 65 to 75 F for 30 seconds with agitation.

Fix: Kodak Fixer or Kodak Fixing Bath F-5 for 5 to 10 minutes at 65 to 75 F, or Kodak Rapid Fixer or Kodafix Solution for 2 to 4 minutes. Agitate films frequently during fixing and do not overwork the fixing bath.

Wash: For 20 to 30 minutes in running water. To minimize drying marks, treat in Kodak Photo-Flo Solution after

washing, or wipe surfaces carefully with a Kodak Photo Chamois or a soft viscose sponge.

Kodak Hypo Clearing Agent can be used after fixing to reduce washing time and conserve water. First, remove excess hypo by rinsing the film in water for 30 seconds. Then bathe the film in Kodak Hypo Clearing Agent solution for 1 or 2 minutes with moderate agitation and wash it for 5 minutes, using a water flow sufficient to give at least one complete change of water in 5 minutes.

CHARACTERISTIC CURVES

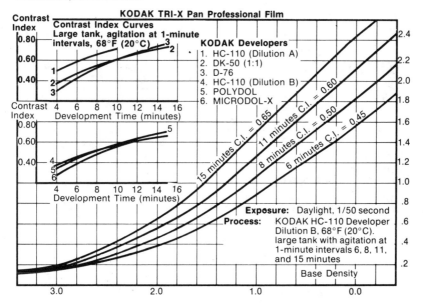

KODAK TRI-X PROFESSIONAL FILM 4164 (ESTAR Thick Base)
ASA 320

GENERAL PROPERTIES

This high-speed, panchromatic film has sensitometric characteristics similar to Kodak Tri-X Pan Professional Film, except that the emulsion is coated on the more dimensionally stable and durable ESTAR Base. Both sides of the film have surfaces suitable for retouching. Available in sheets and 3½-inch long rolls.

FILM SPEED
ASA 320

This number is for use with meters marked for ASA Speeds or Exposure Indexes in either daylight or artificial light. It will normally lead to approximately the minimum exposure required to produce negatives of highest quality.

If, with normal development, negatives are consistently too thin, increase exposure by using a lower number; if too dense, decrease exposure by using a higher number.

DAYLIGHT EXPOSURE TABLE
Shutter speed 1/200 or 1/250.

Bright or Hazy Sun on Light Sand or Snow	Bright or Hazy Sun (Distinct Shadows)	Cloudy Bright (No Shadows)	Heavy Overcast	Open Shade†
f/32	f/22*	f/11	f/8	f/8

*f/11 for backlighted close-up subjects.
†Subject shaded from sun but lighted by a large area of sky.

FILTER FACTORS
Multiply the normal exposure by the filter factor given below.

KODAK WRATTEN Filter	No. 6	No. 8	No. 15	No. 11	No. 29	No. 25	No. 58	No. 47	Polarizing Screen
Daylight	1.5	2*	2.5	4	16	8	8	6	2.5
Tungsten	1.5	1.5	2	4*	10	5	8	10	2.5

*For correct gray-tone rendering of colored objects.

ELECTRONIC FLASH GUIDE NUMBERS

This table is intended as a starting point in determining the correct guide number. The table is for use with equipment rated in beam candlepower-seconds (BCPS) or effective candle-power-seconds (ECPS). Divide the appropriate guide number by the flash-to-subject distance in feet to determine the f-number for average subjects.

Output of Unit (BCPS or ECPS)	350	500	700	1000	1400	2000	2800	4000	5600	8000
Guide Number for Trial	75	90	110	130	150	180	210	250	300	360

(Continued on following page)

The Compact Photo-Lab-Index

FLASHBULB GUIDE NUMBERS

This table is for clear flashbulbs. To get f-number, divide guide number by flash-to-subject distance in feet, taken to a point midway between nearest and farthest details of interest. In small white rooms, use one stop smaller.

Between-Lens Shutter Speed	Syn-chro-nization	AG-1*	M3† 5‡, 25‡	11§ 40§	2§ 22§	Focal-Plane Shutter Speed	31§
Open 1/25-1/30	X or F	200	450	450	550	1/25	675
1/25-1/30	M	200	380	400	500	1/50	380
1/50-1/60	M	180	380	360	500	1/100	270
1/100-1/125	M	160	350	320	420	1/250	190
1/200-1/250	M	130	260	240	320	1/500	135
1/400-1/500	M	100	200	180	240	1/1000	95

Bowl-Shaped Polished Reflectors: *2-inch; †3-inch; ‡4- to 5-inch; §6- to 7-inch. All guide numbers are for bowl-shaped, polished reflectors; they do not apply to other shapes of reflectors. For shallow cylindrical reflectors, divide these guide numbers by 2. For intermediate-shaped reflectors (such as the shallow fan-shaped reflector), divide these guide numbers by 1.4.

RECIPROCITY EFFECT ADJUSTMENTS

Exposure Time (seconds)	Exposure Adjustments	Development Adjustments
1/1000	none	10% more
1/100	none	none
1/10	none	none
1	1 stop more	10% less
10	2 stops more	20% less
100	3 stops more	30% less

SAFELIGHT

Handle in total darkness. After development is half completed, a Kodak Safelight Filter No. 3 (dark green) or equivalent in a suitable safelight lamp with a 15-watt bulb can be used at 4 feet from the film for a few seconds only.

Development: Develop at approximate times and temperatures given below.

Developing Times (in Minutes)

KODAK Developer	Continuous Agitation (Tray)					Intermittent Agitation† (Tank)				
	65 F	68 F	70 F	72 F	75 F	65 F	68 F	70 F	72 F	75 F
POLYDOL	9	8	7½	7	6	11	10	9	8	7
HC-110 (Dil. A)	4½*	4¼*	4*	3½*	3*	6	5½	5	4½*	4*
HC-110 (Dil. B)	9	8	7	6	5	11	10	9	8	7
DK-50 (1:1)	8	7	6½	6	5	10	9	8½	8	7
D-76	8	7	—	6	5	10	9	8½	8	7
MICRODOL-X	10	9	8½	8	7	12	11	10	9	8

†Agitation at 1-minute intervals during development.
*Unsatisfactory uniformity may result with development times of less than 5 minutes.

(Continued on following page)

EASTMAN KODAK

The Compact Photo-Lab-Index

Rinse: Kodak Indicator Stop Bath or Kodak Stop Bath SB-5 for 30 seconds at 65 to 75 F with agitation.

Fix: Kodak Fixer or Kodak Fixing Bath F-5 for 5 to 10 minutes, or Kodak Rapid Fixer for 2 to 4 minutes at 65 to 75 F with agitation.

Wash: For 20 to 30 minutes in running water at 65 to 75 F. To minimize drying marks, treat in Kodak Photo-Flo Solution after washing. To save time and conserve water, use Kodak Hypo Clearing Agent.

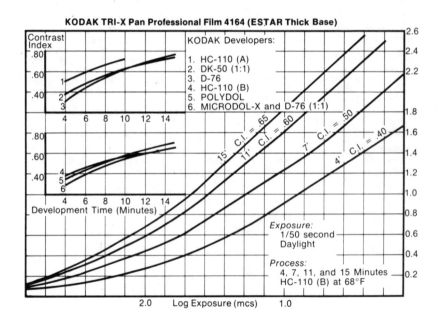

KODAK TRI-X Pan Professional Film 4164 (ESTAR Thick Base)

The Compact Photo-Lab-Index

ELECTRONIC FLASH GUIDE NUMBERS

Output of Unit (BCPS or ECPS)	500	700	1000	1400	2000	2800	4000	5600
Guide Number for Distances in Feet	90	110	130	150	180	210	250	300

To determine the lens opening for electronic flash or flashbulbs, divide the guide number by the distance in feet from flash to subject.

RECIPROCITY EFFECT ADJUSTMENTS

Exposure Time (seconds)	Exposure Adjustments	Development Adjustments
1/1000	none	10% more
1/100	none	none
1/10	none	none
1	1 stop more	10% less
10	2 stops more	20% less
100	3 stops more	30% less

PROCESSING

Development: Development at approximate times and temperatures given below.

Developing Time (in Minutes)

KODAK Packaged Developers	TRAY (Continuous Agitation) or TANK† (Gaseous-Burst Agitation*)					TANK† (Agitation at 1-Min. Intervals)				
	65 F 18 C	68 F 20 C	70 F 21 C	72 F 22 C	75 F 24 C	65 F 18 C	68 F 20 C	70 F 21 C	72 F 22 C	75 F 24 C
HC-110 (Dil. B)	10	9	8½	8	7	12	11	10	9	8
POLYDOL	9	8	7½	7	6	11	10	9	8	7
HC-110 (Dil. A)	4¼†	4¼†	4†	3½	3†	6	5½	5	4½†	4†
DK-50 (1:1)	8	7	6½	6	5	10	9	8½	8	7
D-76	8	7	6½	6	5	10	9	8½	8	7
MICRODOL-X	10	9	8½	8	7	12	11	10	9	8

*1 second every 10 seconds; pressure to raise solution level 5⁄8 inch (16mm).

†Unsatisfactory uniformity may result with development times of less than 5 minutes.

Rinse: Kodak Indicator Stop Bath or Kodak Stop Bath SB-5 for 30 seconds with agitation at 65 to 75 F.

Fix: Kodak Fixer or Kodak Fixing Bath F-5 for 5 to 10 minutes, or Kodak Rapid Fixer for 2 to 4 minutes with agitation at 65 to 75 F.

Wash: For 20 to 30 minutes in running water at 65 to 75 F. To minimize drying marks, treat in Kodak Photo-Flo Solution after washing. To save time and conserve water, use Kodak Hypo Clearing Agent.

(Continued on following page)

EASTMAN KODAK

KODAK TRI-X ORTHO FILM
4163
(ESTAR Thick Base)
D ASA 320; T ASA 200

GENERAL PROPERTIES

A fast, orthochromatic film with fine grain and moderate contrast. It yields negatives with good shadow detail and brilliant highlights. The film is suitable for press, commercial, and industrial photography and any purpose where red sensitivity is unnecessary or undesirable. Both sides of the film are suitable for retouching. Available in sheets only.

DAYLIGHT EXPOSURE TABLE

Shutter speed at 1/200 or 1/250 second.

FILM SPEED
Daylight ASA 320
Tungsten ASA 200

Bright or Hazy Sun on Light Sand or Snow	Bright or Hazy Sun (Distinct Shadows)	Weak, Hazy Sun (Soft Shadows)	Cloudy Bright (No Shadows)	Open Shade† or Heavy Overcast
f/22	f/16*	f/11	f/8	f/5.6

*f/8 for backlighted close-up subjects.
†Subject shaded from the sun but lighted by a large area of sky.

FILTER FACTORS

Multiply normal exposure by filter factor given below.

KODAK WRATTEN Filter	No. 6	No. 8	No. 15	No. 58	No. 47	No. 47B	Polarizing Screen
Daylight	2	2	3	6	5	6	2.5
Tungsten	1.5	2	3	5	8	10	2.5

BLUE FLASHBULB GUIDE NUMBERS

Between-Lens Shutter Speed	Synchronization	M2B*	M3B* 5B† 25B†	11‡§ 40‡§	22B‡ 2B‡	Focal-Plane Shutter-Speed	6B† 26B†
Open 1/25-1/30	X or F	220	320	340	400	1/25-1/30	320
						1/50-1/60	240
1/25-1/30	M	NR	300	300	380	1/100-1/125	150
1/50-1/60	M	NR	280	280	360	1/200-1/250	110
1/100-1/125	M	NR	240	260	300	1/400-1/500	75
1/200-1/250	M	NR	180	200	220	1/1000	55
1/400-1/500	M	NR	140	150	170		

Bowl-Shaped Polished Reflector: *3-inch; †4- to 5-inch; ‡6- to 7-inch. All guide numbers are for bowl-shaped polished reflectors; they do not apply to other shapes or reflectors. For shallow cylindrical reflectors, divide these guide numbers by 2. For intermediate-shaped reflectors (such as the shallow fan-shaped reflector), divide these guide numbers by 1.4.

§Clear bulbs listed because blue bulbs are not available.

NR = Not recommended.

(Continued on following page)

CHARACTERISTIC CURVES

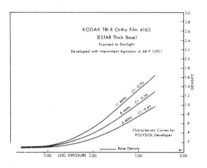

CONTRAST INDEX CURVES

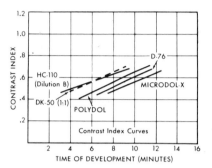

KODAK VERICHROME PAN FILM

ASA 125

GENERAL PROPERTIES

A medium-speed panchromatic film with extremely fine grain. Its excellent gradation and wide exposure latitude make it suited to most picture-taking situations. Available in 126 cartridges; 120, 620, 127, 828, 616, and 116 rolls; and in sizes for Cirkut cameras or Cirkut outfits.

FILM SPEED

ASA 125

This number is for use with meters and cameras marked for ASA speeds, in either daylight or artificial light. It will Normally lead to approximately the minimum exposure required to produce negatives of highest quality.

If, with normal development, your negatives are consistently too thin, increase exposure by using a lower number; if too dense, reduce exposure by using a higher number.

DAYLIGHT EXPOSURE TABLE

Shutter Speed 1/250 Second			Shutter Speed 1/125 Second	
Bright or Hazy Sun Distinct Shadows		**Cloudy Bright No Shadows**	**Heavy Overcast**	**Open Shade†**
On Light Sand or Snow	**Average Subjects**			
f/16	f/11*	f/8	f/5.6	f/5.6

f/8 at 1/125 second for backlighted close-up subjects.
†Subject shaded from the sun but lighted by a large area of sky.

(Continued on following page)

The Compact Photo-Lab-Index

FILTER FACTORS
Increase the normal exposure by the filter factor in the table.

Filter	No. 6 (K1)	No. 8 (2)	No. 15 (G)	No. 11 (X1)	No. 25 (A)	No. 58 (B)	No. 47 (C5)	Polarizing Screen
Daylight	1.5	2*	2.5	4	8	6	6	2.5
Tungsten	1.5	1.5	1.5	4*	5	6	12	2.5

*For correct gray-tone rendering of colored objects.

ELECTRONIC FLASH GUIDE NUMBERS
Use this table as a starting point in determining the correct guide number for electronic flash units rated in beam-candlepower-seconds (BCPS). Divide the proper guide number by the flash-to-subject distance in feet to determine the f-number for average subjects.

Output of Unit —BCPS	350	500	700	1000	1400	2000	2800	4000	5600	8000
Guide Number	45	55	65	80	95	110	130	160	190	220

FLASHBULB GUIDE NUMBERS
Divide the proper guide number by the flash-to-subject distance in feet to determine the f-number for average subjects. These guide numbers are for blue flashbulb. If you use clear flashbulbs, reduce the lens opening by ⅔ stop.

Synchronization	Shutter Speed	Flashcube	Shallow Cylindrical Reflector	Intermediate Shaped Reflector		Polished Bowl-Shaped Reflector		Intermediate Shaped Reflector		Polished Bowl-Shaped Reflector	
		Flashcube	AG-1B	M 2 B	AG-1B	M 2 B	AG-1B	M3B 5B 25B	6B* 26B*	M3B 5B 25B	6B* 26B*
X	1/30	100	75	100	100	130	150	140	NR	200	NR
M	1/30	70	50	NR	70	NR	100	130	140	180	200
	1/60	65	50	NR	70	NR	100	120	100	180	140
	1/125	55	42	NR	60	NR	85	100	70	150	100
	1/250	44	36	NR	50	NR	70	85	50	120	70
	1/500	36	28	NR	38	NR	55	65	34	90	50

*Bulbs for focal-plane shutters; use with FP synchronization.
NR = Not Recommended.

SAFELIGHT
Handle in total darkness. However, when development is half completed, you can use a safelight at 4 feet for a few seconds. Equip the safelight with a Kodak Safelight Filter, No. 3 (dark green) or equivalent and a 15-watt bulb.

(Continued on following page)

82

The Compact Photo-Lab-Index

PROCESSING

Development: Developing times are for small roll-film tanks with agitation at 30-second intervals throughout development.

KODAK Packaged Developers	Developing Times in Minutes*				
	65 F	68 F	70 F	72 F	75 F
D-76	8	7	5½	5	4½*
D-76 (1:1)	11	9	8	7	6
MICRODOL-X	10	9	8	7	6
MICRODOL-X (1:3)†	15	14	12	12	11
POLYDOL	8	6	5	4½*	4*
HC-110 (Dilution B)	6	5	4½*	4*	2*
VERSATOL (1:19)	4½*	4½*	3¾*	3½*	3*

†For greatest sharpness.

*Unsatisfactory uniformity may result with development times of less than 5 minutes.

Rinse: Kodak Indicator Stop Bath, Kodak Stop Bath SB-5, or running water at 65 to 75 F for 30 seconds with agitation.

Fix: Kodak Fixer or Kodak Fixing Bath F-5 at 65 to 75 F for 5 to 10 minutes, or Kodak Rapid Fixer or Kodafix solution for 2 to 4 minutes. Agitate films frequently during fixing.

Wash: 20 to 30 minutes in running water. To minimize drying marks, treat in Kodak Photo-Flo Solution after washing. To save time and conserve water, use Kodak Hypo Clearing Agent.

CONTRAST INDEX CURVES

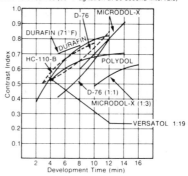

KODAK VERICHROME Pan Film (6041/8041/7042)
Time vs CI curves (68° F agitation at 30 second intervals)

83

KODAK EKTAPAN FILM 4162
(ESTAR Thick Base)
ASA 100

GENERAL PROPERTIES

This is a panchromatic, antihalation film of medium speed on a .007-inch ESTAR Thick Base. It is particularly suitable for portraiture and other close-up work with electronic flash illumination. However, the film yields excellent results with all normal lighting. Because its speed is similar to that of Kodak Ektacolor Professional Film 5026, Type S, it is valuable in situations where color and black-and-white negatives are needed from the same subject. Both base and emulsion sides of the film are suitable for retouching. Available in sheets, 3½-inch and 70mm long rolls.

DAYLIGHT EXPOSURE TABLE

Lens openings at 1/100 or 1/125 second.

Bright or Hazy Sun on Light Sand or Snow	Bright or Hazy Sun (Distinct Shadows)	Cloudy Bright (No Shadows)	Heavy Overcast	Open Shade†
f/22	f/16*	f/8	f/5.6	f/5.6

*For backlighted close-up subjects, use f/8.
†Subject shaded from the sun but lighted by a large area of sky.

FILTER FACTORS

Multiply normal exposure by filter factor given below.

KODAK WRATTEN Filter	No. 6	No. 8	No. 15	No. 11	No. 29	No. 25	No. 58	No 47	Polar-izing Screen
Daylight or Electronic Flash	1.5	2*	3	4	16	8	8	5	2.5
Tungsten	1.5	1.5	2	3*	8	4	8	10	2.5

*For correct gray-tone rendering of colored objects.

ELECTRONIC FLASH GUIDE NUMBERS

This table is intended as a starting point in determining the correct guide number. The table is for use with equipment rated in beam candlepower-seconds (BCPS) or effective candle-power-seconds (ECPS). Divide the appropriate guide number by the flash-to-subject distance in feet to determine the f-number for average subjects.

Output of Unit (BCPS or ECPS)	350	500	700	1000	1400	2000	2800	4000	5600	8000
Guide Number for Trial	40	50	60	70	85	100	120	140	170	200

(Continued on following page)

84

The Compact Photo-Lab-Index

FLASH EXPOSURE GUIDE NUMBERS

Clear Flashbulbs: To get f-number, divide guide number by flash-to-subject distance in feet, taken to a point midway between nearest and farthest details of interest. In small white rooms, use one stop smaller.

Between-Lens Shutter Speed	Syn-chroni-zation	AG-1*	M3† 5‡, 25‡	11§ 40§	2§ 22§
Open 1/25-1/30	X or F	160	240	240	320
1/25-1/30	M	110	220	220	280
1/50-1/60	M	100	200	200	280
1/100-1/125	M	90	180	180	240
1/200-1/250	M	75	140	130	180
1/400-1/500	M	55	110	100	130

Bowl-Shaped Polished Reflectors: *2-inch; †3-inch; ‡4- to 5-inch; §6- to 7-inch. All guide numbers are for bowl-shaped, polished reflectors: they do not apply to other shapes of reflectors. For shallow cylindrical reflectors, divide these guide numbers by 2. For intermediate-shaped reflectors (such as the shallow fan-shaped reflector), divide these guide numbers by 1.4.

Blue Bulbs: If you use blue flashbulbs instead of clear, increase lens opening ⅔ stop.

RECIPROCITY EFFECT ADJUSTMENTS

Exposure Time Seconds	Exposure Adjustments	Development Adjustments
1/1000	none	none
1/100	none	none
1/10	none	none
1	½ stop more	10% less
10	2 stops more	20% less
100	3 stops more	30% less

SAFELIGHT

Handle and process the film in total darkness. After development is half completed, you can use a Kodak Safelight Filter No. 3 (dark green) or equivalent for a few seconds only.

PROCESSING

Development, Develop at approximate times and temperatures given below.

Developing Time (in Minutes) for Sheet Films

KODAK Packaged Developers	Tray (Continuous Agitation)					Tank (Agitation at 1-Min. Intervals)				
	65 F	68 F	70 F	72 F	75 F	65 F	68 F	70 F	72 F	75 F
HC-110 (Dilution A)	3¼	3	2¾	2½	2¼	4*	3¾*	3¼*	3*	2¾*
HC-110 (Dilution B)	5	4½	4¼	4	3½	7	6	5½	5	4¼*
POLYDOL	9½	8	7	6	5	12	10	9	8	7
DK-50 (1:1)	5	4½	4¼	4	3½	7	6	5½	5	4¼*
D-76	9	8	7	6½	5½	11	10	9	8½	7½
MICRODOL-X	12	10	9½	8	7	16	13	12	10	9

*Unsatisfactory uniformity may result with development time of less than 5 minutes.

(Continued on following page)

EASTMAN KODAK

The Compact Photo-Lab-Index

Rinse: Kodak Indicator Stop Bath—30 seconds or Kodak Stop Bath SB-5—30 seconds.

Fix: Kodak Fixer—5 to 10 minutes or Kodak Fixing Bath F-5—5 to 10 minutes or Kodak Rapid Fixer—2 to 4 minutes. Agitate films frequently.

Wash: For 20 to 30 minutes in running water at 65 to 75 F. To minimize drying marks, treat in Kodak Photo-Flo Solution after washing. To save time and conserve water, use Kodak Hypo Clearing Agent.

Mechanized Processing: For information write to Eastman Kodak Company, Rochester, New York 14650.

CONTRAST INDEX CURVES

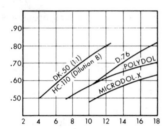

CHARACTERISTIC CURVES

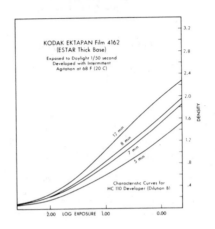

KODAK SUPER PANCHRO-PRESS FILM 6146, TYPE B
ASA 250

GENERAL PROPERTIES

A versatile, medium speed, panchromatic film for portraiture and general purposes in commercial, industrial, and press photography. This film yields

FILM SPEED
ASA 250

good negatives with all normal types of lighting. Both base and emulsion sides are suitable for retouching. Available in sheets only.

DAYLIGHT EXPOSURE TABLE

Shutter speed at 1/200 or 1/250 second.

Bright or Hazy Sun on Light Sand or Snow	Bright or Hazy Sun (Distinct Shadows	Weak, Hazy Sun (Soft Shadows)	Cloudy Bright (No Shadows)	Open Shade† or Heavy Overcast
f/22	f/16*	f/11	f/8	f/5.6

*f/8 at 1/200 or 1/250 second for backlighted close-up subjects.
†Subject shaded from the sun but lighted by a large area of sky.

(Continued on following page)

The Compact Photo-Lab-Index

FILTER FACTORS
Multiply normal exposure by filter factor given below:

KODAK WRATTEN Filter	No. 6	No. 8	No. 15	No. 11	No. 29	No. 25	No. 58	No. 47	Polarizing Screen
Daylight	1.5	2*	3	4	16	8	8	5	2.5
Tungsten	1.5	1.5	2	3*	8	4	8	10	2.5

*For correct gray-tone rendering of colored objects.

FLASHBULB GUIDE NUMBERS
To get the lens opening for electronic flash or flashbulbs, divide the guide number by the distance (in feet) from flash to subject.

Between-Lens Shutter Speed	Synchronization	M2B*	M3B* 5B†, 25B†	11‡§ 40‡§	22B‡ 2B‡	Focal-Plane Shutter Speed	6B† 26B†
Open 1/25-1/30	X or F	200	280	380	400	1/25-1/30	280
1/25-1/30	M	NR¶	260	340	380	1/50-1/60	200
1/50-1/60	M	NR¶	240	320	350	1/100-1/125	140
1/100-1/125	M	NR¶	200	280	300	1/200-1/250	100
1/200-1/250	M	NR¶	170	220	230	1/400-1/500	70
1/400-1/500	M	NR¶	130	160	170	1/1000	45

Bowl-Shaped Polished Reflectors: *3-inch; †4- to 5-inch; ‡6- to 7-inch. All guide numbers are for bowl-shaped polished reflectors; they do not apply to other shapes of reflectors. For shallow cylindrical reflectors, divide these guide numbers by 2. For intermediate-shaped reflectors (such as the shallow fan-shaped reflector), divide these guide numbers by 1.4.

§Clear bulbs listed because blue bulbs not available.

¶NR = Not recommended.

Clear Bulbs: If you usue clear flashbulbs instead of blue, decrease lens opening ⅔ stop.

ELECTRONIC FLASH GUIDE NUMBERS

Output of Unit (BCPS or ECPS)	500	700	1000	1400	2000	2800	4000	5600
Guide Number for Trial	80	95	110	130	160	190	220	260

SAFELIGHT
Handle and process the film in total darkness. After development is half completed, you can use a Kodak Safelight Filter No. 3 (dark green) or equivalent in a suitable safelight lamp with a 15-watt bulb at not less than 4 feet for a few seconds only.

(Continued on following page)

The Compact Photo-Lab-Index

PROCESSING

Development: Develop at approximate times and temperatures given below.

Developing Times (in Minutes)

KODAK Developer*	Continuous Agitation (Tray)					Intermittent Agitation† (Tank)				
	65 F	68 F	70 F	72 F	75 F	65 F	68 F	70 F	72 F	75 F
POLYDOL	11	9	8	7	6	13	11	10	9	8
HC-110 (Dil. A)	4½	4	3¾	3½	3	6	5	4½‡	4¼‡	3½‡
HC-110 (Dil. B)	7	6	5½	5	4½	9	8	7½	7	6
DK-50	4¾	4½	—	4¼‡	4	6½	6	5¾	5½	5
DK-50 (1:1)	9	8	7½	7	6	11	10	9½	9	8
D-76	11	10	9½	9	8	14	13	12	11	10

*Available in ready-to-mix form in several sizes.

†Agitation at 1-minute intervals during development.

‡Unsatisfactory uniformity may result with development times of less than 5 minutes.

Rinse: Kodak Indicator Stop Bath or Kodak Stop Bath SB-5 for 30 seconds.

Fix: Kodak Fixer or Kodak Fixing Bath F-5 for 5 to 10 minutes or Kodak Rapid Fixer for 2 to 4 minutes.

Wash: For 20 to 30 minutes in running water at 65 to 75 F. To minimize drying marks, treat in Kodak Photo-Flo Solution after washing. To save time and conserve water, use Kodak Hypo Clearing Agent.

CHARACTERISTIC CURVES

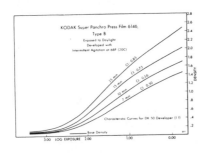

CONTRAST INDEX CURVES

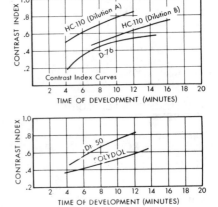

(Continued on following page)

88

KODAK ROYAL PAN FILM 4141 (ESTAR Thick Base)
ASA 400

GENERAL PROPERTIES

A very fast, panchromatic film with medium grain, moderate contrast, and wide exposure and development lati-tude. Both sides of the film are suitable for retouching. Available in sheets, 3½-inch and 70mm rolls.

FILM SPEED
ASA 400

DAYLIGHT EXPOSURE TABLE

Shutter speed at 1/200 or 1/250 second.

Bright or Hazy Sun on Light Sand or Snow	Bright or Hazy Sun (Distinct Shadows)	Cloudy Bright (No Shadows)	Heavy Overcast	Open Shade†
f/32	f/22*	f/11	f/8	f/8

*f/11 at 1/200 or 1/250 second for backlighted close-up subjects.
†Subject shaded from the sun but lighted by a large area of sky.

FILTER FACTORS

Increase normal exposure by the filter factor given below.

KODAK WRATTEN Filter	No. 6 (K1)	No. 8 (K2)	No. 15 (G)	No. 11 (X1)	No. 29 (F)	No. 25 (A)	No. 58 (B)	No. 47 (C5)	Polar- izing Screen
Daylight	1.5	2*	3	4	25	8	8	6	2.5
Photoflood or high- efficiency tungsten	1.5	1.5	2	3*	12	5	6	12	2.5

*For correct gray-tone rendering of colored objects.

FLASH EXPOSURE GUIDE NUMBERS

Clear Flashbulbs. To get f-number, divide guide number by flash-to-subject distance in feet, taken to a point midway between nearest and farthest details of interest. In small white rooms, use one stop smaller.

Between-Lens Shutter Speed	Synchroni- zation	AG-1*	M3†, 5‡, 25‡	11§ 40§	2§ 22§	Focal-Plane Shutter Speed
Open 1/25-1/30	X or F	320	500	500	600	1/25
1/25-1/30	M	220	450	450	550	1/50
1/50-1/60	M	220	420	400	550	1/100
1/100-1/125	M	180	360	360	450	1/250
1/200-1/250	M	150	280	260	340	1/500
1/400-1/500	M	110	220	200	260	1/1000

Bowl-Shaped Polished Reflectors: *2-inch; †3-inch; ‡4- to 5-inch; §6- to 7-inch. All guide numbers are for bowl-shaped, polished reflectors; they do not apply to other shapes of reflectors. For shallow cylindrical reflectors, divide these guide numbers by 2. For intermediate-shaped reflectors such as the shallow fan-shaped reflector), divide these guide numbers by 1.4.

(Continued on following page)

EASTMAN KODAK

ELECTRONIC FLASH GUIDE NUMBERS

This table is intended as a starting point in determining the correct guide number. The table is for use with equipment rated in beam candlepower-seconds (BCPS) or effective candle-power-seconds (ECPS). Divide the appropriate guide number by the flash-to-subject distance in feet to determine the f-number for average subjects.

Output of Unit (BCPS or ECPS)	350	500	700	1000	1400	2000	2800	4000	5600	8000
Guide Number for Trial	85	100	120	140	170	200	240	280	340	400

RECIPROCITY EFFECT ADJUSTMENTS

Exposure Time (seconds)	Exposure Adjustments	Development Adjustments
1/1000	none	10% more
1/100	none	none
1/10	none	none
1	1 stop more	10% less
10	2 stops more	20% less
100	3 stops more	30% less

SAFELIGHT

Handle and process the film in total darkness. After development is half completed, you can use a Kodak Safe-light Filter No. 3 (dark green) or equivalent in a suitable safelight lamp with a 15-watt bulb at not less than 4 feet for a few seconds only.

PROCESSING

Development: Develop at approximate times and temperatures given below.

KODAK Developer	Development Times (in Minutes)									
	Continuous Agitation (Tray)					Intermittent Agitation† (Tank)				
	65 F	68 F	70 F	72 F	75 F	65 F	68 F	70 F	72 F	75 F
POLYDOL	7	6	5½	5	4½	9	8	7½	7	6
HC-110 (Dilution A)	3½	3	2¾	2½	2¼	4*	3¾*	3¼*	3*	2¾*
HC-110 (Dilution B)	7	6	5½	5	4½	9	8	7½	7	6
DK-50	4½	4	4	3¾	3½	5½	5	4¾*	4½*	4¼*
DK-50 (1:1)	7	6	5½	5	4½	9	8	7½	7	6
D-76	9	8	7½	7	6	11	10	9½	9	8
MICRODOL-X	10	9	8½	8	7	12	11	10½	10	9

†Agitation at 1-minute intervals during development.

*Unsatisfactory uniformity may result with development times of less than 5 minutes.

(Continued on following page)

The Compact Photo-Lab-Index

Rinse: Kodak Indicator Stop Bath or Kodak Stop Bath SB-5—30 seconds.

Fix: Kodak Fixer or Kodak Fixing Bath F-5—5 to 10 minutes or Kodak Rapid Fixer—2 to 4 minutes.

Wash: 20 to 30 minutes in running water at 65 to 75 F. To minimize drying marks, treat in Kodak Photo-Flo Solution after washing. To save time and conserve water, use Kodak Hypo Clearing Agent.

CHARACTERISTIC CURVES

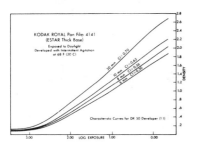

CONTRAST INDEX CURVES

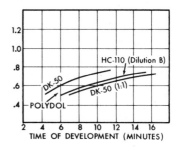

KODAK ROYAL-X PAN FILM
4166
(ESTAR Thick Base)
ASA 1250

GENERAL PROPERTIES

An extremely fast, medium-grain, panchromatic film recommended for use with extremely high shutter speeds or low light levels. Suitable for portraiture, illustrative, and commercial work. Retouching surface on both sides. Available in 120 rolls and sheets.

FILM SPEED
ASA 1250

For very flatly lighted subjects good negatives can be obtained using meter settings of up to ASA 2000 with normal development, or ASA 4000 if recommended development times are increased by about 50 percent.

SUGGESTED EXPOSURE SETTINGS

Lighting Conditions	Average Subject—Normal Development	Flat Subject—Extended Development
Existing Light		
Building interiors—courtrooms 4 to 8 footcandles incident (43 to 86 meter-candles incident)	1/30-f/4	1/30-f/5.6
Sports arenas 16 to 64 footcandles incident (172 to 680 meter-candles incident)	1/125-f/4	1/125-f/5.6
Work areas—store interiors 32 to 125 footcandles incident (340 to 1340 meter-candles incident)	1/125-f/5.6	1/125-f/8
Heavy overcast 400 to 1600 footcandles incident (4300 to 17,200 meter-candles incident)	1/125-f/22	1/125-f/32
Bright or hazy sunlight 5,000 to 10,000 footcandles incident (53,000 to 107,000 meter-candles incident)	1/500-f/32	—
Flashbulbs M synchronization; 1/500 sec No. 5 or 25	f/8-50 feet (15 meters)	f/11-50 feet (15 meters)
No. 22 or 2	f/11-50 feet (15 meters)	f/16-50 feet (15 meters)

ELECTRONIC FLASH GUIDE NUMBERS

To obtain the lens opening for electronic flash, divide the guide number by the distance from flash to subject.

Output of Unit (BCPS or ECPS)	500	700	1000	1400	2000	2800	4000	5600
Guide Number for Distances in Feet	180	210	250	300	350	420	500	600

(Continued on following page)

The Compact Photo-Lab-Index

PROCESSING
Total darkness is required for all dark-room handling.

Development: Develop for approximate times and temperatures given below.

Developing Times for Sheet Films

KODAK Packaged Developers	Developing Times (in minutes)									
	TRAY (Continuous Agitation)					TRANK (Agitation at 1-Min. Intervals)				
	65 F 18 C	68 F 20 C	70 F 21 C	72 F 22 C	75 F 24 C	65 F 18 C	68 F 20 C	70 F 21 C	72 F 22 C	75 F 24 C
HC-110 (Dilution B)	8½	8	7½	7	6½	11	10	9	8½	7½
POLYDOL	7½	6½	6	5½	4½	9½	8½	8	7½	6½
DK-60a	4½	4	3¾	3½	3	6	5	4½*	4*	3½*
DK-50	4¾	4½	4¼	4¼	4	6½	6	5½	5½	5
HC-110 (Dilution A)	5	4½	4¼	4	3½	7	6	5½	5	4½*

*Unsatisfactory uniformity may result with development times of less than 5 minutes.

Developing Times for 120 Rolls

KODAK Packaged Developers	Developing Time (in Minutes)				
	SMALL TANK—(Agitation at 30-Second Intervals)				
	65 F 18 C	68 F 20 C	70 F 21 C	72 F 22 C	75 F 24 C
HC-110 (Dilution B)	10	9	8	7½	6½
POLYDOL	8	7	6½	6	5
DK-60a	5	4½*	4¼*	NR	NR
DK-50	5½	5	4¾*	4¾*	4½*
HC-110 (Dilution A)	6	5	4¾*	4½*	4¼*

*Unsatisfactory uniformity may result with development times of less than 5 minutes.
NR = Not recommended.

Developing Times for Long Rolls in Spiral Reels

KODAK Packaged Developers	65 F 18 C	68 F 20 C	70 F 21 C	72 F 22 C	75 F 24 C
HC-110 (Dilution B)	10½	9½	9	8½	7½
DK-50	6½	5½	5	4½	4

(Continued on following page)

EASTMAN KODAK

Rinse: Kodak Indicator Stop Bath or Kodak Stop Bath SB-5—30 seconds to 1 minute. Use constant agitation. Drain the film for 2 to 5 seconds before immersing it in the fixer. This step is important. The use of acid stop bath minimizes the tendency for dichroic stain deposits on the film surface.

Fix: Kodak Fixer or Kodak Fixing Bath F-5—5 to 10 minutes or Kodak Rapid Fixer—3 to 5 minutes.

Wash: 20 to 30 minutes in running water at 65 to 75 F. To minimize drying marks, treat in Kodak Photo-Flo Solution after washing. To save time and conserve water, use Kodak Hypo Clearing Agent.

KODAK HIGH SPEED DUPLICATING FILM 2575 (ESTAR Base)

GENERAL PROPERTIES

Moderately high-contrast, contact-speed film. Yields high-quality duplicates with maximum density from line or halftone negative or positive originals. Gives excellent results when exposed through the base. Because of its speed, this film can be exposed on a process camera. The ESTAR Base and ESTAR Thick Base dry rapidly when processed whether in an automatic film processor or by other conventional methods. Available in sheets and rolls.

PROCESSING

Development: Develop at 68 F for the times given below.

KODAK HIGH SPEED DUPLICATING FILM 4575 (ESTAR Thick Base)

PRINTING PROCEDURE

Duplicate negatives or positives that are to have the same orientation as the original negative or positive should be made with the base side of the positive or negative in contact with the emulsion side of the duplicating film. Equally good results can be obtained if the emulsion side of the original is in contact with the base side of the duplicating film. For laterally reversed duplicates, the emulsion side of the positive or negative should be in contact with the emulsion side of the duplicating film.

Developer*	Recommended Time (minutes)	Development-Time Range† (minutes)
KODALITH Super RT	2¾	2¼-5
KODALITH	2¾	2¼-5
KODALITH Liquid (1:3)	2¼	2 -5
KODAK D-11	3	2¾-4
KODAK DEKTOL (1:1)	1½	1 -4

*Available in prepared form in several package sizes.
†Over this range, high-quality results can be obtained from properly exposed films.

Rinse: Kodak Indicator Stop Bath or Kodak Stop Bath SB-1a—10 seconds, at 65 to 70 F with agitation.

Fix: Kodak Fixer or Kodak Fixing Bath F-5—2 to 4 minutes or Kodak Rapid Fixer—1 to 2 minutes, at 65 to 70 F with agitation.

Wash: 10 minutes in running water at 65 to 70 F. To minimize drying marks, treat in Kodak Photo-Flo Solution, or wipe surfaces carefully with a Kodak Photo Chamois, a soft, wet viscose sponge, a Kodak Rubber Squeegee, or other soft squeegee.

Mechanized Processing: For information, write to Eastman Kodak Company, Rochester, N.Y. 14650.

EASTMAN KODAK

KODAK DIRECT POSITIVE PANCHROMATIC FILM 5246
D ASA 80; T ASA 64

GENERAL PROPERTIES

This is a medium speed, extremely fine-grain, panchromatic film designed for reversal processing to produce 2 x 2-inch, black-and-white transparencies. This film is well suited for copying prints, other halftones, 3¼ x 4-inch slides, and it can be used for indoor and outdoor picture-taking. Available in 100 ft. 35mm perforated rolls.

FILM SPEED

Daylight—80
Tungsten—64

These speeds are recommended for meters marked for ASA Speeds. Normally they provide a safety factor in exposure when the film is processed exactly as recommended; temperature, time, and agitation are particularly important.

For Copying. These speeds are for trial exposures. They apply to incident-light meters directly and to reflected-light meters used with the Kodak Neutral Test Card (18% reflectance, gray side) at the copyboard. A matte white card will serve, in which case use one-fifth the above, e.g. 12, as the tungsten value.

FILTER FACTORS

Multiply the normal exposure by the filter factor given below.

Light Source	No. 8	No. 15	No. 11	No. 13	No. 25	No. 58	No. 47	No. 47B	Polarizing Screen
Daylight	2*	2.5	4	4	10	5	8	10	2.5
Tungsten	1.5	2	3*	5	5	5	16	20	2.5

*For correct gray-tone rendering of colored objects.

DAYLIGHT EXPOSURE TABLE

Lens opening at 1/100 or 1/125 second.

Bright or Hazy Sun on Light Sand or Snow	Bright or Hazy Sun* (Distinct Shadows)	Cloudy Bright (No Shadows)	Heavy Overcast	Open Shade
Between f/16 & f/22	Between f/11 & f/16	Between f/5.6 & f/8	Between f/4 & f/5.6	Between f/4 & f/5.6

*For backlighted subjects, increase exposure by 2 full stops (use lens opening between f/5.6 & f/8).

PHOTOFLOOD EXPOSURE TABLE

Two No. R2 reflector flood lamps, or two No. 2 photofloods in 12-inch average reflectors, giving comparable light output.

Side Light-to-Subject Distance	3½ ft	4½ ft	6 ft	9 ft	10 ft	13 ft
Camera Light-to-Subject Distance	4½ ft	6 ft	9 ft	13 ft	14 ft	18 ft
Lens Opening at 1/25 sec	f/11	f/8	f/5.6	f/4	f/3.5	f/2.8

(Continued on following page)

EASTMAN KODAK

The Compact Photo-Lab-Index

FLASH EXPOSURE GUIDE NUMBERS

To determine the correct f-number, divide guide number by flash-to-subject distance in feet, taken to a point midway between nearest and farthest details of interest. In small white rooms, use one stop smaller.

Blue flashbulbs are suggested to permit the use of one type of flashbulb for black-and-white and color photography. If clear flashbulbs are used, use about ½ stop smaller lens opening.

Guide Numbers for Blue Flashbulbs

Between-Lens Shutter Speed	Syn-chroni-zation	Flash-Cube	AG-1B*	M2B†	M3B† 5B‡ 25B‡	2B§ 22B§	Focal-Plane Shutter Speed	6B§ 26B§
Open 1/25-1/30	X or F	80	120	110	160	200	1/25-1/30	160
1/25-1/30	M	55	80	NR¶	150	200	1/50-1/60	120
1/50-1/60	M	55	80	NR¶	140	180	1/100-1/125	75
1/100-1/125	M	45	70	NR¶	120	150	1/200-1/250	55
1/200-1/250	M	35	55	NR¶	90	110	1/400-1/500	30

Bowl-Shaped Polished Reflectors: *2-inch; †3-inch; ‡4- 5-inch; §6- to 7-inch.
All guide numbers are for bowl-shaped, polished reflectors; they do not apply to other shapes of reflectors. For shallow cylindrical reflectors, divide these guide numbers by 2. For intermediate-shaped reflectors (such as the shallow fan-shaped reflector), divide these guide numbers by 1.4.

¶ NR = Not Recommended.

PROCESSING

This film must be processed by a special procedure, for which packaged chemicals are supplied under the name "Kodak Direct Positive Film Developing Outfit." At 68 F the processing stops are as follows:

1. First Developer ...6 to 9 minutes
2. Rinse2 to 5 minutes
3. Bleach1 minute
4. Clearing Bath2 minutes*
5. Redeveloper8 minutes
6. Water Rinse1 minute
7. Fixing Bath5 minutes
8. Wash20 minutes**

*Time in excess of 2 minutes should be avoided because of the tendency of this bath to dissolve the silver halide with consequent loss of density in the positive image.

**Kodak Hypo Clearing Agent may be used, if desired, to shorten wash time and conserve water. Use as directed on the label.

SAFELIGHT

Total darkness until bleaching is completed; thereafter a Kodak Safelight Filter 0A (greenish yellow) or equivalent can be used in the recommended manner. Do not inspect the film with white light until fixed completely, or veiled highlights may result.

KODAK PROFESSIONAL DIRECT DUPLICATING FILM SO-015 (ESTAR Thick Base)

PURPOSE

For black-and-white duplicating. A film designed specifically for making duplicates from conventional black-and-white continuous-tone negatives or positives with one exposure and normal processing. The film can be exposed in a contact printer, printer frame, or by means of an enlarger. No special chemicals are needed.

DEVELOPMENT

Tank processing uses DK-50, tray uses Kodak Dektol Developer™, or machine processing can be done with Kodak Versamat Film Processor.™

This film can be used for making duplicate negatives from glass plates or deteriorating nitrate-based film negatives. It can provide duplicate negatives of excellent quality where multiple negatives are required, without the necessity of going through an intermediate diapositive. This duplicating film is a fine grain material, and at ordinary magnification the only visible grain will be that of the material that is being copied.

This film can also be used to copy positives.

TENTATIVE INSTRUCTIONS

The information below is based upon limited testing, and is subject to change. It is intended only as a guide or starting point to assist you in evaluating the film under your own conditions. You may wish to make adjustments of exposure and/or development to suit your individual needs or preferences.

Kodak Professional Direct Duplicating Film SO-015 is an ortho-sensitive medium contrast direct-reversal film used for one-step duplication of continuous-tone black-and-white negatives and positives.

It is coated upon dimensionally stable .007 Estar Thick Base.

SAFELIGHT

Kodak Safelight Filter No. 1A (light red) or equivalent in a suitable safelight lamp with a 15-watt bulb, Safelight should be kept at least four feet from the film.

EXPOSURE

A series of test exposures for the actual working conditions should be made. With a direct reversal film, more exposure produces lighter densities, while less exposure produces heavier densities. A possible trial exposure would be that of using a tungsten light source producing three footcandles at the exposure plane, expose for 40 seconds.

MANUAL PROCESSING

1. **Develop** at 70 F (21 C). Deep tank (agitation at 1-minute intervals): Kodak Developer DK-50 (full strength)—7 minutes.
 Tray continuous agitation: Kodak Dektol Developer (1:1)—2 minutes. Development times may have to be adjusted to obtain desired contrast.
2. **Rinse** at 65 to 75 F (18-24 C) with agitation. Kodak Indicator Stop Bath—30 seconds or Kodak Stop Bath SB-5—30 seconds.
3. **Fix** at 65 to 75 F (18-24 C) with frequent agitation (continuous for first 15 seconds). Kodak Fixer—5 to 10 minutes or Kodak Fixing Bath F-5—5 to 10 minutes or Kodak Rapid Fixer—2 to 4 minutes.
4. **Wash** for 20 to 30 minutes in running water at 65 to 75 F (18-24 C). To minimize drying marks, treat in Kodak Photo-Flo Solution after washing. To save time and conserve water, use Kodak Hypo Clearing Agent.
5. **Dry** in a dust-free place.

MECHANIZED PROCESSING

Chemicals: Kodak Versaflo Developer Starter. Kodak Versaflo Developer Replenisher. Kodak Versamat Fixer and Replenisher, Type B.

(Continued on following page)

EASTMAN KODAK

The Compact Photo-Lab-Index

DEVELOPER TEMPERATURE
Preliminary testing indicates that best results are obtained at a developer temperature of 85 F (29.4 C).

MACHINE SPEED
Machine speeds listed below are recommended for trial and may have to be adjusted to obtain desired contrast.

KODAK VERSAMAT FILM PROCESSOR	RECOMMENDED MACHINE SPEED FOR TRIAL
Model 5	3 feet per minute
Model 11	6 feet per minute
Model 411	3 feet per minute

AVAILABILITY
Sheet Film sizes.

STORAGE
Unexposed film should be kept at 55 F (13 C) or lower in the original sealed package. To avoid moisture condensation on film that has been refrigerated, allow the sealed package to warm up to room temperature before opening.

Exposed film should be kept cool and dry. Process the film as soon as possible after exposure.

Processed film should be stored in a cool, dry area free from dust. Protect processed film from strong light. **Note:** It is suggested that film which must meet archival keeping standards be tested according to ANSI Standards PH1.41 (1971) and PH4.8 (1971) to determine if subsequent washing is necessary.

KODAK PROFESSIONAL COPY FILM 4125 (ESTAR Thick Base)

METER SETTING
T or QUARTZ IODINE ASA 12
WHITE FLAME ARC 25
PULSED XENON 25

GENERAL PROPERTIES
An orthochromatic copy film designed to provide the increased highlight contrast needed in continuous-tone copy negatives and in photomechanical reproduction. Highlight contrast can be controlled by exposure and development to give a fairly accurate reproduction of most black-and-white originals or to maintain clear backgrounds in copies of combined line and continuous-tone material. Available in sheets.

FILM SPEED
Tungsten or Quartz-Iodine ASA 12
White-Flame Arc ASA 25
*Pulsed-Xenon Arc ASA 25

*This value indicates the relative speed of this material to pulsed-xenon illumination as measured by a light integrator.

These speeds are for use with meters marked for ASA Speeds and are for trial exposures in copying. They apply to incident-light meters directly and to reflected-light meters used with the Kodak Neutral Test Card (18% gray side) at the copy board. A matte white card will serve, in which case expose for five times the calculated exposure time.

Examples of Exposure: Under average conditions, with a same-size (1:1) reproduction, suggested trial exposure is as follows:

(Continued on following page)

Light Source	Aperture	Exposure	Filter
White-Flame Arc Two 95-ampere arc lamps, one on each side, 48 inches from the center of the copy	f/32	12 sec	0.6 ND*
Tungsten Two 500-watt reflector-type photolamps, or two 500-watt 3200 K lamps in reflectors, at 36 inches from the center of the copy (640 footcandles)	f/22	8 sec	None
Pulsed-Xenon Arc Two 1500-watt pulsed-xenon lamps in reflectors, at 36 inches from the center of the copy	f/32	8 sec	None

*ND = Neutral Density

Making a Reproduction from a Continuous-Tone Original:

1. Copy a paper gray scale along with the original.
2. Choose a paper from those listed in the first table "Developing Copy Negatives for Reproduction of Photographs."
3. Make a series of test negatives at different exposures and develop them as indicated by the table.
4. The steps marked 0.00 and 1.60 in the paper gray scale represent typical highlight and shadow densities for most originals. With a densitometer, read the corresponding steps in the negative. Select the negative whose aim densities are closest to those indicated by the table.

5. If the densities in the negative gray scale fail to read within the indicated tolerances (± .02 for shadow densities, ± .05 for highlight densities), first adjust the exposure until the shadow matches that given in the table. Then, if necessary, adjust the time of development until the highlight density also matches that in the table.

SAFELIGHT

Use a Kodak Safelight Filter No. 2 (dark red) or equivalent in a suitable safelight lamp with a 15-watt bulb at not less than 4 feet. For short periods of time, a Kodak Safelight Filter No. 1 (red) or equivalent can be used.

PROCESSING

Developing Copy Negatives for Reproduction of Photographs

When You Use this KODAK Paper	Develop KODAK Professional Copy Film 4125 in this KODAK Developer at 68 F (20 C)	For this Development—Time		To Obtain these Densities in the Copy Negative Gray Scale	
		Tray (Continuous Agitation)	Tank (Agitation at 1-Minute Intervals)	Shadow (Tolerance: ± .02)	Highlight Highlight (Tolerance: ± .05)
EKTAMATIC SC* POLYCONTRAST	HC-110 (Dilution E)	4¾ min	6½ min	0.37	1.48
F*	HC-110 (Dilution E)	4½ min	6 min	0.30	1.30
EKTALURE G	HC-110 (Dilution E)	3¾ min	4¾ min‡	0.24	1.12
AZO F†	HC-110 (Dilution B)	3½ min	4 min‡	0.38	1.52
POLYLURE G*	HC-110 (Dilution E)	4½ min	6 min	0.22	1.16

*KODAK POLYCONTRAST Filter PC2, or equivalent.

†Contrast Grade 1

‡Unsatisfactory uniformity may result with development times of less than 5 minutes.

(Continued on following page)

EASTMAN KODAK

EASTMAN KODAK

Developing Copy Negatives for Less Critical Applications

For ordinary copying, reproductions can be obtained by monitoring only the highlight density of the copy negative. For example, the developing times listed below yield negatives suitable for contact printing onto Kodak Azo Paper, Grade 1.

KODAK Packaged Developer	Development Time at 68 F (20 C)		Recommended Highlight Aim Density (Tolerance: ± .05)
	Tray (Continuous Agitation)	Tank (Agitation at 1-Minute Intervals)	
HC-110 (Dilution B)	3½ min	4 min	1:52
DK-50 (1:1)	6 min	8 min	1:52
POLYDOL	4¼ min	5½ min	1:52

*Development times of less than 5 minutes in a tank may produce poor uniformity and should be avoided.

*Unsatisfactory uniformity may result with development times of less than 5 minutes.

Developing for Photomechanical Reproduction

KODAK Packaged Developer	Development Time at 68 F (20 C)		Recommended Highlight Aim Density
	Tray (Continuous Agitation)	Tank (Agitation at 1-Minute Intervals)	
HC-110 (Dilution C)	5½ min	8 min	1.70
D-11	6 min	8 min	1.70

Rinse: Kodak Indicator Stop Bath SB-1a—10 seconds at 65 to 70 F with agitation.

Fix: Kodak Rapid Fixer—2 to 4 minutes, or Kodak Fixer—5 to 10 minutes. 65 to 70 F with frequent agitation.

Wash: 20 to 30 minutes in running water at 65 to 70 F.

100

KODAK ORTHO COPY FILM 5125
T ASA 12

GENERAL PROPERTIES

An orthochromatic film especially designed to provide the increased highlight contrast needed in making continuous-tone copy negatives. It permits the highlight contrast to be controlled to give correct tone reproduction or to maintain clean highlight backgrounds in restorations or in copies of composites containing both continuous-tone and line material. This film also can be used for making continuous-tone positives with improved shadow contrast. Available in 70mm rolls.

FILM SPEED
Tungsten 12

This speed is recommended for use with meters marked for ASA speeds or exposure indexes. It takes into account the ultraviolet absorption of average process lenses.

This setting is for trial exposures in copying. It applies to indicident-light meters directly and to reflected-light meters used with the Kodak Neutral Test Card (18 percent gray side) at the copyboard. A matte white card will serve, in which case expose for 5 times the calculated exposure time.

Because of the increase in highlight contrast, uneven illumination of the copyboard will be more noticeable; therefore, use a meter to check the uniformity of illumination.

Examples of Exposure. Under average conditions, with a same-size reproduction, the suggested exposure for a test negative is as follows:

1. Photofinishing Photocopying (with an auto-focus type of copy camera): With two 150-watt photoflood lamps (without diffusing screens) at an angle of 45° and 13 inches from the center of the copy, the suggested exposure is 3 seconds.

2. General Photocopying (with a copy camera): With two No. 2 reflector-type floodlamps or two 500-watt, 3200 K lamps in reflectors at an angle of 45° and 36 inches from the center of the copy, the suggested exposure is 8 seconds at f/22.

The exposure required to obtain the proper highlight contrast is critical. The exposure level determines the overall contrast and particularly the highlight contrast of the reproduction. If the negative is underexposed, no improvement in highlight contrast will result; if it is overexposed, the highlight tones in the reproduction will be correct, but the middletones will be too dark.

Adjust the exposure to produce a highlight density that is best for your applications. The specific highlight density that you should aim for is dependent upon such factors as the developer used to develop this film, the original to be copied, the photographic paper being used to make the reproduction, whether reproductions are to be made by contact or enlargement, and the types of enlarger and illumination that are used.

In photofinishing photocopying, a correctly exposed negative should have a highlight density of about 1.72 ± 0.05; in general photocopying, a correctly exposed negative should have a highlight density of about 1.75 ± 0.05. The highlight density aim should be obtained by adjusting the exposure level; do not adjust development.

To determine more accurately the optimum exposure level for your particular conditions, select and mount a typical original, along with a suitable reflection gray scale, on the copyboard. Make a series of test exposures and carry them through your regular reproduction process. Select the reproduction which shows the best tone rendering and measure the highlight density of the negative from which it was made.

Use that density value as your highlight density aim for that type of original.

PROCESSING

Development: Develop for approximate times and temperatures given below.

(Continued on following page)

101

PHOTOFINISHING PHOTOCOPYING

KODAK Developer	(Time (minutes)	Suggested Highlight Density Aim
DURAFIN*	71 F (21.5 C)	1.72 ± 0.05

*Prepared from KODAK DURAFIN Developer Replenisher and KODAK DURAFIN Developer Starter.

GENERAL PHOTOCOPYING

KODAK Developer	Time at 68 F (minutes)		Suggested Highlight Density Aim
	Short Lengths in a Tray (continuous agitation	Long Lengths on Spiral Reel	
POLYDOL	4½	5½	1.72 ± 0.05
DK-50 (1:1)	6	8	1.72 ± 0.05

Long Lengths on Spiral Reel. Secure the end of the film with a rubber band or waterproof tape to prevent the film from unwinding during processing. Then use the following agitation procedure.

1. Lower the reel into the developer, giving it a vigorous turning motion sufficient to cause the reel to rotate one-half to one revolution in the developer. Raise and lower the reel approximately one-half inch (keeping the reel in the solution) for the first 15 seconds of development, tapping it against the bottom of the tank to release air bubbles from the film.

2. Agitate once each minute by lifting the reel out of the solution, tilting it 30 degrees to drain for 5 to 10 seconds, and immersing it again with a vigorous turning motion sufficient to cause the reel to rotate one-half to one revolution in the developer. Alternate the direction of rotation each minute.

3. Agitate in the same manner in the stop bath and once per minute in the fixing bath.

Note: Too little agitation during development will cause mottle and uneven development. Too much pumping of the reel in and out of the developer can produce streaks across the film at the reel spokes. Too much turning of the reel in the solution can cause longitudinal streaks on the film. The agitation procedure just described provides a compromise that minimizes these undesirable effects.

Rinse: Kodak Stop Bath SB-1a or Kodak Indicator Stop Bath about 10 seconds, with agitation at 65 to 70 F.

Fix: Kodak Fixer or Kodak Fixing Bath F-5 at 65 to 70 F for 5 to 10 minutes or in Kodak Rapid Fixer for 2 to 4 minutes with agitation.

Wash: 20 to 30 minutes in running water at 65 to 70 F. To minimize drying marks, treat in Kodak Photo-Flo Solution after washing or wipe surfaces carefully with a Kodak Photo Chamois, a soft viscose sponge, a Kodak Rubber Squeegee, or other soft squeegee. To save time, and conserve water, use Kodak Hypo Clearing Agent.

KODAK HIGH CONTRAST COPY FILM 5069
T ASA 64

GENERAL PROPERTIES

A high-contrast panchromatic film designed for making reduced (35mm or smaller) copy negatives of printed matter, engineering drawings, maps, etc. Provides very high sharpness, even when negatives are enlarged to extremely high magnifications. Yields good quality results when originals containing both line and halftone material (such as catalog pages) are copied.

Because this film has a clear base, negatives will appear thinner than those made under the same conditions on gray-base films. Do not increase the background density to that obtained with gray-base films; otherwise, some loss of sharpness may result.

Available in 135 magazines and 50 ft. 35mm perforated rolls.

FILM SPEED

Tungsten—64

This speed is for use with meters marked for ASA speeds. This setting is recommended for trial exposures in copying. It can be used directly with incident-light meters which measure illumination at the copy plane. Or make a meter reading of a matte white card. In this case, set 12 on the meter calculator dial.

It is recommended that two light sources be used, one on either side of the copy material. Arrange them so that the light strikes the material at about a 45° angle. Use a sheet of clean plate glass to hold the copy flat.

FILTER FACTORS

Usually, a filter will not be required to achieve the desired contrast between background and subject matter. In special cases, such as copying material from old newspapers or books with yellowed paper, use a Kodak Wratten Filter No. 8 or No. 15. For copying blueprints, use a No. 25 Filter.

When a filter is used, multiply the normal exposure by the filter factor given below.

KODAK WRATTEN Filter

Light Source	No. 8	No. 15	No. 25
Tungsten	1.2	1.5	8

PROCESSING

Development: Develop at approximate times and temperatures given below.

Developing Times (in Minutes)

KODAK Packaged Developer	SMALL TANK—(Agitation at 30-second Intervals)				
	65 F 18 C	68 F 20 C	70 F 21 C	72 F 22 C	75 F 24 C
D-19	7	6	5	4½	4

Rinse: Kodak Stop Bath SB-5a at 65 to 75 F for about 30 seconds with agitation.

Fix: 65 to 75 F. Agitate films frequently during fixing.

Kodak Fixer
2 to 4 minutes
or Kodak Fixing Bath F-5
2 to 4 minutes
or Kodak Rapid Fixer
1 to 2 minutes

Wash: At least 20 minutes in running water at 65 to 75 F. To minimize drying marks, treat in Kodak Photo-Flo Solution after washing, or wipe surfaces carefully with a Kodak Photo Chamois or a soft, wet viscose sponge. To save time and conserve water, use Kodak Hypo Clearing Agent.

SAFELIGHT

Handle and process the film in total darkness. After development is half completed, a Kodak Safelight Filter No. 3 (dark green) or equivalent in a suitable safelight lamp with a 15-watt bulb can be used for a few seconds only. Keep the safelight at least 4 feet from the film.

KODAK FINE GRAIN POSITIVE FILM 7302

GENERAL PROPERTIES

A low-speed, blue-sensitive film for making positive transparencies from continuous-tone or line negatives. This film features extremely fine grain and high resolving power and provides excellent definition, even with a high degree of magnification. Available in sheets.

EXPOSURE

Transparencies can be printed using contact or projection methods. Relative printing speed is about one-half the speed of Kodabromide Paper, Grade No. 2. Exact printing speed depends on development conditions to be used.

SAFELIGHT

Use a Kodak Safelight Filter 0A (greenish yellow) or No. 1A (light red) or equivalent in a suitable safelight lamp with a 15-watt bulb at not less than 4 feet.

PROCESSING

Development: Develop at 68 F (20 C) with continuous agitation.

Contrast of Original Negative	Kodak Developer	Development Time
High	D-76	4 to 10 minutes
Normal	Dektol (1:2)	2 to 4 minutes
Low	D-11	10 minutes

Because different printing systems yield varying degrees of contrast, adjust the time of development to give the contrast desired. In general, condenser-type enlargers yield higher contrast than either contact printers or diffuse-light enlargers. A dusty or dirty enlarger lens lowers contrast and reduces sharpness.

Rinse: 65 to 70 F with agitation.
Kodak Indicator Stop Bath—30 seconds or Kodak Stop Bath SB-5—30 seconds. A running water rinse can be used if an acid rinse bath is not available.

Fix: 65 to 70 F with frequent agitation.

Kodak Fixer
 2 to 4 minutes

or Kodak Fixing Bath F-5
 2 to 4 minutes

or Kodak Rapid Fixer
 2 minutes

Wash: 15 to 20 minutes in running water at 65 to 75 F. To minimize drying marks, treat in Kodak Photo-Flo Solution or remove excess water with a soft rubber squeegee. To save time and conserve water, use Kodak Hypo Clearing Agent.

EASTMAN KODAK

KODAK COMMERCIAL FILM 6127
KODAK COMMERCIAL FILM 4127
(ESTAR Thick Base)

EXPOSURE INDEX
D ASA 50; T ASA 8
WHITE FLAME ARC ASA 20
PULSED-XENON ARC ASA 12
QUARTZ-IODINE ASA 8
GENERAL PROPERTIES

These medium-speed, blue-sensitive films yield moderately high contrast and are for copying continuous-tone black-and-white originals, as well as for making positive transparencies or similar applications where red and green sensitivity is unnecessary or undesirable. Available in sheets.

KODAK Commercial Film 6127 has an acetate base. KODAK Commercial Film 4127 (ESTAR Thick Base) has an .007-inch ESTAR Base.

EXPOSURE INDEX
White-Flame Arc: 20.
*Pulsed-Xenon Arc: 12..
Daylight: 50.
Tungsten and Quartz Iodine: 8

These speeds are for use with meters marked for ASA speeds; they are recommended for trial exposures in copying. To obtain a trial exposure, take a reflected-light meter reading from the gray (18% reflectance) side of the KODAK Neutral Test Card at the copyboard. If the white (90% reflectance) side of the card is used, multiply the indicated exposure by 5.

*Relative speed of this material is pulsed-xenon illumination as measured by a light integrator.

EASTMAN KODAK

RECIPROCITY EFFECT ADJUSTMENTS

Exposure Time (seconds)	Exposure Adjustment	Development Adjustments
1/100	none	10% more
1/25	none	none
1/10	none	10% less
1	none	20% less
10	½ stop more	30% less
100	1 stop more	40% less

SAFELIGHT
Kodak Safelight Filter No. 1 (red), or equivalent.

PROCESSING
Development for Photographic Copying or General Applications:

KODAK Developer	Developing times in minutes with continuous agitation (tray)				
	65 F	68 F	70 F	72 F	75 F
DK-50	2½	2	—	1¾	1¾
HC-110 (Dilution B)	2¾	2¼	—	2	1¾
HC-110 (Dilution D)	4¾	4½	4¼	4	3¾
D-11	9	8	7	6½	5½

(Continued on following page)

Rinse: Kodak Indicator Stop Bath—30 seconds or Kodak Stop Bath SB-5—30 seconds or Kodak Stop Bath SB-1a—10 seconds.

Fix: Kodak Fixer—5 to 10 minutes or Kodak Fixing Bath F-5—5 to 10 minutes or Kodak Rapid Fixer—2 to 4 minutes.

Wash: 10 to 20 minutes in running water at 65 to 75 F. To minimize dry-ing marks, treat in Kodak Photo-Flo Solution, or wipe surfaces carefully with a Kodak Photo Chamois, a soft viscose sponge, a Kodak Rubber Squee-gee, or other soft squeegee. To save time and conserve water, use Kodak Hypo Clearing Agent.

Mechanized Processing: For information write to Eastman Kodak Company, Rochester, N.Y. 14650.

CHARACTERISTIC CURVES

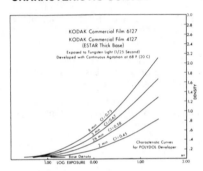

CONTRAST INDEX CURVES

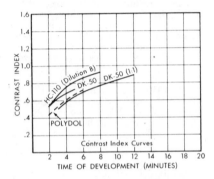

KODAK CONTRAST PROCESS ORTHO FILM 4154 (ESTAR Thick Base)

**EXPOSURE INDEX
T or QUARTZ-IODINE ASA 50
WHITE FLAME ARC ASA 100
PULSED-XENON ARC ASA 100**

GENERAL PROPERTIES

A high-contrast, medium-grain, ortho-chromatic film for copying black-and-white originals and those with black printed or written matter on blue, green, or yellow paper. When developed to a moderately high contrast, this film re-cords the intermediate tones in the lines of etchings, handwriting, and sim-ilar originals. Available in sheets.

FILM SPEED

White-Flame Arc: 100.
Tungsten or Quartz-Iodine: 50.
*Pulsed-Xenon: 100.

These speeds are for use with meters marked for ASA speeds; they are rec-ommended for trial exposures in copy-ing. To obtain a trial exposure, take a reflected-light meter reading from the gray (18% reflectance) side of the Kodak Neutral Test Card at the copy-board. If the white (90% reflectance) side of the card is used, multiply the indicated exposure by 5.

*This value indicates the relative speed of this material to pulsed-xenon il-lumination as measured by a light integrator.

(Continued on following page)

The Compact Photo-Lab-Index

FILTER FACTORS

Multiply The Normal Exposure By The Filter Factor Given Below.

KODAK Filters	No. 6	No. 8	No. 9	No. 15	No. 58	No. 47	No. 47B	Polarizing Screen
White-Flame Arc	2	2.5	3	5	6	6	8	2.5
Tungsten	1.5	1.5	2	3	3	10	16	2.5
Quartz-Iodine	1.2	1.5	2	2.5	3	10	16	2.5
Pulsed-Xenon Arc	2.5	3	4	6	5	6	10	2.5

PROCESSING

Development: Develop at approximate times and temperatures given below.

SAFELIGHT

Use a Kodak Safelight Filter No. 1 (red) or equivalent in a suitable safelight lamp with a 15-watt bulb at not less than 4 feet from the film.

Developing Times (in Minutes)

KODAK Developer	Continuous Agitation (Tray)					Intermittent Agitation* (Tank)				
	65 F (18 C)	68 F (20 C)	70 F (21 C)	72 F (22 C)	75 F (24 C)	65 F (18 C)	68 F (20 C)	70 F (21 C)	72 F (22 C)	75 F (24 C)
D-11 (High contrast)	4¾	4	3½	3	2½	6	5	4½ †	3¾ †	3†
D-8 (Max. contrast) (2:1)	—	2	—	—	—	—	—	—	—	—
HC-110 (High contrast) (Dilution B)	—	5	—	—	—	—	—	—	—	—

*Agitation at 1-minute intervals during development.
†Unsatisfactory uniformity may result with development times shorter than 5 minutes.

Rinse: Kodak Indicator Stop Bath—30 seconds or Kodak Stop Bath SB-5—30 seconds or Kodak Stop Bath SB-1a—at least 10 seconds. A running water rinse can be used if an acid rinse bath is not available.

Fix: Kodak Fixer—5 to 10 minutes or Kodak Fixing Bath F-5—5 to 10 minutes or Kodak Rapid Fixer—2 to 4 minutes. Agitate films frequently.

Wash: For 20 to 30 minutes in running water at 65 to 75 F. To minimize drying marks, treat in Kodak Photo-Flo Solution after washing. To save time and conserve water, use Kodak Hypo Clearing Agent.

Dry in dust-free place.

Mechanized Processing: For information, write to Eastman Kodak Company, Rochester, New York 14650.

CHARACTERISTIC CURVES

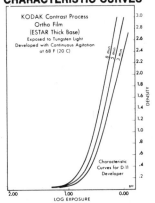

KODAK Contrast Process Ortho Film (ESTAR Thick Base) Exposed to Tungsten Light Developed with Continuous Agitation at 68 F (20 C)

Characteristic Curves for D-11 Developer

CONTRAST INDEX CURVE

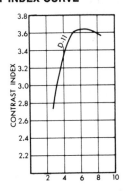

KODAK HIGH SPEED INFRARED FILM 2481 (ESTAR Base)

GENERAL PROPERTIES

A high-speed, infrared-sensitive black-and-white film on dimensionally stable .004-inch ESTAR Base. Sensitive through the visible region of the spectrum and in the infrared to approximately 900 nm, with maximum sensitivity from 750 nm to 840 nm. Used in scientific, medical, biological, industrial, and questioned-document photography. Available in 16mm and 35mm long rolls.

Handle this film in total darkness. No safelight should be used..

FILM SPEED

Exact speed recommendations are not possible because the ratio of infrared to visible radiation is variable and because photoelectric meters are calibrated only for visible radiation. Use a hand-held meter rather than a through-the-lens type.

It is recommended that trial exposures be made to determine proper exposure for the conditions under which photographs will be made. Under average conditions, the following speeds can be used as a basis for determining exposures when meters marked for ASA speeds or exposure indexes are used.

KODAK WRATTEN Filters	Daylight	Tungsten
No. 25, 29, 70 or 89B	50	125
No. 87 or 88A	25	64
No. 87C	10	25
Without a Filter	80	200

FOCUSING

For best definition, take all infrared pictures at the smallest lens opening that conditions permit. If large apertures must be used and the lens has no auxiliary focusing mark, establish a focusing correction by photographic focusing tests. A basis for trial is the extension of the lens by ¼ of 1 percent of the focal length of the lens.

DAYLIGHT EXPOSURE TABLE

The following recommendations are for subjects in bright or hazy sunlight (distinct shadows):

Exposed through KODAK WRATTEN Filter No. 25		No Filter
Distant Scenes	Nearby Scenes	Distant Scenes
1/125 sec at f/11	1/30 sec at f/11	1/125 sec at f/16

(Continued on following page)

The Compact Photo-Lab-Index

PHOTOLAMP EXPOSURE TABLE

For use with a Kodak Wratten Filter No. 25 over the camera lens. Use two 500-watt reflector-type photolamps or two No. 2 photolamps in 12-inch reflectors giving comparable light output. Place one lamp on each side of the camera at an angle of 45° to the camera-subject axis.

Lamp-to-Subject Distance	3 feet	4½ feet	6½ feet
Lens Opening at 1/30 Second	f/11	f/8	f/5.6

ELECTRONIC FLASH GUIDE NUMBERS

Use with a Kodak Wratten Filter No. 87 over the camera lens.

Output of Unit (BCPS or ECPS)	500	700	1000	1400	2000	2800	4000	5600
Guide Number for Trial	40	45	55	65	80	95	110	130

FLASHBULB GUIDE NUMBERS

The following numbers apply for the clear flashbulbs indicated when a Kodak Wratten Filter No. 25, No. 29, No. 70, or No. 89B is used over the camera lens.

Between Lens Shutter Speed	Syn-chroni-zation	AG-1*	M2†	M3† 5‡, 25‡	11§ 40§	2§ 22§	Focal-Plane Shutter Speed	6 26‡
Open, 1/30	X or F	180	180	280	280	340	1/30	250
1/30	M	120	NR	240	240	320	1/60	180
1/60	M	120	NR	240	220	300	1/125	130
1/125	M	100	NR	200	200	260	1/250	90
1/250	M	80	NR	160	150	200	1/500	65
1/500	M	65	NR	120	120	150	1/1000	45

Bowl-Shaped Polished Reflectors: *2-inch; †3-inch; ‡4- to 5-inch; §6- to 7-inch. If shallow cylindrical reflectors are used, divide these guide numbers by 2. For intermediate-shaped reflectors, divide the numbers by 1.4.
NR = Not Recommended.

PROCESSING

Development: Times are given for development in a tank with agitation at 1-minute intervals.

KODAK Developer	65 F 18 C	68 F 20 C	70 F 21 C	72 F 22 C	75 F 24 C
D-76 (Normal Contrast)	14	12	11	10	9
D-19 (High Contrast)	9	8	7½	7	6½

(Continued on following page)

Rinse: At 65 to 75 F with agitation.
Kodak Indicator Stop Bath—30 seconds or Kodak Stop Bath SB-5—30 seconds.
A running-water rinse can be used if an acid rinse bath is not available.

Fix: At 65 to 75 F. Agitate films frequently during fixing.
Kodak Rapid Fixer
 2 to 4 minutes
or Kodak Fixer
 5 to 10 minutes
or Kodak Fixing Bath F-5
 5 to 10 minutes

Wash: For 20 to 30 minutes in running water at 65 to 75 F. To minimize drying marks, treat in Kodak Photo-Flo Solution after washing, or wipe surfaces carefully with a Kodak Photo Chamois or a soft, wet viscose sponge. To save time and conserve water, use Kodak Hypo Clearing Agent.

KODAK HIGH SPEED INFRARED FILM 4143 (ESTAR Thick Base)

GENERAL PROPERTIES

A high-speed, infrared-sensitive film having moderately high contrast on dimensionally stable, .007-inch ESTAR Thick Base. Useful for distant haze penetration and for special effects in commercial, architectural, and landscape photography. With variations in development, can be used in scientific, medical, and documentary photography; in photomechanical work; and in photomicrography. Available in sheets.

FILM SPEED

Exact speed recommendations are not possible because the ratio of infrared to visible radiation is variable and because photoelectric meters are calibrated only for visible radiation. It is recommended that trial exposures be made to determine proper exposure for the conditions under which photographs will be made.

Under average conditions, the following speeds can be used as a basis for determining exposures when meters marked for ASA speeds or exposure indexes are used.

KODAK WRATTEN Filters	Daylight	Tungsten
No. 25, 29, 70, or 89B	50	125
No. 87 or 88A	25	64
No. 87C	10	25
Without a Filter	80	200

FOCUSING

In the interests of best definition, take all infrared pictures at the smallest lens opening that conditions permit. If large apertures must be used, and the lens has no auxiliary infrared focusing mark, establish a focusing correction by photographic focusing tests. A basis for trial is the extension of the bellows by ¼ of 1 percent of the focal length of the lens.

(Continued on following page)

PROCESSING

Development: Develop at approximate times and temperatures given below.

KODAK Developer	TRAY (Continuous Agitation)					TANK (Agitation at 1-Min. Inter.)				
	65 F 18 C	68 F 20 C	70 F 21 C	72 F 22 C	75 F 24 C	65 F 18 C	68 F 20 C	70 F 21 C	72 F 22 C	75 F 24 C
D-76 (Pictorial)	9	8	7½	7	6	12	10	9	8	7½
MICRODOL-X (Pictorial)	13	11	10	9	8	16	14	12	10	9
DK-50 (for High Contrast)	11	9½	8	7	6½	14	12	10	9	8
D-19 (for Maximum Contrast)	13	11	10	9	8 -	16	14	12	10	9

Rinse: At 65 to 70 F in Kodak Indicator Stop Bath or Kodak Stop Bath SB-5 for about 30 seconds with agitation. A running-water rinse can be used if an acid rinse is not available.

Fix: At 65 to 70 F in Kodak Fixer or Kodak Fixing Bath F-5—5 to 10 minutes or Kodak Rapid Fixer—2 to 4 minutes. Agitate films frequently during fixing.

Wash: For 20 to 30 minutes in running water at 65 to 70 F. To minimize drying marks, treat in Kodak Photo-Flo Solution after washing. To save time and conserve water, use Kodak Hypo Clearing Agent.

KODAK 2475 RECORDING FILM (ESTAR-AH Base)
EXPOSURE INDEX 1000

GENERAL PROPERTIES

An extremely high-speed, panchromatic film with extended red sensitivity. It is especially well suited for applications requiring low-level illumination or short-duration exposures, such as law-enforcement photography. It can be processed at temperatures up to 95 F.

The 0.10 density of the base of this film minimizes edge-fog effects, reduces light piping, and provides halation protection.

Kodak 2475 Recording Film is suitable for high-speed, law-enforcement, CRT, flame-study and satellite-tracking photography. Available in 16mm and 35mm long rolls and 135 magazines.

(Continued on following page)

EASTMAN KODAK

The Compact Photo-Lab-Index

DAYLIGHT EXPOSURE TABLE
For subjects in bright sunlight.

Exposed through KODAK WRATTEN Filter, No. 25		No Filter, for "Ordinary" Rendering
Distant Scenes	Nearby Scenes	Distant Scenes
1/125 sec at f/11	1/30 sec at f/11	1/125 sec at f/16

PHOTOFLOOD EXPOSURE TABLE
For use with a Kodak Wratten Filter No. 25 or No. 29 over the camera lens. Use two R2 reflector-type photofloods or two No. 2 photofloods in 12-inch reflectors giving comparable light output. Place one lamp on each side of the camera at a 45° angle to the camera axis.

Lamp-to-Subject Distance	3 feet	4½ feet	6½ feet
Lens Opening at 1/30 Second	f/11	f/8	f/5.6

ELECTRONIC FLASH GUIDE NUMBERS
Use with a Kodak Wratten Filter No. 87C over the camera lens.

Output of Unit (BCPS or ECPS)	500	700	1000	1400	2000	2800	4000	5600
Guide Number for Trial	40	45	55	65	80	95	110	130

FLASHBULB GUIDE NUMBERS FOR CLEAR FLASHBULBS
The following numbers apply with a Kodak Wratten Filter No. 25, No. 29, No. 70, or No. 89B over the camera lens.

Between-Lens Shutter Speed	Synchro-nization	11* 40*	2* 22*	Focal-Plane Shutter-Speed	6† 26†
1/30	M	370	450	1/60	250
1/60	M	330	400	1/125	200
1/125	M	290	350	1/250	130
1/250	M	220	260	1/500	100

Bowl-Shaped Polished Reflectors: *6- to 7-inch; †4- to 5-inch.

(Continued on following page)

EASTMAN KODAK

The Compact Photo-Lab-Index

FILM SPEED

Best results will be obtained with Kodak 2475 Recording Film if the exposure is determined for the actual conditions under which the film is to be used. The following table is provided as a guide to determining exposure.

Photo-recording Sensitivity*	Exposure Index†	CRT Exposure Index‡		
		P11	P16	P24
1250	1000	400	650	250

*Based on development in KODAK Develop DK-50 for 8 minutes at 68 F.

†Based on development in KODAK Developer DK-50 for 5 minutes at 68 F. For most applications of this film, an index of 1600 can be used with most exposure meters. For subjects that are very flatly lighted, an index of 3200 will usually give good results if the film is developed in KODAK Developer DK-50 for 8 minutes at 68 F.

‡Based on development in KODAK Developer DK-50 for 8 minutes at 68 F. Value is expressed as the reciprocal of the exposure in ergs/cm² required for a net density of 0.10.

Suggested Exposure Settings for Existing Light

Lighting Conditions	Average Subject—Normal Development	Low-Contrast Subject—Extended Development
Building interiors—courtrooms 4 to 8 footcandles incident	1/30-f/4	1/30-f/5.6
Sports arenas 16 to 64 footcandles incident	1/125-f/4	1/125-f/5.6
Work areas—store interiors 32 to 125 footcandles incident	1/125-f/5.6	1/125-f/8
Heavy overcast 400 to 1600 footcandles incident	1/125-f/22	1/125-f/32
Bright or hazy sunlight 5,000 to 10,000 footcandles incident	1/500-f/32	

FILTER FACTORS

Increase normal exposure by the filter factor given below.

KODAK WRATTEN Filter	No. 6	No. 8	No. 11	No 15	No. 25	No. 47	No. 58	Polarizing Screen
Daylight	1.5	2*	6	2	3	6	10	2.5
Tungsten	1.2	1.2	6*	1.5	2	16	12	3

*For correct gray-tone rendering of colored objects.

(Continued on following page)

The Compact Photo-Lab-Index

PROCESSING

NOTE: Handle only in total darkness.

Development: Recommended development for 135 magazines in small tanks. Develop the film for the approximate times and temperatures listed below. Agitate at 30-second intervals.

KODAK Packaged Developers	Developing Times (in minutes)						
	65 F (18 C)	68 F (20 C)	70 F (21 C)	72 F (22 C)	75 F (24 C)	85 F (29 C)	95 F (35 C)
Average Subjects							
DK-50	7	6	5	4¾	4	2½	1¾
HC-110 (Dilution A)	5½	4½	4	3½	3	2	1¼
HC-110 (Dilution B)	11	9	8	7	6	3	1¾
Low-Contrast Subjects							
DK-50	10½	9	8½	7½	6½	3¾	2¼
HC-110 (Dilution A)	9½	8	7½	6½	5	2¾	1¾
HC-110 (Dilution B)	17	15	12	11	10	6	3

Use fresh developer and an acid stop bath in order to reduce the possibility of dichroic fog on the film.

Rinse: Kodak Stop Bath SB-1a for 30 to 60 seconds at 65 to 75 F or for 20 to 40 seconds at 85 to 95 F. Agitate film continuously.

Fix: Agitate film frequently during fixing.

KODAK Fixer	Fixing Times (in minutes)	
	65 to 75 F (18 to 24 C)	85 to 95 F (29 to 35 C)
Fixing Bath F-5	8 to 12	6 to 10
Fixer	8 to 12	6 to 10
Rapid Fixer	3 to 5	2 to 4

Wash: 20 to 30 minutes at 65 to 75 F or for 12 to 20 minutes at 85 to 95 F in clear, running water.
Kodak Hypo Clearing Agent can be used after the fixing step to reduce washing time and conserve water.

KODAK EKTACOLOR PROFESSIONAL FILM, TYPE S

SHEET FILM 6101—SHEETS 5026— 35, 46, 70mm 6006—135, 120, 620

A film designed for making color negatives at exposure times at 1/10 second or shorter. The recommended light sources are flashlamps, daylight, and electronic light tubes. Colored couplers in the film provide automatic color correction and make excellent quality in color reproductions possible without supplementary masking. The negatives can be printed on Kodak Ektacolor 37 RC Paper, or by the Kodak Dye Transfer Process. They can also be used to make positive transparencies on Kodak Ektacolor Print Film 4109.

The number given after each light source is for use with meters marked for American Standard (ASA) Speeds or Exposure Indexes. These settings apply to reflected or incident-light readings, properly made, of average subjects. Certain reflected light meters should be pointed downward, if the manufacturer so recommends, to minimize the effect of the sky.

Caution: Do not expose Kodak Ektacolor Professional Film, Type S, for times longer than 1/10 second, because the resulting negatives may contain color-reproduction errors that cannot be corrected satisfactorily in the printing operation.

LIGHT SOURCES AND FILTERS

The use of photoflood or 3200 K lamps is recommended only if sufficient illumination can be obtained to permit an exposure of 1/10 second or shorter.

FLASH EXPOSURE GUIDE NUMBERS

INCLUSION OF GRAY CARD IN SCENE

As an aid in determining the exposures required in making prints from Ektacolor negatives, a neutral gray card having a reflectance of about 18%, such as the gray side of the Kodak Neutral Test Card, should be photographed with the subject. If possible, the card should be placed along the edge of the screen area in such a position; that it receives the full subject lighting but does not interfere with the actual picture and can be trimmed off the final prints. Otherwise, the card should be photographed, with the full subject lighting, on a separate sheet of Ektacolor Film, which should be processed at the same time as the picture.

Lens openings determined in this way apply to the use of a single lamp in all surroundings except small rooms with very light walls, ceilings and furnishings.

For flash pictures with this film, use blue flashbulbs without a filter. With zirconium-filled clear flashbulbs (AG-1, M3, and M5), use a No. 80D Filter. With all other clear flashbulbs, use a No. 80C Filter.

PROCESSING

Chemicals for the processing solutions are supplied in prepared form in the Kodak Color Processing Kit, Process C-22, which is available in 1-pint and 1-gallon sizes. Mixing directions, complete processing instructions, and a handy wall-chart summary of the processing steps are included. Kodak Color Film Chemicals, Process C-22, are also available individually in larger sizes.

Divide the proper guide number by the lamp-to-subject distance in feet to determine the lens opening for average subjects. Use ½ stop larger for dark subjects; ½ smaller for light subjects.

Light Source	Speed	Filter
Daylight	100	None
Photoflood Lamps (3400 K)	32	80B Filter
3200 K Lamps	25	80A Filter

(Continued on following page)

EASTMAN KODAK

ELECTRONIC FLASH GUIDE NUMBERS

This table is intended as a starting point in determining the correct guide number for use with specific equipment.

Effective Candlepower-Seconds Output	700	1000	1400	2000	2800	4000	5600	8000
Guide Number for trial	60	70	85	100	120	140	170	200

GUIDE NUMBERS* FOR FLASHBULBS
For Blue Flashbulbs (or Clear Bulbs with No. 80C or 80D Filter)

Between-Lens Shutter Speed	Syn-chroni-zation	AG-3B†	M2B‡	M3B‡ M5B‡ 5B§ 25B§	11B‖ 40‖¶	22B‖ 2B‖	50B 3B	Focal-Plane Shutter Speed	26B§ 6B§
Open, 1/25-1/30	X or F	180	130	200	200	260	380 (In a 12-in. bowl reflector, use 1/25 second or slower.)	1/25-1/30	190
1/25-1/30	M	120	NR**	190	180	240		1/50-1/60	150
1/50-1/60	M	120	NR**	180	170	220		1/100-1/125	100
1/100-1/125	M	100	NR**	150	150	190		1/200-1/250	70
1/200-1/250	M	80	NR**	120	110	140		1/400-1/500	50
1/400-1/500	M	60	NR**	90	90	110		1/1000	34

*For use with bowl-shaped polished reflectors. If shallow cylindrical reflectors are used, divide these guide numbers by 2.
Bowl-shaped polished reflector sizes: †2-inch; ‡3-inch; §4 to 5-inch; ‖6 to 7-inch.
¶Clear bulbs are listed because the blue bulbs are not available. Use Kodak Filter No. 80C.
**NR—Not Recommended.

These values are intended only as guides for average emulsions. They must be changed to suit individual variations in synchronization, battery, reflector, and bulb position in the reflector.

Caution: Since bulbs may shatter when flashed, the use of a flashguard over the reflector is recommended. **Do not flash bulbs in an explosive atmosphere.**

DAYLIGHT EXPOSURE TABLE

Lens openings at 1/100 second.
For the hours from 2 hours after sunrise to 2 hours before sunset.

Bright or Hazy Sun on Light Sand or Snow	Bright or Hazy Sun (Distinct Shadows)	Cloudy Bright No Shadows Cast (2)	Heavy Overcast	In Open Shade* with Clear Blue Sky
f/22	f/16†	f/8	f/5.6	f/5.6

*Subject shaded from the sun but lighted by a large area of clear, unobstructed sky.
†For backlighted closeups, use f/8.

(Reproduced with permission from a Copyrighted KODAK Publication)

KODAK EKTACOLOR PROFESSIONAL FILM, 6102 TYPE L

EXPOSURE INDEX

3200°K Lamps—64
(for a 5-second exposure)

(Long Exposure)

A sheet film designed for making color negatives at exposure times of 1/10 second to 60 seconds with 3200°K lamps or, with appropriate filters, by photoflood or daylight illumination. Colored couplers in the film provide automatic color correction and make excellent quality in color reproductions possible without supplementary masking. The negatives can be printed on Kodak Ektacolor 37 RC Paper, or by the Kodak Dye Transfer Process. They can also be used to make positive transparencies on Kodak Ektacolor Print Film 4109.

The effective exposure index depends upon the illumination level and exposure time. The speed setting given in each case is for use with meters marked for American Standard (ASA) Speeds or Exposure Indexes.

CAUTION

Do not expose Kodak Extacolor Film, Type L, for times shorter than 1/10 second or longer than 60 seconds, because the resulting negatives may contain color-reproduction errors that cannot be corrected satisfactorily in the printing operation. For short exposures, use Kodak Ektacolor Professional Film 6101 Type S.

INCLUSION OF GRAY CARD IN SCENE

As an aid in determining the exposures required in making prints from Ektacolor negatives, a neutral gray card having a reflectance of about 18%, such as the gray side of the Kodak Neutral Test Card, should be photographed with the subject. If possible, the card should be placed along the edge of the scene area in such a position that it receives the full subject lighting but does not interfere with the actual picture and can be trimmed off the final prints. Otherwise, the card should be photographed, with the full subject lighting, on a separate sheet of Ektacolor Film, which should be processed at the same time as the negatives of the subject.

PROCESSING

Kodak Ektacolor Film, Type L, is **not** processed by the Eastman Kodak Company. Chemicals for processing solutions are supplied in prepared form in the Kodak Color Processing Kit, Process C-22, which is available in a 1-gallon size. Kodak Color Film Chemicals, Process C-22, are also available individually in sizes to make 3½, 10,

Light Source	Filter No.	Exposure Time	Effective Exposure Index
3200°K	None	1/10 sec	100
3200°K	None	1 sec.	80
3200°K	None	5 sec	64
3200°K	None	60 sec	32
Photoflood	81A	1 sec	64 (with filter)
Daylight	85	1/10 sec	64 (with filter)

Set the meter calculator tentatively for an Exposure Index of 50, which applies to a 5-second exposure. Calculate a tentative exposure time for the desired lens opening. If this time is much shorter or much longer than 5 seconds, select from the table the effective Exposure Index which applies. Use this value to determine the correct exposure time at the desired lens opening.

(Continued on following page)

and 25 gallons of each solution. **Follow the processing directions for Kodak Ektacolor Professional Film 6101, Type S,** which are included with the 1-gallon size kit and with separate packages of Kodak Developer, Process C-22.

VIEWING

Developed Ektacolor negatives have a strong over-all cast of orange, caused by the colored couplers left in the film to provide color-correction masks. This orange color, which appears even in the edges masked off by the film holder, is normal and should be disregarded in appraising the negatives.

Exposure can be judged by placing the negatives over an illuminator, such as the Kodak DeLuxe Transparency Il-luminator, Model 2. Viewing the negative through a green filter, such as the Kodak Wratten No. 61 makes it appear much like a black-and-white negative and helps in determining whether adequate shadow detail has been obtained.

RETOUCHING

Information on retouching color negatives is available on request from the Eastman Kodak Co., Rochester, N.Y. 14650.

FILM SIZES AVAILABLE

(For all cameras accommodating sheet film in these sizes.) Inch sizes: 2¼ x 3¼, 3¼ x 4¼, 4 x 5, 5 x 7, 8 x 10 and 11 x 14.

KODACOLOR-X FILM

FOR DAYLIGHT AND FLASH

Kodacolor-X Negative Film is a medium speed color film which produces complementary color negatives with built-in color correction masking. From these negatives, color prints may be made on Kodak Ektacolor 37 RC Paper, or prints may be ordered through Kodak dealers. The films intended for negative developing either by the user, or by Kodak, but the cost of processing is not included in the price of the film, and film to be processed at Kodak laboratories must be sent in through a Kodak Dealer.

Film speeds based on new ASA standard; film has not been changed.

Light sources having different color qualities should not be mixed. In particular, avoid mixing photoflood and daylight or clear flash and daylight.

ASA SPEEDS

Light Source	Speed	With the following filters:
Daylight	80	None required
Photoflood*	25	No. 80B
3200°K Lamps*	20	No. 80A

*Enough light must be provided for an exposure of ½ second or shorter.

(Continued on following page)

The Compact Photo-Lab-Index

DAYLIGHT EXPOSURE TABLE

This table is for average, front-lighted subjects in daylight from two hours after sunrise to two hours before sunset.

Bright or Hazy Sun on Light Sand or Snow	Bright or Hazy Sun* (Distinct Shadows)	Cloudy Bright (No Shadows)	Heavy Overcast	Open Shade
Lens Opening with Shutter at 1/100 or 1/125				
f/16	f/11	f/5.6	f/4	f/4
Exposure Value				
15	14	12	11	11

*For back-lighted subjects, use f/5.6 or EV12.

FLASH EXPOSURES: GUIDE NUMBER TABLE

Use fresh flash batteries. Distance of flashlamp to subject is important. Blue coated lamps should be used as the sole light source indoors.

GUIDE NUMBERS* FOR FLASHBULBS

Use Blue Flashbulbs (or Clear Bulbs with KODAK WRATTEN Filter No. 80C)

Synchronization→ X or F		M	Focal-Plane Shutter Speed	6B§ or 26B§
Between-Lens Shutter Speed	AG-1B† M2B‡	M3B,‡ M5B,‡ 5B,§ 25B§		
1/25-1/30	120	180	1/50	130
1/50-1/60	—	160	1/100	90
1/100-1/125	—	130	1/250	60
1/200-1/250	—	105		

*For use with bowl-shaped polished reflectors. If shallow cylindrical reflectors are used, divide these guide numbers by two.
Bowl-shaped polished reflector sizes: †2-inch; ‡3-inch; §4- to 5-inch.

Note: At 1/25 or 1/30 second, cameras having X or F synchronization can use M3B, M5B, No. 5B, or No. 25B flashbulbs.

Caution: Since bulbs may shatter, use a flashguard over the reflector. **Do not flash bulbs in an explosive atmosphere.**

EXPOSURE FOR FILL-IN FLASH

Where harsh shadows or excessive contrast are found when making close-ups, particularly with side- or back-lighted subjects in bright sunlight, use BLUE FLASHLAMPS to fill in the shadows or reduce the contrast.

(Continued on following page)

The Compact Photo-Lab-Index

Flashbulb No.	Flash-to-Subject Distance	Lens Opening	Shutter Speed
M5B, M25B, 5B, 25B, 6B or 26B	9 to 15 ft 7 to 12 ft	f/16 f/22	1/50-1/60 1/25-1/30
M2B	6 to 9 ft	f/22	1/25-1/30

NOTE: Ranges are given because the amount of fill-in light is a matter of personal preference. At camera-to-subject distances less than those in the table, use an extension cord to keep the flash reflector at the proper distance, or use one or more thicknesses of white handkerchief over the reflector to reduce excessive fill-in light.

Only blue flash lamps should be used for fill-in flash outdoors.

ELECTRONIC FLASH GUIDE NUMBERS

This table is intended as a starting point in determining the correct guide number for use with specific equipment.

Effective candlepower seconds per output (ECPS)	700	1000	1400	2000	2800	4000	5600	8000
Guide Number	55	65	75	90	110	130	150	180

If your prints are consistently too blue, use a Kodak No. 81B filter and increase your exposure by ⅓ stop.

PROCESSING

Kodacolor-X Films are developed by the Eastman Kodak Company on orders placed through photo dealers, but the charge for this service is not included in the price of the film. All the chemicals for preparing a complete set of processing solutions are available in prepared form in the Kodacolor Processing Kit, Process C-22, sold in 1-pint and 1-gallon sizes. Mixing directions and step-by-step processing instructions are included. Kodacolor Film Chemicals, Process C-22, are also supplied separately in larger sizes.

EASTMAN KODAK

KODAK EKTACOLOR INTERNEGATIVE (6110)

COLOR FILM IN SHEETS

This is a sheet film designed for making color internegatives and copy negatives at exposure times of 1 to 16 seconds with 3200 K Lamps. Properly used, it provides color and tone-scale corrections that make excellent quality in color reproductions possible without supplementary masking. The negatives can be used to make prints on Kodak Ektacolor 37 RC Paper or by the Kodak Dye Transfer Process. They can also be used to make positive transparencies on Kodak Ektacolor Print Film 4109 or black-and-white prints on Kodak Panalure Paper.

Film Sizes Available. Inch sizes: 4 x 5, 5 x 7, and 8 x 10.

HANDLING NOTES

Loading. Load in total darkness. CAUTION: To avoid condensation of moisture on unexposed film stored in a refrigerator, remove the package about 3 hours before opening it. (For 10-sheet boxes, 1½ hours will suffice.)

Hold the film with the code notch in the upper right-hand corner when the long edge of the film is held vertically. The emulsion is now facing you; insert the film in the exposing device in such a way that the emulsion side will face the light source or lens.

Storage. High temperature or high humidity may produce undesirable changes in Kodak Ektacolor Films. Keep UNEXPOSED film in its original sealed package in a freezing unit at 0 to —10 F (—18 to —23 C). If storage space in a freezer is not available, store the film in a refrigerator where the maximum temperature is no higher than 35 F (2 C). To avoid changes in the latent image, process EXPOSED film as soon as possible after exposure. Store NEGATIVES in individual Kodak Sleeves in a dark place where the relative humidity is 50 percent or lower and the temperature is 70 F (21 C) or lower. Further details on storage and care are given in the Data Book, Kodak Color Films, sold by Kodak dealers.

Exposure Time Range. These instructions assume an exposure time of 10 seconds, although times from 1 to 16 seconds can be used without changing the characteristics of the internegatives greatly. The effect of increasing the exposure time is to shorten the available latitude of the internegative film. The following procedures should yield good internegatives from most transparencies or subjects being copied, but some exposure adjustment may be necessary to produce optimum highlight or shadow contrast in unusual subjects. Within limits, increasing the exposure of the internegative film increases the contrast of the reproduction, whereas decreasing the exposure decreases the contrast. The change in over-all exposure level to obtain more density in the internegatives (higher contrast) or less density (lower contrast) can be made by adjusting either the exposure time or the light intensity, or both.

CAUTION: Do not expose Kodak Internegative Film for times shorter than 1 second or longer than 16 seconds, because the resulting negatives may contain color-reproduction errors that cannot be corrected satisfactorily in the printing operation.

Processing. Kodak Ektacolor Internegative Film is not processed by the Eastman Kodak Company. Kodak Internegative Replenisher (supplied in 5-gallon size) is converted to working solution by dilution with water and the addition of Kodak Internegative Starting Solution (supplied in 3½-gallon size). Kodak Color Film Processing Chemicals, Process C-22, are used for the remainder of the process.

INTERNEGATIVES FROM TRANSPARENCIES

1. Make exposures by contact or projection with a tungsten enlarger equipped with a Photo Enlarger Lamp No. 213, or with a light source of equivalent color quality. The exposing device should be equipped with heat-absorbing glass (such as Pittsburgh No. 2043) and means for holding filters. Adjust the illumination at the exposing

(Continued on following page)

plane to 3 foot-candles; then reduce the intensity by the equivalent of about 2½ stops. The reduction can be effected either by using a smaller lens opening or adding a Filter, No. 96, of 0.70 density.

2. Add the following trial filter pack, made up from Kodak Color Compensating (CC) Filters or Kodak Color Printing (CP) Filters; 20M + 50Y.

NOTE: Only CC filters can be used in the path of image forming light.

3. Make a 10-second contact exposure through a Kodak Photographic Step Tablet No. 2 or No. 3 onto a strip of internegative film.

4. Process the exposed strip and read the density of each step with a suitable instrument, such as a stable electronic densitometer equipped with the following Kodak Wratten Filters: No. 92 (red), No. 93 (green), and No. 94 (blue). Since all three filters transmit in the infrared, the densitometer should also be equipped with a filter which transmits in the visible and rejects much of the near infrared. Such an infrared rejecting filter will restrict measurements to the red, green, and blue regions.

5. Using separate sheets of paper, plot the red, green, and blue densities of the strip for each step of the step tablet. The Kodak Color Process Record Form No. Y-55 is a suitable rectangular coordinate graph paper. Use red, green, and blue pencils for plotting, respectively, the red, green, and blue densities. The method of plotting, drawing, and interpreting characteristic curves is discussed in **Practical Densitometry** (Kodak Pamphlet No. E-59).

The slope at the high-density end of each curve should be higher than the slope of the low-density portion of the curve. In other words, there should be an upward curve at the high-density end. This upward curve, representing higher contrast, is necessary to keep the highlights of the scene from losing contrast on reproduction.

If the upward-curved portion is not obtained on one (or more) of the curves, the exposure for that particular color should be increased on a second trial. For example, if the green-density curve shows no upward curve, a second trial should be made with less magenta in the filter pack, thus increasing the green exposure.

6. Using a red curve as the reference curve, place the green curve on top of it on an illuminator. Superimpose the high-density and straight-line portions of the two curves as well as possible by shifting the sheets of graph paper in both horizontal and vertical directions (keeping the axes parallel). If the sheet bearing the green curve is to the right of the sheet bearing the red curve, add a corresponding amount of magenta filtration to the filter pack. Ignore any vertical shift between the two sheets.

For example, suppose that the green sheet is approximately 0.05 log E to the right of the red sheet. Add an 05M filter to the pack. If the green sheet had been 0.05 log E to the left of the red sheet, it would have been necessary to subtract 05M filtration from the pack (or add 05G filtration).

7. Leaving the red curve on the illuminator, replace the green curve with the blue curve. Whereas the green curve usually superimposes readily on the red curve, more difficulty may be encountered with the blue curve. The blue curve tends to deviate in the lower densities and some compromise may be necessary.

Again, determine the amount of horizontal shift required to make the curves match, and adjust the filter pack accordingly. For example, if, after the curves have been superimposed as well as possible, the blue sheet is approximately 0.30 log E to the right, add 30Y filtration to the pack. Conversely, if the blue sheet had been, say, 0.10 log E to the left, it would have been necessary to subtract 10Y from the pack.

8. Using the modified filter pack and exposure level determined in Steps 6 and 7, make an exposure series, using a transparency with good highlights and shadows. An exposure range of 1 stop above and 1 stop below the selected level is suggested, with the change in intensity rather than time. Process the internegatives and make the best print

(Continued on following page)

The Compact Photo-Lab-Index

The general rule is:

Green or blue sheet to the right of red sheet, add complementary.

Green or blue sheet to the left of red sheet, subtract complementary.

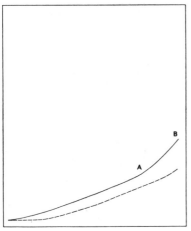

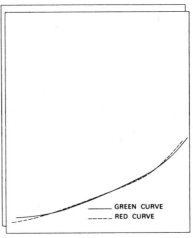

Solid line is typical curve showing correct exposure of internegative. Dashed line is curve showing inadequate exposure.

Note that there is not enough of the high-contrast portion (AB) in the dashed curve.

Sheet bearing green curve (solid line) is 0.05 log E to right of sheet bearing red curve (dashed line).

Add 05M to filter pack to eliminate horizontal shift. Ignore vertical shift.

possible from each on Kodak Ektacolor 37 RC Paper or Kodak Ektacolor Print Film 4109. Choose the best internegative exposure by inspecting the prints.

9. Inspect the test print made from the three internegatives for evidence of undesirable color effects in the lighter densities and highlights relative to the rest of the scene; these effects result from errors in matching the high-density portions of the curves in Steps 6 and 7. They can be corrected by changes in the filter pack for a remake of the internegative according to the following rule: Add a filter of the same color as the shift desired. For example, if the highlights are green, a color shift toward magenta is needed, and magenta filtration should be added

to the pack. A filtration change of 15M will produce a significant effect.

The filter pack and exposure level determined in Step 9 can be used for the vast majority of transparencies. Within limits and with experience, it is possible to adjust the filter pack to change color contrasts in an original transparency to produce an improved copy. Similarly, an exposure change can be used to modify the over-all contrast of the copy.

Repeat Steps 1 through 9 for each new emulsion number of Kodak Ektacolor Internegative Film 6110. If the same film emulsion is used over a period of several months with storage at 35 F (2 C), it is suggested that these steps be repeated about once a month to test for and adjust for any changes that may occur.

(Continued on following page)

EASTMAN KODAK

COPY NEGATIVES

With suitable exposure calibration, Kodak Ektacolor Internegative Film 6110 can be used for copying reflection originals with 3200 K Lamps or other tungsten sources. As in the case of internegatives from transparencies, the contrast can be controlled to a considerable degree by changing the over-all exposure. Contrast increases as exposure is increased and decreases as exposure is decreased.

The procedure for exposure calibration of an emulsion is the same as outlined for internegatives, except that a Kodak Gray Scale, included in Kodak Color Separation Guides, is used in place of a step tablet. This scale has density values printed adjacent to each step. With the suggested filter pack, 90Y (made up of CC Flters over the lens or CP Filters over the light source), make a test exposure, using an exposure index of 0.5 and an exposure time of about 10 seconds. Continue as described in Steps 4 to 9.

CONTAMINATION OF SOLUTIONS

The photographic quality and life of the processing solutions depend on the cleanliness of the equipment in which solutions are mixed, stored, and used. In particular, small quantities of the Fixer and Stop Bath in the developer will seriously impair negative quality. Processing racks should be cleaned thoroughly after each use. Likewise, the contamination of any chemical solution by any other is to be avoided. The best procedure is to use the same tanks for the same solutions each time, and to make sure that each is thoroughly washed before it is refilled. This practice should be employed with both mixing and storage containers.

PRECAUTIONS IN HANDLING CHEMICALS

The developing agents used in this process may cause skin irritation. In case of skin contact with solutions or solid chemicals, especially developers or developing agents, wash at once with an acid-type hand cleaner such as pHisoderm or pHisohex (Winthrop Stearns, Inc.), pH6 (Stepan Chemical Co.), or Sulfo Hand Cleaner (West Disinfecting Co.), and rinse with plenty of water. The use of clean rubber gloves is recommended, especially in mixing or pouring solutions and in cleaning the darkroom. Before removing gloves, rinse them with acid hand cleaner and water. Keep all working surfaces, such as bench tops, trays, tanks, and containers, clean and free from spilled solutions or chemicals.

The hardener solution contains formaldehyde. This is a skin and eye irritant. Adequate ventilation should be provided to prevent accumulation of formaldehyde in the vicinity of the solution or the drying area. Trays and tanks should be covered when not in use.

The Compact Photo-Lab-Index

KODAK EKTACOLOR
SLIDE FILM 5028

FOR SLIDES & TRANSPARENCIES
FROM 35mm ORIGINALS

This film is a multilayer color material designed for direct printing from Kodacolor and Ektacolor negatives and Ektacolor internegatives. It can be exposed with ordinary contact-printing or copying equipment and processed with ordinary darkroom equipment. It yields positive transparencies that can be mounted in standard 2 by 2-inch mounts or, if the film is uncut, used as filmstrips.

SAFELIGHT

Kodak Ektacolor Slide Film is sensitive to light of all colors and preferably should be handled and processed in total darkness. However, it can be handled for a limited period of time under a suitable safelight lamp fitted with a Kodak Safelight Filter, Wratten Series 10 (dark amber), and a 15-watt bulb. The lamp can be used at no less than 4 feet from the film for not more than 30 seconds.

STORAGE

Protection against heat **must** be provided by storing the film in a refrigerator at 55°F., or lower. Even when stored at 55°F. the film may change slowly. A lower temperature, such as 35°F., tends to retard changes, and storage in a freezing unit at 0 to −10°F. is even better. In any case, use the film as soon after receipt as is practical.

To prevent moisture condensation on cold film remove it from the refrigerator about 3 hours before use and do not open the can as long as there is danger of moisture condensation.

To avoid changes in the latent image, process exposed film as soon as possible, seal against humidity if more than 4 hours passes between exposure and processing. Process within 3 days even if frozen. Store processed film at 40-80°F., 30 to 50% R.H.

EXPOSING EQUIPMENT

Almost any diffuse tungsten light source is suitable. The exposing device should be equipped with heat-absorbing glass (such as Pittsburgh No. 2043, 3mm thickness), an ultraviolet absorber (such as Kodak Wratten Filter No. 2B or Kodak Color Printing Filter CP2B [Acetate]), and means for holding filters.

A simple light source can be devised from a Kodak Darkroom Lamp equipped with a Photo Enlarger Lamp No. 212. The aperture should be covered with a diffusing glass. A Kodak DeLuxe Transparency Illuminator, Model 2, equipped with a 75-watt lamp can also be used, as well as any diffusion-type enlarger.

Two types of color-correction filters are available: Kodak Color Printing Filters (Acetate) and Kodak Color Compensating Filters (Gelatin). CP Filters can be used only between the negative and the film. Any number of filters (CP or CC) can be used between the light source and negative, but the number of filters (CC only) used between negative and film should be as small as possible, preferably not over three.

The exposure time varies, depending upon factors such as the subject matter and negative density. However, a typical Kodacolor or Ektacolor negative or Ektacolor internegative requires about 2 seconds exposure when the illumination is 2.5 foot-candles, measured at the printing surface and without the negative or any color-compensating filters in the light beam.

Kodak Ektacolor Slide Film is designed for exposure times between ¼ and 8 seconds. However, exposures longer than 2 seconds require more magenta filtration in the pack and proportionately increased exposure, while exposures shorter than 2 seconds require less magenta filtration and a proportionate reduction in exposure.

(Continued on following page)

EASTMAN KODAK

125

The Compact Photo-Lab-Index

EXPOSURE TECHNIQUE

You can use a contact-printing frame to expose Ektacolor Slide Film in contact with the color negative; you can place the negative in an enlarger negative carrier and expose the slide film on the enlarger easel; or you can load a 35mm camera with the slide film to copy the negative.

For optimum sharpness in slides printed by contact, the emulsion side of the Ektacolor Slide Film should face the emulsion of the color negative. However, this may necessitate focusing adjustments in projecting copy slides that are inter-mixed with original slides, because properly oriented original slides have their base side toward the projector lamp while the copy slides, to be similarly oriented, will have their emulsion side toward the lamp. If you expose Ektacolor Slide Film by any means other than by contact, therefore, the base side of the color negative can face the emulsion side of the slide film.

Be sure that the negative, the filters, and any glass in the exposing system are clean and free from dust.

The filter pack suggested for a trial exposure at 2 seconds is CC40R.

FILTER COMBINATION

If the transparency is not ideal in color balance, determine what color is present in excess. A filter of this color can be added to the filter pack to correct the color balance. However, since it is more desirable to subtract filters from the filter pack, remove the complementary filter(s) if possible.

The following table may be useful in determining what filter adjustment should be made:

EXPOSURE ADJUSTMENT FOR FILTERS

An exposure time that produced a transparency of satisfactory density may not produce the same density when the printing filter pack is changed. Determine the exposure adjustment from the table of computer numbers and factors for Kodak CC and CP Filters in the data sheet for Ektachrome Reversal Print Film.

PROCESSING

Kodak Ektacolor Slide Film is not processed by the Eastman Kodak Company. Chemicals for processing solutions are supplied in prepared form in the Kodak Color Processing Kit, Process C-22. Prepared chemicals to make the individual solutions are also available. Complete processing instructions are included with the instruction sheet for the film.

FILM SIZES AVAILABLE

35mm by 100 feet, perforated or unperforated.

If the overall color balance is:	Subtract these filters:	or	Add these filters:
Yellow	Magenta and Cyan (or Blue)		Yellow
Magenta	Cyan and Yellow (or Green)		Magenta
Cyan	Yellow and Magenta (or Red)		Cyan
Blue	Yellow		Magenta and Cyan (or Blue)
Green	Magenta		Cyan and Yellow (or Green)
Red	Cyan		Yellow and Magenta (or Red)

KODAK EKTACHROME FILM 6115 DAYLIGHT TYPE
ASA D 50

GENERAL PROPERTIES
A color film balanced for exposure in daylight and designed for reversal processing to produce color transparencies. The transparencies can be viewed by transmitted light or projection, and can be printed in color by photomechanical methods, or by photographic methods. These instructions are based on average emulsions used under average conditions. Information apply to film of a specific emulsion number is given on the supplementary data sheet packaged with the film.

DAYLIGHT EXPOSURE TABLE
Basic settings for average emulsions. For the hours from 2 hours after sunrise to 2 hours before sunset.

Bright or Hazy Sun on Light Sand or Snow	Bright or Hazy Sun (Distinct Shadows)	Weak, Hazy Sun (Soft Shadows)	Cloudy Bright (No Shadows)	Heavy Overcast	Open Shade*
1/50 at f/22	1/50 at f/16†	1/50 at f/11	1/50 at f/8	1/50 at f/5.6	1/50 at f/5.6

*Subject shaded from the sun but lighted by a large area of sky.
†For backlighted close-up subjects, use f/8.

In general, best color rendering is obtained in clear or hazy sunlight. Other light sources may not give equally good results even with the most appropriate filters.

The bluish cast which is otherwise evident in pictures taken in shade under a clear blue sky can be minimized by use of the KODAK Skylight Filter, which requires no increase in exposure. The filter is also useful for reducing bluishness in pictures taken on an overcast day and in distance scenes, mountain views, sunlit snow scenes, and aerial photographs.

Fill-in Flash. When lighting contrast is excessive, shadows can be illuminated by using blue flashbulbs. The following table applies to clear sun and sky conditions. With flash fill-in, use the same settings for front-, side-, or backlighting.

Bulb. No.	Bowl-Shaped Reflector Size	Distance	Lens Opening	Shutter Time
5B or 25B	3-inch	5 to 8 ft	f/22	1/25
M3B	3-inch	8 to 12 ft	f/22	1/25
5B or 25B	4-inch	12 to 18 ft	f/16	1/50
22B or 2B	6- to 7-inch	12 to 18 ft	f/22	1/25
		15 to 22 ft	f/16	1/50

Note: Distance ranges are given because the desired amount of fill-in light is largely a matter of personal preference. Shutter synchronization must be suitable for the type of bulb used.

(Continued on following page)

EASTMAN KODAK

127

The Compact Photo-Lab-Index

FLASH EXPOSURE GUIDE NUMBERS

For flash pictures with this film, use blue flashbulbs without a filter. With zirconium-filled clear flashbulbs (AG-1 and M3), use a KODAK Filter No. 80D. With all other clear flashbulbs, use a Filter No. 80C. Divide the proper guide numbers by the flash-to-subject distance in feet to determine the f-number for average subjects. Use ½ stop larger for dark subjects; ½ stop smaller for light subjects.

LONG EXPOSURE

At exposure times of 1/10 second or longer to daylight illumination, refer to the table in this section "Exposure Time and Filter Compensation for Reciprocity Compensation of Kodak Color Films." Under such conditions, it may be preferable to use KODAK Ektachrome Film, Type B, with a KODAK Filter No. 85B.

*Between-Lens Shutter Speed	Syn-chroni-zation	M2B‡	M3B‡ 5B§ 25B§	11†¶ 40†¶	3¶ or 50¶ in a 12-inch Bowl Reflector	Focal-Plane Shutter Speed	6B§ 26B§
Open 1/25-1/30	X or F	95	140	140		1/25-1/30	130
1/25-1/30	M	NR**	130	130	270	1/50-1/60	100
1/50-1/60	M	NR	120	120	(Use 1/25	1/100-1/125	70
1/100-1/125	M	NR	100	100	or	1/200-1/250	50
1/200-1/250	M	NR	85	80	Slower)	1/400-1/500	34
1/400-1/500	M	NR	60	60		1/1000	24

*For use with bowl-shaped polished reflectors. If shallow cylindrical reflectors are used, divide these guide numbers by 2.

Bowl-shaped polished reflector sizes: ‡3-inch; §4- to 5-inch †6- to 7-inch.

¶Clear bulbs are liste dbecause blue bulbs are not available. Use with KODAK Filter No. 80C.

**NR = Not Recommended.

ELECTRONIC FLASH GUIDE NUMBERS

This table is intended as a starting point in determining the correct guide number. It is based on the use of a CC10Y Filter. The table is for use with equipment rated in beam candle-power-seconds (BCPS) or effective candle-power-seconds (ECPS). Divide the proper guide number by the flash-to-subject distance in feet to determine the f-number for average subjects.

PROCESSING

All the chemicals for preparing a complete set of processing solutions are in the KODAK Ektachrome Film Processing Kit, Process E-3. Chemicals are also available as separate units in larger sizes.

Output of Unit (BCPS or ECPS)	350	500	700	1000	1400	2000	2800	4000	5600	8000
Guide Number for Trial	30	35	40	50	60	70	85	100	120	140

Caution: Do not use shutter speeds longer than 1/50 second; otherwise, results may be influenced by illumination other than the electronic flash.

EASTMAN KODAK

KODAK EKTACHROME FILM 6116—TYPE B
ASA T 32
ASA D 25

GENERAL PROPERTIES

A color film balanced for exposure with tungsten (3200K) lamps and designed for reversal processing to produce color transparencies. The transparencies can be viewed by transmitted light or projection, and can be printed in color by photomechanical methods, or by photographic methods.

These instructions are based on average emulsions used under average conditions. Information applying to film of a specific emulsion number is given on the supplementary data sheet packaged with the film.

FILM SPEED

Tungsten (3200K) Lamp	ASA 32 for a ½-second exposure	No filter required
Photolamp (3400K)	ASA 25 for a ½-second exposure	With KODAK Filter No. 81A
Daylight	ASA 25 for a 1/50-second exposure	With KODAK Filter No. 85B

These settings apply to incident-light readings taken from the subject position, and to reflected-light readings from the camera position. For interior scenes, take a reading from the camera position only if both subject and background have about the same brightness. Otherwise, take the reading from a gray card of 18% reflectance held close to the subject, facing halfway between the camera and the main light. Divide the speed by 2 if the reading is taken from the palm of the hand or the subject's face; divide it by 5 if the reading is taken from a white card of 90% reflectance. Set the meter calculator as for a normal subject. When a card or the palm of the hand is used, or when incident-light readings are made, allow ½ stop more exposure for dark subjects; ½ stop less for light subjects.

LIGHT SOURCES

In general, best color rendering is obtained with tungsten (3200K) lamps operating at their rated voltage. If the voltage varies much from the normal, a color change will occur.

Other light sources may not give equally good results even with the most appropriate filters. The filters listed here are suggested for trial.

Unless a special effect is desired, light sources having different color qualities must not be mixed. In particular, avoid mixing tungsten light and daylight. Also avoid the use of discolored or unevenly polished reflectors.

TUNGSTEN (3200K) REFLECTOR-TYPE LAMP EXPOSURE TABLE

Based on the use of two 3200K reflector-type lamps—one as a fill-in light close to camera at lens level, the other as the main light 2 to 4 feet higher and a 45 degrees from the camera-subject axis.

Lens Opening at ½-Second Exposure			f/16	f/11	f/8	f/5.6	f/4
Lamp-to-Subject Distance in Feet	EAL Lamps (G.E.)	Main Light	4½	6	8½	12	17
		Fill-In Light	6	8½	12	17	24
	R-32 Lamps (Sylvania)	Main Light	5½	7½	10½	15	21
		Fill-In Light	7½	10½	15	21	30

(Continued on following page)

129

The Compact Photo-Lab-Index

FLASH EXPOSURE GUIDE NUMBERS

These figures are based on use of the KODAK Light Balancing Filter, No. 81C. Divide the proper guide number by the flash-to-subject distance in feet to determine the f-number for average subjects. Use ½ stop larger for dark subjects; ½ stop smaller for light subjects.

PROCESSING

All the chemicals for preparing a complete set of processing solutions are in the KODAK Ektachrome Film Processing Kit, Process E-3. Chemicals are also available as separate units in larger sizes.

*Between-Lens Shutter Speed	Syn-chroni-zation	AG-1†	M2‡	M3‡ 5§ 25§	11¶ 40¶	3 or 50 in a 12-inch Bowl Reflector	Focal-Plane Shutter Speed	6§ 26§
Open 1/25-1/30	X or F	85	90	130	104	250	1/25-1/30	130
1/25-1/30	M	60	NR**	120	130		1/50-1/60	95
1/50-1/60	M	60	NR	110	120	(Use 1/25	1/100-1/125	70
1/100-1/125	M	50	NR	80	100	or	1/200-1/250	50
1/200-1/250	M	40	NR	75	80	Slower)	1/400-1/500	34
1/400-1/500	M	32	NR	55	60		1/1000	22

*For use with bowl-shaped polished reflectors. If shallow cylindrical reflectors are used, divide these guide numbers by 2.

Bowl-shaped polished reflector sizes: †2-inch; ‡3-inch; §4- to 5-inch; ¶6- to 7-inch.

**NR = Not Recommended.

KODAK EKTACHROME-X FILM
ASA D 64 ASA T 16

GENERAL PROPERTIES
A color film designed for exposure by daylight, electronic flash, or blue flashbulbs. Processed by reversal, it yields color transparencies for projection or color printing.

Exposure times 1/10 second or longer may require an increase in exposure to compensate for the reciprocity characteristics of this film. See table in this section, "Exposure Time and Filter Compensation for Reciprocity Compensation of KODAK Color Films."

FILM SPEED

Daylight	ASA 64	No filter required
Photolamp (3400K)	ASA 20	With KODAK Filter No. 80B
Tungsten (3200K)	ASA 16	With KODAK Filter No. 80A

DAYLIGHT EXPOSURE TABLE
Lens openings with shutter at 1/125 second. For the hours from 2 hours after sunrise to 2 hours before sunset.

Bright or Hazy Sun on Light Sand or Snow	Bright or Hazy Sun (Distinct Shadows)	Weak, Hazy Sun (Soft Shadows)	Cloudy Bright (No Shadows)	Heavy Overcast	Open Shade*
f/16	f/11†	f/8	f5./6	f/4	f/4

*Subject shaded from the sun but lighted by a large area of clear, unobstructed sky.
†f/5.6 for backlighted close-up subjects.

Fill-in Flash: Blue flashbulbs are helpful in lightening the harsh shadows usually found in making close-ups in bright sunlight. A typical exposure is f/22 at 1/25 or 1/30 second, with the subject 8 to 19 feet away.

LIGHT SOURCES
In general, best color rendering is obtained in clear or hazy sunlight. Other light sources may not give equally good results even with the most appropriate filters. The bluish cast that is otherwise evident in pictures taken in shade under a clear blue sky can be minimized by use of the KODAK Skylight Filter, which requires no increase in exposure. This filter is also useful for reducing bluishness in pictures taken on an overcast day and in distant scenes, mountain views, sunlit snow scenes, and aerial photographs.

ELECTRONIC FLASH GUIDE NUMBERS
This table is intended as a starting point in determining the correct guide number. The table is for use with equipment rated in beam candlepower-seconds (BCPS) or effective candlepower-seconds (ECPS). Divide the proper guide number by the flash-to-subject distance in feet to determine the f-number for average subjects.

Output of Unit (BCPS or ECPS)	350	500	700	1000	1400	2000	2800	4000	5600	8000
Guide Number for Trial	32	40	45	55	65	80	95	110	130	160

(Continued on following page)

EASTMAN KODAK

The Compact Photo-Lab-Index

*Between-Lens Shutter Speed	Syn-chroni-zation	Flash-cube	AG-1B†	M2B‡		Focal-Plane Shutter Speed	6B§ or 26B§
Open 1/25-1/30	X or F	80	120	105	160	1/25-1/30	150
1/25-1/30	M	55	80	NR**	150	1/50-1/60	110
1/50-/60	M	55	80	NR	140	1/100-1/125	80
1/100-1/125	M	45	70	NR	120	1/200-1/250	55
1/200-1/250	M	36	55	NR	95	1/400-1/500	38
1/400-1/500	M	28	45	NR	70	1/1000	26

*For use with bowl-shaped polished reflectors. If shallow cylindrical reflectors are used, divide these guide numbers by 2.

Bowl-shaped polished reflector sizes: †2-inch; ‡3-inch; §4- to 5-inch.

**NR = Not Recommended.

FLASH EXPOSURE GUIDE NUMBERS

Use blue flashbulbs without a filter. With zirconium-filled clear flashbulbs (AG-1 and M3), use a KODAK Photoflash Filter No. 80D. With all other clear flashbulbs, use a No. 80C Filter. Divide the proper guide numbers by the flash-to-subject distance in feet to determine the f-number for average subjectes. Use ½ stop larger for dark subjects; ½ stop smaller for light subjects.

PROCESSING

Processed by KODAK and other laboratories.

All the chemicals for preparing a complete set of processing solutions are in the KODAK Ektachrome Film Processing Kit, Process E-4. Chemicals are also available as separate units in larger sizes.

KODAK HIGH SPEED EKTACHROME FILM (DAYLIGHT)

ASA D 160 ASA T 40

GENERAL PROPERTIES

A color reversal film recommended for color photography of fast action, interiors lighted by daylight and other dimly lighted subjects, close-ups that require the utmost depth of field, etc. It is color-balanced for exposure to daylight, blue flashbulbs, and electronic-flash illumination. No filters are required with any of these light sources. In general, for fluorescent illumination and arc lamps, this film is preferable to the tungsten film. When processed, this film produces color transparencies suitable for projection, direct viewing, or use as originals for color prints.

Because of its extreme speed, this film is easy to overexpose under bright sunlight conditions.

Most shutters, except focal-plane shutters, have the higher speed settings calibrated for the maximum lens openings. They are relatively more efficient at smaller lens openings, and so pass more light than calculated. Therefore, under lighting conditions that call for small lens openings at high shutter speeds, use an opening ½ stop smaller than that indicated by an exposure meter. The following table makes allowance for this shutter efficiency effect.

FILM SPEED

Daylight	ASA 160	No filter required
Photolamp (3400K)	ASA 50	With KODAK Filter No. 80B
Tungsten (3200K)	ASA 40	With KODAK Filter No. 80A

DAYLIGHT EXPOSURE TABLE

For average front-lighted subjects in daylight from 2 hours after sunrise to 2 hours before sunset.

Lens Opening with Leaf-Type Shutter at 1/250 Second

Bright or Hazy Sun on Light Sand or Snow	Bright or Hazy Sun (Distinct Shadows)*	Weak, Hazy Sun (Soft Shadows)	Cloudy Bright (No Shadows)	Heavy Overcast	Open Shade‡
f/22†	f/16†	f/11	f/8	f/5.6	f/5.6

*With backlighted close-up subjects, use f/8.

†With focal-plane shutters, use ½ stop larger opening.

‡Subject shaded from sun but lighted by a large area of sky. Use a skylight filter to minimize the bluishness of pictures made in open shade.

Fill-in Flash. Blue flashbulbs are helpful in lightening the harsh shadows usually found in making close-ups in bright sunlight. A typical exposure is f/22 at 1/100 second, with the subject 8 to 10 feet away. When you use a camera with a blade-type shutter, electronic flash is a good fill-in source for this film, as it can be synchronized more easily than flashbulbs at 1/100 second.

FLASH EXPOSURE GUIDE NUMBERS

Use blue flashbulbs without a filter. With zirconium-filled clear flashbulbs (AG-1 and M3), use a KODAK Photoflash Filter, No. 80D. With all other clear flashbulbs, use a No. 80C Filter. Divide the proper guide number by the flash-to-subject distance in feet to determine the f-number for average subjects. Use ½ stop larger for dark subjects; ½ stop smaller for light subjects.

(Continued on following page)

The Compact Photo-Lab-Index

*Between-Lens Shutter Speed	Syn-chroni-zation	Flash-cube	AG-1B†	M2B‡	M3B‡ 5B§ 25B§	Focal-Plane Shutter Speed	6B§ or 26B§
Open 1/25-1/30	X or F	120	180	170	260	1/25-1/30	240
1/25-1/30	M	90	130	NR**	240	1/50-1/60	180
1/50-1/60	M	90	130	NR	220	1/100-1/125	120
1/100-1/125	M	70	110	NR	190	1/200-1/250	90
1/200-1/250	M	55	90	NR	150	1/400-1/500	60
1/400-1/500	M	45	70	NR	110	1/1000	40

*For use with bowl-shaped polished reflectors. If shallow cylindrical reflectors are used, divide these guide numbers by 2.

Bowl-shaped polished reflector sizes: †2-inch; ‡3-inch; §4- to 5-inch.

**NR = Not Recommended.

ELECTRONIC FLASH GUIDE NUMBERS

This table is intended as a starting point in determining the correct guide number. The table is for use with equipment rated in beam candlepower-seconds (BCPS) or effective candle-power-seconds (ECPS). Divide the proper guide number by the flash-to-subject distance in feet to determine the f-number for average subjects.

PROCESSING

Processed by KODAK and other laboratories.

All the chemicals for preparing a complete set of processing solutions are in the KODAK Ektachrome Film Processing Kit, Process E-4. Chemicals are also available as separate units in larger sizes.

Output of Unit (BCPS or ECPS)	350	500	700	1000	1400	2000	2800	4000	5600	8000
Guide Number for Trial	55	65	75	90	110	130	150	180	210	250

KODAK HIGH SPEED EKTACHROME FILM (Tungsten)
ASA T 125 ASA D 80

GENERAL PROPERTIES

A color reversal film balanced for exposure with tungsten (3200K) lamps. It is a special purpose, high-speed film intended primarily for use under existing tungsten light conditions. With most types of fluorescent lighting or arc lamps, KODAK High Speed Ekta-chrome Film (Daylight) will give more satisfactory results. When processed, this film produces positive color transparencies suitable for projection, direct viewing, or use as originals for color prints.

FILM SPEED

Tungsten (3200K) Lamp	ASA 125	No filter required
Photolamp (3400K)	ASA 100	With KODAK Filter No. 81A
Daylight	ASA 80	With KODAK Filter No. 85B

Exposures longer than 1/10 second may require filtration and exposure compensation. See the table in this section, "Exposure Time and Filter Compensation for Reciprocity Compensation of KODAK Color Films."

TUNGSTEN (3200K) LAMP EXPOSURE TABLE

Based on the use of two 3200K reflector-type lamps—one as a fill-in light close to camera at lens level, the other as the main light 2 to 4 feet higher and at 45 degrees from the camera-subject axis.

Lens Opening at 1/50 or 1/60 Second			f/5.6	f/4	f/2.8	f/2
Lamp-to-Subject Distance in Feet	EAL Lamps (G.E.)	Main Light	5	7	10	14
		Fill-in Light	7	10	14	20
	R-32 Lamps (Sylvania)	Main Light	6	9	12	18
		Fill-In Light	9	12	18	25

TRIAL EXPOSURE SETTINGS FOR EXISTING-LIGHT SUBJECTS

Subject	Shutter Speed (Second)	Lens Opening
Home Interiors at Night		
Bright Light	1/30	f/2.8
Average Light	1/8	f/2.8
Dim Light or Candlelight	1/4	f/2.8
Brightly Lighted Street Scenes at Night	1/30	f/2.8
Well-Lighted Night or Indoor Sports	1/60	f/2.8

DAYLIGHT EXPOSURE

With a filter such as KODAK Daylight Filter for KODAK Type B Color Films, No. 85B, for average subjects in bright sunlight: Between f/11 and f/16 at 1/125 second

(Continued on following page)

EASTMAN KODAK

The Compact Photo-Lab-Index

FLASH EXPOSURE GUIDE NUMBERS

Two tables of flashbulb guide numbers are given; one for clear flashbulbs, the other for blue flashbulbs, using the appropriate filter over the lens. Divide the proper guide number by the flash-to-subject distance in feet to determine the f-number for average subjects.

Guide Numbers* for Clear Flashbulbs and KODAK Filter, No. 81C

Between-Lens Shutter Speed	Syn-chroni-zation	AG-1†	M2‡	M3‡ 5§ 25§	11¶ 40¶	Focal-Plane Shutter Speed	6§ 26§
Open 1/25-1/30	X or F	170	180	260	280	1/25-1/30	270
1/25-1/30	M	120	NR**	250	260	1/50-1/60	190
1/50-1/60	M	120	NR	220	240	1/100-1/125	130
1/100-1/125	M	100	NR	190	210	1/200-1/250	95
1/200-1/250	M	80	NR	150	160	1/400-1/500	65
1/400-1/500	M	65	NR	110	120	1/1000	45

Guide Numbers* for Blue Flashbulbs and KODAK Filter, No. 85B

Between-Lens Shutter Speed	Syn-chroni-zation	Flash-cube	AG-1B†	M2B‡	M3B‡ 5B§ 25B§	Focal-Plane Shutter Speed	6B§ or 26B§
Open 1/25-1/30	X or F	90	130	120	180	1/25-1/30	170
1/25-1/30	M	60	90	NR**	180	1/50-1/60	130
1/50-1/60	M	60	90	NR	160	1/100-1/125	90
1/100-1/125	M	50	75	NR	130	1/200-1/250	60
1/200-1 250	M	40	65	NR	105	1/400-1/500	45
1/400-1/500	M	32	50	NR	80	1/1000	30

*For use with bowl-shaped polished reflectors. If shallow cylindrical reflectors are used, divide these guide numbers by 2.
Bowl-shaped polished reflector sizes: †2-inch; ‡3-inch; §4- to 5-inch; ¶6- to 7- inch.
**NR = Not Recommended.

ELECTRONIC FLASH GUIDE NUMBERS

This table is a starting point in determining the correct guide number. It is based on the use of the KODAK Filter, No. 85B. The table is for use with equipment rated in beam candlepower-seconds (BCPS) or effective candle-power-seconds (ECPS). Divide the proper guide number by the flash-to-subject distance in feet to determine the f-number for average subjects.

PROCESSING

Processed by KODAK or other laboratories.
All the chemicals for preparing a complete set of processing solutions are in the KODAK Ektachrome Film Processing Kit, Process E-4. Chemicals are also available as separate units in larger sizes.

Output of Unit (BCPS or ECPS)	350	500	700	1000	1400	2000	2800	4000	5600	8000
Guide Number for Trial	35	45	55	65	75	90	110	130	150	180

EASTMAN KODAK

KODACHROME II PROFESSIONAL FILM (TYPE A)
ASA (3400K) 40

GENERAL PROPERTIES

A color film designed for exposure with photolamps (3400K). Processed by reversal, it yields positive transparencies for projection or color printing.

FILM SPEEDS

Photolamp (3400K)	ASA 40	No Filter required
Tungsten (3200K) Lamp	ASA 32	With KODAK Filter No. 82A
Daylight	ASA 25	With KODAK Filter No. 85 (With this filter, the exposure for average subjects in bright sunlight is 1/125 second with lens set at f/8.)

These settings apply to incident-light meter readings taken from the subject position, and to reflected-light readings taken from a gray card of 18% reflectance held close to the subject, facin halfway between the camera and the main light. They also apply when a reflected-light reading of the scene is taken from the camera position, provided both subject and background have approximately the same brightness. The speed should be divided by 2 of the reading is taken from the palm of the hand or the subject's face, or divided by 5 if the reading is taken from a white card of 90% reflectance. Set the meter calculator arrow as for a normal subject.

When a card or the palm of the hand is used, or when incident-light readings are made, allow ½ stop more exposure for dark subjects; ½ stop less exposure for light subjects.

PHOTOLAMP (3400K) EXPOSURE TABLE

For two new 500-watt, reflector-type photolamps (3400K) at the same distance from the subject; fill-in light close to camera at camera height; main light on other side of camera at 45 degrees to camera-subject axis and 2 to 4 feet higher than fill-in light.

LONG EXPOSURES

When exposure times longer than 1/125 second are used, it is necessary to compensate for the reciprocity characteristics of this film by increasing the exposure and using the KODAK Color Compensating (CC) Filters suggested in the table in this section "Exposure Time and Filter Compensation for Reciprocity Compensation of Kodak Color Films."

Exposure times shorter than 1/1000 second or 100 seconds and longer are not recommended for this film. The information in the table applies only when the film is exposed by photolamp (3400K) illumination for which it is balanced. When other light sources are used, additional adjustments in exposure and filtration may be required (e.g., 3200K lamps require a KODAK Light Balancing Filter, No. 82A).

Lamp-to-Subject Distance	4½ ft	6 ft	9 ft
Lens Opening at 1/50 or 1/60 Second	f/4	f/2.8	f/2

(Continued on following page)

EASTMAN KODAK

EASTMAN KODAK

FLASH EXPOSURE GUIDE NUMBERS

Two tables of flashbulb guide numbers are given; one for clear flashbulbs, the other for blue flashbulbs, using the appropriate filter over the lens. Divide the proper guide number by the flash-to-subject distance in feet to determine the f-number for average subjects.

Guide Numbers* for Clear Flashbulbs and KODAK Filter, No. 81C

Between-Lens Shutter Speed	Syn-chroni-zation	AG-1†	M2†	M3‡ 5§ 25§	11¶ 40¶	Focal-Plane Shutter Speed	6§ 26§
Open 1/25-1/30	X or F	90	90	140	140	1/25-1/30	140
1/25-1/30	M	80	NR**	120	120	1/50-1/60	90
1/50-1/60	M	60	NR	120	120	1/100-1/125	70
1/100-1/125	M	50	NR	100	100	1/200-1/250	50
1/200-1/250	M	42	NR	80	75	1/400-1/500	34
1/400-1/500	M	32	NR	60	60	1/1000	24

*For use with bowl-shaped polished reflectors. If shallow cylindrical reflectors are used, divide these guide numbers by 2.
Bowl-shaped polished reflector sizes: †2-inch; ‡3-inch; §4- to 5-inch; ¶6- to 7- inch.
**NR = Not Recommended.

Guide Numbers* for Blue Flashbulbs and KODAK Filter, No. 85

Between-Lens Shutter Speed	Syn-chroni-zation	Flash-cube	AG-1B†	M2B‡	M3B‡ 5B§ 25B§	Focal-Plane Shutter Speed	6B§ or 26B§
Open 1/25-1/30	X or F	45	65	60	90	1/25-1/30	90
1/25-1/30	M	30	45	NR**	85	1/50-1/60	65
1/50-1/60	M	30	45	NR	80	1/100-1/125	42
1/100-1/125	M	26	38	NR	65	1/200-1/250	30
1/200-1/250	M	20	32	NR	55	1/400-1/500	22
1/400-1/500	M	16	24	NR	40	1/1000	15

*For use with bowl-shaped polished reflectors. If shallow cylindrical reflectors are used, divide these guide numbers by 2.
Bowl-shaped polished reflector sizes: †2-inch; ‡3-inch; §4- to 5-inch.
**NR = Not Recommended.

(Continued on following page)

The Compact Photo-Lab-Index

ELECTRONIC FLASH GUIDE NUMBERS

This table is a starting point in determining the correct guide number. It is based on the use of the KODAK Filter, No. 85. The table is for use with equipment rated in beam candle-power-seconds (BCPS) or effective candlepower-seconds (ECPS). Divide the proper guide number by the flash-to-subject distance in feet to determine the f-number for average subjects.

Output of Unit (BCPS or ECPS)	350	500	700	1000	1400	2000	2800	4000	5600	8000
Guide Number for Trial	20	24	30	35	40	50	60	70	85	100

PROCESSING

Processed by KODAK or other laboratories.

KODACHROME 25 FILM (Daylight)

A color reversal roll film designed for exposure by daylight, electronic flash, or blue flashbulbs. With a suitable filter, it can also be exposed by photolamp (3400 K or Tungsten 3200 K) illumination. Processed by reversal, it yields color transparencies for projection or color printing.

SPEED

The number given after each light source is based on an ANSI Standard and is for use with meters and cameras marked for ASA speeds.

Light Source	Speed	With Filter Such as:
Daylight	ASA 25	None
Photolamp (3400 K)	ASA 8	Kodak Photoflood Filter No. 80B
Tungsten (3200 K)	ASA 6	Kodak 3200 K Filter No. 80A

Note: Exposures 1/10 second and longer may require filtration and exposure compensation. See reciprocity data elsewhere in this section.

(Continued on following page)

DAYLIGHT EXPOSURE TABLE

Lens openings at shutter speeds stated.
For the hours from 2 hours after sunrise to 2 hours before sunset.

Bright or Hazy Sun on Light Sand or Snow	Bright or Hazy Sun (Distinct Shadows)	Weak, Hazy Sun (Soft Shadows)	Cloudy Bright (No Shadows)	Heavy Overcast	Open Shade*
Shutter at 1/125 Second			Shutter at 1/60 Second		
f/11	f/8†	f/5.6	f/4	f/4	f/4

*Subject shaded from the sun but lighted by a large area of sky.
†f/4 for backlighted close-up subjects.

FILL-IN FLASH

Blue flashbulbs help to lighten the harsh shadow usually found in making close-ups in bright sunlight. A typical exposure is f/16 at 1/25 or 1/30 second, with the subject 8 to 10 feet away.

LIGHT SOURCES

In general, best color rendering is obtained in clear or hazy sunlight. Other light sources may not give equally good results even with the most appropriate filters. The bluish cast that is otherwise evident in pictures taken in shade under a clear blue sky can be minimized by use of a skylight filter, which requires no increase in exposure. This filter is also useful for reducing bluishness in pictures taken on an overcast day and in distant scenes, mountain views, sunlit snow scenes, and aerial photographs.

ELECTRONIC FLASH GUIDE NUMBERS

This table is intended as a starting point in determining the correct guide number. The table is for use with equipment rated in beam candlepower-seconds (BCPS) or effective candlepower-seconds (ECPS). Divide the proper guide number by the flash-to-subject distance in feet to determine the f-number for average subjects.

Output of Unit (BCPS or ECPS)		350	500	700	1000	1400	2000	2800	4000	5600	8000
Guide Number for Trial	Feet	20	24	30	35	40	50	60	70	85	100
	Meters	6	7	9	11	12	15	18	21	26	30

*If your slides are consistently blue, use a No. 81B filter and increase exposure by ⅓ stop.

FLASH

For flash pictures with this film use blue flashbulbs without a fiilter. With zirconium-filled clear flashbulbs (AG-1 and M3) use a filter such as the Kodak Photoflash Filter No. 80D over the camera lens. With all other clear flashbulbs use a No. 80C Filter. Divide the proper guide numbers by the flash-to-subject distance in feet to determine the f-number for average subjects. Use ½ stop larger for dark subjects, ½ stop smaller for light subjects.

(Continued on following page)

140

The Compact Photo-Lab-Index

GUIDE NUMBERS* FOR FLASHBULBS
For Blue Flashbulbs (or Clear Flashbulbs with a No. 80C or No. 80 D Filter)

Between-Lens Shutter Speed	Syn-chroni-zation	Flash-cube	AG-1B†	M2B‡	M3B‡ 5B§ 25B§	Focal-Plane Shutter Speed	6B§ or 26B§
Open 1/25—1/30	X or F	45	65	60	90	1/25—1/30	90
1/25—1/30	M	30	45	NR**	85	1/50—1/60	65
1/50—1/60	M	30	45	NR	80	1/100—1/125	42
1/100—1/125	M	26	38	NR	65	1/200—1/250	30
1/200—1/250	M	20	32	NR	55	1/400—1/500	22
1/400—1/500	M	16	24	NR	40	1/1000	15

*For use with bowl-shaped polished reflectors. If shallow cylindrical reflectors are used, divide these guide numbers by 2.

Bowl-shaped polished reflector sizes: †2-inch; ‡3-inch; §4- to 5-inch.

**NR = Not Recommended.

These values are intended only as guides for average emulsions. They must be changed to suit individual variations in synchronization, battery, reflector, and bulb position in the reflector.

CAUTION
Since bulbs may shatter when flashed, the use of a flashguard over the reflector is recommended. Do not flash bulbs in an explosive atmosphere.

PROCESSING
Your dealer can arrange to have this film processed by Kodak or any other laboratory offering such service. Some laboratories, including Kodak, also provide direct mail service whereby you can mail exposed film to the laboratory and have it returned directly to you. See your dealer for the special mailing devices required. Do not mail film without an overwrap or special mailing device intended for this purpose.

FILM SIZES AVAILABLE
KM135-20, KM135-36, KM 135-36 pro-packs (4 rolls).

DIFFUSE RMS GRANULARITY VALUE: 9
(Read at a gross diffuse density of 1.0, using 48-micrometer aperture, 12X magnification.)

RESOLVING POWER VALUES
Test-Object Contrast 1.6:1 — 50 lines per mm
Test-Object Contrast 1000:1 — 100 lines per mm

EASTMAN KODAK

KODACHROME 64 FILM (Daylight)

A color reversal roll film designed for exposure by daylight, electronic flash, or blue flashbulbs. With a suitable filter, it can also be exposed by photolamp (3400 K) illumination. Processed by reversal, it yields color transparencies for projection or color printing.

SPEED

The number given after each light source is based on an ANSI Standard and is for use with meters and cameras marked for ASA speeds.

Light Source	Speed	With Filter Such as:
Daylight	ASA 64	None
Photolamp (3400 K)	ASA 20	Kodak Photoflood Filter No. 80B
Tungsten (3200 K)	ASA 16	Kodak 3200 K Filter No. 80A

Note: Exposure times longer than 1/10 second may require an increase in exposure to compensate for the reciprocity characteristics of this film. See reciprocity data elsewhere in this section.

DAYLIGHT EXPOSURE TABLE

Lens openings with shutter at 1/125 second.
For the hours from 2 hours after sunrise to 2 hours before sunset.

Bright or Hazy Sun on Light Sand or Snow	Bright or Hazy Sun (Distinct Shadows)	Weak, Hazy Sun (Soft Shadows)	Cloudy Bright (No Shadows)	Heavy Overcast	Open Shade*
f/16	f/11†	f/8	f/5.6	f/4	f/4

*Subject shaded from the sun but lighted by a large area of clear, unobstructed sky.
†f/5.6 for backlighted close-up subjects.

FILL-IN FLASH

Blue flashbulbs help to lighten the harsh shadows usually found in making close-ups in bright sunlight. A typical exposure is f/22 at 1/25 or 1/30 second, with the subject 8 to 10 feet away.

ELECTRONIC FLASH

This table is intended as a starting point in determining the correct guide number. The table is for use with equipment rated in beam candlepower-seconds (BCPS) or effective candlepower-seconds (ECPS). Divide the proper guide number by the flash-to-subject distance in feet to determine the f-number for average subjects.

(Continued on following page)

EASTMAN KODAK

The Compact Photo-Lab-Index

Output of Unit (BCPS or ECPS)		350	500	700	1000	1400	2000	2800	4000	5600	8000
Guide Number for Trial*	Feet	32	40	45	55	65	80	95	110	130	160
	Meters	10	12	14	17	20	24	29	33	40	50

*If your slides are consistently blue, use a No. 81B filter and increase exposure by ⅓ stop.

FLASH

For flash pictures with this film use blue flashbulbs without a filter. With zirconium-filled clear flashbulbs (AG-1 and M3) use a filter such as the Kodak Photoflash Filter No. 80D over the camera lens. With all other clear flashbulbs use a No. 80C Filter. Divide the proper guide numbers by the flash-to-subject distance in feet to determine the f-number for average subjects. Use ½ stop larger for dark subjects, ½ stop smaller for light subjects.

GUIDE NUMBERS* FOR FLASHBULBS
For Blue Flashbulbs (or Clear Flashbulbs with a No. 80C or 80D Filter)

Between-Lens Shutter Speed	Syn-chroni-zation	Flash-cube	AG-1B†	M2B†	M3B‡ 5B§ 25B§	Focal-Plane Shutter Speed	6B§ 26B§
Open 1/25—1/30	X or F	70	100	100	150	1/25—1/30	140
1/25—1/30	M	50	75	NR**	130	1/50—1/60	100
1/50—1/60	M	50	70	NR	130	1/100—1/125	70
1/100—1/125	M	40	60	NR	110	1/200—1/250	50
1/200—1/250	M	30	50	NR	85	1/400—1/500	34
1/400—1/500	M	26	40	NR	65	1/1000	24

*For use with bowl-shaped polished reflectors. If shallow cylindrical reflectors are used, divide these guide numbers by 2.

Bowl-shaped polished reflector sizes: †2-inch; ‡3-inch; §4- to 5-inch.

**NR = Not Recommended.

These values are intended only as guides for average emulsions. They must be changed to suit individual variations in synchronization, battery, reflector, and bulb position in the reflector.

CAUTION
Since bulbs may shatter when flashed, the use of a flashguard over the reflector is recommended. Do not flash bulbs in an explosive atmosphere.

PROCESSING
Your dealer can arrange to have this film processed by Kodak or any other laboratory offering such service. Some laboratories, including Kodak, also provide direct mail service whereby you can mail exposed film to the laboratory and have it returned directly to you. See your dealer for the special mailing devices required. Do not mail film without an overwrap or special mailing device intended for this purpose.

FILM SIZES AVAILABLE
KR110-20, KR126-20, KR135-20, and KR135-36.

(Continued on following page)

EASTMAN KODAK

DIFFUSE RMS GRANULARITY VALUE: 10
(Read at a gross diffuse density of 1.0, using 48-micrometer aperture, 12X magnification.)

RESOLVING POWER VALUES
Test-Object Contrast 1.6:1	50 lines per mm
Test-Object Contrast 1000:1	100 lines per mm

KODACHROME 40 FILM 5070 (Type A)

A color reversal roll film designed for exposure with photolamps (3400 K). Processed by reversal, it yields positive transparencies for projection or color printing.

SPEED

Light Source	Speed	With Filter Such as:
Photolamp (3400 K)	ASA 40	None
Tungsten (3200 K)	ASA 32	Kodak No. 82A
Daylight	ASA 25	Kodak No. 85. With this filter the exposure for average subjects in bright sunlight is 1/125 second with lens set at halfway between f/5.6 and f/8

The number given after each light source is for use with meters and cameras marked for ASA speeds. These settings apply to incident-light meter readings taken from the subject position and to reflected-light readings taken from a gray card of 18% reflectance* held close to the subject facing halfway between the camera and the main light. They also apply when a reflected-light reading of the scene is taken from the camera position provided both subject and background have approximately the same brightness. The speed should be divided by 2 if the reading is taken from the palm of the hand or the subject's face, or divided by 5 if the reading is taken from a white card of 90% reflectance.* Set the meter calculator arrow as for a normal subject.

When a card or the palm of the hand is used, or when incident-light readings are made, allow ½ stop more exposure for dark subjects, ½ stop less exposure for light subjects.

*The Kodak Neutral Test Card, which has a gray side of 18% reflectance and a white side of 90% reflectance, is recommended for this purpose.

LONG EXPOSURES

When exposure times longer than 1/25 second are used, it is necessary to compensate for the reciprocity characteristics of this film by increasing the exposure and using CC filters such as the Kodak Color Compensating (CC) Filters. See reciprocity data elsewhere in this section.

Exposure times shorter than 1/10,000 second or longer than 100 seconds are not recommended for this film. The information in the table applies only when the film is exposed by photolamp (3400 K) illumination for which it is balanced. When other light sources are used, additional adjustments in exposure and filtration may be required (e.g., 3200 K lamps require a filter such as the Kodak Light Balancing Filter No. 82A).

COPYING AND CLOSE-UP WORK

In copying, the use of a gray card as described above is recommended for determining exposures. If the camera lens is extended for focusing on a subject closer than 8 times the focal length of the lens, allow for the decrease in effective lens opening.

(Continued on following page)

144

The Compact Photo-Lab-Index

PHOTOLAMP (3400 K) EXPOSURE TABLE

For two new 500-watt, reflector-type photolamps (3400 K) at the same distance from the subject: fill-in light close to camera at camera height; main light on other side of camera at 45 degrees to camera-subject axis and 2 to 4 feet higher than fill-in light.

Lamp-to-Subject Distance	4½ ft	6 ft	9 ft
Lens Opening at 1/50 or 1/60 Second	f/4	f/2.8	f/2

Note: This table is for new lamps only. After burning lamps 1 hour, use ½ stop larger; after 2 hours, 1 full stop larger.

FLASH GUIDE NUMBERS

Divide the proper guide number by the flash-to-subject distance in feet to determine the f-number for average subjects.

GUIDE NUMBERS* FOR BLUE FLASHBULBS AND A NO. 85 FILTER

Between-Lens Shutter Speed	Syn-chroni-zation	Flash-cube	AG-1B†	M2B†	M3B‡ 5B§ 25B§	Focal-Plane Shutter Speed	6B§ or 26B§
Open 1/25—1/30	X or F	45	65	60	90	1/25—1/30	90
1/25—1/30	M	30	45	NR**	85	1/50—1/60	65
1/50—1/60	M	30	45	NR	80	1/100—1/125	42
1/100—1/125	M	26	38	NR	65	1/200—1/250	30
1/200—1/250	M	20	32	NR	55	1/400—1/500	22
1/400—1/500	M	16	24	NR	40	1/1000	15

*For use with bowl-shaped polished reflectors. If shallow cylindrical reflectors are used, divide these guide numbers by 2.
Bowl-shaped polished reflector sizes: †2-inch; ‡3-inch; §4- to 5-inch.
**NR = Not Recommended.
These values are intended only as guides for average emulsions. They must be changed to suit individual variations in synchronization, battery, reflector, and bulb position in the reflector.

CAUTION

Since bulbs may shatter, use a flashguard over the reflector. Do not flash bulbs in an explosive atmosphere.

ELECTRONIC FLASH GUIDE NUMBERS

This table is a starting point in determining the correct guide number. It is based on the use of the Kodak Filter No. 85. The table is for use with equipment rated in beam candlepower-seconds (BCPS) or effective candlepower-seconds (ECPS). Divide the proper guide number by the flash-to-subject distance in feet to determine the f-number for average subjects.

Output of Unit (BCPS or ECPS)		350	500	700	1000	1400	2000	2800	4000	5600	8000
Guide Number for Trial*	Feet	20	24	30	35	40	50	60	70	85	100
	Meters	6	7	9	11	12	15	18	21	26	30

*If your slides are consistently blue, use a No. 81B filter and increase exposure by ⅓ stop.

(Continued on following page)

PROCESSING

Your dealer can arrange to have this film processed by Kodak or any other laboratory offering such service. Some laboratories, including Kodak, also provide direct mail service whereby you can mail exposed film to the laboratory and have it returned directly to you. See your dealer for the special mailing devices required. Do not mail film without an overwrap or special mailing device intended for this purpose.

SIZE AVAILABLE

KPA135-36.

KODACHROME 40 FILM 5070 (Type A)

CHARACTERISTIC CURVES

(not available)

SPECTRAL SENSITIVITY CURVES

(Similar to Kodachrome 25 Film)

MODULATION TRANSFER CURVE

(Similar to Kodachrome 25 Film)

SPECTRAL DYE DENSITY CURVES

(Same as Kodachrome 25 Film)

DIFFUSE RMS GRANULARITY VALUE: 9

(Read at a gross diffuse density of 1.0, using a 48-micrometer aperture, 12X magnification.)

RESOLVING POWER VALUES

Test-Object Contrast 1.6:1	50 lines per mm
Test-Object Contrast 1000:1	100 lines per mm

KODAK EKTACHROME 64 FILM (Daylight)

KODAK EKTACHROME 200 FILM (Daylight)

KODAK EKTACHROME 160 FILM (Tungsten)

These color reversal roll films are for general use and do not require refrigerated storage conditions prior to use. The changes in speed, color balance, and contrast that occur in film during normal room temperature storage, before and after exposure, are anticipated and the films are manufactured to compensate for average changes.

All the exposure and processing data (Process E-6 chemicals) stated on the previous pages for Ektachrome Professional Films of similar speed apply for these general-purpose films.

EASTMAN KODAK

KODAK EKTACOLOR PRINT FILM 4109
(ESTAR THICK BASE)

Ektacolor Print Film is designed for making positive color transparencies from Ektacolor negatives. It is especially suited to the production of one or more display transparencies of any size.

SAFELIGHT—TOTAL DARKNESS IS RECOMMENDED

Kodak Ektacolor Print Film can be handled for a limited time under a Kodak safelight lamp fitted with a Kodak Safelight Filter, Wratten Series 10. The lamp should be fitted with a 15-watt bulb and can be used at no less than 4 feet from the film for no longer than 30 seconds.

Caution: Kodacolor and other Kodak Ektacolor Films must not be handled or processed under any safelight; otherwise, the negative film will be fogged. If no safelight is used, the negative film and print film can be processed together.

PREPARATION

Almost any enlarger equipped with a tungsten lamp is suitable. Fluorescent lamps are generally not recommended. The exposing device must be equipped with heat-absorbing glass (such as Pittsburgh No. 2043), an ultraviolet absorber (such as a Kodak Wratten Filter No. 2B or Color Printing Filter CP2B [Acetate]), and means for holding filters.

Some workers may prefer to use a light box as an exposing device for contact printing. This should be adequate to house a No. 212 photo-enlarging lamp ᵈ be provided with an aperture about 3 inches in diameter through which the light will pass to the printing frame. The aperture must be covered with a diffusion glass, a 2B Filter and a heat-absorbing glass. Some means for holding Color Compensating filters should be provided.

Two types of color correction filters are available, the Kodak Color Printing Filters (Acetate) and Kodak Color Compensating Filters (Gelatin). The CP Filters can be used only above the negative, but CC Filters can also be used below the negative, in the path of image-forming light. Any number of filters can be used above the negative, but the number used below the negative should be as small as possible, not over three.

The exposure time varies, depending upon factors such as the subject matter and negative density. A typical Ektacolor or Kodacolor negative, however, requires 10 to 20 seconds' exposure when the illumination is 2 foot-candles, measured at the printing surface and without any color compensating filters in the light beam.

Kodak Ektacolor Print Film is designed for exposure at this level of illumination. However, variations from one emulsion number to another may necessitate exposure and filter adjustments at the normal illumination level. At other illumination levels, other exposure and filter adjustments may be necessary. The supplementary data sheet packed in each box of film suggests exposure and filter adjustments for exposure times of 10 seconds and 120 seconds. Variations in negatives and in exposing equipment may necessitate other filter adjustments.

PROCEDURE

Exposure is made with the emulsion side of the Ektacolor Print Film facing the emulsion of the Ektacolor negative. It is advisable to place a sheet of black paper (interleaving) behind the Ektacolor Print Film.

The printing frame glass or negative carrier glass of the enlarger must be kept clean and dust-free. The negative, also, should be brushed free of dust particles just prior to making exposures.

TRIAL EXPOSURES

For best tone rendering and color balance, a test transparency from each different negative is recommended. It is

(Continued on following page)

economical to print a portion of the negative on a piece of print film cut to fit a small-size developing hanger. Alternatively, tests from several negatives can be made on one full-size sheet of print film. In any case, make a series of varying exposures from each negative in the same manner as in black-and-white enlarging.

As in black-and-white enlarging, it is possible to dodge or print in an area of the picture to change the density without affecting color balance. On the other hand, the use of color compensating filters in making the dodging or printing-in tools also permits deliberate local changes in color balance when they are wanted.

After exposing and processing the test transparency, allow it to dry thoroughly before attempting to evaluate it, because a transparency of satisfactory density and color balance appears somewhat opaque and too warm while it is still wet. The opalescence that causes these effects can, if desired, be eliminated temporarily by bathing the transparency in Kodak Rapid Fixer used full strength, without the hardener solution. Bathe the transparency for 1 minute after fixing (Step 7 in Process C-22); then, after viewing it, continue the normal process with the 8-minute wash.

VIEWING TEST PRINTS

Test transparencies should always be viewed on an illuminator of the same color quality and brightness as the illuminator to be used with the final transparencies. Illumination of color quality corresponding to a color temperation of 3800 to 4000 K serves well for judging transparencies. From the exposure series on the dry test print,

determine what exposure will yield the best transparency. As in the printing of black-and-white negatives, the effect of increased exposure is one of increased print density.

FILTER COMBINATIONS

If the transparency is not ideal in color balance, determine what color is present in excess. A filter of this color can be added to the filter pack to correct the color balance. However, since it is more desirable to subtract filters from the filter pack, remove the complementary filter(s) if possible.

The following table may be useful in determining what filter adjustment should be made:

For example, if the transparency is too red, remove a cyan filter from the filter pack. If there is no cyan filter present in the filter pack, add yellow and magenta filters (or the equivalent red filter).

The extent of the color-balance change needed can be evaluated by placing Kodak Color Compensating Filters over the test print as it is viewed on an illuminator. The effect of a viewing filter or filter combination should be judged on the basis of the lighter middle tones. A filter of a certain strength used in exposure produces a greater change in color balance than a complementary filter of the same strength used in viewing. In general, therefore, the filter used in the light beam need be only about half the strength of the viewing filter. The printing filter, however, is the complementary color of the viewing filter.

The determination of filter combinations can usually be simplified by thinking of all the filters in terms of the subtractive colors. Bear in mind these relationships:

If the over-all color balance is:	Subtract these filters:	or	Add these filters:
Yellow	Magenta and Cyan (or Blue)		Yellow
Magenta	Cyan and Yellow (or Green)		Magenta
Cyan	Yellow and Magenta (or Red)		Cyan
Blue	Yellow		Magenta and Cyan (or Blue)
Green	Magenta		Cyan and Yellow (or Green)
Red	Cyan		Yellow and Magenta (or Red)

(Continued on following page)

Red (absorbs blue and green) = yellow (absorbs blue) plus magenta (absorbs green)

Green (absorbs blue and red) = yellow (absorbs blue) plus cyan (absorbs red)

Blue (absorbs green and red) = magenta (absorbs green) plus cyan (absorbs red)

Avoid using a filter pack that absorbs light of all three primary colors —red, green, and blue. Absorption of all three is equivalent to neutral density, which increases the exposure time without accomplishing any color correction.

The following method of calculation is recommended:

1. Convert the filters to their equivalents in the subtractive colors—cyan, magenta, and yellow—if not already of these colors (for example, 20R = 20M + 20Y).
2. Add like filters together (for example, 20M + 10M =30M).
3. If the resulting filter combination contains all three subtractive colors, cancel out the neutral density by removing an equal amount of each (for example, 10C + 20M + 20Y = 10M + 10Y + 0.10 neutral density; the neutral density can be eliminated). Generally, the total number of filters should be reduced to a minimum.

EXPOSURE ADJUSTMENT FOR FILTERS

An exposure time which produced a transparency of satisfactory density may not produce the same density when the printing filter pack is changed. The following table provides two simple methods of determining approximate exposure adjustments. If the pack is changed by only one filter, use of the appropriate filter factor is convenient. Otherwise, the use of the computer numbers with the Color-Printing Computer in the **KODAK Color DATA-GUIDE** (sold by Kodak dealers) will probably be preferred.

To use computer numbers: Add the computer-number values for all the filters in the old pack. On the "Density" scale of the Color-Printing Computer, set the sum of the computer numbers so that it is opposite the exposure time used. Read the new exposure time opposite the sum of the computer numbers for the new pack.

EASTMAN KODAK

COMPUTER NUMBERS AND FACTORS FOR KODAK CC AND CP FILTERS

Filter	Computer No.	Factor	Filter	Computer No.	Factor
05Y	.04	1.1	05R	.07	1.2
10Y	.04	1.1	10R	.10	1.3
20Y	.04	1.1	20R	.17	1.5
30Y	.05	1.1	30R	.23	1.7
40Y	.05	1.1	40R	.29	1.9
50Y	.05	1.1	50R	.34	2.2
05M	.07	1.2	05G	.06	1.1
10M	.10	1.3	10G	.08	1.2
20M	.16	1.5	20G	.12	1.3
30M	.22	1.7	30G	.15	1.4
40M	.27	1.9	40G	.18	1.5
50M	.32	2.1	50G	.22	1.7
05C	.06	1.1	05B	.04	1.1
10C	.08	1.2	10B	.12	1.3
20C	.12	1.3	20B	.21	1.6
30C	.15	1.4	30B	.29	2.0
40C	.18	1.5	40B	.38	2.4
50C	.21	1.6	50B	.47	2.9

(Continued on following page)

To use factors: First divide the old exposure time by the factor* for any filter removed from the pack. Then multiply the resulting time by the factor* for any filter added.

*For two or more filters, multiply the individual factors together and use the product.

COLOR BALANCE AND SPEED CHARACTERISTICS

It is characteristic of multilayer color films that noticeable changes in results are caused by manufacturing variations which are negligible with black-and-white films. Unavoidable differences in color balance and speed characteristics will therefore be found among different batches of film. The supplementary data sheet which is packed with each box of film suggests filter and exposure adjustments to compensate for any such differences.

The production control tests for Kodak Ektacolor Print Film are exposed at 10 seconds. Filter recommendations are calculated from these tests. These recommendations should be used as a starting point for calculating trial exposures.

In use, variations from recommended exposure conditions may be necessitated by any of the following: age of the print film, high temperature or humidity during storage (either before or after exposure), illumination of incorrect color quality, processing variations, variations in sensitivity with time of exposure, and the use of color negatives which are abnormal due to improper exposure, processing, or storage conditions.

The sensitivity of each of the three sensitive layers in Ektacolor Print Film varies with the exposure time, and this variation may be different for the three layers. Thus, an emulsion having normal color balance and speed at normal exposure times may not have the same characteristics at longer exposure times or at very short times. The supplementary data sheet packed with each box of film gives recommendations for trial exposures at 10 seconds (normal) and 120 seconds. From these recommendations, exposure and filter recommendations for intermediate exposure times can be estimated.

PROCESSING

Kodak Ektacolor Print Film is **not** processed by the Eastman Kodak Company. Chemicals for processing solutions are supplied in prepared form in the Kodak Color Processing Kit, Process C-22. Prepared chemicals to make the individual solutions are also available. Complete processing instructions are included with processing kits and developer packages. The development time for Kodak Ektacolor Print Film is 12 minutes at 75 F.

Kodak Ektacolor Print Film Additive (for Kodak Developer Replenisher, Process C-22) is supplied separately as a liquid to be diluted to a stock solution before use. For processing Kodak Ektacolor Print Film, the stock solution must be added to the Developer at a rate equal to one percent of the volume of Developer Replenisher (3.25 ml per square foot of film if the basic replenishment rate is used). Alternatively, if a special Developer Replenisher supply is maintained for use with Ektacolor Print Film only, the Additive can be mixed with the Developer Replenisher.

The Additive compensates for the effect of the Ektacolor Print Film on the chemical balance of the Developer; only if it is used as directed with the Ektacolor Print Film can consistent, optimum quality be obtained with all films processed in the C-22 solutions.

Kodak Ektacolor Print Film Stabilizer and Replenisher is recommended for improved dye stability in cases where transparencies may be subjected to lengthy periods of display. It is supplied as a concentrate that is diluted with 6 parts water to make a stock solution. Four parts stock solution are diluted with one part water to make a working solution, which is used instead of Kodak Photo-Flo Solution (but for the same time—1 minute) after the final wash in Process C-22. With replenishment at the rate of 80 ml of stock solution per square foot of film processed, the working solution has a capacity of about 190 square feet of film per gallon. The Stabilizer concentrate keeps indefinitely in a full, stoppered bottle, but unused stock or working solution should be discarded within 8 weeks after mixing.

KODAK VERICOLOR II PROFESSIONAL FILM 4107, TYPE S

A color-negative sheet film for exposure times 1/10 second or shorter. It is balanced for exposure without a filter by electronic flash, daylight, or blue flash, and with the appropriate filter by clear flash. Colored couplers in the film provide automatic color correction and make excellent quality in color reproductions possible without supplementary masking. This film can be processed with Kodak Flexicolor Chemicals for Process C-41. The negatives can be printed on Kodak Ektacolor 37 and 74 RC Papers or by the Kodak Dye Transfer Process. They can also be used to make color transparencies on Kodak Ektacolor Print Film 4109 (Estar Thick Base) or black-and-white prints on Kodak Panalure Papers. This film is also available as Kodak Vericolor II Professional Film, Type S, in several roll sizes.

SPEED

The number given after each light source is based on an ANSI Standard and is for use with meters and cameras marked for ASA speeds.

Light Source	Speed	With Filter Such as:
Daylight	ASA 100	None
Photolamp (3400 K)	ASA 32	Kodak Photoflood Filter No. 80B
Tungsten (3200 K)	ASA 25	Kodak 3200 K Filter No. 80A

CAUTION

Do not expose this film for times longer than 1/10 second, because the resulting negatives may contain color reproduction errors that cannot be corrected satisfactorily in the printing operation. For long exposures use Kodak Vericolor II Professional Film 4108, Type L.

INCLUSION OF GRAY CARD IN SCENE

As an aid in determining the exposures required in making prints from Vericolor II negatives, a neutral gray card having a reflectance of about 18%, such as the gray side of the Kodak Neutral Test Card, should be photographed with the subject. If possible, the card should be placed along the edge of the scene area in such a position that it receives the full subject lighting but does not interfere with the actual picture and can be trimmed off the final prints. Otherwise, the card should be photographed, with the full subject lighting, on a separate sheet of Vericolor II Professional Film, which should be processed at the same time as the negatives.

ELECTRONIC FLASH GUIDE NUMBERS

This table is intended as a starting point in determining the correct guide number. It is for use with equipment rated in beam candlepower-seconds (BCPS) or effective candlepower-seconds (ECPS). Divide the proper guide number by the flash-to-subject distance in feet to determine the f-number for average subjects.

Output of Unit (BCPS or ECPS)		350	500	700	1000	1400	2000	2800	4000	5600	8000
Guide Number For Trial	Feet	40	50	60	70	85	100	120	140	170	200
	Meters	12	15	18	21	26	30	36	42	50	60

CAUTION

Do not use shutter speeds longer than 1/50 second; otherwise, results may be influenced by illumination other than the electronic flash.

(Continued on following page)

EASTMAN KODAK

FLASH EXPOSURE GUIDE NUMBERS

For flash pictures with this film use blue flashbulbs without a filter. With zirconium-filled clear flashbulbs (AG-1 and M3) use a filter such as the Kodak Photoflash Filter No. 80D, over the camera lens. With all other clear flashbulbs, use a No. 80C Filter. Divide the proper guide number by the flash-to-subject distance in feet to determine the f-number for average subjects. Use ½ stop larger for dark subjects, ½ stop smaller for light subjects.

Lens openings determined in this way apply to the use of a single flashbulb in all surroundings except small rooms with very light walls, ceilings, and furnishings. If two bulbs are used at the same distance to light the same area or if the room is small and very light, use 1 stop smaller.

GUIDE NUMBERS* FOR FLASHBULBS
For Blue Flashbulbs (or Clear Flashbulbs with a No. 80C or No. 80D Filter)

Between-Lens Shutter Speed	Syn-chroni-zation	2B♦ 22B♦	M2B‡	M3B‡ 5B§ 25B§	3¶ or 50¶ in a 12-Inch Bowl Reflector	Focal-Plane Shutter Speed	6B§ or 26B§
Open 1/25—1/30	X or F	220	120	180		1/25—1/30	180
1/25—1/30	M	220	NR**	170	320	1/50—1/60	130
1/50—1/60	M	200	NR	160	(Use 1/25	1/100—1/125	85
1/100—1/125	M	170	NR	130	or	1/200—1/250	60
1/200—1/250	M	130	NR	110	Slower)	1/400—1/500	44
1/400—1/500	M	100	NR	80		1/1000	30

*For use with bowl-shaped polished reflectors. If shallow cylindrical reflectors are used, divide these guide numbers by 2.
Bowl-shaped polished reflector sizes: ‡3-inch; §4- to 5-inch; ♦6- to 7-inch.
¶Clear bulbs are listed because blue bulbs are not available. Use with a No. 80C Filter.
**NR = Not Recommended.

These values are intended only as guides for average emulsions. They must be changed to suit individual variations in synchronization, battery, reflector, and bulb position in the reflector.

CAUTION

Since bulbs may shatter when flashed, the use of a flashguard over the reflector is recommended. Do not flash bulbs in an explosive atmosphere.

DAYLIGHT EXPOSURE TABLE

Lens openings with shutter at 1/125 second.
For the hours from 2 hours after sunrise to 2 hours before sunset.

Bright or Hazy Sun on Light Sand or Snow	Bright or Hazy Sun (Distinct Shadows)	Weak, Hazy Sun (Soft Shadows)	Cloudy Bright (No Shadows)	Heavy Overcast	Open Shade*
f/22	f/16†	f/11	f/8	f/5.6	f/5.6

*Subject shaded from the sun but lighted by a large area of sky.
†For backlighted close-up subjects, use f/8.

PROCESSING

Professional photographic laboratories offer processing and printing services for Vericolor II Professional Films. Kodak Processing Laboratories offer processing

(Continued on following page)

and printing services for the Type S films only, in these sizes: 135, 120, 220, 620, and long rolls 35, 46, and 70mm wide. Film in sheets and short rolls can be processed in sink-line equipment with Kodak Flexicolor Chemicals for Process C-41.

FILM SIZES AVAILABLE

Sheets (inches): 2¼ x 3¼, 4 x 5, 5 x 7, and 8 x 10 (film code 4107, Estar thick base). Rolls: VPS120, VPS220, VPS620 (film code 6010, acetate base), VPS135-20, VPS135-36 (film code 5025, acetate base). Long rolls: 35mm and 46mm widths (film code 5025, acetate base), 70mm and 3½-inch widths (film code 2107, Estar base).

DIFFUSE RMS GRANULARITY VALUE: 6

(Read at a net diffuse density of 1.0, using a 48-micrometer aperture, 12X magnification.)

RESOLVING POWER VALUES

Test-Object Contrast 1.6:1 40 lines per mm

Test-Object Contrast 1000:1 80 lines per mm

EASTMAN KODAK

KODAK VERICOLOR II PROFESSIONAL FILM 4108, TYPE L

A color-negative sheet film for exposure times of 1/50 second to 60 seconds with tungsten (3200 K) lamps or, with appropriate filters, by photolamp (3400 K) or daylight illumination. Colored couplers in the film provide automatic color correction and make excellent quality in color reproductions possible without supplementary masking. This film can be processed with Kodak Flexicolor Chemicals for Process C-41. The negatives can be printed on Kodak Ektacolor 37 and 74 RC Papers or by the Kodak Dye Transfer Process. They can also be used to make positive color transparencies on Kodak Ektacolor Print Film 4109 (Estar Thick Base) or black-and-white prints on Kodak Panalure Papers. This film is also available in 120 size.

SPEED

Tungsten (3200 K)—ASA 50 (for a 5-second exposure)

The effective speed depends upon the illumination level and exposure time. The number given in each case is for use with meters marked for ASA speeds.

Light Source	Filter No.	Exposure Time	Effective Speed
Tungsten (3200 K)	None	1/50 to 1/5 sec	ASA 80
	None	1 sec	ASA 64
	None	5 sec	ASA 50
	None	30 sec	ASA 32
	None	60 sec	ASA 25

Set the meter calculator tentatively for a speed of 50, which applies to a 5-second exposure. Calculate a tentative exposure time for the desired lens opening. If this time is much shorter or much longer than 5 seconds, select from the table the effective speed which applies. Use this value to determine the correct exposure time at the desired lens opening.

Photolamps 3400 K	81A	1 sec	(50 (with filter)
Daylight	85B	1/50 sec	(50 (with filter)

CAUTION

Do not expose Kodak Vericolor II Professional Film, Type L, for times shorter than 1/50 second or longer than 60 seconds, because the resulting negatives may contain color reproduction errors that cannot be corrected satisfactorily in the printing operation. For short exposures, use Kodak Vericolor II Professional Film 4107, Type S. If, however, a higher contrast result is desired for commercial applications, Type L film can be exposed with electronic flash and an 85C filter at a speed rating of ASA 50. The resulting negatives will require a filter pack slightly different from that used for negatives produced with the normal light source.

LIGHT SOURCES AND FILTERS

To avoid large changes in the filter pack used later during color printing, it is desirable to bring all negatives to approximately the same balance. Therefore, negatives exposed by photolamp (3400 K) or daylight illumination should be brought close to the same balance as negatives exposed with tungsten (3200 K) lamps by use of the filters listed in the table above.

INCLUSION OF GRAY CARD OR GRAY SCALE IN SCENE

As an aid in determining the exposures required in making prints from Vericolor II negatives, a neutral gray card having a reflectance of about 18%, such as the gray side of the Kodak Neutral Test Card, should be photographed with the subject. If possible, the card should be placed along the edge of the scene area in such a position that it receives the full subject lighting but does not interfere with the actual picture and can be trimmed off the final prints. Otherwise, the card should be photographed, with the full subject lighting, on a separate sheet of Vericolor II Professional Film, which should be processed at the same time as the negatives.

PROCESSING

Professional photographic laboratories offer processing and printing services for Vericolor II Professional Films. The Type L films are not processed or printed by Kodak Processing Laboratories; they do, however, offer a development-only service for the 120-size Type L film. Film in sheets and short rolls can be precessed efficiently in sink-line equipment with Kodak Flexicolor Chemicals for Process C-41.

FILM SIZES AVAILABLE

Sheets (inches): 2¼ x 3¼, 4 x 5, 5 x 7, 8 x 10, and 11 x 14 (film code 4108, Estar thick base). Rolls: VPL120 (film code 6013. acetate base). No long rolls.

DIFFUSE RMS GRANULARITY VALUE: 7

(Read at a net diffuse density of 1.0, using a 48-micrometer aperture, 12X magnification).

RESOLVING POWER VALUES

Test-Object Contrast 1.6:1	40 lines per mm
Test-Object Contrast 1000:1	80 lines per mm

KODACOLOR II FILM

A color negative roll film for exposure by daylight, electronic flash or blue flash-bulbs. The negatives can be used to obtain color prints and enlargements, or they can be printed on Kodak Ektacolor 37 and 74 RC Papers. Transparencies can be made on Kodak Ektacolor Print Film 4109 (Estar Thick Base) or Kodak Ektacolor Slide Film 5028. Kodacolor Slides in 2 x 2-inch mounts can be ordered through photo dealers.

SPEED

The number given after each light source is based on an ANSI Standard and is for use with meters and cameras marked for ASA speeds.

Light Source	Speed	With Filter Such as:
Daylight	ASA 100	None
Photolamp (3400 K)	ASA 32	Kodak Photoflood Filter No. 80B
Tungsten (3200 K)	ASA 25	Kodak 3200 K Filter No. 80A

Note: Exposure times longer than 1 second may require an increase in exposure to compensate for the reciprocity charactristics of this film. Consult reciprocity table in this section.

DAYLIGHT EXPOSURE TABLE

Lens openings with shutter at 1/125 second.
For the hours from 2 hours after sunrise to 2 hours before sunset.

Bright or Hazy Sun on Light Sand or Snow	Bright or Hazy Sun (Distinct Shadows)	Weak, Hazy Sun (Soft Shadows)	Cloudy Bright (No Shadows)	Heavy Overcast	Open Shade*
f/16	f/11†	f/8	f/5.6	f/4	f/4

*Subject shaded from the sun but lighted by a large area of sky.
†f/5.6 for backlighted close-up subjects.

FLASH

For flash pictures with this film use blue flashbulbs without a filter. With zirconium-filled clear flashbulbs (AG-1 and M3) use a filter such as the Kodak Photoflash Filter No. 80D, over the camera lens. With all other clear flashbulbs, use a No. 80C Filter. Divide the proper guide number by the flash-to-subject distance in feet to determine the f-number for average subjects. Use ½ stop larger for dark subjects, ½ stop smaller for light subjects.

GUIDE NUMBERS* FOR FLASHBULBS

For Blue Flashbulbs (or Clear Flashbulbs with a No. 80C or No. 80D Filter)

Between-Lens Shutter Speed	Syn-chroni-zation	Flash-cube	AG-1B†	M2B‡	M3B‡ 5B§ 25B‡	Focal-Plane Shutter Speed	6B§ or 26B§
Open 1/25—1/30	X or F	90	130	120	180	1/25—1/30	180
1/25—1/30	M	60	90	NR**	170	1/50—1/60	130
1/50—1/60	M	60	90	NR	160	1/100—1/125	85
1/100—1/125	M	50	75	NR	130	1/200—1/250	60
1/200—1/250	M	38	65	NR	110	1/400—1/500	40
1/400—1/500	M	32	50	NR	80	1/1000	30

(Continued on following page)

*For use with bowl-shaped polished reflectors. If shallow cylindrical reflectors are used, divide these guide numbers by 2.

Bowl-shaped polished reflector sizes: †2-inch; ‡3-inch; §4- to 5-inch.

**NR = Not Recommended.

These values are intended only as guides for average emulsions. They must be changed to suit individual variations in synchronization, battery, reflector, and bulb position in the reflector.

CAUTION
Since bulbs may shatter when flashed, the use of a flashguard over the reflector is recommended. Do not flash bulbs in an explosive atmosphere.

FILL-IN FLASH
Blue flashbulbs are helpful in lightening the harsh shadows usually found in making close-ups in bright sunlight. A typical exposure is f/22 at 1/25 or 1/30 second with the subject 8 to 10 feet away.

ELECTRONIC FLASH GUIDE NUMBERS
This table is intended as a starting point in determining the correct guide number. It is for use with equipment rated in beam candlepower-seconds (BCPS) or effective candlepower-seconds (ECPS). Divide the proper guide number by the flash-to-subject distance in feet to determine the f-number for average subjects. If color prints are consistently bluish, use a filter such as the Kodak Light Balancing Filter No. 81B over the camera lens and increase exposure ⅓ stop.

Output of Unit (BCPS or ECPS)		350	500	700	1000	1400	2000	2800	4000	5600	8000
Guide Number for Trial	Feet	40	50	60	70	85	100	120	140	170	200
	Meters	12	15	18	21	26	30	36	42	50	60

CAUTION
Do not use shutter speeds longer than 1/50 second; otherwise, results may be influenced by illumination other than the electronic flash.

COPYING AND CLOSE-UP WORK
In copying, the use of an incident-light meter or a reflected-light meter with a gray card is recommended for determining exposures. If the camera lens is extended for focusing on a subject closer than 8 times the focal length of the lens, allow for the decrease in effective lens opening.

PHOTOLAMP (3400 K) EXPOSURE TABLE
For two new 500-watt reflector-type photolamps (3400 K) at the same distance from the subject: fill-in light close to camera at camera height;; main light on the other side of camera at 45 degrees to camera-subject axis and 2 to 4 feet higher than fill-in light. A No. 80B Filter should be used over the camera lens.

Lamp-to-Subject Distance	4½ ft	6 ft
Lens Opening at 1/25 or 1/30 Second	f/4	f/2.8

Note: This table is for new lamps only. After burning lamps 1 hour, use ½ stop larger; after 2 hours, 1 full stop larger.

(Continued on following page)

The Compact Photo-Lab-Index

PROCESSING

Kodacolor II Film is developed by Kodak and other laboratories on orders placed through photo dealers. Some laboratories, including Kodak, also provide direct mail service whereby you can mail exposed film to the laboratory and have it returned directly to you. See your dealer for the special mailing devices required. Do not mail film without an overwrap or special mailing device intended for this purpose. Kodak Flexicolor Chemicals for Process C-41, available in kit form (1-pint size) and as individual components in larger sizes, can be used to process this film.

FILM SIZES AVAILABLE

C110-12, C110-20, C116, C120, C126-12, C126-20, C127, C135-24, C135-36, C616, C620, C828.

DIFFUSE RMS GRANULARITY VALUE: 5

(Read at a net diffuse density of 1.0, using a 48-micrometer aperture, 12X magnification.)

RESOLVING POWER VALUES

Test-Object Contrast 1.6:1 50 lines per mm
Test-Object Contrast 1000:1 100 lines per mm

EASTMAN KODAK

KODACOLOR 400 FILM

A high-speed, color negative roll film that can be used with daylight and most types of existing low-level illumination as well as with supplementary flash. It is color-balanced for daylight, blue flashbulbs, and electronic flash, but its special sensitizing characteristics minimize the photographic difference among various light sources so that conversion filters are not necessary to produce pleasing and acceptable color prints. This film is excellent for dimly lighted subjects, for fast action, for extending the distance range for flash pictures, and for subjects requiring good depth of field or high shutter speeds. For critical use correction filters can be used for photolamp and tungsten illumination.

SPEED

The number given after each light source is based on an ANSI Standard and is for use with meters and cameras marked for ASA speeds.

Light Source	Speed	With Filter Such as:
Daylight	ASA 400	None
Photolamp (3400 K)	ASA 125	Kodak Photoflood Filter No. 80B
Tungsten (3200 K)	ASA 100	Kodak 3200 K Filter No. 80A

Note: Exposure times longer than 1 second may require an increase in exposure to compensate for the reciprocity characteristics of this film. See the reciprocity table elsewhere in this section.

DAYLIGHT EXPOSURE TABLE

Shutter Speed				
1/500 Second		1/250 Second		
Bright or Hazy Sun on Light Sand or Snow	Bright or Hazy Sun (Distinct Shadows)	Cloudy Bright (No Shadows)	Heavy Overcast	Open Shade
f/16	f/16*	f/8	f/5.6	f/5.6†

*f/8 for backlighted close-up subjects.
†Subject shaded from the sun, but lighted by a large area of sky.

EXISTING-LIGHT TABLE

Subjects	Shutter Speed	Lens Aperture
Well-lighted interiors	1/30	f/2.8
Dimly lighted interiors (details in dark objects barely visible)	1/30	f/2.0

ELECTRONIC AND BLUE FLASH EXPOSURE

No filter required. Guide numbers may be calculated on the basis of the film speed of ASA 400. Determine the f-number by dividing the guide number for your reflector and bulb or electronic flash unit by the distance in feet from the flash to your subject. Use these numbers as guides—if your flash negatives are consistently underexposed, use a lower guide number; if overexposed, use a higher guide number.

EASTMAN KODAK

The Compact Photo-Lab-Index

PROCESSING

Kodacolor 400 Film is developed by Kodak and other laboratories on orders placed through photo dealers. Some laboratories, including Kodak, also provide direct mail service whereby you can mail exposed film to the laboratory and have it returned directly to you. See your dealer for the special mailing devices required. Do not mail film without an overwrap or special mailing device intended for this purpose. Kodak Flexicolor Chemicals for Process C-41, available in kit form(1-pint size) and as individual components in larger sizes, can be used to process this film.

FILM SIZES AVAILABLE

CG110-12, CG110-20, CG120, CG135-24, CG135-36.

DIFFUSE RMS GRANULARITY VALUE: 8

(Read at a net diffuse density of 1.0, using a 48-micrometer aperture, 12X magnification.)

RESOLVING POWER VALUES

Test-Object Contrast 1.6:1	40 lines per mm
Test-Object Contrast 1000:1	63 lines per mm

KODAK EKTACHROME 64 PROFESSIONAL FILM 6117 (Daylight)

A color-reversal sheet film balanced for exposure in daylight and designed for Process E-6 to produce color transparencies. The transparencies can be viewed by transmitted light or projection, and can be printed in color by photomechanical methods, or by the other accepted photographic methods. This film is also available as Kodak Ektachrome 64 Professional Film (Daylight) in 135-36 and **120** sizes. This professional film is color-balanced for direct viewing with the standard 5000 K light source adopted by the American National Standards Institute (ANSI Standard PH2.31-1960).

IMPORTANT

These instructions are based on average emulsions used under average conditions. Information applying to film of a specific emulsion number is given on the instruction sheet packaged with the film. The effective speed can be ASA 50, 64, or 80.

SPEED

The number given after each light source is based on an ANSI Standard and is for use with meters and cameras marked for ASA speeds.

Light Source	Speed	With Filter Such as:
Daylight	ASA 64	None
Photolamp (3400 K)	ASA 20	Kodak Photoflood Filter No. 80B
Tungsten (3200 K)	ASA 16	Kodak 3200 K Filter No. 80A

Note: Exposure times longer than 1/10 second may require an increase in exposure to compensate for the reciprocity characteristics of this film. Consult reciprocity data elsewhere in this section.

DAYLIGHT EXPOSURE TABLE

Lens openings with shutter at 1/125 second.
For the hours from 2 hours after sunrise to 2 hours before sunset.

Bright or Hazy Sun on Light Sand or Snow	Bright or Hazy Sun (Distinct Shadows)	Weak, Hazy Sun (Soft Shadows)*	Cloudy Bright (No Shadows)	Heavy Overcast	Open Shade†
f/16	f/11	f/8	f/5.6	f/4	f/4

*With backlighted close-up subjects, use f/5.6.
†Subject shaded from sun but lighted by a large area of clear, unobstructed sky.

LIGHT SOURCES

In general, best color rendering is obtained in clear or hazy sunlight. Other light sources may not give equally good results even with the most appropriate filters.
 The bluish cast which is otherwise evident in pictures taken in shade under a clear blue sky can be minimized by the use of a skylight filter, which requires no increase in exposure. The filter is also useful for reducing bluishness in pictures taken on an overcast day and in distant scenes, mountain views, sunlit snow scenes, and aerial photographs.

LONG EXPOSURES

At exposure times of 1/10 second or longer to daylight illumination, refer to reciprocity data elsewhere in this section. Under such conditions, it may be preferable to use Kodak Ektachrome 50 Professional Film (Tungsten) with a Kodak Filter No. 85B.

(Continued on following page)

The Compact Photo-Lab-Index

FLASH

For flash pictures with this film use blue flashbulbs without a filter. With zirconium-filled clear flashbulbs (AG-1 and M3) use a filter such as the Kodak Photoflash Filter No. 80D, over the camera lens. With all other clear flashbulbs, use a No. 80C Filter. Divide the proper guide number by the flash-to-subject distance in feet to determine the f-number for average subjects. Use ½ stop larger for light subjects.

GUIDE NUMBERS* FOR FLASHBULBS
For Blue Flashbulbs (or Clear Flashbulbs with a No. 80C or No. 80D Filter)

Between-Lens Shutter Speed	Syn-chroni-zation	M2B‡	M3B‡ 5B§ 25B§	2B 22B	3¶ or 50¶ in a 12-Inch Bowl Reflector	Focal-Plane Shutter Speed	6B§ or 26B§
Open 1/25—1/30	X or F	100	150	180		1/25—1/30	140
1/25—1/30	M	NR**	130	170	260	1/50—1/60	100
1/50—1/60	M	NR	130	160	(Use 1/25	1/100—1/125	70
1/100—1/125	M	NR	110	140	or	1/200—1/250	50
1/200—1/250	M	NR	85	100	Slower)	1/400—1/500	34
1/400—1/500	M	NR	65	75		1/1000	24

*For use with bowl-shaped polished reflectors. If shallow cylindrical reflectors are are used, divide these guide numbers by 2.

Bowl-shaped polished reflector sizes: ‡3-inch; §4- to 5-inch.

¶Clear bulbs are listed because blue bulbs are not available. Use with a No. 80C Filter.

**NR = Not Recommended.

These values are intended only as guides for average emulsions. They must be changed to suit individual variations in synchronization, battery, reflector, and bulb position in the reflector.

CAUTION

Since bulbs may shatter when flashed, the use of a flashguard over the reflector is recommended. Do not flash bulbs in an explosive atmosphere.

ELECTRONIC FLASH GUIDE NUMBERS

This table is intended as a starting point in determining the correct guide number. It is for use with equipment rated in beam candlepower-seconds (BCPS) or effective candlepower-seconds (ECPS). Divide the proper guide number by the flash-to-subject distance in feet to determine the f-number for average subjects.

Output of Unit (BCPS or ECPS)		350	500	700	1000	1400	2000	2800	4000	5600	8000
Effective Film Speed ASA 50											
Guide Number for Trial	Feet	30	35	40	50	60	70	85	100	120	140
	Meters	9	11	12	15	18	21	26	30	36	42
Effective Film Speed ASA 64											
Guide Number for Trial	Feet	32	40	45	55	65	80	95	110	130	160
	Meters	10	12	14	17	20	24	29	33	40	50

(Continued on following page)

EASTMAN KODAK

The Compact Photo-Lab-Index

Guide Number for Trial		Effective Film Speed				ASA 80					
	Feet	35	45	55	65	75	90	110	130	150	180
	Meters	11	14	17	20	22	27	33	40	46	55

Do not use shutter speeds longer than 1/50 second; otherwise, results may be influenced by illumination other than electronic flash. If your transparencies are consistently bluish, use a CC05Y or CC10Y filter over the camera lens. Increase exposure ⅓ stop if a CC10Y filter is used.

PROCESSING

Chemicals for preparing a complete set of processing solutions are in the Kodak Ektachrome Film Processing Kit, Process E-6. The kit is available in 1-pint (containing two each of 1-pint units of each developer) and 1-gallon sizes. Chemicals are also available as separate units in larger sizes.

FILM SIZES AVAILABLE

Sheet (inches): 4 x 5, 5 x 7, 8 x 10, and 11 x 14. Also 9 x 12 centimeters.
 Rolls: EPR 135-36 (film code 5017) and EPR120 (film code 6017).

DIFFUSE RMS GRANULARITY VALUE: 12

(Read at a gross diffuse density of 1.0, using a 48-micrometer aperture, 12X magnification.)

RESOLVING POWER VALUES

Test-Object Contrast 1.6:1 50 lines per mm
Test-Object Contrast 1000:1 125 lines per mm

KODAK EKTACHROME 200 PROFESSIONAL FILM (Daylight)

A high-speed color-reversal film recommended for color photography of fast action, interiors lighted by daylight and other dimly lighted subjects, close-ups that require the utmost depth of field, etc. It is color-balanced for exposure to daylight, blue flashbulbs, and electronic-flash illumination. No filters are required with any of these light sources. In general, for fluorescent illumination and arc lamps, this film is preferable to the tungsten film. When processed, this film produces color transparencies suitable for projection, direct viewing, or use as originals for color prints. This professional film is color-balanced for direct viewing with the standard 5000 K light source adopted by the American National Standards Institute (ANSI Standard PH2.31-1960).

IMPORTANT

These instructions are based on average emulsions used under average conditions. Information applying to film of a specific emulsion number is given on the instruction sheet packaged with the film. The effective speed can be ASA 160, 200, or 250.

(Continued on following page)

162

The Compact Photo-Lab-Index

SPEED

The number given after each light source is based on an ANSI Standard and is for use with meters and cameras marked for ASA speeds.

Light Source	Speed	With Filter Such as:
Daylight	ASA 200	None
Photolamp (3400 K)	ASA 64	Kodak Photoflood Filter No. 80B
Tungsten (3200 K)	ASA 50	Kodak 3200 K Filter No. 80A

Note: Exposures 1/10 second and longer may require filtration and exposure compensation. See reciprocity data elsewhere in this section.

Because of its extreme speed, this film is easy to overexpose under bright sunlight conditions.

Leaf shutters have the higher speed settings calibrated for the maximum lens openings. They are relatively more efficient at smaller lens openings, and so pass more light than calculated. Therefore, under lighting conditions that call for small lens openings at high shutter speeds, use an opening ½ stop smaller than that indicated by an exposure meter. The following table makes allowance for this shutter efficiency effect.

DAYLIGHT EXPOSURE TABLE

For average frontlighted subjects in daylight from 2 hours after sunrise to 2 hours before sunset.

Lens opening with shutter at 1/250 second					
Bright or Hazy Sun on Light Sand or Snow	Bright or Hazy Sun (Distinct Shadows)*	Weak, Hazy Sun (Soft Shadows)	Cloudy Bright (No Shadows)	Heavy Overcast	Open Shade†
f/22‡	f/16‡	f/11	f/8	f/5.6	f/5.6

*With backlighted close-up subjects, use f/8.
†Subject shaded from sun but lighted by a large area of clear, unobstructed sky.
‡With blade-type shutters, correct for high speed and small apertures.

FILL-IN FLASH

Blue flashbulbs are also helpful in lightening the harsh shadows usually found in making close-up in bright sunlight. A typical exposure is f/22 at 1/100 second, with the subject 8 to 10 feet away. When you use a camera with a blade-type shutter, electronic flash is a good fill-in source for this film, as it can be synchronized more easily than flashbulbs at 1/100 second.

FLASH

For flash pictures with this film use blue flashbulbs without a filter. With zirconium-filled clear flashbulbs (AG-1 and M3) use a filter such as the Kodak Photoflash Filter No. 80D over the camera lens. With all other clear flashbulbs use a No. 80C Filter. Divide the proper guide numbers by the flash-to-subject distance in feet to determine the f-number for average subjects. Use ½ stop larger for dark subjects, ½ stop smaller for light subjects.

(Continued on following page)

163

GUIDE NUMBERS* FOR FLASHBULBS
For Blue Flashbulbs (or Clear Flashbulbs with a No. 80C or No. 80D Filter)

Between-Lens Shutter Speed	Syn-chroni-zation	Flash-cube	AG-1B†	M2B‡	M3B‡ 5B§ 25B§	Focal-Plane Shutter Speed	6B§ or 26B§
Open 1/25—1/30	X or F	130	180	170	260	1/25—1/30	260
1/25—1/30	M	85	130	NR**	240	1/50—1/60	180
1/50—1/60	M	85	130	NR	220	1/100—1/125	120
1/100—1/125	M	70	110	NR	180	1/200—1/250	85
1/200—1/250	M	55	90	NR	150	1/400—1/500	60
1/400—1/500	M	45	70	NR	110	1/1000	42

*For use with bowl-shaped polished reflectors. If shallow cylindrical reflectors are used, divide these guide numbers by 2.

Bowl-shaped polished reflector sizes: †2-inch; ‡3-inch; §4- to 5-inch.

These values are intended only as guides for average emulsions. They must be changed to suit individual variations in synchronization, battery, reflector, and bulb position in the reflector.

CAUTION
Since bulbs may shatter when flashed, the use of a flashguard over the reflector is recommended. Do not flash bulbs in an explosive atmosphere.

ELECTRONIC FLASH GUIDE NUMBERS
This table is intended as a starting point in determining the correct guide number. It is for use with equipment rated in beam candlepower-seconds (BCPS) or effective candlepower-seconds (ECPS). Divide the proper guide number by the flash-to-subject distance in feet to determine the f-number for average subjects.

Output of Unit (BCPS)		350	500	700	1000	1400	2000	2800	4000	5600	8000
		Effective Film Speed				**ASA 160**					
Guide Number for Trial	Feet	55	65	75	90	110	130	150	180	210	250
	Meters	17	20	22	27	33	40	46	55	65	75
		Effective Film Speed				**ASA 200**					
Guide Number for Trial	Feet	60	70	85	100	120	140	170	200	240	280
	Meters	18	21	26	30	36	42	50	60	70	85
		Effective Film Speed				**ASA 250**					
Guide Number for Trial	Feet	65	80	95	110	130	160	190	220	260	320
	Meters	20	24	29	33	40	40	60	65	80	95

Do not use shutter speeds longer than 1/50 second; otherwise, results may be influenced by illumination other than electronic flash. If your transparencies are consistently bluish, use a CC05Y or CC10Y filter over the camera lens. Increase exposure ⅓ stop if a CC10Y filter is used.

(Continued on following page)

The Compact Photo-Lab-Index

PROCESSING
Chemicals for preparing a complete set of processing solutions are in the Kodak Ektachrome Film Processing Kit, Process E-6. The kit is available in 1-pint (containing two each of 1-pint units of each developer) and 1-gallon sizes. Chemicals are also available as separate units in larger sizes.

FILM SIZES AVAILABLE
EPD135-36 (film code 5036), EPD120 (film code 6036).

DIFFUSE RMS GRANULARITY VALUE: 13
(Read at a gross diffuse density of 1.0, using a 48-micrometer aperture, 12X magnification).

RESOLVING POWER VALUES
Test-Object Contrast 1.6:1	50 lines per mm
Test-Object Contrast 1000:1	125 lines per mm

KODAK EKTACHROME 50 PROFESSIONAL FILM 6118 (Tungsten)

A color-reversal sheet film balanced for exposure to 3200 K tungsten lamps and designed for Process E-6 to produce color transparencies. The transparencies are color-balanced for direct viewing with the standard 5000 K light source adopted by the American National Standards Institute and can be used for photomechanical reproduction. Duplicate transparencies and reflection prints can be made by using the standard photographic methods described elsewhere in this section.

EXPOSURE WITH 3200 K TUNGSTEN LAMPS
The intended exposure range for this film is 1/10 second to 100 seconds. Under studio conditions the average exposure time to tungsten lamps is about 5 seconds. Therefore, this sheet film is color-balanced at a 5-second exposure time with 3200 K tungsten lamps and usually no color correction (CC) filters are necessary

(Continued on following page)

The Compact Photo-Lab-Index

to obtain good color balance. Pictures taken at shorter or longer exposure times usually require CC filters to correct for color balance due to the reciprocity characteristics of the film. The instruction sheet in each box of sheet film has the following supplementary information for the particular emulsion number of film within the box:

1. The effective ASA speed of the film at an exposure time of 5 seconds with 3200 K tungsten lamps is specified.

2. The effective ASA speed of the film and suggested reciprocity correction CC filter(s) at exposure times of ½ and 30 seconds with 3200 K tungsten lamps are specified. The ASA speed includes the exposure increase required by the CC filter(s).

EXPOSURE WITH OTHER LIGHT SOURCES

This film is balanced for 3200 K tungsten lamps. Other light sources may not give equally good results even with the most appropriate filters. If 3400 K photolamps are used, apply the supplementary information data on the instruction sheet plus a Kodak No. 81A Filter and increase the exposure ⅓ stop. If daylight illumination is used, apply the supplementary data plus a Kodak No. 85B Filter and increase the exposure ⅔ stop.

TRIAL EXPOSURES

For the best color balance with your equipment and process, minor adjustments in speed and color balance may be necessary, even at a 5-second exposure time. Use trial exposures to determine these adjustments.

SPEED SETTINGS

The ASA settings apply to incident-light readings taken from the subject position, and to reflected-light readings from the camera position. For interior scenes, take a reading from the camera position only if both subject and background have about the same brightness. Otherwise, take the reading from a gray card of 18% reflectance* held close to the subject, facing halfway between the camera and the main light. Divide the speed by 2 if the reading is taken from the palm of the hand or the subject's face; divide it by 5 if the reading is taken from a white card of 90% reflectance.* Set the meter calculator as for a normal subject. When a card or the palm of the hand is used, or when incident-light readings are made, allow ½ stop more exposure for dark subjects; ½ stop less for light subjects.

*The Kodak Neutral Test Card, which has a gray side of 18% reflectance and a white side of 90% reflectance, is recommended. In daylight, follow the instructions packaged with the card.

COPYING AND CLOSE-UP WORK

In copying, the use of a gray card as described above is recommended for determining exposures. Whenever the subject is closer than 8 times the focal length of the lens, allowance should be made for the decrease in effective lens opening due to bellows extension.

PROCESSING

Chemicals for preparing a complete set of processing solutions are in the Kodak Ektachrome Film Processing Kit, Process E-6. The kit is available in 1-pint (containing two each of 1-pint units of each developer) and 1-gallon sizes. Chemicals are also available as separate units in larger sizes.

FILM SIZES AVAILABLE

Sheets (inches): 3¼ x 4¼, 4 x 5, 5 x 7, 8 x 10 and 11 x 14. Also 9 x 12 centimeters: Rolls: EPY135-36 (film code 5018) and EPY120 (film code 6018).

(Continued on following page)

EASTMAN KODAK

KODAK EKTACHROME 50 PROFESSIONAL FILM (Tungsten) IN ROLLS

This film in 135-36, 120, and long roll sizes is color balanced for exposure times from 1/30 to 1 second. The instruction sheet packaged with the film indicates the effective ASA speed of that particular emulsion. The speed can be 40, 50, or 64. When the speed is ASA 50, the table below indicates the speed and filter suggestions for other light sources. Adjust the speed values in the table accordingly when the indicated effective speed is other than 50.

Light Source	Speed	Filter
Tungsten (3200 K)	ASA 50 (at ½ sec)	None
Photolamp (3400 K)	ASA 40 (at ½ sec)	81A
Daylight	ASA 40 (at 1/60 sec)	85B

DIFFUSE RMS GRANULARITY VALUE: 11
(Read at a gross diffuse density of 1.0, using a 48-micrometer aperture, 12X magnification.)

RESOLVING POWER VALUES
Test-Object Contrast 1.6:1 50 lines per mm
Test-Object Contrast 1000:1 125 lines per mm

KODAK EKTACHROME 160 PROFESSIONAL FILM (Tungsten)

A high-speed color-reversal roll film balanced for exposure with tungsten (3200 K) lamps. It is a special-purpose, high-speed film intended primarily for use under existing tungsten light conditions. With most types of fluorescent lighting or arc lamps, Kodak Ektachrome 200 Professional Film (Daylight) will give more satisfactory results. When processed, this film produces positive color transparencies suitable for projection, direct viewing, or use as originals for color prints. This professional film is color-balanced for direct viewing with the standard 5000 K light source adopted by the American National Standards Institute (ANSI Standard PH2.31-1960).

IMPORTANT

These instructions are based on average emulsions used under average conditions. Information applying to film of a specific emulsion number is given on the instruction sheet packaged with the film. The effective speed can be ASA 125, 160, or 200.

SPEED

The number given after each light source is based on an ANSI Standard and is for use with meters and cameras marked for ASA speeds.

Light Source	Speed	With Filter Such as:
Tungsten (3200 K)	ASA 160	None
Photolamp (3400 K)	ASA 125	Kodak No. 81A
Daylight	ASA 100	Kodak No. 85B

Note: Exposures longer than 1/10 second may require filtration and exposure compensation. See reciprocity data elsewhere in this section.

TUNGSTEN (3200 K) REFLECTOR-TYPE LAMP EXPOSURE TABLE

Based on the use of two 3200 K reflector-type lamps—one as a fill-in light close to camera at lens level, the other as the main light 2 to 4 feet higher and at 45 degrees from the camera-subject axis.

Lens Opening at 1/50 or 1/60 Second			f/8	f/5.6	f/4	f/2.8	f/2
Lamp-to-Subject Distance in Feet	EAL Lamps (G.E.)	Main Light	4	5½	8	11	15½
		Fill-in Light	5½	8	11	15½	22
	R-32 Lamps (Sylvania)	Main Light	5	7	10	13½	20
		Fill-in Light	7	10	13½	20	28

Note: These values are intended only as guides. They give a lighting ratio of about 3 to 1. For a 2-to-1 ratio, move the fill-in light in to the same distance from the subject as the main light and use a ½-stop smaller lens opening.

TRIAL EXPOSURE SETTINGS FOR EXISTING-LIGHT SUBJECTS

Subject	Shutter Speed (Second)	Lens Opening
Home Interiors at Night		
Bright Light	1/30	f/2.0
Average Light	1/8*	f/2.8
Dim Light or Candlelight	1/4*	f/2.8
Brightly Lighted Street Scenes at Night	1/30	f/2.8
Well-Lighted Night or Indoor Sports	1/60	f/2.8

(Continued on following page)

EASTMAN KODAK

The Compact Photo-Lab-Index

*Use a tripod or other firm camera support.

BASIC DAYLIGHT EXPOSURE
With a filter such as the Kodak Wratten Filter No. 85B, for average subjects in bright sunlight: Between f/11 and f/16 at 1/125 second.

FLASHBULB GUIDE NUMBERS
Divide the proper guide number by the flash-to-subject distance in feet to determine the f/number for average subjects.

GUIDE NUMBERS* FOR BLUE FLASHBULBS AND A NO. 85B FILTER

Between-Lens Shutter Speed	Syn-chroni-zation	Flash-cube	AG-1B†	M2B‡	M3B‡ 5B§ 25B§	Focal-Plane Shutter Speed	6B§ or 26B§
Open 1/25—1/30	X or F	90	130	120	180	1/25—1/30	170
1/25—1/30	M	60	90	NR**	180	1/50—1/60	130
1/50—1/60	M	60	90	NR	160	1/100—1/125	90
1/100—1/125	M	50	75	NR	130	1/200—1/250	60
1/200—1/250	M	40	65	NR	105	1/400—1/500	45
1/400—1/500	M	32	50	NR	80	1/1000	30

*For use with bowl-shaped polished reflectors. If shallow cylindrical reflectors are used, divide these guide numbers by 2.

Bowl-shaped polished reflector sizes: †2-inch; ‡3-inch; §4- to 5-inch.

**NR = Not Recommended.

CAUTION
Since bulbs may shatter when flashed, the use of a flashguard over the reflector is recommended. Do not flash bulbs in an explosive atmosphere.

ELECTRONIC FLASH GUIDE NUMBERS
This table is a starting point in determining the correct guide number for your equipment. It is based on the use of the Kodak Filter No. 85B. The table is for use with equipment rated in beam candlepower-seconds (BCPS) or effective candlepower-seconds (ECPS). Divide the indicated guide number by the flash-to-subject distance in feet to determine the f-number for average subjects. Adjust the guide number to fit your requirements.

Output of Unit (BCPS)		350	500	700	1000	1400	2000	2800	4000	5600	8000
		Effective Film Speed				ASA 125					
Guide Number for Trial	Feet	35	45	55	65	75	90	110	130	150	180
	Meters	11	14	17	20	22	27	33	40	46	55
		Effective Film Speed				ASA 160					
Guide Number for Trial	Feet	40	50	60	70	85	100	120	140	170	200
	Meters	12	15	18	21	26	30	36	42	50	60

(Continued on following page)

EASTMAN KODAK

The Compact Photo-Lab-Index

		Effective Film Speed				ASA 200					
Guide	Feet	45	55	65	80	95	110	130	160	190	220
Number for Trial	Meters	14	17	20	24	29	33	40	50	60	65

Do not use shutter speeds longer than 1/50 second; otherwise, results may be influenced by illumination other than electronic flash. If your transparencies are consistently bluish, use a CC05Y or CC10Y filter, or equivalent, over the camera lens. Increase exposure ⅓ stop if a CC10Y filter is used.

PROCESSING

Chemicals for preparing a complete set of processing solutions are in the Kodak Ektachrome Film Processing Kit, Process E-6. The kit is available in 1-pint (containing two each of 1-pint units of each developer) and 1-gallon sizes. Chemicals are also available as separate units in larger sizes.

FILM SIZES AVAILABLE

EPT135-36 (film code 5037), EPT120 (film code 6037).

DIFFUSE RMS GRANULARITY VALUE: 13

(Read at a gross diffuse density of 1.0, using 48-micrometer aperture, 12X magnification.)

RESOLVING POWER VALUES

Test-Object Contrast 1.6:1 50 lines per mm
Test-Object Contrast 1000:1 125 lines per mm

KODAK FILTERS FOR KODAK COLOR FILMS

See film instructions for current recommendations and corresponding speed values.

	Kodak Film			
	Daylight	**Type A**	**Tungsten**	**Type L**
Light Source	**(Kodachrome, Ektachrome, Kodacolor, and Vericolor II Professional, Type S)**	**(Kodachrome 40, 5070, Type A)**	**(Ektachrome)**	**(Vericolor II Professional, Type L)**
Daylight	None*	No. 85	No. 85B	No. 85B
Electronic Flash	None†	No. 85	Not recommended‡	Not recommended
Blue Flashbulbs	None	No. 85	Not recommended‡	Not recommended
Clear Flashbulbs	No. 80C or 80D§	No. 81C	No. 81C	Not recommended
Photolamps (3400 K)	No. 80B	None	No. 81A	No. 81A
Tungsten (3200 K) Lamps	No. 80A	No. 82A	None	None

*With reversal color films, a Kodak Skylight Filter No. 1A can be used to reduce excessive bluishness of pictures made in open shade or on overcast days, or pictures of distant scenes, such as mountain and aerial views.

†If results are consistently bluish, use a CC05Y or CC10Y Filter with Kodak Ektachrome and Ektachrome Professional Films (Process E-6); use a No. 81B Filter with Kodachrome or Kodacolor Films. Increase exposure ⅓ stop when a CC10Y or 81B filter is used.

‡Kodak Ektachrome 160 or Ektachrome 160 Professional Films (Tungsten) can be exposed with a No. 85B Filter.

§Use No. 80D Filter with zirconium-filled flashbulbs, such as AG-1 and M3.

(Continued on following page)

EASTMAN KODAK

STARTING FILTERS AND EXPOSURE INCREASES* FOR TEST SERIES WITH FLUORESCENT ILLUMINATION

Kodak Film Type	Type of Fluorescent Lamp†					
	Daylight	White	Warm White	Warm White Deluxe	Cool White	Cool White Deluxe
Daylight Type and Type S	40M+ 30Y + 1 stop	20C+ +30M +1 stop	40C+ 40M +1⅓ stops	60C+ 30M +1⅔ stops	30M +⅔ stop	30C+ 20M +1 stop
Type B or Tungsten and Type L	85B‡+ 30M +10Y +1⅔ stops	40M+ 40Y +1 stop	30M+ 20Y +1 stop	10Y +⅓ stop	50M+ 60Y +1⅓ stops	10M+ 30Y +⅔ stop
Type A	85§+ 30M +10Y +1⅔ stops	40M+ 30Y +1 stop	30M+ 10Y +1 stop	No Filter None	50M+ 50Y +1⅓ stops	10M+ 20Y +⅔ stop

*Increase a meter-calculated exposure by the amount indicated in the table to compensate for light absorbed by the filters recommended. If this makes the exposure time longer than that for which the film is designed, refer to reciprocity data elsewhere in this section for further filter and exposure-time adjustments that must be added to these lamp-quality corrections.

†When it is difficult or impossible to gain access to fluorescent lamps in order to identify the type, ask the maintenance department.

‡Kodak Wratten Filter No. 85B. §Kodak Wratten Filter No. 84.

RECIPROCITY DATA: KODAK COLOR FILMS

Illumination (intensity of light) multiplied by exposure time equals exposure. You may have seen this relationship expressed as I x t = E. Given this formula, it would appear that when the product of the two is held constant, the photographic effect will always be the same. Actually, the sensitivity of a photographic emulsion may change with changes in the illumination level and the exposure time.

When the lighting is very weak, and a film requires long exposures, the effective speed of an emulsion decreases. For black-and-white films, the loss of effective speed is relatively unimportant because of wide exposure latitude. With multilayer color films, on the other hand, it is often necessary to give more than the calculated exposure when the light intensity is low and the exposure time is long. Furthermore, since sensitivity changes may be different for each of the three emulsion layers, with consequent changes in color balance, it may be necessary to use color compensating filters.

(Continued on following page)

EXPOSURE* AND FILTER COMPENSATION FOR THE RECIPROCITY CHARACTERISTICS OF KODAK COLOR FILMS

Exposure Time (Seconds)

Kodak Films	1/10,000	1/1000	1/100	1/10	1	10	100
Kodacolor II		None No Filter	None No Filter		+½ Stop No Filter	+1½ Stops CC10C	+2½ Stops CC10C+10G
Kodacolor 400		None No Filter	None No Filter		+½ Stop No Filter	+1 Stop No Filter	+2 Stops No Filter
Vericolor II Professional, Type S			None No Filter		Not Recommended		
Vericolor II Professional, Type L		Not Recommended		See film instructions for speed values at 1/50 through 60 seconds' exposure times			
Ektachrome 64 Professional (Daylight) and Ektachrome 64 (Daylight)	+½ Stop No Filter		None No Filter		+1 Stop CC15B	+1½ Stops CC20B	Not Recommended
Ektachrome 50 Professional (Tungsten) Roll Film†	—	+½ Stop CC10G		None No Filter		+1 Stop CC20B	Not Recommended

(Continued on following page)

EASTMAN KODAK

173

EASTMAN KODAK

EXPOSURE* AND FILTER COMPENSATION FOR
THE RECIPROCITY CHARACTERISTICS OF KODAK COLOR FILMS

Kodak Films	Exposure Time (Seconds)						
	1/10,000	1/1000	1/100	1/10	1	10	100
Ektachrome 200 Professional (Daylight) and Ektachrome 200 (Daylight)	+½ Stop No Filter		None No Filter		+½ Stop CC10R	Not Recommended	Not Recommended
Ektachrome 160 Professional (Tungsten) and Ektachrome 160 (Tungsten)	—		None No Filter		+½ Stop CC10R	+1 Stop CC15R	Not Recommended
Ektachrome Infrared	—		None No Filter	+1 Stop CC20B	Not Recommended	Not Recommended	Not Recommended
Kodachrome 40, 5070 (Type A)			None No Filter		+1 Stop CC10M	+1½ Stops CC10M	+2½ Stops CC10M
Kodachrome 25 (Daylight)			None No Filter		+1 Stop CC10M	+1½ Stops CC10M	+2½ Stops CC10M
Kodachrome 64 (Daylight)			None No Filter		+1 Stop CC10R	Not Recommended	Not Recommended

*The exposure increase, in lens stops, includes the adjustment required by any filter(s) suggested.
†For 6118 sheet film, see supplementary data on the instruction sheet packaged with the film.

Notes: The data for each film are based on average emulsions and are rounded to the nearest ½ stop. They apply only to the type of illumination for which that film is balanced, and assume normal recommended processing. The data should be used as guides only. The adjustments are subject to change due to normal manufacturing variations or subsequent film storage conditions after the film leaves the factory.

(Continued on following page)

The Compact Photo-Lab-Index

RESOLVING POWER. The resolving power of a film refers to the limit of the ability of the film to record fine detail distinguishably. Resolving power is also referred to as *resolution*. In measuring resolving power, a parallel-line test chart is photographed, usually at a great reduction in size. The lines on the test chart are separated by spaces of the same width as the lines. Test charts usually contain many target elements of various line sizes. Examination of the film image with a microscope determines the target element with the greatest number of lines per millimetre which are distinguishable, light from dark, in the test film. The higher the number of lines per millimetre that can be distinguished, the higher the resolving power.

Resolving power values are given for two test-object contrasts (TOC), 1.6:1 and 1000:1. The 1000:1 TOC value can be classified by descriptive adjectives according to the following chart:

1000:1 TOC	Classification
50 or below	Low
63, 80	Medium
100, 125	High
160, 200	Very High
250, 320, 400, 500	Extremely High
630 or above	Ultra High

MODULATION TRANSFER FUNCTION is a measurement used to describe the ability of films, lenses, and other optical components to reproduce the detail contained in an object. Modulation transfer characteristics of a film indicate the effects on the microstructure of the image caused by diffusion of light within the emulsion.

To obtain these data, patterns having a sinusoidal variation in illuminance in one direction are exposed onto the film. The "modulation," Mo, of each pattern can be expressed by the formula

$$Mo = \frac{E\ max - E\ min}{E\ max + E\ min} ,$$

in which E represents exposure.

After development, the photographic image is scanned in a microdensitometer in terms of visual density, the densities of the trace are interpreted in terms of exposure, and the effective modulation of the image Mi is calculated. The modulation transfer factor is the ratio of the modulation of the developed image to the modulation of the exposing pattern, or $\frac{Mi}{Mo}$. The modulation transfer curves

show a plot of this ratio (on a logarithmic scale) as a function of the spatial frequency of the patterns in cycles per millimetre. The films were exposed with the specified illuminant to spatially varying sinusoidal test patterns having an aerial image modulation of a nominal 35 percent at the image plane, with processing as indicated.

In most cases, the photographic modulation transfer values are influenced by development adjacency effects and are not equivalent to the true optical modulation transfer curve of the emulsion layer in the particular photographic product.

(Continued on following page)

EASTMAN KODAK

175

The Compact Photo-Lab-Index

By multiplication of ordinates of the individual curves, the modulation transfer data for a film can be combined with similar data for the optical system with which it will be used, to predict the final image-detail characteristics.

GRANULARITY AND GRAININESS are terms that are often confused and used interchangeably in discussions of the uniformity of silver or dye deposits in photographic emulsions. The *granularity* of photographic materials is defined as a mathematical summary of the spatial variations of density that are measured when numerous readings are made with a densitometer having a sufficiently small aperture. Granularity is a purely objective or measured quantity. *Graininess* is subjective and is often defined as the sensation of nonuniformity in an image that is produced in the mind of the observer when the image is viewed. It is usually not "seen" in the film image directly, but in enlargements made from that image.

Granularity measurement data are expressed as Diffuse RMS Granularity Values. This value represents 1000 times the standard deviation of density produced by the granular structure when a uniformly exposed and developed sample is scanned with a densitometer calibrated to read American National Standard diffuse visual density (PH2.19-1959). The measurements, made with a 48-microtre diameter aperture, will indicate the magnitude of the graininess sensation produced by viewing the diffusely illuminated sample with 12X monocular magnification. If the viewing magnification is changed, the rms values may no longer correlate with the relative graininess sensation. RMS (root-mean-square) is a mathematical term used to characterize deviations from a mean value.

Reversal and direct duplicating color films are measured at a gross diffuse density of 1.00. Negative, internegative, slide, and print color films are measured at a net diffuse density of 1.00.

The granularity values can also be given graininess classifications according to the following chart:

Diffuse RMS Granularity Value	Graininess Classification*
45, 50, 55	Very Coarse
33, 36, 39, 42	Coarse
26, 28, 30	Moderately Coarse
21, 22, 24	Medium
16, 17, 18, 19, 20	Fine
11, 12, 13, 14, 15	Very Fine
6, 7, 8, 9, 10	Extremely Fine
less than 5.5	Micro Fine

*Cross-comparisons between negative and reversal films can be misleading. Only similar types of films should be intercompared.

(Continued on following page)

176

KODAK EKTACHROME CHEMICALS FOR PROCESS E-6

Process E-6 was developed for the processing of new KODAK EKTACHROME Films introduced in the past several years. The Process E-6 chemicals are now available in convenient kit form.

The KODAK EKTACHROME Film Processing Kit, Process E-6, contains first developer, reversal bath, color developer, conditioner, bleach, fixer, and stabilizer.

All chemicals are supplied as easy-to-mix concentrates, ready to dilute and use. They are available separately in larger concentrate quantities.

Process E-6 offers improved uniformity and process stability for consistently high-quality results without frequent adjustment of the process. It meets expected environmental requirements and, when operated to capacity, uses less water and energy than earlier processes.

Using Process E-6, roll films can be processed in one-pint tanks, sink lines and automatic processors. Sheet films can be processed in sink lines and automatic processors. Following is a Process E-6 summary of steps for one-pint tanks:

PROCESS E-6 SUMMARY OF STEPS (for 1-Pint Tanks)

Solution or Procedure	Remarks	Temperature °C	°F	Time in Minutes	Total Time at End of Step
1. First Developer	First 4 steps in total darkness. Initial and subsequent agitation in first 3 steps	37.8±0.3	100±½	7	7*
2. Wash†		33.5-39	92-102	1	8
3. Wash†		33.5-39	92-102	1	9
4. Reversal Bath	Initial only	33.5-39	92-102	2	11
Remaining steps can be done in normal room light.					
5. Color Developer	Initial and subsequent agitation	37.8±1.1	100±2	6	17
6. Conditioner	Initial only	33.5-39	92-102	2	19
7. Bleach	Initial and subsequent agitation	33.5-39	92-102	7	26
8. Fixer	Initial and subsequent agitation	33.5-39	92-102	4	30
9. Wash (running water	Initial and subsequent agitation	33.5-39	92-102	6	36
10. Stabilizer	Initial only	33.5-39	92-102	1	37
11. Dry	Remove film from reels; temperature should not exceed 49°C (120°F)				

*For initial films through a 1-pint set of solutions. See instruction sheet for times of subsequent films through the same set of solutions.

†Still water washes. Alternate wash in running water for 2 minutes.

(Continued on following page)

KODAK FLEXICOLOR CHEMICALS FOR PROCESS C-41

Process C-41 is recommended for the processing of KODACOLOR II, KODA-COLOR 400, and KODAK VERICOLOR II Professional Films. Developed to produce color negatives of uniformly high quality, it makes use of a number of KODAK FLEXICOLOR chemicals, available either separately or in convenient kit form.

The KODAK FLEXICOLOR Processing Kit (for Process C-41) includes developer, bleach, fixer, and stabilizer in quantities sufficient to make one pint of solution. The individual chemicals are available for larger amounts of solution.

The chemicals for Process C-41 can be used in small one-pint tanks, rotary tubes, sink-line processing equipment, and continuous machines. Following is a summary of steps for processing KODACOLOR II KODACOLOR 400, and KODAK VERICOLOR II Professional Films, using the processing kit.

PROCESS C-41 SUMMARY OF STEPS (for 1-Pint Tanks)

Solution or Procedure	Remarks	Agitation			°C	°F	Time in Minutes†
		Initial*	Rest	Agitate			
1. Developer	Total darkness	30 sec	13	2	37.8±0.15	100±¼	3¼
2. Bleach		30 sec	25	5	24-40.5	75-105	6½
Remaining steps can be done in normal room light.							
3. Wash	Running water‡				24-40.5	75-105	3¼
4. Fixer		30 sec	25	5	24-40.5	75-105	6½
5. Wash	Running water‡				24-40.5	75-105	3¼
6. Stabilizer		30 sec			24-40.5	75-105	1½
7. Dry	See instructions				24-43.5	75-110	10-20

*Rap the bottom of the tank firmly on the sink or table to dislodge any air bells. Be sure you have read the agitation recommendations elsewhere in these instructions.

†Includes 10-second drain time in each step.

‡Use fresh water changes throughout the wash cycles. Fill the processing tank as rapidly as possible from a running water supply for about 4 seconds. When full, agitate vigorously for about 2 seconds and drain for about 10 seconds. Repeat this full wash cycle. If desired, use a running water inflow-overflow wash with the cover removed from the tank.

(Continued on following page)

178

The Compact Photo-Lab-Index

KODAK EKTAPRINT 2 CHEMICALS FOR PROCESSING KODAK EKTACOLOR 74 RC PAPER

These chemicals can be used in baskets, trays, and tanks for two-solution processing of EKTACOLOR 74 RC Paper. The KODAK EKTAPRINT 2 Processing Kit contains a developer and a bleach-fix in concentrated form to make a 3½ gallon solution. These and other EKTAPRINT 2 Chemicals are also available separately and in larger concentrate quantities.

Drum and tube-type processors used for processing EKTACOLOR RC Paper require KODAK EKTAPRINT 300 Developer.

Three-solution processing can be employed, if desired, with the addition of KODAK EKTAPRINT 3 Stabilizer and Replenisher.

Following is a summary of steps for tray and basket processing of KODAK EKTACOLOR 74 RC Paper. (Tube processing calls for a prewet step before developer step to help prevent streaking.)

SUMMARY OF STEPS FOR TRAY AND BASKET PROCESSES

Solution or Procedure	Remarks	Temperature		Time in Minutes*	Time at End of Step (w/optional steps)	
		°C	°F			
1. Developer	No. 13 Safelight Filter (use 7½-watt bulb)	33±0.3	91±½	3½	3½	
(Optional steps†) a. C-22 Stop Bath	Agitate as described	30-34	86-93	1	(4½)	
b. Wash	Running water			1	(5½)	
2. Bleach-Fix	—	30-34	86-93	1½	5	(7)
Remaining steps can be done in normal room light.						
3. Wash	Running water	30-34	86-93	3½	8½	(10½)
4. Dry	Air-dry—don't ferrotype!	Not over 107	Not over 225			

*Include a 20-second drain time in each process step. Baskets of complex design can be drained for 30 seconds to prevent excessive carry-over.

†The optional steps are suggested if marks or streaks are observed on the surface of prints. Excessive developer carry-over and inadequate agitation are usually responsible for such marks.



EASTMAN KODAK

(Continued on following page)

The Compact Photo-Lab-Index

KODAK EKTAPRINT R-500 CHEMICALS FOR PROCESSING KODAK EKTACHROME RC PAPER, TYPE 1993

These chemicals are specifically intended for processing KODAK EKTACHROME RC Paper, Type 1993, in tube-type or drum processors (such as KODAK Rapid Color Processors).

They include a first developer, stop bath, color developer, bleach-fix and stabilizer, which are available in the KODAK EKTAPRINT R-500 Processing Kit in concentrated form sufficient to make 1-quart solutions. They are available separately in sizes for making 1-gallon solutions.

KODAK EKTACHROME RC Paper, Type 1993, can also be processed in trays, baskets, reels, and automatic processors using EKTAPRINT R-5 Chemicals (no processing kit available).

The new KODAK EKTACHROME 2203 Paper can be processed on continuous processors using KODAK EKTAPRINT R-100 Chemicals. Processing recommendations and chemicals are different from those for Type 1993 Paper. Consequently, the two papers cannot be run in the same process.

Following is a summary of steps for processing EKTACHROME Paper, Type 1993, in the KODAK Rapid Color Processor Models 11 and 16-K.

SUMMARY OF STEPS FOR KODAK RAPID COLOR PROCESSOR, Models 11 and 16-K*

Solution or Procedure	Remarks	Drum Temperature °C	°F	Time in Minutes†	Time End of Step
1. Prewet	In tray of water. 21-39°C (70-102°F)			1	1
2. First Developer	Total darkness for	38±0.3	100±½	1½	2½
3. Stop Bath	first three steps	38±0.6	100±1	½	3
4. First Wash†	Kodak Safelight Filter No. 10, or OA can be	38±1.0	100±2	2	5
5. Color Developer	used for Steps 4 & 5	38±0.6	100±1	3	8
Remaining steps can be done in normal light					
6. Second Wash‡		38±1.0	100±2	½	8½
7. Bleach Fix		38±0.6	100±1	1½	10
8. Final Wash		38±1.0	100±2	1½	11½
9. Stabilizer		38±0.6	100±1	1	12½
10. Water Rinse†		38±1.0	100±2	¼	12¾
11. Dry	Air-dry, not over 66°C (150°F) Do not ferrotype!				

*For summary of steps for Model 30A, see process instruction sheet.

†Include drain time of 10 seconds for prewet step; 5 seconds for other steps.

‡Water flow rate is 7.5 to 9.5 liters/min (2.5 gal/min).

(Continued on following page)

180

KODAK EKTACHROME Professional Films (Process E-6)

A line of improved Kodak Ektachrome professional still camera films and an improved process for them are now available. These new films show improvements in speed, color quality, sharpness, and granularity compared with the Process E-3 Ektachrome professional films that are being replaced. The four new Ektachrome professional films use Process E-6 chemicals at a temperature of 38°C (100.4°F). Having hardened emulsions, the new films do not require prehardener or neutralizer processing steps (as do Process E-4 films) to withstand the higher processing temperature. Reversal exposure with light has been eliminated by a reversal bath prior to the color developer step. This change makes processing much easier when stainless steel reels, rotary tubes, or sink lines are used. The Process E-6 total nominal wet processing time is 50 percent shorter than that of Process E-3, doubling the processing output. The new Process E-6 also uses less water (about 66% less than Process E-3), thereby reducing water costs and possibly pure water and sewer charges. The new films dry faster than the Process E-3 or E-4 films. Process E-6 chemicals will also process two new Ektachrome duplicating films and a line of improved Kodak Ektachrome consumer (amateur) camera films that will be introduced in 1977. The new duplicating films and the new camera films can be processed in the same process, using the same processing times.

FILM STORAGE

All Kodak Ektachrome professional films and the duplicating films in their original sealed packages should be kept in a refrigerator at 13°C (55°F) or lower. Allow packages of film to warm up to room temperature before opening to avoid moisture condensation on the film surfaces. Keep films, before and after exposure, cool and dry. If exposed films cannot be processed within a week, wrap them for protection from moisture and refrigerate until they can be processed. Protect transparencies from strong light and store them in a cool, dry place.

THE NEW FILMS

The new Process E-6 Ektachrome professional sheet films have a nominal speed of ASA 64 for the daylight type and ASA 50 for the tungsten type, representing increases in speed of $\frac{1}{3}$ and $\frac{2}{3}$ of a stop, respectively. These films are also available in regular roll and long roll sizes as indicated in one of the following tables. For the first time, high-speed professional film is available in regular roll and long roll sizes: a nominal speed of ASA 200 for daylight and ASA 160 for tungsten illumination. Pro-packs (four rolls of 135-36 size or five rolls of 120 size) are available for all professional camera films except KODAK EKTACHROME 50 Professional Film (Tungsten).

(*Continued on following page*)

EASTMAN KODAK

The Compact Photo-Lab-Index

EXPOSING THE FILM

Kodak Ektachrome professional films, daylight type, are designed for exposure with daylight, electronic flash, or blue flash illumination. Other light sources can be used with the designated filter and an adjustment in film speed. For best results, Kodak Ektachrome professional films, tungsten type, should be used for tungsten (3200 K) and photoflood (3400 K) illumination.

In order to provide the professional user with accurate speed information for a specific emulsion, the effective film speed (rated speed or ±⅓ of a stop) is imprinted on the instruction sheet packaged with the Process E-6 Ektachrome professional films. The footnotes on one of the exposure tables indicate what the film speeds can be for the various films. For tungsten sheet film, speeds are also given for

½-, 5-, and 30-second exposure times and include the exposure increase required by the suggested CC filters at the 5- and 30-second exposure times. For the best color balance, use of a CC filter may be desirable even at ½ second with tungsten (3200 K) lamps. If so, this filter should be added to the CC filters used at long exposure times.

In terms of color balance, one emulsion can vary from optimum by a CC10 filter, which means that in an extreme case, two emulsions could be as far apart as a CC20 filter. Such an extreme, however, seldom occurs as a result of manufacturing variations alone. Causes to suspect are high temperature or humidity during storage (either before or after exposure), illumination of incorrect color quality, processing variations, and variations in time of exposure.

KODAK EKTACHROME PROFESSIONAL FILMS (Process E-6)
DAYLIGHT TYPE

SHEET FILM
EKTACHROME 64 Professional
(Daylight)
8.2-mil Acetate Base; Code 6117)

Inches: 4 x 5, 5 x 7, 8 x 10, 11 x 14
Centimeters: 9 x 12

LONG ROLL FILM
EKTACHROME 64 Professional
(Daylight)
(5-mil Acetate Base; Code 5017)
EPR404, EPR415, EPR417
35 mm x 100 ft

EPR475	EPR446
70 mm x 100 ft	46 mm x 100 ft
EPR488	
70 mm x 15 ft	

EKTACHROME 200 Professional
(Daylight)
(5-mil Acetate Base; Code 5036)
EPD404
35 mm x 100 ft
EPD475
70 mm x 100 ft

ROLL FILM
EKTACHROME 64 Professional
(Daylight)
(5-mil Acetate Base; Code 5017)
EPR135-36
Single rolls, Pro-packs of 4 rolls
(3.6-mil Acetate Base; Code 6017)
EPR120
Single rolls, Pro-packs of 5 rolls

EKTACHROME 200 Professional
(Daylight)
(5-mil Acetate Base; Code 5036)
EPD135-36
Single rolls, Pro-packs of 4 rolls
(3.6-mil Acetate Base; Code 6036)
EPD120
Single rolls, Pro-packs of 5 rolls

(Continued on following page)

182

The Compact Photo-Lab-Index

TUNGSTEN TYPE

SHEET FILM
EKTACHROME 50 Professional (Tungsten)
(8.2-mil Acetate Base; Code 6118)

Inches: 3¼ x 4¼, 4 x 5, 5 x 7,
8 x 10, 11 x 14
Centimeters: 9 x 12

LONG ROLL FILM
EKTACHROME 50 Professional (Tungsten)
(5-mil Acetate Base; Code 5018)
EPY404
35 mm x 100 ft

EKTACHROME 160 Professional (Tungsten)
(5-mil Acetate Base; Code 5037)
EPT404
35 mm x 100 ft

ROLL FILM
EKTACHROME 50 Professional (Tungsten)
(5-mil Acetate Base; Code 5018)
EPY135-36
Single rolls
(3.6-mil Acetate Base; Code 6018)
EPY120
Single rolls

EKTACHROME 160 Professional (Tungsten)
(5-mil Acetate Base; Code 5037)
EPT 135-36
Single rolls, Pro-packs of 4 rolls
(3.6 mil Acetate Base; Code 6037)
EPT120
Single rolls, Pro-packs of 5 rolls

KODAK EKTACHROME Slide Duplicating Film 5071 (Process E-6)

KODAK EKTACHROME Slide Duplicating Film 5071 is a color reversal film for making slides from original transparencies. It is designed for Process E-6 and can be intermixed with camera films in processing with no adjustment of development times. The film is available in long rolls—35 mm and 46 mm widths—and 135-36 magazines. The characteristics of this slide duplicating film, including low, matched color-layer contrasts, contribute to good color reproduction in most slide duplicating operations.

The film base is 0.13 mm (0.005-inch) acetate. There is no gelatin backing; an antihalation layer is located beneath the emulsion layers.

APPLICATIONS
This material is intended for use in photofinishing and professional slide-duplicating operations for making slide sets or filmstrips. The film is intended primarily for exposure with tungsten illumination (conventional photo enlarger lamps or tungsten-halogen lamps). It can also be exposed in electronic-flash slide-copying devices if color-compensating or color-printing filters are used to balance the light source. Fluorescent lights are not recommended for exposing this film.

PRINTING EQUIPMENT AND EXPOSURE
Use either optical or contact-printing equipment to expose this film. A diffuse optical system minimizes difficulty with dust and scratches. Make a series of exposure tests to determine the proper exposure level. For a tungsten light source, the exposure time should be about 1 second. For electronic flash, the exposure time will be about 1/1000 second. Start with the suggestions given and vary the intensity of the light at the film plane until the slide density is correct. The reciprocity effect with this slide duplicating film is minimal. Adjustment in light intensity may be necessary to maintain correct slide density if extremely short or long exposure times are used.

FILM STORAGE AND HANDLING
Color films are seriously affected by adverse storage conditions. High temperatures or high humidity may produce undesirable changes in the film. These adverse conditions usually affect the three emulsion layers to differing degrees, thus causing a change in color balance as well as a change in film speed and contrast.

183

The Compact Photo-Lab-Index

Keep unexposed film in a refrigerator or a freezer at 13°C (55°F), or lower, in the original sealed container. Remove film from a refrigerator and let it stand about 2 hours before opening the container; remove film stored in a freezer about 8 hours before opening. Sufficient warming time is necessary to prevent the condensation of atmospheric moisture on the cold film. Keep exposed film cool and dry. Process the film as soon as possible after exposure to avoid undesirable changes in the latent image. Store processed film in a dark, dust-free area at a temperature of 10 to 21°C (50 to 70°F) and at a relative humidity of 30 to 50 percent.

Handle unprocessed film only in total darkness. During processing, the film can be exposed to room light after it has been in the reversal bath for one minute.

STARTING FILTER PACK

KODAK EKTACHROME Slide Duplicating Film 5071 has significant sensitivity to both ultraviolet and infrared radiation. An ultraviolet absorber, such as the KODAK WRATTEN Filter No. 2B, is needed in the basic filter pack. The dye systems of KODACHROME and EKTACHROME Films (both older films and recently improved products) display differing degrees of infrared absorption. This can lead to a difference in the color quality of duplicates made from a mixture of original transparencies. The table shows where a KODAK Infrared Cutoff Filter, No. 304, is recommended to compensate for this variability of infrared absorption.

The KODAK Infared Cutoff Filter, No. 304, is a multilayer dichroic interference filter on glass. For effective results with an interference filter, position it **with care** in the light beam. Place the filter close to the light source, perpendicular to a specular, collimated part of the beam. Tipping the filter or allowing the light to pass through the filter at an angle changes the spectral transmittance characteristics of the filter. The KODAK Infrared Cutoff Filter, No. 304, is available in 70 mm (2¾-inch) filter size (Kodak Part No. 541052) to fit several slide duplicating units.

SLIDE DUPLICATING WITH 35 MM CAMERA

A 35 mm single lens reflex camera having a through-the-lens metering system and equipped with a slide duplicating attachment is a convenient unit for making small numbers of duplicate slides. As a starting point, use a tungsten exposure index of 8 (with meters calibrated in ASA Speeds) and the following filters:

Original on this KODAK Film	Use these KODAK Color Compensating Filters, or equivalent
KODACHROME (Process K-12)	CC10M
EKTACHROME (Process E-4)	CC20R
EKTACHROME (Process E-6)	CC10R + CC10M

Place the filters between the transparency and the 3200 K tungsten light source. Make sure that the filter pack is in place when metering or making exposures. Make a filter ring-around and an exposure series to determine the correct color balance and exposure for each new film emulsion used.

PROCESSING AND PROCESS CONTROL

Process KODAK EKTACHROME Slide Duplicating Film 5071 in Process E-6 chemicals. Process the duplicating film separately or along with camera films; no adjustment in the process is necessary. Use the standard first developer time for all films.

Follow the process control methods recommended for Process E-6. Eastman Kodak Company supplies process control strips for Process E-6.

JUDGING EXPOSURES AND ADJUSTING THE FILTER PACK

View slides on a standard illuminator (5000 K, as recommended in ANSI Standard PH2.31-1969) or project them in a darkened room. After examining a slide with illumination of the correct intensity and color distribution, decide if changes in density or color balance of the duplicate are necessary to make it match the original. The following table will be helpful in determining the filter pack adjustment.

184

The Compact Photo-Lab-Index

When making filter corrections in the filter pack, remove filters from the pack whenever possible. For example, if a slide is reddish, remove yellow and magenta filters rather than add a cyan filter. The filter pack should contain filters of only two of the three subtractive colors (cyan, magenta, yellow). The effect of including all three is to form neutral density, which only

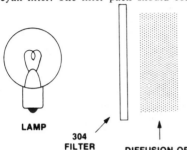

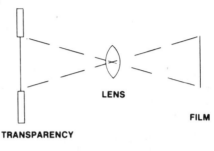

LAMP

304 FILTER

DIFFUSION OR INTEGRATING BAR

TRANSPARENCY

LENS

FILM

lengthens the exposure time without accomplishing any color correction. To eliminate neutral density, determine the color with the lowest filter value, remove the same density from the other two colors. For example:

Filter pack 40C+40M+20Y
Subtract (—) 20C+20M+20Y
 (remove neutral density)
Minimum
 filter pack 20C+20M

Note that in the example given the filter pack of 20C + 20M is nominally equivalent to 20B. Thus, a single blue filter would serve in place of the two filters.

When making simplifications of the filter pack such as removing neutral density or combining filters, keep these factors in mind:

1. The subtraction or substitution may not be exactly equivalent due to differences in absorption characteristics of the different filters.

2. A change in the number of filter surfaces changes the total transmission of the filter pack, because a small

If the overall color balance is	Subtract these filters	or	Add these filters
Yellow	Yellow		Magenta + Cyan
Magenta	Magenta		Yellow + Cyan
Cyan	Cyan		Yellow + Magenta
Blue	Magenta + Cyan		Yellow
Green	Yellow + Cyan		Magenta
Red	Yellow + Magenta		Cyan

amount of image-forming light is lost through reflection at each filter surface.

An ANSI committee has proposed standards for a new projector-type viewer for evaluating small transparencies. The Macbeth Color and Photometry Division of Kollmorgen Corporation (Newburgh, N.Y.) produces the Macbeth Proofflight V-135 viewer, which conforms to the draft specifications.

TRIAL FILTER PACK AND EXPOSURE TIME
PAKOPY PRINTER WITH 3200 K TUNGSTEN LIGHT SOURCE (800 WATTS)

When you duplicate from originals on these KODAK Films[1]	Use a filter pack containing these KODAK Filters, or equivalent	And this printer exposure

The Compact Photo-Lab-Index

KODACHROME (Process K-12) KODACHROME (Process K-14) EKTACHROME (Process E-4) EKTACHROME (Process E-6)	Infrared Cutoff, No. 304 + WRATTEN, No. 2B + Color Compensating, CC25M + Color Compensating, CC45Y + WRATTEN Neutral Density, No. 96 (.40 density)	
EKTACHROME (Process E-4)	WRATTEN, No. 2B + Color Compensating, CC35Y + Color Compensating, CC30C + WRATTEN Neutral Density, No. 96 (.50 density)	One second at f/8
KODACHROME (Process K-12) KODACHROME (Process K-14) EKTACHROME (Process E-6)	WRATTEN, No. 2B + Color Compensating, CC35Y + Color Compensating, CC40C + WRATTEN Neutral Density, No. 96 (.50 density)	

SICKLES-HOMRICH PRINTER
WITH 3350 K QUARTZLINE LAMP/
DICHROIC REFLECTOR ELH
(300 WATTS)

KODACHROME (Process K-12) KODACHROME (Process K-14) EKTACHROME (Process E-4) EKTACHROME (Process E-6)	Infrared Cutoff, No. 304 + WRATTEN, No. 2B + Color Compensating, CC30M + Color Compensating, CC35Y	
EKTACHROME (Process E-4)	WRATTEN, No. 2B + Color Compensating, CC65C + Color Compensating, CC50Y	One second at f/8[2]
KODACHROME (Process K-12) KODACHROME (Process K-14) EKTACHROME (Process E-6)	WRATTEN, No. 2B + Color Compensating, CC75C + Color Compensating, CC50Y	

HONEYWELL-REPRONAR,
MODEL 805A
WITH 5600 K ELECTRONIC-FLASH
LIGHT SOURCE[3]

KODACHROME (Process K-12) KODACHROME (Process K-14) EKTACHROME (Process E-4) EKTACHROME (Process E-6)	Infrared Cutoff, No. 304 + WRATTEN, No. 2B + Color Compensating, CC100Y + Color Compensating, CC25R	f/5.6 High beam
EKTACHROME (Process E-4)	WRATTEN, No. 2B + Color Compensating, CC110Y + Color Compensating, CC05C	f/8 High beam
KODACHROME (Process K-12) KODACHROME (Process K-14) EKTACHROME (Process E-6)	WRATTEN, No. 2B + Color Compensating, CC110Y + Color Compensating, CC15C	

[1]Each listing includes all original camera films intended for the processing method noted in parentheses.

[2]When making size 110 duplicates on 16 mm width film (KODAK EKTA-CHROME Slide Duplicating Film 7071), double the exposure.

[3]With the Bowens Illumitran or other printers having an electronic flash head, use these filter recommendations as a starting point.

KODAK EKTACHROME Duplicating Film 6121 (Process E-6)

KODAK EKTACHROME Duplicating Film 6121 is a color reversal sheet film for the making of high-quality duplicate color transparencies of original transparencies on KODAK EKTACHROME Films, either Process E-3 or Process E-6. Duplicate transparencies can be made same-size, reduced, or enlarged. The film can also be used to make enlarged transparencies from slides on any of the EKTACHROME Films, Process E-4 or E-6, or KODACHROME Films. If somewhat lower contrast is acceptable, the film can be used to copy color prints or other colored reflection copy.

No masking or other means of contrast control is normally required.

The duplicate transparencies made on this film can be displayed on illuminators or can be used as originals for graphic reproduction. They can be separated by conventional film methods or by color scanner for use in catalogs, magazines, and other publications.

The thickness of the duplicating film base is the same as that of camera sheet films, so that both original and duplicate transparencies can be joined by cutting and butting operations. The base has a matte-gel (dyed) antihalation backing, and both sides of the film can be retouched. Duplicate transparencies made on this film can be retouched with KODAK E-6 Transparency Retouching Dyes if they are to be reproduced. Original E-6 transparencies that require dye retouching can be retouched with the same dyes if they are to be duplicated on this film.

FILM STORAGE AND HANDLING

Unexposed film should be stored in a dry place at temperatures not exceeding 13°C (55°F). The film must be handled in total darkness. To prevent moisture condensation on the film surfaces after taking the film from refrigeration, allow the film packages to reach room temperature before opening. A 25-sheet box requires a warm-up time of ½ to 1 hour after removal from refrigerated storage, and of 1 to 1½ hours after removal from freezing-unit storage. Exposed film should be processed as soon as possible to avoid changes in the latent image. Processed film should be kept at 50 percent relative humidity or lower and at 21°C (70°F) or lower to minimize image fading. For long-term keeping, the duplicate transparencies should be sealed in KODAK Storage Envelopes for Processed Film, or equivalent, and stored under refrigeration.

LIGHT SOURCE AND EXPOSING EQUIPMENT

KODAK EKTACHROME Duplicating Film 6121 (Process E-6) is intended primarily for exposure with tungsten illumination such as that supplied by Photo Enlarger Lamps No. 212 or 302, or with tungsten-halogen lamps. Pulsed-xenon light sources can also be used, but fluorescent light sources are not recommended. Appropriate light-balancing filters are usually required with sources other than tungsten.

An enlarger is a convenient light source for making exposures by either contact or projection. The exposing equipment should have a heat-absorbing glass and an ultraviolet absorbing filter such as the KODAK WRATTEN Filter No. 2B or KODAK Color Printing Filter CP2B. A constant-voltage power source minimizes short-term changes in light intensity and color balance.

As a starting point for color correction with a pulsed-xenon light, add CC25M and CC85Y filters to those recommended for tungsten light exposure. See the supplementary Data Sheet packaged with each emulsion for suggested color correction filters for tungsten illumination.

Contact Printing: For adjusting color balance, the exposing equipment must be fitted with a means of holding several filters in the exposing light beam. These can be either CC or CP filters. A color enlarger with color filter dials can also be used.

Projection Printing: If the enlarger has provision for filters between the light source and the transparency being duplicated, use KODAK Color Printing Filters (Acetate), or equivalent, for color-balance adjustments. If filters can be placed only between the lens and the easel, use KODAK Color Compensating Filters (Gelatin), or equiva-

(*Continued on following page*)

187

EASTMAN KODAK

lent, which minimize loss in definition. Use the minimum number of CC filters over an enlarger or camera lens by combining filters. Color enlargers with dial filter settings can also be used.

Copying: When used for copying color prints or other colored reflection copy such as paintings or drawings, KODAK EKTACHROME Duplicating Film yields transparencies of somewhat lower contrast than duplicate transparencies. A standard copy setup can be used for copying on this film, with great care being taken to assure even illumination on the copyboard.

When incandescent illumination is used (3000 to 3200 K), start with the filter pack recommended on the instruction sheet packaged with the film, and make changes based on results. Use only CC filters (gelatin) and **not** CP filters (acetate), because the filters are used in the image forming beam. When using pulsed-xenon for illumination, start with an 85B filter only, and then make changes based on results.

EXPOSING THE FILM

Mask any unwanted portions of the original transparency with black paper. The intensity of the light should be controllable to allow an exposure time of approximately 5 seconds. Exposure is usually then controlled by the lens diaphragm; KODAK WRATTEN Neutral Density Filters can be used if the illumination level is too high. Changes in voltage **must not be used** because the color balance of the exposing light changes with changing voltage. As a guide in determining the correct exposure conditions, make the initial exposure as follows:

Illumination at the Exposure Plane: ½ footcandle, without color correction filters in the light beam. Use a light integrator to measure pulsed-xenon illumination.

CC Filter Pack: Starting point recommendations are given in the Data Sheet packaged with each emulsion (for pulsed xenon, add CC25M and CC85Y to the filter pack recommendations given in the Data Sheet).

Trial Exposure Time: 5 seconds at three intensity levels: normal, 1 stop above normal, and 1 stop below normal. Normal is at the aperture that produces ½ footcandle illumination on the exposing plane.

While 5 seconds is recommended as a convenient exposure time for many situations, shorter times can also be used satisfactorily without getting uncontrollable color shifts. Avoid exposure times much longer than 5 seconds. In situations where it is applicable, suitably filtered electronic flash can be used as a light source.

PROCESSING

The film is processed in Process E-6 chemicals. All processing times are the same as for camera films—the duplicating film and camera films can be processed toegther. The duplicating film can be processed in rack-and-tank as well as other processors. It can also be processed in a professional tank sink line or in rotary-tube processors.

SINK-LINE PROCESSING

Several sheets of KODAK EKTACHROME Duplicating Film 6121 can be processed at the same time when a 3½-gallon tank sink line is used. Color balance and speed are more consistent in consecutive process runs when solution replenishment is carried out as recommended. Complete replenishment instructions are packaged with KODAK First Developer Replenisher, Process E-6. Replenishers increase the capacities of the working solutions to a maximum and increase their life considerably.

For better processing uniformity of 8 x 10 films in 3½-gallon tanks, you can use a KODAK Developing Hanger Rack No. 40 with KODAK Hanger Separators. Load the film in KODAK Film and Plate Developing Hangers, No. 4A, or equivalents, and place the hangers in the rack. Use the separators to maintain equal spacing between the hangers.

If films of different sizes are developed at the same time in a tank, a spaced sheet of discarded E-6 film or acetate sheeting should be loaded in a hanger and placed between the groups of different-sized hangers. This should be the largest size being processed. For example, if 8 x 10-inch film is being processed with 4 x 5-inch film in mul-

(Continued on following page)

tiple hangers, the separator sheet should be the 8 x 10-inch size. The spacer avoids uneven density that would otherwise occur in a large sheet next to smaller sheets, caused by turbulence around the multiple hanger frame members.

Proper agitation is especially important in the first and color developers. Both gaseous-burst and manual agitation procedures can be used. The gaseous-burst procedure is preferred because it produces a somewhat higher agitation level than the manual procedure and for this reason tends to yield more consistent process uniformity.

RETOUCHING DYES

KODAK E-6 Transparency Retouching Dyes are recommended for use on E-6 transparencies that are to be duplicated on KODAK EKTACHROME Duplicating Film 6121 (Process E-6). Retouching done with other dyes may not reproduce as it appears visually and may show up as obvious retouching on the duplicate transparency. The E-6 Retouching Dyes are also designed to be used on duplicates made on this duplicating film that are to be used for photomechanical reproduction. Retouching done with other dyes, such as KODAK EKTACHROME Film Retouching Dyes designated for Process E-3 films, may show up in the reproduction.

JUDGING EXPOSURES FOR
DENSITY AND COLOR BALANCE

All transparencies should be viewed on a standard illuminator (5000 K, as recommended in ANSI Standard PH2.31-1969). Such an illuminator provides the correct light intensity and the spectral distribution characteristics necessary for the critical analysis of color transparencies.

Density: In the section entitled "Exposing the Film," it was suggested that three trial exposures be made. When processed, the three transparencies should be evaluated on the illuminator. It is likely that one of the three exposures was close to correct, producing the proper density level. If all three exposures produced densities that are too great (dark), give **more** exposure by

changing the aperture (not the time) in making a new exposure series. It is important to keep the exposure time relatively constant in order to maintain a consistent filter pack. If the exposure series produced transparencies that are too low in density (light), make a new test-exposure series with less intensity (smaller apertures).

Color Balance Adjustments: If the color balance is not as desired, determine the color or colors that are present in excess. When making judgments, look at the middletones instead of the shadows or the highlights. The required filter-pack adjustment involves removing a filter of the color that is present in excess in the transparency or adding a filter of a color complementary to the excess color. The amount of change is approximately the amount of the viewing filter that is required to make the middletones of the test transparency appear balanced.

For example, if a transparency is too red and requires a 20 cyan viewing filter to make it appear balanced, 20 red filtration should be removed from the original filter pack or 20 cyan filtration should be added to the pack. Whenever there is a choice, remove filters rather than adding them. The table below may be useful in determining filter adjustment.

As a general rule, keep the number of filters in the filter pack to a minimum. When CP filters are being used between the light source and the transparency, this is not critical. Some users find the use of just C, M, and Y filters convenient, because they do not have to stock red, green, or blue color printing filters. In using the CC filters in the image forming beam, the use of more than three filters may lead to loss of definition in the duplicate, and to lowered contrast due to flare.

When some filters of all three colors (C, M, Y) are in the pack, the pack in effect contains some **neutral density,** which can be removed without changing the basic correction of the pack. For instance, if the pack contains 40C + 40M + 20Y, the amount of the lowest value filter can be removed from all three colors, leaving only two colors in the pack.

(Continued on following page)

EASTMAN KODAK

Filter pack 40 + 40M + 20Y
Subtract −20C − 20M + 20Y
 (remove neutral density)
Reduced
 Filter Pack 20C + 20M 0Y
 20B

As can be seen by the table at the bottom of the page, C + M is equivalent to B, so that the 20C + 20M can be replaced by a 20B filter to obtain the minimum number of filters.

When the filter pack is changed, the pack filter factor changes also. This means that the exposure must be changed, or the density of the corrected transparency will differ from that of the test transparency.

SIZES

The film is available in the following sizes:

 4 x 5 inches; 25-sheet packages
 50-sheet packages
 5 x 7 inches; 25-sheet packages
 8 x 10 inches; 25-sheet packages
 50-sheet packages
11 x 14 inches; 25-sheet packages
14 x 17 inches; 25-sheet packages
16 x 20 inches; 25-sheet packages
13 x 18 cm; 25-sheet packages

If overall color balance is:	View through these filters:	Remove these filters from pack:	OR	Add these filters to pack:
Yellow	Magenta + Cyan	Yellow		Magenta + Cyan
Magenta	Yellow + Cyan	Magenta		Yellow + Cyan
Cyan	Yellow + Magenta	Cyan		Yellow + Magenta
Blue	Yellow	Magenta + Cyan		Yellow
Green	Magenta	Yellow + Cyan		Magenta
Red	Cyan	Yellow + Magenta		Cyan

KODAK EKTACHROME PROCESS E-6

PROCESSING THE FILMS

KODAK chemicals for Process E-6, in various sizes, are available for processing the new KODAK Ektachrome professional films in small and large tanks, in rack-and-tank processors, in rotary tubes, and in continuous processing machines, such as the KODAK EKTA-CHROME E-6 Processor. Kodak chemicals for Process E-6 are supplied as liquids and liquid concentrates in Cubitainers® for in-line replenishment.

Here are some important items to consider about sink-line processing for these films:

1. For better temperature control at lower cost,
 a. Use recirculated heated water.
 b. Use stainless steel tank for the first developer.

2. To conserve water and energy in wash steps, nonflowing washes can be used.

3. Only manual agitation is recommended for roll film on reels.

4. Gaseous-burst agitation is recommended for sheet film.

5. Nitrogen used for the first and color developers must be humidified.

6. Air used for the bleach and fixer must be oil-free.

7. The gaseous-burst agitaion consists of a 2-second burst every 10 seconds. Initial manual agitation must be used in sink lines.

8. No gaseous-burst agitation should be given in the reversal bath, conditioner, or stabilizer.

9. An initial manual agitation is required in each solution except the reversal bath, conditioner, and stabilizer. In these solutions, merely tap the hangers or reels to dislodge air bubbles.

10. The agitation procedures are similar to those used for Process E-3 films.

SUMMARY OF STEPS FOR PROCESS E-6 SINK LINE (TENTATIVE)

Solution of Procedure	Remarks	Temperature °C	°F	Time in Minutes*	Total Time End of Step
1. First Developer	First three	38±0.3	100.4±0.5	6†	6
2. First Wash‡	steps in	33 to 39	92 to 102	2	8
3. Reversal Bath	total darkness	33 to 39	92 to 102	2	10
Remaining steps can be done in normal room light.					
4. Color Developer		38±0.6	100.4±1.1	6	16
5. Conditioner		33 to 39	92 to 102	2	18
6. Bleach		33 to 39	92 to 102	6	24
7. Fixer		33 to 39	92 to 102	4	28
8. Final Wash‡	Two tanks:	33 to 39	92 to 102	2	30
	Counterflow	33 to 39	92 to 102	2	32
9. Stabilizer		Ambient		½	32½
10. Dry	Remove films from hangers or reels before drying	Not over 60	Not over 140		

*Include drain time of 10 seconds in each step.

†Time for nitrogen agitation for sheet films. Increase time by 15 seconds when only manual agitation is used. Manual agitation must be used for roll films in reels.

‡For flowing water washes. Nonflowing water washes can be used as follows: for the first wash, use a single tank filled with water at 25 to 39°C (77 to 102°F). Replace this wash after two processing runs, regardless of the quantity of film processed. For the final wash, use three tanks filled with water at 20 to 39° (68 to 102°F) for two minutes each. Replace the water in all three tanks after four processing runs, regardless of the total quantity of film processed. Do not use any final wash tank for a first wash tank. All wash tanks should be drained at the end of each day and left empty over night.

Film Exposure	First Development Time
One stop under	Approx. 8 minutes
(Normal)	(6 minutes)
One stop over	Approx. 4 minutes

IDENTIFYING PROCESSED E-6 EKTACHROME FILMS

Kodak-processed and mounted E-6 Ektachrome slides have a plus (+) symbol on the front and back of the mounts to distinguish them from E-4 Ektachrome slides. Other laboratories may use the same symbol for this purpose. On unmounted E-6 Ektachrome film strips, the edge print reads "Kodak Safety Film," followed by a four-digit code number. This is repeated at approximately 2-inch intervals. A solid square follows each frame number. On 135-20 size film, the three-digit emulsion number appears at the No. 4 frame; on 135-36 size film, the emulsion number is at the No. 21 frame. In addition, the 135-size E-6 films have a 0.05-inch-diameter hole after every fourth perforation along one edge. Long rolls of 35 mm E-6 films are frame numbered 1 through 44, and the emulsion number is printed at 12-inch intervals. The 120-size film has frame numbers 1 through 12, with the emulsion number between the 3rd and 4th frame. Sheet films can be identified by code notches.

RETOUCHING DYES FOR E-6 TRANSPARENCIES

Use KODAK E-6 Transparency Retouching Dyes for retouching original transparencies intended for photomechanical reproduction or for duplicating on KODAK EKTACHROME Duplicating Film 6121 (Process E-6). Process E-3 retouching dyes can be used but some color mismatch may result.

PROCESSING ADJUSTMENTS FOR UNDEREXPOSED OR OVEREXPOSED FILMS

Process E-6 Ektachrome professional film should always be exposed at its stated effective speed for the best results. Compensating for under- or overexposure with process adjustments produces a loss in picture quality. Underexposed and overdeveloped film results in a loss of D-max, a decrease in exposure latitude, a color balance shift, and a significant increase in contrast. Overexposure and underdeveloped film results in a low toe contrast and a color shift. If these losses in quality can be tolerated, and if the processing machine has the flexibility, the first development time in the following table can be used as a guide to compensate for abnormal exposures.

PRINTING THE FILMS

No infrared cutoff filter is required when E-6 Ektachrome films are printed onto KODAK EKTACHROME RC Paper, Type 1993. It is recommended, however, that a KODAK infrared Cutoff Filter No. 301A be used for printing mixtures of Process E-3, E-4, and E-6 Ektachrome films for printing compatibility.

DUPLICATING THE FILMS

Two new Ektachrome duplicating films for use with Process E-6 are available for making duplicate transparencies. KODAK EKTACHROME Duplicating Film 6121 (Process E-6) is a color sheet film for the making of high-quality duplicate color transparencies.
 KODAK EKTACHROME Slide Duplicating Film 5071 (Process E-6) is available in 135-36 size and long rolls in 35 mm and 46 mm widths. It is for making duplicate slides from original Kodachrome and Kodak Ektachrome transparencies.

SEE CHEMICAL TABLE NEXT PAGE

EASTMAN KODAK

KODAK EKTACHROME CHEMICALS FOR PROCESS E-6

NAME	Process E-6 Chemicals — SIZES—To Make:						Process E-6AR Chemicals A 5-gal Cubitainer® will prepare the following amounts of Replenisher°
	1 pint	½ gal	1 gal	3½ gal	5 gal	25 gal	
KODAK EKTACHROME Film Processing Kit, Process E-6	•						
KODAK Developer Kit, Process E-6	Contains two 1-pint units of First and Color Developers	•					
KODAK First Developer, Process E-6		•					
KODAK First Developer Replenisher, Process E-6			•	•	•		
KODAK First Developer Replenisher, Process E-6AR							25 gallons
KODAK First Developer Starter, Process E-6	Starts 25 gallons						
KODAK Reversal Bath, Process E-6		•					
KODAK Reversal Bath and Replenisher, Process E-6			•	•			
KODAK Reversal Bath and Replenisher, Process E-6AR							100 gallons
KODAK Color Developer, Process E-6		•					
KODAK Color Developer Replenisher, Process E-6			•	•	•		
KODAK Color Developer Replenisher, Part A, Process E-6AR						•	25 gallons
KODAK Color Developer Replenisher, Part B, Process E-6AR							25 gallons
KODAK Color Developer Starter, Process E-6	Starts 25 gallons						
KODAK Conditioner, Process E-6		•					
KODAK Conditioner and Replenisher, Process E-6			•	•			
KODAK Conditioner and Replenisher, Process E-6AR							25 gallons
KODAK Bleach, Process E-6		•					
KODAK Bleach Replenisher, Process E-6AR							5 gallons
KODAK Bleach Starter, Process E-6	Starts 25 gallons						
KODAK Fixer, Process E-6		•					
KODAK Fixer and Replenisher, Process E-6			•	•			
KODAK Fixer and Replenisher, Process E-6AR						•	50 gallons
KODAK Stabilizer, Process E-6		•					
KODAK Stabilizer and Replenisher, Process E-6			•	•			
KODAK Stabilizer and Replenisher, Process E-6AR						•	320 gallons
KODAK Defoamer (4 oz bottle)							

°For use in automatic replenishment processes or can be used to prepare varying quantities of replenishers or working solutions.

(*Continued on following page*)

193

IDENTIFYING E-6 PROCESSING ERRORS

When the effects of inadequate storage or improper exposure are eliminated as the causes of poor-quality Ektachrome transparencies, incorrect processing in Process E-6 may be the source of the fault. Errors can occur in chemical mixing, order of solutions in processing, solution temperatures, agitation rates, washing, replenishment rates and contamination of processing solutions. The table relates abnormal appearance of the processed film to possible causes.

Visual examination of processed films is one method for discovery of processing faults. While such examination may point out the type of processing error, it cannot provide all of the information to correct the deficiency. The extent of deviation from normal and the corrective action required are more readily assessed with the aid of sensitometric control strips which are evaluated on a densitometer or compared with a reference strip.

VISUAL EXAMINATION OF PROCESSED FILM

Appearance of Film	Probable Fault
Very High Maximum Density (no image apparent)	First developer and color developer reversed. First developer omitted.
Dark Overall	Inadequate time or low temperature in first developer. First developer diluted, exhausted, or underreplenished. Color developer starter added to first developer.
Very Dark (overall or in random areas)	Bleach or fixer (or both) omitted, reversed, diluted, exhausted, or underreplenished.
Light Overall	Excessive time or high temperature in first developer. Film fogged by light prior to processing. First developer too concentrated. First developer overreplenished or starter omitted in preparation of working (tank) solution. First developer contaminated with color developer.
Light Overall, Blue Color Balance	First developer contaminated with fixer.
Overall Density Variation from Batch to Batch	Inconsistencies in time, temperature, agitation, or replenishment of first developer.
Blue	Reversal bath too concentrated. Color developer alkalinity too low. Excessive color developer starter used in preparing tank solution. Color developer replenisher mixed with Part B only. Process E-4 used in error.

(Continued on following page)

Cyan	First and color developers underreplenished.
Yellow	Color developer alkalinity too high. Color developer starter added to first developer. Color developer replenisher mixed with only Part A.
Low Densities Blue-Green, High Densities Yellow	Color developer contaminated with first developer. Color developer contaminated with fixer.
Blue-Red with High Maximum Density	Color developer replenisher too dilute.
Green	Reversal bath exhausted, diluted, or under-replenished. Film fogged by green safelight. Wash used between reversal bath and color developer.
Very Yellow	Film exposed through base. Film fogged by room lights during first developer step.
Cross-Width Bar Marks (When using stainless steel reels)	Gaseous burst agitation used in first developer.
Scum and Dirt*	Stabilizer requires replacement. (Replace once a week.) Filters in recirculating systems require replacement. (Change once a week.) Air filters in dryer need changing. Dirt in other solutions. Use floating covers on tanks and replenisher solutions whenever possible. Stabilizer too concentrated.

*Foreign particles may be due to buildup of fungus or algae in processing solutions or wash tanks. To minimize this buildup, drain water wash tanks when not in use. When the processing equipment will be out of use for more than 6 weeks, drain and rinse the reversal bath tank and replenisher storage tanks. To remove fungus or algae, scrub the tanks with a stiff bristle brush and a sodium hypochlorite solution (1 part household bleach to 9 parts water). Rinse the tank thoroughly with water to remove the last traces of sodium hypochlorite solution. Use a 50-micrometer (or finer) filter in the water supply.

EASTMAN KODAK

The Compact Photo-Lab-Index

SUMMARY OF STEPS FOR
KODAK EKTACHROME FILM **PROCESS E-3**

(FOR 1-PINT AND ½-GALLON PROCESSING TANKS)

Agitation: See instructions for equipment used and follow them carefully.
Timing: Include drain time (10 seconds) in time for each processing step.

Solution or Procedure	Remarks	Temp F	Temp C	Time in Min	Total Min at End of Step
1. First Developer	Steps 1 through 3 in total darkness	75 ± ½	24 ± 0.3	10*	10
2. Rinse	Running water	73–77	23–25	1	11
3. Hardener		73–77	23–25	3	14
Remaining steps can be done in normal room light.					
4. Wash	Running water	73–77	23–25	3	17
5. Reversal Exposure	Re-expose as prescribed for equipment used. Films must receive at least 1-minute drain before color development.				Reset Timer to Zero
6. Color Developer		73–77	23–25	15	15
7. Wash	Running water	73–77	23–25	5	20
8. Clearing Bath		73–77	23–25	5	25
9. Rinse	Running water	73–77	23–25	1	26
10. Bleach	See warning on label.	73–77	23–25	8	34
11. Rinse	Running water	73–77	23–25	1	35
12. Fixer		73–77	23–25	6	41
13. Wash	Running water	73–77	23–25	8	49
14. Stabilizer	See warning on label.	73–77	23–25	1	50
15. Dry	Before drying films, remove from reels or hangers.	Not over 110	43		

*For initial films through the same set of solutions. See tables on page 4 for development times of subsequent films through same unreplenished set of solutions.

NOTICE: Observe precautionary information on containers and in instructions.

EASTMAN KODAK

The Compact Photo-Lab-Index

SUMMARY OF STEPS FOR
PROCESS E-4

(FOR 1-PINT PROCESSING TANKS

Agitation: See instructions for equipment used and follow them carefully.

Timing: Include time required to drain tank in total time for each processing step.

Solution or Procedure	Remarks	Temperature		Time in Min	Total Min at End of Step
		°F	°C		
1. Prehardener	First 4 steps in total darkness	85±1	29.5±½	3	3
2. Neutralizer		83–87	28–31	1	4
3. First Developer		85±½	29.5±¼	7*	11
4. First Stop Bath	Don't use Second Stop Bath here!	83–87	28–31	2	13
Remaining steps can be done in normal room light.					
5. Wash	Running water	80–90	27–32	4	17
6. Color Developer	See chemical warning notice.	83–87	28–31	15	32
7. Second Stop Bath	Don't use First Stop Bath here!	83–87	28–31	3	35
8. Wash	Running water	80–90	27–32	3	38
9. Bleach	See chemical warning notice.	83–87	28–31	5	43
10. Fixer		83–87	28–31	6	49
11. Wash	Running water	80–90	27–32	6	55
12. Stabilizer	See chemical warning notice.	83–87	28–31	1	56
13. Dry	Dry film off the reel.	Not over 110	Not over 43		

*For initial films through a 1-pint set of solutions. See table on page 4 for development times of subsequent films through the same set of solutions. Use 5-minute time for KODAK EKTACHROME Slide Duplicating Film 5038 (Process E-4) or 7038.

EASTMAN KODAK

197

SUMMARY OF STEPS FOR
PROCESS E-4 ½ -U.S. GALLON (1.89 Liters) SIZE

Agitation: See instructions for equipment used and follow them carefully.

Timing: Include drain time (10 seconds) in time for each processing step.

Solution or Procedure	Remarks	Temperature		Time in Min	Total Min at End of Step
		(°F)	(°C)		
1. Prehardener	Total darkness	85 ± 1	29.5 ± ½	3	3
2. Neutralizer	Total darkness	83–87	28.5–30.5	1	4
3. First Developer	Total darkness	85 ± ½	29.5 ± ¼	6*	10
4. First Stop	Total darkness	83–87	28.5–30.5	2	12
Remaining steps can be done in normal room light.					
5. Wash	Running water	80–90	26.5–32	4	16
6. Color Developer	See warning on label.	83–87	28.5–30.5	15	31
7. Second Stop		83–87	28.5–30.5	3	34
8. Wash	Running water	80–90	26.5–32	3	37
9. Bleach	See warning on label.	83–87	28.5–30.5	5	42
10. Fixer		83–87	28.5–30.5	6	48
11. Wash	Running water	80–90	26.5–32	6	54
12. Stabilizer	See warning on label.	83–87	28.5–30.5	1	55
13. Drying	Remove films from reels.	Not over 110	Not over 43.5		

*Use 4½-minute time for KODAK EKTACHROME Slide Duplicating Film 5038 (Process E-4) or 7038.

NOTICE: Observe precautionary information on containers and in instructions.

EASTMAN KODAK

SUMMARY OF STEPS FOR PROCESS E-4

*For 1-, 3½-gallon (3.8, 13.2 liters) and larger tanks**

Agitation: See instructions for equipment used and follow them carefully.

Timing: Include drain time (10 seconds) in time for each processing step.

Solution or Procedure	Remarks	Temperature		Time in Min	Total Min at End of Step
		°F	°C		
1. Prehardener	See warning on label.	85 ± 1	29.5 ± ½	3	3
2. Neutralizer		83–87	28.5–30.5	1	4
3. First Developer	First four steps in total darkness	85 ± ½	29.5 ± ¼	6†	10
4. First Stop		83–87	28.5–30.5	2	12
Remaining steps can be done in normal room light.					
5. Wash	Running water	80–90	26.5–32	4	16
6. Color Developer	See warning on label.	83–87	28.5–30.5	9‡	25
7. Second Stop		83–87	28.5–30.5	3	28
8. Wash	Running water.	80–90	26.5–32	3	31
9. Bleach	See warning on label.	83–87	28.5–30.5	5	36
10. Fixer		83–87	28.5–30.5	6§	42
11. Wash	Running water	80–90	26.5–32	6	48
12. Stabilizer	See warning on label.	83–87	28.5–30.5	1	49
13. Drying	Remove roll films from reels.	Not over 110	43.5		

*For processing in 1-pint tanks, follow the instructions found in the 1-pint size KODAK EKTACHROME Film Processing Kit, Process E-4.
†Use 4½-minute time for KODAK EKTACHROME Slide Duplicating Film 5038 (Process E-4) or 7038.
‡For unreplenished systems the time should be 15 minutes.
§If KODAK Color Film Liquid Fixer and Replenisher is used, the fixing time can be reduced to 4 minutes.

NOTICE: Observe precautionary information on containers and in instructions.

SUMMARY OF STEPS FOR KODAK COLOR PROCESS C-22 FOR KODACOLOR-X FILMS Pint Size (U.S.)

Agitation: See instructions and follow them closely.
Timing: Include time required to drain tank in time for each processing step.

Solution or Procedure	Remarks	Temp (F)	Temp (C)	Time in Min	Total Min at End of Step
1. Developer	Total darkness	75 ± ½	24 ± 0.3	14* See note	14
2. Stop Bath	Total darkness	73–77	23–25	4	18
3. Hardener	Total darkness	73–77	23–25	4	22

Remaining steps can be done in normal room light.

4. Wash	Running water	73–77	23–25	4	26
5. Bleach	See warning on label	73–77	23–25	6	32
6. Wash	Running water	73–77	23–25	4	36
7. Fixer		73–77	23–25	8	44
8. Wash	Running water	73–77	23–25	8	52
9. Final Rinse	KODAK PHOTO-FLO Solution	73–77	23–25	1	53
10. Dry	Remove film from reel	Not above 110	43		

*Time listed is for initial films through a 1-pint set of solutions. See table on page 3 for development times of subsequent films through the same set of solutions.

Note: Develop KODAK EKTACOLOR Slide Film 5028 for 17 minutes and add 3 minutes to each figure in the "Total Min" column.

NOTICE: Observe precautionary information
on containers and in instructions.

200

SUMMARY OF STEPS FOR
KODAK COLOR FILM PROCESS C-22

1-GALLON SIZE (U.S.)

Agitation: See instructions and follow them closely.
Timing: Include drain time (10 seconds) in time for each processing step.

Step or Procedure	Remarks	Temp (°F)	Temp (°C)	Time in Min	Total Min at End of Step
1. Developer	Total darkness	75 ± ½	24 ± 0.3	13 See note	13
2. Stop Bath	Total darkness	73-77	23-25	4	17
3. Hardener	Total darkness	73-77	23-25	4	21
Remaining steps can be done in normal room light					
4. Wash	Running water	73-77	23-25	4	25
5. Bleach		73-77	23-25	6	31
6. Wash	Running water	73-77	23-25	4	35
7. Fixer		73-77	23-25	8	43
8. Wash	Running water	73-77	23-25	8	51
9. Final Rinse	KODAK PHOTO-FLO Solution	73-77	23-25	1	52
10. Dry	See instructions	Not above 110	43		

Note: Time specified is for KODACOLOR-X Film and for KODAK EKTACOLOR Professional Film, Types S and L. Develop KODAK EKTACOLOR Print Film 4109 for 11 minutes and subtract 2 minutes from each figure in the "Total Min" column. Develop KODAK EKTACOLOR Slide Film 5028 for 17 minutes and add 4 minutes to each figure in the "Total Min" column.

NOTICE: Observe precautionary information on containers and in instructions.

EASTMAN KODAK

SUMMARY OF STEPS FOR
KODAK COLOR FILM PROCESS C-22

EASTMAN KODAK

Agitation: See instructions and follow them closely.
Timing: Include drain time (10 seconds) in time for each processing step.

Step or Procedure	Remarks	Temp	Manual Processing		Automatic Processing	
			Time in Min	Total Min at End of Step	Time in Min	Total Min at End of Step
1. Develop	Total darkness	75 ± ½ F (24 ± 0.3 C)	13 See note	13	12 See note	12
2. Stop Bath	Total darkness	73–77 F (23–25 C)	4	17	4	16
3. Harden	Total darkness	73–77 F (23–25 C)	4	21	4	20
Remaining steps can be done in normal room light						
4. Wash	Running water	73–77 F (23–25 C)	4	25	4	24
5. Bleach	See warning on label	73–77 F (23–25 C)	6	31	6	30
6. Wash	Running water	73–77 F (23–25 C)	4	35	4	34
7. Fix		73–77 F (23–25 C)	8	43	8	42
8. Wash	Running water	73–77 F (23–25 C)	8	51	8	50
9. Final Rinse	KODAK PHOTO-FLO Solution	73–77 F (23–25 C)	1	52	1	51
10. Dry	See instructions	Not above 110 F (43 C)				

Note: Time specified is for KODACOLOR-X Film, KODAK EKTACOLOR Professional Film, Types S and L, and KODAK EKTACOLOR ID/Copy Film 5022. Increase the Developer, Bleach, and Fixer replenishment rates by 40% for KODAK EKTACOLOR ID/Copy Film 5022.
 In all systems, develop KODAK EKTACOLOR Print Film 4109 for 11 minutes and subtract 1 or 2 minutes from each figure in the "Total Min" column. Develop KODAK EKTACOLOR Slide Film 5028 for 17 minutes and add 4 minutes to each figure in the "Total Min" column for manual processing. For automatic processing, develop the slide film for 16 minutes and add 4 minutes to each figure in the "Total Min" column. Note that KODAK EKTACOLOR Print Film Additive must be used with the print and slide films.

**NOTICE: Observe precautionary information
on containers and in instructions.**

KODAK FLEXICOLOR CHEMICALS FOR PROCESS C-41

Process C-41 is recommended for the processing of KODACOLOR II, KODA-COLOR 400, and KODAK VERICOLOR II Professional Films. Developed to produce color negatives of uniformly high quality, it makes use of a number of KODAK FLEXICOLOR chemicals, available either separately or in convenient kit form.

The KODAK FLEXICOLOR Processing Kit (for Process C-41) includes developer, bleach, fixer, and stabilizer in quantities sufficient to make one pint of solution. The individual chemicals are available for larger amounts of solution.

The chemicals for Process C-41 can be used in small one-pint tanks, rotary tubes, sink-line processing equipment, and continuous machines. Following is a summary of steps for processing KODACOLOR II KODACOLOR 400, and KODAK VERICOLOR II Professional Films, using the processing kit.

PROCESS C-41 SUMMARY OF STEPS (for 1-Pint Tanks)

Solution or Procedure	Remarks	Agitation			°C	°F	Time in Minutes†
		Initial*	Rest	Agitate			
1. Developer	Total	30 sec	13	2	37.8±0.15	100±¼	3¼
2. Bleach	darkness	30 sec	25	5	24-40.5	75-105	6½
Remaining steps can be done in normal room light.							
3. Wash	Running water‡				24-40.5	75-105	3¼
4. Fixer		30 sec	25	5	24-40.5	75-105	6½
5. Wash	Running water‡				24-40.5	75-105	3¼
6. Stabilizer		30 sec			24-40.5	75-105	1½
7. Dry	See instructions				24-43.5	75-110	10-20

*Rap the bottom of the tank firmly on the sink or table to dislodge any air bells. Be sure you have read the agitation recommendations elsewhere in these instructions.

†Includes 10-second drain time in each step.

‡Use fresh water changes throughout the wash cycles. Fill the processing tank as rapidly as possible from a running water supply for about 4 seconds. When full, agitate vigorously for about 2 seconds and drain for about 10 seconds. Repeat this full wash cycle. If desired, use a running water inflow-overflow wash with the cover removed from the tank.

EASTMAN KODAK

The Compact Photo-Lab-Index

SURFACES AND CONTRAST GRADES
OF KODAK PHOTOGRAPHIC PAPERS
KODAK BLACK & WHITE MATERIAL

TEXTURE	Smooth	Smooth	Smooth	Smooth
BRILLIANCE	Glossy	Lustre	High Lustre	Matte
Ad-Type		A WH, LW 1-4		
Azo	F WH, SW 0-5 DW 1-3	N WH, DW 1-4		
Dye Transfer	F WH, DW			
Ektalure				
Ektamatic SC	F WH SW, DW	N WH, SW A WH, LW		
Kodabrome II RC	F WH, MW S-UH*	N WH, MW S-UH*		
Kodabromide	F WH, SW 1-5 DW 1-5	N WH, SW 2-4 DW 2-4 A WH, LW 2-5		
Medalist	F WH, SW 1-4 DW 2,3		J WH, DW 2,3	
Mural‡				
Panalure	F WH, SW			
Panalure II RC	F WH, MW			
Panalure Portrait				
Polycontrast	F WH SW, DW	N WH, SW, DW A WH, LW	J WH, SW, DW	

Dye Transfers (See B&W Listings on previous page)
WH—White paper stock; CR—Cream-white paper stock; WM-WH—Warm-white paper stock.
*Available in soft, medium, hard, extra-hard and ultra-hard grades.
†Available in rolls 54 inches wide.

(Continued on following page)

EASTMAN KODAK

SURFACES AND CONTRAST GRADES
OF KODAK PHOTOGRAPHIC PAPERS (continued)
KODAK BLACK & WHITE MATERIAL (Continued)

Fine Grained Lustre	Fine Grained High Lustre	Tweed Lustre	Silk High Lustre	Tapestry Lustre
E WH, SW 1-4 DW 2,3				
G CR, DW				
E WM-WH, DW **G** CR, DW	**K** WM-WH, DW	**R** CR, DW	**Y** WM-WH, DW	**X** CR, DW
E WH, SW 2-4 DW 2-4				
G CR, DW 2-4				
E WH, DW 2,3 **G** CR, DW 2-4			**Y** CR, DW 2,3	
		R, WRM CR, SW 2,3		
E WH, DW				
G CR, DW 2-4				

(Continued on following page)

EASTMAN KODAK

SURFACES AND CONTRAST GRADES
OF KODAK PHOTOGRAPHIC PAPERS (continued)
KODAK BLACK AND WHITE MATERIAL

TEXTURE	Smooth	Smooth	Smooth	Smooth
BRILLIANCE	Glossy	Lustre	High Lustre	Matte
Polycontrast Rapid	F WH, SW, DW	N WH, SW		
Polycontrast Rapid II RC	F WH, MW	N WH, MW		
Portrait Proof				
Resisto		N WH, SW 2,3		
Resisto Rapid Pan		N WH, SW, 2, 3		
Studio Proof	F WH, SW			
Velox	F WH, SW 1-4			
Velox Premier RC	F WH, MW			
Velox Unicontrast	F WH, SW			
Kodak Color Material				
Ektacolor 74 RC	F	N		
Ektacolor 74 Duratrans/4023	F			
Ektachrome RC 1993	F			
Ektachrome 2203				
Dye Transfer (See B&W listings on previous page)				

WH—White paper stock; CR—Cream-white paper stock; WM-WH—Warm-white paper stock.
*Available in soft, medium, hard, extra-hard and ultra-hard grades.
†Available in rolls 54 inches wide.

(Continued on following page)

SURFACES AND CONTRAST GRADES
OF KODAK PHOTOGRAPHIC PAPERS (continued)

KODAK BLACK AND WHITE MATERIAL (Continued)

Fine Grained Lustre	Fine Grained High Lustre	Tweed Lustre	Silk High Lustre	Tapestry Lustre
G CR, DW			Y CR, DW	
G WM-WH, DW		R CR, DW	Y WM-WH, DW	
		R CR, SW		
E WH, MW			Y-WH MW	
			Y WH, MW	

Kodak Color Material (Continued)

E Lustre-Luxe™			Y	
			Y	
			Y	

The Compact Photo-Lab-Index

EASTMAN KODAK

KODAK **PAPERS**

Choice of Surface and Color

Photographic papers come in a wide variety of tone ranges and surfaces. This permits the user to exercise his personal taste in choosing the paper best suited to the subject matter and the particular use of the print.

SURFACE

Glossy paper should be used for prints intended for reproduction, or for prints in which extremely fine detail is important. Glossy paper reproduces a wide brightness range. It has a long density scale. It should be ferrotyped for best results.

High Lustre surfaces give the maximum reflection scale possible without ferrotyping. It falls between the glossy and lustre surfaces in scale.

Lustre surfaces have a shorter density scale than glossy papers, and are suited for exhibition and general use.

Matte surfaces have the shortest density scale and flatten the over-all contrast of the print.

TINT

Some Kodak papers are supplied with a white stock, while others are available with warm-white, or cream-white tinted stock.

White should usually be used for cold-tone subjects, reproduction and commercial work, for high key subjects, snow scenes, seascapes, and for prints to be toned blue.

Cream-White is a warm base tint good for sunlighted and artificially lighted scenes.

Warm-white tint is intermediate between white and cream-white.

SPECIAL SURFACES

Silk paper has a fine clothlike texture and high lustre. It is useful for brilliant pictorial subjects, candid-wedding and school photography.

Tweed paper has a very rough lustre surface, and should be used where detail is to be reduced. Available on a cream-white stock, it is most effectively used in large sized prints.

Tapestry paper has a very rough lustre surface which is suited to large prints and massive subjects where subordination of detail is desirable.

THICKNESS

Kodak papers are designated as lightweight, Single Weight, Middleweight or Double Weight. Generally, Single Weight papers lend themselves to use as smaller prints, while Double Weight is preferable for larger prints. Some papers are supplied in light weight or medium weight for special purposes. Papers identified by the letter A are made to allow folding without cracking. Papers with the Resisto name or with an RC after the paper name have resin-coated bases, which allows for more rapid processing, washing and drying.

PHOTOGRAPHIC PROPERTIES

EMULSIONS

Photographic paper emulsions are usually made of light-sensitive silver salts suspended in gelatin. The speed of the paper is modified by the chemical composition of the silver salts and additives. Printing grade and image tone are likewise determined by the chemical structure of the emulsion. Silver chloride is often used in slower (contact) papers, while silver bromide is usually predominant in the faster projection papers. Sensitizing dyes are used to match sensitivity of the emulsion to different spectral response, and to modify the speed balance among various grades of paper.

CONTRAST

Like color, which must be described in terms of hue, brightness, and saturation, contrast is also a word which has a compound meaning. The two independent attributes which determine contrast are **gradient** and **extent**. Technically speaking, the gradient is the rate at which the density increases with exposure. The extent is the total range of densities available in the print from light to dark.

*Reflection density is $\dfrac{1}{\log \text{reflectance}}$ of area concerned, where the illumination

(Continued on following page)

208

is at 45° to the surface, and the sample is viewed at 90° to the surface.

Since contrast is concerned with subjective impressions, an unexposed sheet of photographic paper does not have contrast. However, it does possess a certain **contrast capacity** which is related to gradient and extent. Actually it is the combined effect of both factors, or technically speaking, the product of those two factors. It should be kept in mind also, that prints do not always utilize the full capacity of the paper contrast. Let's take a closer look at some of the factors which influence these characteristics:

Gradient. For prints made on No. 1 and No. 2 printing grades of the same paper, the available maximum density is the same. If the same negative is used for each, the print on the No. 2 printing grade appears more contrasty. In fact, it is too contrasty if the negative is best suited to the No. 1 printing grade. The reason is that the rate at which density increases with exposure is more rapid for No. 2 printing grade than for No. 1 printing grade. Therefore, No. 2 Printing grade reaches its maximum density sooner, speaking exposure-wise.*

The total interval in exposure is shorter for No. 2 printing grade, that is, its exposure scale is shorter. In the case we have chosen, it is too short to accommodate all the tones represented in the negative. The factor in a paper that makes it fit a negative is this exposure scale. It relates to the density scale of the negative, in a manner described later. Printing grades differ, then, in exposure scale. No. 4 and 5 printing grades have a very short exposure scale; 0 and 1, a long scale. No. 2 and 3 have exposure scales that are in the normal range, in that they fit most good negatives.

Exposure scale should not be confused with the speed of the paper or the exposure required to make a print. It is an expression of the **range** of light intensities required to produce a print having the full range of useful tones from white to black.

Kodak Azo, Velox, Kodabromide, and other papers are supplied in several printing grades to fit negatives which differ in density scale. Such differences

may be due to variations in subject, lighting, exposure or development. Some papers such as Opal and Kodak Portrait Proof, are intended for use with negatives of uniform quality made under carefully controlled conditions of lighting, exposure, and development, and for this reason are supplied in only one printing grade.

Extent or Density Scale. The degree of gloss of the paper has a great effect on its maximum density. Consider two good prints made from the same negatives—one on No. 2 printing grade matte paper and the other on No. 2 printing grade glossy paper. The print on the glossy paper has the higher maximum density, and its shadow tones are somewhat darker than corresponding areas on the matte-surface print. Both papers fit the negative, and therefore both papers are rated as grade No. 2. However, the **glossy print has more contrast.**

*The type of enlarger also affects the image contrast. Prints made with condenser enlargers have more contrast than prints made in diffusion enlargers.

It is possible for prints made on two different types of paper, both having the same grade number and maximum density, to appear different. This is caused by "local" differences in gradient; in other words, their characteristic curves may differ in shape.

VARIATIONS IN HANDLING, AND THEIR EFFECT UPON CONTRAST AND DENSITY

The contrast of photographic papers is, for most practical purposes, inherent in the emulsion and the paper surface; hence it can be controlled only within narrow limits by variations in development time or developer composition.

SENSITOMETRIC CURVES

As photographic paper is exposed to increasing amounts of light, it produces more and more density. This can be shown as a curve by plotting the reflection density of the developed image against the logarithm of the exposure. Such a curve is called a "D-log E curve" or a "sensitometric curve." Logarithmic values are used because the human eye tends to respond logarithmically rather than arithmetically to different intensities of light.

(Courtesy of Eastman Kodak Co.)

(*Continued on following page*)

EASTMAN KODAK

The graph below shows a typical D-log E curves for the six different grades of a family of Kodak papers, all having a glossy surface. The maximum density tends to be the same for the different grades if the surface is the same, but the rate at which density increases with exposure is seen to be least of the grade 0 paper and greatest for the grade 5 paper.

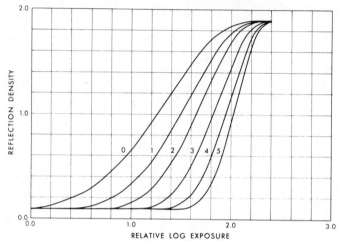

Papers having semimatte or matte surfaces usually give sensitometric curves which are similar to those shown for the glossy papers, except that the maximum densities of the semimatte and matte papers are lower. If the curves for a grade 2 matte paper, all of the same emulsion type, are compared, they usually will be found to be similar to those shown in the next illustration.

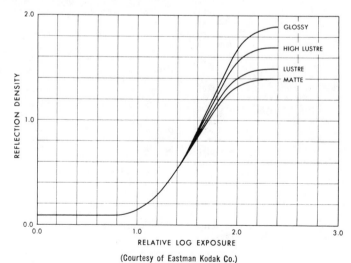

(Courtesy of Eastman Kodak Co.)

(Continued on following page)

EASTMAN KODAK

The Compact Photo-Lab-Index

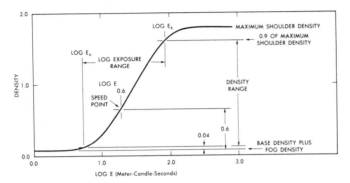

The curve above indicates the location of the speed point, showing how density range and log-exposure are derived.

EXPOSURE SCALE AND SCALE INDEX

The various printing grades of a paper need different ranges of exposures to produce the full scale of tones from white to black. The term "exposure scale" is used for the ratio between the exposure needed to give the faintest useful highlight tone and that required for a full black tone. Thus, a paper with an exposure scale of 1 to 20 will just reproduce all the tones in a negative in which the thinnest part of the image passes 20 times as much light as the densest part. Logarithmic units are usually used for expressing exposure scale because they relate directly to the density difference (density scale) between the highest and lowest densities in the negative. An arithmetic exposure scale of 1 to 20 corresponds to a log exposure scale of 1.30.

A method of determining log exposure scale values for the sensitometric curves of the papers is defined in ANSI Standard for Sensitometry and Grading of Photographic Papers, PH2.2*

Since the term "log exposure scale" is inconveniently long for general use, the American Standard recommends that the name "scale index" be applied to values of log exposure scale that have been rounded off for easy application in practical use. The values are rounded off to the closest figure following the decimal point.

The scale index is useful in the practical problem of fitting the paper to the

negative and also in the more general problem of specifying paper characteristics.

*A copy of this standard can be purchased from the Institute, 1430 Broadway, N.Y., N.Y. 10018, ANSI PH 2.2-1966 (R-1972), American National Standards Institute.

GRADE NUMBER AND SCALE INDEX

The grade numbers, 0, 1, 2, 3, 4, and 5, have for many years been used as an indication of the scale indexes and thus of the types of negative which can be printed successfully on each grade of paper. A negative having a very long density scale usually prints best on a grade 0 paper, which has a long scale index, while a negative having a very short density scale usually prints best on grade 5 paper, which has a short scale index. More recent papers have the grade numbers replaced with grade names: soft, medium, hard, extra hard and ultra hard.

EXPOSURE SCALE VALUES
And Scale Indexes for Kodak Papers

Grade numbers from 0 to 5 have for many years been used as an indication of the scale indexes of papers and thus of the types of negatives which can be printed successfully on each grade of paper. A negative having a very long density scale usually prints best on a Grade 0 paper, which has a long scale index, while a negative having a very

(Courtesy of Eastman Kodak Co.)

(Continued on following page)

EASTMAN KODAK

211

short density scale usually prints best on Grade 5 paper having a very short Scale Index.

For most Kodak papers there is a fairly definite relation between grade number and scale index as indicated in the table below. Some papers do not follow these relations exactly but the approximation is close enough for practical purposes.

Tests made by printing a large number of negatives on various grades of paper, and having observers choose the most pleasing print from each negative, showed that the scale index of the paper should, on the average, be about 0.2 greater than the density scale of the negative. The table which follows shows this relation between the density scale of the negative and the scale index or grade number of the paper.

Paper Grade Number	Log-Exposure Range	Density Scale of Negative Usually Suited For Each Grade
0	1.40-1.70	1.40 or higher
1	1.15-1.40	1.2 to 1.4
2	0.95-1.15	1.0 to 1.2
3	0.80-0.95	.8 to 1.0
4	0.65-0.80	.6 to .8
5	0.50-0.65	less than .6

Kodak Polycontrast Filter Number	Log Exposure Range
4	.65- .70
3½	.70- .80
3	.80- .90
2½	.90-1.00
2 (or 0)	1.00-1.10
1½	1.10-1.20
1	1.20-1.45

Note: All the log exposure range figures approximately describe a suitable negative density scale when contact printing or using a diffusion enlarger. When using a condenser, the required negative density range values are lower.

Multiply the log exposure range value by .76 to find a negative density range suitable for a condenser enlarger. This applies to range guide, number grade and Kodak Polycontrast filter usage.

Paper Grade Name	Log Exposure Range
Soft	1.15-1.40
Medium	0.90-1.15
Hard	0.65-0.90
Extra Hard	0.50-0.65
Ultra Hard	0.35-0.50

PAPER SPEED

Photographic papers differ widely in their sensitivity to light, and thus in the amount of exposure required in printing. A means of numerical rating of their sensitivities or speeds can be helpful to the photographer by indicating the relative exposures required. Suppose for example, that you have made a print on a grade 2 KODABROMIDE Paper, and want to make another print from the same negative on KODAK EKTALURE Paper. The speed numbers show that EKTALURE Paper is about one fourth as fast as KODA-BROMIDE Paper, so it will require an exposure about four times as long. This is perfectly straightforward so long as you are concerned only with papers having the same exposure scale, but

(Courtesy of Eastman Kodak Co.)

(Continued on following page)

becomes a little more complicated when you must compare papers of different scale indexes.

ANSI Paper Speed. When one negative is printed on different grades of paper, the best prints usually are those which reproduce the middle-tones of the picture at about the same density. Because of the differences between the exposure scales of the papers, the relative exposures to make such prints are not directly related to the shadow speeds. Special numbers, called "printing indexes," are given for this situation. They are inversely proportional to the middletone exposures, according to the formula

$$\text{ANSI Paper Speed} = \frac{10,000}{E_m}$$

where E_m is the exposure expressed in meter-candle-seconds, required to produce the middletone density of 0.60 on the paper.

Printing indexes are helpful in finding the new exposure when printing a given negative on a different paper or on a different grade of the same paper. For example, suppose that you have made a print on KODABROMIDE Paper, grade 3, using a 20-second exposure. On examining the print in good light you decide that it is too contrasty and that a better print could be made on grade 2 KODABROMIDE Paper. The exposure time for the second print is easily calculated from the printing indexes for the two grades. The exposure times inversely proportional to the printing indexes. Thus the exposure for grade 2 will be equal to the exposure found for grade 3 multiplied by the printing index for grade 3 divided by the printing index for grade 2, as follows:

20 seconds x 2000 over 3200,
or approximately 12 seconds.

DEVELOPMENT LATITUDE

Sometimes when you're developing a print, the image appears very quickly, and you have to shorten the developing time to avoid getting the print too dark. At other times the print may not seem dense enough after the recommended developing time has elapsed, and you leave it in the developer a little longer than normal. This ability of

a paper to produce an acceptable print by juggling development times is called development latitude.

You normally shouldn't have to "juggle" developing times to get a good print, of course. The best possible prints are made by exposing the paper so that it reaches the density you want when the recommended developing time has elapsed. Acceptable prints can be made, however, throughout a reasonable exposure range.

Warm tone papers, such as KODAK EKTALURE Paper, get progressively colder in image tone with increased development. Contrast also tends to change in such papers. The prints appear lower in contrast with over-exposure and underdevelopment, and show higher contrast with underexposure and overdevelopment. Prints made on KODAK VELOX and KODABROMIDE Papers show practically no change in either image tone or contrast throughout their wide development latitude.

COLOR SENSITIVITY AND SAFELIGHT EFFECTS

Black-and-white photographic papers usually are sensitive to ultraviolet, violet, blue, and blue-green light. This sensitivity does not cut off sharply, though. It decreases gradually as the color of light moves toward the red end of the spectrum. A darkroom safelight has to be a balance between adequate visibility and freedom from fogging. If the safelight recommendations are followed, especially with regard to lamp wattage and the working distances at which they are used fogging of paper by safelight exposure can be avoided.

Bad cases of safelight fogging are easy to detect because the masked border of the paper will show evidence of fogging. It's important to realize that a safelight can degrade the quality of the print image without actually fogging the clear border. This is due to the combined effect of the safelight exposure plus the printing exposure. The safelight exposure alone may not be enough to cause fogging, but when it's added to the normal printing exposure the safelight exposure becomes developable and shows up as gray highlights and a lowering of contrast in a picture.

(Courtesy of Eastman Kodak Co.)

(Continued on following page)

EASTMAN KODAK

CONTRAST OF PRINTS

The contrast of a print depends on the character of the scene; on the type of film, its exposure, and processing; and on the kind of printing paper factors. This **subjective** contrast should not, incidentally, be confused with **objective** contrast which refers to the measurable brightness ratio of any two areas. For example, the objective contrast of two adjacent steps on a gray scale can be measured with a densitometer. Subjective contrast, such as the contrast of a print from a given negative, depends on the printing paper and its handling.

The contrast of a print is a rather complex characteristic to describe. For example, a print made on a G-surface paper is more contrasty when it is wet than when it is dry. A print from a given negative is less contrasty when printed on KODABROMIDE Paper F-2 than when it is printed on KODABROMIDE F-3. A glossy print on No. 2 printing grade is more contrasty than a matte-surface print also on No. 2 printing grade. These are all correct uses of the word "contrast," yet they may be somewhat confusing examples unless the "two-dimensional" aspect of contrast is clear.

Contrast is a word which has two meanings. The two things which determine contrast are **gradient** and **range** (or **extent**). Technically speaking, the gradient is the rate at which the density increases with exposure. The range (or extent) is the total density range available in the print from light to dark. In other words, contrast can be increased by using a paper with a steeper gradient, a higher maximum density or both.

CONTRAST OF PAPERS

Each sheet of photographic paper has a contrast capacity as mentioned earlier. This capacity is the product of gradient and density range. If you print the same negative on No. 1 and No. 2 printing grades of the same paper, the available maximum density is the same. But the print made on the No. 2 paper looks more contrasty. This is because the rate at which density increases with exposure is more rapid for No. 2 printing grade than for No. 1 printing grade. In other words, No. 2 printing grade

paper reaches its maximum density sooner.

The exposure scale of the No. 2 printing grade is shorter. If the negative has a long density scale, the paper may not accommodate all the tones in the negative. Printing grades range in exposure scale from a long scale with a grade 0 to a very short scale with grade 5. No. 2 and 3 have exposure scales that are in the "normal" range—they fit most negatives that are correctly exposed and developed. These same principles apply to name grade papers and selective-contrast papers used with KODAK POLYCONTRAST filters or equivalent.

NEGATIVES FOR BEST PRINT QUALITY

The best prints are made from good negatives. But what exactly **is** a good negative? Actually, it's hard to describe what a good negative looks like. It should have not only detail in the shadows but also highlights that aren't blocked up from overexposure. From a convenience standpoint, a good negative is one that prints well on grade 2 or grade 3 paper.

A negative that prints best on a grade No. 2 or medium grade paper has a density scale between 1.0 and 1.20. This density scale also suits some single contrast grade paper or selective contrast papers with a PC-2 filter paper —another reason for aiming at such quality.

ADJUSTING NEGATIVE CONTRAST BY DEVELOPMENT

Negative contrast can be controlled by varying the film developing time; longer development gives higher contrast, shorter development gives lower contrast. The developing times recommended by the instruction sheets that accompany Kodak films are aimed to yield negatives of average contrast that print well on a normal grade paper. However, printing systems vary in the contrast they yield, and you may need to adjust negative development to suit your particular method of printing.

If your negatives of subjects having a normal brightness range print best on No. 1 paper then reduce the recommended film developing time by about 20 percent. On the other hand, if your

(Courtesy of Eastman Kodak Co.)

(*Continued on following page*)

negatives print best on No. 4 paper, increase the recommended developing time by about 30 percent.

Thin underexposed or underdeveloped negatives generally yield satisfactory prints on No. 4 or No. 5 paper. Negatives with exceptionally high contrast require No. 0 or No. 1 paper. Although passable prints can be made from most negatives, the best print quality is obtained from negatives that print well on grade 2 paper. To minimize grain and keep printing exposure as short as possible, miniature negatives should be developed to a slightly lower contrast and density than the larger sizes.

OTHER FACTORS AFFECTING PRINT CONTRAST

The way a print is made can affect its contrast. Contact printing produces about the same degree of contrast as an enlarger with a diffuse light source. A condenser enlarger, on the other hand, produces greater contrast than diffuse light sources. The difference may be as much as the difference between one or two paper grades.

DEVELOPER AND DEVELOPMENT TIME

The contrast capacity of photographic papers is pretty much built in—there's not much you can do to change it appreciably. Contrast can be changed within fairly narrow limits by variations in development time or developer composition. KODAK SELECTOL-SOFT Developer, for example, is designed to reduce contrast slightly without loss of print quantity. When used with papers for which it's recommended, SELECTOL-SOFT Developer can change the exposure scale about one printing grade.

As we've already mentioned, prolonging processing time increases print density and gives the impression of more contrast. Underdevelopment gives the effect of less contrast. We repeat once more that it's best to pick an appropriate paper for your negative and to develop the paper for the recommended length of time. Over- and under-development can give you troubles in the form of mottle and stain. Some papers have greater development latitude than others.

SELECTIVE CONTRAST PHOTOGRAPHIC PAPERS

While the contrast of most photographic papers is fixed within narrow limits, recent advances have produced variable-contrast papers designed to give a wide range of contrasts. Some of these papers are KODAK POLYCONTRAST, KODAK POLYCONTRAST RAPID, RC, KODAK POLYCONTRAST Rapid, PORTRALURE, and KODAK EKTAMATIC SC. In each case, the contrast is varied by means of filters used between the light source and the printing paper. The KODAK POLYCONTRAST Filter Kit, Model A, can be used with the papers mentioned to provide seven different contrasts of paper, equivalent to printing grades from 1 through 4, in half-grade steps.

"Normal" negatives, which would regularly be printed on grade No. 2 paper, can be printed without a filter (although a No. 2 filter is included in the set so that uniform contrast steps will be available over the entire range). Variable-contrast paper is especially useful in reducing the amount of paper that must be kept in stock, because one box of paper provides all the contrast grades normally required. This eliminates the necessity for buying and storing several different boxes of paper to get a range of contrasts, and cuts the waste of having seldom-used grades spoil on your darkroom shelves.

PAPERS FOR PRINTING COLOR NEGATIVES

Color negatives are becoming increasingly important in all kinds of photography. Negatives from such films as KODACOLOR-II and KODAK VERICOLOR II are the source of almost anything photographic. A color negative can be used to make a color print, a black-and-white print, or a color transparency.

Color prints can be made on KODAK EKTACOLOR 37 RC Paper. This is a multilayer paper designed for direct printing or enlarging from color negatives. The storage requirements are more critical for these papers than for most black-and-white papers. Protect EKTACOLOR Paper against heat and

EASTMAN KODAK

(Courtesy of Eastman Kodak Co.)
(Continued on following page)

store it at temperatures at 50° F or lower.

Making the color prints requires the use of filters, such as KODAK Color Compensating Filters.

Making black-and-white prints from color negatives became practical with the introduction of KODAK PANA-LURE Paper. It's possible to make passable prints on ordinary photographic papers, such as KODABRO-MIDE or KODAK MEDALIST Paper, but PANALURE Paper lets you make really excellent prints. The reasons are simple. The built-in orange mask of KODACOLOR-II negatives acts almost like a safelight for ordinary papers, so exposures need to be very long. Also, black-and-white papers have no red sensitivity, so some of the color differences in the color negative don't register in the print. Reddish or tanned faces are rendered very dark for example. PANALURE Paper has a panchromatic emulsion that can record tone values correctly. Another advantage to using PANALURE Paper is that it provides you with control over tonal rendition. You can darken or lighten any color you wish by using filters during printing. To darken a subject color, use a complementary color filter in the enlarger. To lighten a subject color, use a filter of the same color in the enlarger. If you want a dark, dramatic sky effect in the print, for example, use a red filter, such as the KODAK WRATTEN Filter No. 25 (A), over the enlarger lens while making the print. The effect will be in the same direction as using the same filter over the camera's lens with black-and-white panchromatic film.

PANALURE Paper is available in one normal grade. Its speed is similar to that of KODAK MEDALIST Paper. Because it is sensitive to all colors of light, it should be handled in total darkness or with the KODAK Safelight Filter No. 10 (dark amber).

CHOICE OF PAPER GRADE

Picking the correct grade of paper is essential to good print quality.

A print without enough contrast looks muddy, while the print with too much contrast looks harsh. A print made on the wrong grade of paper may seem passable until you compare it with one made from the same negative on paper of the correct grade.

Remember that a wet print has more contrast and looks lighter than it will when it's dry. Also, darkroom safelight illumination isn't adequate for judging print quality.

PAPER DEVELOPERS

The different developers affect changes primarily in image tone and can be substituted freely if an exact tone is not important. The image tones listed above are the ones obtained with the primary developer recommendations which appear in boldface.

Dektol—Yields neutral and cold tones on cold-tone papers.

Ektaflo, Type 1—The liquid concentrate with characteristics similar to those of Dektol.

Selectol—For warm-tone papers and warmer tones on other papers.

Selectol-Soft—A companion to Selectol, gives lower contrast.

Ektonol—Specially designed for warm-tone papers which are to be toned.

Ektaflo, Type 2—A liquid concentrate with characteristics similar to those of Ektonol.

Versatol—An all-purpose developer for films, plates, and papers.

IMAGE TONE

The color of the silver deposit in the finished print is referred to as "image tone." If brownish the print is said to be "warm" in tone, and if blue-black, it is described as "cold." These differences in color are caused by variations in size and condition of the silver grains which form the image, and they are controlled by the emulsion composition and the conditions of development. KODAK VELOX Paper normally develops to a cold, blue-black image, while KODAK AZO, EKTALURE and PORTRALURE Papers, with normal handling, are warmer in image tone.

Kodak papers are grouped here according to warmth of tone.

(Courtesy of Eastman Kodak Co.)

(Continued on following page)

The Compact Photo-Lab-Index

Tone—Blue-Black
 Kodak Paper—Velox, Velox Unicontrast, Velox Premier
Tone—Neutral-Black
 Kodak Paper—Ad-Type, Azo, Super Speed Direct Positive, Kodabromide, Resisto, Resisto Rapid, Ektamatic SC (Tray), Ektamatic SC (Stabilization Processor) Poly-contrast Rapid, Medalist, School
Tone—Warm-Black
 Mural, Polycontrast, Panalure
Tone—Brown-Black

Kodak Paper — Ektalure, Portrait Proof, Portralure, Panalure Portrait

The warmth of tone of the papers listed as "Warm-Black" or "Brown-Black" can be varied considerably by changes in the developer. KODAK DEKTOL Developer and KODAK Developer D-72 produce comparatively cold tones, while KODAK SELECTOL Developer, KODAK SELECTOL-SOFT Developer, and KODAK Developer D-52 yield warm tones.

KODAK Papers	Safelight Filter	Image Tone Group*	Paper Speeds Contrast Grade or POLYCONTRAST Filter No.						
			WL†	0	1	2	3	4	5
Azo	OC	2	—	6	3	1.6	1.2	.8	.6
Ad-Type	OC	2	—	—	3	1.6	1.2	.8	—
Velox	OC	1	—	—	10	5	4	2	—
Resisto	OC	2	—	—	—	6	6	—	—
Polycontrast	OC	3	160	—	100	125	100	50	—
Panalure	10	3	—	—	—	—	—	250	—
Panalure Portrait	10	4	—	—	—	—	—	100	—
Ektalure	OC	4	—	—	—	—	80	—	—
Portralure	OC	4	50	—	32	—	20	—	—
Kodabromide	OC	2	—	—	500	320	200	160	125
Medalist	OC	3	—	—	160	125	160	200	—
Mural	OC	3	—	—	—	250	250	—	—
Polycontrast Rapid	OC	3	320	—	250	250	160	160	—
Polycontrast Rapid RC	OC	2	320	—	250	250	160	64	—
Portrait Proof	OC	4	—	—	—	—	64	—	—
Ektamatic SC—									
Stabilization	OC	3	400	—	250	250	200	64	—
Tray Processing		2	320	—	200	250	160	64	—

*Key: 1—blue-black 2—neutral-black 3—warm-black 4—brown-black
†White light. These speeds are for selective-contrast papers used without a filter.

(Courtesy of Eastman Kodak Co.)

(Continued on following page)

217

The Compact Photo-Lab-Index

PAPER SPEED

The paper speeds given in the table above are determined by ANSI Standard PH2.2-1966. They provide an approximate indication of the relative exposures needed for the various materials. For example, the speed number for EKTALURE Paper is 125 and that for Polycontrast Paper is 64. Since the higher number indicates a faster emul-

the exposure of EKTALURE Paper. The speeds given are for the average product; aging and adverse storage conditions may alter the speed of a paper. Moreover, the subjective nature of print density will require exposure to be adjusted to suit the subject matter.

Note that paper speeds bear no relationship to ASA film speeds.

sion, Rapid Paper requires about twice

KODAK Developers†	Recommended Time in Sec at 68 F (21 C)	Useful Range in Sec
Dektol (1:2), **Ektaflo Type 1** (1:9), **D-72** (1:2)	60	45 to 120
Ektonol (1:1), **Selectol** (1:1), **D-52** (1:1) **Ektaflo Type 2** (1:9), **Selectol-Soft** (1:1)	120	90 to 240
Dektol (1:2), **Ektaflo Type 1** (1:9), **D-72** (1:2)	60	45 to 120
Dektol (1:2), **Ektaflo Type 1** (1:9), **D-72** (1:2)	60	—
Dektol (1:2), **Ektaflo Type 1** (1:9), **D-72** (1:2)	90	60 to 180
Dektol (1:2), **Ektaflo Type 1** (1:9), **D-72** (1:2) **Ektaflo Type 2** (1:9, **Selectol** (1:1), **Selectol-Soft** (1:1)	90 / 120	60 to 180 / 60 to 180
Selectol (1:1) **Ektaflo Type 2** (1:9), **Selectol-Soft** (1:1)	120	90 to 240
Ektonol (1:1), **Selectol** (1:1), **Ektaflo Type 2** (1:9), **Selectol-Soft** (1:1)	120	90 to 240
Dektol (1:2), **Ektaflo Type 1** (1:9), **D-72** (1:2)	90	60 to 180
Dektol (1:2), **Ektaflo Type 1** (1:9), **D-72** (1:2) **Ektonol** (1:1), **Selectol** (1:1), **Ektaflo Type 2** (1:9), **Selectol-Soft** (1:1)	60 / 120	45 to 120 / 90 to 240
Ektonol (1:1), **Selectol** (1:1), **D-52** (1:1) **Ektaflo Type 2** (1:9), **Selectol-Soft** (1:1) **Dektol** (1:2), **Ektaflo Type 1** (1:9), **D-72** (1:2)	120 / 60	90 to 240 / 45 to 120
Dektol (1:2), **Ektaflo Type 1** (1:9), **D-72** (1:2)	90	60 to 180
Dektol (1:2), **Ektaflo Type 1** (1:9), **D-72** (1:2)	90	60 to 180
Dektol (1:2), **Ektaflo Type 1** (1:9), **D-72** (1:2)	60	—
Ektonol (1:1), **Selectol** (1:1), **D-52** (1:1) **Ektaflo Type 2** (1:9), **Selectol-Soft** (1:1)	120	90 to 240
Stabilization Processing	—	—
Dektol (1:2), **Ektaflo Type 1** (1:9)	60	45 to 120

†Figures in parentheses refer to developer dilutions.

Developers in boldface type in the table are primary recommendations.

(Courtesy of Eastman Kodak Co.)

(*Continued on following page*)

218

EASTMAN KODAK

The Compact Photo-Lab-Index

EXPOSURE DETERMINATION
With Kodak Projection Print Scale

The Kodak Projection Print Scale affords a quick and simple method of determining the correct exposure for any enlargement at any magnification and also aids in selecting the proper contrast of printing paper to use.

This scale is a transparent disk divided into ten sectors, each indicating a different printing time in seconds. In use, the scale should be placed over the sensitized paper on the easel and a test print exposed through it for sixty seconds. Upon development a ten-sector image appears, indicating respective exposures of 2, 3, 4, 6, 8, 12, 16, 24, 32, and 48 seconds. By inspection of this test print, the best exposure should be easily determined.

Complete instructions are printed on the face of the Projection Print Scale.

TEST STRIPS

Another practical and widely used physical aid for gauging exposure is the test strip. After the enlarger has been adjusted for making an enlargement, a narrow strip of the paper to be used is placed within the projected image area so as to include the most important parts of the picture. Successive areas of the test strip are given progressively increasing exposures by intercepting the light beam close to the test strip with a sheet of black photographic paper moved along the strip with the desired steps in exposure time. The exposed test strip is given the full recommended development. Approximately correct exposure may then be visually determined according to the density of the several "steps."

USING A PHOTOMETER

Various photometric methods utilizing homemade and manufactured photometers may be employed to aid in determining print exposures. These may be used to advantage by those who are experienced in their use and familiar with their principles and limitations. A density-exposure calculator method of exposure determination is furnished in the KODAK Darkroom DATA-GUIDE, Publ. No. R-20.

PROCESSING RECOMMENDATIONS
For Kodak Papers

For best print quality and physical performance, all photographic papers should be stored and used at approximately 70°F and 40% relative humidity as shown by dry and wet-bulb thermometers or other means.

SUMMARY
DEVELOPING, FIXING

1. Always prepare solutions carefully using either the ready-to-dissolve Kodak Chemical Preparations or Kodak Tested Chemicals which are ready especially for photographic use.

2. Use enough solution in trays to cover prints by at least ½ inch.

3. Keep all solution temperatures as near 68°F (20°C) as possible.

4. Immerse prints singly, and keep them entirely covered with solution during processing.

5. Agitate prints and separate them frequently while in each solution.

6. Expose prints so that they develop properly in the time recommended.

7. Rinse developed prints at least 30 seconds in Kodak SB-1 Stop Bath.

8. Fix 5 to 10 minutes in a fresh fixing bath, Kodak F-5, or F-6. Overfixation destroys warmth of tone, bleaches the image, and increases the difficulty of washing hypo from the paper base.

KODAK RC papers require only 2 minutes in the recommended fixers.

DARKROOM ILLUMINATION

Most Kodak enlarging papers should be handled and developed by the light of a KODAK Safelight Filter 0C (light amber), used in a suitable safelight lamp with a 15-watt bulb kept at least 4 feet from the paper.

(Courtesy of Eastman Kodak Co.)

(Continued on following page)

SAFELIGHT LAMP RECOMMENDATIONS
Minimum distance from lamp to work area is four feet

Name	Description	KODAK Safelight Filter	Bulb Size
Brownie Darkroom Lamp, Model B	Screws into light socket.	0 (Yellow) Plastic Cup	7-watt
Kodak 2-Way Safelamp	Two sided. Screws into light socket.	0C, 1A, 10 3¼ x 4¾"	15-watt
Kodak Darkroom Lamp	Parabolic, hung on drop cord over bench or sink.	0C, 1A, 10 5½" Circle	15-watt
Kodak Adjustable Safelight Lamp	Parabolic, on standard. For use on a table or mounted on a wall.	0C, 1A, 10 5½" Circle	15-watt
Kodak Utility Safelight Lamp, Model C	Suspended from ceiling by chains. With accessory bracket, used on table or shelf, or mounted on wall.	0C, 1A, 10 10 x 12"	25-watt, indirect at ceiling, 15-watt used on table or shelf.

DEVELOPERS

Some photographers are never happy unless they're manipulating chemicals and processing times for the "magic" combination that will give them better results. We don't want to discourage any budding chemists, but the fact remains that processing according to the manufacturer's recommendations gives more certain results than "home brews" or off-beat processing techniques. Consider this: Every manufacturer wants you to get the best possible results from his products.

In the photographic field, Kodak and other major manufacturers spend large amounts of money in exhaustive and continuing research programs designed to find the best possible ways to handle their products. Such recommendations are published in their data sheets and booklets.

Development Time. Excellent prints are possible only when the printing exposure produces proper print density in the normal developing time. A common cause of "muddy" prints is under-development. You naturally tend to pull out a rapidly darkening print before full development, but the image you get is poor in tone, lacking in contrast, and often mottled from uneven development.

Some papers, such as **KODAK MEDALIST** and **KODABROMIDE**, have more development latitude than others and require less critical exposure.

Overdevelopment, especially in an overworked solution, causes the formation of developer oxidation products which are likely to cause yellow stain. Oxidation also results from other causes such as exposing the developing print to air. Even slight processing stains degrade print quality. Exhausted developers make it difficult to judge print quality accurately because of the dark color of the solution.

Uniform Development. The developing tray should be a little larger than the print. This allows proper agitation and convenience in handling the prints. KODAK trays are made with this need

(Courtesy of Eastman Kodak Co.)

(Continued on following page)

EASTMAN KODAK

in mind. For example, an "8 by 10-inch" tray actually measures about 9 by 11 inches. For best results, slip the print edgewise and face up into the developer solution. Make sure it's covered quickly and evenly. Agitate the solution by rocking the tray or keeping the prints in motion. It's important to keep the prints completely immersed during development to avoid stains from uneven development and oxidation.

STOP BATH

After development, immerse the print for about 5 to 10 seconds in a stop bath, such as KODAK Indicator Stop Bath or KODAK Stop Bath SB-1, at 65 to 70F (18 to 21 C). Agitate the print continuously to make sure it's well treated. If the stop bath is made much stronger than the KODAK SB-1 formula, or if you leave prints in the stop bath considerably longer than necessary, a mottled, "soaking" effect may result.

The KODAK Testing Outfit for Print Stop Baths and Fixing Baths includes a simple test to determine when the stop bath is exhausted. KODAK Indicator Stop Bath and KODAK EKTAFLO Stop Bath, supplied as concentrates, are yellow liquids that change to a purplish blue on exhaustion; at this point, they should be discarded.

FIXING

Ffter the prints have been rinsed carefully in the stop bath, fix them for 5 to 10 minutes at 65 to 70 F with agitation in an acid hardening fixing bath. You could use a solution prepared from KODAK Fixer or made from the formula for KODAK Fixing Bath F-5 or F-6. F-6 is recommended for general use because it has less odor. F-5 is good if prints tend to stick to your ferrotype plates, belts, drums, or drier, or if they soften in the toning bath. KODAFIX Solution KODAK Rapid Fixer, and KODAK EKTAFLO Fixer are also recommended. As single baths, these solutions will fix about 8000 square inches of prints per gallon—100 8 x 10-inch prints, 400 4 x 5-inch prints, etc.

By far the best and most economical system is to use two fixing baths in succession. A two-bath system gives a much more permanent print and lets you use the fixing solution for many more prints.

Here's how it works. Have both baths at 65 to 70 F (18 to 21 C). Fix the prints, with frequent agitation, for 3 to 5 minutes in the first bath. Drain them for five seconds, then fix for 3 to 5 minuates in the second bath.

The two baths are "good" for two hundred 8 x 10-inch prints or their equivalent in other sizes, per gallon of the first bath. After that many prints have been fixed, throw away the first bath, put the second in its place, and mix a new second bath. The new two-bath setup is ready for two hundred more prints. After three more such changes (when you have fixed one thousand 8 x 10-inch prints or their equivalent in other sizes), throw away both baths and start over again. In any case, solutions shouldn't be kept longer than a week.

Avoid prolonged fixing or fixing at high temperatures, especially with warm-tone prints, because the bath tends to bleach the image and change its tone.

Resin-coated papers should be fixed for 2 minutes in a single bath fixer.

WASHING

Papers are washed to remove the fixing solution from both the emulsion and the paper base. If the hypo isn't removed, it will gradually transform the black silver image into a brown or yellowish one. Dissolved silver salts carried from the fixing bath must be removed or clear areas of prints will yellow. If you don't treat your prints in chemicals designed to accelerate washing, wash them for at least one hour with agitation and adequate water flow. Don't soak prints overnight in wash water, though, because bleaching and stains may result.

KODAK Hypo Clearing Agent can be used to reduce washing time and to obtain more complete washing. Transfer the prints, with or without previous rinse, to the clearing agent solution. Treat single-weight papers at least 2 minutes, with agitation, at 65 to 70 F (18 to 21 C). Double-weighted papers should be treated for at least 3 minutes. Wash single-weight papers at least 10

(Courtesy of Eastman Kodak Co.)

(*Continued on following page*)

EASTMAN KODAK

minutes and double-weight papers at least 20 minutes with agitation and normal water flow. If you maintain the water temperature at 65 to 70 F (18 to 21 C), a higher degree of stability can be obtained than you get with normal one-hour washing without the Hypo Clearing Agent Treatment. Here's a real bonus—when you use KODAK Hypo Clearing Agent, your water temperature can be as low as 35 F (1.7 C).

Prints not treated in KODAK Hypo Clearing Agent Solution should be washed for at least an hour in running water at 65 to 70 F (18 to 21 C). Water warmer than that tends to soften the emulsion and doesn't shorten washing time by much. Don't let the stream of water fall directly on the prints. When washing in a tray, place a tumbler or graduate in the tray and let the water overflow from it into the tray. The wash water should move fast enough to fill the washing container 10 to 12 times an hour, and it should keep the prints moving. Trays should not be so loaded that prints mat together and prevent proper washing action. The KODAK Automatic Tray Siphon converts any ordinary tray into an efficient print washer which assures proper movement and agitation of prints during washing.

Prints made on resin-coated papers should be washed for 4 minutes in running water. There is no need to use KODAK Hypo Clearing Agent.

TESTING FOR HYPO AND SILVER SALTS

Even small traces of hypo (fixing bath) retained in prints accelerate the rate of image fading.

If prints don't receive proper fixing, or if they're fixed in a used bath containig dissolved silver compounds ín any quantity, some silver salts will be retained in the paper. These salts are very difficult to remove by washing. Eventually they may discolor and cover the prints with a brownish stain or silver sulfide. The remedy, of course, is adequate two-bath fixing and thorough washing. When testing for residual hypo, also check your prints for silver salts.

DRYING MATTE PRINTS

Sponge the surplus water from both the back and front of the prints, and dry them in a KODAK Photo Blotter Roll, on a muslin-covered rack, or on a twin-belt, matte drying machine.

Prints that dry with an excessive curl can be straightened with a KODAK Print Straightener, Model G.

FERROTYPING

All Kodak F-surface papers except for those with a resin-coated base can be ferrotyped on chromium-plated sheets or on a ferrotyping machine. Prints ferrotyped on plated sheets should be allowed to dry naturally. Those ferrotyped on heated-drum machines are best dried at a temperature of approximately 180 F (82 C).

Cleanliness is most important in all ferrotyping operations. The wash water should be filtered to remove solid particles; the glazing surfaces of plates and machines, as well as the conveyor belts of machines, should be protected from airborne dust.

F-surface resin-coated air-dry with a gloss without ferrotyping. DO NOT FERROTYPE resin coated papers.

TONING

You can choose from various papers to get the warmth of image tone you prefer in the print. You can vary the warmth of tone of such papers as KODAK AZO and MEDALIST by the choice of developer. Using KODAK SELECTOL and EKTAFLO, Type 2, Developers, for example, gives you warmer tones on such papers than KODAK DEKTOL and EKTAFLO, Type 1, Developers.

If you want a more strongly colored image, you can tone the picture. KODAK POLY-TONER is a concentrated solution that can be used to produce a whole range of reddish brown to warm brown, simply by varying the dilution. A number of packaged Kodak toners are available. Or, you can mix your own, using the formulas listed in this section.

The final hue of a toned print is influenced by emulsion type, age, and storage conditions of the paper, processing variations prior to toning, and variations in toning procedure. Successful toning is dependent on correct print processing, including full development, use of a fresh fixing bath, KODAK Hypo Clearing Agent, and adequate washing prior to toning.

The Compact Photo-Lab-Index

PRINTING PROCEDURE

PROJECTION PRINTING

KODAK POLYCONTRAST Paper is designed for printing by exposure to tungsten lamps, such as Photo Enlarger No. 212 or No. 302. When a cool-white (4500 K) flourescent lamp is used, a CP40Y or CC40Y filter is recommended in addition to the appropriate KODAK POLYCONTRAST Filter.

CONTRAST CONTROL

KODAK POLYCONTRAST Filters No. 1, 2, 3, and 4 give a range of contrasts similar to that of the corresponding grades of KODAK Number Grade Papers. Filters No. 1½, 2½, and 3½ yield degrees of contrast midway between these grades.

Negatives of normal contrast, which would regularly be printed on grade No. 2 paper, can be printed without a filter (although a No. 2 filter is included in the set to give uniform contrast steps over the entire range).

The filters in the KODAK POLYCONTRAST Filter Kit (Model A) or KODAK POLYCONTRAST Gelatin Filters are used at the lens. KODAK POLYCONTRAST Acetate Filters can be used **only** between the light source and the negative.

CONTACT PRINTING

Use KODAK POLYCONTRAST Acetate Filters, 11 x 14-inch, between the printing lights and the negative for contrast control. Reduce the total exposure to approximately 1/10 of that used for a contact speed paper.

RINSE

With agitation at 65 to 70 F (18-21 C) for 5 to 10 seconds in KODAK EK-TAFLO Stop Bath or KODAK Indicator Stop Bath. Discard when solution turns a purplish blue.

or in KODAK Stop Bath SB-1. Discard after processing 78 8 x 10-inch prints or equivalent per gallon.

FIX

With agitation at 65 to 70 F (18-21 C) in KODAK EKTAFLO Fixer (1:7), KODAK Fixer, KODAFIX Solution, KODAK Rapid Fixer, or KODAK Fixing Bath F-5 or F-6.

The two-fixing-bath method is recommended. Fix the prints from 3 to 5 minutes in each bath. After fixing 200 8 x 10-inch prints or equivalent per gallon, discard the first bath. Advance the second bath to replace the first and make a new second bath. Discard both solutions after 1000 8 x 10-inch prints or equivalent per gallon have been processed or after 1 week, whichever occurs first.

When the single-bath method is used, fix for 5 to 10 minutes. Discard after fixing 100 8 x 10-inch prints or equivalent per gallon. **Note:** Do not fix prints for total time longer than 10 minutes.

WASH

To reduce time and save water, use KODAK Hypo Clearing Agent. Then wash for 10 to 20 minutes, depending on stock weight of paper. See instructions packaged with chemicals.

Otherwise wash prints for at least 1 hour at 65 to 75 F (18-24 C) in a tank in which there is a complete change of water every 5 minutes. The KODAK Automatic Tray Siphon provides proper change of water for prints washed in a tray.

To minimize curl, bathe the prints in KODAK Print Flattening Solution after washing and before drying. All prints must be fixed and washed thoroughly or they can contaminate other prints treated in the Print Flattening Solution.

DRY

Remove as much excess water as possible. Then place prints on a belt dryer, on cheesecloth stretchers, or between white photo blotters.

Prints on glossy surface paper can be ferrotyped. Use KODAK Dry Mounting Tissue or KODAK Rapid Mounting Cement to mount prints.

TONING

Recommended toners are KODAK Brown Toner, KODAK Sepia Toner, and KODAK Sulfide Sepia Toner T-7a.

(Courtesy of Eastman Kodak Co.)

(Continued on following page)

EASTMAN KODAK

RECOMMENDATIONS FOR TONING KODAK PAPERS IN KODAK TONERS

KODAK Paper	Hypo Alum Sepia T-1a	Sepia or Sulfide Sepia T-7a	Brown or Poly-sulfide T-8	Gold T-21	Rapid Selenium	Poly-Toner (1:24)	Blue
Ad-Type	X	X	P	NR	X	P	NR
Azo	X	X	P	NR	X	P	NR
Ektalure	X	X	X	P	P	P	X
Ektamatic SC*	P	P	P	NR	X	X	X
Kodabromide	X	P	NR	NR	NR	NR	NR
Medalist	P	P	P	NR	X	P	X
Mural	P	P	P	NR	X	P	X
Panalure	P	P	P	X	X	X	X
Panalure Portrait	X	X	X	X	P	P	X
Polycontrast, Polycontrast Rapid Polycontrast Rapid RC	P P	P	P	NR	X	X	X
Portralure	P	P	P	P	P	P	X
Portrait Proof	X	X	X	P	P	P	X
School	X	X	P	NR	X	P	X
Velox	P	P	X	NR	NR	NR	X
Velox Premier	X	X	X	NR	NR	NR	X
Velox Unicontrast	P	P	X	NR	X	NR	X

X—Although not a primary recommendation, a tone can be secured which may have an application for special purposes.
P—Primary recommendation. NR—Not Recommended.
*When processed by conventional tray methods.

KODAK **AZO PAPER**

APPLICATIONS
Contact-printing paper for commercial, industrial, and illustrative photography.

CHARACTERISTICS
Neutral-black image tone.
Surface and contrast characteristics are listed in the following table:

Tint	Brilliance	Texture	Symbol	Weight	Grade
White	Glossy	Smooth	F	Single Weight Double Weight	No. 0, 1, 2, 3, 4, 5 No. 1, 2, 3
White	Lustre	Smooth	N	Double Weight	No. 1, 2, 3, 4
White	Lustre	Fine-Grained	E	Single Weight Double Weight	No. 1, 2, 3, 4 No. 2, 3

SAFELIGHT
Kodak Safelight Filter OC (light amber)

PRINTING INFORMATION

Paper Grade	No. 0	No. 1	No. 2	No. 3	No. 4	No. 5
ANSI Paper Speed	6	3	1.6	1.2	.8	.6

DEVELOPMENT RECOMMENDATIONS
—AT 68 F (20 C)

Kodak Developer	Dilution	Development Time in Minutes Recommended	Development Time in Minutes Useful Range	Cap. (8x10″ prints per gal.)	Purpose
Dektol	1:2	1	¾ to 2	120	Cold Tones
Ektaflo, Type 1	1:9	1	¾ to 2	120	Cold Tones
D-72	1:2	1	¾ to 2	100	Cold Tones
Versatol	1:3	1	¾ to 2	80	Cold Tones
Ektonol	1:1	2	1½ to 4	80	Warmer Tones
Selectol	1:1	2	1½ to 4	80	Warmer Tones
Ektaflo, Type 2	1:9	2	1½ to 4	100	Warmer Tones
D-52	1:1	2	1½ to 4	80	Warmer Tones
Selectol-Soft	1:1	2	1½ to 4	80	Lower Contrast

TONING RECOMMENDATIONS
Kodak Brown Toner
Kodak Poly-Toner
Kodak Polysulfide Toner T-8

(Courtesy of Eastman Kodak Co.)

EASTMAN KODAK

225

KODAK **EKTALURE PAPER**

APPLICATIONS
Enlarging paper (or contact-printing paper, with reduced illumination in the printer) particularly suitable for portrait or pictorial printing.

CHARACTERISTICS
Brown-black image tone. Surface and weight characteristics are listed in the following table:

IMAGE TONE
Neutral-black.

SAFELIGHT
KODAK Safelight Filter OC (light amber)

PRINTING INFORMATION
ANSI Paper Speed: 80

Tint	Brilliance	Texture	Symbol	Weight
Warm-White	Lustre	Fine-Grained	E	Double Weight
Cream-White	Lustre	Fine-Grained	G	Double Weight
Warm-White	High-Lustre	Fine-Grained	K	Double Weight
Cream-White	Lustre	Tweed	R	Double Weight
Warm-White	High-Lustre	Silk	Y	Double Weight
Cream-White	Lustre	Tapestry	X	Double Weight

DEVELOPMENT RECOMMENDATIONS —AT 68 F (20 C)

Kodak Developer	Dilution	Development Time in Minutes		Cap. (8x10″ prints per gal.)	Purpose
		Recommended	Useful Range		
Ektafio, Type 2	1:9	2	1½ to 3	100	Warm Tones
Ektonol	1:1	2	1½ to 3	80	Warm Tones
Selectol	1:1	2	1½ to 3	80	Warm Tones
D-52	1:1	2	1½ to 3	80	Warm Tones
Selectol-Soft	1:1	2	1½ to 3	80	Lower Contrast

TONING RECOMMENDATIONS
KODAK POLY-TONER, KODAK Rapid Selenium Toner, and KODAK Gold Toner T-21.

If prints are to be selenium-toned, reduce developing time slightly because selenium toners tend to increase print density.

The formula for KODAK Toner T-21 is given elsewhere in this section.

(Courtesy of Eastman Kodak Co.)

KODAK EKTAMATIC SC PAPER

APPLICATIONS

Proofing. Quality deadline work. Newspaper work. Medical, military, and police photography.

CHARACTERISTICS

A variable-contrast, enlarging paper. Designed primarily for exposure with tungsten light. Contrast can be varied by using KODAK POLYCONTRAST Filters.

Stabilization processing in the KODAK EKTAMATIC Processor, Model 214-K, or similar processors, provides high production speeds. Can also be processed conventionally in a tray. Keeping life of stabilized prints can be made more permanent by subsequent fixing and washing.

Warm-black image tone with stabilization processing; neutral-black image tone with trap processing. Surface and weight characteristics are listed in the following table:

SAFELIGHT

KODAK Safelight Filter OC (light amber)—since these papers depend on blue and yellow light for contrast control, avoid exposing them to the safelight for any length of time.

Tint	Brilliance	Texture	Symbol	Weight
White	Glossy	Smooth	F	Single Weight Double Weight
White	Lustre	Smooth	N	Single Weight
White	Lustre	Smooth	A	Light Weight

PRINTING INFORMATION

Polycontrast Filter	PC 1	PC 1½	PC 2	PC 2½	PC 3	PC 3½	PC 4	No Filter (white light)
ANSI Speed-Stab. Process	250	320	250	250	200	125	64	400
ANSI Speed-Tray Process	200	250	250	200	160	125	64	320

LIGHT SOURCE FOR PROJECTION PRINTING

Tungsten, similar to a Photo Enlarger No. 212 or 302. Although not recommended for optimum results, light sources other than tungsten may be used with light-source correction filters. Filters suggested as starting points with three common light sources are: CP 40Y or CC40Y with a cool-white (4500 K) fluorescent lamp; a CC or CP correction of 70Y for a 6500 K fluorescent lamp; a combination of the KODAK WRATTEN Filter No. 6 plus a correction of CP40Y or CC40Y with a mercury-arc light source. Light-source correction filters are required in addition to the appropriate KODAK POLYCONTRAST Filter that may be used for contrast control.

STABILIZATION PROCESSING

ACTIVATE

KODAK EKTAMATIC A10 Activator at 70 F (range, 65 to 85 F).

STABILIZE

KODAK EKTAMATIC S30 Stabilizer at 70 F (range, 65 to 85 F).

IMPORTANT

Do not rinse or wash the print after it comes out of the stabilizer.

DRY

Prints coming out of the processor are partially dry and are usable. Complete drying takes only a few additional minutes at room temperature. Auxiliary drying equipment is not recommended.

(Courtesy of Eastman Kodak Co.)

(*Continued on following page*)

EASTMAN KODAK

The Compact Photo-Lab-Index

STABILITY OF PRINTS:

The stabilized prints are subject to deterioration with exposure to both light or heat and humidity. Because of the extreme dependence on the degree and combination of these 'factors, meaningful information can not be given regarding the expected useful 'life of the resultant prints.

REPLENISHMENT OF ACTIVATOR AND STABILIZER

After filling the trays of the processor, add additional solution to maintain the solution level as proctssing proceeds.

CAPACITY

Because of the variable volume of the trays in the equipment, a valid solution capacity in square feet per gallon is not applicable. However, tht processing chemicals should be discarded, and the processor should be cleaned, after about three hundred 8 x 10-inch prints (or the equivalent area in other sizes) have been processed, or after one week's use, whichever occurs first.

STORAGE LIFE

The storage life of the solutions is indefinite in the original sealed package. Do not store chemicals in areas having temperatures about 120 F.

POST STABILIZATION FOR PERMANENCE

If more stable prints are desired, the following post-stabilization treatments are recommended.

FIX

Immerse the stabilized prints for 8 to 12 minutes with agitations in KODAK Fixer, KODAK Fixing Bath F-5 or F-6, KODAK Rapid Fixer, or KODAFIX Solution at 65 to 70 F.

WASH

To reduce time and save water, use KODAK Hypo Clearing Agent. Then wash for 10 minutes. See instructions packaged with chemicals.

Otherwise wash prints for at least 1 hour at 65 to 70 F (18-21 C) in a tank in which there is a complete change of water every 5 minutes.

DRY

Prints can be dried (or prints on the F surface can be ferrotyped) in the normal manner.

RINSE

With agitation at 65 to 70 F (18-21 C) for 5 to 10 seconds in KODAK Indicator Stop Bath or KODAK Stop Bath SB-1.

FIX

With frequent agitation at 65 to 70 F (18-21 C) for 5 to 10 minutes in KODAK Fixer, KODAFIX Solution, KODAK Fixing Bath F-5 or F-6.

WASH

To reduce time and save water, use KODAK Hypo Clearing Agent. Then wash for 10 minutes. See instructions packaged with chemicals.

Otherwise wash prints for at least 1 hour at 65 to 70 F (18-21 C) in a tank in which there is a complete change of water every 5 minutes.

DRY

Remove as much excess water as possible. Then place prints on a belt dryer, on cheesecloth stretchers, or between white photo blotters. Prints on glossy surface paper can be ferrotyped.

TONING

Recommended toners are KODAK Brown Toner, KODAK Sepia Toner, and KODAK Sulfide Sepia Toner T-7a.

TONING RECOMMENDATIONS

These toners are recommended only for prints that have been fixed and washed:

Kodak Hypo Alum Sepia Toner T-1a
Kodak Sulfide Sepia Toner T-7a
Kodak Polysulfide Toner T-8
Kodak Sepia Toner
Kodak Brown Toner

(Courtesy of Eastman Kodak Co.)

The Compact Photo-Lab-Index

KODABROMIDE **PAPER**

APPLICATIONS
General-purpose enlarging paper. Widely used for studio, commercial, press, photofinishing, and exhibition prints.

CHARACTERISTICS
Neutral-black image tone. Surface and contrast characteristics are listed in the following table:

Tint	Brilliance	Texture	Symbol	Weight	Grade
White	Glossy	Smooth	F	Single Weight Double Weight	No. 1, 2, 3, 4, 5 No. 1, 2, 3, 4, 5
White	Lustre	Smooth	N	Single Weight Double Weight	No. 2, 3, 4 No. 2, 3, 4
White	Lustre	Smooth	A	Light Weight	No. 1, 2, 3, 4, 5
White	Lustre	Fine-Grained	E	Single Weight Double Weight	No. 2, 3, 4 No. 2, 3, 4
Cream White	Lustre	Fine-Grained	G	Double Weight	No. 2, 3, 4

SAFELIGHT
Kodak Safelight Filter OC (light amber)

PRINTING INFORMATION

Paper Grade	No. 1	No. 2	No. 3	No. 4	No. 5
ANSI Paper Speed	500	320	200	160	125

DEVELOPMENT RECOMMENDATIONS—AT 68 F (20 C)

Kodak Developer	Dilution	Development Time in Minutes		Capacity (8 x 10-inch prints per gallon)	Purpose
		Recommended	Useful Range		
Dektol	1.2	1½	1 to 3	120	Cold Tones
D-72	1:2	1½	1 to 3	100	Cold Tones
Ektaflo, Type 1	1:9	1½	1 to 3	120	Cold Tones
Versatol	1:3	1½	1 to 3	80	Cold Tones

TONING RECOMMENDATIONS
Kodak Sepia Toner.
Kodak Sulfide Sepia Toner T-7a.

(Courtesy of Eastman Kodak Co.)

KODAK **MEDALIST PAPER**

APPLICATIONS

General-purpose enlarging paper.
Excellent for illustrative, commercial, and pictorial subjects.
Good choice for printing candid wedding pictures.

CHARACTERISTICS

Warm-black image tone. Surface and contrast characteristics are listed in the following table:

Tint	Brilliance	Texture	Symbol	Weight	Grade
White	Glossy	Smooth	F	Single Weight Double Weight	No. 1, 2, 3, 4 No. 2, 3
White	High Lustre	Smooth	J	Double Weight	No. 2, 3
White	Lustre	Fine-Grained	E	Double Weight	No. 2, 3
Cream White	Lustre	Fine-Grained	G	Double Weight	No. 2, 3, 4
Cream White	High Lustre	Silk	Y	Double Weight	No. 2, 3

SAFELIGHT

Kodak Safelight OC (light amber).

PRINTING INFORMATION

Paper Grade	No. 1	No. 2	No. 3	No. 4
ANSI Paper Speed	160	125	160	200

DEVELOPMENT RECOMMENDATIONS—AT 68 F (20 C)

Kodak Developer	Dilution	Development Time in Minutes Recommended	Range Useful	Capacity (8 x 10-inch prints per gallon)	Purpose
Ektaflo, Type 1	1:9	1	¾ to 2	120	Warm Tones
Dektol	1:2	1	¾ to 2	120	Warm Tones
D-72	1:2	1	¾ to 2	100	Warm Tones
Versatol	1:3	1	¾ to 2	80	Warm Tones
Ektaflo, Type 2	1:9	2	1½ to 4	100	Warmer Tones
Ektonol	1:1	2	1½ to 4	80	Warmer Tones
Selectol	1:1	2	1½ to 4	80	Warmer Tones
D-52	1:1	2	1½ to 4	80	Warmer Tones
Selectol-Soft	1:1	2	1½ to 4	80	Lower Contrast

TONING RECOMMENDATIONS

Kodak Poly-Toner. Kodak Sepia Toner. Kodak Sulfide Sepia Toner T-7a. Kodak Brown Toner. Kodak Polysulfide Toner T-8. Kodak Hypo Alum Sepia Toner T-1a.

KODAK **MURAL PAPER**

APPLICATIONS

Enlarging paper for photomural and other large-print work.

CHARACTERISTICS

Warm-black image tone. Surface and contrast characteristics are listed in the following table:

Tint	Brilliance	Texture	Symbol	Weight	Grade
Cream-White	Lustre	Tweed	WRM R	Single Weight	No. 2, 3

SAFELIGHT

KODAK Safelight Filter OC (light amber)

PRINTING INFORMATION

ANSI Paper Speed: 250

DEVELOPMENT RECOMMENDATIONS —AT 68 F (20 C)

Kodak Developer	Dilution	Development Time in Minutes		Cap. (8x10" prints per gal.)	Purpose
		Recommended	Useful Range		
Ektonol	1:1	2	1½ to 4	80	Warm Tone
Selectol	1:1	2	1½ to 4	80	Warm Tone
D-52	1:1	2	1½ to 4	80	Warm Tone
Ektonol	1:3	4	3 to 8	—	Large Prints*
Selectol	1:3	4	3 to 8	—	Large Prints*
D-52	1:3	4	3 to 8	—	Large Prints*
Ektaflo, Type 2	1:9	2	1½ to 4	100	Warm Tone
Selectol-Soft	1:1	2	1½ to 4	80	Lower Contrast
Dektol	1:2	1	¾ to 2	120	Colder Tone
D-72	1:2	1	¾ to 2	100	Colder Tone
Dektol	1:4	2	1½ to 4	—	Large Prints*
D-72	1:4	2	1½ to 4	—	Large Prints*
Ektaflo, Type 1	1:9	1	¾ to 2	120	Colder Tone

*In processing large prints, prolonged development in a dilute solution helps to prevent the streaks and marks caused by uneven development.

TONING RECOMMENDATIONS

Kodak Poly-Toner
Kodak Sepia Toner
Kodak Sulfide Sepia Toner T-7a
Kodak Brown Toner
Kodak Polysulfide Toner T-8
Kodak Hypo Alum Sepia Toner T-1a

(Courtesy of Eastman Kodak Co.)

EASTMAN KODAK

KODAK PANALURE AND PANALURE PORTRAIT PAPER

APPLICATIONS

Black-and-white enlargements (or contact prints, with reduced illumination in the printer) from color negatives. Especially useful in the fields of commercial, portrait, and school photography.

CHARACTERISTICS

Panalure—Warm-black image tone. Panalure Portrait—Brown-black image tone. Surface and weight characteristics are listed in the following table:

Kodak Paper	Tint	Brilliance	Texture	Symbol	Weight
Panalure	White	Glossy	Smooth	F	Single Weight
Panalure Portrait	White	Lustre	Fine-Grained	E	Double Weight

SAFELIGHT

KODAK Safelight Filter No. 10 (dark amber)—keep safelight exposure to a minimum.

PRINTING INFORMATION

Kodak Paper	ANSI Paper Speed	
	With Color Negatives	With Black-and-White Negatives
Panalure	250	400
Panalure Portrait	100	160

DEVELOPMENT RECOMMENDATIONS FOR KODAK PANALURE PAPER—AT 68 F (20 C)

Kodak Developer	Dilution	Development Time in Minutes		Cap. (8x10″ prints per gal.)	Purpose
		Recommended	Useful Range		
Ektaflo, Type 1	1:9	1½	1 to 3	120	Warm Tones
Dektol	1:2	1½	1 to 3	120	Warm Tones
D-72	1:2	1½	1 to 3	100	Warm Tones
Versatol	1:3	1½	1 to 3	80	Warm Tones
Ektaflo, Type 2	1:9	2	1 to 3	100	Warmer Tones
Ektonol	1:1	2	1 to 3	80	Warmer Tones
Selectol	1:1	2	1 to 3	80	Warmer Tones
D-52	1:1	2	1 to 3	80	Warmer Tones
Selectol-Soft	1:1	2	1 to 3	80	Lower Contrast

(Courtesy of Eastman Kodak Co.)

(Continued on following page)

KODAK **PANALURE AND PANALURE PORTRAIT PAPER**
(continued)

DEVELOPMENT RECOMMENDATIONS FOR KODAK PANALURE PORTRAIT PAPER—AT 68 F (20 C)

Kodak Developer	Dilution	Development Time in Minutes		Cap. (8x10″ prints per gal.)	Purpose
		Recommended	Useful Range		
Selectol	1:1	2	1½ to 4	80	Warm Tones
Ektaflo, Type 2	1:9	2	1½ to 4	100	Warm Tones
Selectol-Soft	1:1	2	1½ to 4	80	Lower Contrast
Dektol	1:2	1½	1 to 3	120	Colder Tones
Ektaflo, Type 1	1:9	1½	1 to 3	120	Colder Tones

TONING RECOMMENDATIONS

For Panalure Paper
Kodak Sepia Toner
Kodak Sulfide Sepia Toner T-7a
Kodak Brown Toner
Kodak Polysulfide Toner T-8
Kodak Hypo Alum Sepia Toner T-1a

For Panalure Portrait Paper
Kodak Poly-Toner
Kodak Sulfide Sepia Toner T-7a
Kodak Rapid Selenium Toner
Kodak Polysulfide Toner T-8
Kodak Hypo Alum Sepia Toner T-1a

KODAK **POLYCONTRAST PAPER**

APPLICATIONS

Enlarging paper (or contact-printing paper, with reduced illumination in the printer) particularly useful in the fields of commercial, industrial, photofinishing, and school photography.

Variable-contrast paper for general photographic use and for the darkroom hobbyist.

CHARACTERISTICS

Variable-contrast paper. Use without a filter with normal-contrast negatives, or with KODAK POLYCONTRAST Filters to obtain seven degrees of contrast. Warm-black image tone. Surface and weight characteristics are listed in the following table:

Tint	Brilliance	Texture	Symbol	Weight
White	Glossy	Smooth	F	Single Weight Double Weight
White	Lustre	Smooth	N	Single Weight Double Weight
White	Lustre	Smooth	A	Light Weight
White	High-Lustre	Smooth	J	Single Weight Double Weight
Cream-White	Lustre	Fine-Grained	G	Double Weight

(Courtesy of Eastman Kodak Co.)

(Continued on following page)

The Compact Photo-Lab-Index

SAFELIGHT
KODAK Safelight Filter OC (light amber). Because the paper depends on blue and yellow light exposures for contrast control, keep safelight exposures to a minimum to avoid unwanted contrast changes.

PRINTING INFORMATION

Polycontrast Filter	PC 1	PC 1½	PC 2	PC 2½	PC 3	PC 3½	PC 4	No Filter (white light)
ANSI paper Speed	100	125	125	100	100	80	50	160

LIGHT SOURCE FOR PROJECTION PRINTING
Tungsten, similar to a Photo Enlarger No. 212 or 302. Although not recommended for optimum results, light sources other than tungsten may be used with light-source correction filters. Filters suggested as starting points with three common light sources are: CP 40Y or CC40Y with a cool-white (4500 K) fluorescent lamp; a CC or CP correction of 70Y for a 6500 K fluorescent lamp; a combination of the KODAK WRATTEN Filter No. 6 plus a correction of CP40Y or CC40Y with a mercury-arc light source. Light source correction filters are required in addition to the appropriate KODAK POLYCONTRAST Filter that may be used for contrast control.

CONTACT PRINTING
Use KODAK POLYCONTRAST Acetate, 11 x 14-inch, between the printing lights and the negative for contrast control. Reduce the total exposure to approximately 1/10 of that used for a contact speed paper.

DEVELOPMENT RECOMMENDATIONS —AT 68 F (20 C)

Kodak Developer	Dilution	Development Time in Minutes		Cap. (8x10″ prints per gal.)	Purpose
		Recommended	Useful Range		
Dektol	1:2	1½	1 to 3	120	Warm Tones
D-72	1:2	1½	1 to 3	100	Warm Tones
Ektaflo, Type 1	1:9	1½	1 to 3	120	Warm Tones

TONING RECOMMENDATIONS
Kodak Sepia Toner
Kodak Sulfide Sepia Toner T-7a
Kodak Brown Toner
Kodak Polysulfide Toner T-8
Kodak Hypo Alum Sepia Toner T-1a

234

KODAK **POLYCONTRAST RAPID PAPER**

APPLICATIONS

Enlarging paper especially useful in the fields of commercial, industrial, photofinishing, and school photography.

Variable-contrast paper for general photographic use.

Valuable for printing from dense negatives and for enlarging small negatives to high magnifications.

CHARACTERISTICS

Variable-contrast paper. Use without a filter with normal-contrast negatives, or with KODAK POLYCONTRAST Filters to obtain seven degrees of contrast. Warm-black image tone. Surface and weight characteristics are listed in the following table:

Tint	Brilliance	Texture	Symbol	Weight
White	Glossy	Smooth	F	Single Weight Double Weight
White	Lustre	Smooth	N	Single Weight
Cream-White	Lustre	Fine-Grained	G	Double Weight
Cream-White	High-Lustre	Silk	Y	Double Weight

SAFELIGHT

KODAK Safelight Filter OC (light amber). Because the paper depends on blue and yellow light exposures for contrast control, limit safelight exposures to 3 minutes or less in order to avoid unwanted contrast changes.

PRINTING INFORMATION

Polycontrast Filter	PC 1	PC 1½	PC 2	PC 2½	PC 3	PC 3½	PC 4	White Light (no filter)
ANSI Paper Speed	250	320	250	200	160	125	64	320

LIGHT SOURCE FOR PROJECTION PRINTING

Tungsten, similar to a Photo Enlarger No. 212 or 302. Although not recommended for optimum results, light sources other than tungsten may be used with light-source correction filters. Filters suggested as starting points with three common light sources are: CP 40Y or CC40Y with a cool-white (4500 K) fluorescent lamp; a CC or CP correction of 70Y for a 6500 K fluorescent lamp; a combination of the KODAK WRATTEN Filter No. 6 plus a correction of CP40Y or CC40Y with a mercury-arc light source. Light-source correction filters are required in addition to the appropriate KODAK POLYCONTRAST Filter that may be used for contrast control.

TONING RECOMMENDATIONS

Kodak Sepia Toner
Kodak Sulfide Sepia Toner T-7a
Kodak Brown Toner
Kodak Polysulfide Toner T-8
Kodak Hypo Alum Sepia Toner T-1a

DEVELOPMENT RECOMMENDATIONS —AT 68 F (20 C)

Kodak Developer	Dilution	Development Time in Minutes		Cap. (8x10″ prints per gal.)	Purpose
		Recom-mended	Useful Range		
Dektol	1:2	1½	1 to 3	120	Warm Tones
D-72	1:2	1½	1 to 3	100	Warm Tones
Ektafio, Type 1	1:9	1½	1 to 3	120	Warm Tones

(Courtesy of Eastman Kodak Co.)

KODAK **POLYCONTRAST RAPID RC PAPER**

EASTMAN KODAK

APPLICATIONS

This paper combines the variable-contrast characteristics of KODAK POLYCONTRAST Rapid Paper with the water-resistant base of KODAK RESISTO Papers, which gives it broad applications in commercial, industrial, photofinishing, school, press, nightclub, identification, map-making, and general black-and-white photography.

CHARACTERISTICS

Designed for fast and economical processing. Variable-contrast paper. Use without a filter for normal-contrast negatives, or with KODAK POLYCONTRAST Filters to obtain 7 degrees of contrast. Neutral-black image tone. Dimensionally stable and water-resistant base. Surface and weight characteristics are listed in the following table:

Tint	Brilliance	Texture	Symbol	Weight
White	Glossy	Smooth	F	Medium Weight
White	Lustre	Smooth	N	Medium Weight

SAFELIGHT

KODAK Safelight Filter OC (light amber). Because the paper depends on blue and yellow light exposures for contrast control, limit safelight exposures to 3 minutes or less in order to avoid unwanted contrast changes or chance of fog.

PRINTING INFORMATION

Polycontrast Filter	PC 1	PC 1½	PC 2	PC 2½	PC 3	PC 3½	PC 4	White Light (no filter)
ANSI Paper Speed	250	320	250	200	160	100	50	320

LIGHT SOURCE FOR PROJECTION PRINTING

Tungsten, similar to a Photo Enlarger No. 212 or 302. Although not recommended for optimum results, light sources other than tungsten may be used with light-source correction filters. Filters suggested as starting points with three common light sources are: CP 40Y or CC40Y with a cool-white (4500 K) fluorescent lamp; a CC or CP correction of 70Y for a 6500 K fluorescent lamp; a combination of the KODAK WRATTEN Filter No. 6 plus a correction of CP40Y or CC40Y with a mercury-arc light source. Light-source correction filters are required in addition to the appropriate KODAK POLYCONTRAST Filter that may be used for contrast control.

DEVELOPMENT RECOMMENDATIONS —AT 68 F (20 C)

Kodak Developer	Dilution	Development Time in Minutes		Cap. (8x10″ prints per gal.)	Purpose
		Recommended	Useful Range		
Dektol	1:2	1½	1 to 3	120	Neutral Tones
D-72	1:2	1½	1 to 3	100	Neutral Tones
Ektaflo, Type 1	1:9	1½	1 to 3	120	Neutral Tones

(Courtesy of Eastman Kodak Co.)

(*Continued on following page*)

KODAK **POLYCONTRAST RAPID RC PAPER** (continued)

RINSE

For 5 seconds, with agitation, in KO-DAK EKTAFLO Stop Bath, KODAK Indicator Stop Bath, or in KODAK Stop Bath SB-1, at 65 to 70 F (18 to 21 C).

FIX

2 minutes, with agitation at 65 to 70 F (18 to 21 C) in a fresh solution prepared from KODAK EKTAFLO Fixer, KODAK Fixer, KODAK Rapid Fixer, KODAFIX Solution, or in KODAK Fixing Bath F-5 or F-6.

WASH

For 4 minutes only, with agitation, at 65 to 70 F (18 to 21 C).

DRYING

Sponge surface water from both sides of prints, and dry prints at room temperature, by circulated warm air, or on a double belt drum dryer. The drum temperature should not exceed 190 F (88 C). Low drying temperatures provide maximum dimensional stability.

MOUNTING

KODAK POLYCONTRAST RC Papers can be dry-mounted if the temperature of the press does not exceed 190 F (88 C). Small prints can be mounted with KODAK Rapid Mounting Cement.

TONING RECOMMENDATIONS

Kodak Sepia Toner
Kodak Sulfide Sepia Toner T-7a
Kodak Brown Toner
Kodak Polysulfide Toner T-8
Kodak Hypo Alum Sepia Toner T-1a

KODAK **RESISTO**

APPLICATIONS

Intended for jobs that require fast print service or moderately close size maintenance; valuable for newspaper photographers, night-club operators, identification pictures, and map-making. KODAK RESISTO Paper is for contact printing.

SAFELIGHT

KODAK Safelight Filter OC (light amber)

CHARACTERISTICS

Image-tone, paper-base, surface, and contrast characteristics are listed in the following tables:

Paper	Image Tone	Base
Resisto	Neutral-Black	dimensionally stable and water-resistant

(Courtesy of Eastman Kodak Co.)

(*Continued on following page*)

EASTMAN KODAK

KODAK **RESISTO** (continued)

Paper	Tint	Brilliance	Texture	Symbol	Weight	Grade
Resisto	White	Lustre	Smooth	N	Single Weight	No. 2, 3

PRINTING INFORMATION

Paper Grade	No. 1	No. 2	No. 3	No. 4
ANSI Speed—Resisto	—	6	6	—

DEVELOPMENT RECOMMENDATIONS FOR RESISTO AND RESISTO RAPID—AT 68 F (20 C)

Kodak Developer	Dilution	Development Time in Minutes		Cap. (8x10″ prints per gal.)
		Recommended	Useful Range	
Ektaflo, Type 1	1:9	1	¾ to 2	120
Dektol	1:2	1	¾ to 2	120
D-72	1:2	1	¾ to 2	100

DRYING

Sponge surface water from both sides of prints, and dry prints at room temperature, by circulated warm air, or on a double-belt drum dryer. The drum temperature should not exceed 190 F (88 C). Low drying temperatures provide maximum dimensional stability.

MOUNTING

Prints made on KODAK RESISTO Paper can be dry-mounted if the temperature of the press does not exceed 190 F (88 C). Small prints can be mounted with KODAK Rapid Mounting Cement.

RINSE

For 5 seconds, with agitation, in KODAK EKTAFLO Stop Bath, KODAK Indicator Stop Bath, or in KODAK Stop Bath SB-1, at 65 to 70 F (18 to 21 C).

FIX

2 minutes, with agitation at 65 to 70 F (18 to 21 C) in a fresh solution prepared from KODAK EKTAFLO Fixer, KODAK Fixer, KODAK Rapid Fixer, KODAFIX Solution, or in KODAK Fixing Bath F-5 or F-6.

WASH

For 4 minutes only, with agitation, at 65 to 70 F (18 to 21 C).

KODAK **VELOX PAPER**

CHARACTERISTICS
Blue-black image tone. Surface and characteristics are listed in the following table:

APPLICATIONS
Contact printing of negatives.

SAFELIGHT
KODAK Safelight Filter OC (light amber)

Tint	Brilliance	Texture	Symbol	Weight	Grade
White	Glossy	Smooth	F	Single Weight	No. 1, 2, 3, 4

PRINTING INFORMATION

Paper Grade	No. 1	No. 2	No. 3	No. 4
ANSI Paper Speed	10	5	4	2

DEVELOPMENT RECOMMENDATIONS
—AT 68 F (20 C)

Kodak Developer	Dilution	Development Time in Minutes Recommended	Useful Range	Cap. (2½x3½" prints per quart)	Purpose
Dektol*	1:2	1	¾ to 2	275	Cold Tones
D-72	1:2	1	¾ to 2	230	Cold Tones
Ektaflo, Type 1	1:9	1	¾ to 2	275	Cold Tones
Versatol	1:3	1	¾ to 2	180	Cold Tones

*If you are using KODAK Tri-Chem Packs, dissolve a packet of developer (Dektol) in 8 ounces of water and develop prints for 1 minute at 68 F (20 C). The developer capacity of a packet is approximately fifty 2½ x 3½-inch prints per 8 ounces of developer solution.

TONING RECOMMENDATIONS
Kodak Sepia Toner
Kodak Sulfide Sepia Toner T-7a
Kodak Hypo Alum Sepia Toner T-1a

ADDITIONAL INFORMATION
In addition the contact-speed paper described in this data sheet, three other kinds of VELOX Paper are manufactured: KODAK VELOX Rapid, VELOX UNICONTRAST, and VELOX PREMIER Paper. These materials are used mainly in commercial photofinishing for continuous-roll printing and processing.

KODAK **SUPER SPEED DIRECT POSITIVE PAPER**

An orthochromatic neutral-tone emulsion of sufficient speed for camera use from which a positive print is produced by chemical reversal. Its water-resistant paper base permits rapid processing and drying. It has a smooth, matte surface, and is available in rolls or sheets.

EXPOSURE

Good results with Kodak Super Speed Direct Positive Paper can be secured only if the exposure is correct. Therefore the lighting arrangement must be standardized to a degree which will produce uniform and reproducible exposures. Underexposures will result in prints which are too dark, while overexposure will result in prints which are too light and lacking detail in the lighter portions of the picture.

Moisture and dust in the air will cause the outside surfaces of the camera lens to become coated with a film of dirt which diffuses the light and produces a flat and fogged effect in the prints. To prevent trouble from this source, clean the lens regularly; and if the camera is equipped with a reversing prism, be sure to clean this also.

SAFELIGHT

KODAK Super Speed Direct Positive Paper should be handled and developed by the light of a KODAK Safelight Filter No. 2 (dark red), in a suitable safelight lamp **with a 15-watt bulb, kept at least 4 feet from the paper.**

Note: Excessive safelight exposure caused by the use of the wrong safelight filter or a faded safelight filter, or by the safelight being too close to the paper, will make the finished prints too light.

PROCESSING

In the processing of KODAK Super Speed Direct Positive Paper, there are the three simple but extremely important rules to be followed; neglect of these precautions will cause stains, streaks, and general loss of quality.

1. Wash the prints for at least 15 seconds in running water between the different solutions. If running water is not available, use separate containers for washing the prints after each solution.

2. Do not allow one chemical solution to contaminate another. Always use the same trays for the same solutions, and wash them thoroughly after use.

3. Do not use exhausted solutions. Replace each solution as soon as its action becomes noticeably slow.

KODAK **PREPARED CHEMICALS**

Correctly prepared chemicals for making each of the processing solutions needed for KODAK Direct Positive Paper, are supplied in convenient packages. **KODAK Developer D-88, KODAK Bleach, KODAK Clearing Bath, KODAK Fixer, and KODAK Direct Positive Paper Redeveloper** are available in units to make 1 gallon of working solution. **KODAK Direct Positive Toning Redeveloper** is available in units to make 2 gallons of working solution.

DEVELOPMENT

Develop the prints for 45 seconds to 1 minute in **KODAK Developer D-88** at 68 F (20 C); then wash them for at least 15 seconds in running water.

Note: KODAK Developer D-88 has a short life after exposure to the air; if desired, it can be stored longer after mixing by dividing the solution into four 1-quart bottles filled to the neck and tightly stoppered.

Underdevelopment in the first developer, like underexposure, will result in prints which are too dark; while overdevelopment, like overexposure, will result in prints which are too light. The developer should not be overworked or allowed to remain in the developing tray for too long a time; otherwise yellow stains caused by developer oxidation will occur.

(Courtesy of Eastman Kodak Co.)

The Compact Photo-Lab-Index

KODAK **DEVELOPER D-88**

Dissolve chemicals in the order given:	Avoirdupois U.S. Liquid	Metric
Water about 125 F (50C)	96 ounces	750 ml
KODAK Sodium Sulfite, desiccated	6 ounces	45.0 grams
KODAK Hydroquinone	3 ounces	22.5 grams
*KODAK Boric Acid, **crystals**	¾ ounce	5.5 grams
KODAK Potassium Bromide	145 grains	2.5 grams
**KODAK Sodium Hydroxide (Caustic Soda)	3 ounces	22.5 grams
Water to make	1 gallon	1.0 liter

*Boric acid should be used in the crystal form. The powdered variety is difficult to dissolve.

**Caution: Dissolve the caustic soda in a small volume of water in a separate container; then add it to a solution of the remaining constituents and dilute the whole to 1 gallon. If a glass container is used for dissolving the caustic soda, stir the mixture constantly until the soda is dissolved, to prevent cracking the container by the heat evolved.

BLEACHING

Bleach the prints in **KODAK Bleach** or KODAK Bleaching Bath R-9 for about 30 seconds at 65 to 75 F (18 to 24 C); then wash them for at least 15 seconds in running water. The prints must remain in the bleach until the image disappears.

KODAK **BLEACHING BATH R-9**

	Avoirdupois U.S. Liquid	Metric
Water	1 gallon	1.0 liter
KODAK Posassium Bichromate	1¼ ounces	9.5 grams
*Sulfuric Acid, concentrated	1½ ounces	12.0 ml

*Caution: Always add the sulfuric acid to the water slowly, stirring constantly, and never the water to the acid; otherwise the solution may boil and spatter the acid on the hands or face causing serious burns.

CLEARING

Clear the prints in **KODAK Clearing Bath** or KODAK Clearing Bath CB-1 for about 30 seconds at 65 to 70 F (18-21 C); then wash them for at least 15 seconds in running water. When the prints are placed in the clearing bath, the white light ca be turned on and left on. Be sure to clear the prints for the full time; otherwise yellow stains may rseult.

KODAK **CLEARING BATH CB-1**

	Avoirdupois U.S. Liquid	Metric
KODAK Sodium Sulfite, desiccated	12 ounces	90 grams
Water	1 gallon	1 liter

(*Continued on following page*)

EASTMAN KODAK

241

The Compact Photo-Lab-Index

RE-EXPOSURE

Either turn on the white light as soon as the prints are placed in the clearing bath or expose the prints for 2 or 3 seconds to a 40-or-60-watt bulb placed 6 to 8 inches from the paper.

Note: Re-exposure is necessary only for prints which are to be redeveloped in KODAK Developer D-88.

REDEVELOPMENT

For black-and-white results, redevelop the prints in a fresh batch of **KODAK Developer D-88, KODAK Direct Positive Paper Redeveloper,** or KODAK Sulfide Redeveloper T-19.

If **KODAK Developer D-88** is used, redevelop the prints for about 30 seconds at 68 F (20 C) then wash the prints for 30 seconds* in running water.

*After redevelopment with KODAK Developer D-88, results of slightly greater brilliance can be secured by rinsing the pirnts in running water and then fixing them for about 30 seconds at 68 F (20 C) in a solution prepared from **Kodak Fixer** or in Kodak Fixing Bath F-5 or F-6. If the prints are fixed, it is important to **wash them for 5 to 10 minutes after fixing** to insure removal of the hypo. Fixing is not necessary to make black-and-white prints permanent.

If either **KODAK Direct Positive Paper Redeveloper** or KODAK Sulfide Redeveloper T-19 is used, redevelop the prints for about 60 seconds; then drain, rinse and dry the prints.

KODAK SULFIDE REDEVELOPER T-19

	Avoirdupois U.S. Liquid	Metric
Kodak Sodium Sulfide (not Sulfite)	290 grains	20 grams
Water	32 ounces	1 liter

For brown tones, redevelop the prints in **KODAK Direct Positive Toning Redeveloper** for about 60 seconds.

DRYING

The emulsion of KODAK Super Speed Direct Positive Paper is coated on a water-resistant support, and the drying of prints is therefore rapid. To hasten drying, artificial heat can be employed if desired.

SUMMARY OF PROCESSING
KODAK BLACK-AND-WHITE-PAPERS

CONVENTIONAL PAPERS

DEVELOPMENT

Recommended developers and development times are given in the appropriate data sheets. The "Purpose" column in the table of development recommendations in the data sheets shows the effects of the developers on image tone and contrast, if any.

For best results, maintain the developer temperature at 68 F (20 C). To avoid uneven development, keep the prints completely immersed in the solution, and agitate them throughout the developing time.

STOP BATH

Rinse the prints for 5 to 10 seconds, **with agitation,** in one of the following stop baths: KODAK Indicator Stop Bath, KODAK EKTAFLO Stop Bath,

(Courtesy of Eastman Kodak Co.)

(Continued on following page)

EASTMAN KODAK

or KODAK Stop Bath SB-1. Indicator Stop Bath and EKTAFLO Stop Bath are yellow liquids that turn purplish blue when exhausted. At this point, they should be discarded.

FIXING

Fix the prints, **with agitation,** for 5 to 10 minutes at 65 to 70 F (18 to 21 C) in one of the recommended Kodak fixers. For the most efficient fixing and the greatest economy of chemicals, use the two-bath fixing system in which prints are fixed for 3 to 5 minutes in each of two successive baths.

WASHING

After fixing the prints, wash them for 1 hour either in a tray equipped with a KODAK Automatic Tray Siphon, or in a washing tak where the water changes completely every 5 minutes. For efficient washing, the water should be at 65 to 75 F (18 to 24 C).

To conserve water, to reduce washing time, and to obtain more complete washing, use KODAK Hypo Clearing Agent before washing. This preparation saves at least two-thirds of the time needed to wash single-, light-, and double-weight papers. Directions for use of KODAK Hypo Clearing Agent are printed on the package.

DRYING

To promote even drying, sponge the surface water from the backs and fronts of the prints, and then place them on drying racks, or between clean photo blotters, or on a drying machine.

FERROTYPING

All Kodak F-surface papers except RC papers can be ferrotyped by squeegeeing them in contact with chromium-plated sheets, or by use of a ferrotyping machine.

TONING

The primary toners recommended for use with particular papers are given in the data sheets. Toners other than primary may be used to secure tones for special-purpose applications. Formulas for KODAK Toner T-21, KODAK Polysulfide Toner T-8, KODAK Sulfide Sepia Toner T-7a, and KODAK Hypo Alum Sepia Toner T-1a are given in Kodak Data Book No. J-1, **Processing Chemicals and Formulas,** available from photo dealers.

RESIN-COATED PAPERS

Developing recommendations are given in the appropriate data sheets. Stop bath recommendations are as above for regular papers.

Fix, with agitation, for 2 minutes in one of the recommended fixers.

Wash as above for regular papers, but for 4 minutes only. There is no need to use KODAK Hypo Clearing Agent.

Sponge or squeegee the water from the surface of the prints and air-dry. Do not ferrotype F-surface RC papers; they dry to a high gloss without ferrotyping. Warm air circulation shortens the drying time.

See text for further drying instructions.

TONING

See the data sheet for appropriate toners.

Wash for 4 minutes after fixing and for 4 minutes after toning. Avoid leaving RC papers in water and or solutions for longer times than recommended or the advantages of the resin-coating may be lost.

PROCESSING KODAK EKTAMATIC SC PAPER

This paper is designed to be processed in an activator-stabilizer processor such as the KODAK EKTAMATIC Processor, Model 214-K, which processes about 5.9 feet of paper per minute. It can also be processed as a conventional paper in the developers listed on the data sheet, and following the procedures for conventional papers shown elsewhere on this page.

(Courtesy of Eastman Kodak Co.)

EASTMAN KODAK

The Compact Photo-Lab-Index

KODABROME II Paper and EKTABROME SC Paper

(For Machine Processing on Kodak Royalprint Processor Model 417 and many roller transport and continuous paper processors that employ ordinary black-and-white paper processing solutions.

KODABROME II Paper

DESCRIPTION

A fast black-and-white enlarging paper for general purposes. Available in five contrast grades: Soft, Medium, Hard, Extra Hard, and Ultra Hard.

CHARACTERISTICS

The paper has a developing agent incorporated in the emulsion. It has a water resistant base for rapid processing and drying. Image tone is warm black and the paper is optically brightened for brilliant prints.

SURFACES

The F (smooth glossy) surface does not require ferrotyping, but dries to a glossy finish.

It is also available in N (smooth lustre) surface.

PROCESSING

The **Kodak Royalprint Processor,** Model 417 yields dry, properly fixed and washed prints in 55 seconds for two 8 x 10 prints, and can handle paper up to 17 inches wide. Minimum length is 5 inches.

This paper can be processed in some roller transport and continuous paper processors that use ordinary black and white processing solutions. It is not a stabilization paper.

Prints have optimum process stability, the highest of the three American National Standards Institute (ANSI) categories, the lower two being **short term,** and **commercial.** Prints processed with this paper on the Model 417 are as stable or more stable than conventionally processed prints made on resin-coated paper.

EKTABROME SC Paper

DESCRIPTION

A fast enlarging paper with selective contrast for general purpose black and white printing.

CHARACTERISTICS

Developing agent is incorporated in the emulsion. Contrast is controlled by the use of filters in the enlarger. It has a water resistant base for rapid processing and drying. Image tone is warm black and the paper is optically brightened for brilliant prints.

SURFACES

The F (smooth glossy) surface does not require ferrotyping, but dries to a glossy finish.

It is also available in N (smooth lustre) surface.

PROCESSING

The **Kodak Royalprint Processor,** Model 417 yields dry, properly fixed and washed prints in 55 seconds for two 8 x 10 prints, and can handle paper up to 17 inche wide. Minimum length is 5 inches.

This paper can be processed in some roller transport and continuous paper processors that use ordinary black and white processing solutions. It is not a stabilization paper.

Prints have optimum process stability, the highest of the three American National Standards Institute (ANSI) categories, the lower two being **short term,** and **commercial.** Prints processed with this paper on the Model 417 are as stable or more stable than conventionally processed prints made on resin-coated paper.

EASTMAN KODAK

KODAK **EKTACHROME RC PAPER, TYPE 1993**

A color paper designed for making color prints from positive transparencies such as **Ektachrome,** and **Kodachrome.** It is a resin coated paper, supplied in sheets and rolls, and can be exposed with contact-printing or enlarging equipment, as well as equipment designed for quantity production. Tray, basket and tanks, or photographic processing tubes can also be used.

SURFACES
F—Smooth Glossy
Y—Silk Lustre
This paper should not be ferrotyped.

SAFELIGHT
Kodak Ektachrome RC Paper, Type 1993 should be handled only in total darkness. Do not use No. 10, or 13, nor any other safelight filter.

STORAGE AND HANDLING
To avoid undesirable changes, original sealed packages should be stored in a refrigerator or freezer at 50°F (10°C) or lower.

To avoid moisture condensation on unexposed paper which has been refrigerated, allow paper to warm up to room temperature before opening the sealed bag. For best results, remove unexposed paper from cold storage the day before printing; otherwise, follow typical warm-up times listed below:

NOTE
Never warm up paper on a heated surface (such as on the top of a printer or radiator) to bring it to room temperature.

After removing the paper to be exposed, restore the moisture barrier around the unused paper by pressing out excess air, making a double fold in the open end of the bag and securing it with a rubber band or tape.

LATENT-IMAGE KEEPING
For best results, process exposed paper on the same day as exposure. To minimize latent-image shifts that may result when the exposed paper is held at room temperature 70°F (21°C) for a period of time, keep the interval between exposure and processing as consistent as possible.

It is recommended that exposed paper not be held overnight before processing. However, if it is necessary to hold exposed prints between 8 and 24 hours before processing, store them at 50°F (10°C) or lower. Or, if hold-over time to processing will exceed 24 hours, store the exposed prints at 0°F (−18°C). Maximum hold-over time for exposed, but unprocessed prints, at 0°F is 3 days. Always allow prints to warm up to room temperature before processing. The cold storage procedures are intended to handle unusual situations and to minimize latent-image shifts.

EXPOSING EQUIPMENT
Kodak Ektachrome RC Paper, Type 1993, can be exposed on enlargers and printers with tungsten illumination (Photo Enlarger Lamps No. 212, 302, or tungsten-halogen lamps). The exposing equipment should have:

1. a means for holding color-correction filters such as **Kodak** Color Print-

EASTMAN KODAK

WARM-UP TIMES FOR KODAK EKTACHROME RC PAPER, TYPE 1993

Paper Size	From 0 to 70°F (−18 to 21°C)	From 35 to 70°F (1.5 to 21°C)	From 50 to 70°F (10 to 21°C)
8 x 10-inch (100-sheet box)	4 hours	3 hours	2 hours
16 x 20-inch (50-sheet box)	3 hours	2 hours	2 hours
3½-inch x 700-foot roll	8 hours	6 hours	4 hours
8-inch x 500-foot roll	10 hours	7 hours	4 hours

(*Continued on following page*)

ing (CP) Filters (Acetate), **Kodak** Color Compensating (CC) Filters (Gelatin), or dichroic filters.

 2. a heat-absorbing glass.
 3. an ultraviolet absorber, such as the **Kodak Wratten** Filter, No. 2E.
*Although the **Kodak Wratten** Filter, No. 2E, is recommended for printing onto **Ektachrome** RC Paper, some enlargers and printers are equipped with a **Kodak Wratten** Filter, No. 2B, or equivalent, and may yield acceptable results for many applications.

PRINTING INFORMATION
ENLARGERS

In a low-volume situation, such as where an enlarger is used, it is likely that different film types will be segregated and printed with separate filter packs. If this is the case, it is not necessary to use the **Kodak** Infrared Cutoff Filter, No. 301A. (The 301A Filter is equivalent to approximately 30 cyan filtration.) Optimum results can be obtained without this filter when printing from slides on **Ektachrome** Film (Process E-3 and E-4) and **Kodachrome** 25 (Daylight) and **Kodachrome** 64 (Daylight) Film. (Cardboard slide mounts for **Kodachrome** 25 and 64 Films processed by Kodak and others have a red plus [+] sign on each side.) Acceptable results can also be obtained without this filter when printing from slides on **Kodachrome II and Koda-chrome-X** Film. However, if optimum results are required for critical applications, the 301A Filter is recommended for **Kodachrome II** and **Koda-chrome-X** Film to avoid some loss in red contrast, resulting in warm shadows.

 Use transparencies of good quality to make trial exposures. As a guide in determining the correct exposure, the following is suggested:

After making the first test print, proceed as follows:
 1. Process and dry the test print as recommended; then evaluate color balance and exposure.
 2. Make the necessary filter pack changes and make another test print at selected exposure time and f/s. Once again, process, dry, and evaluate the test print.
 3. Once you obtain a satisfactory print, use that exposure/lens opening/filter-pack combination for other slides on the same type film.
 4. To determine the change in exposure for a change in enlargement, use the Color-Printing Computer in the **Kodak** Color **Dataguide,** sold by photo dealers.

 If your enlarger does not have dichroic filters for the color-correction filter pack, you can use **Kodak** Color Printing Filters (Acetate) or **Kodak** Color Compensating Filters (Gelatin). The CP Filters can be used **only** between the light source and the transparency, but the CC Filters can also be used between the transparency and the paper, where they are in the path of image-forming light. Any number of filters (CP or CC) can be used between light source and transparency, but the number of filters (CC only) used between transparency and paper should be as small as possible, preferably not over three. When cyan filtration is necessary, do not use filters identified by the suffix "2" as in "CC10C-2" or "CP10C-2."

PRINTERS

Set up **Kodak** Roll Paper Color Printers as outlined in the instruction man-

If the overall color balance is:	Subtract these filters:	or	Add these filters:
Yellow	Yellow		Magenta+Cyan
Magenta	Magenta		Yellow+Cyan
Cyan	Cyan		Yellow+Magenta
Blue	Magenta+Cyan		Yellow
Green	Yellow+Cyan		Magenta
Red	Yellow+Magenta		Cyan

(Continued on following page)

ual accompanying the printer.

In automatic, high-volume printers where **one basic filter pack is used,** the use of the **Kodak** Infrared Cutoff Flter, No. 301A, is recommended. The 301A Filter is designed to minimize printing differences when mixtures of **Kodachrome** and **Ektachrome** Slides are printed onto **Ektachrome** 1993 Paper using one filter pack.

VIEWING PRINTS

Ideally, prints should be evaluated under lights of the same color quality and illuminance (at least 50 footcandles) as that under which the final print is to be viewed. Illumination of color quality corresponding to a color temperature of 4000 K ± 1000 K and a Color Rendering Index (CRI) of 85 to 100 (an index of 90 or higher is desirable) serves well for judging prints. This color quality is approximated by several types of fluorescent lamps (in fixtures) such as General Electric Deluxe Cool White, Sylvania Deluxe Cool White, Westinghouse Deluxe Cool White, or Westinghouse Living White.

Satisfactory results can also be obtained by using a mixture of incandescent and fluorescent lights. For each pair of 40-watt Deluxe Cool White fluorescent tubes, a 75-watt frosted tungsten bulb can be used.

ADJUSTING THE FILTER PACK

When the test print is viewed, the desirability of some change in color balance may be apparent. The nature of this change is determined by the predominant color balance of the print; the required filter adjustment involves subtracting a filter of the color of the overall hue or adding a filter that is complemetnary to his overall hue. The following table may be useful in determining the filter adjustment:

Evaluating an area in the print that should be reproduced as a neutral (gray) is useful ___ ___ning what filter correction is needed.

will correct the print, examine the print through a filter that is complementary to the overall hue. (The **Kodak** Color Print Viewing Filter Kit, Publication No. R-25, can be used for this examination. The kit contains six color-print viewing filter cards.) The filter which makes the print appear most pleasing represents the correct color to add, but not necessarily the correct density.

When making filter corrections to the filter pack in the printer, remove filters from the beam whenever possible. For example, if a test print is reddish in balance, remove yellow and magenta filters rather than add cyan filters.

The filter pack should not contain more than two colors of the subtractive filters (yellow, magenta, and cyan). The effect of all three is to form neutral density, which lengthens the exposure time without accomplishing any color correction. To eliminate neutral density, remove the filter or filters of one color entirely, and remove the same density value of each of the other two colors.

EXPOSURE ADJUSTMENT FOR FILTERS

Whenever the filter pack is changed, allowance should be made for the change in exposure introduced by (1) the change in filtering action, and (2) the change, if any, in the number of filter surfaces. Otherwise, the density of the corrected print will differ from that of the test print.

If the pack is changed by only one filter, use of the appropriate filter factor in the following table is convenient. Otherwise, the use of the computer numbers with the Color-Printing Computer in the **Kodak** Color **Dataguide** will probably be preferred.

SUGGESTED STARTING FILTER PACKS AND EXPOSURE TIMES FOR A 8 x 10-INCH PRINT ON KODAK EKTACHROME RC PAPER, TYPE 1993 FROM A 35MM SLIDE

When You Print from Slides on These Kodak Films	Use a Filter Pack Containing These Filters* in an Enlarger With Tungsten-Halogen Lamps	And These Exposures for Trial
Ektachrome	30C + 20Y	10, 20, and 40 sec at f/5.6
Kodachrome 25 & 64 (Daylight)	50C + 20Y	

*Plus a Wratten Filter, No. 2E, or 2B, or equivalent, and a heat-absorbing glass.

(Continued on following page)

247

EASTMAN KODAK

The Compact Photo-Lab-Index

To use computer numbers: Add the computer-number values for all the filters in the old pack. On the "Density" scale of the Color-Printing Computer, set the sum of the computer numbers so that it is opposite the exposure time used. Read the new exposure time opposite the sum of the computer numbers for the new pack.

To use factors: First divide the old exposure time by the factor* for any filter removed from the pack. Then multiply the resulting time by the factor* for any filter added.

*For two or more filters, multiply the individual factors together and use the product.

Note: The filter factors and computer numbers listed in the table are for CC and CP filters, and take into account the effects of filter surfaces. Because of different filtering effectiveness, and the lack of surface effects when changing filtration, dichroic enlargers **may** give slightly different results. Factors for exposure adjustment should be modified when necessary, based on experience.

ADJUSTMENT FOR CHANGE OF EMULSION NUMBER

In multilayer color materials, there are unavoidable differences in color balance and speed from one emulsion number to another. The extent of these variations is noted on the **Ektachrome** RC Paper package label in the form of "Filter Correction" values. After the material leaves the factory, further color-balance and speed variations are minimized by proper storage and processing.

Note that the Filter Correction may contain both + and − values. This information is helpful in changing from one emulsion number to another. Follow the procedure below to determine the new filter pack and exposure time when changing to a new emulsion.

Filter calculations are made easier by converting all filters to their equivalents in the subtractive colors, if they are not already of the subtractive color (for example, 20R = 20M + 20Y). Also, filters of like colors should be added together in the calculations (for example 10M + 20M = 30M).

1. Determine the basic filter pack by **subtracting** the Filter Correction printed on the label for the old emulsion from the filter pack for that emulsion.

EXAMPLE:

Step 1: Suppose the filter pack required for the old emulsion was 10C+05Y, and the Filter Correction printed on the package label of that emulsion was +10C −25M −05Y. Set up these values as follows:

COMPUTER NUMBERS AND FACTORS FOR KODAK CC AND CP FILTERS

Filter	Computer No.	Factor	Filter	Computer No.	Factor
05Y	.04	1.1	05R	.07	1.2
10Y	.04	1.1	10R	.10	1.3
20Y	.04	1.1	20R	.17	1.5
30Y	.05	1.1	30R	.23	1.7
40Y	.05	1.1	40R	.29	1.9
50Y	.05	1.1	50R	.34	2.2
05M	.07	1.2	05G	.06	1.1
10M	.10	1.3	10G	.08	1.2
20M	.16	1.5	20G	.12	1.3
30M	.22	1.7	30G	.15	1.4
40M	.27	1.9	40G	.18	1.5
50M	.32	2.1	50G	.22	1.7
05C	.06	1.1	05B	.04	1.1
10C	.08	1.2	10B	.12	1.3
20C	.12	1.3	20B	.21	1.6
30C	.15	1.4	30B	.29	2.0
40C	.18	1.5	40B	.38	2.4
50C	.21	1.6	50B	.47	2.9

(Continued on following page)

Filter pack used for the old emulsion
(Subtract) old emulsion Filter Correction Value

+10C	0M	+05Y
+10C	−25M	−05Y

To simplify the subsraction of minute values, follow this rule: "Change **all** the signs of the values to be subtracted and proceed as in addition."

+10C	0M	+05Y
−10C	+25M	+05Y
0C	+25M	+10Y

(basic filter pack)

2. Determine the filter pack required for the new emulsion by **adding** the Filter Correction Value printed on the label for the new emulsion to the basic filter pack.

Basic filter pack
(Add) Filter Correction Value for new emulsion

Preliminary filter pack

EXAMPLE:

Step 2: Suppose the Filter Correction Value of the new emulsion is −05C +25M −20Y.

0C	+25M	+10Y
−05C	+25M	−20Y
−05C	+50M	−10Y

3A. If negative filter values are present in the pack, add (by calculation) C, M, and Y "neutral density" equal to the largest negative filter. In this way, one of the three filters will become zero. Look up the neutral density factor in Section A on the following table entitled NEUTRAL DENSITY FACTORS.

EXAMPLE:

Step 3A: Since negative filter values are present in the pack, add 10 neutral density (+10C +10M and +10Y) to these values.

Preliminary filter pack
(Add) neutral density

Final filter pack for new emulsion

−05C	+50M	−10Y
+10C	+10M	+10Y
+05C	+60M	0Y

Look up a 10 neutral density in Section A of the table. The neutral density factor comes out to 1.3 in this case.

or 3B. If all the filter values are positive, subtract C, M, and Y "neutral density" equal to the smallest positive filter value. At least one of the three will now be zero. Look up the neutral density factor in Section B of the table.

or 3C. If the filter values are positive and at least one is zero, go to step 4. Your neutral density factor is 1.0.

4. Calculate the new exposure time by the following formula:

$$\begin{matrix} \text{Exposure Time} \\ \text{for the} \\ \text{New Emulsion} \end{matrix} = \begin{matrix} \text{Exposure Time} \\ \text{for the} \\ \text{Old Emulsion} \end{matrix} \times \text{(Neutral Density Factor)}$$

EXAMPLE:

Step 4: Suppose the exposure time used for the old emulsion was 8.5 seconds

and the neutral density factor was 1.3. Calculate the new exposure time by the formula:

$$\begin{matrix} \text{Exposure Index} \\ \text{for the} \\ \text{New Emulsion} \end{matrix} = \begin{matrix} \text{Exposure Time} \\ \text{for the} \\ \text{Old Emulsion} \end{matrix} \times \text{(Neutral Density Factor)}$$

New Exposure Time = 8.5 X 1.3
= 11 seconds

This is the exposure time that should be tried for the new emulsion.

The Compact Photo-Lab-Index

5. Set the new filter pack and printing times calculated above into the printer. Then make a series of test exposures using a standard transparency. Judge the test prints and, if necessary, correct the filter pack used for the new emulsion. Adjust the exposure time as required by the filter pack correction.

WHITE BORDERS

White borders can be obtained by exposing the border areas of a print while the picture area is protected by an opaque mask. When the enlarger is adjusted as suggested in these instructions, an exposure from 1½ to 2 times the print exposure time will be required, with no transparency in the beam. The filters can be included when the border is flashed. Some overlapping of the print exposure and the border exposure is necessary in order to eliminate dark edges.

With automatic and semiautomatic equipment, follow the instructions supplied with the equipment.

PROCESSING

In sheet form, **Kodak Ektachrome RC Paper**, Type 1993, can be processed in photographic processing trays or processing baskets and tanks with **Kodak Ektaprint R-5 Chemicals**.

Sheets can also be processed on a **Kodak** Rapid Color Processor, Model 11, 16-K, or 30A, or in photographic processing tubes, with **Kodak Ektaprint R-500 Chemicals**.

Instructions for processing the paper are packaged with **Ektaprint R-5** and R-500 Chemicals.

MOUNTING PRINTS

Prints can be mounted satisfactorily with **Kodak** Dry Mounting Tissue, Type 2, or **Kodak** Rapid Mounting Cement. If you use tissue, the temperature across the heating plate should be **180 to 210°F (82 to 99°C)**, and pressure should be applied for 30 seconds or longer in case of a thick mount. Preheat the cover sheet used over the face of the print to remove moisture which might otherwise cause sticking. If prints are mounted behind glass, maintain a slight separation between the prints and the glass.

CAUTION

Temperatures above 230°F and/or high pressures may cause physical and color changes on **Ektachrome** RC Prints.

NOTE

Prolonged exposure of color prints to bright daylight, particularly direct sunlight, should be avoided. **Kodak Ektachrome** RC Paper contains dyes which are as stable as possible, consistent with other requirements.

NEUTRAL DENSITY FACTORS

CC Neutral Density Added in Step 3A or Subtracted in Step 3B	Section A	Section B	CC Neutral Density Added in Step 3A or Subtracted in Step 3B	Section A	Section B
5	1.1	.89	50	3.4	.29
10	1.3	.77	55	4.5	.22
15	1.4	.70	60	5.6	.18
20	1.6	.62	65	7.0	.14
25	1.8	.54	70	8.3	.12
30	2.1	.48	75	9.5	.10
35	2.3	.43	80	10.7	.093
40	2.6	.38	85	11.7	.085
45	3.0	.33			

EASTMAN KODAK

250

INSTRUCTIONS FOR KODAK EKTAPRINT R-5 CHEMICALS FOR PROCESSING KODAK EKTACHROME RC PAPER, TYPE 1993 (+5)

NOTICE: Observe precautionary information on containers and in instructions.

GENERAL INFORMATION

Kodak Ektachrome RC Paper, Type 1993, can be processed in a continuous machine, such as a **Kodak Continuous Color Print Processor, Models 4R, 4R-3, 451,** and **4RT.** Rolls of paper can also be processed on reels, such as **Kodak Processing Reels.** Sheets of paper can be processed in suitable hangers, in a basket such as the **Kodak Processing Basket,** or in trays.

PROCESSING CHEMICALS

The following **Kodak Ektaprint R-5 Chemicals** are supplied in packaged form. Carefully follow the mixing directions included with the chemicals.

Chemical	Sizes Available
Kodak Ektaprint R-5 First Developer Starter	1 pint
Kodak Ektaprint R-5 First Developer Replenisher	5 and 25 gallons
Kodak Ektaprint R-5 Stop Bath and Replenisher	5 and 25 gallons
Kodak Ektaprint R-5 Color Developer Starter	1 pint
Kodak Ektaprint R-5 Color Developer Replenisher	5 and 25 gallons
Kodak Ektaprint R-5 Bleach-Fix and Replenisher	5 and 25 gallons
Kodak Ektaprint 3/R-5 Bleach-Fix Regenerator Starter	1 gallon
Kodak Ektaprint R-5 Bleach-Fix Regenerator	25 gallons
Kodak Ektaprint R-5 Stabilizer and Replenisher	5 and 12½ gallons
Kodak Ektaprint Bleach-Fix Defoamer	8-ounce bottle

PRECAUTIONS IN HANDLING CHEMICALS

The developing agent used in this process may cause skin irritation. In case of contact of solutions with the skin, wash at once with an acid-type hand cleaner and rinse with plenty of water. The use of clean rubber gloves is recommended, especially in mixing or pouring solutions and in cleaning the darkroom. Before removing gloves after each use, rinse their outer surfaces with acid hand cleaner and water. Keep all working surfaces, such as bench tops, trays, tanks, and containers, clean and free from spilled solutions.

The Stabilizer contains formaldehyde, which is a skin and eye irritant. Provide adequate ventilation to prevent the accumulation of formaldehyde vapor in the vicinity of the solution or the drying area. Keep tanks tightly covered when not in use.

CONTAMINATION OF SOLUTIONS

The photographic quality and life of processing solutions depend upon cleanliness of equipment in which solutions are mixed, stored, and used. The contamination of any chemical solution by any other is to be avoided since it will seriously impair print quality. Take extreme care to avoid contamination of Developer with Bleach-Fix during mixing and processing.

If metal processing or storage tanks are to be used with Bleach-Fix, they

(Continued on following page)

should be constructed of Type 316 stainless steel.

Avoid the mixing of chemicals in printing and processing areas as the chemicals may cause spots on prints. Whenever a tank is drained, thoroughly clean and flush with water before refilling.

STORAGE OF SOLUTIONS

Store solutions at a room temperature of 75-85°F (24-29°C). For best results, do not use solutions stored longer than the following times:

	Tanks with Floating Lids
First Developer Replenisher	2 weeks
Stop Bath and Replenisher	8 weeks
Color Developer Replenisher	2 weeks
Bleach-Fix and Replenisher	8 weeks
Stabilizer and Replenisher	8 weeks
Bleach-Fix Defoamer	—

SOLUTION REPLENISHMENT

Accurate solution replenishment is essential for optimum results. Proper maintenance and calibration of replenishment equipment to deliver proper volumes of replenisher solution into the processor tanks are very important.

The following replenishment rates are recommended for processing **Kodak Ektachrome RC Paper, Type 1993.**

	ml/ft^2 of paper
First Developer	70
Stop Bath	140
Color Developer	140
Bleach-Fix	45
Stabilizer	70

No replenishment is required for **Kodak Paper Leader** or **Kodak Machine Test Leader RC Paper.**

PROCESS MONITORING

To monitor processing quality, process **Kodak Ektaprint R-5 Control Strips** on a regular basis. Instructions for the use of control strips are given in Kodak Publication No. Z-112, **Process Monitoring Kodak Ektachrome RC Paper, Type 1993, in Kodak Ektaprint R-5 Chemicals.**

This manual is available from Eastman Kodak Company, Dept. 454, Rochester, New York 14650.

BATCH PROCESSING EQUIPMENT

Kodak Processing Basket

Kodak Hard Rubber Tank, 8 x 10

Kodak Gas Distributor

Kodak Intermittent Gaseous Burst Valve, Model 90B

Kodak Processing Reel

Kodak Developing Hanger Rack No. 40

Kodak Film and Plate Developing Hangers, No. 4A (8 x 10)

Kodak Hanger Separators

Kodak Duraflex Trays

Kodak No. 3F or **No. 3FD Processing Tank** or equivalent equipment from other manufacturers.

CAPACITY OF SOLUTIONS

Without replenishment, 1 U.S. gallon (3.8 liters) of solution will process approximately 13½ ft.2 of RC Paper (24 sheets of 8 x 10 or 46 linear feet of 3½-inch-wide RC Paper).

LOADING THE KODAK PROCESSING BASKET

This stainless steel basket contains 15 compartments, each separated from the other by plastic screening. A cutout portion on one side of the top flange of the basket permits the basket to clear a **Kodak Gas Distributor** that is

(Continued on following page)

252

resting in the 3½-gallon tank. Insert the RC Paper into the basket, one sheet per compartment, emulsion side away from the cutout, which means that during processing the emulsion side will face the operator. Place the stainless steel cover securely over the loaded basket to help prevent the prints from rising out of the solution as the gas bursts take place.

Baskets and tanks are also available from other manufacturers. High-capacity baskets with narrow slots (screen spacing of ¼ inch or less) may require special handling or agitation techniques to prevent the occasional problem of excessive screen pattern with these baskets. If such equipment is used and the problem is encountered, reference should be made to the recommendations of the specific manufacturer.

To prevent the formation of screen patterns, make sure the basket is completely dry before loading the paper into the compartments, and use the special agitation procedures described herein. Always wear clean cotton gloves when loading paper to prevent fingerprints and damage to the paper.

LOADING THE
KODAK PROCESSING REEL

These reels are available in 3½- and 5-inch widths and each reel holds approximately 20 linear feet of paper. Reels are also available from other manufacturers.

Always make sure the reels are dry before loading with paper. Also, always wear clean cotton gloves when loading the paper to prevent fingerprints and paper damage.

LOADING THE
KODAK DEVELOPING HANGER
RACK No. 40

Insert a sheet of paper into the channels of the developing hangers and lock into place by bringing the clip down over the top edge of the print. Make sure that all four edges of paper are within the channels. Place the loaded hangers in the hanger rack. Use **Kodak Hanger Separators** to prevent the hangers from swinging during processing.

Always make sure the hangers are dry before loading. Also, always wear

clean cotton gloves to prevent fingerprints and/or paper damage.

AGITATION

It is important to use the correct agitation technique to minimize or eliminate the effects of uneven processing or screen patterns sometimes encountered.

BASKET PROCESSING AGITATION

The proper agitation for basket processing is a combination of nitrogen burst and manual agitation in each processing solution.

By Hand:

When you immerse the basket in each processing solution and wash, hand-agitate continuously for 30 seconds; then agitate for 5 seconds at 30-second intervals thereafter.

Manually agitate the basket in the following manner:

a. Draw the basket to the front of the tank and lift the basket about 1 inch.

b. Push the basket to the back of the tank. At that back position, lower the basket to the bottom of the tank.

c. Draw the basket sharply forward to the front of the tank again and repeat Steps a and b. Perform these steps rapidly so that each cycle takes only about 1 second. This agitation method requires a minimum back and forth movement of about ¼ inch. **Do not lift the paper out of the solution.**
NOTE: In basket processing, make sure that the basket cover is on securely to prevent the sheets of paper from rising out of the basket.

The initial 30 seconds of continuous hand agitation in each processing solution is needed to eliminate screen patterns even when you are using gaseous-burst agitation. If the initial hand agitation is impractical (it might be with large baskets), the nitrogen supply should be turned on continuously for the initial 30-second agitation period.

Gaseous-Burst Agitation:

General principles of gaseous-burst agitation are given in Kodak Pamphlet No. E-57, **Gaseous-Burst Agitation in Processing**, a single copy of which is

(Continued on following page)

EASTMAN KODAK

available from Dept. 412-L on request. Equipment sold by dealers includes the **Kodak Intermittent Gaseous Burst Valve, Model 90B,** and the **Kodak Gas Distributor** (for **Kodak Hard Rubber Tank,** 8 x 10).

Position the vertical risers of the **Kodak Gas Distributors** on the side of the tank away from the operator. Lower the processing basket into the tank. For proper orientation, the cut-out portion of the basket should be away from the operator, and the emulsion sides of the paper facing the operator.

Use a 1-second burst of gas every 12 seconds at a pressure sufficient to raise the liquid level about ⅝ inch. Use only nitrogen in the First and Color Developers. Nitrogen or oil-free compressed air can be used in the other solutions.

REEL PROCESSING AGITATION

Agitation of a reel is identical to that of the basket except for the method of manual agitation. In the reel process, agitate continuously by hand for at least 30 seconds; then agitate for 5 seconds at 30-second intervals thereafter. Proper agitation consists of a vigorous, rapid, up-and-down movement of about 2 inches, along with a movement toward the sides and ends of the tank. Do not lift the paper out of the solution.

HANGER PROCESSING AGITATION

When processing sheets in hangers, follow the agitation procedure recommended for reel processing. Use **Kodak Hanger Separators** to prevent swaying of the hangers during agitation.

TRAY PROCESSING AGITATION

Agitation for processing in photographic trays is accomplished by interleaving the sheets of paper. **For best results,** especially with large sizes, process no more than three sheets at a time. Rubber gloves must be worn to avoid skin irritation from the processing chemicals.

Immerse the first sheet emulsion side down in the First Developer; then add the second and third sheets (also face down) at 20-second intervals. (Identify the first sheet by clipping off or notch-

ing one corner.) Each 20 seconds thereafter, pull the bottom sheet out, place it on top (without draining), and reimmerse it completely in the solution. Twenty seconds before the end of the development time, remove the first sheet and allow it to drain for 20 seconds; then immerse it in the Stop Bath. Transfer the other two sheets in the same manner, at 20-second intervals. Repeat this procedure in each of the other processing steps.

REVERSAL EXPOSURE

When **Kodak Processing Reels** or **Kodak Processing Baskets** are used, it is not necessary to remove the **Ektachrome RC Paper** from the reel or basket. Expose for 15 seconds with a No. 1 photoflood lamp at a distance of 1 foot from each end of the reel or basket. When fluorescent lamps are used, increase the length of the exposure by 3 or 4 times.

For other batch processing methods, when adequate reversal exposure light cannot be provided over the entire print surface, remove the prints from the wash and expose the emulsion side of each sheet for 15 seconds with a No. 1 photoflood lamp placed 1 foot away. After exposure, return each sheet to the wash until all have been exposed.

CAUTION: In use, photoflood lamps become quite hot and will shatter if any liquid is splashed on their surfaces. Place sheets of glass where they will protect the lamps from being splashed.

WASHING

Provide an adequate supply of clean water at a normal processing temperature. Flow rate specifications are given with each processing cycle given in the instruction sheet.

In batch processes larger than 10 gallons, the flow per minute should be 1/10 of the tank volume, but no less than 5 gallons per minute. The first wash and final wash for a 10-gallon or larger batch process should consist of two wash tanks using a countercurrent flow. An alternative method for 10- to 25-gallon processes is to use one first wash tank and one final wash tank and discard the water from the tank after each processing run.

(Continued on following page)

If the prints become covered with small air bubbles during washing (which will decrease the washing efficiency), install an aspirator in the waterline. This should eliminate the formation of small air bubbles on the print surface.

DRYING

Sheets

Do not ferrotype **Ektachrome RC Paper.** A glossy surface comparable to that obtained with ferrotyped prints is obtained by hot-air impingement drying. Sheets processed in film hangers can be dried in the hangers, or the prints can be removed and placed emulsion side up on cheesecloth. Use a squeegee on the paper base to remove excess moisture.

Do not dry prints between blotter rolls or on a heated continuous-belt dryer. Blotter fibers may stick to the print emulsion, and the belt pattern may be transferred to the faces of the prints.

Prints which are air-dried at room temperature wlil usually have a slightly lower gloss than those which are dried by hot air.

Strips or Rolls

Strips may be dried in the **Kodak Processing Reel.** A glossy surface will result if warm air is circulated through the reel. **CAUTION:** Do not heat plastic reels above 130°F (54°C).

Strips may also be dried by rewinding directly from the processing reel emulsion side out onto a **Kodak Roll Paper Dryer** not above 200°F (93°C). Be sure that all surface moisture is removed from the paper base before it contacts the drum surface.

As in sheet drying, do not ferrotype **Ektachrome RC Paper** in rolls and do not dry in a heated continuous-belt

dryer. Strips air-dried at room temperature will usually have a slightly lower gloss.

SUPPLEMENTARY INFORMATION

If excessive foam appears in the First Developer or Stop Bath, add three drops of **Kodak Anti-Foam** per gallon of tank solution. Foam prevents uniform action of the processing solutions and should be eliminated.

Any chemical contamination at all is likely to have serious effects on print quality. In setting up a process, and after discarding any of the processing solutions, it is extremely important to clean the tanks thoroughly before refilling them. In particular, remove any scale (calcium-silver deposit) from the developer tank. Use **Kodak Developer System Cleaner** or a 10 percent solution of **Kodak Citric Acid (Anhydrous);** then rinse the tank thoroughly with warm water.

CLEANING OF EQUIPMENT

Baskets, reels, and film hangers must be washed thoroughly after each processing run to avoid contamination on the next run. Wash the equipment for 10 minutes at a high water-flow rate.

If the wash tanks used in the processing are also used for cleaning and washing the baskets, reels, or other processing equipment, discard the water from the wash tanks and begin the cleaning operation with fresh water.

TIMING

Start the timer immediately after the first step is started. Always allow a drain time of approximately 15 seconds to be sure the solution has drained from the paper before starting the next step (solution). Always figure this drain time as part of the timing of that particular solution and step of the cycle.

EASTMAN KODAK

SUMMARY OF STEPS APPEARS ON
FOLLOWING PAGE

The Compact Photo-Lab-Index

**SUMMARY OF STEPS FOR
3½-GALLON SINK-LINE
PROCESSING**

Temperature of First Developer:
 85 ± ½°F (29.5 ± 0.3°C)
Temperature of all other solutions:
 85 ± 2°F (29.5 ± 1.1°C)

First two steps must be done in **total** darkness.
Remaining steps may be done in normal room light.

Solution or Procedure	Comments	Processing Time* (minutes)	Total Minutes at End of Step
First Developer	Temperature tolerance ± ½°F (0.3°C)	4	4
Stop Bath		1	5
REMAINING STEPS MAY BE DONE IN NORMAL ROOM LIGHT			
First Wash	Running water at 3 to 4 gallons per minute	4	9
Reversal Exposure	Expose emulsion side for 15 seconds, 1 foot from No. 1 photoflood lamp		Reset Timer
Color Developer		4	4
Wash		1	5
Bleach-Fix		3	8
Final Wash	Running water at 3 to 4 gallons per minute	3	11
Stabilizer	See warning on label	1	12
Rinse	Agitate in running water	½	12½
Dry	Not above 200°F (93°C)		
	Total Process Time	21½	

*All times include a 15-second drain.

**REPLENISHMENT RATES IN ML FOR
3½-GALLON SINK-LINE
PROCESSING**

When adding the necessary replenisher, first remove (but retain) more than enough solution to make room for the replenisher. Then add the necessary replenisher and add enough of the retained solution to restore solution to the original level. Discard the balance of the retained solution.

	1 Full Basket 15—8-in. x 10-in. Sheets	1 Full Reel 3½ in. x 20 ft.	1 Full Reel 5 in. x 20 ft.
First Developer	585	410	585
First Stop	1,170	820	1,170
Color Developer	1,170	820	1,170
Bleach-Fix	375	265	375
Stabilizer	585	410	585

(Continued on following page)

256

KODAK DYE TRANSFER PROCESS

INTRODUCTION

The Kodak Dye Transfer Process is a method for producing high quality color prints in either reflection images on paper, or transparent ones on film base in a wide variety of sizes.

The dye transfer process can use positive color transparencies, color negatives or internegatives, or black-and-white separation negatives as source material for a uniform finished product.

The extreme control of color balance, contrast control and image modification makes the dye transfer process attractive to professionals who require extremely high quality color images.

If the starting point is a positive color transparency, color separation negatives are made on a suitable panchromatic sheet film, such as Kodak Super-XX Pan Film 4142 (Estar Thick Base), by exposures from the transparency through red, green, and blue filters. Then three matrices on Kodak Matrix Film 4150 (Estar Thick Base) are made from the separation negatives by white-light exposures. Direct color-separation negatives can be made successively in a camera if the subject is a still life.

An original color negative or a color internegative is, in effect, a set of color-separation negatives in the form of dye images on one sheet of film. Three matrices, therefore, can be exposed directly from the negative through tricolor filters onto Kodak Pan Matrix Film 4149 (Estar Thick Base).

Regardless of the starting point, the actual matrix processing and printing procedures are substantially the same. After exposure through the base side, the matrix films are developed, fixed, washed in hot water to remove the gelatin in the unexposed areas, and dried. The images that remain are gelatin reliefs, in which the thickness varies with the degree of exposure. The matrices—which are, in effect, red,- green-, and blue-record separation positives—are soaked in solutions of cyan, magenta, and yellow dye, respectively. Each matrix takes up dye in proportion to the thickness of the gelatin. When the three dye images are transferred in register to a sheet of Kodak Dye or Transfer Paper, a color print is produced. Alternatively, the dye images can be transferred to Kodak Dye Transfer Film 4151 (Estar Thick Base) to make "day-night" prints, suitable for viewing either by reflected light or by a combination of transmitted and reflected light.

TRANSPARENCY MASKING

A color transparency is an approximation, although generally a satisfactory and pleasing one, of the original subject. When the transparency is reproduced, there is some loss in reproduction quality because of deficiencies of the dyes in the photographic processes. A more accurate reproduction of the subject can be obtained by making some correction for these deficiencies. This correction procedure, known as "masking," constitutes an additional step in the reproduction process, but the resulting improvements usually more than justify the extra effort involved.

A single mask corrects relative brightness and saturation errors. With most color transparencies, one mask gives acceptable results. To correct hue-shift errors, two masks are necessary. In addition to such a principal mask or masks, a highlight mask is sometimes necessary. to retain important highlight detail. If a highlight mask is needed, it is made first and used with the transparency during exposure of the principal mask or masks.

HIGHLIGHT MASKING

The highlights fall somewhere along the toe portion of the characteristic curve, in many Kodachrome and Ektachrome transparencies; their contrast is therefore lower than that of the middletones. When a print is made, the contrast of the highlights in relation to that of the middletones tends to be lowered further because the highlights again fall on a flatter portion of the characteristic curve.

(Continued on following page)

With subjects containing important highlight areas, it is often worthwhile to correct this error by introducing a highlight mask before making a principal mask or masks. The highlight-masking procedure described here can be used only in conjunction with other masks; in other words, it is supplementary to one of the procedures recommended for use with Kodak Pan Masking Film 4570 (Estar Thick Base).

BASIC OUTLINE OF HIGHLIGHT MASKING PROCEDURE

First, the transparency is printed by contact on Kodalith Ortho Film 2556, Type 3 (Estar Base) with the exposure adjusted so that an underexposed negative is obtained. After development to high contrast in Kodak Developer D-11, this negative, the "highlight mask," will contain densities corresponding to the highlights of the transparency only; other areas will be clear. The highlight mask is registered with the transparency; from the combination, one or more "principal masks" are made. Since the highlights of the transparency have density added to them by the highlight mask, they are printed on the principal mask very much lighter than they would be without the highlight mask.

After the principal mask has been developed, the highlight mask is removed from the transparency and replaced with the principal mask during the exposure of the color-separation negatives. The contrast of the highlights of the masked transparency is now relatively higher than normal. The highlights should therefore reproduce in the print with the desired sparkle and brilliance.

EXPOSURE

As with principal masks, it is convenient to expose highlight masks in a printing frame. The masking film and transparency are exposed emulsion-to-emulsion. The exposure of the highlight mask is fairly critical; an exposure test should be made with each transparency. If the light source is an enlarger that has been set to give an illumination level of 3 footcandles at the exposing plane, with the lens at f/4.5, stop the lens down to f/22 and add a neutral density of 1.0 (Kodak Wratten Neutral Density Filter, No. 96). With other light sources providing 3 footcandles, use a neutral density of 2.4, which can be assembled from a 2.0- and a 0.40-density Kodak Wratten Neutral Density Filter, No. 96. In either case, give a trial exposure of 8 to 16 seconds with no color filter.

After some experience in highlight-masking work, you will find it is fairly easy to judge whether the correct exposure has been given. If the mask is underexposed, the desired highlight-tone correction in the print will not be obtained. On the other hand, overexposure will extend the increase in contrast to the lighter middletones, and result in a harsh effect in the print. Overexposure will also interfere with accurate register of the highlight mask on the original, and may cause edge effects around the whites in the principal mask or masks.

PROCESSING

Masks on Kodalith Ortho Film 2556, Type 3, can be developed by inspection. Develop the film, with continuous agitation, for 2½ to 3½ minutes at 20°C (68°F) in a tray of Kodak Developer D-11, full strength. This developer is supplied in prepared powder form. After development, rinse the film for about 10 seconds in Kodak Stop Bath SB-1a. Fix the film for 2 to 4 minutes in Kodak Fixing Bath F-5 or Kodak Fixer, or for 1 to 2 minutes in Kodak Rapid Fixer. Wash the film for about 10 minutes in running water. Use a temperature from 18.5 to 21°C (65 to 70°F) for rinse, fix, and wash. To minimize drying marks, treat the film in Kodak Photo-Flo Solution after washing, or wipe surfaces carefully with a Kodak Photo Chamois, a soft viscose sponge, a Kodak Rubber Squeegee, or other soft squeegee. Dry the film in a dust-free place with no more than moderate heat.

REGISTERING THE MASK

The developed highlight mask is registered on the emulsion side of the transparency. Unless a pin register system is used, some misregister of the mask may

(Continued on following page)

be evident, especially with a transparency which contains large areas of fine detail. In this case, the mask should be registered most accurately at the most important points in the transparency. The misregister distributed over areas of less importance will be prevented from showing by the diffusion introduced in making the principal mask or masks. After registering the mask tape it to the original, being careful to let the tape touch only the extreme edges of the transparency.

The mask gives a rather strange appearance to the transparency, but this is perfectly normal. The temporary reversal of the highlights will disappear when the highlight mask is replaced by a principal mask.

NOTE: If a step tablet has been placed beside the original (as recommended), the highlight mask should be cut away from this gray-scale area. Otherwise, the gray scale reproduced in the print will show so few steps in the toe that it will be of little help for judging the color balance of the lighter tones in the picture.

SUBSEQUENT PROCEDURE

The principal mask or masks are made in exactly the same way that they would be made if there were no highlight mask on the transparency. After the principal masks have been prepared, the highlight mask is removed and replaced by the principal masks during the exposure of the color-separation negatives.

Since the highlights of the original have been covered by high densities in the highlight mask, they will be relatively light in the principal masks. Large specular highlights in the original transparency will have almost no density at all in the principal masks. As a result, with a principal mask in place, the transparency will appear to have very bright and contrasty highlights. Highlights on faces will even have a greasy appearance, because of their exaggerated contrast in relation to the middletones. When the dye transfer print is made, however, the contrast of this portion of the reproduction curve will be reduced by the toe characteristics of the printing process; only enough contrast will be left to give the desired rendering of highlight areas.

MASKING FOR COLOR CORRECTION
ARRANGEMENT FOR EXPOSURE

Kodak Pan Masking Film 4570 (Estar Thick Base) can be used to make the color correction masks. Place the transparency or color negative in a printing frame on the easel. To simplify subsequent register, diffuse the mask during exposure by placing a piece of Kodak Diffusion Sheet (.003-inch) between the original and the masking film. Consider the matte side of the diffusion sheet as the emulsion side. All three emulsion sides should face the exposing light.

To measure the density range of the mask place a step tablet beside the original before exposing the mask. (Cut the gray-scale area of any highlight mask away before exposing the principal mask). In the processed mask, read the two steps where the step tablet matches most closely the highlight and shadow densities of the unmasked original; then subtract one step from the other.

Single-Mask Procedure. For most transparencies, a single mask exposed with white light is recommended. However, if you want to lighten greens, use a magenta filter, such as a Kodak Wratten Filter No. 33, over the light source. If you want to lighten both blues and greens, use a red filter, such as a Kodak Wratten Filter No. 29. After you expose and process the mask, tape it in register, to the base side of the original transparency. The combination of mask and original is then ready for the making of the three color-separation negatives.

Double-Mask Procedure. To maintain even better color reproduction (i.e., printing saturated reds and greens in the same picture), two principal masks are needed, one exposed by red light and one exposed by green light.

For making color-separation negatives, the red-filter mask is taped in register with the transparency and left there while the red- and green-filter separation

(Continued on following page)

negatives are being exposed. It is then replaced by the green filter mask for the exposure of the blue-filter separation negative. When the original transparency is one that has been processed in Process K-14 (Kodachrome 25 or Kodachrome 64 Film), the masking procedure is as follows: For making color separation negatives, the red-filter mask is taped in register with the transparency when the green-filter separation is being exposed. The green-filter mask is taped in register with the transparency when the red- and blue-filter separations are being exposed. Note: The red filter in this case is a Kodak Wratten Filter No. 24. Use oversize masking film with the Kodak Register Punch and the Kodak Register Printing Frame.

EXPOSURE

The exposure conditions given assume that a tungsten light source is adjusted to give 3 footcandles at the exposing plane (measured without filters).

Color of Exposing Light	KODAK WRATTEN Filter No.	Exposure Time*
White	96 (totaling 1.20 density)	100 sec
Magenta	33	100 sec
Red	29	100 sec
Green	61	150 sec

For Process K-14 Films

Red	24	50 sec
Green	61	150 sec

*If necessary, adjust the exposure time to give just-discernible detail in the darkest shadow area.

PROCESSING

Develop the masks for 3 minutes at 20°C (68°F), with continuous agitation, in a tray of fresh Kodak HC-110 Developer, diluted 1 part stock solution to 19 parts water (Dilution F); or in a tray of Kodak Developer DK-50, diluted 1:4. The density range should be approximately ¼ to ⅓ the density range of the transparency. To obtain more or less contrast reduction, increase or decrease the development time.

REGISTERING THE MASK

If the matrices are to be exposed by enlarging the separation negatives, register the mask on the base side of the transparency. Then place the emulsion side of the transparency so that it faces the emulsion side of the separation-negative material, and print either by contact or by enlarging. (See Figure 1.)

If the matrices are to be exposed by contact, register the mask on the emulsion side of the transparency. Then place the transparency so that its base side faces the emulsion side of the separation-negative material and so that the emulsion sides of the mask, transparency, and negative material all face the light source. (See Figure 2.) The separation negatives can be exposed either by contact printing or by enlarging.

Use of Register Punch. The Kodak Register Punch is very useful in registering color-separation negatives, masks, and matrices. If separation negatives and masks are to be made by contact from a sheet-film transparency, simply attach a strip of punched film to the original. The image can then be positioned exactly relative to the pins on a register board or in a Kodak Register Printing Frame. If a sheet of masking film is punched and placed on the register pins before exposure, it can be registered with the transparency at any time. Thus, during the exposure of a set of separation negatives, one color-correction mask can be substituted for another quickly and with assurance of good register. The masking film should,

(Continued on following page)

The Compact Photo-Lab-Index

of course, be large enough so that it can be punched along one edge without interfering with the picture.

It is also advisable to punch the separation-negative film before exposure so that the image placement will be the same on each. If the negatives are printed by contact on matrix film that also has been punched, the three images will register automatically. If the negatives are printed by projection, however, the matrices must be registered after they have been processed and dyed, unless, of course, the negative carrier has register pins. If it has, the matrices can be prepunched and exposed on a vacuum register board.

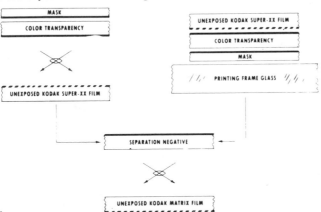

Figure 1

Orientation of color transparency and principal mask in either contact-printing frame or negative carrier of enlarger when matrices are to be made by projection. These procedures furnish the sharpest separation negatives and prints.

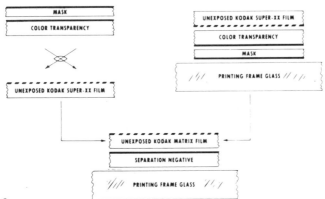

Figure 2

Orientation of color transparency and principal mask in either contact-printing frame or negative carrier of enlarger when matrices are to be made by contact. Prints made by these procedures are not as sharp as those made using the procedures shown in Figure 1.

(*Continued on following page*)

MAKING SEPARATION NEGATIVES FROM A COLOR TRANSPARENCY

PRELIMINARY STEPS

Proper identification of the separation negatives is necessary to avoid confusion. One way is to trim the corners with scissors. Usually, the red-filter negative is left untrimmed, one corner is trimmed from the green, and two corners are trimmed from the blue.

Attach a Kodak Photographic Step Tablet to the transparency. If the separation negatives are to be made by enlargement, prepare a mask from black interleaving paper; cut an opening of the proper dimensions to accommodate the transparency and the step tablet.

Orient the transparency and separation-negative film as described under "Registering the Mask," as shown in Figures 1 and 2.

NEWTON'S RINGS

The close contact between transparency and printing-frame glass sometimes produces Newton's rings. One remedy is to use a fine powder in a small polyethylene squeeze bottle with a short tube projecting from it. The end of the tube should have an opening only a few thousandths of an inch in diameter. In the bottle, place about ½ inch of Oxy-Dry Offset Powder (made by Oxy-Dry Sprayer Corporation, 271 Highland Parkway, Roselle, New Jersey 07203) or a similar powder used for preventing offset on the delivery end of printing presses. First, shake the bottle and tilt it so that the nozzle points upward; then squeeze to apply the powder. The resulting spray should be hardly visible and should be applied to any one of the surfaces involved.

EXPOSURE

Use a suitable panchromatic sheet film, such as Kodak Super-XX Pan Film 4142 (Estar Thick Base), to make the separation negatives.

The following data are given as a guide for making exposure tests when preparing separation negatives from color transparencies. Adjust an enlarger equipped with a tungsten lamp to give 3 footcandles of illumination at the exposing plane (measured without filters) with the lens set at f/4.5. The exposure suggestions are for average transparencies; use ½ stop more exposure for low-key subjects, ½ stop less for high-key originals.

A density of 3.0 in the transparency should, in a properly exposed separation negative, reproduce with a density of about 0.35 to 0.40.

Chart 1

Color Exposing Light	KODAK WRATTEN Filter No.	Use Mask Made with KODAK WRATTEN Filter No.	Exposure Time at f/8
Red	29	29	25 sec
Green	61	29	15 sec
Blue	47B	61	30 sec
For Process K-14 Films			
Red	24	61	8 sec
Green	61	24	15 sec
Blue	47B	61	30 sec

PROCESSING

Develop at 20°C (68°F) for times given below. Adjust times to obtain the desired density range. From normal subjects, a density range of about 1.2 is desirable.

Rinse the film in Kodak Indicator Stop Bath or Kodak Stop Bath SB-5 at 18.5

(Continued on following page)

EASTMAN KODAK

to 24°C (65 to 75°F) about 30 seconds with agitation. Then fix it, with agitation, for 5 to 10 minutes in Kodak Fixer or Kodak Fixing Bath F-5; or 2 to 4 minutes in Kodak Rapid Fixer.

Wash the film for 20 to 30 minutes in running water at 18.5 to 24°C (65 to 75°F) and hang it in a clean, dust-free place to dry.

Chart 2

Dye Transfer Process	KODAK Developer*	Development Times (Minutes)			Approx. Gamma
		Red	Green	Blue	
For color-separation negatives made directly from the subject or from masked color transparencies†	HC-110 (Dil. A)	4½	4½	7	0.90
For color-separation negatives made from unmasked transparencies	HC-110 (Dil. B)	4½	4½	7	0.70

*Tray development at 20°C (68°F) with continuous agitation is recommended.
†Using tungsten illumination as light source.

MAKING DIRECT SEPARATION NEGATIVES

A panchromatic sheet film, such as Kodak Super-XX Pan Film 4142 (Estar Thick Base), can be used in a conventional camera to make separation negatives directly from still subjects. The camera must be firmly braced so that no movement takes place during the course of the three exposures. Since film does not always lie in the same plane in different film holders, it is best to use the same holder for all three exposures. The holder should be loaded and unloaded in total darkness.

LIGHTING

The lighting requirements for direct separation negatives are much the same as those for other types of color photography. Normally, the lighting ratio should be between 2:1 and 3:1. Higher ratios can be tolerated when the subject has a limited range of reflectances or for special effects.

The color quality of the light source affects the filter ratios for the three color filters. Once satisfactory exposure times have been determined for a particular light source, they can be used when other negatives are exposed by the same lighting.

If possible, place a paper reflection scale of neutral-gray steps in the scene. Use a Kodak Gray Scale (included in the Kodak Color Separation Guides), a Kodak Paper Gray Scale, or the gray scale found in the Kodak Color Dataguide. The lighting of the gray scale should correspond as closely as possible to the lighting of the main part of the subject itself. From density readings of the gray scale in the processed negatives, you can determine variations in density and contrast. The gray scale should be located in such a position that it can be trimmed from the final print.

EXPOSURE AND PROCESSING

When Kodak Super-XX Pan Film 4142 (Estar Thick Base) is used in a conventional camera to make separation negatives directly from the subject, typical

(*Continued on following page*)

263

exposure conditions with 450 footcandles of tungsten illumination (3200 K) on the subject are:

Develop at 20°C (68°F) for times given in chart 2. Adjust times to obtain the desired density range. From normal subjects, a density of about 1.2 is desirable.

Chart 3

Color of Filter	KODAK WRATTEN Filter No.	Camera Lens Opening	Exposure Time
Red	29	f/16	15 sec
Green	61	f/16	12 sec
Blue	47B	f/16	20 sec

INTERPRETATION OF GRAY SCALES

A color-balanced set of separation negatives should have the same contrast, as well as approximately equal densities, in corresponding steps of the gray scale. In order to evaluate the results, the densities of the steps in the three gray scales should be read and plotted. This section describes the evaluation of separation negatives from a transparency, but the same principles apply to direct separation negatives.

After the desired densities and contrasts have been obtained consistently in exposing and processing tests, the plotting of each step can then be dispensed with. Instead, the density ranges should be determined from corresponding steps in the three negatives that most closely match those of the diffuse highlight and shadow densities in the red-filter negative.

PLOTTING STEP-TABLET DENSITIES

The densities in the reproduction of the Kodak Photographic Step Tablet, which was placed alongside the transparency when the negatives were exposed, should be plotted against the densities in the step tablet itself. The three curves so obtained provide a measure of the contrast, as well as the relative balance, of the negatives.

Kodak Curve Plotting Graph Paper provides a quick and easy way of plotting step-tablet or gray-scale images. The semitransparent paper stock enables two or more sheets to be superimposed for easy, direct comparison, and is particularly suitable for separation work.

PLOTTING DENSITIES ORIGINATING FROM A TRANSMISSION STEP TABLET

A Kodak Photographic Step Tablet No. 2 or No. 3 has 21 steps, each differing by approximately 0.15 density. The vertical lines marked 1 through 21 along the bottom of the graph paper represent these original step-tablet densities. Plot the density of each step in the step-tablet "image" on the vertical line corresponding to the step number. With a Kodak Photographic Step Tablet No. 1A (an 11-step tablet), use only the odd-numbered lines.

If desired, any "original" step tablet can be calibrated: that is, each step can be measured on a densitometer. The value of each step can then be marked off along the bottom line. Consider the starting point at the far right (Step No. 1) as zero and proceed to the left. The smallest unit division is 0.02. Step No. 2 is 0.15, No. 3 is 0.30, etc. Plot the densities of the step-tablet "image" on vertical lines drawn from the marked-off points.

(Continued on following page)

EASTMAN KODAK

The Compact Photo-Lab-Index

Curves from Unmasked KODAK Photographic Step Tablet

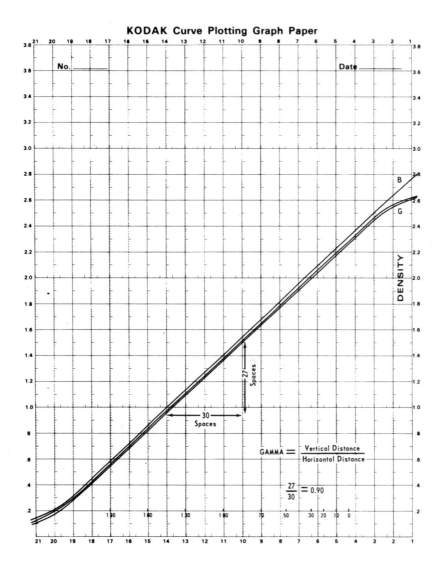

Figure 3a

(Continued on following page)

265

The Compact Photo-Lab-Index

Curves from Unmasked KODAK Photographic Step Tablet

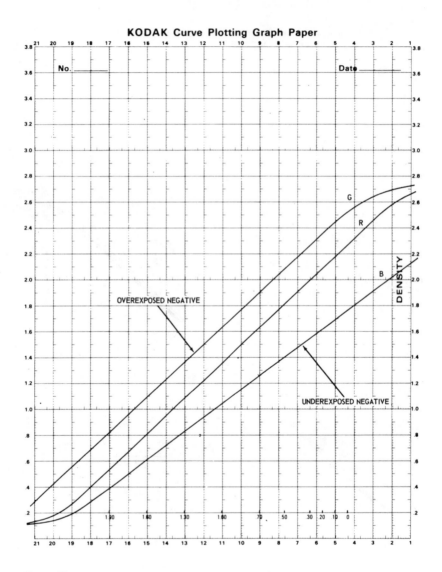

Figure 3b

(Continued on following page)

266

The Compact Photo-Lab-Index

Multiply exposure by the factor shown below the density
difference between the actual and desired curve positions.

Figure 4

PLOTTING DENSITIES ORIGINATING FROM A REFLECTION GRAY SCALE

A Kodak Gray Scale (included in Kodak Color Separation Guides) is a 10-step reflection gray scale which can be placed in a scene to provide a basis for sensitometric measurements of a negative. The density values of the steps in the reflection scale are marked off, in points, on the 0.2 density line (for instance, 1.90, 1.60, 1.30). Plot the density of each step in the gray-scale "image" in each separation negative, along vertical lines drawn from these points. Lay a straightedge along the points you plotted for the red separation negative; with a red pencil, draw a solid, straight line through these points. Use appropriately colored pencils for the other two negatives. The points should fall on the line, or very close to it, if the densities have been carefully read and plotted. The densities at either end of the scale probably will not lie on the straight line connecting the intermediate points, but will form slight curves. The curved lines correspond to the highlight and shadow areas of the transparency.

INTERPRETING THE CURVES

The curves for a perfectly balanced set of separation negatives are not only alike in shape and slope, but superimposed. (See Figure 3a.) If the curves are parallel but do not coincide, the developing times were correct but the three exposure times were not properly balanced. If the curves are not parallel, the development times were incorrect. (See Figure 3b.) If the density range of the transparency recorded in each of the separation negatives is the same, compensation for a slight fault in coincidence can be made by adjustment of the matrix exposures. However, if the lateral displacement is greater than .15 in either direciton, the separations should be remade with the proper exposure corrections.

The exposure corrections can be found from Figure 4. If the densities of the transparency are satisfactorily recorded on the straightline poriton of one of the negatives, its exposure need not be changed. The exposure for each of the other negatives can be corrected by measuring the distance, in terms of the units on the horizontal (log Exposure) scale, that each of the curves needs to be moved either to the right or left. For example, if two curves are super imposed and the third is displaced to the right by a density difference of 0.3, the exposing time for this negative should be multiplied by 2. The distance that the curves need to be shifted in order to bring the reproductions of a fairly neutral shadow density of the transparency to the recommended minimum density of 0.4 in the negatives is measured along the horizontal scale.

MEASURING THE GAMMA

The slope or angle that the line of plotting points makes with the horizontal axis is the gamma to which the negatives have been developed. Gamma can be determined by selecting any convenient point on the curve that is representative of the slope of the whole curve and counting at least 20 divisions to the right. From this point, count the number of divisions vertically until the curve is again reached. Divide the number of vertical steps by the number of horizontal steps taken. Figure 3a illustrates this procedure. For a properly exposed and processed separation negative, this value should be about 0.70 if the original

(Continued on following page)

EASTMAN KODAK

267

transparency was unmasked, or if both the original step tablet and the transparency were masked. If the color transparency was masked but the step tablet was not, the gamma should be about 0.90.

The set of negatives should be remade if there are sizable differences in the slopes of the three curves, because corrections for these differences cannot be made satisfactorily when the matrices are exposed and processed. If the slopes of the lines depart markedly from the recommended gamma, or if the three curves are not closely parallel, the development time should be increased for a negative having a lower value than the recommended gamma, and decreased for a negative having a higher value.

DETERMINING THE DENSITY RANGE

Once a set of well-balanced color-separation negatives has been obtained, determine the density range of the negatives. From the two points on the horizontal scale corresponding to the highlight and shadow densities in the original transparency, draw lines vertically until they intersect the curves of the color-separation negatives. At these points, extend the lines horizontally to the left to the vertical (Density) scale. The difference between these values, which is the density range of the negatives, should be about 1.2 for a transparency with a long brightness range. In the Kodak Dye Transfer Process, however, compensation for separation-negative density ranges as low as 0.9 or as high as 1.8 can be introduced by altering the composition of the matrix film developer.

USING KODAK MATRIX FILM

Matrix exposures are made "through the base" of the Kodak Matrix Film 4150 (Estar Thick Base), with the color-separation negatives oriented in such a way that each matrix image will appear in its correct left-to-right position when seen through the base of the film. The dye images will then be oriented correctly when they are transferred to paper or film. After each matrix is exposed it should be identified to prevent mistakes in the later operations; see the instructions packaged with the matrix film.

MATRICES BY ENLARGEMENT

To prevent misregister or color wedging, and to provide the maximum useful picture area in the finished prints, place each color-separation negative "in the same position" in the enlarger negative holder. The simplest procedure is to tape an oversize sheet of thin white paper on the enlarger easel. Trace on the paper a few key lines and points of the projectd image of one of the negatives. The next negative can then be positioned by moving it in the negative carrier until the image falls approximately on the marks; "do not move the easel."

When placing a matrix film in position for exposure, cover the white paper with half of a fold of the black interleaving paper which is packaged with the matrix film. Mask the film so that there wlil be an unexposed border about ⅜ inch wide to facilitate handling the matrices without damage to the relief images. Use a clean piece of plate glass to hold the film flat during the exposure.

The necessity for using a sheet of glass can be avoided by exposing the film on a Kodak Vacuum Register Board. However, the Kodak Matrix Film cannot be punched and placed over the register pins unless the enlarger head has a provision for pin or edge register of the separation negatives. In this case, punch the unexposed sheets of matrix film, one at a time, and expose them in register.

To expose unpunched film on a register board, place a sheet of white paper of the same size as the matrix film in position over the vacuum channels, with one edge butted against the register pins. Mark the position of an adjacent edge with a piece of masking tape. After composing the picture on the white paper, position the films in the same way for exposure, using a black paper mask to keep the borders clear.

(Continued on following page)

The Compact Photo-Lab-Index

Place the separation negatives in the enlarger, emulsion side toward the light source; see Figure 1. The enlarged images will then be in their corrct left-to-right positions as seen on the enlarger easel. Since the matrices are exposed through the base of the matrix film, the matrix-dye images will also be correctly oriented when they are transferred in the final printing operation.

MATRICES BY CONTACT
For contact printing, an enlarger or a modified safelight lamp can be used as the light source. An enlarger is more convenient, because it allows easy control of exposure. Whatever the light source, the matrix film should be masked to provide an unexposed border of "safe edge" about ⅜ inch wide.

For matrices by contact, orient the separation negative and matrix film as shown in Figure 2. Maximum sharpness in the matrices is obtained by using a small light source at considerable distance from the printing frame. The Kodak Register Printing Frame can be used if the separation negatives have been exposed on the same pin system.

EFFECT OF EXPOSURE ON PRINT QUALITY
When a correctly exposed and processed matrix is dyed, and the dye image is transferred to paper, any diffuse white highlight area shows a just-perceptible transfer of color. The exposure given to the cyan printer (the matrix exposed from the red-filter separation negative) is usually used to establish the overall density of the print. With a properly balanced set of dyes, whites, grays, and blacks in the picture will be reproduced as neutrals in the print when all three matrices have equal densities in the white, gray, and black areas. A slight adjustment of color balance may be required at the transfer stage, but the first objective is equal densities in the neutral areas of all three matrices. Compensation for any density differences among the separation negatives must therefore be made in exposing the individual matrices.

DETERMINING MATRIX EXPOSURES
Make a test exposure from each new set of separation negatives, as follows:

Expose a diffuse white highlight area of the subject from the red-filter negative onto Kodak Matrix Film, and process the film through the wash-off step (see instructions packaged with Kodak Matrix Film). With your fingernail, scratch the white highlight area in the test strip. View the test strip against a dark background by oblique transmitted light. The unscratched area should be just perceptibly darker than the scratched area.

If you lack the experience to make this judgment, dye the test strip cyan and transfer the image onto Kodak Dye Transfer Paper as described in the section, "Making Prints." View the print through a red filter, such as the Kodak Wratten Filter No. 25 or No. 29. The cyan image from a correctly exposed matrix will look like a properly exposed black-and-white print.

With the proper matrix exposure known for the red-filter separation negative, the exposures for the green- and blue-filter negatives can be determined by using a visual or electronic densitometer and the Color-Printing Computer in the Kodak Color DataGuide, No. R-19, sold by photo dealers. The Kodak Graphic Arts Computer, No. Q-12, sold by graphic arts dealers, can be substituted for the Color-Printing Computer.

READING DENSITY
On a visual or electronic densitometer without any filters in the beam, read the density of the diffuse white highlight area in the red-separation negative. Turn the computer density scale until this density is opposite the time used to make the good test-strip exposure. The exposure time for each matrix now appears opposite the highlight density value of the corresponding negative.

If there is no diffuse highlight in the transparency that is a good neutral white, locate the step on the accompanying gray scale that is nearest in density to the

(*Continued on following page*)

The Compact Photo-Lab-Index

highlights of the picture. Identify this step in all three color-separation negatives; then use its densities on the computer in the same manner as specified for a diffuse white highlight.

If the magnification or the lens aperture is changed from that used in exposing the test matrix, proceed as follows: Set the density scale as described above and hold it in position. Turn the lens-aperture dial until the lens aperture used for the test exposure appears opposite the magnification used for the test exposure. For any set of negatives, move the density and lens-aperture dials "together" until the lens aperture and magnification to be used appear opposite each other. The exposure time for each matrix now appears opposite the highlight density value of the corresponding negative.

NOTE: If you decide to use a matrix-developer dilution different from that used for the test strip, adjust the calculated exposure times as suggested in the contrast-control table in the matrix film instructions.

PROCESSING MATRIX FILM

Process the matrices as outlined in the instructions packaged with Kodak Matrix Film.

The processing of Kodak Matrix Film and Kodak Pan Matrix Film requires a nonhardening fixer. Either of two Kodak fixers will fill this requirement: (1) Kodak Color Film Liquid Fixer and Replenisher—used at Process C-22 dilution; or (2) Kodak Ektachrome Film Fixer, Process E-3 (Powder)—used at the replenisher dilution. Kodak Color Film Liquid Fixer and Replenisher is suppiled in 4.8-liter (1¼-gal) jugs of concentrate to make 36.1 liters (9½-gal), and in 57-liter (15-gal) units to make 427.5 liters (112½ gal) of fixer working solution. Kodak Ektachrome Film Fixer, Process E-3 (Powder), is supplied in 1.9-liter (½-gal) and 3.8-liter (1gal) units, and in a 13.2-liter (3½-gal) fixer and replenisher unit. Mix these packages with 1212 milliliters (41 oz), 2425 milliliters (82 oz), and 9.5 liters (2½ gal) of water, respectively, for the proper fixer dilution for matrix film and pan matrix film.

REGISTERING MATRIX FILM

Unless matrices on Kodak Matrix Film have been exposed in register, they will have to be registered visually after they have been processed, dyed, and dried. To save time, the matrices can be dyed directly after processing and then dried. If matrices are registered prior to exposure, the drying step can be omitted. *It is very important to use freshly filtered dyes;* otherwise, foreign particles may become permanently embedded in the soft gelatin relief images. When they have been dried once, the relief images are somewhat more resistant to physical damage.

For dyeing the matrices, carry out Steps 1, 2, 3, and 4 as noted under "Procedure" later in this discussion. Then hang the matrices up to dry, taking care to orient all three images in the same direction.

USE OF REGISTER PUNCH

Mount the Kodak Register Punch in a fixed position relative to an illuminator surface which will support each matrix at the level of the slot in the punch. The slot is 5/16 inch above the bottom of the punch. Care should be taken to keep the glass on which the films are registered from becoming too warm. Excessive heat from the illuminator may lead to size changes and subsequent misregister of the dye images. The use of fluorescent illumination and air-spaced sheets of glass over the light source is recommended.

First superimpose the three dye images approximately in register and make sure that the matrices coincide to about ⅛ inch along the edge that is to be punched. If they do not, trim one or two of the matrices as required.

Then tape the cyan matrix in position for punching, emulsion side down, and punch it. Carefully superimpose the magenta matrix over the cyan matrix. With the aid of a magnifying glass, such as the Kodak Achromatic Magnifier, 5X, check the register at three widely spaced points. Use as guides any small, specular

(Continued on following page)

highlights, such as the catchlights in eyes, or cross marks scratched with a sharp knife along two edges of the transparency before the color-separation negatives were made. Secure the matrix with tape which does not overlap the tape used on the cyan matrix. Punch the magenta matrix and remove it without disturbing the cyan matrix. Finally, register the yellow matrix over the cyan matrix and punch it. Simultaneous punching of the three matrices may result in damage to the register punch.

USING KODAK PAN MATRIX FILM

Kodak Pan Matrix Film 4149 (Estar Thick Base) can be used to make dye transfer prints from color negatives and internegatives.

This film must be handled and processed "in total darkness." It is punched during manufacture to fit the register pins on the Kodak Vacuum Register Board and the Kodak Transfer Register Board.

Matrices are exposed with the emulsion side of a color negative or the base side of the pan matrix film. The matrix images then appear in their correct left-to-right positions when seen through the base of the matrix film, and the dye images are correctly oriented on a paper print.

The matrices of a set include one made through each of the following filters: Kodak Wratten Filters No. 29 (red), No. 99 (green), and No. 98 (blue). A Wratten Filter No. 47B (blue) can be substituted for the Wratten Flter No. 98, if the exposure time proves to be too long. Since the film is fast and panchromatic, it must be handled in total darkness.

Kodak Pan Matrix Film is supplied perforated for use with the Kodak Vacuum Register Board, so matrix register is automatic.

An enlarger is normally used as the light source for either enlarging or contact printing. In either case, the enlarger head should be equipped with baffles to prevent any stray light from reaching the matrix film. After each matrix is exposed, it should be identified to prevent mistakes in the later operations; see the instructions packaged with pan matrix film.

PAN MATRICES BY ENLARGEMENT

Check the enlarger head and its support thoroughly for rigidity. Any movement of the enlarger head during or between exposures will cause misregister. Avoid jarring the enlarger head while changing the filters.

An opaque mask must be used around the negative to prevent white light from getting past the desired image area of the negative and thus affecting the matrices. Black interleaving paper can be used in the negative carrier if the enlarger is not equipped with adjustable masks.

A practical method for composing the picture on the Kodak Vacuum Register Board is to place on the board a sheet of paper (Kodak Dye Transfer Paper or other kind) that is larger than the widest vacuum channel. Locate the paper in such a way that one end extends under the raised clamps and over the register pins. When the clamps are lowered, the pins will perforate the paper. Draw a line lightly with pencil along the location of each of the vacuum channels; then compose the picture within the proper channel. The paper can be kept and reused by replacing it over the pins.

Keep the picture margin ½ inch or more away from the register pins; otherwise, difficulty may arise during transfer of the dye images. On the other three sides, provide for a narrow, unexposed border to facilitate handling the matrices without damage.

When the register board has been positioned properly for the negative to be printed, clamp or tape it securely to the enlarger baseboard to prevent any movement between exposures.

(*Continued on following page*)

EASTMAN KODAK

The Compact Photo-Lab-Index

PAN MATRICES BY CONTACT

If matrices are to be made by contact printing, attach a strip of film containing register perforations to the negative so that it can be positioned identically with three sheets of Kodak Pan Matrix Film. The strip of film can be obtained from a discarded matrix; if a Kodak Register Punch is available, it can be used to punch a discarded sheet of some other type of film. In either case, the perforated strip of film should be wide enough to bring the edge of the negative at least ½ inch away from the pins on the register board.

Having attached the strip of film to the negative, fasten an opaque mask on the base side of the negative to prevent the edges of the matrix film from being exposed. If the register punch is used to perforate the register strip, it is convenient to mask the image area first, and then to punch both the register strip and the opaque mask simultaneously.

The Kodak Register Printing Frame can be used to expose matrices by contact. The Kodak Register Board or the Kodak Vacuum Register Board can also be used in conjunction with a clean cover glass to maintain contact between the color negative and the matrix film. However, the vacuum channels are of no use in this operation. Use an enlarger as the light source, and if a register board is used to hold the negative and matrix film, place it on the easel. With the red separation filter over the enlarger lens, place a sheet of pan matrix film, emulsion down, over the register pins. Place the color negative on top, over the pins, emulsion down. (If the negative is an Ektacolor Internegative, made by contact from an original transparency, place it emulsion up over the pins.) Lay a clean sheet of plate glass over the negative to hold it in contact with the matrix film, and make the exposure. Repeat the same procedure with the green and blue separation filters.

DETERMINING EXPOSURES FOR PAN MATRIX FILM

A correctly exposed matrix will show, after processing, a just-perceptible density in the diffuse white highlights of the subject. The exposure necessary to produce this density is found by making a trial exposure through the red separation filter.

The red-filter exposure found by trial determines the overall density of the final print. The color balance of the print depends upon the relative exposure received by the other two matrices. A balanced set of matrices shows equal densities in those areas that correspond to the neutral areas (white, gray, and black) in the subject originally photographed.

The blue-black pigment cannot be removed from the image on the pan matrix film. It is helpful in making exposure evaluations visually.

GRAY SCALE

A Kodak Neutral Test Card, a Kodak Gray Scale, or the gray scale found in the Kodak Color Dataguide will be helpful in printing if it is included in the original scene when the color negatives are exposed. If it is inconvenient to include such a test image in each negative, a separate negative can be made. In either case, the test image will serve as a reference area only for other negatives made under the same exposure and processing conditions. At least one test exposure should be made for each group of negatives exposed under similar lighting conditions, and at least one test image should be developed in each processing batch.

Proper use of the neutral test card or gray scale provides reliable matrix-exposure information. If a test image is not available, select an area fo the negative that probably represents a neutral object.

MASTER NEGATIVE

For the first negative to be printed, select one exposed to a typical subject containing a Kodak Neutral Test Card or a Kodak Gray Scale. This negative is

(Continued on following page)

termed the "master negative." Before other negatives are printed, it is necessary to establish, as described below, a printing relationship between the master negative and the emulsion number of the pan matrix film in use. The printing times for other negatives can then be calculated from density readings made with a photometer, a densitometer, or a Kodak Video Color Negative Analyzer, Model 2.

TEST PROCEDURE FOR NEW EMULSIONS

The following procedure must be carried out once for each new emulsion number of Kodak Pan Matrix Film used.

1. **Make a mask.** Using interleaving paper from the pan matrix film box, make a mask that adequately covers the projected negative image on the vacuum register board. For large prints, two or more sheets of interleaving paper can be taped together. Mark the area fo a diffuse highlight and the area of the gray card on the mask. Cut out these areas from the mask and reposition the mask on the easel. Tape one edge of the mask to the easel so that it can be folded back.

2. **Tape the diffuse highlight area.** With the mask folded back, position a piece of tape on the vacuum register board alongside the projected diffuse highlight area so that the tape can be used as a guide to positioning a matrix test strip. If the diffuse highlight and gray-card areas are in widely separated portions of the projected image, place another piece of tape alongside the gray-card area.

3. **Make the red-filter exposure.** Clip one end of matrix test strip so that the first-exposure area can be identified later and place the clipped end under the mask in the area of the diffuse white highlight. The base side of the film should face the lens. If the gray-card area is close to the highlight area, position the film so that both areas will be exposed. If the gray-card area is not close to the diffuse highlight area, cover the gray-card opening in the mask by taping a small piece of black paper over it. With the red filter over the lens, the trial exposure might be 15 seconds at $f/8$ for a $2\times$ enlargement. If the gray-card area was not exposed, move the test strip so that the image of the gray card will fall adjacent to the already exposed highlight image. Remove the black paper covering the gray-card area and place it over the highlight aperture, if this area is likely to cause an exposure on the test strip. Make another 15-second exposure.

4. **Make the green-filter exposure.** With the test strip in a lighttight drawer, replace the red filter with the green filter. Now position the test strip under the gray-card mask aperture so that the green exposure will fall adjacent to the red exposure on the strip. Make a 25-second exposure. Repeat, using the blue filter, and give a 45-second exposure.

5. **Process the test strip.** It should show four exposed areas, readily identifiable by their positions in relation to the clipped end. If the green- or blue-filter areas are lighter or darker than the red-filter area, the time of exposure for these two must be lengthened or shortened until all three areas have the same density. Then the overall exposure level should be determined as follows: With your fingernail, scratch the diffuse-highlight area; place the test strip on the bottom of a white tray; the unscratched area should be noticeably darker than the scratched area.

ON-EASEL EXPOSURE DETERMINATION WITH A PHOTOMETER

Once matrix exposure times from the master negative have been established by the test procedure just described, times for exposing other negatives on pan matrix film of the same emulsion number can be determined with an easel photometer having suitable response to red, green, and blue light.

1. With the master negative in the enlarger, the magnification and lens at the same settings as for the test strip, and the photometer probe on either a gray-card or a flesh-tone area, adjust the photometer potentiometers so that the exposure times determined for the red, green, and blue filters are indicated on the meter time scale.

(*Continued on following page*)

2. Place the new negative in the enlarger and set the lens and magnification at the same settings used for the master negative. Place the photometer probe on either a flesh-tone or a gray-card area, whichever was used with the master negative. With the red-reading filter in place, adjust the lens opening so that the meter scale reads the same exposure time as for the master negative; then read the new green and blue exposure times directly.

The change in exposure time required by a change in magnification can be readily calculated by using the Color-Printing Computer in the Kodak Color Dataguide. The Kodak Graphic Arts Exposure Computer, sold by graphic arts dealers, can also be used.

OFF-EASEL EXPOSURE DETERMINATION WITH AN ELECTRONIC DENSITOMETER

An electronic densitometer can be used as follows to determine matrix exposure times for subsequent color negatives once the times have been established for the master negative by the procedure described previously, and as long as the same emulsion number of Pan Matrix Film is used.

1. Read and record the red, green, and blue densities of a flesh-tone or gray-card area in the master negative.

2. Read and record either the flesh-tone or gray-card densities of the new negative.

3. Using the Color-Printing Computer in the Kodak Color Dataguide, set the red density for the master negative opposite the red exposure for the master negative; then read the red exposure for the new negative opposite the red density of the new negative. Repeat with the green and blue densities.

When a flesh tone is used instead of a gray card, both of the above exposure-determination procedures tend to reproduce all flesh tones alike, regardless of individual variations in skin color or in the character of the lighting falling on the original scene. Similarly, all images of a gray card tend to be printed alike, regardless of the position of the card relative to the main light.

OFF-EASEL EXPOSURE DETERMINATION WITH A KODAK VIDEO COLOR NEGATIVE ANALYZER, MODEL 2

The Kodak Video Color Negative Analyzer, Model 2, determines the printing requirements of Ektacolor and Kodacolor-X negatives—without the need for making a test print—by translating the negative into a high-quality positive color television image. When you have obtained the desired density and color balance on the 5 x 5-inch television screen by manipulating the control dials, use the data on the dials to compute deviations in exposure level or color ratio. This method of computation is described in the instruction booklet for the Kodak Video Color Negative Analyzer. Using a Color Negative Analyzer to determine matrix exposure has been found to be effective in obtaining good prints for the first time from new color negatives. This assumes the use of a balanced set of dyes. Little or no dye control is normally required.

MAKING PRINTS

Most of the instructions in this section are the same for both Kodak Matrix Film and Kodak Pan Matrix Film. The instructions for the actual transfer operation are based on the use of the Kodak Dye Transfer Paper with the Kodak Transfer Register Board or Vacuum Register Board. Kodak Dye Transfer Film 4151 (Estar Thick Base) is handled in the same way, except for the conditioning step.

PREPARATION

Making prints efficiently by the dye transfer process requires adequate working space, including a sink area and a transfer area. Seven trays are needed for the working solutions.

(Continued on following page)

For production work, an automatic tray rocker for the dye baths is recommended.

The transfer area should be well lighted (at least 50 footcandles), preferably with the same type of illumination that will ultimately be used to view the prints, so that the print quality and color balance can be judged properly. Illumination of color quality corresponding to a color temperature of 3800 to 5000 K serves well for judging prints. This color quality is approximated by several types of fluorescent lamps (in fixtures), including General Electric Deluxe Cool White, Macbeth Prooflite, Sylvania Deluxe Cool White, and Westinghouse Deluxe Cool White.

MIXING SOLUTIONS

Some of the chemicals for the Kodak Dye Transfer Process are available in prepared form. Follow carefully the mixing directions on the containers. Always use distilled water in making up the working dye baths. If the available tap water has been determined to be unsuitable, you must also use distilled water to make up the first acid rinse bath.

All of the other solutions can be made up with ordinary tap water. When tap water is used in the first acid rinse bath, white highlights and margins in prints may show a tint of color. If this trouble occurs, it can often be eliminated by adding 10 to 40 ml of Kodak Matrix Highlight Reducer R-18 per gallon of 1 percent acetic acid rinse. Depending on the hardness of the water, it may be necessary to use much larger quantities.

CONDITIONING PAPER

Use Kodak Dye Transfer Paper of the next size larger than the picture size. This paper is furnished in double-weight F and G surfaces. For best results, do not attempt to treat more than six sheets at a time.

First, to eliminate any loose gelatin specks along the edges of the paper, rinse each sheet in running water for 30 seconds with agitation; then drain it thoroughly. Second, immerse the sheets, emulsion down, in the working solution of Kodak Dye Transfer Paper Conditioner, immediately interleafing them a few times. Agitate the tray periodically. (If available, an automatic tray rocker provides agitation conveniently. See Figure 5.) The time range for conditioning the paper is 10 minutes to 2 hours.

If unused paper remains in the bath when printing is finished, it can be squeegeed, to remove the excess conditioner, and dried. It will then require only resoaking in the conditioner before use.

When the volume of the paper-conditioner bath becomes insufficient to allow the paper to be completely immersed and to float freely, a fresh bath should be prepared. With extended use, the working solution may accumulate solids, such as paper or gelatin fragments and dust particles. In such cases, the conditioner should be either filtered or replaced.

CONDITIONING FILM

Kodak Dye Transfer Film 4151 (Estar Thick Base) is supplied in sheets larger than the corresponding paper sizes by 1 inch of length and width. This film has a white, translucent appearance; pictures on it can be viewed either by reflected light or a combination of transmitted and reflected light. The "emulsion," or mordanted, side is identified by a notch in the conventional position. The film is also supplied in rolls, wound mordanted (emulsion) side in. This film requires less conditioning time and less transfer time than Kodak Dye Transfer Paper. To condition it, immerse one sheet of film in the paper conditioner, mordanted side up. Agitate the film initially and periodically. After 1 to 2 minutes the film is fully conditioned. Do not extend the time beyond 3 minutes. Also, keep the transfer times for the matrices at a minimum. Times of 2 minutes for the cyan, 3 minutes for the magenta, and 1 minute for the yellow matrix are usually sufficient. Fast drying also helps to retain maximum image sharpness.

(Continued on following page)

The Compact Photo-Lab-Index

CARE OF SOLUTIONS

Dye baths and paper conditioner in trays should not be left uncovered for extended periods of time, since evaporation will change their chemical composition. Covers will also help prevent the solutions from accumulating dust and dirt, which may necessitate spotting work on the prints. For long storage periods, bottles with caps or stoppers are recommended. Do not use glass bottles that have previously been used to store strongly alkaline solutions.

DYEING AND TRANSFERRING

Uneven wetting may cause permanent damage to the matrix films. Handle the matrices emulsion side up while they are in trays.

PROCEDURE

If matrices on Kodak Matrix Film are to be dyed to facilitate register before punching, carry out Steps 1, 2, 3, and 4. Then hang the matrices up to dry; orient all three images in the same direction.

1. **Expand matrices.** To bring the matrices to full expansion, soak them for 1 minute or more in individual trays filled with water at 38 to 49°C (100 to 120°F).

2. **Dye matrices.** Remove the matrices from the hot water, drain them briefly, and place them in the working dye solutions. Dye the red-filter positive cyan, the green-filter positive magenta, and the blue-filter positive yellow. The time of treatment is at least 5 minutes at room temperature; longer dyeing does no harm. Agitate the trays frequently until dyeing is completed; an automatic tray rocker will be found convenient; see Figure 5.

The magenta and yellow matrices can be left in their respective dye baths while the cyan matrix is being transferred.

3. **First acid rinse.** Remove the cyan matrix from the dye bath and drain it until the dye solution begins to form droplets. Place the matrix in a 1 percent solution of acetic acid at room temperature and agitate it for 1 minute before draining and placing the matrix in the second acid rinse. Discard this first acid rinse solution after use.

4. **Second acid rinse.** Place the matrix in a larger tray filled to about three-quarters of its depth with 1 percent acetic acid solution. Lift and reimmerse the matrix at least twice to wash off first acid rinse solution adhering to the surface of the matrix. This bath can be reused until it strongly discolors.

The second acid rinse is often known as the "holding bath," because matrices are left in it for a time ranging from 30 seconds up to several minutes. During this period, the paper is positioned on the transfer surface or, in the case of the magenta and yellow transfers, the preceding matrix is removed from the paper.

5. **Position paper.** Raise the clamps on the register board. Position the paper on the board, emulsion side up, in such a way that the image will fall on the paper when the matrix is registered over the pins. Squeegee the paper lightly several times to flatten it and remove excess paper conditioner.

To prevent bleeding of the dyes, sponge off the transfer surface around the paper with a sponge dampened with 1 percent acetic acid. Also rinse any paper conditioner off your hands with 1 percent acetic acid before handling matrices, but do not use the second acid rinse bath for this purpose.

6. **Position matrix.** Remove the matrix from the second acid rinse and drain it. With the matrix emulsion down, first locate the smaller punch hole over the pin on the register board and press the film down over the pin. Holding the matrix by the end away from the punch holes, locate the elongated hole over the other pin. Run your hand across the film between the holes to smooth the punched edge of the matrix into position and lower the two clamps.

During these operations, be sure to keep the matrix raised sufficiently to prevent the image from touching the paper. At the same time, it is important that a bead of second rinse solution is formed between the punched edge of the

(Continued on following page)

matrix and the paper. During the next step, this liquid will help expel air bubbles and provide good contact between matrix and paper.

7. **Roll matrix into contact.** Use a Kodak Master Print Roller of a size larger than the width of the matrix. Lay the roller on the matrix near the pins of the register board and roll it firmly over the matrix once, toward the hand that is still keeping the matrix from contact with the paper ahead of the roller. Do not pull hard on the matrix with your hand; use only enough tension to keep the matrix from the paper until the roller makes the contact. The weight of the roller plus a slight manual pressure gives adequate contact between the wet matrix and the paper. The proper pressure is just enough to allow the resilience of the soft rubber roller to be felt. Excessive pressure may cause register difficulties due to creeping of the paper. Also, if the Kodak Vacuum Register Board is used for the transfer operation, excessive pressure may cause markings to appear in the picture directly over the vacuum channels.

The cyan image transfers in about 4 minutes, depending on the amount of dye carried by the matrix. While it is transferring, prepare the magenta matrix for transfer. Remove the magenta matrix from the dye bath, drain it, and rinse it in a fresh bath of 1 percent acetic acid (Step 3). Agitate it in the same second acid rinse bath used for the cyan matrix (Step 4), and leave it there while proceeding to Step 8.

8. **Remove matrix.** Lay the roller on the matrix at the edge farthest from the pins and roll it back far enough so that you can grasp the edge of the matrix. Then pull the matrix back slowly, allowing it to push the roller back as far as the pins. Raise the clamps and carefully disengage the matrix from the pins. Start Step 10 and proceed immediately with Step 9.

9. **Transfer magenta.** As soon as cleaning of the cyan matrix has been started (Step 10), transfer the magenta matrix, repeating Steps 6 and 7. The image transfers in 4 to 5 minutes, depending on the amount of dye carried by the matrix. While the magenta dye is transferring, prepare the yellow matrix for transfer, repeating Steps 3 and 4.

10. **Clean matrix after each transfer.** Wash the matrix for a minute or so in running water at 38°C (100°F) before draining it and returning it to the dye bath. If water deposits cause dye buildup in the matrices, treat each matrix in Kodak Matrix Clearing Bath CB-5. Agitate the matrix in the clearing bath for 30 seconds, and wash it for 3 minutes in running water at 20 to 22°C (68 to 72°F). After a clearing-bath treatment, rinse the matrix briefly in the holding bath before returning it to the dye bath. The clearing bath should be replaced at the end of each day, or more often if it becomes strongly discolored in use.

With either treatment, drain each matrix thoroughly before returning it to its dye bath. The purpose of this precaution is to minimize dilution of the dye baths. To avoid difficulties in register and color balance, treat all three matrices of a set identically.

11. **Transfer yellow matrix.** Remove the magenta matrix (Step 8), and put it in warm water (Step 10). Then transfer the yellow matrix, repeating Steps 6 and 7. The image transfers in 2 or 3 minutes. When transfer is complete, remove the yellow matrix (Step 8) and clean it (Step 10).

After the yellow transfers have been completed, it is good practice to swab off with damp absorbent cotton the first two prints from a set of matrices on Pan Matrix Film. This procedure will remove any unhardened gelatin adhering to the prints, thus preventing any veiling of highlights in the picture.

12. **Dry print.** Remove excess moisture from the surface of the print with a squeegee or windshield wiper blade. Squeegee both sides of the print with firm strokes and immediately hang the print up or lay it on a frame covered with plastic screening or cheesecloth. Rapid drying gives maximum sharpness. Shrinkage of a paper print during drying can be minimized by removing excess moisture, and then fastening all four edges of the print to a shellacked board with decorator's tape.

(*Continued on following page*)

EASTMAN KODAK

The Compact Photo-Lab-Index

Prints on the F surface of Kodak Dye Transfer Paper can be hot-ferrotyped in the normal manner, provided excessive heat is avoided. Ferrotype such prints immediately after the yellow transfer.

SUBSEQUENT PROCEDURE

Additional prints are made by repeating the dyeing and transfer procedure as many times as necessary. In most cases, some improvement in print quality can be obtained by using the control techniques described as follows in the next section.

Quantity printing. By using 5-minute dyeing and transfer times for all matrices, one operator can print two subjects simultaneously on separate transfer boards. A time cycle is easily arranged.

Life of matrices. The number of satisfactory prints that can be made from a set of matrices depends almost entirely on the care with which the matrices are handled during the dyeing and transfer oprations. By keeping the solutions clean and avoiding physical damage to the relief images, as many as 100 prints or more can be made from a set of matrices.

Storage of matrices. After the last print has been made, wash each matrix for 1 minute in running water at 37.8°C (100°F), and hang it up to dry. The best place to store the dry matrices is the box in which the film was originally packed. Place each matrix in a separate fold of interleaving paper.

Store the printing data with the matrice so that information about the dye contrast and any control solutions used in the first acid rinse is readily available if printing is resumed. This information can be entered on sheets taped on the outside of the film box or recorded directly on the box.

AUTOMATIC TRAY ROCKER

An automatic tray rocker is an optional piece of equipment that is convenient for dyeing matrices. The construction illustrated elsewhere has been found satisfactory for matrix sizes up to 16 x 20 inches.

The rocker should be pivoted in the center as shown; hinging at the front or rear puts an unnecessary strain on the motor. For smaller matrices, the width of the tray rocker can be decreased if a suitable correction is made in the eccentric.

TOP OF
3/4-IN. PLYWOOD

LENGTH AS NECESSARY
TO ACCOMMODATE TRAYS

SHELF MOUNTED UNDER
REAR OF TOP

1/10-HP 1425- TO 1750-RPM
ELECTRIC MOTOR

GEAR REDUCTION BOX
(REDUCTION RATIO
100:1 TO 150:1)

BEARING POINT IN
CENTER OF TOP

24 IN.

FIGURE 5

1-IN. ECCENTRIC (TO PROVIDE
TILT OF 1 IN. IN 12 IN. OF
TRAY ROCKER TOP WIDTH)

(Continued on following page)

278

CONTROLLING COLOR BALANCE

Usually, some change in the first print is desirable, either to correct for small errors in exposure or processing, or to satisfy personal preference as to print quality. Briefly, overall print density can be reduced by adding sodium acetate to the rinse bath, or it can be increased slightly by adding acetic acid. Density in the highlights can be reduced by adding Kodak Matrix Highlight Reducer.

REDUCING PRINT DENSITY

One of the most useful controls in the dye transfer process is the addition of sodium acetate to the first rinse of one, two, or all three matrices. Equal treatment of all three matrices in the modified rinsing bath results in a lighter print.

However, suppose that a print shows an overall magenta cast. The density of the magenta dye image can be reduced by adding 5 percent solution of sodium acetate only to the first acid rinse bath used with the magenta matrix. Add 1 to 10 milliliters of the 5 percent sodium acetate solution per 150 milliliters of the standard rinse solution. Dye the magenta matrix in the usual manner. When lifting the matrix from the dye bath, drain it until the dye solution begins to run off in droplets before putting it in the acid rinse containing the sodium acetate. Agitate the dyed matrix for 1 minute in the rinse; then put it in the second acid rinse. More sodium acetate or a longer time can be used to reduce the density further.

In this example, only the rinse for the magenta matrix should contain sodium acetate. Depending on the balance, it may be necessary to add sodium acetate to the first acid rinse bath used with two of the matrices, perhaps with a difference in the sodium acetate concentration or in the time of treatment.

Rather large amounts of dye can be removed from matrices by the use of sodium acetate. However, there is a serious decline in photographic quality if you attempt to salvage a definitely overexposed or unbalanced set of matrices by this means.

To make sure of consistent results, the sodium acetate solution should be mixed fresh daily.

REDUCING DENSITY IN HIGHLIGHTS

When the test print is in good balance but the highlights are tinted, add 5 to 10 milliliters of a solution of Kodak Matrix Highlight Reducer R-18 per 150 milliliters of the first acid rinse used with the matrix carrying the color that tints the highlights. Agitate the matrix for 1 minute in the first acid rinse before placing it in the second rinse. If the use of sodum acetate is also necessary, the matrix highlight reducer can be used in the same first rinse bath, and either the time of rinsing or the highlight reducer concentration can be varied as required to produce the desired contrast.

CHANGING CONTRAST

As stated in the instructions packaged with the matrix films, the preferred method of contrast control is adjustment of the degree of acidity of the dye baths. However, contrast can also be increased slightly by adding acetic acid to the first acid rinse bath. Add 3 to 10 milliliters of 28 percent acetic acid per 150 milliliters of the first acid rinse bath. When removing the matrix from the dye bath, transfer it directly without draining, to the tray containing the rinse with excess acid The object is to carry over a little dye into the rinse, so that the rinse bath becomes, in effect, a second dye bath. Agitate the matrix for 1 to 5 minutes in this bath, depending on the increase in contrast needed, and transfer it to the second rinse. As in reducing contrast, it may be necessary to modify the first acid rinse baths used with one, two or all three of the matrices.

Assuming that the calculations involved in making a set of matrices were correct to within 5 or 10 percent, the use of extra acid usually provides adequate correction. If a greater contrast change is needed in one (or more) of the

(*Continued on following page*)

The Compact Photo-Lab-Index

dye images, the matrix can be dyed in a modified dye bath prepared as described on the sheet packaged with the 1-gallon Kodak Matrix Dye Set or the 5-gallon size of Kodak Matrix Dye and Buffer (Cyan).

When many prints are being made, the color balance of the dye baths is maintained by use of the replenishment technique outlined in the data sheet packaged with the Kodak Matrix Dyes.

SPECIAL PROCEDURES

EXTRA RINSE TREATMENTS

Somtimes a print shows a gradual shift in color balance from one side of the print to the other. This effect, known as "wedging," is usually the result of non-uniform processing.

Uniform color balance can sometimes be restored by additional rinsing of one or more matrices in an auxiliary 1 percent acid rinse containing sodium acetate and Kodak Matrix Highlight Reducer R-18. For example, if one side of the print is too yellow, the corresponding side of the yellow matrix can be given extra rinsing in the auxiliary rinse bath after completion of the normal first acid rinse. The time of the extra rinse treatment can be varied across the film by dipping the matrix in gradually and withdrawing it gradually. The action of the extra rinse can be stopped at any time by placing the matrix in the second rinse bath.

When a print shows good color balance but has an excess of one color in a localized area, the chances are that one of the negatives or matrices did not receive full development in that area. Again, the correction is to rinse out some of the dye held by the corresponding matrix. The rinse solution can be applied locally with a camel's-hair brush. Alternatively, it can be applied with a washing bottle of the type sold by scientific supply houses for use in chemical laboratories.

EXTRA TRANSFERS

Instead of removing dye by an extra rinse treatment, it is sometimes advantageous to put additional dye into the picture. The contrast of any of the dye images can be increased greatly by a second transfer from one of the matrices. It is, however, seldom desirable to transfer a second image of full strength. The amount of dye carried by the matrix can be adjusted by one of the following procedures:

1. Redye the matrix briefly. A dyeing time in the range of 10 to 30 seconds is usually satisfactory.

2. Redye the matrix completely, but rinse it afterward in water to remove the dye from all areas except deep shadows. Then rinse it briefly in the holding bath.

3. Instead of redyeing the matrix, return it to the first acid rinse bath, to which has been added 10 to 15 milliliters of 28 percent acetic acid per 150 milliliters of rinse solution. The rinse bath already contains dye carried over from the dye bath; if necessary, add a few additional milliliters of dye solution. Agitate the matrix in the rinse bath for 3 to 4 minutes.

When additional color is required only in certain areas, the following procedure may be useful: After the first transfer, clean the matrix as usual, but do not return it to the dye bath. Instead, use a soft brush of suitable size to put dye solution on the matrix in the areas where it is needed. Depending on the amount of additional color necessary, either a diluted dye solution or the working dye solution can be used. In either case, the application of dye should be followed by the usual first and second acid rinses before the additional dye is transferred to the print.

BLACK PRINTING DYE

You can make a black printing dye for producing black-and-white prints from a single matrix, or for creating special effects in a full-color print, by dissolving the neutral component of Kodak Retouching Colors in 1 liter (34 fl. oz.) of warm

(Continued on following page)

water. Add 5 milliliters of a 5 percent sodium acetate solution and 5 milliliters of a 28 percent acetic acid solution. Dye and transfer the black matrix the same way you would the separation matrices of a color print. If you wish higher contrast from the black dye, double the amount of acetic acid.

REMOVING SPOTS FROM MATRICES

During the printing operation, matrices that initially gave satisfactory results sometimes pick up gelatin specks or foreign articles, with the result that small spots of heavy dye density appear in subsequent prints. In most cases, the specks can be removed by swabbing the matrix lightly with cotton while it is in the first acid rinse bath, provided the difficulty is discovered before the matrix has been transferred several times and before it has been dried.

Occasionally, however, the specks or particles adhere so tenaciously that they cannot be swabbed off without damage to the surrounding gelatin. If a number of prints of the same subject are required, the following corrective procedure may prevent the necessity of remaking the matrices or retouching each print individually.

Support the dyed and dried matrix on an illuminator; holding a sharp etching knife almost at right angles to the matrix, use a series of short, closely spaced strokes to break up the solid clump of dye and blend it with its surroundings. The fine knife marks will not be distinguishable on prints seen at normal viewing distances.

RETOUCHING

Small light spots can be filled in with diluted dye transfer dyes, mixed, if necessary, to provide the proper color. Spotting work can be done on either a wet or dry print. Best results are obtained by applying the dye with a small brush, gradually building up the dye density to match the surrounding area Spots in dark areas may require several applications, or undiluted dye transfer dyes can be used.

Dark spots can be removed without damage to the surface of the print by careful use of a permanganate bleach (Kodak Reducer R-2), followed by a 1 percent sodium bisulfite solution and rinsing. Then add color to match the surrounding area.

An etching knife can be used on prints to remove plus-densities. After extensive etching, it may be necessary to rub the area down with Kodak Abrasive Reducer and spray it with lacquer to hide the difference in surface texture.

SELECTIVE DYE BLEACHING

Occasionally, it may be desirable to bleach individual dyes in prints. The following procedures work fairly well for experienced operators.

To remove cyan dye, use a weak solution of potassium permanganate (about ¼ percent). Do not add acid to the solution and do not use a permanganate concentration high enough to leave a brown stain. You can remove a slight brown stain with 1 percent sodium bisulfite solution.

To remove magenta dye, use undiluted Kodak Photo-Flo 200 Solution. Apply the solution with a cotton swab.

To remove yellow dye, use a 5 percent solution of sodium hypochlorite. Alternatively, use a commercial bleach, such as Clorox or 101, full strength.

After any of these bleach treatments, rinse the treated area with 1/10 percent acetic acid and then blot it off.

MOUNTING

MOUNTING PRINTS

Dye transfer prints made on Kodak Dye Transfer Paper can be mounted satisfactorily with Kodak Dry Mounting Tissue, Type 2. This tissue is coated on both sides with a thermoplastic resin which fuses both the mounting surface and

(Continued on following page)

the print with improved adhesion at lower temperatures and press times. This improved product can be used for mounting prints that are on either resin- or conventional paper base. Follow the instructions carefully for best results.

It is important to start with the dry mounting press set for the recommended temperature range and platen pressure:

Temperature Range: 82 to 99°C (180 to 210°F).

Platen Pressure: sufficient to bond the print, tissue, and mount together in firm contact.

Check the settings on the press occasionally to be sure they remain correct.

For occasional work, if a press is not available, an automatic electric iron can be used. Start at the lowest temperature setting in the synthetic fabric range, and adjust the temperature as necessary. Since settings may vary, a test should be made to be sure that the iron is hot enough to activate the adhesive but not so hot as to scorch or blister the print.

After a print is adhered to the mounting board, place it face down on a cool, flat surface under weight to cool.

If you have trouble dry-mounting dye transfer prints, the list below may be of assistance.

You can also use adhesives that have good adhesion properties, no deleterious effect on dye stability, and resistance to blistering and wrinkling as bonding agents. The following brands meet these specifications: Cascorez G.R.C.-7—Borden Chemical Company, Arabol Department, 1829 54th Avenue, Cicero, Illinois 60650; Special #67 G.V. Padding Compound—Harad Chemical Company, 2076 East 22nd Street, Cleveland, Ohio 44115; Elmer's Glue-All—Borden Chemical Company, New York, N.Y. 10017; Scotch Sprament (Cat. No. 6060), 3M Company, Adhesives, Coatings, and Sealers Division, 3M Center, St. Paul, Minnesota 55101.

Since Eastman Kodak Company has no control over the manufacture of these adhesives, you should make your own tests and evaluations.

Problem	Cause
Blisters	Excessive platen heat or moisture in print or mount
Poor bonding	Insufficient heat or time
Dull spots on ferrotyped print surface	Moisture in cover sheet
Bubbles beneath print	Uneven pressure in press

LACQUERING

You can enhance and protect the appearance of dye transfer prints (and dye transfer "day-night" prints on Kodak Dye Transfer Film) by coating them with one of a number of lacquers available from photo dealers. These lacquers are made especially for photographic use. By varying the type of lacquer, dilution, and method of application, you can achieve a variety of surfaces ranging from glossy to matte and including stipple and brush effects. Lacquering helps protect the surface from abrasions, fingerprints, atmospheric contaminants, humidity, and dirt. You can clean a lacquered print by wiping it with a damp cloth.

MOUNTING BEHIND GLASS

If prints are framed behind glass, a slight separation should be maintained between the print surface and the glass to prevent the print from adhering to the glass. This is usually accomplished by placing a cardboard mat around the print. Even with a mat separator, the print may curl and touch the glass; preferably, drymount the print to heavy cardboard to keep it flat in the frame. Coating the print with lacquer will also help keep the surface from adhering to the glass.

(Continued on following page)

MOUNTING TRANSPARENCIES

Dye transfer "day-night" prints on Kodak Dye Transfer Film can be mounted and displayed in the same manner as large transparencies.

Although dye transfer "day-night" prints are less prone to dye-fading than transparencies made by other systems, they should be protected from heat, humidity, atmospheric contaminants, and ultraviolet radiation. In addition to lacquering, this can be accomplished by laminating with ultraviolet-absorbing plastic sheeting, or by sandwiching in glass. Adequate ventilation of the light box used to illuminate the print is important as well.

FORMULAS FOR SPECIAL DYE TRANSFER SOLUTIONS

1 PERCENT ACETIC ACID SOLUTION

Add 1 part Kodak Glacial Acetic Acid to 100 parts water or 1 part 28 percent acid to 27 parts water. Use 10 ml of glacial acetic acid per 1000 ml of water (1¼ fl. oz. per gallon) or 37 ml of 28 percent acetic acid per 1000 ml of water (4¾ fl. oz. per gallon).

KODAK MATRIX HIGHLIGHT REDUCER R-18

Add 1.2 grams (18 grains) of sodium hexametaphosphate or Calgon to 1 liter (32 fl. oz.) of water at about 32°C (90°F) (Modify according to the hardness of your water supply.)

KODAK MATRIX CLEARING BATH CB-5

To prepare stock solution, add 20 grams (0.7 oz.) of Kodak Anti-Calcium and 48 milliliters (1.6 fl. oz.) of ammonium hydroxide to 1 liter (32 fl. oz.) of water at 32°C (90°F). To prepare working solution, dilute 1 part stock solution in 11 parts water.

5 PERCENT SODIUM ACETATE SOLUTION

Dissolve 5 grams of Eastman Sodium Acetate (anhydrous) [CAT. No. T227]* in a small amount of warm water and add water to make 100 milliliters; or dissolve 1 oz. of sodium acetate in a small amount of warm water and add water to make 20 fl. oz.

*Unlike photographic products, which are distributed solely through photo dealers, Eastman Organic Chemicals are available through laboratory supply houses or on direct order from Eastman Kodak Company, Eastman Organic Chemicals, Rochester, New York 14650. These chemicals are neither intended nor sold for household use. Catalog numbers should be given in the order.

EASTMAN KODAK

EASTMAN KODAK MOTION PICTURE FILM

PLUS—X Negative 5231 Exposure Index — Daylight—80, Tungsten — 64

A high speed, fine grained negative material for general interior photography and for exterior photography under average lighting conditions. This film represents an excellent balance between the maximum desirable speed for most purposes and the finest grain obtainable at that speed. It is widely used for general production work and is also suitable for making composite projection background scenes, since its speed is sufficient to permit the use of small apertures in order to secure good depth of field.

DOUBLE—X Negative, 5222 Exposure Index — Daylight—250, Tungsten 200

A high speed negative material suitable for general production use either outdoors or in the studio. This film represents a major advance in speed-granularity ratio over materials previously available. It finds application in both exterior and interior photography under adverse lighting conditions and will be especially preferred where greater set-lighting economy is desired. It is also useful where greater depth of field is wanted without an increase in illumination level.

4—X Negative, 5224 Exposure Index — Daylight—500, Tungsten—400

An extremely high speed negative material of medium graininess. It is particularly suitable for newsreel work and for exterior and interior photography under adverse lighting conditions. It is also useful where it is desired to obtain great depth of field without an increase in illumination.

35mm EASTMAN TELEVISION RECORDING & SOUND RECORDING FILMS

Television Recording, 5374

Designed for photographing television picture tube images to provide a motion picture record of television programs. Picture tubes with either P-11 (blue) or P-16 (ultraviolet) type phosphors may be photographed satisfactorily using this film. The film yields a negative image. It can also be used in making low-contrast prints from kinescope recordings.

Fine Grain Sound Recording, 5375 (Variable Area)

Designed especially for use with variable-area sound recording equipment. When exposed to high density it can be printed onto black-and white positive films such as Eastman Fine Grain Release Positive 5302/7302 or onto color films such as Eastman Color Print Film 5385/7385, Eastman Reversal Color Print Film 7387, or Eastman Ektachrome R Print Film 5389/7389.

The Compact Photo-Lab-Index

35mm EASTMAN BLACK-AND-WHITE INTERMEDIATE FILMS

Fine Grain Duplicating Panchromatic Negative, 5234

A low-speed panchromatic negative material with extremely fine grain and very high resolving power, coated on the same type of gray base used for panchromatic camera negative materials. It is a companion to Eastman Fine Grain Duplicating Positive Film 5366/7366 and produces duplicate negatives equal in tone rendering and printing detail to the original negative. The panchromatic sensitivity of this film also permits it to be used in making black-and-white separation negatives from color positives where archival protection masters are required.

Panchromatic Separation, 5235

A black-and-white panchromatic material having very low granularity and capable of giving high definition. It is intended primarily for making separation positives from color negative originals such as those made on Eastman Color Negative Film 5254. When processed in conventional negative-type developers, low to medium contrast can be obtained.

High Contrast Positive 5362

A high contrast medium speed positive material with very fine grain and high resolving power. Halation protection is provided by an antihalation undercoat. The film is approximately five times as fast as Eastman Fine Grain Release Positive Film 5302/7302. This high contrast film is useful for titles, silhouette mattes, and any high contrast application.

Fine Grain Duplicating Positive, 5366

A low speed blue-sensitive positive material with micro-fine grain and very high resolving power. It is designed for making master positives from black-and-white camera negatives. Used with Eastman Fine Grain Duplicating Panchromatic Negative Film 5234/7234, excellent duplicate negatives can be made.

35mm EASTMAN BLACK-AND-WHITE PRINT FILMS

Fine Grain Release Positive, 5302

An extremely fine-grain high-resolution film for general black-and-white release printing. This film is also useful for making negative and positive titles, dubbing prints for sound, and making kinescope recordings from negative television-tube images. A gel overcoat protects the emulsion against scratches and abrasions during handling.

Direct MP, 5360

A low-speed orthochromatic film of micro-fine grain ultrahigh resolving power and medium contrast. It can be used for making prints from any black-and-white, or color positive when release print quality is not required. Especially useful for making work prints and musical scoring prints for editing purposes. It can also be used for making direct duplicates of black-and-white negatives.

EASTMAN KODAK

285

The Compact Photo-Lab-Index

35mm COLOR CAMERA FILMS

Eastman Color Negatives, 5254

<div style="float:right">Exposure Index Tungsten 100
Daylight 64 with No. 85 filter</div>

Exposure Index Tungsten 100
Daylight 64 with No. 85 filter

A high speed camera color film designed for use in tungsten light and, with an appropriate filter, in daylight. This film has excellent sharpness, fine grain, and wide exposure latitude. Dye-couplers in the emulsion layers act as built-in color masks after the film is processed and ensure good color reproduction in release prints made from the color negative.

Kodak Ektachrome MS, 5256 Exposure Index-Daylight 64

A color reversal film for daylight. It has moderate speed, extremely fine grain, good sharpness. It is intended primarily for direct projection, but acceptable prints can be made on the following: Direct prints: Eastman Reversal Color Film 7387, Eastman Ektachrome Reversal Print Film 5386/7386, or Eastman Ektachrome R Print Film 5388/7388. Negative/Positive: Eastman Color Internegative Film 5272/7271 and Eastman Color Print Film 5385/7385.

Kodak Ektachrome EF, 5242 (Tungsten)
Exposure Index Daylight—80 with No. 85 Filter Tungsten—125

A high speed reversal color film for tungsten where sufficient exposures can be obtained with lower speed films. It is useful for industrial films with existing light, and many night time sports events, as well as color newsreel work. It can be exposed at effective speeds ranging from ½ to 2 times the normal exposure indexes with little loss in quality. For emergencies the index can be increased 4 to 8 times if the laboratory is notified. While intended primarily for direct projection, it can be duplicated if necessary.

Kodak Ektachrome EF, 5241 (Daylight)
Exposure Index, Daylight 160, Tungsten (3200K with 80A)—40, (3400K with 80B)—50

A high-speed reversal film for daylight when level of illumination is low or for high-speed photography where sufficient exposure cannot be obtained with lower-speed emulsions. It can be exposed ½ to 2 times normal exposure with little loss in quality. For emergencies it can be exposed at 4 to 8 times the normal exposure index if the laboratory is notified. While intended for direct projection color duplicates can be made.

35 mm EASTMAN COLOR INTERMEDIATE FILMS

Color Reversal Intermediate, 5249

Designed for making duplicate negatives from negative originals in one printing stage instead of the two stages usually required for duplication. The duplicate negatives made this way have an effective reproduction contrast near unity, and built in color correcting masks are incorporated ensuring good color reproduction.

Color Intermediate, 5253

Designed for producing color master positives and color duplicate negatives from camera originals made on Eastman Color Negative Film 5254/7254. Reproduction contrast is close to unity, maintaining the contrast close to that of the original negative.

Color Internegative 5271

A low-contrast low-speed film with good sharpness and low granulairty designed for making internegatives from color originals on Eastman Ektachrome Commercial Film 7252. The internegatives can then be printed upon Eastman color print films 5385, 7385, or 7380.

286

The Compact Photo-Lab-Index

35mm EASTMAN COLOR PRINT FILMS

Eastman Color Print, 5385

A multilayer color film for making color release prints from original color negatives, color duplicate negatives, color internegatives derived from color reversal originals, or black and white separation negatives.

Ektachrome Reversal Print, 5386

For color prints from originals made on Ektachrome MS, ER, and EF films. It can be used for making prints from Eastman Ektachrome Commerical Film 7252. It is not intended for original exposures in the camera.

Ektachrome R Print Film 5389

For making color prints from originals made on Kodak Ektachrome MS Film 5256/7256, Kodak Ektachrome EF film 5241/7241 and 5242/7242, but not recommended for use with Eastman Ektachrome Commerical Film 7252 because the contrast would be too low.

Note: The following 35mm Eastman films are available with 16mm, 8mm, and Super-8 perforations: Color Reversal Intermediate, 7249; Color Intermediate, 7253; Color Internegative, 7271; Color Print, 7381 Color Print, 7385; Fine Grain Duplicating Panchromatic Negative, 7234; Panchromatic Separation, 7235; Fine Grain Sound Recording, 7375 (Variable Area); Fine Grain Release Positive 7302.

The following films are available in wide format: Eastman Color Negative, 5254 (65mm); Color Reversal Intermediate, 5249 (65mm); Color Intermediate, 5253 (65mm); Eastman Color Print, 5385 (70mm); Panchromatic Separation, 5235 (65mm).

35mm LEADER

Eastman Clear, 5980 (Thickness .005")

Clear, transparent, uncoated support.

Eastman Black-and-White Opaque, 5981 (Thickness .0083")

Opaque, black on one side and white on the other. Satisfactorily for use in various types of processing machines.

Eastman Green, 5982 (Thickness .0095")

A green transparent uncoated support. Recommended for use in processing machines where long leader life is desired.

Eastman Lightstruck Opaque Film 5995

Exposed film on gray or clear base which, when processed in a positive type developer, yields a density of approximately 3.5 or higher.

Eastman Lightstruck Write-on Film 5996

Exposed, clear-base film of low rawstock density suitable for use as leader on printing originals.

The Compact Photo-Lab-Index

16mm EASTMAN BLACK-AND-WHITE NEGATIVE CAMERA FILMS

PLUS—X, Negative, 7231

Exposure Index Daylight—80 Tungsten—64

High Speed, extremely fine grain negative film for general production use both outdoors and in the studio.

DOUBLE—X Negative, 7222

Exposure Index Daylight—250 Tungsten—200

A high-speed negative film, representing the latest advances in speed-granularity ratio. Suitable for both exterior and interior photography under difficlut lighting conditions.

4—X, 7224

Exposure Index Daylight—500 Tungsten—400

An extremely high-speed negative film suitable for both exterior and interior photography under difficult lighting conditions. Particularly suited for newsreel work and where it is desired to obtain great depth of field without increased illumination.

16mm KODAK BLACK-AND-WHITE REVERSAL CAMERA FILMS

PLUS—X Reversal, 7276

Exposure Index Daylight—50 Tungsten—40

A medium speed reversal type panchromatic film suitable for general exterior photography and for indoor work where ample artificial light is available. When processed by reversal methods, it yields a positive image having good contrast and exceptionally low graininess. It is also useful for television photography for either studio work or kinescope recording.

TRI—X Reversal, 7278

Exposure Index Daylight—200 Tungsten—160

A high-speed reversal panchromatic film suitable for general interior photography with artificial light, available spooled for high-speed cameras and for the regular 16mm motion picture cameras used in news, industry and sports photography. It can also be used under daylight conditions, and is particularly useful for making sports pictures at regular speed or slow-motion pictures in weak light or late in the day.

4—X Reversal, 7277

Exposure Index Daylight—400 Tungsten—320

A high-speed reversal panchromatic film having twice the speed of Kodak Tri—X Reversal Film. Especially suitable for photographing news and sports events under limited available light conditions, and for high-speed photography.

16mm EASTMAN TELEVISION AND SOUND RECORDING FILMS

Television Recording, 7374

Intended for making kinescope recordings of television programs using monitor tubes having either P-11 (blue) or P-16 (ultraviolet) phosphors. Can also be used for making low-contrast prints for either kinescope or regular production negatives when such prints are needed for television transmission.

The Compact Photo-Lab-Index

Fine Grain Sound Recording, 7375 (Variable Area)

Designed for variable area sound recording using a tungsten light source. Can also be used for direct playback purposes.

16mm EASTMAN BLACK-AND-WHITE INTERMEDIATE FILMS

Fine Grain Duplicating Panchromatic Negative, 7234

A low-speed panchromatic duplicating negative material of extremely fine grain and high resolving power. It produces duplicate negatives equal in tone rendering and printing detail to original negatives.

Panchromatic Separation, 7235

A very fine-grain film intended for making black-and-white separation positives from color negatives, such as those made on Eastman Color Negative Film.

High Contrast Positive, 7362

A high-contrast material used for making negative and positive titles, silhouette masks for process work, and traveling mattes for printer light control.

Fine Grain Duplicating Positive, 7366

A yellow-dyed master positive material having micro-fine granularity and very high resolving power.

16mm EASTMAN BLACK-AND-WHITE PRINT FILMS

Fine Grain Release Positive, 7302

A film for general black-and-white production release printing. Also useful for making negative and positive titles, dubbing prints for sound, and kinescope recordings from negative tube images.

Direct MP, 7360

A low-speed orthochromatic film of micro-fine grain, ultrahigh resolving power, and medium contrast. It can be used for making black-and-white prints of any black-and-white or color positive when release print quality is not required. Especially useful for making work prints and musical scoring prints for editing purposes. It can also be used for making direct duplicates of black-and-white negatives.

Reversal Black and White Print Film 7361

A black-and-white reversal film intended for making prints from black-and-white or color positive originals. Suitable for making work prints for editing purposes. Can be processed in same solutions as used for other black-and-white reversal films.

KODAK SUPER 8 FILMS FOR CARTRIDGE MOVIE CAMERAS

PLUS—X Reversal 7276
(See 16 mm above)
Exposure Index Daylight—50 Tungsten—40

TRI—X Reversal 7278
(See 16mm above)
Exposure Index Daylight—200 Tungsten—160

4—X Reversal 7277
(SEE 16 mm above)
Exposure Index Daylight—400 Tungsten—320

EASTMAN KODAK

289

KODAK DOUBLE SUPER 8 FILMS FOR MOVIE CAMERAS

PLUS—X Reversal, 7276
(See 16mm above)
Exposure Index Daylight–50 Tungsten–40

TRI—X Reversal, 7278
(See 16mm above)
Exposure Index Daylight–200 Tungsten–160

4—X Reversal, 7277
(See 16mm above)
Exposure Index Daylight–400 Tungsten–320

LEADER 16mm AND 8mm
(35mm leader listed above)

Eastman Clear, 7980 (Thickness .005")

Clear, transparent, uncoated support. (16mm)

Eastman Green, 7982 (Thickness .0095")

A green, transparent uncoated support, recommended for use in processing machines where long leader life is desired. (16mm)

Kodak White Movie, 7985 (Thickness .006")

White, opaque, suitable for leader and trailer use on release prints. (16mm and 8mm)

Kodak Tapered Processing, 7987 (for Super 8 and 16mm Films)

A 27-inch long white tapered leader supplied in 100 ft. rolls on a 16mm type T plastic core (2 inch O.D.) for splicing 8mm and 16mm master reels for processing.

Eastman Lightstruck Opaque Film 5995

Exposed film on gray or clear base which, when processed in a positive type developer, yields a density of approximately 3.5 or higher. (16mm)

Eastman Lightstruck Write-on Film 5996

Exposed clear-base film of low rawstock density suitable for use as leader on printing originals. (16mm)

The Compact Photo-Lab-Index

16mm COLOR CAMERA FILMS

Eastman Ektachrome Commercial, 7252
Exposure Index Daylight 16 with No. 85 filter, Tungsten—25

Provides low-contrast color original from which a color release print of good projection quality can be made on Eastman Reversal Color Print Film 7387 or on Eastman Color Print Film 7385 through Eastman Color Internegative Film 7271.

Eastman Color Negative, 7254
Exposure Index Daylight 64 and No. 85 filter, Tungsten—100

A high-speed multilayer color film suitable for both exterior and interior photography. Balanced. for 3200K tungsten lamps but can be used in daylight with Kodak Daylight Filter No. 85.

Kodak Ektachrome MS, 7256
Exposure Index, Daylight—64

Medium-speed daylight-balanced camera film which yields a processed color positive intended primarily for direct projection. Color prints may be made from the original, and while not ideal in every respect, they are acceptable for many purposes.

Kodak Ektachrome EF, 7242 (Tungsten)
Exposure Index Daylight—80 with No. 85 Filter, Tungsten—125

High-speed fine-grain color film balanced for tungsten illumination at 3200 K. Used for industrial films under existing plant illumination, for photography of various nighttime sporting events, for high speed photography and newsreel work.

Kodak Ektachrome EF, 7241 (Daylight)
Exposure Index Daylight—160

Daylight balanced color film, companion to Ektachrome EF, 7242 above. Designed for low-level illumination conditions or high speed photography where sufficient exposure cannot be obtained with slower speed color reversal films. The processed color original is suitable for direct projection, or when required, color prints can be made.

16mm EASTMAN COLOR INTERMEDIATE FILMS

Color Reversal Intermediate, 7249

A multilayer color film designed for making duplicate negatives from Eastman Color Negative originals in one printing stage.

Color Intermediate, 7253

A multilayer color film suitable for use in preparing both color master positives and color duplicate negatives from originals on Eastman Color Negative Film. Eliminates the need for making black-and-white separation positives except where protection of the original against fading is desired.

Color Internegative, 7271

A multilayer color film for use as an intermediate material for preparing color prints in 16mm width from reversal type 16mm color originals, such as those made on Ektachrome Commercial and Kodachrome II films.

16mm EASTMAN COLOR PRINT FILMS

Eastman Color Print, 7381

Multilayer color film designed for making 8mm color contact prints from Eastman Color Internegative Film or for 8mm reduction prints from color negatives or color internegatives.

Eastman Color Print, 7385

Used for making color contact prints from Eastman Color Internegative Film or for reduction color prints from 35mm Color Negatives or color internegatives.

Reversal Color Print, 7387

Intended for making duplicates in color of 16mm originals on Ektachrome Commercial and Kodachrome II films.

Ektachrome Reversal Print, 7386

Color reversal print material designed as a companion film to Ektachrome MS Film 7256. The same solutions and technique can be used for developing both materials. The film can also be used for making prints from originals on Ektachrome Commercial and Kodachrome II Films.

Ektachrome R Print Film, 7389

Color reversal print film designed to be compatible with Ektachrome EF Films 7241 and 7242 and Ektachrome MS Film 7256. It is recommended that all four materials be processed in the same chemical formulations (Kodak ME-4 Process) with a reduced development time for the 7389 film.

Eastman Color Print Film 7380 (Super 8 and 8mm)

For making super 8 and 8mm color release prints from original color negatives, color dupe negatives, color internegatives, or B&W separation negatives.

KODAK DOUBLE SUPER 8 FILMS FOR MOVIE CAMERAS

Ektachrome EF, 7242 (Tungsten)
Exposure Index, Daylight—80 with 85 Filter, Tungsten—125

High-speed fine-grain reversal color film designed for projection.

KODAK SUPER 8 FILMS FOR MOVIE CAMERAS

KODAK EKTACHROME 160, TYPE A ASA—Tungsten—160, Daylight—100

A high speed color film designed for existing artificial light exposure without a filter and for daylight exposure with a KODAK Filter No. 85. Available in Super 8mm Cartridges only.

KODAK EKTACHROME 40, TYPE A ASA—Tungsten (3400 K)—40, Daylight—25

A medium-speed color film designed for tungsten exposure without a filter and for daylight exposure with a KODAK Filter No. 85. Available in Super 8mm cartridges only.

The Compact Photo-Lab-Index

MIXING DEVELOPER AND FIXING SOLUTIONS

It is a good general rule to mix the chemicals in the order given in the formula. Certain ingredients in any developer or fixing bath serve to protect other ingredients, either from aerial oxidation or from reacting with each other. Thus the sulfite in a developer protects the developing agents, Elon and/or hydroquinone, from both aerial oxidation and reaction with the sodium carbonate, or other alkali. Therefore, if the alkali is added to the solution of the developing agents before the sulfite is added, the bath will usually become discolored and practically inert as a developer. Generally the sulfite is dissolved first, followed by the developing agents and the alkali; however, since Elon is practically insoluble in a sulfite solution, developers containing Elon are usually prepared by dissolving the Elon first, followed by the sulfite, hydroquinone, and alkali in that order.

When large quantities of developer are prepared, some oxidation of the Elon may take place before the sulfite is added. In this case, it is usually the best practice to dissolve a small part of the sulfite, insufficient to cause precipitation of the Elon, first, after which the Elon is dissolved, followed by the remainder of the sulfite and the other ingredients.

In preparing fixing baths containing an acid hardener, it should be remembered that the sulfite protects the hypo from decomposition by the acetic acid, while alum precipitates from solutions not containing the acid. For this reason, it is equally important to observe the correct order of mixing in preparing hardening fixing baths. The preparation of fixing baths containing chrome alum is even more critical, and instructions concerning the order of mixing and the stirring and temperature must be closely followed.

If clean water and pure chemicals are used, it is usually unnecessary to filter the solutions. If any amount of sediment is noticed, however, the solution should be filtered before storage or use. While cotton in a glass funnel will do an efficient job of filtering, the process may be expedited by the use of a suction pump attached to the water faucet, a large filter flask, and a rapid filter paper in a Buechner funnel.

Kodak Sodium Sulfite, desiccated, is specified in Kodak formulas. In those formulas specifying sodium carbonate, the use of Kodak Sodium Carbonate, monohydrated, is recommended.

MEASUREMENT OF SMALL QUANTITIES

Since the usual studio balance is not sensitive to fractions of a gram or to 1 or 2 grains, accuracy the measurement of small quantities may be obtained by preparing a 10% solution and using that as required. A 10% solution, for example, of potassium bromide (or of any other chemical) contains 10 grams of the chemical in 100 ml of water, hence 10 ml of the solution which is easily measured, contains exactly 1 gram, 1 ml contains 1/10 of a gram, etc.

To prepare a 10% solution correctly, dissolve 1 ounce of the chemical in about 8 ounces of water; after it is completely dissolved, add sufficient water to make the total volume 10 ounces. If the 1 ounce of chemical is dissolved in 10 ounces of water, the total solution volume will be more than 10 ounces and it will not be a 10% solution. In metric measure, to prepare a 10% solution, dissolve 10 grams of the chemical in about 80 ml of water; after it has dissolved, add sufficient water to make a total quantity 100 ml.

STORAGE OF SOLUTIONS

Most stock solutions have good keeping qualities when stored in tightly corked bottles when are practically full. A partly filled bottle contains a good deal of air, which will cause the developer to oxidize; hence it is a better practice to store stock solutions in several small bottles rather than in one large one. The entire contents of a small bottle can be used at one time, leaving the remaining bottles undisturbed.

Developers which are stored in developing tanks should be covered by a floating lid made either of wood, or, in the form of a shallow boat, of Kodacel sheeting. After removing the lid, the surface of the developer should be skimmed with a clean blotter to remove any incrustation before the developer is used.

(continued on following page)

The Compact Photo-Lab-Index

TIME OF DEVELOPMENT

The length of time during which an exposed film must remain in the developer depends upon a number of factors. Certain types of film emulsion require more development than others to produce equal contrasts. With any particular emulsion, the controlling factors are as follows:

 a) The activity of the developer
 b) The temperature of the developer
 c) The degree of agitation of either the materials or the solutions.

In addition, certain workers require a higher contrast than others, depending on the type of work they are doing.

THE USE OF REPLENISHERS

In large-scale processing, it is not economical to attempt to use a developer to the practical exhaustion point and discard it. Usually the quality of the image falls off seriously long before the exhaustion point is reached, and discarding the developer at this stage is wasteful. For this reason, replenishers are usually resorted to in commercial processing. The strength of the replenishers is usually so adjusted that they may be added to the tank to replace the developer carried out on the processed films; thus it is only necessary to maintain the level of the tank at a fixed point to maintain the activity of the developer at its normal degree. Where changes occur in spite of replenishment under these conditions, it is the custom to change the strength of the replenisher until the activity of the developer does remain constant under working conditions of developer loss and replacement.

Replenishment is also applied to small-scale work with low-energy fine-grain developers which fall off markedly in strength even with intermittent use. In this case, however, little developer is lost in processing, and the rule is to add a measured amount of replenisher to the stock bottle before returning the developer to the bottle. Any surplus of used developer is then discarded.

The exact strength and quantity of replenisher required varies with different formulas; specifications for the recommended replenishers and recommended procedures for their use will be found following the respective developer formulas.

Replenishment of developers cannot be carried to an extreme, however, due to the accumulation of silver sludge, dirt, and gelatin in the working bath. Working developers should be discarded at the first sign of stain, fog, or instability.

THE USE OF PREPARED DEVELOPERS

Most of the Kodak developers are available in packaged form, as indicated by the symbol ♦ following the Kodak formula number.

The ingredients and proportions of many of these formulas will be found in the following pages. In addition, Kodak supplies a number of developers in packaged form for which formulas are not published. Where possible, data for the use of these developers is given in this section. A large measure of convenience results from the use of packaged developers, as well as assurance of accuracy in mixing.

HIGH-TEMPERATURE DEVELOPMENT

A number of procedures are given for processing at elevated temperatures. While it is recommended that processing be carried out at between 65° and 75°F (18° to 24°C), it is recognized that this cannot always be done, and special precautions make it possible to carry out the processing of films at higher temperatures.

At temperatures up to 90° to 95°F (32° to 35°C) processing can safely be carried out with the addition of sodium sulfate (not sulfite) to the developer and suitable precautions in fixing and washing. Information on this procedure will be found in this section.

(continued on following page)

The Compact Photo-Lab-Index

In emergencies, at temperatures as high as 110°F (43°C) processing may be carried out by prehardening the film in the special prehardener bath Kodak SH-5. Full instructions for the use of this prehardener, and necessary adjustment in development time, are given under this heading.

RAPID FILM PROCESSING

In military and newspaper work, it is sometimes essential to complete a negative as quickly as possible. This is usually accomplished by the use of a highly concentrated developer such as Kodak D-19 or Kodak D-72 and by taking advantage of certain means of shortening fixing and washing times.

For rapid processing in fresh hypo, fixing may be considered complete when the film has cleared. Constant agitation and a rapid fixing bath, such as Kodak F-7, decrease the fixing time considerably. Kodak F-7 contains approximately 3 pounds of sodium thiosulfate per gallon, with the addition of ammonium chloride and the standard hardener as used in Kodak F-5. It has a shorter fixing time and a considerably greater life than the conventional fixing bath.

Processing is completed by washing the film a few minutes in a rapid stream of water, and drying with a blast of warm air, directed against both sides of the film.

To hasten drying and prevent water marks on the negative, both sides should be wiped with a chamois or a viscose sponge. Rapid drying can also be obtained by one of the following methods:

1. Treat the film in a saturated solution of potassium carbonate, which will remove the water and leave the film dry enough for printing. The film must later be rewashed to remove the potassium carbonate, after which it is again fixed, washed, and dried.
2. Soaking the film for a minute or so in a 90% alcohol bath before drying. Methyl alchol must not be used, because it attacks the film base. Ethyl alcohol may be used successfully provided that the film is not immersed too long, the alcohol is diluted with a least 10% of water, and the drying is carried out at a temperature not over 80°F (27°C). The use of undiluted alcohol or too much heat in drying will cause the film to become opalescent; this, however, may be removed in most cases by rewashing the film and drying slowly.

After the rush prints have been made, the negatives should be returned to the fixing bath for 5 or 10 minutes, and then washed thoroughly and dried in the usual manner, to prevent fading or stain if the negatives are to be stored for any length of time.

For more image stability, films can be treated after fixing with Kodak Hypo Clearing Agent. After fixing, remove excess hypo by rinsing the films in Kodak Hypo Clearing Agent Solution for 1 to 2 minutes with moderate agitation, and wash them for 5 minutes using a water flow sufficient to give a complete change of water in 5 minutes.

For papers (Black-and-White Prints) after normal fixing, transfer prints to the clearing agent solution with or without rinsing. Treat single-weight or thinner papers at least 2 minutes and double weight papers at least 3 minutes, with agitation, at 65° to 70°F (18° to 21°C).

Then wash single-weight or thinner papers at least 10 minutes and double weight papers at least 20 minutes with agitation and normal water flow. The water temperature may be as low as 35°F (2°C). However, if the water temperature can be maintained at 65° to 70°F (18° to 21° to 21°C), a higher degree of stability will result than can be obtained with normal one-hour washing without Kodak Hypo Clearing Agent treatment.

WASHING PROCEDURES

In normal processing, where extreme speed is unnecessary, washing should be as thorough as possible in order to secure the maximum possible permanence of negatives and prints.

Complete washing is obtained in the minimum time when the emulsion is exposed to a rapid flow of fresh water, as when the stream from a hose or a faucet is allowed to flow over the emulsion surface. Under the best conditions of water change, the following times of washing will result in substantially complete removal of hypo from films, plates, and papers:

Films and plates	30 minutes
Single Weight papers	60 minutes
Double Weight papers	1 to 2 hours

295

KODAK DEKTOL DEVELOPER

A prepared, single-powder developer for producing neutral and cold-tone images on cold-tone papers. It remains unusually free from muddiness, sludge, precipitation, and discoloration throughout the normal solution life. It has high capacity and uniform development rate. Although best known as a paper developer, it is also recommended for rapid development of some high-speed negative materials.

Development Recommendations: Papers – Dilute 1 part of stock solution to 2 parts of water. Develop KODABROMIDE, POLYCONTRAST RAPID, and PANALURE Papers about 1½ minutes; all other recommended papers, about 1 minute at 68 F (20 C).

Package Sizes: Carton of 6 packets each to make 8 ounces of working solution; also packages to make 1 quart and ½, 1, 5, 25, and 50 gallons of stock solution.

KODAK EKTAFLO DEVELOPER, TYPE 1

A concentrated liquid prepared developer for print processing. It has similar characteristics to those of DEKTOL Developer, in that it yields neutral or cold tones on cold-tone papers. The concentrate is diluted 1:9 for use.

Development Recommendations: Develop KODABROMIDE, POLYCONTRAST, POLYCONTRAST RAPID, and PANALURE Papers for 1½ minutes at 68 F (20 C). Develop all other recommended papers for 1 minute.

Package Size: 1 gallon of the concentrate in a plastic container.

KODAK SELECTOL DEVELOPER

A long-life prepared developer specially designed for the development of warm-tone papers. It produces the same image tone and contrast as KODAK Developer D-52, remains clear during use, and has high development capacity and good keeping properties. Since the development activity decreases only very slowly with use, constant image tone is easy to maintain.

Development Recommendations: Dilute 1 part of stock solution with 1 part of water. For average results, develop 2 minutes at 69 F (20 C). For slightly warmer image tone, develop 90 seconds. Contrast can be increased slightly with some papers by developing up to 4 minutes. Increased development times will produce colder image tones.

Package Sizes: To make ½, 1, 5, and 50 gallons of stock solution.

KODAK SELECTOL-SOFT DEVELOPER

Except for what the name implies, is similar in all respects to KODAK SELECTOL DEVELOPER. It is recommended whenever results with SELECTOL DEVELOPER tend to be too contrasty for adequate shadow detail. Much softer results can be obtained than with regular SELECTOL DEVELOPER, and there is no sacrifice in tonal scale.

Package Size: To make 1 gallon of stock solution. The stock solution is diluted 1 to 1 for use.

KODAK EKTAFLO DEVELOPER, TYPE 2

A concentrated, prepared, liquid developer for warm-tone papers. It has similar characteristics to those of EKTONOL Developer, and yields rich warm tones on KODAK EKTALURE, POLYLURE, and OPAL Papers. The concentrate is diluted 1:9 for use.

Development Recommendations: Develop warm-tone papers for 2 minutes at 68 F (20 C). Increased developing time results in colder tones.

Package Sizes: 1 gallon of the concentrate in a plastic container.

296

KODAK EKTONOL DEVELOPER

A non-carbonate prepared developer designed for use with warm-tone papers. It minimizes stain on prints which are to be toned. The development rate remains practically uniform throughout the useful life and thus holds the image tone constant from print to print.

Development Recommendations: Dilute 1 part of stock solution with 1 part of water. For average results, develop prints 2 minutes at 68 F (20 C).

Package Sizes: To make 1 and 5 gallons of stock solution.

KODAK VERSATOL DEVELOPER

An ideal all-purpose, prepared developer for use with films, plates, and papers. Remains unusually clear during use.

Development Recommendations: Papers – dilute 1 to 3; develop KODABROMIDE, POLYCONTRAST, POLYCONTRAST RAPID, and PANALURE Papers about 1½ minutes; other papers, about 1 minute at 68 F (20 C). Films and Plates – dilute 1 to 15 and develop VERICHROME PAN FILM about 4½ minutes at 68 F (20 C) in a tray or about 5 minutes at 68 F (20 C) in a tank. Dilute 1 to 3 and develop KODAK PROJECTOR SLIDE PLATES, Contrast, 2 to 6 minutes at 68 F (20 C) in a tray.

Package Sizes: Available in 8-ounce, 32-ounce, and 1-gallon bottles.

EASTMAN KODAK

The Compact Photo-Lab-Index

KODAK HC-110 DEVELOPER
(Liquid volumes are given in the U.S. system)

Kodak HC-110 Developer is a highly active solution designed for rapid development of most black-and-white films. It produces sharp images with moderately fine grain, maximum shadow detail, and long density scale, but causes no loss in film speed. Kodak HC-110 Developer has excellent development latitude and produces relatively low fog with forced development. In most of these characteristics it exceeds Kodak Developers DK-50 and DK-60a, and similar developers. It is particularly suitable for commercial, industrial, graphic arts, and press photography.

HOW TO MIX KODAK HC-110 DEVELOPER

This developer and its replenisher are viscous concentrates that require a relatively large amount of dilution to make a working solution. The simplest and most accurate procedure is to make a stock solution by mixing the entire contents of the bottle of concentrate with the required quantity of water. Then you can dilute the stock solution to make any of six working dilutions, which are designated with the letters A, B, C, D, E, and F. Alternatively, you can mix these working dilutions directly from the concentrate. However, small amounts of viscous liquid are difficult to measure accurately. Therefore, this mixing procedure is recommended only for relatively large quantities of a working dilution. The concentrate should not be regarded as a stock solution for mixing small amounts of working dilutions.

HOW TO MAKE THE STOCK SOLUTION

To make a stock solution from the 2-gallon size:
1. Pour the whole contents of the original plastic bottle into a reclosable container that holds at least 2 quarts.
2. Rinse the plastic bottle thoroughly with water and pour the rinse water into the reclosable container.
3. Add enough water to bring the total volume to 2 quarts.
4. Close the container and shake it until the solution is uniform.
To make a stock solution from the 3½-gallon size: Follow the same procedure as given for the 2-gallon size, but use a reclosable container that holds at least 3½ quarts, and bring the total volume of solution to 3½ quarts.
Table 1 shows how to mix the working dilutions from the stock solution.
Table 2 shows how to make the working dilutions directly from whole bottles of the concentrate.

USES OF WORKING DILUTIONS

DILUTION A

This is the most active of the dilutions. It is used when short developing times are needed for sheet and roll films.

DILUTION B

This dilution permits longer development times, it is recommended for most Kodak sheet and roll films. Developing times for these materials are given in table 3 and 4.

DILUTIONS C, D, and E

These dilutions are generally used for a group of Kodak continuous-tone sheet films employed in graphic arts reproduction. Recommended developing times are given in table 6.

(continued on following page)

The Compact Photo-Lab-Index

DILUTION F

This dilution is for use with Kodak Pan Masking Film (Estar Thick Base) in certain masking procedures used in color printing and some allied processes. Developing times are given in the instruction sheet that accompanies the film.

DEVELOPING TIMES FOR KODAK SHEET AND ROLL FILMS

The recommended developing times for Kodak sheet and roll films are aimed to yield negatives that print well on a normal grade of paper. However, if your negatives are consistently too low in contrast, increase the developing time. If they are consistently too high in contrast, decrease the developing time.

(Table 1 will be found on following page)

TABLE 2

MIXING WORKING DILUTIONS FROM CONCENTRATE

To make this working dilution	Use this amount of concentrate	With this amount of water
	(2-gallon size)	
A	16 fl oz	7½ quarts
B	16 fl oz	15½ quarts
C	16 fl oz	9½ quarts
D	16 fl oz	19½ quarts
E	16 fl oz	23½ quarts
F	16 fl oz	39½ quarts
	(3½-gallon size)	
A	28 fl oz	13 quarts 4 fl oz
B	28 fl oz	27 quarts 4 fl oz
C	28 fl oz	16 quarts 20 fl oz
D	28 fl oz	34 quarts 4 fl oz
E	28 fl oz	41 quarts 4 fl oz
F	28 fl oz	69 quarts 4 fl oz

(Continued on following page)

EASTMAN KODAK

TABLE 1 MIXING WORKING DILUTIONS FROM STOCK SOLUTION

Working Dilution*	To Mix All Quantities	To Mix 1 Pint	To Mix 1 Quart	To Mix 1 Gallon	To Mix 2 Gallons	To Mix 3½ Gallons
A (1:15)	Stock–1 Part Water–3 Parts	Stock 4 oz Water 12 oz	Stock 8 oz Water 24 oz	Stock 1 qt Water 3 qt	Stock 2 qt Water 6 qt	Stock 3 qt 16 oz Water 10 qt 16 oz
B (1:31)	Stock–1 Part Water–7 Parts	Stock 2 oz Water 14 oz	Stock 4 oz Water 28 oz	Stock 16 oz Water 3 qt 6 oz	Stock 1 qt Water 7 qt	Stock 1 qt 24 oz Water 12 qt 8 oz
C (1:19)	Stock–1 Part Water–4 Parts	Stock 3¼ oz Water 12¾ oz	Stock 6½ oz Water 25½ oz	Stock 26 oz Water 3 qt 6 oz	Stock 1 qt 19 oz Water 6 qt 13 oz	Stock 2 qt 26 oz Water 11 qt 6 oz
D (1:39)	Stock–1 Part Water–9 Parts	See Note	Stock 3¼ oz Water 28¾ oz	Stock 13 oz Water 3 qt 19 oz	Stock 26 oz Water 7 qt 6 oz	Stock 1 qt 13 oz Water 12 qt 19 oz
E (1:47)	Stock–1 Part Water–11 Parts	See Note	See Note	Stock 11 oz Water 3 qt 21 oz	Stock 22 oz Water 7 qt 10 oz	Stock 1 qt 6 oz Water 12 qt 26 oz
F(1:79)	Stock–1 Part Water–19 Parts	See Note	See Note	Stock 7 oz Water 3 qt 25 oz	Stock 13 oz Water 7 qt 19 oz	Stock 23 oz Water 13 qt 9 oz

*Figures in parentheses indicate the proportion of concentrate to water.

NOTE: Some quantities of stock solution are too small for convenient measurement. Where quantities are specified for mixing 1 pint or 1 quart, they are rounded to the nearest ¼ fluidounce. Quantities for mixing larger volumes are rounded to the nearest fluidounce.

The Compact Photo-Lab-Index

DEVELOPING TIMES FOR KODAK SHEET FILMS

WORKING DILUTION A Kodak Sheet Films and Film Packs	Developing Times (in Minutes)									
	Tray*					Large Tank†				
	65F	68F	70F	72F	75F	65F	68F	70F	72F	75F
Portrait Panchromatic	3¾	3½	3¼	3	2¾	5	4¼	4	3¾	3¼
ROYAL-X Pan (ESTAR Thick Base)	4½	4	3¾	3½	3	6	5	4½	4	3½
RS Pan (ESTAR Thick Base)	6	5	4½	4¼	3½	8	7	6	5½	4¼
TRI-X Pan Professional (ESTAR Thick Base)	3¼	2¾	2½	2¼	2	3¾	3¼	3	2¾	2½
PANATOMIC-X	3¾	3½	3¼	3	2¾	5	4¼	4	3¾	3¼
ROYAL Pan (ESTAR Thick Base)	3½	3	2¾	2½	2¼	4	3¾	3¼	3	2¾
SUPER-XX Pan (ESTAR Thick Base)	4½	4	3¾	3½	3	6	5	4½	4¼	3½
Super Panchro-Press, Type B	4½	4	3¾	3½	3	6	5	4½	4¼	3½
PLUS-X Pan Professional (ESTAR Thick Base)	3¼	2¾	2½	2¼	2	3¾	3¼	3	2¾	2½
FILM PACKS:										
TRI-X Pan Professional	3¼	2¾	2½	2¼	2	3¾	3¼	3	2¾	2½
PLUS-X Pan Professional	2¾	2½	2¼	2	1¾	3	2¾	2½	2¼	2
WORKING DILUTION B	**65F**	**68F**	**70F**	**72F**	**75F**	**65F**	**68F**	**70F**	**72F**	**75F**
TRI-X Ortho (ESTAR Thick Base)	5	4½	4¼	4	3¾	7	6	5½	5	4½
Portrait Panchromatic	7	6	5½	5	4½	9	8	7½	7	6
ROYAL-X Pan (ESTAR Thick Base)	10	8	7	6	5	13	10	9	8	7
RS Pan (ESTAR Thick Base)	13	10	9	8	7	17	13	11	10	9
TRI-X Pan Professional (ESTAR Thick Base)	5	4½	4¼	4	3¾	7	6	5½	5	4½
PANATOMIC-X	7	6	5½	5	4½	9	8	7½	7	6
ROYAL Pan (ESTAR Thick Base)	7	6	5½	5	4½	9	8	7½	7	6
SUPER-XX Pan (ESTAR Thick Base)	8	7	6½	6	5	11	9	8	7	6
Super Panchro-Press, Type B	7	6	5½	5	4½	9	8	7½	7	6
PLUS-X Pan Professional (ESTAR Thick Base)	6	5	4¾	4½	3½	8	7	6½	6	5
LS Pan (ESTAR Thick Base)	6	5	4¾	4½	3½	8	7	6½	6	5
Commercial	2¾	2¼	2	2	1¾	–	–	–	–	–
FILM PACKS:										
TRI-X Pan Professional	5	4½	4½	4	3¾	7	6	5½	5	4½
PLUS-X Pan Professional	4½	4	3¾	3½	3	6	5	4½	4¼	3½

*Development in a tray, with continuous agitation.

†Development on a hanger in a large tank, with agitation at 1-minute intervals. If possible, development times of less than 5 minutes in a tank should be avoided, since poor uniformity may result.

The Compact Photo-Lab-Index

EASTMAN KODAK

KODAK POLYDOL Developer

KODAK POLYDOL Developer has been formulated to meet the needs of portrait, commercial, industrial, and school photographers for a developer which yields high negative quality as well as long life and high capacity. Although KODAK POLYDOL is primarily a tank developer for sheet and roll films, it performs equally well as a tray developer for sheet films or as a developer for spiral-reel and machine processing of films in long rolls.

With the recommended replenishment procedure, this developer maintains uniform activity throughout a long period of use. Furthermore, KODAK POLYDOL Developer is free from the high peak of activity characteristic of most developers when they are freshly mixed.

KODAK POLYDOL Developer is available in packages to make 1, 3 1/2, and 10 U.S. gallons of working solution. KODAK POLYDOL Replenisher is supplied in packages to make 1 and 5 U.S. gallons of replenisher.

DEVELOPMENT OF SHEET FILMS

	Recommended Developing Time in Minutes			
	Tray		Tank	
KODAK Sheet Film	68F (20C)	75F (24C)	68F (20C)	75F (24C)
RS Pan (ESTAR Thick Base)	9	6	11	8
ROYAL Pan (ESTAR Thick Base)	6	4½	8	6
Super Panchro-Press, Type B	9	6	11	8
SUPER-XX Pan (ESTAR Thick Base)	9	6	11	8
PLUS-X Pan Professional (ESTAR Thick Base)	6	4½	8	6
Portrait Panchromatic	8	5	10	7
PANATOMIC-X	9	6	11	8
TIR-X Pan Professional (ESTAR Thick Base)	6	4½	8	6
TRI-X Ortho (ESTAR Thick Base)	6	4½	8	6

Agitation: The times recommended for tray development are for continous agitation, either by tilting the tray for single films or by leafing through the stack when several films are developed together. The times recommended for tank development are for the development of films in hangers, with agitation by lifting and tilting hangers at 1-minute intervals. Details of these recommended agitation procedures are given in the KODAK Data Books **Negative Making with KODAK Black-and-White Sheet Films,** No. F-5, and **Processing Chemicals and Formulas,** No. J-1.

Agitation: The times recommended for a small tank apply when the film is developed on a spiral reel with agitation at 30-second intervals. The times given for a large tank are for development of several reels in a basket with agitation at 1-minute intervals.

Developing times given for KODAK films are aimed to yield negatives that print well on normal-contrast paper. However, if your negatives are consistently too low in contrast, increase development time, if they are consistently too high in contrast, decrease the developing time. The developing computer in the *KODAK Master Darkroom DATAGUIDE* is a useful aid in making such adjustments.

(Continued on following page)

The Compact Photo-Lab-Index

DEVELOPMENT OF ROLL AND 135 FILMS

KODAK Film	Recommended Developing Time in Minutes			
	Small Tank		Large Tank	
	68F (20C)	75F (24C)	68F (20C)	75F (24C)
VERICHROME Pan, Rolls	10	7	11	8
PLUS-X Pan, Rolls and 135	7	5	8	6
PLUS-X Pan Professional, Rolls	7	5	8	6
PANATOMIC-X, Rolls and 135	7	4½	8	5
TRI-X Pan, Rolls and 135	8	6	9	7
TRI-X Pan Professional, Rolls	7	5	8	6

DEVELOPMENT OF FILMS IN LONG ROLLS

Films in long rolls, such as 35mm or 70mm by 100 feet or 3 1/2 inches by 75 feet, can be developed in spiral reels or in continous processing machines.

DEVELOPMENT IN SPIRAL REELS

KODAK Film	Recommended Developing Time in Minutes*	
	68F (20C)	75F (24C)
PLUS-X Pan — 35mm and 7mm rolls	8	6
PLUS-X Pan Professional (ESTAR Thick Base)— 3½-inch rolls	9	6½
PLUS-X Pan Professional (ESTAR Base) — 35mm, 46mm, and 70mm rolls	9	6½
TRI-X Pan — 35mm rolls	9	6
TRI-X Pan Professional (ESTAR Base) — 70mm	10	7
TRI-X Pan Professional (ESTAR Thick Base) — 3½-inch rolls	10	7
ROYAL Pan (ESTAR Thick Base) — 70mm and 3½-inch rolls	9	6
RS Pan (ESTAR Thick Base) — 3½-inch rolls	14	9
PANATOMIC-X — 35mm and 70mm rolls	8	5
LS Pan (ESTAR Base) — 70mm rolls	10	7
LS Pan (ESTAR Thick Base) — 3½-inch rolls	10	7

*These times apply when the reel is agitated as described in the instruction sheet that accompanies the film.

NOTE: In certain situations, about 4 gallons of solution is required to cover the films adequately. To obtain the required 4 gallons of developer, the 3 1/2-gallon size of KODAK POLYDOL Developer can be used, with the addition of 1 quart of KODAK POLYDOL Replenisher and 1 quart of water. The above time of development will still apply.

Agitation: Films on spiral reels should be agitated once each minute by the lifting-and-turning technique described in detail in the film instruction sheets.

DEVELOPMENT IN CONTINUOUS-PROCESSING MACHINES

KODAK Control Strips, 10-step (for professional B/W film), can be used as a guide in establishing the proper development level for film in a continuous processor. Adjust the development time and temperature to produce the diffuse-density difference recommended in the individual film instruction sheets. Adjustments can be made from these values to suit your particular system or individual preference.

The Compact Photo-Lab-Index

REPLENISHMENT

After developing sheet films or films in rolls, add KODAK POLYDOL Replenisher as required to maintain a constant level of developer in the tank, or at a rate of approximately 5/8 to 3/4 fluidounce per 80 square inches of film. If the carry-out rate should vary, or if the average negatives are unusually dense or thin, it may be necessary to adjust the replenishment rate to keep the activity constant.

For films in long rolls, after each roll developed, KODAK POLYDOL Replenisher should be added to the developer tank as follows:

Size of film	Replenisher
35 mm by 100 feet	15 fluidounces
46 mm by 100 feet	20 fluidounces
70 mm by 100 feet	30 fluidounces
3 1/2 in. by 75 feet	30 fluidounces

USEFUL CAPACITY

Without replenishment – About 40 sheets of 8 by 10-inch film can be developed per gallon of KODAK POLYDOL Developer.

With replenishment – The KODAK POLYDOL Developer and KODAK POLYDOL Replenisher system has been designed to maintain constant developing characteristics for an indefinite period when the replenishment rate is properly adjusted. The replenishment rate should be checked by periodic monitoring of the developer activity. For this purpose, we suggest the use of KODAK Control Strips, 10-step (for professional B/W film), and the procedure described in the KODAK Quality Control System for KODAK Black-and-White Film and Roll Papers.

The sesitometric control strips are available from the Eastman Kodak Regional Marketing and Distribution Centers, and are packaged in 30-strip boxes. The KODAK Quality Control System for KODAK Black-and-White Film and Roll Papers is supplied from Rochester only.

Although some sludge may appear, the system is free from massive sludge formation as well as from staining tendency. Therefore, the working solution should not need replacement for several months. However, it should be replaced if the activity increases or decreases markedly (which indicates that the replenishment rate needs revision); if the bath shows excessive sludging or develops staining or scumming tendency (usually the result of contamination, as with hypo); or if the bath has been exposed excessively to the air (which can be minimized by the use of a floating cover).

STORAGE LIFE

Unused KODAK POLYDOL Developer and POLYDOL Replenisher can be stored in a full, tightly stoppered bottle for 6 months; in a partially full, tightly stoppered bottle for 2 months; in a tank with a floating cover for 1 month; or in an open tray for 24 hours.

TIME-TEMPERATURE CHART

Showing the development time at various temperatures corresponding to certain of the recommended times at 68 F. For other times at 68 F, additional lines can be drawn parallel to those now shown.

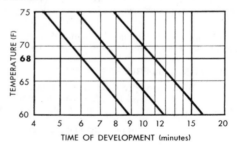

TIME OF DEVELOPMENT (minutes)

EASTMAN KODAK

304

The Compact Photo-Lab-Index

KODAK MICRODOL-X DEVELOPER

(Liquid volumes are given in the U.S. system)

KODAK MICRODOL-X Developer is balanced to produce lower graininess and higher acutance (sharpness) than normal developers, with very little loss in effective film speed. In common with some other fine-grain developers, it tends to produce an image of slightly brownish tone, which gives more printing contrast than is apparent to the eye. Tank development is recommended. For negatives of best quality and minimum graininess, adhere strictly to the recommended times of development. Forced development increases graininess with any developer.

	Recommended Developing Time (in minutes)* in Small Tanks							
	Microdol-X (stock solution)					Microdol-X (1:3)†		
KODAK Films	65 F (18 C)	68 F (20 C)	70 F (21 C)	72 F (22 C)	75 F (24 C)	70 F (21 C)	72 F (22 C)	75 F (24 C)
Verichrome Pan, roll	11	9	8	7	6	12	11	10
Plus-X Pan, 135	11	9	8	7	6	13	12	11
Plus-X Pan Professional 4147 (Estar Thick Base), sheet‡	11	10	9½	9	8	NR	NR	NR
Plus-X Pan Professional, roll and pack	11	9	8	7	6	13	12	11
Royal Pan 4141 (Estar Thick Base), sheet‡	12	11	10½	10	9	NR	NR	NR
Panatomic-X, 135 and roll	11	9	8	7	6	13	12	11
Panatomic-X 6140, sheet‡	17	16	15	14	13	NR	NR	23
Tri-X Pan, 135 and roll	13	11	10	9	8	17	16	15
Tri-X Pan Professional, roll and pack	10	9	8½	8	7	NR	NR	NR
Tri-X Pan Professional 4164 (Estar Thick Base), sheet‡	11	10	9½	9	8	NR	NR	NR
Tri-X Ortho 4163 (Estar Thick Base), sheet‡	11	10	9½	9	8	NR	NR	NR
Infared, 135	17	14	12	11	9	NR	NR	22
Infrared 6130, sheet‡	12	10	9	8	7½	NR	NR	NR
Ektapan 4162 (Estar Thick Base), sheet‡	16	13	12	10	9	NR	NR	NR

*Agitation at 30-second intervals.
†When developing 135-size 36-exposure roll in 8-ounce tank, increase recommended time about 10 percent.
‡ Large Tank, agitation at 1-minute intervals
NR – Not Recommended

LIFE AND CAPACITY

In a completely full and tightly stoppered bottle, an unused KODAK MICRODOL-X stock solution should remain in good condition for about 6 months, and in a partly full, tightly stoppered bottle, about 2 months. In a large tank with floating cover, the safe storage life is about one month.

Without replenishment, the useful capacity is about 320 square inches of film per quart; 160 square inches per pint; 80 square inches per 8 ounces. To maintain uniformity of contrast, a progressive increase in development time is necessary—about 15 percent after each 80 square inches in a quart or after each 320 square inches developed in a gallon of developer.

(Continued on following page)

EASTMAN KODAK

The roll films and corresponding areas are as follows:

828, 126 (12-exp)	=25 sq. in.	120, 620, 135 (36-exp)	= 80 sq. in.
127	=45 sq. in.	116, 616	=100 sq. in.
135 (20-exp)	=50 sq. in.	220	=160 sq. in.

REPLENISHMENT

KODAK MICRODOL-X Replenisher will maintain a remarkably constant rate of development, film speed, and fine-grain characteristics.

In large tanks, add replenisher as needed to replace the developer carried out by the films and to keep the liquid level constant in the tank. On the average, this will take about ¾ ounce per roll or 6 gallons per thousand rolls of film developed.

For best results, the replenishment rate should be checked by periodic monitoring of the developer activity. For this purpose, we suggest the use of KODAK Control Strips, 10-step (for professional B/W film) and the procedure described in the Kodak Quality Control System for Kodak Black-and-White Films and Roll Papers. Information on the use of the control strips can be obtained from Professional, Commercial, and Industrial Markets Division.

With small tanks, add the replenisher at the rate of 1 ounce for each 80 square inches of film developed. This is equivalent to one 36-exposure roll of 35mm film, one No. 120 roll, or two No. 127 rolls.

When KODAK MICRODOL-X Developer is replenished as recommended, about 15 rolls or the equivalent (1200 square inches) can be developed per quart of original developer. The solution should be discarded after 4 months' use, regardless of the number of rolls developed.

DILUTION FOR MAXIMUM SHARPNESS

KODAK MICRODOL-X Developer produces images with excellent definition by combining extremely fine grain and very high acutance (sharpness). Still greater image sharpness can be achieved by diluting one part of MICRODOL-X solution with three parts of water, and increasing the development as shown in the table. To avoid unduly long developing times, the temperature of the solution can be increased to 75 F (24 C).

The diluted developer should not be stored or replenished after use. One roll of film (80 square inches) can be developed in a pint of the diluted developer; or two rolls can be developed simultaneously in a quart. When a 36-exposure roll of 35mm film is developed in an 8-ounce tank, the recommended time should be increased about 10 percent.

KODAK MICRODOL-X Developer contains p-methylaminophenol sulfate. **KEEP OUT OF THE REACH OF CHILDREN.**

CAUTION! Repeated contact may cause skin irration. May be harmful if swallowed. If swallowed, induce vomiting. **CALL A PHYSICIAN AT ONCE.**

Eastman Kodak Company will not be responsible for any skin ailment caused by this product.

EASTMAN KODAK

KODAK DEVELOPER D-7

An Elon-Pyro Developer for Professional Films and Plates

STOCK SOLUTION A

Water (125°F or 52°C) 16	ounces	500.0 ml
Kodak Elon Developing Agent ¼	ounce	7.5 grams
Kodak Sodium Bisulfite ¼	ounce	7.5 grams
Pyro.............................. 1	ounce	30.0 grams
Kodak Potassium Bromide 60	grains	4.0 grams
Add cold water to make 32	ounces	1.0 liter

STOCK SOLUTION B

Water 32	ounces	1.0 liter
Kodak Sodium Sulfite, desiccated 5	ounces	150.0 grams

STOCK SOLUTION C

Water 32	ounces	1.0 liter
Kodak Sodium Carbonate, monohydrated ... 3	ounces	90.00 grams

Dissolve chemicals in the order given.

FOR TRAY DEVELOPMENT

Take 2 ounces (64 ml) each of the A, B, and C solutions for 16 ounces (500 ml) of water. Develop about 7 minutes at 68°F (20°C) (1:1:1:8).

FOR TANK DEVELOPMENT

Take 8 ounces (250 ml) each of A, B, and C and add water to make 1 gallon (4 liters). At a temperature of 68°F (20°C) development time is about 10 minutes. This developer can be used repeatedly for two or three weeks if kept in its normal volume by adding fresh developer in the proportion of 2 ounces (64 ml) each of A, B, and C to 8 ounces (250 ml) of water, although it is usually necessary to increase the development time as the developer ages. (1:1:1:13).

KODAK DEVELOPER D-8 ♦

For Maximum Contrast on Process and Panchromatic Process
Films and Plates, and Kodalith Stripping Film (Superspeed)

STOCK SOLUTION

Water	24	ounces	750.0 ml
Kodak Sodium Sulfite, desicated	3	ounces	90.0 grams
Kodak Hydroquinone	1½	ounces	45.0 grams
Kodak Sodium Hydroxide (Caustic Soda)*	1¼	ounces	37.5 grams
Kodak Potassium Bromide	1	ounce	30.0 grams
Water to make	32	ounces	1.0 liter

*Cold water should always be used when dissolving sodium hydroxide (caustic soda), because considerable heat is evolved. If hot water is used, the solution will boil with explosive violence and may cause serious burns if the hot alkali splatters on the hands or the face.

Dissolve chemicals in the order given. Stir the solution thoroughly before use.

For use, take 2 parts of stock solution and 1 part of water. Develop about 2 minutes in a tray at 68°F (20°C). This formula is especially recommended for making line and halftone screen negatives for printing directly on metal. Wash thoroughly after developing and before fixing, or stains and dichroic fog will result.

Develop Kodalith Transparent Stripping Film 6554, Type 3 about 2 minutes at 68°F (20°C) in diluted developer (2 parts stock solution to 1 part water). After development, rinse in the Kodak Stop Bath SB-1a, for 5 seconds, fix for 1½ minutes in the F-5 fixing bath, and wash for 2 or 3 minutes at 80°F (26°C) when the skin will have loosened sufficiently to permit its being stripped from the support.

For general use, a formula which is slightly less alkaline and gives almost as much density can be obtained by using 410 grains of sodium hydroxide per 32 ounces of stock solution (28 grams per liter) instead of the quantity given in this formula.

♦ Available in packages to make 1 gallon.

KODAK DEVELOPER D-11♦

An Elon-Hydroquinone Process Developer for Process &
Panchromatic Process Films & Plates.

Water (125°F or 52°C)	16	ounces	500.0 ml
Kodak Elon Developing Agent	15	grains	1.0 gram
Kodak Sodium Sulfite, desiccated	2½	ounces	75.0 grams
Kodak Hydroquinone	130	grains	9.0 grams
Kodak Sodium Carbonate, monohydrated	1	ounce	30.0 grams
Kodak Potassium Bromide	73	grains	5.0 grams
Add cold water to make	32	ounces	1.0 liter

Dissolve chemicals in the order given. Develop about 5 minutes in a tank or 4 minutes in a tray at 68°F (20°C). When less contrast is desired, the developer should be diluted with an equal volume of water.

♦ Available in packages to make 1, and 5 gallons.

The Compact Photo-Lab-Index

KODAK DEVELOPER D-13

A Tropical Process Developer for Films

Water (125°F or 52°C)	24	ounces	750.0 ml
Kodak Balancing Developing Agent BD-86	75	grains	5.0 grams
Kodak Sodium Sulfite, desiccated	1¾	ounces	52.5 grams
Kodak Hydroquinone	145	grains	10.0 grams
Kodak Sodium Carbonate (monohydrated)	2	ounces	60.0 grams
Potassium Iodide	30	grains	2.0 grams
*Kodak Sodium Sulfate, desiccated	1½	ounces	45.0 grams
Add cold water to make	32	ounces	1.0 liter

*If it is preferred to use sodium sulfate crystals, instead of the desiccated sulfate, then use 3½ ounces per 32 ounces (105 grams per liter).

Dissolve chemicals in the order given.
Use without dilution. Develop 6 to 7 minutes at 85°F (29°C) or for proportionately longer times at lower temperatures. Rinse thoroughly for 30 seconds and immerse for 3 minutes in 5% formalin solution (37% formaldehyde, diluted: 1 part formaldehyde to 19 parts water). Then wash for 1 minute, fix 5 to 10 minutes in an acid hardening fixing bath (Kodak Fixing Bath F-5) and wash for 15 to 20 minutes.

KODAK DEVELOPER DK-15

A Balanced Alkali Non-Blistering Tropical Developer for Films & Plates.

Water (125°F or 52°C)	24	ounces	750.0 ml
Kodak Elon	80	grains	5.5 grams
Kodak Sodium Sulfite, desiccated	3	ounces	90.0 grams
Kodak Kodalk	¾	ounce	22.5 grams
Kodak Potassium Bromide	30	grains	2.0 grams
*Kodak Sodium Sulfate, desiccated	1½	ounces	45.0 grams
Add cold water to make	32	ounces	1.0 liter

*If it is desired to use crystalline sodium sulfate instead of the desiccated sulfate, then 3½ ounces per 32 ounces (105 grams per liter) should be used.

Dissolve chemicals in the order given.
Average time for tank development is 9 to 12 minutes at 68°F (20°C) and 2 to 3 minutes at 90°F (32°C) in the fresh developer according to the contrast desired. When working *below* 75°F (24°C) the sulfate may be omitted if a more rapid formula is required. Development time *without* the sulfate is 5 to 7 minutes at 65°F (18°C). Develop about 20% less for tray use.
When development is completed rinse the film or plate in water for 1 or 2 seconds only and immerse in the Tropical Hardener (Kodak SB-4) for 3 minutes (omit water rinse if film tends to soften); then fix for at least 10 minutes, and wash for 10 to 15 minutes in water (not over 95°F) (35°C).

KODAK DEVELOPER DK-15a

A low Contrast Tropical Developer for Films & Plates

Water (125°F or 52°C)	24	ounces	750.0 ml
Kodak Elon	80	grains	5.5 grams
Kodak Sodium Sulfite, desiccated	3	ounces	90.0 grams
Kodak Kodalk	73	grains	5.0 grams
Kodak Potassium Bromide	30	grains	2.0 grams
*Kodak Sodium Sulfate, desiccated	1½	ounces	45.0 grams
Add cold water to make	32	ounces	1.0 liter

*If it is desired to use crystalline Sodium Sulfate instead of the desiccated sulfate, then 3½ ounces per quart (105 grams per liter) should be used.

Dissolve chemicals in the order given.

The Compact Photo-Lab-Index

SODIUM SULFATE
In Tropical Developers

Sodium sulfate (desiccated) can be added to certain standard developers (Kodak Developers, D-11, D-19, D-61a, D-76, DK-50, DK-60a, and D-72), to convert them for use at higher temperatures—up to 95°F (35°C). This prevents the gelatin in the emulsion from swelling unduly.

Sodium sulfate (desiccated) is an addition agent permitting development at high temperatures.

DIRECTIONS:

Sodium sulfate is recommended as an addendum for photographic solutions when used at high temperatures and as a swell reducing agent for gelatin when conditions do not permit working at the standard temperature of 68°F.

FOR USE WITH DEVELOPERS.

By adding sodium sulfate, desiccated, to the developer (mixed ready for use) as in the following table, the normal development time recommended at 68°F can be maintained through the range of temperature given. After adding the sulfate to the developer solution, stir until dissolved completely.

Kodak Developers	Range of Temperature	Kodak Sodium Sulfate (Desiccated) Per quart (32oz.)	Per Liter
D-11 D-19 D-61a D-76	75° to 80°F 80° to 85°F 85° to 90°F	1 ounce 290 grains 2½ ounces 3 ounces 145 grains	50 grams 75 grams 100 grams
DK-50 DK-60a D-72 (1:1) Dektol (1:1)	75° to 80°F 80° to 85°F 85° to 90°F* 85° to 90°F*	3 ounces 145 grains 4 ounces 75 grains 5 ounces 5 ounces	100 grams 125 grams 150 grams 150 grams

*If necessary to develop at 90° to 95°F (32° to 35°C) decrease the time about one-third

FOR USE IN A STOP BATH:

Films and plates should be immersed about 3 minutes in one of the following stop baths or in a solution made from Kodak Tropical Hardener after development and before fixation. Agitate the negative frequently while in the stop bath.

Between 68° and 80°F — Kodak Stop Bath SB-5

Water	32 ounces	1 liter	
Kodak Acetic Acid (28%)	1 ounce	32 ml	
Kodak Sodium Sulfate (desiccated)	1½ ounces	45 grams	

Between 80° and 95°F.—Kodak Stop Bath SB-4

Water	32 ounces	1 liter	
Kodak Potassium Chrome Alum	1 ounce	30 grams	
Kodak Sodium Sulfate (desiccated)	2 ounces	60 grams	

Capacity of each stop bath: About 20 to 25 rolls (one roll=about 80 sq. in.) per quart (liter).

Always use a fresh acid hardening fixing bath such as Kodak Tropical Fixer or Kodak Fixing Bath F-5.

310

EASTMAN KODAK

The Compact Photo-Lab-Index

KODAK DEVELOPER D-19 ◆

A High Contrast High Energy Developer for Films & Plates

Water (125° or 52°C)	16 ounces	500.0 ml
Kodak Elon	30 grains	2.0 grams
Kodak Sodium Sulfite, desiccated	3 ounces	90.0 grams
Kodak Hydroquinone	115 grains	8.0 grams
*Kodak Sodium Carbonate, monohydrated .	1¾ ounces	52.5 grams
Kodak Potassium Bromide	75 grains	5.0 grams
Add cold water to make	32 ounces	1.0 liter

Dissolve chemicals in the order given.

This is a high-contrast, long-life, nonstaining tank or tray developer. It causes very little chemical fog, and thus produces exceptionally "clear" negatives. Originally developed for use with X-ray materials, D-19 is now recognized as an excellent developer for aerial films and for use with films and plates when high maximum contrast is desired, or when it is desired to obtain high contrast with a short developing time. Its good keeping qualities when used in tanks, and its rapid development rate make it particularly useful for press photography.

This developer is recommended for use at from 65°F (18°C) to 70°F (21°C) and best results will be obtained within this range. However, acceptable results will be obtained at somewhat higher and lower temperatures.

Increase the time about 25% for tank development.

◆ Available to make 1, 3½, and 5 gallons.

REPLENISHER KODAK D-19R

for Kodak Developer D-19

Water (125°F or 52°C)	16 ounces	500.0 ml
Kodak Elon	65 grains	4.5 grams
Kodak Sodium Sulfite, desiccated	3 ounces	90.0 grams
Kodak Hydroquinone	255 grains	17.5 grams
Kodak Sodium Carbonate, monohydrated .	1¾ ounces	52.5 grams
Kodak Sodium Hydroxide	¼ ounce	7.5 grams
Add cold water to make	32 ounces	1.0 liter

Dissolve chemicals in the order given.

Use without dilution and add to the developer tank in the proportion of 1 ounce of Kodak D-19R per 100 square inches of film processed (about 30 ml for each 8x10 film). The maximum volume of replenisher added should not be greater than the volume of the orginal developer.

OBTAINING HIGHEST EMULSION SPEED

With Kodak Films

There are a number of methods which have been proposed for increasing the effective sensitivity of a film beyond its normal rating. These emergency techniques are of particular value to the news photographer who is occasionally confronted with subjects which are inadequately illuminated under conditions which make it impractical to use flashlamps.

The methods of increasing film speed include intensifying the latent image between exposure and development, and the use of high-emullsion-speed-developers. For the latter method, one of the best formulas is Kodak Special Developer SD-19a, which can more than double the effective emulsion speed of high speed negative films. However, it should be noted that this higher speed is sometimes accompanied by increased graininess and higher fog level. This high fog level is, incidentally, unavoidable. If the development time is shortened to secure less fog, there will be no appreciable gain in emulsion speed.

The Compact Photo-Lab-Index

KODAK DEVELOPER SD-19a
A Special Developer for Increasing Emulsion Speed.

SOLUTION A

Kodak Anti-Fog. No. 2* (0.2% Solution) ...	5	fl. drams	20.0 ml
Hydrazine Dihydrochloride**	24	grains	1.6 grams
Cold water to make	1	ounce	30.0 ml

SOLUTION B

Water (about 125°F or 52°C)	16	ounces	500.0 ml
Kodak Elon Developing Agent	29	grains	2.0 grams
Kodak Sodium Sulfite, desiccated	3	ounces	90.0 grams
Kodak Hydroquinone ¼ oz.	8	grains	8.0 grams
Kodak Sodium Carbonate, monohydrated ..	1¾	ounces	52.5 grams
Kodak Potassium Bromide	72	grains	5.0 grams
Add cold water to make	32	ounces	1.0 liter

*To prepare a 0.2% solution of Kodak Anti-Fog No. 2, disolve 2 grams (30 grains) in 1000ml (32 ounces) of hot distilled water.

**CAUTION: Hydrazine Dihydrochloride is a skin irritant. Avoid contact of the powder or solutions with the skin or eyes. If contact does occur, was with plenty of water immediately. It is advisable to wear rubber gloves and an apron while working with this formula.

Hydrazine Dihydrochloride is obtainable as Eastman Organic Chemical No. 1117, from laboratory supply houses, or on order through the Eastman Organic Chemicals Department, Distillation Products Industries, Division of the Eastman Kodak Company, 343, State St., Rochester, N.Y. 14650.

Dissolve chemicals in the order given. To prepare a working solution add 30ml (1 ounce) of Solution A to 1 liter (32 ounces) of Solution B (which is identical to Kodak Developer D-19) and mix thoroughly. The working solution should be prepared just before using.

The best speed increase is obtained by developing for the time required to give a fog value between 0.20 and 0.40. The developing time will depend on the temperature, processing equipment and agitation. In general, with intermittent agitation in a tray or tank, the correct time of development at 68°F (20°C) with conventional high speed emulsions is between 12 and 20 minutes. The optimum time can be determined for a particular emulsion by cutting a trial underexposure into three or more pieces and developing these pieces for a series of times ranging from 10 to 20 minutes. The time of development which produces the lowest fog density at which a satisfactory speed increase is obtained can be selected.

KODAK DEVELOPER DK-20
For Roll Films, Film Packs, Cut Films and Plates

Water (125°F or 52°C)	24	ounces	750.0 ml
Kodak Elon Developing Agent	75	grains	5.0 grams
Kodak Sodium Sulfite, desiccated ... 3 oz.	145	grains	100.0 grams
Kodalk Balanced Alkali	30	grains	2.0 grams
†*Kodak Sodium Thiocyanate	15	grains	1.0 gram
Kodak Potassium Bromide	7	grains	0.5 gram
Add cold water to make	32	ounces	1.0 liter

*An equal weight of Potassium (Thiocyanate) Sulfocyanate may be substituted.

†Or Kodak Liquid, Use 1.5 mls for each gram.

Dissolve chemicals in the order given.

Average time of development for all Kodak Roll Film is about 15 minutes at 68°F (20°C) in a tank of fresh developer.

Quarterly Supplement No. 125 (New Page)

KODAK REPLENISHER DK-20R
For Fine Grain Developer Formula DK-20

Water (125° or 52°C)		24 ounces	750.0 ml
Kodak Elon Developing Agent		¼ ounce	7.5 grams
Kodak Sodium Sulfite, desiccated	3 oz. 145 grains		100.0 grams
Kodalk Balanced Alkali		290 grains	20.0 grams
†*Kodak Sodium (Thiocyanate)		75 grains	5.0 grams
Kodak Potassium Bromide		15 grains	1.0 gram
Add cold water to make		32 ounces	1.0 liter

*An equal weight of Potassium (Thiocyanate) Sulfocyanate may be substituted.
†Or Kodak Liquid, use 1.5 mls for each gram.

Dissolve chemicals in the order given.

Add one ounce (30.0 mls) of replenisher for each 80 square inches of film processed, discarding some developer if necessary. 80 square inches is equal to one sheet of 8 x 10 film, or one 8-exposure roll of 120 film or one 36-exposure role of 35mm film.

IMPORTANT NOTE: Kodak Developer DK-20 and other developers containing silver halide solvents such as thiocyanates or thiosulfates may form a scum on the surface of the film, especially when partially exhausted. They should not be used with any of the new Kodak roll films, miniature films or film packs; neither should they be used with the new Kodak sheet films such as Royal Pan, Royal Ortho, etc.

KODAK DEVELOPER D-23
An Elon-Sulfite Developer for Low & Medium Contrast

Water (125° or 52°C)		24 ounces	750.0 ml
Kodak Elon Developing Agent		¼ ounce	7.5 grams
Kodak Sodium Sulfite (dessicated)	3 oz. 145 grains		100.0 grams
Add cold water to make		32 ounces	1.0 liter

Dissolve chemicals in the order given.

Average developing time about 12 minutes in a tank or 10 minutes in a tray at 68°F (20°C).

This developer produces negatives of speed and graininess comparable to Kodak Developer D-76. Its low alkalinity and high salt content as well as its low fogging propensity make it suitable for use up to 80°F or 85°F, if the chrome alum stop bath, Kodak SB-4, is employed between development and fixing.

If used without replenishment, increase the processing time by 10% after each roll of 35mm or 120 roll film (80 square inches) has been processed. The developer should be discarded after processing 4 rolls per liter (or 32 ounces).

This developer may be replenished with the Kodak Replenisher, DK-25R. ¾ ounce (22 ml) should be added for each roll of film (80 square inches) processed. Most consistent results are obtained if it is added after each roll has been processed (or after each 40 rolls in a 10-gallon tank). With replenishment, the developer has a life of 100 rolls per gallon (or 25 rolls per liter or quart of developer).

A white scum of calcium sulfite frequently occurs on films processed in high sulfite, low alkalinity developers such as D-23. This scum is soluble in acid stop baths and in fresh acid fixing baths, especially if the film is well agitated. It is slowly soluble in wash water, and may also be wiped or sponged off the wet film, although light deposits may not be noticed until the film is dry. The swell reducing acid stop bath, Kodak SB-5, is especially recommended for its removal.

The Compact Photo-Lab-Index

KODAK DEVELOPER D-25
For Fine Grain, Low & Medium Contrast

Water 125° or 52°C)	24	ounces	750.0 ml
Kodak Elon Developing Agent	¼	ounce	7.5 grams
Kodak Sodium Sulfite (desiccated) .. 3 oz.	145	grains	100.0 grams
Kodak Sodium Bisulfite	½	ounce	15.0 grams
Add cold water to make	32	ounces	1.0 liter

Dissolve chemicals in the order given. Use without dilution.

Average development time for Kodak roll films, about 20 minutes in a tank, at 68°F (20°C). At 77°F (25°C) the average development time is about 11 minutes in a tank and the properties are approximately the same as those of Kodak Developer DK-20 at 68°F. Grain is comparable with that obtained with the popular paraphenylene-diamine-glycin developer, but Kodak Developer D-25 is non-toxic and non-staining.

If it is not essential to obtain minimum graininess, or if it is not convenient to work at the higher temperature, use half the specified quantity of sodium bisulfite. The development time will then be approximately 14 minutes at 68°F. Graininess will be intermediate between that for Kodak D-23 and Kodak D-25.

For replenishment, add Kodak Replenisher DK-25R, at the rate of 1¼ ounces per roll for the first 50 rolls processed per gallon (12 rolls per liter) and at ¾ ounce per roll for the next 50 rolls per gallon. The developer should then be replaced with fresh solution.

KODAK REPLENISHER DK-25R
For Developers D-23 and D-25

Water (125°F or 52°C)	24	ounces	750.0 ml
Kodak Elon Developing Agent	145	grains	10.0 grams
Kodak Sodium Sulfite (desiccated) .. 3 oz.	145	grains	100.0 grams
Kodak Kodalk.......................	290	grains	20.0 grams
Add cold water to make	32	ounces	1.0 liter

Dissolve chemicals in the order given. Use without dilution.

FOR USE WITH KODAK D-23 DEVELOPER

Add ¾ ounce (22 ml) of the above replenisher for each roll of 36-exposure 35mm, or 8-exposure 120 or 620, or equivalent (80 square inches) discarding some developer if necessary.

FOR USE WITH KODAK D-25 DEVELOPER

The replenisher should be added at the rate of 1½ ounces (45 ml) per roll of 80 square inches for the first 50 rolls per gallon (12 rolls per liter). For the next 50 rolls per gallon (or 12 rolls per liter), add only ¾ ounce per roll (22 ml).

Loss of shadow detail becomes excessive after 100 rolls per gallon (25 rolls per liter) have been processed and the developer should be considered exhausted and discarded at this point.

KODAK DEVELOPER D-32
Lantern Slide Developer for Warm Black Tones

STOCK SOLUTION A

Water (125°F or 52°C)	16	ounces	500.0 ml
Kodak Sodium Sulfite (desiccated)	90	grains	6.3 grams
Kodak Hydroquinone	100	grains	7.0 grams
Kodak Potassium Bromide	50	grains	3.5 grams
Kodak Citric Acid	10	grains	0.7 gram
Add cold water to make	32	ounces	1.0 liter

(continued on following page)

314

The Compact Photo-Lab-Index

STOCK SOLUTION B

Cold Water .	32 ounces	1.0 liter
Kodak Sodium Carbonate, monohydrated	1oz.75 grains	35.0 grams
*Kodak Sodium Hydroxide (Caustic Soda) . .	60 grains	4.2 grams

*Cold water should always be used when dissolving sodium hydroxide (caustic soda) because considerable heat is envolved. If hot water is used, the solution will boil with explosive violence and may cause serious burns if the hot alkali spatters on the hands or face. Solution B should be stirred thoroughly when caustic soda is added to it, otherwise heavy caustic solution will sink to the bottom.

Dissolve chemicals in the order given.

For use, take 1 part of A and 1 part of B. For still warmer tones, 1 part of A and 2 parts of B.

Develop about 5 minutes at 68°F (20°C).

KODAK DEVELOPER D-41
Low and Medium Contrast Developer for Photomicrography

Water (125°F or 52°C)	24 ounces	750.0 ml
Kodak Elon .	29 grains	2.0 grams
Kodak Sodium Sulfite (desiccated) . .	3 oz. 145 grains	100.0
Kodak Hydroquinone	73 grains	5.0 ml
Kodak Borax, (decahydrated)	29 grains	2.0 grams
*Kodak Anti-Fog No. 1 (Benzotriazole) (0.2%		
stock solution)	1¼ drams	5.0 ml
Add cold water to make	32 ounces	1.0 liter

*Kodak Anti-Fog No. 1 is supplied in 1-oz., 4-oz., and 1-pound packages of dry powder, and in bottles of fifty 0.45-grain tablets.

Kodak Developer D-41 may be prepared most easily by simply adding the listed quantity of Anti-Fog No. 1 to a previously prepared solution of Kodak Developer D-76, and provides a ready means of obtaining this developer from packaged units of Kodak Developer D-76. Use without dilution and develop 4 minutes tray, 5 minutes tank for low contrast, 5½ minutes tray, 7 minutes tank for medium contrast.

KODAK DEVELOPER D-42
High Contrast Developer for Photomicrography

Water (125°F or 52°C)	24 ounces	750.0 ml
Kodak Elon .	29 grains	2.0 grams
Kodak Sodium Sulfite (desiccated) . .	3 oz. 145 grains	100.0 grams
Kodak Hydroquinone	73 grains	5.0 grams
Kodak Borax, (decahydrated)	29 grains	2.0 grams
Kodak Kodalk .	145 grains	10.0 grams
*Kodak Anti-Fog No. 1 (Benzotriazole) 0.2%		
stock solution)	2½ drams	10.0 ml
Add cold water to make	32 ounces	1.0 liter

*Kodak Anti-Fog No. 1 is supplied in 1-oz., 4-oz., and 1-pound packages of dry powder, and in bottles of fifty 0.45-grain tablets.

Kodak Developer D-42 may be prepared most easily by simply adding the listed quantities of Kodalk and Anti-Fog No. 1 to a previously prepared solution of Kodak Developer D-76, and provides a ready means of obtaining a rapid developer from packaged units of Kodak Developer D-76. Use without dilution and develop 4½ minutes tray, 5½ minutes tank for high contrast.

EASTMAN KODAK

KODAK DEVELOPER DK-50 ♦
Kodalk Developer for Roll Films, Film Packs, Professional Films and Plates.

Water (125°F or 52°C)	16 ounces	500.0 ml
Kodak Elon	37 grains	2.5 grams
Kodak Sodium Sulfite (desiccated)	1 ounce	30.0 grams
Kodak Hydroquinone	37 grains	2.5 grams
Kodak Kodalk	145 grains	10.0 grams
Kodak Potassium Bromide	7½ grains	0.5 gram
Add cold water to make	32 ounces	1.0 liter

Dissolve chemicals in the order given.

For tank development of roll films, film packs, and other sheet films and plates use without dilution. Develop 5 to 10 minutes at 68°F (20°C). For tray development decrease the time about 20%.

♦ **Available in units to make 1, 3½, and 10 gallons.**

KODAK REPLENISHER DK-50R ♦
For Use With Kodak Developer DK-50

Water (125°F or 52°C)	24 ounces	750.0 ml
Kodak Elon	75 grains	5.0 grams
Kodak Sodium Sulfite (desiccated)	1 ounce	30.0 grams
Kodak Hydroquinone	145 grains	10.0 grams
Kodak Kodalk	1 oz. 145 grains	40.0 grams
Add cold water to make	32 ounces	1.0 liter

Dissolve chemicals in the order given.

If developer is diluted with an equal amount of water, the replenisher should likewise be diluted; otherwise it is used full strength. Add replenisher to the tank as needed to maintain the level of the solution. If density of the negative is not maintained, discard some of the developer from the tank at intervals and replace with replenisher.

♦ **Available in units to make 1 gallon.**

KODAK DEVELOPER D-51
Acrol ("Amidol") Developer for Bromide Papers.

STOCK SOLUTION

Water (125°F or 52°C)	24 ounces	750.0 ml
Kodak Sodium Sulfite (desiccated)	4 ounces	120.0 grams
*Di-Aminophenol Hydrochloride (Acrol) ...	1¼ ounces	37.5 grams
Add cold water to make	32 ounces	1.0 liter

*Di-Aminophenol (Acrol) is also known as "Amidol."
Dissolve chemicals in the order given.

For use, take 6 oz. (180 ml) Stock Solution, ¾ dram (3 ml) 10% potassium bromide solution, and 24 oz. (750 ml) of water. This developer oxidizes rapidly when exposed to the air, so that only a quantity sufficient for immediate use should be mixed.

This developer, being non-staining, can be used advantageously for re-development, following the use of stain remover such as Kodak Stain Remover S-6. When removing stains by this method, markings caused by drying of negative without removing the drops of water (water markings) are usually removed also unless the markings are of long standing.

The Compact Photo-Lab-Index

KODAK DEVELOPER D-52 ♦
Warm Tone Paper Developer

STOCK SOLUTION

Water (125°F or 52°C)	16	ounces	500.0 ml
Kodak Elon	22	grains	1.5 grams
Kodak Sodium Sulfite (desiccated)	¾	ounce	22.5 grams
Kodak Hydroquinone	90	grains	6.0 grams
Kodak Sodium Carbonate, monohydrated ..	250	grains	17.0 grams
Kodak Potassium Bromide	22	grains	1.5 grams
Add cold water to make	32	ounces	1.0 liter

Dissolve chemicals in the order given.

For Kodak Opal, Athena, Portrait Proof, Kodabromide, and Azo, use stock solution 1 part, water 1 part. Develop about 2 minutes at 68°F (20°C). More bromide may be added if warmer tones are desired.

♦ **Kodak Selectol Developer, a long-life developer for warm-tone papers, may be purchased in units sufficient to make ½, 1, 5 and 50 gallons of stock solution.**

KODAK DEVELOPER DK-60a ♦
Kodalk Deep Tank or Machine Developer for Kodak Roll Films,
Film Packs, Sheet Films and Plates.

Water (125°F or 52°C)	24	ounces	750.0 ml
Kodak Elon	37	grains	2.5 grams
Kodak Sodium Sulfite (desiccated) .. 1 oz.	290	grains	50.0 grams
Kodak Hydroquinone	37	grains	2.5 grams
Kodak Kodalk	290	grains	20.0 grams
Kodak Potassium Bromide	7½	grains	0.5 gram
Add cold water to make	32	ounces	1.0 liter

Dissolve chemicals in the order given.

Develop about 7 minutes at 68°F (20°C), in a tank of fresh developer.
Tray development times for all Kodak films and film packs should be 20% less than tank development times.
Increase or decrease the times for greater or less contrast.

♦ **Available in units to make 1 and 3½ gallons.**

KODAK REPLENISHER DK-60aTR ♦
Replenisher Solution for Kodak Developer DK-60a, for
Deep Tank Development (Hand Processing)

Water (125°F or 52°C)	24	ounces	750.0 ml
Kodak Elon	75	grains	5.0 grams
Kodak Sodium Sulfite (desiccated) .. 1 oz.	290	grains	50.0 grams
Kodak Hydroquinone	145	grains	10.0 grams
Kodak Kodalk 1 oz.	145	grains	40.0 grams
Add cold water to make	32	ounces	1.0 liter

Dissolve chemicals in the order given.

Add the replenisher before the liquid level in the developer tank has dropped more than 2 inches.
The development time will be maintained approximately constant, provided 8 gallons Kodak Replenisher DK-60aTR are added per 1,000 rolls of film processed (80,000 square inches, or approximately 1 ounce (30.0 ml) per roll.

♦ **Available in units to make 1 gallon.**

KODAK DEVELOPER DK-60b
Kodalk Aerial Film Developer

Water (about 125° or 52°C)	24	ounces	750.0 ml
Kodak Elon	18	grains	1.25 grams
Kodak Sodium Sulfite, (desiccated)	365	grains	25.0 grams
Kodak Hydroquinone	18	grains	1.25 grams
Kodak Kodalk	145	grains	10.0 grams
Kodak Sodium Sulfate, desiccated ... 1 oz.	290	grains	50.0 grams
Kodak Anti-Fog No. 1 (0.2% stock solution)*	¼	fl. oz.	80.0 grams
Kodak Potassium Bromide	4	grains	.25 gram
Water to make	32	ounces	1.0 liter

* A 0.2% stock solution of Kodak Anit-Fog No. 1 may be made by dissolving 15 grams of this chemical in 16 ounces of water, about 125°F (1 gram in 500 ml at 52°C). Cool the stock solution before use. Kodak Anti-Fog No. 1 is supplied in 1 and 4 ounce bottles. For the convenience of small users, it is also available in 0.45 grain tablets. Either of these is available from Eastman Kodak Company, Rochester, N.Y., or through their dealers.

Dissolve the chemicals in the order given.

Use without dilution. Develop in a tank of fresh developer about 20 minutes for high contrast, 13 minutes for medium contrast, or 6 minutes for low contrast, at 68°F (20°C).

When negatives of higher contrast are wanted, develop in Kodak Developer D-19; for low contrast, use Kodak Developer D-76 for 15 minutes at 68°F (20°C).

KODAK DEVELOPER D-61a
Elon-Hydroquinone Developer for General Tray or
Tank Use with Films and Plates.

STOCK SOLUTION

Water (125°F or 52°C)	16	ounces	500.0 ml
Kodak Elon	45	grains	3.0 grams
Kodak Sodium Sulfite, desiccated	3	ounces	90.0 grams
Kodak Sodium Bisulfite	30	grains	2.0 grams
Kodak Hydroquinone	90	grains	6.0 grams
Kodak Sodium Carbonate, monohydrated	200	grains	14.0 grams
Kodak Potassium Bromide	30	grains	2.0 grams
Add cold water to make	32	ounces	1.0 liter

Dissolve chemicals in the order given.

For *tray* use take 1 part of stock solution to 1 part of water. Develop for about 6 minutes at 68° (20°C).

For *tank* use take 1 part of stock solution and 3 parts of water. At a temperature of 68° (20°), the development time is about 12 minutes. It is advisable to make up a greater quantity than is needed to fill the tank. If the developer in the tank is of normal strength, but the volume of solution has been reduced, add a sufficient quantity of the surplus solution diluted 1:3 to fill the tank.

If the strength of the solution, as well as the volume, has been reduced, add a sufficient quantity of the replenisher (formula D-61R) to adjust the development time satisfactorily.

While this developer does not produce negatives of warm tone, they have good printing density and quality and the developer has excellent properties. It is one of the most satisfactory developers for continued use and when kept up to normal volume will give good results over a period of several weeks.

The Compact Photo-Lab-Index

KODAK REPLENISHER D-61R
Replenisher Solution for Tank Dilution of
Kodak Developer D-61a

STOCK SOLUTION A

Water (125°F or 52°C)	96	ounces	3.0 liters
Kodak Elon	90	grains	6.0 grams
Kodak Sodium Sulfite, desiccated	6	ounces	180.0 grams
Kodak Sodium Bisulfite	60	grains	4.0 grams
Kodak Hydroquinone	175	grains	12.0 grams
Kodak Potassium Bromide	45	grains	3.0 grams
Add cold water to make	1½	gallons	6.0 liters

STOCK SOLUTION B

Kodak Sodium Carbonate, monohydrated .	9½	ounces	280.0 grams
Water to make	64	ounces	2.0 liters

Dissolve chemicals in the order given.

For use take 3 parts of A and 1 part of B, and add to the tank developer as needed to maintain strength of the solution. Do not mix A and B until ready for use.

KODAK DEVELOPER D-72 ♦
Universal Elon-Hydroquinone Paper and Lantern-Slide
Developer, and for Negative Development for Press Photography.

Water (125°F or 52°C)	16	ounces	500.0 ml
Kodak Elon	45	grains	3.0 grams
Kodak Sodium Sulfite (desiccated)	1½	ounces	45.0 grams
Kodak Hydroquinone	175	grains	12.0 grams
Kodak Sodium Carbonate, monohydrated	2 oz. 290	grains	80.0 grams
Kodak Potassium Bromide	30	grains	2.0 grams
Add cold water to make	32	ounces	1.0 liter

Dissolve chemicals in the order given.

For use with Kodak Azo, Ad-Type, Velox Resisto, Velox Rapid, Kodabromide and Resisto Rapid—dilute 1 part stock solution, 1 part water, and develop 1 minute at 68°F (20°C). For warmer tones on Kodabromide, dilute 1:3 or 1:4 and ¼ oz. (8 ml) 10% potassium bromide for each 32 oz. (1.0 liter) of working solution, and develop 1½ minutes.

For projector slides dilute 1:2. Develop 1 to 2 minutes at 68°F (20°). For greater contrast dilute 1:1, and for less contrast 1:4. For line drawings, Kodak Developer D-11 is recommended.

For Press Negatives dilute 1:1. Develop about 5 minutes without agitation or 4 minutes with agitation for average contrast at 68°F (20°C). For less contrast dilute 1:2. For greater contrast, use full strength. Greater or less contrast may be obtained also by developing longer or shorter times than those indicated.

♦ Kodak Dektol Developer, a paper developer with increased capacity and life, may be purchased in units sufficient to make 8 oz., 32 oz., ½, 1, 5, 25, and 50 gallons of stock solution.

KODAK DEVELOPER D-76♦
Elon-Hydroquinone Borax Developer for Low Contrast and Maximum
Shadow Detail on Panchromatic Films and Plates

Water (125°F or 52°C)	24	ounces	750.0 ml
Kodak Elon	29	grains	2.0 grams
Kodak Sodium Sulfite, desiccated ...	3 oz. 145	grains	100.0 grams
Kodak Hydroquinone	73	grains	5.0 grams
Kodak Borax (decahydrated)	29	grains	2.0 grams
Add cold water to make	32	ounces	1.0 liter

Dissolve chemicals in the order given.

(continued on following page)

The Compact Photo-Lab-Index

DIRECTIONS FOR MIXING LARGE VOLUMES

Dissolve the Elon separately in a small volume of water (at about 125°F or 52°C) and add the solution to the tank. Then dissolve approximately one-quarter of the sulfite separately in hot water (at about 160°F or 71°C), add the hydroquinone with stirring until completely dissolved. Then add this solution to the tank. Now dissolve the remainder of the sulfite in hot water (about 160°F or 71°C), add the borax and when dissolved, pour the entire solution into the tank and dilute to the required volume with cold water.

♦Available in units to make 1 quart, ½ gallon, 1 gallon, 10 gallons.

KODAK REPLENISHER D-76R ♦
Replenisher for Tank Use with Kodak Developer D-76

Water (125°F or 52°C)	24	ounces	750.0 ml
Kodak Elon	44	grains	3.0 grams
Kodak Sodium Sulfite, desiccated ...	3 oz. 145	grains	100.0 grams
Kodak Hydroquinone	¼	ounce	7.5 grams
Kodak Borax (decahydrated)	290	grains	20.0 grams
Add cold water to make	32	ounces	1.0 liter

Dissolve chemicals in the order given.

In small tank work and intermittent use, add 1 ounce (30.0 ml) of Replenisher for each 80 square inches of film processed, discarding some of the used developer if necessary. 80 square inches is equal to one 8-exposure roll of size 120 film or one 36-exposure roll of 35mm.

In deep tank work, use the replenisher without dilution and add to the tank to maintain the level of the solution. It is frequently advisable to discard some of the developer before adding the replenisher to maintain proper negative quality. The life of Kodak Developer D-76 will be at least 5 times greater if this replenisher is used.

♦Available in units to make one gallon.

HIGH ENERGY KODAK DEVELOPER D-82
For Underexposed Negatives

Water (125°F or 52°C)	24	ounces	750.0 ml
Kodak Wood Alcohol	1½	fl. ozs.	48.0 ml
Kodak Elon	200	grains	14.0 grams
Kodak Sodium Sulfite, desiccated	1¾	ounces	52.5 grams
Kodak Hydroquinone	200	grains	14.0 grams
*Kodak Sodium Hydroxide (Caustic Soda) ..	125	grains	8.8 grams
Kodak Potassium Bromide	125	grains	8.8 grams
Add cold water to make	32	ounces	1.0 liter

Dissolve chemicals in the order given.

NOTE: Cold water should always be used when dissolving sodium hydroxide (caustic soda) because considerable heat is evolved. If hot water is used the solution will boil with explosive violence and may cause serious burns if the hot alkali spatters on the hands or face. It is best to dissolve sodium hydroxide separately in a small volume of water and add the solution after the hydroquinone has been dissolved while stirring vigorously.

Develop about 5 minutes in a tray at 68°F (20°C).

The prepared developer does not keep more than a few days. If wood alcohol is not added and the developer is diluted, the solution is not so active as in the concentrated form. This developer gives the greatest possible density with negatives having a minimum of exposure.

EASTMAN KODAK

HIGH CONTRAST KODAK DEVELOPER D-85
For Line or Half-Tone Negatives of Extreme Contrast

Water (not over 90°F) (32°C) 16	ounces	500.0 ml
Kodak Sodium Sulfite, desiccated 1	ounce	30.0 grams
Paraformaldehyde ¼	ounce	7.5 grams
Kodak Sodium Bisulfite 32	grains	2.2 grams
*Kodak Boric Acid, crystals ¼	ounce	7.5 grams
Kodak Hydroquinone ¾	ounce	22.5 grams
Kodak Potassium Bromide 22½	grains	1.6 grams
Add water to make 32	ounces	1.0 liter

*Use crystaline boric acid as specified. Powdered boric acid dissolves with great difficulty and its use should be avoided.

MIXING DIRECTIONS

Use a one-gallon narrow-mouthed bottle for mixing the developer. First check the volume of the bottle and mark it to indicate the exact level of one gallon of solution. Fill the bottle half full of water at about 90°F (32°C) and dissolve the chemicals in the order given. After adding each chemical, place the stopper in the bottle so that only a small quantity of air is present during agitation. When all the chemicals have been dissolved, add cold water until the solution comes up to the one-gallon mark. Insert the stopper tightly to exclude as much air as possible. Allow the developer to stand about two hours after mixing. Cool to 68°F (20°C) before use. If only a portion of the contents of the bottle is to be used at one time, it is suggested that the balance be saved by filling a bottle of smaller size, which would then be stoppered tightly.

TIME OF DEVELOPMENT

For line negatives, 1½ to 2 minutes at 68°F (20°C); for halftone negatives, not over 2½ minutes at 68°F (20°C). With a correctly timed exposure, the image should appear in 30 to 45 seconds at the temperature specified.

This developer has the property of cutting off development very sharply in the low densities, thus insuring clear dot formation in the halftone negatives.

KODAK DIRECT POSITIVE PAPER DEVELOPER D-88

Water (125°F or 52°C) 24	ounces	750.0 ml
Kodak Sodium Sulfite, dessiccated 1½	ounces	45.0 grams
Kodak Hydroquinone ¾	ounce	22.5 grams
*Kodak Boric Acid, crystals 80	grains	5.5 grams
Kodak Potassium Bromide 36	grains	2.5 grams
Kodak Sodium Hydroxide (Caustic Soda†) . ¾	ounce	22.5 grams
Add cold water to make 32	ounces	1.0 liter

*Crystalline boric acid should be used as specified. Powdered boric acid dissolves only with great difficulty, and its use should be avoided.

†It is desirable to dissolve the caustic soda in a small volume of water in a separate container and then add it to the solution of the other constituents. Then dilute the whole to the required volume. If a glass container is employed in dissolving the caustic soda, the solution should be stirred constantly until the soda is dissolved, to prevent cracking the glass container by the heat evolved.

Dissolve chemicals in the order given. Use full strength at 68°F (20°C).

EASTMAN KODAK

321

KODAK P-AMINOPHENOL HYDROQUINONE FILM, PLATE, AND PAPER DEVELOPER DK-93

Water (125°F or 52°C)	16 ounces	500.0 ml
P-Aminophenol Hydrochloride	73 grains	5.0 grams
Kodak Sodium Sulfite desiccated	1 ounce	30.0 grams
Kodak Hydroquinone	37 grains	2.5 grams
Kodak Kodalk	290 grains	20.0 grams
Kodak Potassium Bromide	7 grains	0.5 gram
Add cold water to make	32 ounces	1.0 liter

Dissolve chemicals in the order given. Use without dilution.

Develop roll film in trays about 7½ minutes or in tanks about 9 minutes at 68°F (20°C).

Develop professional and sheet film in tanks about 6 minutes and in trays about 5 minutes at 68°F (20°C).

For warm tones on papers, use without dilution and develop for 2 minutes at 68°F (20°C). For colder tones, double the quantity of Kodak Kodalk and develop 1 to 2 minutes at 68°F (20°C). In either case, the tones given with this developer are slightly warmer than the normal tones given with Kodak Developers D-52 an D-72.

Recommended also as a substitute for Metol-Hydroquinone developers for those subject in skin irritation due to Kodak Elon (Metol, Pictol, etc.)

KODAK FIRST DEVELOPER D-94
For Kodak Black-and-White Reversal Films

Water, about 70°F (21°C)	24 ounces	750.0 ml
Kodak Elon Developing Agent	9 grains	0.6 grams
Kodak Sodium Sulfite, desiccated ...	1 oz. 290 grains	50.0 grams
Kodak Hydroquinone	290 grains	20.0 grams
Kodak Potassium Bromide	120 grains	8.0 grams
Sodium Thiocyanate	90 grains	6.0 grams
Kodak Sodium Hydroxide	290 grains	20.0 grams
Add cold water to make	32 ounces	1.0 liter

KODAK REPLENISHER D-94R
For Kodak Developer D-94

Water, about 70°F (21°C)	24 ounces	750.0 ml
Kodak Elon Developing Agent	19 grains	1.3 grams
Kodak Sodium Sulfite, desiccated ...	1 oz. 290 grains	50.0 grams
Kodak Hydroquinone	¾ oz. 52 grains	26.0 grams
Sodium Thiocyanate	¼ ounce	7.5 grams
Kodak Sodium Hydroxide	1 oz. 55 grains	34.0 grams
Add cold water to make	32 ounces	1.0 liter

Replenishment rate—1 gallon per 1700 feet of 16mm film (2.2 ml per foot).

KODAK SECOND DEVELOPER D-95
For Kodak Black-and-White Reversal Films

Water, about 70°F (21°C)	24 ounces	750.0 ml
Kodak Elon Developing agent	15 grains	1.0 gram
Kodak Sodium Sulfite, desiccated ...	1 oz. 290 grains	50.0 grams
Kodak Hydroquinone	290 grains	20.0 grams
Kodak Potassium Bromide	75 grains	5.0 grams
Kodak Potassium Iodide	4 grains	0.25 gm
Kodak Sodium Hydroxide	½ ounce	15.0 grams
Add cold water to make	32 ounces	1.0 liter

The Compact Photo-Lab-Index

KODAK REPLENISHER D-95R
For Kodak Developer D-95

Water, about 70°F (21°C)	24	ounces	750.0 ml
Kodak Elon Developing Agent	33	grains	2.2 grams
Kodak Sodium Sulfite, desiccated ...	1 oz. 290	grains	50.0 grams
Kodak Hydroquinone	1 oz. 290	grains	50.0 grams
Kodak Sodium Hydroxide	1 oz. 290	grains	50.0 grams
Add cold water to make	32	ounces	1.0 liter

Replenishment rate – 1 gallon per 5000 feet of 16mm film (0.75 ml per foot).

KODAK NEGATIVE DEVELOPER D-96
For Kodak Motion Picture Films

Water, about 125° (52°C)	24	ounces	750.0 ml
Kodak Elon Developing Agent	22	grains	1.5 grams
Kodak Sodium Sulfite, desiccated	2½	ounces	75.0 grams
Kodak.Hydroquinone	22	grains	1.5 grams
Kodak Potassium Bromide	6	grains	0.4 grams
Kodak Borax, granular, decahydrated	65	grains	4.5 grams
Add cold water to make	32	ounces	1.0 liter

KODAK REPLENISHER D-96R
For Kodak Developer D-96

Water, about 125°F (52°C)	24	ounces	750.0 ml
Kodak Elon Developing Agent	30	grains	2.0 grams
Kodak Sodium Sulfite, desiccated ...	2 oz. 290	grains	80.0 grams
Kodak Hydroquinone	30	grains	2.0 grams
Kodak Borax, granular, decahydrated,	75	grains	5.0 grams
Add cold water to make	32	ounces	1.0 liter

Replenishment rate – 1 gallon per 250 feet of 35mm film (15 ml per foot).

KODAK POSITIVE DEVELOPER D-97
For Kodak Motion Picture Films

Water, about 125° (52°C)	24	ounces	750.0 ml
Kodak Elon Developing Agent	7½	grains	0.5 gram
Kodak Sodium Sulfite, desiccated ...	1 oz. 145	grains	40.0 grams
Kodak Hydroquinone	44	grains	3.0 grams
Kodak Sodium Carbonate, Monohydrated ..	290	grains	20.0 grams
Kodak Potassium Bromide	30	grains	2.0 grams
Add cold water to make	32	ounces	1.0 liter

KODAK REPLENISHER D-97R
For Kodak Developer D-97

Water, about 125°F (52°C)	24	ounces	750.0 ml
Kodak Elon Developing Agent	10	grains	0.7 gram
Kodak Sodium Sulfite, desiccated ...	2 oz. 145	grains	70.0 grams
Kodak Hydroquinone	160	grains	11.0 grams
Kodak Sodium Carbonate, monohydrated ..	290	grains	20.0 grams
Kodak Potassium Bromide	2	grains	0.15 gm
Kodak Sodium Hydroxide	30	grains	2.0 grams
Add cold water to make	32	ounces	1.0 liter

Replenishment rate – 1 gallon per 1900 feet of 35mm film (2.0 ml per foot).

KODAK PYRO STAIN DEVELOPER SD-1

For Producing a Stain Image with a Minimum of General Stain

Water (125°F or 52°C)	24	ounces	750.0 ml
Kodak Sodium Sulfite, desiccated	20	grains	1.4 grams
Pyro	40	grains	2.8 grams
Kodak Sodium Carbonate, monohydrated	88	grains	6.2 grams
Add cold water to make	32	ounces	1.0 liter

Dissolve chemicals in the order given.

Develop about 6 minutes at 68°F (20°C), rinse, and fix in a plain hypo bath.

This pyro formula when used fresh will give a good stain image with a minimum of general stain. Following development, rinse quickly and fix in a large volume of fresh hypo. This developer will give best results when used in a tray. If a negative is stained too strongly the stain may be reduced by first removing it entirely by bleaching it in

Formula Kodak Developer S-6, and then re-developing it in a mildly staining pyro developer such as Formula Kodak Developer D-7. This procedure, however, usually gives more general stain in proportion to the stain image than if the original emulsion had been developed with the above staining developer in the first place.

Although most photographic stains are objectionable, a developer stain image which is formed in position along with the silver image during development is often of great value because it is capable of producing a print in the same way in which a print is produced by a silver image. Photographic papers are usually sensitive to blue light only, which is strongly absorbed by a yellow stain. The stain therefore becomes photographically like a black silver image.

The printing value of a stain image explains why an apparently weak-looking pyro negative will give good prints on a soft printing paper. This is because the stain which appears transparent and weak to the eye is really opaque photographically.

The Compact Photo-Lab-Index

KODAK ACID RINSE BATH FOR PAPERS SB-1

After development, rinse prints thoroughly in running water or for at least 15 seconds in the following acid rinse bath before placing in the fixing bath.

Water	32 ounces	1.0 liter
*Kodak Acetic Acid (28% pure)	1½ fl. oz.	48.0 ml

*To make 28% acetic acid from glacial acetic acid dilute three parts of glacial acetic acid with eight parts of water.

Rinse prints for not less than 15 seconds. Assuming a 1 to 2 second drain of a print following development, the equivalent of approximately 20 8"x10" prints may be processed in 32 ounces (1 liter) of this solution before it becomes alkaline and should be discarded.

KODAK CHROME ALUM HARDENING BATH SB-3
For Films and Plates

In hot weather, the following hardening bath should be used after development and before fixation in conjunction with Formula F-5 or when F-16 does not harden sufficiently.

Water	32 ounces	1.0 liter
Kodak Potassium Chrome Alum	1 ounce	30.0 grams

Agitate the negatives for a few seconds when first immersed in hardener. Leave them in the bath for 3 minutes. This bath should be renewed frequently.

KODAK ACID RINSE BATH SB-1a
For Kodalith Films, Plates, and Paper and Kodalith Stripping Film (Normal)

Water	32 ounces	1.0 liter
*Kodak Acetic Acid (28% pure)	4 ounces	125.0 ml

*To make 28% acetic acid from glacial acetic acid dilute three parts of glacial acetic acid with eight parts of water.

KODAK TROPICAL HARDENER BATH SB-4
For Films and Plates

This solution is recommended for use in conjunction with the Tropical Developer (Kodak Developer DK-15), when working above 75°F (24°C).

Water	32 ounces	1.0 liter
Kodak Potassium Chrome Alum	1 ounce	30.0 grams
*Kodak Sodium Sulfate, desiccated	2 ounces	60.0 grams

*If crystalline sodium sulfate is preferred instead of desiccated sulfate, use 4 oz. 290 grains (140.0 grams) in the formula.

325

The Compact Photo-Lab-Index

After development in a concentrated developer such as Kodak Developer DK-15, rinse the film in water for not more than 1 second and then immerse in the Kodak Hardening Bath SB-4 bath for 3 minutes. Omit the water rinse above 85°F (29.4°C) and transfer directly to the hardener bath for 3 minutes. Agitate for 30 to 45 seconds immediately after immersing in the hardener or streakiness will result.

The hardening bath is violet-blue color by tungsten light when freshly mixed, but it ultimately turns to a yellow-green with use; it *then ceases* to *harden and should be replaced with a fresh bath.* The hardening bath should never be overworked.

An unused bath will keep indefinitely but the hardening properties of a partially used bath fall off rapidly on standing for a few days.

KODAK NON-SWELLING ACID RINSE BATH SB-5
For Roll Films

Water	16	ounces	500.0 ml
*Kodak Acetic Acid (28%)	1	fl. oz.	32.0 ml
†Kodak Sodium Sulfate, desiccated	1½	ounces	45.0 grams
Water to make	32	ounces	1.0 liter

*To make 28% acetic acid from glacial acetic acid dilute three parts of glacial acetic acid with eight parts of water.

†If it is desired to use sodium sulfate crystals instead of the desiccated sulfate, use 3½ ounces per 32 ounces (105 grams per liter).

Agitate the films when immersed in this bath and allow to remain about three minutes before transfer to the fixing bath.

This bath is satisfactory for use to 80°F. It should be replaced after processing about 100 rolls per gallon provided approximately 3 quarts of developer have been carried into the acid rinse bath by 100 rolls. *The bath should not be revived with acid.*

When working at temperatures below 75°F (24°C) the life of the acid rinse bath may be extended by giving films a few seconds' rinse in running water previous to immersion in this rinse bath.

KODAK FORMALIN SUPPLEMENTARY HARDENER SH-1
For All Films and Plates

Water	16	ounces	500.0 ml
Kodak Formaldehyde (37% solution)	2½	drams	10.0 ml
Kodak Sodium Carbonate, monohydrated	88	grains	6.0 grams
Water to make	32	ounces	1.0 liter

This formula is recommended for the treatment of negatives which would normally be softened considerably by a chemical treatment in the removal of several types of stains, or by intensification or reduction.

After hardening for 3 minutes, negatives should always be rinsed and immersed for 5 minutes in a fresh acid fixing bath and well washed before further treatment.

KODAK PREHARDENER SH-5 Kodak Hardener SH-5
For High-Temperature Processing

Water	28	ounces	900.0 ml
*0.5% solution of Kodak Anti-Fog No. 2			
(6-Nitrobenzimidazole nitrate)	1¼	ounces	40.0 ml
Kodak Sodium Sulfate, desiccated	1 oz. 290	grains	50.0 grams
Kodak Sodium Carbonate, monohydrated	175	grains	12.0 grams
Add cold water to make	32	ounces	1.0 liter
Just before use, add:			
Kodak Formaldehyde (37% solution)	1¼	drams	5.0 ml

*To prepare a 0.5% solution, dissolve 1 gram of 6-nitrobenzimidazole in 200 ml. of distilled water (18 grains in 8 ounces of water).

(continued on following page)

The Compact Photo-Lab-Index

Directions for Mixing: The entire bath, with the exception of the Kodak Formaldehyde 37% solution, may be kept as a stock solution. Just before use, 5ml (1¼ drams) of Kodak Formaldehyde 37% solution are added to each liter (32 ounces) of the stock solution and mixed thoroughly.

Directions for Use: Bathe the exposed film in the Prehardener SH-5 for 10 minutes with moderate agitation. Then drain film for a few seconds, immerse in water for 30 seconds, drain thoroughly, and immerse in the developer. The selection of the developer will depend on the contrast and time of development desired. In general, up to 95°F (35°C) conventional developers such as D-76, DK-60a, D-19, etc., may be used without modification. Above 95°F, it may be beneficial to use developers of lower activity, to avoid excessively short developing times.

OUTLINE OF PROCESSING WITH PREHARDENER AT TEMPERATURES BETWEEN 75°F AND 90°F

Kodak Prehardener SH-5 10 minutes
Rinse in water 30 seconds
Develop in customary developer ... — — — — —

Times will be as follows:

75°F — use normal developing time recommended at 68°F without prehardening

80°F85% of time for 68°F
85°F70% of time for 68°F
90°F60% of time for 68°F
95°F50% of time for 68°F

After development rinse, fix in an acid hardening fixing bath such as Kodak F-5, wash and dry in the usual way.

AT TEMPERATURES ABOVE 95°F

Increase the 6-Nitrobenzimidazole content of the prehardener up to double the normal formula concentration, if necessary, to control fog. Process as above, using a low activity developer, to avoid excessively short processing times. The average development time at 110°F (43.3°C) after prehardening is 25% of the normal time at 68°F.

KODAK REPLENISHER SOLUTION SH-5R
For Kodak Prehardener

Water	28 ounces	900.0 ml
*0.5% solution of Kodak Anti-Fog No. 2		
(6-Nitrobenzimidazole Nitrate)	1¼ ounces	55.0 ml
Kodak Sodium Sulfate, desiccated ... 1 oz.	290 grains	50.0 grams
Kodak Sodium Carbonate, monohydrated ..	406 grains	28.0 grams
Add water to make	32 ounces	1.0 liter
Just before use, add:		
Kodak Formaldehyde (37% solution	2 drams	8.0 ml

*To prepare a 0.5% solution, dissolve 1 gram of 6-nitrobenzimidazole nitrate in 200ml of distilled water (18 grains in 8 ounces).

Directions for Mixing: The solution, with the exception of the Kodak Formaldehyde, may be prepared and kept as a stock solution. The formaldehyde should be added just before use and mixed thoroughly.

Directions for Use: For tank use, maintain the original level of the Prehardener solution by frequent additions of the Replenisher. For tray use, mark the original solution level on the storage bottle, and when the solution has been returned to the bottle after use, fill up to this mark with replenisher.

The original Prehardener bath should be discarded and replaced after two months use, or after two to three hundred 8x10 films have been processed per gallon (50 to 75 sheets

The Compact Photo-Lab-Index

8x10 or rolls of 35mm per liter), whichever occurs first. In the event of any serious change in hardening or sensitometric properties, the bath should be replaced at once.

Developers used with this procedure may be replenished in the customary manner, allowing 45ml of replenisher (1½ times the usual quantity) for each 8x10 film or roll of 35mm processed. It will be necessary, since water is carried over into the developer, to discard an equivalent amount of developer, either keeping a record of the quantity of film processed, or estimating the amount of replenisher to be used from the decrease in volume of the Prehardener solution.

KODAK ACID HARDENING FIXING BATH F-5
For Films, Plates, and Papers

Water (125°F or 52°C)	20	ounces	600.0 ml
Kodak Sodium Thiosulfate (Hypo)	8	ounces	240.0 grams
Kodak Sodium Sulfite, desiccated	½	ounce	15.0 grams
*Kodak Acetic Acid (28%)	1½	fl. oz.	48.0 ml
†Kodak Boric Acid, crystals	¼	ounce	7.5 grams
Kodak Potassium Alum	½	ounce	15.0 grams
Add cold water to make	32	ounces	1.0 liter

*To make 28% acetic acid from glacial acetic acid, dilute 3 parts of glacial acetic acid with 8 parts of water.

†Crystalline boric acid should be used as specified. Powdered boric acid dissolves only with great difficulty, and its use should be avoided.

Dissolve the hypo in the specified volume of water (about 125°F or 52°C) and then add the remaining chemicals in the order given, taking care that each chemical is dissolved before adding the next. Then dilute with water to the required volume.

Films or plates should be fixed properly in 10 minutes (cleared in 5 minutes) in a freshly prepared bath. The bath need not be discarded until the fixing time (twice the time to clear) becomes excessive, that is, over 20 minutes. The solution remains clear and hardens well throughout its useful life. About 20 to 25 8x10 films or plates (or their equivalent in other sizes) may be fixed per 32 ounces (1 liter).

The Kodak F-5 fixing bath has the advantage over the older types of fixing baths, which do not contain boric acid, that it gives much better hardening and has a lesser tendency to precipitate a sludge of aluminum sulfite throughout its useful life.

The ingredients other than hypo may be compounded as a stock hardener solution to be added to a solution of hypo, using Kodak Formula F-5a.

KODAK ACID HARDENING STOCK SOLUTION F-5a

Water (125°F or 52°C)	20	ounces	600.0 ml
Kodak Sodium Sulfite, desiccated	2½	ounces	75.0 grams
*Kodak Acetic Acid (28%)	7½	fl. ozs.	235.0 ml
†Kodak Boric Acid, crystals	1¼	ounces	37.5 grams
Kodak Potassium Alum	2½	ounces	75.0 grams
Add cold water to make	32	ounces	1.0 liter

*To make 28% acetic acid from glacial acetic acid, dilute 3 parts of glacial acetic acid with 8 parts of water.

†Crystalline boric acid should be used as specified. Powdered boric acid dissolves only with great difficulty, and its use should be avoided.

Dissolve chemicals in the order given.

Add one part of the cool stock hardener solution slowly to 4 parts of cool 30% hypo solution, while stirring the hypo rapidly.

This will give an acid hardening fixing bath similar to Kodak Formula F-5.

A 30% hypo solution is made by dissolving 10 ounces (300 grams) sodium thiosulfate (hypo) in sufficient hot water to make final volume 32 ounces (1 liter).

328

KODAK ACID HARDENING FIXING BATH F-6
Odorless Bath for Films, Plates, and Papers

This new fixing bath has been prepared for those who are sensitive to sulfur dioxide even in the small concentrations which sometimes emanate from a newly prepared tray of Kodak F-5. The odor of sulfur dioxide is eliminated almost entirely by omitting from Kodak Formula F-5 the boric acid and by substituting for it 15 grams of Kodak Kodalk per liter.

Water (125°F or 52°C)	20	ounces	600.0 ml
Kodak Sodium Thiosulfate (Hypo)	8	ounces	240.0 grams
Kodak Sodium Sulfite, desiccated	½	ounce	15.0 grams
*Kodak Acetic Acid (28%)	1½	fl. ozs.	48.0 ml
Kodak Kodalk	½	ounce	15.0 grams
Kodak Potassium Alum	½	ounce	15.0 grams
Add cold water to make	32	ounces	1.0 liter

*To make 28% acetic acid from glacial acetic acid, dilute 3 parts of glacial acetic acid with 8 parts of water.

Dissolve the hypo in the specified volume of water, about 125°F (52°C) and then add the remaining chemicals in the order given, taking care that each chemical is dissolved before adding the next. Then dilute with water to the required volume.

The ingredients other than hypo may be compounded as a stock hardener solution to be added to a solution of hypo, using Kodak Formula F-6a.

KODAK ACID HARDENER STOCK SOLUTION F6a
For Preparing Kodak F-6 Fixing Bath

An odorless stock hardener Kodak (F-6a) which may be used in place of Kodak F-5a, is prepared by substituting for the boric acid 75 grams of Kodalk per liter (10 ounces per gallon). The modified fixing bath should be used in conjunction with an Acid Rinse Bath such as Kodak SB-1 or a Chrome Alum Hardener Bath such as Kodak SB-3 in order to ensure hardening life for the fixer equal to that of Kodak F-5. The hardening life is half that of Kodak F-5 if a water rinse is used between development and fixation.

These modifications (to Kodak F-5 and F-5a) are recommended for limited use. They are intended for the few users who are affected by the sulfur dioxide odor.

Water (125°F or 52°C)	20	ounces	600.0 ml
Kodak Sodium Sulfite, desiccated	2½	ounces	75.0 grams
*Kodak Acetic Acid (28%)	7½	fl. ozs.	235.0 ml
Kodak Kodalk	2½	ounces	75.0 grams
Kodak Potassium Alum	2½	ounces	75.0 grams
Add cold water to make	32	ounces	1.0 liter

*To make 28% acetic acid from glacial acetic acid, dilute three parts of glacial acetic acid with eight parts of water.

Dissolve chemicals in the order given.

Add one part of the cool stock hardener solution slowly to 4 parts of cool 30% hypo solution, while stirring the hypo rapidly.

EASTMAN KODAK

The Compact Photo-Lab-Index

KODAK RAPID FIXING BATH F-7
For Negative Films

This fixing bath is recommended for use in the machine processing of negative films. It can also be used for papers, but has no advantage over other formulas which do not contain ammonium chloride. With papers it should invariably be used in conjunction with an acid stop bath; otherwise, if the bath becomes alkaline, dichroic fog is apt to be produced.

The advantages of this formula are that (1) the time to clear most negative films is less than that for Kodak Fixer F-5, and (2) the fixation life is approximately 50% greater than that of Kodak Fixer F-5.

Water (125°F or 52°C)	20	ounces	600.0 ml
Kodak Sodium Thiosulfate (Hypo)	12	ounces	360.0 grams
Kodak Ammonium Chloride 1 oz.	290	grains	50.0 grams
Kodak Sodium Sulfite desiccated	½	ounce	15.0 grams
*Kodak Acetic Acid (28%) pure)	1½	ounces	47.0 ml
Kodak Boric Acid Crystals	¼	ounce	7.5 grams
Kodak Potassium Alum	½	ounce	15.0 grams
Add cold water to make	32	ounces	1.0 liter

When compounding this formula, the ammonium chloride should be added to the hypo solution and not to the final fixing bath; otherwise a sludge may form.

Note that the hardening components of Kodak Fixer F-7 are the same as those of Kodak Fixer F-5. For this reason a stock rapid hypo solution can be prepared to be used in conjunction with the stock hardener Kodak Fixer F-5a.

Caution: With rapid fixing baths, do not prolong the fixing time for fine-grained film or plate emulsions or for any paper prints; otherwise the image may have a tendency to bleach, especially at temperatures higher than 68°F (20°C). This caution is particularly important in the case of warm-tone papers.

KODAK RAPID FIXING BATH F-9
For Reduced Corrosion of Metal Tanks

If corrosion is encountered when using Kodak Rapid Fixing Bath F-7 with stainless steel containers, it can be minimized by substituting 2 ounces of Ammonium Sulfate for the 1 oz. 290 grains of Kodak Ammonium Chloride in the 32 oz. formula (60 grams per liter for 50 grams). When changed this way, the formula is known as Kodak Rapid Fixer F-9.

KODAK ACID HARDENING FIXING BATH F-10

Water, about 125 F (52 C)	16	ounces	500.0 ml
Kodak Sodium Thiosulfate	11	ounces	330.0 grams
Kodak Sodium Sulfite, desiccated	¼	ounce	7.5 grams
Kodak Kodalk	1	ounce	30.0 grams
*Kodak Acetic Acid (28%)	2¼	fl. oz	72.0 ml
Kodak Potassium Alum	¾	ounce	22.5 grams
Add cold water to make	32	ounces	1.0 liter

*To make 28% acetic acid from glacial acid, dilute 3 parts of glacial acetic acid with 8 parts of water.

Dissolve the chemicals in the order given, taking care that each chemical is dissolved completely before adding the next.

This bath is especially recommended for use with highly alkaline developers, such as Kodak Developers D-11, D-19, or D-95. Agitate thoroughly on first placing the films in the bath, and at intervals until fixation is completed.

Fix for twice the time to clear the film of its milky appearance. Wash thoroughly and *wipe each negative carefully* before drying. When the time to clear has been increased through use, to twice the time required with a fresh bath, the solution should be discarded. In continuous processing machines, however, the following replenisher should be used to maintain the solution at constant working efficiency.

The Compact Photo-Lab-Index

KODAK REPLENISHER F-10R
For Kodak Fixing Bath F-10

Water, about 125 F (52 C)	16 ounces	500.0 ml
Kodak Sodium Thiosulfate	14 ounces	420.0 grams
Kodak Sodium Sulfite, desiccated	145 grains	10.0 grams
Kodak Kodalk .	1 ounce	30.0 grams
*Kodak Acetic Acid 28%	3 oz 7 fl drams	120.0 ml
Kodak Potassium Alum	¾ ounce	22.5 grams
Add cold water to make	32 ounces	1.0 liter

*To make 28% acetic acid from glacial acetic acid, dilute 3 parts of glacial acetic acid with 8 parts of water.

Replenishment rate—1 gallon per 3700 feet of 16mm film (1.0 ml per foot).

KODAK CHROME ALUM FIXING BATH F-23
For Motion Picture Films

SOLUTION A

Kodak Sodium Thiosulfate (Hypo)	8 ounces	240.0 grams
Kodak Sodium Sulfite, desiccated	180 grains	12.5 grams
Water to make .	24 ounces	750.0 ml

SOLUTION B

Water .	5 ounces	150.0 ml
Kodak Sodium Sulfite, desiccated	75 grains	5.0 grams
*Sulfuric Acid, 5% solution	1¼ fl. oz.	40.0 ml
Kodak Potassium Chrome Alum	1 ounce	30.0 grams
Water to make .	8 ounces	250.0 ml

*To prepare 5% Sulfuric Acid, add 1 part by volume of Sulfuric Acid C.P. (Concentrated) to 19 parts of cold water by volume slowly while stirring. The acid must be added to the water, not vice-versa, otherwise the solution may boil with explosive violence, and if spattered on the hands or face will cause serious burns.

Solutions A and B must be cooled to about 70°F before they are mixed in order to avoid sulfurization. Add Solution B to Solution A while stirring the latter thoroughly. It is not desirable to store Solution B as a stock hardener because it loses its hardening powers on keeping.

The hardening properties fall off rapidly with use, and sulfuric acid should be added at regular intervals to maintain the proper acidity. The quantity required can be determined by titrating 30ml of the fixing bath with 2.5% solution of sulfuric acid, using brom-phenol blue as the indicator. Sufficient acid should be added to change the color of the solution to yellow.

KODAK NON-HARDENING ACID FIXING BATH F-24

Water (about 125° or 52°C)	16 ounces	500.0 ml
Kodak Sodium Thiosulfate (Hypo)	8 ounces	240.0 grams
Kodak Sodium Sulfite, desiccated	145 grains	10.0 grams
Kodak Sodium Bisulfite	365 grains	25.0 grams
Add cold water to make	32 ounces	1.0 liter

Dissolve chemicals in the order given.

This bath is recommended for films, plates or paper when no hardening is desired.

This solution may be used satisfactorily only when the temperature of the developer, rinse bath and wash water is not higher than 68°F (20°C) and provided ample drying time can be allowed so that relatively cool drying air can be used.

The Compact Photo-Lab-Index

EASTMAN KODAK

KODAK ACID HARDENING FIXING BATH F-25
For Motion Picture Film

Water (about 125°F or 52°C)	64	ounces	500.0 ml
Kodak Sodium Thiosulfate (Hypo)	2½	pounds	300.0 grams
*Kodak Sodium Sulfite, desiccated	290	grains	5.0 grams
Kodak Acetic Acid, glacial	1¼	fl. ozs.	10.0 ml
†Kodak Boric Acid, crystals	290	grains	5.0 grams
Kodak Potassium Alum 1 oz.	145	grains	10.0 grams
Add cold water to make	1	gallon	1.0 liter

*This bath contains a minimum quantity of sulfite, which is such that the bath with not sulfurize within a period of 3 to 4 weeks at 70°F (21°C). If the temperature is likely to rise above 70°F (21°C), twice the quantity of sulfite should be used.

†Crystalline boric acid should be used as specified. Powdered boric acid dissolves on with great difficulty, and its use should be avoided.

Dissolve the hypo in one-half the required volume of water and then add the remaining chemicals in the order given after dissolving in a small quantity of water. Dilute with water to the required volume.

Revival of this acid hardening fixing bath is unnecessary as the hardening properties are maintained and the bath will not sludge throughout its useful life. The solution may be used until exhausted with 100 feet of 35mm film per 32 ounces (1 liter), when it should be replaced by a fresh bath.

KODAK STOCK HARDENER F-25a
For Motion Picture Film Fixing Bath F-25

The following fixing bath prepared with this solution will not sulfurize within a period of 3 to 4 weeks, if the temperature will not exceed 70°F (21°C).

Water (about 125°F or 52°C)	16	ounces	500.0 ml
*Kodak Sodium Sulfite, desiccated	365	grains	25.0 grams
Kodak Acetic Acid, glacial	1.6	fl. oz.	50.0 ml
†Kodak Boric Acid, crystals	365	grains	25.0 grams
Kodak Potassium Alum 1 oz.	292	grains	50.0 grams
Add cold water to make	32	ounces	1.0 liter

*This bath contains a minimum quantity of sulfite for use at normal temperatures. If the temperature is apt to rise above 70°F (21°C), twice the quantity of sulfite should be used.

†Crystalline boric acid should be used as specified. Powdered boric acid dissolves only with great difficulty, and its use should be avoided.

Dissolve chemicals in the order given.

For use, add 1 part of stock hardener solution slowly to 4 parts of a cool 30% hypo solution while stirring the latter rapidly.

30% hypo solution is prepared by dissolving 10 ounces (300 grams) of sodium thiosulfate (hypo) in sufficient water to make final volume 32 ounces (1 liter).

HYPO TEST FOR THOROUGHNESS OF WASHING

An accurate determination of the residual hypo content in films and prints can be obtained only by the measurement of the hypo in the processed photographic material. This is particularly true in the case of prints, because the paper support retains hypo in its fiber structure.

KODAK HYPO TEST SOLUTION HT-2

Water	24 ounces	750.0 ml
*Kodak Acetic Acid, 28%	4 ounces	125.0 ml
Kodak Silver Nitrate	¼ ounce	7.5 grams
Water to make	32 ounces	1.0 liter

*To make approximately 28% acetic acid from glacial acetic acid, dilute 3 parts of glacial acetic acid with 8 parts of water.

Store in a screw-cap or glass-stoppered brown bottle away from strong light. Avoid contact of test solution with the hands, clothing, negatives, prints, or undeveloped photographic materials; otherwise black stains will ultimately result.

Testing the Degree of Washing of Prints: After washing, wipe the excess water from the face (emulsion side) of an unexposed piece of the same photographic paper processed with the batch of prints (or from the extra margin area of one of the prints). Place one drop of the test solution on the face of this processed paper sampler. Allow the solution to stand on the paper sample for 2 minutes, rinse to remove the excess reagent, and then compare the stain with the Kodak Hypo Estimator. The Kodak Hypo Estimator is available on request from the Sales Service Division Eastman Kodak Company Rochester 14650, New York.

Archival permanence requires the use of washing aids such as Kodak Hypo Clearing Agent, or even the Hypo Eliminator HE-1. The above spot test is reliable when Kodak Hypo Clearing Agent has been used, but it may give misleading results after certain other washing aids have been employed. The face may show less stain than a print washed only in water, although the total hypo content of the two prints may be equal. In such cases it is desirable to measure the transmission density after total immersion of the print or sample in the silver nitrate test solution.

Testing the Degree of Washing of Films: After washing, cut off a small strip from the clear margin of the film and immerse a portion of it in a small volume of the. test solution for about 3 minutes. Well-washed films, including those for record purposes, should show very little or no discoloration.

The spot technique should not be used on wet films because of the danger of spreading the reagent. It is very useful in testing dry films.

SEA WATER WASHING
Of Photographic Films, Plates and Papers

An investigation carried out by G.T. Eaton and J.I. Crabtree of Kodak Research laboratories on the possibility of washing photographic materials in sea water discloses that: "It is considered that a safe and economical procedure would be to wash photographic films, plates and papers in sea water for one-half of the usually recommended washing time for a given material and then wash in fresh water for about 5 minutes, either in running water or in two successive changes of fresh water."

KODAK HYPO CLEARING AGENT ♦
(Liquid volumes are given in the U.S. system)

DIRECTIONS FOR USE
PAPERS (Black-and-White Prints)

After normal fixing, transfer the prints to the clearing agent solution with or without rinsing.

Treat single-weight or thinner papers at least 2 minutes and double-weight papers at least 3 minutes, with agitation, at 65 to 70 F (18 to 21 C).

Then wash single-weight or thinner papers at least 10 minutes and double-weight papers at least 20 minutes with agitation and normal water flow. The water temperature may be as low as 35 F (2 C). However, if the water temperature can be maintained at 65 to 70 F (18 to 21 C), a higher degree of stability will result than can be obtained with normal one-hour washing without the KODAK Hypo Clearing Agent treatment.

EASTMAN KODAK

333

The Compact Photo-Lab-Index

Prints to Be Toned: If cold wash water is used prior to toning, 2-bath fixation is especially necessary. For the wash prior to toning in Sulfide Sepia Toner T-7a, KODAK POLY-TONER, KODAK Brown Toner, KODAK Rapid Selenium Toner, or KODAK Blue Toner, treat the prints as directed above. This will reduce the washing time by at least 2/3. The 2% KODALK bath required prior to using Rapid Selenium Toner may be combined with the Hypo Clearing Agent bath by dissolving 2-1/2 ounces of KODALK Balanced Alkali in each gallon of Hypo Clearing Agent. Use as described under "Black-and-White Prints."

After toning in KODAK Hypo—Alum Toner T-1a, KODAK Rapid Selenium Toner, or KODAK Gold Toner T-21, treat the prints in Hypo Clearing Agent and wash at 65 to 70 F (18 to 21 C) as described under "Black-and-White Prints."

Black-and-White Prints Exposed to Oxidizing Gases: To prevent fading of prints that may be exposed to oxidizing gases, add 1¼ ounces of KODAK Rapid Selenium Toner stock solution to each gallon of KODAK Hypo Clearing Agent solution. Stir until the solution is mixed thoroughly.

After normal fixing, transfer prints *without rinsing* to the KODAK Hypo Clearing Agent Bath with toner. Treat and wash at 65 to 70 F (18 to 21 C) as described under "Black-and-White Prints." Do not leave prints in the modifed KODAK Hypo Clearing Agent Bath more than 5 minutes.

CAUTION: Selenium salts are hazardous. Note warning on toner label.

FILMS

After fixing, remove the excess hypo by rinsing the film in water for about 30 seconds. Then bathe the film in the KODAK Hypo Clearing Agent solution for 1 to 2 minutes, with moderate agitation, and wash it for 5 minutes, using a water flow sufficient to give a complete change of water in 5 minutes.

Still-Water Wash: When water supplies are limited, substitute a tank of water for the running-water wash. After 2 minutes in the clearing agent solution, wash the films for 10 minutes with occasional agitation. Change the water in the tank after the equivalent of 10 films, 8 x 10-inch, per gallon have been washed.

Capacity: The equivalent of 200—8 x 10-inch prints or 150 to 200—8 x 10-inch films may be treated in each gallon of KODAK Hypo Clearing Agent Bath if a water rinse is used after fixing. Without a water rinse, the capacity is reduced to about 50 to 60—8 x 10-inch films or 80—8 x 10-inch prints or equivalent per gallon.

Image Stability: You can determine the effectiveness of the clearing agent and the washing procedure by testing the washed film or print for residual traces of hypo and silver.

To test for hypo, spot a margin of the film or print with KODAK Hypo Test Solution HT-2 and compare the stain with the KODAK Hypo Estimator. This guide is available from Photo Information Service, Eastman Kodak Company, Rochester, New York 14650.

To test for silver, place a drop of KODAK Residual Silver Test Solution ST-1 in the clear margin of a dry or squeegeed film or print. After 2 or 3 minutes, blot carefully with a clean white blotter. Any coloration in excess of a just visible cream tint indicates the presence of residual silver salts in the film or print. For more critical evaluation of prints, compare the coloration with that produced on a blank sheet of paper which has been processed through two fresh fixing baths and washed thoroughly.

♦Available in 5 quart size. The package contains five packets, each of which will make 5 quarts (4.7 liters) of solution. To prepare: add the contents of one packet to 5 quarts (4.7 liters) of water at about 80 F (27 C). Stir until the chemicals are dissolved completely and the solution is uniform.

ARCHIVAL PROCESSING

When residual chemicals are not completely removed from photographic materials, permanence is impaired. For some purposes, this is not important, because the need for certain work is temporary. Stabilized prints would be in this category. Negatives should be treated to insure long life, since their potential value may not be apparent immediately. If manufacturers' recommended procedures are followed for all sensitized

The Compact Photo-Lab-Index

materials, they will keep for an extended number of years if good storage conditions are available. If time is important, negatives and prints can be rewashed after prints have been made.

Photographs intended for permanent records should be processed to achieve a standard known as *archival permanence*. This standard implies total removal of chemical residues harmful to the photographic image or its support.

CAUSES OF DETERIORATION

Small amounts of hypo (sodium thiosulfate or ammonium thiosulfate) remaining in a photographic material after processing eventually combine with the silver of the image to form silver sulfide. The result of this reaction, as seen in a black-and-white negative or print, is a stained and faded picture. Permanence is also impaired by traces of complex silver compounds (products of the fixing reaction) that remain in the material due to a curtailed fixing time or to an excessive amount of silver compounds in the fixing bath, a condition that exists when a fixing bath has been used beyond its useful capacity.

A further cause of deterioration in negatives and prints is exposure to unfavorable atmospheric conditions. The photographer has little or no control over this aspect of permanence, but he should be aware that the effect of residual hypo and silver is greatly accelerated by high temperature coupled with excessive humidity, as well as by sulfurous matter and harmful gases in the air. Photographs intended for use in tropical climates or in industrial areas should therefore be processed for maximum permanence.

In addition, the particular granular structure of a silver image has a bearing on its tolerance to residual chemicals. For example, fine-grain negatives and prints on warm-tone papers are more susceptible to attack by hypo than are coarse-grained negatives and prints on cold-tone papers. As a practical matter, however, it is easier to process all materials to a high standard of permanence than to select a particular film or paper for special treatment. The purpose of fixing is to dissolve the undeveloped, light-sensitive silver halides from the emulsion. The products of this reaction are complex silver compounds. As more material is fixed in a bath of hypo, the concentration of these silver compounds in the hypo solution becomes greater. When the concentration reaches a certain critical level, some relatively insoluble silver compounds are formed; these compounds cannot be removed by washing. Moreover, as the concentration of silver in the fixing bath increases, so does the time required for complete fixation. As a practical matter, this means that you should test your fixing baths frequently to make sure that they are not used when the amount of silver they bear has reached the critical level.

FIXING

To make a negative or print as permanent as possible, two conditions must be met: (1) All of the undeveloped silver halides in the emulsion must be dissolved by the fixing solution so that the silver compounds thus formed can be removed from the material by washing. (2) Both the fixing chemicals and the soluble silver compounds must be removed from the emulsion and its support by thorough washing.

Fixing Time: A single sheet of film or paper fixes in a relatively short time in a fresh fixing bath, because fresh solution is in contact with the whole surface of the material throughout the immersion time. When a batch of prints or negatives are fixed together in a tray, a different condition exists. The sheets of material adhere to one another, and so prevent access of fresh solution to the surfaces. For this reason, photographic materials must be agitated and separated constantly throughout the fixing time. The effect of lack of agitation is often seen as a stained patch in the center of the negative or print, indicating that solution reached the edges of the material but failed to reach the center of the sheets. This bunching of negatives and prints during fixing is one of the most common causes of deterioration.

Each fixing time recommended by Eastman Kodak Company includes a safety factor that helps to compensate for the difficulties in fixing material in batches and for the slowdown of the fixing reaction by a buildup of silver compounds in the hypo solution. The fixing times recommended should not be exceeded, particularly in the case of paper prints. The reason for this will become apparent later in this discussion.

Practical Limits for Concentration of Silver in Fixing Baths: As stated previously, when the concentration of silver in a fixing bath reaches a certain level, insoluble silver compounds are formed that fail to leave the material in washing. A higher concentration

(Continued on following page)

The Compact Photo-Lab-Index

of silver can be tolerated in a fixing bath for negatives than in one for papers. This is because chemical solutions are not absorbed by the film base. Removal of residual chemicals is therefore relatively simple. The maximum amount of silver that should be allowed to accumulate in a bath used for negatives is about 6.0 grams per liter of hypo solution. As a general rule, this concentration is reached when a film takes twice the time to clear that the same film would take in a fresh bath.

In fixing papers, the situation is more complex; chemical solutions are absorbed by the paper base and the baryta coating on the paper, as well as by the emulsion. As a result, residual chemicals are much more difficult to remove by washing. Experiments have shown that not more than 2.0 grams per liter of silver can be tolerated in a fixing bath used for papers. Obviously, when a single fixing bath is used for prints it must be tested frequently; otherwise, the permissible level of silver can easily be exceeded without the knowledge of the operator. A more certain method of fixing prints is to use a two-bath system.

Fixing Negatives: A few negatives can be fixed in a tray if they are separated and handled carefully. In batch processing, the best method is to use suitable film hangers suspended in a tank. In this way the films are always properly separated. Fixing is carried out with the minimum of handling, and consequently, less damage.

About one hundred 8 by 10-inch films can be fixed in a gallon of hypo solution. However, if you have failed to count the number of films processed, you can check the condition of the fixing bath by observing the time the film takes to clear. If it takes twice the time to clear that the same film would take in a fresh bath, the solution should be discarded. Remember that some types of film take much longer to clear than others; therefore, the same film must be used to check the clearing time in both the fresh bath and the used bath. Whether it is exhausted or not, a tank of hypo should be discarded after 1 month of use.

Fixing Prints: Prints are usually fixed in a tray and often in fairly large batches. Consequently, precautions must be taken to insure complete fixation if the prints are to be permanent.

Always use trays or tanks that are large enough to permit easy handling of the prints. For example, not more than twelve 8 by 10-inch prints can be fixed properly in an ordinary 16 by 20-inch processing tray.

The following question is often asked: "Should prints be placed in the fixer face upward or face downward?" The answer is that most photographic paper floats on the surface of the solution and cannot be left unattended for any length of time no matter which side is upward. Bubbles form under a print that floats face downward; consequently, some areas are only partially fixed. The effect may not be apparent in a black-and-white print, but it will be seen as circular, purplish stains in a print toned by one of the sulfide processes. A print that floats face upward exhibits the same effect, but the purplish stains are irregular in shape.

Exhaustion Life of a Paper-Fixing Bath: As stated earlier, the useful life of a print-fixing bath is shorter than a bath used for fixing negatives. There are two reasons for this: (1) Due to the absorbent nature of paper, silver compounds are difficult to remove from the material by washing. (2) There is always a carryover of stop bath or rinse water to the fixer; thus the hypo solution is diluted and its working strength reduced. This situation cannot be corrected by increasing the fixing time, because there is a significant relationship between fixing time and washing time in print processing. The recommended fixing time is 5 to 10 minutes. Times in excess of 10 minutes permit the hypo solution, and the silver compounds it bears, to penetrate the paper fibres, as well as the spaces between the fibres. Paper in this condition, is difficult to free from residual chemicals by washing. After a period of keeping, the effect can be seen as an overall yellow stain that extends right through the paper base. It becomes apparent immediately if the print is toned by one of the sulfide processes.

Fixing Prints in a Single Bath: As successive sheets of paper are fixed in a bath of hypo, the quantity of silver in the solution builds up. When prints are fixed, a critical concentration of silver is reached after comparatively few sheets of paper have been fixed. The recommended number of 8 by 10-inch prints per gallon of solution (or the equivalent area in other sizes) is 100 for commercial processing. However, if prints with the minimum tendency to stain are required, the bath should be discarded after only thirty 8 by 10 sheets of paper per gallon have been processed. The above figures give only an approximate estimate of the condition of a fixing bath, because the amount of

(Continued on following page)

silver compounds added to the solution by a print depends on how much of the silver halide in the emulsion was developed to metallic silver. Obviously, less silver halide would be left in a very dark print than in a very light one.

Two-Bath Fixing: If space permits, it is always preferable to use the two-bath fixing system in print processing. This method is much more efficient and effects a considerable economy in chemicals. The prints are fixed for 3 to 5 minutes in two successive baths. The major part of the silver halide is dissolved in the first bath, and the remainder is dissolved or rendered soluble by the second bath. To operate a two-bath fixing system, follow this procedure:

1. Mix two fresh fixing baths and place them side by side.
2. Fix the prints for 3 to 5 minutes in each bath.
3. Discard the first bath when two hundred 8 by 10-inch prints per gallon of solution have been fixed.
4. Substitute the second bath for the one you have just discarded; the second bath has now become the first one.
5. Mix a fresh bath and place it beside the first one.
6. Repeat the above cycle four times.
7. After 5 cycles, mix fresh chemicals in both baths.
8. If five cycles are not used in one week, mix fresh solution in each bath at the beginning of the second week.

WASHING

In photographic processing, the purpose of washing is to remove the fixing chemicals and silver compounds that remain in the material. Washing the negatives is a fairly simple operation because chemicals are not absorbed by the film base. Under suitable conditions, negatives are freed from residual chemicals after 20 to 30 minutes of washing.

Washing prints is a different problem; chemicals are absorbed by the paper base, and to remove them completely by washing alone is difficult. Under favorable conditions, prints' are washed well enough for most purposes after 1 hour. If prints are intended as permanent records, they should be treated with a hypo eliminator to remove the last traces of hypo that remain after normal washing.

Washing Apparatus: The water in any tray or tank used for washing photographic materials should change *completely* every 5 minutes. This rate of change should be achieved without excessive turbulence which can damage the films or prints and without splashing adjacent walls or floors.

A test to determine the rate of change of water in a washer can be made quite simply. Add a small quantity of potassium permanganate solution to the water in the tray or tank and observe the time the color takes to disappear. Before you make this test, however, be sure that the water in the vessel is not contaminated by hypo—weak permanganate solution is made colorless by hypo—and that the tank is free from the slimy deposit that accumulates in washers that are not cleaned frequently. Since such a deposit retains chemicals, you should clean the tank or tray before making the permanganate test. By the same token, dirty washers are a source of stains on prints, which are difficult to account for. Washing apparatus should always be kept clean by frequent wiping and rinsing. A 10 percent solution of sodium carbonate helps to remove slimy deposits from the interior surfaces of washing apparatus.

Water Supply: A plentiful supply of pure water is desirable in processing photographic materials for permanence. Municipal water supplies are generally satisfactory for washing negatives and prints. Water may be either hard or soft, according to the amount of calcium or magnesium salts dissolved in it. The degree of hardness has little or no effect on permanence, although very soft water permits gelatin to swell excessively; this may be troublesome in some processes.

If you use water from a well or other untreated source, it may contain sulfides or dissolved vegetable matter. The presence of sulfides can be detected by an odor of hydrogen sulfide when the water is heated. A greenish color in the water indicates dissolved vegetable matter. These impurities can be removed by suitable filtration or treatment.

(continued on following page)

The Compact Photo-Lab-Index

Generally, it is safe to assume that water is satisfactory for photographic washing if it is clear, colorless, and does not have a sulfide odor on heating.

Washing with Sea Water: Sea water is very efficient in removing hypo from negatives and prints. This fact may be of value to those who do processing on board ship. Remember, however, that salt is detrimental to the permanence of a silver image, particularly if residual hypo is present in the material. Therefore, if you use sea water for washing, it is imperative to remove the sea-water salts by a final wash of at least 5 minutes in fresh water.

Wash-Water Temperature: The temperature of the wash water has a definite effect on the rate of removal of hypo and silver complexes from both films and prints. Experiments have shown that a temperature of 40 F (4 C) will slow the removal of residual chemicals, while a temperature of 80 F (27 C) will speed it up. When practical considerations as well as the physical characteristics of film and paper are taken into account, the most suitable range of temperature for washing is 65 to 75 F (18 to 24 C).

Washing Negatives: You can wash a small batch of films or plates in a tray, but avoid excessive turbulence, because these materials tend to scratch one another if allowed to move about too rapidly. The KODAK Automatic Tray Siphon is an attachment that provides adequate water change in a shallow tray without the turbulence that may damage the negatives.

Large batches of negatives should be suspended in hangers and washed in a tank. With suitable hangers, both films and plates can be washed in this way. For good water circulation, place the inlet at one corner at the bottom of the tank. Allow the water to overflow at the top edges of the tank. A single outlet at the top would tend to make uniform currents that might leave certain areas in the tank comparatively stagnant, and so reduce the rate of complete water change.

To conserve water and reduce the cost of washing, do not wash negatives much longer than the recommended 20 to 30 minutes. It is also wasteful to use an unnecessarily high rate of water flow or to wash negatives in a tank much bigger than that needed to accommodate the size or quantity of material being washed.

Washing Prints: Since paper base is absorbent, it is difficult to wash the last traces of hypo and silver from prints. For most purposes, adequate washing is achieved in 1 hour if the water in the washer changes completely every 5 minutes. However, the time of washing and the rate of water flow are both meaningless if the prints are not separated constantly so that water can reach every part of each print throughout the washing time. A well-designed washer can do this fairly well with small prints up to 5 by 7 inches; larger prints need frequent handling to keep them separated. A number of well-designed washers are available from photographic dealers. No washer, however, can perform satisfactorily if you wash too many prints in it at one time. Use two or more tanks and wash the minimum number of prints in each. To conserve water, you can arrange three washers in series, each one at a lower level than its predecessor. In this way, fresh water from the upper tank is used to feed the two lower tanks. Prints are moved at regular intervals from the lowest tank—where the bulk of hypo is removed—to the intermediate tank and then to the upper tank, where washing is completed by the incoming fresh water. Incidentally, don't guess at the washing time, use an alarm clock to time the intervals.

KODAK HYPO CLEARING AGENT

As stated before, sea water removes hypo from photographic materials more quickly than fresh water. Investigations into this effect have shown that certain inorganic salts behave like the salt in sea water. Unlike sea water, however, they are harmless to the silver image. KODAK Hypo Clearing Agent is a preparation of such substances. Its use reduces the washing time for both negatives and prints. At the same time, prints attain a degree of freedom from residual chemicals almost impossible to obtain by washing them with water alone. A further advantage in using KODAK Hypo Clearing Agent is that adequate washing can be achieved with much colder water.

Films or Plates: Rinse films or plates in fresh water for 30 seconds, to remove excess hypo, and then immerse them in KODAK Hypo Clearing Agent solution for two minutes with agitation. Wash them for 5 minutes in a tank where the water changes completely in 5 minutes. To avoid streaks, drying marks, and the formation of water droplets on film surfaces, bathe films in KODAK PHOTO-FLO Solution for 30 seconds and then hang them up to dry.

(see chart on following page)

338

The Compact Photo-Lab-Index

REFERENCE CHART — KODAK HYPO CLEARING AGENT

Photographic Material	Rinse After Fixing	Hypo Clearing Agent	Wash in Running Water	Capacity (8 x 10-inch prints per gallon)
Films	none	1-2 minutes	5 minutes	50-60 or equivalent
Films	1 minute	1-2 minutes	5 minutes	150-200 or equivalent
Single-Weight Prints	none	2 minutes	10 minutes	80 or equivalent
Single-Weight Prints	1 minute	2 minutes	10 minutes	200 or equivalent
Double-Weight Prints	none	3 minutes	20 minutes	80 or equivalent
Double-Weight Prints	1 minute	3 minutes	20 minutes	200 or equivalent

Papers: Rinse prints for 1 minute to remove excess hypo. Treat single-weight papers for 2 minutes, *with agitation,* in KODAK Hypo Clearing Agent solution and then wash them for 10 minutes. Observe the normal recommendations concerning water flow. The prints must, of course, be agitated and separated throughout the washing time.

Rinse double-weight papers for 1 minute in clean water, then immerse them in KODAK Hypo Clearing Agent solution for 3 minutes. Wash the prints for 20 minutes with normal water flow and constant agitation.

Prints can be transferred to the Hypo Clearing Agent solution directly from the fixer without an intermediate rinse. This practice, however, considerably reduces the capacity of the Hypo Clearing Agent solution. For capacity of solution with and without intermediate rinsing, see the reference chart.

Protecting Prints from Oxidizing Gases: A simple method of protecting prints from the effect of oxidizing gases in the atmosphere is to add 2 ounces of KODAK Rapid Selenium Toner stock solution to each gallon of KODAK Hypo Clearing Agent working solution. After normal fixing, transfer the prints, *without* rinsing, to the modified Hypo Clearing Agent bath. Treat and wash the prints as described above. Do not leave the prints in this solution longer than 5 minutes.

PROCESSING PRINTS FOR MAXIMUM PERMANENCE

It is difficult, if not impossible, to remove the last traces of processing chemicals from photographic papers by ordinary means. For the maximum possible permanence, therefore, you should use a hypo eliminator after washing.

In the past, many different formulas have been used as hypo eliminators, but most of them failed to oxidize hypo to harmless sodium sulfate. As a result, intermediate compounds, such as tetrathionate, were formed; these compounds were just as harmful to the silver image as hypo itself. In recent years an alkaline hypo eliminator has been used with much more success. This formula, called Hypo Eliminator HE-1, reduces hypo all the way to sodium sulfate, which is harmless to the silver image and soluble in the final washing.

EASTMAN KODAK

The Compact Photo-Lab-Index

KODAK HYPO ELIMINATOR HE-1

	Avoirdupois U.S. Liquid	Metric
Water	16 ounces	500.0 ml
Hydrogen Peroxide (3% solution)	4 ounces	125.0 ml
*Ammonia Solution	3¼ ounces	100.0 ml
Water to make	32 ounces	1.0 liter

Caution: Prepare the solution immediately before use and keep in an open container during use. Do not store the mixed solution in a stoppered bottle, or the gas evolved may break the bottle.

*Prepared by adding 1 part of concentrated ammonia (28%) to 9 parts of water.

Direction for use: Treat the prints with KODAK Hypo Clearing Agent or wash them for about 30 minutes at 65 to 70 F (18 to 21 C) in running water which flows rapidly enough to replace the water in the vessel (tray or tank) completely once every 5 minutes. Then immerse each print about 6 minutes at 68 F (20 C) in the Hypo Eliminator HE-1 solution, and finally was about 10 minutes before drying. At lower temperatures, increase the washing times.

Life of HE-1 Solution: About fifty 8 x 10-inch prints or their equivalent per gallon.

PROTECTIVE COATING

Even when the last traces of hypo have been removed from a print by chemical means, the silver image is liable to attack by various substances in the atmosphere. Treatment with KODAK Gold Protective Solution GP-1 makes the image less susceptible to such deterioration.

KODAK GOLD PROTECTIVE SOLUTION GP-1

	Avoirdupois U.S. Liquid	Metric
Water	24 ounces	750.0 ml
*Gold Chloride (1% stock solution)	2½ drams	10.0 ml
KODAK Sodium Thiocyanate	145 grains	10.0 grams
Water to make	32 ounces	1.0 liter

*A 1% stock solution of gold chloride may be prepared by dissolving 1 gram in 100 ml of water.

Add the gold chloride stock solution to the volume of water indicated. Dissolve the sodium thiocyanate *separately* in 4 ounces (125 ml) of water. Then add the thiocyanate solution slowly to the gold chloride solution, while stirring rapidly.

For Use: Immerse the well-washed print (which preferably has received a hypo-elimination treatment) in the Gold Protective Solution for 10 minutes at 68 F (20 C) or until a just-perceptible change in image tone (very slight bluish-black) takes place. Then wash for 10 minutes in running water and dry as usual.

Approximate Exhaustion Life: Thirty 8 x 10-inch prints per gallon. For best result, the KODAK GP-1 solution should be mixed immediately before use.

TESTING PROCEDURES

If a single fixing bath is used for prints, test the solution frequently to avoid an undesirable buildup of silver compounds. The KODAK Testing Outfit for Print Stop Baths and Fixing Baths contains a test solution for this purpose. When a certain quantity of the fixer is added to this test solution and a yellow precipitate forms immediately, the bath should be discarded. In using the two-bath system, test the second bath only occasionally. As a rule, the test is negative if the system is operated carefully, but

omissions and accidents sometimes occur in a busy darkroom. Therefore, the test is worthwhile if permanence is important.

Test for Silver: Since the quantity of silver compounds necessary to cause an overall yellow stain on a print or negative is extremely small, there is no simple quantitative method available for its determination. However, the stain that might be visible after a period of keeping can be simulated by the following drop test: Place a drop of KODAK Residual Silver Test Solution ST-1 (formula given below) on an unexposed part of the processed negative or print and blot off the surplus solution with a piece of clean, white blotting paper. Any yellowing of the test spot, other than a barely visible cream tint. indicates the presence of silver. If the test is positive, residual silver can be removed by refixing the print or negative in fresh hypo and rewashing for the recommended time. Prints toned in a sulfide toner or selenium toner will not yield to this treatment, however, because the residual silver has been toned together with the image. The yellow stain so formed is permanent.

KODAK RESIDUAL SILVER TEST SOLUTION ST-1

	Avoirdupois U.S. Liquid	Metric
Water	4 ounces	100 ml
KODAK Sodium Sulfide	36 grains	2 grams

Store in a small stoppered bottle for not more than 3 months. **For use:** Dilute one part of stock solution with nine parts of water. The diluted solution has limited storage life and should be replaced weekly.

Testing Films for Residual Hypo: Quantitative figures for the total residual hypo in the emulsion and backing of film can be determined by the mercuric chloride test described in the U.S.A.S.I. Method for Determining the Thiosulfate Content of Processed Black-and-White Films and Plates, PH4.8-1958. Alternatively, a much simpler and fairly precise estimate can be made with the KODAK Hypo Estimator. In this method, a drop of acidified silver nitrate solution (KODAK Hypo Test Solution HT-2) is applied to a clear area of the film. The stain so produced is then matched to one of the calibrated patches on the Hypo Estimator. Since thses patches represent the stain produced by known quantities of hypo, a fair estimate of the hypo content of the film can be made.

Testing Papers for Residual Hypo: The amount of hypo in photographic paper can be determined quantitatively by the procedure described in the U.S.A.S.I. Method for Determining Residual Thiosulfate and Thiomates in Processed Photographic Papers, PH4.30-1962. In this method acidified silver nitrate is applied to an unexposed part of the processed print. Excess silver nitrate is removed with sodium chloride solution to convert the silver salt to silver chloride, which is then dissolved out in hypo. This step is necessary because the excess silver nitrate would darken in light and yield a false analysis.

The transmission densities of the paper before and after treatment with the silver nitrate solution are read on a densitometer fitted with a KODAK WRATTEN Filter No. 44 (blue-green). The difference in these readings indicates the amount of hypo in the material. The actual quantity of hypo present is determined in milligrams per square inch by reference to a standard curve showing the relationship between density and hypo concentration.

A spot-test adaptation of the above procedure can be used to obtain an estimate of the amount of residual hypo in a print. A drop of the KODAK Hypo Test Solution HT-2 is applied to an unexposed part of the processed print. After 2 minutes the reaction is complete; the stain can then be compared with the calibrated patches on the KODAK Hypo Estimator.

The Compact Photo-Lab-Index

KODAK PERMANGANATE REDUCER R-2
Cutting: For Correcting Overexposed Negatives

STOCK SOLUTION A

Water .	32	ounces	1.0 liter
Potassium Permanganate	1¾	ounces	52.5 grams

STOCK SOLUTION B

Water .	32	ounces	1.0 liter
Sulfuric Acid .	1	fl. oz.	32.0 ml

The best method of dissolving the permanganate crystals in Solution A is to use a small volume of hot water (about 180°F or 82°C) and shake or stir the solution vigorously until completely dissolved; then dilute to volume with cold water. When preparing Stock Solution B, *always add the sulfuric acid to the water slowly with stirring and never the water to the acid,* otherwise the solution may boil and spatter the acid on the hands or face, causing serious burns.

NOTE: If a scum forms on the top of the permanganate solution or a reddish curd appears in the solution, it is because the negative has not been sufficiently washed to remove all hypo, or because the permanganate solution has been contaminated by hypo. The separate solutions will keep and work perfectly for a considerable time if proper precautions against contamination are observed. The two solutions should not be combined until immediately before use. They will not keep long in combination.

A close observance of the foregoing instructions is important. Otherwise an iridescent scum will sometimes appear on the reduced negatives after they are dry; and it is difficult, if not impossible, to remove.

The negative must be thoroughly washed to remove all traces of hypo before it is reduced. For use take 1 part A, 2 parts B and 64 parts of water. When the negative has been reduced sufficiently place it in a fresh batch of Kodak Acid Fixing Bath F-5 for a few minutes, to remove yellow stains, then wash thoroughly.

If reduction is too rapid, use a large volume of water when diluting the solution for use. This solution should *not be used* as a stain remover as it has a tendency to attack the image before it removes the stain. Use Kodak Formula S-6 for removing developer stains.

Precautions: Stains are sometimes produced during reduction unless the following precautions are observed: 1. The negative should be fixed and washed thoroughly before treatment and be free of scum or stain. 2. It should be hardened in the formalin hardener (SH-1) before the reduction treatment. 3. Only one negative should be handled at a time and it should be agitated thoroughly during the treatment. Following the treatment, the negative should be washed thoroughly and wiped off carefully before drying.

KODAK FARMER'S REDUCER R-4a
Cutting: For All Professional Films and Plates to
Correct Overexposed Negatives

STOCK SOLUTION A

Potassium Ferricyanide	1¼	ounces	37.5 grams
Water to make .	16	ounces	500.0 ml

STOCK SOLUTION B

Kodak Sodium Thiosulfate (Hypo)	16	ounces	480.0 grams
Water to make .	64	ounces	2.0 liters

For use take: Stock Solution A, 1 ounce (30 ml); Stock Solution B, 4 ounces (120 ml), and water to make 32 ounces (1 liter). Add A to B, then add the water.

Pour the mixed solution at once over the negative to be reduced. Watch closely. The action is best seen when the solution is poured over the negative in a white tray. When the negative has been reduced sufficiently, wash thoroughly before drying.

(continued on following page)

342

For less rapid reducing action, use one-half the above quantity of Stock Solution A, with the same quantities of Stock Solution B and water.

Solutions A and B should not be combined until they are to be used. They will not keep long in combination.

Farmer's Reducer may also be used as two-solution formula by treating the negative in the ferricyanide solution first and subsequently in the hypo solution. Almost proportional reduction is obtained by this method. See Kodak Formula R-4b.

Precautions: Stains are sometimes produced during reduction unless the following precautions are observed: 1. The negative should be fixed and washed thoroughly before treatment and be free of scum or stain. 2. It should be hardened in the formalin hardener (SH-1) before the reduction treatment. 3. Only one negative should be handled at a time and it should be agitated thoroughly during the treatment. Following the treatment, the negative should be washed thoroughly and wiped off carefully before drying.

TWO-SOLUTION FARMER'S REDUCER R-4b
Proportional: For Correcting Overdeveloped Negatives

Farmer's Reducer may also be used as a two-solution formula by treating the negative in the ferricyanide solution first and subsequently in the hypo solution. This method has the advantage of giving almost proportional reduction and correcting for overdevelopment. The single solution Farmer's Reducer gives only cutting reduction and corrects for overexposure.

SOLUTION A

Kodak Potassium Ferricyanide	¼	ounce	7.5 grams
Water to make .	32	ounces	1.0 liter

SOLUTION B

Kodak Thiosulfate (Hypo)	6¾	ounces	200.0 grams
Water to make .	32	ounces	1.0 liter

Treat the negatives in Solution A with uniform agitation for 1 to 4 minutes at 65-70°F (18-21°C) depending on the degree of reduction desired. Then immerse them in Solution B for 5 minutes and wash thoroughly. The process may be repeated if more reduction is desired. For the reduction of general fog, 1 part of Solution A should be diluted with one part of water.

The ferricyanide solution will keep indefiniely if shielded from strong daylight. If hypo is introduced by alternate treatment the life of the ferricyanide solution will be shortened. The exhaustion life of the ferricyanide solution is approximately 75 feet of 35mm motion picture film per 32 ounces (1 liter) or its area equivalent.

PRECAUTIONS: Stains are sometimes produced during reduction unless the following precautions are observed: 1. The negative should be fixed and washed thoroughly before treatment and be free of scum or stain. 2. It should be hardened in Kodak Hardener (SH-1) before the reduction treatment. 3. Only one negative should be handled at a time and it should be agitated thoroughly during the treatment. Following the treatment, the negative should be washed thoroughly and wiped off carefully before drying.

The Compact Photo-Lab-Index

KODAK ACID PERMANGANATE PERSULFATE REDUCER R-5
Proportional: For Correcting Overdeveloped Negatives

STOCK SOLUTION A

Water 32	ounces	1.0 liter
Kodak Potassium Permanganate 4	grains	0.3 gram
*Kodak Sulfuric Acid (10% solution) ½	fl. oz.	16.0 ml

STOCK SOLUTION B

Water 96	ounces	3.0 liters
Kodak Ammonium Persulfate 3	ounces	90.0 grams

*To make a 10% solution of sulfuric acid, take 1 part of concentrated acid and add it to 9 parts of water, slowly with stirring. *Never add the water to the acid,* because the solution may boil and spatter the acid on the hands or face, causing serious burns.

For use, take one part of A to three parts of B. When sufficient reduction is secured the negative should be cleared in a 1% solution of sodium bisulfite. Wash the negative thoroughly before drying.

This solution is not recommended for motion picture work, as it does not keep well.

PRECAUTIONS: Stains are sometimes produced during reduction unless the following precautions are observed: 1. The negative should be fixed and washed thoroughly before treatment and be free of scum of stain. 2. It should be hardened in Kodak Hardener (SH-1) before the reduction treatment. 3. Only one negative should be handled at a time and it should be agitated thoroughly during the treatment. Following the treatment the negative should be washed thoroughly and wiped off carefully before drying.

KODAK FERRIC ALUM PROPORTIONAL REDUCER R-7
For Motion Picture Work

Water 16	ounces	500.0 ml
Sulfuric Acid 2½	fl. dr.	10.0 ml
Ferric Ammonium Sulfate (ferric alum) ... ½	ounce	15.0 grams
Add cold water to make 32	ounces	1.0 liter

When mixing the formula, be careful to add the acid to the water solution and not the water to the acid, or the solution will boil with explosive violence.

Use the reducer full strength at 65° to 70° (18° to 21°C). Films should be hardened with Kodak Hardener SH-1 and washed before treatment with the reducer solution. Important: Avoid contact with the air during reduction and washing or stains will result. Avoid contamination of this solution with hypo which shortens its life. Wash thoroughly after treating with the reducer.

This solution will keep indefinitely and has an average exhaustion life of 65 feet of 35mm motion picture film per 32 ounces (1 liter) or their area equivalent. Care should be taken to avoid contamination with hypo which reacts with the solution and decreases its useful life.

Precautions: Stains are sometimes produced during reduction unless the following precautions are observed: 1. The negative should be fixed and washed thoroughly before treatment and be free of scum or stain. 2. It should be hardened in Kodak Hardener (SH-1) before the reduction treatment. 3. Only one negative should be handled at a time and it should be agitated thoroughly during the treatment. Following the treatment, the negative should be washed thoroughly and wiped off carefully before drying.

The Compact Photo-Lab-Index

KODAK MODIFIED BELITZSKI REDUCER R-8a
For Correcting Overexposed and Overdeveloped Negatives

Water (125°F or 52°C) 24	ounces	750.0 ml
Ferric Ammonium Sulfate (Ferric Alum) .. 1½	ounces	45.0 grams
*Potassium Citrate 2½	ounces	75.0 grams
Kodak Sodium Sulfite, dessiccated 1	ounce	30.0 grams
Kodak Citric Acid ¾	ounce	22.5 grams
Kodak Sodium Thiosulfate (Hypo) 6¾	ounces	200.0 grams
Add cold water to make 32	ounces	1.0 liter

*Sodium citrate should not be used in place of potassium citrate because the rate of reduction is slowed up considerably.

Dissolve chemicals in the order given.
Use full strength for maximum rate of reduction. Treat negatives 1 to 10 minutes at 65° to 70°F (18° to 21°C). Then wash thoroughly. If a slower action is desired, dilute one part of solution with one part of water. The reducer is especially suitable for the treatment of dense, contrasty negatives.
The exhaustion life of this solution is approximately 35 feet of 35mm motion picture film per 32 ounces (1 liter) or its area equivalent.
Precautions: Stains are sometimes produced during reduction unless the following precautions are observed: 1. The negative should be fixed and washed thoroughly before treatment and be free of scum or stain. 2. It should be hardened in the formalin Kodak Hardener (SH-1) before the reduction treatment. 3. Only one negative should be handled at a time and it should be agitated thoroughly during the treatment. Following the treatment, the negative should be washed thoroughly and wiped off carefully before drying.

KODAK PERSULFATE REDUCER R-15
Super-Proportional: For Great Reduction of Contrast

STOCK SOLUTION A

Water 32	ounces	1.0 liter
Potassium Persulfate 1	ounce	30.0 grams

STOCK SOLUTION B

Water 8	ounces	250.0 ml
*Sulfuric Acid (10%) solution) ½	ounce	15.0 ml
Water to make 16	ounces	500.0 ml

*To prepare a 10% solution of sulfuric acid, take 1 part of Kodak Sulfuric Acid and, with caution to avoid contact with the skin, add it slowly to 9 parts of water with stirring. *Never add the water to the acid,* because the solution may boil and spatter the acid on the hands or face, causing serious burns.

For use: Take 2 parts of Solution A and add 1 part of Solution B. Only glass, hard rubber, or impervious and unchipped enamelware should be used to contain the reducer solution during mixing and use.
Treat the negative in the Kodak Special Hardener SH-1 for 3 minutes and wash thoroughly before reduction. Immerse in the reducer with frequent agitation and inspection (accurate control by time is not possible) and treat until the required reduction is almost attained; then remove from the solution, immerse in an acid fixing bath for a few minutes, and wash thoroughly before drying. Used solutions do not keep well and should be promptly discarded.
For best keeping in storage, the persulfate stock solution A should be kept away from excessive heat and light. Keeping life of stock solution A—about 2 months at 75°F.

The Compact Photo-Lab-Index

EASTMAN KODAK

KODAK MERCURY INTENSIFIER In-1
For Films and Plates

Bleach the negative in the following solution until it is white, then wash thoroughly.

Kodak Potassium Bromide	¾ ounce	22.5 grams
Mercuric Chloride	¾ ounce	22.5 grams
Water to make 32	ounces	1.0 liter

The negative can be blackened with 10% sulfite solution, a developing solution diluted 1 to 2, or 10% ammonia (1 part concentrated ammonia (28%) to 9 parts of water), these giving progressively greater density in the order given. To increase contrast greatly, treat with the following solution:

SOLUTION A

Water 16	ounces	500.0 ml
Sodium or Potassium Cyanide	½ ounce	15.0 grams

SOLUTION B

Water 16	ounces	500.0 ml
Kodak Silver Nitrate, crystals	¾ ounce	22.5 grams

***WARNING:** Cyanide is a deadly poison and should be handled with extreme care. Use rubber gloves and avoid exposure to its fumes. Cyanide reacts with acid to form poisonous hydrogen cyanide gas. When discarding a solution containing cyanide, always run water to flush it out of the sink quickly. Cyanide solutions should never be used in poorly ventilated rooms.

To prepare the intensifier, add the silver nitrate (Solution B) to the cyanide (Solution A) until a permanent precipitate is just produced; allow the mixture to stand a short time and filter. This is called Monckhoven's Intensifier.

Redevelopment cannot be controlled as with the chromium intensifier (Kodak Intensifier In-4), but must go to completion.

This Mercury Intensifier is recommended where extreme intensification is desired but where permanence of the resulting image is not essential. If permanence is essential, either the Chromium (Kodak Intensifier In-4) or Silver (Kodak Intensifier In-5) Intensifier should be used.

PRECAUTIONS: Stains are sometimes produced during intensification unless the following precautions are observed: 1. The negative should be fixed and washed thoroughly before treatment and be free of scum or stain. 2. It should be hardened in the formalin hardener (Kodak Hardener SH-1) before intensification treatment. 3. Only one negative should be handled at a time and it should be agitated thoroughly during the treatment. Following the treatment, the negative should be washed thoroughly and wiped off carefully before drying.

KODAK CHROMIUM INTENSIFIER In-4
For all Professional Films and Plates

STOCK SOLUTION

Water.. 24	ounces	750.0 ml
Kodak Potassium Dichromate	3 ounces	90.0 grams
Kodak Hydrochloric Acid, C.P.	2 fl. ozs.	64.0 ml
Add cold water to make 32	ounces	1.0 liter

For use take 1 part of stock solution to 10 parts of water.

Harden the negative with an alkaline solution of formalin (Kodak Hardener SH-1) before treatment with the chromium intensifier, or the gelatin may reticulate and ruin the negative.

Bleach thoroughly at 68°F (20°C), then wash five minutes and redevelop fully (about 5 minutes) in artificial light or daylight (not sunlight) in any quick-acting, non-staining developer containing the normal proportion of bromide, such as Kodak Developer D-72, diluted 1:3. If the negative is not redeveloped fully then fix for five minutes, and wash

346

thoroughly. Fixing is unnecessary if redevelopment is thorough. The degree of intensification may be controlled by varying the time of redevelopment. Greater intensification can be secured by repition.

Negatives intensified with chromium are more permanent than those intensified with mercury.

The Kodak Chromium Intensifier Powders are as satisfactory as Kodak Intensifier In-4, and are supplied in prepared form ready to use simply by dissolving in water.

***WARNING** *Developers containing a high concentration of sulfite, such as Kodak Developer D-76, are not suitable for redevelopment, since the sulfite tends to dissolve the bleached image before the redeveloping agents have time to act on it.*

PRECAUTIONS: Stains are sometimes produced during reduction unless the following precautions are observed: 1. The negative should be fixed and washed thoroughly before treatment and be free of scum or stain. 2. It should be hardened in the formalin Kodak Hardener (SH-1) before intensification treatment. 3. Only one negative should be handled at a time and it should be agitated thoroughly during the treatment. Following the treatment, the negative should be washed thoroughly and wiped off carefully before drying.

KODAK SILVER INTENSIFIER In-5
For General Use on Films or Plates

The following formula is the only intensifier known that will not change the color of the image on positive film on projection. It gives proportional intensification and is easily controlled by varying the time of treatment. The formula is equally suitable for positive and negative film.

STOCK SOLUTION No. 1 (Store in a brown bottle)

Kodak Silver Nitrate, crystals	2	ounces	60.0 grams	
Distilled water to make	32	ounces	1.0 liter	

STOCK SOLUTION No. 2

Kodak Sodium Sulfite, desiccated	2	ounces	60.0 grams	
Water to make	32	ounces	1.0 liter	

STOCK SOLUTION No. 3

Kodak Sodium Thiosulfate (Hypo)	3½	ounces	105.0 grams	
Water to make	32	ounces	1.0 liter	

STOCK SOLUTION No. 4

Kodak Sodium Sulfite desiccated	½	ounce	15.0 grams	
Kodak Elon	365	grains	25.0 grams	
Water to make	96	ounces	3.0 liters	

Prepare the intensifier solution for use as follows: Slowly add 1 part of solution No. 2 to 1 part of solution No. 1 shaking or stirring to obtain thorough mixing. The white precipitate which appears is then dissolved by the addition of 1 part of solution No. 3. Allow the resulting solution to stand for a few minutes until clear. Then add, with stirring, 3 parts of solution No. 4. The intensifier is then ready for use and the film should be treated immediately. The degree of intensification obtained depends upon the time of treatment, which should not exceed 25 minutes. After intensification, immerse the film for 2 minutes with agitation in a plain 30% hypo solution. Then wash thoroughly.

The mixed intensifier solution is stable for approximately 30 minutes at 68°F (20°C).

PRECAUTIONS: Stains are sometimes produced during intensification unless the following precautions are observed: 1. The negative should be fixed and washed thoroughly before treatment and be free of scum or stain. 2. It should be hardened in the formalin Kodak Hardener SH-1 before intensification treatment. 3. Only one negative should be handled at a time and it should be agitated thoroughly during the treatment. Following the treatment, the negative should be washed thoroughly and wiped off carefully before drying.

347

The Compact Photo-Lab-Index

KODAK QUINONE-THIOSULFATE INTENSIFIER In-6
For Use With Very Weak Negatives

This type of intensifier produces the greatest degree of intensification of any known single solution formula when used with high speed negative materials. The intensified image is of a brownish hue and is not indefinitely permanent, but its permanence under usual conditions of storage is considered analogous to that of uranium-toned images. The intensified image is destroyed by acid hypo so that under no circumstances should the intensified negatives be placed either in fixing baths or in wash water contaminated with fixing bath.

Direction for Use:

Avoid touching the emulsion side of films with the finger before or during intensification or surface markings will be produced. All negatives either dry or freshly processed should be washed 5 to 10 minutes and hardened in Kodak Hardener SH-1, for 5 minutes at 68°F (20°C) and then washed for 5 minutes after intensification. During treatment in the intensifier, agitate frequently to avoid streaking. Treat only one negative at a time when processing in a tray.

For highest degree of intensification, treat for about 10 minutes at 68°F (20°C), then wash 10 to 20 minutes and dry as usual; for a lower degree of intensification treat for shorter times.

Solution A

*Water (about 70°F)	24	ounces	750.0 ml
**Sulfuric Acid (Conc.)	1	ounce	30.0 ml
Kodak Potassium Dichromate	¾	ounce	22.5 grams
Water to make	32	ounces	1.0 liter

**CAUTION: Add the acid slowly and cautiously to the water, stirring carefully to avoid local overheating.

Solution B

*Water (about 70°F)	24	ounces	750.0 ml
Kodak Sodium Bisulfite	52	grains	3.8 grams
Kodak Hydroquinone	½	ounce	15.0 grams
Kodak Photo-Flo 200 solution	1	dram	3.8 ml
Water to make	32	ounces	1.0 liter

Solution C

*Water (about 70°F)	24	ounces	750.0 ml
Kodak Sodium Thiosulfate (Hypo)	¾	ounce	22.5 grams
Water to make	32	ounces	1.0 liter

*The water used for mixing the solutions for the intensifier should not have a chloride content greater than about 15 parts per million (equivalent to about 25 parts of sodium chloride per million), otherwise the intensification will be impaired. If in doubt as to chloride content, use distilled water.

For use: To 1 part of Solution A with stirring add 2 parts of Solution B, then 2 parts of Solution C; continue stirring and finally add 1 part of Solution A. The order of mixing is important and should be followed.

The stock solution for the intensifier will keep in stoppered bottles for several months. The intensifier should usually be mixed fresh before use, but it is stable for two or three hours without use. The bath should be used only once and then discarded, because a used bath may produce a silvery scum on the surface of the image.

KODAK STAIN REMOVER S-6
For Developer or Oxidation Stain on Negatives

Developer or oxidation stain may be removed by first hardening the film for 2 or 3 minutes in the Kodak Hardener Solution formula SH-1 then washing for 5 minutes and bleaching in:

STOCK SOLUTION A

Potassium Permanganate	75	grains	5.2 grams
Water to make	32	ounces	1.0 liter

STOCK SOLUTION B

Cold water	16	ounces	500.0 ml
Kodak Sodium Chloride	2½	ounces	75.0 grams
Sulfuric Acid*	½	fl. oz.	16.0 ml
Add cold water to make	32	ounces	1.0 liter

*Always add the sulfuric acid to the water slowly while stirring and never the water to the acid, otherwise the solution will boil and spatter the acid on the hands or the face, causing serious burns.

Use equal parts of A and B. The solutions should not be mixed until ready for immediate use, since they do not keep long after mixing. All particles of permanganate should be dissolved completely when preparing Solution A, since undissolved particles are likely to produce spots on the negative. Bleaching should be complete in 3 or 4 mintues at 68°F (20°C). The brown stain of manganese dioxide formed in the bleach is best removed by immersing the negative in 1% sodium-bisulfite solution. Then rinse well and develop in strong light (except direct sunlight) with any nonstaining developer, such as Kodak Developer D-72 diluted 1 part to 2 parts of water.

WARNING: Developers containing a high sulfite and low alkali concentration (such as Kodak Developer D-76) should not be used for redevelopment, because the sulfite tends to dissolve the silver image before the developing agents have had time to act upon it.

KODAK STAIN REMOVER S-10
For Removal of Fixer Stains From Clothing

The following formula will remove brownish stains which occasionally appear on clothing where a fixing bath has been spilled or splashed. Usually, this is caused by silver compounds which accumulate in the fixing bath as it is used.

Water	96	fluid oz.	750.0 ml
Kodak Thiourea	10	ounces	75.0 grams
Kodak Citric Acid	10	ounces	75.0 grams
Water to make	1	gallon	1.0 liter

For use: Thoroughly wet the stain with this solution and wait for the stain to disappear. Old stains may require more than one application and a longer time (several minutes) to disappear. The garment should be thoroughly washed after the stains have been removed.

Since newer-type fabrics may be involved, any garment should be tested by applying a small amount of the stain remover to a hidden portion (such as a shirttail or a small piece of the material snipped from an inside seam) to determine whether bleaching or other damage may occur.

Caution: Like all similar solutions, this stain remover contains thiourea, a powerful fogging agent which will contaminate photographic materials and cause black spots. This solution should not be used in the immediate area where light-sensitive photographic materials or processing chemicals are handled. It is difficult to remove traces of this chemical from the hands by washing in water; therefore, contact of the skin with this stain remover should be prevented by the use of rubber gloves. In order to decontaminate the gloves, rinse the outer surfaces in a dilute solution of sodium hypochlorite and then wash thoroughly in warm water. This solution can be prepared by adding one fluid ounce of any commercial hypochlorite solution, such as Clorox, 101, Sunny Sol, etc., to one quart of water.

EASTMAN KODAK

KODAK TRAY CLEANER TC-1
For General Use

Water	. .	32 ounces	1.0 grams
Kodak Potassium Dichromate	3 ounces	90.0 grams
Sulfuric Acid, (conc.)	3 fluid oz.	96.0 ml

Add the sulfuric acid slowly while stirring the solution rapidly.

For use, pour a small volume of the Tray Cleaner solution into the vessel to be cleaned. Rinse around so that the solution has access to all parts of the tray; then pour the solution out and wash the tray six or eight times with water until all traces of the cleaning solution disappear.

This solution will remove stains caused by oxidation products of developers, and some silver stains and dye stains. It is a very useful cleaning agent.

KODAK TRAY CLEANER TC-3
And Hand Stain Remover

SOLUTION A

Water	. .	32 ounces	1.0 liter
Potassium Permanganate	29 grains	2.0 grams
Sulfuric Acid (conc.)	1 dram	4.0 ml

Store the solution in a stoppered glass bottle away from light.

*CAUTION: Always add the sulfuric acid to the solution slowly, stirring constantly, and never the solution to the acid; otherwise the solution may boil and spatter the acid on the hands or the face, causing serious burns.

SOLUTION B

Water	. .	24 ounces	750.0 ml
Kodak Sodium Bisulfite	1 ounce	30.0 grams
Kodak Sodium Sulfite, desiccated	1 ounce	30.0 grams
Add cold water to make	32 ounces	1.0 liter

The Solutions A and B can be used for cleaning several vessels, but should be discarded after use.

An acid fixing bath may be used in place of Solution B, but it is important to wash thoroughly to eliminate hypo from the tray and the hands.

CLEANING TRAYS

To remove stains due to silver, silver sulfide, and many dyes, pour a small quantity of Solution A into the vessel and allow to remain for a few minutes; rinse well and then replace with a similar volume of Solution B. Agitate so as to clear the brown stain completely, then wash thoroughly.

CLEANING THE HANDS

To clean stains from fingernails or skin, remove rings from fingers, and immerse the hands from 1 to 3 minutes in Solution A contained in a glass or similar vessel, gently rubbing the stained areas. Rinse briefly in running water and immerse for a few minutes in Solution B, then wash thoroughly, preferably in warm water.

The Compact Photo-Lab-Index

KODAK ANTI-CALCIUM
For Prevention of Developer Sludge

Kodak Anti-Calcium is a compound which serves to prevent or greatly minimize the formation of calcium precipitates. Kodak Anti-Calcium is of the polyphosphate or so-called "water-softener" family and acts as a calcium binder. It has no detrimental action on the developer.

Owing to the presence of calcium salts in most tap water, many developers have a tendency to produce precipitates commonly known as sludge. The degree of sludging depends greatly on the relative hardness of the water. While sludge does not affect the developer's action, it is nevertheless objectionable because it seriously interferes with clear visibility of the print during development and because these precipitations form a hard to-remove scale on developing hangers, clips, and processing machinery. In addition, it frequently forms a scum on negatives, which is very hard to remove.

The amount of Anti-Calcium needed to bind the calcium in the developer and replenisher depends on the nature of the developer.

GROUP A	8 grains of Kodak Anti-Calcium per quart of developer (0.5 grams per liter) DK-20, D-23, D-25, DK-50, DK-60a, DK-60b, and D-76
GROUP B	30 grains of Kodak Anti-Calcium per quart of developer (2.0 grams per liter) D-11, D-16, D-19, D-19b. and D-61a (tank or tray dilution)
GROUP C	60 grains of Kodak Anti-Calcium per quart of developer (4.0 grams per liter) D-52, and 90 grains per quart (6.0 grams per liter) in D-72

Kodak Anti-Calcium is not recommended for use in caustic developers such as Kodak Developer D-8 and D-82 because caustic developers greatly accelerate the decomposition of Kodak Anti-Calcium and in any case have little tendency toward formation of calcium precipitates.

At elevated temperatures, such as 85°F to 95°F Kodak Anti-Calcium will remain effective for several weeks. An addition of sodium citrate of double the weight of the Kodak Anti-Calcium is suggested under such circumstances.

The Kodak prepared developers, such as Kodak Dektol, Microdol, and Versatol, have, when used with water of normal hardness, no tendency toward calcium precipitation. However, if they are prepared in solution with exceptionally hard water, the addition of Kodak Anti-Calcium will ensure continued absence of such precipitation.

TONING FORMULAS
Toning Baths for Projector Slides, Transparencies, and Motion-Picture Prints

Three distinct methods of toning are possible:

1. Toning by direct development.
2. Toning by replacement of the silver image with inorganic salts (metal tones).
3. Toning with dyes (dye tones).

1. Toning by Direct Development

The color of the silver image produced by development is determined by the size of the silver particles composing the image, and it is possible to control the size of these particles and therefore the color of the image by modifying the nature of the developer.

The developer Kodak Developer D-32 will give pleasing warm-black tones.

The range of colors obtainable, however, is not very great and it is usually easier and more certain to produce such slight modifications of color either by delicate dye tinting or by giving a short immersion in one of the diluted toning baths.

EASTMAN KODAK

The Compact Photo-Lab-Index

2. Toning by Replacement of the Silver Image with Inorganic Salts

Since most toning processes intensify the original silver image, it is best to commence with a slide or a positive print which is somewhat on the thin side. Experience will dictate the most suitable image quality with various toning processes which yields the best results.

Stability of Solutions – All toning baths containing potassium ferricyanide are sensitive to light, the ferricyanide being reduced to ferrocyanide, with the resulting formation of a sludge of the metallic ferrocyanide. When not in use, tanks should be covered to prevent exposure to daylight and small volumes of solution should be placed in dark-brown bottles.

It is also very important that no metallic surface, however small, should come in contact with the solutions. Wooden or stoneware tanks with wooden faucets should be used. Motion-picture film should be wound on wooden racks-free of metal pegs.

KODAK HYPO ALUM SEPIA TONER T-1a
For Warm Tone Papers

Cold Water	90	ounces	2800.0 ml
Kodak Sodium Thiosulfate (Hypo)	16	ounces	480.0 grams

Dissolve throughly, and add the following solution:

Hot water (about 160°F) (70°C)	20	ounces	640.0 ml
Kodak Potassium Alum	4	ounces	120.0 grams

Then add the following solution (including precipitate) slowly to the hypo-alum solution while stirring the latter rapidly.

Cold Water	2	ounces	64.0 ml
Kodak Silver Nitrate, crystals	60	grains	4.0 grams
Sodium Chloride	60	grains	4.0 grams

After combining above solutions

Add water to make	1	gallon	4.0 liters

NOTE: The silver nitrate should be dissolved completely before adding the sodium chloride and immediately afterward the solution containing the milky white precipitate should be added to the hypo-alum solution as directed above. The formation of a black precipitate in no way impairs the toning action of the bath if proper manipulation technique is used.

For use, pour into a tray supported in a water bath and heat to 120°F (49°C). At this temperature prints will tone in 12 to 15 minutes depending on the type of paper. Never use the solution at a temperature above 120°F (49°C). Blisters and stains may result. Toning should not be continued longer than 20 minutes at 120°F (49°C).

In order to produce good sepia tones, the prints should be exposed so that the print is slightly darker than normal when developed normally (1½ to 2 minutes).

The prints to be toned should be fixed thoroughly and washed for a few minutes before being placed in the toning bath. Dry prints should be soaked thoroughly in water. To insure even toning, the prints should be immersed completely, and separated occasionally, especially during the first few minutes.

After prints are toned, they should be wiped with a soft sponge and warm water to remove any sediment, and washed for one hour in running water.

The Compact Photo-Lab-Index

SULFIDE SEPIA TONER T-7a
For Cold Tone Papers

STOCK BLEACHING SOLUTION A

Kodak Potassium Ferricyanide	2½	ounces	75.0 grams
Kodak Potassium Bromide	2½	ounces	75.0 grams
Potassium Oxalate	6½	ounces	195.0 grams
*Kodak Acetic Acid 28%	1¼	fl. ozs.	40.0 ml
Water	. .	64	ounces	2.0 liters

*To make 28% acetic acid from glacial acetic acid, dilute 3 parts of glacial acetic acid with 8 parts of water.

STOCK TONING SOLUTION B

Kodak Sodium Sulfide, desiccated (not Sulfite)	1½	ounces	45.0 grams	
Water to make	. .	16	ounces	500.0 ml

Prepare Bleaching Bath as follows:

Stock Solution A	16	ounces	500.0 ml
Water to make	. .	16	ounces	500.0 ml

Prepare toner as follows:

Stock Solution B	4	ounces	125.0 ml
Water to make	. .	32	ounces	1.0 liter

The print to be toned should first be washed thoroughly. Place it in the Bleaching Bath, and allow it to remain until only faint traces of the halftones are left and the black of the shadows has disappeared. This operation will take about one minute.

NOTE: Particular care should be taken not to use trays with any *iron* exposed, otherwise blue spots may result.

Rinse *thoroughly* in clean cold water.

Place in Toner Solution until original detail returns. This will require about 30 seconds. Give the print an immediate and thorough water rinse; then immerse it for five minutes in a hardening bath composed of 1 part of the stock hardener Kodak Hardener F-1a and 16 parts of water. The color and gradation of the finished print will not be affected by the use of this hardening bath. Remove the print from the hardener bath and wash for one-half hour in running water.

KODAK POLYSULFIDE TONER T-8
For Sepia Toning

The following single-solution toning bath is recommended for use on all Kodak papers except Kodak Kodabromide. It produces slightly darker sepia tones than the redevelopment-sulfide toner, Kodak Toner T-7a, and has the advantage, compared with hypo alum toners, that it will tone in a much shorter time and does not require heating, although raising the temperature to 100°F reduces the time of toning from 15 to 3 minutes.

Water	. .	24	ounces	750.0 ml
Polysulfide (Liver of Sulfur)	¼	ounce	7.5 grams
Kodak Sodium Carbonate, monohydrated	. . .	35	grains	2.5 grams
Water to make	. .	32	ounces	1.0 liter

Dissolve chemicals in the order given.

Immerse the well-washed black-and-white print in the Kodak Toner T-8 bath and agitate for 15 to 20 mintues at 68°F (20°C) or for 3 to 4 minutes at 100°F (38°C).

Approximate life of toning bath is about 150 8x10-inch prints (or equivalent) per gallon. When the bath begins to become cloudy, the life can be extended by the addition of the same quantity of carbonate as in the formula.

After toning, if any sediment appears on the print, the surface should be wiped with a soft sponge and the print then washed for at least 30 minutes before drying.

EASTMAN KODAK

The Compact Photo-Lab-Index

KODAK IRON TONER T-11
For Blue Tones on Slides or Films

Kodak Potassium Persulfate	7 grains	0.5 gram
Iron and Ammonium Sulfate (Ferric Alum)	20 grains	1.5 grams
Oxalic Acid	45 grains	3.0 grams
Kodak Potassium Ferricyanide	15 grains	1.0 gram
Ammonium Alum	73 grains	5.0 grams
Hydrochloric Acid 10%	¼ dram	1.0 ml
Water to make	32 ounces	1.0 liter

Dissolve chemicals in the order given.

The method of compounding this bath is very important. Each of the solid chemicals should be dissolved separately in a small volume of water, the solution then mixed strictly in the order given, and the whole diluted to the required volume. If these instructions are followed, the bath will be pale yellow in color and perfectly clear.

Immerse the slides or films from 2 to 10 minutes at 68°F (20°C) until the desired tone is obtained. Wash for 10 to 15 minutes until the highlights are clear. A very slight permanent yellow coloration of the clear gelatin will usually occur, but should be too slight to be detectable on projection. If the highlights are stained blue, then either the slide (film) was fogged during development, or the toning bath was stale or not mixed correctly.

Since the toned image is soluble in alkali, washing should not be carried out for too long a period, especially if the water is slightly alkaline.

Life of the Bath for Motion Picture Work – If the acid is renewed after toning each 5,000 feet, the bath is capable of toning 36,000 feet per 120 gallons of solution

KODAK IRON TONING BATH T-12
For Blue Tones on Paper Prints

Kodak Ferric Ammonium Citrate (green scales)	60 grains	4.0 grams
Kodak Oxalic Acid, crystals	60 grains	4.0 grams
Kodak Potassium Ferricyanide	60 grains	4.0 grams
Water to make	32 ounces	1.0 liter

Dissolve each chemical separately and filter before mixing together.

Immerse the well-washed print in the toning bath for 10 to 15 minutes until the desired tone is obtained. Then wash until the highlights are clear.

3. Dye Toning

It is not possible to obtain more than a limited number of tones by the use of colored inorganic compounds, owing to the limited number of such compounds. Certain inorganic compounds, however, such as silver ferrocyanide, can be used as mordants for basic dyes such as Victoria Green, Salfranine, etc. If, therefore, a silver image is converted more or less to a silver ferrocyanide image and then immersed in a solution of a basic dye, a mordanted dye image is produced.

KODAK DYE BATH T-17a
For Use with Kodak Toner T-18

Dye	3 grains	0.2 gram
*Kodak Acetic Acid, 10%	1¼ drams	5.0 ml
Water to make	32 ounces	1.0 liter

*To convert glacial acetic acid into 10% acetic, take 1 part glacial acetic acid and add it slowly to 9 parts of water.

Thoroughly dissolve the dye in hot water, filter, add the acid and dilute to volume with cold water.

The following dyes are suitable for toning:

The Compact Photo-Lab-Index

Safranine A Red	Victoria Green Green		
Chrysoidine 3R Orange	*Methylene Blue BB..... Blue		
*Auramine O Yellow	†Methyl Violet Violet		

†For methyl violet use ¼ the quantity of dye given in the formula.

Note: The dyes listed are obtainable from the Eastman Kodak Company, Eastman Organic Chemicals Rochester New York 14650, in small quantities. Larger quantities should be purchased directly from the manufacturer: Allied Chemical Corp., Specialty Chemical Division, Morristown, New Jersey 07960.

KODAK TONING BATH T-18
For Double Tones on Slides or Films

Double Tones: This bath tones the halftones white and the shadows blue. If the resulting image is immersed in any of the basic dye solutions which are used for dye toning (Kodak Toner T-17a), the dye is mordanted to the halftones while the shadows remain more or less blue. By varying the dye solution used, the color of the halftones may be varied at will.

Ammonium Persulfate	7	grains	0.5 gram
Iron and Ammonium Sulfate (Ferric Alum) ..	20	grains	1.4 grams
Oxalic Acid	45	grains	3.0 grams
Kodak Potassium Ferricyanide	15	grains	1.0 gram
Hydrochloric Acid, 10%	¼	dram	1.0 ml
Water to make	32	ounces	1.0 liter

The method of compounding this bath is very important. Each of the solid chemicals should be dissolved separately in a small volume of water, the solutions then mixed strictly in the order given, and the whole diluted to the required volume. If these instructions are followed, the bath will be pale yellow in color and perfectly clear.

DIRECTIONS FOR USE: Tone until the shadows are deep blue. Then wash 10 to 15 minutes. Immerse in the basic dye solution used for dye toning for 5 to 15 minutes until the desired depth of color in the halftones is obtained. Wash 5 to 10 minutes after dyeing until the highlights are clear.

Life of the Bath for Motion Picture Work—If the acid is renewed after toning each 5,000 feet, the bath is capable of toning 36,000 feet per 120 gallons (480 liters) of solution.

KODAK SINGLE SOLUTION DYE TONER T-20
For Slides or Films

*Dye	x	grains	x grams
Wood Alcohol (or Acetone)	3¼	fl. ozs.	100.0 ml
Kodak Potassium Ferricyanide	15	grains	1.0 gram
Kodak Acetic Acid (glacial)	1¼	drams	5.0 ml
Water to make	32	ounces	1.0 liter

*The quantity of dye varies according to the dye used as follows:

Nabor Yellow 6G	3	grains	0.2 grams
Nabor Orange G	3	grains	0.2 grams
Nabor Brilliant Pink	3	grains	0.2 grams
Nabor Blue 2 G	3	grains	0.2 grams
Bismark Brown 53	3	grains	0.2 grams
Phosphine 2 RN	3	grains	0.2 grams
Chrysoidine Base	3	grains	0.2 grams
Chrysoidine 3R	3	grains	0.2 grams
*Auramine	6	grains	0.4 gram
Victoria Green	6	grains	0.4 gram
*Rhodamine B	6	grains	0.4 gram

*The dyes listed are obtainable from Eastman Kodak Company, Eastman Organic Chemicals, Rochester New York, 14650 in small quantities. Larger quantities should be

The Compact Photo-Lab-Index

purchased directly from the manufacturer, Allied Chemical Corp., Specialty Chemical Division, Morristown, New Jersey, 07960.

The nature of the tone varies with time of toning and eventually a point is reached beyond which it is unsafe to continue as the gradation of the toned image becomes affected. Average toning time at 68°F (20°C) is from 3 to 9 minutes. Further details on the use of this formula may be obtained by referring to the following paper: "Dye Toning with Single Solutions," by J. I. Crabtree and C. E. Ives, Trans. Soc. Mot. Pict. Eng. *12* : 967 (1928).

KODAK GOLD TONER (Nelson) T-21
For Warm Tone Papers

The feature of this toning bath is that a variety of excellent brown tones may be obtained by varying the time of toning, that is, the prints may be removed at any time from the bath when a satisfactory color is obtained. For average results, toning will require about 5 to 20 minutes for professional contact papers according to the depth of tone desired. After fixing, wash the prints for a few minutes before toning.

STOCK SOLUTION A

Water (about 125°F or 52°C)	1	gallon	4.0 liters
Kodak Sodium Thiosulfate (Hypo)	2	pounds	960.0 grams
Kodak Potassium Persulfate	4	ounces	120.0 grams

Dissolve the hypo completely before adding the potassium persulfate. Stir the bath vigorously while adding the potassium persulfate. If the bath does not turn milky, increase the temperature until it does. Prepare the following solution and add it (including precipitate) slowly to the hypo-persulfate solution while stirring the latter rapidly. *The bath must be cool when these solutions are added together.*

Cold Water	2	ounces	64.0 ml
Kodak Silver Nitrate (crystals)	75	grains	5.2 grams
Sodium Chloride	75	grains	5.2 grams

NOTE: The silver nitrate should be dissolved completely before adding the sodium chloride.

STOCK SOLUTION B

Water	8	ounces	250.0 ml
Kodak Gold Chloride	15	grains	1.0 gram

For use, slowly add 4 ounces (125ml) of Solution B to Solution A while stirring the latter rapidly.

The bath should not be used until after it has become cold and has formed a sediment. Then pour off the clear liquid for use.

Add the clear solution to a tray standing in a water bath and heat to 110°F (43°C). The temperature, when toning, should be between 100° and 110°F (38° and 43°C). Dry prints should be soaked thoroughly in water before toning.

Keep at hand an untoned black-and-white print for comparison during toning. Prints should be separated at all times to insure even toning.

When the desired tone is obtained, rinse the prints in cold water. After all prints have been toned, return them to the fixing bath for 5 minutes, then wash for 1 hour in running water.

The bath should be revived at intervals by the addition of further quantities of the gold solution B. The quantity to be added will depend upon the number of prints toned and the time of toning. For example, when toning to a warm brown, add 1 dram (4ml) of gold solution after each fifty 8x10-inch prints or their equivalent have been toned. Fresh solution may be added from time to time to keep the bath up to proper volume.

The Compact Photo-Lab-Index

PHOTOGRAPHIC PROCESSING
At Low and Sub-zero Temperatures

A good deal of time and effort has gone into the solution of the problem of high-temperature and tropical processing; it may, in fact, be said to have been solved for any temperature likely to be met with anywhere in the world.

On the other hand, little is known about the feasibility of processing at very low temperatures, and the following material is taken from a report, Communication No. 1019 from the Kodak Research Laboratories, by R. W. Henn and J.I. Crabtree.

It is generally believed that developing agents, and particularly hydroquinone, become inactive below about 55°F and it is usually advised to warm solutions to working temperature rather than to attempt processing in very cold baths. However, it is possible to develop films at low temperatures with modifications of standard formulas, and at very low temperatures with special developers of exceedingly high energy.

DEVELOPERS FOR LOW TEMPERATURE PROCESSING

The principal problem when processing at low temperatures is the loss of activity of the developer, since with most developers the time of development increases two-fold for a drop of 10° to 20°F. It is advisable, therefore, to start with a developer which at normal temperatures is very active. Of the available developers, Kodak Developer D-8, a caustic hydroquinone developer, and a more alkaline variation of the Kodak Developer D-82 with added caustic soda, are especially suitable. Preliminary tests indicated the desirability of an even more active developer, and a caustic solution of two powerful agents, amidol and catechol, was devised.

KODAK HIGH ENERGY DEVELOPER D-82 + Caustic
For Low Temperature Processing

Water (125°F or 52°C)	16	ounces	500.0 ml
Kodak Elon	200	grains	14.0 grams
Kodak Hydroquinone	200	grains	14.0 grams
Kodak Sodium Sulfite	1¾	ounces	52.5 grams
Kodak Sodium Hydroxide	250	grains	17.6 grams
Kodak Potassium Bromide	125	grains	8.8 grams
Kodak Anti-Fog #1	3	grains	0.2 grams
Add cold water to make	32	ounces	1.0 liter

For use down to +30°F: Use above formula undiluted.
For use down to +5°F: Take 3 parts stock solution, 1 part ethylene glycol.
The ethylene glycol should be added prior to storage at low temperatures.

(continued on following page)

EASTMAN KODAK

357

KODAK AMIDOL-CATECHOL DEVELOPER SD-22
For Low Temperature Processing

SOLUTION A

Water (125°F or 52°C)	16	oz.	500.0 ml
Kodak Sodium Bisulfite	3 oz. 145	grains	100.0 grams
Amidol (2.4 Diaminophenol Hydro- chloride	1 oz. 145	grains	40.0 grams
Catechol (Pyrocatechin)	1 oz. 145	grains	40.0 grams
Kodak Anti-Fog #1	30	grains	0.2 grams
Add cold water to make	32	ounces	1.0 liter

SOLUTION B

Cold water	16	ounces	500.0 ml
Sodium Hydroxide	4	ounces	120.0 grams
Kodak Potassium Bromide	290	grains	20.0 grams
Potassium Iodide	60	grains	4.0 grams
Add cold water to make	32	ounces	1.0 liter

For use down to +30°F: Solution A, 1 part; Solution B, 1 part; Water, 2 parts.
For use down to +5°F: Solution A, 1 part; Solution B, 1 part; Water, 1 part; Ethylene Glycol, 1 part.
For use down to −40°F: Solution A, 1 part; Solution B, 1 part; Ethylene Glycol, 2 parts.

The glycol may be divided and added to each of these solutions previous to storage at low temperatures. Combine Solutions A and B only immediately before use, since the mixed developer oxidizes rapidly. Solution A may also deteriorate on keeping, and should be kept well-stoppered and as cool as possible.

The Kodak Developer D-8 is to be preferred over the Kodak Developer D-82+Caustic since it gives less fog. The Amidol-Catechol formula gave very good speed and curves with long straight lines but oxidized rapidly and should, therefore, be considered a special-purpose solution.

THE USE OF ANTIFREEZE MIXTURES

The working temperature of the above solutions is limited more by their freezing point than by their activity. A number of anti-freeze additions were tried, including ethylene glycol, glycerine, and alcohol. Of the three, ethylene glycol proved the most practical and is recommended in all cases. It must, however, be pure; commercial antifreeze solutions for automotive use contain oily compounds intended as rust-preventives, and are likely to leave deposits on the film.

Ethylene glycol does thicken the bath somewhat, and hence tends to decrease the developer activity.

Development is possible at 0°F, a very satisfactory image of reasonable contrast and image speed being obtained when the times are sufficiently extended. The developing temperature could apparently be as low as about −40°F, but owing to the long times involved, no images have been developed to full contrast at this temperature. The Kodak Developer D-8, a hydroquinone developer, maintains its activity surprisingly well at low temperatures; apparently hydroquinone in caustic solution loses activity no more rapidly as the temperature decreases than elon, amidol or catechol.

FIXING

Fixation, like development, is less rapid at lower temperatures and it is advantageous to employ a bath of high activity such as one compounded with ammonium thiosulfate. The optimum concentration of ammonium hypo solutions varies with the temperature, more dilute solutions being advantageous as the temperature is lowered. A hardener is not essential, and it is usually well to omit this to promote rapid washing. Ethylene glycol was found compatible and was added to prevent freezing.

(Continued on following page)

EASTMAN KODAK

The Compact Photo-Lab-Index

Much more rapid fixation may be obtained by the use of a thiocyanate bath. A concentration of about 40% of potassium thiocyanate has been found approximately optimum for temperatures ranging from 20° to 70°F. This bath will clear developed film in 3½ minutes at 20°F, whereas the ammonium hypo baths take over 1 hour.

Since the freezing point of this thiocyanate bath is approximately 0°F, no anti-freeze need be added unless extremely low temperatures are to be encountered. The chief objection to thiocyanate fixing baths is an extreme tendency to swell and soften the gelatin, causing reticulation on drying. This may largely be overcome by adding formalin (about 5%) as a hardener, and at the same time adding sodium carbonate to promote the hardening of the formaldehyde. The permanence of images fixed in this bath appear to be satisfactory, but pending further experience with it, and in view of its high cost, it is recommended only for special purposes.

WASHING

The rate of hypo elimination appears to decrease with the temperature of the wash water, but this is not too serious with negative materials, especially when a non-hardening fixer is employed, since unhardened films wash much faster. It has been found possible to wash films very satisfactorily below the normal freezing temperature of water by employing several changes of baths consisting of a glycol-water mixture.

DRYING

Drying is very slow at low temperatures, and becomes even slower in the absence of an adequate circulation of air. When the air temperature approaches the freezing point, the water in the film may freeze, creating permanent patterns in the gelatin, though the ice will evaporate eventually, even at temperatures well below freezing.

The addition of glycol to the water solution will prevent this freezing, but an alcohol bath is preferred since it will greatly decrease the drying time. Isopropyl alcohol, or a good grade of denatured alcohol, such as ethyl alcohol containing 5% of methyl alcohol, is suitable. These should be used without dilution with water, since it has been found that the alcohol tends to evaporate first, leaving the water to freeze. Film bathed in denatured alcohol has been found to dry in about ½ hour in a moderate current of air at temperatures approaching 0°F. At these low temperatures, and for short times of bathing, denatured alcohol has little or no deleterious action on the film support.

PROCEDURE FOR PROCESSING FILM IN THE +30°F TO +60°F RANGE

1) Develop in Kodak Developer D-8 for times as given on the Time-Temperature Development Chart below.
2) Rinse in dilute acetic acid (Kodak Stop Bath SB-1) for about 1 minute.
3) Fix in Kodak Rapid Fixer diluted 4 parts with 6 parts of water, for 1½ times the time required to clear, which latter should be approximately 4 min. at 60°F or 8 min. at 40°F. The hardener may be omitted.
4) Wash in running water for 30 minutes or in 4 successive changes of water for 2 to 5 minutes in each. Where water is scarce, these rinse baths may be saved, discarding the No. 1 bath each time and employing a fresh No. 4 bath.
5) Dry naturally, or with heat if available. For more rapid drying, bathe in isopropyl alcohol or a good grade of denatured alcohol for 1 to 2 minutes. The film should then be dried without heat or opalescence may result. Use of an 85% alcohol solution will eliminate opalescence but drying will be slower.
6) If the solutions are likely to be subjected to freezing temperatures during storage, 25% of ethylene glycol should be added and the processing times doubled. The alcohol bath is imperative when there is danger of freezing during drying.

(Continued on following page)

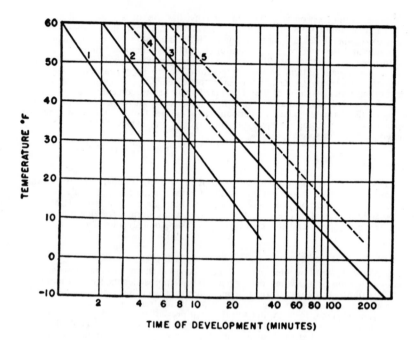

TIME OF DEVELOPMENT (MINUTES)

TIME-TEMPERATURE CURVES FOR LOW TEMPERATURE DEVELOPERS
(1) Kodak SD-22, no glycol; (2) Kodak SD-22, 25% glycol; (3) Kodak SD-22, 50% glycol;
(4) Kodak D-8, no glycol; (5) Kodak D-8 + 25% glycol.

PROCEDURE FOR PROCESSING FILM IN THE +5°F TO +30°F RANGE

1) Develop in Kodak Developer D-8 + 25% Ethylene Glycol or in the Amidol-Catechol formula + 25% Ethylene Glycol for times as indicated in the Time Gamma Temperature Development Chart above.
2) Rinse in a solution containing 1% Acetic Acid and 25% Ethylene Glycol.
3) Fix in a solution containing 2 parts of Kodak Rapid Liquid Fixer, without hardener, 2 parts of Ethylene Glycol and 6 parts of water, until clear. (See Fixing Time Chart below.)
4) Wash in 4 successive baths of a 25% ethylene glycol soution for periods of 5 to 10 minutes each. As few as two successive rinses may be employed if the film is to be washed thoroughly later.
5) Bathe for 2 to 3 minutes in isopropyl alcohol or a good grade of denatured alcohol and dry.

(Continued on following page)

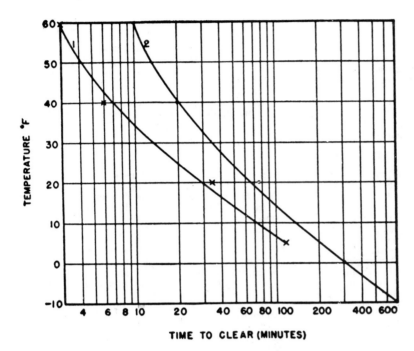

EASTMAN KODAK

TIME TO CLEAR (MINUTES)

APPROXIMATE "TIME TO CLEAR"

In low temperature fixing baths prepared by diluting the Kodak Rapid Liquid Fixer (hardener omitted) with water and ethylene glycol. (1) Fixer 20 parts, glycol 20 parts, water 60 parts; (2) Fixer 10 parts, glycol 50 parts, water 40 parts.

PROCEDURE FOR PROCESSING FILM IN THE −40°F TO +5°F RANGE

1) Develop in the amidol-catechol Kodak Developer SD-22, employing 50% ethylene glycol, for times given by the Time-Temperature Chart above.
2) Fix in solution containing Kodak Rapid Fixer (no hardener) 1 part, ethylene glycol 5 parts, water 4 parts, until clear. (See chart above for fixing time.)
3) Bathe in two successive baths of 50% ethylene glycol for 15 to 30 minutes each.
4) Bathe in isopropyl alcohol or denatured alcohol for 10 minutes and dry.

NOTES ON LOW-TEMPERATURE PROCESSING

Since a developer at 0°F is dangerous to unprotected fingers, it is obvious that suitable handling equipment is necessary. Probably a plastic tank and plastic or metal hangers may serve; the latter will have to be handled with gloves.

The range of temperatures between +30° and +60°F is most likely to be widely used, since such conditions are frequently encountered even in temperate zones, during the winter.

KODAK DEVELOPER D-76

Kodak Developer D-76 produces full emulsion speed and maximum shadow detail with normal contrast, and is well known for superior performance. It produces images with high definition and moderately fine grain. Kodak Developer D-76 is recommended for tray or tank use. For greater sharpness, but with a slight increase in graininess, you can dilute the developer 1:1.

The excellent development latitude of Developer D-76 permits pushed development with very little fog. However, pushed development increases graininess with any developer. Follow the times in the table on the following page for normal development.

LIFE AND CAPACITY

Mix the entire contents of the developer (or replenisher) package at one time. The keeping qualities of unused Kodak Developer D-76 stored in a full, tightly stoppered bottle are excellent. You may want to keep the developer in several smaller bottles rather than one large bottle. This lets you exclude as much air as possible as you use up the developer. The unused solution will keep for six months in a full, tightly stoppered bottle and for two months in a tightly stoppered bottle that is half full.

The capacity of Developer D-76 is 16 rolls of 135-size film (36-exposure), 87 square inches per roll, or their equivalent, per gallon when used full strength without replenishment. This is based on using the developer and pouring it back into the bottle. Increase the development time by 15 percent after each four rolls of film have been processed.

When you use Developer D-76 at the 1:1 dilution, dilute it just before use. No reuse or replenishment is recommended. The capacity of the 1:1 dilution in a single use is about 8 rolls of 135-size film (36-exposure), or equivalent, per gallon of diluted developer. If you use only 8 ounces of solution (1:1) for each 36-exposure roll of 135-size film, increase the recommended development times by approximately 10 percent. The capacity for each gallon of 1:1 solution will then be increased to 16 rolls of film. Do not store the diluted developer for future use or leave it in processing equipment for extended periods.

REPLENISHMENT

Proper replenishment of Developer D-76 with Kodak Replenisher D-76R will maintain a constant rate of development, film speed, and moderately fine grain characteristics without the necessity of increasing the development time. Replenish only full-strength solutions of the developer. Discard Developer D-76 diluted 1:1 after each use, and do not replenish it.

To replenish developer in small tanks, use ¾ ounce of Replenisher D-76R for each 36-exposure roll of 135 film (87 square inches) developed. Add the replenisher to the developer bottle before returning the used developer from the tank.

In large tanks, add replenisher as needed to replace the developer carried out by the films and to keep the liquid level constant in the tank. Ordinarily, you can do this by adding ¾ ounce of Replenisher D-76R for each 8 x 10-inch sheet of film or equivalent, that you process. Add the replenisher and stir it in thoroughly after each batch of film or after not more than four 8 x 10-inch sheets (320 square inches) of film or equivalent have been processed per gallon of developer. Refer to the replenishment table below.

PACKAGE SIZES

Kodak Developer D-76 is packaged to make 1 quart or ½, 1, or 10 gallons of stock solution. Kodak Replenisher D-76R is available in a 1-gallon size.

(Continued on following page)

REPLENISHMENT TABLE FOR FULL-STRENGTH KODAK REPLENISHER D-76R

Film Size	Area (inch2)	Ounces of Kodak Replenisher D-76R Needed
110	11.5	⅛
126	25	¼
135 (20-exposure)	49	½
135 (36-exposure)	87	¾
828	25	¼
127	43	½
120, 620	80	¾
616	105	1
4 x 5-inch sheets	20	¼
8 x 10-inch sheets	80	¾

Kodak Replenisher D-76R extends the capacity of Kodak Developer D-76 to 120 rolls or 8 x 10-inch sheets (9600 square inches) or equivalent per gallon.

(More D-76 data appears on the following pages)

(Continued on following page)

EASTMAN KODAK

EASTMAN KODAK

DEVELOPMENT TIMES (IN MINUTES) IN KODAK DEVELOPER D-76

KODAK Film	Dilution	Small Tank — Agitation at 30-second intervals throughout development					Large Tank — Agitation at 1-minute intervals throughout development				
		65°F 18°C	68°F 20°C	70°F 21°C	72°F 22°C	75°F 24°C	65°F 18°C	68°F 20°C	70°F 21°C	72°F 22°C	75°F 24°C
Verichrome Pan (Rolls and Cartridges)	Full Strength	8	7	5½	5	4½	9	8	7	6	5
	1:1	11	9	8	7	6	12½	10	9	8	7
Plus-X Pan (135 and Long Rolls)	Full Strength	6½	5½	5	4½	3¾	7½	6½	6	5½	4½
	1:1	8	7	6½	6	5	10	9	8	7½	7
Plus-X Pan Professional (Rolls and Packs)	Full Strength	6½	5½	5	4½	3¾	7½	6½	6	5½	4½
	1:1	8	7	6½	6	5	10	9	8	7½	7
Panatomic-X (135 and Long Rolls)	Full Strength	6	5	4½	4¼	3¾	6½	5½	5	4¾	4
	1:1	8	7	6½	6	5	9	7½	7	6½	5½
Panatomic-X Professional (Rolls)	Full Strength	6	5	4½	4¼	3¾	6½	5½	5	4¾	4
	1:1	8	7	6½	6	5	9	7½	7	6½	5½
Tri-X Pan (Rolls, 135, and Long Rolls)	Full Strength	9	8	7½	6½	5½	10	9	8	7	6
	1:1	11	10	9½	9	8	13	12	11	10	9
Tri-X Pan Professional (Rolls and Packs)	Full Strength	9	8	7½	7	6	10	9	8½	8	7
High Speed Infrared (135 and Long Rolls)	Full Strength	13	11	10	9½	8	14	12	11	10	9

(Continued on following page)

DEVELOPMENT TIMES (IN MINUTES) IN KODAK DEVELOPER D-76 FULL STRENGTH

KODAK Film (Sheets)	Tray Continuous Agitation					Large Tank Agitation at • 1-minute intervals throughout development				
	65°F 18°C	68°F 20°C	70°F 21°C	72°F 22°C	75°F 24°C	65°F 18°C	68°F 20°C	70°F 21°C	72°F 22°C	75°F 24°C
Royal Pan 4141 (Estar Thick Base)	9	8	7½	7	6	11	10	9½	9	8
Tri-X Pan Professional 4164 (Estar Thick Base)	6	5½	5	5	4½	7½	7	6½	6	5½
Plus-X Pan Professional 4147 (Estar Thick Base)	7	6	5½	5	4½	9	8	7½	7	6
Ektapan 4162 (Estar Thick Base)	9	8	7	6½	5½	11	10	9	8½	7½
High Speed Infrared 4143 (Estar Thick Base)	11	9½	8½	7½	6½	14	12	11	10	9
Tri-X Ortho 4163 (Estar Thick Base)	6½	6	5½	5	4½	8	7½	6½	6	5½

(Continued on following page)

EASTMAN KODAK

KODAK HC 110 DEVELOPER
HOW TO MIX THE STOCK SOLUTION

To make a stock solution from the smaller size (473 ml or 16 ounce) bottle of concentrate:

1. Pour the entire contents of the original plastic bottle into a container that holds at least 1.9 liters (2 quarts).
2. Rinse the plastic bottle thoroughly with water and pour the rinse water into the container.
3. Add enough water to bring the total volume to 1.9 liters (2 quarts).
4. Stir or shake thoroughly until the solution is uniform.

To make a stock solution from the larger (828 ml or 28 ounce) bottle of concentrate:

1. Pour the entire contents of the original plastic bottle into a container that holds at least 3.4 liters (3½ quarts).
2. Rinse the plastic bottle thoroughly with water and pour the rinse water into the container.
3. Add enough water to bring the total volume to 3.4 liters (3½ quarts).
4. Stir or shake well until the solution is uniform.

To make the replenisher stock solution:

1. Pour the entire contents of the plastic bottle of replenisher concentrate into a container that holds at leas 3.8 (1 gallon).
2. Rinse the bottle thoroughly with water and pour the rinse water into the container.
3. Add enough water to bring the total volume to 3.8 liters (1 gallon).
4. Stir or shake until the solution is uniform.

To mix working dilutions A, B, C, D, E, and F from the stock solution, see table 1.

USES OF WORKING-STRENGTH DILUTIONS

Dilution A: This is the most active of the dilutions. It is especially useful for tray development and gives short developing times for sheet and roll films.

Dilution B: This dilution permits longer development time; it is recommended for most Kodak sheet and roll films. Developing times for these materials are given in tables 3 and 4.

Dilutions C, D, and E: These dilutions are generally used for Kodak continuous-tone sheet films used in graphic arts reproduction. Recommended developing times are given in table 5.

Dilution F: This dilution is for use with Kodak Pan Masking Film 4570 in certain masking procedures used in color printing and some allied processes. Developing times are given in the instruction sheet that accompanies the film.

DEVELOPING TIMES

The developing times given in table 2 assume exposure with camera lenses of moderate flare. They are aimed at giving negatives of full-scale subjects that will match the contrast of normal grade papers when printed with diffusion-type enlargers. For printing with condenser enlargers, shorter development times are required (usually 30 to 50% less). The best developing time depends on a number of conditions, including the flare level of the camera lens.

One way of determining the best time, is to make a series of test negatives at different exposures, including a gray scale in the subject, and keeping a record of your test exposures.

Another method is trial and error. Start with the time given in the tables and adjust it according to your results. If your negatives are consistently too high in contrast, decrease the developing time; if too low in contrast, increase the time.

(Continued on following page)

Table 1

TO MIX WORKING DILUTIONS FROM THE STOCK SOLUTION

Working Dilution		Developer to Water Ratio	To Mix All Quantities	To Mix		To Mix		To Mix		To Mix	
				500 ml	1 Pint	1 Liter	1 Quart	4 Liters	1 Gallon	1 Decaliter	3½ Gallons
A	1:15	Stock	1 Part	125 ml	4 oz	250 ml	8 oz	1 l	1 qt	2.5 l	3 qt 16 oz
		Water	3 Parts	375 ml	12 oz	750 ml	24 oz	3 l	3 qt	7.5 l	10 qt 16 oz
B	1:31	Stock	1 Part	63 ml	2 oz	125 ml	4 oz	500 ml	16 oz	1.25 l	1 qt 24 oz
		Water	7 Parts	437 ml	14 oz	875 ml	28 oz	3.5 l	3 qt 16 oz	8.75 l	12 qt 8 oz
C	1:19	Stock	1 Part	100 ml	3¼ oz	200 ml	6½ oz	200 ml	26 oz	2.0 l	2 qt 26 oz
		Water	4 Parts	400 ml	28¾ oz	800 ml	25½ oz	3.2 l	3 qt 6 oz	8.0 l	11 qt 6 oz
D	1:39	Stock	1 Part	50 ml	—	100 ml	3¾ oz	400 ml	13 oz	1.0 l	1 qt 13 oz
		Water	9 Parts	450 ml	—	900 ml	28¾ oz	3.6 l	3 qt 19 oz	9.0 l	12 qt 19 oz
E	1:47	Stock	1 Part	42 ml	—	84 ml	2½ oz	333 ml	11 oz	835 ml	1 qt 6 oz
		Water	11 Parts	458 ml	—	916 ml	29½ oz	3.667 l	3 qt 21 oz	9.2 l	12 qt 26 oz
F	1:79	Stock	1 Part	25 ml	—	50 ml	1½ oz	200 ml	6 oz	500 ml	22 oz
		Water	19 Parts	475 ml	—	950 ml	30½ oz	3.8 l	3 qt 26 oz	9.5 l	13 qt 10 oz

NOTE: Some quantities of stock solutions are too small for convenient measurement. Where quantities are specified for mixing 1 pint or 1 quart, they are rounded to the nearest ¼ fluidounce. Quantities for mixing larger volumes are rounded to the nearest fluidounce.

EASTMAN KODAK

367

EASTMAN KODAK

Table 2

DEVELOPING TIMES FOR KODAK SHEET FILMS AND FILM PACKS

Developing Time (Minutes)

DILUTION A KODAK Sheet Films	Tray* 65 F 18 C	68 F 20 C	70 F 21 C	72 F 22 C	75 F 24 C	Large Tank† 65 F 18 C	68 F 20 C	70 F 21 C	72 F 22 C	75 F 24 C
Ektapan 4162 (Estar Thick Base)	3¼	3	2¾	2½	2¼	4	3¾	3¼	3	2¾
Royal Pan 4141 (Estar Thick Base)	3½	3	2¾	2½	2¼	4	3¾	3¼	3	2¾
Royal-X Pan 4166 (Estar Thick Base)	5	4½	4¼	4	3½	7	6	5½	5	4½
Super-XX Pan 4142 (Estar Thick Base)	4½	4	3¾	3½	3	6	5	4½	4¼	3½
KODAK Film Packs										
Tri-X Pan Professional	4½	4¼	4	3½	3	6	5½	5	4½	4

DILUTION B KODAK Sheet Films	Tray* 65 F 18 C	68 F 20 C	70 F 21 C	72 F 22 C	75 F 24 C	Large Tank† 65 F 18 C	68 F 20 C	70 F 21 C	72 F 22 C	75 F 24 C
Commercial 6127 and 4127 (Estar Thick Base)	2¾	2¼	2¼	2	1¾	5	NR	NR	NR	NR
Ektapan 4162 (Estar Thick Base)	5	4½	4¼	4	3½	6	6	5½	5	4¼
Plus-X Pan Professional 4147 (Estar Thick Base)	6	5	4¾	4½	4	7	7	6½	6	4½
Royal Pan 4141 (Estar Thick Base)	7	6	5½	5	4½	8	8	7½	7	6½
Royal-X Pan 4166 (Estar Thick Base)	8½	8	7½	7	6½	10	9	9	8½	7½
Super-XX Pan 4142 (Estar Thick Base)	8	7	6½	6	5	11	9	8	7	6
Tri-X Pan Professional 4164 (Estar Thick Base)	6	5½	5	4½	4	8	7½	7	6	5
Tri-X Ortho 4163 (Estar Thick Base)	6½	5½	5	4½	4	8½	7½	7	6½	5
KODAK Film Packs										
Tri-X Pan Professional	10	9	8	7	6	11	10	9	8	7
Plus-X Pan Professional	5	4½	4	3¾	3¼	6½	5½	5	4¾	4

*Development in a tray with continuous agitation.

NOTE: Development times shorter than 5 minutes in a tank may cause poor uniformity.

†Development on a hanger in a large tank with agitation at 1-minute intervals.

NR = Not recommended.

(Continued on following page)

EASTMAN KODAK

Table 3

DEVELOPING TIMES FOR KODAK ROLL FILMS

	Developing Time (Minutes)									
	Small Tank*					Large Tank†				
DILUTION A **KODAK Roll Films**	65 F 18 C	68 F 20 C	70 F 21 C	72 F 22 C	75 F 24 C	65 F 18 C	68 F 20 C	70 F 21 C	72 F 22 C	75 F 24 C
Royal-X Pan	6	5	4¾	4½	4¼	7	6	5½	5	4½
Tri-X Pan	4¼	3¾	3¼	3	2½	4¾	4¼	4	3¾	3¼
Tri-X Pan Professional	NR	NR	NR	NR	NR	6	5½	5	4½	4
135 Films										
Tri-X Pan	4¼	3¾	3¼	3	2½	4¾	4¼	4	3¾	3¼

	Small Tank*					Large Tank†				
DILUTION B **KODAK Roll Films**	65 F 18 C	68 F 20 C	70 F 21 C	72 F 22 C	75 F 24 C	65 F 18 C	68 F 20 C	70 F 21 C	72 F 22 C	75 F 24 C
Panatomic Professional	4¾	4¼	4	3¾	3¼	5½	4¾	4¼	4	3½
Plus-X Pan Professional	6	5	4½	4	3½	6½	5½	5	4¾	4
Royal-X Pan	10	9	8	7½	6½	11	10	9	8½	7½
Tri-X Pan	8½	7½	6½	6	5	9½	8¼	8	7½	6½
Tri-X Pan Professional	10	9	8	7	6	11	10	9	8	7
Verichrome Pan	6	5	4½	4	2	8	6½	6	5½	4½
135 Films										
Panatomic-X	4¾	4¼	4	3¾	3¼	5½	4¾	4¼	4	3½
Plus-X Pan	6	5	4½	4	3½	6½	5½	5	4¾	4
Tri-X Pan	8½	7½	6½	6	5	9½	8½	8	7½	6½

*Development on a spiral reel in a small roll tank, with agitation at 30-second intervals.
†Development of several reels in a basket, with agitation at 1-minute intervals.
NR = Not recommended.
NOTE: Development times shorter than 5 minutes in a tank may cause poor uniformity.

(Continued on following page)

The dilutions of Kodak HC-110 Developer can be replenished with appropriate dilutions made from the replenisher stock solution as given in table 4.

To maintain constant developer activity, replenish the working dilutions, with properly diluted replenisher, at the rate of 22 milliliters per 516 square centimeters (¾ fluid ounce per 80 square inches) of film. However, if the negatives start to get too thin and low in contrast, or too dense and high in contrast, increase or decrease the replenishment rate.

REPLENISHER DILUTIONS

To replenish working dilution	Replenisher stock solution*	Water
A use	1 part	none
B use	2 parts	1 part
C use	1 part	none
D use	1 part	1 part
E use	8 parts	11 parts
F.....	Do not replenish	—

(Continued on following page)

Table 4
DEVELOPING TIMES FOR KODAK CONTINUOUS-TONE GRAPHIC ARTS FILMS

KODAK Films	APPLICATIONS — Graphic Arts	Kodak HC-110 Developer Dilutions	Tray Development Times (minutes) at 68°F (20°C) with continuous agitation
Commercial 4127 (Estar Thick Base)	Gravure	C	3
Gravure Positive 4135	Continuous-tone positives for photogravure and photoengraving	C	4
	Premasks for two-stage masking	C	3
Blue Sensitive Masking 2136	Positive Masks	E	2½

When exposed through color-separation filters:

KODAK Films	APPLICATIONS — Graphic Arts	Kodak HC-110 Developer Dilutions	Cyan	Magenta	Yellow	Black
	Color-separation negatives from masked color transparencies	C	4	3½	4	3¾

KODAK Films	APPLICATIONS — Graphic Arts	Kodak HC-110 Developer Dilutions	Red	Green	Blue
Separation 4131, Negative Type 1	**Color Prints** Color-separation negatives from original subjects or from masked color transparencies	E	4	4	5
	masked color transparencies	D	3	3	4
	Color-separation negatives from unmasked color transparencies	E	2½	2½	3

(Table continued on following page)

371

EASTMAN KODAK

Table 5 (continued)

DEVELOPING TIMES FOR KODAK CONTINUOUS-TONE GRAPHIC ARTS FILMS

KODAK Films	APPLICATIONS — Graphic Arts	Kodak HC-110 Developer Dilutions	Tray Development Times (minutes) at 68°F (20°C) with continuous agitation			
			Cyan Printer Mask	Black Printer Mask	Magenta Printer Mask	Yellow Printer Mask
Super-XX Pan 4142 (Estar Thick Base)	For color-separation negatives made directly from the subject or from masked color transparencies	A			4½	7
	For color-separation negatives made from unmasked transparencies	B			4½	7
	Graphic Arts					
Pan Masking 4570	Camera-back masking	E	4	4	4	—
	Masks on transparencies (for cyan, magenta, yellow, and black printers)	D	3¼	3¼	3¼	3¼
Professional Copy 4125 (Estar Thick Base)	For photomechanical reproduction (for 1.70 highlight aim-density)	C	Tray (continuous agitation) 5½		Tank (intermittent agitation) 8	

(Continued on following page)

With an average drain period between the developer and the stop bath, the stated replenishment rate will usually be sufficient to match the carry-out of developer. However, if much more of the solution is lost in the process than is replaced by replenishment, make up the loss by adding fresh HC-110 Developer of the appropriate dilution.

When dilutions A, B, C, D, and E are used for tank development with the replenishment procedure just described, the developer activity should be monitored by Kodak Control Strips, 10-step (for professional B/W film). The solution can be kept in service for at least 1 month if these strips indicate proper developer activity.

If control strips are not used, Dilutions A, B, C, D, and E can be replenished until 50 20.3 x 25.4cm films per liter (200 8 x 10-inch films per gallon), or the equivalent area in other sizes, have been processed; or when the volume of added replenisher equals the original volume of solution in the tank; or after the developer has been replenished for 1 month.

Dilution F is generally used in a tray for developing masks; therefore it should not be replenished, but used and discarded frequently.

CAPACITY OF WORKING DILUTIONS

	Tray		Tank Without Replenishment		Tank With Replenishment*	
Dilution	20.3 x 25.4 cm Sheets per Liter	8 x 10 Sheets per Gallon	20.3 x 25.4 cm Sheets per Liter	8 x 10 Sheets per Gallon	20.3 x 25.4 cm Sheets per Liter	8 x 10 Sheets per Gallon
A	5	20	10	40	50	200
B	2.5	10	5	20	50	200
C	4	15	8	30	50	200
D	2	8	4	15	50	200
E	1.5	5	3	10	50	200
F	1	2	Not recommended	Not recommended	50	200

*Use and replenish for 1 month only.

STORAGE LIFE OF UNUSED SOLUTIONS

Dilutions	Full stoppered glass bottle	½ Full stoppered glass bottle	Tank with floating lid
Stock solution	6 months	2 months	—
Stock replenisher	6 months	2 months	—
A	6 months	2 months	2 months
B	3 months	1 month	1 month
C	6 months	2 months	2 months
D	3 months	1 month	1 month
E	2 months	1 month	1 month
F	Do not store	—	—

(Continued on following page)

373

EASTMAN KODAK

TO MIX WORKING-STRENGTH DILUTIONS FROM THE CONCENTRATE

Because small amounts of the concentrate are difficult to measure accurately, the working dilutions of Kodak HC-110 Developer should not be prepared directly from the concentrate. However, if a relatively large quantity of developer is needed for immediate use, you can mix a whole bottle of concentrate with a given amount of water. For example, a 16-ounce bottle of concentrate makes 4 gallons of dilution B. The table below shows how the various dilutions can be mixed directly from whole bottles of concentrate.

To Make this Working Dilution	Developer to Water Ratio	Use this amount of concentrate		With this amount of water		Use this amount of concentrate		With this amount of water	
		Milliliters	Fluidounces	Liters	Quarts	Milliliters	Fluidounces	Liters	Quarts/Fluidounces
A	1:15	473	16	7.1	7½	828	28	12.5	13/4
B	1:31	473	16	14.7	15½	828	28	25.75	27/4
C	1:19	473	16	9	9½	828	28	15.75	16/20
D	1:39	473	16	18.4	19½	828	28	32.5	34/4
E	1:47	473	16	22.2	23½	828	28	39	41/4
F	1:79	473	16	37.4	39½	828	28	65.5	69/4

FUJICOLOR F-II COLOR NEGATIVE FILM
135, 126, 110, 120

Fujicolor F-II is a high-speed color negative film designed for daylight, flashcube, blue flashbulb or electronic flash exposure.

No filter is required for exposure under normal daylight or with flashcube, blue flashbulb or electronic flash. Suitable filters should be used with tungsten lamps or with clear flashbulbs. Fujicolor paper is designed for prints made on Fujicolor F-II negative. Other color papers for negative film may also be used. It can also be printed on Fuji Dye Color Print to obtain color prints of better color separation and improved stability. Color slides can likewise be prepared by printing the negative on print film.

EXPOSURE INDEX

Light Source	Exposure Index	Filter Used
Daylight	ASA 100	None
Tungsten (3200K)	ASA 32*	LBB-12** (or Wratten No. 80A)

*Exposure index includes the exposure factor of the light balancing filter.
**Fuji Light Balancing Filter or equivalent.

These indexes should be set on the exposure meter, or cameras with built-in meters for each type of light source. Exposure meters are available in reflective or incident light types, but the latter is generally more convenient for determining exposure or measuring the key to fill light ratio. When using reflective light type exposure meters or cameras with built-in meters, it is recommended to determine the exposure with the meter or camera pointing slightly downwards or to use an 18% reflectance gray card since the subject may be underexposed if the subject is surrounded by brighter background.

In case of Fujicolor F-II 126 and 110 sizes, no particular operation is required for determining exposure, because the film speed is automatically set on the camera by the film speed notch provided on the cartridge.

EXPOSURE UNDER DAYLIGHT

The following table will give average exposures when an exposure meter reading cannot be made.
Exposure Guide Table:* Shutter speed at 1/250 second

EXPOSURE GUIDE TABLE:* Shutter speed at 1/250 second

Light Condition	Seashore & Snow Scenes Under Bright Sun	Bright Sunlight	Hazy Sunlight	Cloudy Bright	Cloudy Day or Open Shade
Lens Aperture	f/16	f/11	f/8	f/5.6	f/4

*This tables applies from 2 hours after sunrise to 2 hours before sunset.
*Use of an exposure meter is recommended in cloudy weather or in the open shade since the difference between bright and dark changes continually for each shot.
*1 or 2-stops larger aperture is usually suitable for close-up back-lighted subjects.
*Use of an ultraviolet absorbing filter such as Fuji Filter SC-40 or SC-40M (or Wratten No. 1A) is recommended for taking snow scenes, mountain scenes or distant landscapes.

(Continued on following page)

EXPOSURE WITH FLASHBULB OR FLASHCUBE

Blue flashbulbs or flashcubes are suitable for flash pictures with Fujicolor F-II. Fuji Light Balancing Filter LBB-8 (or Wratten No. 80C) is required for clear flashbulbs. For ordinary subjects, the correct aperture can be determined by dividing the guide number by the distance from the flash to the subject.

Following table shows the guide numbers applicable when using one flashbulb in a room with relatively weak reflection.

GUIDE NUMBERS FOR FLASHBULBS:* in meters (in feet)

Lens Shutter Speed (sec.)	Open or 1/30	1/30	1/60	1/125	1/250	1/500
Synchro-nization	X or F	M	M	M	M	M
Flashcube	30 (100)	22 (70)	22 (70)	18 (60)	14 (45)	12 (40)
AG-1B	28 (90)	20 (65)	20 (65)	16 (50)	13 (43)	10 (33)
M2B	32 105)	Not Recommended				
M3B 5B 25B	56 (185)	56 (185)	48 (160)	42 (140)	. 34 (110)	26 (85)
11	48 (160)	44 (145)	40 (130)	36 (120)	30 (100)	22 (70)

Focal Plane Shutter Speed (sec.)	1/30	1/60	1/125	1/250	1/500
Synchronization	FP	FP	FP	FP	FP
6B 26B	50 (165)	38 (125)	28 (90)	20 (65)	14 (45)

Note: The letter B stands for blue flashbulb.

*Guide numbers for clear flashbulbs are indicated when Fuji Filter LBB-8 (or Wratten No. 80C) is used over the lens.

*The above table, with the exception of flashcubes, is applicable to a medium-sized folding reflectors (matte reflector of 13-cm size). When using small-sized shallow cylindrical reflectors or large bowl-shaped polished reflectors, cut exposure by one stop.

*The table given above should be considered as a general guide only since flash-bulbs of the same type may give a different light intensity and have variations of color in the blue coating according to the manufacturer. Other variables that must be considered are the type, area and size of reflector, battery condition or reflection from the surroundings. Furthermore, when using a flashbulb in a light room with strong reflection, a still smaller aperture by ½ to 1-stop should be used according to the actual conditions.

(Continued on following page)

*If two flash bulbs are used in parallel, multiply the above guide number by 1.4, or use 1-stop smaller

*Blue flashbulbs can also be used as a supplementary light source to decrease contrast when the main subject is exposed to sunlight while the side of subject or background is insufficiently lighted thus making an intense contrast, or to regulate the ratio of brightness when the main subject is in the shade while background is under light.

EXPOSURE WITH ELECTRONIC FLASH

For ordinary subjects, the correct aperture (f-number) can be determined by dividing the guide number by the distance from the flash to the subject.

Similar to shooting with flashbulbs, the exposure with electronic flash varies according to reflection from the surroundings. In general, smaller electronic flash units due to their lower light output, are easily affected by surrounding conditions, and are apt to give an underexposed image when the exposure is made according to the rated guide number. If the color print made with electronic flash is bluish, use Fuji Filter LBA-4 (or Wratten No. 81D) over the lens. In this case the exposure should be increased about ⅓ stop.

EXPOSURE USING PHOTOFLOOD LAMPS

The following table shows exposure conditions when taking portraits under standard lighting with two 500-watt photoflood lamps. In this case two lamps are located at the same distance from the subject, one being located close to the camera as the supplementary light while the other one being placed 1 meter higher than the former at an angle of 45° with respect to the camera and used as the main lighting.

Distance from Lamp to Subject	Exposure	Filter Used
1.5 meters	1/30 at f/3.5	LBB-12 (or Wratten No. 80A)
2.0 meters	1/30 at f/2.5	

PROCESSING

The film price does not include processing. For processing and printing, the film should be sent to a Fuji's authorized laboratory or other laboratory offering such service, or processed with Fujicolor F-II Processing Chemicals, Process CN-16 (or Process C-41).

FILM SIZES AVAILABLE

Fujicolor F-II	135	24- and 36-exposure
	126	12- and 20-exposure
	110	12- and 20-exposure
	120	6 x 6 cm 12-exposure

STORAGE

Inadequate storage conditions will cause various troubles even within the guaranteed term. Films should be kept in a dry, cool place since prolonged storage in high temperature and humid conditions will result in an undesirable effect on both processed and unprocessed films. Films should not be exposed to formaldehyde gas or automobile exhaust gas when they are loaded in a camera or taken out of the plastic case, as these gases may cause trouble. (Formaldehyde gas can be

(Continued on following page)

The Compact Photo-Lab-Index

emitted, for example, from synthetic interior finishing materials or adhesives for ordinary furniture.) For prolonged storage, unexposed films should be put in a sealed container and kept at a temperature lower than 10°C (50°F). A temperature lower than 0°C (32°F) permits still longer storage. After exposure films should preferably be processed as quickly as possible in order to prevent the eventual change in the latent image.

Processed films should be kept in a dry, cool place at room temperature about 20°C (68°F) or lower and relative humidity of 60% or lower.

Also, processed films should be handled so as to avoid scratches and fingerprints, especially as the latter facilitates the growth of mold.

FILM STRUCTURE

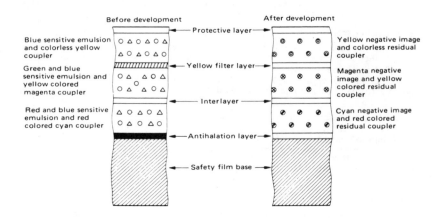

SPECTRAL SENSITIVITY

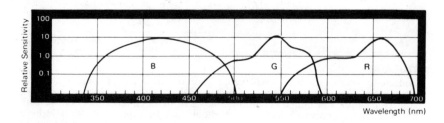

FUJICOLOR F-II 400 COLOR NEGATIVE FILM
135, 120, 110

Fujicolor F-II 400 is an ultra high-speed, daylight type color negative film which is suitable for normal photography, and is excellent for action photography. Its ultra high-speed capability makes it a natural for sports photography of all kinds, as well as indoor, outdoor night scenes where light levels are low. Since Fujicolor F-II 400 is a daylight type film, the use of filters under daylight or with blue flashbulbs and electric flash unit is not required.

Under tungsten or fluorescent lighting conditions, the use of appropriate filters indicated in the chart below is recommended for accurate color rendition.

Fujicolor F-II 400 film will product interesting results even without filtration. This is because of the specially designed spectral sensitivity of this film.

Fujicolor F-II 400 has concentrated latent-image grain technology, producing an especially stable ultra high-speed emulsion. Also because of the use of an image controlling layer within each of the three color image layers, the film has excellent sharpness and fine grain characteristics. Color-couplers are used in the film emulsion, for color rendition control. Because of these structural qualities high quality color prints are obtained even under ordinary shooting circumstances even though the film has ultra high-speed characteristics.

Printing either on Fujicolor Paper or other color papers will result in high quality color prints with this film. Using Fuji Dye Color Print material also ensures increased quality results. The use of Fujicolor Print Film allows production of high quality color slides from this negative material.

EXPOSURE INDEX

Light Source	Exposure Index	Filter Requirements
Daylight	ASA 400, 27 DIN	Not Required
Tungsten Lamps (3200° K)	ASA 125*, 22 DIN*	LBB-12** (or Wratten No. 80B)
Fluorescent Lamps:		
White	ASA 200*, 24 DIN*	CC-20M + CC-20B***
Deluxe White	ASA 250*, 25 DIN*	CC-20B***
Daylight	ASA 200*, 24 DIN*	CC-30M + CC-10R***

*These exposure indexes include the exposure factors for the filters.
**Fuji Light Balancing Filters, or equivalent.
***Color Compensating Filters.

Fluorescent light has special spectral energy distribution characteristics. Therefore, even with the use of these filters absolutely faithful color reproduction is not possible. To compound the problem, there are light quality differences in lamps of differing manufacture, and even color change in the same fluorescent lamps are seen with the aging process. Consequently, the above indicated filters should be used only as a guide.

EXPOSURE UNDER DAYLIGHT CONDITIONS

For best results the use of an exposure meter for accurate exposure is recommended. If such an exposure meter is not available the following table can be used as an approximate guide. Bracketing exposures is advised for important subject matter.

The use of an exposure meter is highly recommended in cloudy weather or in open shade since light intensity differentials are under continual change.

Apertures increased by one or two stops are usually suitable for back lighted close-up subjects.

It is recommended for the adequate recording of snow scenes, mountain scenes or distant landscapes that ultraviolet absorbing filters, such as the Fuji Filter SC-40 or SC-40M (or Wratten No. 1A), be employed.

(Continued on following page)

The Compact Photo-Lab-Index

EXPOSURE GUIDE TABLE

Light Condition	Seashore or Snow Scenes Under Bright Sun	Bright Sunlight	Hazy Sunlight	Cloudy Bright	Cloudy Day or Open Shade
Lens Aperture	f/22	f/16	f/16	f/11	f/8
Shutter Speed	1/500	1/500	1/250	1/250	1/250

This table applies for conditions prevailing from 2 hours after sunrise until 2 hours before sunset.

FLASHBULB EXPOSURE

Blue flashbulbs suitable as light sources with Fujicolor F-II 400 film. When clear flashbulbs are to be employed the use of a Fuji Light Balancing Filter LBB-8 (or Wratten No. 80C) will be required. For ordinary subjects, the correct aperture for flash photography can be determined by dividing the flash guide number by the flash-to-subject distance in meters or feet.

The following table offers an indication of applicable guide numbers when single flash bulbs are used in surroundings of relative low reflectivity.

GUIDE NUMBERS FOR FLASHBULBS: in meters (in feet)

Lens Shutter Speed (sec.)	Up to 1/30	1/30	1/60	1/125	1/250	1/500
Synchronization	X or F	M	M	M	M	M
AG-1B	56 (180)	40 (130)	40 (130)	32 (100)	26 (86)	20 (66)
M2B	64 (210)	Not Recommended				
M3B 5B 25B	112 (370)	112 (370)	96 (320)	84 (280)	68 (220)	52 (170)
11	96 (320)	88 (290)	80 (260)	72 (240)	60 (200)	44 (140)

Focal Plane Shutter Speed (sec.)	1/30	1/60	1/125	1/250	1/500
Synchronization	FP	FP	FP	FP	FP
6B 26B	100 (330)	76 (250)	56 (180)	40 (130)	28 (90)

Note: The letter B in flashbulb designations indicates blue coated bulbs.

(Continued on following page)

MISCELLANEOUS MANUFACTURERS

*Clear flashbulb guide numbers are calibrated for use with a Fuji Filter LBB-8 (or Wratten No. 80C) over the lens.

*The guide numbers indicated above are derived for flashbulbs used with medium sized reflectors (13-cm diameter matted reflectors). When using a small shallow cylindrical reflector or a large-sized bowl-shaped polished reflector, cut exposure by one stop.

*The table indicated above should be considered only as a guide since flashbulbs of the same type may have differing light output and color temperature characteristics according to manufacturer. Other variables that must be considered are the type, size and area of the reflector as well as battery condition and reflectivity characteristics of the surroundings, values indicated are only general guidelines. When using flashbulbs in highly reflective surroundings, aperture size decreases of ½ to 1 stop should be used according to actual conditions.

*When two flashbulbs are to be used in parallel, the above indicated guide numbers should be multiplied by 1.4 or a single stop smaller aperture should be employed.

*Blue flashbulbs can also be used for light source supplementation as contrast reducing fill-in under sunlight exposure conditions or for the regulation of the brightness ratio for a shaded subject with a sunlit background.

ELECTRONIC FLASH EXPOSURE

The lens aperture for electronic flash is determined by dividing the guide number for the particular flash unit by the flash-to-subject distance in meters or feet relative to guide number requirements.

$$\text{Lens Aperture (f-number)} = \frac{\text{Guide Number (ASA 400)}}{\text{Flash-to-Subject Distance}}$$

When an automatic electronic flash unit is used the lens aperture should be closed down two stops smaller than for conditions required with an ASA speed of 100.

Electronic flash is also subject to the reflectivity of the surroundings requiring that lens aperture be opened 1 stop when the subject is found in low reflectivity conditions. This is especially the case for small electronic flash units where, because of the small light output, there is a tendency toward underexposure.

PHOTOFLOOD LAMP EXPOSURE

The following table approximates adequate exposure conditions when making portraits using two 500-watt photoflood lamps. The two lamps are located at the same distance from the subject, one being close to the camera as the fill-in light and the other being placed one meter higher than the former at an angle of 45° with respect to the camera, as the principal light.

Lamp-to-Subject Distance	Exposure	Required Filters
1.5 meters	1/30 sec. with lens closed down 2/3 stop smaller than f 5.6	Fuji Filter LBB-12 (or Wratten No. 80B)
2.0 meters	1/30 sec. with lens closed down 2/3 stop smaller than f 4.	Fuji Filter LBB-12 (or Wratten No. 80B)

PROCESSING

The price of the film does not include processing. For processing and printing the film should be sent to an authorized Fuji laboratory or other laboratory offering similar services. This film is intended for processing in Fujicolor Negative Film Processing Chemicals process CN-16 (or Process C-41).

(Continued on following page)

MISCELLANEOUS MANUFACTURERS

The Compact Photo-Lab-Index

FILM SIZES AVAILABLE

Fujicolor F-II 400	135	24 and 36 exposures
	120	(6 x 6cm 12 exposures)
	110	12 and 20 exposures

STORAGE

Inadequate storage conditions may result in lowered film performance even prior to the expiration date. Since prolonged storage under high temperature and humidity conditions will have adverse effects on both processed and unprocessed film, these materials should be stored under cool and dry conditions. Film should not be handled in atmospheres containing formaldehyde or automobile exhaust gases, for these vapors have untoward effects on the film. (Formaldehyde gas is often emitted from such things as synthetic interior finishing materials or adhesives used in ordinary furniture.) For prolonged storage, unexposed films should be enclosed in a sealed container and kept at a temperature of lower than 10°C (50°F). Temperatures lower than 0°C (32°F) permit even longer storage. After exposure films should be processed as soon as possible in order to prevent eventual changes in the latent image. Processed films should be kept in a cool dry place at room temperatures of about 20°C (68°F) or lower and humidity levels of 60% or lower. Further, processed film should be handled in such a manner as to prevent scratches and finger prints especially since the latter encourage the growth of molds.

TECHNICAL DATA—FILM STRUCTURE

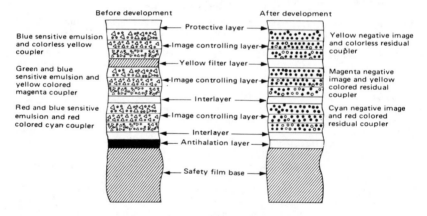

*Image Controlling Layer: New technical innovations producing significant increases in sharpness, graininess and tone reproduction.

RECIPROCITY CHARACTERISTICS

Exposure Time (in seconds)	1/1000-1/10	1	10	100
Exposure Compensation	None	+ 1 stop	+ 2 stops	+ 3 stops
Color Compensating Filters	None	None	None	None

(Continued on following page)

MISCELLANEOUS MANUFACTURERS

382

The Compact Photo-Lab-Index

SPECTRAL SENSITIVITY CURVES

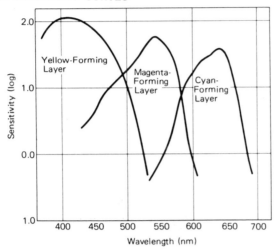

Process: CN-16; Densitometry: Status M; Density: 1.0 above D-min. Sensitivity equals reciprocal of exposure (ergs/cm²) required to produce specified density.

CHARACTERISTIC CURVES

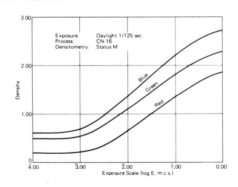

DIFFUSE RMS GRANULARITY VALUE

Micro-Densitometer Measurement Aperture: 48 $\mu\phi$; Magnification: 12X; Measured Sample Density (NET): 1.0.

NOTICE

The sensitometric curves and other data were derived from particular materials taken from general production runs. As such they do not represent in exact duplication the characteristics of every individual piece of material sold. Nor does this data represent a standard for Fuji Film product characteristics since Fuji Film is in a constant process of research and upgrading the quality characteristics of its product line.

(Continued on following page)

MISCELLANEOUS MANUFACTURERS

MODULATION TRANSFER CURVE

Spectral Dye Density Curves

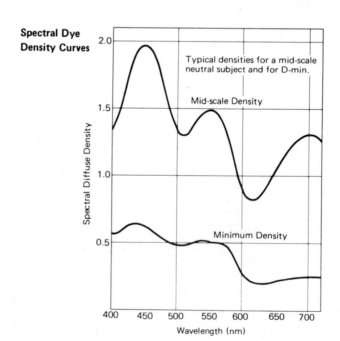

FUJICHROME R100 (135)
(DAYLIGHT TYPE)

Fujichrome R100 is a reversal color film designed for exposure under daylight conditions. It will produce beautiful high quality color slides when processed under specified conditions. This film has high speed, wide latitude, ample color rendition and is capable of vividly reproducing natural colors. The finished slides can be used as printing originals, original transparencies for various color prints and as color slides for viewing or projecting.

EXPOSURE INDEX

Light Source	Exposure Index Fujichrome R100	Filter
Daylight	ASA 100, DIN 21	None
Tungsten (3200 K)	ASA 32*, DIN 16*	Fuji Filter LBB-12**, or Wratten Filter No. 80A or No. 80B

*These exposure indexes include the exposure factors for the filters recommended.
**Fuji Light Balancing Filter.
NOTE: These indexes are based on a shutter speed of 1/250 second.
Exposure times of 1 second or longer may require an increase in exposure and/ or additional color compensating filters. In this case, refer to the material under "LONG EXPOSURES."

LIGHT SOURCES

As this film is designed to provide high quality color reproduction when exposed under clear weather sunlight conditions, the following light sources are recommended for obtaining optimum color rendition.

1. Daylight, 2. Electronic flash, 3. Blue Flashbulbs.

When making photographs under other light source types, refer to the material under "EXPOSURE GUIDE TABLE."

DAYLIGHT EXPOSURE TABLE
FOR FUJICHROME R100

The use of TTL or EE cameras or an exposure meter is most effective for determining correct exposures. When they are not available, refer to the following table as a guide.

This table applies only to light conditions from 2 hours after sunrise to 2 hours before sunset.

LENS APERTURE WITH SHUTTER SPEED AT 1/250 SECOND

Light Condition	Bright Open Places (Beach scenes, mountain and snow scenes, etc.)	Bright Sunlight	Hazy Sunlight	Cloudy Bright (No shadows)	Cloudy Day, Open Shade
Lens Aperture	f/16	f/11*	f/8	f/5.6	f/4

*Use f/5.6 for back-lighted close-up subjects.

(Continued on following page)

The Compact Photo-Lab-Index

EXPOSURE GUIDE TABLE

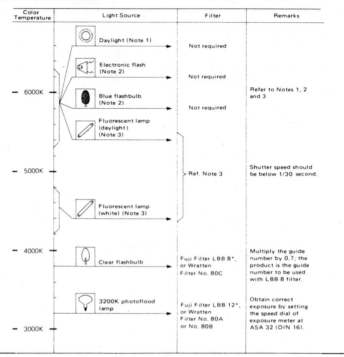

Color Temperature	Light Source	Filter	Remarks
— 6000K	Daylight (Note 1)	Not required	Refer to Notes 1, 2 and 3
	Electronic flash (Note 2)	Not required	
	Blue flashbulb (Note 2)	Not required	
	Fluorescent lamp (daylight) (Note 3)		
— 5000K		Ref. Note 3	Shutter speed should be below 1/30 second.
	Fluorescent lamp (white) (Note 3)		
— 4000K	Clear flashbulb	Fuji Filter LBB-8*, or Wratten Filter No. 80C	Multiply the guide number by 0.7; the product is the guide number to be used with LBB-8 filter.
— 3000K	3200K photoflood lamp	Fuji Filter LBB-12*, or Wratten Filter No. 80A or No. 80B	Obtain correct exposure by setting the speed dial of exposure meter at ASA 32 (DIN 16).

*Fuji Light Balancing Filter

NOTE 1. DAYLIGHT EXPOSURE

No filter is required for photography of average subjects in clear weather daylight conditions. However, under the following conditions, the use of filters is indicated and recommended for better pictures.

Subject Condition	Filter	Exposure Correction
Seaside, mountain & open landscapes in bright sunlight	Fuji Filter SC-40* or SC-40M** (or Wratten Filter No. 2B or No. 1A)	None
Clear weather open shade	Fuji Filter LBA-4*** (or Wratten Filter No. 81D)	+½ stop
Cloudy or rain	Fuji Filter LBA-4*** or LBA-8*** (or Wratten Filter No. 81D or No. 85C)	+½ to +1 stop
Morning/evening clear weather conditions	Fuji Filter LBB-4*** (or Wratten Filter No. 82C)	+½ stop

*Fuji Ultraviolet Filter or equivalent.
**Fuji Skylight Filter or equivalent.
***Fuji Light Balancing Filter or equivalent.

(Continued on following page)

The Compact Photo-Lab-Index

GUIDE NUMBERS FOR FLASH BULBS

For Blue Flashbulbs, or Clear Flashbulbs with Fuji Filter LBB-8 or Wratten Filter No. 80C. Guide numbers are for meter distances. The numbers in brackets are footage equivalents.

Lens Shutter Speed	Synchro-nization	Flash-cube	AG-1B*	M2B	M3B 5B 25B	11**	50**	Focal-plane Shutter Speed	6B 26B
Open 1/30	X or F	30 (100)	20 (65)	30 (100)	46 (150)	52 (170)	115 (380)	1/30	40 (130)
1/30	M	20 (65)	14 (45)	NR†	44 (145)	44 (145)	(Use 1/30 or Slower)	1/60	30 (100)
1/60	M	20 (65)	14 (45)	NR	38 (125)	40 (130)		1/125	20 (65)
1/125	M	18 (60)	12 (40)	NR	32 (105)	38 (125)		1/250	14 (45)
1/250	M	14 (45)	10 (35)	NR	26 (85)	30 (100)		1/500	10 (33)
1/500	M	12 (40)	8 (26)	NR	20 (65)	22 (70)			

*Used in 1 x 2 inch polished reflectors.
**Used in 6- to 7-inch bowl-shaped polished reflectors.
†NR = Not Recommended.
These values are intended only as guides for average subjects. They must be adapted to suit individual variations in synchronization, battery conditions, reflectors and bulb-reflector interrelations.

(Continued on following page)

MISCELLANEOUS MANUFACTURERS

The Compact Photo-Lab-Index

NOTE 2: EXPOSURES WITH ELECTRONIC FLASH OF BLUE FLASHBULBS

For ordinary subjects, the correct lens aperture (f-number) can be determined by dividing the guide number by the distance from the flash to the subject.

Example: If the guide number of an electronic flash calibrated for meter distances is 22 and the distance between the subject and the flash is 2 meters, the aperture will be f/11.

An automatic electronic flash is more convenient as it determines exposure automatically without the need for such calculation.

In general, smaller electronic flash units, due to their lower output, are easily affected by surroundings, and thus tend to result in underexposure when used in accordance with published guide numbers. Flash output may also be adversely influenced by the shape and surface of the reflector contained in the flash unit. It is recommended, therefore, that equipment be tested in actual photographic situations in order to determine adequate guide numbers.

NOTE 3. FLUORESCENT LAMPS

High quality photographic results even with exposure and color balance corrections cannot be expected when pictures are made under fluorescent lamps because this light source has irregular bright line spectral characteristics. Therefore, when using this type of light source, testing is essential to determine optimum exposure conditions and color rendition, using the following table as a guide. Use shutter speeds slower than 1/30 second.

EXPOSURE CORRECTIONS: with shutter speed at 1/8 second.

Type of Fluorescent Lamp	White	Daylight	Deluxe White
Color Compensating Filter*	CC 20M + 5R	CC 10M + 40R	CC 20B + 5C
Exposure Correction**	+1 stop	+1 stop	+1 stop

*Use of a Fuji Color Compensating Filter (or Wratten CC Filter) is recommended.
**Exposure correction values include the exposure factors of the color compensating filters.

LONG EXPOSURES

Identical photographs should result from any 2 differing combinations of shutter speed and aperture if those combinations provide for the same amount of exposure. In actuality, however, pictures taken with extremely long or short shutter speeds do not give the same results as those taken at normal or intermediate shutter speeds. This is due to the phenomenon known as reciprocity failure. Fujichrome R100 film does not require exposure or color balance correction when exposed using shutter speeds between 1/1000 second and ¼ second. When the exposure time required is 1 second or longer, increase the exposure by the amount indicated in the table below to compensate for the reciprocity effect, and correct the color balance with color compensating filters as required.

EXPOSURE CORRECTION TABLE FOR RECIPROCITY CHARACTERISTICS

Exposure Time (sec.)	1/1000 to 1/4	1	4	16
Exposure Correction*	None	None	+½ stop	+1½ stops
Color Compensating Filter**	None	CC-5C	CC-10C	CC-20C

*Includes the exposure factor of the color compensating filters.
**The use of Fuji Color Compensating Filters (or Wratten CC Filters) is recommended.

(Continued on following page)

MISCELLANEOUS MANUFACTURERS

The Compact Photo-Lab-Index

PROCESSING

Exposed films should be processed as quickly as possible. For processing, this film should be sent to a FUJI authorized laboratory or other laboratory offering these services, or processed with Fujichrome Film Processing Chemicals. Process CR-55 or KODAK Process E-4. The price of the film does not include processing.

HANDLING OF FILMS

Be sure to avoid direct sunlight when handling films. In this regard extreme caution is required loading and unloading film. Films stored in a refrigerator should be taken out at least one hour prior to use and unsealed only after they have reached room temperature. Films should be exposed and processed before the expiration date printed on the package.

STORAGE

It is recommended that unexposed films be stored in a cool, dry place, as they are susceptible not only to changes in sensitivity and color balance but also to other physical damage if they are stored under high temperature or high humid conditions. Unexposed films should be stored at a temperature below 10°C (50°F) for short periods and below 0°C (32°F) for prolonged periods so as to maintain their original quality. Care should be exercised not to expose films to harmful gases such as formaldehyde gas or automobile exhaust gas when they are being loaded in the camera or when being removed from the plastic case, as films are sensitive not only to temperature and humidity, but also to the harmful effects of such noxious gases. (Formaldehyde gas is emitted from paints and adhesives used in furniture and new synthetic construction materials.) Developed films should be stored at temperatures below 20°C (68°F) and at relative humidity levels below 60%.

FILM SIZES AVAILABLE

Fujichrome R100; 135 20-exposure and 36-exposure.

FILM STRUCTURE

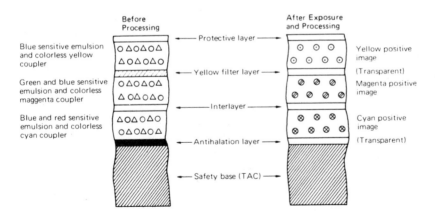

(Continued on following page)

The Compact Photo-Lab-Index

SPECTRAL SENSITIVITY
Below is indicated the spectral sensitivity of the three emulsion layers exposed to a 5400K color temperature light source.

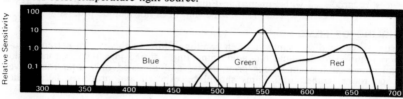

SPECTRAL DENSITY CURVES
Below are indicated the spectral density curves of the film after processing.

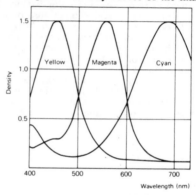

CHARACTERISTIC CURVES The following are the characteristic curves of the film processed under standard processing conditions.

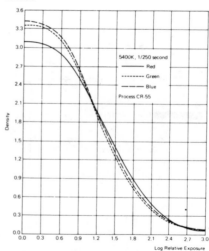

(Continued on following page)

FUJICOLOR PAPER RESIN-COATED TYPE TYPE 8907

Fujicolor Paper Resin-coated Type 8907 is designed to give quality prints by exposure through such color negative films as Fujicolor F-II and Fujicolor F-II 400, whether by contact printing or by enlargement.

It also gives good results with other types of color negative film. It makes a faithful reproduction of color and tone with fine gradation and shows color balance over a wide range from the highlight to the shadow area. When properly processed, it gives color prints of a high degree of permanence in which red, blue and green colors are rendered very clearly and the flesh tones reproduced well. This color paper finds use in wide applications including amateur, commercial and school photography.

Fujicolor Paper Resin-coated Type 8907 is designed to be processed with either Fujicolor Paper Processing Chemicals-Process CP-21, Ektaprint 2 Chemicals or equivalent. It is also compatible with the 3 step processing chemicals like Fuji's Process CP-31 chemicals and Ektaprint 3 Chemicals.

Fujicolor Paper Processing Chemicals-Process CP-21 is of the 2-bath type and its features include rapid processing resulting in high productivity, low chemical cost, minimum space requirements and simplified processing control. In addition, the use of non-polluting chemicals eliminates environmental contamination.

PAPER STRUCTURE

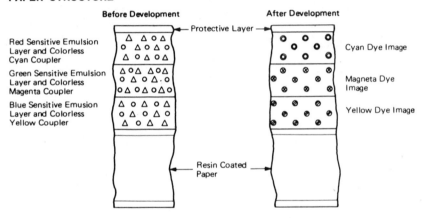

SPEED

Fujicolor Paper Resin-coated Type 8907 has speed equal to or higher than that of high-speed color papers presently available on the market. This speed ensures reduced printing time and a large increase in productivity.

SAFELIGHT

The recommended safelight filter for use in the dark room is Fuji Safelight Filter No. 103A (or Kodak Safelight Filter No. 13). Use this filter in conjunction with a 20-watt tungsten lamp when handling unexposed Fujicolor Paper, but be sure to keep a distance of at least 1 m from the light source and to finish the printing work within 5 minutes. Once exposed, the color paper becomes susceptible to the safelight. Use care to finish the printing work as quickly as possible when handling the exposed color paper.

(Continued on following page)

The Compact Photo-Lab-Index

PROCESSING

Fujicolor Paper, Resin-coated Type 8907, can be processed in any processing equipment using Fuji's Process CP-21 chemicals, Fuji's Process CP-31 chemicals, Ektaprint 3 Chemicals Ektaprint 2 Chemicals or equivalent without altering the standard procedure (processing time, processing temperature, replenishment rate, agitation and equipment of bleach-fix regeneration). It is recommended that exposed color papers be processed as soon as possible after exposure. The time between exposure and development should be fixed for purposes of maximum uniformity. Avoid holding exposed papers over for development the next day.

Processing Chemical Conditions: Conditions for Process CP-21 chemicals (Ektaprint 2 Chemicals) and Process CP-31 chemicals (Ektaprint 3 Chemicals) are shown in the table below.

Processing Step	Processing Conditions			
	Process CP-21 Chemicals (Ektaprint 2 Chemicals)		Process CP-21 Chemicals (Ektaprint 3 Chemicals)	
	Time	Temp. °C (°F)	Time	Temp. °C (°F)
Color Developer	3½ min.	33±0.3 (91±0.5)	3½ min.	31±0.3 (88±0.5)
Bleach-Fix	1½ min.	30-34 (86-93)	1½ min.	31±1.2 (88±2)
Water Wash	3½ min.	24-34 (75-93)	2.0 min.	31±1.2 (88±2)
Stabilizer*	—*	—	1.0 min.	31±1.2 (88±2)
Water Exit Spray*	—*	—	6 sec.	31±1.2 (88±2)
Drying	As required	80±5 (175±10)	As required	80±5 (175±10)

*For two bath processing such as the Process CP-21 chemicals (Ektaprint 2 Chemicals) these steps are eliminated.

REPLENISHMENT RATES

Replenishment rates for Process CP-21 chemicals, Ektaprint 2 Chemicals and Ektaprint 3 Chemicals are shown in the table below.

Solution Processing	Replenishment Rates		
	Process CP-21 (Ektaprint 2 (Chemicals)	Ektaprint 3 Chemicals	Process CP-31
Color Developer	323ml/m^2 (30ml/ft^2)	430.6ml/m^2 (40ml/ft^2)	430.6ml/m^2 (40ml/ft^2)
Bleach-Fix	323ml/m^2 (30ml/ft^2)	366.0ml/m^2 (34ml/ft^2)	737.0ml/m^2 (68.5ml/ft^2)
Stabilizer	—	366.0ml/m^2 (34ml/ft^2)	366.0ml/m^2 (34ml/ft^2)

(Continued on following page)

The Compact Photo-Lab-Index

LIGHT SOURCE FOR VIEWING

A suitable fluorescent lamp with excellent color rendering characteristics is to be used as a light source for inspecting finished prints. The prints are to be examined for their color reproduction under illumination levels of 500 to 1000 lux.

CHEMICAL PACKAGING

Processing Chemicals-Process CP-21 are supplied in 38-liter (10 U.S. gal.) and 95-liter (25 U.S. gal.) packaging.

BLEACH-FIX REGENERATION

For regeneration of the Process CP-21 bleach-fix chemicals see the Fuji Film Processing Manual "Fujicolor Paper Resin-coated Type 8907—Process CP-21."

STORAGE OF RAW PAPER

The raw materials should be stored in a place conditioned at 10°C (50°F) or less and 65% RH or less. High temperatures and humidity will produce a detrimental effect on the color paper and, therefore, finished prints.

The color paper which has been stored at 10°C (50°F) or less should remain in their moisture-proof wrap and allowed to warm up to room temperature prior to use. This will prevent moisture condensation and a detrimental loosening of the coatings on the color paper. The minimum temperature equalization periods are as follows:

1. Temperature Equalization Periods up to 20°C (68°F

	Storage Temperature		
Paper Size	**−20°C (−4°F)**	**0°C (32°F)**	**10°C (50°F)**
8.9 cm x 175.3 m (3½ in. x 575 ft)	6 hours	5 hours	3½ hours

2. Periods of Warm up from 5°C (41°F) to 20°C (68°F) (By Paper Sizes)

8.9 cm x 175.3 m	**12.7 cm x 83.8 m**	**13 cm x 18 cm**	**20.3 cm x 25.4 cm**
4½ hours	5 hours	2 hours	2 hours

Do not heat the color paper in any attempt to expedite temperature equalization, but make it a rule to prepare the color paper the day before use.

SPECTRAL SENSITIVITY

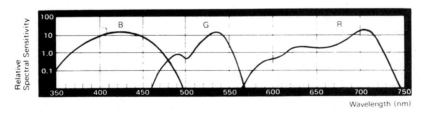

Wavelength (nm)

(Continued on following page)

The Compact Photo-Lab-Index

SPECTRAL DENSITY OF COLOR DYES

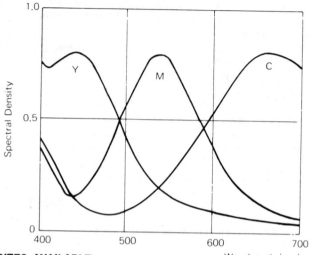

PAPER SIZES AVAILABLE
Roll Paper

Width	Length	83.8m (275 ft)	175.3m (575 ft)	236.3m (775 ft)	350.7m (1150 ft)
7.6cm (3 in.)		●	●	—	—
8.9cm (3½ in.)		●	●	●	●
10.2cm (4 in.)		●	●	●	—
12.7cm (5 in.)		●	●	—	—
20.3cm (8 in.)		●	—	—	—

Other sizes than specified above can be supplied on inquiry.
Paper Surfaces: Matte, lustre, silk and glossy surfaces are available for each of the roll paper sizes.

Sheet Paper

Size		Contents
56 x 91.4 cm	(22 x 36 in.)	20 sheets
45.7 x 55 cm	(18 x 22 in.)	20 sheets
35.6 x 43.2 cm	(14 x 17 in.)	100 sheets
25.4 x 30.5 cm	(10 x 12 in.)	100 sheets
20.3 x 25.4 cm	(8 x 10 in.)	200 sheets
16.5 x 21.6 cm	(6½ x 8½ in.)	200 sheets
13 x 18 cm	(5 x 7 in.)	400 sheets

Paper Surface: All sizes are available with a glossy surface only.

FUJI AUTHORIZED LABS IN U.S.A.
FUJICOLOR AND FUJICHROME PROCESSING

	PRINT	SLIDE
EAST	P.O. BOX 300 HARRISON, NJ 07029	P.O. BOX 300 HARRISON, NJ 07029
MIDWEST	P.O. BOX 573 GLEN ELLYN, IL 60137	P.O. BOX 573 GLEN ELLYN, IL 60137
		P.O. BOX 5364 DALLAS, TX 75281
WEST	P.O. BOX 8531 PORTLAND, OR 97207	P.O. BOX 8531 PORTLAND, OR 97207
	P.O. BOX 8000 SAN FRANCISCO, CA 94128	P.O. BOX 8000 SAN FRANCISCO, CA 94128
	P.O. BOX 85044 SAN DIEGO, CA 92138	P.O. BOX 29920 LOS ANGELES, CA 90029
	P.O. BOX 10428 HONOLULU, HI 96816	P.O. BOX 10428 HONOLULU, HI 96816

FUJI FILM PROCESSING STATION
SINGLE-8 FILM PROCESSING
P.O. BOX 300, HARRISON, N.J. 07029

MISCELLANEOUS MANUFACTURERS

SINGLE-8 FUJICHROME R25

FEATURES

This is a daylight type color reversal 8mm film, designed for use with Single-8 movie cameras. This film provides excellent sharpness, graininess and color rendition. It is ideally suited for outdoor movie-taking under daylight conditions.

EXPOSURE INDEX

Light Source	Exposure Index	
Daylight	ASA 25	15 DIN

SHOOTING

This film is designed for getting best results when shooting in bright sunlight.

1. Load the cartridge correctly by following the directions of your Single-8 movie camera and the film speed will be automatically set.

2. Film base is extremely thin and strong, and has total footage of 50 ft. (15.25 m) enclosed in a compact cartridge enabling the film to run continuously. Film cartridges may be interchanged at any time during shooting with a minimum loss of about 2 in. (5 or 6 cm) of the film.

3. Running at the standard speed of 18 frames per second, this film will give continuous shooting of approximately 3 minutes and 20 seconds.

Shooting Speed and Running Time

Frames/sec	18	24	36
Running Time	3 min 20 sec	2 min 30 sec	1 min 40 sec

4. Strong light at sea or on a snowy mountain in bright sunlight may sometimes cause overexposure. In such a case use ND filter designed to reduce the light intensity without varying color balance.

5. For indoor movie-making under existing light conditions with tungsten lamps such as movielights or photoflood lamps, tungsten-type Fujichrome RT200 (ASA 200) is recommended.

6. The film has a start mark. When film comes to the end, running is automatically stopped at notch in the perforation.

Start Mark and End Notch

(Continued on following page)

MISCELLANEOUS
MANUFACTURERS

The Compact Photo-Lab-Index

PROCESSING
This film should be processed in MCR-57 processing chemicals.

PROCESSING CHARGE
The film price includes processing at any Fuji Film or Fuji Film authorized laboratory.

SPLICING
Be sure to use a Single-B tape splicer and splicing tape when editing. Because this film uses polyester base for support; it cannot be spliced with conventional splicer and film cement.

PROJECTION
Single-8 projectors should be used for projection of the film.
Listed below are running times against footage of the film.

Footage		Running Time	
Feet	**Meters**	**18 frames/sec**	**24 frames/sec**
1	0.305	4 sec	3 sec
2	0.610	8 sec	6 sec
3	0.914	12 sec	9 sec
5	1.52	20 sec	15 sec
10	3.05	40 sec	30 sec
50	15.25	3 min 20 sec	2 min 30 sec
100	30.48	6 min 40 sec	5 min 00 sec

STORAGE
1. Film before processing is liable not only to deteriorate in film speed and color balance but a physical change may also occur if it is stored in a place in a place of high temperature or humidity. The film should be stored in a cool, dry place.
2. If the film is stored in a refrigerator be sure to take out the film at least one hour before use and allow it to reach room temperature. Be sure to expose and process film before the expiration date printed on the film box.
3. Noxious gases such as engine exhaust fumes, and formalin gas emitted by adhesives used in new furniture and new building materials can adversely affect the unexposed film when it is removed from the envelope or loaded in the camera.
4. Have exposed film processed as soon as possible to prevent it from changing in color balance.
5. Store processed film in a can with a drying agent since it may become mildewed if kept in a humid place. In case of fingerprints or dust on your film, clean with a soft cloth dampened with film cleaner before putting it away.

SPECTRAL SENSITIVITY
5400 K Exposure

(Continued on following page)

The Compact Photo-Lab-Index

CHARACTERISTIC
CURVES

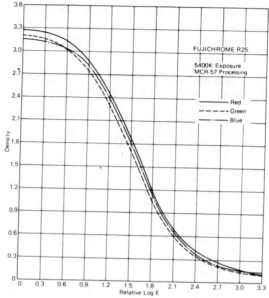

FUJICHROME R25

5400K Exposure
MCR-57 Processing

——— Red
– – – – Green
—·—·— Blue

Density

Relative Log E

SINGLE-8 FUJICHROME RT200

FEATURES

This is a tungsten type color reversal 8mm film, designed for use with Single-8 movie cameras. This film provides excellent sharpness, graininess and color rendition, and is especially designed for use under low-level-light conditions, indoors, on stage or at night.

EXPOSURE INDEX

Light Source	Exposure Index		Filter Used
Tungsten Light (3400 K)	ASA 200	24 DIN	—
Daylight	ASA 50	18 DIN	LBA-12A x 4*

*Fuji Light Balancing Filter specially designed for Fujichrome RT200.

SHOOTING

This film is designed for getting best results when shooting under tungsten light.

1. Load the cartridge correctly by following the directions of your Single-8 movie camera and the film speed will be automatically set.

2. Film base is extremely thin and strong, and has total footage of 50 ft. (15.25 m) enclosed in compact cartridge enabling the film to run continuously. Film cartridges may be interchanged at any time during shooting with a minimum loss of about 2 in. (5 or 6 cm) of the film.

3. Running at the standard speed of 18 frames per second, this film will give continuous shooting of approximately 3 minutes and 20 seconds.

Shooting Speed and Running Time

Frames/sec	18	24	36
Running Time	3 min 20 sec	2 min 30 sec	1 min 40 sec

4. Daylight exposure may give rather a bluish color cast or overexposure. Use of Fuji Light Balancing Filter LBA-12A x 4 is recommended for exposure under daylight conditions. In this case the film speed corresponds with exposure index to ASA 50 (15 DIN).

5. A fluorescent light may give a slightly bluish-green effect. Although it is difficult to expect perfect color correction in this case, a combined use of tungsten lamps will improve the color considerably.

6. Direct lighting at a short distance may cause excessively high contrast, so soft illumination with indirect lighting is more desirable.

7. The film has a start mark. When film comes to the end, running is automatically stopped at notch in the perforation.

Start Mark and End Notch

(Continued on following page)

The Compact Photo-Lab-Index

PROCESSING
This film should be processed in MCR-57 processing chemicals.

PROCESSING CHARGE
The film price includes processing at any Fuji Film or Fuji Film authorized laboratory.

SPLICING
Be sure to use a Single-B tape splicer and splicing tape when editing. Because this film uses polyester base for support, it cannot be spliced with conventional splicer and film cement.

PROJECTION
Single-8 projectors should be used for projection of the film.
Listed below are running times against footage of the film.

Footage		Running Time	
Feet	Meters	18 frames/sec	24 frames/sec
1	0.305	4 sec	3 sec
2	0.610	8 sec	6 sec
3	0.914	12 sec	9 sec
5	1.52	20 sec	15 sec
10	3.05	40 sec	30 sec
50	15.25	3 min 20 sec	2 min 30 sec
100	30.48	6 min 40 sec	5 min 00 sec

STORAGE
1. Film before processing is liable not only to deteriorate in film speed and color balance but a physical change may also occur if it is stored in a place of high temperature or humidity. The film should be stored in a cool, dry place.
2. If the film is stored in a refrigerator be sure to take out the film at least one hour before use and allow it to reach room temperature. Be sure to expose and process film before the expiration date printed on the film box.
3. Noxious gases such as engine exhaust fumes, and formalin gas emitted by adhesives used in new furniture and new building materials can adversely affect the unexposed film when it is removed from the envelope or loaded in the camera.
4. Have exposed film processed as soon as possible to prevent it from changing in color balance.
5. Store processed film in a can with a drying agent since it may become mildewed if kept in a humid place. In case of fingerprints or dust on your film, clean with a soft cloth dampened with film cleaner before putting it away.

SPECTRAL SENSITIVITY 3400K Exposure

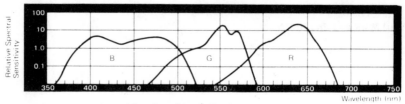

(Continued on following page)

MISCELLANEOUS MANUFACTURERS

The Compact Photo-Lab-Index

CHARACTERISTIC CURVES

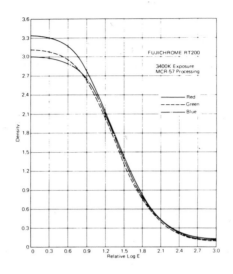

PROFESSIONAL MOTION PICTURE FILMS
FUJICOLOR REVERSAL TV FILM RT-100
16mm TYPE 8426

GENERAL PROPERTIES

This is a high-speed tungsten type color reversal film especially designed for making color newsreel and other material for color TV broadcasts. Its color reproduction, gradation and other picture qualities are finely balanced for color TV transmission. This film, however, also provides an excellent picture quality when projected with a xenon lamp projector.

At the time of processing the prehardener and neutralizer can be omitted, so that from the point of view of stabilization of quality, processing cost reduction, environmental preservation, and in-process time reduction, this film has desirable characteristics.

FILM STRUCTURE

This film is composed of three emulsion layers sensitive to red, green and blue light, respectively, as well as a yellow filter and an antihalation layer, all coated on a clear safety base. A protective layer is coated on the emulsion surface.

Each one of the three emulsion layers contains a different coupler and when the exposed film is processed, the three emulsion layers together form the positive images in the predetermined colors of cyan, magenta and yellow.

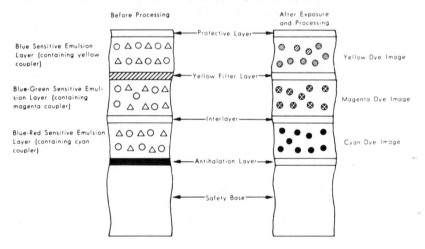

EXPOSURE INDEX

3200K tungsten lamps—100
Daylight—64 (with Fuji Light Balancing Filter LBA-12 or Kodak Daylight Filter No. 85).

These numbers are available for use with exposure meters marked for American National Standard film speed. In some cases, the published exposure indexes may not be applicable exactly as they are, depending upon different types or usages of exposure meters and processing equipment. Therefore, it is recommended that an exposure test to determine a suitable Exposure Index in advance be made if most satisfactory results are to be obtained.

(Continued on following page)

The Compact Photo-Lab-Index

Exposure (Incident Light) Table for Tungsten Light (3200K)
Shutter speed approximately 1/50 second—24 frames per second

Lens Aperture	f/1.4	f/2	f/2.8	f/4	f/5.6	f/8	f/11
Foot-Candle	25	50	100	200	400	800	1600

COLOR BALANCE

Since this film is color balanced for 3200K tungsten lamps, a light balancing filter is not required under such conditions. In may cases, however, the film is often exposed under low color temperature tungsten lamps, or sunlight (which varies according to season, place, and time of day), skylight, cloudy sky and rainy weather. Under these varying conditions, satisfactory color reproduction cannot be obtained unless light balancing filters are used. An amber filter is used to lower the color temperature and a blue filter is used to raise it.

Light sources, such as fluorescent lamps having line spectrum, will not render complete color reproduction. Within certain limits color compensation of this film is possible with filters, but since the exposure index would fall so low with the compensation, it is recommended that under such circumstances the ultra high speed Fujicolor Reversal TV Film RT-400 16mm type 8425 be used.

LIGHTING CONTRAST

The lighting contrast should be somewhat lower than is the case with black-and-white motion picture films and the lighting ratio of the keylight-plus-fill-light to fill-light alone should preferably be 3 to 1 or less.

SPECTRAL SENSITIVITY CURVES
Spectrogram to Tungsten Light (3200K)

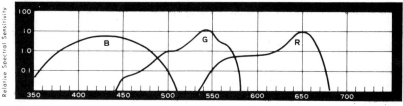

PROCESSING

Processing is carried out in Fuji MCR-40 process.

Eastman Kodak's process ME-4 can also be used without alteration to process this film. Further, in process ME-4 the preharder and neutralizer can be omitted. (In this case a few alterations have to be made in the processing conditions.)

SAFELIGHT

Total darkness is required.

CHARACTERISTIC CURVES

The characteristic curves indicated in the graph were derived by measuring and plotting the integral color density of the film as exposed to a 3200K light source equipped with a Fuji Filter SC-41 to simulate the absorption of ultraviolet rays through the lens in practical photography and processed under standardized conditions.

The curves have been separated on the Log Exposure scale by 1.0 to avoid any overlap.

(Continued on following page)

The Compact Photo-Lab-Index

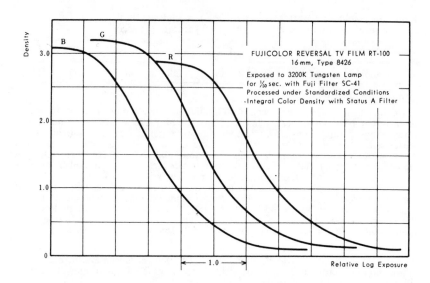

FUJICOLOR REVERSAL TV FILM RT-100
16mm, Type 8426

Exposed to 3200K Tungsten Lamp
for 1/50 sec. with Fuji Filter SC-41
Processed under Standardized Conditions
·Integral Color Density with Status A Filter

SPECTRAL DENSITY CURVES

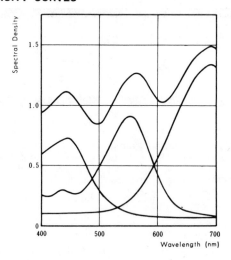

SCREEN PROJECTION

Since the color balance of this film is adapted to the characteristics of color TV transmission, the use of a projector with a light source close to the standard illuminant C (6740K) is recommended, if visual inspection is required. (A xenon

(Continued on following page)

lamp projector is recommended for practical purposes.)

In screening with a tungsten lamp projector, the image wili appear reddish. In this case, place a filter over the projector lens to correct the color temperature. Fuji Light Balancing Filter LBB-12 or equivalent will convert the light source from 3200K to about5400K.

FILM BASE
Clear safety (TAC)

EDGE MARKINGS
Footage number and film identification mark (6), both printed as latent image.

PERFORATION TYPE
IR-7,605mm (1R-2994) 2R-7,605mm (2R-2994).

PACKAGING
16mm 100 ft (30.5 m), Camera spool for daylight loading. 200 ft (61 m), Camera spool for daylight loading. 400 ft (122 m), Type 16P2 core. 1,200 ft (366 m), Type 16P2 core.

STORAGE OF RAW STOCK
Like any other color films, Fujicolor Reversal TV Film RT-100 may undergo some changes in its photographic properties as a result of extended storage. Such changes can be accelerated particularly by heat and moisture. It is therefore recommended that raw stock should be stored at temperatures below 10°C (50°F) to avoid any changes in photographic properties.

When raw stock is opened after removal from refrigerated storage, keep the package sealed until the temperature of the film has reached equilibrium with the room temperature, otherwise condensation of moisture may result.

HANDLING OF EXPOSED FILMS
Exposed film should be processed as quickly as possible. When processing is unavoidably delayed, the film should be stored and handled in the same careful manner as with raw stock. Refrigerated storage is required in the case storage period is longer than one week.

STORAGE OF PROCESSED FILMS
Processed films should be kept in a cool, dark place, fully protected against possible heat, moisture and light. Preferable for such storage purposes is a dark place where the temperature is not higher than 20°C (68°F) and the relative humidity is within the range of 40 to 50 percent.

MISCELLANEOUS
MANUFACTURERS

FUJICOLOR REVERSAL TV FILM RT-400
16mm TYPE 8425

GENERAL PROPERTIES

This is an ultra-speed tungsten type color reversal film designed for making color newsreel and other materials for color TV broadcast, being especially suitable for low level indoor and night time outdoor photography.

Its color reproduction, gradation and other picture qualities are finely balanced for color TV transmission. This film, however, also provides an excellent picture quality when projected with a xenon lamp projector.

Ultra high sensitivity results from standard processing making forced processing unnecessary while providing for stable quality.

Further at the time of processing the prehardener and neutralizer can be omitted, so that from the point of view of stabilization of quality, processing cost reduction, environmental preservation, and in-process time reduction, this film has much to offer.

FILM STRUCTURE

This film is composed of three emulsion layers sensitive to red, green and blue light, respectively, as well as a yellow filter and an anti-halation layer, all coated on a clear safety base. A protective layer is coated on the emulsion surface.

Each one of the three emulsion layers contains a different coupler and when the exposed film is processed, the three emulsion layers together form the positive images in the predetermined colors of cyan, magenta and yellow.

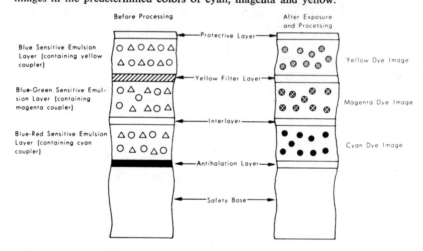

EXPOSURE INDEX

3200K tungsten lamps—400

Daylight—250 (with Fuji Light Balancing Filter LBA-12 or Kodak Daylight No. 85).

These numbers are available for use with exposure meters marked for American National Standard film speed. In some cases, the published exposure indexes may not be applicable exactly as they are, depending upon different types or usages of exposure meters and processing equipment.

Therefore, it is recommended that an exposure test in advance be made if most satisfactory results are to be obtained.

(Continued on following page)

406

The Compact Photo-Lab-Index

Exposure (Incident Light) Table for Tungsten Light (3200K)
Shutter speed approximately 1/50 second—24 frames per second

Lens Aperture	f/1.4	f/2	f/2.8	f/4	f/5.6	f/8	f/11
Foot-Candle	6	13	25	50	100	200	400

Since the lightproofing of this film as wound on the camera spool is fully adequate, this film in spite of its high speed can be handled in the same manner as Fujicolor Reversal TV Film RT-100 16mm Type 8426 when loading and unloading.

COLOR BALANCE

Since this film is color balanced for 3200K tungsten lamps, a light balancing filter is not required under such conditions. In many cases, however, the film is often exposed under low color temperature tungsten lamps, fluorescent lamps, sunlight (which varies according to season, place, and time of day), skylight, cloudy sky and rainy weather. Under these varying conditions, light balancing filters should be used to obtain satisfactory color reproduction.

Light sources, such as fluorescent lamps, having line spectrum, will not render complete color reproduction. Thus in order to provide color compensation within the range of certain limits the filters listed below with the exposure indexes are recommended.

Fluorescent Lamp Type	Filter	Exposure Index
Daylight	LBA-12+CC-30 R	160
White	CC-40 R	200
Warm White	CC-30 R	250

LIGHTING CONTRAST

The lighting contrast should be somewhat lower than is the case with black-and-white motion picture films and the lighting ratio of the keylight-plus-fill-light to fill-light alone should preferably be 3 to 1 or less.

SPECTRAL SENSITIVITY CURVES
Spectrogram to Tungsten Light (3200 K)

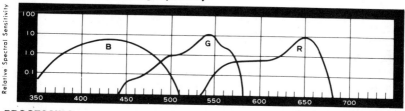

PROCESSING

Processing is carried out in Fuji MCR-40 process.

Eastman Kodak's process ME-4 can also be used without alteration to process this film. Further, in process ME-4 the prehardener and neutralizer can be omitted. (In this case a few alterations have to be made in the processing conditions.)

(Continued on following page)

407

The Compact Photo-Lab-Index

SAFELIGHT
Total darkness is required.

CHARACTERISTIC CURVES
The characteristic curves indicated in the graph were derived by measuring and plotting the integral color density of the film as exposed to a 3200K light source equipped with a Fuji Filter SC-41 to simulate the absorption of ultraviolet rays through the lens in practical photography and processed under standardized conditions.

The curves have been separated on the Log Exposure scale by 1.0 to avoid any overlap.

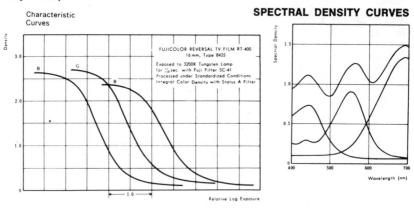

SCREEN PROJECTION
Since the color balance of this film is adapted to the characteristics of color TV transmission, the use of a projector with a light source close to the standard illuminant C (6740K) is recommended, if visual inspection is required. (A xenon lamp projector is recommended for practical purposes.)

In screening with a tungsten lamp projector, the image will appear reddish. In this case, place a filter over the projector lens to correct the color temperature. Fuji Light Balancing Filter LBB-12 or equivalent will convert the light source from 3200K to about 5400K.

FILM BASE
Clear safety (TAC)

EDGE MARKINGS
Footage number and film identification mark (5), both printed as latent image.

PERFORATION TYPE
1R-7,605mm (1R-2994) 2R-7,605mm (2R-29941).

PACKAGING
16mm 100 ft (30.5 m), Camera spool for daylight loading. 200 ft (61 m), Camera spool for daylight loading. 400 ft (122 m), Type 16P2 core. 1,200 ft (366 m), Type 16P2 core.

STORAGE OF RAW STOCK
Like any other color films, Fujicolor Reversal TV Film RT-400 may undergo some changes in its photographic properties as a result of extended storage. Such changes can be accelerated particularly by heat and moisture. It is therefore

(Continued on following page)

recommended that raw stock should be stored at temperatures below 10°C (50°F) to avoid any changes in photographic properties.

When raw stock is opened after removal from refrigerated storage, keep the package sealed until the temperature of the film has reached equilibrium with the room temperature, otherwise condensation of moisture may result.

HANDLING OF EXPOSED FILMS

Exposed film should be processed as quickly as possible. When processing is unavoidably delayed, the film should be stored and handled in the same careful manner as with raw stock. Refrigerated storage is required in the case storage period is longer than one week.

STORAGE OF PROCESSED FILMS

Processed films should be kept in a cool, dark place, fully protected against possible heat, moisture and light. Preferable for such storage purposes is a dark place where the temperature is not higher than 20°C (68°F) and the relative humidity is within the range of 40 to 50 percent.

The Compact Photo-Lab-Index

FUJICOLOR NEGATIVE FILM
35mm TYPE 8517 16mm TYPE 8527
GENERAL PROPERTIES

This is a tungsten type color negative film especially designed for motion picture photography being balanced for 3200K tungsten lamps and incorporating automatic color masking based on color couplers. Even with its high speed this film exhibits superior graininess, definition, gradation and excellent color rendition making it suitable for indoor and outdoor photography and assuring fine reproductions when printed on Fujicolor Positive Film or other color print of similar type.

FILM STRUCTURE

The film is comprised of three emulsion layers being respectively sensitive to red, green and blue light along with a protective layer, a yellow filter layer, an antihalation layer and other layers all coated on a clear safety base. Incorporated in each one of the color layers is to be found a differing coupler and through the processing that takes place after exposure color dye images and color mask images are formed in the emulsion layers. Through the use of this orange colored mask image correct color rendition is assured when this negative film is printed on Fujicolor Positive Film for making color release prints.

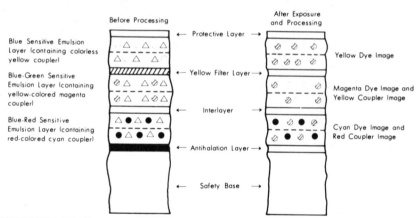

EXPOSURE INDEX

3200K Tungsten Lamps—100.
Daylight—64 (with Fuji Light Balancing Filter LBA-12 or Kodak Daylight Filter No. 85).
These numbers are appropriate for use with exposure meters marked for ASA speed. Since these exposure indexes may not apply exactly as published due to differences in the use of exposure meters and in processing conditions it is recommended exposure tests be made prior to us for the best results.

EXPOSURE

Since this film is color balanced for 3200K tungsten illumination, under such photographic conditions the use of light balancing filters is not necessary but when using this film outdoors under daylight conditions the use of the Fuji Filter LBA-12 (or a light balancing filter of similar characteristics) is required. Exposure under tungsten light at 24 frames/sec will require the following lens openings and illumination levels at an exposure time of 1/50th of a second.

(Continued on following page)

410

MISCELLANEOUS MANUFACTURERS

Lens Aperture	f/1.4	f/2	f/8	f/4	f/5.6	F/8	f/11
Foot-Candles	25	50	100	200	400	800	1600

SPECTRAL SENSITIVITY CURVES
Spectogram to Tungsten Light

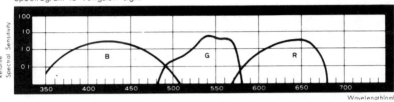

Spectrogram to Tungsten Light

SAFELIGHT
Handle in total darkness.

PROCESSING
This film is to be processed in accordance with the designated processing conditions and formulas provided for Fujicolor Negative Film. Further this film may be processed under conditions and in formulas of process ECN-II published by the Eastman Kodak Company for Eastman Color Negative II Film.

CHARACTERISTIC CURVES
In order to reach conditions closest to actual photographic conditions the exposure was rendered under a 3200K tungsten lamp as the light source with the use of an ultraviolet absorbing filter, the Fuji Filter SC-41. Processing was carried out under standard conditions and the three color densities were measured to render the results indicated in the graph below.

Characteristic Curves

SPECTRAL DENSITY CURVES

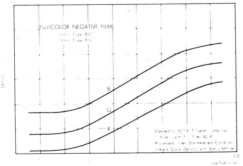

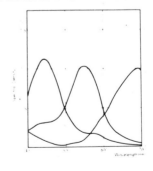

(Continued on following page)

The Compact Photo-Lab-Index

FILM BASE
Clear safety base.

EDGE MARKINGS
35mm Edge number, frame mark and film identification mark (N7) are all printed as latent images.

16mm Edge number and film identification mark (N7) are printed as latent images.

PERFORATION TYPES
35mm N-4.740mm (BH-1866).

16mm 1R-7.605mm (I R-2994) and 2 R-7.605mm (2 R-2994).

PACKAGING
35mm 200 ft (61 m), Type 35P2 core. 400 ft (122 m), Type 35P2 core. 1000 ft (305 m), Type 35P2 core.

16mm 100 ft (30.5 m), Camera spool for daylight loading. (B winding for single perforation film). 200 ft (61 m) Camera spool for daylight loading. (B winding for single perforation film). 400 ft (122 m), Type 16P2 core. (B winding for single perforation film).

STORAGE OF RAW STOCK
Fujicolor Negative Film, like other types of color films, may undergo some changes in photographic properties as a result of extended storage. As these changes can be accelerated particularly through the action of heat and moisture during the storage period it is recommended that raw stock be stored at temperatures below 10°C (50°F). When raw stock that has been in refrigerated storage is to be used, leave the package sealed until the temperature of the film is brought into equilibrium with the room temperature, otherwise condensation of water on the film surface may result.

HANDLING OF EXPOSED FILMS
It is recommended that exposed films be processed as quickly as possible after exposure. When it is not possible to process the film immediately after exposure such film should be handled in the same manner as for raw stock until processing can take place.

STORAGE OF PROCESSED FILMS
Processed Fujicolor Negative Film should be kept in a cool, dark place fully protected against heat, moisture and light. Preferable for such storage purposes is a dark location where the temperature will not exceed 20°C (68°F) and the relative humidity will remain in the 40 to 50 percent range.

FUJICOLOR POSITIVE FILM
35mm TYPE 8812—16mm TYPE 8822
16/8mm TYPE 8822—16/8mm-Type S TYPE 8822

GENERAL PROPERTIES
This film is a high-definition, fine-grain color positive film designed for making color release prints with sound track from color negative films and sound recording films.

SPEED
The speeds of all emulsion layers are so balanced that the optimum results can be obtained when prints are made from color negative films having color couplers incorporated in the emulsion layers. Its high speed enables efficient printing operations even for reduction printing with relatively low light intensity.

FILM STRUCTURE
This film is a multilayer, coupler-incorporated color film comprising three emulsion layers sensitive to red, green, and blue lights respectively, all coated on a clear safety base. These emulsion layers contain colorless couplers which produce yellow, cyan, and magenta dye image respectively when exposed and processed. A protective layer is provided on the top surface to protect the raw stock from scratches or other damages which may be caused during handling. The reverse side of the base is coated with an antihalation layer consisting of synthetic resin containing carbon black, which is removed in alkaline solution during processing.

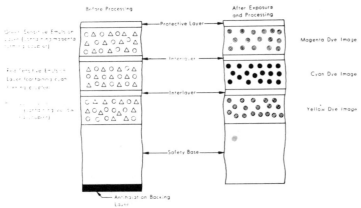

SPECTRAL SENSITIVITY CURVES
Spectrogram to Tungsten Light (2854 K)

Type 8812—8822

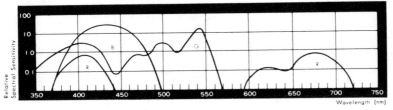

(Continued on following page)

MISCELLANEOUS MANUFACTURERS

413

The Compact Photo-Lab-Index

SAFELIGHT
A Fuji Safelight Filter No. 101A for Fujicolor Positive Film is used with a 20-watt bulb at not less than 1 meter (3½ feet) away.

PROCESSING
This film is processed in accordance with the designated processing conditions and formulas for Fujicolor Positive Film Type 8812 and Type 8822. Also the processing conditions and formulas published by Eastman Kodak company for Eastman Color Print Film, Type 5381 and Type 7381, may be applied without any modification.

CHARACTERISTIC CURVES
To obtain the characteristic curves, the film was exposed to a light source (2854 K) through a set of filters consisting of color compensating filters CC-90Y and CC-60M having a density corresponding to the mask density of the color negative film and a Fuji Filter SC-41 for absorption of ultraviolet rays so as to stimulate practical printing conditions. The exposed film was processed under standardized conditions. Then, the measurement was taken of the integral color density with Status A Filter. The characteristic curves have been shifted on the Log E scale by 1.0 Log E to prevent overlapping.

CHARACTERISTIC CURVES

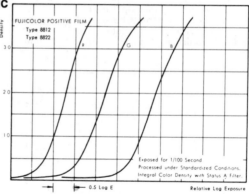

SPECTRAL DENSITY CURVES

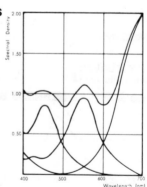

(Continued on following page)

414

The Compact Photo-Lab-Index

FILM BASE
Clear safety (TAC)

EDGE MARKINGS
35mm Frame mark printed as latent image. No film identification mark.
16mm No film identification mark.
16/8mm No film identification mark.
16/8mm—Type S No film identification mark.

FILM DIMENSIONS
35mm American National Standard PH22•36—1964, KS-1870.
16mm American National Standard PH22•109—1974, 1R-3000.
16/8mm American National Standard PH22•17—1965, 2R-1500
16/8mm American National Standard PH22•167, 2R-1667 (1-4)
Type S American National Standard PH22•150—1967, 2R-1667 (1-3)

PACKAGING
35mm 2,000 ft (610 m), Type 35 P3 core. 3,000 ft (915 m), Type 35 P3 core.
16mm 2,000 ft (610 m) x 2 rolls, Type 16 P3 core, A winding or B winding.
16/8mm 2,000 ft (610 m) x 2 rolls, Type 16 P3 core.
16/8 mm—Type S
 (1-4) 2,000 ft (610m) x 2 rolls, Type 16 P3 core.
 (1-3) 2,000 ft (610 m) x 2 rolls, Type 16 P3 core, A winding or B winding

STORAGE OF RAW STOCK
It is recommended that the raw stock should be stored at temperature below 10°C (50°F) to avoid any changes in photographic properties. When raw stock is opened after removal from refrigerated storage, keep the package sealed until the temperature of film has reached equilibrium with the room conditions, otherwise condensation of moisture may result.

STORAGE OF PROCESSED FILM
Processed Fujicolor Positive Films should be kept in a cold, dry place, fully protected against possible heat, moisture and light. Preferable for such storage purposes is a dark place where the temperature is not higher than 20°C (68°F) and the relative humidity is within the range of 40 to 50 percent.

FUJICOLOR POSITIVE HP FILM
35mm TYPE 8813—35/16mm TYPE 8823—16mm TYPE 8823
35/8mm-Type S TYPE 8823—16/8mm-Type S TYPE 8823
16/8mm-Type R TYPE 8823

GENERAL PROPERTIES

This film is a high-definition, fine-grain color positive material designed for making sound track included color release prints from color negative and sound recording films. It is designed for high temperature rapid processing.

SPEED

The film speed is so balanced that optimum results are obtained with prints made from color mask-incorporated negative films and related duplicating materials. High speed enables efficient printing operations even for reduction printing using relatively low light intensities.

FILM STRUCTURE

As a multilayer, coupler-incorporated color material this film is comprised of three emulsion layers coated on a clear safety base sensitive respectively to red, green, and blue lights These emulsion layers contain colorless couplers which produce respectively yellow, cyan, and magenta dye images when exposed and processed. A protective layer is provided on the emulsion surface to protect the raw stock from scratches or other possible damage to which it may be subjected during handling. The reverse side of the base is coated with an antihalation layer consisting of a synthetic resin containing carbon black which is removed during processing.

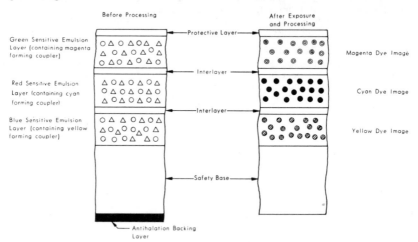

SAFELIGHT

A Fuji Safelight Filter SLG101A or equivalent for Fujicolor Positive Film is used with a 20-watt bulb at a distance of not less than 1 meter (3½ feet) from the film surface.

(Continued on following page)

416

The Compact Photo-Lab-Index

SPECTRAL SENSITIVITY CURVES
Spectrogram for Tungsten Light (2854K)

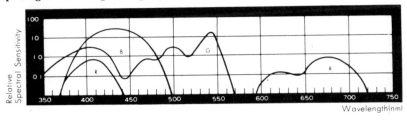

PROCESSING

This film is processed in accordance with designated processing conditions and formulas for Fujicolor Positive HP Film, Type 8813 and Type 8823. Also the processing conditions and formulas published by Eastman Kodak Company for Eastman Color SP Print Film, Type 5383 and Type 7383 (Process ECP-2), may be applied without modification.

CHARACTERISTIC CURVES

To obtain these characteristic curves, the film was exposed to a 2854 K light source through a set of CC-90Y and CC-60M color compensating filters having a density corresponding to the mask density of color negative film and a Fuji SC-41 Filter for absorption of ultraviolet rays in simulation of practical printing conditions. The exposed film was processed under standardized conditions. Then, measurement was made of the integral color density through a Status A Filter. The characteristic curves have been shifted on the scale by 1.0 Log E to prevent overlapping.

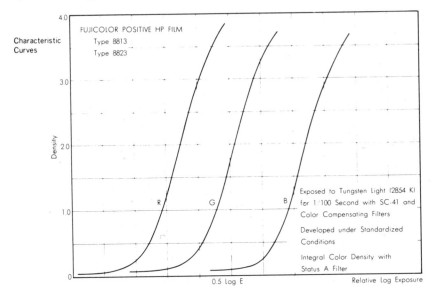

(Continued on following page)

SPECTRAL DENSITY CURVES

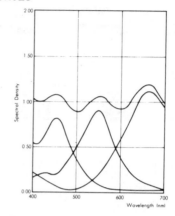

FILM BASE
Clear safety base (TAC).

EDGE MARKINGS
35mm—Frame mark and film identification mark (HP) printed as latent image.
35/16mm—Film identification mark (HP) printed as latent image.
16mm—Film identification mark (HP) printed as latent image.
35/8mm-Type S—Film identification mark (HP) printed as latent image.
16/8mm-Type S—Film identification mark (HP) printed as latent image.
16/8mm-Type R—No film identification mark.

PERFORATION TYPES
35mm—P-4.750mm (KS-1870).
35/16mm—3R-7.620mm 1-3-0 (3R-3000, 1-3-0).
16mm—1R-7.620mm (1R-3000).
35/8mm-Type S—5R-4.234mm, 1-3-5-7-0 (5R-1677, 1-3-5-7-0).
16/8mm-Type S—2R-4.234mm, 1-3 (2R-1667, 1-3), 2R-4.234mm, 1-4 (2R-1667, 1-4).
16/8mm-Type R—2R-3.810mm, 1-4 (2R-1500, 1-4).

PACKAGING
35mm—610m (2000ft), type 35 P3 core, 915m (3000ft), type 35 P3 core.
35/16mm—610m (2000ft), type 35 P3 core, A winding or B winding.
16mm—610m (2000ft), X 2 rolls, type 16 P3 core, A winding or B winding.
35/8mm-Type S—610m (2000ft), type 35 P3 core, A winding or B winding
16/8mm-Type S—(1-3) 610m (2000ft) X 2 rolls, type 16 P3 core, A winding or B winding, (1-4) 610m (2000ft) X 2 rolls, type 16 P3 core.
16/8mm-Type R—(1-4) 610m (2000ft) X 2 rolls, type 16 P3 core.

STORAGE OF RAW STOCK
It is recommended that the raw stock be stored at temperatures below 10°C (50°F) to avoid any changes in photographic properties. When raw stock is opened after removal from refrigerated storage, keep the package sealed until the temperature of the film has reached equilibrium with the ambient air, otherwise condensation of moisture may result.

STORAGE OF PROCESSED FILM
Processed Fujicolor Positive Films should be kept in a cold, dry place. Preferable for such storage purposes are darkened conditions where the temperature is not higher than 20°C (68°F) and the relative humidity is within the range of 40 to 50 percent.

GAFMATE® CHEMISTRY

GAFMATE DEVELOPER

Gafmate developer provides very high contrast. It has extremely long life in all types of automatic processors and in manual processing. Gafmate developer is recommended for processing all Gafmate films and similar high-contrast materials.

Gafmate developer is available in a 2-gallon (7.6 lit.) set, consisting of a 1-gallon (3.8 lit.) bottle each of Part A and Part B concentrates, which make 8 gallons (30.3 lit.) of Gafmate developer working solution. Parts A and B are also available in individual 5-gallon (19 lit.) cubitainers to make 40 gallons (152 lit.) of working solution. Mixing instructions are printed on the labels.

RECOMMENDED DEVELOPMENT OF ALL GAFMATE FILMS IN AUTOMATIC PROCESSORS

	Machine Speed or Dial Setting			
Processor	70°F (21°C)	75°F (24°C)	80°F (27°C)	90°F (32°C)
Du Pont Cronalith 24L	25″/min.	32″/min.	42″/min.	64″/min.
Kodalith	—	—	2.8′/min.	—
LogEtronics	2½ min.	2 min.	1½ min.	1 min.
Pakorol G Pakorol Super G Models: 17-1, 24-1	12″/min.	18″/min.	20″/min.	30″/min.
24-2, 24-3	25″/min.	35″/min.	40″/min.	60″/min.
Pakonolith 24	12″/min.	18″/min.	20″/min.	30″/min.

RECOMMENDED DEVELOPMENT FOR MANUAL (TRAY) PROCESSING

Recommended developing time at 68°F (20°C) with intermittent agitation		
Gafmate Films	Optimum Developing Time	Developing Time Range*
Lithofilms, Econoline films, Contact P405 CF, Contact Duplicating P401 CD, Hi-Speed Duplicating P403 HD	3 minutes	2-4 minutes

*Satisfactory results can be obtained within these developing time ranges.

GAFMATE REPLENISHER

Gafmate replenisher is used with Gafmate developer to maintain a uniform level of activity. It is available as Part A and Part B liquid concentrates, in sizes to make 6 or 30 gallons (22.8 or 114 lit.) of replenisher. Mix according to instructions on label.

(Continued on following page)

419

GAF

MIXING GAFMATE DEVELOPER TANK SOLUTION

	To make 1 gal.	Kodalith Film Processor	DuPont Cronalith 24L	LogEtronics LD-18	LogEtronics LD-24 LD-24A	LogEtronics L-31	LogEtronics LD-42
Tank capacity	1 gal. (3.8 lit.)	12 gal. (45.5 lit.)	18¾ gal. (71.3 lit.)	15 gal. (57.0 lit.)	17 gal. (64.4 lit.)	30 gal. (113.5 lit.)	23 gal. (87.4 lit.)
Water	3 pints (1.46 lit.)	6 gal. (22.7 lit.)	10 gal. (38 lit.)	8 gal. (30.4 lit.)	9 gal. (34 lit.)	15 gal. (56.8 lit.)	12 gal. (45.6 lit.)
Add Gafmate developer part A	1 pint (.476 lit.)	1.5 gal. (5.68 lit.)	2 gal. 44 oz. (8.9 lit.)	1 gal. 3½ qt. (7.1 lit.)	2 gal. 1 pt. (8.05 lit.)	3 gal. 3 qt. (14.2 lit.)	2 gal. 3½ qt. (10.9 lit.)
Add Gafmate developer part B	1 pint (.476 lit.)	1.5 gal. (5.68 lit.)	2 gal. 44 oz. (8.9 lit.)	1 gal. 3½ qt. (7.1 lit.)	2 gal. 1 pt. (8.05 lit.)	3 gal. 3 qt. (14.2 lit.)	2 gal. 3½ qt. (10.9 lit.)
Add water to make	1 gal. (3.8 lit.)	12 gal. (45.5 lit.)	18¾ gal. (71.3 lit.)	15 gal. (57.0 lit.)	17 gal. (64.4 lit.)	30 gal. (113.5 lit.)	23 gal. (87.4 lit.)

(Continued on following page)

MIXING GAFMATE DEVELOPER TANK SOLUTION (continued)

	Pakonolith 24	Pakorol G Model 17-1	Pakorol G Model 241	Pakorol G Model 24-2 Model 24-3	Pakorol Super G Model 17-1	Pakorol Super G Model 24-1	Pakorol Super G Model 24-2 Model 24-3	Pakorol Super G Model 48-1
Tank capacity	9 gal. (34.2 lit.)	5 gal. (19 lit.)	8 gal. (30.3 lit.)	17 gal. (64.4 lit.)	6 gal. (22.8 lit.)	10 gal. (38.0 lit.)	20 gal. (76.0 lit.)	19.5 gal. (74.1 lit.)
Water	5 gal. (19 lit.)	3 gal. (11.4 lit.)	4 gal. (15 lit.)	9 gal. (34 lit.)	3 gal. (11.4 lit.)	5 gal. (19.0 lit.)	10 gal. (38.0 lit.)	10 gal. (38.0 lit.)
Add Gafmate developer part A	1 gal. 1 pt. (4.3 lit.)	2 qt. 1 pt. (2.37 lit.)	1 gal. (3.8 lit.)	2 gal. 1 pt. (8.05 lit.)	3 qts. (2.8 lit.)	1 gal. 1 qt. (4.7 lit.)	2 gal. 2 qt. (9.5 lit.)	2 gal. 1¾ qts. (9.3 lit.)
Add Gafmate developer part B	1 gal. 1 pt. (4.3 lit.)	2 qt. 1 pt. (2.37 lit.)	1 gal. (3.8 lit.)	2 gal. 1 pt. (8.05 lit.)	3 qts. (2.8 lit.)	1 gal. 1 qt. (4.7 lit.)	2 gal. 2 qt. (9.5 lit.)	2 gal. 1¾ qts. (9.3 lit.)
Add water to make	9 gal. (34.2 lit.)	5 gal. (19 lit.)	8 gal. (30.3 lit.)	17 gal. (64.4 lit.)	6 gal. (22.8 lit.)	10 gal. (38.0 lit.)	20 gal. (76.0 lit.)	19.5 gal. (74.1 lit.)

(Continued on following page)

GAF

421

GAF

REPLENISHMENT RATE GUIDE

Milliliters (cc) of Gafmate replenisher to be added for each sheet of Gafmate film developed

Film Size (inches)	Lithofilms and Contact Film P405 CF % D-max area			Hi-speed Duplicating Film P403 HD % D-max area			Contact Duplicating Film P401 CD % D-max area			Econoline Films % D-max area	
	25 line positive	50 halftone	75 line negative	25 line positive	50 halftone	75 line negative	25 line positive	50 halftone	75 line negative	25 line positive	75 line negative
8 x 10	18	32	45	27	48	68	36	64	90	18	45
10 x 12	26	48	67	39	72	100	52	96	134	26	67
11 x 14	34	62	79	51	93	118	68	124	158	34	79
12 x 18	48	86	120	72	129	180	96	172	240	48	120
14 x 17	52	96	138	78	144	177	104	192	276	52	138
16 x 20	70	128	178	105	192	267	140	256	356	70	178
18 x 23	91	166	232	136	249	348	182	332	464	91	232
20 x 24	107	193	267	161	289	400	214	396	534	107	267
24 x 30	160	238	400	240	352	720	320	476	800	160	400
30 x 40	264	480	670	396	720	1000	528	960	1340	264	670

(Continued on following page)

The Compact Photo-Lab-Index

GAFMATE FIXER

A fast-working fixer for use with Gafmate films, Gaftype C paper, and similar materials in automatic processing equipment and in manual processing. Fixer package contains Part A (fixer) and Part B (hardener) concentrates. Gafmate fixer may be used at temperatures from 65-85°F (18-30°C).

FIXING TIME (Manual Processing)

Fresh Gafmate fixer will clear graphic arts films in 1 to 2 minutes. For proper fixation, fix for twice the clearing time. For maximum fixer life, use a 1 to 1½% acetic acid short-stop bath before fixing.

REPLENISHMENT

For each square inch of graphic arts film or paper fixed, replenish with 0.38 ml fixer working solution. For example, a 20″ x 24″ sheet of film requires fixer replenishment with 182 ml working solution (20 x 24 = 480 x 0.38 = 182.4).

NONHARDENING FIXER

A nonhardening fixer can be made by omitting the Gafmate fixer hardener (Part B), replacing it with water to make up the specific volume. Replenishment rates remain unchanged. Use at 65-75°F (18-24°C).

MIXING GAFMATE FIXER WORKING SOLUTION

Fixing Solution	Machine Processing			
	8 Gal. (20.4 lit.)	16 Gal. (60.8 lit.)	20 Gal. (76 lit.)	28 Gal. (106 lit.)
To water 65-75°F (18-24°C)	4 gal. (15.2 lit.)	8 gal. (30.4 lit.)	10 gal. (38 lit.)	14 gal. (53 lit.)
Add Gafmate fixer solution A	2 gal. (7.6 lit.)	4 gal. (15.2 lit.)	5 gal. (19 lit.)	7 gal. (26.6 lit.)
Add Gafmate fixer hardener solution B	1 qt. 9 oz. (1.5 lit.)	3 qt. 6 oz. (3.0 lit.)	1 gal. (3.8 lit.)	5 qt. 19 oz. (5.3 lit.)
Add water 65-75°F (18-24°C) to make	8 gal. (30.4 lit.)	16 gal. (60.8 lit.)	20 gal. (76 lit.)	28 gal. (106 lit.)

GAFMATE PROCESS CONTROL STRIPS

For optimum results with Gafmate chemistry, use Gafmate process control strips.

(Continued on following page)

GAF® PHOTOFINISHING CHEMICALS
SHURFIX® TYPE II FIXER AND HARDENER

Liquid fixer concentrate and separate hardener. Mixed with water (according to "Film Finishing" instructions on container), they provide a fast-working fixer with excellent hardening action and long working life.

FIXING TIME

At 68°F, fix films from 5 to 10 minutes. At other temperatures, films should be left in the fixer for twice the time it takes them to clear.

REPLENISHMENT

Manual Processing: To replenish SHURFIX fixer in deep tanks, add 1 gallon Solution A and 15 oz. Solution B for each 1,000 rolls of 120-size film, 8″ x 10″ sheet film, or their equivalent in other sizes. If two fixer tanks are used, replenish solution in the first tank only.

Machine Processing—44-gallon fixer tank: For each 2,000 rolls of 120-size film, 8″ x 10″ sheet film, or their equivalent in other sizes, add 2 gallons of Solution A and 30 oz. of Solution B.

Machine Processing—83-gallon tank or *two* 48-gallon tanks: For each 2,000 rolls of 120-size film, 8″ x 10″ sheet film, or their equivalent in other sizes, add 1¼ gallons of Solution A and 18 oz. of Solution B. In the two-tank setup, *replenish solution in the first tank only.* To make room for the replenisher, remove from the fixer tank a corresponding amount of solution before replenishing.

Machine Processing—automatic replenishment.

Set SOLUTION A flow meter at the following rates:

31 to 45-gallon tanks	48 to 83-gallon tanks
19 ml per 5-roll rack	12 ml per 5-roll rack
23 ml per 6-roll rack	15 ml per 6 roll rack
27 ml per 7-roll rack	18 ml per 7-roll rack
27 ml per 10-roll rack	18 ml per 10-roll rack
of small films (126 and	of small films (126 and
similar sizes)	similar sizes)

In addition, add 20 oz. SOLUTION B, manually, after each 2,000 120-size rolls or equivalent (in any size tank).

In a two-tank setup, *replenish solution in the first tank only.*

WORKING CAPACITY

Tank Size	Discard fixer (both fixing baths, where two are used) after the following number of 120-size rolls 8″ x 10″ sheet films, or their equivalant in other sizes have been processed	
	Manual Processing	Machine Processing
1-gallon	600	
3½-gallon	2,000	
5-gallon	2,800	
TWO 31-gallon tanks	26,000	
44-gallon		20,000
TWO 48-gallon tanks		36,000
83-gallon		30,000

(Continued on following page)

STORAGE LIFE

Concentrates (in unopened original containers, under 90°F) indefinite
Working solution (in tank) 1 month

AVAILABILITY

SHURFIX Solution A and Solution B are available in 1-gallon plastic bottles and 5-gallon cubitainers.

*Control strips and record forms are available from Laboratory Services, GAF Corporation, Binghamton, N.Y. 13902.

†To prepare approximately 14% acetic acid, mix thoroughly 1 part of glacial acetic acid with 6 parts of water. CAUTION: Always add the acid to the water.

PAPER CHEMICALS
MIRADOL® DEVELOPER

(component of GAF Matched Chemical System: MIRADOL developer, VIVI-STOP short-stop, and VIVIFIX fixer)

All-purpose paper developer for photofinishers. It is excellent for continuous machine processing of single- and double-weight roll papers. MIRADOL developer promotes washing efficiency by minimizing penetration of chemicals into the paper base.

MIXING

Follow instructions on container label.

DEVELOPING TIME AT 68°F

GAF Photofinishing Paper Type 4501 and similar papers: 1 to 1½ minutes. Other papers may require 1½ to 2 minutes.

USE IN PROCESSING MACHINES

Pour 1 quart of cold water into developer tank for *each gallon of its capacity;* then add the following amounts of MIRADOL developer starter solution for each gallon of tank capacity:
Photofinishing papers ¼ oz. (7.5 ml)
All other papers .. ½ oz. (15 ml)
Fill tank with MIRADOL developer *stock solution.*

REPLENISHMENT CHART

Paper Type	Add following amounts of MIRADOL stock solution for each foot of paper processed Width of paper roll			
	3½"	5"	8"	10"
GAF Photofinishing Paper Type 4501 and similar papers	4.5 ml	6.5 ml	10.5 ml	12.5 ml
Other papers may require	10 ml	14 ml	28 ml	23 ml

WORKING CAPACITY

Replenished MIRADOL developer may be used for about 80 hours of average operation, or as long as satisfactory performance is indicated by tests.

(Continued on following page)

GAF

The Compact Photo-Lab-Index

STORAGE LIFE
Unopened can (under 90°F)indefinite
Solution (in tank with floating lid)1 month

AVAILABILITY
MIRADOL developer is supplied in one size, to make 25 gallons of stock solution. Starter solution is available in 1 quart bottles.

VIVIDOL-M® DEVELOPER

Excellent developer for machine or tray processing of *single-weight* roll and sheet papers.

MIXING
Follow instructions on container label.

DEVELOPING TIME AT 68°F
Develop all papers from 1 to 2 minutes (single-weight only).

USE IN PROCESSING MACHINES
Fill developer tank one quarter full of water (one quart of water for each gallon of tank capacity), then fill tank with VIVIDOL-M developer stock solution.

USE IN TRAYS
Use undiluted (stock) solution.

REPLENISHMENT
In processing machines, replenish with the following amounts of VIVIDOL-M stock solution:

	Width of paper roll			
	3½"	5"	8"	10"
Add following amounts of VIVIDOL-M stock solution for each foot of paper processed	10 ml	14 ml	23 ml	28 ml

PAPER CHEMICALS
In trays, use VIVIDOL-M stock solution without replenishment; discard when exhausted.

WORKING CAPACITY
Replenished VIVIDOL-M developer may be used in continuous processing machines for about 80 hours of average operation, or as long as satisfactory performance is indicated by tests.

STORAGE LIFE
Unopened can (under 90°F)indefinite
Solution (in tank with floating lid or in stoppered bottle)1 month
Solution (in completely filled stoppered bottle)6 months

AVAILABILITY
VIVIDOL-M developer is supplied in one size, to make 50 gallons of stock solution.

(Continued on following page)

426

VIVISTOP® SHORT-STOP

(component of GAF Chemicals System)

Fixer-type short-stop for use before VIVIFIX fixer in continuous paper processors. Promotes washing efficiency by minimizing penetration of chemicals into paper base.

MIXING
Follow instructions on container.

USE AND REPLENISHMENT
Use without dilution. Replenish with same solution, at the following rates:

Paper Type	Add following amounts of VIVISTOP short-stop for each foot of paper processed Width of paper roll			
	3½"	5"	8"	10"
GAF Photofinishing Paper Type 4501 and similar photofinishing papers	5.5 ml	8 ml	12.5 ml	16 ml
Other papers may require	10 ml	14 ml	23 ml	28 ml

WORKING CAPACITY
Discard solution after 80 hours of average operation.

STORAGE LIFE
Unopened package (under 90°F)indefinite
Solution (in tank with floating lid)1 month

AVAILABILITY
VIVISTOP short-stop is supplied in one size, to make 25 gallons of working solution.

SHORT-STOP FOR MANUAL PROCESSING
Prepare short-stop by adding 6 oz. of 28% acetic acid* to each gallon of water. Agitate prints in short-stop for 20 seconds, then transfer them to fixer. Capacity is about 300 8" x 10" prints per gallon. Use until pH rises to 5.7.

*To make approximately 28% acetic acid, dilute 3 parts of glacial acetic acid with 8 parts of water.
CAUTION: Always add the acid to the water.

VIVIFIX® FIXER

(component of GAF Matched Chemicals System)

Special fixer for use in machine processing of papers treated in VIVISTOP short-stop (should not be used with other short-stops). In addition to its fixing action, VIVIFIX fixer facilitates print washing by diffusing absorbed chemicals.

MIXING
Follow instructions on container. *Note different dilutions* recommended for photo-finishing papers and for other type papers.

FIXING TIME
A minimum fixing time of 4 minutes at 68°F is suggested.

(Continued on following page)

The Compact Photo-Lab-Index

REPLENISHMENT

Replenish *with working solution recommended for type of paper being processed* (as specified in mixing instructions on container).

Paper Type	Add following amounts of VIVIFIX fixer for each foot of paper processed Width of paper roll			
	3½″	5″	8″	10″
GAF Photofinishing Paper Type 4501 and similar photofinishing papers	16 ml	22 ml	37 ml	44 ml
Other papers may require	20 ml	28 ml	46 ml	56 ml

WORKING CAPACITY

Discard solution after 80 hours of average operation (about 50,000 feet of 3½″ wide paper, or equivalent).

STORAGE LIFE

Unopened package (under 90°F) . indefinite
Solution (in tank with floating lid) . 1 month

AVAILABILITY

VIVIFIX fixer is supplied in one size, to make 50 gallons (for photofinishing papers) or 35 gallons (other papers) of working solution.

SHURFIX® TYPE II FIXER AND HARDENER

Fast-working, large-capacity liquid fixer concentrate and separate hardener, for manual processing of papers.

MIXING

Mix according to "PRINT FIXING" instructions on container.

FIXING TIME

Rinse prints in an acetic acid short-stop* bath (NOT in VIVISTOP short-stop), then fix them for about 5 minutes at 68°F. Reduce fixing time to about 3 minutes when fixing at higher temperatures (no over 75°F). AGITATE AND SEPARATE PRINTS FREQUENTLY. *Do not overfix.*

WORKING CAPACITY

Using a single fixing bath, one gallon of SHURFIX Type II fixer will fix approximately 100 sheets of 8″ x 10″ paper, or equivalent in other sizes.

PAPER CHEMICALS

In volume work, two fixing baths should be used. Fix prints in each bath for about 3 minutes at 68°F. Do not overfix. After 200 8″ x 10″ prints have been fixed in two one-gallon fixing baths (or an equivalent number in larger tanks), discard the first bath, replace it with the second, and mix a fresh second bath. Repeat this cycle 5 times until a total of 1000 8″ x 10″ prints have been fixed per twin-gallon, then discard both baths.

STORAGE LIFE

Concentrate in original container (under 90°F) . indefinite
Working solution . 1 month

AVAILABILITY

SHURFIX Solution A and Solution B are available in 1 gallon plastic bottles and 5-gallon cubitainers.

(Continued on following page)

428

GAF® ACID FIXER WITH HARDENER

General purpose fixer-hardener, supplied in ready-to-dissolve single-powder form.

MIXING
Follow instructions on container.

FIXING TIME
Rinse prints in an acetic acid short-stop* bath (NOT in VIVISTOP short-stop), then fix them for 5 to 10 minutes at 68°F. AGITATE AND SEPARATE PRINTS FREQUENTLY. *Do not overfix.*

WORKING CAPACITY
Using a single fixing bath, one gallon of Acid Fixer with Hardener will fix approximately 100 sheets of 8" x 10" paper, or equivalent in other sizes.
*See "Short-Stop for Manual Processing" mentioned earlier.

In volume work, two fixing baths shoulld be used. Fix prints in each bath for about 3 minutes at 68°F. Do not overfix. After 200 8" x 10" prints have been fixed in two one-gallon fixing baths (or an equivalent number in larger tanks), discard the first bath, replace it with the second, and mix a fresh second bath. Repeat this cycle 5 times until a total of 1000 8" x 10" prints have been fixed per twin-gallon, then discard both baths.

STORAGE LIFE
Unopened package (under 90°F) indefinite
Solution in full, stoppered bottle 2 months
Solution in deep tray 2 weeks
(to minimize evaporation, keep tray covered when not in use)

AVAILABILITY
Acid Fixer with Hardener is available in sizes to make 1 quart, ½ gallon, 1 gallon, and 5 gallons of working solution.

GAF® DEVELOPER SYSTEMS CLEANER

Solution for cleaning the developer systems of all automatic film and paper processors. Do not use in short-stop or acid fixer systems.

MIXING
Follow instructions on package.

USE
Circulate the developer systems cleaner solution for at least 30 minutes before draining, then flush the system by filling with and recirculating clean, warm water. Drain and flush again; repeat until no trace of the orange color remains. In extreme cases of crusty deposits repeat the cleaning procedure with fresh developer systems cleaner solution.

STORAGE LIFE
Unopened package ...indefinite

AVAILABILITY
Supplied in one size, to make 7 gallons of solution.

(Continued on following page)

GAF

HAZARDS AND SAFETY PRECAUTIONS

GLACIAL ACETIC ACID

DANGER! POISON!

Causes severe burns. Keep out of the reach of children. Do not get liquid or vapors in eyes, on skin or clothing. Keep away from heat or open flame. External: Wash with water. Internal: Give magnesia, chalk or whiting in water. Call a physician.

MIRADOL DEVELOPER—Part 1

CAUTION!

May cause skin irritation. May be harmful if swallowed. Contains hydroquinone and Metol. Keep out of the reach of children. Avoid prolonged or repeated contact with dry material. If ingested, induce vomiting. Call a physician.

MIRADOL DEVELOPER—Part 2

DANGER! POISON!

Causes severe burns to skin and eyes. Sodium hydroxide (caustic soda). Keep out of the reach of children. Avoid contact with skin, eyes and clothing. Do not take internally. When handling, wear goggles or face shield. While making solutions, add sodium hydroxide slowly to surface of solutions to avoid violent spattering. In case of contact, immediately flush skin with plenty of water; for eyes, flush with plenty of water for at least 15 minutes and get medical attention.

VIVIDOL-M DEVELOPER

CAUTION!

May cause skin irritation. May be harmful if swallowed. Contains hydroquinone, Metol and mild alkali. Keep out of the reach of children. Avoid prolonged or repeated contact with dry material. If ingested, induce vomiting. Call a physician.

DEVELOPER SYSTEMS CLEANER

DANGER! POISON!

Harmful if swallowed. Causes burns. Contains potassium dichromate and sulfamic acid. Keep out of the reach of children. Avoid contact with skin, eyes, and clothing. In case of contact, flush skin and eyes with plenty of water for at least 15 minutes. For eyes, or if swallowed, get medical attention.

(Continued on following page)

GAF

GAF® TEMPLATE EMULSIONS

INTRODUCTION

Experience in the aircraft and other industries has shown that Template Photography is an efficient production tool. Great savings in both time and money have been made possible through this process which permits the rapid, photographic reproduction of master drawings directly upon emulsion-coated metal sections which are to be used either as patterns for making duplicate pieces, or as the finished pieces themselves.

Although developed expressly for the aircraft industry, Template Emulsions have applications in other fields as well, since these photo-sensitive materials can be applied to many surfaces—metal, glass, china, wood, cardboard, paper and certain plastics.

GAF supplies three types of Template Emulsions, (1) Regular, (2) Type RC, (3) Type WOS:

Type Regular—a medium speed, medium contrast emulsion used with projection printers or enlargers. The photographic characteristics are quite similar to a #2 projection printing paper. A red safelight Series 1A or equivalent can be used with a 15 watt bulb, at a distance of not less than 4 feet.

Type RC—a slow speed, high contrast, reflex type emulsion with low fog level, designed for contact printing techniques. Its slow emulsion speed permits usage in fairly bright safelight. Its panchromatic sensitivity permits registering colored lines or images in proper value. Where such registration is not required, it can be dropped out in the reproduction process by proper filtration. A yellow-green safelight Series OA or equivalent can be used with a 15 watt bulb, at a distance of not less than 4 feet.

Type WOS—(without sensitizers) this is basically Template RC emulsion without panchromatic sensitivity thus rendering the emulsion blue sensitive only, colorblind. A yellow-green safelight Series OA or equivalent can be used with a 25 watt bulb. WOS is available on special order.

SHIPMENT

Template Emulsion is shipped in its gel state in waterproof plastic bags within a cardboard carton. The minimum order is two kilos (4.4 lbs.) which makes a little over two quarts of liquid when the emulsion has been melted. Larger quantities may be ordered. Cartons should be opened under the recommended safelight conditions only. Insulated master cartons holding 32 kilos are packed with dry ice to keep the contents in its gel state in transit.

STORAGE

Template Emulsion which melts at room temperature will keep very satisfactorily for a period of two months or more if stored at temperatures 40°F-50°F. Any electric refrigerator may be used, however actual freezing of the emulsion, which would produce ice crystals, should be avoided.

EQUIPMENT

Probably the most satisfactory method of coating Template Emulsion on large metal sheets or other surfaces, is by the use of spray guns, similar to those employed for paints or lacquers. Prolonged contact of the sensitive emulsion with copper, brass, zinc or iron will cause chemical fogging. Therefore, the reservoir of the spray gun should preferably be stainless steel or of a silver-plated material. Aluminum reservoirs have proved satisfactory as long as the emulsion did not remain in them for long periods. Momentary contact with brass tubes and nozzles in such spray guns probably will not give trouble, but it is nevertheless preferable that these parts be silver-plated, chrome-plated or of stainless steel.

(Continued on following page)

GAF

SUPPORT SURFACE PREPARATION

When the emulsion is coated on most metal plates, including steel, an insulated layer must be provided on the sheet between the metal and the silver emulsion. Otherwise, immediate fogging and breakdown will result. Satisfactory paint or lacquer preparations, such as Dupont "Preparakote," which are photographically inert can be used for this purpose. Before painting, the metal sheets must, of course, be thoroughly degreased and cleaned. Other materials may also be so impervious to solvents that difficulty is experienced in securing a good bond between the emulsion and support. Some plastics, for example, (particularly acrylic materials), offer extreme resistance to adhesive agents. The subbing formula listed has worked well with glass plates and may be satisfactory for other supports.

STORAGE OF COATED PLATES

If it is desired to store plates for some time after applying the sensitive coating and before exposure, it is necessary to insure that the insulating layer between metal and emulsion thoroughly protects the latter. Experiments indicate that commonly used lacquers or paints have a slight solvent action on the metal which forms traces of metal salts on the protective layer. This may produce streaks of fog or an overall fog on sensitized plates stored for several days. The difficulty can be eliminated by washing the painted surface with a very weak acetic acid solution before coating the emulsion. A concentration of about ½% acetic acid is satisfactory. The acid wash should be followed by a washing with pure water.

If fogging of the emulsion, due to the protective lacquer, can not be eliminated by washing, then it may be necessary to use a subbing solution which is sprayed over the lacquer shortly before coating of the sensitive emulsion. The subbing solution dries very rapidly and offers the additional advantage of an excellent bond between the emulsion and lacquer.

The surface of the material should be clean before subbing. Any suitable detergent such as GAF VIVIFLOW 300 wetting agent, diluted 1 to 300, will be satisfactory.

SUBBING SOLUTION

Dissolve 36 grams of clear gelatin in 14 liters of water at 105 to 115°F. After the gelatin is thoroughly dissolved, add 100 ml of a 6% chrome alum solution. Stir thoroughly and add 60 ml of glacial acetic acid. Apply subbing solution to surface to be emulsion coated and dry with warm air. A second layer may be applied for improved adhesion.

EMULSION PREPARATION

When the Template Emulsion is removed from the refrigerator for use, it is placed in a suitable glass, stainless steel or good enamelware container and melted by warming to a temperature of about 100°F. This can be done most satisfactorily in a water bath or double boiler.

Only enough emulsion should be melted for immediate use, because after adding the "Finals," described below, its physical characteristics are somewhat altered and it is less easily remelted. Therefore, care should be taken not to put melted emulsion back with fresh material in the container. However, emulsion without finals is usually quite usable even though it may have been melted and gelled a number of times.

ADDING "FINALS"

Although Template Emulsions can be applied without "additions," it may be desirable to provide better "flow" properties and increased hardening characteristics. If desired, when the emulsion is melted the following ingredients are added with thorough stirring:

(Continued on following page)

GAF

The Compact Photo-Lab-Index

Per 1000 ML (1L) Template Emulsion:
300 ml Methanol
2 ml Amyl Alcohol
3 ml 5% Formaldehyde*
*To prepare 5% Formaldehyde from commonly available 40% Formaldehyde, dilute one part of the latter with seven parts of distilled water.

For further hardening qualities, it may be necessary to increase the formaldehyde (hardening agent) content to 5 to 10 ml per liter of emulsion. Chrome alum may be substituted for formaldehyde—10 ml of 10% chrome alum per liter is recommended.

COATING

Emulsion may be applied by several methods—spraying, flowing, brushing, or mechanically by a lithographer's plate whirler. Since the first mentioned method is the most efficient for the large scale work required in air frame industries, the technique is described in more detail following.

One kilo of emulsion, which makes slightly over one quart of liquid solution when melted, should coat from 50 to 70 square feet of surface, depending upon the porocity of the material coated and the thickness of the layer desired. In some cases, where greater image density is required, it may be desirable to coat a second layer or even a third. In fact, additional layers may be necessary if the first coating is found to be streaked, uneven, or covered with bubbles so often encountered if extreme care is not exercised in coating operations. A short trial and error course should give an operator the "feel" for the most suitable technique, and the correct amount of coating to give a good black image area.

The GAF Corporation does not furnish a coating service. The multitude of applications possible and great variety of requirements would make such a program impractical.

SPRAYING

The technique of spraying GAF Template Emulsion differs little from the technique used when applying, for example, a coating of lacquer.

The most satisfactory air pressure has generally been found to be about 40 pounds, although this may vary with the different types of spray guns.

Suspension of the template sheet at an angle during spraying has been found most satisfactory. It minimizes run off of the emulsion with consequent streaking which occurs if the plate is stood or hung in a vertical position. The best angle appears to be about 45° to 60° from the horizontal (or not closer than 30° to vertical).

Distance of the spray gun to the plate is highly important. Holding the gun too close will result in frothing of the emulsion due to impact of the air stream. If the gun is too far, particles of emulsion will set up or harden before striking the plate. The optimum distance with air pressure of about 40 pounds has been found to be about 6 inches and the width of the spray stream at point of impact should be about the same as the distance from the plate to nozzle.

The emulsion should be applied using a smooth vertical rhythm. The speed of the vertical movement should be adjusted to control the thickness of the sprayed coating. At the end of each stroke, the gun should be turned off to prevent piling up of the emulsion along the edges of the plate.

After spraying, the coating should be allowed to dry thoroughly, preferably in a gentle draft of cool, dry air, free of dust. With the "finals" given above, drying time should be approximately 30 minutes to one hour. One coating of emulsion is sufficient for the majority of applications.

When it is necessary to obtain an especially dense, clear image, it will be found most satisfactory to apply two emulsion coatings with the spray gun, stroke of the second coating at right angles to the first. The second spray coat should be

(Continued on following page)

GAF

applied either immediately following the first or after the first is completely dry. The second coat should never be applied after the first coat is partially dry, or the emulsion may peel off the plate while in the developer.

DEVELOPMENT

GAF VIVIDOL Developer (dilute 1 to 2 parts water) is recommended for use with all GAF Template Emulsions. This is a standard formula for photographic papers and is available in prepared form in sizes to suit the requirements of both large and small users. Development time in VIVIDOL should be one to two minutes at 68°F (20°C). Other formulas for use with photographic papers are also suitable. After development, rinsing should be accomplished in an acetic acid short-stop bath for ten seconds.

GAF LIQUID REPROFIX Fixer with separate hardener, or REPROFIX with incorporated hardener are recommended for fixation. The fixing solution keeps well and may be stored over long periods of time. Fix for 3 to 6 minutes at 68°F (20°C).

Developing of large metal sheets may be carried out in deep tanks or large trays. Developing, fixing and washing may also be done by spraying, flowing, or swabbing the solutions over the plates. In this method, troughs are placed to catch the solutions which flow from the bottom edge of the plates, and a circulating system pumps the solution so that it is used over and over again.

GAF PHOTOGRAPHIC CHEMICALS AVAILABILITY

VIVIDOL DEVELOPER—16 oz., 1 qt., 1 gallon, 5 gallons of stock solution.

LIQUID REPROFIX FIXER—1 gallon concentrate to make 4 gallons of solution, 5 gallon container concentrate to make 20 gallons of solution.

GAF LIQUID REPROFIX HARDENER—1 gallon plastic jug.

GAF REPROFIX FIXER (powder)—1 gallon (24 per case), 5 gallons (6 per case).

(Continued on following page)

GAF PHOTOGRAPHIC FORMULAS

When a photographic emulsion is exposed to light, the silver salt (silver bromide, chloride or iodide) which the light reaches, undergoes a definite though invisible change to form what is known as the latent image. It is not yet definitely known just how this change takes place, but it is believed that the exposed parts of the emulsion gain a certain "activation" that makes them susceptible to the reducing action of a developer. When placed in a developing solution the exposed, "activated" particles of silver salt are reduced chemically to black metallic silver, leaving the unexposed particles of silver salt unchanged. Reduction in this sense does not have the meaning commonly thought of in the photographic field, namely, the lessening of density in a film negative. This *chemical* reduction is a conversion of the silver salt to free silver and for the reaction one or more *reducing agents*— which photographers call "developers"—are necessary.

THE DEVELOPER'S BASIC COMPONENT
The Reducing Agent

There are many chemicals which are reducing agents, but most of them are too powerful to be used for developing because they reduce all the silver salt in the emulsion without regard to the latent image which exposure in the camera has produced. Therefore a reducing agent must be selected which is satisfactory as a developer and which confines its action to the exposed particles of silver salt, leaving the remaining unaffected. Of the reducing agents that are satisfactory for photographic use, metol, hydroquinone and pyro are most commonly used, and there are in addition other developing agents such as glycin, amidol, phenidone and rodinal frequently employed. There are several developing agents on the market under different names from metol, but which are basically chemical— mono-methyl-para-amino-phenol-sulfate.

As has been indicated, the chemical action of these developing agents is fundamentally the same. The photographic effect, however, depends to a large extent on the particular developing agents, and one formula may have, for example, a high percentage of hydroquinone to produce brilliant photographic images while another formula may use a larger ratio of metol to produce softer results.

It is obvious, therefore, that great care should be taken in the preparation of developing solutions, for a slight error in the type or amount of the developing agents (or the other constituents too, for that matter) may have a serious effect on the behavior of the developer. Most successful photographers have found that it is far wiser to use the formulas recommended by the manufacturer and to make sure solutions are carefully and accurately mixed, than to spend time on individual experimenting or research. The use of recommended formulas is undoubtedly one of the most important helps to getting good results in film development.

OTHER INGREDIENTS OF THE DEVELOPING SOLUTION
The Alkali—The Activator

The function and importance of the developing agent in the developer have both been mentioned—but there are three other components which also play an important role in any developing solution. The first of these is the alkali—which is ordinarily essential for development. Most of the developing agents in use today are neutral or slightly acid in their normal state, and in this condition give little or no developing action. However, when an alkaline salt like sodium carbonate is introduced into the solution containing the development agent, a very interesting change takes place. The developing agent forms what is called an alkaline salt which in a photographic sense is a more active material, and it is this alkaline salt of the developing agent that actually reduces the exposed grains of silver salt to metallic silver. The alkali has a secondary effect in the developing solution which is also important. It helps the gelatin emulsion to swell and thus facilitates the penetration of the developing solution throughout the network layer of the emulsion.

(*Continued on following page*)

GAF

It is obvious that the alkali is a really important component of the developing solution and it is likewise evident that care must be exercised in using the right kind and correct amount of alkali. Sodium carbonate is normally recommended though potassium carbonate is sometimes used in its place. The caustic alkalis, sodium hydroxide and potassium hydroxide, should not be substituted unless definitely specified, as they are much stronger and can easily cause fog. Normally they are used only in special-purpose developers giving high contrast. Borax and similar alkalis which are less energetic are often specified for fine-grain development in which grain size must be controlled by softer development. Another alkali used for photographic work is sodium metaborate which is helpful in reducing blister formation where it is difficult to control the temperature of processing solutions during hot weather.

The amount of alkali should, of course, be weighed accurately to the amount specified, as too much may cause fog in developed negatives; too little may result in slow, soft development. It is important to remember when using carbonate that the potassium salt is generally available only in the anhydrous form, while the more generally used sodium salt can be obtained as (1) the anhydrous (desiccated) salt containing about 2% water, (2) the monohydrated salt containing about 15% water, or (3) in crystal form containing about 63% water. The anhydrous and crystalline forms are both unstable at ordinary conditions of temperature and humidity, and must be kept in tightly sealed containers and used with great care to prevent considerable absorption of water from the atmosphere by the anhydrous salt, or loss of water by the crystalline form. The monohydrated form of sodium carbonate is stable and therefore preferred by most photographers for accurate preparation of developing solutions.

THE PRESERVATIVE

It is a characteristic of many photographic reducing agents in alkaline solutions to combine freely and easily with oxygen. Because of this "hunger" for oxygen, alkaline solutions of the developing agents spoil very quickly when exposed to air. To increase their useful life, to allow the developing agent to do its work on the exposed silver halide as desired, and to prevent the occurrence of stains, a preservative must be added to the developing solution.

Sodium sulfite is ordinarily used as the preservative, though in developers prepared for stock in two solutions, preservatives which are slightly acid in solution such as sodium bisulfite and potassium metabisulfite are preferred. Because developing agents keep better in acid solution than in one which is alkaline, it is common practice to use one of these acid sulfites as the preservative in the developer part of the stock solution. In single-solution developers, sodium bisulfite is never used alone as a preservative, since it neutralizes some of the alkali in the solution and would result in softer development. One other interesting point about preservatives is that in some cases the preservative performs a secondary function in the developer. In some fine-grain developers, for instance, a large amount of sodium sulfite is used to aid in keeping grain size at a minimum.

THE RESTRAINER

The fourth and final important component of the typical developing solution is the restrainer, potassium bromide. This necessary constituent of the developing solution acts as a "brake" on the chemical reaction of development and keeps the operation under control. The action of the restrainer is such that an increase in the concentration of potassium bromide in the developer tends to slow down or "restrain" the development of the photographic image. The concentration of potassium bromide in the solution is obviously important, for too much may retard development excessively and indicate an apparent loss of speed, while too little may permit development of fog.

DEVELOPER EXHAUSTION

The chemical reaction of development results in a depletion of certain constituents

(Continued on following page)

436

of the developing solution so that with continued use the developer becomes less efficient. This "exhaustion" of the developer is characterized by a loss in effective speed and gradation of the photographic emulsion (of importance in both film and paper development) and by a change in tone of the developed image (of special importance in making prints). In consequence of this condition, it is standard practice to use fresh developing solution whenever possible, as it is good insurance of obtaining uniformly optimum results with photographic films and papers.

REPLENISHERS

There are, however, occasions when a rather large quantity of developer must be put in use, as in the tank development of films, and in such circumstances it becomes desirable, for reasons of economy, to prolong the usefulness of the developer by the addition of a "replenisher" solution which replaces solution carried away on developed films and helps restore the balance of active ingredients in the solution. For replenishers for GAF formulas commonly used in tank development, see the formulas appended to GAF 17, 17M, 47 and 48M.

By the occasional addition of such replenishers to maintain a constant volume of solution in the developing tank, the useful life of the developer can be prolonged three to four times without seriously degrading the quality of developed negatives. If large amounts of replenisher are to be added at any one time, the activity of the solution may be so increased that developing time will have to be shortened excessively, unless the replenisher is diluted somewhat with water.

Frequent requests are made for information on the exhaustion characteristics of a developer so that the user may have some idea of the amount of film or paper that may be safely processed. The accuracy of information given on this point depends largely on the three following factors which should be considered when interpreting data on exhaustion characteristics.

1. The rate of exhaustion is greatly influenced by the type of negatives or prints. When average density is high, exhaustion will be faster. When average density is low, exhaustion will occur more slowly.

2. The useful life of a developer is shortened by oxidation caused by contact with air. Exhaustion characteristics will, therefore, depend greatly on the age and manner in which the solution is used.

3. The degree of permissible exhaustion of paper developers is also dependent on the acceptable tolerance in variation of image tone of prints. Exhaustion figures cited below are based on what are normally considered acceptable prints, and may require modification if unusually critical standards of uniformity of image tone are established.

With appropriate regard given to the factors mentioned above, the following figures on developer exhaustion may be applied in practice. GAF film developers 17, 17M, 47 and 48M can be safely used without replenishment for the development of 24 rolls of 120 and 620 size (or an equivalent amount of other size film) per gallon of developer if compensation in developing time is made as the solution is used. On the basis of a gallon of developing solution the increase in developing time amounts to approximately 10% or every four rolls of film processed—or, more simply, 10% increase per roll per quart of developer. When used with their respective replenishers at the rate of ½ to ¾ ounce or more of replenisher per roll of film, these developers may be used for approximately 200 120 or 620 rolls per gallon of original developer without necessitating an increase in the original time of development. When adding replenisher, maintain original volume of developer, discarding, if necessary, some used developer.

GAF Paper Developer 103, 125 and 135 may be used satisfactorily without replenishment for the development of from 100 to 125 8 x 10" prints per gallon of working strength developer. This quantity assumes a change of tone within acceptable limits and a slight and progressive increase in exposure and developing time in order to maintain constant print quality throughout the life of the solution.

(Continued on following page)

THE IMPORTANCE OF A SHORT STOP

As negatives or prints are removed from the developing solution, they carry with them considerable amounts of alkali and other chemicals which can contaminate the fixing bath and interfere with its action. Used-up developer carried along with negatives and prints can also cause troublesome stains if some method is not used to stop development instantly and completely. The best and most reliable way of doing this is the well-known short-stop bath of dilute acetic acid which neutralizes any alkali remaining on negatives or prints and prevents contamination of the fixing solution. Yet it is surprising how many photographers still try to get along without this intermediate bath between development and fixation. It is true that an acid fixing bath will give satisfactory results without the use of a preliminary short-stop bath, but its useful life is severely limited when a short-stop is not used.

Photographers frequently ask why acetic acid is used for the short-stop bath and fixing bath instead of other common acids like hydrochloric or sulfuric. The answer lies in the fact that a relatively large amount of acid must be available but the solution must not be too strongly acid. Consequently a compound is used which is weak in acidity but which has available a high reserve of acid to neutralize alkali. A correspondingly larger amount of the weak acetic acid may therefore be used than could be used of a strong acid.

COMPOSITION AND FUNCTION OF THE FIXING BATH

The procedure of fixation is relatively simple but it should be carried out with considerable care, as it can be the source of much trouble when improperly handled. The photographic film negative upon removal from the developing solution is still sensitive to light, as it contains undeveloped silver salt in the shadow portions of the image. To make the negative image permanent by removing this undeveloped silver salt, as well as to make it clear and transparent for printing, the action of the fixing bath must be employed. The principal constituent of the fixing solution is sodium thiosulfate, more commonly known as "hypo" (from its older name of sodium hyposulfite), for in solution this useful chemical has the property of dissolving light-sensitive silver salts. The method by which the silver salt is removed is generally considered as, first, a conversion to a soluble double salt by the hypo, and second, the washing out of this soluble salt with water.

The conventional fixing solution generally contains other chemicals in addition to the hypo. Acetic acid is often included to aid in regulating the acidity of the fixing solution and to prevent stains. However, a hypo solution containing much acid is apt to precipitate sulfur, so another chemical, sodium sulfite, is added to prevent this unwanted reaction.

An additional component of the usual fixing bath is the hardening agent which prevents frilling and softening of the gelatin emulsion. White potassium alum (potassium aluminum sulfate) is usually employed for this purpose, though some photographers prefer potassium chrome alum used with a small amount of sulfuric acid. Care must be used with chrome alum as the hardener, however, as it rapidly loses its strength and is only truly effective when a fresh solution is used.

Fixing bath will seldom, if ever, give trouble when properly prepared from pure chemicals. If a bath turns milky after preparation, it indicates that sulfur is precipitating because of too much or too strong an acid, too little sulfite, too high a temperature of the solution, or improper mixing. A milky appearance of the bath during use is due to the presence of excess alkali and indicates that the bath should be replaced. It is important not to overwork the fixing bath, because a nearly exhausted fixing solution will not completely remove the silver salts, and prints or negatives may turn yellow or stain on aging. A gallon of standard strength fixing bath should fix 100 8 x 10″ double-weight prints or their equivalent. Between 100 and 120 rolls of 120 or 620 film (or equivalent) may be fixed in one

(Continued on following page)

gallon of standard-strength fixing bath if the films have previously been rinsed in a short-stop bath or plain water. When the bath froths or foams, it should be replaced. Many photographers have found that a convenient, certain and economical method of insuring complete fixation lies in the use of two fixing solutions. Fixing is carried out first in the more used of the two baths and finally in the fresher solution. When the older bath becomes exhausted, the partly used solution takes its places and a fresh fixing bath is prepared for the second solution.

SUGGESTIONS FOR TROUBLE-FREE MIXING

The first and perhaps most important point to follow in the preparation of solutions is that of using chemicals which are "photographically pure." Cheap commercial grades of every chemical used in photographic processes can be obtained, but many of them contain impurities which are detrimental to perfect results. Chemicals which are marked "C.P." (Chemically Pure) and those which are marketed for photographic purposes by reliable manufacturers are always safe to use, and can be depended upon. Chemicals marked U.S.P. may be suitable if the amount of impurity present is known to be insignifiicant. This can be determined by looking up the U.S.P. standards for the chemical in question by consulting the United States Pharmacopoeia, eleventh edition (1936), as indicated by the number XI which follows the U.S.P. on chemical container label.

The second most important rule for trouble-free solutions is perhaps that of mixing all components of a solution in the order listed in the formula. This is extremely important and lack of attention to this point can easily result in the formation of precipitates which will not dissolve in the solution. A worth while corollary to this rule is to wait until each chemical is thoroughly dissolved before adding the next component of the solution. In most single-solution developers the preservative sodium sulfite is usually added immediately after the developing agent but before the hydroquinone, if this chemical is used. When two developing agents such as metol and hydroquinone are used, the addition is generally made in the order metol, sulfite, hydroquinone. However, with developing agents like glycin, the sulfite and carbonate are dissolved first, as the glycin dissolves with greater difficulty otherwise.

A third important rule for any photographer is to use the purest water obtainable. Innumerable troubles in developing and fixing have been traced to impurities present in the water. Many photographrs find it a wise decision to use distilled water for all stock solutions, adding tap water for dilution.

The time required for the preparation of processing solutions can be reduced materially by the use of hot water, about 125°F (52°C) as most chemicals dissolve more rapidly in hot than in cold water. A convenient method of preparing one quart of developer, for instance, is to start with about 24-28 ounces of hot water (125°F) and after the addition of all chemicals, to add sufficient cold water to bring the total volume up to 32 ounces.

Another point well worth remembering is that of weighing and measuring all quantities as closely as possible. Particular care should be taken to avoid errors in small quantities, as a 10-grain error is obviously a very serious one on a 50-grain quantity, while on a half-pound quantity it might not have harmful effects.

Finally, and no less important for the order in which it is mentioned, is the matter of temperature. The need for uniform regulation of temperature cannot be overemphasized. While it has in the past been accepted practice to develop film at 65°F and paper at 70°F, practical considerations have resulted in the recommendation of 68°F (20°C) for both film and paper development.

While best results are obtained when film development is carried out at 68°F, there are, of course, certain occasions when surrounding conditions are such that it is impossible to maintain solutions at this temperature. In instances when the temperature is not higher than 75°F or lower than 60°F, development can be

(Continued on following page)

carried out with care if the developing time is modified to keep the contrast of the developed film negative within a desired range.

The GAF formulas in the following pages are provided for those who prefer to mix their own processing solutions and to conduct their own darkroom experiments.

Since packaged developers utilizing these formulas are not available, no data on their performance with GAF films or papers are provided.

When development is necessary at temperatures above 75°F, the use of a chemical such as sodium sulfate, which acts as a "swelling suppressor," is advisable. For development at 80°F 3½ to 5 ounces (100 to 150 grams) of sodium sulfate crystals—or half this amount if anhydrous sodium sulfate is used—should be added to each quart (liter) of developer and stop bath so that protection against excessive swelling will be afforded until films have been hardened in the fixing bath. Development time at 80°F with the proper amount of sodium sulfate added will be approximately 30% less than the normal development time at 68°F. If temperature falls below that for which sodium sulfate addition is made, developing time may have to be lengthened 30% to 50% to compensate for loss in developing action.

Due to the rapid oxidization of pyro at high temperatures, GAF 45 should not be used at temperatures above 75°F.

Another method of minimizing the chance of physical damage caused by processing at high temperatures is the use of a hardening short-stop bath, such as GAF 216, directly after development. In summation, these methods of high-temperature processing should not be considered as preferred developing technique but merely as the best expedient when processing solutions cannot be maintained at 68°F.

AGITATION

Developing times listed with formulas shown on later pages of this section, as well as the time-temperature compensation methods previously described, are based on effective agitation of the film in the developing solution. Effective agitation can be considered to be any method which provides a continual flow of solution across the surface of the film, but for practical considerations an intermittent form of agitation can be employed which will adequately remove development byproducts and supply fresh developing solution to the film emulsion. Such a method requires actual movement of the film in the developer, or developer over the film for 5 seconds out of every minute, and can be achieved by rocking the tray in tray development, or by agitation of the film in the solution when tank development is employed. The important point is that a repeatable method of getting effective agitation should be established if uniformly excellent results are to be obtained in film development.

•
FINE-GRAIN TANK DEVELOPER GAF 12

This fine-grain formula keeps well and makes an excellent tank developer.

Water (125° F or 52° C)	24 ounces	750.0 ml
Metol ¼ oz.	8 grains	8.0 grams
Sodium Sulfite, anhydrous	4¼ ounces	125.0 grams
Sodium Carbonate, anhydrous	84 grains	5.75 grams
Potassium Bromide	36 grains	2.5 grams
Add cold water to make	32 ounces	1.0 liter

Do not dilute for use. Develop 9 to 16 minutes at 68°F (20°C).

FINE-GRAIN BORAX TANK DEVELOPER GAF 17

This is a fine grain developer recommended for all GAF roll, pack and 35mm films. It can also be used for obtaining soft gradation with GAF portrait and press films. It is recommended for motion picture negative development.

Water (125° F or 52° C)	24 ounces	750.0 ml
Metol	22 grains	1.5 grams
Sodium Sulfite, desiccated 2½ oz.	80 grains	80.0 grams
Hydroquinone	45 grains	3.0 grams
Borax, granular	45 grains	3.0 grams
Potassium Bromide 7½ grains		0.5 gram
Add cold water to make	32 ounces	1.0 liter

Dissolve in the order given. Do not dilute for use.

Tank Development Time at 68°F (20°C): 10 to 15 minutes for fine-grain films. 12 to 20 minutes for press and portrait sheet films.

Tank Development Time at 68°F (20°C); 8 to 12 minutes, depending on film type and density desired.

REPLENISHER SOLUTION GAF 17a

For GAF 17

Add ½ to ¾ ounce of replenisher to GAF 17 for each roll of 120 film or 36-exposure 35mm film (or equivalent) developed. Maintain original volume of developer, discarding if necessary some used developer. No increase in original developing time is necessary when replenisher is used in this manner.

Water (125° F or 52° C)	24 ounces	750.0 ml
Metol	32 grains	2.2 grams
Sodium Sulfite, desiccated 2½	80 grains	80.0 grams
Hydroquinone	65 grains	4.5 grams
Borax, granular ½ oz.	44 grains	18.0 grams
Add cold water to make	32 ounces	1.0 liter

Dissolve chemicals in the order given.

(Continued on following page)

GAF

FINE GRAIN METABORATE TANK DEVELOPER GAF 17M

This developer is recommended for those who desire a formula similar to GAF 17, but permitting greater variation in developing time.

Hot Water (125° F or 52° C)	24 ounces	750.0 ml
Metol	22 grains	1.5 grams
Sodium Sulfite 2½ oz.	80 grains	80.0 grams
Hydroquinone	45 grains	3.0 grams
Sodium Metaborate	30 grains	2.0 grams
Potassium Bromide	7½ grains	0.5 gram
Add cold water to make	32 ounces	1.0 liter

Do not dilute for use. Developing time at 68°F (20°C) is 10 to 15 minutes for fine grain films.

Larger amounts of metaborate may be used with corresponding reduction of developing time (up to 10 grams of metaborate per liter with a developing time of 5 minutes at 68°F or 20°C, although slightly coarser grain will result.

REPLENISHER SOLUTION GAF 17M-a
For GAF 17M Developer

Add ½ to ¾ ounce of replenisher to GAF 17M for each roll of 120 film or 36-exposure 35mm film (or equivalent) developed. Maintain original volume of developer, discarding if necessary some used developer. No increase in original developing time is necessary when replenisher is used in this manner.

Water (125° F or 52° C)	24 ounces	750.0 ml
Metol	32 grains	2.2 grams
Sodium Sulfite, desiccated 2½ oz.	80 grains	80.0 grams
Hydroquinone	65 grains	4.5 grams
Sodium Metaborate ¼ oz.	10 grains	8.0 grams
Add cold water to make	32 ounces	1.0 liter

Dissolve ingredients in the order given.

M-H POSITIVE DEVELOPER GAF 20

This clean-working developer is recommended for normal contrast with tray or tank development of positive film.

Water (125° F or 52° C)	24 ounces	750.0 ml
Metol	30 grains	2.0 grams
Sodium Sulfite, anhydrous ¾ oz.	40 grains	25.0 grams
Hydroquinone	60 grains	4.0 grams
Sodium Carbonate, monohydrated ½ oz.	50 grains	18.5 grams
Potassium Bromide	30 grains	2.0 grams
Add cold water to make	32 ounces	1.0 liter

Do not dilute for use. Normal developing time 3 to 5 minutes.

(*Continued on following page*)

M-H TITLE DEVELOPER GAF 22

This formula is recommended for tray or tank development of cine title film and positive film to obtain results of high contrast.

Water (125° F or 52° C)	24 ounces	750.0 ml
Metol	12 grains	0.8 grams
Sodium Sulfite, anhydrous	1¼ ounces	40.0 grams
Hydroquinone ¼ oz.	10 grains	8.0 grams
Sodium Carbonate, monohydrated	1¾ ounces	50.0 grams
Potassium Bromide	75 grains	5.0 grams
Add cold water to make	32 ounces	1.0 liter

Do not dilute for use. Normal developing time 5 to 8 minutes at 65°F (18°C).

X-RAY DEVELOPER GAF 30

This developer is recommended for use with X-ray Film. GAF 30 is also suitable for AERIAL FILM, as it is clean-working, has long life and gives high contrast.

Water (125° F or 52° C)	24 ounces	750.0 ml
Metol	50 grains	3.5 grams
Sodium Sulfite, anhydrous	2 ounces	60.0 grams
Hydroquinone ¼ oz.	20 grains	9.0 grams
Sodium Carbonate, 1¼ oz.	40 grains	40.0 grams
Add cold water to make	30 grains	2.0 grams
Potassium Bromide	32 ounces	1.0 liter

Do not dilute for use.

Normal development time at 68°F (20°C): for X-ray Film, 6 minutes; for Non-Screen X-ray Film, 8 minutes; for aerial films, 10 to 15 minutes depending upon the type of developing machine.

M-H TRAY DEVELOPER GAF 40

This is a brilliant Metol-Hydroquinone tray developer for roll, pack, and cut film.

STOCK SOLUTION

Water (125° F or 52° C)	29 ounces	900.0 ml
Metol	66 grains	4.5 grams
Sodium Sulfite, anhydrous 1¾ oz.	25 grains	54.0 grams
Hydroquinone	¼ ounce	7.5 grams
Sodium Carbonate, monohydrated 1¾ oz.	25 grains	54.0 grams
Potassium Bromide	45 grains	3.0 grams
Add cold water to make	32 ounces	1.0 liter

For use dilute 1 part stock solution with 2 parts water.

Development time 4 to 5 minutes at 68°F (20°C).

(Continued on following page)

M-H TANK DEVELOPER GAF 42

This is a soft-working deep tank formula recommended for pack, roll, and portrait films.

Water (125° F or 52° C)	24 ounces	750.0 ml
Metol	12 grains	0.8 gram
Sodium Sulfite, anhydrous	1½ ounces	45.0 grams
Hydroquinone	18 grains	1.2 grams
Sodium Carbonate, monohydrated ¼ oz.	10 grains	8.0 grams
Potassium Metabisulfite	59 grains	4.0 grams
Potassium Bromide	22 grains	1.5 grams
Add cold water to make	32 ounces	1.0 liter

Do not dilute for use. Develop 15 to 20 minutes at 68°F (20°C).

PYRO DEVELOPER GAF 45

This formula is recommended to those who prefer Pyro development. Stock solutions should be kept in stoppered bottles.

STOCK SOLUTION

SOLUTION 1

Sodium Bisulfite ¼ oz.	35 grains	9.8 grams
Pyro	2 ounces	60.0 grams
Potassium Bromide	16 grains	1.1 grams
Add cold water to make	32 ounces	1.0 liter

SOLUTION 2

Sodium Sulfite, desiccated	3½ ounces	105.0 grams
Add cold water to make	32 ounces	1.0 liter

SOLUTION 3

Sodium Carbonate, monohydrated	2¾ ounces	85.0 grams
Add cold water to make	32 ounces	1.0 liter

Tank Development: Take 1 part Solution 1, 2, 3 and add 11 parts water. Normal development time, from 9 to 12 minutes at 68°F (20°C). Tray Development—Take 1 part each Solution 1, 2, 3 and add 7 parts water. Normal development time, from 6 to 8 minutes at 68°F (20°C). Solutions will keep well when stored separately but final developer should be used immediately after mixing.

(Continued on following page)

METOL HYDROQUINONE DEVELOPER GAF 47

This is a long-life, clean-working formula which will give excellent results for either tray or tank development. It is a standard sheet film developer.

Water (125° F or 52° C)	24 ounces	750.0 ml
Metol	22 grains	1.5 grams
Sodium Sulfite, desiccated	1½ ounces	45.0 grams
Sodium Bisulfite	15 grains	1.0 grams
Hydroquinone	45 grains	3.0 grams
Sodium Carbonate, monohydrated	88 grains	6.0 grams
Potassium Bromide	12 grains	0.8 gram
Add cold water to make	32 ounces	1.0 liter

For the developing times below, do not dilute for use.

Tank Development—Normal development time, 6 to 8 minutes at 68°F (20°C) with occasional agitation. Tray Development—Normal development time, 5 to 7 minutes at 68°F (20°C).

REPLENISHER SOLUTION GAF 47A
For Formula GAF 47

Add ½ to ¾ ounce of replenisher to GAF 47 for each roll of 120 film (or equivalent) developed. Maintain original volume of developer, discarding if necessary some used developer. No increase in original developing time is necessary when replenisher is used in this manner.

Water (125° F or 52° C)		24 ounces	750.0 ml
Metol		45 grains	3.0 grams
Sodium Sulfite, desiccated		1½ ounces	45.0 grams
Sodium Bisulfite		30 grains	2.0 grams
Hydroquinone		88 grains	6.0 grams
Sodium Carbonate, monohydrated	¼oz.	65 grains	12.0 grams
Add cold water to make		32 ounces	1.0 liter

Dissolve chemicals in the order given.

METABORATE DEEP TANK DEVELOPER GAF 48M

The formula is recommended for photofinishing, professional and amateur developing, and is suitable for deep tank use over a long period of time.
Tray Development—Normal developing time, 4 to 6 minutes at 68°F (20°C).

Hot water (125° F or 52° C)		24 ounces	750.0 ml
Metol		30 grains	2.0 grams
Sodium Sulfite		1¼ ounces	40.0 grams
Hydroquinone		22 grains	1.5 grams
Sodium Metaborate	¼ oz.	35 grains	10.0 grams
Potassium Bromide		7½ grains	.5 gram
Add cold water to make		32 ounces	1.0 liter

Do not dilute for use.
Tank Development—Normal developing time, 5 to 7 minutes at 68°F (20°C).

(Continued on following page)

REPLENISHER SOLUTION GAF 48M-a
For GAF 48M Developer

Add ½ to ¾ ounce replenisher to GAF 48M for each roll of 120 film (or equivalent) developed. Maintain original volume of developer, discarding if necessary some used developer. No increase in original developing time is necessary when replenisher is used in this manner.

Hot water (125° F or 52° C)	24 ounces	750.0 ml
Metol	90 grains	6.3 grams
Sodium Sulfite, desiccated	1 ounce	30.0 grams
Hydroquinone ¼ oz.	35 grains	10.0 grams
Sodium Metaborate	1¼ ounces	40.0 grams
Add cold water to make	32 ounces	1.0 liter

Dissolve all ingredients in the order stated.

M-H TRAY DEVELOPER GAF 61

This developer is recommended for use with COMMERCIAL FILM to produce negatives of normal contrast. It may also be used satisfactorily for roll, pack, and sheet film for negatives of average brilliance.

Water (125° F or 52° C)	24 ounces	750.0 ml
Metol	15 grains	1.0 grams
Sodium Sulfite, desiccated	½ ounce	15.0 grams
Hydroquinone	30 grains	2.0 grams
Sodium Carbonate, monohydrated	½ ounce	15.0 grams
Potassium Bromide	15 grains	1.0 gram
Add cold water to make	32 ounces	1.0 liter

Do not dilute for use. Normal development time, 4 to 6 minutes at 68°F (20°C).

RAPID M-H (TROPICAL) DEVELOPER GAF 64

This is a clean-working developer of particular value for rapid development or development at high temperatures.

Water (125ᶜ F or 52° C)	24 ounces	750.0 ml
Metol	36 grains	2.5 grams
Sodium Sulfite, desiccated ¾ oz.	40 grains	25.0 grams
Hydroquinone	95 grains	6.5 grams
Sodium Carbonate, monohydrated ½ oz.	15 grains	16.0 grams
Potassium Bromide	15 grains	1.0 gram
Add cold water to make	32 ounces	1.0 liter

Do not dilute for use.
Normal development time—3 to 4 minutes at 68°F (20°C). 2 to 3 minutes at 85°F (29°C).

HYDROQUINONE CAUSTIC DEVELOPER GAF 70

This developer is recommended for PROCESS FILM used, in reproduction work.
SOLUTION 1

Water (125° F or 52° C)	24 ounces	750.0 ml
Hydroquinone ¾ oz.	40 grains	25.0 grams
Potassium Metabisulfite ¾ oz.	40 grains	25.0 grams
Potassium Bromide ¾ oz.	40 grains	25.0 grams
Add cold water to make	32 ounces	1.0 liter

(Continued on following page)

SOLUTION 2

Cold water	32 ounces	1.0 liter
*Sodium Hydroxide (Caustic Soda) 1 oz.	90 grains	36.0 grams

or

*Potassium Hydroxide (Caustic Potash) 1½ oz.	80 grains	50.0 grams

*Cold water should always be used when dissolving sodium or potassium hydroxide because considerable heat is evolved. If hot water is used, the solution will boil with violence and may cause serious burns if the alkali spatters on the hands or face.

Mix equal parts of Solutions 1 and 2 immediately before use.
Develop films within 3 minutes at 68°F (20°C).

GLYCIN DEVELOPER GAF 72

This formula is recommended for use with COMMERCIAL FILMS in reproduction work and is also suitable for development of roll, pack, and sheet film.

STOCK SOLUTION

Water (125°F or 52° C)	24 ounces	750.0 ml
Sodium Sulfite, desiccated	4¼ ounces	125.0 grams
Potassium Carbonate	8½ ounces	250.0 grams
Glycin 1½ oz.	80 grains	50.0 grams
Add cold water to make	32 ounces	1.0 liter

Tank Development—Take one part stock solution, fifteen parts water and develop 20 to 25 minutes at 68°F (20°C).

Tray Development—Take one part stock solution, four parts water and develop 5 to 10 minutes at 68°F (20°C).

PARAFORMALDEHYDE DEVELOPER GAF 79

One Solution

This is a standard formula recommended for development of Reprolith and Reprolith Ortho Films.

This one-solution formula is recommended for greater convenience. For better keeping quality the two-solution formula is preferred.

Water (not over 90° F or 32° C)	16 ounces	500.0 ml
Sodium Sulfite, desiccated	1 ounce	30.0 grams
Paraformaldehyde	¼ ounce	7.5 grams
Potassium Metabisulfite	38 grains	2.6 grams
Boric Acid Crystals	¼ ounce	7.5 grams
Hydroquinone	¾ ounce	22.5 grams
Potassium Bromide	22 grains	1.5 grams
Add cold water to make	32 ounces	1.0 liter

Dissolve chemicals in the order given and use solution full strength.

Normal Development Time: For Reprolith Film 2 to 3 minutes; for Reprolith Orthochromatic Film 1½ to 3 minutes—at 68 to 70°F (20 to 21°C).

(Continued on following page)

PARAFORMALDEHYDE DEVELOPER GAF 79b
Two Solutions

This developer has better keeping quality than when made in one solution.

SOLUTION 1

Water (not over 90° F or 32° C)	24 ounces	750.0 ml
Sodium Sulfite, desiccated	15 grains	1.0 gram
Paraformaldehyde	1 ounce	30.0 grams
Potassium Metabisulfite	150 grains	10.5 grams
Add cold water to make	32 ounces	1.0 liter

SOLUTION 2

Water (125° F or 52° C)	24 ounces	750.0 ml
Sodium Sulfite, desiccated	4 ounces	120.0 grams
Boric Acid Crystals	1 ounce	30.0 grams
Hydroquinone	3 ounces	90.0 grams
Potassium Bromide	90 grains	6.0 grams
Add cold water to make	96 ounces	3.0 liters

For use mix one part Solution 1 with three parts Solution 2.

Normal Development Time—For Reprolith Film 2 to 3 minutes; for Reprolith Orthochromatic Film 1½ to 3 minutes—at 65 to 70°F (18 to 21°C).

LONG-LIFE REPROLITH DEVELOPER GAF 81

Formula GAF 81 provides a single-solution developer of excellent keeping quality for the development of REPROLITH FILM.

Water (125° F or 52° C)	24 ounces	750.0 ml
Hydroquinone 1 oz.	70 grains	35.0 grams
Sodium Sulfite, desiccated 1¾ ounces		55.0 grams
Sodium Carbonate, monohydrated 2¾ ounces		80.0 grams
Citric Acid	80 grains	5.5 grams
Potassium Bromide ¼ oz.	35 grains	10.0 grams
Add cold water to make	32 ounces	1.0 liter

Do not dilute for use. Normal development time within 3 minutes at 68°F (20°C).

HIGH CONTRAST M-H TRAY DEVELOPER GAF 90

This developer has been particularly designed for use with COMMERCIAL FILMS to produce negatives of brilliant contrast.

Water (125° F or 52° C)	24 ounces	750.0 ml
Metol	72 grains	5.0 grams
Sodium Sulfite, desiccated 1¼ oz.	40 grains	40.0 grams
Hydroquinone	88 grains	6.0 grams
Sodium Carbonate, monohydrated 1¼ oz.	40 grains	40.0 grams
Potassium Bromide	44 grains	3.0 grams
Add cold water to make	32 ounces	1.0 liter

Do not dilute for use. Normal development time, 4 to 6 minutes at 68°F (20°C).

NOTE: This developer may be adapted for very high-contrast work by the addition of 3 grams of Potassium Bromide per liter developer (44 grains per 32 oz.) and development of 2 to 3 minutes at 68°F (20°C). This addition produces FORMULA: GAF 73.

(Continued on following page)

RAPID PROCESSING PROCEDURE
For GAF Films

This GAF procedure has been devised to meet the requirements of those who must carry out finishing operations on exposed films in the shortest possible time. The two-solution method outlined below is intended primarily for sheet films used in news photography, and with favorable drying conditions will permit completion of developing, fixing, washing and drying operations in fifteen minutes or less. Great care should be taken to maintain cleanliness in all operations and to follow directions carefully.

STEP 1. DEVELOPMENT

SOLUTION 1

Water (125° F or 52° C)	24 ounces	750.0 ml
Metol	73 grains	5.0 grams
Sodium Sulfite, anhydrous	1 ounce	30.0 grams
Hydroquinone	¼ oz. 35 grains	10.0 grams
Water to make	32 ounces	1.0 liter

SOLUTION 2

Water (125° F or 52° C)	24 ounces	750.0 ml
Sodium Carbonate, monohydrated	3½ ounces	100.0 grams
Water to make	32 ounces	1.0 liter

Solutions 1 and 2 are stored separately and used separately. Both solutions may be used repeatedly, but Solution 2 should be replaced when it becomes badly discolored. Do not dilute for use.

For development, immerse films in Solution 1, next in Solution 2, allowing 1-minute immersion in each solution (at 70°F, 21°C) and using continual agitation throughout the entire period. Contrast can be controlled by altering time film is kept in Solution 2. Basic immersion time should be changed to 45 seconds for development at 75°F, 1 minute 15 seconds at 65°F.

STEP 2. SHORT STOP

Place films in conventional acetic-acid short-stop bath for five seconds. Agitate thoroughly. For temperatures over 70°F (21°C), dilute the short-stop bath with an equal volume of water.

STEP 3. FIXATION

SOLUTION 3
Part A

Water (125° F or 52° C)	16 ounces	500.0 ml
Hypo	11¾ ounces	350.0 grams

Part B

Water (125° F or 52° C)	5 ounces	150.0 ml
Sodium Sulfite, anhydrous	½ ounce	15.0 grams
Acetic Acid (28%)	1½ ounces	45.0 ml
Potassium Alum	½ ounce	15.0 grams
Add part B to A and add water to make	32 ounces	1.0 liter

Wash films in rapid stream of water for 2 minutes, making sure stream of wash water has access to both sides of film. Films to be stored permanently should be re-washed after immediate use has been filled.

(Continued on following page)

GAF

The Compact Photo-Lab-Index

STEP 4. DRYING

The degree of speed obtainable in this step of the procedure depends greatly upon the nature and suitability of the drying equipment. Dry with mild heat in a strong current of air. Washed films should be freed from all surplus liquid by squeegeeing them against a clean ferrotyping plate. Most rapid drying will be affected by suspending the negative between 250-watt infrared lamps which are spaced 8 inches apart and mounted in 8-inch matte-surfaced aluminum reflectors.

WARNING—Do not use reflectors that throw a concentrated beam because of the danger of too much heat. Use matte-surfaced reflectors. The film should be positioned so that its flat surfaces receive the direct rays of the lamps with one edge of the film facing into a draft of air supplied by a good electric fan which should be operating whenever the lamps are on—the draft of air from fan is essential, otherwise film emulsion will melt. This drying arrangement is for films 5 x 7 or under. Similar arrangements can be devised, but care must be taken to avoid excessive heat, which will melt the emulsion. Before putting a drying unit of this sort in actual use, trial films should be dried and the spacing of lamps and fan adjusted to give most rapid drying without endangering the film negative.

PAPER DEVELOPER GAF 103

This formula is recommended as a developer for Cold Tone papers when cold, blue-black tones are desired.

STOCK SOLUTION

Water (125° F or 52° C)	24 ounces	750.0 ml
Metol	50 grains	3.5 grams
Sodium Sulfite, desiccated	1½ ounces	45.0 grams
Hydroquinone ¼ oz.	55 grains	11.5 grams
Sodium Carbonate, monohydrated 2½ oz	35 grains	75.0 grams
Potassium Bromide	18 grains	1.2 grams
Add cold water to make	32 ounces	1.0 liter

PAPER DEVELOPMENT: Dilute 1 part stock solution with 2 parts water. Normal development time is 1 to 1½ minutes.

DIRECT BROWN-BLACK PAPER DEVELOPER GAF 110

Beautiful warm tones may be obtained with this developer on both contact and projection papers.

STOCK SOLUTION

Water (125° F or 52° C)	24 ounces	750.0 ml
Hydroquinone	¾ ounce	22.5 grams
Sodium Sulfite, desiccated 1¾ oz.	50 grains	57.0 grams
Sodium Carbonate, monohydrated	2½ ounces	75.0 grams
Potassium Bromide	40 grains	2.75 grams
Add cold water to make	32 ounces	1.0 liter

For use dilute 1 part stock solution with 5 parts water.

Give prints 3 to 4 times normal exposure and develop 5 to 7 minutes at 68° F (20°C).

(Continued on following page)

450

AMIDOL PAPER DEVELOPER GAF 113

This formula is intended for tray development only and must be mixed fresh each time. It is recommended only for small lots of prints.

Amidol	96 grains	6.6 grams
Sodium Sulfite, desiccated	1½ ounces	44.0 grams
Potassium Bromide	8 grains	0.5 grams
Add cold water to make	32 ounces	1.0 liter

Do not dilute for use. If hot water is used for dissolving chemicals the sodium sulfite and potassium bromide should be dissolved first and the amidol added only after the solution has cooled.

If the paper you use shows any chemical fog with this formula, use twice the amount of potassium bromide specified above.

Develop 1 to 2 minutes at 68°F (20°C).

GLYCIN HYDROQUINONE DEVELOPER GAF 115

This is a warm tone developer suitable for Allura and similar papers.

STOCK SOLUTION

Water (125° F or 52° C)	24 ounces	750.0 ml
Sodium Sulfite, desiccated	3 ounces	90.0 grams
Sodium Carbonate, monohydrated	5 ounces	150.0 grams
Glycin	1 ounce	30.0 grams
Hydroquinone ¼ oz.	30 grains	9.5 grams
Potassium Bromide	60 grains	4.0 grams
Add cold water to make	32 ounces	1.0 liter

For warm tones, dilute 1 part stock solution with 3 parts water and develop prints 2½ to 3 minutes at 68°F (20°C).

For very warm tones and more open shadows, diute 1 part stock solution with 6 parts water, giving prints 3 to 4 times normal exposure and 2½ to 5 minutes' development. Because of dilution of the developer, solution will exhaust more rapidly and will require more frequent replacement.

SOFT-WORKING PAPER DEVELOPER GAF 120

This is a soft-working developer, primarily intended for portrait work where soft gradation is required.

STOCK SOLUTION

Water (125°F or 52° C)	24 ounces	750.0 ml
Metol ¼oz.	70 grains	12.3 grams
Sodium Sulfite, desiccated 1 oz.	88 grains	36.0 grams
Sodium Carbonate, monohydrated 1 oz.	88 grains	36.0 grams
Potassium Bromide	27 grains	1.8 grams
Add cold water to make	32 ounces	1.0 liter

For use, dilute 1 part stock solution with 2 parts water. Normal developing time, 1½ to 3 minutes at 68°F (20°C).

(Continued on following page)

GAF

TWO-TRAY PRINT DEVELOPMENT

While the majority of photographic prints can be prepared most conveniently by development in a single solution, some occasions are often met in which the critical nature of the subject requires a degree of control over contrast that is not normally available. In such instances the two-tray print development procedure can be employed to good advantage, for it permits control over print gradation that cannot be obtained by usual variations of exposure and developing time.

The two-tray procedure involves the use of two separate developing solutions, usually a soft-working formula, such as GAF 120, and a brilliant-working developer, like GAF 130—though some workers prefer the combination of GAF 120 and 125. Development is begun in one solution and completed in the other, the first developer used having the greater effect. This procedure is particularly helpful in producing full-scale prints which exhibit well modulated gradation in both highlight and shadow.

METOL-HYDROQUINONE DEVELOPER GAF 125

This formula is recommended for most high quality enlarging papers, and can also be used for development of roll, pack and sheet film when brilliant negatives are desired.

Water (125°F or 52° C)	24 ounces	750.0 ml
Metol	45 grains	3.0 grams
Sodium Sulfite, desiccated	1½ ounces	44.0 grams
Hydroquinone ¼ oz.	60 grains	12.0 grams
Sodium Carbonate, monohydrated	2¼ ounces	65.0 grams
Potassium Bromide	30 grains	2.0 grams
Add cold water to make	32 ounces	1.0 liter

PAPER DEVELOPMENT: Dilute 1 part stock solution with 2 parts water. Develop 1 to 2 minutes at 68°F (20°C). For softer and slower development dilute 1 to 4 and develop 1½ to 3 minutes at 68°F (20°C). For greater brilliance, shorten the exposure slightly and lengthen the development time. For greater softness, lengthen the exposure slightly and shorten the development time.

FILM DEVELOPMENT: Dilute 1 part stock solution with 1 part water and develop 3 to 5 minutes at 68°F (20°C). For softer results, dilute 1 to 3 and develop 3 to 5 minutes at 68°F (20°C).

UNIVERSAL PAPER DEVELOPER GAF 130

This formula is a universal developer for all projection and contact papers. It gives rich black tones with excellent brilliance and detail. GAF 130 provides unusual latitude in development and is clean-working even with long developing times.

STOCK SOLUTION

Water (125°F or 52° C)	24 ounces	750 .0 ml
Metol	32 grains	2.2 grams
Sodium Sulfite, desiccated	1¾ ounces	50.0 grams
Hydroquinone ¼ oz.	50 grains	11.0 grams
Sodium Carbonate, monohydrated	2½ ounces	78.0 grams
Potassium Bromide	80 grains	5.5 grams
Glycin ¼ oz.	50 grains	11.0 grams
Add cold water to make	32 ounces	1.0 liter

(Continued on following page)

The Compact Photo-Lab-Index

The prepared stock solution is clear but slightly colored. The coloration in this case does not indicate the developer has deteriorated or is unfit for use.

For use, dilute 1 part stock solution with 1 part water.

Normal developing time at 68°F (20°C) 1½ to 3 minutes.

Greater contrast can be obtained by using the developer stock solution full strength. Soft results can be obtained by diluting 1 part stock solution with 2 parts water.

WARM-TONE PAPER DEVELOPER GAF 135

This developer is recommended for rich, warm-black tones with chloride and bromide papers.

STOCK SOLUTION

Water (125°F or 52° C)	24 ounces	750.0 ml
Metol	24 grains	1.6 grams
Sodium Sulfite, desiccated ¾ oz.	20 grains	24.0 grams
Hydroquinone	96 grains	6.6 grams
Sodium Carbonate, monohydrated ¾ oz.	20 grains	24.0 grams
Potassium Bromide	40 grains	2.8 grams
Add cold water to make	32 ounces	1.0 liter

For use, dilute 1 part stock solution with 1 part water. A properly exposed print will be fully developed at 68°F (20°C) in about 1½ to 2 minutes. Complete development may be expected to take slightly longer with rough-surfaced papers than with semi-glossy or luster-surfaced papers. For greater softness, dilute the bath with water up to equal quantities of developer and water. To increase the warmth, add bromide up to double the amount in the formula. The quantity of bromide specified in the formula, however, assures rich, warm, well-balanced tones.

ACID HARDENING FIXING BATH GAF 201

This hardening fixing bath for use with either film or paper may be stored indefinitely and used repeatedly until exhausted. If the fixing bath froths, turns cloudy, or takes longer than 10 minutes to fix out completely, it must be replaced by a fresh solution.

SOLUTION 1

Water (125° F or 52° C)	16 ounces	500.0 ml
Sodium Thiosulfate (Hypo)	8 ounces	240.0 grams

SOLUTION 2

Water (125° F or 52° C)	5 ounces	150.0 ml
Sodium Sulfite, desiccated	½ ounce	15.0 grams
Acetic Acid (28%)	1½ ounces	45.0 ml
Potassium Alum	½ ounce	15.0 grams
Add solution 2 to 1 and water to make	32 ounces	1.0 liter

Dissolve chemicals thoroughly in order given and stir rapidly while adding Solution 2 to Solution 1. Glacial Acetic Acid may be diluted to 28% concentration by adding 3 parts of acid to 8 parts of water. Do not dilute for use. Normal fixing time 5 to 10 minutes at 68°F (20°C).

(Continued on following page)

GAF

453

CHROME ALUM FIXING BATH GAF 202

This hardening fixing bath for use with films in hot weather should be used fresh, as it does not retain its hardening solution.

SOLUTION 1

Water (125° F or 52° C)	80 ounces	2.5 liters
Sodium Thiosulfate (hypo)	2 pounds	960.0 grams
Sodium Sulfite, desiccated	2 ounces	60.0 grams
Add cold water to make	96 ounces	3.0 liters

SOLUTION 2

Water	32 ounces	1.0 liter
Potassium Chrome Alum	2 ounces	60.0 grams
Sulfuric Acid (C. P.)*	¼ ounce	8.00 ml

*CAUTION: Always add the sulfuric acid to the water slowly while stirring, and never the water to the acid, otherwise the solution may boil and spatter the acid on the hands or the face, causing serious burns.

Slowly pour Solution 2 into Solution 1 while rapidly stirring the latter. Do not dilute for use. Do not dissolve the chrome alum at a temperature higher than 150°F (66°C). Always rinse films thoroughly before fixing at 68°F (20°C).

NONHARDENING METABISULFITE FIXING BATH GAF 203

This fixing bath is recommended for use when hardening is not desired, as for instance, for greatest accuracy of registration in color work with Reprolith Film.

STOCK SOLUTION

Sodium Thiosulfate (hypo)	16 ounces	475.0 grams
Potassium Metasulfite	2¼ ounces	67.5 grams
Add cold water to make	32 ounces	1.0 liter

The potassium metabisulfite should be added to the hypo solution after it gets cool. Dilute 1 part stock solution with 1 part water. Normal fixing time, 5 to 10 minutes at 68°F (20°C).

ACID HARDENING FIXING BATH GAF 204

This hardening fixing bath for use with either film or paper may be stored indefinitely and used repeatedly until exhausted.

Water (125°F or 52° C)	24 ounces	750.0 ml
Sodium Thiosulfate (hypo)	8 ounces	240.0 grams
Sodium Sulfite	½ ounce	15.0 grams
Acetic Acid (28%)	2½ fl. oz.	75.0 ml
Borax	½ ounce	15.0 grams
Potassium Alum	½ ounce	15.0 grams
Add cold water to make	32 ounces	1.0 liter

Dissolve chemicals thoroughly in the order given and stir rapidly. Do not dilute for use. Normal fixing time, 5 to 10 minutes at 68°F (20°C). Glacial acetic acid may be diluted to 28% concentration by adding 3 parts of acid to 8 parts of water.

(Continued on following page)

The Compact Photo-Lab-Index

ACID STOP BATH GAF 210

This solution is recommended for use between developer and fixer, to prevent staining of film negatives and prints.

Acetic Acid, 28% pure*	1½ ounces	45.0 ml
Add cold water to make	32 ounces	1.0 liter

*Glacial acetic acid (99.5%) may be diluted to the 28%c concentration by mixing 3 parts of glacial acetic acid with 8 parts of water.

CHROME ALUM HARDENING BATH GAF 216

This bath may be used in place of the regular acetic stop bath to give additional hardening to film. It is particularly desirable in hot weather, for tropical development, and for negatives which have to be enlarged wet.

Potassium Chrome Alum	1 ounce	30.0 grams
Water	32 ounces	1.0 liter

Films should be agitated thoroughly when immersed in the solution. Maximum hardening will be obtained with about 3 minutes treatment.

The solution should be used fresh, as it does not keep well. Formation of a greenish sludge is an indication that the solution should be replaced by a fresh bath.

If the chrome alum used is such that a sludge is formed when the bath is first used, an addition of concentrated sulfuric acid (2 ml per liter or ½ dram per 32 ounces) can be made to the solution to overcome this condition.

SEPIA TONER GAF 221

This toner is recommended for warm-brown sepia tones.

SOLUTION 1 (Bleach)

Water (125° F or 52° C)		24 ounces	750.0 ml
Potassium Ferricyanide 1½ oz.	80 grains		50.0 grams
Potassium Bromide ¼ oz.	35 grains		10.0 grams
Sodium Carbonate, monohydrated ½ oz.	70 grains		20.0 grams
Add cold water to make		32 ounces	1.0 liter

SOLUTION 2 (Redeveloper)

Sodium Sulfide, desiccated	1½ ounces	45.0 grams
Add cold water to make	16 ounces	500.0 ml

For use as described below, dilute 1 part Solution 2 with 8 parts water.

IMPORTANT: Be sure to use sodium sulfide, not sodium sulfite, in compounding the redeveloper. Also use clean trays, free from exposed iron spots especially with bleaching bath. Otherwise blue spots may form on prints.

Prints should be washed thoroughly and then bleached in Solution 1 until the black image is converted to a very light brown color (about 1 minute). Prints should then be washed for 10 to 15 minutes and redeveloped in diluted Solution 2.

Redevelopment should be complete in about 1 minute. After redevelopment the prints should be washed for about 30 minutes and then dried. If the toner should leave sediment which results in streaks or finger marks on the surface of the paper, the print should be immersed for a few seconds in a 3% solution of acetic acid, after which a 10-minute washing is necessary.

(Continued on following page)

455

HYPO ALUM TONER GAF 222

This toner is recommended for beautiful reddish-brown tones.

SOLUTION 1

Water	80 ounces	2350.0 ml
Sodium Thiosulfate (hypo)	15 ounces	450.0 grams

SOLUTION 2

Water	1 ounce	30.0 ml
Silver Nitrate	20 grains	1.3 grams

SOLUTION 3

Water	1 ounce	30.0 ml
Potassium Iodide	40 grains	2.7 grams

Add Solution 2 to Solution 1. Then add Solution 3 to the mixture. Finally add 105 grams (3½ ounces) of GAF Potassium Alum to this solution, and heat the entire bath to the boiling point, or until sulfurization takes place (indicated by a milky appearance of the solution). Tone prints 20 to 60 minutes in this bath at 110-125°F (43-52°C). Agitate prints occasionally until toning is complete.

Care should be taken to see that the blacks are fully converted before removing the prints from the toning bath, otherwise double tones may result.

NELSON GOLD TONER GAF 223
E. K. Co., U.S. Patent No. 1,849,245

This formula is suitable primarily for professional contact papers. With this toner it is possible to obtain a variety of pleasing brown tones by varying the time of toning. Prints may be removed from the bath when the desired color is reached.

SOLUTION 1

Warm water, about 125° F (52° C)	1 gallon	4.0 liters
Sodium Thiosulfate (hypo)	2 pounds	960.0 grams
Ammonium Persulfate	4 ounces	120.0 grams

Dissolve the Hypo completely before adding the Persulfate. Stir vigorously while adding the Persulfate. If the bath does not turn milky, increase the temperature until it does.

Prepare following solution and add it (including precipitate) slowly to the Hypo-Persulfate solution while stirring the latter rapidly. Bath must be cool when these solutions are added together.

Cold water	2 ounces	64.0 ml
Silver Nitrate	75 grains	5.2 grams
Sodium Chloride	75 grains	5.2 grams

Note: The Silver Nitrate should be dissolved completely before adding Sodium Chloride.

(Continued on following page)

SOLUTION 2

Water	8 ounces	250.0 ml
Gold Chloride	15 grains	1.0 gram

For use, add 4 ounces (125 ml) of Solution 2 slowly to Solution 1 while stirring the latter rapidly.

The bath should not be used until after it has become cold and has formed a sediment. Then pour off the clear liquid for use.

Pour the clear solution into a tray standing in a water bath and heat to 110°F (43°C). The temperature, when toning, should be between 100 and 110°F (38 and 43°C). Dry prints should be soaked thoroughly in water before toning.

Keep at hand an untoned black-and-white print for comparison during toning. Prints should be separated at all times to insure even toning.

When the desired tone is obtained, rinse the prints in cold water.

After all prints have been toned, return them to the fixing bath for five minutes, then wash for one hour in running water.

The bath should be revived at intervals by the addition of further quantities of the gold Solution 2. The quantity to be added will depend upon the number of prints toned and the time of toning. For example, when toning to a warm brown, add 1 dram (4 ml) of solution after each fifty 8 x 10 prints, or their equivalent, have been toned. Fresh solution may be added from time to time to keep the bath up to the proper volume.

GOLD TONER GAF 231

This formula gives a range of red tones to sepia-toned prints, the brilliance of the tone depending on the paper used. On some papers brilliant chalk red tones can be formed. If desired, deep blue tones may also be obtained with this formula by using black-and-white prints instead of prints that have first been sepia-toned. Unusual effects of mixed tones of blue-black shadows and soft reddish highlights can be produced by using prints which have been partially toned in a Hypo Alum sepia-toner.

For Red Tones: Prints must first be bleached and processed by the sulfide redevelopment method (see GAF 221). After washing, place prints in above solution until toning is complete (requires 15 to 45 minutes). For redder tones one-half the specified amount of Thiocyanate may be used.

For Deep Blue Tones: Omit sepia-toning operation and place well-washed black-and-white prints directly in above toning solution.

For Mixed Tones: Prints should be incompletely toned in a Hypo Alum Toner, such as GAF 222, and washed before treatment in above solution.

Water (125°F or 52° C)	24 ounces	750.0 ml
*Ammonium Thiocyanate	3½ ounces	105.0 grams
†Gold Chloride, 1% Solution	2 fl. ounces	60.0 ml
Add cold water to make	32 ounces	1.0 liter

*May be substituted by:

Sodium Thiocyanate	3¾ ounces	110.0 grams
or		
Potassium Thiocyanate	4½ ounces	135.0 grams

†The contents of a 15 grain bottle of GAF Gold Chloride dissolved in 3½ oz. of water will make a 1% solution.

(Continued on following page)

IRON BLUE TONER GAF 241

Producing brilliant blue tones, this formula is suitable for some projection papers.

Water (125°F or 52° C)	16 ounces	500.0 ml
Ferric Ammonium Citrate	¼ ounce	8.0 grams
Potassium Ferricyanide	¼ ounce	8.0 grams
Acetic Acid, 28%	9 ounces	265.0 ml
Add cold water to make	32 ounces	1.0 liter

Solution should be prepared with distilled water if possible. If enameled iron trays are used, no chips or cracks in the enamel should be present or spots and streaks may appear in the print.

Prints for blue toning should be fixed in plain, non-hardening hypo bath (which should be kept at a temperature of 68°F (20°C) or under to avoid undue swelling). When prints have been fully toned in the above solution, they will be greenish in appearance, but will be easily washed out to a clear blue color when placed in running water.

The depth of the blue toning will vary somewhat with the quality of prints toned in it, light-toned prints generally toning to the lighter blues. Some intensification of the print usually occurs in toning; consequently, prints should be slightly lighter than the density desired in the final toned print.

Wash water should be acidified slightly with acetic acid, since the blue tone is considerably weakened when wash is quite soluble in alkaline solutions and water is alkaline. Pleasing variations in the tone can be obtained by bathing the washed prints in a ½% solution (5 grams per liter) of Borax which produces softer, blue-gray tones, the extent depending on the length of treatment.

MONCKHOVEN'S INTENSIFIER GAF 331
For Reproduction Films

This formula gives very great intensification and contrast for line drawing and half-tone reproduction work.

SOLUTION 1

Potassium Bromide	¾ ounce	23.0 grams
*Mercuric Chloride	¾ ounce	23.0 grams
Add cold water to make	32 ounces	1.0 liter

SOLUTION 2

Cold water	32 ounces	1.0 liter
*Potassium Cyanide	¾ ounce	23.0 grams
Silver Nitrate	¾ ounce	23.0 grams

*WARNING: Because of the deadly poisonous nature of this intensifier, it should be used with care and bottles containing it should be suitably marked. Never mix cyanide solutions with acids or use them in poorly ventilated rooms. Discard waste solutions into running water.

The silver nitrate and the potassium cyanide should be dissolved in separate lots of water, and the former added to the latter until a permanent precipitate is produced. The mixture is allowed to stand 15 minutes, and after filtering, forms Solution 2.

Place negatives in Solution 1 until bleached through, then rinse and place in Solution 2. If intensification is carried too far, the negative may be reduced with a weak solution of hypo.

(Continued on following page)

GAF

CHROMIUM INTENSIFIER GAF 332

This formula is recommended because it is convenient in use and gives permanent results. The degree and character of intensification can be controlled to an extent by modification of the developing time used for the redeveloper.

Cold water	32 ounces	1.0 liter
Potassium Bichromate	135 grains	9.0 grams
Hydrochloride Acid (C.P.)	1.6 drams	6.0 ml

Immerse negatives in this solution until bleached, wash for 5 minutes in running water, and redevelop in bright but diffused light in a Metol Hydroquinone developer such as GAF 47. Negatives should then be given a 15-minute wash before drying. Intensification may be repeated for increased effect.

If any blue coloration of the film base is noticeable after intensification, it may be easily removed by washing the film for 2 or 3 seconds in water containing a few drops of ammonia, in a 5% solution of potassium metabisulfite, or a 5% solution of sodium sulfite. This treatment should be followed by a thorough washing in water.

GREEN TONER GAF 251

This formula produces rich green tones by combining the effects of iron blue toning and sulfide sepia toning. It must, however, be employed carefully and with particular attention both to the directions outlined below and to cleanliness in handling prints throughout all stops of the process. This formula will work with most warm-tone Bromide papers, but it would be wise to test the paper you select before attempting production.

SOLUTION 1

Potassium Ferricyanide	1¼ oz.	35 grains	40.0 grams
Water		32 ounces	1.0 liter
Ammonia .91 S.G. (25% in weight)		3 drams	15.0 ml

SOLUTION 2

Ferric Ammonium Citrate	½ oz.	30 grains	17.0 grams
Water		32 ounces	1.0 liter
Hydrochloric Acid Conc.		1¼ ounces	40.0 ml

SOLUTION 3

Sodium Sulfide	30 grains	2.0 grams
Water	32 ounces	1.0 liter
*Hydrochloric Acid Cons.	2½ drams	10.0 ml

*Do not add Hydrochloric Acid to Solution 3 until immediately before use.

Black and white prints to be toned should be darker and softer than a normal print, using approximately 25% over-exposure on the next softer grade of paper. Development of the print should be carried out in a suitable developer (A125 or A135) with particular attention given to avoid under-development. Prints should be fixed as usual, thoroughly washed and completely dried before toning.

Prints to be toned should be first soaked in cold water until limp and then placed in Solution 1 until bleached. This operation should be completed in 60 seconds or less, and the bleached prints immediately transferred to running water where thorough washing (at least 30 minutes) is effected.

(*Continued on following page*)

Bleached prints are then placed in Solution 2 for 45 seconds to 1 minute, toning being permitted to continue until the deepest shadows are completely toned. Prints should then be washed briefly (4 to 6 minutes), excessive washing being undesirable in view of the solubility of the blue image. If wash water is slightly alkaline, it should be acidified somewhat with acetic acid to prevent degradation of the blue tone during washing.

The blue-toned prints are next immersed in Solution 3 until the green tone is sufficiently strong, the operation requiring about 30 seconds. Toned prints should then receive a final washing of 20 to 30 minutes in neutral or slightly acidified wash water and dried. Avoid heat and belt drying machines for drying.

FARMER'S REDUCER GAF 310

This is a cutting reducer for lessening the density of heavy negatives and at the same time increasing their contrast. It is especially valuable for reproduction films to clear the whites.

SOLUTION 1

Sodium Thiosulfate (hypo)		8 ounces	240.0 grams
Add cold water to make		32 ounces	1.0 liter

SOLUTION 2

Potassium Ferricyanide ½ oz.	55 grains		19.0 grams
Add cold water to make		8 ounces	250.0 ml

For use mix one part Solution 2 and four parts Solution 1 in 32 parts water. Solutions 1 and 2 should be stored separately and mixed immediately before use.

FLATTENING REDUCER GAF 311

This reducer is useful for lessening the density and contrast of heavy negatives.

Potassium Ferricyanide 1oz.	75 grains		35.0 grams
Potassium Bromide ¼ oz.	40 grains		1.0 liter
Add cold water to make		32 ounces	10.0 grams

Bleach in this solution and after thorough washing, redevelop to desired density and contrast in GAF 47 or other negative developer except fine-grain developers. Then fix and wash in usual manner. Conduct operation in subdued light.

MERCURY INTENSIFIER GAF 330

This intensifier is recommended for increasing the printing density of thin, flat negatives.

Potassium Bromide ¼ oz.	35 grains		10.0 grams
*Mercuric Chloride ¼ oz.	35 grains		10.0 grams
Add cold water to make		32 ounces	1.0 liter

*POISON—DANGER

Do not dilute for use. Negatives to be intensified must be very thoroughly washed first, or yellow stains may result on the intensified negative. Immerse negatives in above solution until thoroughly bleached to the base of the film and then wash in water containing a few drops of hydrochloric acid. Redevelop bleached negatives in 5% Sodium Sulfite or any standard developer. Surface scum which forms during storage of the bleaching solution does not affect the bleach but should be removed before using the solution.

(Continued on following page)

PINAKRYPTOL GREEN DESENSITIZER GAF 351

This solution is suitable for treatment of exposed films previous to development, to permit increased darkroom illumination and greater safety for film inspection during development.

STOCK SOLUTION

Pinakryptol Green	15 grains	1.0 gram
*Water to make	16 ounces	500.0 ml

*Use of a 50-50 water-alcohol mixture for solution will improve the keeping qualities of the desensitizer.

For use, dilute 1 part stock solution with 10 parts water. Immerse films for 2 minutes at 68°F (20°C) with room in total darkness, and then transfer to developing solution. After 2 minutes development, films may be inspected for 10 to 15 second periods at 1-minute intervals, illumination being supplied by a yellow-green safelight (such as Ansco A6 with 10-watt lamp) placed 2 to 3 feet distant. Desensitized films should be developed approximately 50% longer in GAF 17 and GAF 47, than nontreated films to obtain comparable gradation and shadow detail.

If preferred, the same stock solution may be used directly in the developer in the proportion: 1 part desensitizer, 30 parts developer. This procedure should not be followed with developers containing more than 1 gram per liter (15 grains per quart) of hydroquinone.

GAF

ILFORD, SPEED OF BLACK-AND WHITE FILMS

ROLL & 35mm	E.I.	D.I.N.
FP4	125	22
HP4	400	27
Pan F	50	18

SHEET FILM		
Commercial Ortho	D-80	D-20
	T-40	T-27
FP4 Professional	125	22
HP4 Professional	400	27

MOTION PICTURE FILM		
FP4 Negative	D-125	D-22
	T-100	T-21
Mark V Negative	D-250	D-25
	T-200	T-24
Pan F Negative	D-50	D-18
	T-32	T-16

EXPOSURE AND FILM SPEED

Ilford films have good exposure latitude and will perform well at their nominal speed ratings. However, to obtain optimum results when using ultra fine-grain, or high energy developers, E.I. ratings should be adjusted to compensate for variations in processing.

The developer time/film speed ratings shown in the table are designed to produce negatives of average contrast when processed in a spiral tank at a temperature of 68°F with the tank agitated continuously for the first ten seconds, and for ten seconds of each minute of development time thereafter. By using diluted developers, further acutance can be obtained, and such dilution will improve subjects with an extreme brightness range. By using this method, shadow and highlight densities can be retained while keeping the negative sufficiently contrasty to produce brilliant prints. Dilute developer should be used once and then discarded.

ILFORD BLACK-&-WHITE STILL FILMS

HP-4 E.I. 400

A high-speed black-and-white panchromatic negative film designed for action shots and low-light conditions. It is fine grained, has good tonal rendering and excellent electronic flash compatibility. If necessary, it can be pushed for higher E.I. ratings with forced development. It is available in 35mm, 120 rolls and standard bulk 35mm and sheet film sizes.

FP-4 E.I. 125

A medium-speed all-purpose black-and-white panchromatic film for use where difficult or abnormal exposure conditions exist. The film has wide latitude, useful speed, fine grain, and good tonal range. It gives a **7 stops over and 2 stops under** latitude and a micro-thin emulsion for high acutance and fine detail. Available in 35mm, 120, 127 and 620 rolls, and standard bulk 35mm and sheet film sizes.

PAN F E.I. 50

An ultra-fine-grain black-and-white panchromatic film for large blowups with maximum acutance. It gives optimum results under both artificial light and daylight conditions. Its fine grain and wide exposure latitude make it ideal for portraits, still life, nature studies, and other critical uses. When high speed is of secondary importance and extreme detail is required, Pan F would be the choice as against a faster film. It is available in 35mm and 120 rolls, as well as standard bulk film sizes.

COMMERCIAL ORTHO

Commercial Ortho is a fast orthochromatic film of medium contrast and fine grain. It is a general-purpose film for the commercial studio, intended particularly for photography by artificial light, but recommended for any type of commercial work where high speed and good contrast is desirable. It is also suitable for copying continuous-tone monochrome originals.

(*Continued on following page*)

ILFORD

ILFOLITH

Ilfolith IH4 is a high-contrast ortho-chromatic graphic arts type of film for high quality screen and line negatives. Although primarily designed for use in photomechanical reproduction, it is also suitable wherever image modification, posterization and other special effects are required. The film provides extremely high definition, and can reproduce fine line work with fidelity. It is available in sheet film sizes 4x5, 5x7 and 8x10.

PROCESSING ILFORD FILMS

It is recommended that for best results Ilford developers should be used to process Ilford films. However, for convenience, in the table below, other popular developers have been listed.

ILFORD PAN F

Developer	ASA	Dilution	Time*
ID11	50	None	6
or	50	1 + 1	9
D76®	50	1 + 3	14
	80	None	4
Microphen	80	1 + 1	5
	80	1 + 3	9
Perceptol	25	None	10
or	32	1 + 1	12
Microdol X	32	1 + 3	15

RECIPROCITY

No compensations for reciprocity effect is necessary with Ilford FP4 or HP4 when exposures are between ½ and 1/1000 of a second. Exposure times longer than ½ second must be adjusted to allow for reciprocity failure as shown in the table below:

ILFORD HP4

Developer	ASA	Dilution	Time*
ID11	400	None	7
or	400	1 + 1	12
D76®	400	1 + 3	20
	650	None	5
Microphen	650	1 + 1	9
	650	1 + 3	18
Perceptol	200	None	9
or	320	1 + 1	13
Microdol X	320	1 + 3	21

ILFORD FP4

Developer	ASA	Dilution	Time*
ID11	125	None	6½
or	125	1 + 1	9
D76®	125	1 + 3	15
	200	None	5
Microphen	200	1 + 1	8
	200	1 + 3	11
Perceptol	64	None	10
or	100	1 + 1	11
Microdol X	100	1 + 3	16

*These developing times may be increased up to 50% for additional contrast as may be required when using diffusion or cold light type enlargers.

SAFELIGHT

All Ilford panchromatic films are sensitive to light of all colors, and therefore should be handled and developed in total darkness. During processing, however, light from a very dark green safelight such as a Kodak Wratten Series 3, used as recommended by the manufacturer, may be used to illuminate a clock, but its direct light must not fall upon the film.

TABLE FOR RECIPROCITY ADJUSTMENT

Indicated Exposure Time/Seconds	Actual Exposure Time/Seconds For Ilford FP4	Actual Exposure Time/Seconds For Ilford HP4
0.1	0.10	0.10
1	1.2	1.1
2	2.6	2.5
4	6.2	5.5
8	14.5	13
16	35	30
32	82	75
64	205	190
128	498	488

®D76 is a trademark of the Eastman Kodak Co.

(*Continued on following page*)

ILFORD

The Compact Photo-Lab-Index

LIFE OF DEVELOPER

As each roll of film is processed in a given quantity of developer, there is a slight decrease of activity in the solution. This must be compensated for with each roll that is developed, after the first roll to assure complete full development. This may be done in one of two ways: 1) Additional time may be given for each succeeding roll. For example, 9 36-exposure rolls may be processed in one quart of Microphen developer, but the time must be increased 10% for each roll after the first. 2) The developer activity may be maintained at a constant level by the addition of a replenisher solution.

Complete information on solution capacities and replenishment requirements is included with each package of Microphen or Perceptol developer and replenisher.

ACTIVITY LOSS COMPENSATION CHART

When developer instructions refer to an increase in time of 10% for each additional roll, the chart below allows you to read the new time directly below the original time.

PUSH PROCESSING

When pictures are taken under adverse lighting conditions, it is necessary to use higher than normal Exposure Indexes, by push processing.

Ilford films can be push processed, but as with any film, while a printable film can be produced, it will usually show an increased granularity, higher contrast, a higher fog level than a normally processed negative and a questionable degree of highlight details. These characteristics will vary depending upon subject matter and the amount of forced processing. The following table suggests some starting points from which to work. Critical work should be protected by shooting specific tests in advance so that predictable results can be obtained.

The table is based upon the use of a spiral reel developing tank and intermittent agitation 10 seconds/minute at 68°F.

Developer	Dilution	FP4		HP4	
		ASA	Time	ASA	Time
Microphen	None	320	9	800	7½
	None	400	13	1600	17
	None	650	17	3200	25
Microphen	1 + 1	320	12	800	11
	1 + 1	800	20	—	—
	1 + 1	1000	30	—	—
HC-110	1 + 7	250	7½	800	9½
	1 + 7	1000	16	3200	16

TIME-TEMPERATURE CHART

When it is necessary to process films at temperatures other than those recommended, the chart below will provide the necessary information to compensate for the new temperature. To use the chart, start with the developing time recommended (68°F-20°C). Locate the point representing this time on the 20°C line (note the row of figures in the center of the chart). Follow the diagonal line corresponding to this time to the point where it crosses the horizontal line representing the temperature to be used. The new developing time is shown vertically below the intersection.

(Continued on following page)

The Compact Photo-Lab-Index

Example: If 10 minutes at 20°C is the recommended time, the time at 22°C will be 8¼ minutes; at 18°C, it will be 12 minutes.

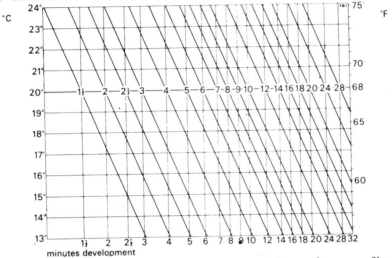

minutes development

Assessment of the results will indicate what can be accomplished vs. what is acceptable.

Additionally, the following information is based on data published by the manufacturers of the developers shown.

It is suggested that anytime a new film/developer combination is tried for the first time, the photographer pre-test and determine if the results obtained meet his requirement and expectations.

Developer	Dilution	FP4		HP4	
		ASA	Time	ASA	Time
Acufine	None	200	4(1)	1600	8(2)
	1 + 1	200	8(1)	1600	16(2)
	1 + 3	200	16(1)	1600	32(2)
Acu-1	1 + 5	—	—	1000	12½
	1 + 10	250	9(2)	—	—
Ethol T.E.C.	1 + 15	320	10	1000	15(2)
Ethol Blue	1 + 30	320	3	1200	6½
	1 + 60	320	6	—	—
Ethol UFG	None	320	3½	1000	5¼
	1 + 5	320	8¾	1000	13

(1) Manufacturer recommends a 50% increase in time for 120 roll film.
(2) Manufacturer recommends a 25% increase in time for 120 roll film.

There is no guarantee or endorsement of the performance of these developers or the accuracy of the times given. It is recommended that the manufacturer be contacted if you require further information on their preparation and use.

Also, if you are switching to Ilford film from another brand of film, the ASA/developer/time/temperature procedures you have already established for films with comparable basic speed ratings represent excellent starting points from which you can make changes if you find them necessary.

(Continued on following page)

ILFORD

The Compact Photo-Lab-Index

FIXING AND WASHING

After development, Ilford films should be rinsed in water or a stop bath and then fixed in an acid fixer and hardener. The time recommended by the fixer manufacturer will be satisfactory.

After fixing, Ilford film should be thoroughly washed in running water for 15 to 20 minutes. A final rinse in water to which a wetting agent has been added will aid rapid and uniform drying.

LITH FILM PROCESSING

Ilfolith IH4 lith film should be processed in Ilford SX200 developer. Generally high contrast lithographic films are tray developed by inspection using a red safelight (Ilford LR915, Kodak Wratten 1A or equivalent). When processing a fine line negative, it is recommended that a properly exposed film be developed for 2¼ to 3 minutes at 68°F with gentle agitation. Development time may vary widely with different developer dilutions for the achievement of special effects. Fixing and washing should follow the usual procedure as outlined in the paragraph above. Machine processing can be determined by test, and using the recommendations of the machine manufacturer.

ILFOBROM

Ilfobrom is a premium quality line of black-and-white bromide enlarging papers. They have rich blacks, clean whites and a full gray scale. There are a variety of surfaces and contrasts to enable the operator to work with either condenser or diffusion enlargers. Grades are spaced at 0.2 logarithmic exposure units between each of the six contrast grades 0 to 5. Speed is constant from grade to grade and batch to batch. This permits the changing of contrast grades without changing exposure time except that grade 5 is ½ the standard speed.

There is no batch-to-batch variation in either image color or base tint, and the base is such that clean bright prints can be expected. There is no variation of contrast due to changes in exposure time.

There are six double weight character surfaces: glossy, semi-matt, matt, velvet stipple, velvet lustre, and rayon. Single weight glossy is available in standard sheet and roll sizes.

ILFOSPEED

Ilfospeed is a polyethylene resin-coated enlarging paper. The speed, uniform contrast grade spacing and other photographic characteristics are the same as those of Ilfobrom enlarging paper. The same image characteristic of clean whites and rich blacks occur as in Ilfobrom. The basic difference is that Ilfospeed can be processed and dried quickly because solutions cannot penetrate the waterproof polyethylene resin coating, eliminating the need for extensive washing and drying. Ilfospeed comes in the same six contrast grades as Ilfobrom, and is supplied in glossy, silk and semi-matt surfaces in standard sheet and roll sizes. This material should not be ferrotyped, the glossy surface is inherent in the resin coating. Ilfospeed paper when used with Ilfospeed developer, Ilfospeed fixer and the Ilfospeed 4250 dryer makes up the Ilfospeed system which produces high quality prints in four minutes.

ILFOBROM PROCESSING

Ilfobrom enlarging paper is exposed and processed in essentially the same way as other enlarging papers. While other paper developers can be used, Bromophen developer is recommended to bring optimum results.

SPEED

Ilfobrom is a medium speed paper designed for enlarging, but with proper illumination, it can also be used for contrast printing.

SAFELIGHT RECOMMENDATIONS

A light brown safelight such as the Ilford 902 or Kodak Wratten OC should be used when processing Ilfobrom enlarging paper.

PROCESSING

Ilfobrom may be developed in 1 to 3 minutes is a standard paper developer such as Bromophen at 68°F. Bromophen is a Phenidon-Hydroquinone paper developer. In use, the photographic image appears quickly and then density increases slowly to allow accurate control of print quality.

A standard acid short stop bath should be used between the developer and fix to avoid staining or streaking the print.

(Continued on following page)

466

The Compact Photo-Lab-Index

Ilfobrom should be fixed for 10 minutes in a fixer recommended for use with photographic paper. Then, prints should be thoroughly washed in running water at 68° to 75°F, for a minimum of 30 minutes.

Ilfobrom prints can be heat dried or ferrotyped in the normal manner. Prints which are to be air dried rather than ferrotyped should be wiped to remove any excessive moisture in order to prevent the formation of drying marks.

ILFOSPEED PROCESSING

Ilfospeed paper is a polyethylene resin-coated paper specially made for rapid processing and drying. For optimum quality, Ilfospeed developer and Ilfospeed fixer are recommended.

SPEED

Ilfospeed is a medium-speed enlarging paper that has essentially the same speed as Ilfobrom papers.

SAFELIGHT

A light brown safelight such as the Ilford 902 of Kodak Wratten OC shuld be used for the processing of Ilfospeed paper.

PROCESSING

With Ilfospeed developer, a phenidone-hydroquinone formula, the image appears after six seconds and is fully developed in one minute at 68°F (20°C). Development should be followed by a brief water rinse. Then the Ilfospeed print should be immersed in Ilfospeed fixer for just 30 seconds. After fixing, Ilfospeed prints need only two minutes' washing for permanence.

Since the surface characteristic of Ilfospeed paper (including glossy) is a function of the resin coating, prints should not be ferrotyped. All Ilfospeed prints should be dried in the Ilfospeed 4250 dryer or equivalent, or air dried.

ILFOPRINT

The Ilfoprint System of stabilization papers, chemicals, and processors has been designed to work together to provide simple, fast and economical means of producing quality prints. With Ilfoprint it is possible to process as 8x10 print in just 10 seconds where print permanence is not critical.

Ilfoprint papers have a special developing agent incorporated into the emulsion. After a print is exposed in an enlarger, a contact printer or other device, it is fed into the Ilfoprint processor. Within the processor, rollers evenly apply an activator to develop the print, and a stabilizer to stop development action to make the print semi-permanent. The finished print is ejected from the machine in a damp-dry state. The papers yield a neutral black image tone on a bright white background. The papers are available in glossy, semi-matt and velvet stipple surfaces, in three weights, double, single and document, and in both projection and contact speeds.

PROCESSING

Ilfoprint papers are processed in stabilization machines such as the Ilford Super 12 (for prints up to 12 inches in width) and the Ilford Super 24 (for prints up to 24 inches wide). Two chemical solutions are used: Ilfoprint Activator and Ilfoprint Stabilizer. Both are supplied in quart sized plastic bottles at working strength. The bottles fit the system to maintain correct solution levels, and the chemicals are supplied in bulk for high volume users. One quart of activator and stabilizer will satisfactorily process approximately 200 to 400 8x10 prints.

PRINT PERMANENCE

The life of a finished Ilfoprint stabilization print is dependent upon its storage and use conditions. If finished prints are continuously exposed to direct sunlight or other strong sources of ultraviolet light, image, or background degradation may become apparent in a matter of days. Alternately, processed prints stored away from light and high humidity conditions will remain in good condition over a period of many months.

If required, Ilfoprints can be made permanent by conventional fixing, washing, and drying after leaving the processor.

SAFELIGHT

Ilfoprint projection speed papers must be handled in a light brown safelight, such as the Ilford 902, or the Kodak Wratten OC. Contact speed papers may be used in subdued room light as long as there is no predominance of fluorescent illumination.

The Compact Photo-Lab-Index

ILFORD PAN F FILM
Fine Grain Black-&-White
35mm Film and 120 Roll Film

GENERAL PROPERTIES

Pan F film is a fine grain panchromatic emulsion which is recommended for artificial light and daylight photography, particularly where sharpness and lack of grain are more important than film speed.

The fine grain and wide exposure latitude of Pan F make it an ideal film for reversal processing. Warm tone transparencies are produced on reversal. Available in 120 roll film and 35mm magazines and long rolls.

FILM SPEED
ASA 50; DIN 18

METER SETTINGS: Meter calibration—(See "Development")

WEDGE SPECTROGRAM
Wedge spectrogram to tungsten light (2850 K).

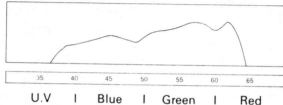

| .35 | 40 | 45 | 50 | 55 | 60 | 65 |

U.V | Blue | Green | Red

RECIPROCITY CHART

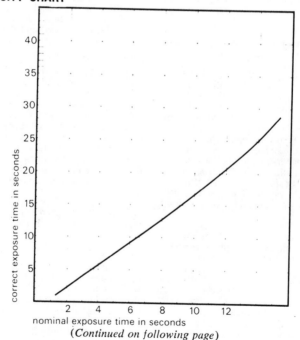

correct exposure time in seconds

nominal exposure time in seconds

(*Continued on following page*)

ILFORD

The Compact Photo-Lab-Index

RECIPROCITY CHARACTERISTICS

Pan F is designed so that maximum emulsion speed is obtained over the range of exposure times normally used in photography—from 1/2 to 1/1000 second. At extremely long or very short exposure times, the nominal exposure —obtained from an exposure meter or guide—should be increased to compensate for the falling off in film speed due to the reciprocity effect. The graph shows the relationship between the nominal exposure time and that which should actually be given in practice.

For extremely short exposures, such as 1/10,000 second, the lens aperture should be opened by 1/2 stop over the indicated setting.

FILTER FACTORS

The factors quoted below give a practical guide to the increase in exposure necessary when using the filters listed. Daylight factors may vary with angle of the sun and the time of day. In the late afternoon, or in the winter months when the daylight contains more red light, the factors for green and blue filters may have to be slightly increased. Factors for tungsten light are based on an average tungsten source which has a color temperature of 2850 K. The filter factors are intensity scale factors, but for most purposes exposures can be increased by either using a larger aperture or a slower shutter speed.

Filter	Daylight	Tungsten
Light Yellow (K1) (Kodak Wratten® #6)	1.5	1.25
Medium Yellow (K2) (Kodak Wratten #8)	2.0	1.5
Dark Yellow (G) (Kodak Wratten #15)	2.0	1.5
Light Yellow-Green (X1) (Kodak Wratten #11)	3.5	4.0
Tricolor Red (A) (Kodak Wraten #25)	6.0	4.0
Tricolor Blue (C5) (Kodak Wratten #47)	7.0	13.0
Tricolor Green (B) (Kodak Wratten #58)	6.0	6.0

SAFELIGHT

Pan F should be handled and developed in total darkness. A Kodak Wratten Series 3 safelight (very dark green) may, however, be used provided that no direct light is allowed to fall on the film.

PROCESSING

Development

The characteristic curves show a range of development times in Ilford ID/11 (D76® type) and the contrast time curves show how contrast varies with development time in different developers.

If Pan F is developed in Ilford Microphen developer a speed increase of about ½ a stop can be obtained. For the finest grain, Pan F should be developed in Ilford Perceptol. When the film is to be developed in Microphen or Perceptol (full strength) the meter settings quoted below should be used.

Meter Settings	Microphen	Perceptol
ASA	80	25
DIN	20	15

®D76 is a trademark of the Eastman Kodak Co.

The development times will depend on the contrast required. Contrast is measured in terms of G, that is the slope of the straight line joining the point on the characteristic curve 0.1 above fog density and the point 1.5 log exopsure units away.

A negative developed to a G of about 0.55 is satisfactory for most purposes. In some cases a slightly harder negative may be required, for example when using a cold cathode enlarger, and in such cases a G of 0.70 is recommended. The following table gives development times in minutes for processing in a spiral tank at 68° F (20° C) with agitation for the first 10 seconds of development, and for 10 seconds every minute for the remainder of the development time.

Ilford Developer	G0.55	G0.70
ID-11 (D-76® type)	6	9
Microphen	4	6
Perceptol	10	15

When continuous agitation is given— as in a tray or with some types of de-

(*Continued on following page*)

ILFORD

469

The Compact Photo-Lab-Index

DEVELOPMENT TIMES (minutes)—intermittent agitation

Ilford Developer	Dilution	G0.55	G0.70
ID-11 (D-76® type)	1+1	9	14
	1+3	14	21
Microphen	1+1	5	8
	1+3	9	14
Perceptol	1+1	12	17
	1+3	15	24

veloping tanks—the development times should be reduced by one quarter.

Development of Pan F in diluted Perceptol achieves further actuance. Dilute development is particularly suitable for subjects with long tonal scales— shadow and highlight densities are retained while negatives are sufficiently contrasty to produce bright prints. Diluted developer should be used once only and then discarded.

When using dilute development technique with ID-11, there is no need to alter the film speed. With Microphen the film speed must be set to ASA, DIN 20. With Perceptol the film speed must be set to ASA 32, DIN 16.

FIXATION

After development the film should be rinsed and then fixed in an acid fixer, such as Ilfospeed Fixer, which fixes the film in 2 minutes. If a hardening fixer is required, the fixing time should be 3 to 5 minutes.

WASHING

After fixation the film should be thoroughly washed in running water for 15 to 20 minutes. A final rinse in water to which Ilford Ilfotol or suitable wetting agent has been added will aid rapid and uniform drying.

CONTRAST INDEX CURVES

Contrast Index curves for Pan F with intermittent agitation give the average gradient over a range of 1.5 log exposure units from a point 0.1 above fog.

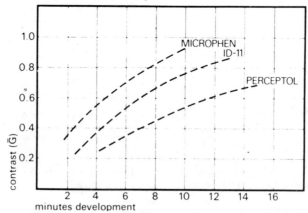

Characteristic Curve for Pan F appears on following page

®D76 is a trademark of the Eastman Kodak Co.

• (*Continued on following page*)

The Compact Photo-Lab-Index

CHARACTERISTIC CURVES
Developed in ID-11 at 20° (68° F) with
intermittent agitation.

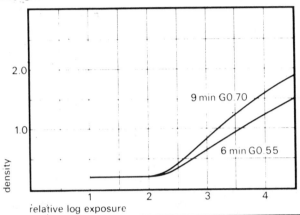

ILFORD FP4 FILM
ASA 125
35mm & 120 Roll Film

GENERAL PROPERTIES
Ilford FP4 films are fine grain medium-contrast panchromatic films with a speed rating of 125 ASA to daylight. FP4 films have a high acutance emulsion and wide exposure latitude which make it ideal for all indoor and outdoor photography, particularly when giant enlargements are to be made. Suitable results can be obtained even if it is overexposed by as much as six stops, or underexposed by two stops. Available in 120, 220, 126, 127 and 620 rolls; and 35mm magazines and long rolls, and a wide range of sheet film sizes.

FILM SPEED

Meter Calibration	Daylight	Tungsten
ASA	125	100
DIN	22	21

WEDGE SPECTROGRAM

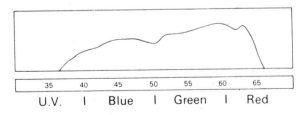

U.V. | Blue | Green | Red

Wedge spectrogram to tungsten light (2850 K)

(Continued on following page)

FILTER FACTORS

The factors given are intensity scale factors, but for most purposes expo- sure can be increased either by using a larger aperture or a slower shutter speed.

Filter	Daylight	Tungsten
Light Yellow (K1) (Kodak Wratten® #6)	1.5	1.25
Medium Yellow (K2) (Kodak Wratten #8)	2.0	1.5
Dark Yellow (G) (Kodak Wratten #15)	2.0	1.5
Light Yellow-Green (X1) (Kodak Wratten #11)	3.5	4.0
Tricolor Red (A) (Kodak Wratten #25)	6.0	4.0
Tricolor Blue (C5) (Kodak Wratten #47)	7.0	13.0
Tricolor Green (B) (Kodak Wratten #58)	6.0	6.0

RECIPROCITY CHARACTERISTICS

There is no need to compensate for reciprocity characteristics when FP4 is given exposure times between 1/2 to 1/1000 second. Exposure times which are longer than 1/2 second must be adjusted to allow for reciprocity failure.

The graph below can be used to cal- culate the new exposure times allowing for reciprocity characteristics. The times on the horizontal axis represent the estimated exposure times, the vertical axis gives the corrected exposure times.

For extremely short exposure times, such as 1/10,000 second, the lens aper- ture should be opened by 1/2 stop over the indicated setting.

SAFELIGHT

FP4 film should be handled and devel- oped in total darkness. A Kodak Wrat- ten Series 3 safelight (very dark green) can be used for brief inspection during processing.

PROCESSING
Development

FP4 is shown to best advantage if it is developed in either Ilford ID-11, a D76 type developer, Ilford Microphen, or Ilford Perceptol. These are fine grain

(Continued on following page)

472

developers—Microphen giving FP4 a speed increase of ⅔rds of a stop.

When FP4 is to be developed in Microphen or Perceptol (full strength) the meter settings quoted should be used.

Meter Calibration	Daylight	Tungsten
ASA	200	160
DIN	24	23

The development times given below are in minutes and refer to development at 68° F (20° C) using intermittent agitation, that is, agitation for the first 10 seconds of development, then for 5 seconds every minute for the remainder of the development time. Negatives should be developed to a G of 0.55 except when a cold cathode enlarger is used when a negative developed to a G of 0.70 is more satisfactory — a slightly harder negative giving better results with this type of enlarger.

Ilford Developer	G0.55	G0.70
ID-11 (D76® type)	6½	10
Microphen	5	7½
Perceptol	10	13

If continuous agitation is given—as in a tray or with some types of developing tanks—three-quarters of the development time stated should be given.

Development of FP4 in diluted ID-11, Microphen or Perceptol further increases the already high acutance of this film—the greater the dilution, the better the acutance. Dilute development is particularly suitable for subjects with long tonal scales—shadow and highlight densities are retained while negatives are sufficiently contrasty to produce bright prints. With this development technique film speed is fully maintained, but development times have to be increased. Diluted developer should be used once only, and then thrown away.

Ilford Developer	Dilution	G0.55	G0.70
ID-11 (D-76® type)	1+1	9 min.	14 min.
	1+3	15 min.	22 min.
Microphen	1+1	8 min.	13 min.
	1+3	11 min.	20 min.
Perceptol	1+1	11 min.	15 min.
	1+3	16 min.	28 min.

CONTRAST INDEX CURVES

Contrast Index Curves for ID-11 with continuous and intermittent agitation give the average gradient (G) over a range of 1.5 log exposure units from a point of 0.1 above fog.

continuous agitation —————— intermittent agitation — — — —

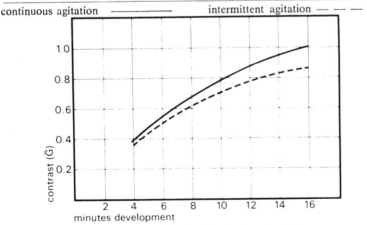

contrast (Ḡ)

minutes development

®D76 is a trademark of the Eastman Kodak Co.

(*Continued on following page*)

ILFORD

The Compact Photo-Lab-Index

FIXING

After development rinse the film and fix in an acid fiixer, which fixes the film in 2 minutes. An acid hardening fixer can be used—it fixes and hardens the film in 5 to 10 minutes.

WASHING

After fixing, the film should be thoroughly washed in running water for 15 to 20 minutes. A final rinse in water to which a wetting agent has been added will aid rapid and uniform drying.

SENSITOMETRIC CURVES

Contrast-time curve for Microphen with intermittent agitation gives the average gradient over a range of 1.5 log exposure units from a point of 0.1 above fog.

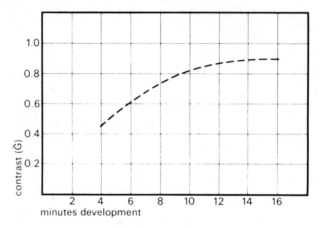

Contrast-time curve for Perceptol with intermittent agitation gives the average gradient over a range of 1.5 log exposure units from a point of 0.1 above fog.

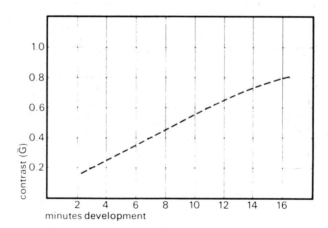

(Continued on following page)

474

The Compact Photo-Lab-Index

CHARACTERISTIC CURVES
Developed in ID-11 at 20° C (68° C)
with intermittent agitation.

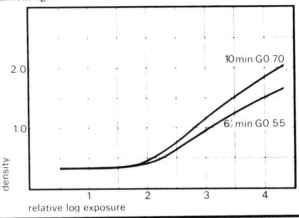

ILFORD HP4 FILM
ASA 400
35mm & 120 Roll Film

GENERAL PROPERTIES
HP4 roll film is a medium-contrast, fine grain panchromatic film which has a speed rating of 400 ASA to daylight. It is the ideal film to use under adverse lighting conditions—extra speed can be gained by developing it in Microphen—and has a particularly good response to electronic flash, maintaining film contrast even for extremely short exposure times.

FILM SPEED
ASA 400 DIN 27

WEDGE SPECTROGRAM
Wedge spectrogram to tungsten light (2850 K)

U.V. | Blue | Green | Red

FILTER FACTORS
The factors given are a practical guide to the increase in exposure necessary when using the filters listed. The daylight factors may vary with the angle of the sun and the time of the day. In

Filter	Daylight	Tungsten
Light Yellow (K1) (Kodak Wratten® #6)	1.5	1.25
Medium Yellow (K2) (Kodak Wratten #8)	2.0	1.5
Dark Yellow (G) (Kodak Wratten #15)	2.0	1.5
Light Yellow-Green (X1) (Kodak Wratten #11)	3.5	4.0
Tricolor Red (A) (Kodak Wratten #25)	6.0	4.0
Tricolor Blue (C5) Kodak Wratten #47)	7.0	13.0
Tricolor Green (B) (Kodak Wratten #58)	6.0	6.0

(Continued on following page)

475

The Compact Photo-Lab-Index

the late afternoon, or in the winter months when the daylight contains more red light, the factors for green and blue filters may have to be slightly increased. The factors for tungsten light are based on an average tungsten source which has a color temperature of 2850 K. The filter factors are intensity scale factors, but for most purposes exposures can be increased by either using a larger aperture or a slower shutter speed.

RECIPROCITY CHARACTERISTICS

HP4 is designed to give maximum emulsion speed for the range of exposure times normally used in photography—from 1 second to 1/1000 second. At extremely long or very short exposure times, the nominal exposure—obtained from an exposure meter or guide—should be increased to compensate for the falling off in film speed due to the reciprocity effect. The graph can be used to calculate the new exposure times allowing for reciprocity characteristics. The times on the horizontal axis represent the estimated exposure times; the vertical axis gives the corrected exposure times.

For exposure times between 1/1000 and 1/10,000 second, the lens aperture should be opened up by 1/2 stop over the indicated setting.

SAFELIGHT

HP4 should be developed in total darkness. A Kodak Wratten Series 3 safelight (very dark green), may, however, be used provided that no direct light is allowed to fall on the film.

PROCESSING
DEVELOPMENT

The sensitometric curves show a range of development times in ID-11, a D76® and the contrast/time curves illustrate how contrast varies in different developers. An increase in the film speed of HP4 can be obtained if it is developed in Ilford Microphen fine grain developer.

For the finest grain, HP4 should be developed in Ilford Perceptol. When HP4 is to be developed in Microphen

(Continued on following page)

The Compact Photo-Lab-Index

or Perceptol (full strength) the meter settings quoted below should be used.

Meter Settings	Microphen	Perceptol
ASA	650	200
DIN	29	24

The development times given will depend on the negative contrast required. Ilford measures contrast in terms of G, that is, the slope of the straight line joining the characteristic curve 0.1 above fog density and a point 1.5 log exposure units away. A negative developed to a G of 0.55 is satisfactory for most purposes. In some cases, a slightly harder negative may be required, for example, when using a cold cathode enlarger, when a G of 0.70 is recommended.

The table gives HP4 development times in minutes for processing in a spiral tank at 68° F (20° C) with agitation for the first 10 seconds of development and then for 10 seconds every minute for the remainder of the development time.

Ilford Developer	G0.55	G0.70
ID-11 (D76® type)	7	10
Microphen	5	7½
Perceptol	9	13

Where continuous agitation is to be used—as in a tray or some types of developing tanks—these times should be reduced by one-quarter.

Development of HP4 in diluted ID-11, Microphen or Perceptol further increases acutance. Dilute development is particularly suitable for subjects with long tonal scales—shadow and highlight densities are retained while negatives are sufficiently contrasty to produce bright prints. Diluted developers should be used once only and then discarded.

When using the dilute development technique with ID-11 there is no need to alter the film speed. With Microphen the film speed must be set to ASA 650 DIN 29. With Perceptol the film speed must be set to ASA 320, DIN 26.

DEVELOPMENT TIMES (Minutes)—Intermittent Agitation

Ilford Developer	Dilution	G0.55	G0.70
ID-11	1+1	12	18
	1+3	20	30
Microphen	1+1	9	18
	1+3	18	27
Perceptol	1+1	13	19
	1+3	21	30

FIXATION

After development, HP4 should be rinsed in water or a stop bath and then fixed in an acid fixer, which fixes the film in 2 minutes. If a hardening fixer is required, the fixing time should be 3 to 5 minutes.

WASH

After fixing, the film should be thoroughly washed in running water for 15 to 20 minutes. A final rinse in water to which a wetting agent has been added will aid rapid and uniform drying.

Contrast/Time Curves and Characteristic Curves are on following pages

®D76 is a trademark of the Eastman Kodak Co.

(*Continued on following page*)

The Compact Photo-Lab-Index

CONTRAST/TIME CURVES

Contrast Index Curves for HP4 in ID-11 with continuous and intermittent agitation give the average gradient over a range of 1.5 log exposure units from a point 0.1 above fog.

continuous agitation ——————— intermittent agitation — — — —

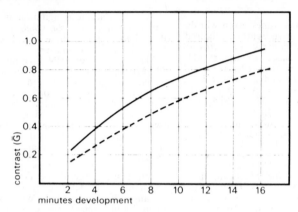

Contrast-time Curves for HP4 in Microphen with continuous and intermittent agitation give the average gradient over a range of 1.5 log exposure units from a point 0.1 above fog.

continuous agitation ——————— intermittent agitation — — — —

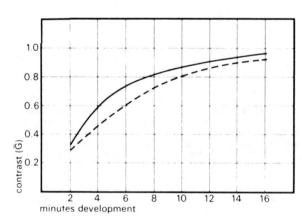

More Curves appear on following page

(*Continued on following page*)

478

The Compact Photo-Lab-Index

Contrast-time Curves for HP4 in Perceptol (full strength) with continuous and intermittent agitation give the average gradient over a range of 1.5 log exposure units from a point 0.1 above fog.

continuous agitation intermittent agitation

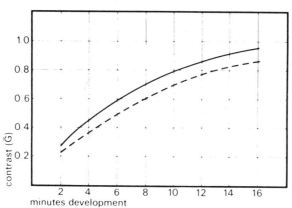

CHARACTERISTIC CURVES

HP4 developed in ID-11 at 68° F (20° C) with intermittent agitation.

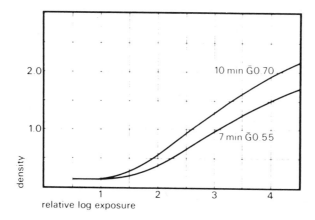

ILFORD HP4
Fast B&W Professional Sheet Film

GENERAL PROPERTIES
Description and Uses

Ilford® HP4 Professional Sheet Film is a medium contrast, fine grain panchromatic film which has a speed rating of 400 ASA in daylight. It gives excellent tonal rendering and has a particularly good response to electronic flash as film contrast remains unchanged, even for extremely short exposure times. HP4 Professional Sheet Film is coated on 8/1000 inch (0.20mm) acetate safety base and is also coated with an anti-halation backing which clears during development.

Ilford HP4 Professional Sheet Film has surfaces which have been modified and improved from the original to accept pencil, aerograph and other retouching techniques, on both sides of the negative.

METER SETTINGS

meter calibration
(see also 'Development')

ASA	400
DIN	27

WEDGE SPECTROGRAM

Wedge spectrogram to tungsten light (2850 k)

Wedge spectogram to tungsten light (2850 K)

FILTER FACTORS

The factors quoted in the table give a practical guide to the increase in exposure necessary when using the filters listed. Daylight factors may vary with the angle of the sun and the time of day. In the late afternoon or the winter months when the daylight contains more red light, the factors for the green and blue filters may have to be slightly increased. Factors for tungsten light are based on an average tungsten source which has a color temperature of 2850°K.

These factors are intensity scale factors, but for most purposes exposures may be increased by either using a larger aperture or a slower shutter speed.

Filter	Daylight	Tungsten
Light Yellow (K1) (Kodak Wratten® #6)	1.5	1.25
Medium Yellow (K2) (Kodak Wratten #8)	2.0	1.5
Dark Yellow (G) (Kodak Wratten #15)	2.0	1.5
Light Yellow-Green (X1) (Kodak Wratten #11)	3.5	4.0
Tricolor Red (A) (Kodak Wratten #25)	6.0	4.0
Tricolor Blue (C5) (Kodak Wratten #47)	7.0	13.0
Tricolor Green (B) (Kodak Wratten #58)	6.0	6.0

®Wratten is a trademark of Eastman Kodak

RECIPROCITY CHARACTERISTICS

There is no need to compensate for reciprocity characteristics when HP4 is given exposure times between ½ to 1/1000 second. Exposure times which are longer than ½ second must be adjusted to allow for reciprocity failure. The graph can be used to calculate longer exposure times allowing for reciprocity characteristics. The times on the horizontal axis represent the estimated exposure times; the vertical axis gives the corrected exposure times.

For extremely short exposure times, such as 1/10,000 second, the lens aperture should be opened by ½ stop over the indicated setting.

(Continued on following page)

The Compact Photo-Lab-Index

RECIPROCITY CURVE

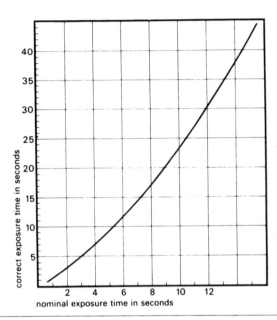

correct exposure time in seconds (y-axis: 5, 10, 15, 20, 25, 30, 35, 40)

nominal exposure time in seconds (x-axis: 2, 4, 6, 8, 10, 12)

ILFORD

DEVELOPMENT

The choice of a developer will be influenced by a number of factors including grain and speed. The meter settings quoted for HP4 relate to normal processing in developers such as ID-11 or D76®.

An increase in the film speed of HP4 can be achieved if it is developed in Ilford Microphen® developer.

For the finest grain, HP4 should be developed in Ilford Perceptol.

When the film is to be developed in Microphen or Perceptol (full strength) the meter settings quoted below should be used.

Meter settings	Microphen	Perceptol
ASA	650	200
DIN	29	24

The development times will depend on the contrast required. Contrast is measured in terms of G, that is the slope of the straight line joining the

point on the characteristic curve 0.1 above fog density and the point 1.5 log exposure units away.

A negative developed to a G of 0.55 is satisfactory for most purposes. In some cases a slightly harder negative may be required, for example when using a cold cathode enlarger, for which purposes a G of 0.70 is recommended.

The development times are given in minutes and refer to development at a temperature of 20° C (68° F). For tank processing, agitation should be carried out for the first 10 seconds of development and thereafter for 10 seconds at the end of every minute. Continuous agitation should be used for tray processing.

SAFELIGHT

HP4 should be handled and developed in total darkness. A Kodak Wratten Series 3 safelight (very dark green) may however, be used with care provided that no direct light is allowed to fall on the film.

®D76 is a trademark of the Eastman Kodak Co.

(*Continued on following page*)

The Compact Photo-Lab-Index

Ilford developer	Agitation	Development Times	
		G0.55	G0.70
for fine grain with increased speed Microphen	continuous	3½	5½
	intermittent	5	7½
for fine grain ID-11	continuous	5	8
	intermittent	7	10
for ultra fine grain Perceptol	continuous	6	9
	intermittent	9	13

Maximum foot speed is obtained by development in Microphen for 17 minutes. This gives a G of 0.90. Increased development will give an increase in G but no increase in foot speed. Development of HP4 in diluted ID-11, Microphen or Perceptol further increases acutance. Dilute development is particularly suitable for subjects with long tonal scales—shadow and highlight densities are retained while negatives are sufficiently contrasty to produce bright prints. Diluted developer should be used only once and then discarded.

Development times (minutes)—intermittent agitation

ILFORD Developer	Dilution	G0.55	G0.70
ID-11 (D76® type)	1 + 1	12	18
	1 + 3	20	30
Microphen	1 + 1	9	18
	1 + 3	18	27
Perceptol	1 + 1	13	19
	1 + 3	21	30

When using dilute development technique with ID-11, there is no need to alter the film speed. With Microphen the film speed must be set to ASA 650, DIN 20. With Perceptol the film speed must be set to ASA 320, DIN 26.

FIXATION

After development, films should be rinsed and then transferred to an acid fixer. For rapid fixing, a hardening fixer is recommended. Films should be fixed for twice the time that the emulsion takes to clear.

WASHING

After fixation, films should be washed in running water for 15 to 20 minutes. A final rinse in water to which a wetting agent has ben added will aid rapid and uniform drying.

®D76 is a trademark of the Eastman Kodak Co.

(Continued on following page)

482

The Compact Photo-Lab-Index

CONTRAST/TIME CURVES

Contrast-time curves for HP4 and ID-11 with continuous and intermittent agitation give the average gradient over a range of 1.5 log exposure units from a point 0.1 above fog.

─────────── continuous ─ ─ ─ ─ ─ ─ intermittent

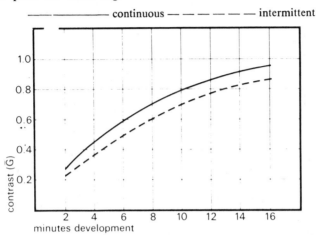

Contrast-time curves for HP4 in Microphen with continuous and intermittent agitation give the average gradient over a range of 1.5 log exposure units from a point 0.1 above fog.

─────────── continuous ─ ─ ─ ─ ─ ─ intermittent

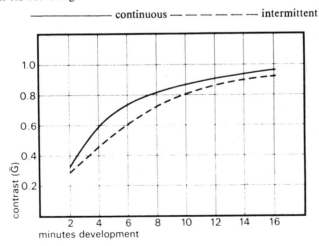

(Continued on following page)

483

The Compact Photo-Lab-Index

Contrast-time curves for HP4 in Perceptol (full strength) with continuous and intermittent agitation give the average gradient over a range of 1.5 log exposure units from a point 0.1 above fog.

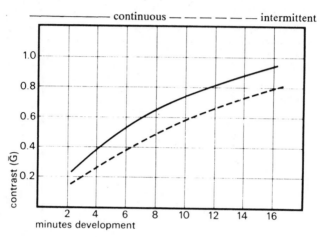

CHARACTERISTIC CURVES

HP4 developed in ID-11 at 20° C (68° F) with intermittent agitation.

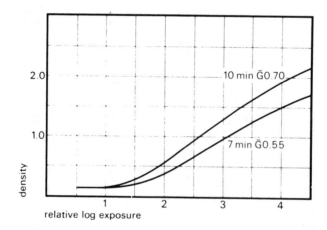

ILFORD COMMERCIAL ORTHO FILM
ASA D 80 ASA T 40

GENERAL PROPERTIES

Commercial Ortho is a fast orthochromatic film of medium contrast and fine grain. It is a general-purpose film for the commercial studio, intended particularly for photography by artificial light, but recommended for any type of commercial work where high speed and good contrast is desirable. It is also suitable for copying continuous-tone monochrome originals.

Commercial Ortho is coated on .008 inch (0.02mm) safety base with an antihalation backing which clears during development. Available in sheet film sizes only.

FILTER FACTORS

Ilford Filter	Daylight	Tungsten
Medium Yellow (K2) (Kodak Wratten #8)	2	1½
Dark Yellow (G) (Kodak Wratten #15)	3½	2

FILM SPEED

Meter	Daylight	Tungsten
ASA	80	40
DIN	20	17

SAFELIGHT

An Ilford Iso Safelight, No. 906 (dark red) is recommended for use with this film.

FIX

After development, films should be rinsed and then transferred to an acid fixer such as Ilford Hypam, Ilfofix or Ilford IF-23. Films should be fixed for twice the time the emulsion takes to clear.

WASH

After fixation, films should be thoroughly washed in running water for thirty minutes. A final rinse in water to which Ilford Ilfotol wetting agent has been added will promote rapid uniform drying.

WEDGE SPECTROGRAM

Wedge spectogram to tungsten light (2850 K).

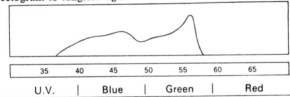

	U.V.		Blue		Green		Red

PROCESSING DEVELOPMENT	Development Time at 20° C (68° F)	
Ilford Developer	**Tray (Continuous Agitation)**	**Tank (Intermittent Agitation)**
For general use	minutes	minutes
ID-2 (1 + 2)	3	—
ID-2 (1 + 5)	—	6
PQ Universal (1 + 9)	3¾	—
JQ Universal (1 + 19)	—	6
For fine grain		
ID-11	9½	12
Microphen	9½	12
For rapid development		
Contrast FF (1 + 4)	2½	—

(Continued on following page)

485

The Compact Photo-Lab-Index

SENSITOMETRIC CURVES

Developed in ID-2 (1:2) at 68° F (20° C) with continuous agitation.

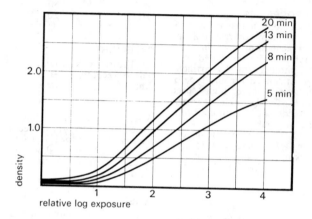

CONTRAST INDEX CURVES

Contrast Index Curves for Autophen, PQ Universal (1:9), ID-2 (1:5), Microphen, ID-48, ID-11 with intermittent agitation give average gradient over a range of 1.5 log exposure units from a point 0.1 above fog.

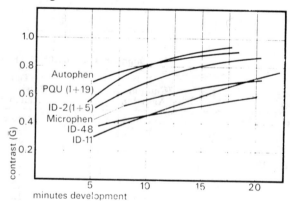

486

The Compact Photo-Lab-Index

ILFORD HP5 FAST B&W 35mm FILM
ASA 400

HP5 is a fast black and white film. When given standard development it has a rating of 400 ASA 27 DIN to daylight. HP5 has fine grain, excellent edge contrast and sharpness to give high image quality. These characteristics give prints with outstanding brightness and tonal range.

By extending development with developers such as ILFORD MICROPHEN, useful speed increases are obtained making HP5 the film for all photography where factors such as poor lighting and high shutter speeds demand greatest emulsion sensitivity.

Ilford HP5 will yield superior negatives when processed in tanks, in continuous roller transport or drum processors.

FILTER FACTORS

The factors quoted below give a practical guide to the increase in exposure necessary whn using the filters listed. The factors for tungsten light are based on an average tungsten source which has a color temperature of 3,200°K.

Filter	Daylight	Tungsten
Light Yellow (K1) (Kodak Wratten #6)	1.5	1.25
Medium Yellow (K2) (Kodak Wratten #8)	2.0	1.5
Dark Yellow (G) (Kodak Wratten #15)	2.0	1.5
Light Yellow-Green (X1) (Kodak Wratten #11)	3.5	4.0
Tricolor Red (A) (Kodak Wratten #25)	6.0	4.0
Tricolor Blue (C5) (Kodak Wratten #47)	7.0	13.0
Tricolor Green (B) (Kodak Wratten #58)	6.0	6.0

RECIPROCITY CHARACTERISTICS

HP5 need not be corrected for reciprocity law failure when exposures between ½ and 1/10,000 second are given. Exposure times longer than ½ second must be adjusted to allow for reciprocity failure; use the graph to calculate the increased exposure time which should be given once the measured time is known. For extremely short exposure times it may be necessary to use a larger lens aperture than that indicated.

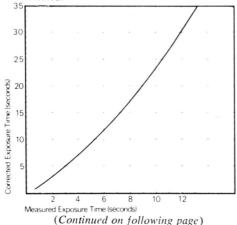

(*Continued on following page*)

487

The Compact Photo-Lab-Index

SAFELIGHT RECOMMENDATIONS
Safelights must be used with great caution with this fast film: during the first three quarters of the planned development time it is strongly recommended that HP5 is handled in total darkness. After this time, periodic use of a Kodak Wratten Series 3 safelight (very dark greeen) may be made to check negative density for short intervals.

NORMAL EXPOSURE DEVELOPMENT DATA
The table gives the recommended ASA settings for HP5 and corresponding development times for most commonly used developers. These data assume processing in a spiral tank with agitation for the first 10 seconds of development and then for 10 seconds every minute for the remainder of the development time.

Development and ASA Determination Table

Developer	Dilution	ASA	Development Time at 68°F(20°C)	at 75°F(24°C3
ID-11	none	400	7	4¾
or	1 + 1	400	12	8
D76	1 + 3	400	23	15½
	none	640	6	4
Microphen	1 + 1	640	9½	6¼
	1 + 3	640	21	14
HC-110	1 + 7	400	6	4
DK-50	1 + 1	400	6½	4¼
Acufine	none	500	5	3½
Diafine	none	500	3	3
	none	200	11	7¼
Perceptol	none	400	16½	11
	1 + 1	200	14	9¼
	1 + 3	200	22	14½
	none	160	11	7¼
Microdol-X	none	320	16½	11
	1 + 1	200	14	9¼
	1 + 3	200	22	14½
	1 + 25	250	7	4¾
Rodinal	1 + 50	250	14	9¼
	1 + 75	200	16	10¾

The development times given are for negatives printed in condenser-type enlargers with normal average scene brightness on Ilford contrast grades 2 and 3 enlarging paper.

(Continued on following page)

The Compact Photo-Lab-Index

When continuous agitation is used, recommended development times should be decreased by from 25% to 40%.

Development times shorter than 5 minutes should be avoided because consistent results are difficult to obtain.

Also, if you are switching to Ilford HP5 from another brand of film, the ASA/developer/time/temperature and agitation procedures you have already established for films with a basic 400 ASA speed rating represent excellent starting points from which you can make changes if you find them necessary.

PUSH PROCESSING DEVELOPMENT DATA

Ilford HP5 film can produce quality prints even when forced to extreme exposure indexes thru push processing techniques. Natural and low-light situations can easily be coped with and special situations requiring high shutter speeds such as sports events and news photography can be handled by using HP5.

Knowledgeable professional and serious amateur photographers realize that the exposure indexes given for push processing are based on practical evaluation of film speed and not based on the rendering of shadow detail as is ASA. Thus, HP5 can be used over an enormous range of exposure indexes and development times yet still yield optimum quality prints by proper selection of the approximate contrast grade of printing paper.

The following table gives the recommended higher-than-rated ASA settings for HP5 and corresponding push development times for most commonly used high energy developers. These data assume processing in a spiral tank with agitation for the first 10 seconds of development and then for 10 seconds every minute for the remainder of the development time.

Developer	Dilution	Exposure Index	Development Time at 68°F(20°C)	at 75°F(24°C)
ID-11 or D76	none	800	11½	7¾
	none	1600	22½	15
Microphen	none	800	8	5¼
	none	1600	12	8
	none	3200	18	12
HC-110	1 + 7	1200	12	8

As noted in the normal development section, if you are switching to Ilford HP5 from another brand of film, the EI/developer/time/temperature and agitation procedures you have already established for pushing films with a basic 400 ASA speed rating represent excellent starting points for push processing too. You can make changes if you find them necessary.

When continuous agitation is used, recommended development times should be decreased by from 25% to 40%.

FIXATION

After development the film should be rinsed and then fixed in a conventional non-hardening rapid fixer such as Ilfospeed fixer, which fixes the film in about 2 minutes. If a hardening fixer is used, the time should be extended to 3-5 minutes.

WASHING

The washing time for a film largely depends on whether or not it has been hardened during fixation.

Where films have been hardened in a hardening fixer, thoroughly wash the film in running water (not over 25°C) for 5 to 10 minutes.

(Continued on following page)

The Compact Photo-Lab-Index

Where it is considered unnecessary to harden film and where the processing temperature is below 25°C an alternative method of washing may be followed which not only saves water and time, but still gives archival permanence.
1. Process your film in a spiral tank.
2. Fix it, using a non-hardening fixer such as Ilfospeed fixer.
3. After fixation, fill the tank with water at the same temperature as the processing solutions, and invert it five times.
4. Drain the water away and refill. Invert the tank ten times.
5. Drain and refill it for the third time and invert the tank twenty times.

A final rinse in water to which a conventional wetting agent has been added will aid rapid and uniform drying. The film should then be dried in a dust-free atmosphere.

SPECTRAL SENSITIVITY

Wedge spectrogram to tungsten light (2,850°K)

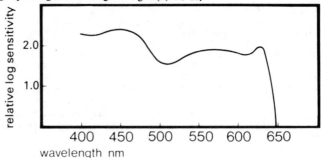

EQUAL ENERGY CURVE

Wedge spectrogram to tungsten light (2850 K)

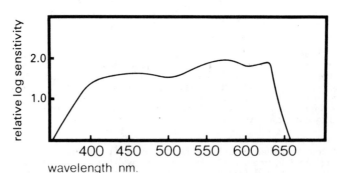

CONTRAST/TIME CHARTS

The charts that follow show the development times for 'normal' and 'high' contrast, and, in addition offer other times to compensate for subject brightness variations. The N— and H— times may be used where the subject brightness range is large, and conversely the longer times indicated by N+ and H+ may be used where the subject brightness range is low. The times below are a guide because it is appreciated that certain conditions may require even greater vari-

(*Continued on following page*)

ations in development time. Further, the effective exposure index that occurs due to the length of development time is indicated along the right hand edge of the charts.

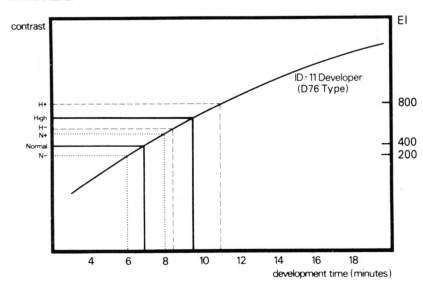

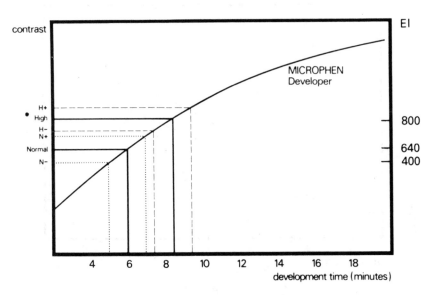

(Continued on following page)

The Compact Photo-Lab-Index

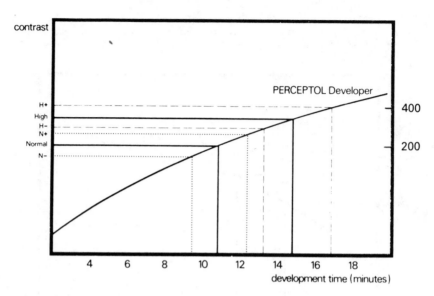

CHARACTERISTIC CURVE
HP5 developed in ID-11 (D-76 Type) at 20 C (68 F) with intermittent agitation.

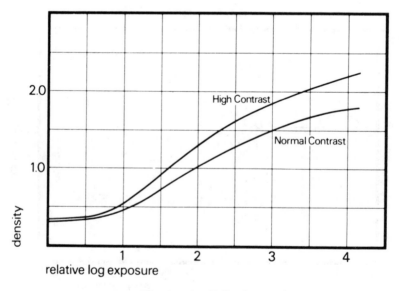

(Continued on following page)

ILFORD LITH FILM
Orthochromatic High Contrast Sheet Film

Ilford Ilfolith® IH4 sheet film is an orthochromatic lith-type material of extremely high contrast. It is designed to produce the highest quality screen and line negatives.

Although primarily intended for use in a wide range of commercial photo-mechanical reproduction techniques, Ilfolith IH4 is also suitable for creative photographic applications in which an extremely high contrast film is desired to achieve dramatic visual impact.

Ilfolith IH4 provides extremely high definition. Thus, extremely fine line work can be reproduced.

WEDGE SPECTROGRAM
Wedge spectrogram to tungsten halogen light (3,200 K).

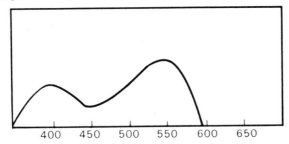

· wavelength nm.

DEVELOPMENT
Ilfolith IH4 lith film should be processed in Ilford SX200 developer. Generally, lith films are tray developed by inspection using a red safelight (Kodak Wratten® 1A or equivalent). When processing a fine line negative, it is recommended that a properly exposed film be developed for 2¼ to 3 minutes at 68° F with gentle agitation. Development time may vary widely with different developer dilutions or for the achievement of special effects.

Fixing and washing should follow in the usual way.

Ilford and Ilfolith are trademarks of Ilford, Ltd.

493

ILFORD FILMS
Exposure Compensation for Reciprocity Characteristics

EXPOSURE COMPENSATION FOR RECIPROCITY CHARACTERISTICS

There is no need to compensate for reciprocity characteristics when FP4 or HP4 are given exposure times between ½ and 1/1000 second. Exposure times which are longer than ½ second must be adjusted to allow for reciprocity failure.

For extremely short exposure times, such as 1/10,000 second, the lens aperture should be opened by ½ stop over the indicated setting.

The table below can be used to determine the new exposuret imes allowing for reciprocity characteristics for long exposures.

Indicated Exposure Time (Seconds)	FP4 Actual Exposure Time (Seconds)	HP4 Actual Exposure Time (Seconds)
0.1	0.1	0.1
1.0	1.2	1.1
2.0	2.6	2.5
4.0	6.2	5.5
8.0	14.5	13.0
16.0	35.0	30.0
32.0	82.0	75.0
64.0	205.0	190.0
128.0	498.0	488.0

ILFORD

ILFORD BLACK-AND-WHITE MOTION PICTURE FILMS

NEGATIVE FILMS
D minimum 50

PAN F NEGATIVE CINE FILM
(35mm and 16mm)
ASA D average 25; T 20

A medium-speed, extremely fine-grain panchromatic film coated on a gray anti-halation safety base, for all types of subjects by daylight. It is also useful for television recording and when developed to high contrast positive-type developer, for traveling mattes, titles, etc.

FP 4 NEGATIVE CINE FILM
(35mm and 16mm)
D minimum 160
ASA D average 80; T 64

A fast, fine-grain panchromatic film coated on gray anti-halation safety base, intended for 16mm cinematography of all subjects by daylight and many interior subjects as well.

MARK V NEGATIVE CINE FILM
D minimum 500
ASA D 250; T 200

A very fast fine-grain panchromatic motion picture film coated on .005 inch gray anti-halation safety base. It is rated at ASA Daylight 250, Tungsten 200 for normal processing conditions, but its speed can be doubled when processing is strictly controlled. Further-more, speeds as high as 1300 ASA have been realized in Ilford Microphen without loss of image quality or grain structure.

Packing available: 35mm negative cine films: 200 ft., 400 ft., and 1000 ft. on 2 inch cores. 16mm negative cine films: 100 ft. and 200 ft. daylight loading spools; unspooled lengths of 100 ft. without a core; and 200 ft., 400 ft., and 1000 ft., on 2 inch core; and 2400 ft. on a 3 inch core.

Perforations and magnetic stripe: 35mm negative cine films have standard (0.1870 inch) negative perforations. All the available packings of 16mm negative cine films can be supplied with a magnetic sound stripe (single perforation) in lengths of 110 ft. (including leader and trailer) on a spool; and 400 ft., 600 ft., and 1200 ft. on a 2 inch molded core.

POSITIVE FILMS
FINE GRAIN SAFETY POSITIVE
(16mm)

A slow film of very fine-grain, coated on safety clear or gray base, intended for making release prints from 16mm negatives and for use in title cameras. Supplied with perforations on both sides, or one side only for sound, winding A or B. Available in 400 ft., 600 ft. and 1200 ft. lengths on 2-inch plastic cores, and 100 ft. lengths on daylight-loading spools. Also available in standard 8 or Super 8mm.

ILFORD

495

ILFORD BLACK-AND-WHITE PHOTOGRAPHIC PAPERS

ILFOBROM

Ilfobrom paper is an enlarging paper with six evenly spaced contrast grades and an identical image color throughout the range. The speed of grades 0-4 is the same, while the speed of 5 is exactly half the others. Ilfobrom retains its handling qualities in partly exhausted developer, and is very resistant to developer contamination.

ILFOPRINT PROJECTION PAPERS—YR, DR

Rapid-processing photostabilization papers for use in Ilfoprint and similar machines These papers are intended for the production of enlargements from conventional continuous-tone and line negatives and may also be used for contact printing.

ILFOPRINT CONTACT PAPERS—CS, DS

Rapid-processing photostabilization papers for use in Ilfoprint and similar machines. These papers are intended for the production of contact prints from conventional continuous-tone negatives and drawings, plans and other documents.

NS6, NL6 AND NT6 RECORDING PAPERS

Fast, blue-sensitive, medium contrast papers, differing only in nature of base. NS6 has the standard 0.0067 in. Glossy Single-weight base; NL6 has a thinner 0.0041 in. semi-matt base, allowing somewhat greater lengths to be accommodated in cassettes; NT6 has an ultra-thin 0.0031 in. highly translucent base for use when maximum recording capacity is required, when dyeline or

The following tables show the surface and contrast grade availability as well as the specific product designation for Ilfobrom® and Ilfospeed® enlarging papers.

Ilfobrom® Papers	Contrast Grade and Ordering Code					
Single Weight	**0**	**1**	**2**	**3**	**4**	**5**
Glossy	IB0.1P	IB1.1P	IB2.1P	IB3.1P	IB4.1P	IB5.16
Semi Matt		IB1.24P	IB2.24P	IB3.24P	IB4.2P	
Double Weight	**0**	**1**	**2**	**3**	**4**	**5**
Glossy	IB0.1K	IB1.1K	IB2.1K	IB3.1K	IB4.1K	
Semi Matt			IB2.24K	IB3.24K	IB4.24K	
Matt			IB2.5K	IB3.5K	IB4.5K	
Velvet Stipple	IB0.26K	IB1.26K	IB2.26K	IB3.26K	IB4.26K	
Rayon		IB1.35K	IB2.35K	IB3.35K		

Ilfospeed® Papers	Contrast Grade and Ordering Code					
Mid Weight	**0**	**1**	**2**	**3**	**4**	**5**
Glossy	0.1M	1.1M	2.1M	3.1M	4.1M	5.1M
Semi Matt		1.24M	2.24M	3.24M	4.24M	
		1.35M	2.35M	3.35M	4.35M	

Ilfobrom and Ilfospeed are trademarks of Ilford, Ltd.

(*Continued on following page*)

496

ILFORD

PROCESSING RECOMMENDATIONS FOR ILFORD PAPERS

Ilfospeed	Ilford Developer	Image Tone	Dilution	Development Time in Minutes at 20° C (68° F)	Ilford Safelight
Ilfobrom	Bromophen	Neutral Black	1 + 3	1½-2	S No. 902
	PQ Universal	Neutral Black	1 + 9	1½-2	(light brown)
	Contrast FF	Neutral Black	1 + 4	¾-1	
Ilfoprint Contact	1A-13/1521 Ilfoprint Activator & Stabilizer	Neutral Black			Artificial Lighting
	PQ Universal		1 + 4		
	Bromophen		1 + 1		
Ilfoprint Projection	IA11/1S21	Neutral Black	Undiluted	Machine processed	S No. 902 (light brown)
	PQ Universal	Neutral Black	1 + 9	1½-2	or
	Bromophen	Neutral Black	1 + 3	1½-2	LR 915 (light red)

diazo copies are to be made, and when the record is to be projected or trans-illuminated. The papers are primarily intended for recording fast-moving light spots and traces of blue fluorescent screens.

ILFORD ILFOBROM
Enlarging Paper

GENERAL PROPERTIES

Ilfobrom is an versatile enlarging paper which makes it possible for prints of consistently high quality to be produced with maximum efficiency, even under difficult working conditions. The main characteristics of Ilfobrom are:
An equal and constant grade spacing. The results of research carried out by Ilford have shown that a grade spacing of 0.2 logarithmic exposure units is ideal for most purposes. The six grades of paper have been designed to accommodate the complete range of negative contrasts and are intended for use with both diffuser and condenser enlargers. The small but constant difference in contrast between the grades ensures that there is a 'right' grade of paper for every type of negative. If in fact the spacing between the grades was any smaller, it would be difficult to detect the contrast difference between adjacent grades of paper.

SURFACES AND CONTRASTS OF ILFORD PAPERS

The table on the previous page shows the surfaces and contrasts available in the principal types of Ilford papers. Code numbers and letters are given.

When ordering a paper which has more than one degree of contrast, the contrast number is inserted in the code directly after the first group of letters. Thus, for example, if Ilfobrom paper, grade 3, glossy, single weight, is to be ordered, it is specified as follows:

Ilfobrom IB3-1 P

In general, the method is to give the information in the following order: Name of paper, code letters, contrast number, surface and weight (P for single weight, K for double).

PAPER CONTRAST SCALE

The contrast of a paper is a measure of its capacity to accept extremes of exposure and indicates the difference in exposure between that required to produce a tone just distinct from the base

(Continued on following page)

The Compact Photo-Lab-Index

and that producing the maximum black. The greater the difference between the two exposures, the lower the contrast of the paper. The difference in this value in terms of log exposure is known as the exposure or contrast scale of the paper. This figure should approximately correspond to the negative density (measured on the baseboard) which will give optimum results when printed on this grade of paper.

The following table indicates the contrast scale of each grade of Ilfobrom paper:

Ilfobrom Paper Grade	Contrast Scale
0	1.6
1	1.4
2	1.2
3	1.0
4	0.8
5	0.6

Constant speed from grade to grade and batch to batch. Ilfobrom glossy grades 0-4 have the same emulsion speeds, while grade 5 is half the speed of the others. This enables reprints to be made on adjacent grades of paper without the need for further tests. It is also a great advantage when using enlarger exposure meters as one calibration will cover all six grades of paper—for grade 5 the readings are simply doubled.

No variation in either image color or base tint. Ilfobrom has been specially designed to give a constant image color and base tint from grade to grade and batch to batch. The image color is neutral black, while the addition of a new type of optical bleach to both the emulsion and the new paper base ensures clean, bright prints.

Changes in exposure do not affect image contrast. A variation in the length of exposure given for a negative on any grade of paper will not affect print contrast. A change in contrast can only be achieved by using a different grade of paper.

A 'built-in' resistance to contaminated solutions. Ilfobrom maintains its handling properties in partially exhausted developer and also has a very good resistance to the effects of developer contamination. This allows print quality to be maintained under less than ideal conditions.

WEDGE SPECTROGRAM

Wedge spectrogram to tungsten light (2850 K)

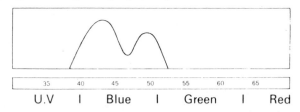

| 35 | 40 | 45 | 50 | 55 | 60 | 65 |

U.V | Blue | Green | Red

SAFELIGHT

A Kodak Wratten® OC safelight (light brown), should be used with Ilfobrom enlarging paper.

DEVELOPMENT

Ilford Bromophen developer diluted 1+3, which is supplied in powder form, is particularly recommended for use with Ilfobrom. Any other standard print developer can also be used. Ilfobrom paper should normally be developed for 1½ to 2 minutes at 20° C (68° F). Whenever rapid development is required, as for instance in press work, Ilfobrom should be developed in Ilford Ilfospeed Developer for 60 seconds at 20° C (68° F).

FIXATION

Ilfobrom paper should be fixed in acid fixer for 5 to 10 minutes.

(Continued on following page)

The Compact Photo-Lab-Index

WASH
Prints should be thoroughly washed in running water for a minimum of 30 minutes.

DRYING
Ilfobrom prints can be heat dried or ferrotyped in the normal manner. Prints which are to be air dried rather than ferrotyped should be wiped to remove excessive moisture in order to prevent the formation of drying marks.

CHARACTERISTIC CURVES
Developed in Bromophen (1+3) for 2 minutes at 20° C (68° F) with continuous agitation.

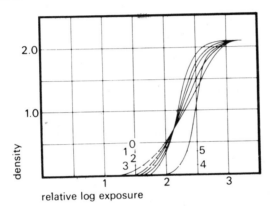

PAPER CONTRAST SCALE
The contrast of a paper is a measure of its capacity to accept extremes of exposure and indicates the difference in exposure between that required to produce a tone just distinct from the base and that producing the maximum black. The greater the difference between the two exposures, the lower the contrast of the paper. The difference in this value in terms of log exposure is known as the exposure or contrast scale of the paper. If optimum quality prints are to be obtained from a negative it should be printed on a paper grade whose contrast scale value is slightly greater than the negative density range when measured on the baseboard.

Ilfobrom paper grade	Contrast Scale
0	1.6
1	1.4
2	1.2
3	1.0
4	0.8
5	0.6

Ilford, Bromophen and Ilfobrom are trade marks of Ilford Ltd.

ILFORD

499

ILFORD ILFOPRINT Activation-Stabilization Processing System

Ilfoprint is a complete photo-stabilization system. It comprises a range of activation / stabilization papers and chemicals and processors, which accepts paper up to 30.5 cm (24 inches) wide. With the Ilfoprint system high quality prints can be ready for use about twenty seconds after exposure.

ILFOPRINT PAPERS

Ilfoprint papers have the same photographic characteristics as conventional silver sensitized papers and should be exposed in the normal way. Ilfoprint is characterized by excellent tone gradation, and has a similar image color to conventional bromide prints. Continuous tone and line papers are available in the Ilfoprint system with both projection and contact speed. While Ilfoprint papers are intended for processing in an Ilfoprint process with Ilfoprint Activator and Stabilizer, they can be processed in other activation stabilization systems, or conventionally. Where stabilized prints are to be ferrotyped they must be fixed and washed first.

ILFOPRINT PROJECTION PAPERS—YR

Ilfoprint YR is a projection speed paper with similar speed to Ilfobrom and Ilfospeed. The recommended safelight is the same as for Ilfobrom and Ilfospeed—a Kodak Wratten OC (light brown). Alternatively Ilfoprint YR papers may also be handled in Graphic Arts darkrooms where light red safelight filters are fitted.

Ilfoprint YR papers are continuous tone papers recommended primarily for the production of high quality enlargements, although they are suitable for making quick contact prints. The high contrast single-weight glossy paper (YR 4.1P) in particular, is also ideal for producing excellent screen and line contact prints of lith negatives and positives.

The print quality of YR is enhanced by its neutral black image color. Ilfoprint YR glossy papers are available in four equally-spaced contrast grades; grades 1 to 3 have the same speed while grade 4 is half the speed of the others.

ILFOPRINT CONTACT PAPERS—CS, DS

Ilfoprint CS and DS papers should be exposed using document copying equipment employing a high intensity light source. Both these contact speed papers may be safely handled in artificial lighting for the length of time needed to make a print. Prolonged exposure to artificial light should be avoided as this may cause a los of print quality.

Ilfoprint CS papers are intended for the production of contact prints from continuous tone negatives. The higher contrast grades may also be used for making half-tone prints by contact for page make-up when such work has to be carried out in normal artificial lighting.

Ilfoprint DS papers are intended for making same-size copies of letters, drawings, plans and other documents, and also for proofing line and screen negatives.

ILFOPRINT ACTIVATOR

Extremely rapid processing is made possible because the developing agent, hydroquinone, is incorporated in Ilfoprint emulsions. Development, the reduction of exposed silver halides to metallic silver, is almost instantaneous when the paper comes into contact with a highly alkaline solution, the activator.

Choosing the Ilfoprint for the Job

Job	Recommended Ilfoprint Paper	
	Continuous Tone	Line
Enlargements (tungsten and		YR3 or 4
cold cathode)	YR	YR3 or 4
Contact prints in the enlarger	YR	
Contact prints in the contact		
frame	CS	DS4, CS3 or 4

(Continued on following page)

ILFOPRINT STABILIZER

In conventional development-fixation processes the function of the fixer is to convert the unexposed, undeveloped silver halides to soluble salts which are removed from the emulsion. In the Ilfoprint system the stabilizer converts these silver halides to stable compounds which remain in the emulsion. The stabilizing agent is ammonium thiocyanate, and the halides are converted to silver thiocyanate complex salts.

RETOUCHING ILFOPRINTS

All Ilfoprints accept retouching very well. For retouching stabilized prints use oil based solutions as the water based types can cause staining.

THE PERMANENCE OF ILFOPRINTS

Ilfoprint stabilization techniques produce an Ilfoprint which maintains its quality for several years if stored in cool, dry conditions, away from direct sunlight. A high degree of permanence can be achieved if the print is fixed in a conventional fixer and washed. This can be done immediately after the Ilfoprint has emerged from the processor or at any time before the printhas begun to deteriorate. In this way prints may be produced extremely rapidly for a particular purpose and then fixed and washed for archival records.

Since Ilfoprint papers have silver halide emulsions, fixing follows the usual procedure, except that the print should be immersed in fixer for twice the time recommended for conventional prints (for example, approximately 10 minutes in standard acid) and subsequently washed for about 30 minutes. After fixing and washing, the prints may be heat dried or ferrotyped and retouched int he normal manner. Ferrotyping must not be attempted with a print which has not been fixed and washed.

CONVENTIONAL PROCESSING

Ilfoprint papers may be conventionally processed if required and the very similar to Ilfobrom papers under the same processing conditions, although an increase in contrast can be expected.

Any tray developer such as Ilford Bromophen is suitable. Normal paper fixers are recommended for fixing, both when the image has been developed in conventional developers, and when a stabilized print is being fixed for archival permanence.

SPECTRAL SENSITIVITY

Ilfoprint YR
Wedge spectrogram to tungsten light (2850 K)

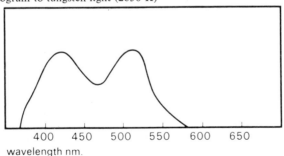

wavelength nm.

The wedge spectrograms for other Ilfoprint materials are similar to the one above.

(*Continued on following page*)

501

ILFORD

The Compact Photo-Lab-Index

CHARACTERISTIC CURVES

Characteristic Curves for Ilfoprint papers processed in an Ilfoprint Processor containing Ilfoprint Activator and Stabilizer.

ILFOPRINT YR

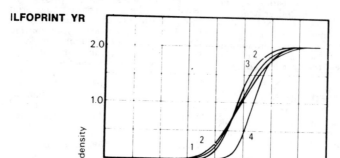

ILFOPRINT DS

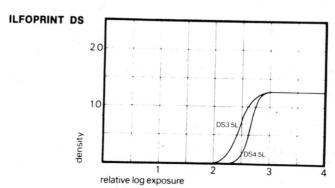

ILFOPRINT CS

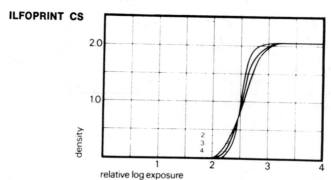

The Compact Photo-Lab-Index

ILFORD ILFOSPEED
Tray Processing System

The Ilfospeed Tray Processing System yields print quality that equals that of the more conventional long tray processing, washing, and ferrotyping times used since the earliest days of photography. Developing, fixing and washing times are shorter with the Ilfospeed system, tray processed prints can be made in one tenth the time of the usual methods.

The Ilfospeed system comprises Ilfospeed paper, Ilfospeed developer, Ilfospeed fixer and the Ilfospeed 4250 Dryer, which, when used together can produce high quality prints in four minutes (see summary below).

SUMMARY OF THE ILFOSPEED SYSTEM

PRINTING
Ilfospeed paper is similar to Ilfobrom in that it is a projection speed paper with equal contrast spacing between grades and a neutral black image color.

DEVELOPING
Ilfospeed developer (1+9) at 20° C. Development is complete in 60 seconds. Rinse the prints and transfer them to the fixer.

FIXING
Ilfospeed fixer (1+3) at 20° C. Fixation is complete in 30 seconds.

WASHING
Wash the prints in a good supply of fresh running water for 2 minutes.

DRYING
Use the Ilfospeed 4250 Dryer, which will dry a 20.3 x 25.4 cm (8 x 10 inch) print in approximately 30 seconds.

Total time for processing and drying —4 minutes.

ILFOSPEED PAPER
Ilfospeed paper is a special material designed for rapid processing nad drying. It is a midweight, polyethylene laminated paper which has a neutral black image color and a pure white base, and is available with a Glossy, Semi-matt, Silk and Pearl finish. Pearl is new to the Ilfospeed range and retains the high maximum density associated with Ilfospeed glossy prints but has low surface reflectance. This makes it especially suitable for retouching and reproduction work. It also has an ideal surface for exhibition work.

Ilfospeed paper can be used with all types of enlargers and is available in six equally spaced grades. All grades have a high maximum density and are consistent from batch to batch. With Ilfospeed, as with Ilfobrom, grades 0-4 have the same emulsion speed and grade 5 has half the speed.

CHARACTERISTIC CURVES
Developed in Ilfospeed developer (1+ 9) for one minute at 20° C with continuous agitation.

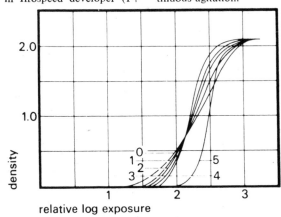

(Continued on following page)

503

Ilfospeed paper offers other advantages. Because Ilfospeed paper has a polyethylene coating on each side of the paper base, it is not only firmer than conventional papers but is flatter and can be exposed without a masking frame, for borderless prints. Ilfospeed paper also remains flat during and after processing.

Another useful feature of Ilfospeed paper is its backwriting coat. This special surface accepts pencil, most ballpoint pens, some felt tip pens, certain stamp pad inks and all printing inks formulated for polyethylene printing.

Ilfospeed paper should not be ferrotyped using conventional equipment, because in a conventional dryer there is no way for the water to escape from the emulsion layer, and print damage would result. Use the Ilfospeed 4250 Dryer or air dry.

SAFELIGHT RECOMMENDATIONS

A safelight such as a Kodak Wratten OA or OC is suitable for use with Ilfospeed.

ILFOSPEED DEVELOPER

Ilfospeed developer contains Phenidone® and hydroquinone, and gives a very brief induction period with a short developing time.

The image appears after six seconds and Ilfospeed paper is fully developed in only one minute. Image build-up can be carefully controlled even when developing an overexposed print for the minimum recommended time of 35 seconds. Ilfospeed paper can be used with other developers but like other papers, will require approximately 30 seconds for the image to appear, and two or even three minutes for complete development to take place.

PREPARATION

Ilfospeed developer is supplied as a liquid concentrate and is economical to use. The recommended dilution is one part developer to nine parts water.

USE

The recommended development time for Ilfospeed paper is one minute at 68° F (20° C). This short development time produces prints similar in contrast and maximum density to prints processed for two minutes in other tray developers.

The minimum recommended development time using Ilfospeed developer is 35 seconds. Over-exposed prints processed in this way are almost indistinguishable from those correctly exposed and processed. When batch processing, exposure can be adjusted and development times extended to ensure even developmnt and print consistency.

After development, rinse the prints and transfer them to Ilfospeed fixer.

ILFOSPEED FIXER

Ilfospeed Fixer is a rapid acting ammonium thiosulphate fixer, supplied in liquid concentrate form.

PREPARATION

Ilfospeed Fixer should be mixed by adding one part concentrate to three parts water.

USE

The recommended fixing time is 30 seconds at 20° C. Thorough initial agitation should be given.

Hardener should not be used with the Ilfospeed System.

After fixing, the prints should be washed. With conventional papers, long wash times are necessary to remove chemicals which have ben absorbed by the paper. The polyethylene coating on each side of Ilfospeed paper prevents this absorption, and wash times are therefore short. A print washed for two minutes in running water is completely free of chemicals used in processing.

MOUNTING

Ilfospeed prints can be mounted using either dry mounting tissue or double-sided adhesive tapes and tissues.

Manufacturers of mounting materials will provide detailed instructions on using their materials for polyethylene coated papers.

RETOUCHING

Ilfospeed prints can be spotted and airbrushed using dye or watercolor, the same way as conventional papers. Knifing Ilfospeed prints should be done with care, using a sharp pointed blade and stippling action.

ILFORD

ILFORD MICROPHEN
Fine Grain
High Energy Developer

DESCRIPTION AND USES

Ilford Microphen is a fine grain developer which gives an effective increase in film speed. Grain size is reduced and grain clumping prevented because of the low alkalinity of the developer.

The majority of developers which give an increase in film speed usually produce a corresponding increase in grain size. Microphen, however, has been specially formulated to overcome this disadvantage—and is therefore said to have a high speed/grain ratio. That is, it yields a speed increase while giving the type of fine grain result associated with MQ borax developers. A speed increase of half a stop can be achieved from most films. HP5, for example, can be up ratd from 400 ASA to 650 ASA if it is developed in Microphen.

Microphen is a clean working long life developer, supplied as a powder, which is dissolved to make a working strength solution.

Microphen can also be used at dilutions of 1:1 and 1:3.

DEVELOPMENT TIMES

Recommended times for the development of Ilford films and plates are given below. These times may be increased by up to 50 per cent for greater contrast, or where the highest speed is essential—as in the case of known underexposure.

General purpose materials are normally developed to a G (average contrast) of 0.55 if a tungsten enlarger is used for printing, and to a G of 0.70 if a cold cathode enlarger is used. The times given below are in minutes and refer to development at 68° F (20° C) with intermittent agitation. If continuous agitation is used these times should be reduced by one quarter.

General Purpose Films	ASA	G0.55	G0.70
Sheet Film			
HP4 Professional	650	5	8
FP4 Professional	200	5	8½
120 Rolls and 35mm			
HP4	650	5	7½
FP4	200	5	7½
Pan F	80	4	6

DILUTE DEVELOPMENT

Development of FP4 and HP4 in diluted Microphen increases acutance; the greater the dilution, the better the acutance. Dilute development is particularly suitable for subjects with long total scales; shadow and highlight densities are retained while negatives are sufficiently contrasty to produce bright prints. With this development technique film speed is fully maintained, but development times have to be increased.

Diluted developers should be used once only and then discarded.

DEVELOPMENT OF SPECIALIZED FILMS

When developing to a G0.70, film speed is increased by approximately 1/3 stop.

A guide to the recommended development time for Commercial Ortho is given below. These times are given for a developer temperature of 20° C and can be varied by the user according to the processing conditions.

Ilford Film	ASA	Dilution	G0.55	G0.70
FP4	200	1 + 1	8	13
	200	1 + 3	11	20
HP4	650	1 + 1	9	18
	650	1 + 3	18	27
Pan F	80	1 + 1	5	8
	80	1 + 3	9	14

(Continued on following page)

505

Ilford Material	Continuous Agitation	Intermittent Agitation
Sheet Film Commercial Ortho	9½	12

USEFUL LIFE WITHOUT REPLENISHMENT

If Microphen is stored in a well-stoppered bottle it will keep well and can be repeatedly used. Under normal conditions six rollfilms or six 36 exposure 35mm films can be developed in 600 ml (20 oz.) of developer. To maintain uniform contrast for all six films the development time should be increased by 10 per cent for each successive film developed.

USEFUL LIFE WITH REPLENISHMENT

Microphen Replenisher is available for deep tank processing. It is designed to prolong the useful life of the developer and to maintain constant activity over a long period of time. The replenisher should be made up according to the instructions packed with it.

The most satisfactory method of replenishing Microphen is to add a small quantity of replenisher when the original volume has decreased by 5 per cent or when about 14 sq. feet (1.3m²) sensitized material has been processed in each gallon (4.5 liters) of developer. No limit is set to the amount of replenisher which may be added to a given volume of original developer. Replenishment may be continued until it becomes necessary to discard the solution in order to clean out the tank. If the tank is only used intermittently, it should be covered with a well-fitting lid to minimize developer oxidation and loss of water through evaporation.

ILFORD PERCEPTOL DEVELOPER

DESCRIPTION AND USES

Perceptol is an extra fine grain developer. It has been specifically formulated to get optimum results from high-resolution lenses, to exploit the fine grain structure of FP4 and to produce significantly finer grain in HP4 negatives when compared with development in ID-11 or D-76®.

Perceptol produces excellent results with any lens/film combination and is therefore ideal when texture and definition are critical. Negatives processed in Perceptol are capable of producing sharper and better-quality enlargements than those produced in a standard fine-grain developer. Perceptol is supplied as a powder from which a solution is made by dissolving two separately-packed ingredients in warm water at about 105° F (40° C). The solution can be diluted for special techniques as explained later. Perceptol contains a sequestering agent to counteract the effect of hard water precipitates and being in powder form it has excellent keeping properties even in the tropics. When made up, the unused solution will last for about six months in air-tight bottles.

The solution can be replenished but without replenishment, one gallon (4.5 liters) of full-strength Perceptol will develop twenty 120 roll films in deep tanks or machines. When replenished, one gallon (4.5 liters) will develop ninety 120 films or the equivalent.

FULL-STRENGTH DEVELOPMENT AND REPLENISHMENT

When it is known that full-strength Perceptol will be the developer used, films must receive about double the normal exposure. Films should therefore be rerated at the following adjusted figures.

Film	Nominal Rating ASA	DIN	Adjusted Rating ASA	DIN
Pan F	50	18	25	15
FP4	125	22	64	19
HP4	400	27	200	24

(Continued on following page)

DEVELOPMENT TIMES

For enlarging with a tungsten light source, films should be developed to a G (average gradient) of 0.55. For enlarging with a cold cathode source films should be developed to G0.70.

In full-strength Perceptol, the times quoted below will give these values. The times are in minutes and assume intermittent agitation, i.e., agitation for the first ten seconds of development, then for ten seconds every minute for the remainder of the time. Temperature of the solution should be 68° F (20° C). To compensate for loss of activity, increase the development time by 10 percent after eight films have been processed in each gallon (4.5 liters), or forty films per 5 gallons (22.5 liters), of developer.

General Purpose Films	G0.55	G0.70
Sheet Film		
HP4	9	13
FP4	9½	13½
120 Rolls and 35mm		
HP4	9	13
FP4	10	13
Pan F	10	15

REPLENISHMENT TECHNIQUE

When processing in deep tanks or machines, effective developer life is increased if Perceptol developer is replenished. Replenisher should be added at the following rates.

Tank Size	When to Add Replenisher	Amount of Developer to Be Removed	Amount of Replenisher to Be Added
½ gallon 2.5 liters	After every 6 films*	70 ml (2½ oz.)	116 ml (4 oz.)
1 gallon (4.5 liters)	After every 10 films*	120 ml (4¼ oz.)	210 ml (7½ oz.)
3 gallons (13.5 liters)	After every 30 films*	350 ml (12½ oz.)	630 ml (22½ oz.)
5 gallons (22.5 liters)	After every 50 films*	600 ml (21 oz.)	1050 ml (37½ oz.)
12 gallons (54 liters)	After every 120 films*	1400 ml (50 oz.)	2520 ml (90 oz.)

*One 120 rollfilm is the equivalent of one 36 exposure 35mm film or one 8 x 10 inch sheet film.

DILUTION TECHNIQUE

To increase acutance, Perceptol can be used as a "one shot" developer. For this technque, Perceptol solution can be diluted 1:1 or 1:3 with water. When diluted 1:1, the 600 ml size will make 1200 ml providing enough solution for four 120 roll films to be processed using a 300 ml tank. With the 1:3 dilution, the 600 ml size will make up to 2400 ml so that eight of these films can be processed using a 300 ml tank.

With this techniue, the film should have previously been rated at the ASA/DIN figure recommended below. Dilute Perceptol immediately before use and ensure that there is enough working strength solution to fill the processing tank. Use once and discard. The following times and speed ratings for dilution, or "one shot" technique are recommended when procesing at 20° C (68° F) with intermittent agitation i.e. agitation for the first ten seconds of development, then for ten seconds every minute for the remainder of the time. The times are in minutes, for G0.55.

Film	ASA/DIN for 1 + 1			ASA/DIN for 1 + 3		
HP4	320	26	13 min.	320	26	21 min.
FP4	100	21	11 min.	100	21	16 min.
Pan F	32	16	12 min.	32	16	15 min.

ILFORD

ILFORD BROMOPHEN DEVELOPER
Standard Paper Developer

DESCRIPTION AND USES

Bromophen is the standard Ilford universal-type developer in powder form. It is a Phenidone hydroquinone formula with all the advantages that this provides, including long working life and high capacity.

Bromophen is particularly recommended for obtaining maximum quality from Ilfobrom and is suitable for roll sheet films when a high degree of enlargement is not necessary.

The versatility of Bromophen makes it suitable for a very wide range of applications—the stock solution made up from the powder may be diluted according to application, developing time and contrast desired.

WORKING STRENGTHS

For use, recommended rates of dilution for Bromophen stock solution are given below.

Sensitive Material	Dilution
Contact papers	1:1
Bromide papers for automatic printing	1:3
Rapid development of paper	1:1
Tray development of sheet films	1:3
Tank development of sheet films	1:7

DEVELOPMENT TIMES—PAPERS

The development times given below are in minutes and refer to development at 68° F (20°C).

Ilford Material	Dilution of Stock Solution	Time
Ilfobrom Paper	1 + 3	1½-2
Rapid Development of Ilfobrom Paper	1 + 1	1-1½
Films	1 + 7	1½-3*

*More accurate times cannot be given for such a quick acting developer and it is suggested that tests be made, which for evenness of development must employ continuous agitation.

Ilford, Bromophen, Ilfobrom and Phenidone are trade marks of Ilford Lt.

Ilford Paper	Dilution	Time
Contact	1:1	¾-1
Ilfobrom	1:3	1½-2
For rapid development of papers		
Ilfobrom	1:1	1-1½

The development time for Ilford Commercial Ortho is given for intermittent and continuous agitation—at a developer temperature of 68° F (20° C). These times can be varied by the operator.

DEVELOPMENT TIMES— FILMS AND PLATES

The development times given for general purpose films are for two average contrasts G and refer to intermittent agitation only. If negatives are to be printed using a tungsten enlarger they should be developed to a G of 0.55. Similarly, negatives which are to be printed on a cold cathode enlarger should be developed to a G of 0.70. If continuous agitation is to be used at a dilution of 1:7, these times should be reduced by one quarter.

General Purpose Materials	G 0.55	G 0.70
Sheet film HP4	4	7½
Roll film HP4	3	4½

Ilford Material	Continuous Agitation (Dilution 1:3)	Intermittent Agitation (Dilution 1:7)
Commercial Ortho	3¾	7½

Intermittent agitation—agitation for the first 10 seconds of development, then for 5 seconds every minute for the remainder of the development time.

CIBACHROME PRINT MATERIAL

Cibachrome print material consists of a white opaque support coated with light-sensitive emulsion layers and auxiliary layers on one side, and a matte, anticurl gelatin layer on the opposite side.

When unexposed, unprocessed material is viewed in white light, it appears dark brownish-gray from the front (emulsion side) and pure white from the back.

• After processing, normal drying produces a glossy print without special treatment.

Cibachrome print material is packaged in light-tight hermetically-sealed plastic pouches which protect it from moisture and other harmful vapors until the seal is broken.

STORAGE

Unopened packages of Cibachrome print material may be kept at temperatures near 70°F for periods of several months. For longer storage, refrigeration is recommended. After refrigeration, the material should be allowed to come to room temperature before opening the package to avoid moisture condensation on the emulsion layers.

Opened packages of Cibachrome print material should not be refrigerated, but kept at normal room temperature.

BASIC FILTER PACK INFORMATION

On the back of each package of Cibachrome-A print material is a printed label listing the basic filter pack information for each of the following types of slide film material: Kodachrome, Ektachrome, Agfachrome and Fujichrome. The filter pack recommendation for Kodachrome can be used also for GAF slide films.

For example:

BASIC FILTER PACK

	Koda.	Ekta.	Agfa	Fuji
Y	60	65	55	70
M	00	00	00	15
C	15	15	05	00

This chart indicates that under standardized average printing conditions, like those used at the factory, a filter pack

of Y 60, M 00 and C 15, would provide optimum color reproduction of a properly exposed and processed Kodachrome slide.

Therefore, **when you make your first Cibachrome print,** use the appropriate filter pack listed on the back of the print material envelope for the specific type of slide film you are printing.

For a variety of reasons, however, the test conditions in the factory may be different from the working conditions in your own darkroom, and therefore you may need to "adjust" the basic filter pack to get a proper color balance in your print.

Suppose, for example, that upon using the filter pack listed on the pack of print material your first Cibachrome print was too magenta and that you had to add Y 15 and C 15 (equals green 15) to get a correctly balanced color print to match the Kodachrome slide.

Your "adjusted" filter pack
would then be:
Basic filter pack from envelope:	Y 60	M 00	C 15
Your "system correction factor":	+Y 15		+C 15
"Adjusted" filter pack:	Y 75		C 30

The "adjusted" filter pack of Y 75 and C 30 would then be used for all Kodachrome slides with that particular package of Cibachrome print material. To shift to other types of slide films, simply apply your "system correction factor" of +Y 15 and +C 15 to the filter values shown on the print material package for the type of slide film to be printed. For example, your Ektachrome filter pack would be Y 80 and C 30 instead of the recommended Y 65 and C 15 as listed on the package.

The inherent color balance of Cibachrome print material, like that of all other color printing materials, varies to some extent from batch to batch. For that reason you may find different basic filter pack information on different batches of Cibachrome print material.

Once you determine your "system correction factor" for your first batch

(Continued on following page)

ILFORD

of Cibachrome print material, merely apply the same factor to the filter pack data on the next package of Cibachrome you use.

EXAMPLE:
1st package of Cibachrome print material purchased:

Kodachrome data (on
1st package) Y 60 M 00 C 15
Your "system cor-
rection factor": +Y 15 +C 15
"Adjusted" filter pack
for 1st package: Y 75 C 30

2nd package of Cibachrome print material purchased:

Kodachrome data (on
2nd package): Y 50 M 00 C 20
Your "system cor-
rection factor": +Y 15 +C 15
"Adjusted" filter pack
for 2nd package: Y 65 C 35

3rd package of Cibachrome print material purchased:

Kodachrome data (on
3rd package): Y 65 M 05 C 00
Your "system cor-
rection factor": +Y 15 +C 15
"Adjusted" filter pack
for 3rd package: Y 80 M 05 C 15

Because the combination of yellow, magenta, and cyan filters in the same filter pack would create neutral density and reduce the light intensity, it is desirable to eliminate the neutral density from the filter pack by subtracting the lowest filtration factor in the same amount from each of the 3 filter colors; that is, subtract Y 05, M 05, and C 05.

Therefore, the "adjusted" filter pack for the 3rd package would be:

Y 80	M 05	C 15
−Y 05	−M 05	−C 05
Y 75	M 00	C 10

Although your system correction factor will tend to remain the same for appreciable periods of time, it may have to be adjusted occasionally owing to aging of your enlarger lamp and filters and changes in processing procedures, etc. However, the Cibachrome system is quite tolerant to color balance changes and you will find it easy to secure good results consistently.

CIBACHROME CHEMISTRY

CAUTION: Read carefully and follow all directions, and observe all cautions printed on packages and labels. Cibachrome chemicals are not to be used by children except under adult supervision.

Even though the solid chemicals are provided in sealed packages and all liquids are protected by child-resistant safety caps, KEEP OUT OF REACH OF CHILDREN. It is recommended that clean rubber gloves be used in all mixing of chemicals and whenever chemicals can come in contact with the skin. Remove spilled solutions from all surfaces in the darkroom.

Mixing: There are only three solutions required for processing Cibachrome print material:

Step 1: developer
Step 2: bleach
Step 3: fixer

In mixing the chemicals, please be sure to follow all of the directions on each label carefully as errors in preparation can cause various faults in final prints.

Use clean vessels for mixing, and wash and rinse carefully after use to avoid contamination.

The developer can be mixed to make 1 quart at a time (for ten 8x10 inch prints); or ½ gallon at a time (for twenty 8x10 inch prints); or you may mix for individual 8x10 inch prints as follows:

15 ml. Part A developer, plus
15 ml. Part B developer, and
add water to make 90 ml or 3 ounces

The bleach can be mixed to make 1 quart, or ½ gallon at a time. See package directions.

The fixer can be mixed to make one quart, or ½ gallon at a time. See package directions.

Storage: All Cibachrome chemicals should be stored at room temperature in well sealed glass or polyethylene bottles.

The concentrated stock solutions will keep for several months in the tightly sealed bottles. Part 1B of the developer may turn yellowish on extended storage, but this will not affect its strength nor stain prints.

Storage life of the working solutions at room temperature is as follows:

developer: up to 3 weeks
bleach: up to 5 weeks
fixer: up to 1 year

(Continued on following page)

WHAT YOU NEED FOR CIBACHROME COLOR PRINTING

ENLARGER

Your enlarger need not be elaborate, but should have:

1. a color-corrected projection lens of at least an f 4.5 maximum aperture
2. preferably a 150 or 100 watt lamp; however, a 75 watt lamp will be satisfactory if the enlarger has efficient utilization of light
3. a color head, or a filter drawer or system to hold the filters, preferably between the light source and the slide to be projected
4. a heat absorbing glass in the enlarger head
5. optionally, a voltage regulator for the enlarger, especially if your electrical supply is subject to voltage fluctuations of more than ±10 volts.

FILTERS

As with all color printing processes, you will need an assortment of color-printing filters, including:

1. an ultra-violet absorbing filter
2. yellow: .05, .10, .20, .30, .40, .50
magenta: .05, .10, .20, .30, .40, .50
cyan: .05, .10, .20, .30, .40, .50

It is recommended you use Cibachrome color printing filters available from your photo dealer.

Cibachrome filters are cast acetate in which the colorant is dispersed throughout the sheet; therefore, they withstand abrasions better than gelatin filters.

The filters are supplied in 6 inch by 6 inch size ... large enough to fit all amateur enlarger filter drawers. For enlargers that accept 3 inch by 3 inch filters, the Cibachrome filters may be cut to make four complete sets of filters.

The Cibachrome filter set contains yellow, magenta and cyan filters in densities of .05, .10, .20, .30, .40 and .50. A UV absorbing filter is also included in the filter set.

DRUM OR TRAYS

For drum processing, it is recommended you use the Cibachrome drum processor available from your photo dealer.

The Cibachrome processing drum has been specially designed to make it easy for you to develop your prints in room light.

The concept of the drum enables you to change it from an 8x10 inch drum to an 11x14 inch drum by simply changing the center tube portion. Each of the end pieces has a cup which holds over 6 ounces of fluid, more than enough to process one 11x14 inch print.

For tray processing, hard rubber, plastic or type 316 stainless steel trays are ideal. If you use enamelled trays, be sure there are no chips in the enamel surface, or any rust spots.

For most efficient use of chemicals in tray processing the bottom of the trays should be flat, with neither ridges nor depressions.

MISCELLANEOUS NECESSITIES:

You should also have available:

1. a photographic thermometer accurate to ± ½° F
2. a darkroom timer or clock
3. clean bottles for Cibachrome chemistry, either glass or polyethylene. For ease in mixing, use wide-neck bottles of at least ½ gallon capacity
4. rubber gloves for mixing chemicals, or anytime your hands may come in contact with the chemicals. Gloves are essential for tray processing
5. measuring cups for chemistry. Each Cibachrome chemistry kit provides three specially marked cups for your convenience.

Optional equipment: an enlarging meter, and a print dryer designed for resin coated papers.

GENERAL INFORMATION

The first and most important thing to remember in printing Cibachrome material is that it is a **direct positive** material. That means it reacts to exposure variations and changes in the same way as reversal color film, such as Kodak Ektachrome and Kodachrome or Agfachrome, which you use in making your slides.

(Continued on following page)

The Compact Photo-Lab-Index

As you know, these materials respond to changes in light just as you would expect; that is, more light gives you a lighter image, and less light a darker image. By the same token, if the light becomes more yellow, the direct positive color image becomes more yellow; if the light is more red, then the image becomes more red, etc. As a result, it is quite simple to estimate what changes to make and the extent of correction once a first test print has been made with Cibachrome print material.

This ease of working starts right with the composing of your print on the enlarging easel. You will see your slide in natural color and will find it easy to adjust the magnification and cropping to obtain just the effect you want in the final print.

Of course, if you have experience in making black-and-white prints or color prints from **negative** films, you will have to remember to use just the opposite correction in Cibachrome printing.

SELECTION OF STANDARD SLIDE

It is important that you first select a slide to be used as a standard, then print, process, and adjust the color balance until you get a color print to your satisfaction. Use that same filter pack as the starting point for later prints from other slides on the same type of film.

You will find that you need a different basic filter pack for each different type of color film you use (Kodachrome, Ektachrome, Agfachrome, Fujichrome, etc.).

In selecting a slide to be used as a standard, be sure that it incorporates the following characteristics:

1. flesh tones or neutral grays
2. normal overall density (within ½ stop of normal exposure)
3. good color balance
4. good range of colors

The inclusion of flesh tones or neutral grays is vital because your color balance should be corrected to these tones in order to assure a satisfactory filter pack for succeeding prints.

IDENTIFICATION OF CIBACHROME EMULSION SIDE

The emulsion side of Cibachrome print material is smooth, but the back side is almost as smooth, and it may be difficult at first to determine the emulsion side in total darkness.

If you have difficulty in feeling the difference, try swishing your thumb across one side at a time while holding it close to your ear. You will hear a "whisper" from the **back** side, and no sound from the emulsion side.

If you should make a mistake and try to expose through the back side, you will be able to tell during exposure. The emulsion side is dark gray, and the back side is gleaming white.

RECIPROCITY FAILURE

This effect refers to the loss in photographic efficiency at low light intensities. With dark slides, a weak light source in your enlarger, or great magnification, you may expect to encounter reciprocity failure and will have to make adjustments in exposure and filter balance. Your print will tend to become darker and more bluish-cyan in color balance. Correct by increasing exposure and adding some yellow and subtracting cyan filtration.

(Continued on following page)

512

DIFFERENCES IN EXPOSING CIBACHROME AND NEGATIVE-TO-POSITIVE MATERIALS

If you have ever made black-and-white prints or conventional color prints from color negatives such as Kodacolor, you will have to remember that making Cibachrome prints will be different in these ways:

	Cibachrome	negative-to-positive
to lighten a print	more light and/or more time	less light and/or less time
to darken a print	less light and/or less time	more light and/or more time
to make significant changes in the density of a print	increase or decrease exposure by 2 times	increase or decrease exposure by only 25%
to make significant changes in color balance	change appropriate filter(s) by at least .20 density	change appropriate filter(s) by .05 density
borders of print if covered during exposure	will be black	will be white
dust particles, scratches	will appear as black spots or lines . . . so slides must be carefully cleaned	will appear as white spots or lines
color filter corrections		will be opposite of Cibachrome corrections

DODGING

To "dodge," which is normally meant to lighten a specific area, you must **add more light** to that area of a Cibachrome print. This is generally done by using your hands to block out all of the area not to be lightened, or by using "dodging" kits of **opaque** plastic or cardboard available from your photo dealer.

The amount of extra light to be given to the area depends upon the effect you desire and must be done by judgment or trial-and-error.

BURNING-IN

The technique of "burning-in" a print is just the reverse of "dodging." There will be occasions when you will want to darken an area of your print, and with Cibachrome, you must decrease the amount of light to that area.

If it is a large portion of the print, it can easily be done with your hands by blocking out the area to be "burned-in." If it is a small area, you can use a small piece of opaque plastic or cardboard attached to a long wire. Kits are available from your photo dealer.

PROCEDURE

STARTING FILTER PACK

Use the filter pack recommended on the back label of the Cibachrome "A" print material package for the type of slide film you will use.

(Continued on following page)

ILFORD

INITIAL EXPOSURE PROCEDURE

1. insert filter pack as suggested above, **plus** the UV absorbing filter
2. adjust the enlarger for the print size you desire
3. focus sharply on the reverse side of a previously processed piece of Cibachrome or double-weight paper
4. set exposure as follows:

If you have a direct reading light meter, remove your slide and leave filters in place. Set the meter on the easel and adjust the f/stop to secure a reading of 0.5 foot candle. Replace slide and set exposure for 10 seconds. Of course, if your enlarger gives less light, the exposure time will have to be increased proportionally, e.g., at 0.25 ft/c use 20 seconds.

If you don't have a direct reading light meter, use one sheet of Cibachrome print material and, with the Cibachrome exposure mask, make a test series of at least 4 exposures. Use 10-second exposures at f/4.5, f/5.6, f/8 and f/11 to make an 8x10 inch enlargement of a full 35mm slide. A handy exposure mask is packed in 8x10 inch Cibachrome print material for your convenience.

In exposing Cibachrome, it is preferable to adjust the lens aperture and maintain constant exposure time, but if your enlarger does not deliver sufficient light, you will have to increase the time of exposure to obtain a well exposed print.

1. in TOTAL DARKNESS, insert Cibachrome material into easel or frame, emulsion side up
2. expose print
3. process print

LATITUDE OF CIBACHROME

One of the many advantages of Cibachrome is the great latitude, both in exposure and in filtration.

As you will note in studying your test sheet, you must be bold in making your corrections for exposure. Oftentimes, to make a significant change in density, you must increase or decrease your exposure by changing the lens aperture by one to two full stops or by altering the exposure time by a factor of two to four.

Also in making corrections for color balance, a change of at least .20 density in your filters may be necessary.

LATENT IMAGE

The latent image of Cibachrome is very stable. You may process immediately after exposure, or if you wish, prints may be kept at room temperature unprocessed overnight or even a weekend without noticeable change in overall density of color balance.

CAUTIONS

As in all color printing systems, you must be aware of:

1. lamp aging. Tungsten light changes toward yellow-red with bulb aging which will affect filtration.
2. filter aging. Gelatin or acetate filters can fade with continued use which will affect color balance
3. dirt and fingerprints on your enlarger lens will affect the contrast and quality of your print
4. large voltage fluctuations; more than ± 10 volts will affect your exposure and color balance.

FILTER PACK DATA FOR DIFFERENT SLIDE FILMS

KODACHROME AND GAF COLOR SLIDE

See Kodachrome data on back of print material envelope.

If you use Kodachrome, or GAF color slide, and want to shift to:
Ektachrome—add Y 10 and C 10
Agfachrome—subtract Y 10 and C 10
Fujichrome—subtract Y 15 and C 05

EKTACHROME

See Ektachrome data on back of print material envelope.

If you use Ektachrome, and want to shift to:
Kodachrome—subtract Y 10 and C 10
GAF color slide—subtract Y 10 and C 10
Agfachrome—subtract Y 20 and C 20
Fujichrome—subtract Y 25 and C 15

(Continued on following page)

ILFORD

AGFACHROME
See Agfachrome data on back of print material envelope.

If you use Agfachrome, and want to shift to:
Kodachrome—add Y 10 and C 10
GAF color slide—add Y 10 and C 10
Ektachrome—add Y 20 and C 20
Fujichrome—subtract Y 05 and add C 05

FUJICHROME
See Fujichrome data on back of print material envelope.

If you use Fujichrome, and want to shift to:
Kodachrome—add Y 15 and C 05
GAF color slide—add Y 15 and C 05
Ektachrome—add Y 25 and C 15
Agfachrome—add Y 05 and subtract C 05

PROCESSING CIBACHROME PRINT MATERIAL
DRUM PROCESSING STEPS

TOTAL TIME: 12 MINUTES at 75°F ± 3°F (24°C ± 2°C)

1. DEVELOP (2 minutes)
In TOTAL DARKNESS, place the exposed Cibachrome print in the drum (be sure the drum is clean and DRY). For one 8x10 inch print, pour in 3 ounces (90 ml) of developer and agitate rapidly for the first 15 seconds of development. Then agitate gently and evenly through remainder of the cycle.

Start draining the developer 15 seconds prior to Step 2. Drain carefully for the full 15 seconds and then add bleach to the drum.

If there is evidence of an unpleasant odor, use a 10 to 15 second water rinse and drain after development on subsequent occasions. To do this, drain the developer as recommended, then quickly pour 3 ounces of 75°F water into the drum and drain for 10 to 15 seconds. Then add the bleach solution.

2. BLEACH (4 minutes)
Pour in 3 ounces (90 ml) of bleach and agitate rapidly for first 15 seconds and then agitate gently and evenly throughout remainder of cycle.

Start draining the bleach 15 seconds prior to Step 3. Drain carefully for the full 15 seconds and then add fixer to the drum.

If there is evidence of an unpleasant odor, use a 10 to 15 second water rinse and drain, as described in Step 1 on subsequent occasions. After rinsing, add the fixer solution.

IMPORTANT: Pour the **used** bleach into a polyethylene pail or bucket of at least ½ gallon capacity, and neutralize with 2 Cibachrome neutralizer tablets for each 3 ounces of bleach used. **Do not cover container.** When the solution stops fizzing, pour down drain.

3. FIX (3 minutes)
For each 8x10 inch print, use 3 ounces (90 ml) of fixer and agitate uniformly and gently throughout the entire cycle. Fix for the full 3 minutes, then drain for 5 to 10 seconds.

4. WASH (3 minutes)
Wash for 3 minutes in rapidly running, clean water at 75°F.

Total elapsed time: 12 minutes.

To dry, remove the print from the drum, and remove the surface liquid with a soft rubber squeegee or clean chamois cloth. Hang up, or lay flat on a blotter or drying rack (emulsion side up), or use a print dryer designed for resin coated papers.

Approximate drying times:
1. air drying, 1½-2 hours
2. electric fan, 15-18 minutes
3. blower-type hair dryer, 6-8 minutes

Note: a wet Cibachrome print will look somewhat more magenta than a dry print.

INSERTING THE MATERIAL
TOTAL DARKNESS is required in inserting the exposed Cibachrome material into the processing drum.

Curve the exposed sheet to be processed into a cylindrical shape with the emulsion side facing in. Make sure the tube is perfectly dry so the print will easily slide all the way in, and will not be damaged when you replace the end-cap onto the drum.

(Continued on following page)

ILFORD

Once the cap is securely in place, the lights may be turned on for the remainder of the process.

MEASURING CHEMICALS

Chemicals should be carefully measured in the graduated beakers furnished with Cibachrome kit as follows:

8x10 inch print: 3 ounces (90 ml)

11x14 inch print: 6 ounces (180 ml)

Care should be taken to use the correct beaker for each component of chemistry every time so there will be no chance of contamination. Rinse well after each use.

Note: some graduates you may already have in your darkroom may be marked in cc's (cubic centimeters). Cubic centimeters and milliliters (ml) are equivalent measures; therefore you would use 90 cc for an 8x10 inch print.

TEMPERATURE AND TIME

The standard temperature for processing Cibachrome print material is 75°F.

However, if necessary, you can work with solution temperatures of from 65°F to 85°F if appropriate compensation is made in the time of processing (see table below).

It is important that in any given processing run the temperature of all solutions and of the wash water be kept within 3° of each other.

	68° F ± 3° F (20° C ± 1½° C)	(24° C ± 1½° C) 75° F ± 3° F	82° F ± 3° F (28° C ± 1½° C)
Developer	2½ min.*	2 min.*	1½ min.*
Bleach	4½ min.*	4 min.*	3½ min.*
Fix	3½ min.	3 min.	2½ min.
Wash	3½ min.	3 min.	2½ min.
Total time	14 min.	12 min.	10 min.

*Includes 15 second drain.

An increase or decrease in image contrast equal to about one grade of paper can be achieved through variations in developing time up to ± ½ minute. Shorter times will yield lower contrast at some sacrifice in speed, and vice versa.

Unless processing is done under extreme climatic conditions, the short duration of each step should enable you to stay within the prescribed temperature limits. Otherwise, it is recommended that you pre-heat or pre-cool the drum, depending on the temperature condition, and that you roll the drum in a water bath at the proper temperature.

AGITATION

During the development and bleaching steps, agitation during the first 15 seconds should be rapid and vigorous. Thereafter, agitation should be more gentle and even throughout the remainder of the cycle. If a motorized base is used, the drum should be agitated rapidly by hand for the first 15 seconds of the developing and bleaching steps, and then placed on the motorized base for the remainder of the cycle.

In using a motorized base, it is recommended that the revolutions per minute (RPM) of the drum on the base should not exceed 40 RPM. If the motor base rotates in a single direction only, the drum should be reversed several times in order to assure even processing.

CONSISTENT TECHNIQUE

As with all color processes, it is important that you develop a consistent technique and procedure, and that you use them each time you make color prints.

Consistency in work habits will lead to uniformity in color print quality.

CAUTION

Read and follow all caution information on packages and labels.

Even though the solid chemicals are supplied in sealed packages, and all bottles have child-resistant safety caps, KEEP OUT OF REACH OF CHILDREN.

(*Continued on following page*)

TRAY PROCESSING STEPS
TOTAL TIME: 12 MINUTES at 75°F ± 3°F (24°C ± 2°C)

1. DEVELOP (2 minutes)

Developing Cibachrome print material in trays must be done IN TOTAL DARKNESS.

For each 8x10 inch print, pour 3 ounces (90 ml) of developer into a flat-bottomed tray. Three ounces will barely cover the 8x10 inch print, and therefore agitation must be continuous and vigorous for the entire cycle.

Start draining the developer 15 seconds prior to Step 2, then rinse briefly in a tray filled with 75°F water, and drain 5 to 10 seconds before placing the print in the bleach tray.

2. BLEACH (4 minutes)

The first 3 minutes of the bleaching step must be done in TOTAL DARKNESS.

Use 3 ounces (90 ml) of bleach for each 8x10 inch print to be processed, and agitate continuously and vigorously for the entire cycle.

After 3 minutes in the bleach, you may turn on the lights; continue to agitate the solution.

Start draining the bleach 15 seconds before the end of this step, then rinse briefly in clean water, and drain 5 to 10 seconds before placing the print in the fixer tray.

IMPORTANT: neutralize used bleach as described in step 2, in previous instructions, before disposal.

3. FIX (3 minutes)

Use 3 ounces (90 ml) of fixer for each 8x10 inch print and agitate continuously and vigorously for the full 3 minutes, then drain for 5 to 10 seconds.

4. WASH (3 minutes)

Wash for 3 minutes in rapidly running, clean water at 75°F.

Total elapsed time: 12 minutes.

To dry, remove the surface liquid with a soft rubber squeegee or clean chamois cloth. Hang up, or lay flat on a blotter or drying rack (emulsion side up), or use a print dryer designed for resin coated papers.

Note: These instructions are for the benefit of those who prefer tray processing to drum processing. Advantages of trays are the simplicity of equipment and the possibility of processing more than one print at a time. Disadvantages are working in total darkness for 5 minutes and the possibility of scratching the prints. CAUTION: in tray processing, use clean rubber gloves to avoid contact of the solutions with the skin.

TRAY PROCESSING PROCEDURE
TYPES OR TRAYS

Plastic, hard rubber or type 316 stainless steel trays are recommended, but enamelled trays may be used if they are not chipped or rusted.

For processing a single 8x10 inch print in just 3 ounces of solution, it is important that the bottom of the tray be flat, with no ridges or depressions.

PROCEDURE

Because step 1 and step 2 are IN TOTAL DARKNESS, you should prepare one tray with developer and one tray with bleach before the lights are turned off.

Although the beginning is well advised to start tray processing with one print at a time, the more experienced worker may prefer to process several prints at a time. This can be done successfully with Cibachrome print material provided only that adequate solution volumes are employed; that it, at least 3 ounces per 8x10 inch print, and that care is taken to avoid scratching or gouging the swollen and fairly delicate emulsion during interleafing of the sheets. It is essential also that each print of a batch receive the correct treatment time in each solution. This can be assured by immersing and removing the sheets in 10 second intervals, always maintaining the same order.

MEASURING CHEMICALS

Chemicals should be carefully measured in the graduated breakers furnished with Cibachrome chemistry as follows:

(*Continued on following page*)

ILFORD

8x10 inch print: 3 ounces (90 ml)
11x14 inch print: 6 ounces (180 ml)
Care should be taken to use the correct beaker for each component of chemistry every time so there will be no chance for contamination. Rinse well after each use.

TEMPERATURE AND TIME

The standard temperature for proces-sing Cibachrome print material is 75°F.

However, if necessary, you can work with solution temperatures of from 65° F to 85°F if appropriate compensation is made in the time of processing (see table below).

It is important that in any given processing run the temperature of all solution and of the wash water be kept within 3° of each other.

	68° F ± 3° F (20° C ± 1½° C)	75° F ± 3° F (24° C ± 1½° C)	82° F ± 3° F (28° C ± 1½° C)
Developer	2½ min.*	2 min.*	1½ min.*
Bleach	4½ min.*	4 min.*	3½ min.*
Fix	3½ min.	3 min.	2½ min.
Wash	3½ min.	3 min.	2½ min.
Total time:	14 min.	12 min.	10 min.

*Includes 15 second drain and rinse.

An increase or decrease in image contrast equal to about one grade of paper can be achieved through variations in developing time up to ± ½ minute. Shorter times will yield lower contrast at some sacrifice in speed, and vice versa.

Unless processing is done under extreme climatic conditions, the short duration of each step should enable you to stay within the prescribed temperature limits. Otherwise, it is recommended that you pre-heat or pre-cool the trays, depending on the temperature condition, and that you float the trays in a water bath at the proper temperature.

AGITATION

For a single print, constantly agitate by raising and lowering each of the four sides of the tray to make sure that the entire surface of the sheet is swept over by solution throughout each processing step.

For several prints, agitate by interleafing, continually taking the print from the bottom and placing it on top. Processing prints face down will help reduce scratching of the emulsion.

CONSISTENT TECHNIQUE

It is important that you develop a consistent technique and procedure, and that you use them each time you make color prints.

Consistency in work habits will lead to uniformity in color print quality.

CAUTION

Read and follow all caution information on packages and labels.

Even though the solid chemicals are supplied in sealed packages, and all bottles have child-resistant safety caps, KEEP OUT OF REACH OF CHILDREN.

PROCEDURE

RETOUCHING

The amount of retouching to be done on your Cibachrome prints will depend largely upon the condition of your slide. IT IS ESSENTIAL to have your slide absolutely clean before enlarging because as mentioned previously, dust particles will be printed black. Clean your slide carefully, and after you have placed it in the negative carrier, it is a good idea to recheck it with a magnifying glass or small loupe to make sure all dust particles have been removed.

If the slide has been scratched, apply a small quantity of "no-scratch" solu-

(Continued on following page)

ILFORD

tion or oil from your face to help reduce the effect of the scratch, as it may print as a black line.

Black spots on your final Cibachrome prints can best be covered with opaque colors, such as artists' acrylic paints in the proper shade.

Retouching white spots, or adding color to lighter areas, is easily accomplished with Cibachrome transparent retouching colors. These colors contain the same dyes as are in the Cibachrome print image and have a high resistance to fading.

Cibachrome retouching colors are water soluble and may be applied with a brush or cotton swab. They can be used in any desired concentration, but it is recommended you start with dilute colors. If too much color has been applied, the density of the retouched area can be reduced by prolonged washing (about one half hour).

MOUNTING

Cibachrome prints may be easily mounted with the two-sided adhesive mounts available at most photo dealers, or with the photo-mount adhesives available in aerosol cans. In each case, be sure to follow the directions printed on the package.

In mounting Cibachrome, extra care must be taken to carefully roll out all bubbles and air spaces so that the print is perfectly flat.

Because of the lasting qualities of Cibachrome, it is advisable to use heavy cardboard, or even Masonite, as a permanent mount.

Your Cibachrome print may be sprayed with a gloss finish to protect it from finger prints, dust and scratches, or if you prefer, it may be sprayed with a matte varnish to soften the high gloss finish.

REMOVING FINGER PRINTS

Finger prints on Cibachrome prints may be caused in several ways, among them

1. by touching the image surface of the print with wet fingers before processing, especially if wet with a processing solution . . . and by touching the print image during processing with contaminated fingers i.e., bleach or fixer on fingers while print is in developer. The image will be affected and there is no way to correct other than by retouching.

2. if carelessly handled with wet or dirty fingers after processing and drying. Finger prints may be removed by washing the print again; superficial dirt and finger grease may be easily removed with film cleaner and a soft cotton cloth or swab. Do not use facial tissues.

ILFORD

CIBACHROME MAGNIFICATION TABLE AND EXPOSURE GUIDE

When you make prints of different size from one of your slides, you will have to change your print exposure as you change from one magnification to another. In order to avoid problems with reciprocity failure, you should try to maintain similar exposure times and make the necessary compensations in total exposure by varying the lens aperture. The light intensity at the easel will be directly proportional to $(1 + m)^2$ where m is the magnification ratio. For example, if you project a 1 x 1½

inch (35mm) slide film image first to a 4x5 inch size, and then to an 8x10 inch size, the difference in the intensity of illumination at the easel will be:

$$\frac{(1 + 8)^2 = 81}{(1 + 4)^2 = 25} \text{ or } 3.2x$$

This means the 8x10 inch print will require 3.2 times more exposure than the 4x5 inch print.

The following table will help in determining the necessary changes in exposure as you switch from size to size.

(Continued on following page)

The Compact Photo-Lab-Index

from		to	
4x5 inch	**5x7 inch**	**8x10 inch**	**11x14 inch**
exposure factor:	1.4x	3.2x	5.8x
example: f/8, 10 seconds	f/8, 14 sec.	f/8, 32 sec., or preferably, f/5.6, 16 sec.	f/5.6, 29 sec., or preferably, f/4.5, 21 sec.
(This sample is for illustrative purposes only. Your actual print exposures may be quite different.)			

8x10 inch	**4x5 inch**	**5x7 inch**	**11x14 inch**
exposure factor:	0.31x	0.44x	1.8x
example: f/5.6, 16 seconds	f/8, 10 sec.	f/8, 14 sec.	f/5.6, 29 sec., or preferably, f/4.5, 21 sec.
(This sample is for illustrative purposes only. Your actual print exposures may be quite different.)			

CIBACHROME PROCESSING CHART FOR DRUM AND TRAY TECHNIQUES

The standard temperature for processing Cibachrome print material is 75°F. However, if you must process at lower or higher temperatures, make time adjustments as shown below. Temperatures below 65°F and above 85°F are likely to yield poor photographic results and/or physical defects.

	Recommended 75°F ± 3°F	Low 68°F ± 3°F	High 82°F ± 3°F
1. Develop 15 second drain°	2 min.	2½ min.	1½ min.
2. Bleach 15 second drain°	4 min.	4½ min.	3½ min.
3. Fix	3 min.	3½ min.	2½ min.
4. Wash	3 min.	3½ min.	2½ min.
Total time	12 min.	14 min.	10 min.

*Start draining 15 seconds prior to next step. If there is evidence of an unpleasant odor, on subsequent processing rinse quickly with about 3 ounces of water at 75°F (or temperature used for developer and bleach) and drain for 10-15 seconds.

Each package of Cibachrome chemistry describes what to do in case the particular chemistry is inadvertently swallowed or splashed into the eyes. If a physician requires additional information in case of an accident with Cibachrome chemistry, he can call Ciba-Geigy Corporation (Product Misuse) at (914) 478-3131.

(*Continued on following page*)

520

CIBACHROME COLOR CORRECTION GUIDE

Using the color Correction Chart as
a guide:

if the print is too	add	or subtract
blue	yellow	blue (magenta and cyan)
yellow	blue (magenta and cyan)	yellow
green	magenta	green (yellow and cyan)
magenta	green (yellow and cyan)	magenta
cyan	red (yellow and magenta)	cyan
red	cyan	red (yellow and magenta)

Note: if you view a Cibachrome print while still wet, it will look somewhat more magenta than when completely dry. In color printing, it is important to remember these 3 basic filter rules:

1. use as few filters as possible, therefore

2. if possible, subtract filters to make a correction rather than add unnecessary neutral density; that is,

3. never have yellow, magenta and cyan filters in the same filter pack as it merely reduces the light intensity.

ILFORD

521

The Compact Photo-Lab-Index

ILFORD PHOTOGRAPHIC FORMULAS

PYRO-SODA DEVELOPER
For Films and Plates **Ilford ID-1**

STOCK SOLUTION A

Warm Water (125 F or 52 C)	24 ounces	750.0 ml
Potassium Metabisulfite	365 grains	25.0 grams
Pyrogallic Acid	3 oz. 150 grains	100.0 grams
Add cold water to make	32 ounces	1.0 liter

Ensure that the potassium metabisulfite is dissolved before adding the pyrogallic acid.

STOCK SOLUTION B

Warm Water (125 F or 52 C)	24 ounces	750.0 ml
Sodium Carbonate (monohydrated)	1 oz. 200 grains	44.0 grams
Sodium Sulfite (desiccated)	1 oz. 292 grains	50.0 grams
Potassium Bromide	17 grains	1.2 grams
Add cold water to make	32 ounces	1.0 liter

For tray development, mix 1 part A, 10 parts B, 9 parts water. Develop for 2-1/2 to 5 minutes at 68 F (20 C). For tank development mix 1 part A, 5 parts B, 20 parts water. Develop for 5 to 10 minutes at 68 F (20 C).

METOL-HYDROQUINONE DEVELOPER
For Plates and Films **Ilford ID-2**

STOCK SOLUTION

Warm Water (125 F or 52 C)	24 ounces	750.0 ml
Metol .	30 grains	2.0 grams
Sodium Sulfite (desiccated)	2-1/2 ounces	75.0 grams
Hydroquinone	120 grains	8.0 grams
Sodium Carbonate (monohydrated)	1 oz. 190 grains	43.0 grams
Potassium Bromide	30 grains	2.0 grams
Add cold water to make	32 ounces	1.0 liter

For Tray Development, dilute 1 part of the above stock solution with 2 parts of water. Develop 3 to 5 minutes at 68 F (20 C). For Tank Development dilute 1 part of stock solution with 5 parts of water. Develop 6 to 12 minutes at 68 F (20 C).

Available as an Ilford packed chemical in sizes to make 1 U.S. gallon, 1000 ml, 2.5 liters and 5 liters, metric measure, and 80 ounces, and 1 gallon British Imperial measure.

ILFORD

METOL TANK OR TRAY DEVELOPER
For Soft Gradation and Maximum Shadow Details Ilford ID-3

STOCK SOLUTION A

Warm Water (125 F or 52 C)	24 ounces	750.0 ml
Metol .	175 grains	12.0 grams
Sodium Sulfite (desiccated)	1 oz. 292 grains	50.0 grams
Add cold water to make	32 ounces	1.0 liter

STOCK SOLUTION B

Warm Water (125 F or 52 C)	24 ounces	750.0 ml
Sodium Carbonate (monohydrated)	2 oz. 293 grains	87.0 grams
Potassium Bromide	30 grains	2.0 grams
Add cold water to make	32 ounces	1.0 liter

Mix 1 part A, 1 part B, 6 parts water. Develop films and plates approximately 12 minutes in a tray or 5 minutes in a tank, and papers for 1-1/2 to 2 minutes. ID-3 may be made up in one solution. The superior keeping properties of the separate solutions make the two solution formula preferable when consistency of performance is especially important.

AMIDOL DEVELOPER
For Films and Plates Ilford ID-9

Warm Water (125 F or 52 C)	24 ounces	750.0 ml
Sodium Sulfite (desiccated)	3 oz. 145 grains	100.0 grams
Amidol .	1/2 oz. 73 grains	20.0 grams
Potassium Bromide	88 grains	6.0 grams
Add cold water to make	32 ounces	1.0 liter

This developer has very poor keeping qualities and should be used as soon as possible after mixing. Develop 6 to 10 minutes at 68 F (20 C).

METOL-HYDROQUINONE-BORAX DEVELOPER
For Tank or Tray Use Ilford ID-11

Warm Water (125 F or 52 C)	24 ounces	750.0 ml
Metol .	30 grains	2.0 grams
Sodium Sulfite (desiccated)	3 oz. 145 grains	100.0 grams
Hydroquinone .	75 grains	5.0 grams
Borax .	30 grains	2.0 grams
Add cold water to make	32 ounces	1.0 liter

Use full strength. Develop from 5 to 13 minutes at 68 F (20 C).

An Extra-fine grain Developer can be prepared by adding to the above, Ammonium Chloride at the rate of 40 grams of Ammonium Chloride per liter of prepared Ilford ID-11 (1 ounce 145 grains per quart). Camera exposures should be doubled and developing time increased to twice the specified time for ID-11.

Available as an Ilford packed chemical in sizes to make 1 U.S. gallon 570 ml metric measure, and 8 oz., 1 gallon, 3 gallons and 5 gallons British Imperial Measure.

REPLENISHER

For Metol-hydroquinone-borax Developer Ilford-11R

Warm Water (125 F or 52 C)	24 ounces	750.0 ml
Metol .	44 grains	3.0 grams
Hydroquinone .	112 grains	7.5 grams
Sodium Sulfite (desiccated)	3 oz. 148 grains	100.0 grams
Borax .	291 grains	20.0 grams
Add cold water to make	32 ounces	1.0 liter

Add the replenisher to the developer tank so as to maintain the level of solution. Where the tank is in continuous use a quantity of replenisher equal to that of the original developer may normally be added before the solution is discarded.

Available as an Ilford packed chemical in sizes to make 80 ounces British Imperial measure, of working strength solution.

HIGH CONTRAST DEVELOPER

For Line and Screen Negatives Ilford ID-13

STOCK SOLUTION A

Warm Water (125 F or 52 C)	24 ounces	750.0 ml
Hydroquinone .	365 grains	25.0 grams
Potassium Metabisulfite	365 grains	25.0 grams
Potassium Bromide	365 grains	25.0 grams
Add cold water to make	32 ounces	1.0 liter

STOCK SOLUTION B

Sodium Hydroxide	1 oz. 292 grains	50.0 grams
*Cold water to make	32 ounces	1.0 liter

*Caution: A good deal of heat is liberated when dissolving Sodium Hydroxide, and if warm water is used, it may boil with explosive violence. Use only cold water to dissolve caustic alkalis.

Mix equal parts of A and B immediately before use. The mixed solution has very poor keeping qualities and should be discarded immediately after using. With normal exposures, development is complete in 2-1/2 to 3 minutes.

METOL-HYDROQUINONE DEVELOPER

For X-Ray, Aerial and Scientific Films Ilford ID-19

Warm Water (125 F or 52 C)	24 ounces	750.0 ml
Metol .	35 grains	2.3 grams
Sodium Sulfite (desiccated)	2 oz. 175 grains	72.0 grams
Hydroquinone .	132 grains	8.8 grams
Sodium Carbonate (monohydrated)	1-3/4 oz. 52 grains	56.0 grams
Potassium Bromide	60 grains	4.0 grams
Add cold water to make	32 ounces	1.0 liter

Recommended development times for aerial films at 68 F (20 C) are about 13 minutes in a spool tank or about 8 minutes in an automatic processing machine. For scientific materials see the instructions issued with the materials concerned.

Available as an Ilford packed chemical in sizes to make 80 ounces, 1 gallon, and 5 gallons, British Imperial measure of working strength solution.

REPLENISHER
For ID-19 Metol-hydroquinone Developer Ilford ID-19R

Warm Water (125 F or 52 C)		24 ounces	750.0 ml
Metol .		57 grains	4.0 grams
Sodium Sulfite (desiccated)	2 oz.	201 grains	72.0 grams
Hydroquinone .		232 grains	16.0 grams
Sodium Carbonate (monohydrated)	1 oz.	384 grains	56.0 grams
Sodium Hydroxide		109 grains	7.5 grams
Add cold water to make		32 ounces	1.0 liter

Add the replenisher to the developer tank so as to maintain the level of solution. Where the tank is in continuous use, a quantity of replenisher equal to that of the original developer may normally be added before the solution is discarded.

Available as an Ilford packed chemical in sizes to make 1 gallon. In two 80 ounce units British Imperial measure of working strength solution.

METOL-HYDROQUINONE DEVELOPER
For Bromide Paper Ilford ID-20

STOCK SOLUTION

Warm Water (125 F or 52 C)		24 ounces	750.0 ml
Metol .		22 grains	1.5 grams
Sodium Sulfite (desiccated)		365 grains	25.0 grams
Hydroquinone .		88 grains	6.0 grams
Sodium Carbonate (monohydrated)	1 oz.	75 grains	35.0 grams
Potassium Bromide		30 grains	2.0 grams
Add cold water to make		32 ounces	1.0 liter

For use, dilute 1 part of stock solution with 1 part of water. With Bromide paper this developer gives good neutral blacks. Developing time is 1-1/2 to 2 minutes for normal exposures.

AMIDOL DEVELOPER
For Bromide Papers Ilford ID-22

Warm Water (125 F or 52 C)	24 ounces	750.0 ml	
Sodium Sulfite (desiccated)	365 grains	25.0 grams	
Amidol .	88 grains	6.0 grams	
Potassium Bromide (10% solution)	1/4 fl. oz.	8.0 ml	
Add cold water to make	32 ounces	1.0 liter	

Use full strength. Develop about 2 minutes. This developer should be freshly made just before using, and should be discarded after use. It does not keep in stock solution form.

ILFORD

AMIDOL DEVELOPER

For Contact Papers **Ilford ID-30**

Warm Water (125 F or 52 C)	24 ounces	750.0 ml
Sodium Sulfite (desiccated)	365 grains	25.0 grams
Amidol	88 grains	6.0 grams
Potassium Bromide (10% solution)	1/2 fl. dram	2.0 ml
Add cold water to make	32 ounces	1.0 liters

This developer does not keep; it should be made up just before use and discarded immediately after using. Develop contact papers 45 to 60 seconds.

METOL-HYDROQUINONE DEVELOPER

For Oscillograph Films and Papers **Ilford ID-33**

Warm Water (125 F or 52 C)	24 ounces	750.0 ml
Metol	75 grains	5.0 grams
Sodium Sulfite (desiccated)	1 oz. 292 grains	50.0 grams
Hydroquinone	120 grains	8.0 grams
Sodium Carbonate (monohydrated)	1 oz. 195 grains	43.3 grams
Potassium Bromide	75 grains	5.0 grams
Add cold water to make	32 ounces	1.0 liter

Use full strength. Develop about 5 minutes.

METOL-HYDROQUINONE DEVELOPER

For Films, Plates and Papers **Ilford ID-36**

Warm Water (125 F or 52 C)	24 ounces	750.0 ml
Metol	22 grains	1.5 grams
Sodium Sulfite (desiccated)	365 grains	25.0 grams
Hydroquinone	93 grains	6.3 grams
Sodium Carbonate (monohydrated)	1-1/4 oz. 45 grains	40.5 grams
Potassium Bromide	6 grains	0.4 grams
Add cold water to make	32 ounces	1.0 liter

For contact papers, use full strength; develop 45 to 60 seconds.

For enlarging papers, use 1 part ID-36 and 1 part water and develop for 1-1/2 to 2 minutes.

For tray development of films and plates, take 1 part of ID-36 and 1 part of water; develop 3 to 5 minutes.

For tank development of films and plates, use 1 part of ID-36 and 3 parts of water; develop 6 to 10 minutes.

GLYCIN DEVELOPER

For Films and Plates **Ilford ID-60**

Warm Water (125 F or 52 C)	24 ounces	750.00 ml
Sodium Sulfite (desiccated)	291 grains	20.0 grams
Potassium Carbonate	2 ounces	60.0 grams
Glycin	1 ounce	30.0 grams
Add cold water to make	32 ounces	1.0 liter

Dilute 1:7 and develop for about 12 minutes in a tray or 15 minutes in a tank at 68 F (20 C).

ILFORD

PHENIDONE-HYDROQUINONE DEVELOPER
For Films and Plates **Ilford ID-62**

STOCK SOLUTION

Warm Water (125 F or 52 C)	24 ounces	750.0 ml
Sodium Sulfite (anhydrous)	1 oz. 292 grains	50.0 grams
Hydroquinone .	175 grains	12.0 grams
Sodium Carbonate (desiccated)	2 ounces	60.0 grams
Phenidone .	7-1/2 grains	0.5 grams
Potassium Bromide	30 grains	2.0 grams
Benzotriazole :	3 grains	0.2 grams
Add cold water to make	32 ounces	1.0 liter

For use with contact papers, dilute 1:1 and develop 45 to 60 seconds.
For use with enlarging papers, dilute 1:3 and develop 1-1/2 to 2 minutes.
For tray development of films and plates, dilute 1:3 and develop 2 to 4 minutes.
For tank development, dilute 1:7 and develop for 4 to 8 minutes.

PHENIDONE-HYDROQUINONE DEVELOPER
For Films and Plates **Ilford ID-67**

STOCK SOLUTION

Warm Water (125 F or 52 C)	24 ounces	750.0 ml
Sodium Sulfite (anhydrous)	3-1/2 ounces	75.0 grams
Hydroquinone .	115 grains	8.0 grams
Sodium Carbonate (desiccated)	1-1/4 ounces	37.5 grams
Phenidone .	4 grains	0.25 grams
Potassium Bromide	30 grains	2.0 grams
Benzotriazole .	2-1/2 grains	0.15 grams
Add cold water to make	32 ounces	1.0 liter

For tray development, dilute 1:2 and develop 2-1/2 to 5 minutes.
For tank development, dilute 1:5 and develop 5 to 10 minutes.
This developer has characteristics approximating those of Ilford ID-2.

PHENIDONE-HYDROQUINONE-BORAX FINE GRAIN DEVELOPER
For Films and Plates **Ilford ID-68**

Warm Water (125 F or 52 C)	24 ounces	750.0 ml
Sodium Sulfite (desiccated)	2 oz. 372 grains	85.0 grams
Hydroquinone .	75 grains	5.0 grams
Borax .	92 grains	7.0 grams
Boric Acid .	29 grains	2.0 grams
Potassium Bromide	15 grains	1.0 grams
Phenidone .	1.9 grains	0.13 grams
Add cold water to make	32 ounces	1.0 liter

Use undiluted; develop films for 8-10 minutes, plates for 4-7 minutes at 68 F (20 C).

ILFORD

The Compact Photo-Lab-Index

REPLENISHER

For ID-68 Phenidone-hydroquinone-borax Developer Ilford ID-68R

Warm Water (125 F or 52 C)	24 ounces	750.0 ml
Sodium Sulfite (desiccated)	2 oz. 372 grains	85.0 grams
Hydroquinone	117 grains	8.0 grams
Borax	. .	92 grains	7.0 grams
Phenidone	. .	3.2 grains	0.22 grams
Add cold water to make	32 ounces	1.0 liter

Add the Replenisher to the developer tank so as to maintain the level of solution. Where the tank is in continuous use a quantity of replenisher equal to that of the original developer may normally be added before the solution is discarded.

WARM TONE DEVELOPER

For Ilford Kenprint Paper and Contact Lantern Plates Ilford ID-78

Warm Water (125 F or 52 C)	24 ounces	750.0 ml
Sodium Sulfite, desiccated	1 oz. 292 grains	50.0 grams
Hydroquinone	175 grains	12.0 grams
Sodium Carbonate, desiccated	2 ounces	62.0 grams
Phenidone	. .	7-1/2 grains	0.5 grams
Pottasium Bromide	6 grains	0.4 grams
Add cold water to make	32 ounces	1.0 liter

Dilute 1 part of the above stock solution with one part of water and develop for 1 minute at 68 F (20 C). For longer development times, dilute 1 part of stock solution with 3 parts of water and develop for 2 minutes at 68 F (20 C).

ILFORD ILFOFIX

DESCRIPTION AND USES

Ilfofix is a highly concentrated multi-purpose acid hardening fixer supplied in powder form. It has been specially formulated to give maximum efficiency and long life with all materials where a hypo based fixer is required.

Ilfofix is the standard Ilford powder fixer—not only for general purpose films, plates and papers but also for graphic arts and X-ray materials, as well as recording films and papers.

Any method of silver recovery can be used with Ilfofix—for maximum efficiency and fixer life the electrolytic method is recommended.

WORKING STRENGTH

Slowly pour the contents of the pack into about three-quarters of the total volume of warm water (specified on the label) at a temperature of not more than 27 C (80 F) and stir until completely dissolved. Add cold water to make up the total volume.

X-ray films—use undiluted.

Films and plates—use undiluted where rapid fixing is required or at 1 + 1 for a normal fixation rate.

Papers—dilute 1 + 2 for use.

FIXING TIMES

In order to avoid the risk of insufficient fixation, materials should remain in the fixer for double the time it takes to clear the emulsion in a fresh solution. The clearing time can be easily found by allowing a drop of fixer to act on a piece of unprocessed film for about 30 seconds. This should then be immersed in the fixing bath, the time taken for the spot to disappear being the clearing time.

The times given below are the average fixing times in minutes for materials which are to be fixed in a fresh solution.

(continued on the following page)

ILFORD

528

MATERIALS	DILUTION	FIXING TIME
X-ray films (double sided)	–	5
films and plates	–	4
films and plates	1 + 1	50
papers	1 + 2	5

CAPACITY

The approximate fixing capacity of one gallon (4.5 liters) of working strength Ilfofix is:

 30 square feet (2.8 m²) of double sided X-ray film
 60 square feet (5.5 m²) of film and plates
 100 square feet (9 m²) of paper

If a dilution of 1 + 1 is used for films and plates the capacity per gallon of working strength fixer is halved.

REPLENISHMENT

Fixers are eventually exhausted due to a build up of metallic silver in the bath, coupled with the dilution of the fixing bath due to a carry-over of solutions from preceding baths.

The activity of a film fixer can be restored by the addition of fresh fixer and the silver content can be allowed to rise to a high level (10 grams per litre) without serious effect. The useful life of paper fixers is mainly limited by the concentration of silver in the solution which, if allowed to build up to about 3 grams per litre, will tend to remain in the paper after washing and cause print staining. This can be avoided by the use of two-bath fixing but where this is not possible, no more than 25 per cent of the original solution should be replenished before discarding the solution. The silver concentration in a fixing bath can be accurately determined by using silver estimator papers.

CHECKING ACTIVITY

Acidity

The pH (acidity) of the fixer should ideally be 5.0 and this can be readily checked with pH papers. If the pH is found to be too high (above 6.0) add a few drops of a 50 per cent solution of acetic acid stirring the solution continuously, until the pH value drops to between 4.8 and 5.5. The use of an acid stop bath before fixation will help prevent this rise in pH.

Specific gravity

A further check on fixer activity can be easily made by measuring its specific gravity. If the specific gravity is kept at a constant level, the life of the fixer will be prolonged.

The specific gravity of a working strength film fixer should be 1.17 and this can be checked with a hydrometer. If the specific gravity of the solution is low it can be restored by adding fresh fixer.

ILFORD HYPAM FIXER AND HARDENER

DESCRIPTION AND USES

Ilford Hypam Fixer is an acid fixer supplied in concentrated liquid form, with the advantages of being rapid in action and convenient in use. It is suitable for use with films, plates and papers. Hypam contains no hypo—the fixing agent used is ammonium thiosulphate.

Ilford Hypam Hardener is a concentrated liquid hardener supplied for use with Ilford Hypam Fixer when a hardening-fixing bath is required. Use of the hardener is always recommended when films or plates are being processed; it reduces the danger of abrasion of wet negatives and speeds up the drying operation.

No extra bath (such as an acid stop bath) is required with Hypam. Developed negatives and prints should simply be given a rinse in fresh water and then immersed straight away in the fixer.

(*continued on the following page*)

ILFORD

The Compact Photo-Lab-Index

MAKING UP

Film and Plate Fixing

Mix 1 part of concentrated Hypam with 4 parts of water. If hardening is required add 1 part of Hypam Hardener to every 40 parts of diluted fixer.

Paper Fixing—Normal Strength

Mix 1 part of concentrated Hypam with 9 parts of water. If hardening is required add 1 part of Hypam Hardener to every 80 parts of diluted fixer.

Paper Fixing—Rapid

Make up Hypam to the film and plate strength.

FIXING TIMES

In Hypam at temperatures around 20 C (68 F), the fixing times for Ilford films and plates range from only 1 to 2 minutes, depending on the material in use. The fixing time for Ilford papers is only about half a minute using Hypam at the film strength (1 + 4). When used at the 1 + 9 dilution papers should be fixed for 3 to 5 minutes at 20 C (68 F).

The following are clearing times at 20 C (68 F) for some typical Ilford materials using Hypam diluted 1 + 4 without hardener. If the hardener is used 3 to 5 minutes must be allowed to achieve maximum hardening.

Standard X-ray Film	30 seconds
Selochrome Roll Film	35 seconds
N.40 Process Plate	45 seconds
HP4 Flat Film	55 seconds
HP3 Plate	35 seconds
N.30 Ordinary Plate	60 seconds

Capacity

When using Hypam for film and plate fixing it should be discarded or regenerated when the clearing time in the used fixer exceeds twice the clearing time in the unused fixer. This permits about 240 8 × 10 inch films or 120 size roll films to be fixed in 1 gallon (4.5 litres) of working strength fixer.

When Hypam is used for fixing papers it should be discarded after about 400 sheets of 8 × 10 inch paper have been fixed in 1 gallon of working strength solution. This figure may, however, be exceeded whenever print stability is not critically important.

Working strength Hypam Fixer and Hardener will keep for several months. In the concentrated form the fixer and hardener will keep for about a year in sealed containers. Do not mix the concentrated solutions; always dilute the fixer before adding the hardener.

ACID FIXING BATH

For Films, Plates and Papers Ilford IF-2

Sodium Thiosulfate	6 oz. 288 grains	200.0 grams
Potassium Metabisulfite	183 grains	12.5 grams
Add cold water to make	32 ounces	1.0 liter

For films and plates: use undiluted and fix for 10 to 20 minutes.
For papers: dilute with an equal volume of water and fix for 5 to 10 minutes.
For more rapid fixing the quantities of hypo and metabisulfite may be doubled.

ACID HARDENING FIXING BATH
For X-Ray Materials and Films and Plates Ilford IF-9

Chrome Alum .	183 grains	12.5 grams
Sodium Metabisulfite	183 grains	12.5 grams
Sodium Sulfite (desiccated)	93 grains	6.25 grams
Sodium Thiosulfate (Hypo)	12-1/2 ounces	400.0 grams
Add cold water to make	32 ounces	1.0 liter

Dissolve the chrome alum, metabisulfite and sulfite in 750ml of warm water not above 100 F (38 C). Then add and dissolve the hypo. Finally add cold water to make 1000ml.

ACID HARDENING FIXING BATH
For Contact and Enlarging Papers Ilford IF-13

STOCK HARDENING SOLUTION

Sodium Sulfite (desiccated)	1 oz. 292 grains	50.0 grams
Acetic Acid 99% (Glacial)	2-1/2 ounces	75.0 ml
Potassium Alum	3 oz. 145 grains	100.0 grams
Add cold water to make	32 ounces	1.0 liter

Dissolve the Sulfite in 8 ounces of warm water, allow to cool and add the acetic acid slowly, stirring all the time. Dissolve the alum in 20 ounces of hot water, allow to cool, and add to the acid-sulfite mixture. Make up to the final quantity with cold water.

WORKING SOLUTION

Sodium Thiosulfate (Hypo)	6 oz. 292 grains	200.0 grams
Stock Hardening Solution	4 ounces	125.0 grams
Add cold water to make	32 ounces	1.0 liter

All mixing must be done at a temperature below 70 F (21 C).

ACID HARDENING FIXING BATH
For Films and Plates Ilford IF-15

SOLUTION A

Warm Water (125 F or 52 C)	16 ounces	500.0 ml
Sodium Thiosulfite (Hypo)	10 oz. 292 grains	320.0 grams
Sodium Sulfite (desiccated)	1 ounce	30.0 grams

SOLUTION B

Warm Water (125 F or 52 C)	6 ounces	150.0 ml
Boric Acid crystals	145 grains	10.0 grams
Acetic Acid 99% (Glacial)	4.8 fl. drams	18.0 ml
Potassium Alum crystals	365 grains	25.0 grams

Dissolve the hypo in hot water, and when cool add the sulfite. Dissolve the boric acid, acetic acid, and alum in hot water. When both solutions are cold, slowly pour Solution B into Solution A, then add cold water to · make 32 ounces or 1 liter respectively.

ILFORD

FARMER'S REDUCER
For Films and Plates

SOLUTION A

Sodium Thiosulfate	6-3/4 ounces	200.0 grams
Water to make .	32 ounces	1.0 liter

SOLUTION B

Potassium Ferricyanide	3 oz. 145 grains	100.0 grams
Cold water to make	32 ounces	1.0 liter

To use, take a sufficient amount of Solution A to cover the negative and add just enough of solution B to color the solution a pale yellow. Energy of reduction is proportional to the amount of Solution B used, and the process should be closely watched. When sufficient reduction is attained, wash thoroughly and dry in the normal manner.

PERSULFATE REDUCER
For Films and Plates

Ammonium Persulfate	365 grains	25.0 grams
Cold water to make	32 ounces	1.0 liter

It is important that the water be free from dissolved chlorides; distilled water is preferable. One or two drops of sulfuric acid should be added to the mixed solution to insure consistent action. Remove the negative from the reducer just before reduction is complete and rinse with a 5% solution of Sodium Sulfite to stop the action, then wash thoroughly.

PROPORTIONAL REDUCER
For Films and Plates

SOLUTION A

Warm Water (125 F or 52 C)	24 ounces	750.0 ml
Potassium Permanganate	4 grains	0.25 grams
*Sulfuric Acid (conc.)	22 minims	1.5 ml
Add cold water to make	32 ounces	1.0 liter

SOLUTION B

Ammonium Persulfate	365 grains	25.0 grams
Cold water to make	32 ounces	1.0 liter

*Caution: Always add the acid to the water, never water to acid.

For use mix one part of Solution A with 3 parts of Solution B. When reduction has gone far enough, pour-off the reducer and flood the negative with a 1% solution of Sodium Bisulfite to clear it.

IODINE-CYANIDE REDUCER
For Films, Plates and Papers Ilford IR-5

STOCK IODINE SOLUTION

Warm Water (125 F or 52 C)	24 ounces	750.0 ml
Potassium Iodide .	365 grains	25.0 grams
Iodine Crystals .	60 grains	4.0 grams
Add cold water to make	32 ounces	1.0 liter

STOCK CYANIDE SOLUTION

*Potassium Cyanide	120 grains	8.0 grams
Add cold water to make	32 ounces	1.0 liter

*Caution: Potassium Cyanide is a dangerous poison; it must be used only in a well ventilated room. Avoid breathing its fumes; do not discard cyanide solutions in a sink which may contain acid. See Section 13: PHOTO CHEMICALS for further information.

For use, take 1 ounce of each stock solution and add water to the mixed solutions to make 20 ounces (or take 25ml of each solution and add water to make 500ml of working bath).

DEVELOPER STAIN REMOVER
For Films and Plates

Warm Water (125 F or 52 C)	24 ounces	750.0 ml
Potassium Permanganate	88 grains	6.0 grams
Sodium Chloride	1/4 oz. 82 grains	13.0 grams
Acetic Acid 99% (Glacial)	1 oz. 5 fl. drams	50.0 ml
Add cold water to make	32 ounces	1.0 liter

Immerse for 10 minutes with constant rocking, rinse and place in a 5% solution of potassium metabisulfite until the brown stain is completely discharged. Redevelop in any ordinary developer, such as Ilford ID-36, and wash thoroughly.

NOTE: This bleach has a tendency to soften the gelatin and the negative should first be hardened in a 1% Chrome Alum solution for 3 to 5 minutes and rinsed before bleaching.

DEVELOPER STAIN REMOVER
For Bromide Prints

Potassium Alum, Saturated Solution	10 ounces	250.0 ml
Hydrochloric Acid, concentrated	1/4 ounce	6.0 ml

Wash print thoroughly after treatment.

ILFORD

MERCURIC CHLORIDE INTENSIFIER

BLEACHING SOLUTION

Warm Water (125 F or 52 C)	24 ounces	750.0 ml
Mercuric Chloride	365 ounces	25.0 grams
Ammonium Chloride	365 ounces	25.0 grams
Add cold water to make	32 ounces	1.0 liter

The negative must be thoroughly washed before being placed in the above bleaching solution; if it is not perfectly free from hypo, irremovable stains may result.

Bleach until the image is white throughout. Wash well in running water and blacken in one of the following:

a) 1 part of ammonia sp. gr. .800 to 100 parts of water. This gives the most intensification, but the intensified image is not permanent.

b) Any standard developer, such as Ilford ID-36. This gives somewhat less intensification, but the process may be repeated, if more density is required.

c) A 20% solution of Sodium Sulfite.

Wash thoroughly after blackening by any of the above methods.

MERCURIC IODIDE INTENSIFIER

Warm Water (125 F or 52 C)	24 ounces	750.0 ml
Mercuric Iodide	145 grains	10.0 grams
Sodium Sulfite (desiccated)	3 oz. 145 grains	100.0 grams
Add cold water to make	32 ounces	1.0 liter

Dissolve the Sodium Sulfite in the water first, then add the Mercuric Iodide. To ensure permanence, the negative after intensification is washed and developed with any plate developer, such as Ilford ID-36, for a few minutes. It is then washed thoroughly and dried in the normal manner.

CHROMIUM INTENSIFIER

BICHROMATE STOCK SOLUTION

Potassium Bichromate	3 oz. 145 grains	100.0 grams
Water to make	32 ounces	1.0 liter

This solution keeps indefinitely.

BLEACHING SOLUTION A

Bichromate stock solution	3-1/4 fl. oz.	100.0 ml
Hydrochloric Acid (conc.)	37 minims	2.4 ml
Cold water to make	32 ounces	1.0 liter

BLEACHING SOLUTION B

Bichromate stock solution	3-1/4 fl. oz.	100.0 ml
Hydrochloric Acid (conc.)	3 fl. drams	12.0 ml
Water to make	32 ounces	1.0 liter

The bleaching solution should be freshly made. Solution A gives more infensification than Solution B. Immerse the washed negative into either of these solutions until it is entirely bleached, wash until the yellow stain is completely removed, and redevelop in strong artificial light or subdued daylight (NOT direct sunlight, which will cause stains!) with any negative developer such as Ilford ID-36. Wash thoroughly.

MONCKHOVEN'S INTENSIFIER

BLEACHING SOLUTION			Ilford I.In-4
Mercuric Chloride (corrosive sublimate)	365	grains	25.0 grams
Potassium Bromide	365	grains	25.0 grams
Add cold water to make	32	ounces	1.0 liter

DARKENING SOLUTION			
Potassium Cyanide	225	grains	14.0 grams
Silver Nitrate	3/4	ounce	22.0 grams
Add cold water to make	32	ounces	1.0 liter

Dissolve the cyanide and silver nitrate in separate quantities of water and gradually add the silver nitrate solution to the cyanide, with constant stirring, until a permanent precipitate is just produced. Allow the mixture to stand for a short time and then filter it. After thoroughly washing the negative, immerse it in the bleaching solution until the image is white throughout. Wash it in running water for 20 minutes and then immerse it in the darkening solution until it has blackened. Wash the negative thoroughly before drying. If, after intensification, the negative is too dense it can be reduced with a 5% solution of hypo.

Caution—Mercuric Iodide is a poison. Potassium Cyanide is a very strong poison and must be handled with extreme care.

URANIUM INTENSIFIER

STOCK SOLUTION A			Ilford I.In-5
Uranium Nitrate	3/4	ounce	22.0 grams
Water to make	32	ounces	1.0 liter

STOCK SOLUTION B			
Potassium Ferricyanide	3/4	ounce	22.0 grams
Water to make	32	ounces	1.0 liter

The intensifier is prepared for use by mixing Solution A, 4 parts; Solution B, 4 parts; Acetic Acid 99% (glacial), 1 part. After treatment the negative is washed in several changes of water acidulated with a few drops of glacial acetic acid. The intensification can be removed by washing in a weak solution of sodium carbonate, and is, in any case, of limited permanence.

ILFORD

SULFIDE TONER
For Bromide and Multigrade Papers

<div align="right">Ilford IT-1</div>

STOCK FERRICYANIDE SOLUTION

Warm Water (125 F or 52 C) 24 ounces	750.0 ml	
Potassium Ferricyanide 3 oz. 145 grains	100.0 grams	
Potassium Bromide 3 oz. 145 grains	100.0 grams	
Add cold water to make 32 ounces	1.0 liter	

For use, dilute 1 part of the above stock solution with 9 parts of water.

STOCK SULFIDE SOLUTION

Sodium Sulfide 1 oz. 292 grains	50.0 grams	
Cold water to make 32 ounces	1.0 liter	

For use, dilute 1 part of the above stock solution with 9 parts of water.

Prints which have been correctly exposed and fully developed produce the best tones. After the print has been fixed and thoroughly washed, immerse in the diluted ferricyanide solution until it is completely bleached. Then wash for about 10 minutes and place in the sulfide solution, where it will redevelop to a rich sepia color. Warmer tones can be produced by reducing the potassium bromide in the above formula to 1/4 of the amount given. Wash the print thoroughly after toning.

HYPO ALUM TONER

<div align="right">Ilford IT-2</div>

Hot water 32 ounces	1.0 liter	
Sodium Thiosulfate 5 ounces	150.0 grams	

Dissolve and then add, a little at a time:

Potassium Alum 365 grains	25.0 grams	

Until ripened, this bath has a reducing action on prints; ripening is best done by immersing some spoiled prints, or by adding about 2-1/2 grains (.12 gram) of silver nitrate, which has previously been dissolved in a small amount of water, to which is added, drop by drop, sufficient strong ammonia to form and then redissolve the precispitate formed.

This bath lasts for years, and improves with keeping; it should be kept up to level by addition of fresh solution.

The prints, which should be developed a little further than for black-and-white, are toned at about 120 F (50 C) for about 10 minutes. A lower temperature is not recommended as toning is unduly prolonged; higher temperatures give colder tones.

Finally, wash the prints thoroughly and swab with a tuft of cotton before drying.

Warmer tones can be obtained by adding 15 grains (or 1 gram) of potassium iodide to each liter of the toner.

ILFORD

SELENIUM TONER
For Purple to Reddish Brown Tones on Papers Ilford IT-3

STOCK BLEACHING SOLUTION

Potassium Ferricyanide	3 oz. 145 grains	100.0 grams
Potassium Bromide	3 oz. 145 grains	100.0 grams
Add cold water to make	32 ounces	1.0 liter

For use dilute 1 part with 9 parts of water.

SELENIUM-SULFIDE STOCK SOLUTION

Sodium Sulfide	3 oz. 205 grains	104.0 grams
Selenium Powder	99 grains	6.8 grams
Add cold water to make	32 ounces	1.0 liter

Dissolve the sulfide and warm the solution before adding the selenium; continue heating until the latter is completely dissolved.

For use dilute 1 part with 10 parts of water.

Tone the prints for 2 to 3 minutes keeping them moving in the bath. Wash the prints thoroughly before drying.

GOLD TONER
For Red Tones on Papers Ilford IT-4

Warm Water (125 F or 52 C)	24 ounces	750.0 ml
Ammonium Thiocyanate	292 grains	20.0 grams
Gold Chloride	15 grains	1.0 grams
Add cold water to make	32 ounces	1.0 liter

Prints are first toned in the Sulfide or Hypo-Alum toners, then in the above toning bath, where the sepia tone will change to reddish brown and then to red. The approximate time of toning is 10 minutes for a red tone. The prints are then refixed in a 10% solution of Sodium Thiosulfate (Hypo) for 5 to 10 minutes, and finally washed thoroughly in running water.

GOLD-THIOCARBAMIDE TONER
For Blue Tones on Papers Ilford IT-5

STOCK SOLUTION A

Thiocarbamide	225 grains	14.0 grams
Water to make	32 ounces	1.0 liter

STOCK SOLUTION B

Citric Acid Crystals	225 grains	14.0 grams
Water to make	32 ounces	1.0 liter

STOCK SOLUTION C

Gold Chloride	88 grains	6.0 grams
Water to make	32 ounces	1.0 liter

For use, take 1 part Solution A, 1 part Solution B, 1 part Solution C, and 10 parts of water. Prints on Bromide paper should be toned from 15 to 30 minutes, according to tone required. Keep prints moving during toning and wash thoroughly after the desired tone is reached.

ILFORD

FERRICYANIDE-IRON TONER

For Blue Tones on Bromide Papers Ilford IT-6

SOLUTION A

Warm Water (125 F or 52 C)	24 ounces	750.0 ml
Potassium Ferricyanide	30 grains	2.0 grams
*Sulfuric Acid (conc.)	1 fl. dram	4.0 ml
Add cold water to make	32 ounces	1.0 liter

STOCK SOLUTION B

Warm Water (125 F or 52 C)	24 ounces	750.0 ml
Ferric Ammonium Citrate	30 grains	2.0 grams
*Sulfuric Acid (conc.)	1 fl. dram	4.0 ml
Add cold water to make	32 ounces	1 liter

*CAUTION: Always add the acid to the water, slowly, while stirring. NEVER add water to the acid, which may boil violently.

For use, mix equal parts of each solution just before use. The prints, which should be slightly lighter than normal, must be thoroughly washed before toning. They are then immersed in the toning solution until the desired tone is reached. They are then washed until the yellow stain is removed from the whites. If the wash water is alkaline, some bleaching of the image may take place; this may be prevented by washing the toned prints in several changes of water, each slightly acidified with a few drops of sulfuric or acetic acid.

ILFORD

ILFORD MICROPHEN FINE GRAIN DEVELOPER

DESCRIPTION AND USES

Ilford Microphen is a fine grain developer which gives an effective increase in film speed. Grain size is reduced and grain clumping prevented because of the low alkalinity of the developer.

The majority of developers which give an increase in film speed usually produce a corresponding increase in grain size. Microphen, however, has been specially formulated to overcome this disadvantage–and is therefore said to have a high speed/grain ratio. That is, it yields a speed increase while giving the type of fine grain result associated with MQ borax developers. A speed increase of half a stop can be achieved from most films.

Microphen is a clean working long life developer, supplied as a powder, which is dissolved to make a working strength solution.

Microphen can also be used at dilutions of 1:1 and 1:3.

DEVELOPMENT TIMES

Recommended times for the development of Ilford films and plates are given below. These times may be increased by up to 50 per cent for greater contrast, or where the highest speed is essential–as in the case of known under-exposure.

General purpose materials are normally developed to a \overline{G} (average contrast) of 0.55 if a tungsten enlarger is used for printing, and to a \overline{G} of 0.70 if a cold cathode enlarger is used. The times given below are in minutes and refer to development at 68 F (20 C) with intermittent agitation. If continuous agitation is used these times should be reduced by one quarter.

General Purpose Films	\overline{G} 0.55	\overline{G} 0.70
Sheet Film		
HP4	5	8
FP4	5½	9½
Roll Film		
HP4	5	8
FP4	5½	9½
35mm Film		
HP4	5	8
FP4	5½	9½
Pan F	3	4½

DILUTE DEVELOPMENT

Development of FP4 and HP4 in diluted Microphen increases acutance; the greater the dilution, the better the acutance. Dilute development is particularly suitable for subjects with long tonal scales; shadow and highlight densities are retained while negatives are sufficiently contrasty to produce bright prints. With this development technique film speed is fully maintained, but development times have to be increased.

Diluted developers should be used once only and then discarded.

Ilford Film	Dilution	\overline{G} 0.55	\overline{G} 0.70
FP4	1 + 1	7	12
	1 + 3	8½	16
HP4	1 + 1	9	15
	1 + 3	18	— *
Pan F	1 + 1	4	6
	1 + 3	7	10½

*not recommended

539

The Compact Photo-Lab-Index

DEVELOPMENT OF SPECIALIZED FILMS

Recommended development times for specialized sheet films and plates are given for both intermittent and continuous agitation—at a developer temperature of 68 F (20 C). These times can be varied by the user according to the processing conditions.

Ilford Material	Continuous Agitation	Intermittent Agitation
Sheet Film		
Fine Grain Ordinary	4	5
Commercial Ortho	9½	12
Plates		
N.30 Ordinary	4	5
N.25 Soft Ordinary	3¼	4
Special Rapid	3¼	4
G.30 Chromatic	4	5
R.25 FP Special	3¼	4
R.20 Special Rapid Panchromatic	4¾	6
R.10 Soft Gradation Panchromatic	4¾	6
FP4	6	7½
HP3	6	7½

USEFUL LIFE WITHOUT REPLENISHMENT

If Microphen is stored in a well-stoppered bottle it will keep well and can be repeatedly used. Under normal conditions eight rollfilms or eight 36 exposure 35mm films can be developed in 600 ml of developer. To maintain uniform contrast for all eight films the development time should be increased by 10 per cent for each successive film developed.

USEFUL LIFE WITH REPLENISHMENT

Microphen Replenisher is available for deep tank processing. It is designed to prolong the useful life of the developer and to maintain constant activity over a long period of time. The replenisher should be made up according to the instructions packed with it.

The most satisfactory method of replenishing Microphen is to add a small quantity of replenisher when the original volume has decreased by 5 per cent or when about 14 square feet of sensitized material has been processed in each gallon of developer. No limit is set to the amount of replenisher which may be added to a given volume of original developer. Replenishment may be continued until it becomes necessary to discard the solution in order to clean out the tank. If the tank is only used intermittently, it should be covered with a well-fitting floating lid to minimize developer oxidation and loss of water through evaporation.

The Compact Photo-Lab-Index

ILFORD PERCEPTOL DEVELOPER

DESCRIPTION AND USES

Perceptol is an extra fine grain developer. It has been specifically formulated to get optimum results from high-resolution lenses, to exploit the fine grain structure of FP4 and to produce significantly finer grain in HP4 negatives when compared with development in ID-11.

Perceptol produces excellent results with any lens/film combination and is therefore ideal when texture and definition are critical. Perceptol is supplied as a powder from which a solution is made by dissolving two separately-packed ingredients in warm water at about 105 F (40 C). The solution can be diluted. Perceptol contains a sequestering agent to counteract the effect of hard water precipitates and being in powder form it has excellent keeping properties even in the tropics. When made up, the unused solution will last for about six months in air-tight bottles.

The solution can be replenished but without replenishment, one gallon (4.5 liters) of full-strength Perceptol will develop twenty 120 roll films in deep tanks or machines. When replenished, one gallon (4.5 liters) will develop ninety 120 films or the equivalent.

FULL-STRENGTH DEVELOPMENT AND REPLENISHMENT

When it is known that full-strength Perceptol will be the developer used, films must receive about double the normal exposure. Films should therefore be re-rated at the following adjusted figures.

Film	Nominal Rating ASA	Nominal Rating DIN	Adjusted Rating ASA	Adjusted Rating DIN
Pan F	50	18	25	15
FP4	125	22	64	19
HP4	400	27	200	24

DEVELOPMENT TIMES

For enlarging with a tungsten light source, films should be developed to a \overline{G} (average gradient) of 0.55. For enlarging with a cold cathode source films should be developed to \overline{G} 0.70.

In full-strength Perceptol, the times quoted below will give these values. The times are in minutes and assume intermittent agitation, i.e., agitation for the first ten seconds of development, then for ten seconds every minute for the remainder of the time. Temperature of the solution should be 68 F (20 C). To compensate for loss of activity, increase the development time by 10 per cent after eight films have been processed in each gallon (4.5 liters), or forty films per 5 gallons (22.5 liters), of developer.

Film	\overline{G} 0.55	\overline{G} 0.70
Pan F	8½	12½
FP4 (Roll/flat/35 mm)	8	10½
HP4 (Roll/flat/35 mm)	8½	11½

DILUTION TECHNIQUE

To achieve a fuller film speed and to give maximum developer usage, especially when processing in a spiral tank, Perceptol solution can be diluted 1:1 or 1:3 with water. When diluted 1:1, the 600 ml size will make 1200 ml providing enough solution for four 120 roll films to be processed using a 300 ml tank. With the 1:3 dilution, the 600 ml size will make up to 2400 ml so that eight of these films can be processed using a 300 ml tank.

(Continued on following page)

ILFORD

With this technique, the film should have previously been rated at the ASA/DIN figure recommended below. Perceptol should be diluted immediately before use with just the right amount of water to fill the tank and the film processed at the recommended time. Discard each 300 ml of diluted developer after one use.

The following times and speed ratings for dilution, or "one-shot", technique are recommended when processing at 68 F (20 C) with intermittent agitation i.e. agitation for the first ten seconds of development, then for ten seconds every minute for the remainder of the time. The times are in minutes.

Film	ASA/DIN for 1:1			ASA/DIN for 1:3		
Pan F	32	16	10½ min	32	16	13½ min
FP 4 (Roll/flat/35 mm)	100	21	9 min	100	21	13 min
HP4 (Roll/flat/35 mm)	320	26	12 min			**

**not recommended

REPLENISHMENT TECHNIQUE

When processing in deep tanks or machines, effective developer life is increased if Perceptol developer is replenished. Replenisher should be added at the following rates.

Tank Size	When to Add Replenisher	Amount of Developer to Be Removed	Amount of Replenisher to Be Added
2.5 litres	After every 6 films*	70 ml (2½ oz)	116 ml (4 oz)
1 gallon (4.5 litres)	After every 10 films*	120 ml (4¼ oz)	210 ml (7½ oz)
3 gallons (13.5 litres)	After every 30 films*	350 ml (12½ oz)	630 ml (22½ oz)
5 gallons (22.5 litres)	After every 50 films*	600 ml (21 oz)	1050 ml (37½ oz)
12 gallons (54 litres)	After every 120 films*	1400 ml (50 oz)	2520 ml (90 oz)

*One 120 rollfilm is the equivalent of one 36 exposure 35 mm film or one 8 X 10 inch sheet film.

ILFORD

The Compact Photo-Lab-Index

ILFORD BROMOPHEN DEVELOPER

DESCRIPTION AND USES

Bromophen is the standard Ilford universal-type developer in powder form; it replaces ID-20, ID-36 and PFP. It is a Phenidone hydroquinone formula with all the advantages that this provides, including long working life and high capacity.

Bromophen is particularly recommended for obtaining maximum quality from Ilfobrom and is suitable for roll, sheet films and plates when a high degree of enlargement is not necessary.

The versatility of Bromophen makes it suitable for a very wide range of applications—the stock solution made up from the powder may be diluted according to application, developing time and contrast desired.

WORKING STRENGTHS

For use, recommended rates of dilution for Bromophen stock solution are given below.

Sensitive Material	Dilution
Contact papers	1:1
Bromide papers for automatic printing	1:3
Rapid development of paper	1:1
Tray development of sheet films and plates	1:3
Tank development of sheet films and plates	1:7

DEVELOPMENT TIMES—PAPERS

The development times given below are in minutes and refer to development at 68 F (20 C)

Ilford Paper	Dilution	Time
Contact	1:1	¾-1
Ilfobrom	1:3	1½-2
Rollhead – Contact Type C	1:3	1½-2
For rapid development of papers		
Ilfobrom	1:1	1-1½
Rollhead – Contact Type C	1:1	1-1½

DEVELOPMENT TIMES—FILMS AND PLATES

The development times given for general purpose films are for two average contrasts \bar{G} and refer to intermittent agitation only. If negatives are to be printed using a tungsten enlarger they should be developed to a \bar{G} of 0.55. Similarly, negatives which are to be printed on a cold cathode enlarger should be developed to a \bar{G} of 0.70. If continuous agitation is to be used at a dilution of 1:7, these times should be reduced by one quarter.

General Purpose Materials	\bar{G} 0.55	\bar{G} 0.70
Sheet film		
HP4	4	7½
Roll film		
HP4	3	4½

(*Continued on following page*)

The Compact Photo-Lab-Index

The development times for Ilford specialized materials are given below for both continuous and intermittent agitation.

Ilford Material	Continuous Agitation (Dilution 1:3)	Intermittent Agitation (Dilution 1:7)
Sheet film		
Fine Grain Ordinary	1½	3
Commercial Ortho	3¾	7½
Plates		
N.30 Ordinary	1½	3
N.25 Soft Ordinary	2	4
Special Rapid	2	4
G.30 Chromatic	1½	3
Selochrome	2	4
R.25 FP Special Rapid Panchromatic	1½	3
R.10 Soft Gradation Panchromatic	3½	7
FP4	3	6
HP3	3¼	6½
Lantern plates		
Contact Lantern	¾	
Special Lantern, Soft and Normal	1¾	
Special Lantern, Contrasty	2½	
Diapositive, Normal	1¾	
Diapositive, Contrasty	2½	

Intermittent agitation—agitation for the first 10 seconds of development, then for 5 seconds every minute for the remainder of the development time.

ILFORD PQ UNIVERSAL DEVELOPER

DESCRIPTION AND USES

Ilford PQ Universal is primarily a paper developer which can also be used to develop sheet films and plates. It is a Phenidone hydroquinone developer supplied as a liquid concentrate which is diluted for use according to its application. Being Phenidone-based, PQ Universal has excellent keeping properties and is not easily exhausted.

WORKING STRENGTHS

For use, the concentrated solution should be diluted as given below.

Sensitive Material		Dilution
Enlarging and rollhead papers		1:9
Films and plates	in tray	1:9
	in tank	1:19
Contact papers		1:4
Lantern and diapositive plates		1:4

The Compact Photo-Lab-Index

DEVELOPMENT TIMES
Development times are given in minutes and refer to development at 68 F (20 C).

Ilford Paper	Development Time
Ilfobrom	1½-2

The development times given for general-purpose films are for two \bar{G} (average contrast) and refer to intermittent agitation only—that is, agitation for the first 10 seconds of development, then for 10 seconds every minute for the remainder of the development time. If negatives are to be printed using a tungsten enlarger, they should be developed to a \bar{G} of 0.55. Similarly, negatives which are to be printed on a cold cathode enlarger should be developed to a \bar{G} of 0.70. If continuous agitation is used, three-quarters of the development times stated should be given.

General-purpose Films	\bar{G} 0.55	\bar{G} 0.70
Sheet Film		
HP4	3½	6
FP4	3	4
Roll Film		
HP4	3½	6
FP4	3	4

DEVELOPMENT TIMES FOR SPECIALIZED FILMS
Recommended development times for specialized sheet films and plates are given for both intermittent and continuous agitation at a developer temperature of 68 F (20 C). These times can be varied by the user according to the processing conditions.

Ilford Material	Continuous Agitation	Intermittent Agitation
Sheet Film		
Fine Grain Ordinary	1½	3
Commercial Ortho	3¾	7½
Plates		
N.30 Ordinary	1½	3
N.25 Soft Ordinary	2	4
Special Rapid	2	4
G.30 Chromatic	1½	3
Selochrome	2	4
R.25 FP Special	1½	3
R.20 Special Rapid Panchromatic	2	4
R.10 Soft Gradation Panchromatic	3½	7
FP4	3	6
HP3	3¼	6½

ILFORD GRAPHIC ARTS MATERIALS

THE ILFORD GRAPHIC ARTS CODE

The films are coded as follows: —
The first letter indicates the color sensitivity: —
 B for blue-sensitive (i.e., sensitive to the blue end of the spectrum only)
 G for blue and green-sensitive (i.e., orthochromatic)
 R for blue, green and red-sensitive (i.e., panchromatic)
The first number represents the thickness of the base in thousands of an inch.
The letter E, when inserted immediately before the point, indicates that the film has a polyester base of exceptional dimensional stability.
The number after the point represents the contrast of the film: it does not give an exact quantitative indication, but a higher inherent contrast.
The plates are coded as follows: —
 The first letter indicates the color sensitivity in the same way as for the films.
 The number after the point indicates the inherent contrast in the same way as for the films.

FILMS AND PLATES FOR GRAPHIC ARTS
For Black and White Line Copy

ILFORD

 N.40 Process Plate
 N.50 Thin Film Halftone Plate
 Line Flat Films

FILMS AND PLATES
For Colored Line Copy

ILFORD

G.30	Chromatic Plate
G.50	Ortho Halftone Plate
R.40	Rapid Process Panchromatic Plate
R.52	Plate

FILMS AND PLATES
For Continuous Tone Colored Copy

ILFORD

 Selochrome Plate
 R.20 Special Rapid Panchromatic Plate

FILMS AND PLATES
For Continuous Tone Black and White Copy

ILFORD

 Special Rapid Plate
 N.30 Ordinary Plate
 Fine Grain Ordinary Flat Film
 Commercial Ortho Flat Film

ILFORD

The Compact Photo-Lab-Index

ILFORD GRAPHIC ARTS FILMS AND PLATES

Line Films N5.50, N4E.50

Slow, very fine grain, blue-sensitive, extremely high contrast. For making line and screen negatives and positives in the camera or by contact. Recommended where dot-etching methods of tone-and color-separation are employed. Sheet film or in rolls.

FINE GRAIN ORDINARY FILM N5.31

Blue-sensitive, medium speed and contrast with a long straight line region to the characteristic curve. The surfaces are treated to facilitate retouching and reduce the incidence of Newton's rings. Used for the preparation of continuous-tone negatives and positives, and for making masks for color and tone correction when reproducing reflection copy. Sheet film.

FORMOLITH SP4 FILMS G7E.74, G4E.74, G5.74, G3.74, G3.74D, G5.74D

Orthochromatic, extreme contrast. For the preparation of high quality line and screen negatives and positives in all photomechanical reproduction processes. Produces dots suitable for dot etching. Recommended for the production of line and screen positives by the bleach etch method of reversal development. Also for use in phototypesetting machines. G.74D Diaback films have a backing which allows exposures to be made through the base. Sheet films or rolls.

N.60 PHOTOMECHANICAL PLATE

Blue-sensitive, slow, extremely fine grain, very high contrast. For making line negatives in the camera, line and screen negatives and positives by contact and photogravure copy screens by contact.

THIN FILM HALF-TONE PLATES N.50

Blue-and blue-green sensitive, very fine grain, very high contrast. For making line and screen negatives and positives in the camera and by contact. Has a thin emulsion and can be processed very rapidly. M.50M has a matt emulsion for ease of retouching and N.50S a stripping emulsion; available on special order.

PROCESS PLATES N.40

Blue-sensitive, slow, very fine grain, medium to high contrast. For continuous-tone work when negatives and positives of high contrast are required and when positives have to be made from low contrast negatives. N.40M has a matt emulsion for ease of retouching and N.40S a stripping emulsion; available on special order.

ORDINARY PLATES N.30

Blue-sensitive, medium speed, fine grain, medium to high contrast. For the making of negatives and positives for photogravure.

N.25 SOFT ORDINARY PLATE

Blue-sensitive, medium speed, fine grain, medium to high contrast. For making negatives and positives for photogravure when a softer result than that given by Ordinary plates is required.

G.72 FORMOLITH ORTHO

Orthochromatic, very high resolution, extreme contrast. For making line and screen negatives and positives in the camera and by contact for letterpress, photolithography and silk screen processes. Recommended for the production of positives by reversal development.

G.50 ORTHO HALF TONE PLATE

Orthochromatic, slow, very fine grain, extremely high contrast. For making line and screen negatives and positives in the camera and by contact.

The Compact Photo-Lab-Index

G.30 CHROMATIC PLATE

Orthochromatic, medium speed, fine grain, medium to high contrast. For the preparation of negatives for indirect blockmaking and photogravure.

R.52 PLATE

Panchromatic, slow, fine grain, very high contrast. For making line and screen color separation negatives for blockmaking and photolithography and for making line and screen monochrome negatives from colored and tinted originals. Produces dots suitable for dot-etching. Has a thin pre-hardened emulsion and may be processed very rapidly. Produces dots suitable for dot-etching.

R.40 RAPID PROCESS PANCHROMATIC PLATE

Medium-speed, fine grain, high contrast. For making color separation screen negatives; used in photolithography where a fully exposed type of negative is required and sharpness of dot is not of primary importance; for making monochrome line and screen negatives from colored and tinted originals; for making continuous-tone color-separation negatives when it is necessary to increase the contrast of the original.

R.30 TRICHOME PLATES

Panchromatic, fast, medium to high contrast. For making continuous-tone color separation negatives for all processes, by direct separation from colored originals or by working from transparencies.

SPECIAL RAPID PANCHROMATIC PLATE R.20

Medium speed, fine grain, medium to high contrast. For making color separation negatives from color originals for blockmaking and photogravure.

SOFT GRADATION PANCHROMATIC PLATES R.10

Fast medium contrast, medium grain. For continuous-tone separation for color photogravure.

The Compact Photo-Lab-Index

ILFORD MATERIALS FOR SCIENTIFIC WORK

SELECTION OF MATERIAL

It is recommended that photographic material for scientific work be selected by reference to the following considerations, taken in the order give:
- a) nature of radiation to be recorded,
- b) sensitivity and contrast required,
- c) duration of exposure,
- d) special grain requirements, if any,
- e) need for special techniques at the exposing or processing stages,
- f) factors limiting the physical form of the material.

NATURE OF RADIATION TO BE RECORDED

This may be visible radiation or some other form such as x-rays or atomic particles. Photographic materials for recording visible radiation may be classified in three main groups according to their special sensitivity as follows:

Group	Spectral Sensitivity
Non-color-sensitive (ordinary)	Blue and shorter wavelengths
Orthochromatic	Green and shorter wavelengths
Panchromatic	Red and shorter wavelengths

Not all the materials in one spectral grouping have exactly the same spectral range of sensitivity.

To avoid the need for unduly dim safelights, materials sensitive to the longer-wave region of the visible spectrum should not be chosen unless sensitivity is needed in such regions: in an obvious example, if the problem involves the recording of U.V. spectra, panchromatic emulsions should be avoided as they offer no advantage in sensitivity over non-color-sensitized materials.

Special materials are available for recording other than visible or near-visible radiation.

SENSITIVITY AND CONTRAST

Having selected the material according to the radiation to be recorded, the relative sensitivity level (speed) and contrast should next be considered. If only a 'two-tone' record is desired, as when copying a line diagram, the highest contrast consistent with adequate sensitivity should be chosen. Materials of lower contrast are needed for continuous-tone records, or for records which may contain a range of intensities, as in spectrography, or of exposure times, as in some oscillograph recording. As a general guide, higher sensitivity is associated with lower contrast, though exceptions will be found. It is not possible to combine maximum speed with maximum contrast, or with extremely low graininess.

DURATION OF EXPOSURE

All emulsions exhibit to some degree the phenomenon known as 'reciprocity failure'. This phenomenon is frequently referred to as 'i.t. failure', since it related to the failure of the emulsion to give the same photographic effect when illumination (i) and time (t) are varied proportionately.

Materials most suitable for snapshot exposures of the order of 1/1000 second, are generally not so fast when exposure times are of less than about 1/1000 second or more than about one second. In a great deal of ordinary photography there is no need to pay much attention to this factor, but in work where maximum speed is desirable with exposures of unusually long or short duration reciprocity failure must be taken into account. There are in the Ilford range several plates whose degree of reciprocity failure is small at one or other extreme of exposure time.

(*Continued on following page*)

SPECIAL GRAIN REQUIREMENTS

The grain of photographic materials influences both the appearance and the resolution of detail of photographs taken with them. Unless the photographic record is to be enlarged 10 diameters or more, the graininess of the developed image can usually be ignored in scientific work. Graininess is occasionally a dominant factor, however, as in graticule work. Adequate fineness of grain can then be secured only, as a rule, at the cost of reduced sensitivity.

RESOLVING POWER
Of Materials Used for Reproduction

The resolving power of a given emulsion is its ability to separate closely spaced points in the image—on resolving power depends the ability to obtain fine detail. Therefore the resolving power of a material is generally given as the number of lines per millimeter which can be distinguished as individual lines. Thus a pattern of lines spaced 1/100 of a millimeter apart, photographed on a film having resolving power of 50 lines per millimeter, will not be imaged as separate lines but as a uniformly gray patch.

Since the resolving power of a good lens is well above that of the finest film emulsions available at present, it is obvious that the detail visible in the copy will be a function of the film in question.

SPECIAL TECHNIQUES

Generally the sensitive material is exposed without special pre-treatment and is processed, after exposure, in conventional processing baths. Sometimes, however, pretreatment of the material may be desirable or there may be need for special processing conditions. Such variations from ordinary practice include the following techniques.

a) Prior treatment of the emulsion surface with a fluorescent material—required when ordinary materials are used to record short-wave ultra violet radiation.

b) Prior hypersensitization of the material by exposure to mercury vapour or by bathing methods; or supplementary pre- or post-exposure, or techniques with the same object in view.

c) Prior bathing of the material in a solution of a desensitizing dye.

d) Special rapid processing techniques—useful in some cases of oscillograph recording.

BASE MATERIALS

The materials in general use as supports for photographic emulsion are glass, plastic film and paper.

Glass

Emulsions coated on glass are widely used for scientific work. The greatest advantages of this form of base are rigidity and dimensional stability.

Film

Film base is usually cellulose acetate or polyester. Polyester-based films have considerably greater dimensional stability than those on acetate base. With flat (sheet) film there is sometimes a choice of thickness.

Paper

Paper is generally employed as a support for print making materials (e.g. materials for making positives). Paper-based materials are only occasionally used for the original exposure.

Special emulsions required in limited quantities are coated on glass because manufacturing problems generally prohibit the use of film or paper for small quantities.

(*Continued on following page*)

ILFORD

The Compact Photo-Lab-Index

ILFORD CODES

Many Ilford products are designated by codes instead of, or in addition to, names. In the case of films and plates primarily intended for use in the graphic arts and also in the case of recording films, a letter is used to indicate the color sensitivity of the material as follows:

R indicates sensitivity to red, green, blue and ultra-violet radiation (a panchromatic material).

G indicates sensitivity to green, blue and ultra-violet radiation (an ortho-chromatic material).

B or N indicates sensitivity to blue and ultra-violet radiation (a blue-sensitive material).

The base thickness of films is indicated by a figure which is equal to the thickness in thousandths of an inch. A number indicating contrast, in the case of graphic arts materials, is included in the codes of films and plates. This number does not give a quantitive indication, but a higher number does indicate a higher inherent contrast or speed.

Graphic arts films

The sensitivity code letter comes first, followed by the figure indicating the thickness of the base. This is followed by a point after which is the number indicating the order of contrast. A film that is coated on a polyester base has the letter E immediately before the point and one with matt emulsion has the letter M at the end of the code.

For example, G4E.72 is orthochromatic, has a 4/1000 inch polyester base and has extremely high inherent contrast. N5.31M is blue-sensitive, has a 5/1000 inch base, medium to high contrast and a matt backing.

Graphic arts plates

The sensitivity code letter comes first, followed by a point, followed by the number indicating the order of contrast. A plate having a matt emulsion has the letter M at the end of the code.

For example R20M is panchromatic, with medium contrast and a matt emulsion.

Recording Films

The order is base thickness followed by color sensitivity followed by speed. For example, 5R61 has a 5/1000 inch base, is panchromatic and is of medium speed.

ANALYSIS OF MATERIALS

Materials have been grouped in seven sections as indicated below.

SECTION 1

Materials for recording wavelengths less than 2000 A and charged particles. Excludes X-ray materials.

SECTION 2

Films for recording gamma–rays and X-rays.

SECTION 3

Films and plates sensitive to blue and ultra-violet radiation.

SECTION 4

Films and plates sensitive to green, blue and ultra-violet radiation.

SECTION 5

Films and plates sensitive to red, green, blue and ultra-violet radiation.

SECTION 6

Plates sensitive to infra-red and other radiation.

(*Continued on following page*)

The Compact Photo-Lab-Index

SECTION 7

Papers.

In general, within each spectral grouping, the materials are listed in order of speed with the slowest first. It should be noted that the speed, contrast and grain descriptions are in very general terms; for further information reference should be made to the Technical Information Sheet specific to the material.

Papers cannot be classified in the same way as films and plates. They are therefore listed together in Section 7 in order of speed with the slowest at the top. Color materials have been excluded from the analysis.

SECTION 1

Ilford materials for recording wavelengths less than 2000 Å and charged particles. Excludes X-ray materials.

Q Plates

For recording radiation of low penetrating power such as (a) positive ions in mass spectrography (b) electromagnetic radiation from very soft X-rays of a few angström units to ultra-violet up to about 2000 Å.

No. 60 Photomechanical Plate

An extremely high contrast plate for use in electron micrography.

Rapid Process (Experimental) Plate

A high contrast plate giving very high speed when used for electron micrography.

Nuclear Research Emulsions Types G.5, K.5 and L.4

The most commonly used emulsion for nuclear track recording. Sensitive to charged particles of any energy.

Type K.2

Sensitive to protons to approximately 80 MeV.

Type K.1

Records protons to about 7 MeV. Particularly valuable when particles of low energy have to be recorded in a gamma-ray background.

Type K.0

Most suitable for alpha-particles and protons of less than 5 MeV.

SECTION 2

Ilford X-ray films

For use with or without salt intensifying screens (speeds assessed using screens)

Read Seal X-ray Film	Very fast, medium contrast
Rapid R Film	Extra fast, medium contrast

For use without salt intensifying screens

Industrial G X-ray Film

The Compact Photo-Lab-Index

SECTION 3—Ilford films and plates sensitive to blue and ultra-violet radiation

FILMS	Sensitivity Range (A)	Speed	Contrast	Grain
N5.50, N4E.50 Line Films	2300-5200	slow	very high	very fine
Fine Grain Safety Positive Film	2300-5200	slow	high	very fine
Track Chamber Film	2300-5100	medium	medium	very fine
N5.31 Fine Grain Ordinary Series 3 Films	2300-5200	medium	medium	fine
PLATES				
Contact Lantern Plate	2300-4000	very slow	very high	very fine
High Resolution Plate*	2300-4000 and 4400-5300	very slow	very high	very fine
N.60 Photo-mechanical Plate	2300-4500	very slow	very high	very fine
EM-6**	2300-4500	very slow	very high	very fine
Maximum Resolution	2300-5100	very slow	extremely high	extremely fine
N.50 Thin Film Half-Tone Plate	2300-5300	slow	very high	very fine
EM-5**	2300-5300	slow	very high	very fine
N.40 Process Plates	2300-5200	slow	high	very fine
EM4**	2300-5200	slow	high	very fine
Diapositive Plates- contrasty	2300-5200	slow	high	very fine
medium	2300-5200	slow	medium to high	very fine

*laboratory product made to special order only.

**Electron Microscope Plates.

(*Continued on following page*)

ILFORD

553

Section 3 continued

PLATES	Sensitivity Range (A)	Speed	Contrast	Grain
Special Lantern Plates—				
contrasty	2300-5200	slow	high	very fine
normal	2300-5200	slow	medium to high	very fine
soft	2300-5200	slow	medium	fine
N.30 Ordinary Plate	2300-5200	medium	medium to high	fine
N.25 Soft Ordinary Plate	2300-5200	medium	medium	fine
Special Rapid Plate	2300-5200	medium	high	fine
Rapid Process (Experimental) Plate*	2300-5200	medium	high	fine
Zenith Plate*	2300-5200	medium	medium	medium
Zenith Astronomical Plate*	2300-5200	medium***	medium	medium
LN Plate*	2300-5200	fast	medium	medium

*laboratory product made to order only.

**Electron Microscope Plates.

***this plate retains most of its speed when exposure times are very long.

The Compact Photo-Lab-Index

SECTION 4—Ilford Films and plates sensitive to green, blue and ultra-violet radiation

FILMS	Sensitivity Range (A)	Speed	Contrast	Grain
G5.74, G7E.74, G3.74 and G4E.74 Formolith Ortho Films	2300-5900	slow	extremely high	very fine
IN5 Ilfoline	2300-5800	slow	extremely high	very fine
Commercial Ortho Film	2300-5900	medium	medium	medium
5G.91 Recording Film	2300-5900	very fast	high	medium
PLATES				
G.72 Formolith Plate	2300-5900	slow	extremely high	very fine
G.50 Ortho Half-tone Plate	2300-6000	slow	very high	very fine
G.30 Chromatic Plate	2300-5800	medium	medium to high	fine
Selochrome Plate	2300-5800	fast*	medium	medium

*this plate retains most of its speed when exposure times are very short.

ILFORD

The Compact Photo-Lab-Index

SECTION 5–Ilford films and plates sensitive to red, green, blue and ultra-violet radiation (panchromatic)

FILMS	Sensitivity Range (A)	Speed	Contrast	Grain
Micro-neg Pan Film	2300-6600	slow	very high	extremely fine
Pan F Film	2300-6700	medium	medium to high	very fine
FP4 Film	2300-6700	medium	medium	very fine
Aerial A Film	2300-6700	fast	high	fine
HP4 Film	2300-6700	very fast	medium	medium
PLATES				
R.52	2300-6600	slow	very high	very fine
R.40 Rapid Process Panchromatic Plate	2300-6700	medium	high	fine
R.20 Special Rapid Panchromatic Plate	2300-6500	medium	medium	fine
R.10 Soft Gradation Pan Plate	2300-6500	fast	medium	medium
FP4 Plate	2300-6600	fast	medium	fine
R.30 and R.30M Trichrome Plates	2300-6600	fast	medium to high	medium
Astra III Plate*	2300-7100	fast**	medium	medium
HP3 Plates	2300-6700	very fast***	medium	medium
Holographic Plate HeNe*	2300-6700	very slow	very high	extremely fine

*laboratory product made to order only.

**This plate retains most of its speed when exposure times are very long

***This plate retains most of its speed when exposure times are very short.

ILFORD

556

The Compact Photo-Lab-Index

SECTION 6—Ilford plates sensitive to infra-red and other wavelengths

PLATES	Sensitivity Range (A)	Speed	Contrast	Grain
Infra-red Process Plate*	2300-5200 and 7400-8800	slow	high	very fine
Long-range-spectrum Plate*	2300-8800	medium	high	fine
RL Plate	2300-7400	very fast	medium	medium

SECTION 7—Ilford papers

	COLOR SENSITIVITY	RELATIVE EXPOSURE***
CS Ilfoprint Contact Paper**		
DS Ilfoprint Contact Document Paper**		
Kenprint S Paper	blue-sensitive	20
LR Ilfoprint Projection Paper	blue-sensitive	5
R Ilfoprint Paper	blue-sensitive	5
DR Ilfoprint Projection Document Paper	blue-sensitive	5
Ilfobrom Paper	blue-sensitive	5
NS Recording Paper	blue-sensitive	¼

*laboratory product made to order only.
**these papers are specially designed for exposure to high intensity light sources.
***to tungsten light.

ILFORD

557

ILFORD PHOTOGRAPHIC EMULSIONS FOR NUCLEAR RESEARCH

TYPE OF EMULSION

Ilford Nuclear Research Emulsions are available in three distinct types of which the mean crystal diameters are:

G 0.27μ
K 0.20μ
L 0.14μ

The range of sensitivities is as follows:

Sensitive to all charged particles of any energy G.5 K.5 L.4

Less strongly sensitized recording protons to about 80 MeV (β =0.4). Slow electrons produce tracks of a few grains only K.2

Records protons to about 7 MeV (β =0.12) K.1

Records protons to 5 MeV (β =0.1). Records thorium α−particles as nearly continuous tracks K.0

Special Emulsions

In addition to the above, the following emulsions are generally available.

Diluted Emulsions: G.5, K.2 and K.5 emulsions with two or four times the normal gelatin/silver ratio.

Loaded Emulsions: K.1 and K.2 emulsions loaded with 16 mg of lithium or 23 mg of boron per ml. Separated isotopes may be used by special arrangement at the customer's risk.

Emulsion with Extra Plasticizer: for use in vacuum or under very dry conditions, G.5 and the K series are supplied to order with extra plasticizer.

Availability

Ilford Nuclear Research emulsions are available as plates or as emulsion film without support, i.e. 'pellicles'. In both forms, standard emulsion thicknesses are 100μ, 200μ, 400μ, 600μ, $1,000\mu$ and $1,200\mu$. 10μ and 50μ plates are also available. Emulsion thickness is liable to vary by up to 10 per cent.

All unloaded emulsions are also supplied in gel form. For plates, the standard thickness of glass is 1.25 to 1.4 mm, but glass of other thicknesses may generally be used if specified. 'Glass treated for emulsion support' is available, which is equally suitable for mounting emulsion films for processing, and for use with emulsion in gel form.

On request, sheets of emulsion film are supplied as a 'stack', firmly bound between end-plates of perspex or glass by means of adhesive tape. Unless special instructions are received, the emulsion sheets are interleaved with approximately 25μ thick tissue.

Whenever possible the dimensions of plates or emulsion films should be in numbers of whole inches. For many experiments involving low energies, 1 X 3 inch plates are convenient.

Ordering

It would be impracticable and generally undesirable to maintain large stocks of nuclear emulsions, so immediate delivery cannot generally be made. Batches of the three emulsions in greatest demand, G.5, K.2 and K.5 (except in 10μ thickness) are produced at frequent intervals and delivery of small quantities is generally made within two to three weeks. Larger orders for these emulsions may require special production arrangements and should be placed in good time.

Batches of the other emulsions (and all emulsions in 10μ thickness) are subject to rather longer delivery delays, averaging 3-5 weeks.

(*Continued on following page*)

The Compact Photo-Lab-Index

Storage

Nuclear emulsions should be kept in a cool, dry place until they are used (10 C and 50 per cent relative humidity are ideal conditions). Emulsion in gel form deteriorates at temperatures appreciably above 5 C, and should be kept in refrigerated storage without freezing.

The useful life of nuclear emulsion, particularly if sensitive to minimum ionization, is usually determined by the exposure it receives through cosmic radiation and local radioactivity, and the amount of background that can be tolerated in the particular application.

After exposure, latent image fading should be avoided as far as possible. This is progressively more severe in the order G.5, K.5, and L.4. Where development takes place shortly after exposure, latent image regression should not present any problems. If a delay is likely between exposure and processing the emulsion should ideally be stored at a temperature of 5 to 10 C with a 50 per cent relative humidity.

Application

Nuclear Physics

Much of the pioneering work in the high energy field leading to the discovery of the π-meson, the π-μ meson decay, and the heavy particles in cosmic radiation was done with Ilford C.2 emulsion, now replaced by K.2. This emulsion was also used for the first detection of mesons produced in the laboratory. Its modern equivalent, K.2, is still widely used in low energy nuclear physics as, for example, in the detection of neutrons through knock-on protons. Other emulsions in the series should be selected for use according to the particles being studied and the discrimination required.

Ilford G.5, K.5 and L.4 emulsions have been used in all fields of high energy nuclear physics, in work with cosmic radiation at high altitudes, and with high energy machines. Charged K-mesons, hyperons and excited nuclear fragments were discovered in G.5, which was also used for the recording of 'complete' heavy meson decays, and for the study of the unstable heavy particles produced in very powerful machines. The first photographs of the antiprotons were also obtained in the G.5 emulsion.

The heavy primaries of cosmic radiation have been examined by the technique of delta-ray counting, K.5 and L.4 being available when finer grain is desired. The less sensitive emulsions may be used to give unblocked tracks with strongly ionizing particles such as cosmic ray heavy primaries.

REFERENCES

C. F. Powell, P. H. Fowler and D. H. Perkins, The Study of Elementary Particles by the Photographic Method, Pergamon Press, 1959.

Walker H. Barkas, Nuclear Research Emulsions, Academic Press, 1963.

AUTORADIOGRAPHY

The special needs of workers in medical and biological research using radioactive nuclides, and in mineralogical research, may be met from this emulsion series. When individual β-particle tracks are required to give the highest possible resolution an electron-sensitive emulsion must be used.

For tritium studies, in which the electrons have very low energy, K.2 may give the best discrimination, while C14 demands the use of K.5 or G.5. The choice of emulsion will always depend on the radioactivity being studied, and the discrimination required.

Emulsion is available as plates, pellicles and in gel form or as 4-3/4 X 6-1/2 inch (120 X 165 mm) stripping plates, either with a 50μ or a 5μ layer of emulsion on a 10μ plain gelatin support. When using stripping plates small pieces of the emulsion (or emulsion and gelatin) are cut to the appropriate size and stripped off the glass support as required.

For details of the varied techniques in autoradiography refer to:

G. A. Boyd, Autoradiography in Biology and Medicine, Academic Press, New York, 1955.

A. W. Rogers, Techniques of Autoradiography, Elsevier Publishing Co, 1967.

ILFORD

The Compact Photo-Lab-Index

COMPOSITION

The composition of a nuclear emulsion is liable to vary from batch to batch. It is also affected by the prevailing humidity.

The following figures show the mean composition of 40 batches of G.5 emulsion in g per ml, in equilibrium with air at 58 per cent relative humidity at normal room temperature.

Ag	1.817	±	0.029
Br	1.388	±	0.020
I	0.0120	±	0.0002
C	0.277	±	0.006
H	0.0534	±	0.0012
O	0.249	±	0.005
N	0.074	±	0.002
S	0.0072	±	0.0002
Density	3.8278	±	0.0354

The limits quoted are the batch variation at two standard deviations. These figures also apply to the other emulsions of the G, K and L series.

The mean density and composition at other humidities may be derived from the following table. This shows the gain or loss of weight and volume of 1 ml of emulsion at 58 per cent R.H. when it is brought into equilibrium with air at other humidities.

per cent R.H.-	mg/cc	$ccX10^{-3}/ml$†
0*	− 85	−72
15	− 69	−58
32	− 45	−38
58	0	0
72	+ 43	+36
84	+112	+95

*Over concentrated sulphuric acid.

†Throughout the range of conditions between relative humidities of 15 per cent and 84 per cent, 1 g of water taken up by the emulsion occupies 0.84(c)ml.

The above figures will not vary by more than ± 2 per cent in respect of batch-to-batch variations.

PROCESSING

Ilford Nuclear Research Emulsions are non-color-sensitive and may conveniently be handled in an orange safelight. Ilford S Safelight (No. 902) is recommended for general darkroom illumination and Ilford F Safelight (No. 904) for direct illumination. Although these emulsions are not readily fogged in the darkroom, caution is necessary as the times involved in handling are often long. Emulsion should not be exposed to light other than safelight illumination until fixation is complete.

No single procedure has been established for processing Ilford Nuclear Research Emulsions as each group of workers employs a technique which best suits its working conditions and experimental aims.

Since nuclear emulsions are most often used in layers much thicker than those of normal photographic materials, special precautions are generally needed to obtain uniform development throughout the layer. In general, development occurring while the developer is diffusing into the emulsion must be negligible compared with the total development. With layers 100μ thick or less this result may be achieved by using a dilute developer, with or without a preliminary soaking in water.

50μ plates may be developed for 5 to 20 minutes in ID-19 or Ilford PHEN-X developer diluted with an equal volume of water, at 23 C.

Five minutes development is adequate for the less sensitive emulsions used, for example, to detect α-particles from radioactivity. Fifteen minutes is suggested for G.5.

The plates are then rinsed in water, fixed for 50 per cent longer than the clearing time, washed for 15 minutes and dried.

The following procedure has occasionally been used for developing 100μ layers by Ilford Limited.

(Continued on following page)

1. Soak in distilled water for 20 minutes at 20 C.
2. Develop in ID-19, or PHEN-X diluted 1 + 9 at 20 C using continuous agitation such as mechanical rocking. For G.5 develop 60 to 70 minutes; for K.2, K.1, etc, 15 to 35 minutes.

ID-19	
Metol	2.2g
Sodium sulphite, anhyd	72 g
Hydroquinone	8.8g
Sodium carbonate, anhyd	48 g
Potassium bromide	4 g
Water to make	1 litre

Alternatively, Ilford Phen-X Developer, supplied as a packed chemical, may be used. Development times are the same as for ID-19.
3. Transfer to 1 per cent acetic acid stop-bath at 20 C for 10 minutes, and while the emulsion is in this bath, remove surface fog by gently rubbing with cotton wool.
4. Fix in 30 per cent plain hypo (2 hours with agitation).
5. Wash for 4 hours in running water.

For emulsion layers thicker than 100μ on which quantitative work is to be carried out, the 'temperature cycle' method of development of Dilworth, Occhialini and Payne is most frequently employed. By this method the developer is cooled to a temperature at which it is virtually inactive. The emulsion is then immersed in the developer until such time as the developer has penetrated the emulsion. The plate is then removed from the developer and allowed to reach the required development temperature. It is maintained at this temperature until development has been completed. For emulsion layers thicker than 200μ a neutral amidol developer should be used as first suggested by Dilworth, Occhialini and Vermaesen. Even for thin emulsion layers (100μ and less) temperature cycle development in amidol gives better discrimination between tracks and the background for both thin and thick emulsion layers. The following procedure is suggested for developing 100μ and 200μ G.5, K.5 and L.4 emulsions.
1. Soak the emulsion in distilled water for 30 minutes (100μ) or 50 minutes (200μ) beginning at 20 C and cooling to 5 C.
2. Soak in 'Brussels amidol' developer for 50 minutes at 5 C.

Brussels amidol developer	
Sodium sulphite, anhyd	18 g
Potassium bromide	0.8g
Amidol	4.5g
Boric acid	35 g
Water to make	1 litre

Remove plates from developer and remove surface liquid by blotting with filter paper.
3. Warm plates for 50 minutes at 25 C.
They may be warmed by placing them in a stainless steel dish maintained at the required temperature by a surrounding water bath. Another convenient apparatus consists of a narrow horizontal chamber entering the side of a thermostatically controlled water bath; into this slides a stainless steel drawer carrying the plates soaked in developer.
4. Transfer to stop bath of 1 per cent acetic acid and leave for 30 minutes (100μ) or 50 minutes (200μ). During this time remove surface fog gently as previously described.
5. Rinse and transfer to 30 per cent plain hypo for 2 hours (100μ) or 5 hours (200μ).
6. Wash in running water for 4 hours (100μ) or 8 hours (200μ). For 200μ layers, soak for 30 minutes in 1 per cent glycerol before drying horizontally in a gentle current of clean air.

ILFORD DARKROOM SAFELIGHT FILTERS

Safelight Number	Name	Color	For use with
900	BR	Bright Red	Slow orthochromatic materials. Formolith etc.
902	S	Light Brown	Slow, blue-sensitive materials, including Ilfobrom, Ilfoprint Projection and Ilfoprint Projection Document papers.
903	Infra red	Yellow-green	Infra-red plates which are not sensitive to green.
904	F	Dark brown	Process Films, Process Plates, Special Lantern Plates, and other fast blue-sensitive materials.
906	Iso	Dark red	Orthochromatic materials.
907	G	Dark green	Very slow panchromatic plates and films.
908	GB	Very Dark Green	All panchromatic plates and films except the very slowest. Although designed for the maximum possible efficiency this safelight must be used with extreme care. Hypersensitive materials must not be exposed to its direct light for any appreciable length of time.
909	Bright	Green	Desensitised panchromatic films and plates.
910	VS 2	Orange	Contact Lantern plates and other very slow blue-sensitive materials.
914	NX	Sepia	X-ray Films. Not suitable for use with color-sensitive materials.

ILFORD

ILFORD DARKROOM LAMPS

Darkroom Lamp	Safelight Size (in inches)	Type	Bulb
No. 2 A lamp of pyramid form held by a stirrup so that it can be locked in any position. For ceiling, wall, shelf or bench fixing.	8×10	With diffuser	For direct illumination: 15-watt For reflected illumination: 25-watt
No. 4 For wall or bench use. The frame holding the safelight filter can be swung upwards to reveal an illuminated glass panel for negative examination. The safelight panel is indirectly lit.	8×10	No diffuser	25-watt or 40-watt
No. 7 For ceiling suspension. Two safelights, an upper and a lower, provide reflected and direct illumination at the same time.	Upper: 10×12 Lower: 8×10	No diffuser With diffuser	15-watt or 25-watt
No. 8 For wall mounting. May be fixed with safelight screen horizontal or inclined.	8×10	With diffuser	15-watt or 25-watt
Junior A smaller version of No. 8 Darkroom Lamp.	5×7	With diffuser	15-watt or 25-watt

ILFORD

INTRODUCTION TO THE POLAROID SECTION

This section covers the products of a single manufacturer; it differs from all other sections of the Photo-Lab-Index in that it explains not only the use of the various sensitized materials, but also of certain items of equipment. The reason for this departure from Photo-Lab-Index policy should be obvious; these materials and the cameras or film holders in which they are used are all part of a single integrated system; one cannot be used without the other.

In setting up such a new system, a manufacturer has several areas of freedom; it is not always necessary for him to follow conventional procedures when the material itself is highly unconventional. Thus, the first Polaroid camera introduced the idea of cross-coupling the lens aperture and shutter-speed controls, and assigning a single number to each combination. This was the forerunner of today's EVS system, and worked in exactly the same way—only the numerical values were different. More recent models of the Polaroid camera utilize the now-standard EVS values. Tables are given in this section for comparison of both these systems with the conventional f/stop-shutter speed combinations.

Likewise, as long as a single-number exposure system is used, it is not really necessary to know the speed of the film in conventional terms. However, there are certain models of Polaroid cameras with conventional lens and shutter combinations; in addition, a 4 x 5 packet is available for the use of Polaroid materials with standard press and view cameras. In such cases, it is necessary to know the film speed for exposure determination, and tables of speeds for meters calibrated in ASA Exposure Indexes are given in this chapter.

This section is not intended to serve as a catalog of Polaroid products, and only the data for Polaroid sensitized materials will be kept up to date as far as possible. Such items of equipment as are listed are not necessarily current; in fact, most listings will remain as long as there is any likelihood that the item in question is in the hands of users who may require numerical data to use it. For instructions for the use of current items of equipment or information on availability of such items, see your dealer or write Polaroid Corporation, Cambridge, Massachusetts 02139. Polaroid offers a toll-free number, Monday through Friday, 9 a.m.-8 p.m. Eastern Time. For product information or technical assistance, dial (800) 225-1618.

FACTS COMMON TO ALL POLAROID LAND FILMS

DEVELOPMENT TIME

Recommended development time depends on two things: 1) the type of film being used, and 2) the temperature of the film and/or camera during processing. It is therefore not only important to check the film instructions for development times for that type material, but also to be alert to the temperature of the film/camera combination at the time you use it. This is especially true of color film because correct color balance depends on correct development time, which in turn depends on the temperature of the film/camera. With black-and-white film types producing paper prints, development time can be used to control somewhat the contrast of the picture—longer development times increasing contrast.

Low temperatures affect the development of all film types by slowing it down. With roll and 4 x 5 color film, pictures should not be processed if camera and/or film are 60° F or less, and this temperature may be reached in as litle as 20 minutes when the camera and film are exposed to very cold weather. At temperatures below 65° F, Type 668 or 108 color pack pictures should be developed in the No. 193 Cold-clip.

Providing development time instructions are following, black-and-white pictures can be made when the processing temperature is just above-freezing. If the camera is very cold, or when using it outdoors in very cold weather, it should be carried inside your jacket or coat so that normal body heat will keep the pods of reagent from freezing.

(*Continued on following page*)

564

Underdevelopment with black-and-white materials will produce faint, gray, dull pictures with little or no contrast. Underdeveloped color pictures have brownish-pink color tones.

Severe overdevelopment should likewise be avoided. With black-and-white materials, it can spoil picture quality and lead to damage when the print coater is used. With color film, overdevelopment will produce pictures which are too green or blue in over-all color tone.

EXPIRATION DATE

Each individual roll and box of film carries a definite date stamped on the box, and this date allows a wide margin of safety (several months from date of manufacture). The film will probably produce satisfactory pictures for some time beyond this date, but age may adversely affect performance under certain conditions. It is for this reason that the replacement guarantee does not apply to outdated film. A partially used roll may remain in the camera until the time of its expiration date and still be used successfully, provided the camera is not stored in hot or humid areas.

STORAGE AND THE EFFECTS OF TEMPERATURE

All sentized photographic materials are perishable and can be damaged by high temperature and high relative humidity. Care should be taken to handle and store the film as recommended below, with as much protection as possible against heat and moisture and away from X-rays, radioactive materials and chemical fumes.

Film can be safely carried and shipped in baggage sections of airplanes provided they are pressurized. If not, film should be carried in hand luggage into cabin of plane. Film should not be removed from its box or foil wrap until just prior to use, nor should it be tightly squeezed into luggage since this may physically damage its components.

Polaroid film wrappers will provide ample protection to withstand, through the expiration date printed on the box, normal handling in the humidities encountered in most places in the U.S.A. This wrapper does not provide protection against heat and therefore Polaroid film should not be stored or left near radiators, hot pipes or in unventilated areas where the temperature may climb. The glove compartment, trunk, and rear deck of automobiles may reach very high temperatures (in excess of 200° F) in the hot sun. Excessive heat may damage the film, resulting in fogged or flat, gray pictures, or a collection of developing agents on the positive print.

It is good practice to store your unopened picture rolls in the refrigerator. Whenever possible, store the film under these conditions:

For storage up to 2 months, keep temperature below 70° F.

For storage up to 6 months, keep temperature below 55° F.

For storage up to 9 months, keep temperature below 50° F.

Generally speaking, there is no low temperature limit for storing Polaroid Land film, and this means that it can be frozen (or stored in a deep-freeze) for long periods of time. However, before film that has been stored below 60° F is used, it must be brought back to room temperature before the foil wrapper is opened. While cold storage and freezing retard or suspend the effects of age, the film guarantee applies to the date stamped on the side of the film box. Cold storage does not extend the guarantee beyond the printed expiration date, although such storage may well lengthen the useful life of the film.

PROTECTION AFTER OPENING

Once the moisture vapor-barrier wrapper is opened, the picture roll loses its protection against moisture. Under humid or high-temperature conditions, use the film as soon as practicable and do not allow it to remain in the camera longer than necessary. On long trips through high-temperature regions, an insulated container will provide protection to your camera and film.

(*Continued on following page*)

POLAROID

565

4 x 5 film packets can be damaged by exposure to humidity over 75% R.H. at 70° F or above. Type 58 color film is especially affected by heat and should always be kept under refrigeration until needed. To provide humidity protection, each box of 4 x 5 packets includes a polyethylene bag. After removing the foil wrap from the box, the tray of packets should be immediately inserted in the bag and the end of the bag folded over several times to seal out moisture. When humidity is high, packets should be developed within 15 minutes after removing them from the polyethylene bag.

Once the protective wrapper is removed, care should be taken to keep the film away from formaldehyde, industrial gases, motor exhausts, solvents, mercury and radiation in any form.

POLAROID EXPOSURE VALUES

AND CORRESPONDING APERTURE AND SHUTTER VALUES

The unique design of the lens and shutter system of certain Polaroid cameras makes it possible for one adjustment to determine both the proper size of the lens opening and the time the shutter stays open. Speed and aperture combinations which correspond to the shutter numbers on various camera models are shown in the table below.

CAMERA MODEL

Shutter No.*	E.V.	80	95	95A, 95B, 700 150, 160, 800	850 & 900
1	10	—	1/8 @f/11	1/12 @f/8.8	1/12 @f/8.8
2	11	1/25 @f/8.8	1/15@f/11	1/25 @f/8.8	1/25 @f/8.8
3	12	1/25 @f/12.5	1/30@f/11	1/50 @f/8.8	1/50 @f/8.8
4	13	1/100@f/8.8	1/60@f/11	1/100@f/8.8	1/50 @f/12.5
5	14	1/100@f/12.5	1/60@f/16	1/100@f/12.5	1/50 @f/17.5
6	15	1/100@f/17.5	1/60@f/22	1/100@f/17.5	1/50 @f/25
7	16	1/100@f/25	1/60@f/32	1/100@f/25	1/50 @f/35
8	17	1/100@f/35	1/60@f/45	1/100@f/35	1/50 @f/50
9	18	1/100@f/50	—	—	1/100@f/50
10	19	—	—	—	1/200@f/50
—	20	—	—	—	1/300@f/58
—	21	—	—	—	1/300@f/82
—	22	—	—	—	1/600@f/82

*Used on Models 80, 95, 95A, 700 only. All others used EV numbers.

Note that the original number system (1-8 or 2-9) in the first column of the table and EV system (10-17 or 11-18) in the second column give the same values. Only the numbers differ. The EV system is merely an extension of the original Polaroid Land Camera numbering system to provide greater range for future cameras. While apertures and speeds vary somewhat between models, the effective exposure is the same. For example, shutter no. 3 on the Model 95 is f/11 at 1/30 which gives the same exposure as shutter no. 3 on Models 80, 95A, and the 700, and EV no. 12 on models 80A, 95B, 150, and 800. In each case, a faster or slower shutter speed is matched to a larger or smaller opening so that all models give similar exposure ranges for existing-light or flash pictures.

(*Continued on following page*)

566

POLAROID

SPEED OF POLAROID FILMS

Film Type	Format	Picture Obtained	Picture Size (Inches)	Speed (ASA Equiv.)	*Devel. Time at 75° F (24° C)
Roll Films					
20	8 exposure roll	Black and white print	2½ x 3¼	2500	15 sec.
32	8 exposure roll	Black and white print	2½ x 3¼	400	15 sec.
37	8 exposure roll	Black and white print	2½ x 3¼	2500	15 sec.
38	6 exposure roll	Color print	2½ x 3¼	75	60 sec.
42	8 exposure roll	Black and white print	3¼ x 4¼	200	15 sec.
47	8 exposure roll	Black and white print	3¼ x 4¼	2500	15 sec.
Pack Films					
107	8 exposure pack	Black and white print	3¼ x 4¼	2500	15 sec.
108	8 exposure pack	Color print	3¼ x 4¼	75	60 sec.
88	8 exposure pack	Color print	3¼ x 3⅜	75	60 sec.
87	8 exposure pack	Black and white coaterless print	3¼ x 3⅜	2500	30 sec.
Professional Pack Films					
664	8 exposure pack	Long-scale black and white print	3¼ x 4¼	500	30 sec.
665	8 exposure pack	Black and white print and a negative	3¼ x 4¼	75	30 sec.
667	8 exposure pack	Black and white coaterless print	3¼ x 4¼	2500	30 sec.
668	8 exposure pack	Color print	3¼ x 4¼	75	60 sec.

POLAROID

(Continued on following page)

567

POLAROID

SPEED OF POLAROID FILMS (cont.)

Film Type	Format	Picture Obtained	Picture Size (Inches)	Speed (ASA Equiv.)	*Devel. Time at 75° F (24° C)
4 x 5 Film Packets					
51	20 single exposure packets	High contrast black and white print	4 x 5	200	15 sec.
52	20 single exposure packets	Black and white print	4 x 5	400	15 sec.
57	20 single exposure packets	Black and white print	4 x 5	3000	15 sec.
58	10 single exposure packets	Color print	4 x 5	75	60 sec.
55P/N	20 single exposure packets	Black and white print and a negative	4 x 5	50	20 sec.
Special Purpose Films					
46-L	8 exposure roll	Continuous-tone black and white transparencies	3¼ x 4	800	2 min.
146-L	8 exposure roll	High contrast black and white transparencies	3¼ x 4	200	15 sec.
410	8 exposure roll	High contrast black and white print	3¼ x 4¼	10,000	15 sec.**

*Processing times mentioned on the above table may require some modification dependent upon the temperature conditions. More detailed information can be found with the instruction sheet packed with each particular type of film.

**To facilitate rapid sequence recording, Type 410 Land Film may be advanced at 2-second intervals and prints developed 13 seconds outside the camera.

***The ASA equivalent speed of Type 413 infrared Land Film ranges between 200 and 800, depending on the filters used.

POLAROID LAND CAMERA AND FILM GUIDE

Polaroid Camera or Camera Back	Film	Lighting
MP-4 Multipurpose Land Camera	Roll Films: Types 42, 47, 48, 46-L 146-L, 410 and 413 with #44-46 Land roll film back. Pack Films: Types 667, 668 and 665 with #44-47 Land pack film back. 4 x 5 Films: Types 51, 52, 55P/N, 57 and 58 with #500 or #545 Land Film Holder.	Four 150-watt reflector floodlamps for standard Model MP-4. Four 150-watt reflector floodlamps for XL Model MP-4. Four 150-watt reflector floodlamps for XIR Model MP-4. (Correcting filters are required when using Types 48, 58, and 108 color film).
CU-5 Close-up Land Camera	Types 667, 668 and 665 pack films.	Built-in electronic ring flash. Special accessories available for auxiliary lighting.
ID-3 Land Identification System	Type 668 bulk pack film (specially color-balanced for use with ID-3 System).	Built-in electronic flash.
XR-7 System for X-ray crystallography	Type 57 4 x 5 film.	No visible light. Gamma radiation is utilized.
Model 195 Land Camera	Types 667 and 668 pack films.	AG-1B flashbulbs.
Automatic Color Pack Cameras (Models 420, 430, 440, 450, 360, 350, 340, 335, 320, 315, 250, 240, 230, 225, 220, 215, 210, 135, 125, 104, 103, 102, 101 and 100.)	Types 107 and 108 pack films.	M-3 clear flashbulbs (except Model 360 which has built-in electronic flash).

POLAROID

(*Continued on following page*)

569

POLAROID

Polaroid Camera or Camera Back	Film	Lighting
Land roll film cameras Models 95*, 95A, 700, 110, 110A, 110B, 120, 150, 160, 800, 850 and 900. *Models 95 and 110 require factory modification before using currently manufactured films.	Types 42, 47, 48, 46-L, 146-L, 410 and 413 roll films.	With Type 42 and Type 46-L film: Press 25 or 25B or No. 5 or 5B flash-bulbs for direct or bounce flash; AG-1 or AG-1B flashbulbs with flasher on wink-light. With Type 47 film: Wink-light to 8 feet; AG-1 or AG-1B flashbulbs with flasher on wink-light beyond 8 feet, Bounce flash with No. 5 or Press 25 flashbulbs. With Type 48 film: AG-1B flashbulbs with flasher on wink-light; Press 25B or No. 5B flashbulbs. With Type 146-L film: Reflector floodlamp illumination from two sides. With Type 413 film: PH/5R flash-bulbs or Press 25 or No. 5 flashbulbs plus IR filter.
Colorpack II and Super Colorpack	Types 107 and 108 pack films.	Flashcubes
Square Shooter	Type 88 pack film.	Flashcubes
Swinger Model 20	Type 20 roll film.	AG-1 flashbulbs with built-in flash.
Big Shot	Type 108 pack film.	Magicubes
Model CB40 Land film back, Series 40 roll film adapter	Types 42, 47, 48, 46-L, 146-L, 410 and 413 roll film.	
4 x 5 Land Film Holder #500 and #545	Types 51, 52, 55P/N, 57 and 58 4 x 5 Land films.	
Model CB100 Land camera back, Series 100 pack film adapter	Types 667, 668 and 665 pack films.	

The Compact Photo-Lab-Index

POLAROID BLACK AND WHITE STILL FILMS

Since Polaroid Land Picture Rolls, packs and 4 x 5 packets differ markedly from conventional film in the way the picture is formed and in photographic characteristics the terminology of conventional photography cannot be applied directly. However, for comparison, and to aid in selecting the type of film best adapted to your requirements, the following data will prove helpful.

POLAROID LAND PICTURE ROLL TYPE 20

Black and white film for "Swinger" camera only. Panchromatic, speed equivalent of ASA 2500, 15 second development time for paper print 2½ x 3¼ inches, eight exposures per roll.

POLAROID LAND POLAPAN PICTURE ROLL TYPE 32

Black and white film for series 80 cameras and Polaroid Series 30 Land roll film back. Panchromatic, speed equivalent of ASA 400, 15 second processing time for paper print 2½ x 3¼ inches, eight exposures per roll.

POLAROID LAND POLAPAN PICTURE ROLL TYPE 37

Black and white film for series 80 and J33 cameras and Polaroid series 30 Land roll film back. Panchromatic, speed equivalent of ASA 2500, 15 second processing for paper print 2½ x 3¼ inches, eight exposures per roll.

POLAROID LAND POLAPAN PICTURE ROLL TYPE 42

Black and white film for all Polaroid roll film cameras using Series 40 film (except J66), Polaroid Model CB40 Land roll film adapter, and No. 226 Land roll film back. Panchromatic, speed equivalent of ASA 200, 15 second processing for paper print 3¼ x 4¼ inches, eight exposures per roll.

POLAROID LAND PICTURE ROLL TYPE 47

Black and white film for all Land roll film cameras using Series 40 roll film, Polaroid Model CB40 Land roll film adapter, and No. 226 Land roll film back. Panchromatic speed equivalent of ASA 2500, 15 second processing for paper print 3¼ x 4¼ inches, eight exposures per roll.

POLAROID LAND FILM TYPE 665

Black and white panchromatic film which provides both a long-scale print and a fine-grain negative after 30 seconds development. The negative requires brief after-treatment in a solution of sodium sulfite. Speed equivalent of ASA 75.

POLAROID LAND FILM PACK TYPE 107

Black and white panchromatic film pack for all Polaroid Color Pack Cameras, Model 180, Colorpack II, MP-4 Multipurpose Land Camera with No. 226 pack film back, CU-5 Close-up Camera, and Polaroid Model CB100 Land Pack film adapter. Speed equivalent of ASA 2500, 15 second processing time for paper print 3¼ x 4¼ inches, eight exposures per pack.

POLAROID LAND FILM TYPE 667

Similar to Type 107, but requires no print coating after development. Speed equivalent to ASA 2500, 30 second developing time.

POLAROID LAND 4 x 5 FILM PACKET TYPE 51/HIGH CONTRAST

Color blind, extremely high contrast, black and white film packet for Polaroid Land 4 x 5 No. 500 or No. 545 Land Film Holder and MP-4 Multipurpose Land Camera with No. 500 or No. 545 Land Film Holder. Used for line copies, "status," etc. Speed equivalents of 200 ASA Daylight, 60 ASA Tungsten. Processing time 15 seconds for line, 10-13 seconds for halftones, 20 4 x 5 single exposure packets per box.

POLAROID LAND POLAPAN 4 x 5 FILM PACKET TYPE 52

Black and white panchromatic film packet for Polaroid Land 4 x 5 No. 500 or No. 545 Film Holder and MP-4 Multipurpose Land Camera with No. 500 or No. 545 Land Film Holder.

(Continued on following page)

POLAROID

571

Fairly high contrast continuous tone film, prints may be enlarged up to three times. Speed equivalent of ASA 400, processing time 15 seconds, 20 4 x 5 single exposure packets per box.

POLAROID LAND 4 x 5 FILM PACKET TYPE 55 P/N

Black and white high resolution panchromatic film packet providing both a paper print and a film negative without a darkroom. Negative is capable of enlargement up to 25X. For Polaroid Land 4 x 5 No. 500 or No. 545 Film Holder and MP-4 Multipurpose Land Camera with No. 500 or No. 545 Land Film Holder. Film speed equivalent of ASA 50, processing time 20 seconds, 20 4 x 5 single exposure packets per box.

POLAROID LAND 4 x 5 FILM PACKET TYPE 57

Black and white, high speed, panchromatic film for Polaroid Land 4 x 5 No. 500 or No. 545 Film Holder, MP-4 Multipurpose Land Camera with No. 500 or No. 545 Land Film Holder, and XR-7 System for X-ray crystallography. Prints are capable of 2X enlargement. Speed equivalent of ASA 2500, 15 second processing time, 20 4 x 5 single exposure packets per box.

POLAROID LAND PROJECTION FILM TYPE 46-L

Continuous-tone transparency film producing 3¼ x 4 inch slides (image area 2-7/16 x 3¼) for standard lantern slide projectors. For use in MP-4 Multipurpose Camera with No. 266 Land roll film back; all Polaroid Land roll film cameras except Models 20, 80, 80A, 80B, J33, and J66; Polaroid Model CB40 Land roll film adapter. The transparencies, after dipping in a fast drying hardening solution, can be snapped into Polaroid plastic print mounts (No. 633). Speed equivalent of ASA 800, 2 minute processing time, eight exposures per roll.

POLAROID LAND POLALINE PROJECTION FILM TYPE 146-L

High-contrast transparency film producing 3¼ x 4 inch slides (image area 2½ x 3¼) for standard lantern slide projectors. For use in MP-4 Multipurpose Camera with No. 266 Land roll film back; all Polaroid Land roll film cameras except Models 20, 80, 80A, 80B, J33, and J66; Polaroid Model CB40 Land roll film adapter. The transparencies, after dipping in a fast drying hardening solution, can be snapped into Polaroid plastic print mounts (No. 633). Speed equivalent of ASA 200, 15 second processing time, eight exposures per roll.

POLAROID LAND POLASCOPE TRACE RECORDING FILM TYPE 410

Extremely fast film with high contrast, particularly suited for oscilloscope trace recording, photomicrography, metallography, other low-light-level photography, and reproduction of line copy. For use in MP-4 Multipurpose Camera with No. 266 Land roll film back; all Polaroid Land roll film cameras except Models 20, 80, 80A, 80B, J33, and J66; Polaroid Model CB40 Land roll film adapter. Speed equivalent of ASA 10,000, 15 second processing time for print 3¼ x 4¼ inches, eight exposures per roll.

POLAROID COLOR STILL FILMS

POLAROID POLACOLOR LAND PICTURE ROLL TYPE 38

Color film for Polaroid camera Model J33 with No. 330 Adapter; Models 80, 80A, 80B with factory modification; and Series 30 roll film back (no longer manufactured). Pictures are fully finished when removed from the back of the camera and do not require coating. Speed equivalent of ASA 75, 60 second processing time for print 2½ x 3¼ inches, six exposures per roll.

USING FILTERS WITH POLAROID BLACK-AND-WHITE MATERIALS

POLAROID ORANGE FILTER

When the orange filter is used with panchromatic materials, a large part of the blue light is absorbed. Thus, the blue sky becomes darker, making white cloud formations more pronounced. This filter also cuts through the blue light in distant ground haze giving you sharper landscape shots. Use the orange filter (indoors and outdoors) whenever you want blue subjects (sky, letterheads, clothing, blueprints, etc.) to photograph darker. Set shutter two f/numbers lower than the normal exposure to make up for the blue light the filter absorbs. Any object which has color tones lying at the blue end of the spectrum (blue, indigo and violet) will appear darker in the picture.

POLARIZING FILTER

Because this is a colorless gray filter, it affects your eye just the way it affects the picture, which makes experimentation easy. This filter absorbs the polarized light found in many natural and artificially lighted scenes—light that is distracting or by its glare prevents a clear view of the object. There are two common sources of polarized light:

1. Light that reflects from glass, water, wood, wet streets and other non-metallic surfaces. The obscuring glare of sunlight glancing off such surfaces can spoil a picture. The filter stops this polarized glare, but permits useful light to pass, thus making it possible to take pictures through glass windows and to eliminate the reflections on water so that surface and sub-surface detail is improved. Use of the polarizing filter brings out the detail and texture in objects which have been lacquered or varnished, or have finishes of leather, wood, tile, or the like. Glare and reflection control reaches a maximum when the camera is placed at an angle of 33° from the plane of the reflecting surface.

2. Light from a clear, blue sky is often polarized, and the effect of the filter on such polarized sky light is to darken the sky and increase the contrast of clouds. The sky is most strongly polarized when it is bluest, and a slight overcast will reduce the effect of the filter. The degree of polarization in sky light will depend on the position of the sun. When the sun is directly overhead, polarization is slight, and so the filter is less useful. When the sun is lower in the sky, polarization is greater, which is why the polarizing filter can be used effectively in photographing sunsets. Stand with the sun off your shoulder and scan the sky ahead, turning the filter slowly as you do so. Note how the sky darkens and lightens as the filter is turned.

The actual position of the polarizing filter on the lens is of utmost importance. Before putting the filter on the camera, view the scene through it as you turn it slowly. When you find the position at which glare is most reduced, note the number on the filter-rim which is at the top. Then place the filter on the camera with this number at the top. If you change the composition of your picture from horizontal to vertical or vice versa, be sure to change the filter position. If you cannot see any change when you look through the filter, polarization in the scene is not sufficient and the scene either does not require the use of the filter, or you must change the angle at which you photograph the scene. Increase exposure by setting shutter two f/numbers lower when filter is used.

Indoors, this filter can be used to reduce reflections on artificially lighted non-metallic surfaces such as marble, china, glass, wood, etc. The camera-subject angle should be about 33° for maximum effectiveness. Complete reflection control on some surfaces requires the use of polarizing filters on the light source as well as on the lens. (This is why glare from metallic surfaces cannot be reduced when photographed in the sunlight.) Control of reflections in picture and document copying also requires filters on the lights.

(Continued on following page)

POLAROID

The Compact Photo-Lab-Index

HALF-STEP FILTER

This is a neutral gray filter that cuts out just enough light to equal half of a Polaroid Land Camera shutter number. For instance, if a picture taken on No. 11 were a little too light to suit you, and the same scene taken on No. 12 turned out a little too dark, you would like to be able to shoot half-way between. That is what the filter does. With the shutter at No. 11, the filter absorbs just enough light to give you an effective setting of 11½. A half-step (or neutral density) filter is not included in the No. 551 kit nor offered as a separate item for camera Models 110 and 110A.

The 4-S Light Reducing Filter is designed for use with camera models series 80, 95, 150, 160, 700, 800, and 110 when using 3000 speed film in bright light outdoors when not using an electric-eye shutter attachment. With the filter over the lens, the speed of the film is cut to 200 and you should set the shutter 5 numbers lower. If you have a meter, set the meter scale to 200 and set the shutter to the reading given by the meter. Do not use this filter indoors, nor with slower film types, nor with electric eye cameras. Its sole function is to prevent overexposure when using 3000 speed films outdoors.

The lens cap on the Model 110B offers an f/90 aperture in the lens cap, thus eliminating the need for the 4-S filter, and an accessory f/90 lens cap is available to Model 110A owners through their dealers. Note that no filters can be used when the f/90 lens cap is in front of the lens.

USING FILTERS IN PAIRS

The filter mounts are designed to "stack" one filter on the other, and you may sometimes wish to use more than one of them. For example, the orange and polarizing filters can often be used together for an exaggerated dark-sky effect.

USING FILTERS TO CUT EXPOSURE

In close-up flash photography, regardless of film type being employed, the subject may be overexposed even with the highest shutter number. One or more filters over the lens will prevent this. Also, filters will help eliminate some of the glare of a bulb when making direct flash pictures, and will soften and cut exposure to produce a more flattering, pleasing flash picture.

FILTER FACTORS

Because filters cut down the light that passes through the camera lens, compensation (called the filter factor) must be made by using a lower shutter number. The table below tells you exactly how to set the shutter of your camera for each different filter according to film type used.

Filter Type	Set Lens	Daylight Filter Factor
Polaroid Orange	No. 2 lower	4
Polarizer	No. 2 lower	4
Wratten No. 8 (yellow)	No. 1 lower	2
Wratten No. 11 (light green)	No. 2 lower	4
Wratten No. 58 (green)	No. 3 lower	8
Wratten No. 47 (blue)	No. 3 lower	8
Wratten No. 25 (red)	No. 3 lower	8

(Continued on following page)

574

The Compact Photo-Lab-Index

**POLAROID POLACOLOR LAND
PACK FILM TYPE 88**

Color film for the Polaroid Square Shooter Land Camera. Pictures develop outside the camera after the tab is pulled. They do not require coating. Speed equivalent of ASA 75, processing time 60 seconds for print 3¼ x 3⅜ inches, eight exposures per film pack.

**POLAROID POLACOLOR LAND
PACK FILM TYPE 108**

Color film for all Polaroid Color Pack Cameras (except Square Shooter), Model 180, Big Shot (Portrait Land Camera), Colorpack II, MP-4 Multipurpose Land Camera with No. 226 pack film back, CU-5 Close-up Camera, Polaroid Model CP-100 Land pack film adapter, and ID-2 Land Identification System. Pictures develop outside the camera after the tab is pulled. They do not require coating. Speed equivalent

of ASA 75, 60 second processing time for print 3⅜ x 4¼ inches, eight exposures per film pack.

**POLAROID POLACOLOR LAND
PACK FILM TYPE 668**

Similar to Type 108 in all respects but specifically color-balanced to electronic flash. This is the professional version of the film and is subject to more stringent quality control than Type 108.

**POLAROID POLACOLOR LAND
4 x 5 FILM PACKET TYPE 58**

Color film for use in Polaroid Land 4 x 5 No. 500 or No. 545 Film Holder, MP-4 Multipurpose Land Camera with No. 500 or No. 545 Land Film Holder. Color balanced for daylight (5500 K), blue flashbulb, or electronic flash. Speed equivalent of ASA 75, 60 second processing time, ten 4 x 5 single exposure packets per box.

POLAROID

575

SHEET FILMS

Film Type	Format	Picture Obtained	Picture Size	Approx. Speed (ASA Equiv.)	Devel. Time At 75°F (24°C)
51	Single exposure packet (20 packets to box, except Type 58— 10 packets)	High contrast black and white print		200	15 sec.
52		Black and white print		400	
55P/N		Black and white print and a permanent negative	4x5 in.	50	20 sec.
57		Black and white print		2500	15 sec.
58		Color print		75	60 sec.

PACK FILMS

Film Type	Format	Picture Obtained	Picture Size	Approx. Speed (ASA Equiv.)	Devel. Time At 75°F (24°C)
107	8 exposure pack	Black and white print	3¼x4¼ in.	2500	15 sec.
108		Color print		75	60 sec.
665	"	Black and white print and a permanent negative		75	30 sec.
667	"	Black and white print		2500	30 sec.
668	"	Color print		75	60 sec.

ROLL FILMS

Film Type	Format	Picture Obtained	Picture Size	Approx. Speed (ASA Equiv.)	Devel. Time At 75°F (24°C)
42	8 exposure roll	Black and white print		200	15 sec.
47		High contrast black and white print	2½x3¼ in.	2500	15 sec.
410 trace recording	8 exposure roll	Continuous-tone black and white transparency		10,000	15 sec.[1]
46L			3¼x4¼ in.	800	2 min.
146L		High contrast black and white transparency		100	30 sec.

X-RAY FILMS

Film Type	Format	Picture Obtained	Picture Size	Approx. Speed (ASA Equiv.)	Devel. Time At 75°F (24°C)
TLX	Single exposure packet (25 packets to box)	Translucent-based black and white print	10x12 in.	2500	45 sec.[2]
3000X		Black and white print			

1. To facilitate rapid sequence recording, Type 410 film may be advanced at 2-second intervals and prints developed 13 seconds outside the camera.

2. Polaroid x-ray films, sold by Picker Corporation, are designed for use with Picker Polaroid cassettes and processors.

POLAROID

RETOUCHING TYPE 55 NEGATIVES

Type 55 negatives can be retouched in much the same way as a conventional negative. All retouching, however, should be done on the **emulsion** side of the negative and not on the base side, which is common practice with conventional negatives. A very soft retouching pencil can be used without retouching fluid, and virtually all retouching pencils can be used with retouching fluid, which should be applied on the emulsion side of the negative. Adhesion difficulties will probably be experienced if retouching pencil or retouching fluid application is attempted on the base side of the negative.

One way to correct large pin-holes in the negative is to apply a small drop of opaque to the pin-hole, which will cause a white spot in the print when an enlargement is made. The density of this white spot can be corrected through the application of spotting colors to the print.

Achieving good and consistent results with Polacolor Film is possible

only with careful attention to the following factors:
1. Development time
2. Development temperature
3. Speed of pull
4. Proper storage

DEVELOPMENT TIME

First, it must be understood that development begins the instant the picture is pulled through the rollers and ends the instant that the positive is separated from the negative or peeled. With Polaroid black-and-white films, a very slight increase in contrast results from developing longer than the recommended time. Polacolor is much more sensitive. Underdevelopment of Polacolor results in reddish or warmish tones that tend to be flat and muddy. Overdevelopment with Polacolor results in: (1) increased contrast, (2) increased color saturation and (3) a shift in color balance toward blue or cyan. As little as ten extra seconds will produce this shift toward blue. Thus for pictures with optimal color balance, a development time of precisely sixty seconds is essential at normal temperatures.

ROLL AND PACK FILMS—REFLECTION PRINTS

Type	Speed (ASA equivalent)	D-Max	D-Min	¾-¼ Slope	Resolution (lines/mm)
32	400	1.6	.02	1.3-1.4	22-28
42	200	1.6	.02	1.3-1.4	22-28
37	2500	1.6	.02	1.3-1.4	22-28
47	2500	1.6	.02	1.3-1.4	22-28
410	10,000	1.6	.02	3.0	22-28
107	2500	1.6	.02	1.3-1.4	22-28
667	2500	1.6	.02	1.3-1.4	22-28
413	200-800*	1.6	.02	2.1-2.4	22-28

ROLL FILMS—TRANSPARENCIES

Type	Speed (ASA equivalent)	D-Max	D-Min	¾-¼ Slope	Resolution (lines/mm)
46-L	800	2.7	.04	2.5	32-35
146-L	200**	2.5	.04	2.2	32-35

4 x 5 FILMS—REFLECTION PRINTS

Type	Speed (ASA equivalent)	D-Max	D-Min	¾-¼ Slope	Resolution (lines/mm)
51	300***	1.7	.00	3.0-4.0	22-28
52	400	1.7	.02	1.3-1.4	22-28
57	2500	1.6	.02	1.3-1.4	22-28
55P/N	(Positive) 64	1.7	.02	1.4 (Positiive)	14-17
	(Negative) 64	1.5	.18	.7 (Negative)	150-165

*Depending upon filters being used.
**This is daylight speed. In tungsten lighting, speed is approx. 100.
***This is daylight speed. In tungsten lighting, speed is approx. 125.

POLAROID

(*Continued on following page*)

577

Advantage may be taken of this increase in contrast and saturation by purposely overdeveloping, and compensating for the color shift with warming filtration. Experience has shown that a magenta color compensating filter works best. The necessary strength of the filter may be generalized as follows: for every twenty seconds of overdevelopment, filter CC10M. In this way, a development time of 80 seconds would require warming filtration of CC10M; 100 seconds would require CC20M; and 120 seconds would require CC30M.

TEMPERATURE

The 60 second development time is recommended only when the temperature is between 75 and 85 degrees Fahrenheit. For temperatures outside this range, development time must be increased if higher and decreased if lower. Please see the tip sheet for details.

SENSITOMETRIC DATA

The figures given below are approximate and should be interpreted accordingly. While this information will vary from time to time as product changes and improvements are effected, it can be used as a representative average, bearing in mind that normal manufacturing tolerances may occasionally cause slight deviations.

HOW TO INTERPRET THE SPECTRAL RESPONSE CURVES

A non-technical explanation: In the graphs, the base represents the visible portion of the spectrum with the various colors identified according to their wavelengths in nanometer (a nanometer is one billionth of a meter and is equivalent to one millimicron or 10 Angstrom units).

The visible part of the spectrum (shown below) extends approximately from 400 to 700nm. Below about 400nm is the ultra-violet region and from about 700nm on up is the infrared region. Although invisible, ultraviolet and infrared are important photographically.

The graph line indicates the relative sensitivity of the film to light of different colors (wavelengths) as measured against the vertical column, which is shown as a logarithmic scale. The higher the line, the greater the sensitivity of the film to that particular color.

For example, Type 51 and Type 146L films have a "color blind" emulsion of silver halides without additional color sensitizers.

They are most sensitive to ultraviolet, violet and blue, in that order. That they are barely sensitive to blue-green is shown by the plunging curve at about 500nm. They are insensitive to yellow, orange, and red.

Thus, the curve shows that with these films it would be useless to try to make pictures through a red filter.

Compare this to the curve for Types 47, 57, and 107, films with emulsions that include sensitizers to make them "panchromatic"—sensitive to all colors.

The curve shows high sensitivity to the full visible spectrum up to about 650nm, where it drops.

For the scientist: The spectral response curve represents the $-\log$ (energy in ergs/sq. cm) of a monochromatic exposure which is required to produce a reflection density of 0.5 in the print.

(To translate the energy requirements into more familiar units, it is helpful to know that 10^7 ergs equal one watt second.)

For example, the curve for Type 57 film gives a $-\log$ energy reading of 2.3 at 400 nanometers. This means that the total energy needed to produce a 0.5 density in the print is $10^{-2.3}$ ergs/sq. cm, or .005 ergs/sq. cm. This is specified as a sensitivity of $10^{-2.3}$ or 200 reciprocal ergs/sq. cm.

In general, the D/logE curve of any of these films does not change

(*Continued on following page*)

POLAROID

578

TYPE 51

GENERAL DESCRIPTION

Ultra-high contrast 4x5 Land film producing a positive print. It is designed for reproduction of black and white with no intermediate gray tones. It is ideal for graphic arts applications including line and screened artwork (with Polaroid MP-4 Instant Halftone Kit). The emulsion is sensitive to blue light only; that is, red, yellow, and green are reproduced as black, while blue tends to photograph as white. This characteristic, plus high contrast, makes Type 51 useful for some types of photomicrography, metallography, and other scientific applications.

TECHNICAL CHARACTERISTICS

Polaroid Type 51 Land film characteristic curve

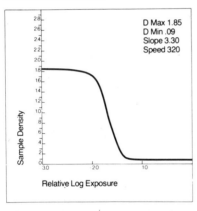

D Max 1.85
D Min .09
Slope 3.30
Speed 320

Sample Density

Relative Log Exposure

Density is ANSI visual diffuse reflection density.
Zero reference for photographic print density is BaSO₄.

Polaroid Type 51 Land film reciprocity compensation

Exposure time (seconds)	Use either adjustment Aperture	Exposure (seconds)
1/1000	None	None
1/100	None	None
1/10	None	None
1	1/3 stop	1.3
10	2/3 stop	16
100	1 1/3 stops	260

Reciprocity diagram is on following page.

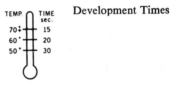

TEMP.	TIME sec.
70°	15
60°	20
50°	30

Development Times

Blue sensitive emulsion—use no filters

ASA equivalent—
320 daylight 26 DIN
100 Tungsten 21 DIN

D-max 1.75 Slope 3.35

D-min .00 Resolution 28-32 lines/mm

NOTE: The speed quoted for tungsten lighting should be regarded as only a rough approximation. The spectral energy distribution of tungsten bulbs will vary from type to type, as well as with age, so that one of two test shots may be required to establish optimum exposure under various conditions.

MP-4	Model Lights	4-150 W	4-150 W

Mid bellows position

Basic Exposures	1/4 @ f/16	1/4 @ f/11-16

Exposure: As with all high-contrast film, the exposure latitude of Type 51 film is limited. The degree of whiteness of the paper, the color of the artwork in the original, and the bellows extension of the camera (and thus, the reproduction scale) all influence the determination of exposures for the most satisfactory black and white reproductions. The exposure guide will be helpful as a starting point for line reproductions of good, clean black and white originals.

(*Continued on following page*)

The Compact Photo-Lab-Index

Magnification	.5X	1:1	1.5X	2X	3X	4X	5X	6X	7X	8X	9X	10X
Exposure Increase in Stops	1	2	2.5	3	4	4.5	5	5.5	6	6.33	6.67	7

*For average product, using recommended processing.

Polaroid Type 51 Land film reciprocity compensation

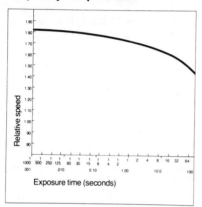

Relative speed

Exposure time (seconds)

Polaroid Type 51 Land film spectral sensitivity

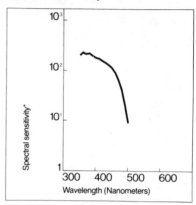

Spectral sensitivity*

Wavelength (Nanometers)

*Spectral sensitivity equals reciprocal of exposure (ergs/cm²) required to produce a 0.6 visual density.

TYPE 52, 42

GENERAL DESCRIPTION

General purpose, medium speed films producing paper print positives with excellent tonal range, fine grain, and medium contrast. They provide optimum quality for reproduction, equal in every way to prints produced by conventional processes. They are ideal for general photography, exposure testing, and many scientific and technical applications.

Formats:

(Type 52)—4x5 packet; image area 3.5x4.50″ (8.9x11.5 cm.)

Type 42)—roll; image area 2.875x 3.75″ (7.35x10.55 cm.)

Development for longer than recommended time will increase contrast slightly but will not damage print. Development for less than 10 seconds produces a print which may be objectively faint.

TEMP. F.	TIME sec.
70±	15
60°	20
50°	30
40°	50
35°	60

ASA speed equivalent:
 Type 52—400 ASA, 27 DIN
 Type 42—ASA, 24 DIN
T42 Resolution 25-28 lp/mm
D-max 1.75 Slope 1.3-1.4
D-min .02 Resolution 35-40 lines/mm

FILTER FACTORS: Increase exposure by the amount indicated.

Wratten Filter	#6 K-1	#8 K-2	#15 G	#11 X1	#25 A	#29 F	#58 B	#47 C5	Polascreen 4X
Filter Factor	2X	2X	3X	4X	8X	16X	8X	8X	

(*Continued on following page*)

The Compact Photo-Lab-Index

significantly with the wavelength of the exposure, except in the deeper ultraviolet. Therefore, the monochromatic exposures required to produce densities other than 0.5 can be estimated from the spectral sensitivity curve and the D/logE curve.

To calculate the results of a polychromatic exposure, one must perform the following steps:

(1) Read off the appropriate points on the log (spectral sensitivity) plot at equally spaced points (every 10 nanometers).

(2) Take the antilog of the log sensitivity to obtain the linear sensitivity in units of sq. cm/erg.

(3) Determine the incident energy* in ergs/sq. cm sec. in each 10nm wavelength band. Multiply the sensitivity by the incident energy at each wavelength point. This gives the exposure in units of sec.$^{-1}$ occurring in each 10nm band.

(4) Add together all the narrow band exposures obtained in step (3). The resulting number has units of sec.$^{-1}$ and gives the number of exposures to 0.5D which can be made in one second. The reciprocal of this number is thus the required exposure time in seconds,

*This must be the incident energy on the film as derived from the source brightness, lens aperture, lens spectral transmission, etc.

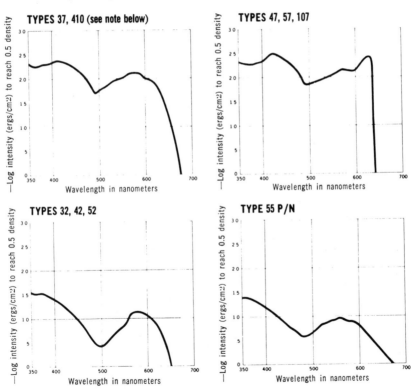

(*Continued on following page*)

The Compact Photo-Lab-Index

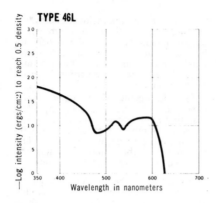

TYPE 46L

—Log intensity (ergs/cm²) to reach 0.5 density

Wavelength in nanometers

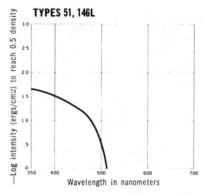

TYPES 51, 146L

—Log intensity (ergs/cm²) to reach 0.5 density

Wavelength in nanometers

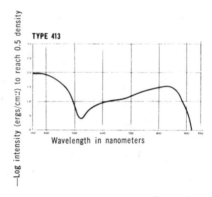

TYPE 413

—Log intensity (ergs/cm²) to reach 0.5 density

Wavelength in nanometers

NOTE, TYPES 37, 410: The negative in Type 410 film is similar to the negative in Type 37 film. Within experimental error, the spectral response curve for Type 410 is the same as that of Type 37, but with the peak of the curve shifted to —log intensity = 3 or 1000 cm²/erg.

(Continued on following page)

582

POLAROID

The Compact Photo-Lab-Index

TECHNICAL CHARACTERISTICS

Polaroid Type 42 Land film spectral sensitivity

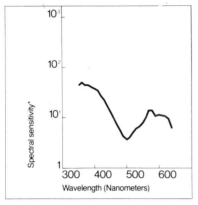

*Spectral sensitivity equals reciprocal of exposure (ergs/cm²) required to produce a 0.6 visual density.

Polaroid Type 52 Land film spectral sensitivity

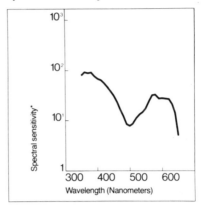

*Spectral sensitivity equals reciprocal of exposure (ergs/cm²) required to produce a 0.6 visual density.

Polaroid Type 42 Land film characteristic curve

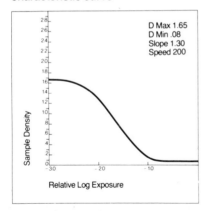

D Max 1.65
D Min .08
Slope 1.30
Speed 200

Density is ANSI visual diffuse reflection density.
Zero reference for photographic print density is BaSO₄.

Polaroid Type 52 Land film characteristic curve

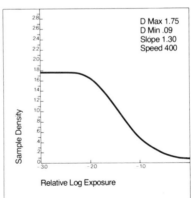

D Max 1.75
D Min .09
Slope 1.30
Speed 400

Density is ANSI visual diffuse reflection density.
Zero reference for photographic print density is BaSO₄.

POLAROID

(Continued on following page)

The Compact Photo-Lab-Index

Polaroid Type 42 Land film reciprocity compensation

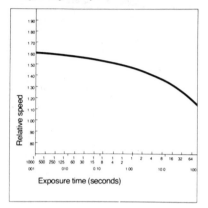

Exposure time (seconds)

Polaroid Type 52 Land film reciprocity compensation

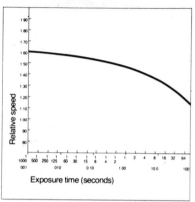

Exposure time (seconds)

Polaroid Type 42 Land film reciprocity compensation

Exposure time (seconds)	Use either adjustment	
	Aperture	Exposure (seconds)
1/1000	None	None
1/100	None	None
1/10	None	None
1	1/2 stop	1.5
10	1 stop	20
100	1 1/2 stops	300

Polaroid Type 52 Land film reciprocity compensation

Exposure time (seconds)	Use either adjustment	
	Aperture	Exposure (seconds)
1/1000	None	None
1/100	None	None
1/10	None	None
1	1/2 stop	'1.5
10	1 stop	20
100	1 1/2 stops	300

MP-4	Model Lights	4-150W	4-150W	
*Basic Exposure (Type 52)		1/8@ f/32	1/8@ f/22-32	Mid bellows position

**For Type 42, increase exposures one stop.

Magnification	.5X	1.1	1.5X	2X	3X	4X	5X	6X	7X	8X	9X	10X
Exposure Increase in Stops	1	2	2.5	3	4	4.5	5	5.5	6	6.33	6.67	7

**For average product, using recommended processing.

(*Continued on following page*)

584

The Compact Photo-Lab-Index

TYPE 55 P/N

GENERAL DESCRIPTION

A medium contrast, extremely fine grain material producing both a print positive and a fully developed and fixed negative, capable of enlargement up to 25X. Type 55 P/N has many applications in commercial and industrial photography; and is particularly suited to mural production, slide copying, portraiture, and as an exposure testing medium for color films.

Format:
4x5 Land film packet only; image area 3.5x4.5" (8.9x11.5 cm.)

TECHNICAL CHARACTERISTICS

Polaroid Type 55 Land film spectral sensitivity

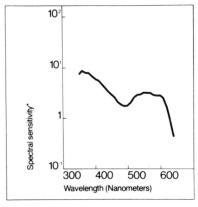

*Spectral sensitivity equals reciprocal of exposure (ergs/cm²) required to produce a 0.6 visual density.

Polaroid Type 55 Land film reciprocity compensation

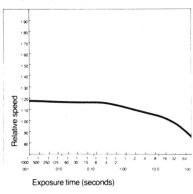

Exposure time (seconds)

Polaroid Type 55 Land film characteristic curve

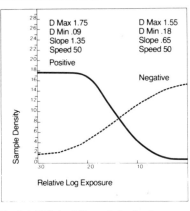

Relative Log Exposure

Density is ANSI visual diffuse reflection density. Zero reference for photographic print density is BaSO₄.

Negative:
D-max 1.65 Slope .7
D-min .18 Resolution 150-160
 lines/mm
Positive:
D-max 1.75 Slope 1.4
D-min .02 Resolution 22-25 lines/mm

ASA equivalent speed 50, DIN 18

Clearing negative: After 20 seconds, the negative is completely fixed and is no longer light sensitive. Within 3 minutes of separation from positive, immerse with continuous agitation in the 18% sulfite solution (formula below) at 65°-70°F (18°-21°C). For enlargements greater than 3X, two minutes in the acid hardening bath (formula below) is recommended:

TEMP. F	TIME sec.
70°	20
60°	35-45
50°	60-90

POLAROID

(Continued on following page)

585

The Compact Photo-Lab-Index

18% Sulfite			Acid hardening bath:		
Water	1000 ml	32 oz.	Water, about 68°F	500 ml	16 oz.
Sodium Sulfite	180 ml	6 oz.	Acetic Acid, 28%	250 ml	8 oz.
(Anhydrous)			Potassium Alum	16 gms	¾ oz.
			Water to make	1000 ml	32 oz.

Complete clearing instructions are packed with each film box.

MP-4	Model Lights	4-150W	4-150W	
Basic Exposure		1/2 @ f/22	1/2 @ f/16-22	Mid bellows position

Magnification	.5X	1.1	1.5X	2X	3X	4X	5X	6X	7X	8X	9X	10X
Exposure Increase in Stops	1	2	2.5	3	4	4.5	5	5.5	6	6.33	6.67	7

FILTER FACTORS: Increase exposure by the amount indicated.

Wratten Filter	#6 K-1	#8 K-2	#15 G	#11 X1	#25 A	#29 F	#58 B	#47 C5	Polascreen
Filter Factor	1.5X	1:5X	2X	4X	8X	16X	8X	8X	4X

TYPE 57, 47, 107, 667, 87

GENERAL DESCRIPTION

2500 speed Land films providing medium contrast paper print positives.

Their ultra-high sensitivity makes them ideal for photography of high speed events, many scientific applications with low level ambient light, and general photography with suitable equipment.

TECHNICAL CHARACTERISTICS

Polaroid Type 47 Land film characteristic curve

D Max 1.70
D Min .06
Slope 1.50
Speed 3000

Density is ANSI visual diffuse reflection density.
Zero reference for photographic print density is BaSO₄.

Polaroid Type 57 Land film characteristic curve

D Max 1.70
D Min .09
Slope 1.40
Speed 3000

Density is ANSI visual diffuse reflection density.
Zero reference for photographic print density is BaSO₄.

(Continued on following page)

586

The Compact Photo-Lab-Index

Polaroid Type 47 Land film spectral sensitivity

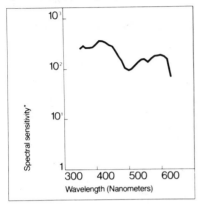

*Spectral sensitivity equals reciprocal of exposure (ergs/cm²) required to produce a 0.6 visual density.

Polaroid Type 57 Land film spectral sensitivity

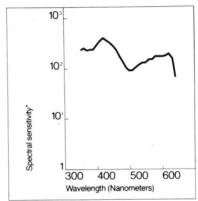

*Spectral sensitivity equals reciprocal of exposure (ergs/cm²) required to produce a 0.6 visual density.

Polaroid Type 47 Land film reciprocity compensation

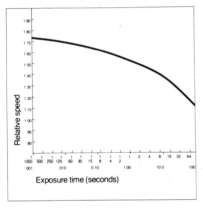

Polaroid Type 57 Land film reciprocity compensation

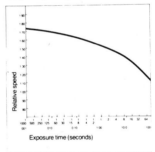

Polaroid Type 47 Land film reciprocity compensation

Exposure time (seconds)	Use either adjustment Aperture	Exposure (seconds)
1/1000	None	None
1/100	None	None
1/10	1/3 stop	.13
1	2/3 stop	1.6
10	1 stop	20
100	2 stops	400

Polaroid Type 57 Land film reciprocity compensation

Exposure time (seconds)	Use either adjustment Aperture	Exposure (seconds)
1/1000	None	None
1/100	None	None
1/10	1/3 stop	.13
1	2/3 stop	1.6
10	1 stop	20
100	2 stops	400

(Continued on following page)

587

POLAROID

The Compact Photo-Lab-Index

FILTER FACTORS: Increase exposure by the amount indicated.

Wratten Filter	#6 K-1	#8 K-2	#15 G	#11 X1	#25 A	#29 F	#58 B	#47 C5	Polascreen
Filter Factor	2X	2X	3X	4X	8X	16X	8X	8X	4X

Speed equivalent—2500 ASA, 36 DIN
D-max 1.6 Slope 1.3-1.4

D-min .02 Resolution 20-22 lines/mm

Film	Format	Image	Area
47	Roll	2.875 x 3.75"	(7.35 x 10.55 cm.)
107	Pack	2.875 x 3.75"	(7.35 x 10.55 cm.)
57	4 x 5 Packet	3.50 x 4.50"	(8.9 x 11.5 cm.)

MP-4 Model Lights 4-150W 4-150W

Basic Exposure

	1/60 @ f/32	1/60 @ f/22-32	Mid bellows position

Magnification	.5X	1.1	1.5X	2X	3X	4X	5X	6X	7X	8X	9X	10X
Exposure Increase in Stops	1	2	2.5	3	4	4.5	5	5.5	6	6.33	6.67	7

Development for longer than the recommended time will increase contrast slightly but will not damage the print.

Development for less than 10 seconds produces a print which may be objectionably faint.

Polaroid Type 87 Land film spectral sensitivity

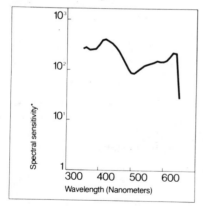

Wavelength (Nanometers)

Spectral sensitivity*

*Spectral sensitivity equals reciprocal of exposure (ergs/cm²) required to produce a 0.6 visual density.

Polaroid Type 87 Land film characteristic curve

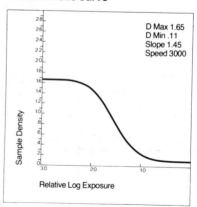

D Max 1.65
D Min .11
Slope 1.45
Speed 3000

Sample Density

Relative Log Exposure

Density is ANSI visual diffuse reflection density.
Zero reference for photographic print density is BaSO₄.

(Continued on following page)

POLAROID

Polaroid Type 87 Land film reciprocity compensation

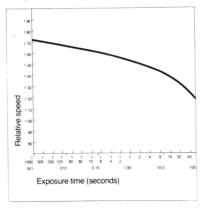

Exposure time (seconds)

Polaroid Type 87 Land film reciprocity compensation

Exposure time (seconds)	Use either adjustment	
	Aperture	Exposure (seconds)
1/1000	None	None
1/100	None	None
1/10	1/3 stop	.13
1	2/3 stop	1.6
10	1 stop	20
100	1 2/3 stops	260

TYPE 58, 48, 108, 668, 88

GENERAL DESCRIPTION

Polaroid Polacolor Land films produce color prints which are both sharp and virtually grainless, with a wide range of hues. Shadow detail is exceptional; highlights remain clear and skin tones are especially accurate.

TECHNICAL CHARACTERISTICS

Exposure Meter Setting:
75 ASA (19 DIN). Color temperature —6250°K.

Light Sources and Filters:
Daylight: No filters are needed. A Kodak Wratten 1A filter or equivalent is helpful for reducing excessive bluishness in pictures made in open shade or overcast skies. Standard UV filters can be used to reduce the effect of distant haze. In daylight, polarizing filters will deepen colors and improve contrast by cutting glare and reflections.

Electronic Flash: Ordinarily, no filters needed. With a new unit, a Wratten 81A or equivalent may improve color balance.

Floodlamps: Since the color temperature of lamps may vary somewhat due to age and/or line voltage changes, these recommendations should be considered only as guides. With 3200°K, quartz iodine, or photo-flood lamps, use Wratten 80B+ CC20B (meter setting 20 ASA, 14 DIN).

MP-4	Model Lights	4-150W	4-150W	Mid bellows position
Basic Exposure		1/2 @ f/11	1/2 @ f/8-11	

Use of Tiffen 840B (Wratten 80B+CC40B) (ASA 12 meter setting 12 DIN)

NOTE: Exposures significantly longer than 1 second may result in reciprocity failures and color shift. Add cc filtration as required to correct balance.

Film speed is affected by the temperature at time of development. Processing is not recommended when the temperature is below 65°F (18°C) or above 85°F (30°C). However, if processing must be done at or near the extreme temperature limits of 60°F and 90°F, the exposure and development should be modified as follows:

(*Continued on following page*)

POLAROID

The Compact Photo-Lab-Index

Processing Temperature
60°F (15°C)
90°F (32°C)

Exposure Compensation
Increase 1/3 stop
Decrease 1/3 stop

TEMP. F.	TIME sec.
75°	60
70°	70
65°	90

Normal development time is 60 seconds at 75°F (24°C) or above. Pictures that are developed for less than the recommended time will have warmer than normal tones, and may lack contrast and color. Pictures that are overdeveloped will tend to have bluish tones. However, extended development does increase contrast and saturation. For flatly lighted subjects, try 90-120 second development. Additional warming filtration may be added as required to balance this shift to blue.

TYPE 46-L

GENERAL DESCRIPTION

A high speed, medium contrast panchromatic projection film designed to produce transparencies with continuous tone reproduction. Excellent sharpness, brilliance, and tonal rendition, Type 46-L may be used in daylight with Polaroid Land cameras of the roll film variety to photograph pictorial subjects directly, or in MP-4 for flat copy or small object photography.

Format:
Roll film only, image size 2-7/16"x 3-1/4" (6.2x8.3 cm.).

TECHNICAL CHARACTERISTICS

Polaroid Type 46-L Land film spectral sensitivity

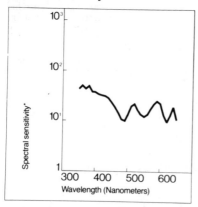

*Spectral sensitivity equals reciprocal of exposure (ergs/cm²) required to produce a 0.6 visual density.

Polaroid Type 46-L Land film characteristic curve

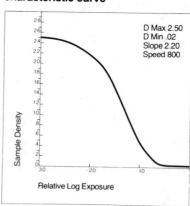

D Max 2.50
D Min .02
Slope 2.20
Speed 800

Density is ANSI visual diffuse reflection density.
Zero reference for photographic print density is BaSO₄.

(Continued on following page)

590

POLAROID

ASA equivalent speed—800, DIN 30
D-max 2.8 Slope 1.8
D-min .05 Resolution 35-40 lines/mm

The contrast characteristics of Type 46L can be manipulated over a wide range to suit the requirements of the subject. Contrast can be increased by extended development up to five minutes. Contrast can be decreased by under-developing (for 90 or 60 seconds), by pre-flashing, or both. These techniques are particularly useful in copying transparent originals; such as, color slides or x-rays. Pre-flashing gives increased shadow detail without loss of highlight contrast. Expose to sub-illumination source at 6-7 stops below main exposure, then make main exposure as usual.

MP-4	Model Lights	4-150W	4-150W	Mid bellows position
Basic Exposure		1/15 @ f/22-32	1/15 @ f/22-32	

Magnification	.5X	1:1	1.5X	2X	3X	4X	5X	6X	7X	8X	9X	10X
Exposure Increase in Stops	1	2	2.5	3	4	4.5	5	5.5	6	6.33	6.67	7

POLALINE TYPE 146-L

GENERAL DESCRIPTION

A very high contrast transparency material designed to record line copy as black and white, without gray tones. It produces dense black image areas and highly transparent highlight areas for maximum brilliance in projection.

Format:
Roll film only; image size is 2-7/16″ x 3-1/4 (6.2x8.3 cm.)

TECHNICAL CHARACTERISTICS

Polaroid Type 146-L Land film spectral sensitivity

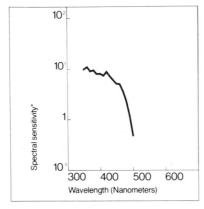

*Spectral sensitivity equals reciprocal of exposure (ergs/cm²) required to produce a 0.6 visual density.

Polaroid Type 146-L Land film characteristic curve

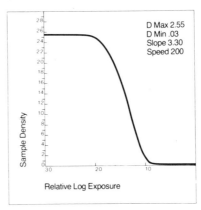

Density is ANSI visual diffuse reflection density.
Zero reference for photographic print density is BaSO₄.

(Continued on following page)

591

ASA equivalent speed:
 200-Daylight DIN 24
 60-Tungsten DIN 19

D-max 2.3 Slope 3.00+
D-min .02 Resolution 40-50 lines/mm
Blue sensitive—use no filters.

NOTE: The speed quoted for tungsten lighting should be regarded as only a rough approximation The spectral energy distribution of tungsten bulbs will vary from type to type, as well as with age, so that one of two test shots may be required to establish optimum exposure under various conditions.

MP-4	Model Lights	4-150W	4-150W	Mid bellows position
Basic Exposure		1/2 @ f/22-32	1/2 @ f/22	

Magnification	.5X	1:1	1.5X	2X	3X	4X	5X	6X	7X	8X	9X	10X
Exposure Increase in Stops	1	2	2.5	3	4	4.5	5	5.5	6	6.33	6.67	7

Exposure: As with all high-contrast film, the exposure latitude of Type 146-L film is limited. The degree of whiteness of the paper, the color of the copy, the line voltage, and the bellows extension of the camera (and thus, the reproduction scale) all influence the determination of exposure for the most satisfactory black-and-white reproductions. The exposure guide will be helpful as a starting point for line reproduction of good, clean black-and-white originals.

Color sensitivity: Type 146-L is sensitive to blue light only. Other colors (red, yellow, green) photograph as black blue tends to photograph as white. For example, blue graph lines drop out, red and green are retained. If blue must be retained, make an intermediate copy on Type 52 film.
Development for longer than the recommended time will increase density. Development for less than 10 seconds produces a transparency which may be objectionably faint.

POLASCOPE TYPE 410

GENERAL DESCRIPTION

An extremely high speed material specifically designed for recording with low level light sources, such as short duration oscilloscope traces, high magnification macrophotography or photomicrography, high speed events, and other scientific applications. Because of its high contrast and relatively coarse grain structure, it should not be used for general purpose photography of pictorial subjects unless such effects are desired.

Format:
Roll film only, image size is 2.875x 3.75" (7.35x10.55 cm.)

Spectral Sensitivity: PolaScope roll film is panchromatic. It can be used for photographing traces from blue, green or yellow phosphors. It is most effective when used with a blue PII type phosphor. Note: Most oscilloscopes have filters in front of the tube to increase contrast when viewing. These filters should be removed during photography. They cut down the amount of light reaching the film, and do not improve the quality of the photograph.

Writing Rate: The writing rate of any photographic material for oscilloscope recording is dependent on the circuit parameters of the oscilloscope as well as the characteristics of the film. Variations in accelerating potential and beam current can have an appreciable effect on the measured writing rate. Quantitative values, therefore, should be measured for each specific situation. Comparative data indicates that PolaScope film has approximately twice the writing rate of Polaroid 3000 speed film used under comparable conditions.

(Continued on following page)

The Compact Photo-Lab-Index

TECHNICAL CHARACTERISTICS

Polaroid Type 410 Land film spectral sensitivity

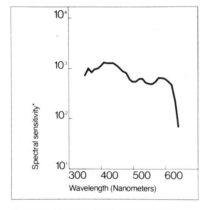

*Spectral sensitivity equals reciprocal of exposure (ergs/cm²) required to produce a 0.6 visual density.

Polaroid Type 410 Land film characteristic curve

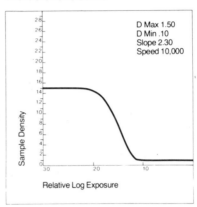

D Max 1.50
D Min .10
Slope 2.30
Speed 10,000

Density is ANSI visual diffuse reflection density. Zero reference for photographic print density is BaSO₄.

Development time is 15 sec. @ 68° F and above.

ASA equivalent speed—10,000, 41 DIN D-max 1.6 Slope 2.0
 D-min .02 Resolution 22-28 lines/mm

MP-4	Model Light	4-150W	4-150W	Mid bellows position
Basic Exposures		1/125 @ f/45	1/125 @ f/32-45	

Magnification	.5X	1:1	1.5X	2X	3X	4X	5X	6X	7X	8X	9X	10X
Exposure Increase in Stops	1	2	2.5	3	4	4.5	5	5.5	6	6.33	6.67	7

STAINS AND THEIR REMOVAL

Polaroid Land photographic products are packed with a "Caution Notice" advising that contact with Print Coater liquid, dippit solution, the damp negative, or developer from Polaroid Land film can cause stains. Reasonable care in handling these materials will prevent contact with and possible staining of clothes, furniture, etc. For example, the damp negative should always be folded in half, damp side in, before discarding. When using the Cold Clip, do not squeeze it tightly because this may force the developer out from the edges where it can cause damage. The

Print Coater should always be returned to its vial when not in use (never lay the applicator down on a table), and always place a picture you are coating on a magazine or piece of paper which will catch the overrun of the coating solution.

If through accident any of the above materials do come in contact with fabrics, clothes, furniture, and the like, prompt action with water will often prevent permanent damage (delay or drying cleaning will set the stain), and the following procedures are recommended:

(*Continued on following page*)

593

DEVELOPER FROM THE POD OR A DAMP NEGATIVE

The viscous solution in the pod has a high alkalinity. While the solution as it comes from the pod or as it remains on the damp negative will stain fabric it will not deteriorate cloth. The stain can be removed or minimized by washing the spot with a soapy solution to which a little Sodium Perborate or bleach, such as Clorox, has been added. Soaking may be required, and rather than soak the entire garment, place some of the solution in a saucer and dip the stained portion in it.

If rubbing is necessary, use the balls of the fingers since scraping with a nail may cause structural damage to the material. It is advisable to try the solution on a seam or other hidden portion of the garment to make sure that the material will accept the solution safely.

Use a sponge wet with the solution to remove stains from rugs, upholstery or wood furniture. If the stain sets on wood, the piece may require refinishing to remove all traces of damage.

DIPPIT SOLUTION

This solution is very acidic, but immediate and copious washing with plain cool water will usually quickly remove it from fabric.

PRINT COATER LIQUID

This water soluble liquid plastic can be removed with water immediately after being spilled or some hours later may involve some soaking and rubbing with balls of the fingers. Spots on leather when hardened. Removal from fabric or wood objects may require gentle rubbing with a water-dampened cloth and afterwards a polishing with paste wax or saddle soap.

EXPOSURE GUIDE FOR MP-4 CAMERA & LIGHTS & POLAROID LAND FILMS

The MP-4 lamps and lamp arms should be positioned and angled for regular copying work, as indicated on the equipment and in the MP-4 instruction book. The lamps must be of the correct voltage for the power supply used.

This is intended as an exposure guide, and not a precise exposure indicator. Each user will experience unpredictable variables in his operating conditions, which will affect exposure to some extent. Among these are the brightness of "univited" window light or room lighting, differences in color and contrast of the subject material, line voltage fluctuation and the age of the lamps.

How to use the tables:
Table A: Find the number that applies to the film type you are using. Example 4.

Table B: Measure the length of the material being copied and the length of its focused image on the ground glass, to determine the reproduction scale. In this table, find the appropriate number. Example 2.

Table C: Decide which lens f-number you wish to use. Find the number that corresponds to that f-number. Example 5.

Add the numbers you have taken from A, B, C. Total of examples given, 11.

Table D: Find the number that represents this total. Next to it you will see the recommended shutter speed.

Example 11 indicates a shutter speed of 1/8 sec.

If your total has a 1/2 in it, use the lower full number. Thus, if the total is 12 1/2, use the figure 12 in table D.

(*Continued on following page*)

The Compact Photo-Lab-Index

TABLE A Film Type and Film Speed (ASA equivalent)

Film Types		Speed	
47, 57, 107		3000	1
46-L		800	3
52		400	4
42		200	5
51	(tungsten lighting)	125	6
146-L	(tungsten lighting)	100	6
105 Positive/Negative		75	6½
55 Positive/Negative		50	7
Polacolor Types 48, 58, 108			
with 80B & CC20B or equivalent filters		24	8
with 80B & CC40B or equivalent filters		12	9

TABLE B

	Repro Scale	
Reducton	1:10 to 1:5	1
	1:4 to 1:2	2
Same size	1:1	3
Magnification	1.5x	3½
	2x	4
	3x	5
	4x	5½
	5x	6
	6x	6½
	7x, 8x	7
	9x 10x	8

TABLE C Lens Aperture

f/4.5	½
f/5.6	1
f/8	2
f/11	3
f/16	4
f/22	5
f/32	6

When setting the lens between two f-numbers, use half numbers. Thus, for f/11-f/16 use 3½.

TABLE D

Total from A, B & C	Shutter speed (exposure time)
7	1/125 sec.
8	1/60
9	1/30
10	1/15
11	1/8
12	1/4
13	1/2
14	1
15	2
16	6*
17	15*
18	40*
19	1½ min.*
20	4 min.*

*Compensation for reciprocity failure:

Normally, when an exposure meter or exposure chart indicate an exposure of about 4 sec. or longer, the exposure time needed in practice will be longer, due to a lowering of the film's effective sensitivity in low light levels. This effect, known as low light-level reciprocity failure, is common to most photographic emulsions. In this guide, table D has a built-in reciprocity failure compensation for the numbers 16 to 20. Reciprocity failure effects tend to vary somewhat from film to film, and the compensations incorporated here are an average for Polaroid Land film types in general. Thus, the times indicated are a rough guide only.

POLAROID

"Polaroid" and "Polacolor" are trademarks of Polaroid Corporation, Cambridge, Mass., U.S.A. "Polaroid" ®

The Compact Photo-Lab-Index

Polaroid Type 667 Land film spectral sensitivity

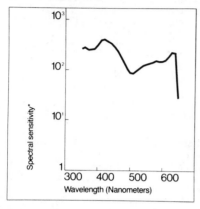

*Spectral sensitivity equals reciprocal of exposure (ergs/cm²) required to produce a 0.6 visual density.

Polaroid Type 667 Land film characteristic curve

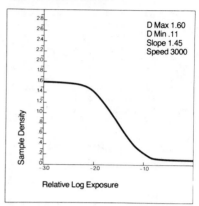

Density is ANSI visual diffuse reflection density.
Zero reference for photographic print density is BaSO₄.

Polaroid Type 667 Land film reciprocity compensation

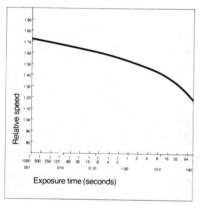

Polaroid Type 667 Land film reciprocity compensation

Exposure time (seconds)	Use either adjustment	
	Aperture	Exposure (seconds)
1/1000	None	None
1/100	None	None
1/10	1/3 stop	1.3
1	2/3 stop	1.6
10	1 stop	20
100	1 2/3 stops	400

The Compact Photo-Lab-Index

Polaroid Type 107 Land film characteristic curve

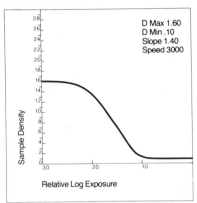

D Max 1.60
D Min .10
Slope 1.40
Speed 3000

Density is ANSI visual diffuse reflection density.
Zero reference for photographic print density is BaSO₄.

Polaroid Type 107 Land film reciprocity compensation

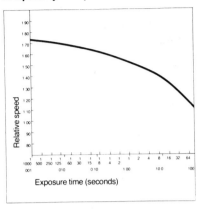

Polaroid Type 107 Land film reciprocity compensation

Exposure time (seconds)	Use either adjustment Aperture	Exposure (seconds)
1/1000	None	None
1/100	None	None
1/10	1/3 stop	.13
1	2/3 stop	1.6
10	1 stop	20
100	2 stops	400

BESELER PHOTO MARKETING CO., INC.

BESELER RP5 REVERSAL PRINT CHEMISTRY
for Kodak Ektachrome RC Type 1993® Color Paper

This chemistry will produce color paper enlargements from reversal or other color positive transparencies using Kodak Ektachrome RC Type 1993® color paper.

DIRECTIONS FOR USE

This remarkable chemistry will produce color prints of outstanding quality from your color slides with Kodak Ektachrome RC Type 1993® color paper. Color by Beseler RP5 chemistry has been specifically designed for use in plastic processing drums such as Color by Beseler color print drums. Processing is very simple, requiring only six chemical steps and two brief water washes. While no prewetting of the paper or preheating of the chemistry is required, either of these techniques may be utilized if desired.

MIXING INSTRUCTIONS

The complete package of Color by Beseler RP5 chemistry must be mixed at one time to make 32 oz. (1L) of working strength solution. Use new, clean brown glass bottles for the greatest possible chemistry storage life. Start with the mixing of the FIRST DEVELOPER.

Mix each additionl chemical in the order of use. Carefully wash out and clean the mixing graduates, stirring rod, etc. after each chemical has been mixed.

(See MIXING CHART)

If you have had water problems in the past or if you have reason to doubt the quality of your tap water, you can use distilled water for the mixing of this chemistry. As an alternative, put a suitable water filter and the appropriate filter cartridge on your faucet to remove particles, chlorine, minerals, gases, etc. from the tap water. Avoid skin contact with the working strength of concentrate solutions. Wear rubber gloves. Where required, completely mix each concentrate into solution before adding the next liquid concentrate.

You will note that the stop bath bottles are not compeltely filled. This is done intentionally to provide the correct quantity of concentrate to make 32 ounces of working solution.

The actual chemical contents in each bottle is approximately as follows:

Component	Bottle Content
First Developer	100ml
First Stop Bath	22ml
Color Developer, Part 1	50ml
Color Developer, Part 2	30ml
Color Developer, Part 3	50ml
Second Stop Bath	20ml
Bleach Fix, Part 1	100ml
Bleach Fix, Part 2	100ml
Bleach Fix, Part 3	100ml

Note: 100ml=3.38 oz.

CAUTION
Keep Out of the Reach of Children

The kit contains chemicals which may be dangerous if misused. Harmful if taken internally. If swallowed, call a physician at once. Read the specific warnings listed below for each chemical.

All of the chemical concentrates may cause skin irritation. Keep out of eyes, cuts, or open wounds. Wear rubber gloves when mixing and using the chemistry. Before removing the gloves, wash them in a 2% acetic acid solution and rinse with water. In case of eye or skin contact, immediately flush with plenty of water.

First Developer—If swallowed, call a physician. Contains: Hydroquinone and potassium sulfite.
First Stop Bath—If swallowed, call a physician. Contains: Sodium acetate.
Color Developer Part 1—If swallowed, call a physician. Contains: Hydroxylaminsulfate and benzyl alcohol.
Color Developer Part 2—If swallowed, call a physician. Contains a p-phenylene diamine derivate.
Color Developer Part 3—If swallowed, call a physician. Contains: Potassium carbonate.
Second Stop Bath—If swallowed, call a physician. Contains: Acetic acid.

(Continued on following page)

Bleach Fix Part 1—If swallowed, call a physician. Contains: Ammonium thiosulfate.
Bleach Fix Part 2—If swallowed, call a physician. Contains: EDTA Na Fe and Ammonium hydroxide.
Bleach Fix Part 3—If swallowed, call a physician. Contains: Ammonium thiosulfate.
Stabilizer—If swallowed, call a physician. Contains: Formaldehyde & Methanol.
Chemicals may cause stains on implements or clothing. Use with adequate ventilation. Children should use this kit only with adult supervision.

MAKING THE FIRST REVERSAL COLOR PRINT

(1) Choose a color slide you want to print. Properly exposed color slides will produce the best print quality. The film may have to be removed from a cardboard slide mount so it will be held flat in the enlarger negative carrier. For Beseler enlargers special slide mount negative carriers are available.
(2) Unless your enlarger has built-in ultraviolet (UV) and infrared (R) filtration, you must put a UV filter and heat absorbing glass (IR filter) into the enlarger filter drawer. The UV filter in the Color by Beseler filter set provides satisfactory results.
(3) Put the slide you want to print in a carrier and insert it into the enlarger. Switch your enlarger timer to the "focus" position to turn on the enlarger. Turn off the room lights.
(4) Open the enlarging lens to its maximum aperture. Adjust the height of the enlarger until the desired image size is obtained. Focus and compose the image and then turn off the enlarger.
(5) Create the filter pack shown in the TRIAL EXPOSURE TABLE and insert it into the enlarger filter drawer. Set your enlarger timer for a 20 second exposure and adjust the enlarging lens aperture to f5.6 as suggested in the TRIAL EXPOSURE TABLE. This recommendation is for an 8" x 10" print from a 35mm slide. For a 5" x 7" print, use 10 seconds. For an 11" x 14" print use 40 seconds.

MIXING CHART	To Make (1L) 32 oz. W.S.
FIRST DEVELOPER	
1. Start with water 90 -100 F (32 -38 C)	24 oz. (.7L)
2. While stirring, add "FIRST DEVELOPER CONCENTRATE"	complete bottle
3. While stirring, add water to make	32 oz. (1.0L)
FIRST STOP BATH	
1. Start with water ambient to 100 F (38 C)	30 oz. (.94L)
2. While stirring, add "FIRST STOP BATH" concentrate	two complete bottles
3. While stirring, add water to make	32 oz. (1.0L)
COLOR DEVELOPER	
1. Start with water 90 -100 F. (32 -38 C)	24 oz. (.7L)
2. While stirring, shake well and add "COLOR DEVELOPER PART 1"	complete bottle
3. While stirring, add "COLOR DEVELOPER PART 2"	complete bottle
4. While stirring add "COLOR DEVELOPER PART 3"	two complete bottles
5. While stirring, add water to make	32 oz. (1.0L)
SECOND STOP BATH	
1. Start with water ambient to 100 F (38 C)	31 oz. (.97L)
2. While stirring, add "SECOND STOP BATH"-concentrate	complete bottle
3. While stirring, add water to make	32 oz. (1.0L)
BLEACH FIX	
1. Start with water 90 -100 F (32 -38 C)	20 oz. (.6L)
2. While stirring, add "BLEACH FIX PART 1"	complete bottle
3. While stirring, add "BLEACH FIX PART 2" •	complete bottle
4. While stirring, add "BLEACH FIX PART 3"	complete bottle
5. While stirring, add water to make	32 oz. (1.0L)
STABILIZER	
1. Stabilizer mix 31 oz. water	complete bottle
*If crystals are present heat or crush crystals to help dissolve them.	

(Continued on following page)

TRIAL EXPOSURE TABLE (20 Seconds at f/5.6)		
FILM	AMBIENT TEMP.	110°F PREHEAT
Kodachrome	00Y + 10C	25Y + 40C
Ektachrome	15Y + 20C	40Y + 45C
Agfachrome	15M + 00C	10Y + 25C
Fujichrome	15Y + 15C	40Y + 40C
GAF slide film	00Y + 10C	25Y + 40C

MAKE A TEST STRIP

An alternate method of determining correct exposure is to make a test strip.

(1) In the dark, place a sheet of Kodak Ektachrome RC, Type 1993 color paper in your easel and cover three quarters of it with a piece of cardboard. Make a 10 second exposure.

(2) Move the cardboard to uncover the second quarter of the paper and make a 10 second exposure. Both the first and the second sections of the paper will receive light during this exposure.

(3) Move the cardboard again to uncover the third quarter of the paper. Make a 10 second exposure to all three sections of the color paper.

(4) Remove the cardboard entirely. Uncover all of the paper and make another 10 second exposure. The paper now has sections exposed at 10 seconds, 20 seconds, 30 seconds, and 40 seconds.

(5) Process the test strip print using any one of the processing techniques described later in these instructions. Use exactly the same processing technique (ambient temperature, or preheated chemistry) for the test strip and all subsequent prints. Wash and dry the test strip. It can now be evaluated for the correct density (lightness-darkness).

EVALUATING THE TEST STRIP FOR DENSITY

(1) If any section of the processed test strip shows exactly the correct density (exposure), you're finished testing. Write down the exposure time that produced the correct density test strip.

(2) If all four sections of the test strip are TOO DARK, open up the aperture of your enlarging lens by two full f/stops and repeat the test using the same exposure times. The original test strip was underexposed.

(3) If all four sections of the test strip are TOO LIGHT, close down the aperture of your enlarging lens by two full f/stops and repeat the test using the same exposure times. The original test strip was overexposed.

(4) If one section of the test strip is too light and the adjoining section is too dark, an intermediate exposure time is required. For example if the exposure time for the dark section was 10 seconds, and the exposure time for the light section was 20 seconds, the proper exposure time will be in between 10 and 20 seconds.

(5) Always try to make large exposure (density) corrections (full f/stops) by adjusting the enlarging lens aperture. Small exposure corrections (some fraction of one full f/stop) are best made by adjusting the exposure time with the enlarger timer. Try not to use exposure times shorter than 5 seconds or longer than 60 seconds. (See table below).

Remember:

IF PRINT IS TOO LIGHT, REDUCE EXPOSURE.

IF PRINT IS TOO DARK, INCREASE EXPOSURE.

Once the aperture setting and the exposure time have been determined, the next step is to identify the PREDOMINANT color on the correctly exposed section of the test strip. NOTE: Do not attempt to evaluate the predominant color cast until the correct print density has been obtained.

IDENTIFY THE PREDOMINANT COLOR CAST

(1) If your test strip happens to be perfectly color balanced, you are ready to make a full size color print without any adjustments to the filter pack. It is more likely that your test strip will have a predominant color cast which you will want to remove before making your full sized color print.

(2) You must first identify the predominant color cast. Look for a color cast in a flesh tone, gray or neutral color area. Do not try to determine what the predominant color cast is from the highlight or shadow areas of the print. The print must be properly exposed (density) before you can evaluate it for color.

(Continued on following page)

(3) Locate the PREDOMINANT COLOR of your print on the Color Balancing table and determine how much of a color cast exists (slight, moderate, etc.). Add (+) or subtract (−) the filters recommended in the "FILTER CORRECTION" column.

(4) If the indicated correction will result in a filter pack which contains more than two colors (cyan + magenta + yellow filters), do NOT make the correction. Instead, refer to the "ALTERNATE CORRECTION" column and make that correction. All three colors (cyan, magenta and yellow) should NEVER be in your enlarger filter pack at the same time.

(5) You cannot remove more filtration than there is in the filter pack. If making the indicated adjustment will result in a negative filtration value for any color, remove all filtration of that color and make another print. If the PREDOMINANT COLOR is still present, refer to the "ALTERNATE CORRECTION" column and make that adjustment.

BESELER TWO STEP COLOR RULE

You shouldn't have any difficulty in identifying the color cast if it is yellow or green, but you may experience some difficulty as a beginning color printer in distinguishing between the similar colors of blue and cyan (a blue-green), and between red and magenta (a purplish-red). If you do experience some difficulty, the Beseler TWO STEP COLOR RULE should help provide a simple solution.

For Bluish Looking Prints:

STEP #1 Assume that the predominant color cast of the print is blue and make the appropriate filter pack correction. The next print will be perfectly color balanced if the color cast was blue. If the color cast was actually cyan instead of blue, the next print will be green.

STEP # 2 If the next print is green, make the appropriate filter pack adjustment and then make a perfectly color balanced print.

BLUE + GREEN = CYAN

For Reddish Looking Prints:

STEP #1 Assume that the predominant color cast of the print is magenta and make the appropriate filter pack correction. The next print will be perfectly color balanced if the color cast was magenta. If the color cast was actually red, the next print will be yellow.

STEP #2 If the next print is yellow, make the appropriate filter pack adjustment and then make a perfectly color balanced print.

MAGENTA + YELLOW = RED

FILTER FACTORS

Every filter added to or subtracted from the enlarger filter pack affects both the color balance of the print and its density (exposure). When the filter pack is changed, the density must be corrected also to help produce a satisfactory print.

Use the FILTER FACTOR table to determine the correct filter factor for any filter added to or subtracted from the filter pack. Multiplying or dividing your exposure time by the necessary filter factor will help produce a print with correct density.

When ADDING filters, multiply the exposure time by the filter factor. When adding several filters, multiply their individual filter factors together and

EXPOSURE CORRECTION TABLE		
Original Print is	Correct by	Alternate correction
		Divide exposure time by:
Very slightly too light	close lens ½ f/stop	1.5
slightly too light	close lens 1 f/stop	2
moderately too light	close lens 2 f/stops	4
greatly too light	close lens 3 f/stops	8
		Multiply exposure time by:
Very slightly too dark	open lens ½ f/stop	1.5
slightly too dark	open lens 1 f/stop	2
moderately too dark	open lens 2 f/stops	4
greatly too dark	open lens 3 f/stops	8

(Continued on following page)

601

then multiply the exposure time by the product. When SUBTRACTING filters, divide the exposure time by the filter factor. When subtracting several filters, multiply their individual factors together and then divide the exposure time by the product.

FILTER FACTOR TABLE

Magenta	Factor	Yellow	Factor	Cyan	Factor	Red	Factor
50	1.7	50	1.2	50	1.7	50	2.0
40	1.5	40	1.2	40	1.5	40	1.7
30	1.4	30	1.1	30	1.4	30	1.5
20	1.3	20	1.1	20	1.3	20	1.4
10	1.2	10	1.1	10	1.2	10	1.2
5	1.1	5	1.1	5	1.1	5	1.1
2.5	1.1	2.5	1.1	2.5	1.1	2.5	1.1

These filter factors are for the Color by Beseler Color Printing Filters. Other brands are likely to have somewhat different filter factors.

NOTE: Always try to make large exposure (density) corrections (full f/stops) by adjusting the enlarging lens aperture. A 2.0 filter factor equals 1 f/stop. Small exposure corrections (some fraction of one full f/stop) are best made by adjusting the exposure time with the enlarger timer. Try not to use exposure times shorter than 5 seconds or longer than 60 seconds.

AMBIENT TEMPERATURE PROCESSING

Ambient (room) temperature processing is the simplest and most repeatable method of processing a color print. Since both the chemistry and processing drum are used at the existing room temperature, absolutely no temperature control of any kind is required.

Use a thermometer to measure the temperature of the FIRST DEVELOPER. Find the required processing times for this temperature on the TIME/TEMPERATURE CHART and process for the indicated times in each chemical step.

Time/Temperature Chart (Minutes)

Room Temp. C	F	First Developer	First Stop Bath	First Wash	Color Developer	2nd Stop Bath	Bleach Fix	Final Wash
37.5	100	1	1/2	2	2	1/2	2	2
35.6	96	1-1/2	1/2	2	2-1/4	1/2	2	2
33	92	2	1	2	2-1/2	1	2	2
30	86	3	1	2	3	1	3	2
28	82	3-1/2	1	2	3-1/2	1	3	2
26	79	4	1	2	4	1	3	2
24.5	76	4-1/2	1	4	4-1/2	1	3	4
23	73	5	1	4	5	1	3	4
21	70	5-1/2	1	4	5-1/2	1	3	4
20	68	6	1	4	6	1	3	4

(RE-EXPOSE)

WASH TIME

2 minutes between 82°-100°F and 4 minutes at a temperature lower than 82°F.

NOTE: Only processing times and temperatures at conveniently measured minute intervals are shown. In between times and temperature can be interpolated if desired.

NOTE: After all processing steps are completed, place the print in a tray of stabilizer solution and agitate for one minute.

AMBIENT TEMPERATURE PROCESSING PROCEDURE

Load the exposed paper into a clean dry Color by Beseler or other brand of processing drum and stand the drum on its feet on any reasonably level surface. NOTE: Different brands of pro-

COLOR BALANCING TABLE

Predominant Color	Filter Correction	Alternate Correction	Over Correction
Very slightly YELLOW	10 yellow	+10 cyan + 10 magenta	
Slightly YELLOW	20 yellow	-20 cyan + 20 magenta	
Moderately YELLOW	30 yellow	-30 cyan + 30 magenta	BLUE
Greatly YELLOW	40 yellow	+40 cyan + 40 magenta	
Very slightly BLUE	-10 yellow	10 cyan - 10 magenta	
Slightly BLUE	-20 yellow	-20 cyan - 20 magenta	
Moderately BLUE	-30 yellow	-30 cyan - 30 magenta	YELLOW
Greatly BLUE	-40 yellow	40 cyan - 40 magenta	
Very slightly MAGENTA	-10 magenta	-10 cyan + 10 yellow	
Slightly MAGENTA	-20 magenta	-20 cyan + 20 yellow	
Moderately MAGENTA	30 magenta	+30 cyan + 30 yellow	GREEN
Greatly MAGENTA	40 magenta	+40 cyan + 40 yellow	
Very slightly GREEN	-10 magenta	10 cyan - 10 yellow	
Slightly GREEN	-20 magenta	20 cyan - 20 yellow	
Moderately GREEN	-30 magenta	30 cyan - 30 yellow	MAGENTA
Greatly GREEN	-40 magenta	40 cyan - 40 yellow	
Very slightly CYAN	10 cyan	-10 yellow + 10 magenta	
Slightly CYAN	20 cyan	-20 yellow + 20 magenta	
Moderately CYAN	30 cyan	-30 yellow + 30 magenta	RED
Greatly CYAN	40 cyan	-40 yellow + 40 magenta	
Very slightly RED	-10 cyan	10 yellow - 10 magenta	
Slightly RED	-20 cyan	20 yellow - 20 magenta	
Moderately RED	-30 cyan	30 yellow - 30 magenta	CYAN
Greatly RED	-40 cyan	40 yellow - 40 magenta	

(*Continued on following page*)

cessing drums require different volumes of chemistry to properly process a color print. The 8 x 10 Color by Beseler drum can use as little as 1½ ounces (45ml) of chemistry at ambient temperature to process a reversal color print. Other 8 x 10 processing drums may require as much as 3 or 4 ounces (90ml or 120ml) of chemistry. Consult your drum instruction sheet for the manufacturer's recommedations.

Read the TIME/TEMPERATURE CHART and pour into the drum the required amount of the FIRST DEVELOPER at ambient temperature. IMMEDIATELY begin continuous and vigorous agitation by rolling the drum from side to side at the rate of one complete left-right cycle per second for the first 20 seconds and thereafter at the rate of one cycle every 2 seconds for the remainder of the processing time. At the end of the recommended processing time, thoroughly drain the drum (shake it dry).

Pour in the required volume of the FIRST STOP BATH. IMMEDIATELY begin continuous and vigorous agitation by rolling the drum from side to side at the rate of one complete left-right cycle per second for the required processing time. At the end of the recommended processing time, thoroughly drain the drum (shake it dry).

Remove the drum end cap and place the print in a tray of running water for 2 minutes between 82°F-100°F, and 4 minutes at a temperature lower than 82°F. While the print is washing in the tray of water, turn on a 100 watt tungsten light bulb 18 to 24 inches above the tray. Expose the front and back of the print for at least 15 seconds per side. THIS STEP IS NOT CRITICAL. The print cannot be overwashed or overexposed. While the print is washing, thoroughly wash the processing drum and end cap in water of the same temperature. After the print has been washed for the appropriate length of time, load it into the processing drum. Shake the drum dry of any water to avoid diluting the COLOR DEVELOPER.

Pour into the drum the required volume of the COLOR DEVELOPER. IMMEDIATELY begin continuous and vigorous agitation by rolling the drum from side to side at the rate of one complete left-right cycle per second for the first 20 seconds and thereafter at the rate of 1 cycle every 2 seconds for the remainder of the processing time. At the end of the recommended processing time, thoroughly drain the drum (shake it dry).

Pour in the required volume of the SECOND STOP BATH and IMMEDIATELY begin continuous and vigorous agitation by rolling the drum from side to side at the rate of one left-right cycle per second for the required processing time. At the end of the recommended processing time, thoroughly drain the drum (shake it dry).

Pour in the required volume of the BLEACH FIX. IMMEDIATELY begin continuous and vigorous agitation by rolling the drum from side to side at the rate of one left-right cycle per second for the first 20 seconds and thereafter at the rate of 1 cycle every 2 seconds for the remainder of the processing time. Thoroughly drain the drum. Processing is now complete.

Remove the print from the drum and wash it in a tray of running water for 2 minutes between 82°F-100°F, and 4 minutes at a temperature lower than 82°F. The print can now be dried. It is a characteristic of Ektachrome 1993 paper to have a bluish opalescent cast when wet. Because of this, print evaluation of density and color balance should only be made from dry color prints.

After the final wash, place the print in a tray of stabilizer solution, and agitate for one minute. Remove the print from the tray, and wipe off the excess solution with a sponge or squeegee. The print may now be dried according to instructions.

Stabilizer solution may be re-used for all prints made from the RP5 kit.

Thoroughly wash and dry the processing drum before using it again.

OPTIONAL PRESOAK
(for ambient temperature drum processing)

If you wish to presoak and precondition the paper and then process at ambient temperatures, simply stand the 8 x 10 drum on its feet and fill it with 16 ounces (500ml) of ambient temperature water (32 ounces (1000ml) for 11 x 14 and 16 x 20 drums). Begin agi-

(Continued on following page)

tation by gently rolling the drum from side to side for one minute. Drain out all of the presoak water so as not to dilute the first developer. Shake the drum dry. Stand the drum on its feet and pour in the required volume of ambient temperature FIRST DEVELOPER. Process according to instructions.

OPTIONAL PREHEATED CHEMISTRY (for high temperature drum processing)

By preheating only the FIRST DEVELOPER and COLOR DEVELOPER solutions and pouring them into an ambient temperature processing drum, considerably shorter processing times can be obtained. The FIRST DEVELOPER and COLOR DEVELOPER solutions can be preheated to 110°F (43°C) with a coffee cup immersion heater, a hot plate, or a water bath. The FIRST STOP BATH, SECOND STOP BATH, and BLEACH FIX are used at ambient (room) temperature.

NOTE: If the optional preheated chemistry technique is chosen, no less than 2½ ounces (75ml) of preheated chemistry should be used to adequately warm the new 8 x 10 Color by Beseler processing drum. If you are using a different brand of 8 x 10 processing drum, use the volume of chemistry recommended by the drum maufacturer of not less than 2½ ounces (75ml).

PREHEATED PROCESSING PROCEDURE (minutes)

Pre-heat Devel-oper Temper-ature	First Devel-oper*	First Stop Bath	First Wash	REEXPOSE +	Color Devel-oper*	2nd Stop Bath	Bleach Fix	Final Wash+
43 C 110 F	1	½	2		2	½	2	2

*Preheat to 110° F. (43° C.) before using.

FIRST AND FINAL WASH

2 minutes between 82°-100°F, and 4 minutes at a temperature lower than 82°F.

NOTE: After all processing steps are completed, place the print in a tray of stabilizer solution and agitate for one minute.

Preheat the FIRST DEVELOPER TO 110°F (43°C). Stand the drum on its feet. Pour in the required volume of preheated FIRST DEVELOPER and

IMMEDIATELY begin continuous and vigorous agitation by rolling the drum from side to side at the rate of one left-right cycle per second for the first 20 seconds and thereafter at the rate of 1 cycle every 2 seconds for the remainder of the processing time. Thoroughly drain the drum (shake it dry).

Pour in the required volume of ambient (room temperature) FIRST STOP BATH and IMMEDIATELY begin continuous and vigorous agitation at the rate of one left-right cycle per second for the required processing time. Thoroughly drain the drum.

Remove the drum end cap and place the print in a tray of running water for the required time. While the print is washing in the tray, expose the front and the back of the print for at least 15 seconds per side to the light of a 100W tungsten bulb 18 to 24 inches above the tray. Thoroughly wash the drum and end cap with room temperature water.

After the print has been washed and re-exposed, load it into the processing drum. Shake the drum so as not to dilute the COLOR DEVELOPER. Preheat the COLOR DEVELOPER to 110°F (43°C). Stand the drum on its feet. Pour in the required volume of preheated COLOR DEVELOPER and IMMEDIATELY begin continuous and vigorous agitation by rolling the drum from side to side at the rate of one left-right cycle per second for the first 20 seconds and thereafter at the rate of 1 cycle every 2 seconds for the remainder of the processing time. Thoroughly drain the drum (shake it dry) and stand it on its feet.

Process in the required volume of ambient (room) temperature SECOND STOP BATH and then BLEACH FIX according to the instructions listed in the ambient processing section.

Wash the print in a tray of running water for 2 minutes between 82°F-100°F and 4 minutes at a temperature lower than 82°F. After the final wash, place the print in a tray of stabilizer solution, and agitate for one minute. Remove the print from the tray, and wipe off the excess solution with a sponge or squeegee. The print may now be dried according to instructions.

Stabilizer solution may be re-used for

Continued on following page)

all pritns made from the RP5 kit. Thoroughly wash and dry the processing drum before using it again.

MISCELLANEOUS INFORMATION
Keeping Properties
Store unopened chemistry in a dry place at normal room temperature. Do not refrigerate or freeze it.

For the longest storage life, the mixed working strength chemistry should be kept in full, tightly capped brown glass bottles. The storage life of a partly full bottle of the FIRST DEVELOPER or COLOR DEVELOPER can be extended to the storage life listed for a full bottle by using Color by Beseler XDL Spray. XDL Spray is a heavier than air neutral gas that extends the storage life of all black-and-white and color developers.

Working Solution	Keeping Properties
First Developer	About 4 weeks
First Stop Bath	About 2 months
Color Developer	About 4 weeks
Second Stop Bath	About 2 months
Bleach Fix	About 2 months

COLOR PRINT EVALUATION
When wet: Kodak Ektachrome RC, Type 1993 paper has a slight, bluish-opalescent color cast. This opalescent cast disappears as the color paper dries. For this reason, evaluation of print density and color balance are best made after the paper has fully dried. The best way to evaluate your reversal print is to compare it to the color transparency used to make it.

Judgment for proper color balance should be made by light of similar characteristics to the light under which the print will ultimately be viewed. The ideal solution is to view and evaluate all color prints in daylight or an artificial light source composed of two lights, one tungsten and one fluorescent.

PRINT DRYING
Your prints may either be air dried or heat dried emulsion side up at temperatures not in excess of 200°F (90°C). Handle the wet paper carefully only by its edges. Do not place anything in direct contact with the emulsion while it is wet. To remove excess moisture and speed drying, a squeegee or print roller may be used with reasonable care.

COLOR PAPER STORAGE
Store your paper in the refrigerator at 50°F or below. Before opening the package, allow the paper to reach room temperature to prevent moisture condensation from forming. Allow 2 hours for the paper to reach room temperature after removing it from the refrigerator. NOTE: Always tightly reseal the unused portion of the paper before returning it to the refrigerator.

VOLTAGE STABILIZER
Any fluctuation in the line voltage will cause a change in both the intensity and color of the light coming from your enlarger. We recommend the use of a voltage stabilizer for your enlarger to eliminate these fluctuations.

PROCESSING TIMES
The processing times shown for Color by Beseler RP5 do not include any necessary time to properly drain your processing drum.

The Color by Beseler #8912 drum requires a drain time of only 5 seconds. Other drum brands may require considerably longer drain times. With any brand drum, shake the drum downwards and to one side to completely drain it. SHAKE THE DRUM DRY. Drain times must be added to the total processing time listed for each chemical step.

CONSISTENCY
Be consistent. This is the #1 rule of color printing. The more consistent you are in every step of your processing technique, the more consistent will be your results. Too help improve your own consistency: purchase an accurate photographic thermometer (regularly check its accuracy), always process your prints for the same length of time at the same temperature, always process each print ﬁn the same volume of chemistry, agitate your drum the same way each time, and use the same wash water temperature.

FINGERPRINTS
Always handle color paper only by the edges of the print. Never touch the surface of the print with hands wet from chemicals, water, or normal skin oil. If you seem to have difficulty in avoiding fingerprinting, wear a pair of dry cotton or plastic gloves while ex-

(Continued on following page)

posing the paper and inserting it in the drum.

DODGING AND BURNING IN

Prints from color slides can be improved frequently by the usual methods of burning in and dodging. Because of working from a positive transparency, to a positive print, one must become accustomed to the fact that dodging will darken the print, while burning in will lighten it. This is the opposite of the usual negative/positive situation.

CLEANLINESS

A few precautions will eliminate many possible color printing problems:

(1) Before mixing the chemistry, obtain a set of new, clean brown glass bottles. Label both the bottle and the bottle cap for its contents (#1, #2, #3, #4, #5). Avoid any chance of storage bottle contamination. Always put the same chemistry in the same bottle.

(2) Properly label a set of plastic graduates specifically for RP5 chemistry. Use these graduates only for this chemistry.

(3) After each print, thoroughly wash your processing drum. Shake out any excess moisture in the drum and end caps. Dry both with a disposable paper towel. Also remember to wash the graduates, stirring rod, thermometer, etc. after each print.

(4) Wash and dry your hands after processing each print. Do not touch a new sheet of color paper with water or chemicals on your hands.

(5) At the end of the printing session, wash and dry the drum and all processing accessories. Store in a dry, dirt-free place.

WASHING AND PRINT PERMANENCE

Proper final washing of the print is essential for the geratest color print permanence. Print washing should be done with constant agitation in a tray of rapidly changing water.

The washing times and temperatures listed in these instructions are the shortest to produce good print permanance. With RP5 chemistry, washing times can be increased 100% without harming the color paper in any way.

Prints processed in Color by Beseler RP5 chemistry and washed according to the instructions have excellent fade resistant properties. It should be noted that all color dyes will fade in time. Prolonged exposure to intense light (especially (UV), heat, or humidity are the primary causes of print fading.

No specific claim as to print permanence or fade resistance is made for Color by Beseler RP5 chemistry. It will not be replaced, nor is it otherwise warranted against any change in print color or density.

UNEVEN DEVELOPMENT
(areas of greater or lesser density than the rest of print)

Possible Cause	Solution
1) Not enough solution.	Follow agitation recommendations in the dation. Measure volumes carefully.
2) Agitation rate too slow during first 20 seconds	Follow agitation recommendations in the instruction sheet.
3) Inconsistent agitation	Follow agitation recommendations in this instruction sheet.
4) Rolling surface not level.	Check it and correct.

(*Continued on following page*)

DENSITY OR COLOR SHIFT FROM ONE PRINT TO NEXT

Possible Cause

1) Process times not maintained the same for each print.

2) Processing temperatures not maintained the same for each print

3) Agitation different from print to print.

4) Variations in voltage to enlarger lamp.

5) Different volumes of chemistry used for each print.

Solution

Follow the instructions carefully for processing times in FIRST DEVELOPER and COLOR DEVELOPER.

Check to see if temperature has changed. Check thermometer. Follow the instructions for a specific time/temperature. Try to always process at approximately the same time/temperature for all prints.

Try to agitate per instructions the same way each time. Consider purchasing #8921 Motor Base Drum Agitator.

Make prints from 10 a.m. to 4 p.m. or after 7 p.m. when others are less likely to turn on appliances. Purchase a voltage stabilizer.

Use the amount of chemistry required by the drum maker. Measure volumes carefully. Use the same amount of chemistry each time.

WHITE PRINT, ALMOST NO IMAGE

Possible Cause

1) FIRST STOP BATH and SECOND STOP BATH reversed.

Solution

Check order of chemicals and labeling of bottles.

COLOR BY BESELER RP5
TIME/TEMPERATURE CHART

Room Temp. C:	F.	First Developer	First Stop Bath	First Wash †		Color Developer	Second Stop Bath	Bleach Fix	Final Wash†
37.5	100	1	½	2		2	½	2	2
35.6	96	1½	½	2		2¼	½	2	2
33	92	2	1	2		2½	1	2	2
30	86	3	1	2		3	1	3	2
28	82	3½	1	2	RE-EXPOSE	3½	1	3	2
26	79	4	1	2		4	1	3	2
24.5	76	4½	1	4		4½	1	3	4
23	73	5	1	4		5	1	3	4
21	70	5½	1	4		5½	1	3	4
20	68	6	1	4		6	1	3	4

WASH TIME: 2 MINUTES BETWEEN 82°-100 F, AND 4 MINUTES AT A TEMPERATURE LOWER THAN 82 F.
NOTE: After all processing steps are completed, place the print in a tray of stabilizer solution and agitate for one minute.

COLOR BY BESELER RP5
CHEMISTRY PRE-HEAT CHART

Pre-Heat Developer Temperature	First Developer	First Stop Bath	First Wash**		Color Developer*	Second Stop Bath	Bleach Fix	Final Wash**
43 C. \| 110 F.	1	½	2	RE-EXPOSE	2	½	2	2

*Pre-heat to 110 F (43 C) before using.
**WASH TIME: 2 MINUTES BETWEEN 82°-100 F, AND 4 MINUTES AT A TEMPERATURE LOWER THAN 82 F.
NOTE: After all processing steps are completed, place the print in a tray of stabilizer solution and agitate for one minute.

BESELER CN2 COLOR NEGATIVE CHEMISTRY
for Color Negative Films

Color by Beseler CN2 can be used for the following color negative films:
Kodacolor II
Vericolor II
Eastman Color Negative Type 5247
Fujicolor II.
It should not be used for the following:
Kodacolor-X
Ektacolor-S
Other C-22 type films.

CN2 process has been designed for home processing in inversion type developing tanks.

The CN2 chemistry in this processing kit can be used at your choice of either 85°F (30°C) or 75°F (24°C). Either temperature is considerably easier to achieve and maintain in your darkroom than the super-hot processing temperatures recommended for other brands of chemistries. The 75°F (24°C) processing temperature is very close, if not identical, to many household ambient (room) temperatures. If the temperature of the mixed CN2 chemistry is 75°F ± 1°F, no temperature control (heating or cooling) of any kind is required. Process your film according to the 75°F (24°C) recommendations on the TIME / TEMPERATURE CHART.

If you prefer, use the faster processing times in CN2 chemistry at 85°F (30°C). If the ambient (room) temperature is less than 85°F±½°F or 75°F±1°F, you must use some technique to heat and hold the processing tank, chemistry, and water wash at this higher temperature.

Recommended is the use of a water filled tray or dishpan large enough to hold the chemistry bottles and developing tank. Stainless steel developing tanks will do a superior job of transmitting heat from a water bath to the chemicals inside. Use a tray deep enough for water to just cover the top of the film tank. Just a few of the many ways to reach and consistently hold the required 75° or 85° processing temperature include: running water of the correct temperature, raising the ambient temperature to the required processing temperature, use of a temperature-adjustable food tray warmer under the tray of water, or an aquarium heater adjusted to produce the correct chemical temperature. Regardless of the method used, be sure to check the temperature frequently and try to hold it within the recommended tolerances.

PROCESSING

Bring all CN2 chemicals up to the desired processing temperature. In a changing bag or in total darkness load exposed color film onto a clean film reel and put it into the film tank. If one roll of film will be processed in a two roll film tank, insert an empty reel in the tank to prevent overagitation during development.

Use a wrist watch or an accurate timer for all processing times and agitation cycles. Start the timer and fill the processing tank with CN2 DEVELOPER of the correct temperature. Rap the bottom of the tank twice on a table top to dislodge any air bubbles on the film. GENTLY invert the tank twice and put it in the water bath (if one is being used.) Thereafter, GENTLY invert the tank once every 15 seconds for the remainder of the developing time. The tank should ALWAYS be returned to the water bath after each agitation to guarantee proper temperature control. About 15 to 30 seconds before the end of the processing time, begin draining the CN2 DEVELOPER from the tank into its storage bottle. Shake the tank to help it drain completely.

Start the timer and immediately begin filling the tank with CN2 BLEACH-FIX of the correct temperature. Invert the tank gently and continuously for the first 15 seconds. Thereafter, gently invert the tank once every 15 seconds for the remainder of the processing time. **In between** agitation cycles, return the tank to the water bath. At the end of the recommended processing time, drain the CN2 BLEACH-FIX into its storage bottle. Processing times in this step are not critical and can be extended without harm.

Remove the top of the processing tank and wash the film in 75°F to 100°F (24°C-40°C) running water for 4 minutes. If running water is not available, fill the tank with heated water from the water bath. Agitate continu-

(Continued on following page)

ously for 30 seconds. Drain and repeat for a total of 4 minutes washing time in 8 changes of water. The washing time is not critical and can be extended without harm.

After the film washing is completed, immerse the film reel for 30 seconds in ambient temperature CN2 WETTING AGENT. Hang the film to dry in a clean, dust free place.

Tightly recap all of the chemistry storage bottles. For future reference, mark the label of CN2 DEVELOPER with the film size and number of rolls of film just processed.

Other than the processing temperature and time listed for the Color by Beseler CN2 DEVELOPER, the temperature/time tolerances for CN2 BLEACH FIX, wash and CN2 WETTING AGENT are much greater.

While excellent results can be obtained with these chemicals anywhere within the listed temperature ranges, it is a good practice to maintain them at the same temperature as the CN2 DEVELOPER if possible.

EASTMAN COLOR NEGATIVE 5247

When processing Eastman Color Negative 5247 film, the black carbon jet backing should be removed during the water wash.

Carefully remove the film from the reel. Gently wipe the black backing from the film with running water and a damp photo-quality fine pore sponge. DO NOT TOUCH OR RUB THE FILM EMULSION. Continue to wash until all visible black particles of the backing have been removed from the film. Eastman Color Negative 5247

TIME/TEMPERATURE CHART
COLOR BY BESELER CN-2 PROCESSING KIT 75°F (24°C)

	Temperature	1st & 2nd rolls*	3rd & 4th rolls	5th & 6th rolls
CN2 Developer	75°F±1°F (24°C±.6°C)	16 min.	18 min.	20 min.
CN2 Bleach-Fix	75°F±5°F (24°C±3°C)	9 min.	9 min.	9 min.
Water Wash	75°F to 100°F (24°C to 38°C)	4 min.	4 min.	4 min.
CN2 Wetting Agent	68°F to 100°F (20°C to 38°C)	½ min.	½ min.	½ min.

*135-36 or 120

COLOR BY BESELER CN-2 PROCESSING KIT 85°F (30°C)

	Temperature	1st & 2nd rolls*	3rd & 4th rolls	5th & 6th rolls
CN2 Developer	85°F±½°F (30°C±.3°C)	8 min.	9 min.	10 min.
CN2 Bleach-Fix	85°F±10°F (30°C±6°C)	8 min.	8 min.	8 min.
Water Wash	75°F to 100°F (24°C to 38°C)	4 min.	4 min.	4 min.
CN2 Wetting Agent	68°F to 100°F (20°C to 38°C)	½ min.	½ min.	½ min.

*135-36 or 120

MISCELLANEOUS MANUFACTURERS

(*Continued on following page*)

The Compact Photo-Lab-Index

	Increase Development per roll processed	Capacity per kit
135-36 or 120	5%	Up to 6 rolls
135-20 or 126-20	3%	8 rolls
126-12	3%	10 rolls
110-12 or 110-20	2%	16 rolls
220	12%	3 rolls

film should not be processed in the same CN2 chemicals kit which is used for Kodacolor II, Vericolor II, etc. Mix a separate Color by Beseler CN2 processing kit only for the development of Eastman Color Negative 5247 film.

PROCESSING CAPABILITY

Color by Beseler CN2 color negative chemistry can be reused at the times shown on the 75°F and 85°F charts for up to 6 rolls of 135-36 or 120 film. To determine the proper extended development times in CN2 DEVELOPER for other roll film sizes, increase the first roll development time by the percentage shown for each roll processed.

MIXING INSTRUCTIONS

It is not normally necessary to use distilled water for the mixing of Color by Beseler CN2 chemistry. Use normal tap water unless you have experienced bad water problems in the past. If your local water supply contains large quantities of minerals, dissolved metals, or chemical impurities, superior results will be obtained by using a BESELER WATER FILTER.

Use new, clean brown glass bottles for the greatest possible chemistry storage life. Start with the mixing of the CN2 DEVELOPER. Mix each additional chemical in order of use. Carefully wash out and clean the mixing graduate, stirring rod, etc. after each chemical has been mixed.

Avoid skin contact with the working strength or concentrate solutions. Wear rubber gloves. Completely dissolve and mix each component into solution before adding the next part. For more detailed information, see the cautionary information elsewhere in these instructions.

CN2 DEVELOPER
(1) Start with 10 ounces (.3L) of water 75°F-85°F (24°C-30°C)
(2) While stirring, add "CN2 DEVELOPER PART 1." Mix completely.
(3) While stirring, add "CN2 DEVELOPER PART 2." Mix completely.
(4) While stirring, add "CN2 DEVELOPER PART 3."
(5) While stirring, add water to make 16 ounces (.5L).*

CN2 BLEACH-FIX
(1) Start with 10 oz. (.3L) of water 120°F-140°F (50°C-60°C)
(2) While stirring, add "CN2 BLEACH-FIX PART 1."
(3) While stirring, add "CN2 BLEACH-FIX PART 2."
(4) While stirring, add "CN2 BLEACH-FIX PART 3."
(5) While stirring, add water to make 16 ounces (.5L).*

CN2 WETTING AGENT
(1) Add contents of "CN2 WETTING AGENT to water 68°F to 100°F (20°C-38°C) to make 16 ounces (.5L).*

*Each chemical step in this kit can be mixed to make either 16 ounces or 17 ounces of working solution. Mix this kit to make the amount of solution (number of ounces) required by your processing tank. Processing times in all steps remain as shown with either 16 ounces or 17 ounces of solution.

Once mixed, the CN2 processing kit can be used immediately.

STORAGE LIFE

Store unopened, unmixed, CN2 chemistry in a dry place at normal room temperature. Do not refrigerate or freeze mixed or unmixed Color by Beseler CN2 chemistry. For the longest storage life, the mixed working strength chemistry should be kept in full, tightly capped brown glass bottles.

(Continued on following page)

The Compact Photo-Lab-Index

Working Solution	Keeping Properties
CN2 DEVELOPER (full bottle)	about 6 weeks
CN2 DEVELOPER (partly full bottle)	about 1-2 weeks
CN2 BLEACH-FIX	about 2 months
CN2 WETTING AGENT	about 2 months

The storage life of the CN2 DEVEL-OPER in partly full bottles can be extended to the times listed for full bottles by using Color by Beseler XDL spray. XDL spray is a heavier-than-air neutral gas that extends the storage life of all black-and-white and color developers.

COLOR FILM CARE

You can accumulate a number of rolls of color negative film for batch processing at one time. This is one way to guarantee you will use up the full capacity of the CN2 processing kit.

All color films respond best to proper pre- and post-exposure care. If possible, refrigerate all unexposed color film. After it has been exposed, if you won't be processing the film immediately, put it into a tightly capped can. Refrigerate the exposed film until you are ready to process it.

TROUBLESHOOTING

When using CN2 color negative chemistry you can avoid most problems by following the instructions carefully, maintaining temperature control within the tolerances recommended, agitating according to the directions, and using clean brown glass storage bottles and a clean reel and tank.

Some possible problems and their likely cause are listed below:

THIN NEGATIVES

Possible Cause	Solution
1) Low developer temperature	Follow temperature control instruction.
2) Developer oxidized or exhausted	Do not try to over-use the chemistry. Use brown glass bottles. Use XDL spray.
3) Film was underexposed	Expose film per factory recommendations.

STREAKS OF HIGHER DENSITY AT SPROCKET HOLES

Possible Cause	Solution
1) Over-agitation	Follow agitation instruction.
2) Processed one film in a 2 reel size tank.	Put empty film reel on top of full one.

STREAKS OR LOWER DENSITY AT TOP OF FILM

Possible Cause	Solution
1) Not enough solution in tank to cover film.	Mix this kit to make 16 oz. or 17 oz. solution as required by maker your film tank.

IRREGULAR BLACK SPECKS ON NEGATIVE

Possible Cause	Solution
1) ECN 5247 film not fully washed.	Remove all black backing from film during water wash.

(Continued on following page)

MISCELLANEOUS MANUFACTURERS

611

CAUTION
Keep Out of the Reach of Children
The CN2 kit contains chemicals which may be dangerous if misused. Harmful if taken internally. If swallowed, call a physician at once. Read the specific warnings listed below for each chemical.

All chemical concentrates and working solutions may cause skin irritation. Keep out of eyes, cuts, or open wounds. Wear rubber gloves when mixing and using this chemistry. Before removing the gloves, wash them in a 2% acetic acid solution and rinse with water. In case of eye or skin contact, immediately flush with plenty of water.

The CN2 DEVELOPER contains substances that may stain or discolor certain plastic processing tanks and reels. Avoid skin contact with this solution.

CN2 Developer Part 1—If swallowed, call a physician. Contains: Hydroxylamine sulphate.
CN2 Developer Part 2—If swallowed, call a physician. Contains: Sodium sulphite and p-phenylenediamine derivate.
CN2 Developer Part 3—If swallowed, call a physician. Contains: Potassium bromide and potassium carbonate.
CN2 Bleach-Fix Part 2—If swallowed, call a physician. Contains: Ammonium bromide.
CN2 Belach-Fix Part 2—If swallowed, call a physician. Contains: EDTA NaFe.
CN2 Bleach-Fix Part 3—If swallowed, call a physician. Contains: Ammonium thiosulphate.
CN2 Wetting Agent—If swallowed, call a physician. Contains: Stab. formalin.

Chemicals may cause stains on implements or clothing. Use and mix with adequate ventilation. Children should use CN2 chemistry only with adult supervision.

BESELER 2-STEP, COLOR PRINT CHEMISTRY
for Kodak and other type "A" color papers

This chemistry will produce quality color prints from Kodak Ektacolor RC and similar type "A" color papers of other manufacturers.

Color by Beseler chemistry may be used in plastic processing drums such as the Color by Beseler color print processors, in motorized processors such as the Kodak model II drum, or in open trays.

Processing is very simple and requires only two chemical steps, followed by a brief wash in ordinary tap water. While no pre-wetting of the paper, pre-heating of the drum or intermediate rinsing are required, any or all of these techniques may be utilized if desired.

AMBIENT TEMPERATURE PROCESSING

Ambient (room) temperature processing is the simplest and most repeatable method of processing a color print. Since both the chemistry and the processing instrument (drum or tray) are used at existing room temperature, absolutely no temperature control of any kind is required.

Simply find the processing times on the time/temperature chart and process for the indicated times in STEP #1 and STEP #2.

(*Continued on following page*)

The Compact Photo-Lab-Index

TIME/TEMPERATURE CHART F

Room Temp.	Processing Time (Min.) Step #1	Step #2
107°F	1 minute	1 minute
101°F	1½ minutes	1 minute
96°F	2 minutes	1 minute
92°F	2½ minutes	1 minute
89°F	3 minutes	1½ minutes
86°F	3½ minutes	1½ minutes
83°F	4 minutes	1½ minutes
81°F	4½ minutes	2 minutes
79°F	5 minutes	2 minutes
77°F	5½ minutes	2 minutes
75°F	6 minutes	2½ minutes
72°F	7 minutes	2½ minutes
70°F	8 minutes	2½ minutes
68°F	9 minutes	3 minutes
66°F	10 minutes	3 minutes

TIME/TEMPERATURE CHART C

Room Temp.	Processing Time (Min.) Step #1	Step #2
42°C	1 minute	1 minute
38°C	1½ mintues	1 minute
36°C	2 minutes	1 minute
33°C	2½ minutes	1 minute
32°C	3 minutes	1½ minutes
30°C	3½ minutes	1½ minutes
28°C	4 minutes	1½ minutes
27°C	4½ minutes	2 minutes
26°C	5 minutes	2 minutes
25°C	5½ minutes	2 minutes
24°C	6 minutes	2½ minutes
22°C	7 minutes	2½ minutes
21°C	8 minutes	2½ minutes
20°C	9 minutes	3 minutes
19°C	10 minutes	3 minutes

AMBIENT TEMPERATURE DRUM PROCESSING

Load the exposed paper into a clean Color by Beseler or other brand of processing drum and stand the drum on its feet on any reasonably level surface. Consult the TIME/TEMPERATURE chart and pour-in the required amount of STEP #1 chemistry at ambient temperature. IMMEDIATELY begin continuous and vigorous agitation by rolling the drum from side to side at the rate of one complete left to right cycle per second for the first 20 seconds and thereafter at the rate of 30 cycles per minute for the remainder of the processing time.

At the end of the recommended processing time, thoroughly drain the drum (shake it dry) and pour-in STEP #2. IMMEDIATELY begin continuous and vigorous agitation by rolling the drum from side to side at the rate of one complete left to right cycle per second for the first 20 seconds and thereafter, at the rate of 30 cycles per minute for the remainder of the processing time.

At the end of the recommended processing time, drain out STEP #2. Processing is now complete. The print should be washed and dried. Do not use a holding tray or batch washing.

OPTIONAL PRE-SOAK)
(for ambient temperature drum processing)

If you wish to pre-soak (and pre-condition) the paper and then to process at ambient temperature, simply stand the drum on its feet and fill it with 16 ounces (500 ml) of ambient temperature water. (32 ounces [1 liter] for 11 x 14 and 16 x 20 drums). Rotate the drum for one minute and then drain-out ALL of the pre-soak water so as not to dilute the STEP #1 chemistry. (Shake the drum absolutely dry.)

Stand the drum on its feet and pour-in the required quantity of ambient temperature STEP #1 chemistry. Process according to instructions.

OPTIONAL HEAT-SOAK
(for high-temperature drum processing)

If you wish to pre-soak the paper and to pre-heat the drum, just lay a straight-edge from the ROOM TEMPERATURE column to the DESIRED PROCESSING TEMPERATURE. The point of intersection of the WATER TEMPERATURE Column indicates the correct temperature of the pre-soak water.

Stand the processing drum on its feet and fill it with 16 ounces (500 ml) of pre-soak water of the required temperature. (32 ounces [1 liter] for 11 x 14 and 16 x 20 drums). Rotate the drum for one full minute and then drain-out ALL of the pre-soak water. (Shake the drum absolutely dry, so as not to dilute the STEP #1 chemistry.)

Stand the drum on its feet and pour-in the required quantity of ambient temperature STEP #1 chemistry. Process according to instructions.

(*Continued on following page*)

613

The Compact Photo-Lab-Index

PRE-SOAK CHART

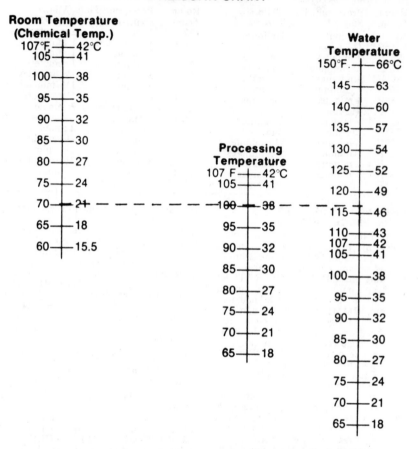

Room Temperature (Chemical Temp.)

°F	°C
107°F	42°C
105	41
100	38
95	35
90	32
85	30
80	27
75	24
70	21
65	18
60	15.5

Processing Temperature

°F	°C
107 F	42°C
105	41
100	38
95	35
90	32
85	30
80	27
75	24
70	21
65	18

Water Temperature

°F	°C
150°F	66°C
145	63
140	60
135	57
130	54
125	52
120	49
115	46
110	43
107	42
105	41
100	38
95	35
90	32
85	30
80	27
75	24
70	21
65	18

Example: If the room temperature is 70°F. and the desired processing temperature is 101°F, then the correct temperature for the pre-soak water is about 117°F. (Dotted line is example only. Make your own line for other temperature conditions.)

2 MINUTE COLOR PRINTS IN A DRUM

Load the exposed paper into a clean and dry processing drum and stand the drum on its feet on a level surface. Heat the Step #1 to 125°F (52°C) and pour it into an ambient temperature drum and IMMEDIATELY begin continuous and vigorous agitation by rolling the drum from side to side at the rate of one complete left to right cycle per second during the first 20 seconds and then at the rate of 20 left to right cycles during the remaining 40 seconds of processing time.

Thoroughly drain the drum (shake it dry) and pour-in STEP #2. IMMEDIATELY begin continuous and vigorous agitation by rolling the drum from side to side at the rate of one com-

(Continued on following page)

The Compact Photo-Lab-Index

8 x 10 Prints	Step #1	Step #2	Process Time
#1	3 oz.* (90ml)	3 oz.* (90ml)	Normal
#2	+½ oz. (15ml)	+½ oz. (15ml)	+10%
#3	+½ oz. (15ml)	+½ oz. (15ml)	+10%
#4	+½ oz. (15ml)	+½ oz. (15ml)	+10%

*In any brand 8 x 10 drum, use at least 3 oz. for the first print. Use 5 oz. (150ml) for 11 x 14 drums, and 8 oz. (240ml) for 16 x 20 drums.

plete left to right cycle per second during the first 20 seconds and then at the rate of 30 left to right cycles during the remaining 40 seconds of processing time. Pour-out STEP #2. You're all done processing.

RE-USABLE CHEMISTRY (DRUM PROCESSING)

Beseler TWO-STEP Chemistry is re-usable up to four times within a period of a few hours. This lowers the cost of processing a color print in a drum.

For each re-use (8 x 10 print or equivalent), add ½ oz. (15 ml) of fresh STEP #1 to the used STEP #1 and ½ oz. (15 ml) fresh STEP #2 to the used STEP #2 and increase processing times by 10% (STEP #1 and STEP #2). Discard the exhausted chemistry after it has been used four times. (For larger print sizes, add 1 oz. (30 ml) fresh chemistry per 11 x 14 and 2 oz. (60 ml) per 16 x 20 print. Always increase processing times 10% per re-use regardless of print size.)

TRAY PROCESSING AT AMBIENT TEMPERATURES

Only two trays are required. Pour one quart (1 liter) of ambient temperature STEP #1 into an 8 x 10 tray and one quart (1 liter) of ambient temperature STEP #2 into a second 8 x 10 tray. (Use ½ gallon (2 liters) for 11 x 14 trays and use one gallon (4 liters) for 16 x 20 trays.)

Consult the time/temperature chart for processing times in STEP #1 and STEP #2. Use plastic or stainless steel print tongs to totally immerse the exposed sheet of paper face down into tray #1 and agitate the print continuously for the recommended processing time.

Use a second set of print tongs to totally immerse the print and to agitate it continuously in tray #2 for the recommended processing time.

Use the tray #2 print tongs to lift the print out of the tray and allow it to drain back into tray #2 for 20 seconds. The print is now fully processed, and ready for washing.

RE-USING THE CHEMISTRY (TRAY PROCESSING)

After processing the first five 8 x 10 prints, add 5 oz. (150 ml) of fresh STEP #1 chemistry to tray #1 and 5 oz. (150 ml) of fresh STEP #2 chemistry to tray #2 and increase processing time by 10% (tray #1 and tray #2) for the next five prints. Continue to add 5 oz. (150 ml) of fresh chemistry to each tray and to increase processing time by an additional 10% (both trays) for each additional five 8 x 10 prints which are processed. (Add 10 oz. (300 ml) of fresh chemistry for five 11 x 14 prints and 20 oz. (600 ml) for five 16 x 20 prints. Increase processing times 10% for each five prints, regardless of print size.)

Critical workers wishing to obtain the ultimate degree of uniformity may elect to add fresh chemistry and to adjust processing times after processing each individual print. (Add one oz. (30 ml) of fresh chemistry to each tray and increase processing times by 2% in STEP #1 and in STEP #2.)

Partially used chemistry which has not been used to exhaustion may be stored in a pair of clean, empty bottles for subsequent re-use. (The keeping properties vary with the degree of oxidation caused by exposure to air while in the trays, and with the number of prints which have been processed.)

DO NOT MIX PARTIALLY USED CHEMISTRY WITH FRESH CHEMISTRY, AS THE KEEPING PROP-

(Continued on following page)

MISCELLANEOUS MANUFACTURERS

615

ERTIES OF THE FRESH CHEMISTRY WILL BE GREATLY REDUCED!

When used as directed, one gallon of chemistry will process up to 100 8 x 10 prints or their equivalent.

CHEMICAL CONTAMINATION

The resulting print quality and the useful life of the two processing chemicals depends upon the cleanliness of the equipment in which the chemicals are mixed, stored and used. The contamination of one chemical by the other is to be avoided, since it will seriously impair print quality. Take extreme care to avoid the contamination of STEP #1 by even the smallest quantity of STEP #2 during mixing, measuring or processing. Wash processing drum, thermometer, etc., in running water after each use in STEP #2.

Label all STEP #2 containers, graduates, and other implements. Use them only for STEP #2; never with STEP #1 unless they have been thoroughly washed in running water.

STREAKING OR STAINING

Large amounts of carry-over of STEP #1 into STEP #2 caused by incomplete draining of STEP #1, waiting too long before beginning agitation in STEP #2, or inadequate agitation during the first 20 seconds in STEP #2 can result in blue streaks or stains.

Drain thoroughly after STEP #1 and begin agitation in STEP #2 immediately at the rate of one left-right cycle per second during the first 20 seconds and subsequently at the rate of 30-40 cycles per minute thereafter for the remainder of the processing time. If streaking or staining persists, add a brief cold water rinse in between STEPS #1 and #2. (3 oz. [90 ml] of 65-70° water; agitate for 5-10 seconds. Drain and repeat a second time.)

If you are experiencing localized streaking or staining problems when processing with trays, deep tanks, mechanical processors (like the Kodak Model II) or drums that drain incompletely, it is probably caused by insufficient (excessive carryover) of STEP #1 into STEP #2. In such cases, an intermediate rinse with room temperature

2% acetic acid for 10-15 seconds may be used as an alternative to the cold water rinse already suggested.

TROUBLE SHOOTING
Uneven Development:
1. Not enough solution (STEP #1).
2. Rolling (agitation) surface not level.
3. Waited too long before beginning agitation (STEP #1).
4. Agitation rate too slow during first 20 seconds (STEP #1).
5. Inconsistent agitation (STEP #1).

Localized Blue Streaks or Stains:
1. Waited too long before beginning agitation (STEP #2).
2. Agitation rate too slow during first 20 seconds (STEP #2).
3. Inconsistent agitation (STEP #2).
4. Insufficient drain (STEP #1): Drain thoroughly or add a cold water rinse after STEP #1.

Cyan Cast Over Entire Print (Cyan Borders):
1. Step #1 is contaminated: Wash all utensils in cold water and mix fresh STEP #1.
2. Print exposed to B & W safelight.
3. If STEP #1 is greatly contaminated you may see a reddish-purple cast over the print and in the borders.

Pinkish Cast Over Entire Print (Pink Borders):
1. Forgot to drain out STEP #1. Repeat exposure and use a fresh 3 oz. (90 ml) of STEP #1 and STEP #2 to process.
2. Step #2 is contaminated: Wash all utensils in cold water and mix fresh STEP #2.

Yellow or Reddish Areas:
1. Paper is light-fogged.

Blue Splotches on Face of Print:
1. Trace quantities of STEP #1 trapped between drum walls and back of paper: 1) Use a water presoak before STEP #1; 2) Use a cold water rinse after STEP #1.

Color Shift When Re-using Chemistry:
1. Forgot to add ½ oz. (15 ml) fresh STEP #1 and ½ oz. (15 ml) fresh STEP #2 for each re-use in a drum (8 x 10 prints).

(*Continued on following page*)

2. Forgot to add 1 oz. (30 ml) fresh STEP #1 and 1 oz. (30 ml) fresh STEP #2 for each re-use in a tray (8 x 10 prints).

Density Shift (Lighter) When Re-using Chemistry:

1. Forgot to increase processing time 10% for each re-use in a drum.
2. Forgot to increase processing time 10% for each five prints processed in a tray.

WIDE TOLERANCE

All processing times quoted represent actual processing times with continuous agitation at the recommended rates. To these actual processing times you must add the "drain and fill" times in drum processing and the "drain" time in tray processing. (About 20 seconds with either method.)

Shorter processing times are not recommended but longer times (up to 25% longer in STEP #1 and up to 100% longer in STEP #2) will have virtually no adverse effect.

PRINT WASHING

Wash each print individually immediately after processing it, wash for 2½ minutes at approximately 85°F (30°C) or 5 minutes at 75°F (24°C) in a tray of rapidly changing water.

Do not wash prints substantially longer than the recommended times. It is not advisable to keep processed prints in a holding tray or batch washing several together. Wash and dry each processed print on an individual basis for optimum results.

DRYING

Dry prints in accordance with the recommendations of the paper manufacturer. No special drying procedure is required for prints processed in Color by Beseler TWO-STEP chemistry.

GOOD PRINT PERMANENCE

Color papers processing in Color by Beseler TWO-STEP Chemistry and washed according to directions have excellent fade-resistant properties. It

should be noted however, that all color dyes will fade in time, if exposed to intense or prolonged light. No claim or guarantee as to specific fade-resistance is made for COLOR BY BESELER, TWO-STEP chemistry.

LONG STORAGE LIFE

Unopened packages of Color by Beseler TWO-STEP color chemistry are guaranteed to be good for use for one full year from date of purchase. Store unopened chemistry in a dry place at normal room temperature. Do not refrigerate or freeze it.

Once mixed, the liquid chemistry has a useful life of 8-10 weeks when stored in well-filled, tightly capped brown glass bottles.

MIXING INSTRUCTIONS:
ONE QUART (1 LITER) SIZE

Mix contents of STEP #1 Package as follows:

A. Shake bottle labeled "A" and empty contents into 3 quarts (3 liters) of water at 77°F (25°C). Stir very thoroughly.

B. Add part "B" and stir until dissolved.

C. Add part "C" and stir until dissolved.

D. Add part "D" and stir until dissolved.

E. Add sufficient additional water at 77°F (25°C) to make a total of one quart (32 oz.) (1 liter). Stir until uniform.

Mix contents of STEP #2 Package as follows:

A. Dissolve Part "A" in 24 oz. of (720 ml) of water at 77°F (25°C). Stir thoroughly.

B. Add part "B" and stir until dissolved.

C. Add sufficient additional water at 77°F (25°C) to make a total of one quart (1 liter). Stir until uniform.

NOTE: The quart of TWO-STEP chemistry is now ready for immediate use.

(*Continued on following page*)

MIXING INSTRUCTIONS:
ONE GALLON (4 LITER) SIZE

Mix contents of STEP #1 Package as follows:

A. Shake bottle labeled "A" and empty contents into 3 quarts (3 liters) of water at 77°F (25°C). Stir very thoroughly.

B. Add part "B" and stir until dissolved.

C. Add part "C" and stir until dissolved.

D. Add part "D" and stir until dissolved.

E. Add sufficient additional water at 77°F (25°C) to make a total of one gallon (4 liters). Stir until uniform.

Mix contents of STEP #2 Package as follows:

A. Dissolve Part "A" into 3 quarts (720 ml) of water at 77°F (25°C). Stir thoroughly.

B. Add part "B" and stir until dissolved.

C. Add sufficient additional water at 77°F (25°C) to make a total of one gallon (4 liters). Stir until uniform.

NOTE: The gallon of TWO-STEP Chemistry is now ready for immediate use.

MIXING INSTRUCTIONS:
3½ GALLONS (13.2 LITERS)
2-STEP CHEMISTRY

Mix contents of STEP #1 Package as follows:

A. Empty contents of the bottle labeled PART "A" into 11 quarts (10 liters) of water at 77°F (25°C). Stir very thoroughly.

B. Add part "B" and stir until dissolved. -

C. Add part "C" and stir until dissolved.

D. Add. part "D" and stir until dissolved.

E. Add sufficient additional water at 77°F (25°C) to make a total of 3½ gallons (13.2 liters). Stir until uniform.

Mix contents of STEP #2 package as follows:

A. Dissolve part "A" into 11 quarts (10 liters) of water at 77°F (25°C). Stir thoroughly.

B. Add part "B" and stir until dissolved.

C. Add sufficient additional water at 77°F (25°C) to make a total of 3½ gallons (13.2 liters). Stir until uniform.

NOTE: The 3½ gallons (13.2 liters) of TWO-STEP Chemistry are now ready for immediate use.

SPECIAL NOTE: It is not necessary to use distilled water for mixing Beseler TWO-STEP color chemistry. Use normal tap water. However, if your local water supply contains large quantities of minerals, dissolved metals or chemical impurities, superior results will be obtained by using a BESELER WATER FILTER.

CAUTION

Harmful if taken internally. If accidentally swallowed, induce vomiting and call a physician at once. Keep out of eyes and cuts or open wounds (wear rubber gloves). Some people may be adversely affected as a result of contact. If skin irritation or inflammation occurs, rinse the affected area immediately with a solution of 2% acetic acid and water and follow by washing in running water.

(NOTE: Ordinary household vinegar may be substituted for the acetic acid). KEEP THIS AND ALL OTHER PHOTOGRAPHIC CHEMICALS OUT OF THE REACH OF CHILDREN.

STEP #1 Contains: Sodium hydroxide, benzyl alcohol hydroxylamine sulfate, p-phenylene diamine derivative, sodium sulfite, and potassium carbonate.

STEP #2 Contains: Ethylene diamine tetraacetic acid iron salt an ammonium thiosulfate.

BESELER 2-STEP, 2 MINUTE COLOR PRINT CHEMISTRY
for Agfa and other type "B" color papers

This chemistry will produce quality color prints from AGFA and similar type "B" color papers of other manufacturers.

Color By Beseler Chemistry may be used in plastic processing drums such as the COLOR BY BESELER color print processors, in motorized processors such as the Kodak model II drum, or in open trays.

Processing is very simple and requires only two chemical steps, followed by a brief wash in ordinary tap water. While no pre-wetting of the paper, pre-heating of the drum or intermediate rinsing are required, any or all of these techniques may be utilized if desired.

AMBIENT TEMPERATURE PROCESSING

Ambient (room) temperature processing is the simplest and most repeatable method of processing a color print. Since both the chemistry and the processing instruction (drum or tray) are used at existing room temperature, absolutely no temperature control of any kind is required.

Simply find the processing times on the time/temperature chart and process for the indicated times in STEP #1 and STEP #2.

TIME/TEMPERATURE CHART

Room Temp.	Processing Time (Min.) Step #1	Step #2
108°F	1 minute	1 minute
100°F	1½ minutes	1 minute
95°F	2 minutes	1 minute
91°F	2½ minutes	1½ minutes
87°F	3 minutes	1½ minutes
84°F	3½ minutes	1½ minutes
82°F	4 minutes	1½ minutes
79°F	5 minutes	2 minutes
77°F	6 minutes	2 minutes
74°F	7 minutes	2 minutes
72°F	8 minutes	2½ minutes
70°F	9 minutes	2½ minutes
68°F	10 minutes	2½ minutes

AMBIENT TEMPERATURE DRUM PROCESSING

Load the exposed paper into a clean Color by Beseler or other brand of processing drum and stand the drum on its feet on any reasonably level surface. Consult the TIME/TEMPERATURE chart and pour-in the required amount of STEP #1 chemistry at ambient temperature. IMMEDIATELY begin continuous and vigorous agitation by rolling the drum from side to side at the rate of one complete left to right cycle per second for the first 20 seconds and thereafter at the rate of 30 cycles per minute for the remainder of the processing time.

At the end of the recommended processing time, thoroughly drain the drum (shake it dry) and pour-in STEP #2. IMMEDIATELY begin continuous and vigorous agitation by rolling the drum from side to side at the rate of one complete left to right cycle per second for the first 20 seconds and thereafter, at the rate of 30 cycles per minute for the remainder of the processing time.

At the end of the recommended processing time, drain-out STEP #2. Processing is now complete. The print may be individually washed and dried at this time, or it may be placed in a holding tray, filled with ambient temperature water, to which may be added up to nine additional prints for subsequent "batch" washing and drying.

OPTIONAL PRE-SOAK
(for ambient temperature drum processing)

If you wish to pre-soak (and pre-condition) the paper and then to process at ambient temperature, simply stand the drum on its feet and fill it with 16 ounces of ambient temperature water. (32 ounces for 11 x 14 and 16 x 20 drums) Rotate the drum for one minute and then drain-out ALL of the pre-soak water so as not to dilute the STEP #1 chemistry. (Shake the drum absolutely dry.)

Stand the drum on its feet and pour-in the required quantity of ambient temperature STEP #1 chemistry. Process according to instructions.

(Continued on following page)

ROOM TEMP. (Chemical Temp.)	DESIRED PROCESS. TEMP.	WATER TEMP.
		• 138°
		• 136°
		• 134°
		• 132°
(F.)		• 130°
	• 110°	• 128°
• 100°		• 126°
	• 108°	• 124°
• 95°	• 106°	• 122°
	• 104°	• 120°
• 90°	• 102°	• 118°
	• 100°	• 116°
• 85°	• 98°	• 114°
	• 96°	• 112°
• 80°		• 110°
	• 94°	• 108°
• 75°	• 92°	• 106°
	• 90°	• 104°
• 70°	• 88°	• 102°
	• 86°	• 100°
• 65°	• 84°	• 98°
	• 82°	• 96°
• 60°		• 94°
	• 80°	• 92°
• 55°	• 78°	• 90°
	• 76°	• 88°
• 50°		• 86°
	• 74°	• 84°
	• 72°	• 82°
	• 70°	• 80°
	• 68°	• 78°
		• 76°
		• 74°
		• 72°
		• 70°

OPTIONAL HEAT-SOAK

(for high-temperature drum processing)

If you wish to pre-soak the paper and to pre-heat the drum, just lay a straight-edge from the ROOM TEMPERA-TURE column to the DESIRED PROCESSING TEMPERATURE. The point of intersection of the WATER TEMPERATURE Column indicate the correct temperature of the pre-soak water.

Stand the processing drum on its feet and fill it with 16 ounces of pre-soak water of the required temperature. (32 ounces for 11 x 14 and 16 x 20 drums) Rotate the drum for one full

(*Continued on following page*)

minute and then drain-out ALL of the pre-soak water. (Shake the drum absolutely dry, so as not to dilute the STEP #1 chemistry.)

Stand the drum on its feet and pour in the required quantity of ambient temperature STEP #1 chemistry. Process according to instructions.

2 MINUTE COLOR PRINTS IN A DRUM

Load the exposed paper into a clean and dry processing drum and stand the drum on its feet on a level surface. Heat the chemistry to 125°F (STEP #1 and STEP #2). Pour STEP #1 into an ambient temperature drum and IM-MEDIATELY begin continuous and vigorous agitation by rolling the drum from side to side at the rate of one complete left to right cycle per second during the first 20 seconds and then at the rate of 20 left to right cycles during the remaining 40 seconds of processing time.

Thoroughly drain the drum (shake it dry) and pour-in STEP #2. IMMED-IATELY begin continuous and vigorous agitation by rolling the drum from side to side at the rate of one complete left to right cycle per second during the first 20 seconds, then at the rate of thirty left to right cycles during the remaining 40 seconds of processing time. Pour-out STEP #2. You're all done processing.

RE-USABLE CHEMISTRY (DRUM PROCESSING)

Beseler TWO-STEP Chemistry is re-usable up to four times within a period of a few hours. This lowers the cost of processing a color print in a drum.

For each re-use (8 x 10 print or equivalent), add ½ oz. of fresh STEP #1 to the used STEP #1 and ½ oz. of fresh STEP #2 to the used STEP #2 and increase processing times by 5% (STEP #1 and STEP #2). Discard the exhausted chemistry after it has been used four times. (For larger print sizes, add 1 oz. fresh chemistry per 11 x 14 print and add 2 oz. per 16 x 20 print. Always increase processing times 5% per re-use regardless of print size.)

8 x 10 PRINTS	STEP #1	STEP #2	PROCESS TIME
#1	—	—	Normal
#2	+½ oz.	+½ oz.	+5%
#3	+½ oz.	+½ oz.	+5%
#4	+½ oz.	+½ oz.	+5%

TRAY PROCESSING AT AMBIENT TEMPERATURES

Only two trays are required. Pour one quart of ambient temperature STEP #1 into an 8 x 10 tray and one quart of ambient temperature STEP #2 into a second 8 x 10 tray. (Use ½ gallon for 11 x 14 trays and use one gallon for 16 x 20 trays.)

Consult the time/temperature chart for processing times in STEP #1 and STEP #2. Use plastic or stainless steel print tongs to totally immerse the exposed sheet of paper face down into tray #1 and agitate the print continuously for the recommended processing time.

Use a second set of print tongs to totally immerse the print and to agitate it continuously in tray #2 for the recommended processing time.

Use the tray #2 print tongs to lift the print out of the tray and allow it to drain back into tray #2 for 20 seconds. The print is now fully processed. Place it in a holding tray of tap water for eventual washing and drying, 10 prints at a time.

TWO MINUTE COLOR PRINTS IN A TRAY

Achieve and maintain a chemical temperature of 108°F in tray #1 and tray #2. Use print tongs to totally immerse the exposed sheet of paper face down into TRAY #1 and agitate the print continuously for 1 minute.

Use the print tongs to lift the print out of the tray by one edge and allow it to drain back into tray #1 for 20 seconds, then drop the print face down into tray #2. (Do not allow the print tongs to come into contact with tray #2 or its contents.)

Use a second set of print tongs to totally immerse the print and agitate it continuously for 1 minute in tray #2.

(Continued on following page)

MISCELLANEOUS MANUFACTURERS

Use the tray #2 print tongs to lift the print out of the tray and allow it to drain back into tray #2 for 20 seconds.

The print is now fully processed and ready to be washed and dried.

RE-USING THE CHEMISTRY (TRAY PROCESSING)

After processing the first five 8 x 10 prints, add 5 oz. of fresh STEP #1 chemistry to tray #1 and 5 oz. of fresh STEP #2 to tray #2 and increase processing time by 5% (Tray #1 and Tray #2) for the next five prints. Continue to add 5 oz. of fresh chemistry to each tray and to increase processing time by an additional 5% (both trays) for each additional five 8 x 10 prints which are processed. (Add 10 oz. of fresh chemistry for every five 11 x 14 prints and add 20 oz. for every five 16 x 20 prints.) Increase processing times 5% for each five prints, regardless of print size.

Critical workers wishing to obtain the ultimate degree of uniformity may elect to add fresh chemistry and to adjust processing times after processing each individual print. For each 8 x 10 print add one oz. of fresh chemistry to each tray and increase processing times by 1% in STEP #1 and in STEP #2.

Partially used chemistry which has not been used to exhaustion may be stored in a pair of clean, empty bottles for subsequent re-use. (The keeping properties vary with the degree of oxidation caused by exposure to air while in the trays, and with the number of prints which have been processed.)

DO NOT MIX PARTIALLY USED CHEMISTRY WITH FRESH CHEMISTRY, AS THE KEEPING PROPERTIES OF THE FRESH CHEMISTRY WILL BE GREATLY REDUCED!

When used as directed, one gallon of chemistry will process up to 100 8 x 10 prints or their equivalent.

CHEMICAL CONTAMINATION

The resulting print quality and the useful life of the two processing chemicals depends upon the cleanliness of the equipment in which the chemicals are mixed, stored and used. The contamination of one chemical by the other is to be avoided, since it will seriously impair print quality. Take extreme care to avoid the contamination of STEP #1 by even the smallest quantity of STEP #2 during mixing, measuring or processing. Wash processing drum, thermometer, etc., in running water after each use in STEP #2.

Label all STEP #2 containers, graduates, and other implements. Use them only for STEP #2; never with STEP #1 unless they have been thoroughly washed in running water.

STREAKING OR STAINING

Large amounts of carry-over of STEP #1 into STEP #2 caused by incomplete draining of STEP #1, waiting too long before beginning agitation in STEP #2, or inadequate agitation during the first 20 seconds in STEP #2 can result in blue streaks or stains.

Drain thoroughly after STEP #1 and begin agitation in STEP #2 immediately at the rate of one left-right cycle per second during the first 20 seconds and subsequently at the rate of 30-40 cycles per minute thereafter for the remainder of the processing time. If streaking or staining persists, add a brief cold water rinse in between STEPS #1 and #2. (3 oz. of 65°-70°F water; agitate for 5-10 seconds. Drain and repeat a second time.)

TROUBLE SHOOTING

Uneven Development:
1. Not enough solution (STEP #1).
2. Rolling (agitation) surface not level.
3. Waited too long before beginning agitation (STEP #1).
4. Agitation rate too slow during first 20 seconds (STEP #1).
5. Inconsistent agitation (STEP #1).

Localized Blue Streaks or Stains:
1. Waited too long before beginning agitation (STEP #2).
2. Agitation rate too slow during first 20 seconds (STEP #2).
3. Inconsistent agitation (STEP #2).
4. Insufficient drain (STEP #1): Drain thoroughly or add a cold water rinse after STEP #1.

(Continued on following page)

Cyan Cast Over Entire Print (Cyan Borders):
1. Step #1 is contaminated: Wash all utensils in cold water and mix fresh STEP #1.
2. Print exposed to B & W safelight.

Pinkish Cast Over Entire Print (Pink Borders):
1. Step #2 is contaminated: Wash all utensils in cold water and mix fresh STEP #2.

Yellow or Reddish Areas:
1. Paper is light-fogged.

Blue Splotches on Face of Print:
1. Trace quantities of STEP #1 trapped between drum walls and back of paper: 1) Use a cold water rinse after STEP #1.

Color Shift When Re-using Chemistry:
1. Forgot to add ½ oz. fresh STEP #1 and ½ oz. STEP #2 for each re-use in a drum (8 x 10 prints).
2. Forgot to add 1 oz. fresh STEP #1 and 1 oz. fresh STEP #2 for each re-use in a tray (8 x 10 prints).

Density Shift (Lighter) When Re-using Chemistry:
1. Forgot to increase processing time 5% for each re-use in a drum.
2. Forgot to increase processing time 5% for each five prints processed in a tray.

WIDE TOLERANCE

All processing times quoted represent actual processing times with continuous agitation at the recommended rates. To these actual processing times you must add the "drain and fill" times in drum processing and the "drain" time in tray processing (about 20 seconds with either method).

Shorter processing times are not recommended but longer times (up to 25% longer in STEP #1 and up to 100% longer in STEP #2) will have virtually no adverse effect.

PRINT WASHING

If you prefer to wash each print individually immediately after processing it, wash for 3½ minutes at approximately 86°F. There is certainly no necessity to take the time to wash each print immediately after it has been processed. As an alternative, up to 10 prints may be processed and then placed into a holding tray filled with ambient temperature water until ready to wash. All 10 prints may then be washed together for double the time recommended for washing one print at a time.

DRYING

Dry prints in accordance with the recommendations of the paper manufacturer. No special drying procedure is required for prints processed in Color by Beseler TWO-STEP chemistry.

GOOD PRINT PERMANENCE

Color papers processing in Color by Beseler TWO-STEP Chemistry and washed according to directions have excellent fade-resistant properties. It should be noted however, that all color dyes will fade in time, if exposed to intense or prolonged light and no claim or guarantee as to specific fade-resistance is made for COLOR BY BESELER, TWO-STEP chemistry.

LONG STORAGE LIFE

Unopened packages of Color by Beseler TWO-STEP color chemistry are guaranteed to be good for use for one full year from date of purchase. Store unopened chemistry in a dry place at normal room temperature. Do not refrigerate or freeze it.

Once mixed, the liquid chemistry has a useful life of 8-10 weeks when stored in well-filled, tightly capped brown glass bottles.

MIXING INSTRUCTIONS: ONE QUART SIZE

Mix contents of STEP #1 Package as follows:
A. Dissolve Part "A" into 24 oz. of water at 77°F. Stir very thoroughly.
B. Add Part "B" and stir until dissolved.
C. Add Part "C" and stir until dissolved.
D. Add sufficient additional water at 77°F to make a total of one quart (32 oz.). Stir until uniform.

(Continued on following page)

MISCELLANEOUS MANUFACTURERS

Mix contents of STEP #2 Package as follows:

A. Dissolve Part "A" into 24 oz. of water at 77°F. Stir thoroughly.
B. Add Part "B" and stir until dissolved.
C. Add sufficient additional water at 77°F to make a total of one quart (32 oz.). Stir until uniform.

NOTE: The quart of TWO-STEP chemistry is now ready for immediate use.

MIXING INSTRUCTIONS: ONE GALLON SIZE

Mix Contents of STEP #1 Package as follows:

A. Dissolve Part "A" into 3 quarts (96 oz.) of water at 77°F. Stir very thoroughly.
B. Add Part "B" and stir until dissolved.
C. Add Part "C" and stir until dissolved.
D. Add sufficient additional water at 77°F to make a total of one gallon 128 oz.). Stir until uniform.

Mix contents of STEP #2 Package as follows:

A. Dissolve Part "A" into 3 quarts (96 oz.) of water at 77°F. Stir thoroughly.
B. Add Part "B" and stir until dissolved.

C. Add sufficient additional water at 77°F to make a total of one gallon (128 oz.). Stir until uniform.

NOTE: The gallon of TWO-STEP Chemistry is now ready for immediate use.

SPECIAL NOTE: It is not necessary to use distilled water for mixing Beseler TWO-STEP color chemistry. Use normal tap water. However, if your local water supply contains large quantities of minerals, dissolved metals or chemical impurities, superior results will be obtained by using a BESELER WATER FILTER.

CAUTION

Harmful if taken internally. If accidentally swallowed, induce vomiting and call a physician at once. Keep out of eyes and cuts or open wounds (wear rubber gloves). Some people may be adversely affected as a result of contact. If skin irritation or inflammation occurs, rinse the affected area immediately with a solution of 2% acetic acid and water and follow by washing in running water.

(NOTE: Ordinary household vinegar may be substituted for the acetic acid.) KEEP THIS AND ALL OTHER PHOTOGRAPHIC CHEMICALS OUT OF THE REACH OF CHILDREN.

COLOR BY BESELER COLOR PRINTING FILTER SET

Filter Sets consist of a complete set of 22 acetate printing filters in 3″ x 3″ and 5½″ x 5½″ sizes. Used for subtractive color printing, the 5½″ filters will fit the filter drawer of a Beseler 23C and most other medium format enlargers. The 3″ filters will fit most smaller enlargers.

Each kit contains seven gradations of density (for a filter range of 2.5 and 157.5) in each of three colors: cyan, magenta, and yellow. A UV (Ultra-violet absorption) filter is included in each set.

Used in conjunction with the Color by Beseler subtractive calculator, these color printing filters are all you need to expose a perfectly color-balanced print, no matter what the color values of the original negative. Filters come in a convenient file storage box for easy access.

BESELER ULTRAFIN FD1

A specially formulated developer designed to give best results with low and medium speed roll films, UltraFin FD1 is a surface-type compensating developer with a film speed increase. Surface development, development of only the very top layer of the film, enhances the inherent fine grain structure of modern films. Negatives will have high acutance and exceptional sharpness. UltraFin FD1's compensating formulation keeps density from rapidly building up in the highlights of the negative, while continuing development in the shadow areas. The result is negatives that are very easy to print on a normal grade of paper even if the brightness range (contrast) of the scene is greater than normally encountered.

High speed films should only be processed in UltraFin FD1 if the exposures were made of extremely contrasty subject matter. UltraFin FD2 is especially formulated for surface-type compensating development of high speed film exposed within a normal to high contrast range.

EXPOSURE

Film to be processed in UltraFin FD1 should be exposed at higher than the normal manufacturer's recommendations. The Exposure Index listed for a particular film is a recommendation only. Tests with your equipment will help you to determine the best Exposure Index to produce the results you prefer. Over-exposure will lead to dense negatives, less fine grain, less detail and prints of reduced quality. Underexposure will lead to less shadow detail and prints of higher contrast. Delicate negatives properly exposed and developed are desirable. Check the development chart for specific Exposure Index recommendations.

DEVELOPMENT

UltraFin FD1 developer is designed for one use only. Once used, the exhausted developer should be discarded. One complete bottle of UltraFin FD1 concentrate should be added to water to make 16 ounces of working solution. This working solution should be used 2-3 hours after mixing. For the processing of one roll of film in 16 ounces of solution, read development times from the **one roll** column. When processing two rolls simultaneously, or the second roll of two consecutive rolls, read development times from the **two rolls** column.

For single reel 35mm and subminiature tanks, pour out ½ of the contents of a bottle of UltraFin FD1 and mix with water to make 8 ounces of solution. This working strength solution should be used only once. The remainder of concentrated developer will keep for a few weeks if the bottle is filled to the top with water and recapped. NOTE: Follow development time recommendations listed on "2 rolls" column.

	Add Water to Make
½ bottle	8 oz. solution (250ml)
1 bottle	16 oz. solution (500 ml)
1 bottle	20 oz. solution*(625 ml)

*For 220 roll film tanks requiring 20 oz. solution. Process for 20% more than development times listed on "two rolls" column.

Experience shows that the best development occurs in a roll film inversion tank. Agitation should be three inversions of the tank after pouring in the developer. Then rap the tank on a hard surface or table top to dislodge any air bubbles that may be on the film surface. For the next two minutes of development time, invert the tank once every 30 seconds. For the remainder of the development time, invert the tank once per minute.

Development should be followed by a 30 second rinse in a good stop bath. Use of a stop bath guarantees that film development will not continue beyond the recommended development time. The film should be fixed in a fresh fixing bath for twice the time it takes the film to clear. Delicate negative detail may be destroyed by fixing times much longer than necessary. Use of Beseler UltraClear HCA hypo clearing agent will greatly reduce film washing times. Beseler UltraWet speeds drying, kills bacteria and fungus, and makes the film dust repellent, due to an anti-static formulation.

(Continued on following page)

MISCELLANEOUS MANUFACTURERS

625

The Compact Photo-Lab-Index

DEVELOPING TIME IN MINUTES

Film	Exposure Index	One Roll (18°C) 64°F	(20°C) 68°F	(22°C) 72°F	(24°C) 75°F	Two Rolls (18°C) 64°F	(20°C) 68°F	(22°C) 72°F	(24°C) 75°F
Agfapan 25	40	9	8	7¼	6	11	10	9	7½
Agfapan 100	125	10½	9½	8½	7	13¼	12	10¾	9
Agfa IF 15	50	7¼	6½	6	5	9	8¼	7½	6¼
Agfa IF 17	80	10	9	8	6¾	12¼	11¼	10¼	8½
Agfa ISS	320	17½	16	14½	12	22	20	18	15
Ilford Pan F	80	10½	9½	8½	7	13¼	12	10¾	9
Ilford FP4	400	7¼	6½	6	5	9	8¼	7½	6¼
Panatomic-X	80	5½	5	4½	3¾	7	6¼	5¾	4¾
Plus-X	320	9	8	7¼	6	11¼	10	9	7½
Tri-X	800	19¾	18	16¼	14½	24¾	22½	20¼	18
Verichrome	160	16	14½	13	11	20	18¼	16½	13¾
Recordak Microfile AHU*	12	6	5½	5	4	—	—	—	—

*Dilute 1 bottle to make 32 ounces of solution (1000ml)

(*Continued on following page*)

The Compact Photo-Lab-Index

"One Roll" is:	"Two Rolls" are:
One 135-20	Two 135-20
One 135-36	Two 135-36
One 120	Two 126
One 126	Two 120
One 110	One 220
	The second roll of two consecutive rolls in 16 oz. of solution

For best results and greatest consistency, keep all chemistry and wash water within 10°F or less. Recommended developer temperature for highest quality is 68°F or 72°F.

Extremely accurate control of subject contrast and tonal reproduction can be accomplished with UltraFin FD1 and UltraFin FD2.

NOTE: The normal color of the developer concentrate is yellow or light brown. The working strength developer solution should be clear and colorless. If the working strength solution is discolored, it is oxidized and should be discarded. The developing tank and reels should be regularly cleaned. If the tank and reels are not cleaned of chemical residues, films developed in them may have higher than normal fog levels.

CAUTION

Harmful if taken internally. If accidendentally swallowed, call physician at once. Keep out of eyes and cuts or open wounds. (Wear rubber gloves.) If skin irritation or inflammation occurs, discontinue use and consult physician. **Keep all photographic chemicals out of the reach of children.** Contains: Sodium sulfite and hydroquinone.

BESELER ULTRAFIN FD2

A specially formulated developer designed to give best results with low and medium speed roll films, UltraFin 2 is a surface-type compensating developer with a film speed increase. Surface development, development of only the very top layer of the filmfi enhances the inherent fine grain structure of modern films. Negatives will have high acutance and exceptional sharpness. UltraFin FD2's compensating formulation keeps density from rapidly building up in the highlights of the negative, while continuing development in the shadow areas. The result is negatives that are very easy to print on a normal grade of paper even if the brightness range (contrast) of the scene is greater than normally encountered.

Low speed, fine grain films should be processed in Beseler UltraFin FD1.

EXPOSURE

Film to be processed in UltraFin FD2 should be exposed at higher than the normal manufacturer's recommendations. The Exposure Index listed for a particular film is a recommendation only. Tests with your equipment will help you to determine the best Exposure Index to produce the results you prefer. Over-exposure will lead to dense negatives, less fine grain, less detail and prints of reduced quality. Underexposure will lead to less shadow detail and prints of higher contrast. Delicate negatives properly exposed and developed are desirable. Check the development chart for specific Exposure Index recommendations.

DEVELOPMENT

UltraFin FD2 developer is designed for one use only. Once used, the exhausted developer should be discarded. One complete bottle of UltraFin FD2 concentrate should be added to water to make 16 ounces of working solution. This working solution should be used within 15 minutes after mixing. For the processing of one roll of film in 16 ounces of solution, read development times from the **one roll** column. When processing two rolls simultaneously, or the second roll of two consecutive rolls, read development times from the **two rolls** column.

Experience shows that the best development occurs in a roll film inversion tank. Agitation should be three

(*Continued on following page*)

The Compact Photo-Lab-Index

Film	Exposure Index	DEVELOPING TIME IN MINUTES							
		One Roll				Two Rolls			
		64°F	68°F	71°F	75°F	64°F	68°F	71°F	75°F
Agfapan 100	200	8	7¼	6½	5¾	10	9	8	7¼
Agfapan 400	800	17½	16	14½	12¾	22	20	18	16
Agfa IF 17	125	8¼	7½	6¾	6	10½	9½	8½	7½
Agfa ISS	320	10½	9½	8½	7	13½	12	10¾	9½
Agfa ISU	650	22	20	18	16	27½	25	22½	20
Ilford FP4	400	6	5½	5	4½	7¾	7	6¼	5½
Ilford HP4	800	11½	10½	9½	8½	14½	13¼	12	10½
Plus-X	400	7	6½	6	5¼	9	8¼	7½	6½
Tri-X	800	10½	9½	8½	7½	13¼	12	10¾	9½
Royal-X	2000	22	20	18	16	27½	25	22½	20
2475 Recording*	2000	16½	15	13½	12	21	19	17	15¼

*Only recommended for objects with high contrast

(Continued on following page)

The Compact Photo-Lab-Index

inversions of the tank after pouring in the developer. Then rap the tank on a hard surface or table top to dislodge any air bubbles that may be on the film surface. For the next two minutes of development time, invert the tank once per 30 seconds. For the remainder of the development time, invert the tank once per minute.

Development should be followed by a 30 second rinse in a good stop bath. Use of a stop bath guarantees that film development will not continue beyond the recommended development time. The film should be fixed in a fresh fixing bath for twice the time it takes the film to clear. Delicate negative detail may be destroyed by fixing times much longer than necessary. Use of Beseler UltraClear HCA hypo clearing agent will greatly reduce film washing times. Beseler UltraWet speeds drying, kills bacteria and fungus, and makes the film dust repellent, due to an antistatic formulation.

For best results and greatest consistency, keep all chemistry and wash

water within 10°F or less. Recommended developer temperatures for optimum results are 68°F and 71°F.

Extremely accurate control of subject contrast and total reproduction can be accomplished with UltraFin FD1 and UltraFin FD2.

NOTE: If the developer concentrate is dark yellow or brown, it is oxidized and should be discarded. The developing tank and reels should be regularly cleaned. If the tank and reels are not cleaned of chemical residues, films developed in them may have higher than normal fog levels.

CAUTION

Harmful if taken internally. If accidentally swallowed, call physician at once. Keep out of eyes and cuts or open wounds. (Wear rubber gloves.) If skin irritation or inflammation occurs, discontinue use and consult physician. **Keep all photographic chemicals out of the reach of children.** Contains: Sodium sulfite and hydroquinone.

BESELER ULTRAFIN FD5

UltraFin FD5 is a specially formulated developer designed to give high resolution, generally normal film speeds, a tight, sharp grain pattern and a long tonal scale. It will help produce negatives with good acutance and maximum sharp detail in big enlargements for sharpness. UltraFin FD5 gives crisp, scenics, exhibition prints, scientific photography and general use.

High, moderate, and slow speed films can be processed with equally good results in UltraFin FD5. Many films to be processed in UltraFin FD5 should be exposed at their normal speed ratings. Some films when processed in UltraFin FD5 should be exposed at higher than normal speed ratings. Each recommended speed rating has been individually determined to produce superior negative quality for that particular film. Read the Exposure Index chart BEFORE exposing your film.

NOTE: The Exposure Index listed for a particular film is a recommendation only. Tests with your equipment will help you to determine the best Exposure Index to produce the results you prefer. Overexposure will lead to dense negatives, more apparent grain, less detail, and prints of reduced quality. Underexposure will lead to less shadow detail and weak looking prints of higher contrast. Delicate negatives properly exposed and developed are desirable.

MIXING INSTRUCTIONS

UltraFin FD5 developer is designed for one use only. Once used, the exhausted developer should be discarded. UltraFin FD5 can be used at two different dilution rates, 1:15 ad 1:30.

1:15 DILUTION

The 1:15 dilution rate is recommended for all general processing use.

(Continued on following page)

MISCELLANEOUS MANUFACTURERS

The Compact Photo-Lab-Index

1:15 DILUTION DEVELOPING TIME IN MINUTES

Film	Exposure Index	One Roll (18°C) 64°F	(20°C) 68°F	(22°C) 72°F	(24°C) 75°F	Two Rolls (18°C) 64°F	(20°C) 68°F	(22°C) 72°F	(24°C) 75°F
Agfapan 25	32	6½	6	5½	4½	9	8	7	6
Agfapan 100	125	7¾	7	6¼	5¼	10½	9½	8½	7¼
Agfa IF 17	100	10½	9½	8½	7¼	14¼	13	11¾	9¾
Agfa ISS	200	12½	11¼	10¼	8½	17	15½	14	11½
Ilford Pan F	80	4½	4	3½	3	6	5½	5	4¼
Ilford FP4	200	6½	6	5½	4½	9	8	7	6
Ilford HP4	400	10	9	8	6¾	13½	12¼	11	9¼
Panatomic-X	32	6½	6	5½	4½	9	8	7	6
Plus-X	125	9¼	8½	7½	6¼	12½	11½	10½	8½
Tri-X	800	14¼	13	11¾	9¾	19¼	17½	15¾	13¼
Verichrome	160*	13¾	12½	11¼	9½	18¾	17	15¼	12¾
Infrared	—	14¼	13	11¾	9¾	19¾	18	16¼	13½
Hi Speed Infrared	—	5	4½	4	3½	6½	6	5½	4½
2475 Recording	1600	16½	15	13½	11¼	22	20	18	15

*Note: If film is accidentally exposed at normal ASA speed, reduce development time by 20%

(*Continued on following page*)

1:15 DILUTION CHART

UltraFin FD5	Add Water to Make	Develop at
½ bottle	8 oz. (250 ml) solution	listed times
½ bottle	10 oz. (300 ml) solution	listed times + 20%
1 bottle	16 oz. (500 ml) solution	listed times
1 bottle	20 oz. (600 ml) solution	listed times + 20%

One complete bottle (1 oz.) of Ultra-Fin FD5 concentrate can be added to water to make 16 oz. or 20 oz. of 1:15 working solution. This working solution should be used within 2 to 3 hours after mixing. For the processing of one roll of film in 16 oz. of solution, read development times from the "one roll" column. When processing two rolls simultaneously or the second roll of two consecutive rolls in the 16 oz. of solution, read development times from the "two rolls" column. If your processing tank requires 20 oz. of solution, increase the development times listed in the "one roll" and "two rolls" columns by 20%.

To make a 1:15 working solution for single reel 35mm and subminiature tanks, pour out ½ of the contents of a bottle of developer concentrate and mix with water to make 8 oz. of solution. This working strength solution can be used to process one roll of film at the times listed in the "one roll" column and a second roll of film at the times listed in the "two rolls" column. If your processing tank requires 10 oz. of solution, increase the listed development times by 20%. The remainder of the concentrated developer will keep for a few weeks if the bottle is filled to the top with water and re-capped.

1:30 Dilution

UltraFin FD5 can be used at a 1:30 dilution rate as a slightly finer grain, soft working, compensating developer primarily for slow speed films. It can also be used for moderate or high speed films exposed in high contrast situations.

UltraFin FD5 used at a 1:30 dilution rate has the capacity to develop a max-imum of one roll of film per 8 oz. of solution. In multi-reel tanks, each roll of film requires at least 8 oz. of solution—2 rolls in 16 oz., 4 rolls in 32 oz.

For large multi-reel film tanks, one bottle (1 oz.) of UltraFin FD5 concentrate should be added to water to make 32 oz. of solution. For medium sized developing tanks, one-half bottle (½ oz.) of UltraFin FD5 should be added to water to make 16 oz. of solution. For single reel developing tanks, ¼ oz. (7.5 ml) can be carefully measured in a calibrated graduate and mixed with water to make 8 oz. of solution.

Do not attempt to reuse 1:30 working strength solution for a second consecutive roll of film. Read all development time information from the 1:30 dilution chart.

DEVELOPMENT

Experience shows that the most even and consistent development occurs in an inversion-type roll film tank. Agitation should begin with three inversions of the tank after pouring in the working solution developer. Then rap the tank on a hard surface or table top to dislodge any air bubbles that may be on the film surface. For the next two minutes of development time, invert the tank once every 30 seconds. For the remainder of the development time, invert the tank once per minute.

AGITATION PROCEDURE

Pour in developer	→ Invert 3 times, then rap.
Next 2 minutes	→ 1 inversion per 30 seconds
Remainder of time	→ 1 inversion per minute

1:30 DILUTION CHART

UltraFin FD5	Add Water to Make	Develop at
¼ bottle*	8 oz. (250 ml) solution	listed times
½ bottle	16 oz. (500 ml) solution	listed times
1 bottle	32 oz. (1000 ml) solution	listed times

*¼ oz. (7.5 ml) measure carefully!

(Continued on following page)

631

1:30 DILUTION DEVELOPING TIME IN MINUTES

Film	Exposure Index.	One Roll			
		(18°C) 64°F	(20°C) 68°F	(22°C) 72°F	(24°C) 75°F
Agfapan 25	32	11	10	9	8
Agfapan 100	125	13	12	10½	9
Agfa IF 17	100	19	17	15½	13
Agfa ISS	200	—	—	—	—
Ilford Pan F	80	11	10	9	8
Ilford FP4	200	13	12	10½	9
Ilford HP4	400	—	—	—	—
Panatomic-X	32	12¼	11	10	8¼
Plus-X	125	22	20	18	15
Tri-X	800	—	—	—	—
Verichrome	160	—	—	—	—
Infrared	—	—	—	—	—
Hi Speed Infrared	—	13	12	10½	9
2475 Recording	1600	—	—	—	—

*Note: If film is accidentally exposed at normal ASA speed, reduce development time by 20%

(*Continued on following page*)

The Compact Photo-Lab-Index

"One Roll" is:	"Two Rolls" are:	
One 135-20	Two 135-20	
One 135-36	Two 135-36	
One 120	Two 126	or the second roll of two
One 126	Two 120	consecutive rolls of film.
One 110	One 220	

Development should be followed by a 30 second rinse in a fresh stop bath. Use of a stop bath guarantees that film development will not continue beyond the recommended development time. The film should be fixed in a fresh fixing bath for twice the time it takes the film to clear. Fix in Beseler UltraFix, a high capacity rapid fixer, for 3-5 minutes. With any fixer, do not overfix. Delicate negative detail may be destroyed by fixing times much longer than necessary.

Use of Beseler UltraClear HCA hypo clearing agent will greatly reduce film washing times while also insuring superior image permanence. Beseler UltraWet speeds drying, kills bacteria and fungus, and makes the film dust-repellent due to an anti-static formulation.

For the best results and greatest consistency, keep all chemistry and wash water within 5°F (2°C) or less.

NOTE: If the working solution is dark yellow or brown, the concentrate is oxidized and should be discarded.

CAUTION

Harmful if taken internally. If accidentally swallowed, call physician at once. Keep out of eyes and cuts or open wounds. (Wear rubber gloves.) If skin irritation or inflammation occurs, discontinue use and consult physician. **Keep all photographic chemicals out of the reach of children.** Contains: Sodium sulfite and hydroquinone.

BESELER ULTRAFIN FD7
WITH REPLENISHER

UltraFin FD7 is an exceptional developer designed to produce maximum effective film speed with excellent shadow detail. Film processed in UltraFin FD7 will have fine grain, good acutance, smooth tonality, and a compensating effect with high contrast subjects. UltraFin FD7 is an excellent general purpose developer for all types of photography.

The FD7 replenisher tablets supplied with this chemistry are an easy, convenient way to maintain constant developer activity, uniform emulsion speed and total range, and identical processing times for each roll of film processed.

EXPOSURE INDEX

High, moderate, and low sensitivity films can be processed with equally good results in UltraFin FD7. Films to be processed in UltraFin FD7 should be exposed at the Exposure Index recommendation shown on the development chart. Read the Exposure Index recommendation BEFORE exposing your film. This Exposure Index recommendation will produce a normally exposed negative with excellent shadow detail for a normal subject contrast range between 1:20 and 1:100.*

*For subject contrast ranges greater than 1:100 or less than 1:20, the UltraFin Technique should be applied. The UltraFin Technique is a method of contrast compensation by adjustment of exposure and development.

Each Exposure Index recommendation has been individually determined to be correct for that particular film when exposed with a properly functioning camera. These negatives will print with a condenser enlarger on a #2 or #3 grade paper.

NOTE: The Exposure Index listed for a particular film is a recommendation only. Tests with your equipment will help you to determine the best Exposure Index to produce the results you prefer. Overexposure will lead to dense negatives, more apparent grain, and reduced highlight detail. Underexposure will lead to less shadow detail and weak looking prints of higher contrast. Delicate negatives properly exposed and developed are preferred.

(Continued on following page)

633

The Compact Photo-Lab-Index

MAXIMUM EXPOSURE INDEX

Film	Maximum Exposure Index	(20°C) 68°F	(22°C) 72°F
Ilford HP4	1600	18	16
Plus-X	400	17	14
Tri-X	1600	17	14
Royal-X	1250	12	10
2475 Recording	1000	18	16

MAXIMUM EXPOSURE INDEX

A special MAXIMUM EXPOSURE INDEX film speed is shown on a separate development chart for certain high speed films only. This MAXIMUM EXPOSURE INDEX should be used only when required—surveillance photography, low subject contrast (1:16 or less), astrophotography, and available light situations. Do not use for general photography. Grain size and negative contrast will be higher than normal when using this recommendation. Use your exposure meter accurately. Brace the camera or use a tripod when exposing the film at slow shutter speeds. Blurry, out of focus, or dense negatives will print with more apparent grain than pictures made from sharp, properly exposed negatives.

DEVELOPMENT

Practical experience shows that the most even and consistent development is produced by using an inversion-type roll film tank.

Use an accurate thermometer to measure the temperature of the UltraFin FD7. Find the correct processing time for this temperature on the DEVELOPMENT CHART. The recommended development temperature for best results is 68°F to 72°F (20°C to 22°C). The temperature of the solution can be raised or lowered by using a water bath. Put all processing chemicals in the water bath and regulate the water temperature to produce the desired chemical temperature. In-between agitation cycles, put the developing tank in the water bath also.

If one roll of film is being processed in a multi-reel tank, fill the rest of the tank with empty reels to avoid possible over-agitation during development. Pour in sufficient UltraFin FD7 (See Mixing Instructions) to fill the tank and immediately start the timer. Agitation should begin with three gentle inversions of the tank. Rap the tank bottom on a table to dislodge any air bubbles that may be on the film surface. For the next two minutes of development time, gently invert the tank once every 30 seconds. For the remainder of the development time, invert the tank once per minute.

AGITATION PROCEDURE

Pour in Developer	→ Invert tank 3 times, then rap
Next 2 minutes	→ 1 inversion per 30 seconds
Remainder of time	→ 1 inversion per minute

About 15 to 30 seconds before the end of the processing time, begin draining the UltraFin FD7 from the tank into its storage bottle. Shake the tank to help it drain completely. When you have finished processing this film, the UltraFin FD7 developer should be replenished.

Development should be followed immediately by a 30 second rinse in a fresh stop bath (2% acetic acid). Agitate continuously.

(Continued on following page)

The Compact Photo-Lab-Index

DEVELOPMENT CHART (MINUTES)

Film	Index Exposure	(18°C) 64°F	(20°C) 68°F	(22°C) 72°F	(24°C) 75°F
Agfapan 25	25	11	10	9	7.5
Agfapan 100	100	16.5	15	13.5	11
Agfapan 400	400	13	12	11	9
Agfa IF 17	40	13	12	11	9
Agfa ISS21	200	13	12	9.5	7
Agfa ISU27	800	20	18	14.5	11
Ilford Pan F	100	9	8	7.2	6
Ilford FP4	250	17.5	16	14.5	12
Ilford HP4	800	16.5	15	13.5	11
Panatomic-X	50	9	8	6.5	5
Plus-X	200	13	12	11	9
Plus-X Prof.		13	12	11	9
Tri-X	800	11	10	9	7.5
Tri-X Prof.	800	11	10	9	7.5
Verichrome Pan	250	15.5	14	11	8.5
Royal-X	1250	11	10	8	6
Hi-speed Infrared	125	9	8	6.5	5
2475 Recording	800	16.5	15	12	9

Use of a stop bath guarantees that film development will not continue beyond the recommended processing time. The film should be fixed in a fresh fixing bath for twice the time it takes the film to clear. If you're using Beseler UltraFix, a high capacity rapid fixer, fix with continuous agitation for 3-5 minutes. With any fixer, do not overfix. Delicate negative detail may be destroyed by fixing times much longer than necessary.

Use of Beseler UltraClear HCA hypo clearing agent after the fixer will greatly reduce film washing times while also insuring superior image permanence. Beseler UltraWet speeds drying, kills bacteria and fungus, and makes the film dust-repellent due to an anti-static formulation.

For the best results and greatest consistency, keep all chemistry and wash water within 5°F (2°C) or less of the developer temperature.

(Continued on following page)

REPLENISHMENT

After processing the first film and each additional film up to 9 rolls, crush one replenisher tablet per roll of film and stir it into the stock solution. Stir the chemistry for ½-1 minute and let stand. The replenisher will go into solution slowly but dissolve fully with time.

If the replenished UltraFin FD7 must be used immediately after replenishment and the replenisher tablet hasn't fully dissolved, use the solution anyway. The undissolved replenisher will not harm the film in any way and will dissolve during processing.

For Each	Add Per Roll Processed
126	½ tablet
135-20	½ tablet
135-36	1 tablet
120	1 tablet
220	2 tablets

After processing the ninth roll of film in UltraFin FD7, crush and dissolve two replenisher tablets. The capacity of 32 ounces (1 liter) of UltraFin FD7 with replenishment is a maximum of 10 rolls of 135-36 or 120 film.

MIXING INSTRUCTIONS

While stirring, add the contents of the package labelled PART A to 25 ounces (800 ml) of water between 85°F and 100°F (30°C-38°C). Stir until the powder is fully dissolved. Next add the contents of the package labeled PART B and mix well. Stir to mix the powders into solution. Do not shake the bottle or mix air into the solution. Add water to bring the solution volume up to 32 ounces (1 liter). The mixed Ultra-Fin FD7 can be used immediately.

Ordinary tap water may be used in most cases to make working strength UltraFin FD7. If you have experienced bad water problems (particles, minerals, or unusual PH) in the past, use of a Beseler Water Filter to remove these impurities is advisable. Distilled water is not required but can be used to mix this chemistry.

Store the mixed UltraFin FD7 in full, tightly capped brown glass bottles for the best keeping properties. Mixed, properly replenished UltraFin FD7 will have a storage life of several months. In partly full bottles, the maximum storage life can be attained by using Color by Beseler XDL Spray. XDL Spray is an inert, heavier-than-air gas that extends developer life. Add XDL Spray into the mouth of the storage bottle to force air out and prevent premature oxidation of the solution.

Stored and replenished UltraFin FD7 may become yellowish or cloudy. This is quite normal and does not indicate a problem of ay kind.

CAUTION

Harmful if taken internally. If accidentally swallowed, call physician at once. Keep out of eyes and cuts and open wounds. (Wear rubber gloves.) If skin irritation or inflammation occurs, discontinue use and consult physician. **Keep all photographic chemicals out of the reach of children.** Developer contains: Hydroquinone, an aminophenol derivate and sodium sulfite. Replenisher contains: Hydroquinone.

EDWAL SCIENTIFIC PRODUCTS CORP.
EDWAL FOTOTINTS

Edwal Fototints consist of a set of twelve scientifically selected dyes for retouching color films and prints, and for imparting color to slides and movie titles. They have been formulated and tested for use in audiovisual photographic and graphic arts applications.

AVAILABILITY
1 oz. and 4 oz. glass bottles.

COLORS
Red, green, blue, magenta, cyan, yellow, amber, orange, violet, olive, brown, gray.

CHARACTERISTICS
Edwal Fototints are strongly absorbed by gelatin causing the dye to be very efficiently used. For this reason, they may be used at dilutions up to 1:50. They require no pre-conditioner, and leave no residue on the surface after application. The colors are clear and saturated, and colors can be mixed to obtain any desired tint. For projection slides or other projected photo-visuals, visual inspection of dye intensities can be used to determine screen effect. The dye colors can be reproduced easily on color film without color-distortion, an important point where duplication of transparencies is required.

RETOUCHING COLOR FILMS AND PRINTS
Edwal Fototints are used to alter colors on color films (negative or positive) and color prints, using standard retouching methods. Sable brushes, obtainable at any art supply store, should be used in sizes 0, 1, 3, or 3. Pinholes and dust spots can be eliminated by careful application of the appropriate color. It is best to use a dilution of Fotoprint that is somewhat lighter than the color to be matched. Additional color can be applied by successive treatments, until the nearby background color is matched. Control over the saturation of color can be easily achieved by the degree of dilution that is used for any given situation. If, by some miscalculation, the added color is too dark, excess color can be removed by adding a little Edwal Film, Glass and Chrome Cleaner, or 5% ammonia solution. Ektacolor prints have a slight bluish color when wet. For this reason it is best to wait until the print is dry before attempting to retouch. Avoid the use of a wetting agent, because this may result in the spreading of Fototint into areas where it is not desired.

TINTING AND TONING B&W FILMS
Black-and-white films and prints can be toned with Edwal Color Toners, washed, dried and then tinted with Edwal Fototints. Then entire print can be immersed in a 1:50 solution, or by applying the desired tint to a dry print by the brush-on method. When using a brush, the solution should be at least 1:10, because the tint is strongly absorbed by the gelatin and paper base. It is advisable to experiment upon a scrap transparency or print on the same material before applying the dye to your finished work.

Two-color movie titles can be made by toning a strip of black-and-white movie film with an Edwal Color Toner, washing, and then Fototinting the background in whatever color is desired. Live action black-and-white scenes, of course, can be handled in the same way.

MAKING COLOR FILTERS
High contrast films such as Kodalith, that has not been developed, but has been cleared by fixing and washing, may be colored with Edwal Fototints to produce an infinite variety of special purpose filters according to the desires of the photographer. Colors are produced by immersing the fixed and washed film in the appropriate concentration of the Fototint, or the film may be dried and multiple bands of different colors may be added with a brush. The gray Fototint is photographically neutral and may be used to make neutral density filters. For motion

(Continued on following page)

picture special effects work, filters can be designed to fit the matte box, applying the dye in a pattern that would selectively hold back some portions of the picture area, while allowing full exposure to pass through in other areas.

THEATRICAL GELS

Pieces of clear litho film (fixed and washed without development) can be dyed with Fototints, dried, and then sandwiched with B&W textured slides to make a variety of different-colored background slides from one basic B&W design.

Ordinary theatrical gels used in color overlays frequently have a number of pinholes. The operator can make his own "gels" by Fototinting fixed, washed, and dried litho film, without pinholes or other imperfections.

CAUTION

Edwal Fototints contain acetic acid and analine dyes. Harmful if swallowed. In case of contact with skin, wash immediately. Old stains can be removed by diluted laundry bleach (Clorox, Linco, or other chlorine type bleach solutions) KEEP OUT OF REACH OF CHILDREN.

TITLE SLIDES USING EDWAL FOTOPRINT COLORS

The prepared line copy, artwork and lettering is photographed at ASA 1 on Kodalith or other suitable sized litho film. This film is then developed, fixed, washed, and dried in the customary manner to produce a black-and-white slide film in which the values are the opposite of the original. Recommended for this use is Edwal Fine Line Developer, 2½ minutes at 70° using vigorous agitation for one minute, and then "still developing" (no agitation) emulsion side up to complete the development.

The film is fixed, washed and dried in the usual manner.

After drying, the Fototint colors are then applied to the emulsion side of the B&W title slide with a fine camel-hair or sable brush. Colors are applied one at a time, and then blotted with tissue. For stronger colors, the Fototint concentrate is applied full-strength and

allowed to penetrate about ten seconds before it is blotted. For a medium color, only one or two seconds are needed before blotting.

For intense colors, Fototints can also be applied to the back of the film where the dye will be absorbed by the anti-curl backing.

When each letter is to be colored differently, it is best to color every alternate letter, let them dry, and then fill in those between, since the wet emulsion tends to allow the liquid to spread into unwanted areas.

If a large drop of the dye has been laid down, touching the edge of the drop with a dry tissue will allow the drop to be withdrawn sufficiently so that blotting will not squeeze the dye into adjacent areas. If too much color is applied, the saturation can be reduced by washing with water. If the entire slide is to be dyed one color, it is best to dilute a small amount of Fototint with water before immersing the slide. Fully saturated colors can be obtained even with a 1:50 Fototint dye solution by allowing the slide film to soak long enough. Diluted Fototints may be saved, and used over and over again.

The finished slide will have colored letters or design on a black background. It may be projected as it is, or may be used to make a "burnthrough" colored background. This burnthrough technique may also be used, in some cases, to overlay colored letters superimposed over a color photograph.

BURNTHROUGH TECHNIQUE

After selecting your color slide that is to be used for the background, recopy it on color duplicating film in a 35mm copy camera. Slide duplicators such as the Bowens Illumitran are ideal for duplication of slides and burnthrough.

After making the exposure of the background transparency, do not advance the film in the camera, but make the necessary adjustments to allow a second exposure onto the same frame. This second exposure is made of the litho film that has been prepared with the Edwal Fototints. This makes a superimposed image combining the two exposures; the original background

color slide with continuous tone image, and the high contrast film which was dyed. The color reversal film used for making these combined copies is processed in the usual manner. It does not matter whether the background slide is copied onto the duplicating film first, or if the high contrast film is first. These multiple exposures will work as well either way. One caution must be observed. Since you are combining exposures, care must be taken to assure that any lettering that is burned over such a background slide, must fall into an area that is sufficiently dark to register the burnthrough properly. Also, the color as applied to the slide will be modified by the background slide to some extent. The darker the area in which the burnthrough lettering is to appear, the purer the Fototint colors will remain. If white letters are to be burned in, a little gray Fototint dye can be applied to prevent flare at the edges of the lettering, or the exposure on white lettering can be reduced approximately half a stop. Avoid attempting burnthrough over very light areas such as sky, clouds, white shirts and similar scene elements. The layout of the lettering should be arranged to fit the subject in such a way that it will be easily read against the background over which it appears.

Because the end result of such double exposures are combinations of the colors of the background slide and the dyed high contrast slide, it is best to make a test to help predict the color shifts that may be encountered.

Take a black card 8″ x 11″ and subdivide it into 12 2″ squares by running strips of one inch masking tape to separate them. Copy this on litho film, to obtain clear squares against a black background. Color each square with a different Fototint color. Shoot these tinted squares superimposed over various color backgrounds to see what the combined effect of the Fototint and background produces. Make an added reference shot of just the litho film along, for comparison.

Appearance of litho film made from test card

In this way, you will learn the results of various combinations. Similar tests can be run with the tinted squares negative over proposed photographs, turn the tinted slide into four different positions to bring various squares over different portions of the color photograph. By studying the combined effect of these multiple exposures, you will be able to shoot such effects with carefully predictable results.

The Compact Photo-Lab-Index

EDWAL SCIENTIFIC PRODUCTS CORP.
EDWAL FILM CLASSIFICATION

35mm FILMS AND SMALLER

AGFA: 25 I, 100 II, 200 III, 400 III, 1000 V.
GAF: 125 II, 250 IV.
EASTMAN KODAK: Panatomic-X II, Infrared III, High Speed Copy Film I, Plus-X II, Improved Tri-X III, 2475 V, 2484 VII, XT Pan II.
ILFORD: FP3 and FP4 II, HP3 and HP4 III, Pan-F I, HPS V.
MINOX: 25 ASA I, 50 ASA II, 100 ASA IV, Plus-X II, Tri-X III.
FUJI: Neopan SSS V.
H&W: VTE III, VTE Ultra III.

ROLL FILMS AND PACKS

GAF: 125 II, 250 IV.
EASTMAN KODAK: Plus-X II. All others III.
ILFORD: FP3, HP3 III, Selechrome III. HPS and HP4 V.
LUMIPAN: V.
FUJI: Fujipan K II.

SHEET FILMS

AGFA: 100 II, 200 III, 400 IV.
GAF: Vivipan III, 2831 III, 2863 V, 2881 VI.
DUPONT: Cronar Commercial CCS7 IV.
EASTMAN KODAK: Commercial IV, Infrared IV, Super Panchro Press Type B VI, Super-XX VI, Royal Pan V, Tri-X Ortho III, Tri-X III, Royal X VI, Plus-X III, Kodak Ektapan 4162 V.
ILFORD: Commercial Ortho IV, FP3 III, HP3 III, HPS V.

CONTRAST CONTROL

Contrast is usually increased or decreased by increasing or decreasing developing time according to the photographer's judgment. However, contrast may also be increased or decreased by using lesser or greater dilutions of FG7 Concentrate to make the working solution. Thus in the "single-use" methods, a 1:19 or even 1:31 dilution may be used to hold highlight detail without losing shadow area density. Exposure should be increased ½ f-stop for 1:19 or a full f-stop for 1:31 dilution. Likewise, contrast may be increased without changing developing time by using higher concentrations; e.g., 1:11 or even 1:9 for the "single use" methods (6 and 7).

EDWAL FG7

WHAT FG7 IS AND DOES

1. General Information

Edwal FG7 is a compensating, general purpose developer for continuous-tone films, and tends to prevent blocking-up on contrasty subjects. It is softer working than the long-scale developers, Edwal Super 12 or Edwal Super 20, but not as soft-working as Edwal Minicol II. Edwal FG7 gives a rather full-bodied negative with good resolution or "acutance."
Seven methods and dilutions are available:

(continued on following page)

640

A. Rapid development for sheet film: 1:1 dilution.
B. Rapid development for roll film: 1:2 dilution.
C. Professional, photo finishing, and deep tanks: 1:3 dilution.
D. Single-use development: 1:15 dilution.
E. Available light: 1:3 or 1:15 dilution (with sulfite).
F. FG7 Automatic (two-bath): 1:1, 1:3, or 1:5 dilution.
G. Controlled Monobath: 1:15 dilution followed by Hi-Speed Liquid Fix Contrate.

2. Grain

At 1:2 or 1:3 dilution, Edwal FG7 gives fine enough grain for many purposes, but is not an ultra-fine grain developer such as Edwal Super 20. For finest grain on medium and high speed films, the 1:15 dilution using 9% sodium sulfite instead of water is recommended, producing fine enough grain for practically any use.

When diluted 1:15 with plain water, Edwal FG7 is a non-solvent type developer which gives very fine grain with thin-emulsion films such as Panatomic-X, and reasonably fine grain on medium and high-speed films.

3. Practical Film Speed and Exposure Methods

Edwal FG7 is best used with a higher exposure index than the film manufacturers recommend.

Some practical ratings for normal development are:

Tri-X	2400	GAF 500		1000
Royal-X	4800	ISS		500
		Plus-X		500
	Panatomic-X		125	

for 1:3 or 1:5 dilutions on 35mm and roll films. For 1:1, 1:2, or on sheet films, use 1 stop more exposure.

These suggested film speeds are based on the commonly used light measuring procedure with a reflected light meter (e.g., G.E. or Weston) held at camera position and pointed at the shadow area of the subject. Users of spot or incident light meters, etc., should make a test strip to determine which practical film speed is best for their method.

HOW TO USE EDWAL FG7
FOR RAPID DEVELOPMENT

Edwal Fine Grain Concentrate No. 7 (FG7) will develop every modern film for any common use by variation of dilution and developing time. Its normal color is pale tan to lavender. It keeps well even in a partly full bottle, but should be stored at room temperature (below 85°F) for longest shelf life.

1. RAPID DEVELOPMENT FOR SHEET FILMS: (Fine Grain in 4 minutes) Dilute FG7 Concentrate with an equal volume of water. Develop (minutes):

Film Class

	I	II	III	IV	V	VI	VII
65°F	2	2½	3	3½	4	5	6
70°F	1¾	2	2½	3	3½	4	5
75°F	1½	1¾	2	2½	3	3½	4
80°F	1¼	1½	1¾	2	2½	3	3½
85°F	1	1¼	1½	1¾	2	2½	3

(continued on following page)

MISCELLANEOUS MANUFACTURERS

2. RAPID DEVELOPMENT FOR ROLL FILMS: (Fine Grain in 5 minutes) Dilute FG7 Concentrate with two parts water. Develop (minutes):

	I	II	III	IV	V	VI	VII
			Film Class				
65°F	3	3½	4	5	6	7½	9
70°F	2½	3	3½	4	5	6	7½
75°F	2	2½	3	3½	4	5	6
80°F	1¾	2	2½	3	3½	4	5
85°F	1½	1¾	2	2½	3	3½	4

3. FOR AVAILABLE LIGHT: Use Method 4 or Method 7. Prolong developing times 50% for a 100% film speed increase, or 100% for maximum speed (usually 300% to 400% increase).

With extended development using 1:1, 1:2, 1:3, and 1:15 with 9% sulfite dilutions (Methods 1, 2, 4, and 7), increasing the developing time about 50% will double the effective film speed. Doubling the standard developing time will produce about a four-fold increase in apparent film speed, but on many films some shadow detail is lost, even though the negative is considered to be "printable." Further increases in developing time produce relatively little increase in film speed. Care must be taken to keep exposures down to give a fairly thin, fine grain negative.

4. FOR DEEP-TANK DEVELOPMENT: Dilute FG7 Concentrate with 3 parts water. Develop (minutes):

	I	II	III	IV	V	VI	VII
			Film Class				
60°F	4	5	6	7½	9	11	13
65°F	3	4	5	6	7½	9	11
70°F	2½	3	4	5	6	7½	9
75°F	2	2½	3	4	5	6	7½
80°F	1¾	2	2½	3	4	5	6
85°F	1½	1¾	2	2½	3	4	5

To get film speed equal to Method 7, develop in next higher film class.

For photo finishing or other situations where both regular and thin emulsion films are to be developed in the same tank, the 1:3 dilution with plain water should be used. This gives fine grain on the medium and high speed films, plus good acutance and extremely fine grain on thin emulsion films. This same dilution can be used for ultra speed films such a Royal-X if agitation is frequent and efficient to avoid any tendency to dichroic fog.

To replenish FG7 at the 1:1, 1:2, or 1:3 dilutions, add ½ oz. concentrate for each 80 to 100 square inches of film in small tanks. In deep tanks add just enough concentrate to keep the level up. Where developer carry-out is large, as with commercial development of film packs, replenishment should be with FG7 diluted 1:1.

5. FOR FG7 AUTOMATIC (TWO-BATH) DEVELOPMENT: Especially good for high contrast subjects. To make Solution A, dilute FG7 1:1 for most films 1:3 or 1:5 for fine grain films. To make Solution B, dilute FG7 B Concentrate 1:1. Develop all films 1 minute in Solution A and 2 minutes in Solution B.

FOR FG7 AUTOMATIC (TWO-BATH SYSTEM)

Use FG7 Concentrate at 1:1 (or higher) dilution for Solution A, and use FG7 Solution B Concentrate at 1:1 dilution for Solution B in the two-bath system described in detail in the FG7 AUTOMATIC information which follows on the next page. This is a rapid, simple method which eliminates many of the chances

(continued on following page)

for human error, and does away with the necessity for temperature adjusting and exact watching of long developing time. During the 1-min. immersion in Solution A, the correct amount of developing agent is automatically absorbed by the emulsion. During the 2-min. in Solution B, development is completed and automatically stops when the developing agent has been used up. Maximum film speed is automatically obtained. Exposure indexes of 3200 for Tri-X, 800 for Plus-X, and 160 for Panatomic-X are possible. Grain is satisfactory for most purposes, especially with the fine grain films, but is not as fine as on negatives of comparable density obtained with other FG7 developing methods.

KEEPING CHARACTERISTICS

Edwal FG7 Concentrate normally has a pale lavender or tan color due to the developing agents used, and will retain that color as long as it is in good condition. It contains so much active ingredient that it keeps well even in a partly full bottle if tightly sealed. The 1:1, 1:2, and 1:3 dilutions will keep for months in tightly closed glass bottles. Polyethylene "squeeze-type" bottles are not recommended for long storage because air diffuses through the walls. The 1:15 dilutions should be made up just before using.

FG7 Concentrate will keep for a year or more at room temperature, but if stored for several months at 90°F cr higher there may be some loss of film speed (about ½ stop to one full stop). If crystalization occurs due to low temperature, crystals will gradually redissolve if warmed to room temperature and shaken or stirred in a beaker. The solution containing crystals may first be shaken vigorously to get a uniform mixture, and then the necessary amount withdrawn to make the working solution. Crystals will dissolve quickly on dilution.

PRECAUTIONS

Edwal FG7 will not stain hands or clothing in ordinary use. However, if spilled or allowed to dry up completely, it may produce brownish stains, which will usually wash out with warm water and a detergent, FG7 contains no metol and can be safely used by many people who are allergic to developers. Occasionally on very long storage a small amount of sediment will form. This may be filtered out or allowed to remain in the bottom of the bottle, since it does no harm and there will be no change in the developing power of the clear liquid.

CAUTION: Contains sodium sulfite and hydroquinones. Harmful if taken internally. KEEP OUT OF REACH OF CHILDREN.

FG7 "AUTOMATIC" DEVELOPMENT
TWO-BATH METHOD
EDWAL "AUTOMATIC" (TWO-BATH) DEVELOPMENT AND ITS ADVANTAGES

Edwal "Automatic" Film Development gives automatic control of contrast at the most desirable value for making a good print, automatically produces maximum normal film speed, and does away with the need for exact time and temperature control. All films, fast or slow, are developed for the same length of time. Any temperature between 65° and 85°F is satisfactory. Experienced photograpers can go up to 95°.

The procedure is simple and rapid. The film to be developed is dipped for 1 min. in Solution A, consisting of Edwal FG7 concentrate diluted 1:1, then for two min. in Solution B which consists of Edwal FG7 Solution B concentrate diluted 1:1, then rinsed, fixed and washed as usual. In the first solution (A) the film becomes saturated with enough developing agent to create the image, but little development takes place until it is dipped into Solution B which causes development to be completed very rapidly.

Cost per film is low. Solution A and Solution B can be used over and over until about 50 rolls are developed in a quart of each. Grain, while not quite as fine as with standard development in Edwal FG7, is satisfactory for all ordinary purposes.

(continued on following page)

With the Edwal "Automatic" method, contrast can be controlled over a reasonable range by varying the immersion time in Solution A between 30 sec. minimum and 2 or 3 min. maximum. For still stronger contrast, Solution A is made from Edwal FG7 concentrate full strength instead of 1:1. For the lower contrast necessary for some of the slower films, Solution A is made by diluting Edwal FG7 concentrate 1:3 or, for some films, 1:5.

OPERATING DETAILS

1. Edwal FG7 concentrate and FG7 Solution B concentrate are each diluted 1:1 with water to make the two working solutions A and B. These solutions should be stored in full, tightly closed, **glass** bottles. Plastic bottles are not recommended for long storage because air diffuses through the plastic bottle walls, causing loss of strength.

2. Film can be developed in tanks or trays. The best tanks are those which can be completely filled and completely emptied in 15 seconds or less. Immersion times are usually measured from the time you **begin** to pour the developer into the tank to the time you **begin** to pour the developer out of the tank. Note: If development can be done in a darkroom that is really dark, Solution A and Solution B can be put in separate tanks and the film dipped 1 min. in Solution A and then transferred to the Solution B tank which is then covered, and processing finished in ordinary light as usual. DO NOT PRE-SOAK FILMS IN WATER.

3. Solution A immersion should be accurately timed, but time in Solution B need not be closely measured. Increasing or decreasing the immersion time in Solution A will increase or decrease contrast somewhat. Increasing or decreasing the immersion time in Solution B has no noticeable effect, except that the minimum immersion time should be at least 1 min. The maximum should not be more than 4 or 5 min. at room temperature. The time between immersion in Solution A and Solution B should be as short as possible.

4. Agitation in Solution A should be vigorous for the first five seconds, and gentle and continuous thereafter. Agitation should be gentle and continuous for the first 30 seconds in Solution B and about 10 sec. at 30 sec. intervals thereafter.

5. After the film has been removed from Solution B, it should be rinsed gently in plain water for 20 to 30 seconds. The water should then be poured off, fixer should be poured in, and the film fixed in a strongly hardening rapid fixer (Edwal Quick-Fix or Hi-Speed Liquid Fix with hardener) and then washed as usual. Use of Edwal Hypo Eliminator after fixing is recommended for shortest washing time.

6. All processing solutions (Solution A, Solution B, rinse water, and fixer) should be at the same temperature, especially when developing above 75°F, to avoid possible reticulation. Once the film has been thoroughly fixed in Edwal Quick-Fix with hardener, it may be washed in cool water if necessary, but should not be plunged directly into cold water from a warm fixing bath. The film may be transferred from the fixer to a bath of water at the same temperature, and then the cooler wash water slowly run in to provide a gradual temperature transition.

REPLENISHMENT AND RENEWAL

Neither the A nor the B solutions require replenishment in normal operation. A certain amount of Solution A will be carried out by the film. This may be replaced by adding Edwal FG7 at the same dilution originally used for Solution A. If this is done, a corresponding amount of fresh Solution B working solution should be added to the original working Solution B bottle, discarding enough of the old solution to allow the addition of the new.

If immersion times longer than 1 min. in Solution A are used, there will be a gradual loss of activity, in which case FG7 **concentrate** rather than FG7 at 1:1 dilution may be used as the "make-up solution" to maintain volume. If "make-up solution" is not added to keep the level up, about 50 rolls of film

(continued on following page)

The Compact Photo-Lab-Index

usually can be processed in a quart of Solution A, and corresponding quart of Solution B made by diluting 16-oz. of FG7 concentrate and 16-oz. of FG7 Solution B concentrate respectively.

Some sediment gradually appears in both working solutions as more and more film is processed, and there is some darkening in color. These do not seem to seriously affect the developing power but it is just as well to discard the working solutions if they get too "dirty" looking and start again with fresh ones.

TEMPERATURE

While 70° to 75° is best, "automatic" (two-bath) development with FG7 Solutions A and B may be used at any temperature from 65° to 95°F. The immersion time in Solution A should be reduced to about 45 seconds above 75° and to about 30 seconds above 85°. Immersion in Solution B should be kept down to 1 minute above 85°.

CONTRAST CONTROL

With most films, the proper degree of contrast for best print-making is automatically produced using Solution A made by diluting FG7 concentrate 1:1 with water. To increase contrast, use full strength FG7 as Solution A, or allow the film to remain in the Solution A for 2 or 3 min. rather than the recommended 1 min. time.

With the fine-grain films, Solution A made by diluting FG7 1:1 gives excessive contrast with the standard 1 min. immersion time. Contrast can be reduced somewhat by shortening the Solution A immersion time down to a minimum of 30 seconds. However, the best method is to use a higher dilution with a 1 min. immersion time. Suggested dilutions for several such films are:

1:3 Dilution
Plus-X
Agfa ISS
Agfa IFF
Panatomic-X

1:5 Dilution
Ilford FP4
Ilford Pan F

FILM SPEEDS

The following film speeds for miniature and roll films are suggested, based on the commonly used methods of determining exposure by measuring reflected light. For cut film, one stop more exposure will be desirable.

Tri-X3200
Agfa 4001000
GAF 5001000

Plus X	1000 (1:1)	800	(1:3)
Panatomic-X	200 (1:1)	160	(1:3)
ISS	640 (1:1)	500	(1:3)
IFF	125 (1:1)	100	(1:3)
Versapan	500 (1:1)	400	(1:3)
FP4	640 (1:1)	500	(1:5)
Pan-F	300 (1:3)	200	(1:5)

6. FOR THIN EMULSION FILMS: high resolution) Dilute FG7 Concentrate with 15 parts water. Use developing times twice as long as those shown for the same film under Method 7, but for best results do not develop above 75°. Three rolls may be developed in 16-oz. if all done the same day. Increase time 10% for each roll.

7. FOR "ONE-USE" DEVELOPMENT of medium and high speed films: Dilute FG7 Concentrate with 15 parts of an approximately 9% sodium sulphite solution and develop (minutes).

(continued on following page)

MISCELLANEOUS MANUFACTURERS

645

	Film Class						
	I	**II**	**III**	**IV**	**V**	**VI**	**VII**
65°F	5	6	7	8	9	11	14
70°F	4	5	6	7	8	9	11
75°F	3	4	5	6	7	8	9
80°F	2½	3	4	5	6	7	8
85°F	2	2½	3	4	5	6	7

This method gives very fine grain on the medium and high speed films. Film speed is about ½ f-stop higher than with the 1:3 dilution described above. Use developer only once.

FG7 Concentrate is diluted with 15 parts of water. Film is developed using times under Method 6 in the instruction folder. This method gives very fine grain and good resolution on the fine grain films. Each 16-oz. of 1:15 diluted FG7 may be used to develop a second and third roll if done the same day. Increase developing time 10% for each roll after the first.

For finest grain on medium and high speed films, FG7 Concentrate is diluted with 15 parts of a 9% sodium sulfite solution in place of ordinary water. See Method 7 in the instruction folder.

A 9% SOLUTION OF SODIUM SULFITE can easily be made in any of the following ways:

1. Dissolve a pound of sodium sulfite in 5 qts. of water. (If a 5-qt. container is not available, dissolve 1 lb. sulfite in a gallon of water in a gallon jug. Then add 1-oz. water for each 4-oz. sulfite solution when diluting the FG7.)

2. Dissolve 45 grams of sulfite in 1 pt. of water (45 grams is approximately **1 fl. oz. by volume** of sodium sulfite filled level full but not packed down).

3. Use an Edwal SPEED CUP which holds 1 fl. oz. to measure out sulfite for 1 pt. of solution. Five plastic SPEED CUPS with directions for use can be obtained direct from Edwal Scientific Products Corporation, by sending your name and address with 35 cents in stamps or coin.

USE OF 9% SULFITE FOR FINER GRAIN: For finest grain on small size medium and high speed films, FG7 concentrate should be diluted 1:15 with 9% sulfite as in mehtod 7 (One-Use Development). 9% sulfite may also be used if desired for increased fineness of grain as follows:

a) In Method 2 dilute with one part water and one part 9% sulfite instead of 2 parts water;

b) In Methods 3 and 4 dilute with 1 part water and 2 parts 9% sulfite instead of with 3 parts of water. Use same developing times as when diluting with water above.

AGITATION: Agitate 10 sec. out of each 30 sec. for Methods 1 and 2 above; 5 sec. in each 30 sec. for all other methods.

TO REPLENISH: For the 1:1, 1:2 or 1:3 dilution, add ½-oz. concentrate for each roll (80 sq. in.) developed in Methods 1, 2, 3, and 4 above. No replenishment in methods 5, 6, and 7.

FILM SPEED: For methods 4, 6, or 7 on 35mm and roll films use the suggested speed ratings and methods of exposure given in this section in the pages devoted to FG7. Adjust exposure to give the thinnest negative that has good shadow detail.

For **sheet films** developed by Methods 4, 6, or 7, and for any film developed by Methods 1 or 2, use ½ to 1 stop more exposure than for roll films developed by Methods 4, 6, or 7.

(continued on following page)

EDWAL SUPER 12
THE "AVAILABLE LIGHT" DEVELOPER

Edwal Super 12 is an old style (introduced about 1936), fine grain developer which has continued in use because it produces negative densities which are proportional to the brightness values of the subject over a much wider range than with the "compensating" developers now in common use. Hence, it will put "snap" into a flat scene for high speed electronic flash, for developing copy negatives in mural ᴧ ᴧking where the big enlargement must have the same tone range as the print being copied, etc. Also it is used industrially as a replenisher for Super 20 in deep tanks.

FILM SPEED

Edwal Super 12 produces maximum film speed. It can be used with the same exposure index ratings that are recommended for Edwal FG7, e.g.: 640 for Plus-X and 2400 to 3200 for Tri-X at normal developing times.

GRAIN

Edwal Super 12 produces "fine grain" negatives, giving 10 to 12 diameter enlargements on coarse grain films, more on medium and fine grain types.

PRECAUTIONS

Super 12 is a "staining developer" in that it will produce purple or black stains if spilled and allowed to dry out or oxidize in the air. Stains can be prevented by using newspaper under developing tanks, etc., to catch stray splashes or spills. Spills on other surfaces or on the hands should be washed off thoroughly with soap and water within 10 or 15 minutes to prevent oxidation, which produces the stain color. Stains can be removed with permanganate and muriatic acid (see data on Scum, Fog & Stains) later in this Section. Persons who are allergic to developing agents may have an irritation or rash if Super 12 comes in contact with their skin. CAUTION: Super 12 contains sodium sulfite and paraphenylene diamine. Harmful if swallowed. A strong sensitizer. Allergic persons should avoid direct contact. KEEP OUT OF REACH OF CHILDREN.

HOW TO USE EDWAL SUPER 12
Temperature

Super 12 may be used "as is" at any developing temperature from 65° to 85°F. It may be used above 85° if 45 grams of anyhydrous sodium sulfate (not sulfite) are dissolved in each quart of developer.

Developing times at 85° with sulfate are the same as for the same film at 80° without sulfate. Developing times decrease about 20% for each 5° rise in temperature up to 100°F. For processing above 75° all solutions, including wash water should, if possible, be at the same temperature, and if a stop bath is used it should be made up with only about 10ml (1/3 oz.) of acetic acid per quart and should contain 2 oz. (60 grams) of anhydrous sodium sulfate per quart to prevent undue emulsion swelling.

REPLENISHMENT

For small tanks, self-replenishment is recommended as follows: Develop 3 rolls in a quart of fresh Super 12, and then replenish by adding 3 oz. fresh developer after the third roll, and after each succeeding roll. Discard enough old solution each time to mantain the proper level in the storage bottle. Replenishment is continued indefinitely. The developer is maintained in efficient working condition, giving the finest possible grain and good film speed. If the developer shows signs of weakening, use a double quantity (6 oz.) of fresh developer for one replenishment and then proceed as usual.

Super 12 may also be used without replenishment, according to directions on the bottle label. For self-replenishment in deep tanks, the quantity of solution to be added is usually ½ to ⅓ that recommended for small tanks.

(continued on following page)

The Compact Photo-Lab-Index

SPEED LIGHT AND BULB FLASH

Super 12 is suitable for speedlight units with a flash duration between 1/2000 and 1/10,000 seconds. Usually no increase in developing time is needed. Also, for bounce flash or flood-lighted shots. For longer flash-duration speedlights or for bulb flash on camera, a softer working developer such as Edwal FG7 or Minicol II should be used.

FOR FINE GRAIN (THiN EMULSION) FILMS

For **maximum resolution,** develop at 70°F in fresh Super 12 diluted with 9 parts of water, using a developing time twice that recommended for the class number of your film in undiluted Super 12. Use diluted solution only once. At this dilution Super 12 loses its "high fidelity", characteristics and becomes a mildly compensating developer.

For **general photography,** develop in fresh Super 12 diluted 1:1 with water, using the regular developing time recommended on the bottle label. Replenish with 1 oz. undiluted Super 12 after each roll until 17 rolls have been developed per quart.

KEEPING CHARACTERISTICS

Super 12 normally has the color of weak tea and will retain that color as long as it is in good condition. It will keep for years in a tightly sealed bottle. If the cap should be loose enough to allow air to gradually enter the bottle, the solution will become chocolate brown or red and should then be discarded.

EDWAL SUPER 20

FOR EXTREME FINE GRAIN

Edwal Super 20 is a true "super fine" grain developer, meaning that it will consistently produce negatives capable of 15 to 25 diameter enlargements from coarse grain films, 20 to 30 diameters or more frcm medium speed films, and practically unlimited enlargements when used with fine grain films.

For comparison, its companion developer, Edwal FG7, is a "fine grain" (not super fine grain) developer, capable of 10 to 15 diameter enlargements from coarse grain, high speed films.

NEGATIVE QUALITY

Edwal Super 20 is a long scale developer, producing a rather "snappy" negative. It gives densities which are proportional to the brightness in the original subject over a longer range than do the compensating type developers. Super 20 gives high acutance (detail delineating power) so that small details will appear more clearly on very big enlargements than is usually the case.

FILM SPEED

Super 20 should be used with an exposure index half that recommended for use with Edwal FG7. Typical recommended Super 20 film speeds for 35mm and smaller films are: Improved Tri-X 800 and Improved Panatomic-X 40. Super 20 contains paraphenylene diamine, and because of this gives higher film speed than the "non-diamine" super fine grain developers.

HOW TO USE EDWAL SUPER 20
TEMPERATURE

Edwal Super 20 gives best results at 70°F, but the full strength solution can be used up to 85°F of all solutions, including wash water, are at the same temperature. Care should be taken to avoid excessively rapid drying or touching the emulsion of the film with any solid object until completely dry. For development at 85°F or above, dissolve 45 grams of andyrous chemically pure sodium

(continued on following page)

sulfate (not sulfite) in each quart of developer and 22½ grams in each 16 oz. of replenisher. Developing times for 85° with sulfate are the same as at 80° without sulfate. Times at 90° with sulfate are the same as times at 85° without sulfate, etc.

FOR MEDIUM SPEED FILMS AND TRI-X

Develop in full strength Super 20 with replenishment, using Super 20 Replenisher at the rate of 1-oz. replenisher per 80 sq. in. roll of film. Two 16-oz. bottles of replenisher may be used with one qt. of Super 20 to develop thirty-three 36-exposure rolls of 35mm film or the equivalent in other sizes.

For Minox or other subminiature tanks holding very small amounts of developer, full strength Super 20 can be used once and then discarded.

FOR FINE GRAIN FILMS

Use Super 20 diluted 1:1 with water as the working solution, and replenish with ½-oz. Super 20 Replenisher for each 80 sq. in. roll of film or equivalent. Use the same developing times which are given for full strength Super 20 in the table.

FOR "SINGLE USE" DEVELOPMENT OF FINE GRAIN FILMS

Dilute Super 20 1:7 (2-oz. Super 20 to make 16 oz. working solution) and use a developing time twice as long as that given in the developing timetable. Do not use above 75°F.

RECOMMENDED FILMS FOR USE WITH SUPER 20

Super 20 gives good results under ordinary developing conditions with Tri-X and most medium speed and fine grain films. It should not be used with Royal-X, Super Hypan, or with the European high speed films except with continuous and efficient agitation, because these films tend to produce dichroic fog with developers of this type. Recently two medium speed U.S.A. films, Verichrome Pan and Professional Plus-X, have also begun to show dichroic fog with Super 20, so should have continuous efficient agitation if used.

REMOVAL OF DICHROIC FOG

If it is desired to use Super 20 to develop one of the above mentioned films which tend to give dichroic fog, or if this fog is accidentally obtained through poor agitation, it can be easily removed by soaking the film in water until thoroughly wet and then dipping or swabbing it for 4 to 10 seconds in ½ strength Farmer's Reducer and immediately immersing it in water. It should then be washed and dried as usual. Repeat if necessary.

FOR SUPER FINE GRAIN PHOTO FINISHING

Photo finishers who specialize in subminiature work use Super 20 in their deep tanks and replenish by adding Edwal Super 12 (instead of Super 20 Replenisher) from time to time as needed to keep the level up. Tank life is very long—often 6 months to a year—and negative quality is good.

PRECAUTIONS

Super 20 is a "staining developer" in that it will produce deep purple or black stains if spilled and allowed to dry out or oxidize in the air. Stains can be prevented by using newspaper under developing tanks, etc. to catch stray splashes or spills. Spills on other surfaces should be washed up thoroughly within a few minutes, before oxidation has a chance to produce colors. Stains on the skin will be prevented by prompt and thorough washing with soap and water. If stains do appear, they can be removed with permanganate and muriatic acid data on Fog, Scum & Stains later in this section). CAUTION: Super 20 contains sodium

(continued on following page)

sulfite and paraphenylene diamine. Harmful is swallowed. A strong sensitizer; allergic persons should avoid direct contact. KEEP IT OUT OF REACH OF CHILDREN.

EDWAL MINICOL II

Minicol II is a super-compensating, maximum acutance developer similar to the old original Edwal Minicol but especially adapted to single-use work. The Minicol II Concentrate keeps very well, even in a partly full bottle, and is economical to use.

Minicol II produces finer grain than most other developers, not because of silver-solvent action, but because the image is produced rather slowly, causing more gradual energy release and less disturbance as the silver particles are built up.

Minicol II at 1:7 dilution is primarily intended for use with thin emulsion, fine grain films such as Panatomic-X and Pan-F. It also gives excellent results with the medium speed films such as Plus-X, Versapan, and FP3. Minicol II may also be used at 1:7 dilution with 9% sulfite for single use, super-compensating, fine grain development of fast films such as Tri-X, Super Hypan, HPS, etc. When so used, it requires one f-stop more exposure than Edwal FG7.

FILM SPEED

Typical recommended film speeds for low and medium speed 35mm and roll films to be developed in Minicol II diluted 1:7 with water are:

Pan-F	80
Panatomic-X	80
Plus-X	320
Versapan	200

HOW TO USE MINICOL II
FOR SLOW AND MEDIUM SPEED FILMS

Minicol II Concentrate is diluted with 7 parts water to give 8 parts working solution. This is recommended for development of one roll of film in a small spiral reel tank of developer, but two rolls can be satisfactorily processed without increase in developing time if they can be loaded into the tank at the same time. If necessary, two films can be developed consecutively in 16 oz. of Minicol II working solution, provided the second film is developed within an hour or two after the first and if the developing time of the second film is increased 15%.

FOR HIGH SPEED FILMS

High speed films may be developed in Minicol II diluted with plain water. For finest grain on these films, however, it is recommended that Minicol II Concentrate be diluted with a 9% sulfite solution and the developing times be reduced to one-half those given on the Minicol II label for Minicol II diluted with plain water. Minicol II produces a rather soft, highly compensated negative with the fast films. For most purposes Edwal FG7, which produces a snappier negative, will be more suitable on these films.

TEMPERATURE

Developing times from 65° to 75°F are given on the bottle label for Minicol II diluted with water. If it is desired to use Minicol II above 75°F, dilute the concentrate with a solution of 2 oz. anhydrous (Chemically pure) sodium sulfate (not sulfite) in a quart of water, instead of plain water. The developing time at 80°F in such a solution would be the same as the developing time at 75°F without sodium sulfate. For each increase of 5° above 80°F, reduce the developing time 20%. Some increase in contrast will occur at higher developing temperatures.

(continued on following page)

The Compact Photo-Lab-Index

KEEPING CHARACTERISTICS

Minicol II normally has a very faint yellowish color and will retain that color as long as it is in good condition. It will keep for years in a tightly sealed glass bottle. The working solution should be made up just before use. If it is desired to make up working solution and keep it for several days before use, this can be done if the water is deoxygenated by boiling for 10 minutes or by letting it stand several hours in a sealed bottle after dissolving about 10 grams of sodium sulfite in a quart.

If it is desired to keep Minicol II Concentrate for several months when the bottle is half full, the concentrate can be diluted with an equal part of water. After that, 2 oz. of the 1:1 Minicol II should be used in place of 1 oz. of full strength concentrate. This procedure can be repeated again after the bottle becomes half empty the second time. From that point on, 4 oz. of the partly diluted Minicol II would be used instead of 1 oz. of full strength Minicol II Concentrate.

PRECAUTIONS

Persons who are allergic to metol or similar developing agents should avoid direct contact with Minicol II since it may produce a skin rash. Minicol II will not stain hands or clothing under ordinary conditions. However, brown stains may result if it is allowed to oxidize severely. Such stains usually wash out with ordinary soap and water. WARNING—Minicol II contains sodium sulfite and hydroquinones. Harmful if taken internally. KEEP OUT OF REACH OF CHILDREN.

EDWAL T.S.T. (Twelve-Sixteen-Twenty)
LIQUID PAPER DEVELOPER CONCENTRATE

Edwal T.S.T. (Twelve-Sixteen-Twenty) is a liquid paper-developer concentrate which will handle paper development from high-volume print production to warm-tone portrait work. It contains a unique combination of ingredients which gives the following advantages to the photographer:

1. Does away with powder mixing—instantly ready. Saves time and clean up.
2. Stores a lot in a small space—does away with big stock bottles.
3. Lasts a week in a tray.
4. Gives 12 gal. heavy-duty strength, 16 gal. commercial strength, or 20 gal. portrait strength (up to 40 gal. for some warm-tone papers) developer from 1 gal. of concentrate.
5. Gives uniform contrast at standard developing time, with any dilution or temperature. Can also be made to give three degrees of contrast on the same paper though use of specified procedures.
6. Develops 3,000 to 4,000 excellent quality 8 x 10 prints in a gallon of concentrate diluted 1:11. This is over 250 prints per gal. of working solution, compared with 125 to 150 8 x 10's per gal. from the usual D-76 type formulation. on test runs, 360 8 x 10's have been developed in 1 gal. 1:11 working developer, equal to 4,320 prints per gal. of concentrate.

Edwal T.S.T. is very highly concentrated. It has the good qualities of both metol and phenidone: good tray life, good maintenance of activity under heavy use, and constant contrast at varying temperatures. It is a normal speed, detail-delineating developer which has little tendency to "block up."

HOW TO USE EDWAL T.S.T.
MIXING

Each T.S.T. package contains a large bottle of concentrate (Solution A) and a small bottle (Solution B). To make standard T.S.T. working developer, 1 oz.

(continued on following page)

Solution B is used with each 8 oz. Solution A, no matter what the final dilution of the working bath may be. Dilute Solution A first and then add Solution B. Use of extra Solution B (up to 25% more) gives longer tray life. Use of less Solution B gives a faster working, more contrasty developer. Solution A may be diluted and used alone, without B, for hard water may cause milkiness to appear during use. If so, use Edwal Water Conditioner in dilution water.

1. **For Heavy-Duty** (1:11) Pour 1 gal. T.S.T. Concentrate into 10 gal. water with continuous mixing. Then add 16 oz. Solution B and water to make 12 gal. Mix thoroughly. For a stronger working solution (1:7) use less water to give 8 gal. total instead of 12. These strengths give cold tones and normal contrast at 2 to 3 min. developing times.

2. **Commercial** (1:15) Proceed as in paragraph 1 but make final volume 16 gal. instead of 12. Cool tones. Normal contrast. Tray Life: 5 working days under light load.

3. **Portrait** (1:19) Proceed as in paragraph 1 but make final volume 20 gal. instead of 12. Cool tones. Normal contrast at full 2½ to 3 min. development. Warmer tones and softer contrast are obtained at 1¼ to 1½ min. development or through higher dilutions, up to 1:39 for warm-tone papers. Recommended Tray Life: 1 day.

Small Quantities: To make 1 gal. T.S.T. working solution:

at 1:7 dilution—use 16 oz. Solution A and 2 oz. Solution B.

at 1:11 dilution—use 12 oz. Solution A and 1½ oz. Solution B.

at 1:15 dilution—use 8 oz. Solution A and 1 oz. (30 ml) Solution B.

at 1:19 dilution—use 6½ oz. Solution A and 25 ml Solution B.

Use the graduated measuring cup (packed in each 1-gal. T.S.T. carton) to measure Solution B.

CONTRAST CONTROL

Edwal T.S.T. gives uniform contrast at all recommended dilutions and at all temperatures from 50°F to 90°F when full development (2½ min, for enlarging papers) is used. However, when the developing time it cut down to the minimum which will give a well developed print, (1 to 1½ min., depending on the paper) the contrast difference between the 1:11 and the 1:15 dilution is about the same as between grade 3 and grade 2 papers. The contrast difference between the 1:15 and the 1:19 dilutions is about half the difference between grade 2 and grade 1 papers. That between the 1:7 and the 1:11 dilutions is very small.

EXPOSURE AND WORKING TEMPERATURE

To get identical print densities on a single grade of paper with 1:7, 1:11, 1:15, and 1:19 dilutions requires slightly more exposure (about 10%) for each increased dilution. Addition of potassium bromide to T.S.T. working solution has no effect on contrast but does cause some increase in the exposure needed to give the same density. Best working temperature is between 65°F and 75°F, but any temperature from 50°F to 90°F is satisfactory. Underexposed prints can often be salvaged by extending development beyond 3 min. without staining.

STORAGE

Storage at room temperature (65°F to 80°F) is best. Crystallization may occur below 60°F, but if the amount is small, it is only necessary to shake the concentrate to get a uniform mixture and then dilute as usual. Crystals in the concentrate will largely redissolve if warmed to room temperature and shaken occasionally. High temperature storage of T.S.T. Concentrate (85°F to 90°F or higher) will gradually cause some loss of developing speed, but will have no

(continued on following page)

serious effect on the total amount of paper that can be processed. Storage over 2 or 3 weeks in partly full containers should be avoided. Remaining concentrate should be transferred to smaller glass bottles. If the 5-gal. carboy is used with a faucet (see Carboy Instruction Sheet), atmospheric pressure will collapse the bottle so that air will not enter as solution is withdrawn.

CONTAINERS

T.S.T. Concentrate is packaged in 1-gal. plastic bottles and 5-gal. plastic carboys, which have become very popular because they do not break easily and are reusable. However, all such bottles allow gradual diffusion of air through the walls, which in time will cause loss of developer strength. While T.S.T. can be satisfactorily stored for several months in these containers, it should not be stockpiled, but should be purchased as needed and used promptly.

PRECAUTIONS

Since Edwal T.S.T. Paper Developer Concentrate contains metol, persons who are allergic to this or any other photo chemicals should avoid direct contact with the solution. Irritation or rash may result. Edwal T.S.T. Paper Developer is "non-staining" in the usual sense, in that it will not stain hands or equipment in normal use. It will, however, produce brown stains if spilled and allowed to dry. Such stains can usually be washed out with warm water and a laundry-type detergent.

KEEPING DEVELOPER TRAY CLEAN

When T.S.T. is used and then left overnight in the tray, silver will often form a black or brown deposit on the tray. This is due to silver bromide which is dissolved from the prints and then gradually reduced, depositing silver as the developer stands. This does no harm and the tray can easily be cleaned by switching trays between developer and fixer when a new fixer bath is made. If the developer is pushed hard the first day, some of this silver may be formed fast enough to cause an appearance of "milkiness." If this happens, it does not indicate that the developer is exhausted. The "milkiness" does no harm and will settle out overnight.

EDWAL SUPER 111 & EDWAL PLATINUM DEVELOPER

Edwal super 111 is a professional and industrial paper developer, made to give a neutral (not bluish) black image and has the following characteristics:
1. Because of the unusual developing agents used, the solution can be (and is) made extremely concentrated so that one gallon makes 10 gal. of working solution, thus keeping the cost of working solution down to a very reasonable level.
2. It is very clean working (extremely low tendency to fog) which allows it to be used for developing such emulsions as seismograph paper, and autopositive and copy papers, as well as for hte usual continuous-tone picture making.
3. Because it contains no hydroquinone, it is not susceptible to aerial fog, or to high-temperature fog when the developer is used above 75° or 80° F.
4. Super 111 works well with chlorobromide papers such as Medalist, Indiatone, and others, and can be used for prints for exhibition work or for sale. It also produces an image which lends itself to toning.

Edwal Platinum Developer is an amateur-type paper developer based on the same formula and giving the same results as Super 111, but somewhat less concentrated. It is sold in 4-oz. (to make 1 qt. of working solution) and 16-oz. (to make 1 gal.). It is packed in glass bottles and is guaranteed for a shelf life of five years.

HOW TO USE EDWAL SUPER 111 AND
EDWAL PLATINUM PAPER DEVELOPER

EXPOSURE

Exposure is best determined by means of test strips or a projection print scale. However, where these are lacking, an initial estimate can be made on the basis that, when correctly exposed, the print will begin to show an image of 7 to 12 sec. at 70° to 75°F. For best results, exposure should be regulated so that the print can be developed at 70°F a full 45 sec. for contact paper, and 1½ to 2 min. (maximum 3 min.) for enlarging papers. Development is more rapid at higher temperatures.

CONTRAST

The usual dilution of 1:9 for Super 111 and 1:7 for Platinum concentrate produces standard contrast on cold-tone papers and a somewhat snappier-than-usual print on warm-tone papers. Softer results can be obtained by diluting with more water. Contrast can be increased if needed by diluting with less water. For developing copy papers or line reproduction papers, a 1:7 dilution is usually used with Super 111.

TEMPERATURE

Both Edwal Super 111 and Edwal Platinum Developer may be used at any temperature from 65° to 75°F with normal procedure, and up to 85°F if care is taken not to handle the emulsion side of the print while wet with developer. Above 85°, 2 oz. of anhydrous sodium sulphate should be added to each quart of working solution to allow use up to 95°F without fogging or staining.

DEVELOPMENT OF SLIDES

Super 111 at 1:9 or Platinum at 1:7 are excellent developers for slides because they give practically no fog and avoid the necessity of using Farmer's Reducer to "clean up" a slide, which is often necessary with ordinary developers.

DEVELOPMENT OF FILM

Super 111 and Edwal Platinum Developer can be used to develop film. For tray development dilute Super 111 with 10 parts of water, or Platinum with 8 parts, and develop 3 to 7 min. at 70°F. For tank development, dilute Super 111 with 25 parts of water, or Platinum with 20 parts, and develop common roll films 10 to 12 min. at 70°F; thin emulsion films are developed 5 to 6 min. at 70°F. These are "long-scale" developers, giving rather snappy negatives. Shorter developing times will give less contrast.

KEEPING QUALITIES

Super 111 and Platinum are clear solutions with a slight tan or lavender color and will remain in this condition without loss of strength for years in a tightly closed glass bottle. Developers should not be stored in polyethylene plastic (squeeze type) bottles for long periods since they may lose strength due to oxygen and carbon dioxide which diffuse through the walls of such bottles. If Super 111 or Platinum become dark brown or black, it is a sign of serious oxidation and the developer should be discarded. Both concentrates keep well in partly full, **tightly closed** glass bottles because they contain so much active ingredient that the small amount of air in the bottle has practically no effect.

PRECAUTIONS

Edwal Super 111 and Platinum Developer contain metol. Persons who are allergic to this chemical should avoid direct contact with the solution. These developers are "non-staining" in the usual sense. They will form brown stains if spilled and allowed to dry, but the stains are usually removed by ordinary soap and water.

EDWAL STAT PAPER DEVELOPER CONCENTRATE

Edwal Stat Paper Developer is a liquid concentrate for high-contrast paper developing in manual or automatic equipment. Mixing does not need hot water or subsequent cooling. Working solution is ready for use immediately if mixed at room temperature. Packaging: 1 gal. plastic bottle, 4/cs, with Solution B to make 8 gal. for machine or 10 gal. for manual tray processing. Also packed 1 gal. 4/cs **without Solution B** for manual tray processing only. Each gallon makes 10 gallons working developer.

Developer has good working temperatures latitude (70° to 80°F) without fog. Non-allergenic. Works cleaner than powders, doesn't "black-up" the tank. Can be replenished. Replenishing solution is made from same concentrate as developer. No separate replenisher concentrate is necessary. Developer is clean working, and developing speed does not fall off with extended use.

HOW TO USE EDWAL STAT PAPER DEVELOPER
FOR AUTOMATIC MACHINES USE THE EDWAL STAT DEVELOPER WITH SOLUTION B

For automatic machines, the developer concentrate and Solution B can be mixed with part of the water in a bucket and then added to the remaining water which has already been placed in the machine tank. However, there must be complete stirring to get a really uniform mix to obtain proper developing results. Use 1 gal. developer concentrate plus a 12-oz. bottle of Solution B to make 8 gal. developer. Use water at about room temperature (70° to 80°F) since developing action is slowed down considerably below 65°. If cold water is used to mix developer in the machine, mix it the night before and let it stand overnight to attain room temperature before using.

The developer concentrate is quite heavy, so should be poured into the water when mixing, rather than vice versa. When mixing, pour developer concentrate into the dilution water with stirring and then add Solution B. **Mix thoroughly** before using. Mix commonly used quantities as follows:

To Make	Developer Concentrate	Solution B
10 qts. (2-2½ gal.)	40 oz.	3¾ oz.
16 qts. (4 gal.)	2 qt.	6 oz.
20 qts. (5 gal.)	2½ qt.	7½ oz.
32 qts. (8 gal.)	1 gal.	12 oz.
88 qts. (22 gal.)	2½ gal.	30 oz.

Developer mixed as above, with Solution B, will last several days in a tray if the liquid depth is once inch or more, and will last several weeks in an automatic machine without serious discoloration.

FOR MANUAL PROCESSING USE EDWAL STAT PAPER DEVELOPER WITHOUT SOLUTION B

In small trays, best results are obtained without Solution B, diluting the developer concentrate 1:9 (1 gal. to make 10 gal. working solution). This dilution should be made up fresh each day. Working developer temperature may be anywhere between 65° and 80°F. If developer is to be kept an extra day in the tray, about ¼ of the Solution B shown in the above mixing quantity table should be used. For 3 days total tray life use ½ the Solution B and for 4 days or more use the full amount, same as for automatic machines.

TO REPLENISH

Use replenisher made by diluting developer concentrate and Solution B with 25% less water than used for mixing working developer. Thus 2 qts. of developer concentrate plus 6 oz. Solution B would make 3 gal. replenisher.

(continued on following page)

Add **replenisher** whenever needed to extend the life of the working bath, first removing enough used developer to make room for replenisher. Not more than ¼ the total amount of developer in a tank should be replaced by replenisher at any one time and the replenisher should be well mixed into the developer before using.

PRECAUTIONS

Stat Paper Developer Concentrate is packed in plastic bottles, which do not break easily, but which like all other bottles of this type allow air to gradually diffuse through the walls so that the concentrate should not be kept more than four or five months, if maximum activity is required. Orders should be placed as needed, rather than stockpiling large amounts.

Edwal Stat Paper Developer Concentrate should preferably be stored at room temperature (below 80°F). Long storage about 90°F will result in gradual loss of activity.

EDWAL STABILIZATION CHEMICALS

Edwal now markets two types of stabilization chemicals: (1) **Edwal Universal Activator and Stabilizer** will process all brands of continuous-tone stabilization papers except Ektamatic. (2) **Edwal HST Activator and Stabilizer** are specifically intended for high speed typesetting paper and use in Ektamatic machines with Ektamatic paper.

Both Edwal stabilization chemistries produce prints having maximum stability and minimum stickiness. They produce excellent contrast and have a high through-put capacity—over 350 8 x 10 prints have been processed in a single quart of each of the two solutions without necessity of increasing exposure to maintain image density. For archival permanence, see below.

HOW TO USE EDWAL STABILIZATION CHEMISTRY

Both the Edwal Universal and the HST chemistries are furnished in ready-to-use form in quart bottles packed six to a case and in 2½-gallon cubitainers. The Activator and Stabilizer are placed in the processing machine as usual. Do not mix them with other brands. If you are changing from another brand, fill the processor with warm water and run the processor rolls one to two hours to remove the old chemistry as thoroughly as possible before putting in the new solutions.

PROCESSING PROCEDURE:

In most machines, prints will process satisfactorily in Edwal chemistry at any temperature between 65°F. and 85°F. Used solution may be allowed to remain in the processor overnight if desired, but performance is better if solutions are drained into a clean bottle for overnight storage and the processor rinsed with cool water. Maintain solution level in the processor by additions or by an automatic feed system. Directions of the machine manufacturer should be carefully followed.

DRYING:

The semi-dry prints from the processor may be air-dried or may be heat-dried at temperatures up to 140°F. Drying face up on a heated dryer usually gives the fewest surface defects. However, prints dried face down usually have less tendency to curl. Face-to-drum drying may cause warm image tones. Follow instructions of dryer manufacturer on cleaning of drum and frequency of washing or changing canvas.

CLEANING:

Usually flushing trays and rollers with cool water after emptying will keep a stabilization processor clean. Detergents are not recommended since some

(continued on following page)

MISCELLANEOUS MANUFACTURERS

rollers tend to absorb them. Rollers should not be washed with excessively hot water.

If a dark stain or deposit builds up in the Activator (or developer) tray, this may be removed with Edwal Single Solution Tray Cleaner, following directions furnished with the bottle. For cleaning larger units (½ gal. capacity or more) use of Edwal T.T.&S. Cleaner (two solution type) is more economical.

FOR COMPLETE PERMANENCE:

Permanent prints with high gloss and good flatness, equal in quality to those produced by any method, may be obtained as follows:

1. Put the semi-dry prints from the stabilization processor into Edwal Quick-Fix with hardener at 1:5 dilution for 2 to 3 minutes, preferably in a print rocker or other agitating device. Usual capacity is 200 to 250 8 x 10 prints per gal.
2. Remove prints from fixer, rinse a few seconds in running water, and immerse in Edwal Hypo Eliminator working solution 1 minute for single weight, 2 to 3 minutes for double weight paper, to cut washing time and insure complete hypo removal if wash water is cold.
3. Wash prints in running water 10 to 15 minutes for single weight, 15 to 20 minutes for double weight. If Hypo Eliminator is not used, wash 30 to 60 minutes in water at 55°F. or warmer.
4. To get good flattening and high gloss, soak washed prints 2 to 4 minutes in Edwal Super-Flat print flattener. Usually 12 oz. Super-Flat concentrate and 5 oz. Super-Flat B per gal. of flattening solution is best for most stabilization papers. The prints can be allowed to accumulate in the Super-Flat bath (overnight if necessary) without any damage.
5. Dry on a drum dryer at 240°F. or higher to get maximum flatness and gloss.

PRECAUTIONS:

Avoid spilling or splashing one solution into the other, especially Stabilizer into Activator. If this happens there will be an odor of ammonia. The contaminated solution should be discarded.

Activator and Stabilizer are both irritating to skin or eyes and should be flushed freely with water in case of spills or splashes. Both are harmful if taken internally. If the Activator is accidentally swallowed, drink plenty of milk or water. If the Stabilizer is swallowed, drink some water and then induce vomiting. **In either case call a physician. KEEP OUT OF REACH OF CHILDREN.**

USEFUL INFORMATION ON
EDWAL UNIVERSAL STABILIZATION CHEMICALS

During use, the volume of the stabilizer stays about the same, whereas the volume of the activator goes down. The reason for this is the fact that the activator goes down because it is absorbed by the paper, but the volume of the stabilizer remains constant because the stabilizer carried out by the paper is replaced by liquid brought in by the activator, and its acidity which stops the developing action has largely been used up.

If the working capacity is not used up in one day, as would be the case for 100 to 150 prints in a quart of Edwal Activator and Stabilizer, more prints can be made on the following day. There will probably be about half the activator left and the chemicals can be used until a total of about 300 8 x 10 prints have been run through the quart of Edwal Activator and Stabilizer.

At night it is possible to leave the solutions in the processor overnight, and run them several days or a week before discarding them. This sometimes causes loss of strength in the activator so that the blacks are not as good toward the end. It is actually preferable to drain solutions into bottles at night, and rinse the processor.

Used solutions can be run back into the unused solutions in the original

(continued on following page)

bottle as long as neither the used activator nor the used stabilizer are contaminated. However, if contamination might have taken place, especially through a splash of a stabilizer into the activator (which would cause a smell of ammonia), it would be best to keep the unused solutions separate.

When Edwal Universal Activator and Stabilizer are first used in a processor that has been running another brand, the first prints sometimes may have a yellowish color which disappears as more prints are made. This is caused by the fact that certain stabilizers saturate the processor rollers so that they cannot be cleaned by the usual rinsing procedure. Since such stabilizers are quite different from the Edwal chemistry, they will cause the yellow color mentioned above when used with Edwal, or any other chemistry that is not compatible with them. As the old stabilizer gradually works out of the rollers, the yellowish color on the prints disappears, and the Edwal Stabilizer will then work normally. For this reason, when changing from another brand to Edwal chemistry, it is best to run the processor a while with some Edwal solutions in it just to clean up the rollers, making a print from time to time until the yellowish color has disappeared. Once the prints lose the yellow color, the solutions should be discarded, and fresh solution introduced into the processor. With the fresh solutions, prints will show a complete absence of the yellow stain, and good whites will be obtained.

THE EDWAL "CONTROLLED MONOBATH" METHOD

Travelers or others who do not wish to save used solutions will find the following "single use" method for developing and fixing in the same solution very convenient:

1. Develop the film in FG7 using Method 6 (see above).
2. When development is finished, add 1 oz. Edwal Hi-Speed Liquid Fix Concentrate for each pint of working solution direct to the developer in the tank. Mix thoroughly and fix 2 to 3 min. for Class I, II, or III films; 4 to 6 min. for films in Classes IV through VII. For films in Classes IV through VII, or for any film developed in Method 7, use 2 oz. Hi-Speed Liquid Fix Concentrate (instead of 1 oz.) per pint of developer. Fix Royal-X or Isopan Record 3 to 4 min.
3. Discard the used solution and wash film as usual. If hardening is desired, immerse film in a solution of ½ oz. of Edwal Anti-Scratch Hardener in a pint of water for 2 to 3 min. with agitation, between fixer and washing.

Precaution: The Hi-Speed Liquid Fix Concentrate must be quickly and completely mixed with the developer in the tank in step 2. Tanks which can be picked up and shaken are the best. For other small roll film tanks, it is best to pour out 4 or 5 oz. of developer, then add the Hi-Speed Liquid Fix Concentrate, and then pour back part of the used developer (or plain water) to force the fixer out of the center of the reel into the main body of solution. Agitate vigorously to get complete mixing.

EDWAL QUICK-FIX
WHAT QUICK-FIX IS AND DOES

Edwal Quick-Fix, has the following characteristics:

Long Working Life. Quick-Fix lasts longer than any other similar fixer because Quick-Fix commercial concentrate has a high concentration of active ingredients. (Only 30% water.)

Long Shelf Life. At ordinary room temperature Quick-Fix concentrate is guaranteed for a five-year shelf life if packed in glass, and a two-year shelf life if packed in plastic. Much longer actual shelf life has been reported (up to 10 or 12 years).

Non-Corrosive to Stainless Steel. Quick-Fix does not cause corrosion of stainless steel mixing and storage systems at points of turbulence, such as valves, pumps, etc., or areas of altered resistivity such as welded joints.

(continued on following page)

Non Fading. Prints can be left in Quick-Fix for one to two hours without fading.

Ultra-High Speed. The "ultra-speed" dilution of Quick-Fix fixes fine grain films in 30 seconds or less and the heaviest coated x-ray films in 3 minutes or less at room temperature. Fixing temperatures up to 110°F can be used, resulting in fixing times less than half those at room temperature.

Hardening of Negatives. Quick-Fix with full hardener content gives negatives which after drying cannot be scratched with the fingernail. Hardening is complete as fast as fixing. Controllable hardening for prints is easily attained through regulation of the amount of hardener added when mixing. Quick-Fix has no offensive odor and is non-allergenic to most people. In fact, the chief ingredient is believed to have a beneficial effect on the skin.

HOW QUICK-FIX DIFFERS FROM EDWAL INDUSTRAFIX

Edwal Quick-Fix is designed for commercial, freelance, studio, advanced amateur, or military processing of film where rapid, powerful hardening is an advantage. **Edwal IndustraFIX** has a built-in controlled hardening rate so that by varying immersion times any degree of retouchability and amenability to reducing, cyaniding, etc., can be obtained, for use in graphic arts, large-scale print-making, portrait studios, etc.

HOW TO USE EDWAL QUICK-FIX
X-RAY, MOVIE FILM PROCESSING, AND ULTRA-SPEED STRENGTH

Quick-Fix should be diluted according to the directions on the container to make 1 gal. working solution from each "1-gal. size" unit or from 27-oz. of the Quick-Fix commercial concentrate contained in the 3-gal., 5-gal., or 25-gal. sizes. This is commonly referred to as the 1:3 dilution though the 1:3 ratio is not exact when using 27-oz. to make 1 gal. Fixer concentrate should always be poured **into the water** rather than vice-versa, especially when mixing in a deep tank, since Quick-Fix concentrate is very heavy. Mixing should be vigorous while the Quick-Fix concentrate is being added. The hardener should not be added until the fixer concentrate has been pretty well mixed with the makeup water.

Quick-Fix at this ultra-speed strength can be used at any temperature from 45°F (slow) up to 110°F (very fast). Clearing times at room temperature and 110°F are shown in the table. Fixing time is twice the clearing time.

Typical Clearing Times in 1:3 Quick-Fix:

	70°F.	110°F.
Panatomic-X	11 sec.	5 sec.
FP4	24 sec.	13 sec.
Plus-X	25 sec.	13 sec.
Versapan	23 sec.	10 sec.
GAF 500	50 sec.	24 sec.
R S Pan	50 sec.	23 sec.
Tri-X sheet film	40 sec.	19 sec.
Reprolith Hy-Ortho	16 sec.	8 sec.
Dental X-Ray	38 sec.	
Medical X-Ray	45 sec.	22 sec.

FOR DEEP TANKS

Quick-Fix is mixed as above but the final amount of water is adjusted to make 3½ gal. from the "3-gal. size," 6 gal. from the "5-gal. size," and 30 gal. from the "25-gal. size."

(continued on following page)

MISCELLANEOUS MANUFACTURERS

The Compact Photo-Lab-Index

FOR STANDARD SPEED RAPID FIXING

Dilute Quick-Fix concentrate as described above, but add water to make final volume 4 gal. from the "3-gal. size," 7 to 7½ gal. from the "5-gal. size," and 35 to 37½ gal. from the "25-gal. size." Fine grain films are fixed in less than a minute, and high speed films in 2 to 3 minutes. Papers are fixed in 1 minute when fresh and up to 2 minutes after prolonged use. Fixing time for paper is approximately the same as the **clearing time** for a high speed film. This strength is suggested for fixing both film and paper in the same bath. Fixing of film leaves a little iodide in the bath which cuts down the tendency to fading if prints happen to be left in fresh fixer for a long time.

For fixing "stabilization" processed prints to make them permanent, fix 1 to 2 min. in 1:5 Quick-Fix and wash as usual.

USE WITH AND WITHOUT A STOP BATH

For maximum life, Quick-Fix must be used with a full strength acid stopbath. For processors or tray-use without a stop bath, add 1 oz. Edwal Fixer Rejuvenator per gal. of working fixer whenever the fixer bath begins to feel slippery. This will often triple or quadruple the life of the bath and can be repeated several times if necessary, depending on the amount of developer "carry-over."

STORAGE TEMPERATURE

Quick-Fix concentrate will usually keep one to two years at 70° to 90°F. The working solution will keep for six months or longer at ordinary room temperature. Quick-Fix is not harmed by extreme cold. It will crystallize before 0°F but will reliquify at room temperature.

TESTS FOR EXHAUSTION

The best test is to check the clearing time on a small strip of undeveloped film. Clearing time will remain below 1 minute for most types of film through much of the useful life of the bath, but towards the end will go above 2 minutes with portrait or press-type films. After that, clearing time will rise rapidly and the bath should be renewed.

QUICK-FIX CLEARING AND FIXING TIMES STAY SHORT TO THE END OF ITS LIFE

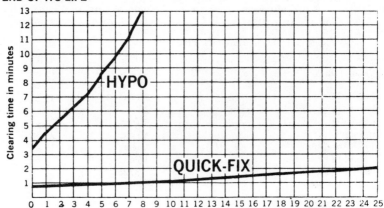

Thousands of square inches of film fixed in 1 gallon of Quick-Fix working solution.

(continued on following page)

The Compact Photo-Lab-Index

PRECAUTIONS

Quick-Fix is harmless to most materials. It washes out of clothing readily with cold water. Quick-Fix which has been used long enough to contain a good deal of dissolved silver may cause silver stains on clothing if sent to the laundry or cleaners without first rinsing out the fixer with plain water. Such silver stains may be removed according to directions given later in this Section on Fog, Scum & Stains.

QUICK-FIX PACKAGING

The "25-gal." Industrial Size contains 5.27 gallons in a plastic, non-returnable (but reusable) carboy which can be emptied by means of a carboy pump, faucet, or probe. The contents makes 25 gal. fixer for x-ray, movie film processing, or ultra-speed or high temperature uses; 30 gal. for commercial deep tank; 35 to 37½ gal. for a film machine or standard rapid fixing of film (2 to 3 minutes) or paper (1 to 2 minutes); or up to 60 gal. for paper, Kodalith, or stripping film. The 80-oz. bottle of Edwal Anti-Scratch Hardener is packed separately.

The "5-gal." Commercial Size is a 135-oz. plastic bottle of concentrate with 20-oz. hardener to make 5 gal. for x-ray or ultra-speed fixing, 6 gal. for deep tank, or 7 to 7½ gal. for standard rapid fixing of film and paper.

The "3-gal." Professional Size (plastic bottles) makes 3 gal. for x-ray, 3½ gal. for a professional deep tank, or 4 gal. for standard rapid fixing of both film and paper.

The "1-gal." size makes 1 gal. for x-ray or ultra rapid fixing, or 1½ gal. for standard rapid fixing of both film and paper. Now packed in plastic bottles.

EDWAL HYPO ELIMINATOR

Edwal Hypo Eliminator is a non-allergenic, practically neutral (neither acid nor alkaline) concentrate, each gallon of which gives 16 gallons of working solution which does the following:
1. Reduces the washing time by at least two-thirds.
2. Gives absolutely permanent prints and films.
3. Rectifies the "hard to wash" condition caused by overfixing.
4. Improves ferrotyping.
5. Produces complete hypo elimination practically as fast when the wash water is cold as when it is at room temperature.
6. Has a preservative action which tends to prevent discoloration of prints in cases where complete washing is impossible.
7. Does not affect gloss.

Edwal Hypo Eliminator is not an oxidizing "hypo neutralizer" which can cause image fading when prints are left in it for a long time. Neither is it an alkaline "washing aid" which tends to reverse gelatin hardness and cause sticking.

HOW TO USE EDWAL HYPO ELIMINATOR
DILUTION

For standard operation, Edwal Hypo Eliminator Concentrate is diluted with 15 parts of water to make 16 volumes of working solution. This working strength is recommended for normal operations where an immersion time of 1 to 2 min. for films, or 2 to 3 min. for paper is possible.

For rapid processing, where a 1 min. immersion time for paper and a 30 to 60 sec. immersion time for film is used, the Edwal Hypo Eliminator working solution should be made by diluting Hypo Eliminator Concentrate with only 9 parts of water.

For slower processing, it is often convenient to leave prints in the Hypo Eliminator Concentrate for 4 min. or more. In this case, a working solution made by diluting Hypo Eliminator Concentrate with 19 parts of water gives better results than the usual 1:15 dilution.

(continued on following page)

The Compact Photo-Lab-Index

FOR USE WITH FILMS

After fixing, films should be rinsed in running water 30 to 40 sec. to remove excess fixer and then should be placed in the Hypo Eliminator working solution for 1 to 2 min. with mild agitation. Film is then washed in running water for 5 min. and dried as usual. A final 20 sec. rinse in an Edwal Kwik-Wet bath is recommended.

FOR USE WITH PAPERS

After fixing, rinse prints in running water for 30 sec. or more to remove excess fixer and then immerse single weight paper in Edwal Hypo Eliminator working solution for 2 min., double weight paper for 3 min. After this, single weight paper will be washed completely free of hypo in 7 to 10 min., double weight paper in 15 to 20 min., assuming good circulation in the wash bath.

TEMPERATURE

Edwal Hypo Eliminator Concentrate keeps well at any temperature, though it will crystallize below freezing. This does not damage. Crystals will dissolve if warmed. If warming is inconvenient, merely stir to shake to get a uniform mixture and then add dilution water. Crystals dissolve immediately.

Wash water temperature can be 35° to 75°F or higher. Above 75° prints should be handled carefully. Washing rate is practically the same at 35° as at 70°, but prints washed between 65° and 75° have an extremely high image stability, better than is normally obtained with the usual one hour wash without the use of Edwal Hypo Eliminator.

LASTING POWER AND STORAGE LIFE

Edwal Hypo Eliminator has a guaranteed storage life of five years when packed in glass, two years or more when packed in plastic. It does not oxidize or lose strength during use as does a developer or fixer but will lose effectiveness due to accumulation of hypo in the eliminator bath during use. With a preliminary rinse as recommended, 1 gal. of 1:15 Edwal Hypo Eliminator will process 12,000 to 15,000 sq. in. of film or paper. Without the preliminary rinse, only about half this amount should be processed. If only commercially acceptable residual hypo content is needed, the above capacity figures can be doubled.

TESTING FOR RESIDUAL HYPO

The (American National Standards Institute, Inc., 1430 Broadway, New York, N.Y. 10018) publishes "The American Standard Method for Determining the Thiosulfate Content of Processed Photographic Film" and "American Standard Method for Determining Residual Thiosulfate and Tetrahtionate in Processed Photographic Papers" which are available from the American National Standards Institute, Inc. at a nominal charge.

However, a simpler and faster testing method for practical work is simply to tone, in Edwal Brown Toner, a test print which has been through the standard Hypo Eliminator and wash procedure. If hypo has been completely removed, clear brown tones will be obtained with no fading in highlight areas and no lack of toning in shadow areas. If a slight amount of hypo is present, the highlight areas will tone a bright orange or yellowish color instead of a true brown. If still more hypo is present, toning in the darker areas of the print will be slowed down or in some cases completely prevented. If considerable hypo is present, there will be not only lack of toning in the dark areas of the print, but detail in lighter areas will fade out.

H&W CONTROL 4.5

The combination of VTE (very thin emulsion) films and H&W Control Developer has established a new concept of standards for small format photography. Fine grain films such as H&W Control VTE Pan and VTE Ultra Pan, allows the resolution capability to approach that of the finest lenses. Under carefully controlled conditions it is possible to record 160 lines/mm on VTE Pan film and 200 lines/mm on VTE Ultra Pan Film. Enlargements made from such negatives are difficult to distinguish from those made with large format cameras.

H&W Control 4.5 Developer Concentrate is a major revision of the original Control Developer formula. It differs from the earlier products by providing extended latitude, shorter processing time, and better keeping qualities. When image sharpness in great enlargement is of utmost importance, the ability of Control 4.5 Developer to render separation of tones over a very wide brightness range, with no loss of toe speed, permits the use of the VTE films in many more applications than before.

EXPOSURE

The Exposure Index (or ASA setting on cameras with built in meter) formerly recommended for H&W Control VTE Pan Film was 80 when developed in H&W Control Developer. This was a practical E.I. for a scene brightness range of five stops. An exposure in the middle of this range gave some detail in the shadows, and printable separation in the highlights. Giving more exposure would improve shadow detail in such a scene, but because of relatively early shouldering, would degrade highlight rendition.

The Control 4.5 Developer greatly reduces this limitation, and in fact, with lower temperature development, eliminates it entirely.

Since working methods, and equipment vary considerably, the Exposure Index given is a suggested starting point from which your own tests and notes should be made.

SUGGESTED EXPOSURE INDEX

H&W Control VTE Pan Film, 35mm & 120 E.I. 50

H&W Control VTE Ultra Pan Film, 35mm E.I. 16

Filter Factors: The following filter factors were established by tests made with Leitz filters outdoors on a bright midsummer afternoon. As expected, these factors are similar to factors published for conventional panchromatic films, and other filters can be expected to respond similarly. However, filters can vary from maker to maker, and light varies in its color; so the photographer should use the table below only as a rough approximation, as a starting point. Preliminary tests under field conditions should be made, and test exposure should be bracketed.

DEVELOPMENT

H&W Control 4.5 Developer Concentrate is formulated to give best results with H&W Control VTE Pan and VTE Ultra Pan Films at a dilution ratio of about 1:22.5, or 10½ ml per eight ounces (237 ml) of working developer solution per roll of 35mm film. For a 120 roll of VTE Pan, use 18 ml per 14 ounces. In multiple reel tanks, observe the dilution ratio of 1:22.5 or multiply the amount of developer concentrate and water by the number of rolls of film to be developed. A level full H&W Control measuring cap contains 10½ ml, as does an H&W Control 6-pack vial when the low point of the meniscus is at the top of the label.

Filter Factors for H&W Control VTE Pan and VTE Ultra Pan Film

Leitz Filter	Yellow 1	Yellow 2	Orange	Red	Green	Blue	Polarizer
Equivalent (Wratten No.)	K-1 (6)	K-2 (8)	G (15)	A (25)	B (58)	C-5(47)	
Exposure Factor	1.5x	2x	4x	8-12x	3x	3x	3x

(Continued on following page)

MISCELLANEOUS MANUFACTURERS

The Compact Photo-Lab-Index

Water for Dilution: Any water safe for drinking that is neutral or slightly alkaline is suitable. When water and the Control 4.5 Concentrate first mix, the color is pale yellow-tan. While the user adjusts the solution to the proper temperature, the color fades. With most waters, the solution is colorless in about ninety seconds. This process is normal and one need not wait for its completion.

Agitation: Give the film ten seconds of continuous agitation after the developer has been poured into the tank. With a spiral-reel inversion-type tank, agitation is best accomplished with gentle inversions and rightings of the tank, each cycle taking approximately two seconds. At the first half-minute, and on each half-minute thereafter (timed from the beginning of the pouring of the developer into the tank), the tank should be inverted and righted three times, taking about six seconds.

The purpose of agitation is to diffuse the elements of the dynamic developer-emulsion interaction, to the end that image density everywhere in the negative is in exact proportion of amount of exposure received. Thus, proper agitation results in negatives that are free from mottling and gravitational streaking. More agitation than is necessary increase graininess and the gradient of the curve. Tanks of different manufacture vary in size, therefore in the amount of turbulence generated by each inversion and righting of the tank. With a Nikor single-reel 35mm tank holding a 36-exposure roll of film, the frequency of agitation recommended above is adequate for most continuous-tone requirements. If a special assignment demands evenness of densities beyond these requirements, more frequent agitation is needed, and a shorter development time in order to approximate the normal curve. For agitation every 20 seconds, suggested development time is 4 minutes.

End of Development: Begin to pour the developer from the tank at the end of the time cycle which began with the start of the pour-in. The used developer is to be discarded.

No rinse after development is necessary, though water at the same temperature can do no harm. An acidic stop bath has been recommended because it halts development fairly immediately; also it prevents alkalization of the fixer and so prevents fixer life from being shortened. However, an acid fixer halts development as rapidly as a stop bath; and if, on calculation, hypo is found to be cheaper than time, one can proceed directly from development to fixing. There is no loss of image quality or increase in grain as a result of so doing.

Fixer: A rapid fixing bath is unnecessary, since in fresh standard fixers the VTE films clear in ten to fifteen seconds and can be supposed to be fixed in slightly more than twice that time. Fix for no longer than 2 minutes. Before proper fixation of the VTE films takes even that long, the fixer will test as used up (testing with, e.g., Edwal Hypo-Chek or 5% potassium iodide solution).

Neutralizing Bath: Any standard hypo clearing bath can be used and is recommended to conserve water.

Washing: After the final wash, a wetting agent is recommended in order to prevent water spots on the negatives. The water used for this step is critical: the wetting agent should be mixed with distilled or filtered and deionized water. Use no stronger a wetting agent solution than necessary to assure flow, because too high a concentration will leave scum on the film.

All subsequent treatment of the film is standard. Drying time at room temperature with unblown air is between five and twenty minutes, depending on humidity. Dry in a dust-free place; dust or dirt which dries into the emulsion will leave spots even if the film is cleaned chemically after drying. All steps possible must be taken to keep dust out of the darkroom.

Caution: A kind of streak occasionally appearing in even-toned portions of some frames is traceable to the rapidity with which the H&W Control 4.5 Developer oxidizes, and fortunately it can be prevented. These streaks are

(Continued on following page)

664

created at the end of development, by the last few drops running down the film after the used developer has been poured out and before the next bath has been poured in. They do not appear in every roll, and some users have developed dozens of rolls without their occurrence. They never occur in roller—or belt-driven processing. Since rapid aerial oxidation is the cause, the preventive is to eliminate air contact time. This can be accomplished as follows: At the end of development pour into the tank 4 ml of 28% acetic acid (per 8 ounces of solution), replace the cap, invert and right the tank ten times (taking 20 seconds), then pour out the solution and pour in the next bath. This process will generate considerable gas pressure, necessitating holding the cap loosely while inverting and righting the tank. What has taken place is that the acetic acid has deactivated the developer, in fact has transformed it into a mild stop bath. If this procedure is followed, the bath following the acidifying of the developer is properly the fixer.

Characteristic Curves: The curves below apply to 36-exposure rolls of 35mm film. For 120 roll film (available in VTE Pan) times should be reduced 10%. For 20-exposure 35mm rolls (available in VTE Pan) reduce times 5%.

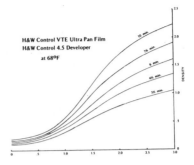

H&W Control VTE Ultra Pan Film
H&W Control 4.5 Developer
at 68°F

Of interest are curves showing results of lower — and higher — temperature development of H&W Control VTE Pan film:

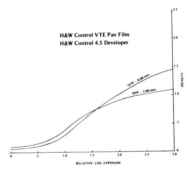

H&W Control VTE Pan Film
H&W Control 4.5 Developer

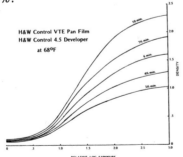

H&W Control VTE Pan Film
H&W Control 4.5 Developer
at 68°F

RELATIVE LOG EXPOSURE

It will be noted that the brightness range accommodated, or exposure latitude, is extended with lower-temperature development, shortened with higher. H&W Control VTE Ultra Pan Film responds similarly. The following table can be used as a guide:

H&W Control VTE Pan and
VTE Ultra Pan
35mm x 36-exposure films
H&W Control 4.5 Developer
Concentrate
10½ ml per 8 ounces

Temperature (°F)	Development Time (min.)
78	3
73	3½
68	4½
64	5½
60	6½
55	8

(Continued on following page)

665

The Compact Photo-Lab-Index

ANTIHALATION

H&W Control VTE Pan and VTE Ultra Pan Films are protected against halation by dyes that inhibit passage of light. In the case of VTE Pan, the dye material is applied to the tri-acetate film base, preventing the smooth base from acting as a mirror. With VTE Ultra, the dye is dispersed throughout the emulsion, preventing light from bouncing from one grain of halide to another, thus further preventing irradiation.

In both cases the dye is dissolved during development in H&W Control Developer and is poured out with the used developer at the end of development. If any trace of the antihalation dye remains visible in the image area of the film when processing is completed—in the VTE Pan a deep blue and in the VTE Ultra a salmon-pink—it is a sure sign that an error has been made: either an inadequate amount of developer concentrate was used to make up the working solution, or agitation was insufficient. In either event one can also expect to see flat or mottled negatives.

Some film reels are constructed so that they prevent circulation of solution at the film edges. When such reels are used, the picture area may be perfectly processed but traces of the antihalation dye remain on the film edges. This will not affect the print.

Antihalation dye remaining on the film after processing can be removed by bathing for a minute in a solution of water and sodium carbonate (2%) or bicarbonate (5%), followed by washing and drying.

RECIPROCITY

CALCULATED EXPOSURE

The graph above gives compensation factors for long exposures of H&W Control VTE Pan and VTE Ultra Pan Films. Experience has confirmed this curve, which was first published two years ago. The development time factor should be observed if normal contrast is to be obtained. It may be noted that the curve proceeds so gradually that beyond a point of calculated exposure H&W Control VTE Pan seems actually to be faster than a coarser-grain conventional continuous-tone film. This is in fact the case.

For short exposures to 1/10,000-second no compensation is needed. At 1/100,000, ½- to 1-stop wider lens opening will compensate. At 1/1,000,-000-second, 1- to 1½-stop wider lens opening is required.

KEEPING

Bottles of H&W Control 4.5 Developer Concentrate must be kept full or decanted into smaller bottles so that free air is kept at a minimum. The H&W Control 6-pack vials are ideal for storage of single-use amounts of the Concentrate, which must be stored undiluted.

Storage at temperatuers above 70°F is to be avoided, but on the other hand do not refrigerate. Storage below 40°F does not improve shelf life, and can be expected to cause needle-like precipitation of chemicals. If precipitation occurs, chemicals may safely be re-dissolved by immersing the bottle for a few minutes in hot water. It is not necessary to store in the dark. The enemies of this developer are air and prolonged heat.

The date of manufacture appears on all bottles and 6-packs of H&W Control 4.5 Developer Concentrate. The purpose of this date is to permit monitoring, in order to compensate for gradual loss of contrast over long periods by extending developing time. Six months after date of manufacture, add a half-minute to the original developing time; a year after, add a minute. If stored at 70°F or below there will be no loss of toe speed for one year, and these recommended increases in developing time may be over-generous.

(Continued on following page)

The Compact Photo-Lab-Index

At this time no confident recommendation can be made regarding the use of H&W Control 4.5 Concentrate that is more than a year old. It can be said, however, that in direct bottle-to-bottle testing over a short period of time, the 4.5 Concentrate ages at less than half the rate of the former product.

H&W CONTROL PRODUCTS
H&W CONTROL VTE PAN ASA 50-80

H&W Control VTE Pan Film is available in 35mm x 100-foot rolls, 36-exposure and 20-exposure cartridges, 16mm single-perf., B-wind, in 100-foot and 400-foot rolls, and 120 roll film spools.

H&W CONTROL ULTRA PAN ASA 16-25

H&W Control VTE Ultra Pan Film is available in 35mm in both 100-foot rolls and 36-exposure cartridges, and in 16mm single perf., B-wind, in 100-foot and 400-foot rolls.

H&W Control 4.5 Developer Concentrate is available in boxes of six single-use vials, and in 120-ml and 480-ml bottles.

H&W Control Reversal Processing of 16mm x 100-foot or 400-foot rolls of either VTE Ultra Pan or VTE Pan is done only by The H&W Company. Mailers can be obtained from the H&W dealers.

For those without access to a darkroom, many custom photo labs across the country process H&W still films.

H & W MAXIMAL

H & H MAXIMAL is a Developer/Replenisher system which offers high speed, rich gradation, and excellent film printing contrast. MAXIMAL DEVELOPER works at a low pH, which minimizes grain clumping so that photographers can realize as nearly as possible the enlargement potential of the films they are using. MAXIMAL REPLENISHER restores the developer precisely so that consistent contrast and film speed are maintained throughout the life of the developer.

THE FILMS

As the films usable for continuous tone photography range from Kodak's 2475

to films such as Agfa Scientia 10E75, it is useful to define certain categories when discussing films and developers.

Very High Speed:
Kodak 2475, Royal-X Pan, etc.

Medium Emulsion:
Tri-X, Plus-X, HP4, HP3, GAF 125, etc.

Thin Emulsion:
Panatomic-X, Pan F, KB 14, etc.

Very Thin Emulsion:
H & W Control VTE Pan, VTE Ultra, etc.

Extremely Thin Emulsion:
Kodak 649, Agfa Scientia 10E75, etc.

In moving through this range, one finds that the inherent contrast of the films tends to increase in the direction of the Extremely Thin Emulsions. There are exceptions to this rule, but generally, "softer" developers are required for each step toward the thinner films. This requires a different balancing of developing agents if maximum film speed is to be obtained from each category.

Consider, for example, what happens if a developer of the optimum formulation for Royal-X Pan is used on Pan-X. In order to have a printable contrast, the Pan-X must be substantially underdeveloped, thereby giving up a great deal of film speed. The results may print well; but with an appropriate developer formula Pan-X is capable of significantly more speed with comparable printing results.

We find that with Tri-X good negatives can be obtained over a range of EI 25 to 1250 by the use of a wide range of developer formulas. Shooting Tri-X at EI 25 and developing accordingly, however, does not make it as fine grain as Pan-X or even Plus-X. With MAXIMAL, one can use a fine grain film to obtain a desired Exposure Index. This will yield better results than using "fine grain" developers that work at ASA film speeds.

H & W MAXIMAL is optimized for the Medium Emulsion Films. This formula offers no particular advantage with the Very High Speed Films, as a bit more energy is required in their

(*Continued on following page*)

development. With the Thin Films the results are excellent. Not too much underdevelopment is necessary and therefore the film speeds are reasonably high for this class of films. MAXIMAL is not recommended for continuous tone use with the Very Thin or Extremely Thin Emulsion Films.

ASA AND EXPOSURE INDEX

The ANSI PH2.5-1960 sets forth the criteria for establishing an ASA film speed. Of importance here is that the Standard, calls for the use of one specific developer formula, with the developing time being adjusted to produce a certain density range. When a film is developed in another developer, the speed for that film/developer combination may depart from the ASA speed. A film speed rating arrived at with other than the ASA developer is termed "Exposure Index." For purposes of meter setting, etc., ASA and EI should be considered to be identical.

The EI's given in the chart "Time and Temperature Table for H & W MAXIMAL" are based on the amount of exposure necessary to produce a toe density of 0.10 ± 0.01 above base plus fog, and an overall contrast considered to be optimum for condenser enlarging. The nominal gamma when these recommendations are followed is about 0.65. With the panchromatic films listed below, these EI's apply to both daylight and tungsten illumination.

˙EXPOSURE

Exposure latitude is a function of film latitude. Film latitude can be described as the length of the D Log E curve over which usable separations of tone exist. In order for exposure latitude to exist, the film latitude must exceed the photographer's requirements. With this condition, the photographer has a certain margin for error that will still place the important parts of the subject within the film latitude. With H & W MAXIMAL, some film latitude is sacrificed for film speed and, therefore, exposures must be made accurately.

PREPARING THE SOLUTIONS

Prepare MAXIMAL Developer and Replenisher at least 8 hours before first use; if possible, allow 24 hours to assure complete chemical activity of the solutions. If powder photo-chemicals such as D-76 dissolve in local tap water without creating a grey fog, that water should be suitable for MAXIMAL. If a cloud does appear, it may be filtered out, or the developer can be used as is without any alteration of its working characteristics. For guaranteed clear mixes, use distilled water. In no case should sequestering additives be used. For instance, sodium hexametaphosphate (Calgon) is a sequestering agent that prevents mineral clouding of photo solutions, but the effect of its pH will alter the carefully adjusted pH of MAXIMAL.

Dissolve contents of the packet labeled H & W MAXIMAL DEVELOPER in 22 oz. of hot (125-150°F) water. Stir constantly as the chemicals are added to the water to prevent caking. Rinse the packet with 2 oz. of hot water and add the contents to the 22 oz. Continue to stir gently until all the chemicals are dissolved and then add cold water to make 32 oz. (1 quart). For gallon and larger sizes of MAXIMAL, increase the amounts of water proportionately. Follow the same procedure to prepare H & W MAXIMAL REPLENISHER. Pour the solutions into separate glass or PVC bottles and label.

STORAGE

As with all photographic developers, the prevention of oxidation is the prime consideration in the storage of H & W MAXIMAL Developer and Replenisher. Tightly stoppered glass or high quality PVC bottles should be used as they are the most common materials of low oxygen permeability. With roll film use, the Developer bottle will be kept full between uses, and therefore no particular problems with developer life should be encountered. It is best to put the Replenisher into several small bottles so that most of the solution can be kept from contact with free air while part of it is being used. With sheet films, the use of a floating lid in the developer tank is essential to obtain maximum life. If the developer is to be used only occasion-

(*Continued on following page*)

ally, it is best to pour it into a glass or PVC bottle between uses.

In the normal use of replenished developer systems, a black sludge will form which falls to the bottom. This is harmless, but can be filtered out if the photographer has any misgivings about its presence.

DEVELOPING WITH H & W MAXIMAL

The times in the chart on the back have been rounded off to the nearest half minute. Individual preferences for negative density, equipment, and procedures may necessitate modifying the times accordingly. These times are based on the proper contrast for condenser enlarging. For diffusion or cold-light enlarging requirments, times must be increased in order to provide greater contrast.

Following developtment, stop, fix and wash as usual.

35mm FILMS:

Use H & W MAXIMAL Developer full strength. Measure enough to cover the number of reels being processed. **Either before or during development add to the Developer bottle 1 oz. of MAXIMAL Replenisher per 36-exposure roll, or 3/5 oz. (18 ml) per 20-exposure roll.**

When the developer is poured into the developing tank, give the film 15 seconds constant, gentle agitation. Rap the bottom of the tank with the heel of the hand after initial agitation to dislodge air bubbles which may have been trapped in the reel. At the beginning of each minute thereafter give the film 6 seconds agitation. With a spiral reel, inversion-type tank, agitation is best accomplished by inverting and righting the tank slowly so that each cycle takes approximately 2 seconds.

When development is completed, return to the Developer bottle only enough of the used developer to bring the total volume back to 32 oz. Discard the remainder.

With this system, H & W MAXIMAL will process 36 rolls of 35mm/36-exposure film per quart.

120 ROLL FILMS:

Follow the procedure outlined above for 35mm films but measure 14 oz. (some tanks require 16 oz.) of the developer for each roll of film being processed. Before or during development add 1 oz. of Replenisher to the Developer bottle for each roll. After development return only enough of the used developer to bring the total volume to 32 oz. One quart of MAXIMAL Developer/Replenisher will process 34 rolls of 120 film.

SHEET FILMS:

The time/temperature recommendations given are based on tank development. (After filling the tank with the proper amount of MAXIMAL, make a mark at the top of the developer level (masking tape, etc. is sufficient).

For consistent results, agitate the sheets with two agitation cycles initially and two cycles on the minute for the balance of development. Standard procedure is recommended, with one cycle defined as follows: lift the hangers and tilt 60° forward, return to the tank, lift and tilt 60° backward, and then return to the tank.

After each development, replenish at the rate of 10 ml per 20 square inches of film; one ounce for each 60 square inches is sufficiently accurate. As the quantity of developer must remain constant for consistent results, use a small cup to remove some developer from the tank before replenishing. After adding the appropriate amount of MAXIMAL Replenisher, refill the tank to the marked level. Discard the excess. Stir the replenisher into the developer before using again.

For tray development of sheet films, do not develop more than three 4 x 5's (or equivalent) per 8 oz. of developer. Development times may have to be modified to reflect the agitation patterns used.

AVAILABILITY

H & W MAXIMAL Developer/Replenisher is available in 1 quart, 1 gallon and 5 gallon sizes.

(*Continued on following page*)

TIME AND TEMPERATURE TABLE FOR
H & W MAXIMAL DEVELOPER

	Exposure Index	Development time in minutes: 68° F	74° F	80° F
35mm Films				
Tri-X	1250	8	7	5½
Plus-X	640	7	6	4½
Pan-X	200	5	4	3
HP4	1250	8	6½	5
FP4	500	6	5	4
Pan F	200	5	4	3
GAF 500	1000	8	6½	5
GAF 125	640	8	7	5½
120 Roll Films				
Tri-X	800	8	7	5½
Tri-X Pro.	640	8	6½	5
Plus-X Pro.	250	5	4	3
Verichrome Pan	250	7	6	4½
Pan-X	80	5	4	3
HP4	640	9	7	5
FP4	200	7	6	4½
GAF 125	250	7	5½	4
Sheet Films				
Tri-X Pan Pro.	640	7	5½	4*
Royal Pan	500	8	6½	5*
Plus-X Pro.	250	7½	6½	5*
Ektapan	200	8	6½	4½*
GAF Pro. 2863	500	9	7½	6*
GAF Versapan	250	9	7	5*

*While the roll films respond well to processing at high temperature, there may be an increase in relative fog when the sheet films are developed in MAXIMAL at 80° F.

positive, any one of these, but not all three on one roll. Such varying subjects should each be handled on separate rolls of film for optimum results. To achieve technically excellent reversal results, the entire roll should contain subjects of similar brightness range. However, aesthetic and artistic considerations of mood or faithful reproduction of the original may dictate a softer or more contrasty than normal positive. Almost any brightness range can be accommodated by varying the length of time that the film is kept in the first developer. The following table gives some starting-point suggestions for obtaining full-scale positives.

First Developer Time at 68° F	Subject Brightness Range in Stops
4½ Min.	6 and over
5¼ Min.	4-6
6½ Min.	2¼-4

For best results, black-and-white film, when intended for reversal, gives best results when exposure is slightly on the underexposed side, rather than toward overexposure. Overexposure tends to wash out lighter tones, and in projection tests, burnt-out highlights look worse to the eye, than do blocked shadows, exactly the opposite condition that is found with paper prints. In general, when bracketing exposures, go further in the direction of under-exposure, than over.

To zero in on your particular working conditions, it is wise to make some test shots of gray scales so that the tonal scale may readily be determined, before attempting any critical work. The investment in effort involved in using the gray scales will help to achieve dependable and predictable results when you are ready to photograph your subjects.

RECOMMENDED EXPOSURE INDEX (EI or ASA)

H&W Control VTE Pan Film 50
H&W Control VTE Ultra Pan Film 16

PROCESSING

Black-and-White reversal processing is somewhat similar to that of color reversal processing. The first step is that of developing the negative image—that is to reduce to silver, all halide grains that have been exposed. For this purpose, developer and development time/temperature are chosen to considerably higher gamma and overall density range (more contrast) than would be appropriate were a paper print to be made from the negative.

The next step is to bleach, or dissolve away the negative image. Adequate rinsing after the first development is essential, because any residual development agent left in the tank would combine with the bleaching agent to produce permanent stains. Bleach strength and time of immersion must be enough to eliminate the negative image silver, but not enough to begin eating away at the unexposed silver halide which is to produce the final positive image.

The yellowish mask left on the film from the bleaching solution must then be removed. This can be accomplished by lengthy and energetic washing, but it is more practical and convenient to use a couple of water rinses followed by immersion for a short time in a clearing bath which acts as a neutralizing solution.

Next, the film is exposed to a fairly bright light to expose the residual silver halide so that it may be developed. Too weak a light will be inadequate since the smallest grains might not respond no matter how long the exposure were continued. Alternatively, too strong a light (direct sunlight) can actually have the effect of weakening the final image. Exposure too close to a hot light could, by sudden heating of the emulsion, result in reticulation of the gelatin. Adequate re-exposure will take place if the room lights are on and the entire length of the film is passed back and forth for a minute about a foot away from one of the lights.

The final image forming step is to reduce to silver, all the residual halide grains on the film which are now totally exposed. Any active developer such as D-11, D-72 or equivalent, will do, except that a compensating type of developer would be unsuitable, because such a developer is designed to pre-

(*Continued on following page*)

vent formation of the high image densities necessary in the projected positive transparency to appear as solid blacks.

When development is completed, the fixing process will remove any silver halide that may have been left unexposed during the re-exposure step. Washing and drying are done in the usual way.

AGITATION

During development the film requires ten seconds of continuous agitation after the developer has been poured into the tank. With a spiral-reel inversion-type tank, agitation is best accomplished with gentle inversions and rightings of the tank, each cycle taking approximately two seconds. Each 15 seconds, the tank should be inverted and righted three times, taking six seconds. Whatever method of agitation you use, it is imperative that your method is consistent from roll to roll.

PREPARATION OF SOLUTIONS

First Developer: Dissolve the contents of the pouch in 24 oz. of water at 150° F. Add cold water to make 1 quart of stock solution.

For a working solution, take one part stock solution to 3 parts water.

Bleach: For a working solution: 1 part Bleach A + 1 part Bleach B + 28 parts water,.

or

8ml Bleach A + 8ml Bleach B + add water to make 8 oz. (per roll)

Summary of procedure:

Develop at 68° F for 4½ minutes with agitation each 15 seconds. Discard used solution. Agitate as described earlier.

Rinse with 5 complete changes of water.

Bleach for 1½ minutes, agitating after first 30 seconds. Discard used solution, and at this point, remove the top of the tank.

Rinse with 2 changes of water.

Clear for 1 minute. Solution can be re-used.

Re-expose as described earlier.

Develop in D-19 or D-72 diluted 1:1, (or equivalent), for 2 minutes. Agitate every 30 seconds.

Fix in any standard fixer for 1 minute.

Wash and dry as usual.

Transparencies of this kind can be used for a variety of audio-visual applications, and wherever consistent and rapid results for projection slides are required.

TKO CHEMICAL CO., INC.

ORBIT BATH

Orbit bath is a multi-purpose photo concentrate which acts as a stop-bath, hypo accelerator-eliminator, ferrotype conditioner and cleaner.

MIXING

Use 4 ounces of Orbit Bath, add water to make one gallon. This working solution will handle approximately 600 sheets of 4 x 5 film, or 80 8 x 10 double weight prints. OB working solution has a working life which approximates that of an ordinary hypo bath.

USE

Black & white prints (single- or double-weight, any finish):
1. Agitate in working solution for 2 minutes following hypo bath.
2. Wash 5 minutes in running water bath. Dry.

Stop bath:
1. Place print in Orbit Bath working solution for 30 to 45 seconds (in place of acid stop baths).

Toned or hand-colored prints:
1. Agitate in working solution 2 minutes following hypo bath.
2. Wash 5 minutes in running water.
3. Place in toning bath until print is completely toned.
4. Agitate in working solution 2 minutes.
5. Wash 5 minutes in running water. Dry.

Photographic films and plates:
1. Agitate continuously in working solution for 30 seconds following hypo bath.
2. Wash 5 minutes in an effective negative washer. Dry.

Color film:
1. Process normally.
2. Before drying agitate continuously in working solution 30 seconds.
3. Wash 5 minutes in an effective negative washer. Dry.

Color prints:
1. Process normally.
2. Before drying agitate in working solution 2 minutes.
3. Wash 5 minutes in running water. Dry.

Polaroid black & white 55P/N pack:
1. Peel print & negative from the developer pack and place negative in working solution of Orbit Bath 3 minutes using gentle fingertip agitation.
2. Wash 5 minutes in running water. Dry.

NOTE: If using in the field, peel the positive and negative from pack and place negative in Orbit Bath working solution. Negative can be held up to 9 hours. Upon return, process in fresh solution as directed above, except finger agitation should not be required.

Drum cleaning:
1. Saturate lint-free cloth with full strength Orbit Bath.
2. Wipe surface while drum is warm and turning—at least three revolutions.
3. Rinse with clean cloth which has been saturated with water (filtered preferred). Clean ferrotyping sheeting, plates, etc., in same manner.

Apron cleaning:
1. Use Orbit Bath concentrate.
2. Dry with large blotter.
3. Repeat process until stains are gone.

Clean tools and hands:
1. Agitate vigorously 15 to 30 seconds in Orbit Bath working solution.
2. Will not kill developer.
3. Non-acidic, non-alkaline, non-inflammable, non-toxic.

(Continued on following page)

MISCELLANEOUS MANUFACTURERS

O-FIX

DIRECTIONS FOR USE

1. Mixture of "O-Fix" for black and white film: Add 4 oz. of Orbit Bath concentrate to a gal. of working solution of Fix.
 a. For Developing:
 Develop film in developer according to manufacturer's recommendation.
 b. Place film in "O-Fix" for 2 min. —wash in running water for 5 min.—dry in normal manner.

2. Mixture of "O-Fix" for black and white prints: Add 6 oz. of Orbit Bath concentrate to a gal. of working solution of Fix.
 a. Develop print in developer according to manufacturer's recommendation.
 b. Place print in Orbit Bath working solution (using Orbit Bath as short stop), remove from Orbit Bath short stop after 30 sec.
 c. Place print in "O-Fix" for 2 min. —wash in running water bath 5 min.—dry in normal manner.

3. For Toning: Remove print from toning bath, place print in separate working solution of Orbit Bath for 2 min. —then wash in running water bath for 5 min.—dry in normal manner.

4. Exhaustion Rate: "O-Fix" will process approximately 80, 8 x 10 double weight prints, or 150 sheets 8 x 10 film.

Prints fixed accordingly are effectively freed of residual hypo. Hypo level is reduced to archival limits (1.0 mg/cm^2) within 10 minutes after fixing. No eliminator bath prior to wash is necessary to accelerate wash time. The savings in time and wash water are obvious. It should be emphasized that no deleterious effects resulted from a mixture of fixer and Orbit Bath solution. The fixing solution remained clear and normal exhaustion rates were maintained.

Orbit Bath is not a neutralizer. It works as a Catalyst that accelerates the Hypo to a chemical conclusion.

ETHOL UFG DEVELOPER

DESCRIPTION

U F G, as its name implies, is an "ultra-fine-grain" developer that retains the inherent grain structure of the film emulsion developed in it. This developer, when used as instructed, produces negatives of very high acutance, normal contrast, and extreme latitude with all types of films, ranging in size from the sub-miniature Minox film to the 8 x 10 sheet film. Due to the extreme latitude, it is ideally suited to the needs of the photojournalist, the professional custom lab and the working press, i.e., TRI-X 35mm exposed at ASA-50 to ASA-3200 on the same strip of film renders quality prints from each frame when developed in U F G (3 stops underexposed and 3 stops overexposed). As indicated, U F G adapts itself to contrast control of the negatives, according to the brightness range of the lighting and subject matter. For very contrasty subjects, increase exposure and decrease the development; for flatly-lighted subjects, decrease the exposure and increase the developing time. Additional compensation in negative development is obtained by diluting U F G and using as a "one-time" developer; a Replenisher is available for repeated or deep-tank use of the "stock" developer. Both U F G and the Replenisher, when fresh, reveal a characteristic pale, yellow-brown color, approximately that of weak tea; this is normal and is not an indication of oxidation. U F G and its Replenisher are supplied both in powder form and in liquid "ready-mix." U F G is panthermic and may be safely used at temperatures from 60 to 90 degrees Fahrenheit; preference is limited to the range of 65 to 80 degrees.

Water quality is important for quality U F G processing; it should be as pure as possible for longest "stock life." If your water supply is not free of minerals and foreign matter, the use of boiled or distilled water is recommended. If you feel that contamination is not your problem and you are having some difficulty with the life of your developer, the answer may be the water.

If possible, **do not pour** solutions in and out of the daylight load tanks; preferably fill the tank with developer first and, in the dark, drop the loaded reel into it. Following development, lift reel out, **into** the next solution instead of pouring in and out; this contributes to more accurate timing and more uniform developing of the negatives.

*Note: TRI-X PAN has been assigned the E.I. of 1200 and 650; developing times have been given for each rating. It is suggested the E.I. of 650 be used when the subject brightness is very contrasty or where the additional speed is not required; the negative quality at both E.I. 1200 and 650 is very comparable.

GOOD HOUSEKEEPING

Cleanliness is a must; U F G, as well as other film developers, can be contaminated by foreign matter—especially by fixer or other developers. This will cause rapid exhaustion. Tanks and reels should be cleaned periodically, particularly when changing from another developer to U F G. A solution of 2 ounces sodium sulfite and 3 ounces sodium carbonate per gallon of hot water is an excellent cleaner; allow the tanks and reels to remain in this solution overnight and then rinse thoroughly. Always dry tanks and reels IMMEDIATELY after use with a clean lint-free towel.

STORAGE

If U F G is stored properly in full or covered containers away from excessive heat, it will last well over a year. It is suggested, where possible, to store the developer in the cooling chamber of the refrigerator for maximum life; allow it to reach proper temeprature before use. Filled sheet film tanks should have floating lids or be tightly covered with Saran Wrap.

(continued on following page)

The Compact Photo-Lab-Index

REPLENISHMENT

Although development may be carried out in U F G without replenishment, it is not generally recommended. If you are developing in this manner, then add 10% to the developing time after your 2nd roll and limit to 25 rolls per quart. Replenishment is definitely recommended if U F G is not used with the "dilution and discard" method. The average rate of replenishment is at the rate of ½ ounce per 80 square inches of developed film—this means 1 roll of 120 or 35mm, 36 ex., 4 sheets of 4 x 5 or 1 of 8 x 10. Add the replenisher to the "stock" after each batch of film and stir well. Replenisher may be added until the amount of replenisher added equals the amount of the original "stock" U F G. Properly replenished it will develop at least 60 rolls of film per quart. Replenishment is affected by types of emulsions, storage conditions, overexposures, contamination, etc., therefore we can only give you a guide.

DILUTION

Where longer developing times are desirable or greater contrast control is needed, then dilution is definitely recommended; discard immediately after one-time use. Dilution may be desirable for one or more of the following reasons: time control, finer grain, contrast control, higher acutance or increased effective film speeds. **Never** dilute U F G "stock" that has had replenisher added to it. **Constant Agitation** is used with diluted U F G to prevent the gradation from becoming too soft. (Remember that exposure controls density, development controls contrast.) As a guide for developing films by a dilution of 1:5, it is recommended normal times be multiplied by approximately 2½ times and constant agitation used. For those who wish to develop for longer times, but do not wish to dilute, then add 1 ounce of sodium bisulfite per gallon of developer and triple the development times shown in the chart. If you wish to replenish this solution, then add 2 ounces of sodium bisulfite per gallon of replenisher. Note: Using the sodium bisulfite makes U F G reusable and is not in the category of a one-time use developer as when dilution is used. The sodium bisulfite does not affect the quality, but care must be exercised where film speed is important, as the speed will be affected slightly.

AGITATION

For 35mm and 120 roll films, tanks are preferred that can be inverted during agitation. Immediately after immersing films, agitate for the first 15 seconds; thereafter, agitate 5 seconds at the end of each 30 seconds. Our method, is 3 gentle inversions while rotating counterclockwise during the 5 seconds every 30 seconds, followed by putting the tank down with a gentle tap at the end of each 5-second inversion period, to dislocate any air bubbles that may have formed. The idea is to get even development of the films and consistently reproducible results. If you are getting these, but the developing times in the table are too long or too short for your purposes, then don't change your agitation, but instead change the developing times accordingly. If a multiple-reel tank is used for the development of one roll, we recommend that you insert empty reels to prevent too violent agitation by the reel shooting the length of the tank with each inversion. Where very deep roll-film developing tanks are used, it is suggested reels be placed on a long wire and agitation carried out by a gentle lifting and turning of the reels during the agitation periods; **do not** lift out of the solution.

For agitation of sheet film in hangers, agitate during the first 15 seconds then follow with agitation 5 seconds each 30 seconds thereafter. Hangers should be placed in the tank as a group, tapping the hanger bars on the top of the tank to dislodge any air bells. After agitation period lift hangers clear of the

(continued on following page)

676

The Compact Photo-Lab-Index

solution, drain 1 to 2 seconds from each corner and replace smoothly into the tank; repeat these cycles until development is complete. Developing in a tray or dish, with constant agitation, will reduce developing time by 20%.

SHORT-STOP

A short-stop **is not** recommended except in cases where the temperature exceeds 80 degrees. If temperatures over 80 degrees are used, a hardening stop bath is advised; use 1 teaspoon of sodium bisulfite and 1 teaspoon of potassium chrome alum per quart of water. Use once and discard. In lieu of the short-stop, a brief water rinse of 30 seconds to 1 minute should be used.

FIXING FILM

Use a rapid-hardening fixer. Fix for twice the clearing time. Thick emulsion or high-speed films will require about 1/3 longer to fix than the slower thin-emulsion films; do not overfix—delicate halftones will be destroyed. If your fixer is not fresh, fogged or stained films may be expected.

WASHING—DRYING

Follow the wash with a brief 30- to 60-second immersion in a good wetting agent; remove film from reel and hang up by the end. Soak a viscose photo sponge in the wetting solution, squeeze out, and wipe down film one side at a time. Allow film to dry in an area free from dust and at a temperature as close as possible to the processing temperature; use no heat or fan.

TEMPERATURE

The importance of accurate temperature uniformity throughout the developing process, cannot be over-emphasized. Keep an ACCURATE laboratory "standard" thermometer aside to **check your working thermometer** against frequently. Inaccuracies in thermometers are very common and can play havoc with the negative contrast. Keep developer, fix, wash and drying at the same temperature.

TIME AND TEMPERATURE TABLE

Since photography is not an exact science and variables are encountered with each photographer and his equipment, the following tables are furnished as a guide—a STARTING POINT—so that he may achieve the optimum negative quality.

There is NO SINGLE CORRECT DEVELOPING TIME to give optimum results UNDER ALL CONDITIONS. The ideal negative is a delicate balance of exposure and development of the film, taking into consideration the brightness range of the subject, the latitude of the film and the photographer's aesthetic objectives.

Under normal conditions and using a double-condenser enlarger, the E.I.'s given in the table, should give optimum print quality when the negatives are developed as instructed. Negatives that are to be enlarged with a diffusion type enlarger will require about 20% longer developing times, as they require a higher gamma.

Ideally, negatives should be developed for different times according to the lighting, film contrast, exposure, and the brightness range of the subject, but this can only be done in the case of sheet films. Admittedly, roll films with mixed subjects and lighting conditions must get a compromise development; for these we recommend the times given in the table as a starting point. To cope with this situation, it is suggested that a 36-exposure roll of film, of the type normally used, be exposed as follows: bracket a series of 6 exposures with sunlight, 6 on a dull overcast day, 6 with your electronic flash, 6 with the

(continued on following page)

MISCELLANEOUS MANUFACTURERS

677

The Compact Photo-Lab-Index

flashbulbs most frequently used, 6 under photofloods, and 6 under contrasty available-light conditions; develop this 36-exposure test roll NORMALLY. After the film has dried, select the best negative in each classification, record the proper E.I. or guide number from each tested series. In this way, the best exposure may be used for future shooting, for this given film and given developing time. Needless to say, if you shoot the entire roll under the same conditions, then by all means change the development time to suit those conditions.

Note: The Recommended E.I. (Exposure Index) listed below, may be above or below that listed by the film manufacturer, but has been determined to give the best Exposure Index to arrive at the optimum negative with proper development in U F G.

Note: When diluted developer is used, ALWAYS USE CONSTANT AGITATION.

ETHOL UFG

EXPOSURE INDEX			NORMAL DEVELOPING TIME (Minutes)			
Daylight	Tungsten	35mm Films	65°	70°	75°	85°
——	4000	Kodak "2475" (gamma .70)	12½	10½	8¾	7½
——	6000	Kodak "2475" (gamma 1.00)	18½	16½	14½	13
——	3200	Kodak "2484" (gamma .70)	11¼	9¾	8½	7¼
——	5000	Kodak "2484" (gamma 1.00)	17¾	14½	11½	9¾
1200	1000	Kodak Tri-X	7	5¼	4	3
650	500	Kodak Tri-X	4	3½	3	2¾
400	400	Kodak Tri-X	3½	3	2¾	2¼
——	2000	**Kodak Tri-X	—	7½	—	—
——	4000	**Kodak Tri-X	—	9½	—	—
320	250	Kodak Plus-X	4	3¼	2¾	2¼
80	64	Kodak Panatomic-X	3¼	2	1¼	—
320	250	Ilford FP-4	4¼	3½	2¾	2½
1000	800	Ilford HP-4	6¼	5¼	4½	3¾
80	64	Ilford Pan-F	3	2¼	—	—
160	125	GAF Prof. Film Type 2681	3¾	3¼	2¾	2¼
1200	1000	GAF 500	5½	4¼	3¼	2½
250	200	GAF 125	4¾	4	3½	2¾
800	640	Fuji Neopan SSS	8½	7	6	5

**These are "push processing" indexes only.

(continued on following page)

ETHOL UFG

EXPOSURE INDEX			NORMAL DEVELOPING TIME (Minutes)			
Daylight	Tungsten	120 Films	65°	70°	75°	85°
1200	1000	Kodak Tri-X	6½	5¼	4¼	3½
650	500	Kodak Tri-X	4¾	4	3½	2¾
400	400	Kodak Tri-X	4¼	3½	3	2½
800	650	Kodak Tri-X Pan Prof.	7	5	3½	2½
320	250	Kodak Plus-X Pan	3¼	2¾	2¼	1¾
160	125	Kodak Verichrome Pan	3	2½	2¼	1¾
80	64	Kodak Panatomic-X	6¼	4½	3¼	2½
——	1600	Kodak Royal-X Pan Impr.	11	8	5¾	4
200	160	Ilford FP-4	4½	3½	2¾	2
1600	1200	Ilford HP-4	5¾	4¾	2¾	2¼
1000	800	GAF 500	6½	5¼	4½	3½
250	200	GAF 125	4½	3½	2¾	2
320	250	GAF Prof. Film Type #2681	3	2½	2¼	2
160	125	Agfapan ISS	2½	2¼	2	1¾
1000	800	Fuji Neopan SSS (Optimum)	11¼	9	7¼	5¾
800	640	Fuji Neopan SSS	8¾	7	5½	4½
500	400	Fuji Neopan SSS	5¾	5	4¼	3¾

(continued on following page)

ETHOL UFG

EXPOSURE INDEX			NORMAL DEVELOPING TIME (Minutes)			
Daylight	Tungsten	SHEET FILM	65°	70°	75°	85°
500	400	Kodak Tri-X (Estar Base)	3¾	3¼	2½	2
200	160	Kodak Plus-X	4¼	3¼	2¾	2
200	160	Kodak Super-XX	9¼	7¼	5¾	4¾
100	80	Kodak Ektapan	7	5¾	4½	3¾
1280	1000	Kodak Royal-X Pan Impr. 4166	13	11	9¼	8
400	400	Kodak Royal Pan	5¼	4	3¼	2½
400	320	Kodak Panchro Press B	7	5¼	4¼	3¼
64	32	Kodak Commercial Ortho	4½	3¾	3	2½
160	80	Kodak Super Speed Ortho	5¾	5	4½	3¾
——	20	Kodak Prof. Copy 4125	—	4	—	—
125	100	GAF Versapan Gafstar #2831	8	7	6	5¼
500	500	GAF Prof. Film Type #2863	8¼	6½	5¼	4¼
160	125	GAF Superpan Gafstar #2881	4¼	3½	2¾	2¼
32	25	Agfapan 25	7¾	6¾	5¾	5
100	80	Agfapan 100	6¾	5½	4¾	3½
250	200	Agfapan 200	9¾	8½	7¼	6¼
400	320	Agfapan 400	9½	7¾	6½	5¼
160	125	Ilford FP-4	7¼	5½	4	3
400	320	Ilford HP-4	8¾	7	5½	4½

ELECTRONIC FLASH

Negatives exposed by electronic flash units having a duration shorter than 1/2000th second, will require from 25% to 50% increase in developing time. Most of the popular flash units **do not** fall in this category and developing times will remain unchanged.

The exposure index and developing times recommended in the above charts, are based upon tests conducted in our laboratories. A small tolerance must be allowed to compensate for the many variables involved; i.e., thermometers, water supply, exposure meters, agitation and shutter speeds.

If any questions or problems arise, please write the Technical Department, Ethol Chemicals, Inc.

ETHOL T E C COMPENSATING DEVELOPER

T E C is a compensating developer, offering maximum shadow detail, economy, developing control, and acutance. T E C is panthermic, and may safely be used at temperatures from 60 to 80 degrees F.

GENERAL INFORMATION

T E C is available as a liquid concentrate in a package of 3 1-ounce bottles and also in a 4-ounce bottle. For use it is diluted 1 part developer to 15 parts water; use once and discard. It is recommended that a temperature range of 70° to 75° F be used. T E C is also available in a 2-SOLUTION powder form. Dissolve can (A) in ½ gallon of water and Can (B) in ½ gallon of water. FOR USE: Take 1 part (A), 1 part (B) and 14 parts water, use once and discard. TWO BATH DEVELOPMENT may be used as an alternate method of processing with the 2-Solution T E C. To use this method, prepare "stock" (A) and (B) solutions in the usual way. Use two containers for developing; Kinderman, Nikor, or Plastic 2-quart juice containers with lids are excellent. Fill one with the (A) solution, the other with the (B) solution; adjust temperatures to 75° F. Place film reels into (A) and then into (B), for the recommended times, WITHOUT ANY RINSE BETWEEN. Follow with water rinse and rapid fixer. NOTE: For economy and negative control: "A" is the developing agent, which will help control your density. "B" is the activator for controlling contrast. Times may be changed in "A" or "B" or both, in order to achieve the desired control. If you desire to develop by inspection, start your inspection as you are ready to remove the film from the "A" bath.

The recommended E.I. (Exposure Index) listed in the chart may be above or below that listed by the film manufacturer, but has been determined to be the best exposure index to arrive at the optimum negative with proper development in T E C.

WATER quality is important for quality processing. It should be as pure as possible. If your water supply is not free of minerals and foreign matter, the use of bottled or distilled water is recommended.

If possible, **do not pour** solutions in and out of daylight loading tanks. Preferably, fill the tank with developer, and, in the dark, drop the loaded reel into it. Following development, lift the reel out, into the next solution. This contributes to more accurate timing and more uniform development of the negatives.

T E C is **not** a fine grain developer for HIGH SPEED films. Although high speed films will achieve maximum definition when developed in T E C, they will have more grain than if developed in a fine grain developer. There is NO film speed loss to high speed films when developed in T E C; i.e., TRI-X 35mm exposed at ASA-50 to ASA-2400 on the same strip of film, renders printable negatives from each frame.

GOOD HOUSEKEEPING

Cleanliness is a must. T E C as well as other film developers can be contaminated by foreign matter. Tanks and reels should be cleaned periodically: a toothbrush makes an excellent tool for cleaning reels. Always dry tanks and reels IMMEDIATELY after use, with a clean, lint-free towel.

STORAGE

T E C will keep almost indefinitely in its original sealed container. After opening a bottle and using part, it is recommended the remainder be placed in small, full bottles, or used within a period of 3 weeks. For **maximum** life, opened bottles should be stored in the cooling chamber of the refrigerator. Tests indicate a life beyond 6 months when stored in this manner. DO NOT USE IF DEVELOPER HAS TURNED BROWN OR REDDISH BROWN.

(continued on following page)

The Compact Photo-Lab-Index

Longer life can be expected from 2-SOLUTION T E C, because of the separation of chemicals.

AGITATION

For 35mm and 120 roll films, tanks that can be inverted during agitation are preferred. Immediately after immersing films, agitate for the first 15 sec.; then agitate 5 sec. at the end of each 30 sec. The method is 3 gentle inversions during the 5 sec., with a gentle rotation of the tank followed by putting the tank down with a gentle tap at the end of each interval to dislodge any air bubbles that may have formed. Where very deep roll film tanks are used, it is suggested reels be placed on a long wire and agitation carried out by a gentle lifting and turning of the reels during the agitation periods. **Do not** lift out of the solution.

For agitation of sheet film in hangers, agitate during the first 15 sec., then follow with agitation 5 sec. each 30 sec. thereafter. Hangers should be placed in the tank as a group, tapping the hanger bars on the top of the tank to dislodge any air bells. After the agitation period, lift hangers clear of the solution, drain 1 to 2 sec. from each of the lower corners, and replace smoothly in the tank. Repeat these cycles until development is complete. Developing in a tray or dish, with constant agitation, will reduce developing time by approximately 20%.

SHORT STOP

A short stop is NOT recommended except in cases where the temperature exceeds 75° F. If temperatures over 75° are encountered, a hardening stop bath is advised. Use 1 tsp. sodium bisulfite and 1 tsp. potassium chrome alum per qt. of water. Use once and discard. In lieu of the short stop, a brief water rinse of 20 to 30 sec. may be used, if desired.

FIXING THE FILM

Use a rapid hardening fixer. Fix for twice the clearing time. Thick emulsion or high speed films will require about ⅓ longer to fix than the slower, thin emulsion films. Do not over-fix . . . delicate half-tones will be destroyed and grain clumping will result. If your fixer is not fresh, fogged or stained film may be expected.

WASHING—DRYING

Follow the wash with a brief 30 to 60 sec. immersion in a good wetting agent; use 3 or 4 drops to a quart of DISTILLED WATER. Tap water **is not** recommended. Remove film from reel and hang by the end. Soak a viscose sponge in the wetting solution, squeeze out, and wipe down film, one side at a time. Allow film to dry in a dust-free area, and at a temperature **not in excess** of 5° higher than the final bath. Use no heat or fan.

TEMPERATURE

The importance of accurate temperature uniformity throughout the developing procedure cannot be over-emphasized. Inaccuracies in thermometers are very common, and can play havoc with negative contrast. Check your thermometer often. Keep developer, fix, wash and drying at the same temperature. Avoid high-temperature processing of high-speed films; chemical fog may result.

TIME AND TEMPERATURE TABLE

Photography is not an exact science, and variables are encountered with each photographer and his equipment. The following tables are furnished as a guide; a STARTING POINT so that you may achieve the optimum negative quality. Using a double condenser enlarger, the E.I.'s given in the table should give optimum print quality when the negatives are developed as instructed. Negatives that are to be enlarged with a diffusion type of enlarger will require about 20% longer developing times, as they require a higher gamma. There is NO SINGLE CORRECT DEVELOPING TIME to give optimum results UNDER ALL CONDITIONS.

ETHOL TEC TIME AND TEMPERATURE TABLE

E.I. USED FOR DILUTION DISCARD METHOD			DEVELOPING TIME IN MINUTES FOR DILUTION DISCARD METHOD				E.I. USED FOR TWO-SOLUTION METHOD		TIME IN MINUTES FOR TWO-SOLUTION METHOD AT 75°	
Daylight	Tungsten	35mm Films	65°	70°	75°	80°	Day.	Tung.	"A"	"B"
500	400	GAF 500	24½	18	13½	10¼	640	500	5	4
200	160	GAF 125	8¼	7	6	5¼	200	160	2¾	4
1000	800	†Fuji Neopan SSS	32	26	21½	17½	*—	—	—	—
800	640	†Fuji Neopan SSS	26½	22	18¾	15¾	*—	—	—	—
		Sheet Films								
400	400	Kodak Tri-X Pan	11	9¾	8½	7½	320	320	2	2
200	160	Kodak Plus-X	9	8	7	6¼	200	160	3	2½
100	80	Kodak Ektapan	16¾	14¼	12	10¼	*—	—	—	—
400	320	GAF Prof. Type 2860	16	13	10¾	9	400	320	1	1½
160	125	GAF Prof. Type 2831	14½	12½	10½	9	160	125	1	2
400	400	GAF Prof. Type 2863	23	19	16	13¼	*—	—	—	—
500	400	Agfapan 400	27½	21½	16¾	13¼	*—	—	—	—
25	20	Agfapan 25	11¾	10	8¾	7½	*—	—	—	—

*(Data not available at this time.)

NOTE: • The liquid ready-mix TEC is diluted 1:15 for use.
 • The 2-SOLUTION TEC, as per instructions under GENERAL INFORMATION.
 • Shake "A" and "B" "stock" solution before use.
 • The above tables apply to ALL TEC packings.
 # Omit "B" solution unless you wish to obtain added contrast.
 † Different E.I. using different developing times.

MISCELLANEOUS MANUFACTURERS

ETHOL TEC TIME AND TEMPERATURE TABLE

E.I. USED FOR DILUTION DISCARD METHOD		35mm Films	DEVELOPING TIME IN MINUTES FOR DILUTION DISCARD METHOD				E.I. USED FOR TWO-SOLUTION METHOD		TIME IN MINUTES FOR TWO-SOLUTION METHOD AT 75°	
Daylight	Tungsten		65°	70°	75°	80°	Day.	Tung.	"A"	"B"
1000	800	Kodak Tri-X Pan	16	12	9½	7¼	1200	1000	4	3
320	250	Kodak Plus-X Pan	7	6¾	6¼	6	160	125	2	2
80	64	Kodak Panatomic-X	6¼	5½	4¾	4½	80	64	1½	1
8	6	Kodak High Contrast Copy (Diluted 1:30)	5¼	5	4¾	4½	8	6	3¾	#
1000	800	Ilford HP-4	16½	15	13¾	12½	*—	—	—	—
320	250	Ilford FP-4	11¼	10	8¾	7¾	*—	—	—	—
64	50	Ilford Pan-F	7½	6½	5½	4¾	100	80	2¼	2
500	400	GAF 500	16¼	14	12½	11	800	640	5	3¾
320	250	GAF Prof. Type 2681	8¾	8¼	7¾	7¼	*—	—	—	—
250	200	GAF 125	9¾	8¾	7¾	7	320	250	2	3
1000	800	Fuji Neopan SSS	24	21	18¼	16	*—	—	—	—
80	64	VTE Pan (diluted 1:30)	—	10	—	9	*—	—	—	—
		120 Roll Films								
800	800	Kodak Tri-X Pan	15	13	11	9½	640	640	4	3
400	320	Kodak Tri-X Pan Prof.	17	14½	11½	9½	400	320	2½	2
160	125	Kodak Plus-X Pan	10	7¾	6	4½	250	200	2	2
80	64	Kodak Panatomic-X	7¾	6	4¾	3¾	100	80	2¼	2¾
1000	800	Ilford HP-4	23	18½	14½	12¼	*—	—	—	—
250	200	Ilford FP-4	7½	6½	5¾	5	*—	—	—	—

"ETHOL BLUE—HIGH PERFORMANCE DEVELOPER"

DESCRIPTION

Ethol BLUE is a ·new concept in film development, highly concentrated for the dilution and one-time-use method of processing. It is panthermic and may be safely used at temperatures from 65 to 90 degrees F.; preference is limited to the range of 65 to 80 degrees F.

GENERAL INFORMATION

Ethol BLUE provdes high, effective film speeds, a maximum of shadow detail, high acutance, medium fine grain, processing control, ease of use and economy. It is ideally suited to the requirements of the photojournalists and the available light photographer.

BLUE is available in a (1) pint and 4 oz. liquid concentrate. It is normally diluted 1:30 for use, but for extended processing control or for special applications, it may be diluted upwards to 1:120.

The recommended E.I. (Exposure Index) listed in chart below may be con-considerably above that listed by the film manufacturer, but has been determined to be the best exposure index for a negative of optimum quality with proper development in Ethol BLUE.

Because Ethol BLUE has such great latitude, there are, in some cases, more than one index listed for certain films. Where this has been done, the asterisk (*) will indicate the optimum index for that film.

If possible, do not pour solutions in and out of daylight loading tanks. Preferably, fill the tank with developer and, in the dark, drop the loaded reel into it. Following development, lift the reel out, into the next solution. This contributes to more accurate timing and more uniform development of negatives.

DILUTION

Where longer developing times are desirable, or greater contrast control is needed, then extended dilution upwards to 1:120 is suggested; discard immediately after one-time-use. Do not be alarmed if any crystalization occurs in the "stock" developer. **Simply place bottle in hot water, shaking occasionally, until crystals dissolve.**

STORAGE

Ethol BLUE has extremely long shelf life in its "stock" solution form. Do not dilute "stock" until ready to use. Simply store bottle at room temperature. Do not refrigerate. Ethol BLUE will last well over one year if kept tightly ·stoppered in its original bottle. Occasionally the stock solution will darken to a brown or a black color. This is due to peculiarities in certain raw materials and does not indicate that the developer is exhausted. Continue to use as recommended.

(continued on following page)

The Compact Photo-Lab-Index

AGITATION

For 35mm and 120 roll films, tanks that can be inverted during agitation are preferred. Immediately after immersing the films, agitate for the first 15 sec.; then agitate 5 sec. at the end of each 30 sec. The method is 3 gentle inversions with a gentle rotation—during the 5 seconds every 30 seconds, followed by putting the tank down with a gentle tap at the end of each 5-second agitation period, to dislodge any air bubbles that may have formed. This method of agitation is advised for even development of the films and consistently reproducible results. If you are getting consistent negatives, but the developing times in the tables are too short for your purposes, then do not change your agitation, but instead change the developing times—based upon your dilution or the need of more or less contrast. Where deep roll film tanks are used, it is suggested reels be placed on a long wire and the agitation be carried out by a gentle lifting and turning of the reels during the agitation periods. Do not lift reels out of the solution.

SHORT STOP

An acid short stop is not recommended. Instead of an acid stop-bath, a brief rinse of 20-30 seconds in plain water may be used. If temperatures of over 75°F. are encountered, a hardening stop-bath of 1 tsp. sodium bisulfite and 1 tsp. of potassium chrome alum in a quart of water is recommended. Use once and discard.

FIXING THE FILM

Use a rapid hardening fixer and fix for twice the clearing time. DON'T over-fix—delicate half-tones will be lost and grain clumping will result. If fixer isn't fresh, it is possible film may be fogged or stained.

WASHING-DRYING

Wash films in a rapid washer, such as the Miller Hurricane film washer. Follow the wash with a brief 30- to 60-second immersion in a good wetting agent; remove film from reel and hang up by the end. Soak a photo viscose sponge in the wetting solution, squeeze out, and wipe gently down film, one side at a time. Allow film to dry in a dust-free area and at a temperature as close as possible to the processing temperature that was used; use no heat.

TEMPERATURE

The importance of accurate temperature uniformity throughout the developing procedure cannot be over-emphasized. Inaccuracies in thermometers are very common, and can play havoc with negative contrast. Check your thermometer often. Keep developer, fix, wash and drying at the same temperature. Avoid high temperature processing of high speed films, if possible; chemical fog may result.

TIME AND TEMPERATURE TABLE

Photography is not an exact science, and variables are encountered with each photographer and his equipment. The following tables are furnished as a guide; a STARTING POINT so that you may achieve the optimum negative quality. Using a double condenser enlarger, the E.I.'s given in the table should give optimum print quality when the negatives are developed as instructed. Negatives that are to be enlarged with a semi-diffusion or diffusion type of enlarger will require about 20% to 30% longer developing times respectively, as they require a negative to be developed to a higher contrast index for ease of printing. There is NO SINGLE CORRECT DEVELOPING TIME to give optimum results UNDER ALL CONDITIONS.

(continued on following page)

MISCELLANEOUS MANUFACTURERS

ETHOL BLUE

TIME AND TEMPERATURE CHART

EXPOSURE INDEX				NORMAL DEVELOPING TIME IN MINUTES				
Daylight	Tungsten	35mm Films	DILUTION	65°	70°	75°	80°	
2400	2000	Kodak 2475	1:30	12¾	10	8	6¼	
2400	2000	Kodak Tri-X	1:30	8¼	6¾	5½	4½	
2000	1600	*Kodak Tri-X	1:30	7¾	6	4¾	3¾	
1600	1280	Kodak Tri-X	1:30	7½	5¼	3¾	2¾	
400	400	Kodak Tri-X	1:60	6	5½	5	4¾	
500	400	Kodak Plus-X		4½	3½	2¾	2	
500	400	Kodak Plus-XX	1:60	7¼	6	5	4	
400	320	Kodak Plus-X	1:30	3½	2¾	2	1½	
125	100	Kodak Panatomic-X	1:60	7	5½	4¼	3¼	
64	50	*Kodak Panatomic-X	1:60	4½	3¾	3	2½	
80	64	Kodak Panatomic-X	1:120	8	7	6	5¼	
10	8	Kodak High Cont. Copy	1:120	—	6	—	—	
320	250	Ilford FP-4	1:30	3¾	3	2½	2	
320	250	Ilford FP-4	1:60	7	6	5	4¼	
1600	1200	Ilford HP-4	1:30	11	8	5½	4	
1200	1000	*Ilford HP-4	1:30	8¼	6½	5	3¾	
80	64	Ilford Pan-F	1:60	5¼	4½	3¾	3¼	
320	250	GAF 125	1:30	7	5½	4½	3½	
1000	800	GAF 500	1:30	8½	7	5¾	4¾	
1200	1000	*Fuji Neopan SSS	1:30	9½	7½	6	4¾	
640	500	Fuji Neopan SSS	1:30	6¼	5	4	3	
250	200	Lumipan	1:60	—	5¼	—	—	
800	640	Imperiale S Pan	1:30	—	5	—	—	
32	25	VTE Pan	1:90	6¼	5½	4¾	4¼	

*Different EI using different developing times.

(continued on following page)

MISCELLANEOUS MANUFACTURERS

ETHOL BLUE

TIME AND TEMPERATURE CHART

EXPOSURE INDEX				NORMAL DEVELOPING TIME IN MINUTES			
Daylight	Tungsten	120 Films	DILUTION	65°	70°	75°	80°
1000	800	*Kodak Tri-X	1:30	5¾	4½	3¾	3
1600	1200	Kodak Tri-X	1:30	6¼	5	4	3¼
32	25	Kodak Panatomic-X	1:60	4¼	3¼	2¾	2
200	160	Kodak Verichrome Pan	1:60	6½	5	3¾	3
320	250	Kodak Plus-X	1:30	3½	2¾	2	1½
1200	1000	Kodak Royal-X Pan Imp.	1:30	9	7¼	5¾	4¾
800	640	Fuji Neopan SSS	1:30	9¼	6½	4¾	3½
160	125	Ilford FP-4	1:30	3	2½	2¼	1¾
1000	800	Ilford HP-4	1:30	7¼	6	5	4
800	640	*GAF 500	1:30	10¾	8	6	4½
1000	800	GAF 500	1:30	13½	10	7½	5½
250	200	GAF 125	1:30	6½	5¼	4¼	3¼

4 x 5 Sheet Film

Daylight	Tungsten	Film	DILUTION	65°	70°	75°	80°
500	400	Kodak Tri-X Pan Prof.	1:30	6¾	5½	4¼	3½
160	125	Kodak Plus-X Pan Prof.	1:60	7¾	7	6¼	5¾
2000	1600	Kodak Royal-X Pan Imp.	1:30	12	9¾	8	6½
640	500	Kodak Royal Pan	1:30	7¼	6	5	4¼
125	100	Kodak Ektapan	1:60	8½	6¾	5¼	4
200	160	Ilford FP-4	1:60	7¾	6¾	6	5
500	400	Ilford HP-4	1:30	7	6	5	4¼
800	640	GAF Prof. Type 2863		8½	7¼	6	5

*Different EI using different developing times.

MISCELLANEOUS MANUFACTURERS

ETHOL 90 DEVELOPER

DESCRIPTION

Ethol 90 is a fine-grain, normal contrast, long-scale, very rapid working developer. It is used in an extremely broad range of general and scientific photographic applications, including press, industrial and commercial photography, available light, macrophotography, electron microscopy, holography, x-ray, cineflure, cardiology, and in automatic processing of motion-picture negative and positive films.

GENERAL

No special equipment or procedures are required. Ethol 90 is available in both powder and liquid form. It also has its own replenisher, both powder and liquid. The liquid 90 is a ready-to-use working solution. Simply bring the liquid to the required temperature and process. The powder form is dissolved in ¾ths the final volume of water at 80°—100°F. Then add cold water to make up the balance.

USE

Normal development times for most films, exposed at double their ASA rating, is 90 seconds at 70°F. with CONSTANT GENTLE AGITATION. If development is extended to about 6 minutes the ASA rating for slow films may be increased to 3X, and for fast films up to 6X. If impractical to hold temperature at 70°F., follow the chart below. Times may be changed to meet individual contrast and density requirements.

Degrees, F.	60	65	70	75	80	85	90	95	100
Time, Seconds	180	120	90	60	50	40	30	25	20

If you prefer longer developing time, this is accomplished by diluting 1 part of Ethol 90 to 10 parts water, or 1 part to 20 parts water. This will give slightly increased film speed, as well as slightly finer grain. For slower, thin-emulsion films, the dilution method is recommended. Used in this manner, 90 becomes a one-time developer, and must be discarded after use. Do not use developer in which film has been processed, or to which replenisher has been added, for the dilution method.

REPLENISHER

For more stable life, and constant results, Ethol 90 replenisher is recommended, when using 90 stock developer. As a starting point, use ½ oz. Ethol 90 replenisher for each 80 sq. in. of film processed (1 roll 35mm, 36 exp., roll 120 films).

TIME AND TEMPERATURE TABLES

There is no EXACT DEVELOPING TIME to give optimum results UNDER ALL CONDITIONS and since Ethol 90 is so broad in scope, no attempt is made to give a table covering all films. Below are a few of the most popular films, which should give a starting point, a guide to cotninue with tests on films other than those indicated herein.

(continued on following page)

MISCELLANEOUS MANUFACTURERS

The Compact Photo-Lab-Index

ETHOL 90

EXP. INDEX	FILM	DILUTION	AGITATION	TIME, MIN., 70°F.
400	Tri-X	Full Str.	Normal	1½
800	Tri-X	Full Str.	Constant	1½
1600	Tri-X	Full Str.	Normal	6
500	Tri-X	1:10	Normal	6
800	Tri-X	1:10	Constant	6
1000	Tri-X	1:10	Normal	6½
2000	Tri-X	1:10	Normal	9
50	Panatomic-X	1:20	Normal	5¼
80	Panatomic-X	1:20	Constant	5¼
250	Plus-X	1:20	Normal	5½
320	Plus-X	1:20	Constant	5½

64-80 HIGH-CONTRASTY COPY Full Str. Normal 4¼ (for line copy work)

Since Ethol 90 has a degree of compensating action, push processing will give but a minimum increase in grain, and will not block highlights while the developer continues to work in the shadow areas.

CINEFLURE FILM

In processing of cineflure films, Ethol will give **better contrast.** The film base is extremely clear, compared to films processed in other developers.

Radiation factors may be reduced by 50% or more. (Reduce KV by 10, or reduce milli-amperage by 50%). The 50% factor is conservative. If development is extended to about 6 min. at 70°F., the ASA rating of slow films may be increased by 3X and fast films to 8X. Normal x-ray fixers may be used. Aside from lower radiation levels, improved contrast, and a clearer film base, Ethol 90 gives a lower tube load and, therefore, longer life. Low-gain, borderline image tubes may still be usable and life extended; less radiation to the doctor and the patient, and fewer repeat examinations.

Below is a brief table which should give processors of Cineflure, and other films, an adequate starting point on which to base their individual tests.

FILM	MACHINE		DEV. TIME	TEMP.	
DOUBLE-X	Fisher-Processall	25' per min.	48 sec.	85° F.	(1)
DOUBLE-X	Fisher-Processall	5½' per min.		75° F.	
CINEFLURE	Fisher-Processall	4' per min.	88-90 sec.	75° F.	
CINEFLURE	Fisher-Processall	4' per min.	1½ min.	84° F.	
CINEFLURE	Picker-Smith (with Nitrogen-burst agitation)	2' per min.	3 min.	68° F.	(2)
EK Fine Grain Positive	Houston Fearless (with circulating pump agitation)	3' per min.	3 min.	75° F.	(2)

(1) Replenishment rate 63—72 ml per min.
(2) Dryer temperature at 120° F.

(continued on following page)

690

The Compact Photo-Lab-Index

ELECTRON MICROSCOPY

In using Ethol 90 for processing of plates and films for electron microscopy, you will find that you obtain superior contrast along with much shorter developing time (2 min. to 6 min. at 70° F.) than that obtained with other developers. To get higher acutance and contrast, you may use constant agitation.

To retain normal contrast, use one-half oz. Ethol 90 Replenisher for each 80 sq. in. of film processed. If you desire more contrast in your negatives, you may use more replenisher, up to an amount which will maintain the original volume of developer.

As previously stated, Ethol 90 will not block highlights, and will give excellent shadow detail.

To obtain superior clarity, sharpest detail, and highest resolution for extreme enlargements, use Ethol 90 for negative processing and a point light source enlarger for printing.

ETHOL LPD DEVELOPER
For all Printing Papers, Lantern Slides, Press Negatives and Microfilms
DESCRIPTION

LPD is a simple, easy to use paper developer that offers long life, economy and tone control. It gives brilliant blacks, the pure sparkling whites, and has a capacity to maintain quality for many prints. It is non-staining and free from tendency to irritate skin.

LPD is a paper developer available either as a powder or liquid. It is a non-staining developer that gives brilliant prints with rich blacks and clean whites. It is a long scale, neutral tone, normal contrast developer with a good developing capacity that may be used in the usual dilute-discard method, or may be replenished.

LPD offers great print capacity, i.e., a tray of ½ gallon of working solution will process a minimum of 360 8x10 single weight prints, when properly replenished. Uniform quality and tone is maintained throughout the useful life of the developer. Replenishment according to directions will allow extended use of the developer making it unnecessary to discard if only a few prints have been made.

LPD may be used with all types of printing papers. Tones may be varied from cold to warm by selection of the paper, and by varying the dilution of the stock solution.

It can also be used for processing projector slides, press negatives and microfilms.

LPD does not stain and irritate the skin, as is characteristic of so many developers. Most developers contain Metol, which is a toxic developing agent. LPD contains no Metol. Instead, Phenidone® has been used. This developing agent is non-toxic and has made it possible for many photographers to return to the lab without fear of skin problems.

LPD contains Hydroquinone, which is a regenerating chemical that acts very rapidly on the Phenidone.® When LPD is used as directed, full strength of the solution is maintained until all the working and replenishment solution has been used.

LPD is versatile, and it may be used with all types of printing papers. Tones may be varied from the very cold to very warm just by selection of the paper and the dilution of the "stock" developer.

LPD developer may also be used for the processing of lantern slides, press negatives, and microfilms.

MIXING

LPD is a single-mix powder which dissolves easily in tap water at 80 to 100 degrees F. The contents of the can should be dissolved in ¾ the final volume of water, and then cold water added to bring the solution up to the indicated amount. This becomes the "STOCK" solution. When diluting the developer, be

(continued on following page)

691

sure to stir well to obtain a more uniform solution. LPD Liquid Concentrate in 1 qt. and 5 gallon sizes are also available and should be mixed as per directions on the container.

NORMAL USE

To make a working solution, dilute the stock solution 1:2 with water, and develop the prints for 1½ to 2 minutes at 70 degrees F. This dilution will produce a neutral tone.

TONE CONTROL

LPD offers the unique ability of print tone control. Where most developers change in contrast as they are diluted, LPD maintains a uniform contrast, but changes tone. i.e., a dilution of 1:4 produces warm tones; 1:2 neutral tones; and 1:1, or full strength, produces the colder tones.

Very wide tone latitude is obtained by the choice of paper, coupled with the appropriate dilution of the developer. Fast bromide papers will give a very blue-black tone, while the chloro-bromide papers would naturally produce warmer tones. Prints should be exposed sufficiently to give good blacks. LPD does not sacrifice emulsion speed, so the normal exposure should be correct.

SHORT STOP AND FIX

Even though LPD has a minimum tendency to stain, it is advisable to use a short stop. Any regular stop-bath may be used and any of the fixers; however, if a rapid-fix is used, care should be taken not to leave the prints in too long, or bleaching will result and tones will be sacrificed.

TO REPLENISH

After printing 15 8 x 10 prints in tray containing 1 quart of solution, replenish with 5 oz. of replenisher; after 30 prints in tray using ½ gallon of solution, replenish with 10 oz. of replenisher; after 60 prints in tray containing 1 gallon of solution, replenish with 20 oz. replenisher.

WHEN DONE WITH PRINT SESSION

1. Pour solution remaining in tray back into working solution bottle.
2. Replace depleted portion from replenisher bottle.
CONTINUE UNTIL ALL REPLENISHER HAS BEEN USED, THEN START PROCEDURE WITH FRESH SOLUTIONS.

NOTE

The above proportions apply to single weight paper, 8 x 10 size. For those who wish to use this system with double weight papers, you may compute that each 8 x 10 double weight paper uses approximately ½ ounce of developer.

Do not attempt to print 70 or 80 prints before replenishing. Replenish as indicated above. This will assure you that your solution is at full strength, for as explained previously, a Phenidone® developer regenerates quickly.

For those who prefer a more contrasty type of solution or for those who use continuous automatic machines, or for those who wish to hold working time to a minimum, make working solution by diluting stock solution 1:1. For this purpose, use straight stock solution as your replenisher.

FOR SOFTER PRINTS

Make solution on a 1 to 4 basis and replenish as follows. Make the original stock solution. Remove ⅕ of this into another bottle and fill with water to make your working solution. Now take the first bottle which still has ⅘ of the solution remaining and split into 2 bottles containing equal amounts of solution and fill these two bottles with water. You now have 2 bottles of replenisher from which you may replenish on the same basis as the above.

INFORMATION FOR THE NEW PLUS-X FILM AS APPLIED TO ETHOL UFG, TEC, 2 SOLUTION TEC & BLUE

DEVELOPER	DILUTION	FORMAT	E.I. DAY/TUNG	FILM	65°	70°	75°	80°
UFG	—	35mm	1200/1000	Kodak Tri-X	6½	5¼	4¼	3½
UFG	—	35mm	320/250	Kodak Plus-X	4¾	4	3½	3
UFG	—	120mm	320/250	Kodak Plus-X Pan	6¾	5	3¾	2¾
UFG	—	120mm	125/125	Kodak Plus-X Pan	2¾	2¼	2	1½
TEC	1:15	35mm	400/320	Kodak Plus-X	15	12	9¾	7¾
TEC	1:15	120mm	320/250	Kodak Plus-X Pan	11	9	7¼	6
TEC	1:45	35mm	25/20	VTE Ultra	23½	20	17	14½
TEC	1:45	120mm	50/50	VTE Pan	—	13	—	—
TEC	1:30	35mm	80/80	** Kodak Photomicrography Monochrome Film	—	7	—	—
2 SOL TEC	—	35mm	5000	Kodak 2475		7-A; 6-B @ 75°		
2 SOL TEC	—	35mm	500/400	Kodak Plus-X		3-A; 3-B @ 75°		
2 SOL TEC	—	120mm	400/320	Kodak Plus-X Pan		3-A; 3-B @ 75°		
2 SOL TEC	—	35mm	1200/1000	Ilford HP-4		5-A; 4-B @ 75°		
2 SOL TEC	—	120mm	1000/800	Ilford HP-4		5-A; 4-B @ 75°		
2 SOL TEC	—	35mm	320/250	Ilford FP-4		3½-A; 3-B @ 75°		
2 SOL TEC	—	120mm	400/320	Ilford FP-4		3-A; 3-B @ 75°		
BLUE	1:30	35mm	400/320	* Kodak Plus-X	3¾	3	2½	2¼
BLUE	1:60	35mm	400/320	Kodak Plus-X	6	5	4¼	3½
BLUE	1:30	120mm	320/250	* Kodak Plus-X Pan	4½	3½	2¾	2¼
BLUE	1:60	120mm	320/250	* Kodak Plus-X Pan	8¼	6½	5	4
BLUE	1:60	120mm	125/125	Kodak Plus-X Pan	5	4	3¼	2¾

*Optimum index and/or dilution.
**For general photography (continuous tone).

MISCELLANEOUS MANUFACTURERS

693

The Compact Photo-Lab-Index

The following table is a guide for exposure and development under different brightness ranges.

	Brightness Range (approx.)	Exposure	Stops	Development Factor
Misty Landscapes	1:10	⅓ X	Under 1½	2X or 100% Over
Distant Views	1:20	⅓ X	Under 1½	1.5X or 50% Over
Street Scenes (diffuse Light)	1:40	½ X	Under 1	1.2X or 20% Over
Summer Landscapes	1:100	Normal	Normal	Normal
Back Light (Natural)	1:250	2X	Over 1	.8X or 20% Decrease
Interiors	1:500	4X	Over 2	.7X or 30% Decrease
Exteriors (Sun)	1:1000	6X	Over 2½	.6X or 40% Decrease

Note: Increase or decrease in development factor applies to optimum development times as listed in Ethol film development charts.

ACUFINE INC.
ACUFINE FILM DEVELOPER

Acufine is a maximum acutance, ultra-fine-grain film developer, combining optimum quality, with the highest **effective** speeds currently available with single solution developers. It is a modern developer formulated for modern emulsions, and fully exploits the inherent capabilities of any film. Acufine's higher speed ratings permit the use of slower films, with superior resolving power and finer grain in situations that previously required high-speed films.

PREPARATION

Acufine Film Developer is packaged in single-mix dry powder form, readily soluble in water. (70° to 90°F.) Although the water in most areas is suitable, the use of distilled water is recommended wherever the mineral content or alkalinity is high. Acufine, either dry or in solution, may assume a slight coloration which will in no way affect its chemical properties.

STORAGE

Acufine Film Developer, in solution, will retain its full strength for approximately one year if normal precautions are taken against contamination and oxidation. All storage and processing equipment must be clean. If deposits of previously-used chemicals remain on any items of equipment, these should be soaked overnight in a solution of approximately one ounce of sodium sulfite per gallon of water, and then thoroughly rinsed. To minimize oxidation, Acufine Film Developer should be stored in full, tightly-capped, amber glass or polyethylene bottles. When stored in open tanks, floating lids should be used.

RECOMMENDED EXPOSURE INDICES

The high film speed ratings listed on the chart are in every sense the normal exposure indices for Acufine. It cannot be overemphasized that the recommended exposure development values are calculated for optimum quality negatives, and are not the result of "pushing." At the recommended speeds and developing times, Acufine works best. . . . To alter the speed rating and/or developing times will result in negatives of less than Acufine's optimum quality.

A single index is given for each film since the color sensitivity of most modern exposure meters eliminates the need of separate tungsten ratings.

DEVELOPING TIMES

The developing times will produce negatives of ideal contrast for printing in modern condenser enlargers. For cold-light and diffusion-type enlargers, development may be increased by 25%. Contrast may be increased or decreased to meet the individual's requirements by varying developing times ±25% from normal. Extreme variations from the chart recommendations will affect quality and film speed.

Whenever the conditions require higher than normal Acufine ratings, medium and high speed emulsions may be "pushed" in Acufine to produce the maximum possible speeds, but at some sacrifice in quality. The maximum gain of 2X to 3X the recommended indices is achieved at approximately double the developing time. With slow films, the speed gained by force development is negligible.

(continued on following page)

695

AGITATION

The developing times listed on the chart are based on **gentle** agitation for the first ten seconds after immersion, followed by **gentle** agitation for five seconds every minute. Excessive or vigorous agitation is to be avoided since it results in greatly increased contrast, with little or no speed gain. Less than recommended agitation promotes the possibility of irregular development, low contrast, and loss of speed. Constant agitation cannot be compensated for by decreasing development.

REPLENISHMENT

Acufine Replenisher is strongly recommended for maintaining consistency in quality and developing time. Replenisher should be added and thoroughly stirred into the developer at the end of each processing cycle. Average replenishment is at the rate of ½ fl. oz. per 80 square inches of film. (1 roll of 36 exposure 35mm, or 1 roll of 120/620, or four 4 x 5 sheets.) Replenishment may be continued until a volume equal to the original amount of developer has been added. Without replenishment, four rolls may be developed at normal times. Increase the developing time by 2% for each additional roll. Develop no more than 16 rolls per quart in this manner.

ONE TIME USE

If longer developing times are desired for more convenient control, Acufine Film Developer may be used as a diluted preparation with no change in either film speed or quality. The following chart gives the time factors for the recommended dilutions.

Recommended Dilution Ratio:	Development Increase
1 part Developer to 1 part water	2X
1 part Developer to 3 parts water	4X

Diluted developer must be used only once, immediately after preparation, and then discarded.

RECIPROCITY FAILURE

Reciprocity failure is the speed loss incurred by all photographic emulsions with exposures of extremely short or long duration. This effect is unnoticed with most popular electronic flash units, but if the flash duration is 1/2000th of a second or faster, development should be increased by 25%. Reciprocity failure also becomes noticeable with exposures of approximately 10 seconds and becomes more pronounced with increased times. The exposure compensation necessary for these conditions varies with each type of film, but for most practical applications, exposures of 2X to 4X the calculated time should be used.

ACUFINE FILM DEVELOPER

35mm FILMS	ASA	65F	68F	70F	75F	80F	85F
Kodak Tri-X	1200	6	5¼	4¾	3¾	3	2¼
Kodak Plus-X	320	5	4½	4	3¼	2½	2
Kodak Panatomic-X	100	2½	2¼	2	1¾	1¼	1
Kodak 2475 Recording	3200	8¾	7¾	7	5½	4½	1½
Infrared Tungsten	40	8¾	—	7	5½	4½	3½
Agfa Agfapan 1000	2400	10	—	8	6¼	5	4
Agfa Isopan U	500	5¾	—	4½	3½	2¾	2¼
Agfa Isopan SS	200	4¼	—	3½	2¾	2¼	1¾
Agfa Agfapan 100	320	8¾	7¾	7	5½	4½	3½

(continued on following page)

696

ACUFINE FILM DEVELOPER (Continued)

35mm FILMS	ASA	65F	68F	70F	75F	80F	85F
Agfa Agfapan 400	800	8¾	7¾	7	5½	4½	3½
Agfa Isopan Record	1000	8¾	7¾	7	5½	4½	3½
Agfa Isopan F	125	3¾	3¼	3	2¼	1¾	1½
Agfa Isopan FF	64	2½	2¼	2	1¾	1¼	1
Ilford FP 4	200	5	4½	4	3¼	2½	2
Ilford HP 4	1600	10	8¾	8	6¼	5	4
Ilford Pan F	64	2½	2¼	2	1¾	1¼	1
Ansco Super Hypan	1000	8¾	7¾	7	5½	4½	3½
Ansco Versapan	250	4¾	4¼	3¾	3	2¼	1¾
Sakura Konipan SSS	1000	8¾	—	7	5½	4½	3½
Sakura Konipan SS	400	8¾	—	7	5½	4½	3½
Fuji Neopan SSS	1000	6	—	4¾	3¾	3	2¼
Fuji Neopan SS	400	7½	—	6	4¾	3¾	3

SHEET FILMS	ASA	65F	68F	70F	75F	80F	85F
Kodak Super Pan Portrait	320	12½	—	10	8	6½	5
Kodak Plus-X Pan	320	10	8¾	8	6¼	5	4
Kodak Super-XX	500	12½	11	10	8	6½	5
Kodak Tri-X	800	6¼	5½	5	4	3¼	2½
Kodak Panatomic-X	80	6¼	5½	5	4	3¼	2½
Kodak Tri-X Pack	800	10	8¾	8	6¼	5	4
Kodak Royal-X Pan	3000	15	13	12	9½	7½	6
Kodak Royal Pan	1000	10	8¾	8	6¼	5	4
Kodak Super Panchro Press B	320	10	8¾	8	6¼	5	4
Kodak LS Pan	100	5¾	5	4½	3½	2¾	2¼
Kodak RS Pan	800	17½	—	14	11	9	7
Dupont Cronar XF Pan	125	7½	—	6	4¾	3¾	3
Dupont Cronar High Speed Pan	400	10	—	8	6¼	5	4
Dupont Cronar Arrow Pan	400	15	—	12	9½	7½	6
Dupont Cronar Press	600	15	—	12	9½	7½	6
Gevapan 30	125	7½	—	6	4¾	3¾	3
Gevapan 33	320	10	—	8	6¼	5	4
Gevapan 36	600	15	—	12	9½	7½	6
Ilford Special Portrait 124	200	7½	—	6	4¾	3¾	3
Ilford FP 3	320	10	—	8	6¼	5	4
Ilford HP 3	800	10	—	8	6¼	5	4
Ilford HP 3 Matte	800	10	—	8	6¼	5	4
Ilford HP 4	1000	15¾	—	12½	10	8	6½
Agfa IP 21	200	14	—	11¼	9	7¼	5¾
Agfa IP 21 Matte	200	14	—	11¼	9	7¼	5¾
Agfa IP 24 Matte	400	8¾	—	7	5½	4½	3½
Ansco Finopan	200	10	—	8	6¼	5	4
Ansco Superpan	500	11	—	8¾	7	5¾	4½

(continued on following page)

ACUFINE FILM DEVELOPER (Continued)

120/620/127 FILMS	ASA	65F	68F	70F	75F	80F	85F
Kodak Tri-X Professional	800	7½	6½	6	4¾	3¾	3
Kodak Tri-X	1200	7½	6½	6	4¾	3¾	3
Kodak Plus-X	320	5	4½	4	3¼	2½	2
Kodak Verichrome Pan	250	5¾	5	4½	3½	2¾	2¼
Kodak Panatomic-X	100	5¾	5	4½	3½	2¾	2¼
Kodak Type 2475 Recording	3200	8¾	—	7	5½	4½	3½
Agfa Pro 100	320	12½	11	10	8	6½	5
Agfa Pro 400	800	12½	11	10	8	6½	5
Agfa Isopan Record	1000	8¾	7¾	7	5½	4½	3½
Agfa Isopan F	125	4¼	3¾	3½	2¾	2¼	1¾
Agfa Isopan FF	64	3¾	3¼	3	2¼	1¾	1½
Agfa Isopan SS	200	5¾	—	4½	3½	2¾	2¼
Agfa Isopan U	500	5¾	—	4½	3½	2¾	2¼
Ansco Super Hypan	1000	10	8¾	8	6¼	5	4
Ansco Versapan	250	7½	6½	6	4¾	3¾	3
Ilford FP 4	200	7½	6½	6	4¾	3¾	3
Ilford HP 4	1600	12½	11	10	8	6½	5

AUTOFINE DEVELOPER
AUTOFINE FILM DEVELOPER

Autofine is a long-scale, ultra-fine-grain, maximum acutance film developer formulated for use with all films at **manufacturer-rated film speeds.** It is a modern developer for modern emulsions and fully exploits the optimum quality inherent in any given film. It is a developer which has great latitude, extremely low fogging tendencies, and free of contamination.

AUTOMATIC PROCESSING

Autofine has been created with a specific eye to the needs of photofinishers with automatic processing equipment. The time-temperature chart will indicate that a developing time of 7 minutes at 70° will process all widely-used films to produce negatives of almost ideal contrast.

PREPARATION

Autofine is packaged in single-mix dry powder form, readily soluble in water (80° to 90°F). Although the water in most areas is suitable, the use of distilled water is recommended wherever the mineral content or alkalinity is high. Autofine, dry or in solution, may assume a slight coloration that in no way will affect its chemical properties.

STORAGE

Autofine Film Developer, in solution, will retain its full strength for approximately one year if normal precautions are taken against contamination and oxidation. All storage and processing equipment must be clean. If deposits of previously used chemicals remain on any items of equipment, the equipment should be soaked overnight in a solution of approximately one ounce of sodium sulfite per gallon of water, then thoroughly rinsed. To minimize oxidation, Autofine should be stored in full, tightly-capped bottles of polyethylene or amber glass.

(continued on following page)

AUTOFINE DEVELOPER (Continued)

RECOMMENDED EXPOSURE INDICES

The speed ratings listed on the chart are the normal ASA exposure indices recommended by the film manufacturers. These indices contain a "safety factor" which allows for some variation in film speeds. Individual preferences in negatives may vary and alteration of the ASA values where desired is recommended. Although noticeable speed gain may be obtained by extending developing times, it is not recommended because of the risk of increased grain and contrast. Where high speed and optimum quality are desired Acufine and Diafine film developers are preferred.

DEVELOPING TIMES

The developing times will produce negatives of ideal contrast for printing in modern condenser enlargers. For cold light and diffusion type enlargers, development may be increased by 25%. Contrast may be increased or decreased to meet individual requirements by varying developing times ±25% from normal. Extreme variations from the chart recommendations will affect quality and film speed.

AGITATION

The developing times listed on this chart are based on **gentle agitation** for the first 10 seconds after immersion, followed by **gentle agitation** for 5 seconds every minute. Excessive or vigorous agitation is to be avoided since it results in greatly increased contrast, with little or no speed gain. Less than recommended agitation promotes the possibility of irregular development, low contrast, and loss of speed. Constant agitation cannot be compensated for by decreasing development. For users of nitrogen burst equipment, the recommended rate of agitation is 2 seconds at thirty-second intervals.

REPLENISHMENT

Autofine Replenisher is strongly recommended for maintaining consistency in quality and developing time. Replenisher should be added and thoroughly stirred into the developer at the end of each processing cycle. Average replenishment is at the rate of ½ fluid ounce per 80 square inches of film. (1 roll of 36 exposure 35mm, or 1 roll of 120/620, or four 4 x 5 sheets.) Replenishment may be continued until a volume equal to the original amount of developer has been added.

RECIPROCITY FAILURE

Reciprocity failure is the speed loss incurred by all photographic emulsions with exposures of extremely short or long duration. This effect is unnoticed with most popular electronic-flash units, but if the flash duration is 1/2000th of a second or faster, development should be increased by 25%. Reciprocity failure also becomes noticeable with exposures of approximately 10 seconds and becomes more pronounced with increased times. The exposure compensation necessary for these conditions varies with each type of film, but for most practical applications, exposures of 2X to 4X the calculated time should be used.

AVAILABLE SIZES

AUTOFINE	1 quart
FILM DEVELOPER	1 gallon
	30* gallon
	48* gallon
AUTOFINE	1 quart
REPLENISHER	1 gallon

*on special order

(continued on following page)

The Compact Photo-Lab-Index

AUTOFINE DEVELOPER (Continued)
ASA EXPOSURE INDICES AND RECOMMENDED DEVELOPMENT TIMES

Very gentle agitation: 10 seconds on immersion, 5 seconds every minute thereafter.

SHEET FILMS	ASA	65F	70F	75F	80F	85F	90F
Kodak Tri-X	320	13	10	8	6½	5	4
Kodak Plus-X	125	13	10	8	6½	5	4
Kodak Panatomic-X	64	13	10	8	6½	5	4
Kodak Super-XX	200	13	10	8	6½	5	4
Kodak Portrait Pan	125	13	10	8	6½	5	4
Kodak LS Pan	50	13	10	8	6½	5	4
Kodak Royal-X Pan	1250	15¾	12½	10	8	6½	5¼
Kodak Royal Pan	400	13	10	8	6½	5	4
Kodak Super Panchro Press B	250	13	10	8	6½	5	4
Ansco Super Hypan	320	13	10	8	6½	5	4
Ansco Versapan	125	13	10	8	6½	5	4
Ansco Finopan	64	15¾	12½	10	8	6½	—
Ansco Superpan	250	15¾	12½	10	8	6½	—
Ilford HPS	800	15¾	12½	10	8	6½	5¼
Ilford FP3	125	15¾	12½	10	8	6½	5¼
Ilford Special Portrait 124	125	11	8¾	7	5¾	4½	—
Ilford HP-3	400	18¾	15	12	9¾	7¾	—
Ilford HP-3 Matte	400	18¾	15	12	9¾	7¾	—
Ilford HP-4	400	17½	14	11	9	7	—
Agfa IP-21	100	17½	14	11	9	7	—
Agfa IP-21 Matte	100	17½	14	11	9	7	—
Agfa IP-24 Matte	200	11	8¾	7	5¾	4½	—
120/620/127 FILMS							
Kodak Royal-X Pan	1250	15¾	12½	10	8	6½	5¼
Kodak Tri-X Professional	320	11	8¾	7	5¾	4½	3½
Kodak Tri-X	400	11	8¾	7	5¾	4½	3½
Kodak Plus-X	125	6½	5	4	3¼	2½	2
Kodak Verichrome Pan	125	9½	7½	6	4¾	3¾	3
Kodak Panatomic-X	50	9½	7½	6	4¾	3¾	3
Ilford HPS	800	15¾	12½	10	8	6½	5¼
Ilford HP3	400	15¾	12½	10	8	6½	5¼
Ilford FP3	125	11	8¾	7	5¾	4½	3½
Ilford FP-4	125	11	8¾	7	5¾	4½	—
Agfapan 100	100	13	10	8	6½	5	—
Agfapan 400	400	13	10	8	6½	5	—
Agfa Isopan Record	640	15¾	12½	10	8	6½	5¼
Agfa Isopan F	100	9½	7½	6	4¾	3¾	3
Agfa Isopan FF	25	6½	5	4	3¼	2½	2
Agfa Isopan SS	160	9½	7½	6	4¾	3¾	3
Ansco Super Hypan	500	11	8¾	7	5¾	4½	3½
Ansco Versapan	125	9½	7½	6	4¾	3¾	3

(continued on following page)

700

MISCELLANEOUS MANUFACTURERS

AUTOFINE DEVELOPER (Cont'd.)

ASA EXPOSURE INDICES AND RECOMMENDED DEVELOPMENT TIMES

35mm FILMS	ASA	65F	70F	75F	80F	85F	90F
Kodak Tri-X	400	11	8¾	7	5¾	4½	3½
Kodak Plus-X	125	9½	7½	6	4¾	3¾	3
Kodak Panatomic-X	32	9½	7½	6	4¾	3¾	3
Ilford HPS	800	14	11¼	9	7¼	5¾	4½
Ilford HP3	400	11	8¾	7	5¾	4½	3½
Ilford FP-4	125	9½	7½	6	4¾	3¾	—
Ilford FP3	125	9½	7½	6	4¾	3¾	3
Ilford Pan-F	50	6½	5	4	3¼	2½	2
Agfa Agfapan 100	100	13	10	8	6½	5	—
Agfa Agfapan 400	400	13	10	8	6½	5	—
Agfa Agfapan 1000	800	15¾	12½	10	8	6½	—
Agfa Isopan Record	640	11	8¾	7	5¾	4½	3½
Agfa Isopan F	100	9½	7½	6	4¾	3¾	3
Agfa Isopan FF	25	6½	5	4	3¼	2½	2
Agfa Isopan SS	200	9½	7½	6	4¾	3¾	3
Ansco Super Hypan	500	14	11¼	9	7¼	5¾	4½
Ansco Versapan	125	9½	7½	6	4¾	3¾	3

ACU-1 FILM DEVELOPER

ACU-1 is a maximum acutance, ultra-fine-grain film developer, combining optimum quality. with **great effective** speed It is a modern developer formulated for modern emulsions, and fully exploits the inherent capabilities of all films. ACU-1's higher speed ratings permit the use of slower films with superior resolving power and finer grain in situations that previously required high speed films. ACU-1 is a developer designed for those who prefer to work with a "one-time" use preparation with convenient dilution ratios.

PREPARATION

ACU-1 concentrate is packaged in single-mix dry powder form, readily soluble in water (70 to 90°F). Prepare the concentrated "stock solution" by dissolving completely the full contents of the can in 1 quart of water (946 ml). Although the water in most areas is suitable, we recommend the use of distilled water wherever the mineral content or alkalinity of the tap water is high. ACU-1 concentrate, either dry or in solution, may assume a slight coloration which in no way will affect its chemical properties.

STORAGE

ACU-1 "stock solution" will retain its full strength for approximately one year if normal precautions are taken against contamination and oxidation. All storage and processing equipment must be clean. All equipment suspected of contamination should be soaked for eight hours in a solution of approximately one ounce of sodium sulfite per gallon of warm water, and then thoroughly rinsed. To minimize oxidation, ACU-1 should be stored in full, tightly-capped amber glass or polyethylene bottles. For infrequent use, it is recommended that the concentrate be stored in several small bottles to assure longer life.

(continued on following page)

The Compact Photo-Lab-Index

RECOMMENDED EXPOSURE INDICES

The high speed ratings listed on the chart are the normal exposure indices for ACU-1. The recommended exposure/development values are calculated for optimum quality negatives, and are not the result of "pushing." Alteration of these values, variations of personal technique excepted, will result in negatives of less than ACU-1's best quality.

A single index is given for each film since the sensitivity of most modern exposure meters eliminates the need of separate tungsten ratings.

RECOMMENDED EXPOSURE INDICES AND DEVELOPING TIMES

Dilution Ratios: 1:5 Dilution/5⅓ oz. or 157ml developer Balance water to make 1 quart (946ml). 1:10 Dilution/3 oz. or 86ml developer. Balance water to make 1 quart (946ml).

35mm FILMS

	EXPOSURE INDEX	DILUTION DEV:WATER	68F	70F	75F	80F	8F5
Kodak Tri-X	1200	1:5	11	10	8	6½	5
Kodak Plus-X	320	1:10	10	9	7	5½	4½
Kodak Panatomic-X	100	1:10	6¼	5½	5	4	3¼
Ilford HP 4	1000	1:5	13½	12½	10	8	6½
Ilford FP 4	250	1:10	10	9	7	5½	4½
Ilford Pan F	125	1:10	6¼	5½	5	4	3¼
Agfa Isopan Record	1000	1:5	12½	11	10	8	6½
Agfapan 100	320	1:5	8½	7½	6	4¾	3¾
Agfapan 400	800	1:5	8½	7½	6	4¾	3¾
Agfapan 1000	2400	1:5	11	10	8	6½	5
Agfa Isopan U	400	1:5	8½	7½	6	4¾	3¾
Agfa Isopan SS	200	1:5	10	9	7	5¾	4½
Agfa Isopan F	125	1:5	6¼	5½	5	4	3¼
Agfa Isopan FF	50	1:10	5½	5	4	3¼	2½
Ansco Super Hypan	800	1:5	12½	11	10	8	6½

ROLL FILMS

	EXPOSURE INDEX	DILUTION DEV:WATER	68F	70F	75F	80F	8F5
Kodak Tri-X Professional	800	1:5	10	9	7	5¾	4½
Kodak Tri-X	1200	1:5	15½	14	11	9	7
Kodak Plus-X Professional	320	1:10	6¼	5½	5	4	3¼
Kodak Verichrome Pan	250	1:5	12½	11¼	9	7¼	5¾
Kodak Pan-X Professional	100	1:10	6¼	5½	5	4	3¼
Ilford HP-4	1000	1:5	12½	11	10	8	6½
Ilford FP-4	250	1:10	12½	11¼	9	7¼	5¾
Agfa Isopan Record	1000	1:5	12½	11	10	8	6½
Agfa Isopan U	400	1:5	10	9	7	5¾	4½
Agfa Isopan SS	200	1:5	11	10	8	6½	5
Agfa Isopan F	125	1:5	10	8¾	7	5¾	4½
Agfa Isopan FF	50	1:10	6¼	5½	5	4	3¼
Ansco Super Hypan	1000	1:5	12½	11	10	8	6½

IMPROVED DIAFINE

Diafine is usable over a wide temperature range with **one developing time for all films.** Fast, medium and slow films can be developed simultaneously without adjustment in developing time. All films with the exception of a few extremely slow emulsions are automatically developed to the most desirable contrast. Time and temperature have no practical effect if the minimum recommendations are observed.

Diafine film developer produces the greatest effective speed, ultra-fine grain, maximum acutance and highest resolution. It is a characteristic of Diafine film developer to permit wide latitude of exposure without the necessity of time-temperature compensation.

PREPARATION

Diafine is supplied in dry powder form to make two separate solutions (A & B). The two powders contained in a carton of Diafine are to be prepared and used separately.

Dissolve the contents of the smaller can (Solution A) in water (75 to 85°F) to make the volume specified on the carton. Dissolve the contents of the larger can to make an equal amount of Solution B. Label the storage containers clearly. For maximum consistency and stability, use distilled water. As with any photographic developer, all storage and processing equipment must be clean.

In use, the solutions will become discolored and a slight precipitate may form which in no way will affect the working properties of Diafine. The precipitate may be removed, if desired, by filtering.

TIME AND TEMPERATURE

Diafine may be used within a temperature range of 70 to 85°F with a minimum time of 3 minutes in each solution. Increased developing times will have no practical effect on the results. It is recommended that you do not exceed 5 minutes in either solution.

DEVELOPING PROCEDURE

Do not pre-soak films.
Any type of tank or tray may be used.
1. Immerse film in Solution A for at least 3 minutes, agitating very gently for the first 5 seconds and for 5 seconds at 1-minute intervals. **Avoid excessive agitation as this may cause some loss of shadow speed and excessive contrast.**
2. DRAIN, BUT DO NOT RINSE.
3. Immerse film in Solution B for at least 3 minutes, agitating gently for the first 5 seconds and for 5 seconds at 1-minute intervals. **Avoid excessive agitation.**
4. Drain and rinse in plain water for about 30 seconds. Use of an acid stop bath is not recommended.
5. Fix, wash and dry in the usual manner.
Optimum results are obtained if all solutions, including the wash, are maintained at the same temperature. Care must be exercised to prevent any amount of Solution B from entering Solution A.

REPLENISHMENT

Diafine does not require replenishment. It is an extremely stable formula and has an unusually long work life, if normal precautions are taken against contamination.

When necessary, the level of the solutions can be maintained by the addition of fresh Diafine. Add **equal amounts** of fresh A & B to their respective working solutions. Since the introduction of dry film into Solution A decreases the volume of A more rapidly than that of B, some of the B will have to be discarded before adding the fresh B solution.

(continued on following page)

EXPOSURE RECOMMENDATIONS

MINIATURE AND ROLL FILMS	EXPOSURE INDEX†
Kodak Tri-X	2400
Kodak Tri-X Professional 120	1600
Kodak Plus-X Pan	640
Kodak Panatomic-X	200
Kodak Verichrome Pan	640
Kodak Royal-X Pan	3200
Agfa Isopan Record	1600
Agfa ISS	500
Agfa IF	200
Agfa IFF	100
Ilford Pan F	200
Ansco Super Hypan	1000
Ansco Versapan	400

SHEET FILMS	
Kodak Royal X	3000
Kodak RS Pan	2000
Kodak Royal Pan	2000
Kodak IS Pan	160
Kodak Tri-X	1600
Kodak Super XX	1000
Kodak Plus-X	640
Kodak Panchro Press B	640
Kodak Portrait Pan	400
Kodak Panatomic X	200
Ansco Super Hypan	1500
Ansco Versapan	400
Dupont Cronar Press	1600
Dupont Cronar High Speed Pan	640
Dupont Arrow Pan	640
Dupont XF Pan	160

†Determined by sensitometric means and verified by practical applications for meters calibrated on the ASA system. Slight adjustments of the ratings may be necessary to compensate for variations in meters, equipment and personal technique.

THE BAUMANN INDEX

The B-Index (Baumann Index) indicates the relative speeds of the various papers when developed in PRINTOFINE. On this chart, 1000 is the index assigned to the fastest of the papers tested.

If one has determined the correct exposure for the paper he normally uses, the B-Index will permit the photographer to rapidly estimate the exposure required by a different type of paper. If the paper presently in use has a B-Index of say 500, and the photographer wishes to change to a paper with a B-Index of 250, he will know that the new paper is only one-half as fast as his normal grade, and will therefore have to expose it twice as long.

We must make it clear that the B-Index is not an absolute speed rating, and is designed only to show the relative speeds of various papers when developed in PRINTOFINE.

The data is based on the most commonly used light source, the #212 150w. lamp. Color changes caused by the use of other lamps, filters, or large voltage changes will produce differences in the indexes, especially with the variable contrast papers. Speeds are based on the minimum exposure necessary to produce a maximum black for a given paper.

(continued on following page)

The Compact Photo-Lab-Index

PRINTOFINE PAPER DEVELOPER

PRINTOFINE Paper Developer is a high capacity print developer usable with all contact and enlarging papers. Characteristic of this product are its long tonal scale, rich deep blacks, freedom from fog and outstanding shelf and tray life.

In dry powder form, PRINTOFINE may be slightly pink or brown. Dissolve the powder in water at a temperature of 75° to 95°F. PRINTOFINE will be slightly yellow or pink upon mixing, but will clear somewhat upon standing. Shelf life of stock solution in full container is approximately 1 year at 75°F.

For use, dilute stock solution 1:2. Normal developing time for enlarging papers is 1½ minutes at 75°F. Developing•time may be varied to correct for minor exposure errors. No fog is evident with PRINTOFINE even with developing times up to 6 minutes (at 75°F).

For convenience, a working temperature of 75°F. is recommended, but equally good results will be obtained within a range 60° to 85°F. The time corrections necessary to maintain a constant degree of contrast and density are as follows:

60°—3 minutes	75°—1½ minutes
65°—2 minutes	80°—1¼ minutes
70°—2 minutes	85°—1 minute

The "working" life of PRINTOFINE in an open tray is two days. One quart of PRINTOFINE will process more than sixty 8 x 10 prints with no change in quality or processing.

Diluted 1:1, PRINTOFINE Paper Developer is well-suited to litho type films used for line copy. Normal development time at 70°F is from two to four minutes.

Available sizes: 1 quart, 1 gallon, 5 gallons, 25 gallons.*

*On special order.

RELATIVE SPEEDS OF PAPERS DEVELOPED IN PRINTOFINE

		INDEX*			INDEX*
Velour Black	1	500	Cykora	1	335
	2	600		2	600
	3	750		3	375
	4	500		4	215
Varigam	0	75	Kodabromide	1	1000
	1	135		2	500
	2	250		3	600
	3	250		4	500
	4	165		5	375
Brovira	1	250	Medalist	1	250
	2	600		2	215
	3	500		3	335
	4	500		4	300
	5	700	Jet	1	1000
	6	375		2	750
Polycontrast	1	165		3	750
	2	335		4	500
	3	300	Opal	—	60
	4	190	Indiatone	—	100
Portriga Rapid	2	700	Ektalure	—	200
	3	700	Allura	—	250
	4	1000			

*The Baumann Index

BEST PHOTO INDUSTRIES, INC.

PANTHERMIC 777

Panthermic 777 works over a wide temperature range. It is a fine grain formula which eliminates the necessity of having to cool a warm developer, or warm a chilly one. Consistent results can be expected as long as the temperature is above 60F and below 90F, and the appropriate developing time is selected. It is desirable to have all processing solutions (developer, short stop, fixer, wash) at approximately the same temperature.

Panthermic 777 yields fine grain, the size of the individual particles is exceedingly small, and the graininess and its distribution is smooth and free of clumping. The character of this developer remains practically constant at any temperature within its working range. While it is true that the grain size at 90 degrees is slightly coarser than that obtained at 60 degrees, the difference is almost imperceptible except by examination under a high power microscope.

RESOLUTION

The detail-holding power of an emulsion is a function of its graininess, and for this reason the type of image structure obtainable with 777 makes it particularly desirable whenever maximum sharpness is required.

SPEED, GRADATION AND DENSITY

Panthermic 777 has speed characteristics approximately equal to those of the conventional Metol-Hydroquinone and other widely used developers. Emulsion speed is not sacrificed for the sake of fine grain.

Good results can be obtained with a reasonable amount of under- or over-exposure, and contrast can be controlled to any desirable degree without impairing the constancy of grain structure. As with the temperature changes, there is barely any noticeable grain difference when working for high or low contrast. The densities obtained with 777 are suitable for contact or projection printing, neutral in color, free from dichroic and surface images.

Contrast is increased by longer developing times, and decreased by shorter times.

REPLENISHMENT

The 777 replenisher system permits the development of a definite area of emulsion in a definite quantity of developer, and requirements can be easily calculated in advance. Replenisher is added to the developer after each use, and in proportion to the area of film that has been processed, the total volume of the developing solution is kept constant at all times. Extended replenishment is often desirable and perfectly feasible. Replenishment can be extended over long periods of time and for a great quantity of films, such as is the case in large volume amateur or professional use. After the developer has been almost totally replaced by replenishment, the solution attains well-stabilized characteristics and many users have replenished over a period of years with satisfactory results.

The criterion for extended replenishment is active use of the working solution and consequent frequent replenishment. For such use, a minimum of one film a week per unit of working solution is recommended. If long intervals elapse between replenishment, some deterioration from exposure to air and the effect of time may be expected. If this becomes noticeable in the manner in which films are processed, the solution should be discarded, and replaced by fresh developer.

USE WITHOUT REPLENISHMENT

777 Developer may, upon occasion, be used without replenishment, however, speed and gamma will both drop with each successive film, development time being constant. Increasing time of development with each film will not remedy the loss, for increasing time results in increasing contrast only. This

will accomplish matching of the highlight densities, but the slope of the characteristic curve will be steeper and there will be correspondingly less and less shadow detail recorded, less speed obtained.

The replenishment table is based upon average energy requirements. If, however, on extended replenishment a majority of the negatives are developed to high gammas, more replenishment will naturally be necessary because of the increased energy demand.

The exact amount of Replenisher increase must be determined by experience. If a falling-off in density becomes noticeable on successive films, it is suggested that the quantity of Replenisher be at first doubled, then reduced to a point where densities remain constant. This procedure will also compensate energy losses due to long use in open or lightly covered tanks. Replenishment should never be less than the quantities given in the table, for it may be impossible to maintain the working solution volume. A 35mm or 120 roll of film normally carries off slightly more than ¾ oz. of developer in the emulsion, and there are other losses in handing the solutions, plus those caused by time and slight oxidation.

Any solution that has developed a deep, wine-red color, should be regarded with suspicion and discarded.

DEVELOPING IN DAYLIGHT TANKS

After the tank is loaded, closed, and the white light on, take the temperature of the working developer; consult table for the required developing time, and pour in the developer. If possible, keep the reel in motion throughout development.

When development is completed, quickly dump the contents of the tank into an empty graduate, refill with stop bath, allow to remain 30 seconds, pour off, replace with hypo— and proceed with fixation, washing and drying as in regular practice. Now, **before returning the used developer to its bottle, carefully measure the required amount of replenisher and pour into the bottle first. Then pour back the developer up to the mark only, and**

discard any remainder in the graduate. Proceed as above for each successive film developed.

Before starting development have all materials readily at hand. It is also advisable to put the tank in a clean tray during development in order to catch any solution spilled over, for it may be needed to regain the original working level. Be sure to empty the contents of the tray into the graduate at the same time as the tank or its developer may become contaminated with short-stop or hypo.

PROFESSIONAL SIZED TANKS

It will not be necessary to empty the tank of the working developer after each use, but it should be equipped with a neat-fitting cover of the floating type, and preferably a second cover. In such use, after each batch of negatives is developed, compute and measure the necessary amount of replenisher, then dip out a quantity of the working developer and add the replenisher, and then pour back the working developer up to the original level, discarding any remainder. This procedure should be repeated with each batch of film.

Agitation during development is a matter of great importance and it should preferably be continued in the stop and fixing baths. Constant agitation essential for the exact repition of results and for obtaining optimum gradation characteristics, as it increases the supply of fresh solution to the denser areas where silver is being produced and where more chemical energy is required for full and proper action.

Filtering. It is normal for a precipitate consisting of finely divided silver to accumulate in the 777 working solution with use. This precipitate starts forming an hour or so after each use and a portion may plate on the walls of the bottle or container, the major part settling out as a black sludge. This silver is inert and has no adverse effect on the film or development, but it is good practice to filter it out from time to time. It is also normal for the working solution to acquire a yellow or orange color with

use, but this color is harmless, being derived mostly from dyes used in film backing materials. It should not be mistaken for oxidation of the solution.

A strong red color is indicative of developer oxidation. Such a condition is cause for alarm and a small test negative should be developed in it before the solution is put to regular use. Developer showing this color cannot be restored by replenishment and should be discarded.

Cold weather may cause a precipitate to form in the developer or replenisher but this can be redissolved by heating the solution to above 160F.

DEVELOPING TIMES AND TEMPERATURES

The following table is intended to be a guide in selecting the appropriate time for developing certain films at various temperatures of Panthermic 777 Developer. It should be borne in mind that there is no **exact** developing time for roll film because each frame varies from the next in terms of exposure, lighting, subject matter, etc. Since the entire roll is developed at one time an average for all the various conditions of exposure must be considered in arriving at the proper time for the roll. Where unusual conditions of exposure are encountered the developing times should be adjusted accordingly.

Manufacturers of photographic film occasionally make changes in their products which necessitate changes in exposure and developing requirements. For this reason their recommendations should be followed if there is an indication of conflict with other data.

DEVELOPING TIME—MINUTES FOR NORMAL CONTRAST

GAF ALL-WEATHER Pan	12	8	6	5
GAF VERSAPAN	14	10	8	6
GAF SUPER HYPAN	18	14	10	7
Ilford FP3	12	8	6	5
Ilford HP3	14	10	8	7
Ilford HPS	16	12	10	9
Kodak PANATOMIC-X (Improved)	16	7	5¼	3
Kodak VERICHROME Pan	14	9	7	6
Kodak PLUS-X Pan	16	10	8	3½
Kodak TRI-X Pan Professional	17	10½	7½	4
Kodak Improved TRI-X	20	12	9	4½
Kodak ROYAL X Pan	21	15	11	8

REPLENISHMENT TABLE
Minimum required replenisher for average use.

ROLL FILM				FILM PACKS, SHEET FILMS AND PLATES			
Size	No. of Exposures	In Ozs.	In ml	Size	No. of Exposures	In Ozs.	In ml
35mm. casette or roll	36	1½	45	2¼″ x 2¼″	12	1½	45
1⅝″ x 2½″	8	1	30	2¼″ x 3¼″	12	2¼	65
2¼″ x 2¼″	12	1½	45	2¼″ x 4¼″	12	3	90
2¼″ x 3¼″	8	1½	45	3¼″ x 4¼″	12	4¼	120
2¼″ x 4¼″	8	2	60	9 cm x 12 cm	12	5	140
				4″ x 5″	12	6	170

Add 1 oz. or 30 ml of replenisher for each 40 sq. cm of film developer.

BERKEY MARKETING COMPANIES, INC.

MINOX BLACK-AND-WHITE AND COLOR FILMS

MINOX ASA 25 BLACK-AND-WHITE FILM

An extremely fine grain film designed for extreme sharpness, for use in outdoor picture taking on sunny or average days, and for indoor snapshots with Minox flash units.

AVAILABILITY

36 exposure cartridges.

EXPOSURE

For Minox B, before loading film into camera, set camera for ASA 25. For using the camera without exposure meter, for most front lighted average subjects, the following shutter times may be used:

EXPOSURE TABLE

From 2 hours after sunrise, to 2 hours before sunset.

Condition	Shutter Speed
Bright Sunlight	1/200
Hazy Sunlight	1/150
Cloudy Bright	1/100
Cloudy Dull	1/20

For light colored subjects, (people in light colored clothing) or light surroundings (light colored buildings, bright beach, or snow) use next higher shutter setting.

For flash pictures with the Minox B/C flash, and AG-1B (blue) flashbulbs, or with Minox Cube Flasher, set shutter speed at 1/20.

Camera-to-Shutter Distance	Filter
1-3 ft.	Neutral Density
2-8 ft.	Green
3-14 ft.	None

The above flash distances are approximate for subjects and surroundings of average color and contrast. For darker subjects, the distance should be shortened, and for lighter subjects the distance should be extended.

For flash pictures with the Minox ME-1 Electronic Flash Unit, follow the directions supplied with the unit.

Caution: Film cartridge contains 36 exposures. Watch the exposure counter. After you have taken the 36th exposure, push and pull the camera twice before removing the cartridge, to avoid fogging the last shots.

MINOX ASA 50 BLACK-AND-WHITE FILM

A fine grain film for outdoor picture taking under average light conditions, and for indoor snapshots with Minox flash units.

AVAILABILITY

36 exposure cartridges.

EXPOSURE

For Minox B, before loading film into camera, set camera for ASA 50. For using the camera without exposure meter, for most front lighted average subjects, the following shutter times may be used:

EXPOSURE TABLE

From 2 hours after sunrise, to 2 hours before sunset.

Condition	Shutter Speed
Bright Sunlight	1/500
Hazy Sunlight	1/300
Cloudy Bright	1/200
Cloudy Dull	1/100

For light colored subjects (People in light colored clothing) or light surroundings (light colored buildings, bright beach, or snow) use the next higher shutter setting.

For flash pictures with Minox B/C flash and AG-1B (blue) flashbulbs, or with Minox Cube Flasher, set shutter speed at 1/20.

(*Continued on following page*)

MISCELLANEOUS MANUFACTURERS

The Compact Photo-Lab-Index

Camera-to-Shutter Distance	Filter
2-7 ft.	Neutral Density
3-14 ft.	Green
4-16 ft.	None

The above flash distances are approximate for subjects and surroundings of average color and contrast. For darker subjects, the distance should be shortened, and for lighter subjects, the distance should be extended.

For flash pictures with the Minox ME-1 Electronic Flash Unit, follow the directions supplied with the unit.

Caution: Film cartridge contains 36 exposures. Watch the exposure counter. After you have taken the 36th exposure, push and pull the camera twice before removing the cartridge to avoid fogging the last shots.

Caution: Film cartridge contains 36 exposures. Watch the exposure counter. After you have taken the 36th exposure push and pull the camera twice before removing the cartridge to avoid fogging the last shots.

MINOX KODAK TRI-X PAN (ASA 400) BLACK-AND-WHITE FILM

36 exposure cartridge spooled and packaged by Minox

An ultra-speed film designed for picture taking indoors without flash, and for outdoor pictures under poor light conditions. Not recommended for use with the Minox in sunlight.

EXPOSURE CONTROL/METER SETTING

Set the ASA dial to 400. If it is necessary to make an outdoor exposure in bright light, use a neutral density filter.

Shutter settings without exposure meter, outdoors/daylight.

Light overcast	1/1000
Heavy overcast	1/500

Indoors/daylight and night pictures. While correct shutter settings depend upon the amount of existing illumination, type of subject, color of surroundings, etc., the following approximate settings will serve as a guide under average conditions. When in doubt, bracket exposures by taking an additional picture at the next higher shutter setting, and one at the next lower setting.

EXPOSURE TABLE

From 2 hours after sunrise to 2 hours before sunset.

Home interiors—daylight near windows	1/125
Home interiors—bright artificial light	1/30
Offices—daylight near windows	1/250
Offices—bright artificial light	1/60
Museums, trade shows, school rooms, stores and commercial and industrial interiors	1/60-1/125
Spot lighted circus, stage, ice shows	1/125
Inside subway cars, lighted buses	1/30
Television pictures	1/15
Street scenes with bright illumination	1/30

Caution: Film cartridge contains 36 exposures. Watch the exposure counter. After you have taken the 36th exposure push and pull the camera twice before removing the cartridge to avoid fogging the last shots.

MINOX KODAK PLUS-X PAN (ASA 125) BLACK-AND-WHITE FILM

36 exposure cartridge spooled and packaged by Minox

A versatile film suitable for use without flash in brightly lit interiors, outdoor picture taking on a dull day, or for indoor snapshots with Minox flash units.

(Continued on following page)

The Compact Photo-Lab-Index

AVAILABILITY

36 exposure cartridges.

EXPOSURE

For Minox B, before loading film into camera, set for Plus-X film by moving ASA pointer between the 100 and 200 mark, but about one quarter of the distance away from the 100 mark. For very bright subjects such as beach and snow scenes in brilliant sunlight, use the built-in neutral density filter during exposure measurement and actual exposure. For setting the shutter without the exposure meter, the following will be found satisfactory:

EXPOSURE TABLE

From 2 hours after sunrise, to 2 hours before sunset.

Condition	Shutter Speed
Bright Sunlight	1/1000*
Hazy Sunlight	1/750
Cloudy Bright	1/500
Cloudy Dull	1/200

*For light subjects (people in light colored clothing) or light surroundings (light colored buildings, bright beach, or snow) use the 1/1000 setting and the green filter.

In bright artificial light use the following:

Home interiors (light colored walls)	1/10 to 1/20
Offices, stores and schoolrooms	1/20 to 1/50
Spot lighted circus, stage, and ice shows	1/50 to 1/100

For flash pictures with Minox B/C flash and AG-1B (blue) flashbulbs, or with Minox Cube Flasher, set shutter speed at 1/20.

Camera to Subject Distance	Filter
9-15 ft.	Neutral Density
14-20 ft.	Green
19-26 ft.	None

The above distance ranges are approximate for subjects and surroundings of average color and contrast. For darker subjects, shorten the distance, for very bright subjects, extend the distance.

For flash pictures with Minox ME-1 Electronic Flash Unit, follow the directions supplied with the unit.

MINOCHROME (ASA 20) FOR COLOR SLIDES

A fine grain film of the reversal type which gives sharp transparencies that can either be used as projector slides, or as originals in making color prints. The film is suitable for picture-taking in daylight and for indoor snapshots using the Minox B/C flash unit and AG-1B (blue) flashbulbs.

EXPOSURE

For Minox B, before loading film into camera, set the ASA dial to below 25 where you would estimate 20 to be. For exposure meter measurement, point the camera at the principle part of the scene, or take a close-up measurement whenever possible. For shutter settings without the exposure meter, the following settings may be used as a guide for most average subjects outdoors in daylight.

EXPOSURE TABLE

From 2 hours after sunrise to 2 hours before sunset.

Bright or Hazy Sun (From Lighted subjects	1/200
Bright or Hazy Sun (Side Lighted subjects)	1/150
Cloudy Bright	1/50
Cloudy Dull	1/20
Open Shade	1/20

(Continued on following page)

For light subjects (people in light colored clothing) or light surroundings (light colored buildings, bright beach or snow) use one half to one full stop higher setting. Example: Setting for average subject—200. Move dial midway between 200 and 500, or all the way to 500 depending upon the brightness of the subject.

Note—for intermediate speeds on your Minox, set the shutter speed dial between the nearest settings engraved in the scale. Estimate the placement. Example, for 150, set the dial equidistant between 100 and 200.

For flash pictures with Minox B/C flash unit and AG-1B (blue) flashbulbs, set the shutter at 1/20.

Camera-to-Subject Distance	Use Filter
2-4 ft.	Neutral Density
5-10 ft.	None

The above flash distances are approximate for subjects of average color and contrast. For dark subjects, shorten the distance, for bright subjects, extend the distance.

IMPORTANT—When using color film, never use the green or orange filters. Skylight filters R3 and R6 may be used to minimize bluish haze in distant views or to reduce the bluishness of snow scenes, seascapes or high altitude scenes, in picture made on overcast day or in open shade.

MINOX COLOR NEGATIVE FILM ASA 20 FOR COLOR PRINTS

A fine grain color negative film that yields color negatives from which color prints can be made. This film is suitable for taking pictures in daylight, and for indoor snapshots with Minox flash units. It is supplied in Minox cartridges of 15 and 36 exposures.

MINMAX

KROM-X™
Processing Data and Information

PRODUCT DESCRIPTION

KROM-X is a highly concentrated additive used with the first developer in the Kodak E-3 or E-4 processing kits. It permits the use of effective exposure indices of up to 1,200 for daylight High Speed Ektachrome, and greatly expanded indices for other films compatible with these processes . . . all with no noticeable loss in transparency quality.

Add 20 ml. of KROM-X to each liter (2/3 oz./qt.) of first developer and lengthen the developing times as suggested on the KROM-X processing chart. The rest of the processing remains unchanged, and all temperature tolerances are normal.

Some adjustments for individual films are discussed below.

EXPOSURE NOTES

Ektachrome Professional Films—Since the speed of this film may vary from emulsion to emulsion, some proportionate adjustments in exposure may be necessary at the expanded indices. It is always a good idea to test shooting and processing, bracketing your exposures, to establish a set of norms consistent with your individual tastes.

With Ektachrome Professional films, there is no grain or contrast buildup in shots made in very low light. However, at around 20 foot candles, reciprocity failure begins, and adjustments downward should be made in the exposure indices to compensate.

As happens with normal exposure and processing, some color shift can occur with very long exposures, and may require greater filtration to correct.

High Speed Ektachrome (EH); High Speed Ektachrome, Type B (EHB); Ektachrome X; Fujichrome and other E-4 compatible films

Normal photographic situations or shots made under average light will usually result in transparencies of optimum quality, even when the exposure indices are at the upper limits. However, in very low light situations, a phenomenon occurs with these films.

This "reciprocity graininess." In light levels requiring relatively slow shutter speeds, there is a very noticeable buildup of grain. With EH and EHB, this seems to begin at about 1/60 of a second, with graininess building rapidly as shutter speeds are slowed. With EX and Fujichrome, the critical shutter speed for "reciprocity graininess" begins at about 1/30 sec.

Use the fastest shutter speed practical for each photographic situation, if minimum grain is of major importance.

DIRECTIONS FOR USE

Use 20 ml. of KROM-X per liter (2/3 oz./qt.) of E-3 or E-4 first developer. Replenishment is not recommended for first developer, but manufacturer's recommendations may be followed for extending times, replenishment and useful life for all other solutions.

Follow manufacturer's recommendations on times and temperatures throughout entire process EXCEPT for first developer times given below:

TABLE I
E-4 PROCESS
Develop @ 85°F/29.4°C

Film	Exposure Index	First developer time
Ektachrome X	250	12 min.
	500	16 min.
Fujichrome II*	250	12 min.
	500	16 min.
HS Ektachrome Daylight	650	12 min.
	1000	16 min.
HS Ektachrome Type B	500	12 min.
	1200	16 min.

*Requires 40 ml. of KROME-X per liter (1-1/3 oz./qt.)

Since photography is not an exact science and variables are encountered by each photographer, the tables above are to be used primarily as a guide—a starting point for the achievement of optimum transparency quality. There is no single developing time that will consistently yield optimum results under all conditions. The ideal transparency is a

(Continued on following page)

MISCELLANEOUS MANUFACTURERS

713

TABLE 2
E-3 PROCESS
Develop @ 75°F/23.9°C

Film	Exposure Index	First developer time
Ektachrome	160	20 min.
Professional	320	24 min.
Ektachrome	125	20 min.
Professional, Type B*	250	24 min.

*Requires blue filtration, 10-20C

INCREASE II™

PROCESSING DATA AND INFORMATION

INCREASE II is a highly concentrated, stable, extended speed additive for C-41, C-22, and similar negative color developers. Effective exposure indices may be raised as much as ten times normal without apparent loss in negative quality.

Contrast may be controlled to a surprising degree by varying the amount of INCREASE II used in the developer. This is the only place that any modifications are made; the more INCREASE II that is put into solution to lower contrast, the greater amount of time needed in the developer to maintain density. Except for this, all other solutions, times and sequences remain normal.

Close examination of negatives processed in developers modified with INCREASE II reveals extremely fine grain, high acutance, long tonal scales, and outstanding color saturation. There is little evidence of any chemical fog buildup from the extended developing times, even when they approach 30 minutes.

E-3 and E-4 reversal films, when processed in the C-22 modification, yield unmasked negatives of surprising quality. In appearance, they closely resemble Kodacolor II negatives, and may be used to make black and white prints without the need to resort to panchromatic papers. Transparencies may also be made from them merely by copying

delicate balance of exposure, development, processing chemistry, film latitude, lighting conditions, and individual tastes.

Once opened, KROM-X has a shelf lime of more than a year under normal conditions. Unopened, no limit has yet been determined.

NOTE: MinMax color additives are specifically formulated for use ONLY with Kodak developers.

CAUTION! Causes skin irritation. Do not get in open cuts. In case of contact, flush with plenty of water. Harmful if swallowed; call physician at once. Keep out of the reach of children.

the negatives on the same type of film and under the same lighting conditions as used in making the original negatives It is possible to have both positives and negatives on the same roll of film.

EXPOSURE NOTES

Since INCREASE II functions primarily as a contrast control agent and inhibits the grain clumping tendencies normally associated with "pushed" films, it may be used with films exposed at standard exposure indices in order to lower contrast while maintaining the finest possible grain and the greatest possible acutance. Optimum results are derived at about 1½ to 2 stops beyond the normal ASA's. All color films may be pushed to greater exposure indices than the upper limits shown in the chart below, but negative quality tends to fall when the E.I.'s are so extended. Overall results are at least equal to those obtained with films processed normally ad according to manufacturer's recommendations.

RECOMMENDED E.I. LIMITS FOR SELECTED FILMS

C-41 Compatible Films

Film	Range	Optimum
Kodacolor II	160- 800	320
Vericolor II (S)	250-1000	640
Vericolor II (L)	160- 320	200
Fujicolor II	160-1000	640

(*Continued on following page*)

C-22 Compatible Films

Film	Range	Optimum
CPS, CPL, Kodacolor X Fujicolor	125- 640	250
EX, EP, EPB	200- 800	500
EH, EHB	250-1600	640

IMPORTANT INFORMATION STUDY CAREFULLY

1. Follow manufacturer's recommendations carefully with respect to shutter speeds when using professional type films, discussed under (2) below. General use films, such as Kodacolor II, Fujicolor II, Ektachrome X, etc., tend to build graininess very rapidly at shutter speeds below 1/60 of a second. **Because of this, always use the highest possible shutter speed practical for any situation when minimum grain size is of prime importance.**

2. Reciprocity failure begins to occur at about 20 foot-candles with professional films, such as Vericolor II, Ektachrome Professional, etc. Be sure to adjust exposure indices proportionate to the manufacturer's recommendations with respect to standard film speed ratings when engaged in low light level photography. Follow the guidelines on shutter speeds, regardless of the exposure index used.

DIRECTIONS FOR USING INCREASE II

First, and most important, always use either distilled or de-ionized water for mixing of all developers, especially color developers. While the amount of INCREASE II used may be varied to suit individual tastes or needs, the following amounts as a basic set of dilutions for the average picture situation under ordinarily lighting conditions are recommended.

C-41 Compatible Films:
Use 25ml. per liter (¾ oz./qt.) of developer.

C-22 Compatible Films:
With standard, masked negative color films (e.g. Ektacolor), use 15 ml. per liter (½ oz./qt.) of developer.

With Ektachromes and other similar chromogenic (reversal) films, use 20 ml. per liter (⅔ oz./qt.) of developer.

When adding INCREASE II to the developer, begin stirring 30 seconds before, continue stirring while adding, and keep on stirring for at least 30 seconds afterwards.

If replenishing, use the same amount of INCREASE II in the replenisher as in the developer. For each stop "push," the replenishment rate must be increased by 50% over the manufacturer's recommendation. For this reason, replenishment is not recommended, but one-shot use of developer when pushing more than 1½ stops is suggested. Continuing to add replenisher after this point is not economically justifiable.

For times and temperatures, use the tables provided below. **If temperatures other than those recommended by the manufacturer of the films (C-41) compatible) are used for Flexicolor (C-41) processing, then Flexitemp must be used in the developer in conjunction with INCREASE II.**

When using FLEXITEMP, it is recommended that INCREASE II **follow** the FLEXITEMP in the mixing.

TECHNIQUE VARIATIONS

Since photography is not an exact science and variables are an accepted part of the art, the tables given and the quantities of INCREASE II suggested are merely a beginning point. Each photographer should run sufficient test negatives to enable him to establish individual norms for the production of optimum quality negatives.

Additional amounts of INCREASE II will lower the contrast and extend the tonal range and vice-versa. Since INCREASE II permits the extending of developing times to build density without an accompanying buildup of contrast, then the greater the amount of additive used, the greater the amount of development time needed. Conversely, if negatives appear to be too thin, but the tonal range normal, then any increase of developing time to build more density calls for more INCREASE II.

In using this method of enhancing negative speed, **development time controls the density, and INCREASE II controls the tonal range, or contrast.** As a general rule of thumb, each additional 5 ml. of INCREASE II requires

(Continued on following page)

715

The Compact Photo-Lab-Index

an upward adjustment of 15% in the development time and vice-versa.

A "red shift" occurs in the masking of C-41 compatible films with the developing times being extended radically. This reduces the inordinantly high printing filtration requirements normally associated with such films as Vericolor II. In the INCREASE II modified process, the filtration levels seldom exceed 90Y + 40M, and are usually lower. This reduces printing exposure times by as much as 50%—a situation that could be most important in large volume operations. Lowered temperatures in the FLEXITEMP modification have the same effect. Optimum time-temperature combinations are shown on the tables provided.

TABLE I: C-41 COMPATIBLE FILMS

Temperature[1] F°	C°	Exp. Index	Time Min./Sec.	Exp. Index	Time Min./Sec.	Exp. Index[2]	Min./Sec. Time
100	37.8	250	5:15	500	8:00	800/1000	12:00
90	32.2		6:00		8:35		14:10
89	31.7		6:25		9:00		14:40
88	31.1		6:40		9:55		15:25
87	30.5		7:10		10:30		16:35
86	30.0		7:40		11:05		17:40
85	29.4		8:10		12:00	Optimum→	18:30
84	28.9		8:35		12:45		19:30
83	28.3		9:55	Optimum→	13:15		20:35
82	27.8		10:35		14:20		21:40
81	27.2	Optimum→	11:25		15:20		23:20
80	26.7		12:30		16:20		25:25
79	26.1		13:40		17:30		27:40
78	25.6		14:50		19:00		NR*
77	25.0		15:55		20:40		NR
76	24.4		17:30		22:10		NR
75	23.9		18:50		25:30		NR
74	23.3		21:10		NR*		NR
73	22.8		23:35		NR		NR

*NR: Not Recommended.
Storage life of INCREASE II in closed containers is in excess of one year.

[1]When processing at temperatures other than 100°F/37.8°C, FLEXITEMP **must** be used in conjunction with INCREASE II. (See processing information on FLEXITEMP).

[2]Use an E.I. of 800 for KODACOLOR II instead of 1000. Some shadow detail may be lost, or color shifts may occur if greater E.I.'s are used.

TABLE II is on Following page

(*Continued on following page*)

MISCELLANEOUS MANUFACTURERS

716

The Compact Photo-Lab-Index

TABLE II: C-22 Compatible Films; Masked (Reg.) Negative Color Print Films

Film	Exposure Index	Time @ 75°F/23.9°C
CPS, CX & Fujicolor I	250	16 min.
	500	19½ min.
CPL	320	19½ min.

Use 15 ml. per liter (½ oz./qt. of C-22 developer.

TABLE III: C-22 Compatible Films; Kodak Reversal Films processed as negatives. (See caution below regarding commercial printing).

Film	Exposure Index	Time @ 75°F/23.9°C
EX and EP	125	9½ min.
	250	11 min.
	500	14½ min.
	800	17 min.
EH	320	10 min
	640	12 min.
	1200	19 min.
	1600	22½ min.
EH and EP, Type B	125	9½ min.
	160	11 min.
	250	14½ min.
	320	16 min.
	500	18 min.

Use 20 ml. per liter (⅔ oz/qt.) of C-22 developer.

IMPORTANT CAUTION: Unless you do your own printing, or have access to a custom printer, do not use reversal films as negatives. Few commercial labs will accept them for printing.

NOTE: MinMax color additives are specially formulated for use only with Kodak developers.

CAUTION! Contains potassium bromide. Causes skin irritation. Do not get in open cuts. In case of contact, flush with plenty of water. Harmful if swallowed; call physician at once. Keep out of the reach of children.

FLEXITEMP™

PROCESSING DATA AND INFORMATION

FLEXITEMP is a highly concentrated additive for the processing of C-41 films over a very wide temperature range, with a lower limit of 73°F or 22.8°C and an upper limit of 90°F or 32.2°C.

Because of a "red shift" in the masking—which results in a lowered print filtration requirement and thus shorter print times—negative quality improves with the use of FLEXITEMP in conjunction with C-41 developer.

FLEXITEMP also makes possible the processing of negative color films at normal room temperatures. This permits as precise holding of any particular temperature as would be possible with the most sophisticated processing equipment. When using FLEXITEMP, the photographer or lab technician determines the desired temperature, not the manufacturer. Optimum results occur at 85°F or 29.4°C.

FLEXITEMP may be stored in either glass or plastic containers. When stored in glass, its shelf life is in excess of one year.

FLEXITEMP may be stored in plastic containers that are designed for color developers, or in any long-chain polymer plastic of the same kind used by Kodak for their photo graduates. Storage in such plastics should be limited to no more than 16 weeks. Since plastic "breathes," oxidation problems can occur after this time.

Note: Do not use FLEXITEMP or store it in the styrene plastics or damage will result to the container.

DIRECTIONS FOR USE

Add 10 ml. of FLEXITEMP to each liter of C-41 developer, and process according to the time / temperature chart below. All steps subsequent to development are normal and temperature is non-critical, although it is suggested that times of post-development steps be increased approximately 10% if temperatures below 85°F or 29.4°C are

used. The times given below are for all C-41 compatible films (Kodacolor II, Vericolor II, Fujicolor II, etc.)

Temperature		Time
F°	C°	Min./Sec.
90	32.2	4:55
89	31.7	5:05
88	31.1	5:20
87	30.5	5:40
86	30.0	5:55
85	29.4	6:15
84	28.9	6:40
83	28.3	7:10
82	27.8	7:40
81	27.2	8:15
80	26.7	9:00
79	26.1	9:50
78	25.6	10:40
77	25.0	11:35
76	24.4	12:50
75	23.9	15:00
74	23.3	16:45
73	22.8	19:00

Replenishment: Use 11 ml. of FLEXITEMP in the replenisher and follow manufacturer's recommendations for replenishment rates:

NOTE: MinMax color additives are specially formulated for use ONLY with Kodak developers.

For extremely high speed photography, with ASA ratings of color negative films pushed as high as 1,000, use INCREASE II, in conjunction with FLEXI-TEMP.

CAUTION! Contains benzyl alcohol. Causes eye irritation. Do not get in eyes or on open cuts. In case of contact, flush with plenty of water. Harmful if swallowed; induce vomiting. Call physician at once. Keep out of the reach of children.

(Continued on following page)

MISCELLANEOUS MANUFACTURERS

The Compact Photo-Lab-Index

FACTOR "8"
**PROCESSING DATA
AND INFORMATION**

PRODUCT INFORMATION
FACTOR 8 is a highly concentrated additive used in the processing of a great variety of black and white films. It is so powerful that mixing just a small amount into the developer enables the photographer to multiply the ASA rating of his films up to 8 times.

With FACTOR 8, Tri-X may now be rated at 3200, Plus-X at 1000, Panatomic-X at 250 and 2475 recording film at 8000!

In exhaustive tests using FACTOR 8 with widely assorted films and developers, it has been determined that FACTOR 8 has the effect of improving overall picture quality and lengthening the tonal scale, without having to resort to special developers.

FACTOR 8 may be used with developers of a medium activity and alkalinity level such as Microdol, D-76, HC-110 (A or B dilution), DK-50, DK-60, etc. Ilford films tend to respond best in HC-110B, D-76 and Microphene.

FACTOR 8 is suitable for developers of the "blitzing" variety such as Acufine **only** to extend the tonal scale and to tighten the grain structure at up to a 1-stop push.

DIRECTIONS FOR USE
A little FACTOR 8 goes a long way. Use the table below as a guide, bearing in mind that contrast can be widely varied, depending on the amount of FACTOR 8 used.

TECHNIQUE VARIATIONS
Since photography is not an exact science and variables are encountered by each photographer, the table above is to be used primarily as a guide—a starting point for the achievement of optimum print quality. There is no single criterion that will consistently yield optimum results under all conditions. The ideal print is a delicate balance of exposure, development, processing chemistry, film latitude, lighting conditions and individual tastes.

CAUTION! Causes skin irritation. Do not get in open cuts. In case of contact, flush with plenty of water. Harmful if swallowed; call physician at once. Keep out of the reach of children.

Film speed	Quantities	Developing Time
1-stop push	Add 8 ml. per liter of developer (¼ oz./qt.)*	Increase manufacturer's recommendation by ½
2-stop push	Add 8 ml. per liter of developer (¼ oz./qt.)*	Double manufacturer's recommendation
3-stop push	Add 10 ml. per liter of developer (⅓ oz./qt.)†	Triple manufacturer's recommendation

*For 2475 recording film, use 10 ml./liter.

†For 2475 recording film, use 15 ml./liter.

MISCELLANEOUS MANUFACTURERS

COMPARISON OF THERMOMETER SCALES

Basic Conversion Factors

To convert Fahrenheit into Centigrade: Subtract 32; multiply by 5 and divide by 9.
Example: 125°F. — 32 = 93 × 5 = 465 ÷ 9 = 51.67°C.

To convert Centigrade into Fahrenheit: Multiply by 9; divide by 5; add 32 to result.
Example: 18°C. × 9 = 162 ÷ 5 = 32.4 + 32 = 64.4°F.

°C.	°F.	°C.	°F.	°C.	°F.
+100	+212				
99.44	211	74.44	166	49.44	121
98.89	210	73.89	165	48.89	120
98.33	209	73.33	164	48.33	119
97.78	208	72.78	163	47.78	118
97.22	207	72.22	162	47.22	117
96.67	206	71.67	161	46.67	116
96.11	205	71.11	160	46.11	115
95.55	204	70.55	159	45.55	114
95	203	70	158	45	113
94.44	202	69.44	157	44.44	112
93.89	201	68.89	156	43.89	111
93.33	200	68.33	155	43.33	110
92.78	199	67.78	154	42.78	109
92.22	198	67.22	153	42.22	108
91.67	197	66.67	152	41.67	107
91.11	196	66.11	151	41.11	106
90.55	195	65.56	150	40.55	105
90	194	65	149	40	104
89.44	193	64.44	148	39.44	103
88.89	192	63.89	147	38.89	102
88.33	191	63.33	146	38.33	101
87.78	190	62.78	145	37.78	100
87.22	189	62.22	144	37.22	99
86.67	188	61.67	143	36.67	98
86.11	187	61.11	142	36.11	97
85.55	186	60.55	141	35.55	96
85	185	60	140	35	95
84.44	184	59.44	139	34.44	94
83.89	183	58.89	138	33.89	93
83.33	182	58.33	137	33.33	92
82.78	181	57.78	136	32.78	91
82.22	180	57.22	135	32.22	90
81.67	179	56.67	134	31.67	89
81.11	178	56.11	133	31.11	88
80.55	177	55.55	132	30.55	87
80	176	55	131	30	86
79.44	175	54.44	130	29.44	85
78.89	174	53.89	129	28.89	84
78.33	173	53.33	128	28.33	83
77.78	172	52.78	127	27.78	82
77.22	171	52.22	126	27.22	81
76.67	170	51.67	125	26.67	80
76.11	169	51.11	124	26.11	79
75.55	168	50.55	123	25.55	78
75	167	50	122	25	77

°C.	°F.	°C.	°F.	°C.	°F.
24.44	76	— 0.55	31	—25.55	—14
23.89	75	— 1.11	30	—26.11	—15
23.33	74	— 1.67	29	—26.67	—16
22.78	73	— 2.22	28	—27.22	—17
22.22	72	— 2.78	27	—27.78	—18
21.67	71	— 3.33	26	—28.33	—19
21.11	70	— 3.89	25	—28.89	—20
20.55	69	— 4.44	24	—29.44	—21
20	68	— 5	23	—30	—22
19.44	67	— 5.55	22	—30.55	—23
18.89	66	— 6.11	21	—31.11	—24
18.33	65	— 6.67	20	—31.67	—25
17.78	64	— 7.22	19	—32.22	—26
17.22	63	— 7.78	18	—32.78	—27
16.67	62	— 8.33	17	—33.33	—28
16.11	61	— 8.89	16	—33.89	—29
15.55	60	— 9.44	15	—34.44	—30
15	59	—10	14	—35	—31
14.44	58	—10.55	13	—35.55	—32
13.89	57	—11.11	12	—36.11	—33
13.33	56	—11.67	11	—36.67	—34
12.78	55	—12.22	10	—37.22	—35
12.22	54	—12.78	9	—37.78	—36
11.67	53	—13.33	8	—38.33	—37
11.11	52	—13.89	7	—38.89	—38
10.55	51	—14.44	6	—39.44	—39
10	50	—15	5	—40	—40
9.44	49	—15.55	4		
8.89	48	—16.11	3		
8.33	47	—16.67	2		
7.78	46	—17.22	1		
7.22	45	—17.78	0		
6.67	44	—18.33	— 1		
6.11	43	—18.89	— 2		
5.55	42	—19.44	— 3		
5	41	—20	— 4		
4.44	40	—20.55	— 5		
3.89	39	—21.11	— 6		
3.33	38	—21.67	— 7		
2.78	37	—22.22	— 8		
2.22	36	—22.78	— 9		
1.67	35	—23.33	—10		
1.11	34	—23.39	—11		
0.55	33	—24.44	—12		
0	32	—25	—13		